	DATE DUE		
2-16			

NORTH AMERICAN INDIAN
JEWELRY AND ADORNMENT

From Prehistory to the Present

NORTH AMERICAN INDIAN JEWELRY AND ADORNMENT

From Prehistory to the Present

Lois Sherr Dubin

Original photography by Togashi,
Paul Jones, and others

HARRY N. ABRAMS, INC., PUBLISHERS

For my late parents, Shirley Rosenfeld Sherr and Louis Sherr,
wise and beloved elders, and my sister, Lynn Sherr,
a continual source of strength and inspiration

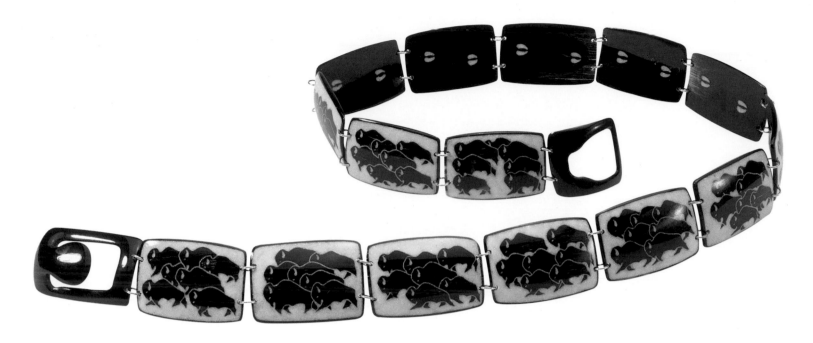

Project Manager: Margaret L. Kaplan
Senior Editor: Harriet Whelchel
Designer: Dana Sloan
Photo Assistant: Michele Adams

LIBRARY OF CONGRESS CATALOGING-IN-PUBLICATION DATA
Dubin, Lois Sherr.
 North American Indian jewelry and adornment : from prehistory
to the present
/ Lois Sherr Dubin ; original photography by Togashi, Paul Jones,
and others.
 p. cm.
 Includes bibliographical references and index.
 ISBN 0-8109-3689-5 (hardcover)
 1. Indians of North America—Jewelry. 2. Indian metalwork—
North America.
 3. Indian beadwork—North America. I. Togashi. II. Jones, Paul.
III. Title.
 E98.J48D83 1999
 739.27'089'97—DC21 98-37491

Printed and bound in Hong Kong

 Harry N. Abrams, Inc.
100 Fifth Avenue
New York, N.Y. 10011
www.abramsbooks.com

Above: Concha belt of inlaid buffalo horn. Kevin and Valerie Pourier (Oglala Lakota). Each of the fifteen conchas depicts a different grouping of seven buffalo; both buffalo and the number 7 are sacred to the Lakota. Across the back of the belt are pairs of inlaid hoof prints. 1997. Typical concha length, 2" (5.1 cm). Collection Dolores Schapiro

Page 1: See page 26.

Pages 2–3: See page 236.

Endpapers: Mosaic inlay brooches representing dancers celebrating the annual *Shalako* ceremony at Zuñi Pueblo. Leo Pablano (Zuñi). 1940s. Tallest, 5½" (14 cm). Collection Keith K. Kappmeyer

Binding: Stamped design after 1017, page 494

Author's Note
Because Native words have often been transliterated into English, several different spellings for the same word often exist. Also, the terms used to designate cultural groups have changed over the years. Throughout this book, the spelling and usage of Native words and group and tribal names reflect the latest information known to the author. I have tried to be respectful and accurate in each situation.
 To the fullest extent possible, Native peoples are presented in their own voices.

CONTENTS

ACKNOWLEDGMENTS

To write any book, but particularly one of this complexity and density, is both an intensive collaborative process and a huge commitment. This book brought with it many responsibilities: to the Indian peoples and their heritage; the artists and scholars upon whose work I have drawn; the galleries, museum staffs, and collectors, all of whom care deeply about the treasures—intellectual and physical—which they entrusted to me; and the publisher, Harry N. Abrams, Inc., who, once a book project is undertaken, assign enormous resources of staff, time, and finances to its production.

I have also been most fortunate during the course of this project. Although the book's general idea came about during a March 1989 dinner with Paul Gottlieb, the president, publisher, and editor-in-chief of Abrams, it grew in breadth and concept several years into the research, after long conversations with Navajo-Hopi jeweler Jesse Lee Monongye and Lakota artist and scholar Arthur Amiotte. Then, in the summer of 1992, I attended my first powwow (accompanied by godson Michael Berkowitz and close friend Robert Liu, editor of *Ornament Magazine*). After witnessing the beauty and depth of artistic talent exhibited through the stunning regalia at the Black Hills Powwow in Rapid City, South Dakota, it became obvious that I needed to spend substantial time in all regions within Indian country and meet a variety of artisans. Subsequently, I made repeated visits to several key areas, including the Black Hills of South Dakota and Wyoming; Crow Country in Montana; the Southwest's Four Corners area; Fort Hall, Idaho; Warm Springs, Oregon; the Wind River Reservation, Wyoming; and Philadelphia, Mississippi, home of the Mississippi Band of Choctaw Indians. I also traveled to the Hoopa Reservation in California, to Alaska and Maine, as well as important Native urban communities in Wichita, Toronto, Montreal, and Vancouver, Canada. Throughout these ten years, I met extraordinary people, conducted numerous interviews, and have only begun to understand the Native artisan's remarkably gifted heritage. It has been a great privilege and an illuminating way to gain insight into North America.

A thank-you to all the Indian artists, elders, and friends to whom I asked innumerable, sometimes dumb, questions and yet always received thoughtful, articulate answers. For giving me large chunks of their time and selflessly introducing me to other artists, I am grateful to Joallyn Archambault, George Blake, Fred Brady, Lynn Burnette, Sr., LaVerna Capes, Drusilla Gould, Rusty Houtz, Gerry Krausse, James Little, Rosalie Little Thunder, Richard McClelland, Jesse Lee Monongye, Dorothy Frost Naranajo, Verma Nequatewa and Bob Rhodes, Chad Nielsen, Linda Poolaw, Kennard Real Bird, Bill and Martine Reid, Ramona and Norman Roach, Knovotee Scott, Don Secondine, Linda Sheehan, Vicki Sherman, Charlotte Shike, Bob Smith, Ralph Stegner, Maxine Switzler, Emily Waheneka, Denise Wallace, Don Yeomans, and Mitchell Zephier. Lynn Burnette, Jr., interviewed Madonna Thunder Hawk, Rosalie Little Thunder, and Jimmy Oldman. The Southwest chapter owes much of its richness to interviews made possible by Joe and Cindy Tanner, who introduced me to their many artist friends. I am indebted to Barry Mowatt, for his introductions to Don Yeomans and Bill Reid, and to Eric Oesch, for his help throughout two visits to the Red Earth Native American Cultural Festival in Oklahoma City. Bill McLennan was generous with information and concepts.

Scholars and authors whose writings were pivotal for the book's direction—and for much of its foundation—include: Ted J. Brasser, David Brose, James A. Brown, Joseph Eppes Brown, Edmund Carpenter, K. C. Chang, Ralph T. Coe, Richard Conn, Kate Duncan,

Brian Fagan, Ann Fienup-Riordan, William Fitzhugh, Jill and Peter Furst, Wesley Jernigan, Alvin M. Josephy, Susan A. Kaplan, Jim Keyser, Armand Labbé, Tom Lowenstein, Evan M. Maurer, N. Scott Momaday, Alfonso Ortiz, Richard Pegg, Larry Penney, Ruth Phillips, Martine Reid, Doris Shadbolt, Leslie H. Tepper, David Hurst Thomas, Judy Thompson, and Ruth Whitehead. Of immense importance was the scholarly *Handbook of North American Indians* series published by the Smithsonian Institution. I consulted each volume with great frequency.

At the nearly one hundred museums and institutions where helpful staff members answered a range of requests and often worked with me for days, I particularly wish to thank: **Alabama Museum of Natural History**: Robert Huffman; **American Museum of Natural History**: Paul F. Beelitz, Lorann S. A. Pendleton, Kristen Mable, John Hansen, David Hurst Thomas, Lisa Whittall; **Anthropological Archives, Smithsonian Institution**: Paula Fleming; **Arizona State Museum**: G. Michael Jacobs, **Atka Lakota Museum**: Jim O'Donnell; **Buffalo Bill Historical Center**: Emma I. Hansen; **Canadian Museum of Civilization**: Odette Leroux, Judy Thompson, Louis Campeau, Margery Toner; **Choctaw Museum of the Southern Indian**: Martha and Bob Ferguson; **Denver Art Museum**: Nancy Blomberg, Cynthia Nakamura, Tom Berry, John French, Chris Stiles and William L. Ryan; **Duhamel Collection**: Robert Preszler; **First Nations Center, Toronto**: Pat Turner; **Gilcrease Museum**: Daniel C. Swann; **Heard Museum**: Diana Pardue, Deb Slaney; **Idaho Museum of Natural History**: Sharon S. Holmer; **Indian Arts and Crafts Board, U.S. Department of the Interior**: Meredith Stanton; **Indian Museum of North America at Crazy Horse Monument**: Ruth Ziolkowski; **Millicent Rogers Museum**: Guadalupe Tafoya; **Museum of Northern Arizona**: Paul Drummond; **National Museum of the American Indian**: Mary Jane Lenz, Janine Jones, Marian A. Kaminitz, Sharon E. Dean; **Natural History Museum of Los Angeles County**: Margaret Hardin, Chris Coleman; **Newfoundland Museum**: Kevin McAleese; **Peabody Museum of Archaeology and Ethnology, Harvard University**: Kathy Skelly, Martha Labell, Ann-Marie Victor-Howe, Amanda Proctor; **Rochester Museum and Science Center**: Charles F. Hayes, Martha Sempowski, Lorraine Saunders, Annette Nohe, Betty Prisch, Lea Kemp; **Shoshone-Bannock Tribal Museum**: the late Joyce Ballard, Drusilla Gould, Rusty Houtz, Lillian Vallely; **Sioux Indian Museum**: Paulette Montileaux; **South Dakota State Historical Society**: Claudia Nicholson, LaVera Rose; **Southern Plains Indian Museum**: Rosemary Ellison; **Southwest Museum**: Cheri Doyle; **Texas Memorial Museum**: Elaine Sullivan; **The Museum at Warm Springs**: Michael Hammond; **University of British Columbia Museum of Anthropology**: Bill McLennan, Jill Baird; **University of Pennsylvania Museum**: Lucy Fowler Williams.

Gallery owners who were enormously helpful include: Jack Bryan and Heddy Mann of Alaska on Madison, John Krena of Four Winds Gallery, Jeffrey R. Myers, Joseph Gerena, Steve Sonders of Red Earth Gallery, the late Lovena Ohl, Bill Faust III, Putt Thompson at Custer Battlefield Trading Post, Leona Lattimer, Margaret Kilgore, Marquetta Monongye, Gail and John Liman, Jon Bonnell, Pam King of Buffalo Gallery, Betsy and Grant Turner of Long Ago and Far Away, and Maureen Zarember of Tambaran Gallery.

I thank the following reviewers, who critiqued draft chapters: George Blake, Robert Bringhurst, Kari Chalker, Wilford Colegrove, Tanja Dorsey, Drusilla Gould, Michael Hammond, Alden Hayes, Armand Labbé, Michael Lekberg, Ricky Lightfoot, Richard McClelland, Claudia Nicholson, George Reed, Jay Selman, Vicki Sherman, Barbara Shumiatcher, Bob Smith, Cindy Tanner and Joe Tanner, Cathy Vogele, and Rosalie Solow Wolff.

Travel companions to Indian country during various stages of the book included: Rosalie Aslesen, Kari Chalker, Carol and Ralph Colin, Blas Flores, Esther Gushner, Mel Hammerberg, Karen and Alden Hayes, Jeffrey Hilford, Benta Hirsch, Margaret Kaplan, Michael Lekberg, Eveli (Evelyn Sabatie), Dolores Schapiro, Vicki Sherman, Lynn Sherr, Holly Whitmore, Lucy Fowler Williams, Jennifer Wolff, and Rosalie Solow Wolff.

Encouragement and help was given by: Jamey D. Allen, Ann Simmons Alspaugh, Richard Berkowitz, Trudy Berkowitz, Toby Bowlby, Robert S. Carlsen, Roch Carrier, Rosa Content, John Gray, Deirdre Haaf, John Haaf, Andrew Hilford, Randy Irwin, Sandra Kerno, Michael Lekberg, Martha Longenecker, Linda Martin, Terry Moore, Barbara Plumb, Denise Reich, David Rinehart, Mildred Rizzo, Bonnie Roche, Shoshana, Barbara Shumiatcher, Lea Simonds, Jim Stewart, Nancy and Don Todd and Leslie van Breen and Cathy Vogele, and Peter and Helen Weill. Gaye Fillmore both provided a home and led me to superb jewelry collections. The generosity of all the collectors, including Jean Harlan and Herbert and the late Bernice Beenhouwer, is gratefully acknowledged.

The superb work of photographer Togashi and also Paul Jones was augmented by the outstanding photographs taken especially for this book by, among others: Hillel Burger, Tom Fields, Karen Furth, Karen Hayes, Bill McLennan, Dick Meier, Trevor Mills, Billy Moore, Claude Sandell, Steve Schenck, Fred Schoch, Richard Spas, Simon Spicer, and Tom Travis. I also wish to acknowledge James Cook, Bruce Hucko, Eberhard Otto, Ann Parker, John Ratzloff, Debra Schuler-Murray, and Ulli Steltzer for the inclusion of their fine archival photographs, as well as Theresa and Paul Harbaugh of Azusa Publishing.

Beth Pacheco, Vivian Slee, Terry Guzman, Emilie Dyer, and Oren Safdie worked on various research, writing, and editing phases of the book, Oren for more than five years. Additionally, Beth thoughtfully edited many of the artists' interviews; Terry wrote the powwow essay in the final chapter. It is an infinitely better book due to each of their talents and input. Michael Guran is responsible for the glorious seasonal rounds and was the map design consultant; Jean LeGwin was responsible for the outstanding design and production of the maps; Rob Levine worked with the diagrams and drawings. Photographic assemblies were made by Bob Reed of Reed Photo Art in Denver.

At Harry N. Abrams, Inc., the finest of publishers, I thank senior vice president, executive editor, and friend, Margaret L. Kaplan; Harriet Whelchel, a gifted and sensitive editor; designer Dana Sloan, whose talent brought order and beauty; and Michelle Adams and Barbara Lyons in the photo and permissions department. I am especially grateful to Paul Gottlieb, an inspired, broadly based, and supportive leader. It is a rare privilege these days for an author to work so closely and respectfully with such a marvelous team throughout the book's production.

For contributing forewords, I am indebted to Chief Phillip Martin, David Hurst Thomas, and Lorann S. A. Pendleton.

Finally, there are those who cross friendship and professional boundaries, including Alan Morris, wise attorney and good friend, and Joe Tanner, whose depth of knowledge, sharing of information and many kindnesses frequently strengthened both me and the book. I consider a number of the artists as more than casual acquaintances and hope our relationships will grow in the years ahead. Thank you, Dilly Schapiro, for providing emotional support, and Rosalie Solow Wolff, astute critic and dear friend. Nina Safdie made many trips to New York from Montreal, and Dina Hoshen traveled from Israel to New York numerous times. Both helped develop the book's visual concepts. Tanja Dorsey shared discoveries with me as a traveling partner in Ontario and on the Northwest Coast. A deeply heartfelt thanks to David Goldberg not only for finding synonyms, but also just for being there. And to my sister, Lynn, as always, thank-you for your ever-present and loving guidance. It has indeed been a collaborative journey.

FOREWORD

by Chief Phillip Martin,

Mississippi Band of Choctaw Indians

Within these pages are gathered a magnificent array of beadwork, jewelry, and other regalia created by American Indians over more than a thousand years. These objects, appreciated by many for their characteristic beauty and craftsmanship, are material reflections of the inner spirit at work among the people who made them. They are also evidence of a long and rich history—a circle of American Indian cultures that have risen and prospered despite almost incredible odds. Adversities such as loss of home-land, the threat of physical and spiritual extermination, and generations of poverty and dependence have not quelled the American Indian spirit. It continues to thrive today.

Many Indian tribes, including the Mississippi Band of Choctaw Indians, are taking action to ensure that their traditions are kept alive. Among the Mississippi Choctaw, the study of Choctaw language and art forms are part of the regular curriculum in our tribal school system. We feel strongly that young people must learn to appreciate and value their tribal history. Without this basic understanding of what their ancestors have experienced, they will not be prepared to succeed in the future.

The opportunities available to Choctaw youth today have not always been so read-ily accessible. After the creation in the early twentieth century of the Choctaw Indian Reservation near Philadelphia, Mississippi, most of the Choctaw people were mired in dismal circumstances that included poverty, unemployment, lack of education, and dependence on ill-conceived and paternalistic government programs. Now, however, we are experiencing an economic, educational, and cultural rebirth that began with the formal reestablishment of the Choctaw tribal government by constitution in 1945. This federally recognized tribal constitution provided a framework for the economic, health, and educational reforms instigated and carried out by the current tribal administration. In that effort, the importance of local identification of need, local control over supply of services to tribal membership, and local ownership of tribal affairs cannot be overstated.

Since 1979, we have succeeded in bringing more than six thousand permanent, full-time jobs to the reservation, and the tribe is beginning to see the benefits of self-determination at work. Today, health and life expectancy among the Choctaw people are improving, better housing is available to them, children and parents are achieving educational goals, and families are prospering.

The thousands of jobs carried out on the reservation include the manufacture of wiring harnesses, printed circuit boards, and audio speaker systems for automobiles and the hand-finishing of greeting cards. These jobs require employees to pay close attention to detail and to exercise a degree of finesse as they assemble the sometimes very small and delicate pieces of their work. The skill and precision evident in such work being produced by Choctaw Indian employees is consistent with the quality of traditional Choctaw art forms, such as beadwork and swamp-cane basketry, for which our artisans are renowned.

The Choctaw language continues to be spoken in 85 percent of all tribal households. We keep our language alive by using it in everyday conversation, in homes, at school, and during community social functions. Similarly, we ensure that traditional forms of art and entertainment are kept alive by incorporating them into the fabric of our everyday lives. We regularly enjoy Choctaw dances, stickball games, and the preparation of traditional Choctaw foods. We remain active in the handcrafting of beaded jewelry and clothing and the weaving of baskets.

We firmly believe that the Choctaw language, as well as our historical forms of art and entertainment, are inseparable elements of our identity. There is something inside ourselves—part of what makes us Choctaw—that is visibly manifested in our works of art. While the availability of natural materials has often dictated what is created—for example, Choctaw basketry has developed in part due to the abundance of Misssissippi swamp cane—Choctaw artisans have always imbued their work with quality and substance. The materials, colors, and patterns that we use are full of history and meaning for each of us. We have received this information from our ancestors, who, in turn, had received it from their forefathers, and we continue the tradition. We understand the importance of remaining connected to the past in our everyday lives. In this way, we remember who we are and where we have come from, and this knowledge gives us direction for the future.

We hope that the objects and information presented here will inspire you to see and learn more about American Indian art, and that your exploration might bring you to visit the Choctaw Indian Reservation, where you would be a welcome guest. We invite everyone to step into our circle and join us as we celebrate in the light of our rekindled tribal self-determination and the continuing creation of Choctaw Indian art.

I would like to thank the author of this book, Ms. Lois Dubin, for her interest in American Indian people, including the Mississippi Choctaw. I have enjoyed long conversations with her and have listened with fascination to her stories of extensive travels and time spent among many different cultures and in lands both far and near. We very much appreciate her efforts to document the lives of aboriginal peoples throughout North America. This beautifully illustrated book is an excellent resource for school and public libraries and for students of all ages and origins. Even more important, it is a moving testament to the extraordinary talents within and enduring spirit of Native American culture.

FOREWORD

by David Hurst Thomas, Curator of Anthropology, American Museum of Natural History,

and Lorann S. A. Pendleton, Director, Nels Nelson American Archaeology Laboratory,

American Museum of Natural History

Two well-worn copies of Lois Dubin's *The History of Beads from 30,000 B.C. to the Present* sit in our archaeology laboratory at the American Museum of Natural History. It is a comprehensive, global overview of bead technology and trade patterns—a first-rate sourcebook that has been invaluable in our Spanish Mission archaeology program. Dubin's *History of Beads* is an authoritative reference found in research libraries around the world, appropriately recognized as one of the best such volumes ever written.

North American Indian Jewelry and Adornment is a very different book. Although the subject matter overlaps somewhat with her earlier work, Dubin's current approach and objectives differ dramatically. This book is not encyclopedic or comprehensive—nor was it designed to be.

This book is instead a "forum"—as Dubin puts it—a conversation connecting the art of American Indian ornamentation with the worlds that produced it. The author spent nearly ten years seeking out those who made the artwork shown here. And the text bristles with Indian voices. Artists describe what inspired them. They explain what they were trying to achieve. Knowledgeable tribal members help us understand what ancient archaeological artifacts may have meant to their makers, and what they mean today.

Lois Dubin argues that today's silversmiths and beadworkers have taken over from the traditional Native American shaman. Once, the shamans communicated spirituality through dance, music, and sacred imagery. Today, the spirit of the shaman carries on through the hands and mind of Indian artists.

By combining tribal traditions with extensive word-by-word testimony from con temporary artists, Dubin sets out a long-term Native American history—not history in the sense of tracing migrations or establishing DNA linkages between modern tribes, but rather a more fundamental kind of history that connects with underlying value systems and innate creativity. *North American Indian Jewelry and Adornment* explores something deeper than Indian history. It approaches a kind of archaeology of the mind.

Dubin cuts across the grain of conventional scholarship. In one sense, her approach appears slightly out of fashion; in another, she anticipates perspectives that are today making a dramatic comeback.

Let us explain this paradox.

Anthropologists have long been conflicted about what to do with Native American oral history. A century ago, archaeologists routinely worked closely with Indian people, believing that long-standing tribal tradition provides the best way to under-stand the past. Frank Cushing, for instance, was a nineteenth-century archaeologist who spent four-plus years among the Zuñi, mastering the language and receiving instruction in myth and ritual. Cushing would boast, "They love me, and I learn."[1] Although clearly exaggerating his degree of Native acceptance, Cushing's scholarship

convinced a generation that studying Indian traditions and migration tales would unlock the origins and evolution of Native Southwestern society. Adolph Bandelier, Jesse Walter Fewkes, Cosmos and Victor Mindeleff, among others, bought into Cushing's method of "conjectural history" for interpreting the archaeological past.

Then, in the early twentieth century, the pendulum reversed direction. Archaeologists and ethnologists began to mistrust the "real" historical content of traditional Indian knowledge. They worried that because mythology and folklore required non-Western perceptions of time, these transgenerational stories were fundamentally ahistorical.

Ethnographer Robert Lowie, in his 1916 *Presidential Address to the American Folk-Lore Society,* threw down the gauntlet:

The psychologist does not ask his victim for his reaction-time, but subjects him to experimental conditions that render the required determination possible. The palaeontologist does not interrogate calculating circus-horses to ascertain their phylogeny. How can the historian beguile himself into the belief that he need only question the natives of a tribe to get at its history.[2]

In an indelible fit of pique, Lowie concluded, "I cannot attach to oral traditions any historical value whatsoever under any conditions whatsoever."[3]

Many archaeologists would come to agree with Lowie. In the 1920s, a profound sense of skepticism greeted anybody relying on "primitive history" (Lowie's term) to reconstruct the remote past. Oral history was relegated to the realm of the "just-so story," perhaps retaining some ethnographic interest for study as such, but providing little factual information about the past. A new generation, sparked by Alfred V. Kidder, Nels Nelson, and Clark Wissler, promoted a new archaeology grounded in stratigraphic principles and more rigorous interpretation of archaeological materials. Over the next few decades, archaeology would turn its back on history, oral or otherwise. Post-Sputnik archaeology again reinvented itself with an emphasis on transcultural regularities and correlations. Science-minded archaeologists deliberately sought out allies in the generalizing social sciences, especially economics, political science, and sociology. By the 1970s, few archaeologists had any sustained contact with Native Americans at all.

Small wonder that American archaeologists came to perceive themselves as sole proprietors and reigning authorities of the remote Indian past. After all, we were taught, the Indians had all become cowboys.

And with authority came a certain power over that past. When archaeologists appeared as expert witnesses in court cases, their testimony would often carry more weight than that of tribal elders. Archaeologists wrote the books about First Americans, gave the public lectures, and taught the classes. Archaeologists generally controlled access to museum collections of Native American objects from that very distant past.

So it was that two histories evolved for ancient Native America. One was written down in books, taught in schools, and exhibited in museums—it was a history reflecting the perspective of the outsider, the conqueror of continents. An entirely different history existed in Indian Country, a history handed down by Indian people from elder to child, as tribal tradition, language, spirituality, ritual, and ceremonies—and, significantly, as jewelry and personal ornamentation. Such knowledge was acquired by living the culture and by listening to the tales of the elders, the parents, and the grandparents.

Today, many archaeologists have come full circle, recognizing that both historical pathways may have their own kind of validity. Many contemporary archaeologists (ourselves included) accept the once-tarnished notion that real history is indeed embedded in Native American oral tradition.

This relatively recent turnaround has required that archaeology reconsider its epistemological roots. To understand the past, many archaeologists would argue today, we must develop more empathetic, particularistic approaches. We must factor in not just human thoughts and decisions, but also such highly subjective elements as affective states, spiritual orientations, and experiential meanings. Such empathetic approaches assume that the inner experience of human beings is worthy of study both for its own sake and as a clue for interpreting the human past.

This is why Lois Dubin's approach is both antiquated and refreshingly new. She joins a new generation of archaeologists who are once again listening to Native Americans, who believe they are hearing some of the same history that archaeologists have long sought from the archaeological record. Dubin is a world-class listener.

She is also a gifted storyteller. In these pages, she tells us how Rhonda Holybear uses nineteenth-century ledgerbooks as inspiration for her extraordinary beadwork. She explains how a horse-tooth necklace protects horses from going lame (it is "just like insurance on a car"). She reveals why working silver is like riding a bucking horse, why deerhide should be brain-tanned and smoked, why buckskin fringe should be curved (not straight), why Indian artists refuse to haggle or bargain. She shares with us a Yukon River mask once designated as "degenerate art" by Hitler's Third Reich. She wonders over the value of a single turquoise-colored glass bead at Point Barrow in the 1880s (several thousand dollars, it turns out).

While reading the draft manuscript, we couldn't stop taking notes—lots of notes. The book is chock full of wonderful tidbits, object lessons about a past we did not know. These are not cultural traditions hygienically sealed in time. These are stories drawn from long-standing tribal traditions, yet they reflect changes that are still taking place.

From these perspectives, the outside forces of change (so-called acculturation) are not contaminating—they are enlightening. The art of ornamentation reflects how this history can be seamlessly integrated into contemporary expression.

NOTES
1. Cushing quoted in Hinsley 1981, 195
2. Lowie 1917, 163
3. Lowie 1915, 598

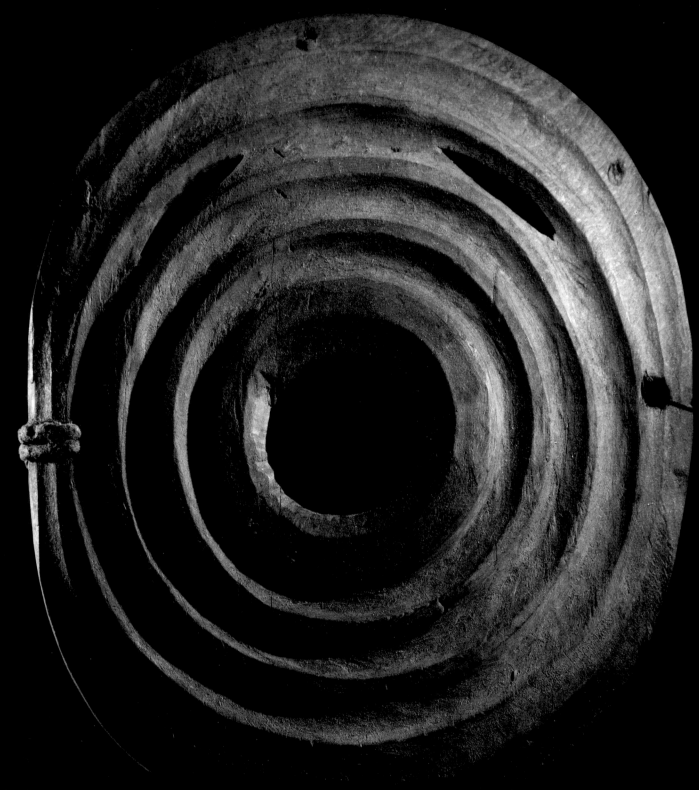

1 *The central opening in this Bering Sea shaman's mask simultaneously represents the sun and Hole-in-the-Earth, through which the shaman ascends or descends to the upper and lower worlds. The pattern of concentric circles emphasizes growth or energy emanating from a central point, a fundamental Native American concept. Collected at Razboinski, Lower Yukon River, late nineteenth century. Wood with red pigment and rawhide strap. Height, 7¼" (18.4 cm). Smithsonian Institution*

ENTERING THE CIRCLE

"In the traditional world of the nomadic tribes, one departs and returns. The journey is not linear and permanent . . . but circular and . . . continuous. And no . . . essential journey is complete until the return is made. Often the return is physical, as it was with the tribes that moved with the seasons, spiritually and in pursuit of game, returning always to their origin places, to their native grounds. One returns to one's native landscape whenever possible to renew oneself."

—**Charles Woodard, 1989**[1]

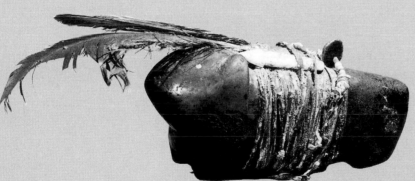

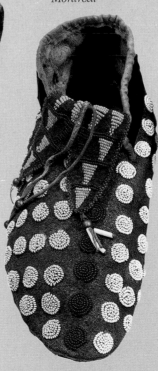

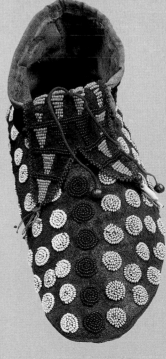

3 The circle is a recurring Plains motif: it has neither beginning nor end, and it symbolizes the sun, the moon, the calendar year, and life itself. The red-ocher backing identifies these as a shaman's moccasins. Blackfoot. Nineteenth century. Hide, beadwork. Length, 10½" (26.7 cm). McCord Museum of Canadian History, Montreal

2 *Stone bear fetish with an attached arrowhead and feathers. The animal ally is joined in spirit with the hunter, who seeks its blessing. Zuñi Pueblo. Late nineteenth century. Height, 2⅝" (6.7 cm). The Metropolitan Museum of Art, The Michael C. Rockefeller Memorial Collection, Bequest of Nelson A. Rockefeller, 1979.206.434*

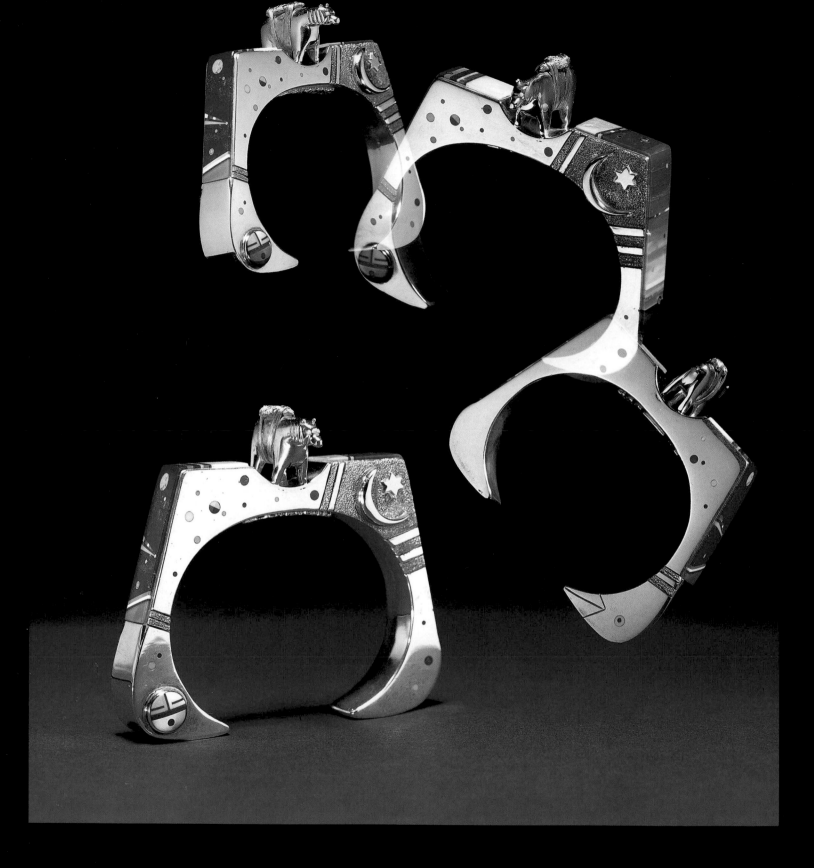

Though not a hunter, I am certainly a gatherer. I rarely return from Indian country without carrying home a bracelet, necklace, or buckle, all of which form permanent links with their makers and the places I have journeyed. *Bear Looking Over the Universe* connects me to Jesse Lee Monongye, his Navajo and Hopi people, and the luminous Southwestern landscape. Aleutian jeweler Denise Wallace's sea otter-woman transformation pin/pendant (168) brings memories of otters embracing pups amid Pacific Ocean kelp. Knokovtee Scott's carved purple mussel-shell earrings (380) recall Oklahoma's gifted Creek and Cherokee artisans.

Why do I have such a visceral response to Indian jewelry and beadwork? What lies behind this work's universal appeal? In an era of increasing separateness, Native American art provides connections: the objects feel familiar, not arbitrary. Southwestern turquoise and Great Plains beading are recognized hallmarks of past cultures. Not as well known is the wide variety of contemporary Indian adornment being created throughout the continent. Design and technical excellence still define Indian jewelry, beadwork, and ceremonial clothing.

In my Manhattan apartment I touch a beaded Lakota pouch and reflect on the colors, textures, and sounds of a northern Plains powwow. Native American adornment, layered with artistry and content, stimulates thought. How, I wonder, have the Indian people not only survived near annihilation but also continued to produce such a concentration of superb artisans within a relatively small population—approximately 2.5 million registered tribal members in the United States and Canada. The abundance of Native talent is one of America's best-kept secrets. Gallery owners like the late Lovena Ohl knew. Those close to Native Americans know. The Indians themselves know, but their abilities are so innate they insist the extraordinary is ordinary. What influences have made this remarkable cultural continuum possible?

Spirituality, the foundation of Native peoples' lives for thousands of years, is ultimately responsible for their survival as well as for the intrinsic quality of creative activity. American Indian aesthetics cannot be understood apart from the sacred. Yet few if any words existed in Native languages for either art or religion. Artifacts were generally created as items to be used, not as "art." Today's Native Americans remain deeply spiritual, and artistic expression continues to be woven into the fabric of daily life. The pragmatic connects to the sacred, the artifact to the belief system, and individuals understand their place within the universe.

This book presents an overview of Native North American adornment from the earliest times to the present. It attempts to be neither encyclopedic nor definitive, but to present high points and representative adornment examples throughout Indian America's long history. In the absence of written languages, adornment became an important element of Indian communication, conveying many levels of information.[2] During the late nineteenth century, wearing Native clothing signaled resistance to assimilation. It remains a major statement of tribal and individual identity.

The book is divided into cultural and geographic regions, a helpful concept for describing human adaptation to particular environments. Thus the close relationship of Native Americans to their natural surroundings as seen within a historic context provides the book's conceptual framework. However, boundaries should be regarded with caution since an area's residents may share more with the people in adjoining regions than within their own areas.

Native beliefs are expressed as much as possible from the Native perspective; rather than speak for the people, I have attempted to provide a forum. To experience first-hand attitudes and feelings, I traveled throughout Indian America, an itinerary that took me to dozens of remote reservations as well as urban communities.

4 *Seen here from various angles, this bracelet, which creator Jesse Lee Monongye (Hopi and Navajo) calls* Bear Looking Over the Universe, *connects daily, seasonal, and cosmic cycles. From one viewpoint, the bracelet displays a Navajo setting-sun motif; from another, Venus the planet, a crescent moon, and the approach of night. The migration of geese represents the change of seasons. A Zuñi bear fetish with attached arrowhead symbolizes the unity of man as hunter and bear as spirit helper. 1995. 14-karat inlaid gold, silver, lapis lazuli, opal, turquoise, sugilite, coral, gold-lip oyster shell. Height, 2½" (6.4 cm). Private collection*

5 *The composition of this Naskapi robe illustrates the worldview of the northeastern boreal forest hunters. Wearing the robe placed a hunter or shaman in contact with the spirit world, assuring the sun's return, the world's renewal, and the reappearance of the caribou. The pattern, divided into three rectangular sections (cosmic zones) is linked by a cross, symbolizing the four cardinal directions, and the Great Soul Spirit. The Great Soul Spirit's representative, the sun, is the central image from which curving lines spiral out, connecting plant and animal growth with the sun's power. Two outer sections contain stylized trees and plants, suggesting the forest and summer (the best time for the hunt). The middle section displays caribou antler symbols, representing the winter caribou herd.*

Parallel lines and rows of dots— the trails and tracks of animals—surround the central images. The white of the skin associates at once snow, winter, and the caribou. Designs were painted with the sacred color red, representing heat and fire (sun) and blood (life), and a blue-green pigment. An overall golden cast results from aged fish glue. Ritualism connected to creating and wearing the robe also focused upon the sun, of prime importance for survival in northern latitudes. To absorb the sun's power, designs could only be painted as the sun was rising. When not worn, the painted side of the robe was hung outside facing the sun, both to please the spirits and to garner new energy. All other times, the magic paintings were hidden from view. Even while luring caribou, the hunter wore the robe with the painted designs inside.

Red fringes, beaded pendants, and ribbons also were added to the robe only while the sun was rising. The red-painted fringes, often detached from the robe and worn as necklaces, recall skeletal imagery (pages 43–45). T-shaped endings of the robe's painted cross with the dot-in-circles motifs further suggest joint markings and skeletal motifs.

By the 1930s, caribou were scarce and nomadic lifeways were curtailed. Although the robes are no longer made, they encompass spiritual concepts that remain important to contemporary Naskapi. Collected, Labrador, c. 1740. Tanned caribou skin, porcupine quills, paint, fish glue, brass, hair, quillwork. Length, 46½" (118.0 cm). Canadian Museum of Civilization

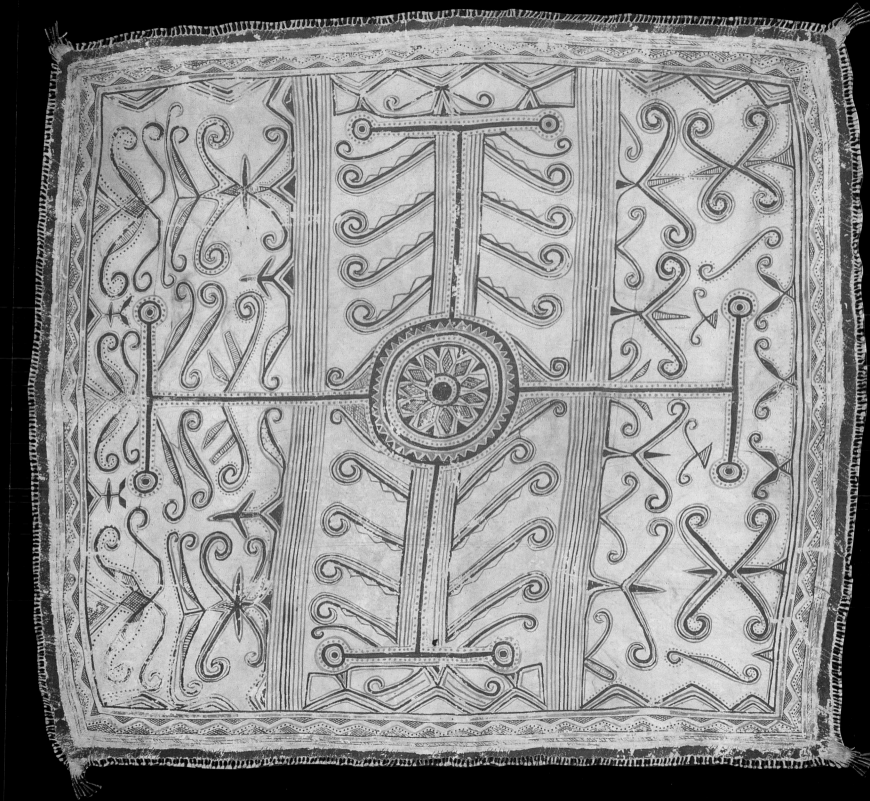

Documenting information involved eight years of encounters across the United States and Canada. Much depended upon circumstance. What was found during one visit might be gone by the next. These are quickly changing times.

I conducted research at museums and institutions, galleries, private collections, and reservations. Tribal members helped me decipher historic artifacts, revealing the depth of lore contained within Native America's adornment. Contemporary artisans are keenly aware of their responsibility as "guardians of traditions"[3] from which their imagery and inspiration derive. In interviews with me, they generously and eloquently describe this process, which provides insight into a remarkably adaptive heritage. "What's important is that we keep our traditions flexible," remarks Deron Twohatchet, a young Kiowa filmmaker. "It's amazing how our craftspeople keep incorporating new materials and using them for traditional adornment and clothing."[4]

Though my initial focus was on individual and tribal uniqueness, a larger picture became apparent. In transcribing more than two hundred taped interviews from all regions, I was stunned by numerous similarities in thinking, values, and even phrases. Therefore, I chose to emphasize equally commonalities that were not preconceived but that emerged during the information-gathering process. The essence of these intertribal connections—the Native American's ability to function within several worlds while maintaining a spiritual core—appears to rest upon an ancient construct of shamanism.[5] The practice of shamanism not only links groups within Native North America, it also may link Native North America with ancient Northeast Asia. Anthropologists have suggested widespread cultural diffusion from mainland Asia throughout the Pacific Rim. Formal and stylistic similarities in some Native North American and Asian objects provide further evidence of cross-cultural connectedness.[6]

I realized that to write with minimum intrusiveness, I had to enter the Native mindset. Indian concepts of connectedness merged neatly with my education in landscape architecture and ecology. I fully appreciate a pragmatic approach to design. When I asked Yakama beader Delores George why Plateau people beaded green or purple horses during the late 1800s, she replied, "Because we were at the end of the trade routes, and these were the color beads left for us to work with."[7] Above all, I've had to depart from Western linear thinking and enter Indian circular time.

A circle of reciprocity connects nature, Native Americans, and adornment. Central to the visual language of Indian people is the belief that all creation—animals, plants, rocks, water, stars, and sun—is imbued with spiritual energy and shares the world equally. Artifacts link humans and animals, the physical and the spiritual (6, 10, 82). Wearing a bear mask, a shaman reveals his bear spirit (81). These artifacts take many forms—amulets, masks, and clothing, for example—all reflecting humankind's oneness with nature: everything is interdependent and must exist in harmony.

The concept of circularity informs Indian thought and art. All of life participates in a continual cycle of birth and rebirth. Solar and lunar cycles are acknowledged daily. Phases of the moon coincide with menses and pregnancy cycles, as well as agricultural cycles and tides of the seas. Time revolves around seasons and patterns of movement (seasonal rounds) from one food source to another. The cosmic circle, symbolized by sacred sun and four cardinal-direction motifs, is a recurring theme in Native iconography. Wearing a pendant with sun and four direction motifs aligns one's personal circle within the universal circle (8).

As part of the universal circle, the tribe encircles the family; at the circle's core stands the individual, who also passes through the life cycle. Tribes link to other tribes through circular trade routes and reciprocal gift-giving practices. In earlier times, ritual, in tandem with seasonal cycles, helped to order life around a ceremonial center

for both the individual and the group. While boundaries may change, rituals remain constant.

Conjunctions of the moon, stars, and planets were closely observed and understood as having power to affect life on earth. The Chumash of southern California depicted stars and constellations on shell ornaments and deer-bone whistles to form star maps (905).[8] All tribes participated in ritual circuits mirroring the sun's path from east to west.

Duality (paired opposites) is implicit to the fundamental Native belief in harmony (see pages 220–221). Within a layered cosmos exists opposing spirit forces of Sky World and Under World. In between is This World, the earth, which is conceived by many tribes as an island. The humans in This World must maintain equilibrium. Integral to this effort is the shaman, a mystical figure who journeys through all these worlds and connects the present to the distant past. Shamans were believed to have extraordinary abilities to communicate with the supernatural. They could see spirits, travel across space, or transform themselves into other creatures. Able to foster a balance of spiritual opposites, they served as intermediaries between people, animals, and spirits.

Much Native American art is directly influenced by shamanistic practices. Many tribes believe that creativity is "a personal gift from the spirits . . . and a form of divine inspiration."[9] Though shamans themselves rarely wear ornamentation, numerous shamanic themes appear in Native American adornment. Since shamanism rests upon multiple states of being—and the transition between these states—and relies on performance (drums, songs, dances) more than the visual (paintings, jewelry, elaborate costumes), shamanistic artifacts are strongly tied to ritual use as opposed to static display.[10]

The predominance of animal images on shaman artifacts is linked with the animal world of the hunt and the ability to communicate with those beings that provided food, clothing, and shelter. Antler headdresses (34) are shamanic metaphors indicating the unity of man and animal.[11] Shaman motifs found throughout Native America include animals and humans with skeletal imagery (43–50), spirit lines (lifelines depicting spiritual power or energy: see 254, 266), and the cosmic tree (813), a vertical axis connecting the upper and lower worlds climbed by the shaman in his ecstatic journeys.[12]

Nature is imbued with spirits: some are benign helpers, others terrifying and threatening. All are powerful. Creatures who transcended boundaries by existing in simultaneous worlds (as shamans did) were accorded special esteem and served as shaman spirit helpers. Birds' ability to fly symbolized shamanic heavenly journeys; waterbirds—loons and ducks—represented the shaman's ability both to descend underwater and ascend to the sky. Frogs, transformed from aquatic tadpoles to terrestrial quadrupeds, transmitted power to Northwest Coast shamans through their tongues.[13]

Across Native America, teachings are conveyed by sacred clowns or tricksters, such as coyote, who challenges society's taboos. Hero and jokester, creator and destroyer, the clown's actions serve to remind of realities beneath idealized surface appearances.

As identities are ambiguous, objects too defy categorization. Purposeful items, well conceived to accomplish a task, are simultaneously aesthetic and designed to honor and mollify the spirit world. Garments, jewelry, and tools incorporating spirit motifs are spiritually endowed, eliciting help and protection for the owner. Ivory snow goggles, worn by an Arctic shaman to prevent snow blindness, were also engraved with spirit-helper motifs to empower the wearer (129).

Significant to the Native world in which everything continues and nothing ever ends is the concept of simultaneity: coexistent realities, only one of which is typically

6 *Triple transformation dance mask: (1) a sculpin or bullhead (deep-sea scavenger) transforms to (2) Raven-of-the-Sea, finally emerging as (3) Born-to-Be-Head-of-the-World. Successive images disclose the multiple identities this legendary hero is capable of assuming. When the mask is fully open, characteristics from all three creatures are seen simultaneously. Sculpin eyes are painted on the inner surface of the first section, raven features are depicted inside the middle section, and Born-to-Be-Head-of-the-World's powerful face gazes out from the mask's center. Kwakwaka'wakw (Kwakiutl). Collected Hopetown, 1902. Wood, rope. Length 35" (89.0 cm). American Museum of Natural History, 16/8942*

7 *A shaman's box of helper spirits includes a doll, sealskin amulet, faceted Venetian glass beads, fossil shell with an attached aggregate, etched pendants, and claws that were placed on fingers for transformation. The doll was used as a helper to exorcise evil spirits and/or in curing ceremonies. The wooden box is inset with Chinese-made blue glass beads, highly valued throughout North America. The etched pendants resemble Tutchone, Beothuk, and Tlingit pendants seen in 200, 201, and 802. King Island Eskimo. Collected at Point Barrow, Alaska, nineteenth century. Doll height, 5¼" (13.3 cm). Collection Jeffrey R. Myers*

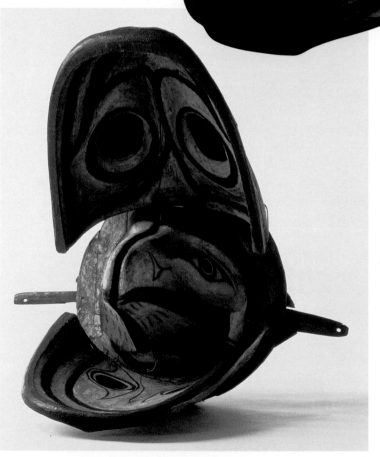

1

2

3

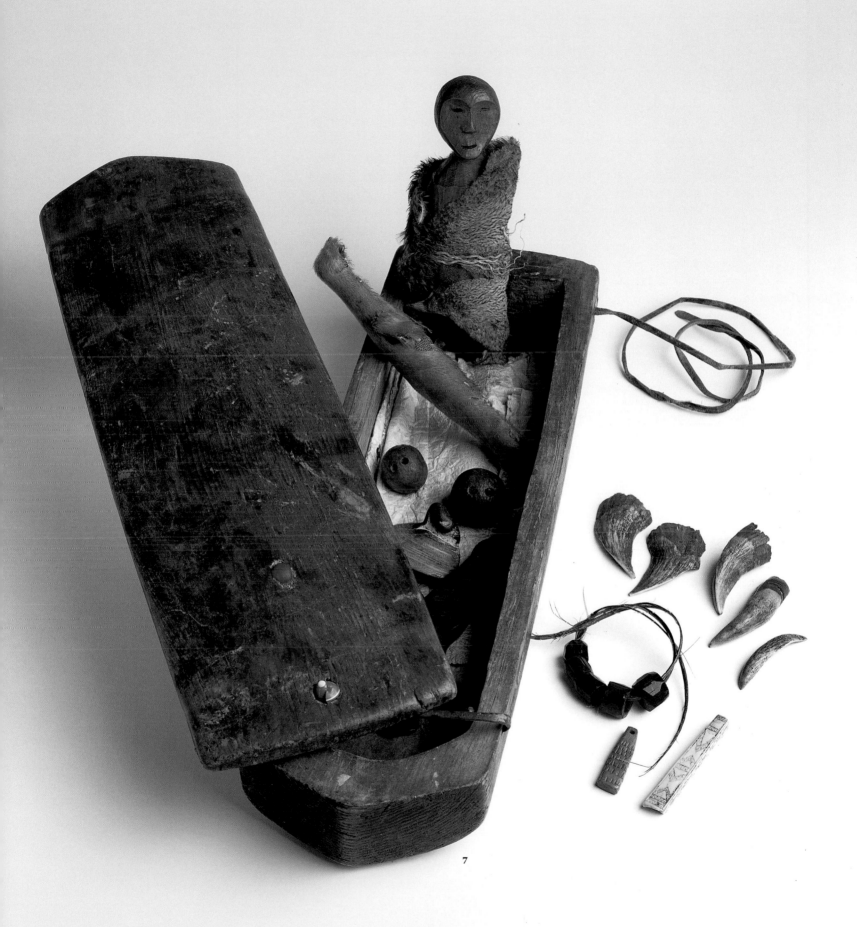

revealed at any given time.[14] Kwakwaka'wakw (Kwakiutl) composite masks (6) included multiple beings "with little indication of where one ended, and another began."[15] When everything has life, even masks and jewelry are sentient and may wear their own adornment. Thus evolved "adorned adornment" (75, 76).

The Naskapi of Labrador painted beautiful imagery on finely crafted hide coats to honor the caribou who gave its life for the clothing (5). It was also believed that live caribou would be pleased with the respectful treatment accorded their skins and willingly appear during the next hunt. The robe was a Naskapi hunter's most sacred and efficient tool.[16] Vision quests, a time of isolation and fasting when spirit helpers appear in dreams, are valued personal rituals. Incorporating the helper's persona into clothing and adornment affirms the experience (489).

Festivals provide opportunities to wear one's finest garments and jewelry. Ceremonial regalia, the major form of visual artistic expression, is a complex assemblage of clothing, ornaments, and body decoration, all meant to contribute toward an individual's self-presentation.[17]

Ceremonies emphasize reciprocity through public displays of gifting. Social status and power accrue to those who give. Acquiring prestige, more important than the accumulation of wealth, requires generosity. Exotic adornment distributed to priests and warriors helped Mississippian chieftains consolidate power (278). Dispersing a cache of silver and copper bracelets at a nineteenth-century Northwest Coast potlatch (a ceremonial giveaway) brought prestige to the giver (833).

Within the many beliefs and uses represented in the vast array of Native adornment, several important underlying concepts can be recognized. Inherent within Native ornaments and clothing is movement. A sense of movement might be incorporated into the imagery itself to reflect the life force represented by the image. In other cases, elements such as animal teeth or claws, quills or feathers, added motion and drama: "To move—particularly in ceremonial clothing—was to experience the click and clash of teeth and dewclaws, the swaying of feather tufts."[18] Adornment created for performances was elaborated among the Northwest Coast tribes (807) and Katsina dancers of the Pueblos. On the Plains, people and horses adorned in beadwork, fringes, and feathers (508) were meant to be viewed on the move.

Hidden (or private) imagery, understood only by the artisan or owner, conceptually relates a Plains vision-quest necklace (page 247) to a Southwestern Hopi bracelet (1129). Such self-directed designs are intended for viewing from the wearer's perspective.

The nomadic lifestyles of many Native tribes encouraged adornment, objects that could easily be worn or carried. The monumental scale of the Northwest Coast's totem poles and canoes (773) should be understood in the context of their surrounding forests, where trees two hundred feet tall were common.[19]

Finally, an overriding concern for quality is intrinsic to Native adornment, which is marked by skill and craftsmanship, signifying a unity of beauty and function. "To live and work properly, according to tribal ideals and rituals, was an affirmation of one's spiritual world view."[20]

Native American communities build upon ancient traditions. The styles and materials of nineteenth-century Delaware bandolier bags mirrored forced migrations from the Atlantic Coast to the Midwest, Texas, and Oklahoma, while also maintaining a "Delawareness." Joe Baker, a fourth-generation member of the Whiteturkey family, completed a bag in 1995 that poignantly brings Delaware beadwork into the present (355). The Shoshone-Bannock of Fort Hall, Idaho, pass family beadwork patterns down through generations. Great-great-grandmother's designs adorn her grandchildren's

powwow regalia (691). Among the Lakota of South Dakota and Crow of Montana, geo-metric motifs on buffalo parfleche bags reappear within contemporary beadwork and silver jewelry (514). The economic growth of the remarkable Choctaw band of Mississippi has permitted the florescence of traditional tribal beadwork and basketry (392, 395, 410). Artisans of different tribes continue to inspire each other. Elaine Buchanan Bear (Winnebago) and Paul La Rose (Northern Ute–Shoshone) together bead the same dress (1218). Tis Mal Crow (Lumbee-Hitchiti) works with Great Lakes and Basin imagery (465) and wears Plateau beaded regalia. Native and non-Native artisans still borrow from one another.

Native North American adornment crosses categorical boundaries. Body paint, tat-toos, amulets, masks, and hunting hats—all adornment—are worn both for beauty and as visual prayers for protection. The timeless concept of *simultaneity* (multiple layers of reality) gives form to artifacts. Ancient iconography is interpreted with contemporary materials. More than beautiful ornamentation, adornment is a visual language express-ing the joy of creativity, pride in attention to craftsmanship, and the desire to share with others. Above all, it honors oneself as well as one's people by doing things well.

—L. S. D.

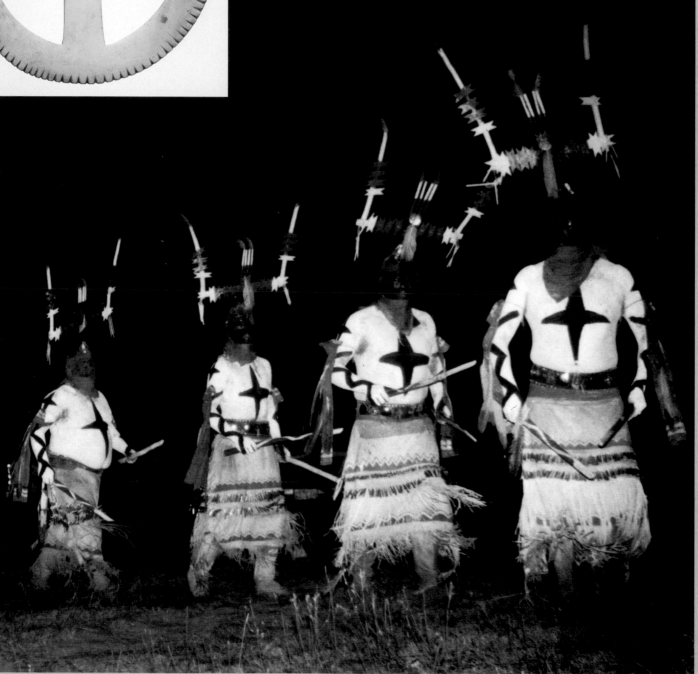

◁**8** *A Mississippian culture shell gorget (neck or breast ornament) with sacred sun, concentric circles, and cardinal-direction imagery. An equal-armed cross symbolizes the four directions as well as the four seasons, which, when identified with directional winds, ensures life-giving weather. Horizontally, the cross with its four quadrants placed upon a sun circle is a cosmic map. Vertically, earth and cosmic tree form the cross design. The motif also represents a path with openings into Sky World and Under World, enabling shamanic access to the spirits. Key Marco, Florida, A.D. 1000–1400. Diameter, 4½" (11.29 cm). The University of Pennsylvania Museum, 40891*

FORMING THE CIRCLE
THE EARLY AMERICANS

"I think that each of us bears in his genes or in his blood or wherever a recollection of the past. . . . Even the very distant past. . . . In the case of the Kiowa, it's a remembering of the migration. A remembering of coming out of the log. A remembering of crossing the Bering land bridge. . . . I have a sense of the Kiowa's existence as a people from the time they lived in Asia to the present day."

—**N. Scott Momaday (Kiowa), 1989**[1]

◁ **9** *Chiricahua Apache mountain spirits (gaan) of eastern New Mexico are believed to live within the mountains. During ceremonies, four dancers impersonate the spirits, each representing a cardinal direction. They are assisted by a sacred clown, whose carnal behavior compels the group to look behind illusionary appearances to see reality. The carved and painted headdresses are revered: their "horns" recall the gaan spirits who protect game animals; the two short wooden dangles ("earrings") at the end of each support "strike one another like chimes." 1991*

10 *Native North Americans believe that everything—animal and plant, wind and rock—has a life-energy force that is spiritual, not physical. Contoured beaded lines within this Nez Percé pouch appear as echoing waves of the encircled and undoubtedly spiritual center motif. Emphasizing life's connectedness, the sharp pointed symbol represents simultaneously the four directions, with the rising and setting points of the winter and summer solstices, Morning Star, the sun, the whirling four winds, and a flower. 1870s. Glass beads, cloth, hide. Width, 7¾" (19.7 cm). Collection Tambaran Gallery*

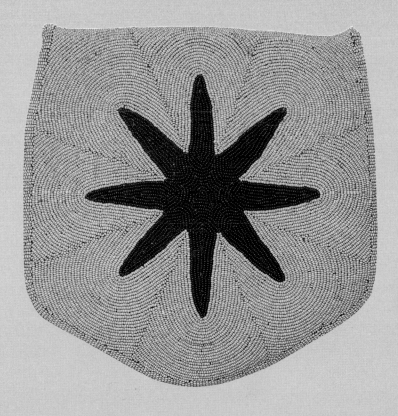

11 *A buckle and earrings display traditional and contemporary sun motifs. Lee Yazzie (Navajo). 1980s. Silver, turquoise. Buckle length, 2¾" (7.0 cm). Collection Tanner*

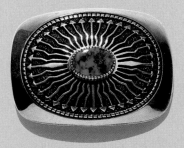

ORIGINS: ESTABLISHING THE CONTINUUM

The Americas have been inhabited for at least fourteen thousand years, and possibly as early as thirty-five thousand years ago. It is believed that the peopling of the New World coincided with the explosion of human settlement that took fully modern humans, *Homo sapiens sapiens*, to all parts of the world after 38,000 B.C.[2] Populating the Americas is estimated to have occurred during three periods, each lasting several thousand years. According to physical anthropologist Christy G. Turner, the peoples often referred to as Paleo-Indians were among the first wave. Dispersed and settled throughout North and South America, they are considered the forebears of most contemporary Native American people. The second wave, the ancestors of today's Dene, Navajo, Apache, and Northwest Coast Indians, moved from eastern Siberia and the interior of Alaska southward into the New World. A third wave, the ancestors of the Eskimo/Aleuts, settled along the Alaskan coast and the Aleutian Islands.[3] Five main language groups generally correlate with these migrating groups: Paleo-Indians, thought to be Algonquian or Iroquoian speakers—Algonquians were once spread broadly across the North American continent; Iroquoians lived in the eastern United States and eastern Canada; Uto-Aztecan groups, who lived in the western United States to Central America; Athapaskan speakers living in Canada, the Northwest, and southwestern United States and Mexico; and Inuit (Eskimo) and Aleut peoples living in the Arctic.

Anthropologists have long postulated that entry into the New World was across the Bering Strait when lower sea levels created a thousand-mile-wide land bridge, called Beringia, joining Siberia and Alaska. Others theorize that maritime-adapted peoples may have journeyed along Pacific Coast routes rather than an interior ice-free corridor. While genetic evidence implies a strong link between Native American and Asian peoples,[4] the connections are more than biological. Artifacts and burial customs from Ipiutak, a whale-hunting town located near Point Hope, Alaska, inhabited from the second to sixth century A.D., resemble those of northeastern Asian and early Chinese cultures and speak of similar, fully developed cosmologies.[5]

Not all Native Americans accept the one-way Bering Strait origination theory. Tribal creation stories join Indian beginnings with the land itself. In contrast to Judeo-Christian scripture, the aboriginal cosmos was not viewed hierarchically with man "created in God's image" at the apex. Rather, God (the Creator) is manifest in all matter and each life form. Robert Smith (Oneida) says, "Many Indians believe that this land—the Americas—was the Garden of Eden and the Indians were not thrown out because we did not disobey the Creator. We lived in harmony with his creation."[6] Lakota scholar Vine Deloria, Jr., challenges scientific migration and evolution theories, preferring truths preserved within tribal oral histories and sacred traditions.

Through storytelling, Indian elders teach cultural and moral values to the younger generation. In the distant past, artisans added an important dimension to oral tradition, recording the beliefs of their peoples in a visual language of motifs and symbols. Some are mysterious and obscure; others are open and familiar. Many suggest connections with shamanism. "Symbols were painted in an attempt to gain some measure of control over threatening forces or poorly understood phenomena, to safeguard the balance of power in the universe and the continued prosperity of the group. Thus the art can be considered a religious expression made in an effort to propitiate the supernatural."[7]

Themes appear to have traveled from Paleolithic Asia to the Americas

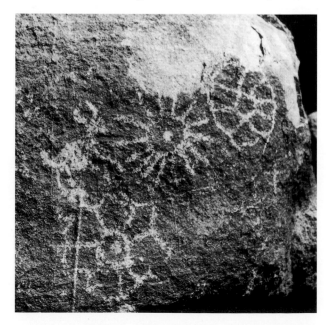

12 *Petroglyphs of ancient sun motifs; two (top right and bottom left) suggest both a sun and a squash blossom. Saguaro National Monument, Arizona*

and across the American continent with the never-ceasing movements of the Native peoples. Iconography displayed on Chinese and Native American artifacts—splayed figures, skeletal imagery, beastly creatures on masks, upper- and lower-world spirit helpers, and the use of red ocher—transcends geographic and historic boundaries.

AN ADORNMENT OVERVIEW: PALEO-INDIAN TO EUROPEAN CONTACT

Throughout North America, the retreat of the glaciers was marked by increasing diversity in environment and signs of human movement and adaptation. Scholars speculate that a major movement, called the New Haven retreat, occurring around 15,000 B.C., opened up new routes into the North American continent and fostered the spread of the Paleo-Indian peoples, who date conservatively from 13,000 B.C. to 6000 B.C. Paleo-Indians dressed in hides and finely woven fabrics of plant material, wore jewelry, and participated in ritual. At the Anzick site in Montana (c. 9500–8500 B.C.), two children, covered with red pigment, were buried with more than one hundred artifacts of stone and bone.[8]

To make their own ornaments, Paleo-Indians tended to work local and readily available materials, but they eagerly sought rare materials for prestige items. To obtain the unusual, they established an extensive trade network that crisscrossed the continent. Alibates agate, a mottled or banded red, blue, and purple stone, was traded from its Texas quarry, starting around 9000 B.C. and continuing through historical times.[9] Obsidian (volcanic glass), valued for tools and ceremonial regalia, has been found on archaeological sites far from its place of origin. Edziza, a British Columbia obsidian quarry, was in use from 8000 B.C. until European contact.[10] A string of fifty olivella shells from the California coast, dating about 6000 B.C., was excavated from a Nevada site.

Burials of the Archaic Woodlands period (c. 8000–1000 B.C.) frequently contained red ocher, perhaps associating red pigment with blood and life. Over time, Archaic groups became specialized hunters and gatherers and settled into more precise territories, especially where abundant year-round food resources were available. Group size increased, as did the use of adornment. Russell Cave, on the Alabama-Tennessee state line, was occupied as a winter hunting camp from about 7000 B.C. to A.D. 1000. Bone and antler beads and one possibly of marine shell, dating from 7000 B.C to 5000 B.C., were recovered.

Shell was coveted, and the raw material traveled great distances. Pacific Coast shells are found as far east as the upper Missouri River area and were common in the Southwest. Native copper beads from the Lake Superior area were traded to other regions as early as 3000 B.C. Stone beads carved by Poverty Point southeastern artisans (c. 1500 B.C.) portend the spectacular jewelry and regalia of ancient eastern Woodlands traditions of about 1000 B.C. to A.D. 1500 (264–81).

As precontact clothing was made of organic, perishable materials (skins, fur, feathers, fibers), most ancient garments are known from contemporaneous art: Mississippian etchings, Archaic effigy figures, and petroglyphs (278, 645, 646). Journal descriptions of traders and explorers provide insight into early contact times.

The earliest recorded European–Native American trade occurred between tenth-century Vikings and Arctic Inuit (Eskimo) peoples. At L'Anse aux Meadows, an eleventh-century Viking site in Newfoundland, archaeologists found a small, spherical, clear-glass bead. As Viking women wore glass-bead rosaries, it is uncertain whether the first bead was imported for ornament or trade. Long before Europeans arrived in the sixteenth century, their goods traveled along Indian trade networks. A perforated Norse coin, minted A.D. 1065 to 1080, was found near Maine's Penobscot Bay in twelfth- or thirteenth-century contexts. Probably obtained from Vikings, the coin was carried south by Native traders.[11]

EUROPEAN ENTRY INTO NORTH AMERICA

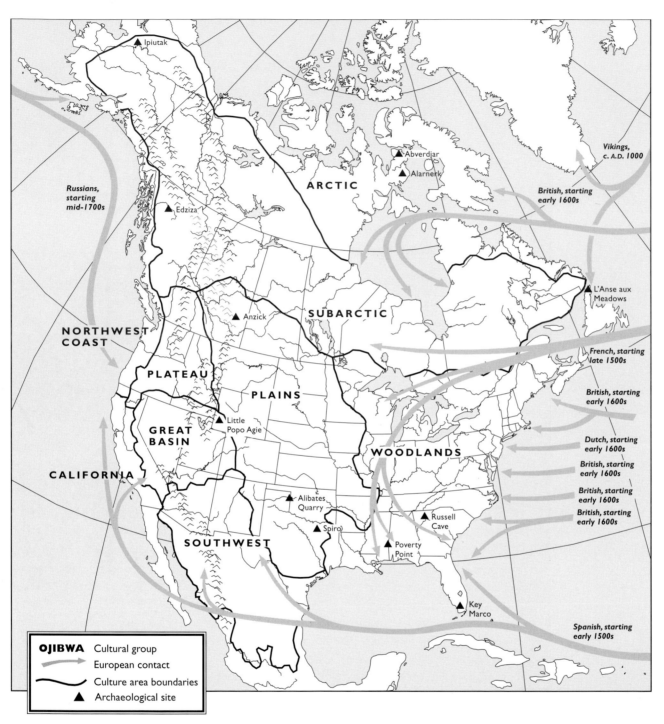

Russians, starting mid-1700s

Ipiutak

ARCTIC

Abverdjar

Alarnerk

Vikings, c. A.D. 1000

British, starting early 1600s

Edziza

SUBARCTIC

L'Anse aux Meadows

NORTHWEST COAST

Anzick

French, starting late 1500s

PLATEAU

PLAINS

British, starting early 1600s

GREAT BASIN

Little Popo Agie

WOODLANDS

Dutch, starting early 1600s

British, starting early 1600s

CALIFORNIA

British, starting early 1600s

British, starting early 1600s

Alibates Quarry

Russell Cave

SOUTHWEST

Spiro

Poverty Point

Key Marco

Spanish, starting early 1500s

OJIBWA Cultural group

→ European contact

〰 Culture area boundaries

▲ Archaeological site

The maps above and opposite provide a diagrammatic guide to Native culture groups and territories in Canada, the United States, and northern Mexico as of the earliest known dates for which reliable information is available. For example, the regions mapped for Pueblo groups in the Southwest during the early sixteenth century are juxtaposed with those of the Southeast and Northeast in the seventeenth and eighteenth centuries and the Plains in the nineteenth. After European contact, all tribes lost territory; most moved, some became extinct, and some new groups arose.

For more specific information, maps showing place names, archaeological sites, contemporary cities, and Native communities mentioned in the text accompany each chapter. Early contact and explorer routes and trade network systems relevant to adornment and clothing are included as part of each culture-area map or on a separate map. Trade patterns are shown in various degrees of complexity according to known information.

CULTURAL AREAS OF NORTH AMERICAN INDIAN GROUPS, c. 1500–1850

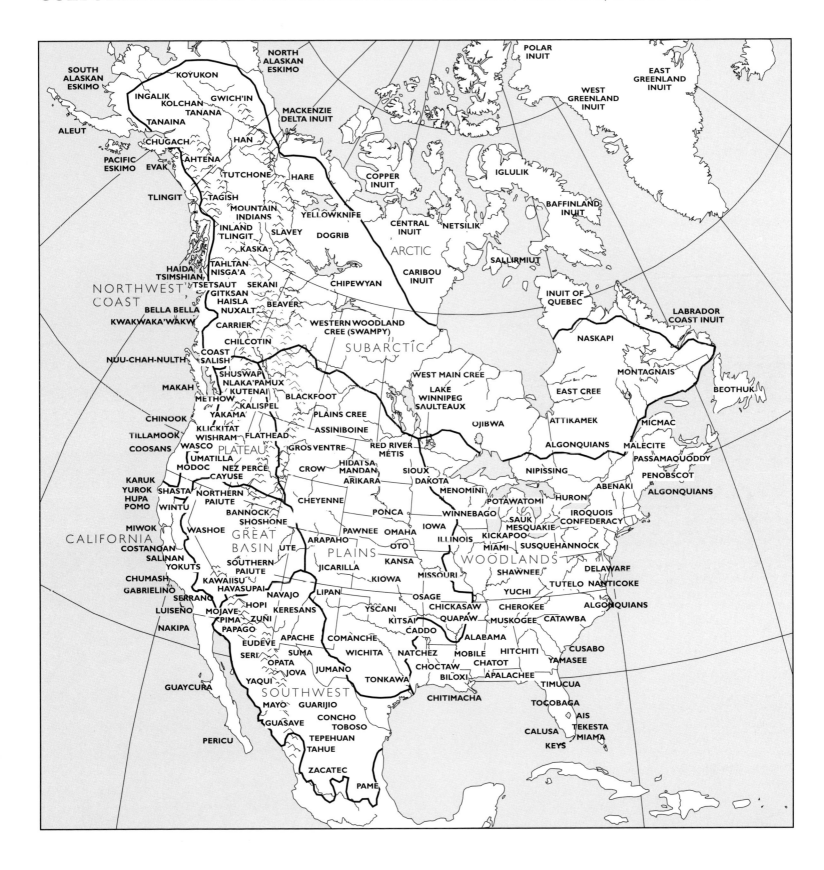

SOUTH ALASKAN ESKIMO
KOYUKON
NORTH ALASKAN ESKIMO
POLAR INUIT
EAST GREENLAND INUIT
INGALIK
KOLCHAN
TANANA
GWICH'IN
WEST GREENLAND INUIT
TANAINA
MACKENZIE DELTA INUIT
ALEUT
CHUGACH
HAN
PACIFIC ESKIMO
AHTENA
TUTCHONE
HARE
COPPER INUIT
IGLULIK
EVAK
TLINGIT
TAGISH
MOUNTAIN INDIANS
YELLOWKNIFE
CENTRAL INUIT
NETSILIK
BAFFINLAND INUIT
INLAND TLINGIT
SLAVEY
DOGRIB
ARCTIC
SALLIRMIUT
KASKA
HAIDA
TSIMSHIAN
TAHLTAN
NISGA'A
TSETSAUT
SEKANI
CHIPEWYAN
CARIBOU INUIT
INUIT OF QUEBEC
NORTHWEST COAST
GITKSAN
HAISLA
NUXALT
BEAVER
LABRADOR COAST INUIT
BELLA BELLA
KWAKWAKA'WAKW
CARRIER
WESTERN WOODLAND CREE (SWAMPY)
NASKAPI
CHILCOTIN
SUBARCTIC
NUU-CHAH-NULTH
COAST SALISH
MONTAGNAIS
SHUSWAP
NLAKA'PAMUX
WEST MAIN CREE
LAKE WINNIPEG SAULTEAUX
BEOTHUK
MAKAH
KUTENAI
METHOW
EAST CREE
CHINOOK
KALISPEL
YAKAMA
PLAINS CREE
ATTIKAMEK
MICMAC
TILLAMOOK
KLICKITAT
WISHRAM
FLATHEAD
ASSINIBOINE
OJIBWA
ALGONQUIANS
MALECITE
COOSANS
WASCO
PLATEAU
GROS VENTRE
RED RIVER MÉTIS
NIPISSING
PASSAMAQUODDY
UMATILLA
MODOC
NEZ PERCE
CAYUSE
CROW
HIDATSA
MANDAN
ARIKARA
SIOUX
DAKOTA
HURON
PENOBSCOT
KARUK
YUROK
HUPA
POMO
SHASTA
WINTU
NORTHERN PAIUTE
CHEYENNE
MENOMINI
POTAWATOMI
IROQUOIS CONFEDERACY
ABENAKI
ALGONQUIANS
BANNOCK
SHOSHONE
PONCA
WINNEBAGO
SAUK
MESQUAKIE
KICKAPOO
MIWOK
WASHOE
GREAT BASIN
UTE
PAWNEE
OMAHA
IOWA
ILLINOIS
MIAMI
SUSQUEHANNOCK
CALIFORNIA
COSTANOAN
ARAPAHO
PLAINS
OTO
WOODLANDS
DELAWARF
SALINAN
YOKUTS
SOUTHERN PAIUTE
JICARILLA
KANSA
KIOWA
MISSOURI
SHAWNEE
TUTELO
NANTICOKE
CHUMASH
GABRIELINO
KAWAIISU
HAVASUPAI
NAVAJO
LIPAN
OSAGE
YUCHI
SERRANO
HOPI
KERESANS
YSCANI
CHICKASAW
CHEROKEE
CATAWBA
ALGONQUIANS
LUISEÑO
MOJAVE
PIMA
ZUÑI
KITSAI
QUAPAW
MUSKOGEE
NAKIPA
PAPAGO
APACHE
COMANCHE
CADDO
ALABAMA
EUDEVE
SUMA
WICHITA
NATCHEZ
MOBILE
HITCHITI
CUSABO
SERI
OPATA
JOVA
JUMANO
TONKAWA
CHATOT
YAMASEE
YAQUI
CHOCTAW
BILOXI
APALACHEE
GUAYCURA
SOUTHWEST
MAYO
GUARIJIO
CHITIMACHA
TIMUCUA
GUASAVE
CONCHO
TOBOSO
TOCOBAGA
AIS
PERICU
TEPEHUAN
TAHUE
CALUSA
TEKESTA
MIAMA
ZACATEC
KEYS
PAME

31

NATIVE NORTH AMERICAN–ASIAN CONNECTIONS

ative Americans share a fundamental worldview—all matter is inter-related—with numerous Asian cultures. Visual patterns from both regions reinforce these deep underlying connections. For example, both groups often expressed this idea in transformation figures that combined human and animal attributes. These unified forms symbolized "a world of shared powers and responsibilities in which the respect inherent in ritual, as well as ecological balancing, is needed for all to survive in harmony."

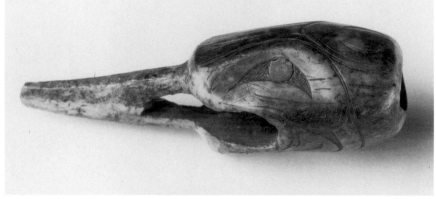

15 *A carved-ivory loon head from the Ipiutak site, at Point Hope, Alaska, dating A.D. 100–600. The loon, an important shamanic helper, assisted the shaman's ascent to Sky World. It is possible that cultural influences from northeast Asia contributed to the formation of the Ipiutak culture in Alaska. Length, 2¹⁵⁄₁₆" (7.4 cm). American Museum of Natural History, 60.2/2637*

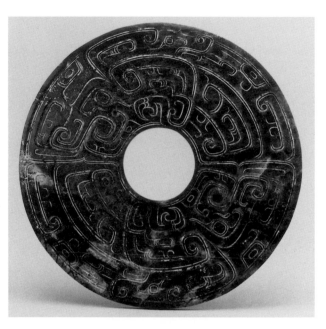

13 *Chinese disk (bi). The importance of the circle in ancient China is found in the abundance of bi, a ring of hard-stone jade that represented the universe. Western Zhou dynasty, 10th–8th century B.C. Nephrite. Diameter, 9⅝" (24.5 cm). Seattle Art Museum, Eugene Fuller Memorial Collection, 39.11*

14 *The shaman had the ability to travel between different universal realms—Sky World, This World, and Under World. This drawing of an etched-bronze vessel fragment depicts a shaman who travels in all three directions: birds lead him upward, and snakes accompany him downward. The imagery parallels that of Native American shamanic-animal relationships. Found in a tomb near Huaiyin, China. Warring States period, 475–221 B.C.*

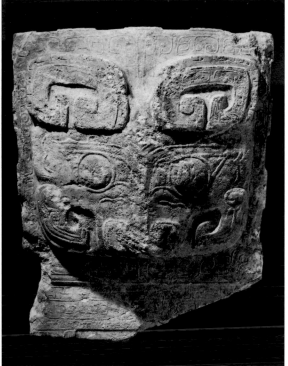

17 Ancient Chinese stone mask with t'ao-t'ieh tiger motifs, a two-dimensional, flattened version of the tiger statuette (16). A diamond lozenge in the center of the forehead separates left from right and appears in the vast majority of ancient Chinese animal masks. Shang dynasty, 1750–1050 B.C. Height 10¹³⁄₁₆" (27.5 cm), Museum Rietburg, Zurich, Edvard von der Heydt Collection

16 Statuette with the head and paws of a tiger and the body of a man, the totem of a tiger-worshiping tribe. It may represent a shaman who has assumed an animal guise. Chinese totems from Shang and Chou times not only assumed spirit-creature forms resulting from a union of humans and animals, but also were adorned with conceptual symbols that resonate in later Native North American iconography. These include formlines (lines that expand and contract), eyes, and pairs of curving spirals, curls, and U shapes. Animals are often represented as composite beasts, another indication of their magic powers. Similar imagery is found in artifacts of pre-Columbian Mesoamerica and Peru. From a tomb at Anyang. Shang dynasty, 1750–1050 B.C. Marble. Height 14⅝" (37.1 cm), Institute of History and Philology Academia Sinica

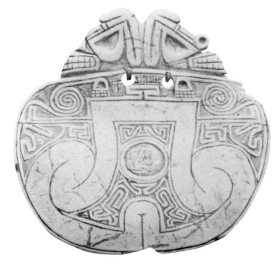

18 A Taino shell pendant exhibits unexplained similarities with ancient Chinese iconography. Peoples of Taino heritage still live in Cuba and Puerto Rico, though for years it was believed that the culture had been annihilated. Dominican Republic, 10th–15th century A.D. Height, 3⅜" (8.6 cm). The Metropolitan Museum of Art, Fay Collection

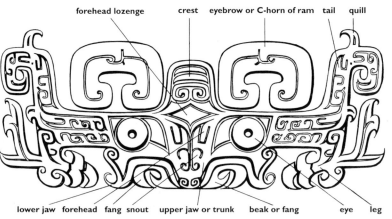

forehead lozenge crest eyebrow or C-horn of ram tail quill

lower jaw forehead fang snout upper jaw or trunk beak or fang eye leg

19 T'ao-t'ieh mask. The "masks," or beastly faces, on Shang dynasty ritual objects are composed of stylized anatomical parts, including fangs, eyes, horns/eyebrows, claws, and tails. As seen in this diagram, the always symmetrical design displays both sides of a creature that is split. Both facial details and the entire body are simultaneously revealed.

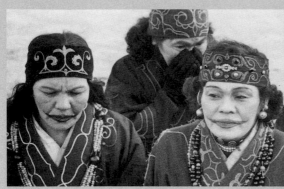

20 *Ainu women of northern Japan wear clothing with glass-beaded double-curve motifs similar to those seen throughout Indian America. 1954. Courtesy The Corning Museum of Glass*

21 *A paper-appliqué stencil with spiral designs of fish and cocks flanks a grinning beastly face. The stencil was used as a design guide by Siberian Amur River seamstresses to decorate fishskin coats. Nineteenth century. Length, 14⅛" (36.0 cm). American Museum of Natural History, 70-1936b*

22 *Floral beadwork incorporating double-curve motifs is seen on this northern Plains Blackfoot martingale (horse gear). 1885. Beads, cloth. Length, 53½" (136.0 cm). Denver Art Museum, 1938.42*

23 *A Micmac cloth hat with beaded double-curve motifs (two equal, opposed curving lines emanating from a common point) recalls t'ao-t'ieh imagery. New Brunswick, 1825–60. Length, 15¼" (38.7 cm). National Museum of the American Indian, 3/2081*

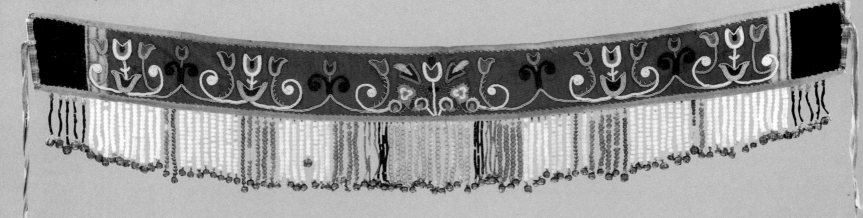

On the eve of Columbus's New World voyage in 1492, a wide range of Indian cultures existed between the Arctic Ocean and northern Mexico. Much of North America was occupied by various forms of village-farming societies, but there existed also hunting and gathering bands, which stood in stark contrast to the agricultural civilizations of the Mississippian peoples. Anthropologists have organized the more than three hundred North American tribes into broad natural areas whose groups have basic cultural similarities: Arctic, Subarctic, Woodlands, Plains, Great Basin, Plateau, Northwest Coast, California, and Southwest. Although wide differences among the groups developed under the influences of environment, subsistence, and social organization, all shared a deep appreciation for adornment.

European entry into the American continent caused substantial changes in Native lives. A large percentage of the Indian people died from European-introduced diseases for which they had no natural immunity. Many tribes were decimated by the effects of alcohol. Increased competition for land by Euro-American colonists resulted in forced removals and resettlement. And introduced trade goods altered indigenous methods of manufacture, subsistence, and ornamentation.

The Indians' earliest choice of European trade materials corresponded to their social, religious, and economic aboriginal value. For millennia, magical qualities had determined the selection of materials used for an object's manufacture. Now, metal tinklers attached to garment fringes replaced rattling deer dewclaws; copper kettles served as metal sources for adornment.[12] Glass beads and silver brooches substituted for the sacred crystal and shell that had been exchanged across North America for thousands of years. All were incorporated into Native clothing forms.[13] Although the missionaries disapproved of the practice of body painting and tattooing, both forms of adornment continued to some extent into the twentieth century.[14]

Imported cloth replaced indigenous skin clothing as the large game disappeared. Once introduced, cloth was readily adopted because it was more easily worked, lighter in weight, and easier to clean than animal skin. It could also be woven for coolness or warmth, as needed. By the mid-1800s, ceremonial cloth outfits blended Native and European styles throughout the eastern Woodlands. The ancient associations of the colors red and black were reflected in trade broadcloth in those colors, intended to replicate smoked skins painted with red ocher. Micmac hats, of black, blue, and red wool broadcloth, were embroidered with white-glass beadwork. Although constructed from imported trade materials, the hats' curvilinear designs reflect aboriginal iconography (see 236). Only in isolated areas, such as Labrador, where caribou were plentiful, did the use of skin garments continue.[15]

Silver ornaments were originally made by European silversmiths for the Indian fur-trade market. Woodland Indian artisans eventually reinterpreted the European-introduced forms, which were primarily of British, Scandinavian, and French heritage. Techniques and styles spread to the Plains, Northwest Coast, and Southwest, combining in the latter area with Mexican influence, itself of Spanish and Moorish origins.[16]

Early contacts between Native Americans and Europeans provided initial economic benefits for both sides. The fur trade began as a mutual exchange between two differing but developed cultures. In its final stages, however, when Indians relied upon nonnative products to survive, Euro-American traders set the exchange in terms that reduced the Indians to poverty.[17] The fur trade brought other complications. An excessive hunting of pelts disrupted balanced and traditional patterns of belief based upon sacred human/animal partnerships. The accompanying missionaries preached foreign religions that further discredited Indian beliefs. Acceptance of Christianity eventually required abandoning many traditional lifeways, including language and much ceremonial clothing.

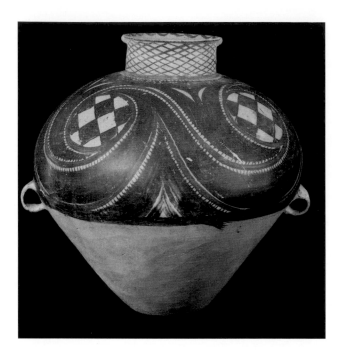

24 *Chinese mortuary earthenware pot with painted spirals and curvilinear designs, from a Neolithic culture of the Middle Yellow River Valley. Yangshao culture, c. 4000–3500 B.C. Height, 15" (38.1 cm). Courtesy Joseph Gerena Fine Arts*

25 *The scroll motif was used on pottery, stone, and shell throughout most of the southeastern United States since ancient times. The two curved lines on this pot, found in Louisiana, may have symbolized water, clouds, snakes, or interlocking birds. The ambiguity is possibly intentional, denoting simultaneous representations: Sky and Under World water; Sky World birds, and Under World snakes. Caddoan culture. Late Mississippian period, fifteenth century. Clay, ground shell. Height, 4¹⁄₁₆" (10.3 cm). Denver Art Museum, 1937.185*

26 *Choctaw man's bandolier sash. Scroll designs persist in embroidered beadwork. The motif continues today (see 392). Neshoba County, Mississippi, c. 1907. Broadcloth, glass beads. Length, 43¾" (111.0 cm). National Museum of the American Indian, 1.8864*

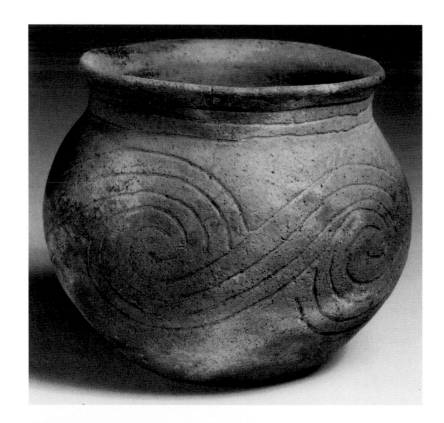

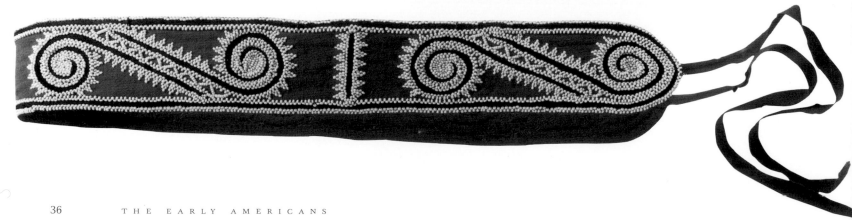

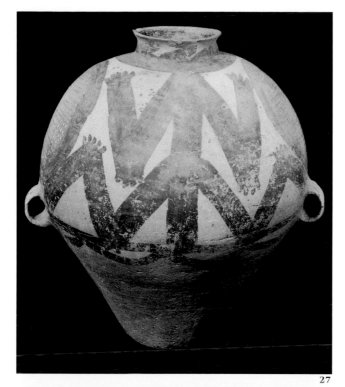

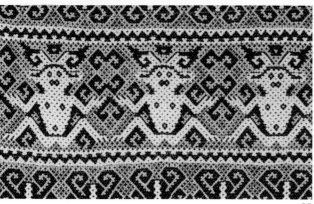

27 *Chinese (Mayiayao-culture) pottery vessel. The splayed or squatting figure may relate conceptually to an ancient Paleolithic tradition: when split to create a flat expanse, animal skins symbolized totality. c. 2400–2000 B.C. Height, 15" (38.1 cm). Courtesy Joseph Gerena Fine Arts*

28 *Indonesian beadwork detail showing splayed figures wearing headresses with horns. Dayak, Kalimantan (Borneo), c. 1890s. Width, 19½" (49.5 cm). Private collection*

29 *Iroquois carved-antler comb. Design of a splayed man wearing a headdress with horns while holding an animal in each hand. The form of the headress and the position of the man's arms and legs resembles that of the figures in 28. Monroe County, New York, n.d. National Museum of the American Indian, 24/2596*

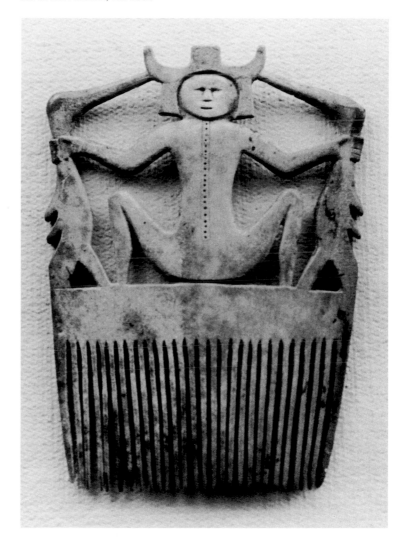

By the close of the nineteenth century, most Native peoples had been forced onto reservations, where the United States and Canadian governments tried to reshape them into the Euro-American mold of Christians, farmers, and small-business owners. To accelerate assimilation into the Western lifestyle, the Bureau of Indian Affairs (BIA) established boarding schools for Native children that were far from their homelands. Upon arrival, they were forced to cut their long hair (considered a source of sacred power) and wear Western-style school clothes. Youngsters were forbidden to speak their tribal languages. Sanctioned roles were undermined; deeply held beliefs were negated. Although most BIA schools are now closed, their traumatic effect endures. A few women, however, credit the schools with teaching skills like sewing that, due to cultural disruption, were no longer taught in their own homes. A Warm Springs bead-worker recalls: "I do have good feelings about the boarding schools. I wouldn't have learned a lot of the things I know if I had always been at home."[18]

Although most political and economic structures were destroyed, Native people retained many cultural traditions during the reservation period. Generosity, patterns of sharing, and extended kinship remained important; quality craftsmanship continued. Indian populations, which had steadily decreased since the eighteenth century, began to expand after 1900. Women's inherent creative energy became central to Native survival. With traditional subsistence bases gone, they now had to participate in the cash economy in order to survive. Beginning in the late eighteenth century, Northeastern Woodland artisans had made moccasins and dolls to sell to non-Natives and army officers posted in Quebec. The northeastern tribes, among the first to experience contact, recognized that their altered lifestyles required extra income. Nonetheless, from the earliest times, art produced for sale often incorporated the same high aesthetics and technical standards as work created in traditional contexts. Dolls wore accurate replications of tribal clothing (231). Beaded hats, moccasins, and bags were made both for sale to tourists and to be worn by the Native people.[19]

After the establishment of reservations in the second half of the nineteenth century, Native dress also became "a means of resisting assimilation by asserting cultural integrity."[20] With the availability of new materials and additional leisure time, women created "objects that related in important functional and spiritually protective ways to their lives."[21] It is also probable that the great care and artistry put into the work were visual prayers—a request for extra help from the spirit world in those difficult times. As Barbara A. Hail further noted: "The legacy of this creative outpouring successfully communicated the unique individual and social identity of the artists to their own people, to the dominant white society of the time, and to the future. Undoubtedly, the process of creation and the knowledge that they were passing on to the younger generations their traditional cultural ideas through their art became a source of strength that sustained the artists during this most difficult half-century."[22]

During the seventeenth and eighteenth centuries, men's pouches, worn bandolier-style with a cross-shoulder strap, had been an important and sacred component of Woodland dress. Decorated with quilled and painted designs symbolizing the owners' guardian spirits, they held personal medicines and essential hunting or warfare paraphernalia. By the mid-nineteenth century, as pressure to wear white men's clothing accelerated, the wearing of beaded shoulder bags by Native men in the earlier crisscross bandolier style was likely an act of defiance to preserve traditional lifestyles (357). So too was the use of European-style floral motifs (considered by the Euro-Americans to be a sign of civility and assimilation), in combination with indigenous geometric images.[23]

By the late nineteenth century, Native revitalization movements—the activities of the Midewiwin Society in the Great Lakes and the practice of the Ghost Dance, and,

30

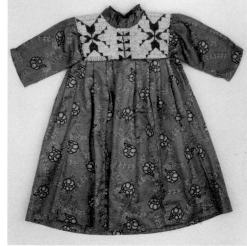

31

30 *Native designs are joined with foreign trade materials and styles in this baby's baptismal cap of hide embellished with beadwork and silk trim. Rosalie Little Thunder (Lakota) feels that "the elegant, consistent vertebrae design signifies a wish for the baby's future quality of life: health, safety, and stability." Sioux. Crow Creek Reservation, c. 1895. Height, 7¼" (18.4 cm). South Dakota State Historical Society, Pierre*

31 *Child's dress of an imported silk floral fabric with a Lakota Sioux geometric beaded design panel. c. 1890s. Length, 23" (58.4 cm). Duhamel Collection*

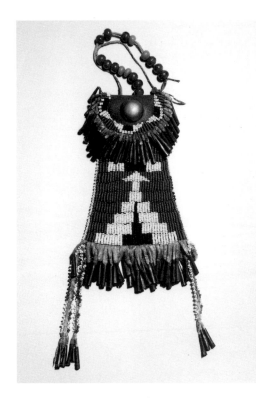

32 *This beaded ration-ticket case is a poignant example of the quality given to even such symbolically painful items. Ration tickets resulted from the focused destruction of the buffalo. (Estimated at 60 million in the 1850s, the buffalo were nearly extinct by 1880.) With their subsistence base gone, proud Plains people were forced onto reservations and became dependent on the federal government for food rations. Probably Kiowa. Late 1800s. Commercial leather, beads, copper, tin. Length, 14⅛" (36.0 cm). Texas Memorial Museum, The University of Texas at Austin*

later, the Peyote Cult, in the Basin and Plains—provided occasions for displaying regalia. Although the BIA discouraged Indian dances, and their practice died out briefly following the Wounded Knee massacre in 1890, they were revived in 1923 by returning World War I Indian veterans. Powwows, or secular dances, continue as important displays of Indianness.[24] "The honoring and gifting ceremonialism of the modern powwow circuit with its requisite regalia, fancy-dress code, and behavioral systems is a stunning example of disguised and active resistance," observed Ralph Coe. "The powwows, potlatches, giveaways, and ceremonial feasts are massive preservation mechanisms."[25]

THE CULTURAL CONTINUUM

Native America's cultural continuum rests upon a dual foundation of flexibility and spirituality. For millennia, hunter-gatherers, tribal leaders, and artisans have understood the relationship between compromise and survival: the need to modify behavior in response to changing conditions.[26] Indian people who live simultaneously and "with equal success in the white and Indian worlds are aware of shifting gears, knowing on a conscious level what kind of behavior is called for in different situations. Truly bicultural, they thrive on the richness of two traditions."[27] Much of today's finest adornment is created by Native artisans who move with ease between multiple realities.

Twentieth-century work draws upon ancient concepts, not to create a pastiche but because the imagery—feathers, sun, corn—is still deeply meaningful and communicates spiritual values of harmony and balance. Tradition is perpetuated by observing the techniques and styles of an elder or relative, "who in turn had learned them from a grandmother, grandfather, mother, father, aunt, uncle, older brother or sister. . . . It is a circuit along which there is constant movement from old to young, from relative to friend. As the elder passes on, she or he is replaced."[28] Above all, commented Armand Labbé, "Native Americans teach through example and living: it is incumbent upon the young to observe keenly and deeply with respect and gratitude. One is expected to take responsibility for one's own education. One is never forced to learn. For this reason, tradition is only passed on by those who have perceived its value."[29]

In the past, shamans communicated spiritual revelations through dance, music, and sacred imagery. Today's Native artisans—important conduits for expressing the sacred—can be seen as North America's contemporary shamans. "As the traditional Indian shaman sought to prevent soul loss," wrote Joanne MacDonald, "it can be said that the shaman is not dead, the shamanic spirit finds its expression among the [Indian] artists."[30]

"I pray for and credit my heavenly father with inspiration," says Navajo jeweler Lee Yazzie (1083). "I pray for the capacity to observe. In everything we create, we have to look around and see something, even though it's not there. When I create something, I pray for that enlightenment, rather than asking to have something thrown in my lap. When I feel I can't do these things by myself—that the power comes from somewhere else—I know that I am resigning to His power. I receive His blessings that I need. That's my source of inspiration. That's to whom I give credit. Creativity is almost spiritual. You know for that one moment you were in the sun. You were blessed with light. You had the opportunity to be under that light and experience a moment in time to create something divine. I think there are times when you are blessed with divine inspiration—all of us—but some of us don't recognize it. . . . The Lord hasn't separated the Indian, He's blessed them with certain things. There's so much creative talent because the Lord blessed us. He knows the environment, and the way that we are living, and that we need it. We can fall back on it in order to survive in this complicated world."[31]

ANIMAL SYMBOLISM

hole animal-skin headdresses are associated with shamanistic prac-
tices, warfare, and hunting rituals across a wide geographic area
extending from Asia to the eastern Woodlands of North America.
Head regalia, such as antler crowns, are shamanic metaphors indicating
power, respect, and human/animal bonding.

33 *Female shamans wearing antler headdress-
es. Etched-bronze bowl fragment. South China,
late Chou dynasty, c. 900–771 B.C. Height, 3"
(7.6 cm). Seattle Art Museum, Eugene Fuller
Memorial Collection, 51.43*

▽ **34** *In this Pueblo Deer Dance near San Juan
Pueblo, New Mexico, participants dressed as
deer follow a figure representing the eagle, related
symbolically to the sun and the Sky Father. In
turn, the eagle supplies the dancers with arrows
for hunting deer, a gesture intended to bring
good fortune to the town's hunters. Library of
Congress*

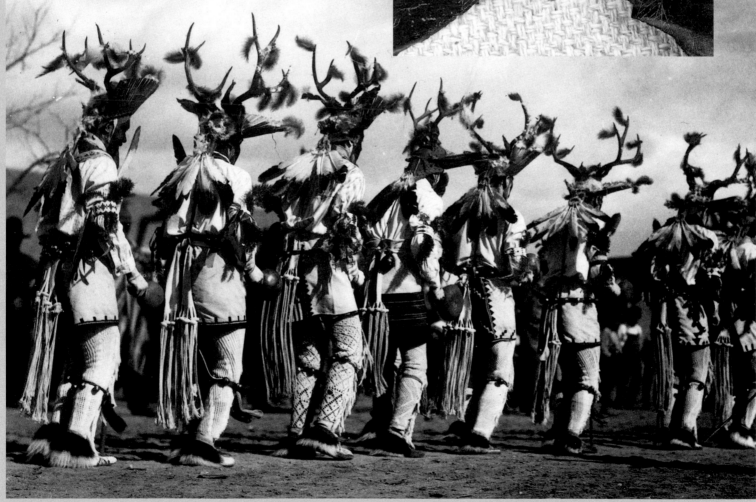

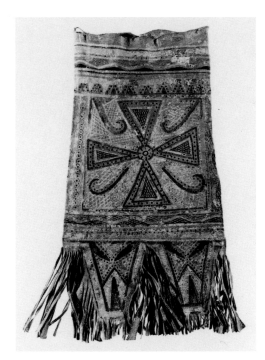

35 *Four decorated tabs at the bottom of a Naskapi pouch represent the four legs of an animal, implying ancient animal symbolism for the object. The pouch's opening was seen as the animal's mouth. The four-direction motif, symbolic of the shaman, was probably placed on the bag to assuage the spirits of the seasons. Before 1780. Tanned caribou skin, fish glue, sinew. Length, 16⅛" (41.0 cm). Canadian Museum of Civilization*

36 *Four tabs serve here as protective flaps at the bag's opening. Although the tab location has shifted, and they are now decorated with beadwork rather than painting, a conceptual relationship with the Naskapi pouch (35) remains. Plains Cree. c. 1890s. Glass and brass beads, hide. Length, 37" (93.9 cm), McCord Museum of Canadian History, Montreal*

37 *This pipe bag is thought to have been made during the Reservation Era but modeled after an old style used by the Lakota Sioux groups during the 1850s and 1860s. Though this bag is of cowhide, older ones were crafted from two small animal skins, the legs forming the two pointed appendages. The beaded horse hoofprints may represent the number of horses owned or stolen by the bag's owner. The beaded pipe design signifies that the bag's pipe was used. Since pipes are regarded as sacred, the bag is, according to Rosalie Little Thunder, "a symbol of prayer." c. 1890. Cowhide, human hair. Length, 36¼" (92.0 cm). The Southwest Museum, Los Angeles, 491.G1864*

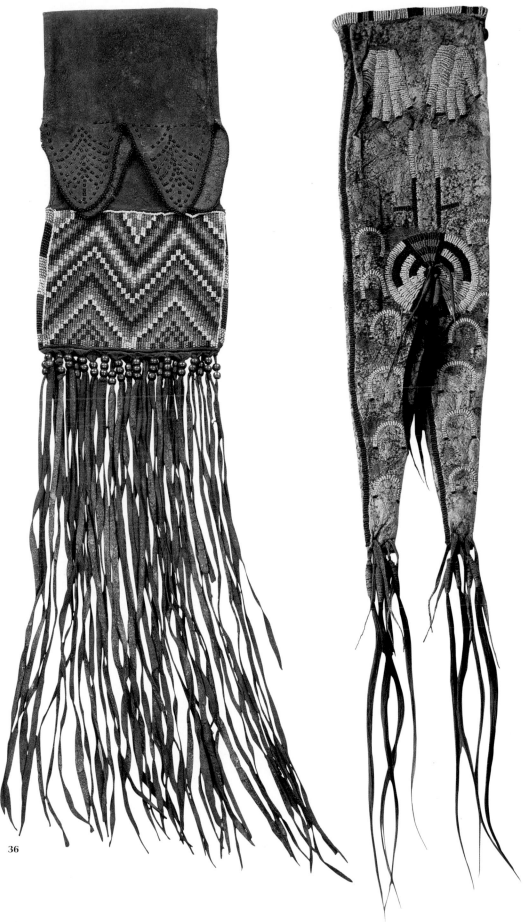

36

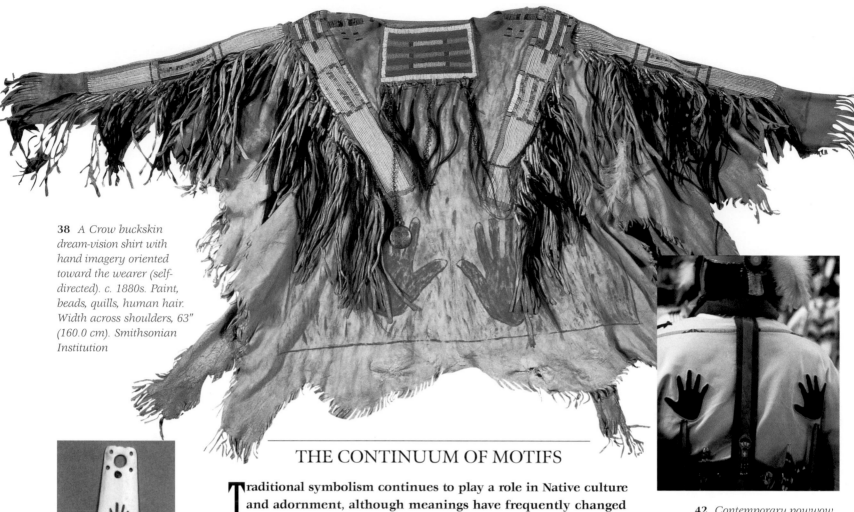

38 *A Crow buckskin dream-vision shirt with hand imagery oriented toward the wearer (self-directed). c. 1880s. Paint, beads, quills, human hair. Width across shoulders, 63" (160.0 cm). Smithsonian Institution*

42 *Contemporary powwow outfit featuring beaded hands. Red Earth Native American Cultural Festival, Oklahoma City, 1995*

THE CONTINUUM OF MOTIFS

Traditional symbolism continues to play a role in Native culture and adornment, although meanings have frequently changed or become obscure. Human hands, for example, are an ancient and widespread Native American motif. During the Hopewell period (c. 200 B.C.–A.D. 500) a mica hand pendant (280) possibly represented an "ancestral relic," the preserved hand of a revered ancestor. Hands have also symbolized presence ("I am here"), spiritual power, and hand-to-hand military combat.

39 *Elk-antler roach spreader. A headdress of porcupine hair (called a roach) is held in place by means of flat antler or rawhide plaques. This example shows two military symbols—the group of spear points and the human hand—signifying that the wearer has engaged in hand-to-hand combat. Pawnee. Southern Plains, 1830. Length, 7⁷⁄₁₆" (19.0 cm). Denver Art Museum, 1968.354*

40 *Prayer rock. South Dakota, n.d. South Dakota State Historical Society, Pierre*

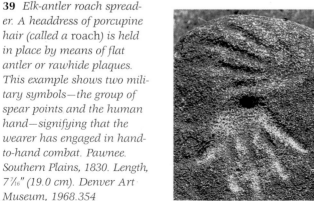

▽41 *Two hand images from Zuñi Pueblo. Although hands are seen on pre-sixteenth century Southwestern pottery (1016) and petroglyphs, the original meaning behind their use is unclear. It has been suggested that historic examples may have been influenced by Hispanic mila-gros, small silver body parts given to the saints as votive offering for cures. LEFT: Turquoise hand with red-shell nails. Leekya Deyuse (Zuñi). 1930. Length, 4½" (11.4 cm) RIGHT: Leather band ketoh (bowguard) with spondylus shell and turquoise inlaid into silver. c. 1900. Length, 4⁵⁄₁₆" (11.0 cm). The Heard Museum*

SKELETAL RIB-CAGE IMAGERY

keletal imagery, reflecting beliefs that life's essence resides and is reborn in bones, probably originated among Upper Paleolithic hunter-gatherers around 15,000 B.C. to 10,000 B.C. The motif, found worldwide, is seen in North America among the Eskimo/Inuit, Northwest Coast, Woodlands, Plains, and Pueblo peoples. Skeletal ("X-ray") imagery also signifies shamanism. An Arctic Inuit relates: "Especially very late in the evening as the sun is setting when suddenly the shaman is half red with the light, half blue with the shadow, his shadow can disassociate itself from him and take on its own independent life and disappear into the twilight. At that point, the shaman can become transparent." Anthropologist Knud Rasmussen noted that it was necessary "for the shaman to see himself as a skeleton." Skeletal imagery is the invisible made visible. It is the inner spiritual essence behind outer, less significant realities.

Shamanic artifacts from the central Arctic's Dorset period (A.D. 100–600) display some of North America's earliest skeletal images (45, 78). Marking joints through ornamentation is a form of skeletal imagery. In Eskimo/Inuit culture, joint marks identified the location of the soul. Adornment such as tattooed lines, clothing seams, linear beadwork, and bracelets both marked the spiritual boundaries of the body and served as apertures through which communication and transformation might occur.

The Tlingit of the Northwest Coast never depicted the entire skeleton; they usually chose the backbone and its related ribs to represent the entire body (814). The Tlingit saw the bones of animals as a means of regeneration, often cremating salmon bones so that the souls of the salmon would enter into other fish. This simultaneous death and rebirth phenomenon occurs in the sacred sphere of the shaman. Entering and leaving a trance, shamans go through a birth/rebirth ceremony.

The spiritual significance of bones in Native American culture suggests that breastplates (48) may be transformed skeletal imagery. Great Lakes and Northern Plains rock art skeletal imagery possibly evolved into rib-bone and "hairpipe" breastplates, constructed from long tubular beads measuring one and a half inches in length—called hairpipes by white traders—and strung diagonally or horizontally on buckskin cords in two or more vertical rows. A similar bead was worn for hair ornamentation.

43 *Possible rib-cage motif on a pottery bowl. China. Yang-shao culture, c. 2200–1700 B.C. Museum of Far Eastern Antiquities, Stockholm, K5495*

Ancient eastern Woodland Indians wore beads resembling hairpipes that were made from the long, central columns of marine mollusk (*Busycon*) shells. The most common type of hairpipe was originally made from the lip of the West Indian conch. By 1798, the non-Native Campbell family, the leading makers of shell wampum in Passaic, New Jersey, also controlled the commercial manufacture of shell hairpipes. During the early nineteenth century, American and Canadian traders offered silver hairpipes for trade.

The Comanche are believed to have made the first hairpipe breastplates before 1854; the concept then spread throughout the Plains and eventually into the Basin and Plateau. In 1880, hairpipes began to be made from cowbone as shell had become too expensive. With affordable materials, the length of breastplates increased. Although it is unclear if hairpipe breastplates are a vestige of the skeletal motif, they continue as a significant form of Plains adornment (49).

44 *Necklace of fox bone and sinew from the Copper Inuit of the Arctic's Northwest Territories. For Native Americans, life's substance is contained within bones. 1914–16. Circumference, 9⁷⁄₁₆" (24.0 cm). Canadian Museum of Civilization*

45 *Bone maskette with what may be stylized skeletal imagery: the X probably represents the head; transverse lines, the vertabrae and scapulae; slanting lines, the ribs; and longitudinal line, the leg bones. Dorset culture, A.D. 100–600. Found at central Abverdjar, Arctic. Caribou scapula. Height, 2½" (6.4 cm). Cambridge University Museum of Archaeology and Ethnology*

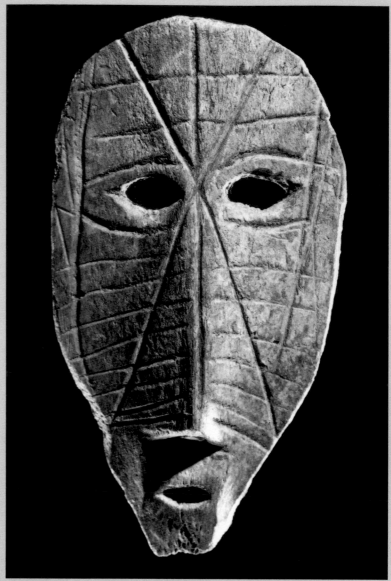

45

44

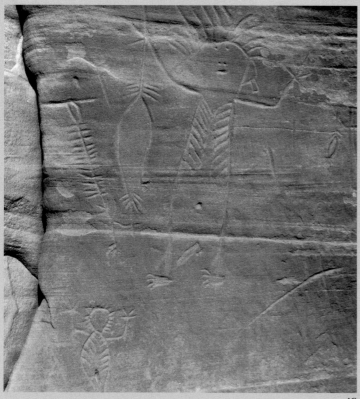

46

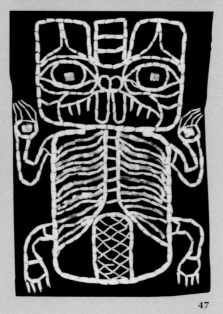

47

46 *Petroglyph of a human figure featuring possible rib-cage imagery. Little Popo Agie site, Wyoming, c. A.D. 1300–1775*

47 *Elaborate skeletal design is embroidered with dentalium shells on a man's shirt. Haida. Alaska, n.d. National Museum of the American Indian*

48

48 *Elk-rib bones on a red-flannel breastplate. Rib bones preceded hair-pipes as a breastplate material. Ojibwa. Probably mid-nineteenth century. Length, 15" (38.1 cm). University of Pennsylvania Museum, 29-48-67*

49 *Contemporary powwow dancer with a hairpipe breastplate similar to the earlier version seen below (50). Red Earth Festival, Oklahoma City, 1994*

▽**50** *Eugene Bruno (Lakota) with a hairpipe breastplate. 1904. Smithsonian Institution*

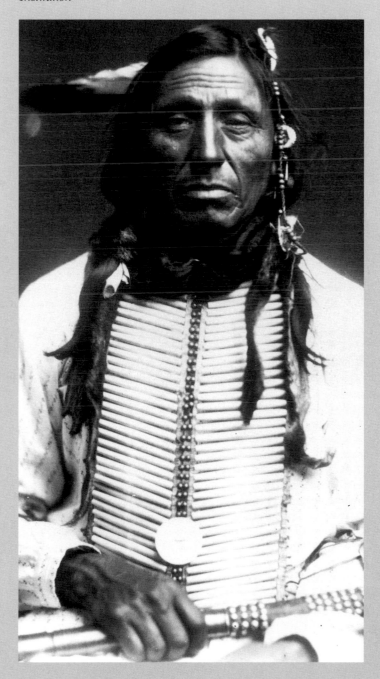

49

TRADE AND TRANSFORMATION

During the early contact period, Native Americans responded to European-introduced trade goods within the context of existing cultural values. Materials with spiritual associations expanded to include silver, glass, and brass. Silver recalled shell, and glass replicated crystal. Brass became a substitute for the life-enhancing "power" of copper. By the late sixteenth century, discarded brass kettles were skillfully recycled as a raw material for pendants and beads.

52

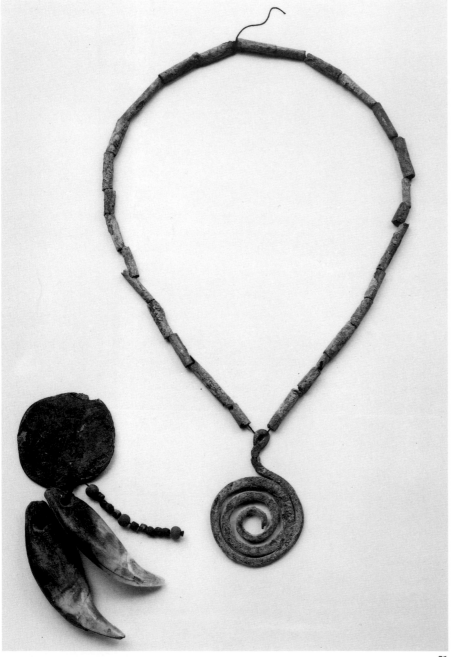

51

51 *Two Iroquois (Seneca) necklaces from Livingston County, N.Y.* LEFT: *Pendant of bear and canine teeth, brass, and glass beads combines indigenous and early European trade materials.* A.D. *1590–1610.* RIGHT: *Necklace of recycled brass. c.* A.D. *1570–85. Spiral diameter, 1¾" (4.5 cm). Rochester Museum and Science Center, New York*

52 *Brass gorget in the form of a bird-man. The metal's thickness suggests it came from an early European kettle. Abenaki. New Hampshire, n.d. Length, 9⁹⁄₁₆" (24.0 cm). Peabody Museum of Archaeology and Ethnology, Harvard University, 10/1536*

53 *Yukon necklace of bicultural* ▷ *materials: aboriginal caribou hide with porcupine-quill embroidery is adorned with non-Native glass beads, buttons, and clock springs. n.d. Length, 14.5" (36.8 cm). McBride Museum, Meek Collection, Whitehorse, Yukon, X72.1.53q*

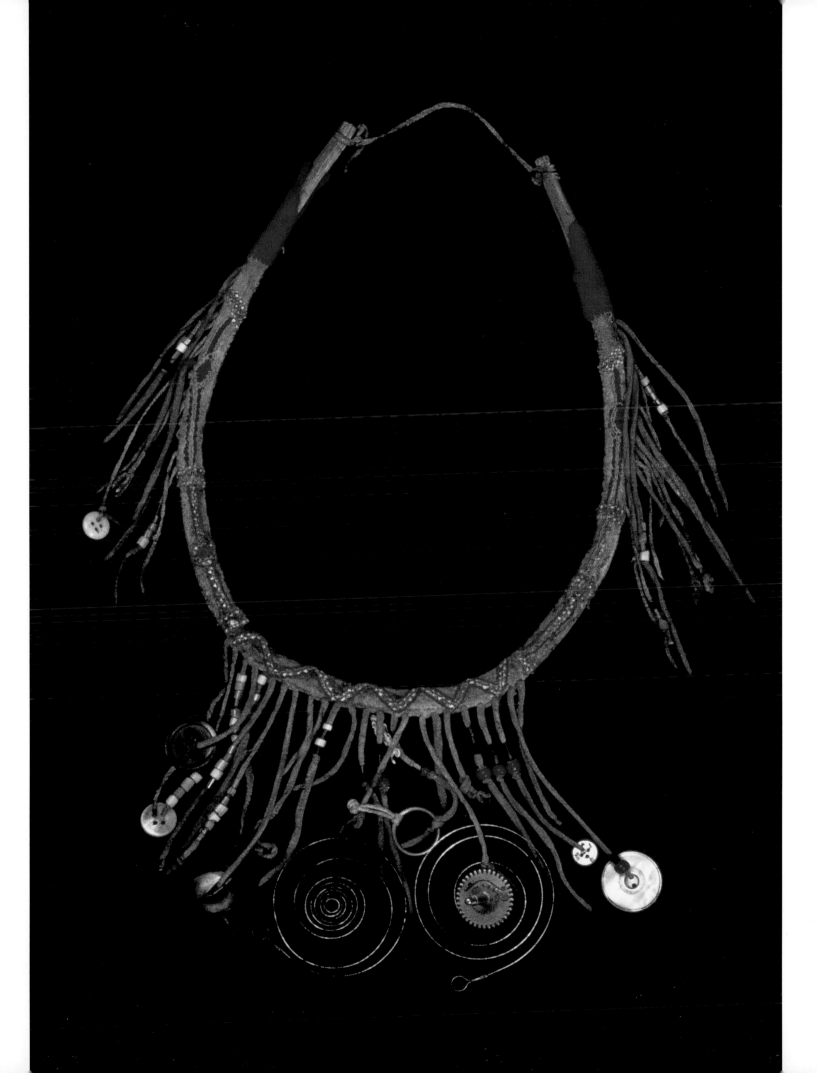

TRANSFORMATION OF A DANCE SASH

Sioux bandolier dance sashes reflect available northern Plains resources at the time each was assembled, from 1850 to 1930. The sashes convey the Sioux's innate creativity and maintenance of quality while using whatever materials were available.

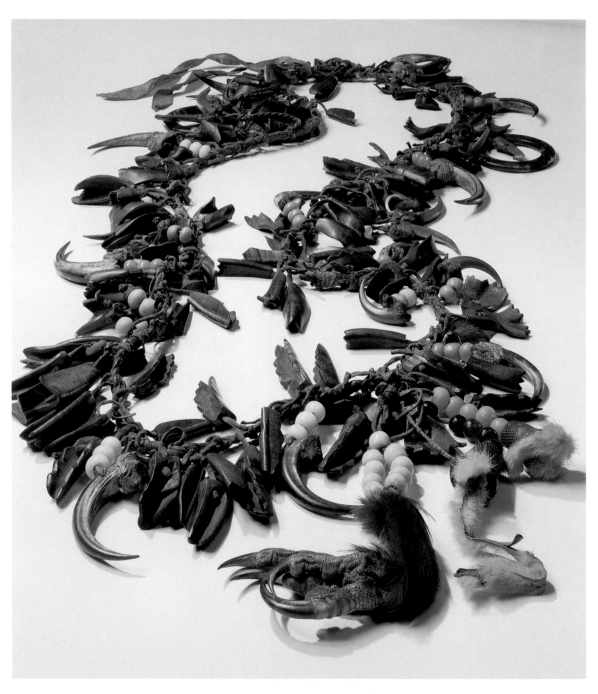

54 *Mirroring the bountiful Plains environment, the objects strung on plaited buckskin include eagle talons, bird feet, dewclaws, buffalo horn, brass thimbles, bells, glass beads, and ribbons. Madonna Thunder Hawk (Lakota) speculates, "It could have been used in healing ceremonies because of the eagle talons." Devil's Lake Reservation, Sisseton, North Dakota, c. 1850–70. Length, 42⅞" (109.0 cm). The University of Pennsylvania Museum, 37676*

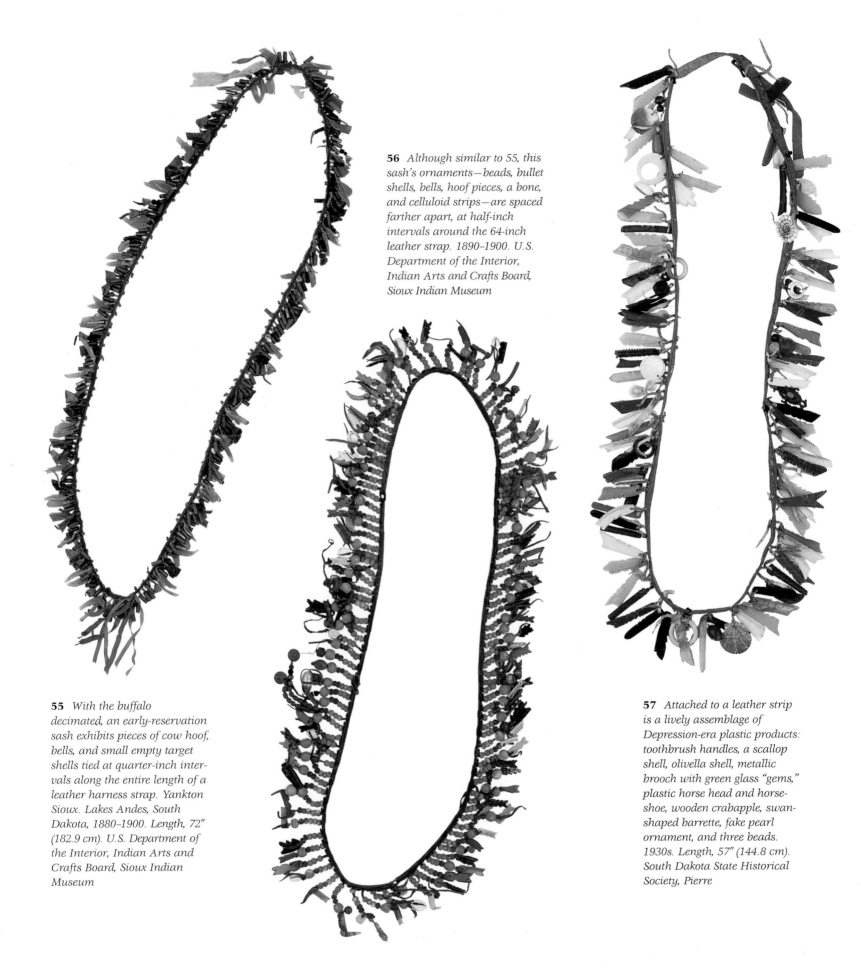

56 *Although similar to 55, this sash's ornaments—beads, bullet shells, bells, hoof pieces, a bone, and celluloid strips—are spaced farther apart, at half-inch intervals around the 64-inch leather strap. 1890–1900. U.S. Department of the Interior, Indian Arts and Crafts Board, Sioux Indian Museum*

55 *With the buffalo decimated, an early-reservation sash exhibits pieces of cow hoof, bells, and small empty target shells tied at quarter-inch intervals along the entire length of a leather harness strap. Yankton Sioux. Lakes Andes, South Dakota, 1880–1900. Length, 72" (182.9 cm). U.S. Department of the Interior, Indian Arts and Crafts Board, Sioux Indian Museum*

57 *Attached to a leather strip is a lively assemblage of Depression-era plastic products: toothbrush handles, a scallop shell, olivella shell, metallic brooch with green glass "gems," plastic horse head and horse-shoe, wooden crabapple, swan-shaped barrette, fake pearl ornament, and three beads. 1930s. Length, 57" (144.8 cm). South Dakota State Historical Society, Pierre*

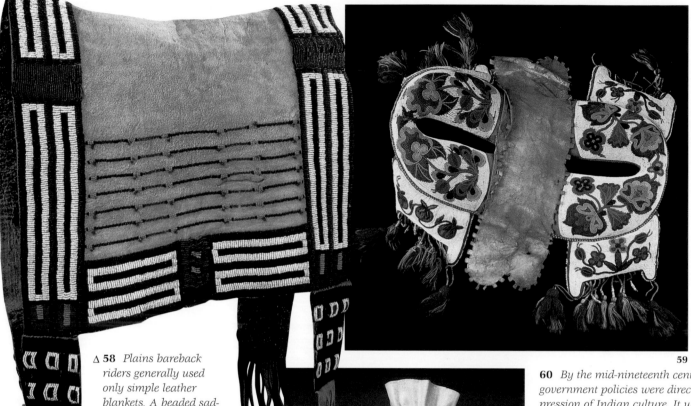

△ 58 *Plains bareback riders generally used only simple leather blankets. A beaded saddle blanket, used for parades and formal ceremonies, exemplifies early Plains beadwork of the 1840s. At this time, the availability of large "pony" beads led to bold compositions based upon aboriginal geometric patterns. Bison leather, beads, cloth. Length, 70⅛" (178.0 cm). Denver Art Museum, 1939.30*

59 *Floral designs spread west via the Great Lakes fur trade, often supplanting indigenous Western geometric styles. This ceremonial saddle combines early Spanish forms with Woodlands floral decoration. Unlike the beading in 58, the beading here incorporates tiny seed beads, which had been introduced into the Plains by the 1860s, enabling more intricate detail. The saddle was made as a gift for the prominent leader and medicine man Sitting Bull by his wife following the Battle of Little Bighorn. Hunkpapa (Eastern Sioux). North Dakota, 1880s. Hide, beads. Length, 18⅛" (46.0 cm). Peabody Museum of Archaeology and Ethnology, Harvard University, 10/28101*

59

60

60 *By the mid-nineteenth century, American government policies were directed toward suppression of Indian culture. It was believed that Native acceptance of European-style floral beadwork (initially learned from nuns at mission schools) signaled Indian conversion to a "civilized" and Christian way of life. Yet the incorporation of floral designs in this bag represents a compromise with assimilation rather than a concession: the bag's pouchlike form and aboriginal geometric patterns acknowledge and honor the past. Ojibwa. Mid to late nineteenth century. Length, 8" (20.3 cm). Collection Debbie MacDonald*

61 *An assemblage of images illustrates Navajo-Hopi artist Jesse Lee Monongye's bicultural outlook and marvelous humor. Pac-Man signifies the control exerted by "this little square thing from our home." The ladder contrasts non-Native superstition (walking under a ladder brings bad luck) with its Native symbolism as a way to the heavens. The tipi motif suggests the irony of a non-Native friend, Michael, residing in a Vermont tipi. Also included are a flying pizza, detonator (war symbol), never-ending highway, and a Christmas tree with presents. The Big Dipper stands in for the cosmos. The buckle's back has a hidden eagle and Hopi sun face. 1992. Jet, sugilite, coral, turquoise, opal, mother-of-pearl malachite, spondylus, magnesite, lapis lazuli, gold, silver. Length, 3½" (9.0 cm). Collection Pat and Bert Corcoran*

61

DOLLS

ative Americans have a long tradition of crafting dolls for play, for religious ceremonies, and, since the eighteenth century, for trade and sale to non-Natives. Whether the dolls are made as a loving mother's gift or by young girls themselves as a way to learn proper sewing skills and tribal patterns, details that are emphasized in dolls' clothing, jewelry, and beadwork offer a unique way of seeing what Native people consider essential.

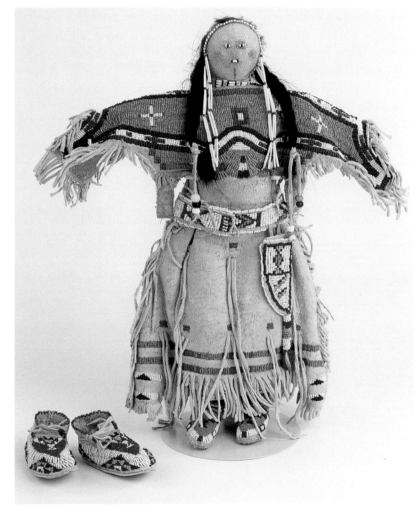

62 *A beaded buckskin doll with buffalo hair, made c. 1880–90 by Mary Weasel Bear (Lakota) for her granddaughter, Lydia Bluebird. Porcupine quill necklace and earrings imitate dentalium shells. The miniature moccasins, dating 1880, were crafted either for a doll or to demonstrate a woman's beading skills. The doll's knife sheath and belt were added in the 1940s. Doll height, 13½" (34.3 cm). Moccasin length, 3" (7.6 cm). Atka Lakota Museum, Collection Lydia Bluebird*

63 *This beautifully crafted contemporary doll wears a traditional beaded wedding robe, a garment of continuing symbolic importance within the Crow tribe. Felistas Yellow Mule (Crow). 1996. Hide, beads, hair. Height, 16½" (41.9 cm). Courtesy Crow Trading Post, Crow Agency, Montana*

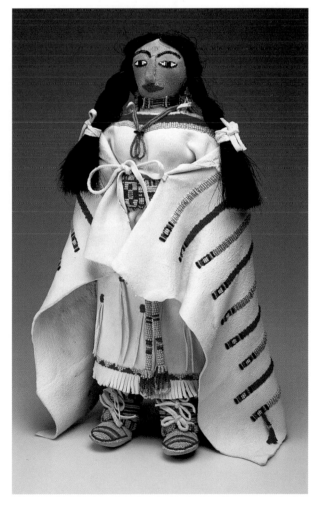

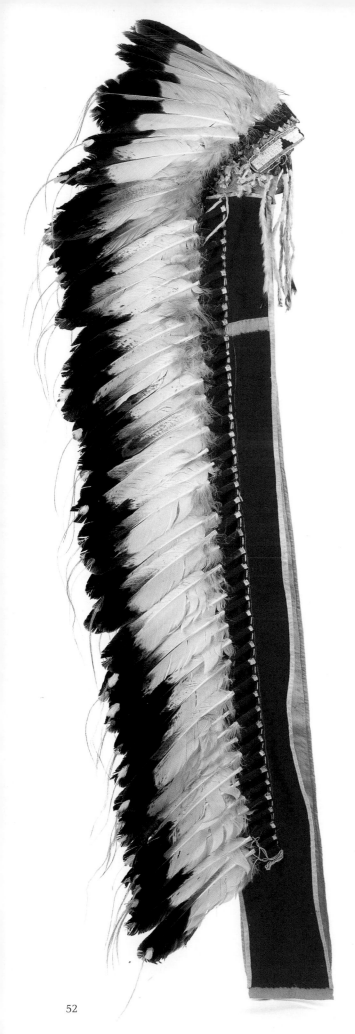

FEATHERS

The most important of all the creatures are the wingeds, for they are nearest to the heavens, and are not bound to the earth as are the four-leggeds, or the little crawling people.

—Black Elk

For Native Americans, feathers serve as metaphors for birds and the powers of the sky. Retaining the bird's potency and essence, feathers connect humans with the bird's power and spirit. Stylized black and white feathers usually represent the eagle, the Native American's most spiritual creature. Birds were revered because of their ability to fly; eagles in particular were esteemed for their beauty, strength, and fierceness as hunters. Eagle feathers were used by warriors as protective amulets and to symbolize valor and military success. Feathers continue to be worn for sacred rituals and secular adornment.

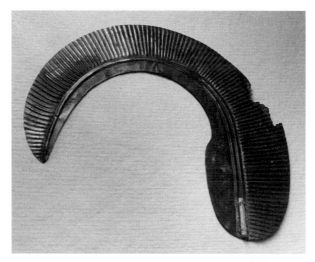

64 *A copper plume (a long feather ornament) worn as a headpiece during the Mississippian period, may have signified elite status through connection with the upper spirit world. Spiro Mound, Oklahoma, c. 1200–1350. Length, 12" (30.5 cm). National Museum of the American Indian, 21/1273*

◁ **65** *Eagle-feather warbonnets are among the most majestic items of Plains Indian regalia. Only exceptional warriors were accorded the right to wear them. Displaying an eagle bonnet, a warrior was spiritually transformed into an eagle, the chief of all birds, soaring toward Sky World and the rays of the sun. Lakota. South Dakota, c. 1885–1910. Length, 73½" (186.7 cm). South Dakota State Historical Society, Pierre*

66 *Silver feather belt by Gale Self (Choctaw). Raised in Oklahoma, Self was taught silversmithing by a Navajo elder. 1995. Typical feather length, 3" (7.6 cm); overall length, 44" (111.8 cm). Private collection*

67 *Feather bracelet. Sterling silver, cut, etched with soldered rib. Yazzie (Navajo). 1995. Height, 1⅝" (4.1 cm). Collection Glass*

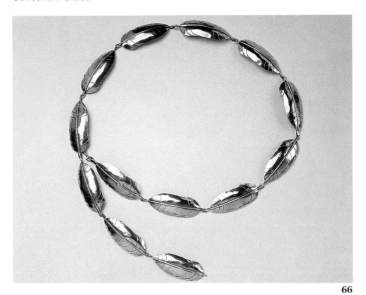

66

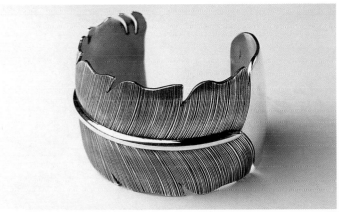

67

68 *"Eagle-feather" earrings of painted bone. 1994. 1. and 2. Lonnie Church (Cherokee), Michelle Church (Sioux). 2. Length, 2" (5.1 cm). Collection Bryny Anderson. 3. Ron English (Ojibwa). 1, 3, Private collection*

69 *Contemporary eagle-feather earrings and a pin/pendant. 1. Tim Whirlwind Soldier (Sioux). Silver and brass. 2. Reed Haskell (Sioux). Silver and pigment inlay. 3. Lonnie Church (Cherokee) and Michelle Church (Sioux). Painted bone. 4. David Haskell (Sioux). Brass (jeweler's gold). 5. Michael James Haskell (Sioux). Silver, catlinite. 6. Michael Kirk (Isleta Pueblo). Silver, glass beads. 7. Lena Platero (Navajo). Silver. 8. Mitchell Zephier (Sioux). Pin/pendant of silver, brass, copper. 9. Ray Tracey (Navajo). Silver. 10. David Claymore (Sioux). Silver inlaid with pigments. 1992–94. Length of pendant, 4¾" (12.1 cm). All Private collection, except 9, Collection Vivian Slee*

69

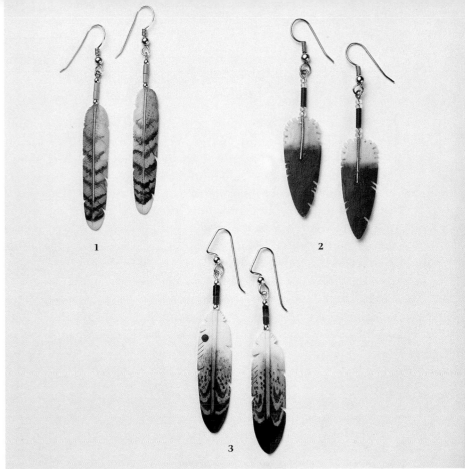

1

2

3

68

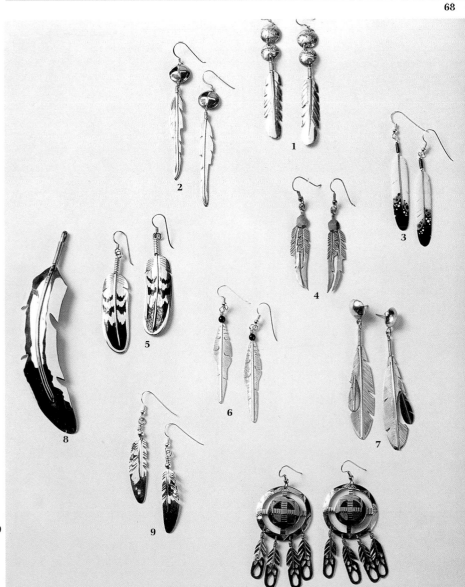

1

2

3

4

5

6

7

8

9

DREAM CATCHERS

Native Americans believe that dreams have the ability to direct one's path in life. Among the Ojibwa, a netted hoop called a dream catcher is hung above an infant's crib or in the bedroom. As the night air becomes filled with both good and bad dreams, freely swinging dream catchers capture those floating by. The good dreams, "knowing the way," pass through the center hole and fall gently off the soft feather onto the sleeper. The bad dreams, "not knowing the way," become trapped in the webbing and expire in the early morning light. Dream catchers in the form of spider webs symbolize the web of life woven by Spider Woman. As long as the web remains unbroken, dreams and visions can be helpful in solving problems. Female Ojibwa elders made the original dream catchers from red willow, twisted sinew, and assorted bird feathers. Today, they are a pan-Indian art form.

71

70 *This shield reflects the association among spirit catcher, spider web, warrior, and shield that existed among the Sioux. The shields were thought to catch and dissipate evil spirits as they became lost while wandering through the maze. The Santee Sioux called this type of shield t'o'k'a, or "enemy shield," because its "magic" spider web had the power to entice enemies and trap them for the kill. The web also offered protection because bullets and arrows passed through it, leaving only a hole. The attached feathers and medicine bags further helped destroy bad spirits. Lakota. c. 1885. Rawhide. Length, 20½" (52.1 cm). Indian Museum of North America at Crazy Horse Monument*

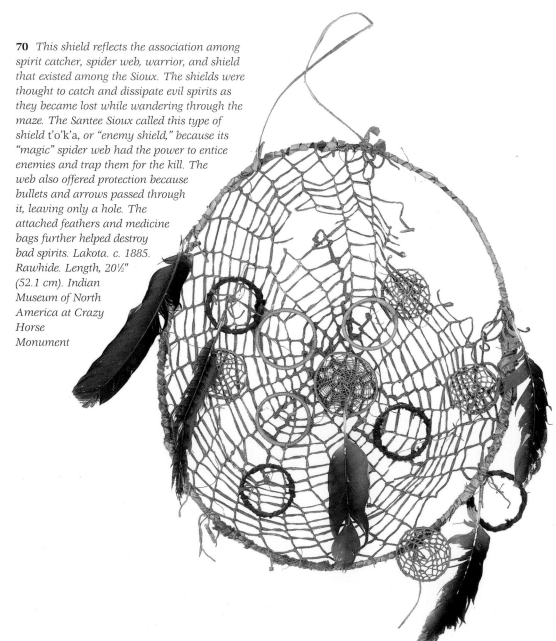

72

71 *Dream-catcher earrings. Artist and tribe unknown. 1993. Sterling silver. Diameter, 1³⁄₁₆" (3.0 cm). Private collection*

72 *Amulet similar to one seen in 73. Gros Ventre. Nineteenth century. Hide, feathers. Pendant diameter, 2" (5.1 cm). American Museum of Natural History, 50/1922*

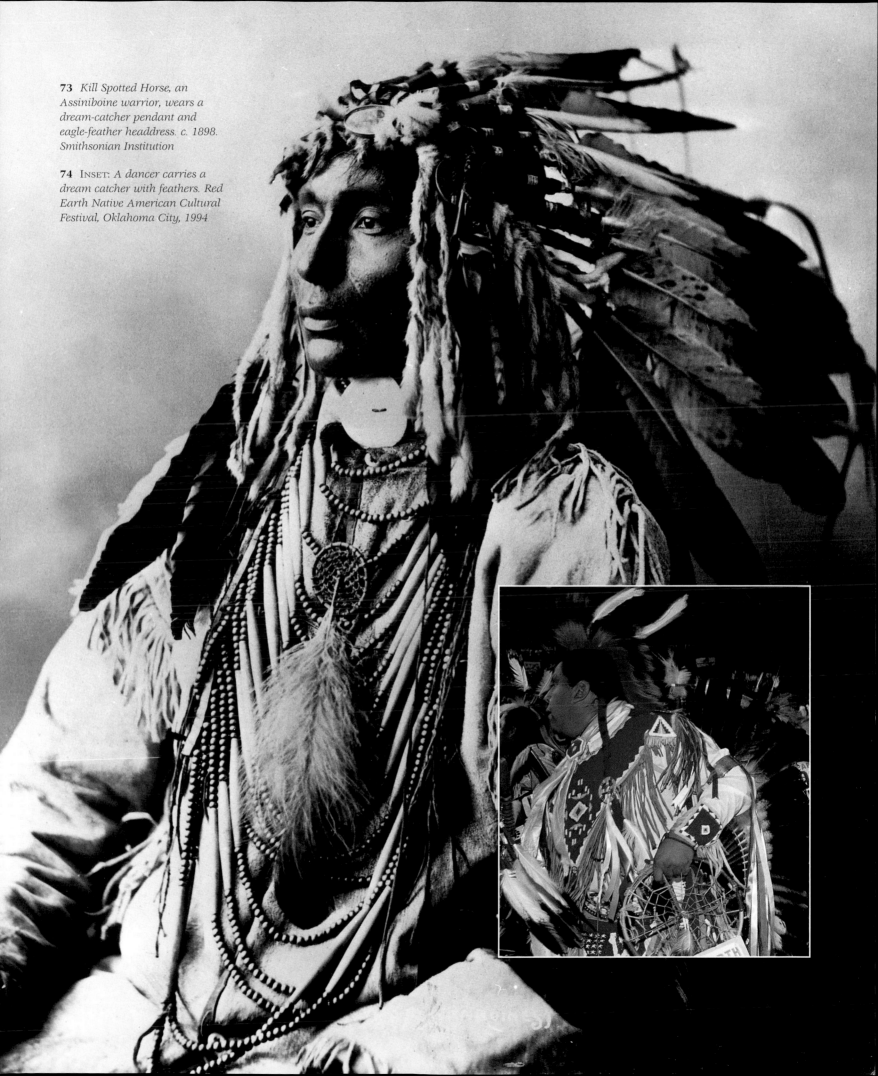

73 *Kill Spotted Horse, an Assiniboine warrior, wears a dream-catcher pendant and eagle-feather headdress. c. 1898. Smithsonian Institution*

74 INSET: *A dancer carries a dream catcher with feathers. Red Earth Native American Cultural Festival, Oklahoma City, 1994*

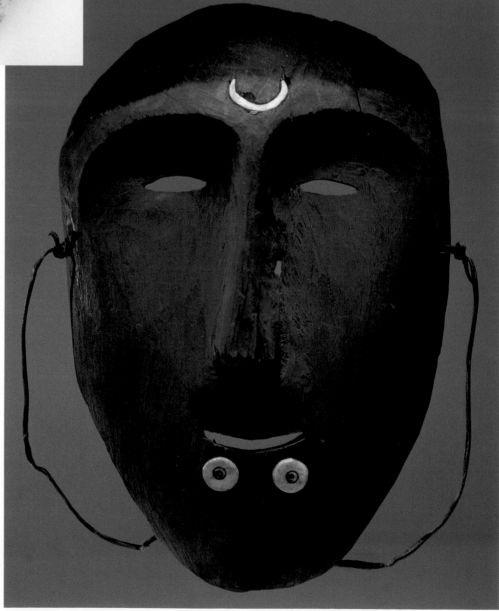

76 *A Bering Sea Eskimo wooden dance mask wears labrets (lip ornaments). It also has a brow-nose line in the shape of a whale's tail, a feature typical of Eskimo symbolism in this area and to the north. The mustache, beard, and position of the labrets indicate the figure is male. The crescent-shaped ivory insert on his forehead probably represents lunar imagery. Accessioned 1909. Height, 9¼" (23.5 cm). Peabody Museum of Archaeology and Ethnology, Harvard University, 10/75044*

75 *Because everything had a spirit, even fetishes needed their own protection. A Zuñi turquoise rattlesnake fetish wears a necklace of shell, turquoise, and coral beads. Serpents were considered more dangerous than traditional animals of prey; thus, the choice of serpent imagery indicates a fetish of great power. c. 1943–44. Turquoise, coral, shell. Length, 2⁹⁄₁₆" (6.5 cm). Museum of Northern Arizona*

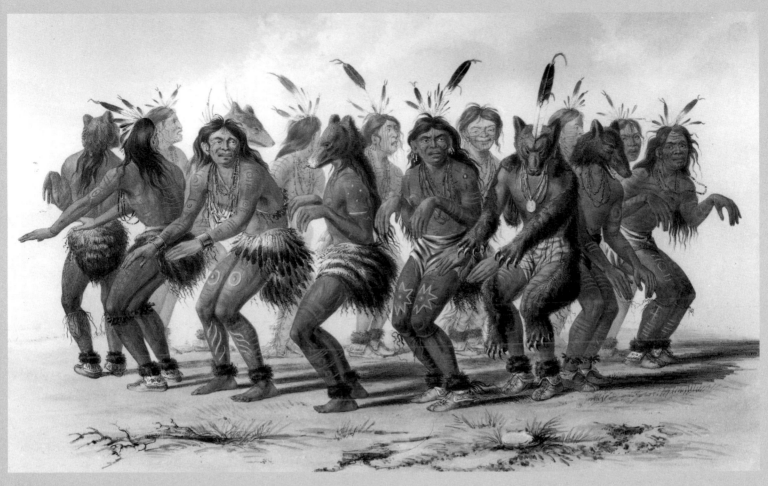

77 *George Catlin.* The Lakota's Bear Dance. *1832. Lithograph. The Southwest Museum, Los Angeles*

THE BEAR

Bear imagery in particular links past to present throughout Native America. Since Paleolithic times, bears have been sacred: an eight-thousand-year-old effigy depicting a grizzly bear was excavated from an archaeological site in San Diego County, California.

Native people believed that of all animals, the bear had the most dangerous soul. Therefore, when a hunter killed a bear, the animal's skin, head, and organs were handled carefully to avoid the bear soul's revenge. The Ojibwa revered the bear, which played a significant part in their Midewiwin (a secret society) ceremonies. After a bear was killed by an Ojibwa, its head was decorated with the family's adornment: silver arm and wrist bands, ribbons, and wampum belts. It was then placed upon a scaffold and given a ceremony. During a feast, all ate bear

meat. An attractive beaded man's costume was laid out for a male bear, a woman's outfit for a female. A speaker would then address the bear respecfully, flattering him and saying that other bears would be equally welcome. At the end of the ceremony, the bear's bones were carefully buried.

As Indians considered the bear to be one of the most powerful spirits, shamans often sought it as a spirit helper. Shamans who had a bear spirit helper wrapped themselves in bear skins, wore necklaces of bear claws, and painted bear signs on their face and body. Bear motifs continue to be beaded onto contemporary outfits and incorporated into jewelry. The ritual association remains strong.

78 *This carved ivory bear-man could represent either a shaman's spirit helper or the shaman himself, traveling between worlds. The skeletal motif denotes shamanism; the head and joints marked with Xs emphasize important, vulnerable areas. The body is hollow; at the back of the throat is a cavity that contained red ocher. This cavity was closed by a sliding lid. Dorset culture. Alarnerk, Central Arctic, c. A.D. 600. Height, 6¼" (15.9 cm). Canadian Museum of Civilization*

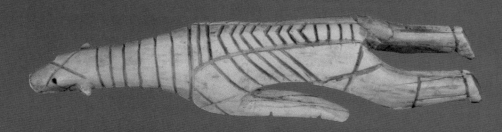

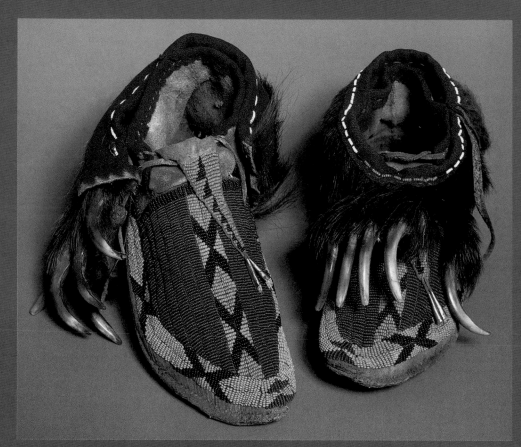

79 *Moccasins belonging to Yankton Dakota Chief Medicine Bear display the grizzly bear's distinctive long and curving claws, which were awarded to the bravest warrior in the tribe; Medicine Bear exhibited six wounds as proof of the right to wear the claws. Bear symbols were frequently produced from bear parts: skin, claws, jaws, or paws. It was not necessary to have a realistic or complete image. Collected before 1880. Length, 10⅝" (27.0 cm). Beads, hide, bear claws. Robert Hull Fleming Museum, University of Vermont*

80 *The two sides of this pendant— entitled* Universe within the Bear— *simultaneously link the cosmos and continent, represented by the bear, who lives in all regions of North America. Polar bear's opal coat displays the day sky with a Hopi sun face; black bear's onyx night sky is inlaid with Halley's comet, Saturn, earth, and the moon. The chain includes gold, opal, turquoise, lapis lazuli, and coral beads, a golden arrowhead, and bear-paw amulets. Jesse Lee Monongye (Navajo-Hopi). 1990. Bear height, 2" (5.1 cm). Private collection*

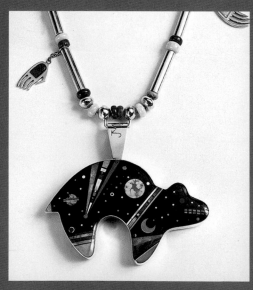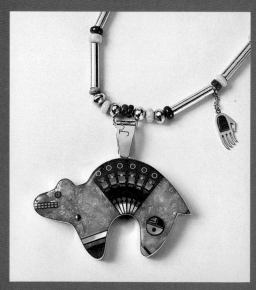

81 *Masks reveal rather than hide. "They are not meant to confuse realities or depart from reality," writes N. Scott Momaday. "To the contrary, they are useful in presenting the reality of the moment." To uncover bear spirit, one wore a mask. This bear mask, with its humanlike soul (inua) seen in the bear's right eye (partly obscured by human hair), expresses the coexistence of these two spirits within one being. It was carved by a western Alaskan Eskimo shaman, who used it in a ceremonial reenactment of his actual encounter with a bear. The back of the mask is encircled with a red-painted groove to endow "spiritual life." The mask was meant to be destroyed after the ceremony, for others were never permitted to wear shaman's masks; however, the shaman exchanged this mask with ethnologist Edward W. Nelson for iron to be used as a knife handle. Wood. Height, 9¹/₁₆" (23.0 cm). Collected by Nelson at Sabotinsky, Alaska, 1878–81. National Museum of Natural History, 48986*

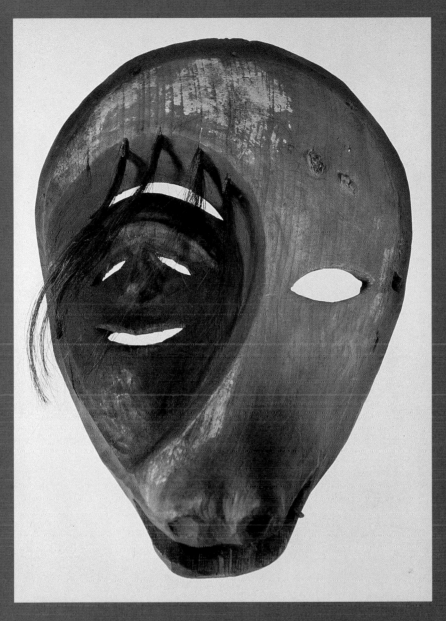

▽ 82 *This belt shows five Arctic shamans with their spirit helpers in the act of transformation. Each shaman has four (simultaneous) components: animal-shaman, mask, animal transformed, and animal etching. All masks have hinged doors that open to reveal the inner spirit.*
LEFT TO RIGHT (PAGES 59–61): 1. Walrus-man shaman: human shaman with a walrus mask that lifts up, revealing the face of a shaman singing; the arms are hinged and movable. The walrus mask represents the emerging animal spirit and opens to reveal a human spirit face. A walrus transformation and etched walrus scrimshaw complete the set. 2. Wolf-man shaman; wolf mask; wolf transformation; OVERLEAF: wolf scrimshaw. 3. Bird-man shaman; bird mask; bird transformation; bird scrimshaw. 4. Bear-man shaman; bear mask; bear transformation; bear scrimshaw. 5. Seal-man shaman; seal mask; seal transformation; seal scrimshaw. Denise Wallace (Chugach Eskimo–Aleut) and Samuel Wallace. 1991. Sterling silver, 14-karat gold, fossil mammoth ivory, walrus ivory, lapis lazuli, petrified coral, spectrolite, chrysophrase, sugilite, abalone shell, opal, lepidolite. Average figure height, 3" (7.62 cm). Collection Mr. and Mrs. Joel Rahn

1

2

SHIFTING BOUNDARIES
THE ARCTIC

"There is no boundary between the possible and the impossible when spiritual forces are free to intervene at any moment."

— **Diamond Jenness, 1922**[1]

83 *A shaman's transformation* ▷ *doll illustrates walrus-man's power to move between many worlds: sea and land, spiritual and earthly, animal and human. Collected at Brevig Mission, Nome, Alaska. Mid-nineteenth century. Wood, ivory, fur. Height, 3³⁄₁₆" (8.1 cm). Private collection*

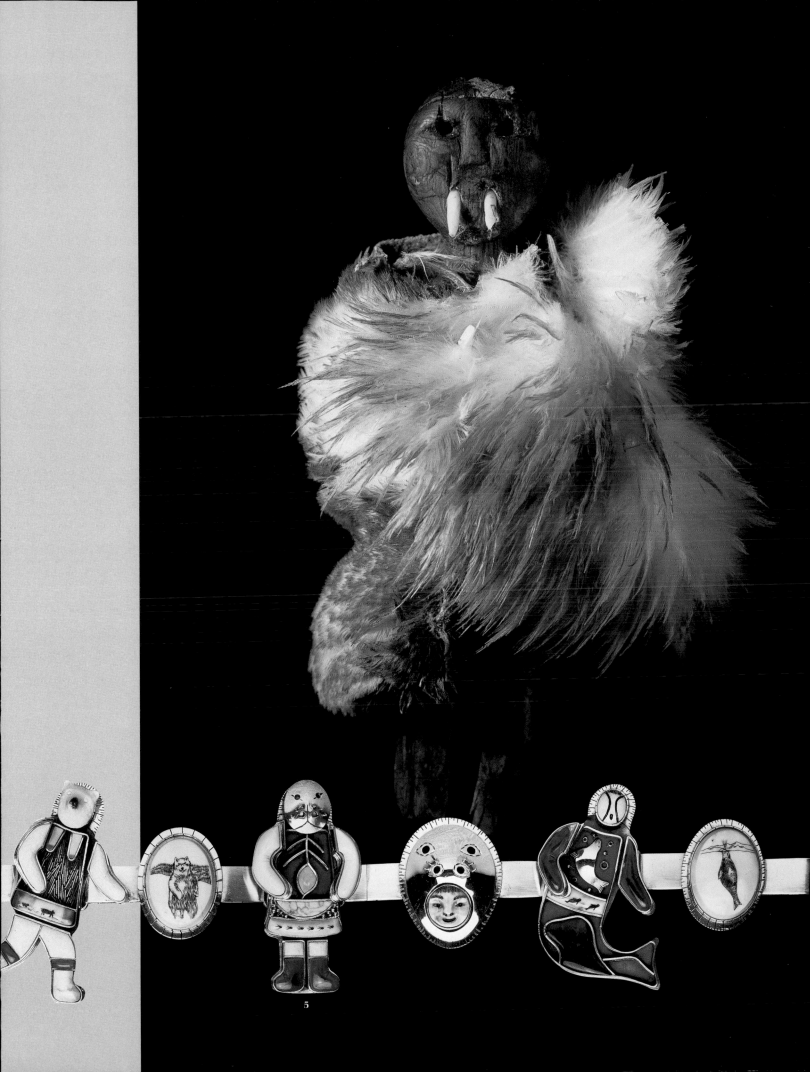

The Arctic may be perceived as limitless: physical boundaries, like spiritual ones, are transitional. Land blends into sea beneath an unbroken expanse of snow. The ice-floe edge recedes and extends, steaming into mist as the hunter crosses it in pursuit of seal. For much of the year, brief days disappear into long dark nights. Treeline merges into tundra, and the summer shades into winter, where the focus shifts from the bountiful land to a sky magically lit by the aurora borealis. "In winter there is no middle distance, no perspective, no outline, nothing the eye can cling to except thousands of smoky plumes running along the ground before the wind—a land without bottom or edge."[2] In spring, caribou and whales migrate north in great herds, returning south after giving birth to their young. Though these animals sustain human life, there is no certainty as to when or where they will reappear.

The divide between earthly and spiritual worlds is also ambiguous. Arctic mythologies refer to a time when humans could transform themselves into animals, and animals into humans, while maintaining their original *inuas,* or spirits. Traditional Arctic clothing and adornment accentuated this uncertainty. As Susan A. Kaplan wrote: "A man crossing the tundra wearing a birdskin parka appeared both as a man and as a giant bird. Flocks of waterfowl, feeling that this figure was somehow familiar, might have allowed themselves to be caught by him. People who saw him from afar might have paused to consider whether they were viewing the spirit of a bird."[3] Hunters wore labrets (lip ornaments) to become walruslike and were, for a time, imbued with the walrus's identity and predatory power (86).

Seeking a fixed point of reference, Arctic peoples developed a belief system based on the interconnectedness of all living things. In a region of limited plant life, harsh climate, and unpredictable bird and mammal migratory patterns, their essential relationship was with the animals who provided food, clothing, and shelter. At the foundation of their beliefs was a need to reconcile shifting boundaries between animal as spiritual partner and as food and sewing material.[4]

All Arctic peoples believed that a successful hunt depended upon animals' willingness to surrender to hunters. Proper human conduct stressed a respectful relationship with animals, who possessed souls and were capable of awareness. "It is told that even when seals are killed, they do not forget their consciousness. They know the exact manner in which they are handled after they have been caught. For those who handle them carelessly, they know about those people. They would not go to them anymore."[5]

Well-made hunting paraphernalia—weapons, clothing, amulets, and headgear— were both a necessity and a sign of respect. Most implements contained animal motifs, for it was believed that the qualities of an animal were embodied symbolically in the object designed in its image. Animals, pleased to see themselves beautifully portrayed, would be attracted to those who held them in such high regard.

Arctic seamstresses creatively transformed resources into clothing and regalia. The Aleutians wore garments of fur, birdskin, and waterproof walrus intestines. They attached sea-lion whiskers and bird feathers to their hunting hats. Fish, the principal food for the Bering Sea Eskimo in the Yukon–Kuskokwim Delta area, were also valued for their skins, which were fashioned into elegant parkas, boots, and bags.[6] In the Canadian Arctic, most garments were made of caribou fur; boots were waterproof sealskin (97, 110).

In these egalitarian societies, every member was responsible for making artifacts for personal and family use and for the group's security. The elegant crafting of a harpoon head, a soapstone oil lamp, or whaling amulet was not an act apart from everyday efforts at survival. There was no separation between function and decoration, no distinction between a tool and a sculpture. The Eskimo simply say, "A man should do all things properly."[7]

Native North Americans followed "seasonal rounds," or cycles, that permitted them to make efficient use of available food resources within their region at different places and times throughout the year. In the Arctic, for example, plant life is limited, but animal life abounds. Thus, the seasonal round of the Bering Strait Eskimo shown below followed a wide range of birds, fish, land mammals (primarily caribou in the interior), and marine mammals—seal, walrus, sea otter, and whale—which formed the nucleus of a rich Arctic subsistence economy. The monthly names are those of the King Islanders.

Many scholars believe that the original inhabitants of the Arctic—the ancestors of the Eskimo and the Aleuts—came to North America from Siberia prior to the most recent submergence of the Beringian Land Bridge, c. 9000–8000 B.C. Although Paleo-Indian and other hunting peoples lived on the treeless tundra as early as 8000 B.C., millennia would pass before humans there developed the technology to hunt Arctic sea mammals.[8] Thus, Arctic coastlines were among the last habitats on earth to be occupied on a permanent basis. Evidence of sea-mammal hunting in the Bering Sea region, around 2500 B.C., marks the emergence of Paleo-Eskimo cultures—Alaskan outgrowths of the Siberian Neolithic. These early cultures spread in two directions: south to the Aleutian Islands and southwest Alaska, and northeast across the Arctic Ocean coast through present-day Canada and Greenland. As the people adapted to new ecologies, distinctive cultures developed: the Pre-Dorset and Dorset in the east and the Old Bering Sea and Ipiutak in the west. By A.D. 1000, the western groups included the Birnirk, Punuk, and Thule. The Thule, accomplished sea-mammal hunters, migrated eastward across the Arctic, extending their inherited Old Bering Sea–Alaskan culture into Greenland (blending with or replacing Dorset cultures). They established a cultural base, which continued into historical times, and are considered the ancestors of contemporary Inuit. While no direct link between Old Bering Sea and Dorset ivory carving and contemporary Inuit work is evident, earlier clothing forms such as the parka continued.[9]

Thule adornment suggests a different attitude toward animals than that of the Dorset cultures. Earlier Dorset bear carvings, both realistic and highly stylized, are shaman spirit-helper amulets that were used specifically to appease and attract the bear (78). Thule people, in contrast, wore numerous bear incisor-teeth pendants, indicating that they regarded the bear as a trophy to be captured and displayed.[10] Physical evidence for a distinct Dorset culture ends by A.D. 1000; the Dorset may have substituted a more efficient Thule technology for their own.

Distinctive in language and physical appearance from all other native North American people, the Eskimo—now called Inuit in eastern Alaska and Canada, and Kalaadlit in Greenland—have a connection to northeast Siberians reaching back into Paleolithic times. Archaeologists have uncovered objects possibly used in shamanistic rites—amulets, snow goggles, and breastplates—from Old Bering Sea sites in Siberia and Alaska (c. 500 B.C.–A.D. 500) and Dorset sites in Canada (c. 800 B.C.–A.D. 1000). These works feature fascinating though elusive design motifs evocative of Chinese Shang (c. 1600–1100 B.C.), Chou (c. 500 B.C.), and Scytho-Siberian (c. 1000 B.C.–A.D. 500) cultures[11] (128–31).

Seasonal Round of the Bering Strait Eskimo

FEAST OF THE DEAD

Fixing our kayaks for springtime

MARCH

Month of the prematurely born seal

FEBRUARY

Month for going out hunting with our kayaks

APRIL

WHALING CEREMONIES

MESSENGER FEAST

Reverse dance month

JANUARY

seal (all year)

bowhead whale

walrus

seabird eggs

Ice starts to melt from the island

MAY

Dance month

DECEMBER

crab, tomcod

Vernal Equinox

salmon

Unnoticed moon

JUNE

Winter Solstice

Summer Solstice

picked greens

waterfowl

polar bear

Autumnal Equinox

blueberries, blackberries, salmonberries

JULY

NOVEMBER

Going up to the back of the island to hunt there

sea ice

river ice

Going over to the mainland

ptarmigan

OCTOBER

Icy month

small mammals (all year)

SEPTEMBER

AUGUST

(No name)

Ready to go back to the island

BLADDER FESTIVAL

THE ARCTIC

CULTURE AREA AND PRECONTACT TO EARLY-CONTACT TRADE NETWORK

The North American Arctic extends six thousand miles, from the Alaskan shore of the Bering Sea to western Greenland. Most of the territory lies north of the Arctic Circle. The treeline marks the northern limit of the boreal forest, beyond which lies tundra, a treeless plain of moss, lichen, and low-growing shrubs. The treeline-tundra border is the historic divide between Arctic and Subarctic peoples. In this region of extreme contrasts, temperatures range from -60 degrees Fahrenheit in winter to 52 degrees in July. In the far north, the summer sun shines almost continuously for two months; winter has seventy-two sunless days. At the region's southern limits, day alternates with night in all seasons.

The Arctic coastlines support considerable environmental diversity, from the glacial fjords of Greenland to the rocky Arctic Ocean shoreline of northern Canada. South of the Bering Strait, on the Alaskan coast, is the Kuskokwim Delta, a broad marshy alluvial plain that encompasses flat lowlands and rugged woodlands with a rich array of vegetation. The North Pacific Ocean defines the more moderate southern coastal border of the region, where the climate is foggy and stormy but the temperature rarely drops below freezing.

The map at right presents the approximate territories of Arctic groups during the mid-1800s throughout most of the region, and slightly earlier for the Kotzebue Sound and Interior North Alaskan Eskimo and the Labrador Coast Inuit. It also generally indicates major precontact and early contact trade routes. Today, Native peoples are generally known as Eskimo in Alaska and Inuit in Canada and Greenland. For the location of contemporary Native lands, see page 551.

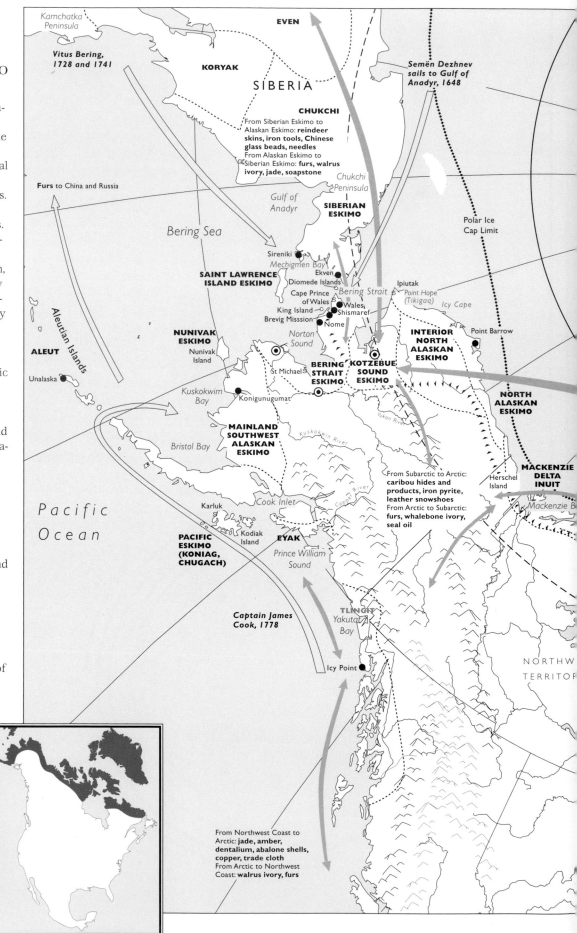

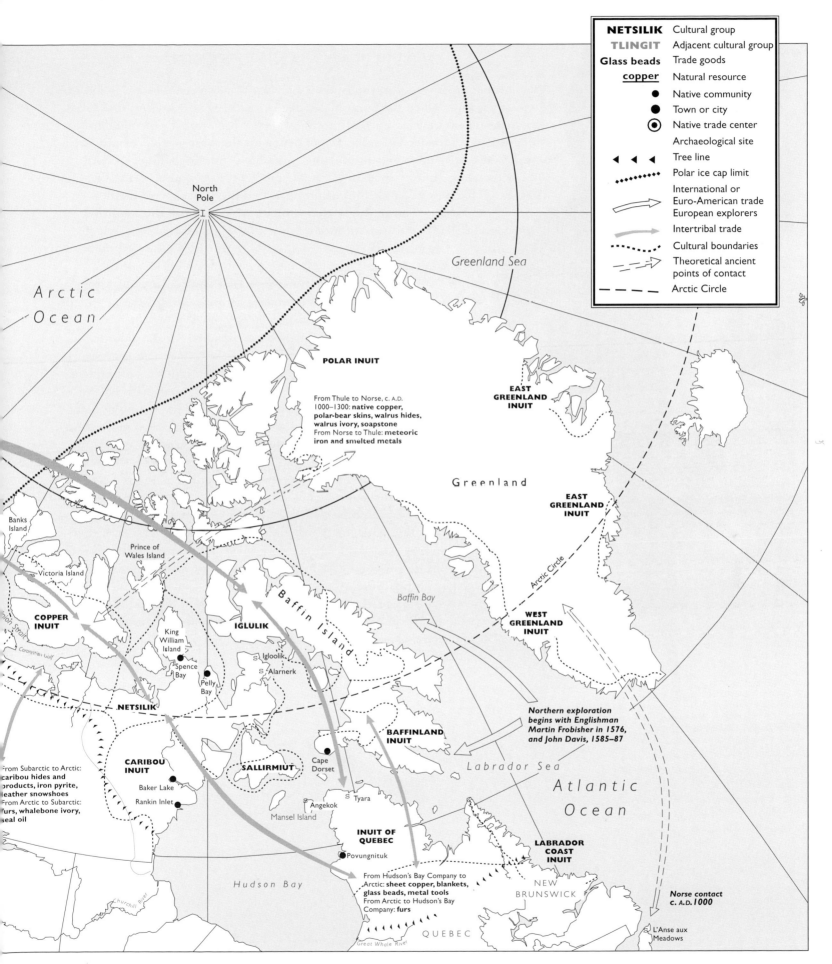

NETSILIK Cultural group
TLINGIT Adjacent cultural group
Glass beads Trade goods
<u>copper</u> Natural resource
● Native community
● Town or city
◉ Native trade center
 Archaeological site
◄ ◄ ◄ Tree line
•••••• Polar ice cap limit
⟶ International or Euro-American trade European explorers
⟶ Intertribal trade
•••• Cultural boundaries
⇢ Theoretical ancient points of contact
– – – Arctic Circle

North Pole

Greenland Sea

Arctic Ocean

POLAR INUIT

From Thule to Norse, c. A.D. 1000–1300: **native copper, polar-bear skins, walrus hides, walrus ivory, soapstone**
From Norse to Thule: **meteoric iron and smelted metals**

EAST GREENLAND INUIT

Greenland

EAST GREENLAND INUIT

Banks Island

Prince of Wales Island

Victoria Island

Baffin Bay

Arctic Circle

COPPER INUIT

King William Island

IGLULIK

Baffin Island

Spence Bay

S Igloolik
S Alarnerk

Pelly Bay

WEST GREENLAND INUIT

NETSILIK

BAFFINLAND INUIT

CARIBOU INUIT

SALLIRMIUT

Cape Dorset

From Subarctic to Arctic: **caribou hides and products, iron pyrite, leather snowshoes**
From Arctic to Subarctic: **furs, whalebone ivory, seal oil**

Baker Lake

Rankin Inlet

Labrador Sea

Atlantic Ocean

Northern exploration begins with Englishman Martin Frobisher in 1576, and John Davis, 1585–87

S Tyara

Angekok

Mansel Island

INUIT OF QUEBEC

LABRADOR COAST INUIT

Povungnituk

NEW BRUNSWICK

From Hudson's Bay Company to Arctic: **sheet copper, blankets, glass beads, metal tools**
From Arctic to Hudson's Bay Company: **furs**

Hudson Bay

Churchill River

QUEBEC

Great Whale River

Norse contact c. A.D. 1000

S L'Anse aux Meadows

65

WALRUS-MAN AND LABRETS

The animal most important to human survival in western Alaska was the walrus. Its body yielded food and materials for clothing and shelter; tusks and bones became tools and art. Hunters respected the animal's formidable strength and aggressive behavior. Dependence on the walrus was visually articulated in the daily dress and adornment of the men. Wearing labrets on both sides of the lower lip conveyed an image of emergent tusks and, with the tusklike white fur gores on the parka (86), communicated the walrus-man duality.

Labrets date to the second millennium B.C. from the Neolithic Siberian Tar'ia culture but are unknown in Siberia during historical times. In eastern Siberia, ethnologist John Murdoch observed men with a small cross or circle tattooed beneath each corner of the mouth, the usual location for a labret. He believed this was either a vestige of the ancient use of labrets or an imitation of the people of the Diomedes Islands and Alaskan coast (see 85).

Worn by the Aleuts and Eskimo of western Alaska, labrets did not appear in the northern Arctic east of the Mackenzie District. At Point Barrow in 1887, Murdoch noted that men older than nineteen wore labrets, many of which were white marble inlaid with half of a blue glass bead. Ancient jade labrets were attached to an amulet belt.

Boys received labrets at puberty. Slitlike holes were pierced on each side of the lower lip, into which small labrets were inserted. To prevent them from slipping out, the flared end rested against the lower gum. Throughout life, the slits were stretched by increasing the size of the labret, which displayed information about sex, status, and origin. Prestige could be increased by wearing larger and more elaborate labrets.

While traveling with the Point Hope Eskimo during frigid weather, Edward Nelson observed that "labrets were invariably removed in order to prevent the lip from freezing, as must have occurred had they remained in place. The labrets were removed and carried in a small bag until we approached a village at night, when they were taken out and replaced, that the wearer might present a proper appearance before the people. They were also sometimes removed when eating and before retiring for the night."

84 *A walrus-man transformation carving, identified by the double-tusk motif. Holding a harpoon and wearing a hunting visor, the figure stands on a stool. Collected at Point Barrow, 1897. Wood, skins, and ivory. Height, 11¾6" (30.0 cm). The University of Pennsylvania Museum, 41855*

85 *Tattooing replacing labrets.* LEFT: *Mechigmen Bay man.* RIGHT: *Saint Lawrence Island man. Both drawings were made by Edward Nelson in 1899.*

86 *Eskimo from Icy Point, Alaska, wear labrets and parkas with gores of white fur, suggesting tusked walrus-men. 1877–81. Smithsonian Institution*

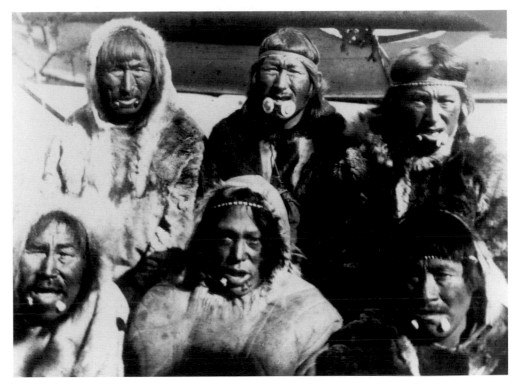

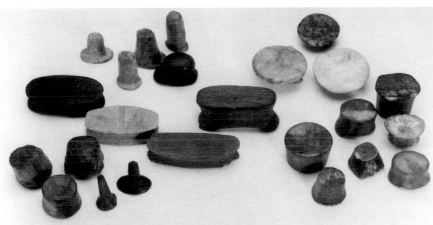

◁ 87 *A collection of fifteenth- to nineteenth-century ivory, wood, and stone labrets from the Bering Sea region, recovered by Eskimos from the villages of Shishmaref, Wales, Brevig Mission, and Teller. Styles vary with locality. Longest length, 2⅛" (5.5 cm). Collection Jeffrey R. Myers*

▽ 88 *Animal-teeth labrets are carved faces. The labret face on the right wears its own labrets, another example of "adorned adornment." Bering Sea Eskimos. Nineteenth century. Height of left labret 1⁹⁄₁₆" (4.0 cm). Private collection*

89 *A walrus-ivory Old Bering Sea/Punuk (c. A.D. 500–1000) maskette has the same circle and rosette tattoos in the same facial location as seen in 85. It also features a raven's-foot motif. The thousand-year difference between the two images indicates the ancient continuum of concepts on both sides of the Bering Sea: labrets worn in Siberia have been traced to the second millennium B.C. From the Ekven site, Chukotka, Siberia. Height, 1³⁄₁₆" (3.0 cm). Museum of Anthropology and Ethnography, Leningrad, 6479–522*

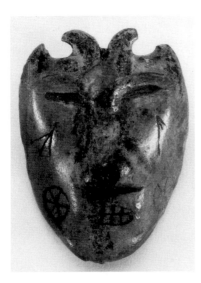

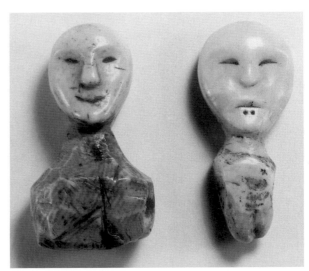

Images derived from shamanism and hunting magic link the ancient Arctic with its recent past. Motifs found on Old Bering Sea and Dorset artifacts—skeletal and joint markings, nucleated circles, masking, beastlike teeth, multiple images, and mythological imagery—reappear in historic art forms. Bering Sea Eskimo and Aleut hunting-hat ornaments demonstrate a two-thousand-year continuum of animal imagery, spanning Old Bering Sea and Ipiutak periods to the late nineteenth century[12] (91–93, 95).

The southern coast of Alaska was home to the Aleut and Pacific Eskimo (including the Koniag and Chugach)—a diverse group whose cultures varied significantly from those to the north, the Bering Sea Eskimo and North Alaskan Eskimo. Milder climates and abundant food supported larger populations which required complex social systems for regulating goods distribution. Expanded trade, warfare, and ceremonial life were accompanied by increasing quantities of regalia and adornment.[13]

The Kachemak culture (2000 B.C.–A.D. 1000), which emerged with large coastal settlements in the Kodiak–Cook Inlet region and is ancestral to the Koniag, is of particular importance to the study of prehistoric adornment. By the first century A.D., Kachemak ivory engravings, etched with copper tools, had dot-and-circle motifs and spurred lines similar to those of the Old Bering Sea people. Between A.D. 600 and A.D. 1000, the Kachemak were adorning themselves with copper beads and bracelets, labrets, and pendants of bone, stone, jet, amber, marble, and ivory. Stone and shell beads, earrings, nose rings, combs, and polished stone mirrors have also been found.[14] The more recent Koniag culture (c. A.D. 1200–mid-1700s) displayed numerous ceremonial and religious items—masks, figurines, and amulets—as well as items of adornment. In contrast to North Alaskan Eskimo adornment, which was almost entirely for the purpose of protection and hunting magic, Pacific Eskimo objects possessed amuletic content but also conveyed status and wealth. Painted bentwood hunting hats (92, 94, 95) exemplify this ancient duality.

Between three to five thousand years ago, the North American Arctic could be divided among the three primary language groups—Iñupiaq, Yup'ik, and Alutiiq—in existence today. Paralleling the Thule (route), Iñupiaq is spoken from Norton Bay to Greenland. The Yup'ik region, south of Norton Bay to the Kuskokwim Delta, approximates the territory of Old Bering Sea cultures. Alutiiq is the language of the south coast of the Alaskan peninsula and the Aleutian Islands. Since earliest times, however, Arctic peoples from Siberia to Greenland have been linked by trade. While most clothing came from local resources, prestige accrued through wearing exotic goods. Thus, the raw materials and finished products used for adornment and tools were important items in these exchange systems. Prior to European contact, walrus ivory, nephrite (jade), feathers, soapstone, iron, and copper were widely traded adornment materials.

Archaeological finds throughout the Canadian Arctic suggest that Thule traders controlled scarce commodities, including copper from the Coppermine area, soapstone from several locales, meteoric iron and smelted metals obtained from the Greenlandic Norse (Vikings), who had established colonies in Greenland by A.D. 1000.[15] They also traded the Norse polar-bear skins, walrus hides, and ivory.[16] In search of rare materials, possibly for their own pendants and combs, they excavated the ivory of extinct mammoth preserved in the frozen tundra. Thule are also known to have bartered with Subarctic Indians for iron pyrite (see 119), leather, and snowshoes.[17]

An ancient international trade network connected Asia and America in the Northwest Pacific region. Iron-bladed tools used for Ipiutak and Punuk (A.D. 500–1000) carvings reached Alaska from Siberia.[18] Archaeological artifacts reveal that prehistoric northeastern Siberians and North American Arctic peoples were linked culturally through similar beliefs in hunting magic. By the sixteenth century, however, changing

90 *In 1892, John Murdoch wrote: "There is [in the National Museum of Natural History at the Smithsonian Institution] a string of four small beads made from amber picked up on the beach. They are of dark honey-colored transparent amber, about ⅓" long and ½" diameter at the base. Such beads are very rare at the present day. The above specimens were the only ones seen." Probably from Point Barrow*

technologies had transformed Siberian hunters into breeders of reindeer (domesticated caribou) and metalworkers. A herding economy replaced the hunting one, and reindeer fertility rituals succeeded hunting magic. Humans now had greater control over their food supply, and sacred imagery changed: animal motifs evolved into stylized anthropomorphic and geometric forms (106). Geometric forms generally elaborated European-influenced secular Siberian clothing.

In the North American Arctic, however, subsistence patterns did not change. The Eskimo remained hunters of caribou and sea mammals. Garments continued to contain animal spirit-helper themes, reflecting the ancient mystique animals held for those who pursued rather than raised them.[19]

The cut and patterns of nineteenth-century Siberian, Alaskan, Canadian, and Greenland clothing, nonetheless, imply cultural connections. The tail extension of the fur parka's back flap is common to the Siberian Koryak people's burial parkas, central Canadian hunting parkas (158), and Greenland women's parkas. Rectangles, squares, concentric circles, star rosettes, and joint marking motifs decorated clothing on both sides of the Bering Strait.[20] This dissemination of patterns and motifs probably resulted from a combination of diffusion, trade, and population movements.

SHAPING ARCTIC ADORNMENT: FORMS AND BELIEFS

Traditional Arctic ornamentation and clothing encompass several themes reflecting a cosmology, or worldview: duality (paired opposites such as male and female or human and animal); simultaneity; need for protection, both spiritual and physical; shamanism and the ability to "see what is normally unseen";[21] and the importance of giving and sharing. These themes, which became ritualized in a series of seasonal ceremonies, influenced the form and meaning of Arctic adornment. The nature of Arctic beliefs can be better understood through familiarity with the story (told throughout Arctic Canada, Greenland, and Siberia) of the powerful sea woman, Sedna:

The sea harvest sustained life, and the sea was home to Sedna. As a young woman, she had resisted human suitors, choosing instead to marry a fulmar (seabird) who wooed and won her with promises of riches. When her husband carried her to his home, a slovenly hovel, Sedna realized that she had been deceived. Despondent, she summoned her father to rescue her. As father and daughter fled by kayak, a terrible storm enveloped them. The furious fulmar and his comrades flapped their wings, creating huge waves to prevent the escape. To appease the birds, her father threw Sedna into the sea. She clung desperately to the boat. But as the storm raged, her father cut off her fingers, joint by joint. As Sedna sank to the bottom of the sea, her finger joints transformed into sea mammals—the seal, the walrus, and the whale.

Now, in her undersea home, Sedna is these animals' keeper. Because of her father's cruelty, she abhors human beings and expresses that hatred by creating storms to prevent the hunt and by restraining the animals to control their availability. Having no fingers, Sedna cannot groom herself. It is the shaman's duty to visit her, comb her hair, and please her so that she will release game for hunting. Only experienced shamans can journey beneath the sea to placate Sedna.[22]

Sedna detests contact between the creatures of the land and those of the sea, particularly between the caribou and her favorites, the sea mammals. Inuit taboos separate products of the land and sea: seal and caribou meat are not eaten together; sewing of caribou skins must be completed before sealing camps are moved onto the sea ice.

HUNTING HATS

Hunting hats were both functional and spiritual. They protected from rain and sea glare and, at the same time, served as visual metaphors. All hunting headgear—goggles, visors, and hats—were essentially zoomorphic masks that transformed wearers into potent hunters. Feathers and bird-head and bird-wing carvings, as well as eye iconography, some highly abstracted into scrolls and spirals (95), emphasized bonds between sea hunters and bird spirits. The latter provided power and magical protection. Hunting-hat ornaments (91) from Old Bering Sea graves (c. 300 B.C.–A.D. 500) suggest a visual connection between Old Bering Sea hunting ritual and nineteenth-century Bering Sea Eskimos (92). Symbols of rank and status, these spectacular hats were worn exclusively in southwestern Alaska and the Aleutian Islands.

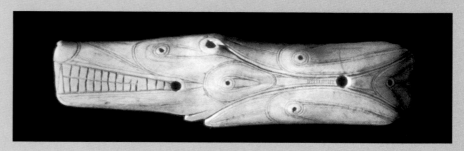

91 *This Old Bering Sea (A.D. 300–500) ivory transformation carving (possibly a hunting-visor ornament) depicts a bear or mythological beast with wolf teeth. Traditional motifs—toothy grin, nucleated "all-seeing" eyes, tracks, and hatched spirit line—enhanced sea hunting weapons into nineteenth-century Bering Sea Eskimo culture (92). These conventions may link Paleo-Eskimos to their Yukon-Kuskokwim descendants. Saint Lawrence Island, Miyowgagh site. Length, 3½" (8.9 cm). National Museum of Natural History, Smithsonian Institution, 371978*

92 *A painted bentwood hunting hat has a feather "tail" inserted in a loop of grass. It is adorned with walrus-ivory pendants of a seal, walrus, and gull, and winglike open carved volutes. Symbolically, the pointed visor and its ornate decorations resemble a bird in flight, possibly meant to deceive the hunted animal. Wearing the hat while skimming the water in his kayak, the hunter would appear to powerful sea mammals as a "harmless little seabird." The etched motifs are a continuation of ancient iconography seen in 91. Bering Sea Eskimo. Collected at Norton Sound in 1843. Length, 20⅞" (53.0 cm). Museum of Anthropology and Ethnography, Leningrad, 593–51*

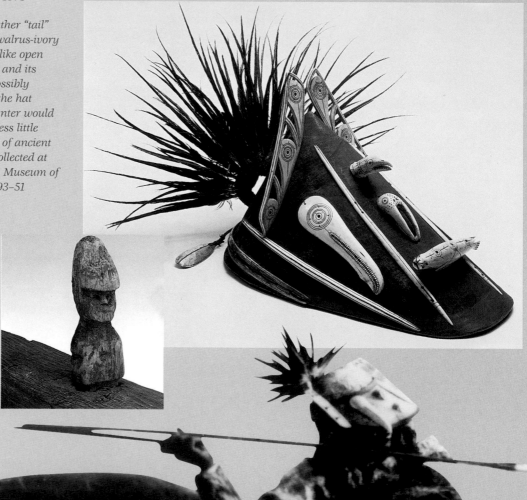

93 *Detail of a carved wooden figure in a kayak, wearing a hunting hat, reportedly from the Karlak site (1350–1500) on Kodiak Island. Kodiak may have been the center for the most elaborate prehistoric hunting headgear. Man height, 2⅞" (7.3 cm). Collection Paul Goldstein*

94 *A Norton Sound hunter wearing a bentwood visor similar to the hat in 92. Photograph by E.W. Nelson, c. 1880. Smithsonian Institution*

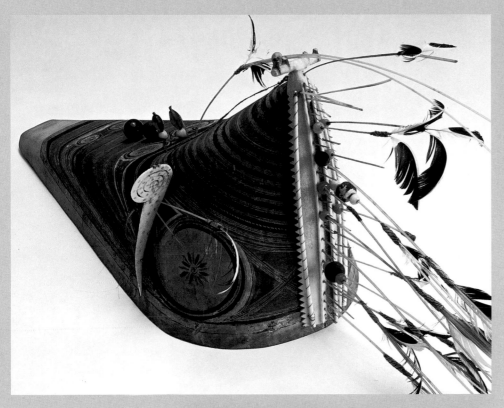

95 *Aleutian hunting hat from Unalaska Island, c.1820–45. Painted bentwood, walrus ivory, Venetian and Chinese glass beads, sea-lion whiskers, dyed grass, yarn, sinew, hair, feathers. National Museum, Finland, VK207*

96 *An Aleutian figure from a belt called* Crossroads of Continents. *The closed figure (left) wears Aleutian garments seen on 97. The parka opens on a hinge (right) revealing images of the Aleutian land and seascape. Made by Denise Wallace, Samuel Wallace, Ron Free. Collection dw Studios. 1990. Sterling, 14-karat gold, fossilized ivory. Height, 3⅜" (8.6 cm)*

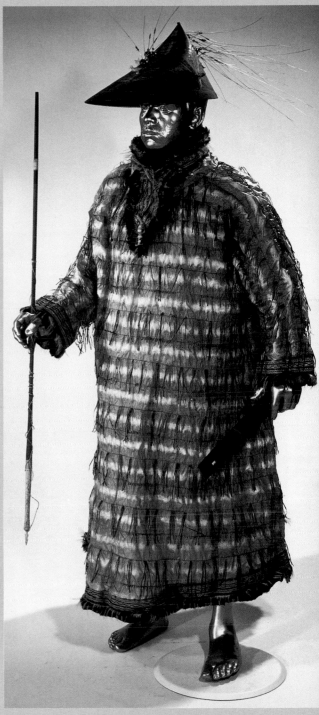

97 *Aleutian chief or prominent hunter mannequin is dressed in a richly adorned early nineteenth-century hunting outfit. His gutskin parka (*kamleika*) is embellished with yarn, applique designs, and hair embroidery. He wears a painted bentwood hat resembling 95. Museum of Anthropology and Ethnography, Leningrad, 593-18, 2868-82*

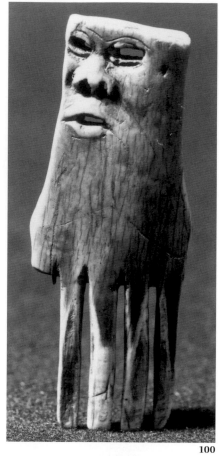

98

99

100

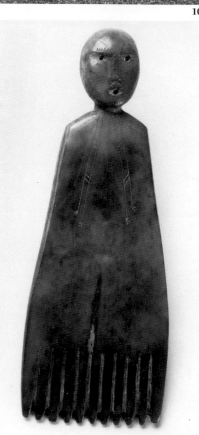

101

102

98 *A bow-hunting wrist guard from the Punuk period, c. A.D. 900, contains incised track marks and joint marker dots, motifs seen in earlier Old Bering Sea art. The geometric style and paired curved lines are typical of the Punuk period. Saint Lawrence Island. Walrus ivory. Length, 5⅜" (13.8 cm). American Museum of Natural History, 60.1.9017*

99 *Carved from walrus tusk, this comb is an elegant, humanlike variant of the motifs adorning the Punuk wrist guard (98). Attributed to the Thule, it is incised and conceived in a two-dimensional manner, a design concept not observed in earlier, sculpted-in-the-round Old Bering Sea or central-Arctic Dorset culture carvings (100). Walrus ivory. Length, 4⅜" (10.9 cm). Eskimo Museum, E.M.20*

100 *Carved man-hand-comb from the Dorset culture (A.D. 300–1000), a "visual pun," exemplifies the ancient Arctic tendency to create forms with both hidden surprises and simultaneous images. Ivory. Length, 2⅜" (6.3 cm). Canadian Museum of Civilization*

101 *Three carved and engraved ivory combs from the Bering Sea area. Made in the nineteenth century, they beautifully illustrate the Eskimo ability to combine function and adornment. On the far left is a female figure wearing a ringed frock. The border design may be a vestige of Thule patterning. The middle comb is crowned with a whale's tail; the one to the right is a caribou. Height of left comb, 4" (10.2 cm). Private collection*

102 *A female-form ivory comb wears a necklace, as does the comb (far left) in 101. Both show the Native North American tendency toward "adorned adornment." Collected at Point Barrow by V. Stefansson, 1912. Length, 3⅜" (8.1 cm). American Museum of Natural History, 60/8876*

These taboos reflect the belief that Sedna controls underwater animals and will not release them unless the rules of appropriate behavior are followed.

Inherent to the legend of Sedna is the concept of duality, or complementary opposites. Traditional Inuit and Eskimo peoples viewed the cosmos as many pairs of opposites that join to form a whole: spiritual and earthly realms; land and sea; life and death; human and animal; male and female. Men and women played contrasting yet mutually dependent roles—all geared toward survival. The focal point of communal male activity was the ceremonial house, where hunting implements, amulets, and ceremonial masks were carved and infused with magic. Women, in contrast, worked primarily in their homes, where they processed and distributed the products of the hunt. Within the domestic sphere, they cared for and taught children, sewed carefully tailored garments and boots, and carried out their roles in the spiritual life of the community.[23] A woman's ability to sew warm winter clothing with tight, even seams was as crucial to survival as a man's ability to hunt. The design of the Copper Inuit parka beautifully illustrates the concept of paired opposites (153, 159).

Thule use of antler and ivory is archaeological evidence for an ancient belief in duality. Where both antler and ivory were available, arrowheads for hunting caribou were carved from antler. Ivory, on the other hand, was preferred for artifacts associated with pursuing sea mammals and for winter activities on the sea ice: harpoons, snow goggles, and sled shoes. In addition, women's objects—needle cases, thimbles, thimble holders, combs, and pendants—were always carved from ivory. As paired opposites, men, the land, and antler complemented women, the sea, and ivory.[24] These Thule distinctions are congruent with their Inuit descendants' separation of land and sea products.

Related to the concept of duality is the belief in *simultaneity*. The Eskimo/Inuit universe was multilayered. Even their objects often contained multiple images, any of which could be revealed at a given time. Such multiple images appear in amulets, clothing, hunting hats, and masks (83, 100, 105, 129). The "visual pun" within the man-hand-comb (100) is an example of how objects and clothing communicated multiple meanings. Garments provided physical protection, conveyed transformation concepts, and served as hunting magic.[25] Taking the idea a step further, Arctic women not only adorned their men with protective symbols, but also adorned the objects that they used, such as their kayaks and amulets. "Adorned adornment" occurs throughout Native America, but it attained a particularly unique expression in Arctic artifacts (88, 102).

Masking, a form of simultaneity, was a means of both covering and signifying identity. Masks themselves had multiple symbolic references. In the North American Arctic, particularly, they were the visible embodiment of shaman spirit helpers. Worn in ceremonies, masks represented the possibility of existing in more than one form—either human or animal.[26] Bering Sea Eskimo masks, made by shamans, are acknowledged masterpieces of complex symbolism (125–27).

The existence of many worlds and many realities created uncertainty and fear among humans. As a result, the need for protection, from both the known and the unknown, was an important element of Arctic beliefs and adornment. The wearing of amulets was a common means of protection and/or empowerment, as was the ancient practice of body tattooing. In the Bering Sea region tattooing dates back at least twenty-five hundred years.[27] Tattooing conveyed identity and status but served a primarily protective function, for women particularly. Lines and motifs on specific parts of the body safeguarded against evil spirits and diseases. The most common motif, a group of lines on the chin, was intended as a fertility charm and marked the passage to womanhood.

The process, as described by anthropologist Anne-Marie Victor-Howe, was painstaking: "The thighs of young girls were tattooed when they reached puberty. Tattooing was

generally performed by an older woman who began by marking small dots on the skin surface to trace the design she wanted. She then lifted the skin, usually with her left hand, and with her right hand passed a small needle and thread through it. The thread had been coated with a mixture of soot and urine and left a dark blue pigment under the skin. When she was done, the tattooer massaged the tattoo with more soot and urine."[28] Saint Lawrence Islanders Lilly Apangalook, Estel Oosevaseuk, and Linda Womkon Badthen remember that "tattoos were desirable decoration. . . . It was embarrassing for a woman not to wear them. Without tattoos, a woman looked like a man."[29]

On Saint Lawrence Island, tattoos were important ceremonial adornment that might replace clothing and jewelry. "Islanders performed dances during the winter, inside the *aagra* [ceremonial house]. With the heat from seal oil lamps and many people gathered in a small place, little clothing was necessary. . . . Dancers wore only breeches of very fine caribou skin sewn or tied on their hips. . . . Women's skin was well-decorated with tattoos on the face, arms, hands, breasts and stomach."[30] Because bodies were often tattooed at places where belts and bracelets were worn, it is likely that jewelry, including headbands, necklaces, and bracelets, had a protective as well as decorative function.[31]

The carefully articulated seams of most Arctic clothing refer to tattooed joint markings. In the central Canadian Arctic, seamstresses inserted horizontal and contrasting fur into the shoulder and wrist of the outer parka sleeve as a symbolic reference to the joints beneath the fabric. Throughout the nineteenth and twentieth centuries, when glass seed (micro) beads became more plentiful, Hudson Bay seamstresses preserved the symbolic significance of tattooing in their beadwork, a relationship clearly evident in beaded parkas[32] (161, 162). With European contact, tattooing, like the wearing of labrets, became a lost tradition.

The circle, perhaps the dominant image in Arctic iconography, was often associated with protection. Acts of encircling were performed as protection from "spiritual invasion." In the Netsilik region, "People walked in a circle around strangers so that their footsteps would contain any evil spirits that might have accompanied the newcomers."[33] Red lines encircling a mask (see 81) and snow goggles (132) provided similar protection. Throughout the Arctic, wearing encircling belts prevented "fusion with spirits." After puberty, young women wore belts, both to protect themselves and to prevent their unclean air from contaminating others[34] (109). Strands of glass beads connected to ivory earrings circled and protected the vulnerable neck (141–42).

As one who appeared to provide a measure of control in an extremely uncertain world, the shaman was respected and feared in Arctic society. Shamans knew when to hold dance festivals honoring animal spirits and how to predict weather that aided hunters. Their ability to travel between realms was important to Yupiit festivals.[35] Shaman garments contained images of hunting spirits. They carried amulets of animal spirit helpers that, in visions, had taught them lore. When called on to perform in the men's ceremonial house, a shaman might transform into one of the amulets[36] (113, 117).

While only shamans had the power to communicate directly with animal spirit helpers through received visions, certain kinds of vision imagery, primarily eye motifs, are believed to extend human sight into the supernatural world. The circle-dot motif, called *ellam iinga*, "the eye of awareness" in the Central Yup'ik language—appears on hunting amulets as well as on artifacts worn for everyday use (91, 92, 103, 129). Hunting amulets were supposed to watch for prey and by "clairvoyant powers sight it at a great distance."[37]

Circle-dot iconography has an ancient heritage related to skeletal imagery (see page 43) and tattoo joint marking. For the Eskimo, the soul resided in the joints, and a single-dot motif at the joint (joint mark), like the circle-dot motif, may have denoted enhanced vision. To commemorate a special event, Eskimo men of Saint Lawrence

Island were tattooed with a single prick on wrist, elbow, and shoulder joints, as well as back of neck, middle of back, hip, knee, and ankle. For example, each dot might have been a tally mark denoting the number of whales killed in a given hunt. Tlingit and Haida peoples from adjacent areas to the south clearly showed eye-shaped markings at joints. This strongly suggests that the single-dot joint mark, as used in Eskimo and Inuit tattooing, echoes eye-motif forms.[38]

Dot, circle-and-dot, and concentric circle-and-dot designs represent both supernatural vision and the universe. In masked dancing, a major part of Bering Sea Eskimo ceremony, the hooped mask, like the circle-dot motif, functioned as eyes which see into the beyond. The mask's central image is framed in wooden rings that represent different levels of the universe (125).

Vision imagery is frequently linked to bird symbolism. Bird heads adorned shamanic garments so that the shaman could see clearly all souls in all worlds. South of the Bering Strait, Yup'ik Eskimos depicted birds as messengers between realms—earth to sea and human to nonhuman. The use of bird imagery to assist shamans' travel may derive from Siberia, when shamans' coats were seen as bird "skins" that enabled them to fly between worlds. The spiral motif on Aleutian hunting hats, combining a bird's beak and eye and the universal circle motif, is a metaphor for this Bering Sea Yup'ik/Aleut belief system[39] (95).

Since prehistory, the loon has held special meaning for the Eskimo and Inuit. In Arctic origin stories, loon was "the earth-diver who brought up bits of the primordial ocean bottom to form the world."[40] As important assistants to journeying shamans, loons ornamented Siberian shaman garments. Many loon-head carvings (140) were found at the Old Bering Sea Ipiutak site. One burial held a male skeleton with inset eyes of ivory and jet and a loon skull with similar ivory-and-jet eyes. As archaeologist Henry B. Collins has noted: "The Ipiutak burial of a man and a loon, both provided with permanent ever-seeing eyes, might also be a reflection of the mythological theme of the loon as a sight-restoring medium. . . . The burial illuminates . . . an ancient belief in the loon not only as a companion on an underworld flight but also as a creature who brings everlasting vision."[41] Headdresses with a loon beak and feathers were worn in traditional dance ceremonies through the early twentieth century (138–39).

The concept of *giving*, as opposed to hoarding, was an important Arctic belief. Sharing was necessary to survival in hard times. At Kotzebue Sound in northern Alaska, a shaman said, "The seals, who know the hunters, want them to be good and generous, and have nothing against their taking them, but they avoid greedy and wicked people."[42]

Giving was ritualized: "Upon killing a female animal, the hunter often left a piece of sealskin or caribou skin as a needle case for the animal's soul."[43] Numerous ceremonies commemorated gifting and feasting, ranging from family distributions after a child caught his first bird or seal to the Messenger Feast, an elaborate intercommunal festival celebrated throughout Alaska and the central Arctic. The value afforded to giving and sharing underlies the Native American's high standard of excellence. One honored family and tribe by giving back in material form the lessons of craftsmanship taught by the elders. Similarly, one demonstrated respect for an animal by beautifully decorating its skin and carving fine implements from its bones or tusk.

All of these interrelated beliefs coalesced in a yearly cycle of ceremonies involving humans, animals, and the supernatural. Animals were feted based on their importance to local economies. Most rites emphasized that proper action in the past and present was necessary for future prosperity. Within the annual cycle, autumn and spring equinoxes mark the two great periods of activity. Winter brings the hunting of the ringed seal at seal breathing holes, vital open vents in the thickened ice. Since ancient times, from Siberia to Greenland, hunters have hovered in anticipation over these holes.

AMULETS

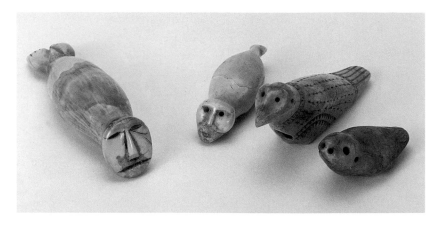

Amulets were elaborately developed in relationship to the hunt. In the all-encompassing spiritual world, every object was imbued with spirit *(inua)*. For strength and protection, hunters carried personal amulets, carvings, or unworked materials believed to contain magical attributes.

▽ **104** *These earrings are a contemporary version of nineteenth-century protective hunting amulets (103). Etched and carved fossil ivory, sugilite, sterling silver. Denise Wallace and Samuel Wallace. 1992. Length ⁹⁄₁₀" (2.2 cm). Private collection*

△ **103** *Pair of wooden amulets in the form of smiling male and frowning female faces. Conventionalized male and female representations in the Bering Sea area were frequently attached inside hunters' kayaks as protectors from evil sea-dwelling spirits. Collected 1890s. Longest length, 6⅞" (17.5 cm). National Museum of Natural History, Smithsonian Institution, 3846*

105 *Ivory shaman and hunting amulets from the Bering Sea region. All nineteenth century, except snowy owl, seventeenth century. LEFT: A shaman's amulet of a man transforming into a walrus. Length, 3½" (9.0 cm). RIGHT: Three hunting amulets: whale-man, snowy owl, and seal. All collection Jeffrey R. Myers, except seal, Private collection*

▽ **106** *A Siberian Chukchi tribesman wore these wooden "guardian" charms around his neck. Each humanoid charm signifies a specific guardian; all but one are male, and the one female charm is "the mistress." Additional charms are from animal parts. Collected at Marinskii Post, Siberia, 1900–1901. Length, 35¾" (91.0 cm). American Museum of Natural History, 70-7810*

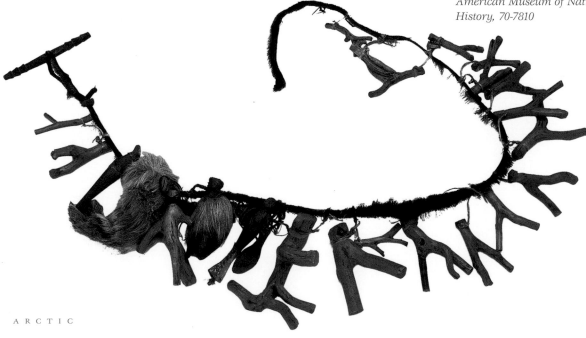

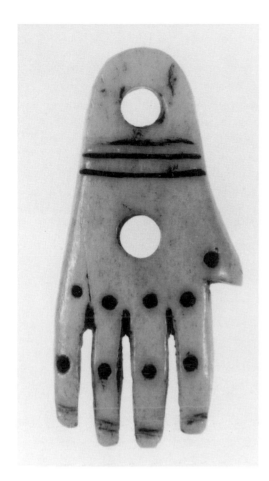

107 *Ivory pierced-hand amulets with truncated thumbs are associated with semihuman spirit controllers called* tunghat, *whose superhuman predatory capabilities were restrained by thumbless hands. The middle hole represents passage from This World to Sky World; joint marks indicate locales of spiritual strength. Jack Bryan interprets the hole in the hand as a means for the spirits to run free, eluding humans. Bering Sea region. Nineteenth century. Length, 1⅜" (3.6 cm). The University of Pennsylvania Museum, NA 1121*

108 *Etched ivory amulet of Tí-sŭkh-púk, the worm-man. There are many legends about this feared creature who took the form of a man, huge worm, or caterpillar. Tí-sŭkh-púk was portrayed with "flaring nostrils and a huge toothy grin splattered with blood from his most recent meal." Women wore amulets like this one while berry picking, for protection from the Tí-sŭkh-púk, who hid among the tall marsh grasses. Collected at Cape Prince of Wales, 1905. Length, 2⅜" (6.0 cm). The University of Pennsylvania Museum, NA 1051*

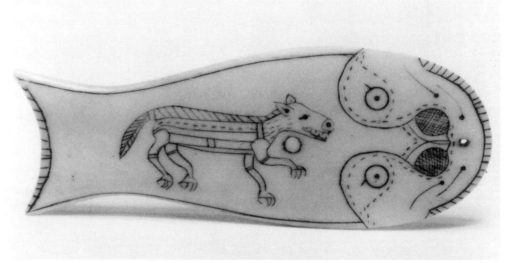

109 *Within western Alaska, women ▷ wore belts with overlapping rows of caribou incisors, in which sufficient bone was left to retain the teeth in their natural position. Made by men, the belts could contain the teeth of more than one hundred caribou. A source of family pride, they were passed from mother to daughter. The belts represented hunting prowess and were thought to have curative powers that increased with time. Striking a diseased area with the end of a caribou belt would facilitate healing. Norton Sound. Nineteenth century. Length, 50" (127.0 cm). National Museum of Natural History, Smithsonian Institution, 176071*

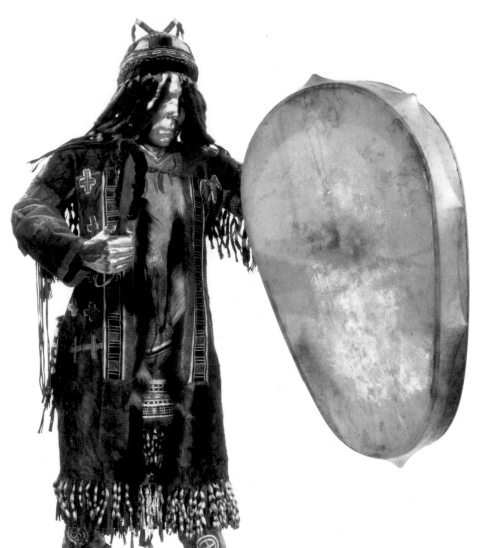

ARCTIC SHAMANS

The term *shaman* originated with the Tungus of central Siberia. Walrus ivory chains have been found in shamans' graves in both Siberia and western Alaska. Possibly shamans' regalia, they are the ivory equivalents of similar iron objects that Siberian shamans attached to their garments. Similar details in the outfits of Siberian and North American shamans suggest connections based on comparable beliefs in visions and supernatural experiences—in this case that the rattling sounds would attract the prey to the hunter.

111, 112 *Walrus-ivory chains dating back to the Old Bering Sea culture (A.D. 100–600) have been found in shamans' graves in both Siberia and western Alaska. The middle chain has a loon head.* **111:** *From the Ekven site, Chukotka, Siberia. Length, 16⅛" (41.0 cm). Museum of Anthropology and Ethnology, 6588-40.* **112:** *From the Ipiutak site at Point Hope, Alaska. American Museum of Natural History, 7581, 60.24102*

110 *Reindeer-skin and fur outfit belonging to Siberian shaman Igor Shamanov of the Yukaghir Alaseia clan. Images of ancestral shamans (right), vertebrae on the back, and crosses representing birds (left) protected the shaman with spirit-helper power. The tasseled hat assured blocked vision, an important ritual concept in many North Pacific cultures (see page 124). The coat, believed to be a birdskin, enabled flight. Trade materials incorporated into this traditional regalia include red flannel and glass beads. All collected in Markovo, Siberia, 1900–1901. American Museum of Natural History, 70-5620a,b,c. 70-5773a,b*

111

112

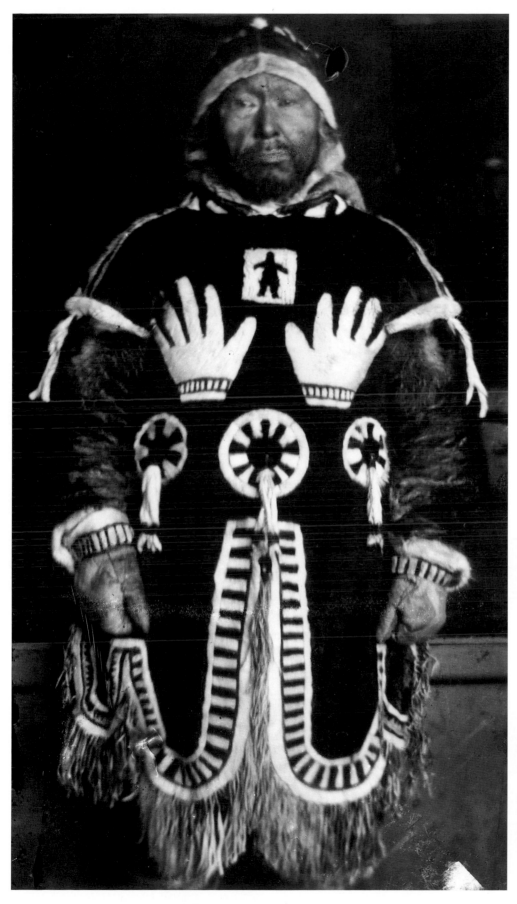

113 Qingailsaq, an Iglulik shaman from the central Canadian Arctic, wears the parka, hat, and mittens he made following an encounter with mountain spirits. As Bernadette Driscoll relates: "The hands show how he was accosted by these spirits; the two polar bears (or giant caribou) over the shoulder blades allude to his helping spirits. The existence of this costume suggests a prehistoric tradition of shamanic costume in the Canadian Arctic, probably with roots in Siberia. . . . Certain details on this outfit are similar to details on Siberian shamans' costumes. . . . The shamans' heads and hands are covered by ritual garb. Images of helping spirits are attached to the costume; valuable ritual fabric—white caribou fur and red cloth—are used; elaborate fringes, tassels, and chevron patterns (references to braiding) are found in the costumes. The outfit of the Iglulik shaman, like those of his Siberian colleagues, derived from a vision or supernatural experience." Photograph taken c. 1902. Comer Collection, Mystic Seaport Museum, Connecticut

114 This Siberian Yukaghir shaman figure is based on the shaman's outfit in 110. Sterling, 14-karat gold, fossilized ivory, lace agate, chrysoprase, coral. Height, 3⅝″ (9.2 cm). From the Crossroads of Continents belt. Made by Denise Wallace and Samuel Wallace. 1990. Collection dw Studio

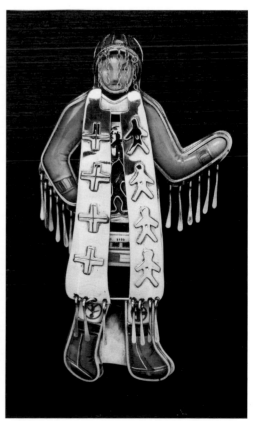

SHAMAN HELPERS

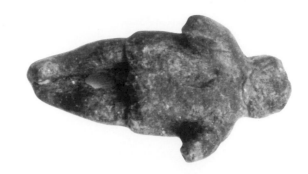

"The shamans say that sometimes, on their spirit flights, they can see behind each human being . . . a mighty procession of spirits aiding and guiding, as long as the rules of life are duly observed."

The shaman was assisted in his duties by helping spirits in the form of amulets, songs, incantations, and masks. Amulets representing guardian spirits (acquired during a vigil or vision quest) were made from ivory, wood, metal, stone, fur, and bone. A pebble, a splinter of wood, or a fragment of skin might be used to make a realistic animal carving. The powers of spirit helpers resided in their secret and multi-layered symbolism known only to the shaman: a loon claw increased powers of observation; a seal-man amulet was a supernatural gift received during a visit to the seal's spirit home.

Shamanic power derived from seeing and entering places not accessible to ordinary people. The pervasiveness of bird imagery on shamanic helpers expressed their extraordinary ability—assisted by bird spirits—to fly to the upper and lower worlds.

118 *A flying shaman amulet from the Late Dorset culture (c. A.D. 800) found in Shuldham Island, Labrador. Note the waist-length jacket, possibly a parka. Soapstone. Length, 1³⁄₁₆″ (2.95 cm). Courtesy of the Newfoundland Museum*

115

116

115 *Ivory amulet from the Dorset culture (c. A.D. 500) depicts a pair of swans in flight. The incised parallel lines may represent feathers or a skeletal motif. Most Dorset art was associated with shamanism. Angekok site, Mansel Island, Northwest Territories. Length, 2¼″ (5.8 cm). Canadian Museum of Civilization*

116 *This shaman's ivory gorget may be a bird in flight. Saint Lawrence Island. c. 1850. Length, 7¹¹⁄₁₆″ (19.5 cm). Private collection*

117 *This shaman's helper was attached to the shaman's belt. Containing multiple images, the wood and ivory carving was meant to be seen from more than one viewpoint. When viewed vertically, the carving shows a man eating a seal; horizontally, a seal emerges from the mouth of a man. Length, 7¼″ (18.5 cm). Point Barrow. Eighteenth century. Collection Jack Bryan*

117

119 *Male and female ivory shaman figures, each wearing adornment. The male's necklace features a bird or shaman figure (seen in 120). Embedded within the female shaman's chest is shiny pyrite, symbolizing good luck. Bering Sea area. Nineteenth century. Height, 2⅛″ (5.5 cm). Private collection*

120 *An Alaskan bear claw and Chinese glass-bead necklace, dating from the mid- to late nineteenth century, with a carved, seventeenth-century shaman's-doll amulet. The amulet itself wears a necklace, possibly of bear claws. This necklace, a fine example of assemblage, belonged to someone of status. Amulet height, 3⅝″ (9.2 cm). Private collection*

119

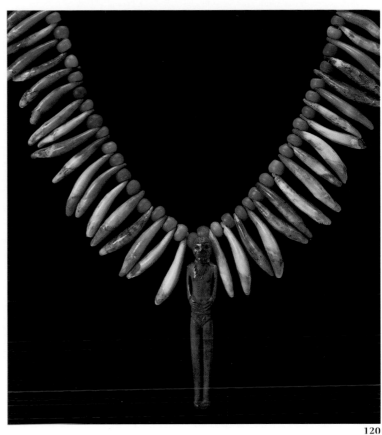

120

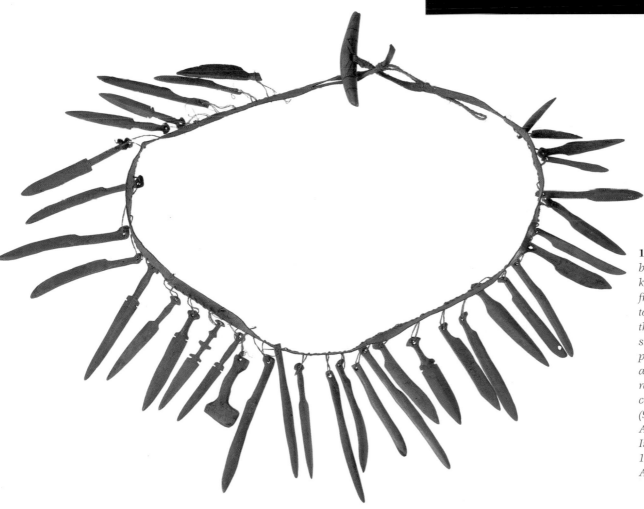

121 *This Netsilik shaman's belt contains various miniature knives and implements carved from caribou antler and attached to a hide band. The Inuit knife, the* pana, *was used to build snowhouses, butcher meat, and protect against enemies. As an amulet, the shaman's pana represented his or her ability to combat evil spirits. Length, 36¼″ (92.0 cm). Collected by Roald Amundsen on King William Island, Northwest Territories. 1903–5. Institute and Museum of Anthropology, University of Oslo*

122

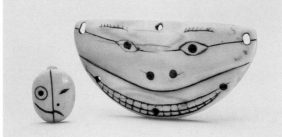

123

MASKING

A group of men sat on the floor and began beating gutskin drums. A few people started chanting. A shaman, wearing a face mask or the skin of an animal, moved to the center of the floor. At first the shaman resembled a man who was dancing; however, as the evening wore on people realized that a dangerous and powerful wolf was in their midst.

—Susan A. Kaplan, 1983

122 This miniature carved mask of bone from Kodiak Island dates to the Kachemak culture (c. 500 B.C.–A.D. 500) and indicates elaborated ceremonialism on the south Alaskan coast. Crowned with a headdress and realistic eyeholes, it may have masked a tiny ritualistic figurine. Uyak site. Height, 3½" (9.0 cm). National Museum of Natural History, 363740

123 Another diminutive ivory mask was found at the Tyara site, Northwest Territories. Dating from 720 B.C., it is the oldest radiocarbon–dated example of Dorset art and probably connects to shamanism. The concave back of the mask is filled with parallel incised lines. Height, 1⅜" (3.5 cm). Canadian Museum of Civilization

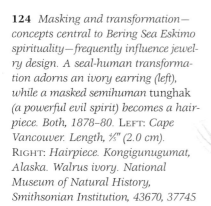

124

124 Masking and transformation—concepts central to Bering Sea Eskimo spirituality—frequently influence jewelry design. A seal-human transformation adorns an ivory earring (left), while a masked semihuman tunghak (a powerful evil spirit) becomes a hairpiece. Both, 1878–80. LEFT: Cape Vancouver. Length, ⅘" (2.0 cm). RIGHT: Hairpiece. Kongigunugumat, Alaska. Walrus ivory. National Museum of Natural History, Smithsonian Institution, 43670, 37745

125 A painted wooden dance mask of a raptor (probably an owl) with prey in his mouth. This mask portrays animals and their spirits encircled by hoops, feathers, and appendages. The surrounding hoops symbolize the universe. Feathers represent the stars, and appendages display fauna and helpers important to the owl, including a beluga whale and owl talons. The division of the rings into four sections refers to the universe and the sacred four cardinal points. 1900–1910. Wingspan width, 15¼" (39.0 cm). Collection Jeffrey R. Myers

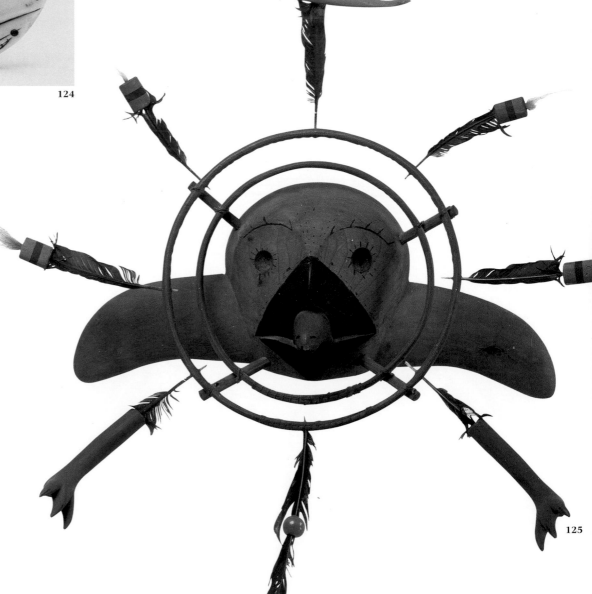

125

126 *This marvelous wooden owl-spirit (inua) mask, depicted by the downcast beak and mouth, is from the Lower Yukon River area of Alaska. Holes around the mask's periphery held snow-goose feathers. The overall form has been skillfully integrated with the natural woodgrain. At one time part of a German collection, the mask was confiscated by the Nazis and labeled "degenerate art" during Hitler's Third Reich. Height, 7¼" (18.4 cm). Lower Yukon River area. 1890–1910. Collection Jack Bryan*

∇ **127** *Finger masks, also called dance fans, were worn by Bering Sea women dancers performing* inqasgiq *(communal-house) ceremonies. These fans with their animal or human faces recall the hooped mask worn by the central male dancer (125). Similar encircling-ring imagery is evoked through the rounded, swaying fringes of feathers when the fan is held in the female dancers' hands. The wooden body is filled with seeds or beads that rattle when the mask is used. Late nineteenth century. Height from top of feather to bottom of finger holes, 11" (28.0 cm). Private collection*

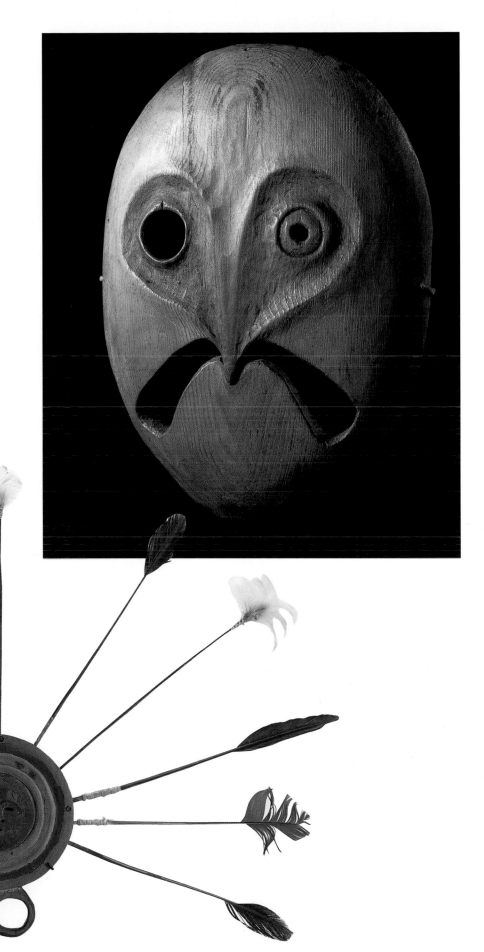

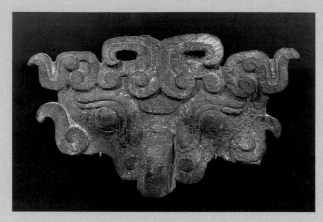

128 *Ancient Chinese bronze architectural element with t'ao-t'ieh tiger motif, which resonates through later native North American work. Shang dynasty (1750–1050 B.C.). Height, 7½" (19.1 cm). Courtesy Joseph Gerena Fine Arts*

▽ **129** *Siberian ivory snow goggles. The front (below left) is etched with nucleated eyes, track lines, and the sinuous curves associated with classic Old Bering Sea art. The back (below right) reveals fleshy eye pouches hidden beneath the skin. Viewed both horizontally and vertically, the designs form the faces of sculpins, deep-water scavengers that were powerful shamanic helpers within the Old Bering Sea culture. All of these motifs, and the concept of hidden imagery known only to the wearer (the eye pouches), are seen in North American shamanic artifacts. Sireniki, Siberia, 250 B.C.–A.D. 200. Length, 5⅝" (14.3 cm). Collection Jeffrey R. Myers*

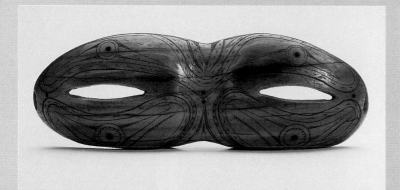

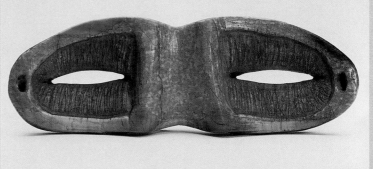

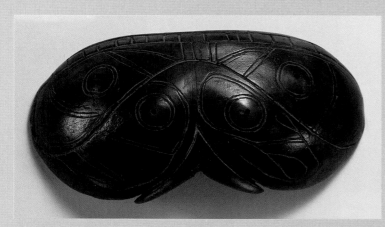

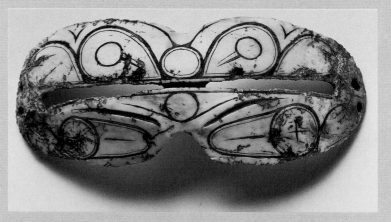

130 *Walrus ivory pectoral with an etched walrus motif from the Old Bering Sea culture, c. A.D. 100. The transformation of ancient iconographic patterns into walrus imagery reflects the significance of walrus hunting in this region. Saint Lawrence Island. Length, 3½" (9.0 cm). Collection Jeffrey R. Myers*

131 *Engraved ivory snow goggles from the Ipiutak site at Point Hope, Alaska, A.D. 100–600. Steel blades were used in Siberia before this time. Ipiutak engravings appear to be metal-cut, indicating possible Siberian-Alaskan contact. Length, 4¼" (10.8 cm). American Museum of Natural History, 60.1/7518*

VISION IMAGERY: SNOW GOGGLES

Hunters' goggles exhibit an important principle of the Arctic aesthetic: utility, spirituality, and adornment merge. Designed to permit a satisfactory field of vision, goggles protected against snow and sea glare. At the same time, their spirit-helper imagery—a delicately etched mythical bird or grotesque sculpin, for example—empowered the wearer. Eye motifs—the circle-and-dot (129) and the petaloid shape with circle-and-dot (resembling an eye within a beak)—gave the wearer superhuman vision. Like masks, goggles enabled transformation—into several possible identities, including that of one's prey.

The goggles in 129 and 131 contain zoomorphic patterns that relate stylistically to beastly creatures on Chinese artifacts (17, 128) and the walrus ivory pectoral (130), suggesting a connection between ancient Asian and Arctic design traditions. Although the iconographic links with northeast Asia are ambiguous, bilateral symmetry, double-curve Shang cheek lines, and stylized tiger eyebrows and eyes reappear as surface patterns on North American Arctic artifacts. The complex iconography of ancient ivory goggles indicates they were used ceremonially before or with the taking of the first whale.

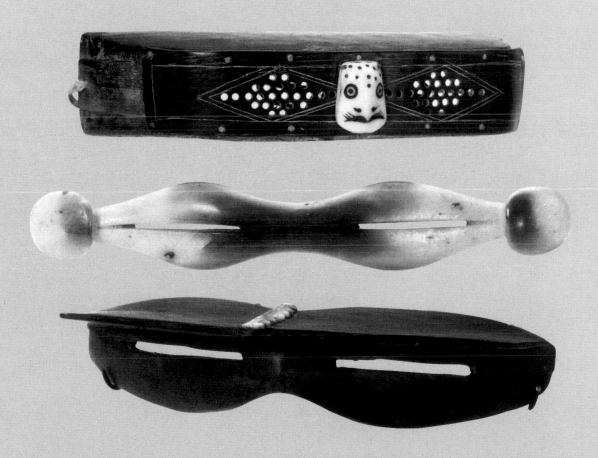

132 *Three nineteenth-century Bering Sea snow goggles. Wooden goggles with attached ivory amulet (top) recall the shape and eye slits typical of Old Bering Sea culture goggles. The eccentrically shaped ivory goggles in the middle appear to be a design innovation. On the wooden goggles at bottom, a painted red line encircles the eyes beneath the visor (a similar red line is seen on the shaman's mask 81). The hunter wearing these goggles was, by extension, encircled and protected. TOP: Length, 4¹⁵⁄₁₆" (12.5 cm). Collection Jack Bryan. MIDDLE: Saint Lawrence Island. Private collection. BOTTOM: Private collection*

To Eskimo and Inuit, the hole, like the circle, represents life. Prior to winter sealing, therefore, ceremonies were held to appease Sedna and other mythical figures for taboo violations. Springtime brought similar ceremonies to ensure success during the whaling season. Special adornment was displayed on these occasions (137).

Whaling Ceremony and Regalia

In northern Alaska, the importance of the great whales and the danger inherent in their pursuit was symbolized in ceremonies, rituals, and regalia. Rituals involved interaction among whaling captains *(umialik)* and their wives, shamans, and the entire community. The intent was to avoid slighting the whales, who would withhold themselves from hunters if treated disrespectfully.

Springtime was the first season in the Arctic world's annual cycle, and the whale hunt was considered a rite that marked this renewal of the cycle.[44] Whaling season commenced with the breakup of spring ice and return north of migrating herds. Preparations included holding ceremonial dances, wearing new clothing, and carving special amulets and implements for the hunt. Because the Takigagmiut of Point Hope (or Tikigaq) believed that the whale was able to see the *umialik* and his wife, they assumed important roles in ceremonies. When the whaling boat was launched, the *umialik's* wife lay flat on the beach at the ice edge. The harpooner pretended to catch her but actually threw the harpoon in the water. Through sympathetic magic, the whale would then be drawn to the harpooner.

Whalers sang chants and carried amulets and charms to attract their prey. Personal amulets included whale effigies (136), owlskins, and eagle heads attached to the whaling boat *(umiak)* or hung on cords around the neck, worn on the belt, or sewn to parkas. Particularly important were ancient amulets that would be connected to past successes or to the spirit world.[45] Amulets of water-worn amber fragments were wrapped in leather and hung on belts[46] (90).

Clean, well-made clothing was of utmost importance to the ritual. Greenland Inuit whalers bedecked themselves as if for a wedding. Otherwise, they believed, the whales would evade them because they abhorred uncleanliness.[47] While the men were engaged in whaling activity, women remained in the village, forbidden to sew or engage in any heavy work. Their dignified silence permitted the whale to go willingly to the hunters.

Numerous rituals followed the capture of the whale, whose soul *(inua)* was believed to live on. "The whale did not really die; it just took off its outer parka. And then its soul-inua went back in search of a new body."[48] As the whale was towed to the ice edge, the *umialik's* wife, dressed in fine clothing, greeted the whale ceremonially, offering it a drink of freshwater. (Salt water was believed to make whales thirsty.) At Point Hope, while the whale's bones were returned to the sea for regeneration, a portion of the whale tail was used in ceremony. Whales, born submerged, need tails for movement at the moment of birth. The tail, not the head, emerges first from the uterus.[49] Considered a sacred part of the whale, the tail symbolized life.

A successful hunt signaled ceremonies and great feasting to which neighboring villages were invited. Celebrated throughout Alaska, the Messenger Feast, a variation of the Northwest Coast potlatch (a gift-giving ceremony), achieved prestige for the host through the distribution of his surplus goods. Organized by the *umialik* and his crew, this weeklong winter gathering assembled members of different societies (coastal and interior Eskimo and Athapaskan Indian) for feasting, trading, storytelling, and athletic events.[50] A vast array of adornment and clothing was displayed and exchanged.

The ancient and poignant association of the loon and whale is portrayed in whaling ceremonial dancing, as explained by Anne-Marie Victor-Howe: "In the *umialik*

mind the loon's behavior is reminiscent of the whale: both migrated in the same direction in springtime. . . . Also the color of its black and white robe was similar to the color of the bowhead whale's skin. These colors signified the rhythm of time, the seasons, and the alternation of day and night, and life and death. . . . The fact that the loon was worn on the performer's head during the ritual signified the desire to obtain better sight in order to locate the whale. The hunters identified with the loon in that they wished to be as accurate as the bird in spearing its prey."[51] Additionally, the loon was lauded for its song and the grace of its dance in the courtship ritual. It may have been a symbol for the artistic aspect of human behavior expressed in the love of dance, music, and personal adornment[52] (139).

In the twentieth century, alternative food sources have diminished reliance on the whale, yet its cultural significance endures. While most of the old whaling ritual is gone, the hunt carries on its fifteen-hundred-year tradition as a sacred event at Tikigaq, the oldest continuously settled Native American site on the continent.[53]

NEW INFLUENCES ON OLD FORMS

Dates, places, and intensity of European contact varied widely throughout the Arctic. The Inuit were the first Native North American people to establish contact with Europeans, the Vikings in Greenland, around A.D. 900–1000. Norse explorers may also have reached the northeastern coast of North America in the tenth century. By the seventeenth century, Russian, British, and American explorers had introduced European utilitarian and decorative goods, all of which were used for adornment. The Eskimo bartered furs, ivory, and whale products for bells, pewter spoons, metal buttons, metal coins, glass beads, thimbles, needles, cloth, and woolen blankets.

European materials had little impact on the Arctic aesthetic until the eighteenth century, when increasing quantities of European trade goods began to influence Arctic clothing and ornamentation. On Eskimo Island, Labrador, items found at an eighteenth-century communal house included rhinestone cuff links, buttons, a coin, a pewter spoon made into a pendant, and 8,968 glass beads.[54] Farther west, following Russian expansion into Siberia and Alaska from the fifteenth to nineteenth century, European imports became more widely available to Native peoples.

In North America and Siberia, trading partnerships in which sea-mammal products were exchanged for those of the forest had long existed between coastal and interior dwelling peoples. Large trade fairs in the Bering Strait region extended these relationships. From the late eighteenth to the mid-nineteenth century, Siberians, Aleutians, Eskimo, Inuit, and Athapaskan Indians met and bartered at annual conclaves. The fairs, supplemented by commerce at smaller settlements, formed an extensive intertribal native trade network, spanning most of northern North America and eastern Siberia. In addition to European goods, indigenous materials—jade, ivory, chert, dentalium, shell, beadwork, and clothing—moved great distances along these routes (see map, page 64).[55]

Highly valued trade cloth was used in new ways within traditional designs (see page 98). Fabric supplemented and eventually replaced fur clothing. A parka constructed from fabric has, like the fur garment, an inner and outer layer. The inner parka is wool duffel; the outer, a heavy cotton. Most fabric parkas were styled like traditional fur parkas, with recognizable regional variations (166). Today, some hunters still favor fur parkas, though younger men may prefer down jackets. Also, contemporary women are often inexperienced at sewing furskin, which is difficult to work inside modern heated homes, where furs lose suppleness and dry out quickly.[56]

133 *A slate whale-effigy amulet from the Old Bering Sea culture. Whaling dates to the second millennium B.C. Found at Saint Lawrence Island. Length, 3³⁄₁₆" (8.2 cm). Courtesy Joseph Gerena Fine Arts*

134 *Chipped-stone whale effigies were worn around the whaler's neck or attached to his headband (136) for protection and good fortune. They were also thought to encourage the whales to consent to be hunted. Collected in the Point Barrow region, c. 1894. Jasper. Length, 1¾" (4.5 cm). Peabody Museum of Archaeology and Ethnology, Harvard University, 10/R69*

133 134

▽ **135** *Ivory amulets in the forms of fish, seals, and whales are combined with glass trade beads and attached to pieces of skin. The red glass beads are Venetian; the deep blue and turquoise-colored wound-glass beads are Chinese. These amulets, probably attached to clothing, were collected about 1875 among the Canadian Mackenzie Inuit, the easternmost tribe to be considered part of the whaling complex. Average amulet length, 3¹⁵⁄₁₆" (10.0 cm). The McCord Museum of Canadian History, Montreal*

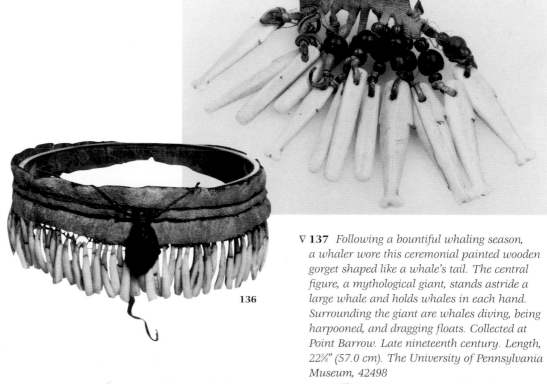

136 *During the whale hunt, head-bands with stone whale-effigy amulets suspended from the center were worn by both the whaling captain (umialik) and the head harpooner. Using these particular headbands, made from strips of fur and the teeth of inland Dall sheep, for hunting large sea mammals contradicts a northern Arctic taboo—the mixing of land and sea products. At Point Barrow, where this headband was collected in 1897, the rules were obviously bent. Length, 20³⁄₈" (52.0 cm). The University of Pennsylvania Museum, 41849*

136

▽ **137** *Following a bountiful whaling season, a whaler wore this ceremonial painted wooden gorget shaped like a whale's tail. The central figure, a mythological giant, stands astride a large whale and holds whales in each hand. Surrounding the giant are whales diving, being harpooned, and dragging floats. Collected at Point Barrow. Late nineteenth century. Length, 22³⁄₈" (57.0 cm). The University of Pennsylvania Museum, 42498*

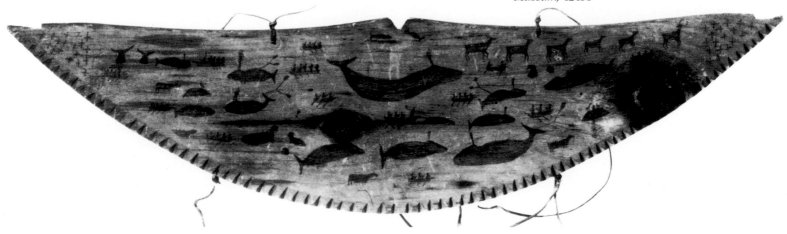

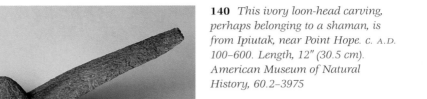

140 *This ivory loon-head carving, perhaps belonging to a shaman, is from Ipiutak, near Point Hope.* c. A.D. *100–600. Length, 12" (30.5 cm). American Museum of Natural History, 60.2–3975*

∇ **138** *Inuit dancer from Dolphin and Union Strait, in a Copper Inuit–style loonskin hat, performs at a farewell celebration for Denmark's Fifth Thule Expedition, 1924. The dancer, singing songs he wrote and owned, performed to the beat of a drum, sometimes joined by others during the refrain. His hat, made from white caribou fur, ocher-stained caribou skin, and dark sealskin, is adorned with two powerful amulets: a yellow-billed loon's beak and an ermine skin that hangs down the back of the neck. As few could afford to own such a prestigious item, it was passed around and worn by both men and women throughout the ceremony. The National Museum of Denmark, Department of Ethnology, NC 2274*

139 *Loonskin headdress made from the beak and skin of a yellow loon. Suspended from its nostrils are two highly valued turquoise-colored wound glass beads from China, traded into northern Alaska through Siberia. Length from top of head to tip of longest wing, 11⅜" (29.0 cm). Collected 1917–19 at Point Barrow, Alaska. The University of Pennsylvania Museum, NA 7009*

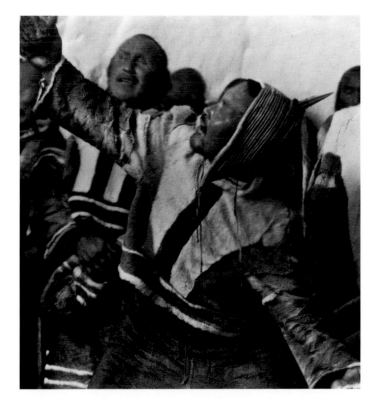

It is believed in ancient times that all animals had the power to change their forms at will. When they wished to become people they merely pushed up the muzzle or beak in front of the head and changed at once into man-like beings. The muzzle of the animal then remained like a cap on top of the head, or it might be removed altogether, and in order to become an animal again it had only to pull it down.

—Edward W. Nelson, 1899

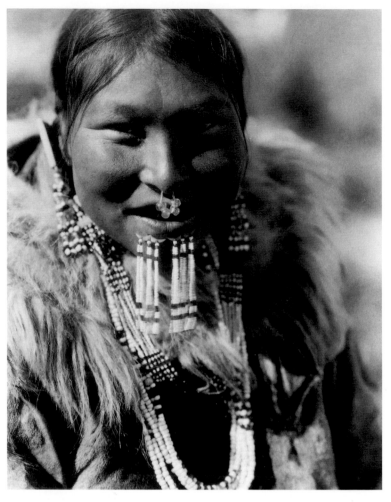

GLASS BEADS AND TRADE

Always a coveted trade item, glass beads worn in quantity conveyed status and wealth. Bering Sea Eskimos, unlike Canadian and Greenland Inuit and Siberians, never used beads on clothing, preferring to attach them to traditional ivory ornaments. They did, however, add strings of beads and some beadwork edging to fur pouches and belts.

◁ **141** *Kenowun, a young Nunivak Island woman, wears a variety of beaded facial adornment, including a nose ring, long earrings, and a chin labret with strings of glass seed beads. Photograph by Edward Curtis, 1929. Courtesy of the Library of Congress*

142 *Adorned adornment. Ivory earrings (top) with face images wear the lip and nose bead jewelry seen in 141. The men's earrings (bottom) are pieces of ivory attached to one another with strands of beads. The strands of multicolored glass beads hung down under the chin. Regarding the single earring in the middle, John Murdoch wrote from Point Barrow in 1887–88, "At present, one earring is much more frequently worn than a pair." All late nineteenth century. TOP: Length, ⅝" (2.0 cm). Collection Hedy Mann. MIDDLE: Collection Jeffrey R. Myers. BOTTOM: Ivory, glass beads. Length, 10⅝" (27.0 cm). Collection Jeffrey R. Myers*

143 *Earrings of dentalium shell, Chinese glass beads, and ivory collected among the Mackenzie Delta Inuit at Herschel Island. Pacific dentalium shells, acquired from neighboring Athapaskan traders, were rare and expensive. The highly valued Chinese blue beads, passed down through generations, reached the western Canadian Arctic from Sibera via Alaskan Eskimos. Nineteenth century. Length, 2⅝" (6.7 cm). McCord Museum of Canadian History, Montreal*

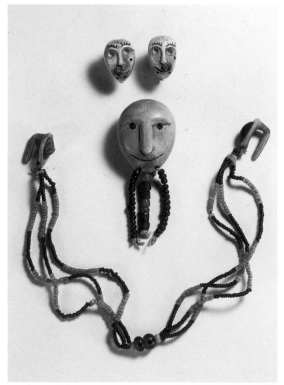

142

143

144

145

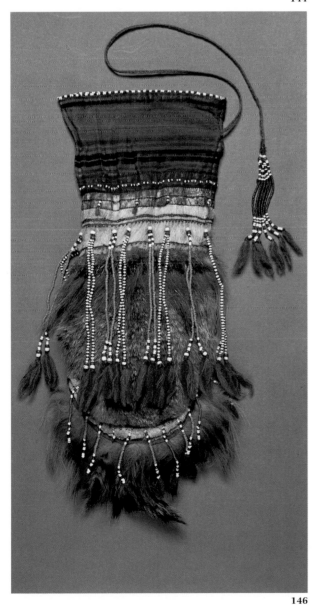

146

144, 145 *By the late nineteenth century, labrets incorporated prestigous glass trade beads or were made of bottle glass. Blue wound-glass beads of Chinese manufacture (144, top row; 145) were highly favored. At Cape Smythe, Alaska, Vilhjalmur Stefansson noted in 1914 that broken bead halves were frequently used for labrets; their broken sides were ground flat and held in place with seal-oil glue. 144: Collected in the Bering Sea or North Alaska region from 1878 to 1880. Ivory, limestone, glass. Outside diameter of top left labret, ⅚" (2.0 cm). The National Museum of Natural History, Smithsonian Institution, 37663, 16204, 38800, 44906. 145: Ivory base and blue wound-glass beads, Nunivak Island. Collected 1905. Height, 1⁹⁄₁₆" (3.9 cm). The University of Pennsylvania Museum, NA 380*

146 *A small pouch made from fur strips of six different animals incorporates bead-embroidered cloth and strings of glass beads with wool tassels. Length, 14⅞" (36.0 cm). Collected at Nunivak Island, 1905. The University of Pennsylvania Museum, NA 186*

147 *Traditional ivory-animal ear ornaments, attached to long strands of glass beads ending in brass loops, border the face with color and motion. Similar earrings are worn by Kenowun (141). Collected at Nunivak Island, 1905. Length, 12³⁄₁₆" (31.0 cm). The University of Pennsylvania Museum, NA 364*

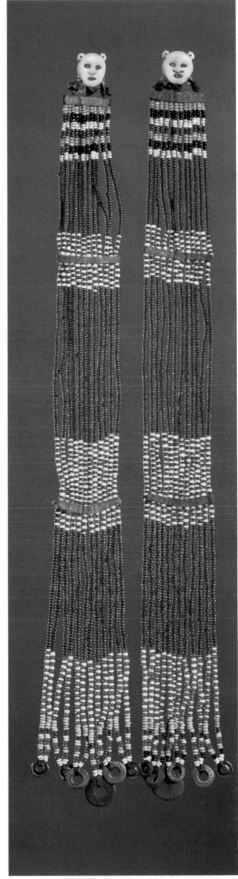

147

Beads of glass, a material unknown to Native cultures, were the most popular trade item. Adorning headbands, parkas, and wooden hunting hats, they served as both decoration and as protective amulets. Glass beads were incorporated into earrings, necklaces, bracelet, headbands, hairpieces, labrets, parkas, and hats (95, 149, 163). Even the West Alaskan Yup'ik, who retained their traditional culture into the mid- to late 1800s, preferred glass to earlier ivory and jet beads.[57]

In the Pacific Northwest, Chinese- and European-manufactured glass beads had long ago entered Alaska via Siberia through ancient trade networks. From the mid-eighteenth to the end of the nineteenth century, Russian fur traders brought increasing quantities of European, Chinese, and Japanese beads (150). Chinese and Japanese beads also entered the trade network through direct contact with the Japanese in Kamchatka. The majority of beads, however, came into the Arctic with European and American traders during the late nineteenth and early twentieth centuries.[58]

The extraordinary value of glass beads is illustrated in a story related by prospector Charles Brower in 1883, at Point Barrow, three hundred fifty miles north of the Arctic Circle: "One day a lone Eskimo came up the coast from Icy Cape . . . his sole wealth consisting of one turquoise [glass] bead and a couple of dogs hitched to a broken-down sled. He was on his way to Nubook to trade. I turned to Captain Herendeen: 'What can he get for one bead?' 'We'll see when he gets back.'. . . That lone Eskimo's reappearance in Utkiavie, after concluding his trade with the headman at Nubook, showed the part these beads played in the economic life of the natives all along the coast. In exchange for his one turquoise bead, the fellow showed up with a new sled, five dogs, ten large slabs of whalebone, five cross foxes, and one silver foxskin, *the value of which was well over a thousand dollars.*"[59]

Prior to European contact, Eskimo, Inuit, and Aleutians had made artifacts for their daily life and sacred needs. Later, they traded these personal items to outsiders attracted by the skillfully carved ivory and beautifully sewn skin garments. In time, the work was modified for a foreign market. By the end of the nineteenth century, ivory carvings produced specifically for sale to American whalers no longer had pragmatic or spiritual relevance for their makers. Nonetheless, in keeping with Native standards of excellence, many of these nineteenth-century pieces are exquisitely crafted (167, 170).

At the same time, where traditional ceremonies continued, sacred beliefs were powerfully expressed in, for example, Bering Sea Eskimo masks of the nineteenth and twentieth centuries (81, 125, 127). Moreover, even when trade cloth and glass beads were incorporated into clothing and jewelry made for personal use, the items frequently retained spiritual symbolism (110, 151, 162).

Yet the influx of traders and settlers brought profound changes in lifeways. Roman Catholic and Anglican missionaries introduced Christianity; teachers, the English language. Both attempted to suppress traditional beliefs. Missionaries considered shamanism evil and were strongly opposed to the wearing of amulets. For the native North American, pride in one's place in the natural order gave way to feelings of inadequacy.

Relocation to prefabricated government housing in village settlements and dependence upon store-bought food created further anomie. Western manufactured clothing was introduced. Children were forcibly separated from their families and placed in boarding schools. In consequence, hunting, carving, and sewing skills that had always passed in apprentice fashion from one generation to the next diminished.

148 *Glass-bead adornment was worn by eastern Canadian Inuit as early as the seventeenth century. In this 1768–69 portrait by English artist John Russell, Mikak, an Inuit from Labrador, has tattoo lines on chin, cheeks, and brow, wears long beaded hair ornaments, and holds an English medal. Note the similarities of Mikak's beaded hair ornaments to the Nunivak Island earrings, 147. Despite the physical distance of thousands of miles and a time difference of nearly one hundred and fifty years, resemblances can be seen in Arctic adornment even after European contact, which might indicate earlier precontact familiarity with similar objects. Institut und Sammlung für Völkerkunde der Universität Göttingen*

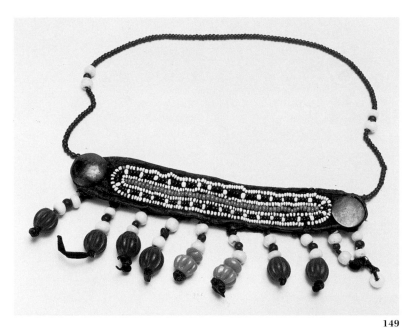

149 *This brightly colored Siberian Koryak woman's dance headband demonstrated both her craftsmanship and her husband's ability to obtain coveted brass buttons, Venetian glass beads, and Chinese glass "melon" beads. The hanging strings of beads might also have had religious meaning. Like the tassels on Siberian shaman hats (204) and the beaded strands of the Tanaina puberty veil (206), they partially obstructed the dancer's vision. Kushka, Siberia, 1900–1910. Koryak. Length, 7⁷⁄₁₆" (18 cm). American Museum of Natural History, 70 3590*

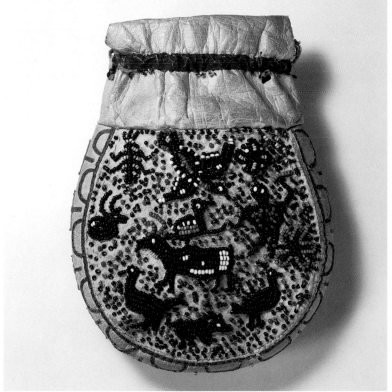

150 *A headband of beads on the skin of a mountain sheep* (Ovis montana), *used as a "charm" in whaling. Collected from the North Alaskan Coast Eskimo at Point Barrow, this headband violates the Arctic taboo of strict separation of land and sea products. The beads, possibly of Japanese manufacture, were obtained through the Siberian-Alaskan trade network. Collected 1898. Length, 17⅞" (45.4 cm). The University of Pennsylvania Museum, 42255*

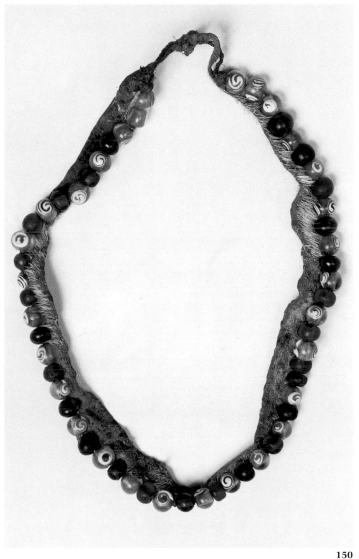

151 *A bag, perhaps an amulet pouch, was collected from the Siberian Chukchi. Beadwork, embroidered onto scraped hide, may represent the belief that all beings are connected: man + duck + reindeer. The animal in the upper right is possibly a sculpin. The sides of the bag have leather strips showing crosses and a hooped pattern. The U-forms bordering the bag recall ancient Punuk designs. On the back is a name written in beads, Ayfsons Otavejnw. Late 1800s–early 1900s. Length, 6⁵⁄₁₆" (16.0 cm). Collection Hedy Mann*

TODAY'S EXPRESSIONS

Traditional artisans and their belief systems never completely disappeared. Canadian Inuit women continued to sew and embroider parkas (165); Alaskan Eskimo men carved ivory bracelets and rings (172). During the 1940s, ivory carving was the main source of income for many Bering Strait Eskimos, most of whom lived at a near subsistence level. The men enjoyed carving, so long as they could also hunt. On King and Diomede Islands, the men resourcefully exploited technology: sewing machines were converted into lathes for making ivory beads. Taboos against using electrical tools to carve animals were set aside for the time-consuming process of beadmaking.[60]

At the turn of the century, there was a need among the Eskimo to replace the fur trade as a source of income. Awareness of their innate creative abilities stimulated numerous Alaskan art, jewelry, and textile projects. In Canada, the Hudson's Bay Company, Canadian Handicrafts Guild (now the Canadian Guild of Crafts), and the federal government established a foundation for outstanding programs that Inuit cooperatives have developed into today's financially successful cottage industries.[61]

For the most part, Inuit art today is tied to the life known and remembered and to technical mastery, much of which is still self-acquired. The contemporary work of Arctic carvers, sewers, jewelers, and dollmakers epitomizes their adaptability and enduring high standard. Many artists indicate that their work is a legacy and record of the old ways for their grandchildren and future generations of Inuit.[62] Jewelry and carvings explore and confirm traditional Inuit spiritual beliefs; however, some changes are evident. Women are now carvers (178–82), and traditional themes are being reinterpreted (168, 174–75).

Within traditional Arctic cultures, carving was as important as hunting. The skills were considered reciprocal: those learned in carving could be useful in manual work related to hunting. And since it was believed that a boy could not become a proficient carver unless he began when very young, most youngsters were given tools and ivory by the age of four. "The carver . . . explains that the reason he carves so well is because his father began teaching him when he was very, very young. And if a man carved a pleasing object two thousand years ago, that was because his father had taught him, too. Thus . . . Eskimo history is . . . a continuum of fathers teaching their sons to make beautiful things of ivory."[63]

A high percentage of adult Inuits still know how to carve. Moreover, within relatively small Eskimo and Inuit populations, numerous individuals are gifted artisans. A carver explains: "Why are Inuit such good artists? I think it is because of strong will and determination, the determination to make something, carvings and drawings, because of need. Because with fewer sealskins being sold, people must make other things to compensate for [the loss of] the sealskins."[64]

Aliva Tulugak of Povungnituk, a second-generation carver, suggests that "young people should learn to carve . . . because what they learn with their hands can be put to use in sled-making or harpooning, or any activity that is useful when they are away from the village. In the 1950s [the beginning of the contemporary Inuit art movement] carvers used the skills learned in making hunting implements to carve images in stone."[65] Aliva's suggestion is a startling reversal of that process. Inuit art seems to have come full circle.

THE PARKA

The parka, essential to Arctic clothing, provided not only physical protection from cold but also, through its stylistic elements, identified the wearer by gender and community. Clothing, like masking, could also express spiritual transformation. The design of the central Arctic parka beautifully synthesizes these functional, social, and spiritual qualities.

The traditional parka, a fur jacket with an attached hood, was worn in two fur layers, with the fur of the inner layer facing the body. Air trapped between the layers acted as insulation. Most parkas were of caribou or seal fur. Caribou fur was preferred in winter because the long hollow caribou hairs supplied additional insulation, while the more water-repellent sealskin was used in spring and summer.

Parkas worn by men and women had two distinct forms, mirroring their contrasting but complementary roles within Inuit society. The male parka's zoomorphic imagery projected hunting; the female parka, while incorporating animal references, focused attention on the maternal role. The Copper Inuit male's parka, with caribou ears on the hood and stylized predator tail on the back panel (inset with white fur strips), underscores the importance of inland caribou hunting.

The female parka (*amautik*) is distinguished by a large pouch or hood baby carrier (*amaut*) on the back. The *amaut* could be enlarged with additional pieces of fur to accommodate the growing child. In effect a "second womb," it enabled intimate mother-infant bonding. The parka's broad shoulders allowed the mother to move the baby to the breast within the parka's warmth. The phallic quality of the *kiniq*, a narrow appendage on the front of the parka, further suggests fertility, as well as the duality inherent in Arctic male and female relationships.

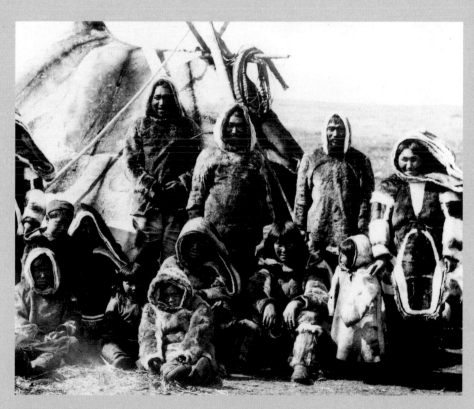

152 *An Eskimo band from Great Whale Rive (Poste-de-la-Baleine), Nouveau-Québec. This photograph, taken in 1876 on the east coast of Hudson's Bay, demonstrates the similarity of women's parkas throughout the eastern Canadian Arctic. Note that the parka at far right exhibits the same uteral motif as the Labrador parkas (153). Canadian Museum of Civilization*

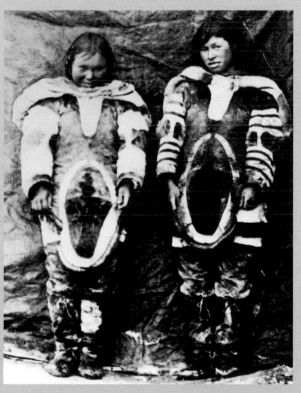

153 *Two young Inuit women from Labrador wear parkas* (amautik) *with inset fur patterns suggesting the uterus over the woman's womb, an extraordinarily graphic representation of the parka as a "metaphor" of maternity. This design feature was found on women's parkas in the eastern and western Arctic. Photographed 1916. Canadian Museum of Civilization*

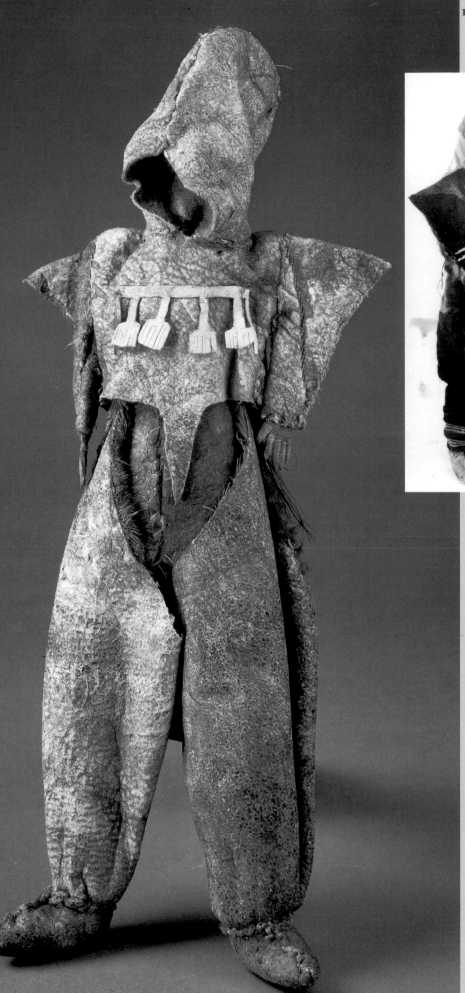

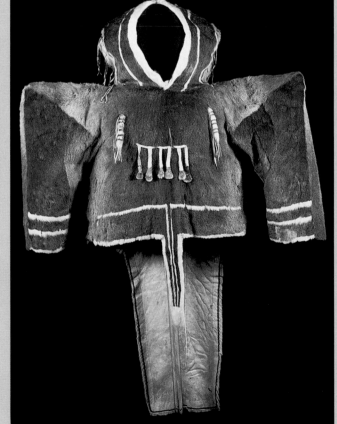

154 *A Copper Inuit doll wears a fur and hide parka similar to the woman's parka (156), including the kiniq and caribou-palate amulet. Collected at Coppermine River, King Williams Land, n.d. Height, 12⁷⁄₁₆" (31.0 cm). Peabody Museum of Archaeology and Ethnology, Harvard University, 10/87689*

155 *A young Copper Inuit girl wears a traditional parka with caribou foretooth amulets. Women who desired male children wore caribou charms. Early twentieth century. Coronation Gulf, Northwest Territories. Canadian Museum of Civilization*

156 *An exceptionally handsome example of a Copper Inuit woman's parka (amautik) showing the expanded baby-carrying pouch (amaut), broad shoulders for breastfeeding, the kiniq appendage, the back tail, and a protective caribou-palate amulet attached to the chest. Collected 1920–21. Length, 48" (121.8 cm). Peabody Museum of Archaeology and Ethnology, Harvard University, 10/97894*

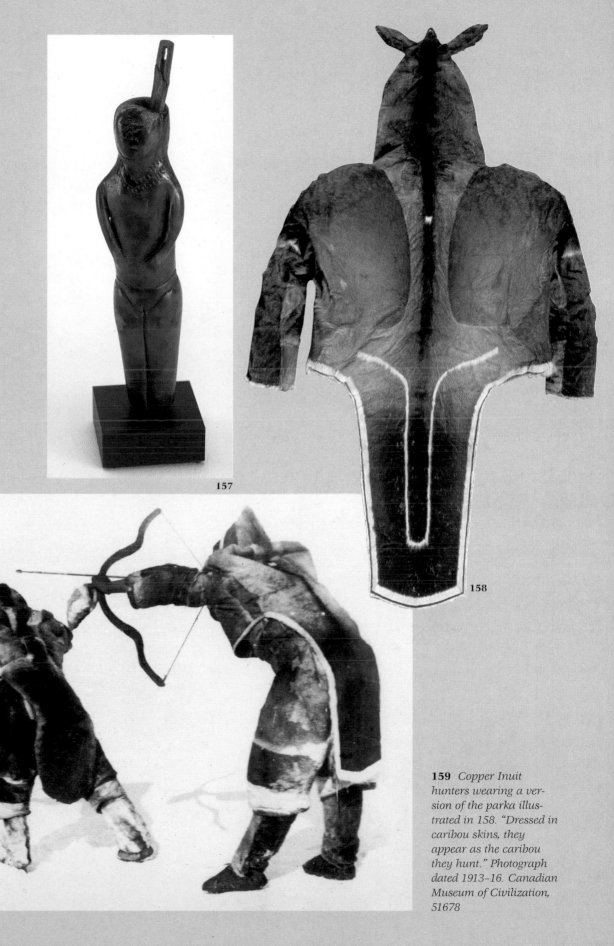

157 *An ivory needle holder belonging to a Bering Sea Eskimo woman. The front is a female wearing a necklace and dance apron. (On the reverse, the head rests in a parka hood from which emerges a protective bear-spirit face.) The vulva line depicted simultaneously with the dance apron probably represents the idea of the unseen made visible. The care vested in crafting the holder, as well as the iconography of the carving itself, indicates the importance of needlework to the Eskimo. Point Hope, Alaska, 1775–1880. Height, 7½" (19.1 cm). Private collection*

158 *This Copper Inuit male parka formed a complementary pair with the female parka (156). Collected 1913–16. Sealskin, caribou fur. Length, 55⅛" (140.0 cm). Canadian Museum of Civilization*

157

158

159 *Copper Inuit hunters wearing a version of the parka illustrated in 158. "Dressed in caribou skins, they appear as the caribou they hunt." Photograph dated 1913–16. Canadian Museum of Civilization, 51678*

TATTOOING, GLASS BEADWORK, AND THE PARKA

eedle and thread, tools for tattooing, are also the tools for beadworking. During the late nineteenth century, as missionaries discouraged the ancient practice of tattooing, its symbolic function entered into beadwork. Beads were applied to the woman's inner parka, where spiritually empowering amulets were once attached. The relationship between beadwork and traditional tattoo patterns can be seen in beaded parkas from the central Canadian Arctic. Beadwork over the chest and around shoulders and wrists and simple geometric motifs set between pairs of horizontal lines restate tattoo motifs. Hood designs frequently contain abstractions of animal vertebrae and skeletal rib-cage designs (163).

The beaded parka of the central Arctic bridges Inuit history. Its formal conventions recall archaic forms of tattooing, joint marking, and skeletal design. At the same time, introduced European materials—glass beads, thread, and cloth—denote the influence of external trade and contact.

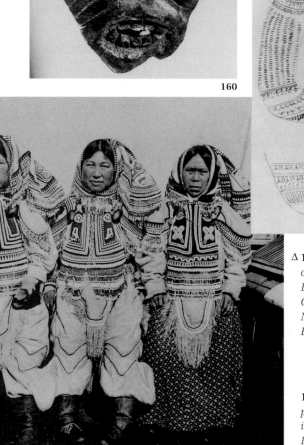

160 *The parallel lines on the cheeks of this stone-maskette amulet are probably tattoos and may relate to the skeletal motif. Igloolik. Dorset culture, c. A.D. 500. Length, 1¾" (4.49 cm). Eskimo Museum, Churchill*

160

△ **161** *Traditional female tattoo patterns on the face, arms, hands, and thighs. By Arnarulunguaq (Netsilik), c. 1931. Central Canadian Arctic. The National Museum of Denmark, Department of Ethnology*

162 *Inuit women in beaded inner parkas, which demonstrate how tattooing patterns were applied to beadwork. Photograph taken in the Northwest Territories by the A. P. Low Expedition, 1903–4. National Archives of Canada*

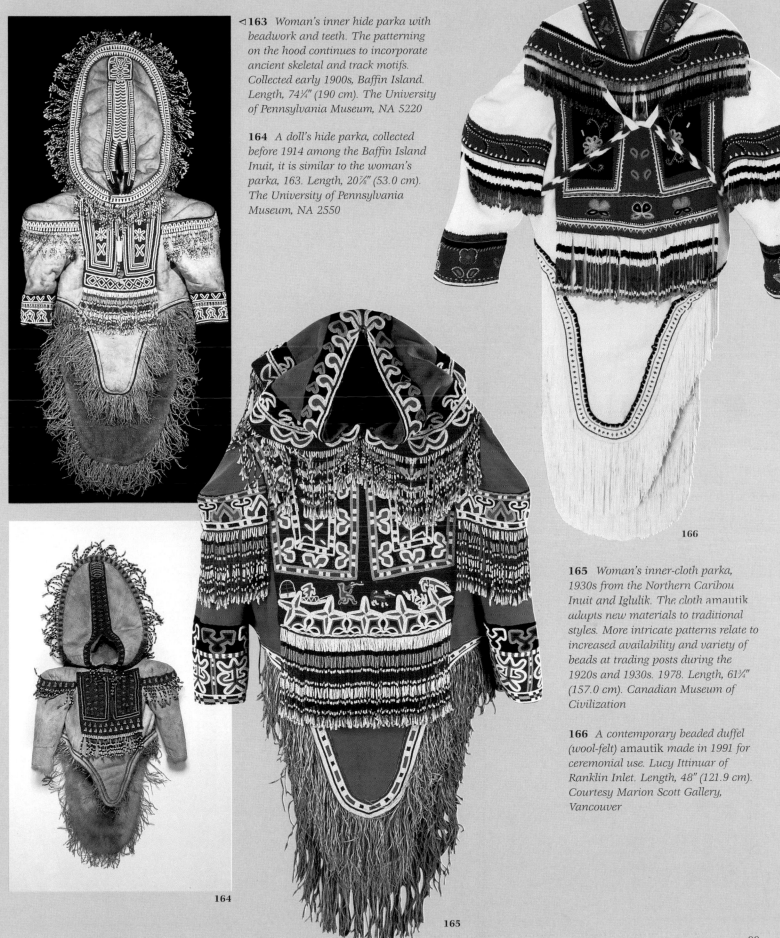

163 Woman's inner hide parka with beadwork and teeth. The patterning on the hood continues to incorporate ancient skeletal and track motifs. Collected early 1900s, Baffin Island. Length, 74¼" (190 cm). The University of Pennsylvania Museum, NA 5220

164 A doll's hide parka, collected before 1914 among the Baffin Island Inuit, it is similar to the woman's parka, 163. Length, 20⅞" (53.0 cm). The University of Pennsylvania Museum, NA 2550

166

165 Woman's inner-cloth parka, 1930s from the Northern Caribou Inuit and Iglulik. The cloth amautik adapts new materials to traditional styles. More intricate patterns relate to increased availability and variety of beads at trading posts during the 1920s and 1930s. 1978. Length, 61¾" (157.0 cm). Canadian Museum of Civilization

166 A contemporary beaded duffel (wool-felt) amautik made in 1991 for ceremonial use. Lucy Ittinuar of Ranklin Inlet. Length, 48" (121.9 cm). Courtesy Marion Scott Gallery, Vancouver

164

165

167 LEFT: *In this traditional ivory amulet used for hunting magic by nineteenth-century Aleutians, a sea otter rests on his back.* RIGHT: *The ivory seal, reminiscent of the Aleutian sea otter, is from King Island. It was made for adornment during the late nineteenth or early twentieth century. The latter is an example of the finest commercial carving. The carvers maintained their tradition of excellence whether the work was for commercial or for personal use.* LEFT: *Height, 3" (7.6 cm). Both Collection Jeffrey R. Myers*

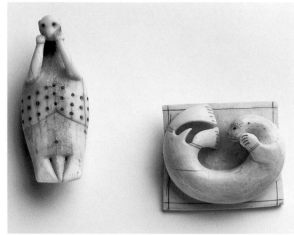

167

168 *Men dressed elegantly when hunting sea otter in the belief that the otters would be drawn to the human finery. Denise Wallace relates that when she was growing up, girls were encouraged to observe sea otter mothers caring for their young as an example of loving mothering. Sea otter–woman transformation pin/pendant, from the* Sea Otter Belt *by Denise Wallace and Samuel Wallace, 1995. No. 2, edition of 5. Chrysoprase, chrysocolla, sugilite, lapis lazuli, silver, gold, fossil ivory. Length, 2⅞" (7.3 cm). Private collection*

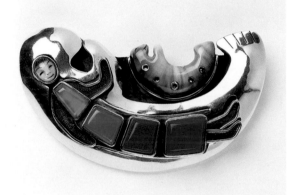

168

169 *An etched-ivory pendant exemplifies the technical virtuosity of Alaskan carvers at the turn of the century. Height, including the silver border, 1⁵⁄₁₆" (3.4 cm). Private collection*

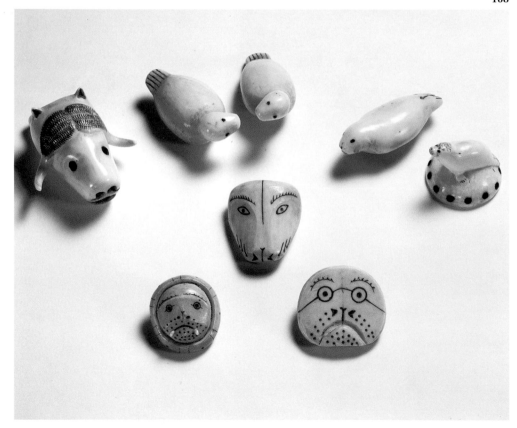

◁**170** *A collection of sensitively carved ivory buttons made for trade. (Traditional Eskimos did not wear buttons.)* TOP ROW: *Five effigy buttons, c. 1900–1915. The three with faces are nineteenth-century buttons from Sitka, Alaska.* BOTTOM: *A man-walrus transformation button. He wears a parka hood, has a walrus face, and nucleated (all-knowing) eyes. Widest, ¹¹⁄₁₆" (2.8 cm). Collection Jeffrey R. Myers and Private collection*

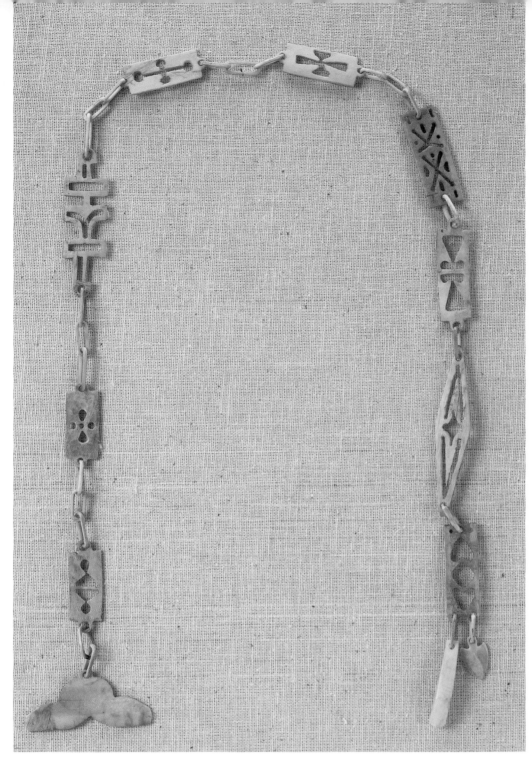

171 *An ivory filigree chain carved in Nome, Alaska, at the turn of the century. These chains, inspired by traditional Siberian shaman amulets and chains, some dating to the Old Bering Sea culture (111–12), were worn in layers on the Alaskan shaman's parka during ceremonial dances; their clicking noises accompanied the dancing. Length, 27⅛" (69.0 cm). Private collection*

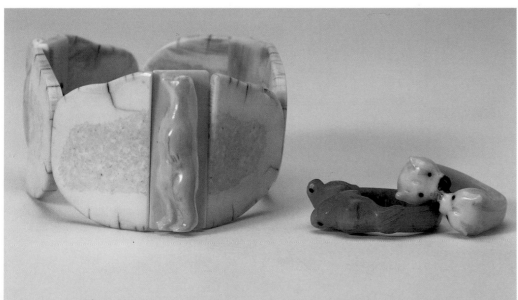

172 *This ivory bracelet and two rings are fine examples of Alaskan ivory carvings made during the 1930s and 1940s. Height of bear figure on bracelet, 1½" (3.8 cm). Collection Hedy Mann*

THE *ULU*: TRANSFORMING A TRADITIONAL FORM

The semicircular *ulu* knife—used with a rocking motion to cut food, skins, and thread—was an Arctic woman's most important tool. Its prominent role in traditional lifeways gave it nearly mythic status. Introduced by the Norton culture Eskimos (who settled much of the Alaska coast about 500 B.C.), the earliest *ulu* were slate blades wedged into handles of caribou antler or wood. Following European contact, steel blades were set into walrus-ivory handles. In the eastern Arctic, the blade is separated from the handle by a small shank.

173 *Ulu knife from the central Canadian Arctic. n.d. Wood and steel. Height, 5⅝" (14.3 cm). Collection Nina Safdie*

174 *A group of contemporary Canadian Inuit ulu-motif jewelry items including (counterclockwise from top) wood and silver cuff links; a carved black baleen pendant on a beaded sinew cord; ivory pin and earrings; argillite pin; silver and copper pin, height, 1⅝" (4.1 cm). All, Collection Dorsey.*

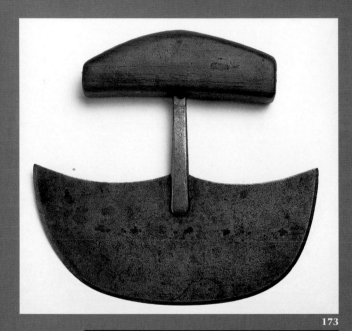

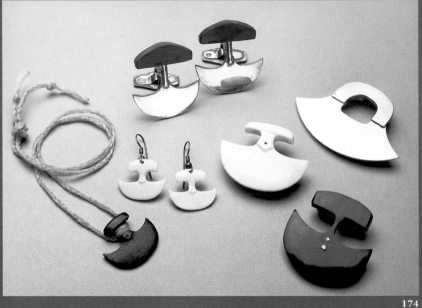

173

174

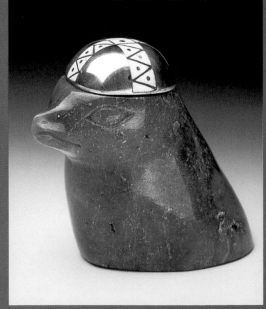

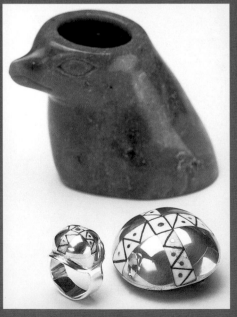

◁**175** LEFT TO RIGHT: *A contemporary green soapstone bird-seal sculpture transforms into a jewelry box. The cap is a pin; inside is a matching ring of silver inlaid with ivory. The interior of the sculpture has breathing holes. Made by P. Etidloee of Cape Dorset in the early 1970s. Overall height (closed), 3½" (8.9 cm). Pin diameter, 1½" (3.8 cm). Collection Dorsey*

CONTEMPORARY ARCTIC ARTISANS

"Women have real important roles. . . . They have been capable for a long time, but it is just now that their capabilities are coming into the open." In her powerful self-portrait, *Ookpik Fetching Water,* **Ookpik Pitsiulak** pays tribute to outstanding women, especially to her grandmother who worked for many years as a housekeeper. "She wasn't just a cleaning lady. She did cooking and sewing and still managed to do beautiful beadwork. . . . She was a real woman." Ookpik's work eloquently expresses the Inuit woman's struggle to survive day to day in the modern world, while continuing to carry on traditions.

A sense of irony is reflected in **Thomassie Kudluk**'s work. Physically hampered by a bad leg, only one working arm, and poor eyesight, he capitalized on his humor and understanding of the ordinary "less than perfect" Inuit man and woman. Limited in his physical ability to carve, he used what nature had to offer. In *Beautiful Woman,* he worked with the predetermined shape of a found object, an antler, creating the form within its natural curves. Kudluk submitted the work to a contest sponsored by the Canadian Department of Indian and Northern Affairs. When he learned that entries had to be jewelry, he added a looped thong to the top of his 18" (45.7 cm) caribou-antler carving. Because of this perseverance, Kudluk was deeply respected within the community.

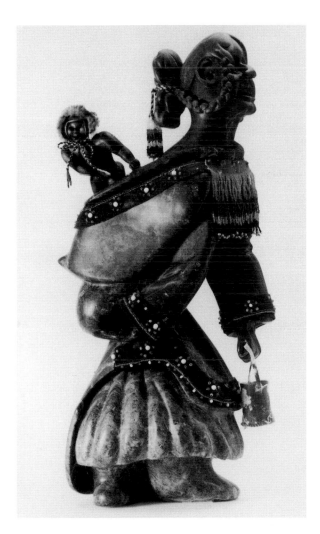

176 Ookpik Fetching Water.
Ookpik Pitsiulak (Inuit). 1990. Greenstone (serpentine), glass beads, wool fabric, wool cord, sealhide, tanned leather, fur. Height, 25" (63.5 cm). Canadian Museum of Civilization

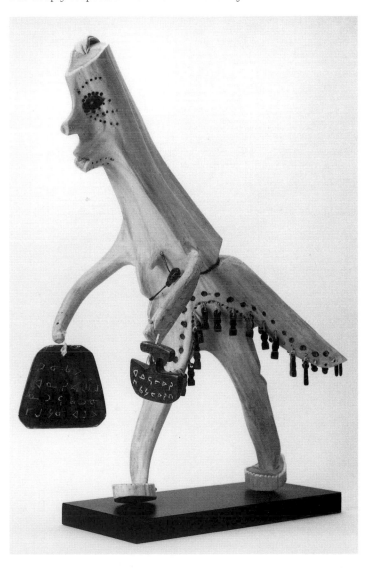

177 Beautiful Woman. *Thomassie Kudluk (Inuit). 1976. Antler, stone. Height, 18" (45.7 cm). Private collection*

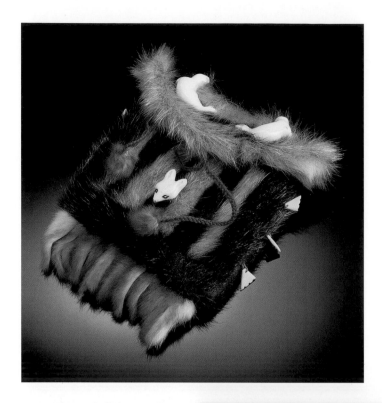

Qaunak Mikkigak's work has a surrealist quality yet is deeply rooted in Inuit tradition and beliefs. Exaggerated scale, hands protruding from heads, goose bones completing the body of a man—all emerge from the artist's imagination but are consistent with the mythical interpretations of the Inuit. Simultaneous images, shifting from animal to person, are in keeping with Arctic notions of duality, the unity of all life, and the absence of fixed physical and spiritual boundaries.

Δ **178** *Belt pouch. "It's a small pouch where you carry your money. . . . I thought perhaps if we had our pouches there as necklaces, we would not lose our money so much." Qaunak Mikkigak (Inuit). 1976. Sealskin, red fox fur, ivory, wood, sinew, cotton cloth. Height, 6⁵⁄₁₆" (16.0 cm). West Baffin Eskimo Cooperative Limited, Cape Dorset*

179 *Neck pouch. Qaunak Mikkigak. 1976. Stone, ivory, sealskin. Width, 17⅛" (43.5 cm). West Baffin Eskimo Cooperative Limited, Cape Dorset*

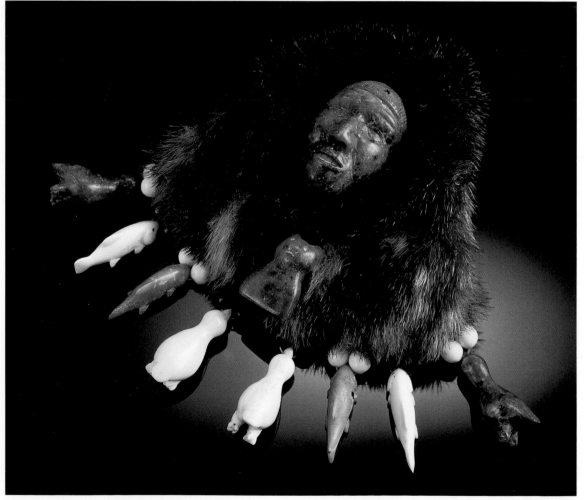

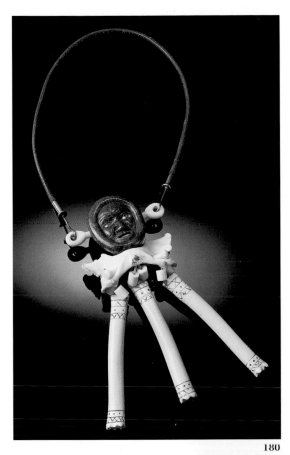

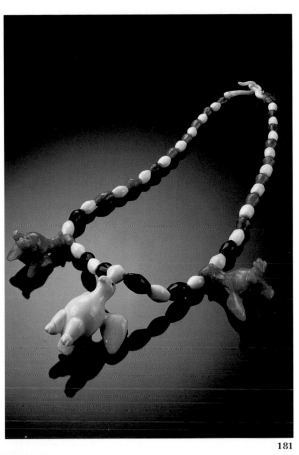

180 *Necklace. "They . . . are made out of the bones of seal . . . and geese. . . . I made sure that these parts look like the ones I used to have. . . . I put them there to ensure that the necklace looks and feels solid." Qaunak Mikkigak. 1976. Stone, ivory, bone, sinew, leather, metal. Length, 14⅛" (36.0 cm). West Baffin Eskimo Cooperative Limited, Cape Dorset*

181 *Necklace. "We used to have necklaces like these and I really used to admire them when I was a little girl. So I made them out to look like the ones I used to have. . . . I made them in contrast with each other because I liked it that way." Qaunak Mikkigak. 1976. Ivory, stone, metal, sinew. Length, 11¹³⁄₁₆" (30.0 cm). West Baffin Eskimo Cooperative Limited, Cape Dorset*

180 181

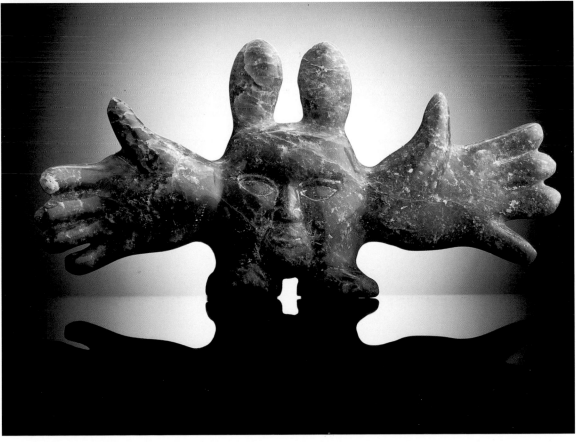

182 Head with Hands, *a greenstone transformation sculpture, evokes an Inuit mythological creature,* tunnituarruk, *"a flying head with human hands and bird feet who taught throat singing [the tunnituarruk's ordinary language] to the Inuit." Mikkigak is herself an accomplished traditional throat singer. Qaunak Mikkigak. 1991. Width, 8" (20.3 cm). Canadian Museum of Civilization*

Denise Wallace, a Chugach Eskimo–Aleut, and her non-Native husband, Samuel, combine their respective expertise in metalwork and lapidary to make original jewelry whose complex and multilayered designs are inspired primarily by Aleutian tradition, stories, and symbolism. In describing the work, Denise states, "It is not abstract, but rather representative of objects, people, and legends of our belief system, [in which] all things are interconnected." The most prevalent motif in the Wallaces' work is transformation. Pieces often have doors that open up to reveal hidden images. Denise explains, "It has a basis in traditional masks where a face might open up in the body of an animal, and inside there would be another face. You find this theme of transformation in many traditional pieces, from small carvings and fetishes to large masks. It's a way to show the inner spirit of an animal, person, or object."

As a teenager, Denise lived in Alaska with her Aleutian grandmother, whose stories and songs would provide a resource of ideas for her granddaughter's fertile imagination. "My grandmother told stories and sang songs that were mixtures. The stories were Aleut; the music and melodies were Russian. The main spiritual influence in the area was from the Russian Orthodox Church, so it was also a transformation." She adds, "Even today, I borrow a little from the others: Yup'ik Eskimo, the Tlingit, and the Athapaskans. Alaska was a gathering place for all these people. Because we borrowed from each other in the past, it's still all right to borrow!"

Samuel Wallace describes their collaboration as a division of responsibility, "Designs are hers, and stones are mine." He continues, "For us, translucent stones don't work; they're dependent upon light reflection and refraction, and there is virtually none when stones are inset the way that ours are. We use solid, vivid colors. I don't overpolish. To me that takes away from the nature of the stone."

The Wallaces created their remarkable *Crossroads of Continents* belt after viewing the "Crossroads of Continents" exhibition (an overview of the interconnecting cultures of the Bering Sea region's Siberian, Alaskan, and Canadian Native peoples) at the American Museum of Natural History in 1988. The belt, composed of ten detachable figures (four are seen in 96, 114, 208, and 818), incorporates the dress, adornment, and lifeways of the ethnic cultures represented in the show. To create the belt required more than twenty-five hundred hours. Each tiny figure wears accurately rendered regional clothing. Garments open on small hinged doors to reveal images of the landscape, everyday life, or legends—portrayed in lapidary work and inked scrimshaw drawings. Several figures contain compartments with removable earrings and pendants. "When closed, the belt has no beginning or end, symbolizing birth and rebirth and connecting the past with the present."

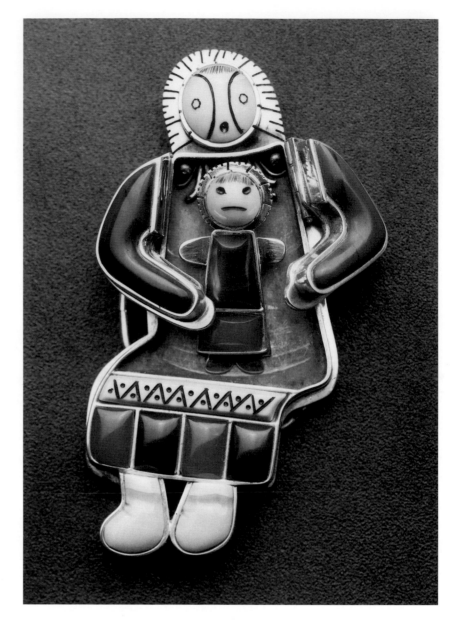

183 *Dollmaker pin/pendant. Denise Wallace and Samuel Wallace. 1991. Sterling silver, fossilized walrus ivory, chrysocolla, sugilite. Height, 3¼" (8.3 cm)*

DOLLS

Dolls have long been central to Arctic cultural traditions. Early doll prototypes, carved ivory female figurines from the Old Bering Sea I (Okvik) culture (c. 200 B.C.–A.D. 100), may have been ceremonial or fertility figures rather than toys. Some appear pregnant, while others exhibit the skeletal rib-cage motif typically associated with shamanism. Shaman figurine doll amulets were worn in historic times (119–20), although an earlier Thule-period ivory figurine (184) was probably a toy.

While the function of the ancient figurines remains unclear, historic and contemporary Arctic play dolls were manufactured using similar principles: carefully carved heads, arms either nonexistent or sculpted against the body, and partially carved upper torsos attached to cloth bodies. The lack of limbs permitted little outfits to be changed easily.

Arctic dolls were gifts, either carved for girls by their fathers or made by mothers or the girls themselves. Creating doll clothes was a valuable learning experience. Preparing the materials, sewing the pieces together, and repeating tribal patterns developed skills that enhanced marriage possibilities. Traditionally, young girls learned by observing their mothers. According to Ann Fienup-Riordan, "Yup'ik Eskimo girls played with dolls until first monthly periods. . . . It seems only appropriate that a girl would be required to put away her *irianiaguaq* (literally, pretend child) between the time she could play with it and the time she could produce her own."

Since the late nineteenth century, dolls in ethnic garb have been made for sale to non-Natives. Dollmaking has become an important art form in Alaska and Canada. Although today, most young Eskimo and Inuit girls play with commercially manufactured rather than traditional dolls, contemporary Arctic dollmakers have vivid memories of playing with dolls. "Each doll had a name and could act and talk like a person," remembers Anaoyok Alookee of Spence Bay. "Together, the dolls of each little girl formed a separate and very real family . . . including a teenage girl, grandmother, younger brothers and sisters, pregnant mother. . . . Men [were] not very important—usually they went out hunting and were not around much."

When playing with dolls, Inuit children imitated adults, thereby observing and learning appropriate behavior. Modern Inuit children have lost this traditional way of playing. "Nowadays children don't make play dolls," Alookee says, "because there are more children to play with, not like in the old days in the camps, and they watch TV and go to the gym."

184 *Ivory doll from the Thule culture (A.D. 1200–1300s), found on Saint Lawrence Island. Height, 5⅞" (14.9 cm). Courtesy Joseph Gerena Fine Arts*

185 *Drawing of an ivory doll, similar to 184, collected by E. W. Nelson on Saint Lawrence Island, c. 1881. Height of doll, approximately 3" (7.6 cm).*

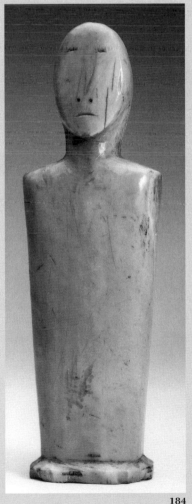

184

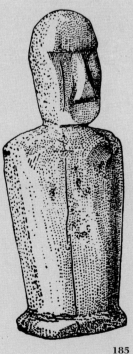

185

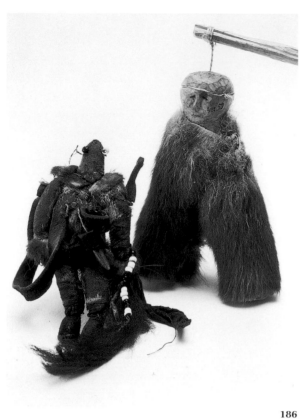

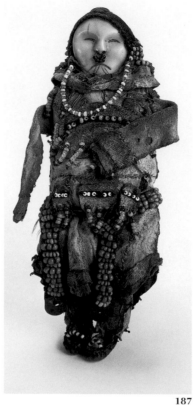

186 *Guardian dolls.* LEFT: *Sun-worm doll, "a guardian of women, has fur clothing, beady eyes, a fur tail, and a hexagonal nut strung on a lanyard. The body contains a worm, 'the vivifying one' that falls from the sky into a woman's root basket and protects her from sterility." Koryak, Siberia. Collected 1900–1901. Height, 4⁵⁄₁₆" (11.0 cm). American Museum of Natural History, 70-3594.* RIGHT: *Suspended Chukchi ancestor-guardian amulet of wood and skin. Nineteenth century. Museum of Anthropology and Ethnography, Leningrad, 422-77*

187 *A nineteenth-century Eskimo doll from King Island, Alaska. She has an ivory head and wears a beaded nose ornament, earrings joined in a strand of beads below the neck, and a wide belt covered with tiny beads representing caribou teeth as in 109. Height, 5½" (14.0 cm). National Museum of the American Indian, 5/9836*

186

187

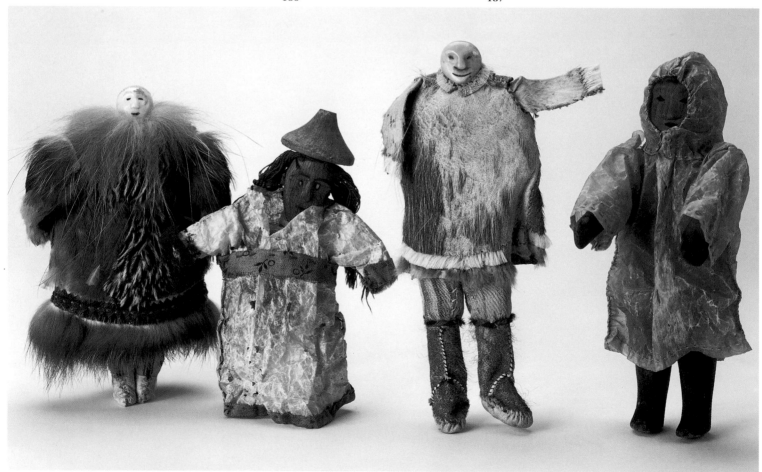

188

◁ **188** *Nineteenth-century dolls from Alaska.* LEFT TO RIGHT: *Bering Sea region doll with an ivory face and eiderdown parka. Height, 1¾"* (4.5 cm). Collection Hedy Mann; Aleut doll with carved wooden face wears a spruce-root hat, gutskin robe, and facial tattoos. Collection Alaska on Madison; Alaskan Eskimo doll with carved ivory face, skin parka, and boots. Collection Jeffrey R. Myers; Bering Sea Eskimo wooden doll with seal-intestine or gutskin parka. Collection Hedy Mann*

189 *Two Canadian Inuit dolls dressed in furs and skins sit on a caribou antler. 1970s. Height, approximately 5" (12.7 cm). Collection Hedy Mann*

190 Mother Carrying a Child in Her *Amauti* [Parka]. *This contemporary doll, made in the 1990s in Cape Dorset, retains some vestige of old parka forms, but has "flattened out"; the tail symbolism, however, is still intact. Creelike embroidered floral motifs reflect designs borrowed by the Inuit women from Subarctic seamstresses in the early twentieth century. Duffel, glass beads, stroud, wool, cotton, nylon, sealskin, fur. Height 20" (50.8 cm). Collection Dorsey*

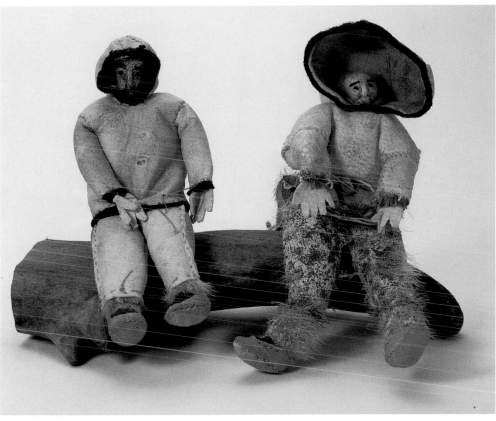

While making a brief visit to Sledge Island, two little girls in the house where we stopped amused us by watching their opportunity . . . to place their dolls standing in a semicircle before us upon the floor, while they sat quietly behind as though permitting their dolls to take a look at the strangers.

—Edward W. Nelson, 1899

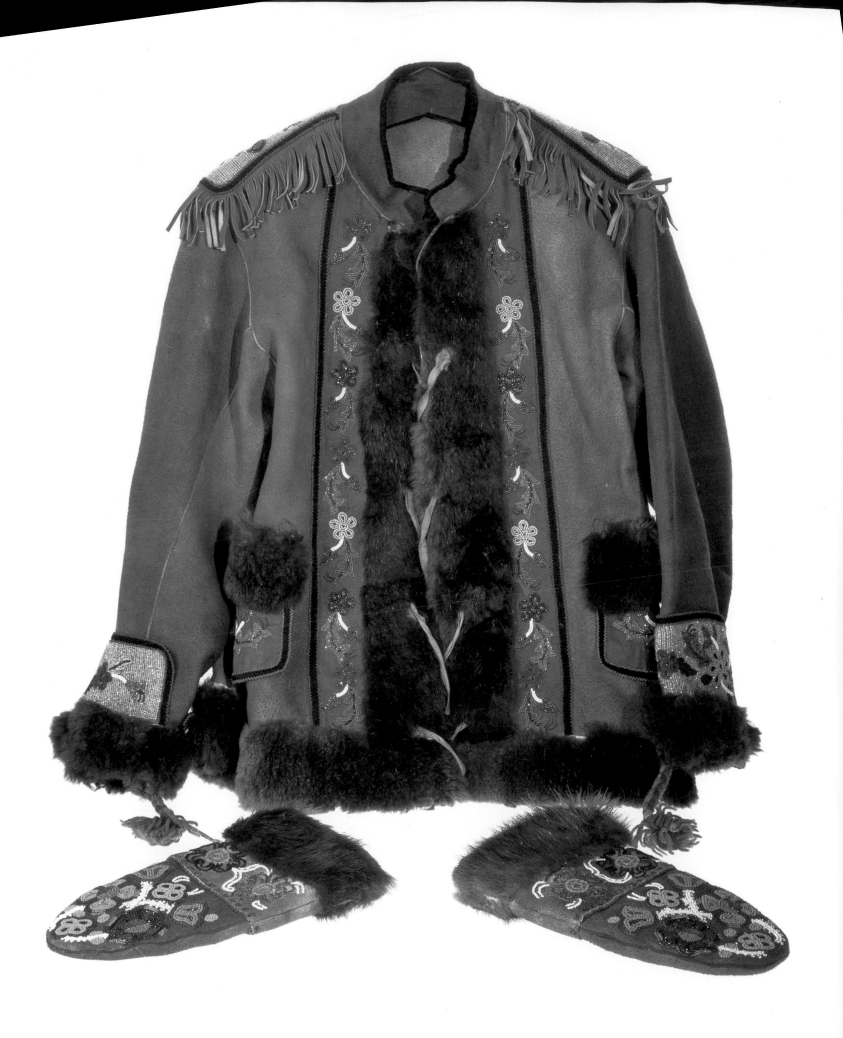

FLOWERS AND FURS
THE SUBARCTIC

"At Christmas the natives bring their furs and settle around in cabins by the river. For days, we would see them arriving like black snakes on the river from north and south, their long dog teams behind them as they ran. Several miles away from the fort, they made a stop to smarten themselves and the dogs. Black velvet saddle blankets, brightly beaded and fringed with red, white, green, and blue wool were fastened on the backs of the dogs. Fox tails and coloured ribbons decorated the leather collars and standing-irons. Up the hill they would come, the men shouting as they swung through the gates of the Fort with their carriole piled with furs, heading for the Big House."

— **Annie Card, Fort Simpson, Northwest Territories, 1911**[1]

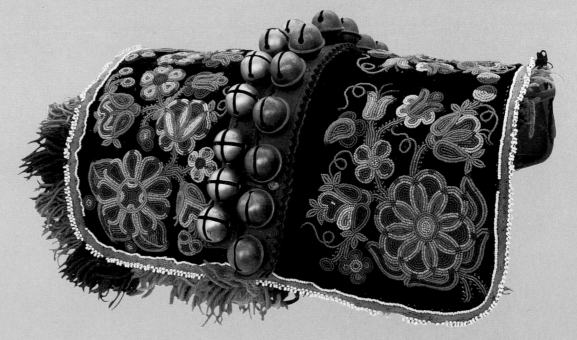

192 *When the dog sled was a major form of Subarctic transportation, beaded dog blankets brightened special occasions as far west as the Upper Yukon River. The most elaborately embroidered blankets, including this example, are from the Great Slave Lake–Mackenzie River region. Nineteenth century. Glass and metal beads, sinew, thread, velvet, wool, hide, sleigh bells. Length with fringe, 18½" (47.0 cm). McCord Museum of Canadian History, Montreal*

◁**191** *A man's beaded smoked-hide jacket with attached mittens epitomizes Subarctic fur-trade fashion of the late nineteenth and early twentieth centuries. Indian seamstresses combined aboriginal and European elements in creating this vivid, uniquely northern clothing for Native and non-Native traders. Caribou or moosehide, trimmed with porcupine quillwork, fringes, and fur (all indigenous traditions) was cut in European styles and embroidered with bead or silk floral motifs. Probably Gwich'in, Great Slave Lake–Mackenzie River region. Peabody Museum of Archaeology and Ethnology, Harvard University, 61-8-10/39087*

Dog teams wearing beaded regalia moved across a canvas of white winter like brushstrokes of color upon the Subarctic landscape. A reverence for beauty was as essential to survival as the clothing that protected against extreme conditions. A man's dignified appeearence was amplified by his wife's handiwork and lent an elegance to Subarctic life. When the Europeans arrived and the fur trade ensued, Native fashions were as profoundly influenced as those of the Euro-Americans. Women embellished smoked hides with newly available silk threads and glass beaded embroidery. In this seemingly unlikely environment, flower motifs became predominant, which sparked a remarkable and enduring indigenous tradition.

South of the tundra-treeline zone lies the Subarctic. Also called the *taiga,* this broad expanse of coniferous forests, bogs, waterways, and mountains reaches from interior Alaska and the Canadian Rockies to Labrador and Newfoundland. Immense in territory (two million square miles) and relatively uniform in climate, the Subarctic can be divided into four subregions: the Precambrian Shield (a great geological formation beneath most of eastern Canada); the mountainous Cordillera, west of the Mackenzie River basin; the Alaskan Plateau; and southern Alaska.

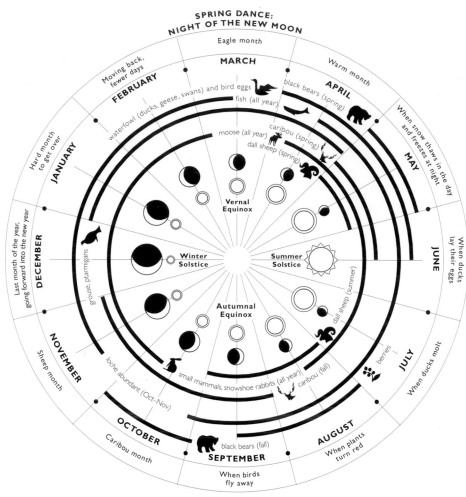

Seasonal Round of the Teetl'it Gwich'in

Dense spruce forests dominate the northern taiga, giving way to hemlock and pine farther south. Poplar, aspen, and white birch are found throughout most of the Subarctic. Winters are intensely dark and cold. A warm summer, forty to sixty frost-free days, is generally too brief to allow cultivated crops but long enough for the prolific growth of berry bushes, herbs, and wildflowers. Soils are typically thin and support only limited vegetation. Where soils have built up and the climate is slightly milder, there is some small-scale agriculture. Most of the Subarctic has "discontinuous permafrost"—soils that thaw in some areas and not others. This has resulted in numerous bogs and wet forestland basins that are breeding places for dense swarms of insects. In summer, early peoples escaped mosquito-infested woods and assembled at river mouths or large interior lakeshores.

The Subarctic's fluctuating environmental conditions made predictable, large-scale congregations of animals impossible. Oral traditions refer to shifting ranges of caribou and moose: animals moved constantly in search of food, and people moved in pursuit of animals. This nomadic existence precluded many material possessions. Subsequently, clothing provided more than vital physical protection. It communicated group affiliation, an individual's status and identity, and, through its embellishment, could be spiritually empowering. Clothing was also the principal form of artistic expression.

In the Subarctic—where adaptation to challenging conditions means survival—such autonomy and flexibility are highly valued. An openness to new ideas may explain the dynamic quality of Native creativity during the centuries when trade in

furs lured Europeans into all parts of the region. Native artisans, introduced to foreign goods and technologies, incorporated them into their work in remarkable ways. European contact, however, led to a terrible paradox for Subarctic peoples: with the Europeans came diseases, depletion of natural resources, and cultural disorder. Even so, during the late nineteenth century, a time of great stress, Subarctic women produced remarkably beautiful beaded and silk-floss-embroidered garments that were dominated by flower motifs.

PEOPLING THE SUBARCTIC: HISTORICAL OVERVIEW

The end of the Ice Age opened the Subarctic to human habitation. Hunter-gatherers followed the shrinking ice sheets, arriving around 8000 B.C. in the west and c. 5000 B.C. in the east. Two migratory groups eventually correlated with two major language families: the Algonquians and the northern Athapaskans. South and east of Hudson Bay, Algonquians comprise many tribes and are probably the descendants of peoples who had long practiced agriculture in areas farther south. In contrast, the Athapaskan speakers—west of Hudson Bay, including Alaska and interior Canada—may have been later arrivals to the region. By the time of European contact, Archaic Subarctic cultures could be grouped into the Beothuks of Newfoundland, the Montagnais-Naskapi of Quebec and Labrador, the Cree and Ojibwa of the Hudson Bay lowlands, and the northern Athapaskans.[2]

Subarctic Indians hunted and fished their respective territories. Caribou, moose, waterfowl, and fish have been important food sources since prehistoric times. Caribou, especially, provided food, hide for clothing, and materials for domestic, spiritual, and hunting purposes. Families frequently had to live separated from each other to avoid overhunting scarce animals. Dispersed populations prevented elaborate ritualism and formation of complex political institutions. Leaders generally were successful hunters; however, these egalitarian groups feared excessively powerful individuals. Social control was maintained by supernatural sanctions and cooperative relationships. Shamans had perhaps the most power in any group and were treated with due respect.

Camp life centered on family and hunting-gathering routines. Division of labor was based on gender: men hunted and trapped; women gathered firewood, cooked, and continually made and repaired clothing. Women were responsible for all aspects of garment manufacture: tanning the hides, cutting and stitching together the pieces, and embellishment of the finished product. Related families shared tasks. The generational mix of females assured a range of abilities and experience and permitted women the time they needed to produce beautifully decorative as well as everyday clothing.[3]

Prehistoric sites dating to 5500 B.C. indicate elaborate burial ceremony. The objects they yield provide a glimpse of early maritime practices that suggest spiritual links between ancient and historic cultures. L'Anse Amour, on the southern Labrador coast, contains the remains of a twelve-year-old boy surrounded by sand that was stained red with ocher. An ivory walrus tusk, incised bone pendant, and bird-bone flute were placed near the youth. A second site, at Port aux Choix, Newfoundland, dating to the second and third millennia B.C., holds one hundred graves adorned with red ocher. Quantities of shell beads, perhaps originally sewn to clothing, are an intriguing discovery, given the importance of beadwork in Subarctic life thousands of years later.[4]

Many objects appear to have had a dual ornamental-spiritual function. Bear and wolf teeth, seal claws, and loon and great auk bills served as embellishments and hunting talismans. Antler combs, pendants, and pins carved to signify birds' heads were both decorative and amuletic, as were white quartz pebbles, amethyst crystals, and oddly shaped stones—some fashioned as birds or animals. In one grave, two rows of shell beads covering a skull suggest an ornamented parka hood.[5]

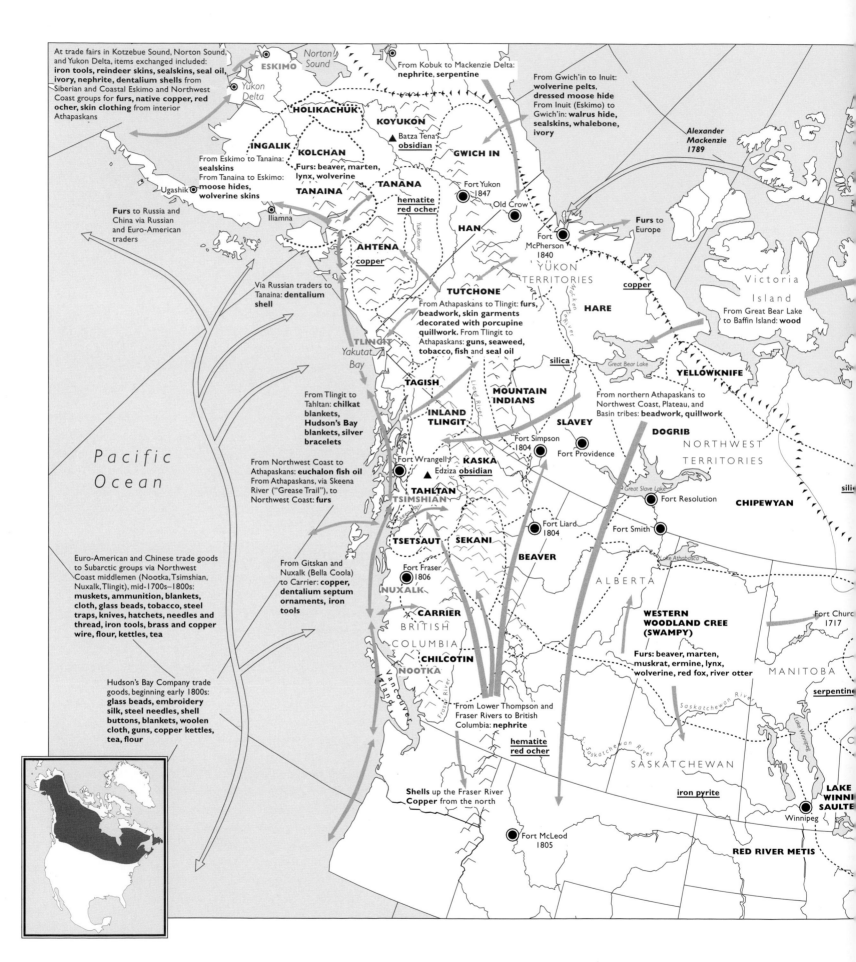

At trade fairs in Kotzebue Sound, Norton Sound, and Yukon Delta, items exchanged included: **iron tools, reindeer skins, sealskins, seal oil, ivory, nephrite, dentalium shells** from Siberian and Coastal Eskimo and Northwest Coast groups for **furs, native copper, red ocher, skin clothing** from interior Athapaskans

ESKIMO

Norton Sound

Yukon Delta

From Kobuk to Mackenzie Delta: **nephrite, serpentine**

From Gwich'in to Inuit: **wolverine pelts, dressed moose hide** From Inuit (Eskimo) to Gwich'in: **walrus hide, sealskins, whalebone, ivory**

Alexander Mackenzie 1789

HOLIKACHUK

KOYUKON

▲ Batza Tena **obsidian**

GWICH IN

INGALIK KOLCHAN

From Eskimo to Tanaina: **sealskins** From Tanaina to Eskimo: **moose hides, wolverine skins**

Furs: beaver, marten, lynx, wolverine

TANAINA TANANA

Fort Yukon 1847

Old Crow

HAN

Ugashik ⊙

hematite red ocher

Furs to Russia and China via Russian and Euro-American traders

Iliamna

AHTENA **copper**

Fort McPherson 1840

Furs to Europe

YUKON TERRITORIES

copper

Victoria Island

From Great Bear Lake to Baffin Island: **wood**

Via Russian traders to Tanaina: **dentalium shell**

TUTCHONE

From Athapaskans to Tlingit: **furs, beadwork, skin garments decorated with porcupine quillwork.** From Tlingit to Athapaskans: **guns, seaweed, tobacco, fish and seal oil**

HARE

Great Bear Lake

silica

YELLOWKNIFE

Pacific Ocean

TLINGIT

Yakutat Bay

TAGISH

MOUNTAIN INDIANS

From northern Athapaskans to Northwest Coast, Plateau, and Basin tribes: **beadwork, quillwork**

From Tlingit to Tahltan: **chilkat blankets, Hudson's Bay blankets, silver bracelets**

INLAND TLINGIT

SLAVEY

Fort Simpson 1804

Fort Providence

DOGRIB

NORTHWEST TERRITORIES

From Northwest Coast to Athapaskans: **euchalon fish oil** From Athapaskans, via Skeena River ("Grease Trail"), to Northwest Coast: **furs**

Fort Wrangell

KASKA

▲ Edziza **obsidian**

Great Slave Lake

Fort Resolution

CHIPEWYAN

TAHLTAN

TSIMSHIAN

Lake Athabasca

Fort Liard 1804

Fort Smith

silic

Euro-American and Chinese trade goods to Subarctic groups via Northwest Coast middlemen (Nootka, Tsimshian, Nuxalk, Tlingit), mid-1700s–1800s: **muskets, ammunition, blankets, cloth, glass beads, tobacco, steel traps, knives, hatchets, needles and thread, iron tools, brass and copper wire, flour, kettles, tea**

TSETSAUT SEKANI

BEAVER

From Gitskan and Nuxalk (Bella Coola) to Carrier: **copper, dentalium septum ornaments, iron tools**

Fort Fraser 1806

NUXALK

ALBERTA

WESTERN WOODLAND CREE (SWAMPY)

Fort Churc 1717

CARRIER

BRITISH

COLUMBIA

CHILCOTIN

NOOTKA

Vancouver Island

Furs: beaver, marten, muskrat, ermine, lynx, wolverine, red fox, river otter

MANITOBA

Hudson's Bay Company trade goods, beginning early 1800s: **glass beads, embroidery silk, steel needles, shell buttons, blankets, woolen cloth, guns, copper kettles, tea, flour**

Fraser River

From Lower Thompson and Fraser Rivers to British Columbia: **nephrite**

serpentine

Saskatchewan River

hematite red ocher

Saskatchewan River

SASKATCHEWAN

Shells up the Fraser River **Copper** from the north

iron pyrite

LAKE WINNI SAULTE

Winnipeg

Fort McLeod 1805

RED RIVER METIS

114

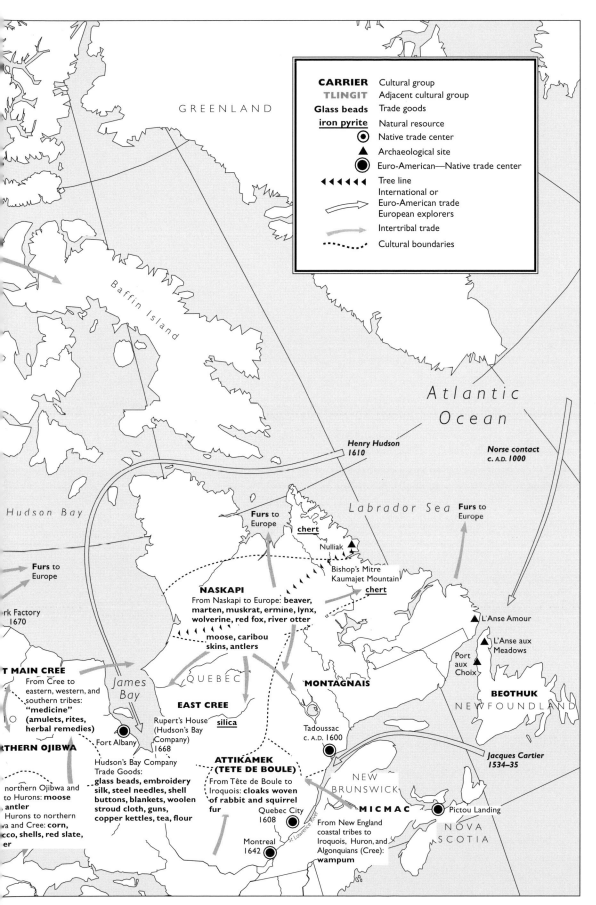

THE SUBARCTIC

CULTURE AREA AND PRECONTACT TO EARLY-CONTACT TRADE NETWORK

Following contact, the European fur trade was a pervasive influence among the region's Native groups. From the early 1600s to the late 1800s, the establishment of trading posts transformed Native cultural lifeways in varying ways. Most affected were seasonal movement patterns. Access to Euro-American trade goods also profoundly influenced material culture, although some bands living in the interior—farthest from direct Euro-American contact—retained their traditional lifeways into the twentieth century.

The map at left presents the approximate territories of Subarctic Athapaskan-speaking groups at about 1800 west of the Hudson Bay, and at approximately 1850 for the Algonquian-speaking groups east of Hudson Bay. See also the map of contemporary Native lands, page 551.

Within the map:

CARRIER — Cultural group
TLINGIT — Adjacent cultural group
Glass beads — Trade goods
iron pyrite — Natural resource
◉ Native trade center
▲ Archaeological site
◉ Euro-American—Native trade center
◀◀◀◀◀ Tree line
→ International or Euro-American trade European explorers
→ Intertribal trade
···· Cultural boundaries

GREENLAND

Baffin Island

Atlantic Ocean

Henry Hudson 1610

Norse contact c. A.D. 1000

Hudson Bay

Labrador Sea

Furs to Europe

Furs to Europe

Furs to Europe

chert

Nulliak ▲

Bishop's Mitre
Kaumajet Mountain

chert

NASKAPI
From Naskapi to Europe: **beaver, marten, muskrat, ermine, lynx, wolverine, red fox, river otter**

moose, caribou skins, antlers

▲ L'Anse Amour

▲ L'Anse aux Meadows

rk Factory 1670

Port aux Choix ▲

T MAIN CREE
From Cree to eastern, western, and southern tribes: **"medicine" (amulets, rites, herbal remedies)**

James Bay

QUEBEC

MONTAGNAIS

BEOTHUK

N E W F O U N D L A N D

EAST CREE

Rupert's House (Hudson's Bay Company) 1668

silica

Tadoussac c. A.D. 1600

THERN OJIBWA

Fort Albany

Hudson's Bay Company Trade Goods:
glass beads, embroidery silk, steel needles, shell buttons, blankets, woolen stroud cloth, guns, copper kettles, tea, flour

ATTIKAMEK (TETE DE BOULE)
From Tête de Boule to Iroquois: **cloaks woven of rabbit and squirrel fur**

Jacques Cartier 1534–35

NEW BRUNSWICK

northern Ojibwa and to Hurons: **moose antler**
Hurons to northern va and Cree: **corn, cco, shells, red slate, er**

Quebec City 1608

MICMAC

Pictou Landing

N O V A S C O T I A

Montreal 1642

From New England coastal tribes to Iroquois, Huron, and Algonquians (Cree): **wampum**

St. Lawrence River

115

Prior to European contact, wood, bone, horn, and antlers were used for sewing implements. Moose and caribou provided most skins for clothing. Skins were smoked and tanned, preserved with animal brains and spinal fluid to keep them malleable, and then sewn with sinew. Red ocher prevented stiffening when the skin was wet.[6]

Bark, "the skin of trees," was also used for clothing but less frequently. In a practice suggestive of the land/sea dichotomy observed by Arctic people, tree bark was sewn only with split roots; animal skin only with shredded sinew.[7] Found in the grave of a Newfoundland Beothuk man, a group that was decimated by 1829, was a pair of beaverskin leggings containing a spiritual as well as stylistic dichotomy. One legging, painted with red ocher, has bird claws and bone pendants attached to the outer edge. It is stitched to the second legging with split spruce root integrated with sinew thread.[8] Perhaps as their culture declined, the Beothuk ignored the bark-hide taboo.

Quillwork—the use of colored porcupine or bird quills as decoration—is an ancient, distinctly North American Indian artform. Desirable trade items, quills traveled great distances. Moccasins with quillworked toes, c. A.D. 1200–1300, found at Promontory Point, Utah, may be Athapaskan in origin.[9] After contact, quillwork became the prototype for much geometrically patterned glass beadwork. The Cree, Gwich'in (Kutchin), and Chipewyan all combined quill and moosehair embroidery.

Colors in a rich indigenous palette were obtained from natural dyes—black from charcoal, yellow from alder bark, red from currants or red ocher, blue from blueberries. Dying entailed soaking and boiling materials such as skins, Native textiles, porcupine quills, and moosehair in water mixed with plant substances and an iron-holding clay.[10]

Though a small population (perhaps sixty thousand in the sixteenth century) was spread across the vast Subarctic area, groups were not truly isolated, and artisans were not limited to local materials. Intertribal trade, conducted primarily along waterways, made possible the exchange of goods and materials throughout and beyond the entire region. It was the foundation for the cross-continental European fur trade that began in the early seventeenth century.

CLOTHING AND ORNAMENTATION

Distinctive Subarctic clothing styles—close-fitting sleeve cuffs and necklines, and combined legging-moccasins—protected against winter's intense cold and summer's stinging insects while allowing necessary movement for hunting-gathering activities[11] (207). Lacking pockets, people carried personal belongings in bags and pouches hung around the neck (210). Many elements of dress were similar across the region, but tribal and regional variations existed, particularly in ceremonial apparel. Embellishment was influenced by local climate, resources, intertribal contacts, and belief systems. Painting and quillwork adorned the earliest clothing, as did colorful feathers and dyed animal hair. Claws, teeth, and seed and shell beads were attached to a hide's surface—or to fringes made from bands of tanned skins slashed into thin strips. The prolific use of fringes on indigenous clothing appears to have had a dual practical and symbolic purpose. Their swinging movement helped repel mosquitos and black flies and diverted rainwater. At the same time, fringes added grace to a dancer's performance.[12]

The first Europeans to the eastern and western Subarctic encountered Indians wearing thoughtfully composed ensembles that included hair and body decoration as well as garments and ornamentation—necklaces, earrings, nose pins, and, in the far west, labrets. Early descriptions indicate that individuality was largely conveyed through hairstyling, face painting, jewelry, and attached amulets.[13]

INDIGENOUS MATERIALS AND TECHNIQUES

193 *An Ojibwa scraped-birchbark container. The technique entails scraping away the dark outer layer of the bark to create patterns in the lighter underlayer. This "figure-ground reversal," the emergence of lighter background forms from receding darker surface motifs, is in itself an act of transformation. Nineteenth to early twentieth century. Height, 6⅞" (16.3 cm). Peabody Museum of Archaeology and Ethnology, Harvard University, 10/32703*

194 *Swampy Cree quilled pouch incorporating European trade materials with an indigenous art form. The quillwork displays two techniques: loom-woven panels and quill-wrapped fringes. The red wool tassels probably replaced earlier red-dyed deerhair. The front of the pouch is sealskin; the back, blue stroud cloth. Both the quills and glass beads are multi-colored, and all sewing, beading, and quillwork is with sinew. Length without fringe, 9⁷⁄₁₆" (24.0 cm). Canadian Museum of Civilization*

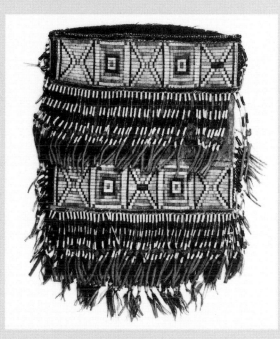

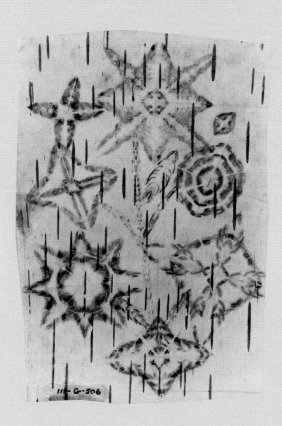

◁**195** *A rectangle of thin inner birchbark has been folded and bitten, producing, when unfolded, eight different bilaterally symmetrical designs. The technique reinforces the ancient northern aesthetic of bilateral symmetry. Held to the light, the dot patterns may have inspired templates for beadwork. Northern Ojibwa. 1879. Length, 4⁵⁄₁₆" (12.5 cm). Canadian Museum of Civilization*

196 *Caribou-horn armbands with incised (possibly symbolic) linear geometric patterns. Related iconography appears on Subarctic ritual equipment and northern Athapaskan scraped-birchbark containers. The wound beads are Chinese; the white hearts and faceted beads are Venetian. Collected among the Hare (Tinne) in British Columbia or Alaska, n.d. Diameter, 3¹⁵⁄₁₆" (10.0 cm). Peabody Museum of Archaeology and Ethnology, Harvard University, 10/K96*

Hairstyles were an important aspect of men's overall appearance. Carefully designed and ornamented hair signaled distinction and status. The most elaborate arrangements were western. Tanaina, Gwich'in, and Han men bound their greased long hair at the nape of the neck with a band of dentalium shells, marked a red ocher part, sprinkled fine bird down, and placed feathers, possibly signifying clan, into the back. Long hair was cut only for warfare or when in mourning.[14]

Identifying facial painting was applied for large social gatherings and travel through foreign territories. The Montagnais painted their faces before visiting; Ojibwa stained themselves with oil pigments before approaching or crossing paths with other tribes. Patterns of red and black lines distinguished Tanaina clans. West Main Cree men's faces were painted in various patterns for feasts: black and red across the eyes, mouth, and nose; longitudinal marks down the face; squares in circular spots; one side of the face red and the other black. Face painting could be ceremonial or an aesthetic complement to clothing. Self-decoration was important to young men seeking communal recognition and the attention of young women. It appears to have had practical purpose as well for the Newfoundland Beothuk, who were called "Red Indians" because they covered their faces with red ocher, possibly to ward off insects.[15]

SPIRITUAL BELIEFS EXPRESSED IN CLOTHING AND ORNAMENTATION

Simultaneity

The all-important respectful relationship between animals and humans was sanctioned in garments that maintained animals' forms (211). East Cree hunters wore coats of caribou hide that retained the hair. Outlined in paint on the inside were the eyes, mouth, and skin of the caribou, symbolically endowing the garment and its wearer with the speed, endurance, and cunning of the living animal,[16] echoing the similar concept underlying the Inuit hunting parka (158).

Native artisans followed similar conventions in decorating both the human body and the skins of animals. Red pigment was applied to human skin and to hide pouches and garments. Both body painting and the painting and embroidery that enhanced clothing featured similar design motifs: animal forms, figures, stripes, dots, arabesques, and trellises. Red, green, and black colors dominated. The same parallel holds for hair and fringes and anatomy and seams: human locks were decorated with silver, beads, and shells. Similarly, red-dyed animal-hair tassels were fastened to moccasins and pouches, strung on beaded thongs, and wrapped with cones of brass or tin. Wampum strings were intertwined with both human hair and hide fringes. Elegant woven and embroidered ornaments were worn around the neck, wrist, and waist and sewn across legging and coat seams. Following a successful hunt, the Eastern Cree ritually adorned the slain animal skins with ocher stripes and dots, beads and ribbons as a sign of respect to the animals' spirits. These parallels in human-skin and animal-hide decoration point to the perception of oneness—"a common identity"—in human and animal realms.[17]

Shamans and Adornment

The influence of shamanism is particularly evident in southwestern Subarctic regalia. A Tanaina shaman's caribou-skin parka was ornamented with numerous appendages that clattered when he danced. The outfit was further enhanced with painted designs, armbands, and necklaces of teeth, claws, or feathers of animals with whom he had bonded in dreams.[18] Dolls, dressed in the shaman's image, served as helpers (197).

Anthropologist George Thornton Emmons described a Tahltan shaman's healing

197 *Representing a Tanaina shaman, this wooden doll acted as the shaman's familiar (helper) in curing ceremonies. The doll was believed to enter the patient's body and with supernatural power expel the evil spirits causing sickness.*

The shaman's great status was expressed in elaborately decorated clothing and paraphernalia. Hanging from the doll's belt are costly imported items, reflecting the Tanaina's importance as middlemen in the fur trade between the Russians and inland tribes. These ornaments include Chinese glass beads, dentalium shells from Vancouver Island, French and Russian gaming tokens from the seventeenth to eighteenth century, an American infantry officer's uniform button, and the teeth and jawbone of a baby caribou. Tiny metal implements— a saw, knife, and mirror—aided shamans in looking into the future. Early to mid-nineteenth century. Height, 10¹³⁄₁₆" (27.5 cm). National Museum of the American Indian, 10/6091

technique: "When the shaman treats a patient, he or she sits near the patient who begins to tremble, indicating that his spirit is manifesting itself. The shaman takes off his clothing, puts on a waist cloth, lets down his hair and sprinkles it with swansdown, puts on his head the neck skin and head of a swan or crown of grizzly bear claws, and around the neck, mink or ermine skins, swan or loon necks and heads, owl claws, bird skins, a rope of cedar bark or small spirit chains, each sewed in a tiny skin case . . . sometimes the shaman's wrists and arms to the elbow are painted with red ochre."[19]

Spirit Helpers and Dreams
Subarctic peoples sought guidance through dreams, shamanic intervention, and "medicine," the spiritual energy in nature's objects. Amulets, body tattoos, and painted motifs on clothing (200–202, 213) served as spirit helpers that affirmed contact with the supernatural, empowering and protecting the wearer. Such "communion" was rarely discussed openly; rather, it was contemplated and nurtured as private knowledge. For this reason, much imagery on clothing and adornment was understood only by the maker.[20] Among the Montagnais, Naskapi, and East Main Cree, designs on clothing and hunting equipment were considered necessities that pleased the animals' spirits. Montagnais believed that hunters communicated through dreams to animals and supernatural spirits. A Montagnais painted coat is the hunter's dream interpreted in a richly decorated caribou skin (213). The difference between shamans and other hunters resulted mainly from the extent of spiritual power received in dreams or vision images.[21]

Spirit helpers, imbued with "medicine," accompanied the stages of life: infancy, adolescence, and maturity. Slavey mothers enclosed a tiny piece of their newborn's umbilical cord in small quilled and beaded pouches of tanned skin, which they hung around the infants' necks. The Cree attached a pair of fetal caribou bones to a son's cradle to ensure his luck as a caribou hunter. The Tanaina fastened a claw necklace around a baby boy's neck to make him strong.[22]

A Naskapi newborn was presented with a *mitishi,* a circular or oval disk representing the individual's life or soul. Kept throughout life, it became an adult male's hunting charm. Ornaments of maturity incorporated materials from physically and spiritually powerful animals such as bears and eagles. The killing of a full-grown grizzly marked a Gwich'in boy's coming of age: he wore the claws as the symbol of male adulthood. Eventually, his mother or wife would create a special garment as a backdrop for proudly displaying the trophy claws.[23]

Throughout the Subarctic, where clothing covered the entire body for most of the year, tattooing was usually limited to the face and hands. However, West Main Cree, trading on Hudson Bay in the late eighteenth century, were observed with tattoos upon their "breasts, backs, hands, arms and faces . . . marked with a variety of figures, some resembling birds, others beasts, and fishes; while others have borders, flourishes or plain lines according to their fancies." These tattoos signaled courage rather than decoration, acknowledging that the wearer had endured a painful procedure in order to receive the special powers of spirit-helper imagery.[24]

Ceremony with elaborate rituals utilizing masking was limited by the nomadic quality of Subarctic life. With the exception of those groups influenced by the Northwest Coast cultures—Tanaina, Ingalik, and Koyukon—carved masks were rare.

Color
Color contained spiritual power. Red, usually obtained from ocher (hematite), and black, acquired from charcoal, predominated in face painting and hide decoration.

Both had spiritual associations: red with blood, fire, warmth, and life; black may have been linked to anger, death, and sorrow.[25] Highly valued, red ocher was sprinkled on ancient burial sites. Slavey skin lodges were commonly painted with a band of red, which formed a protective ring around the occupants. Tahltan shamans applied red paint to the body of a woman undergoing difficult childbirth.[26] Accentuating incised horn and bone designs by rubbing red ocher or charcoal into them was an ancient northern Athapaskan artistic tradition. Among their Dene descendants, red lines along the seams inside clothing implies that cutting lines were marked with red ocher or berry juice. The locations from which ocher was extracted were regarded as sacred. The Gwich'in left sinew or beads after taking pigment from the ground.[27] A continuing use of red ink on hide probably relates to the ancient use of red ocher on skins.[28]

Gift-Giving

Reciprocal gift-giving, manifested in numerous ways, was integral to most Native cultures. Decorating animal skins was a sign of respect and gratitude given in return for the animal's sacrifice; making beautiful objects was construed as giving something back to one's teachers; even "self decoration was a quest for beauty with which to please both spirits and the human community."[29]

Though early Subarctic culture provided little opportunity for accumulating material wealth, some, through knowledge and skills, garnered more than others. Most surplus was channeled into gifts and feasts. A wealthy person was perceived as one who assembled material for distribution. The potlatch—a display of generosity for the purpose of validating one's position and increasing prestige—was the high ceremony of the Northwest Coast that influenced neighboring western Athapaskan ceremonials. Descriptions of seventeenth-century Algonquian Feasts of the Dead so closely parallel nineteenth-century Northwest Coast potlatches as to suggest that similar motives were involved.[30]

Gift-giving was a culmination of life. Individuals were carefully adorned and clothed for burial, perhaps for the afterlife. "With all the ornaments owned by the family . . . they dressed his hair with red paint mixed with grease and painted his body and his face red with vermillion; they put on him one of his handsomest shirts . . . [and] a jacket and a blanket. . . . He is, in a word, as properly garbed as if he had to conduct the most solemn ceremony. They take care to adorn the place where he is with necklaces of porcelain and glass beads."[31]

Western Athapaskans honored their deceased with the Death Potlatch. As whole communities gathered to grieve, women sewed and beaded garments for a giveaway. By giving to those assembled, the family paid the deceased's debts, severing earthly ties and freeing the individual's spirits to "continue their life-cycle in the next dimension."[32]

From earliest times, Native peoples have attended annual trading ceremonies to exchange surpluses of local products as well as luxury goods from remote parts of the continent. The economic implications of ritualized gift-giving would subsequently affect the European fur trade.

NEW INFLUENCES ON OLD FORMS

The Fur Trade

Regular trading contacts between Europeans and Indians had begun during the early sixteenth century, mostly along the eastern coast. Later in the century, Europeans' attraction to the beaver felt hat created an overseas demand for beaver pelts. By 1650, a developing fur trade augmented established exchange relationships along the Saint Lawrence River. The Hudson's Bay Company ("The Bay"), still in existence, was founded by English aristo-

crats in 1670 when it established Charles Fort at the mouth of Ruperts River on James Bay.

Native people initially viewed trade in furs as a form of gift exchange. Hudson's Bay Company traders used gifts to spur Indians to trap furs. In a variation of ceremonial generosity for political gain, the Indian leaders redistributed these luxuries among kinsmen to aquire greater prestige and authority. Gift-giving ceremonies to forge and strengthen liaisons were ancient Indian institutions; thus, if the Company neglected to observe a preliminary gifting ritual, no exchange would take place.[33]

Indians who had been leaders in intertribal trade adapted readily to fur marketing, becoming middlemen in Native-European transactions. The Montagnais, Algonquian, Nipissing, and Ottawa were well placed geographically to exploit foreigners' voracity for furs and more remote Indians' desires for useful and exotic imports. Pacific Northwest groups such as the Tlingit obstructed the direct access of interior Athapaskans to Europeans and Russians, while trading them imports for furs. In turn, Athapaskans closest to the coast themselves became middlemen in trade with those farther inland.

199 *This neck collar, worn by a young Tahltan girl following her seclusion, conveyed marital eligibility and high status. Dentalium shells, glass beads, and a yarn fringe were sewn onto a tanned skin stretched over a bentwood frame. c. 1900. Width, 11¹³⁄₁₆" (30.0 cm). National Museum of Natural History, Smithsonian Institution, 24838*

△ **198** *Subarctic Athapaskan girls used necklaces such as the one above in their first seclusion rites. Attached to glass beads are a hollow goose- or swan-bone drinking tube, bone scratcher, and scratching stick. Observing strict taboos, a girl drank only through the tube and was not permitted to comb or touch her hair with her hands. Group unknown. Nineteenth century. Bird and animal bone, yellow, red, blue, and black glass beads, leather thong. Length, 17⅝" (45.0 cm). Canadian Museum of Civilization*

PUBERTY CEREMONIAL ADORNMENT

Throughout life, Athapaskan women observed behavioral restrictions, including days of separation. For months following the first menses, Athapaskan girls lived apart in temporary shelters, attended and instructed by close female relatives. In this period of isolation devoted to physical and mental development, patience and diligence were stressed. Girls learned sewing, quillwork, and beading or silk-floss embroidery—skills essential to their future roles as wives and mothers. Special clothing and adornment were worn during and after confinement, for pubescent girls were believed to have enormous spiritual power. Were they to look at men or game, the consequences for the hunt could be disastrous; therefore, skin hoods and veils hid their faces and obstructed vision (206).

SPIRITUAL SYMBOLISM: ANCIENT CONNECTIONS

Incising geometric designs on bone, ivory, and stone pendants was an ancient Subarctic tradition that continued into the nineteenth century. While there are no direct similarities between the ancient Nulliak stone pendants from Labrador (202) and early contact-era bone and ivory Beothuk pendants from Newfoundland (200), they may have served related functions within Paleo-Indian and early contact cultures. At the same time, close parallels between bone and ivory pendants from the East Coast Beothuk and the Tutchone of interior British Columbia suggest regional variations within an ancient, widespread northern artistic tradition.

A connection to magic and/or spirituality is implied in the Beothuk pendants' similarity with the Athapaskan Tutchone shaman's necklace (201) and a necklace (of probable Athapaskan origin) used by a Tlingit shaman (799). Northwest Coast shamans were known to wear an array of carved spiritual helpers.

Archaeologist William Fitzhugh suggests that bifurcation, a common feature on several Nulliak pendants, may mirror the central fissure or V-shaped cleft at the summit of Bishop's Mitre, the dominant peak of the Kaumajet Mountain skyline thirty miles (approximately fifty kilometers) across from Nulliak. (The bifurcated cleft is also seen in plummets from nearby archaeological sites.) Since prominent landscape features, particularly mountains, are important to the spiritual life of hunter-gatherers, Bishop's Mitre might well have been reproduced in amulets.

Athapaskan, Beothuk, and Nulliak pendants, although created within a few standardized forms, show considerable diversity in shape and incised motif. Fitzhugh has considered that their individuality has social and spiritual implications. He proposes that the artifacts functioned as keepers of the individual's soul: the designs, "owned" by individuals, are described by shamans or made in response to dreams. The Nulliak pendants, each with different designs, were excavated from individual family dwelling spaces within an Archaic maritime longhouse. Such personalized items for Fitzhugh are indications of a distinctive, organized Archaic maritime culture in the Subarctic, and possibly as far south as Maine.

Currently, archaeological finds are limited; however, Fitzhugh believes that greater contextual evidence might reveal that a system of engraved geometric designs was an ancient and important means for communicating spiritual beliefs within the Northeast or possibly the entire Subarctic.

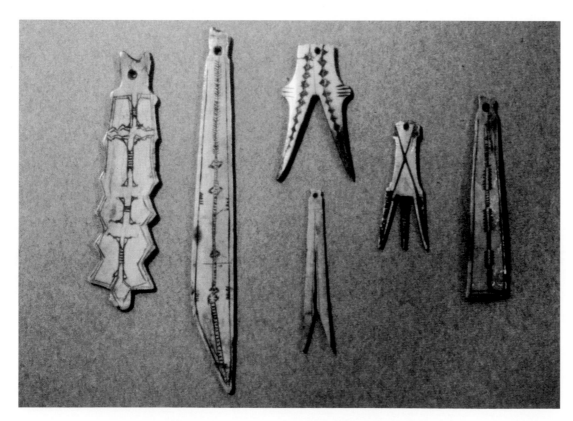

200 *Beothuk pendants of engraved caribou bone and walrus ivory. c. late 1400s–mid-1800s? Length, 5⅛"–5⅞" (13.0–15.0 cm). Courtesy of the Newfoundland Museum*

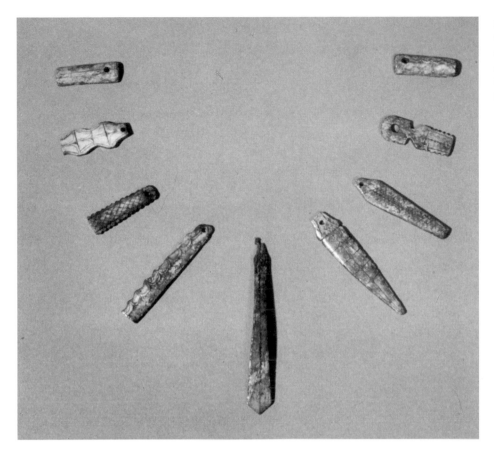

201 *Tutchone shaman's necklace with engraved (ivory or bone?) pendants from the northern interior of British Columbia. Mid-nineteenth century. Length of longest, 3¹⁵⁄₁₆" (10.0 cm). Canadian Museum of Civilization*

△ 202 *Nulliak Cove 1 pendants. Northern Labrador. c. 2000 B.C. Engraved soapstone. Newfoundland Museum, Saint John's*

203 *The V-shaped cleft in this Nulliak soapstone pendant (inset) possibly replicates the bifurcated cleft of Bishop's Mitre. Northern Labrador. c. 2000 B.C.*

204 *A Siberian Koryak shaman's hat with long seal fur tassels. Accessioned 1907. Height, 24" (61.0 cm). American Museum of Natural History, 70.0-387*

205 *A Koniag Eskimo dancer's head-dress. Beaded veils concealed vision, as did the tassels on Siberian shaman hats (204). Uhashk, Alaska. Collected 1884. Sinew and glass beads. Length, 20⅛" (51.0 cm). National Museum of Natural History, 90453*

206 *Tanaina puberty veil. This unusually long veil consists of numerous bead strings held in leather bands: the rectangular blocks of beaded color derive from decorative fringes typical of the region's indigenous clothing. c. 1900. Glass beads, dentalium shells, leather, yarn. Length, 29⅛" (74.0 cm). Denver Art Museum, 106.1975*

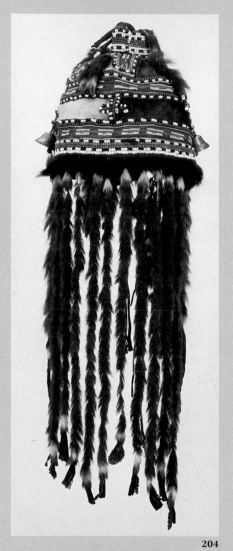

204

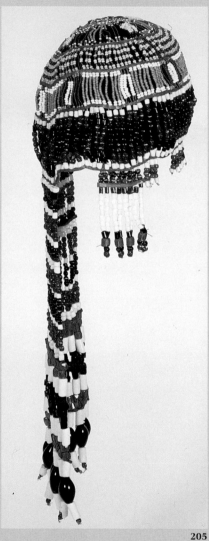

205

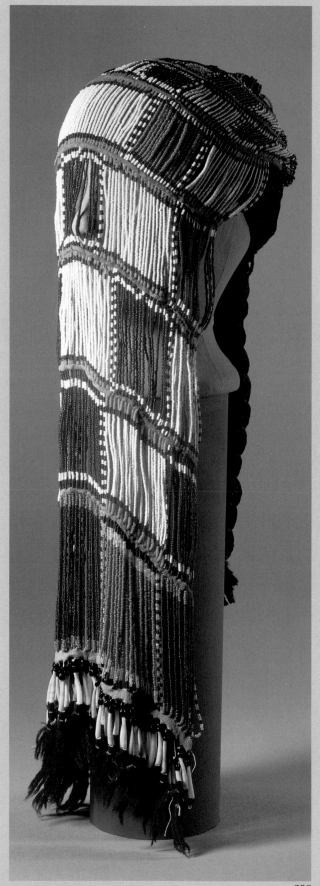

206

HIDDEN VISION

Based on the belief that shamans, and pubescent girls, possessed great, possibly destructive supernatural power, both wore veils that blocked their vision, protecting others from its potentially harmful effects. This ancient and important concept spans northeastern Siberia, the North Pacific Arctic, and the Subarctic.

Coastal chiefs on inland trading excursions attempted to reinforce commercial bonds by offering their highly ranked young women in marriage to Athapaskan leaders. These kin ties brought many Cordilleran Athapaskans—Tagish, Tahltan, and Carrier—into the Northwest Coast sphere of influence.[34]

The traditional view that coastal Tlingit always dominated trading encounters with interior Athapaskan tribes is challenged by Annie Ned of Athapaskan and Tlingit ancestry, the granddaughter of the man known as Hutshi chief, who was a central figure in Athapaskan-Tlingit trade. [Hutshi chief had both an Athapaskan name, Kakhah, and a Tlingit name, Kaajoolaaxi.] Mrs. Ned celebrates her Athapaskan roots. She remembers her father's accounts of destitute Tlingit following the Alsek River to its source, where they encountered beautifully dressed Athapaskans. According to Mrs. Ned: "They had nothing, those Tlingit people, just cloth clothes, groundhog clothes. Nothing! Athapaskans had . . . buckskin parky, silver-fox, red fox, caribou-skin parky sewed up with porcupine quills." The Tlingit, she believes, were eager to have these things."[35] Others have also recorded the Tlingit's admiration for moosehide clothing made by inland Athapaskans (215). Ms. Ned believes that eventually the Tlingits dominated relationships because they had direct access to trade goods and Yukon people "got crazy for it."[36]

The fur trade led to intermarriage not only among Native groups but also between Native women (primarily Cree, Ojibwa, Chipewyan, and Santee Dakota) and French or Scottish traders. The children and descendants of those marriages, called Métis, created a crucial role for themselves as intermediaries between fur-trading Indians and Europeans. The Métis built a discrete culture in southern Canada but never functioned as a separate community in Alaska.[37] Distinctive Métis clothing was widely traded throughout the Subarctic and the northern Plains (214).

In the early years, European trading companies extended credit to successful Indian fur trappers to keep them indebted and productive. The Indians eventually found themselves in a system that compromised their autonomy and fostered dependency. Native people had always taken furs for their own clothing; they now had to hunt and trap more selectively for commercial purposes. Frequently their labors did not best serve their own survival needs. With more emphasis placed on trapping furbearers than on hunting food animals, the Native diet shifted to European foodstuffs. Flour, lard, sugar, and tea, as well as tobacco and liquor, became necessities, tying bands to trading posts for supplies. Bands that had traditionally gathered in summer at favorite fishing spots now settled near trading posts, where families might choose to alter their seasonal rounds, remaining until autumn to trap for the Company.[38]

European imports—guns, hatchets, copper kettles—originally luxuries, eventually became essentials. Wool cloth, steel needles, and glass seed beads represented hours of savings in time and energy for Native craftswomen. Wool cloth, for example, was an attractive, warm, and comfortable alternative to animal hides, which necessitated long hours of painstaking preparation before they could be cut and sewn for clothing.

Decorative trade goods were also prestigious. Wearing trade finery signaled connections with the powerful Europeans, enhancing an individual's status in much the same way that beautiful clothing and careful grooming did before contact. A consequent practice at posts such as The Bay was to gain the loyalty of productive Native hunters by bestowing upon them the honorary title of "trading captains" and presenting them gifts of European attire: "a coat of coarse red cloth decorated with lace, a felt hat with lace and a feather."[39] The Native "captains" bargained with the traders on behalf of their bands and were further provided with presents, including beads, to be distributed among their people. This appointed position of authority, however, was limited to the duration of the fur-trading venture.[40]

EARLY CONTACT CLOTHING

Because the migratory Subarctic people had few heavy possessions, their artistry focused upon adorning clothing, jewelry, and weapons, both as a means of individual expression and to convey group affiliation. Few changes were seen in the style of traditional clothing and adornment during the initial periods of contact. Instead, introduced materials such as glass beads were used in locations and patterns consistent with indigenous quillwork.

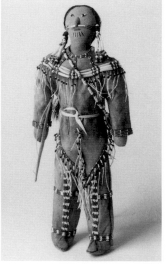

208

209

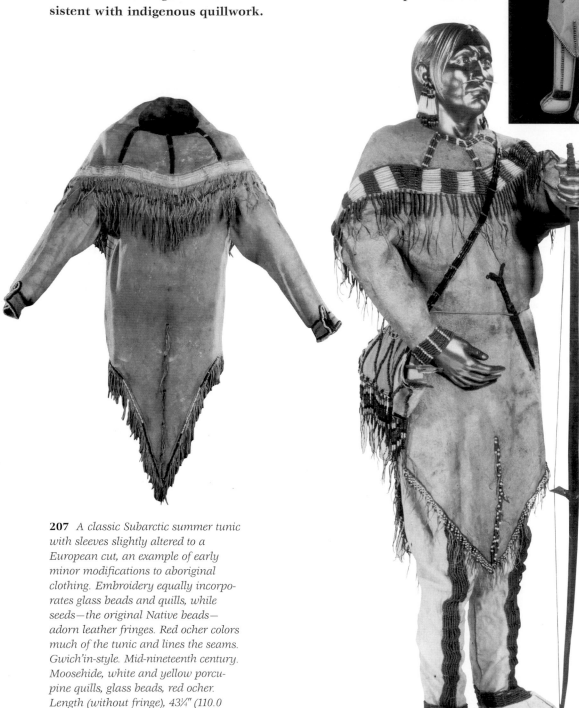

207 *A classic Subarctic summer tunic with sleeves slightly altered to a European cut, an example of early minor modifications to aboriginal clothing. Embroidery equally incorporates glass beads and quills, while seeds—the original Native beads— adorn leather fringes. Red ocher colors much of the tunic and lines the seams. Gwich'in-style. Mid-nineteenth century. Moosehide, white and yellow porcupine quills, glass beads, red ocher. Length (without fringe), 43¼" (110.0 cm). Canadian Museum of Civilization*

208 *Athapaskan figure created by artists Denise Wallace (Chugach Eskimo–Aleut) and Samuel Wallace after the 210 outfit. From the* Crossroads of Continents *belt. 1988. Sterling, 14-karat gold, fossil walrus tusk with multicolored scrimshaw, lapis inlay. Height, 3⅞" (9.8 cm). Collection dw Studio*

209 *Dressed in 1820s-style northern Athapaskan clothing, this doll was made in 1994 by Angela Swedberg of Ojibwa and Swedish heritage. Smoked and unsmoked caribou hide, antique beads, dentalium shell, wood, metal, and "natural earth paint." Height, 14¾" (37.5 cm). Collection Charles Gold*

◁**210** *A typical old-style northern Athapaskan (Gwich'in) hunter's outfit consisting of a long-sleeved upper tunic and a lower garment combining leggings and moccasins. The tunic, leggings, and bag, of tanned caribou or moosehide, are decorated with fringes, glass beads, dentalium shells, and red ocher. Shell earrings, a nose pin, and tattoos augment the hunter's dignified appearance. Yukon River, Alaska. Collected 1860. Tunic length, 44⅞" (114.0 cm). National Museum of Natural History*

211 *An Ojibwa man's ceremonial broadcloth cape with an assemblage of joined human, animal, floral, and geometric motifs. The hood's lynx head shape transferred the animal's power to the wearer. Early nineteenth century. Broadcloth, seed beads, silk ribbons. Length, 25½" (65.0 cm). Royal Ontario Museum, 916.22.1*

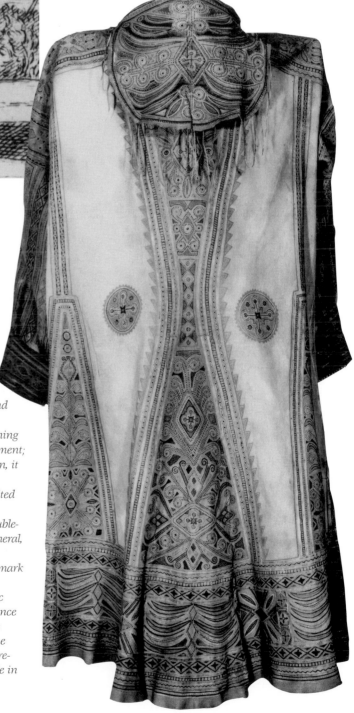

◁**212** *In this engraving, a European wears a late seventeenth-century version of the justacorps, a close-fitting man's garment that was modified in cut—made looser—for use by soldiers and others in North America. The style influenced Native clothing such as the Montagnais coat (213). 1698. Amérique septentrionale et méridionale, N. de Fer, Paris. National Archives of Canada, NMC 23330*

213 *Innu-painted caribou-skin coats honored the highly valued caribou and ensured a successful hunt for the Montagnais and Naskapi. The colorful paintings, alluding to the sacredness of hunting, protected against evil spirits. Among the most glorious of Native bicultural artifacts, this garment, seen from the back and dating from 1700, has European styling, but its essence remains wholly aboriginal.*

Two important conduits of spiritual guidance within the Innu culture were dreaming and drumming. Men dreamed of spirit helpers that would empower hunting equipment; women then painted the designs. The coats were sold or traded after the hunt, when, it was believed, they had lost their power. Polygamy among the Innu may relate to a man's annual need for several painted coats. A hunter would have certainly benefited from an additional wife able to help with the intricate painting.

This elegant coat's complex patterning incorporates both a quadrate layout and double-curve motifs, whose specific meanings were known only by the dreamer/wearer. In general, the designs suggest growth, interpreted variously as flowers, celestial bodies, or caribou horns. At the back of the coat, in the center, was inserted a separate triangle of skin to mark the source of the coat's power, the "Magical Mountain of the Lord of the Caribou."

Father Paul LeJeune described painted robes worn by the Montagnais in Quebec City in 1637–38, in Jesuit Relations, *a fascinating series of letters sent back to France and published for many years to keep up support for Jesuit missionary work in the New World. The Innu's transition from painted robes to coats was influenced by the shape of the* justacorps *(212) as well as the French and English custom of giving presentation coats (called chief's coats) to Indian leaders. The last Innu coat was made in 1930. Southwestern Quebec. Length, 48" (122.0 cm). Pitt River Museum, 1952.5.01*

In the seventeenth and eighteenth centuries, Natives converted in great numbers to Christianity yet continued to recognize a pantheon of guardian spirits and to take part in shamanistic curing and divination rituals.[41] Christian teaching orders, beginning with the French Ursulines in 1639, founded mission schools that would dot the continent by the close of the nineteenth century, markedly affecting the Subarctic aesthetic.

Children spent years far from their home villages in these institutions, where needlework was an important part of their secular education. They were instructed in "civilized" techniques and elements of style: cutting European patterns, operating sewing machines, sewing on buttons, making buttonholes and pockets, knitting sweaters and socks. The well-educated young woman was expected to master finer work: silk embroidery, crocheting, and needlework. Students demonstrated great aptitude, very likely the result of the importance accorded such abilities in their own cultures and the lessons learned early in childhood.[42]

Within the church and mission schools, wearing European-style clothing indicated a genuine conversion to Christianity. Nevertheless, girls were encouraged to produce some indigenous garments, such as smoked hide moccasins, because they were practical and inexpensive. Ironically, many produced this basic Indian garment under the instruction of non-Native women.

Cultural crossings also occurred between Native artisans and French Ursuline nuns, whose tradition of fine needlework had continued for close to two centuries. Teachers and students used materials initially imported from France; however, pressures to economize fostered experimentation with local resources. Eventually, indigenous moosehair would replace French silk and metallic thread in European-style floral designs (242). Similarly, Native seamstresses taught European women skills in moosehair, which was reintroduced to the Native community via mission schoolteachers. Sister Beatrice Leduc, a Gray nun, played an important role in reestablishing decorative work in moosehair tufting as a Dene art form[43] (227).

CHANGES IN STYLE: EUROPEAN TECHNOLOGY AND NATIVE VIRTUOSITY

European settlement and the expansion of colonial power took place over three centuries. Native Subarctic cultures could remain substantially intact as long as fur existed to be taken and the church remained at a distance. Societies, particularly those farther removed, adapted gradually to increasing change. These cultural adjustments are mirrored in modifications to clothing and adornment. During this period, Indians showed remarkable virtuosity using European technology and incorporating imported goods (207).

The effect of European trade on Subarctic clothing was at first minimal. Imported glass beads, silk ribbons, and brightly colored cloth directly replaced indigenous materials without substantially altering aboriginal forms and functions. Native artisans chose selectively from the range of available trade goods, preferring colors and textures that accorded with ancient symbolic traditions. Steel hatchets substituted for stone gorgets as prestigious adornments; metal cones attached to fringes replaced rattling devices made from the dewclaws of deer.[44] Black and red, similar to shades formerly achieved with vegetable dyes, ochers, and by smoking hides, were the most popular colors for clothes. Red-cloth-encircled skirts replaced red ocher. Wool blankets were draped like skin robes; wool-yarn trim mirrored dyed animal-hair tassels. Glass beads were placed on clothing in geometric patterns similar to those created with porcupine quills. Red and white beads predominated, replicating the natural shades of ocher, shells, and quills. Pouches, necklaces, and mittens displayed glass beads in various ways.

THE MÉTIS

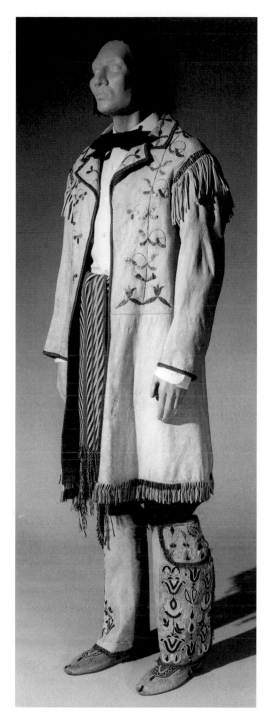

The Métis, children and descendants of marriages between Native women (primarily Cree, Ojibwa, Chipewyan, and Santee Dakota) and French or Scottish traders, created a crucial role for themselves in the fur trade as intermediaries between Indians and Europeans. They built a distinct culture in southern Canada but never functioned as a separate community in Alaska. The Canadian Constitution of 1982 gave the Métis status as an aboriginal population.

Métis women created singular clothing with floral motifs that combined techniques of silk floss, porcupine quill, and glass-bead embroidery. Their colorful yet delicate semifloral artistry, which strongly influenced the Dene and Santee Dakota, earned the Métis the designation Flower Beadwork People.

Métis men's formal dress reflected their convergent cultural identities. Seamstresses abandoned the loose-fitting, poncholike shirts of the Plains Indians for tailored, tight-fitting, tanned-hide frock coats with cuffs, collars, and buttons and buttonholes. The half-leggings worn over trousers by some Métis men probably derived from Mexican-style chaps, which Métis men trading along the Santa Fe Trail were known to wear.

215 *Tanana Chief Thomas and his son in early twentieth-century hide jackets with beaded floral motifs. The jacket replaced the English hunting-style shirt, which had succeeded the indigenous pointed tunic (210). Chief Thomas's young wife's dress was made by the chief's first wife. Tanana, Alaska. The University of Pennsylvania Museum, S8-137221*

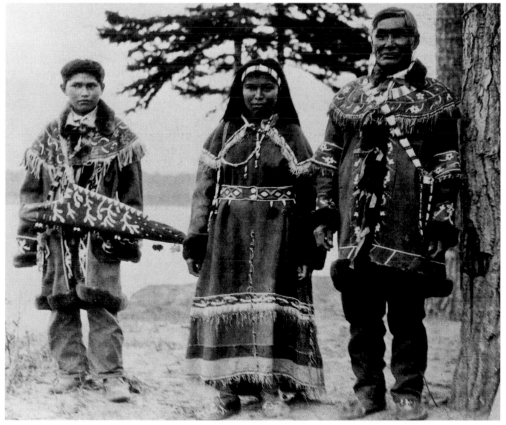

△ **214** *Métis coat with half-leggings combines Native and foreign elements. The coat is an exact copy of a Prince Albert jacket, although it is made of leather and decorated with Indian porcupine-quill embroidery. The half-leggings have typical Métis beaded floral patterns. The L'Assomption sash hanging from the waist was made by French Canadians for the Indian trade. Manitoba, 1840s. Coat: leather, porcupine quills, silk ribbon. Half-leggings: leather cuffs with glass beads. Frock coat length, 38⅞" (99.0 cm). Denver Art Museum, 1937.323*

RECIPROCAL NATIVE INFLUENCES:
CULTURAL SHARING

Linked through trade and intermarriage, Northwest Coast and neighboring Subarctic Athapaskan groups exchanged design motifs and techniques. It is generally assumed that Athapaskans borrowed patterns from the Northwest Coast; however, coastal Tlingit did incorporate Athapaskan geometric motifs into their quillwork and basketry (216, 217). At the same time, Athapaskan Tahltan beadwork designs appear to have been influenced by Tlingit spruce-root basket motifs (218). The similarities may derive from ancient origins.

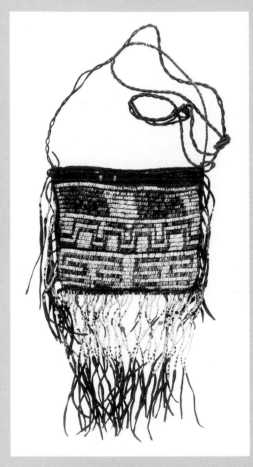

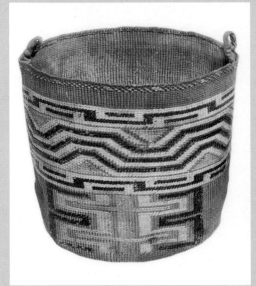

216 *The quill embroidery on this Tlingit bag may reflect Athapaskan prototypes. Since the porcupine was not native to coastal Alaska, the Tlingit traded European goods to their inland neighbors in exchange for bundles of loose quills or finished embroidery. Tlingit women processed the quills— splitting, dyeing, and then sewing them to clothing and footwear in geometric motifs evocative of the Athapaskan style. Collected Fort Wrangel, Alaska, 1885. Length, 8¹⁄₁₆" (20.5 cm). The University of Pennsylvania Museum, NA 4282*

217 *Tlingit basketmakers adapted these transferred quillwork designs to their baskets. The geometric quality of the basket above diverges from characteristic Northwest Coast motifs— totemic animal figures reflecting ancestry and social hierarchy. Here again, geometric patterns may have been borrowed from Athapaskan porcupine-quill embroidery. Collected southeast Alaska, 1905. Height, 6¹⁄₁₆" (15.4 cm). The University of Pennsylvania Museum, NA 1262*

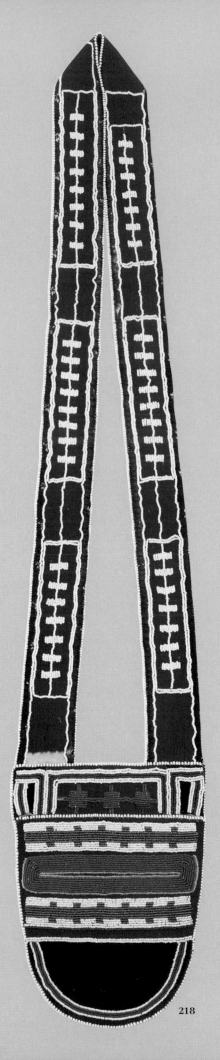

218

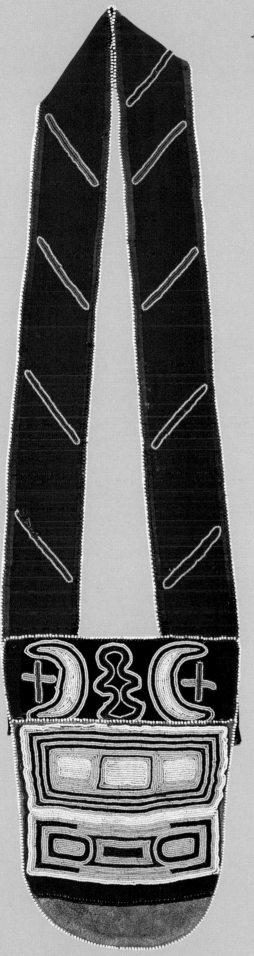

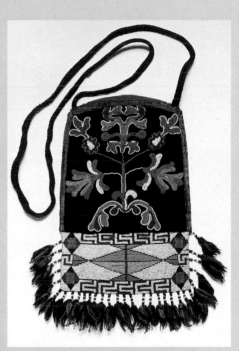

◁**218** *Two Tahltan men's shoulder bags contain beaded motifs mirroring Tlingit spruce-root baskets from the same period. Alternating dark and light concentric outlines relate to two-dimensional painted designs of northern Northwest Coast artifacts. The center of the Tahltan form is sometimes left unbeaded so that the dark background creates a dark inner core. Similarly, in the Northwest Coast formline system, a dark inner ovoid usually appears at the center of a complete ovoid (see page 398). Both collected in British Columbia, 1906. Cloth, glass beads. Far left pouch length, 10" (25.4 cm). National Museum of the American Indian, 1/888, 9371*

219 *Athapaskan, Tlingit, and Eskimo groups used the same materials to craft similar objects. This beaded Athapaskan bag, made from a duck's foot, was collected from the Nunivak Island Eskimo in 1905. Length, 5¼" (13.3 cm). The University of Pennsylvania Museum, NA190*

220 *This Northwest Coast Tlingit bag had its stylistic origins in the Great Lakes, and traveled west in "partnership" with octopus bags (see 240.46 on the floral beadwork chart, page 138). The embroidered beaded floral foliate scroll style is typically Tlingit, while the loomed geometric beadwork at the bottom may be Athapaskan. Collected by Louis Shotridge, 1917. Fabric, hide, and glass beads. Length, 15¼" (39.0 cm). The University of Pennsylvania Museum, NA 5773*

221 *This magnificent horse bridle with its fine quillwork cover was created in the early twentieth century, a time when Athapaskans were decimated by disease and the overhunting of their animals. Probably western Canadian Athapaskan, from the Yukon or Northwest Territories. Length, 13½" (34.2 cm). Denver Art Museum, 13/11*

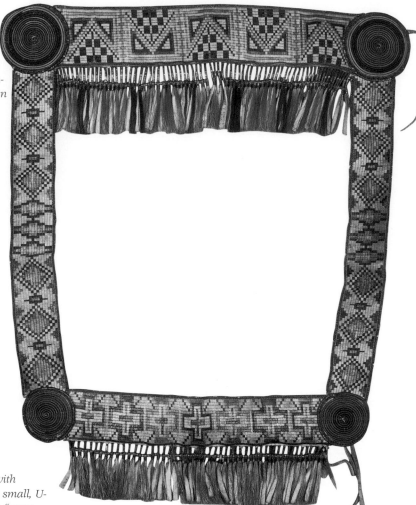

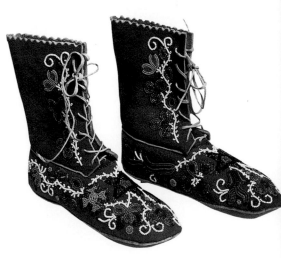

222 *The quality of this quillwork equals the finest quilling of the past (see 221). Shown are two porcupine-quill bands (front and back views) on their bow looms, woven on cotton thread warp and weft. There are 1,152 quill units per square inch in each band. Rosa Minoza (Slavey), Fort Providence, Northwest Territories. 1996. Dyed porcupine quills. Length (top), 9¾" (24.8 cm); width, 1" (2.54 cm). Collection Dorsey*

223 *Beaded moccasins with seamed and pointed toes; small, U-shaped upper; and ankle "wrap-arounds"—a style worn by the Dene during the nineteenth century. Showing similar footwear to those of Gwich'in beadmakers in the early 1980s, Kate Duncan and Eunice Carney noted: "Elderly eyes lit up on seeing the pointed toe moccasin, the sharp moccasin once again. Several older women had made the type, but not for many years." Made by Anne Cady (Gwich'in). 1930. Beads, skin, leather. Length, 8¾" (22.2 cm). Denver Art Museum, 1935.38*

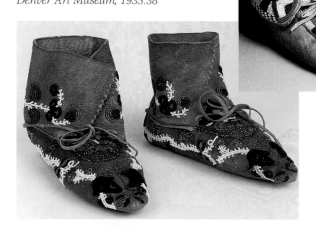

224 *A unique pair of Carrier moccasins in which floral motifs transform into geometric forms. c. 1965. Collected at Fort Fraser, British Columbia. Smoked moose hide, glass beads. Length, 11¼" (28.6 cm). Natural History Museum, Los Angeles County*

225 *Dance boots made by Gwich'in beadworker Eunice Carney. 1986. Leather and beads. Height 8¼" (21.0 cm). Collection of the Newark Museum, Purchase 1986, The Members' Fund, 86.32*

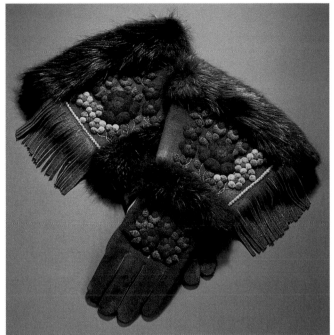

227

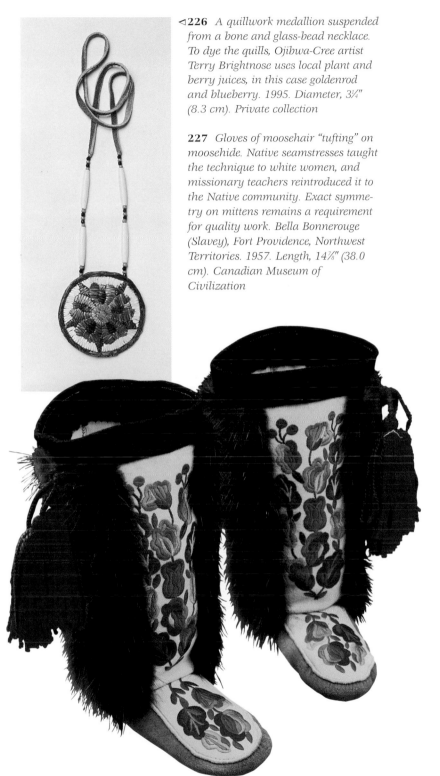

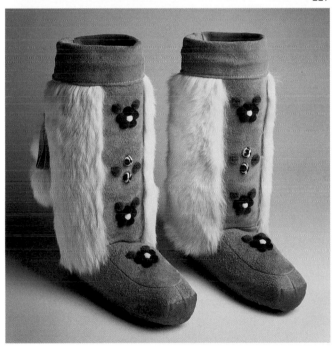

◁226 *A quillwork medallion suspended from a bone and glass-bead necklace. To dye the quills, Ojibwa-Cree artist Terry Brightnose uses local plant and berry juices, in this case goldenrod and blueberry. 1995. Diameter, 3¼" (8.3 cm). Private collection*

227 *Gloves of moosehair "tufting" on moosehide. Native seamstresses taught the technique to white women, and missionary teachers reintroduced it to the Native community. Exact symmetry on mittens remains a requirement for quality work. Bella Bonnerouge (Slavey), Fort Providence, Northwest Territories. 1957. Length, 14⅞" (38.0 cm). Canadian Museum of Civilization*

229 *Contemporary moosehair-embroidered mukluks. Northwest Territories, 1996. Hide, moosehair, rabbit fur. Height, 13½" (34.3 cm). Collection Gail Limon*

228 Mukluks, *a type of boot used for many years in the Arctic, are recent to the Subarctic. Bright and warm, decorated mukluks are worn by Natives and non-Natives to northern winter festivals. Rose Tsetso (Slavey), Fort Simpson, Northwest Territories. 1991. Beaver fur, smoked moosehide, stroud, embroidery thread, wool yarn. Height, 16⅞" (43.0 cm). Canadian Museum of Civilization, V1-N-209*

Beads were strung on skin fringes, added to porcupine-quill wrapping, or replacing organic seed beads such as silver willow (*Elaeagnus*)[45] (194). After the arrival of Europeans in James Bay around 1743, the Cree changed their parkas into coats simply by cutting the fronts open. A sash or belt held the garment together.[46]

The fur trade also created markets for clothing that retained traditional styles and techniques. The predominantly all-male fur-trade personnel patronized local Native seamstresses, depending upon them for making and repairing the clothing needed for the northern environment: fur moccasins, mittens, hats, and winter outerwear. Women's skill in working fur hides continued to be essential to the Subarctic economy. Conversely, in response to a desire by outsiders for "authentically traditional" Native handwork, women also created apparel considered unfashionable by indigenous populations. In the 1880s Catherine Stewart, the Gwich'in wife of a Hudson's Bay Company trader in Fort McPherson, continued to craft traditional caribou-skin garments for European customers even after she ceased wearing them herself.[47]

By 1850, clothing styles and adornment throughout the Subarctic reflected the varying effects of more than two hundred years of cultural contact. Denigrated by missionaries and regarded as old-fashioned by the Native population, face painting, tattooing, and nose ornaments had generally disappeared. Garments fashioned from imported textiles in European styles indicated modernity and identity with the powerful outsiders. Those, such as the Dene, who lived close to trading posts had adopted European style more quickly than more distant groups. In the 1860s, Dene women were observed wearing "beautiful shawls of tartan . . . over very proper cloth dresses of wool or printed calico." Successful trappers, particularly younger men, might exchange furs for clothing, outfitting themselves in navy blue serge suits.[48]

As the nineteenth century ended, converging cultures produced a hybrid fashion, termed the Mackenzie River style, that was colorful and distinctly western North American. Initially connected to trading-post life along main fur trade routes in the central western Subarctic, Mackenzie River–style clothing—of smoked moose or caribou hide decorated with elaborate floral patterns embroidered in glass beads or silk thread—reflects the influences of the fur-trade society, goods and technology from abroad, mission education, and the fashions of the Métis people. The style spread throughout the Subarctic and onto the northern Plains and Plateau.[49]

Glass Beadwork

Native artisans initially believed European cloth, metal, and beads contained magical properties, giving them a kind of inherent spirit-helper status. The Ojibwa called the spiritual power residing in nature *manitou.* Their neighbors, the Naskapi, termed European cloth "skin of the *manitou,*" and their word for glass beads means "*manitou* berry."[50] One of the new European goods, beads were perhaps the most avidly incorporated into the Native aesthetic. Beadwork provided an ideal means of expanding the ancient northern tradition of garment ornamentation.

Glass beads had entered the eastern Subarctic at the beginning of the seventeenth century with French traders and the establishment of trading posts in Quebec. In the eighteenth century, glass beads were introduced to Native groups along the coast of Russian America via the Russian fur trade. By the 1830s, at the mouth of the Yukon River, beads were prominently displayed on clothing alongside dentalium shells (which had been obtained from the Northwest Coast through ancient tribal barter networks) and were desirable trade items farther inland (197). Among several western Athapaskan groups, particularly the Gwich'in, successful men wore broad bands of beads and dentalia, several yards long, weighing as much as ten pounds, around the neck or over the shoulder.[51]

230 *Baby's slippers, crafted and lined with rabbit fur, a traditional Subarctic material accessible to all. Terry Brightnose (Ojibwa-Cree). 1995. Length, 4" (10.2 cm). Private collection*

231 *Two Slavey dolls from the late nineteenth century wear smoked-hide dresses, embroidered moccasins, and head scarves, typifying the modestly decorated Slavey women's clothing of the same period. Northern Athapaskan women used their energy and resources to enhance children's and husbands' clothing rather than their own. Height of left doll, 15½" (39.4 cm). Royal Ontario Museum, HK 1868, HK 1865*

232 *Elaborately beaded mittens were not worn in the coldest weather; glass beads retain and conduct cold to the wearer's hands. The colorful, braided-yarn cord worn around the neck and joining the mittens prevented their loss. Mittens suspended from cords were noted by early Subarctic explorers, though it is unclear if the concept is indigenous. Great Slave Lake–Mackenzie River region. Late nineteenth–early twentieth century. Deerskin, fur, cloth, beads. Length, 10½" (26.7 cm). National Museum of the American Indian, HF 22/4205*

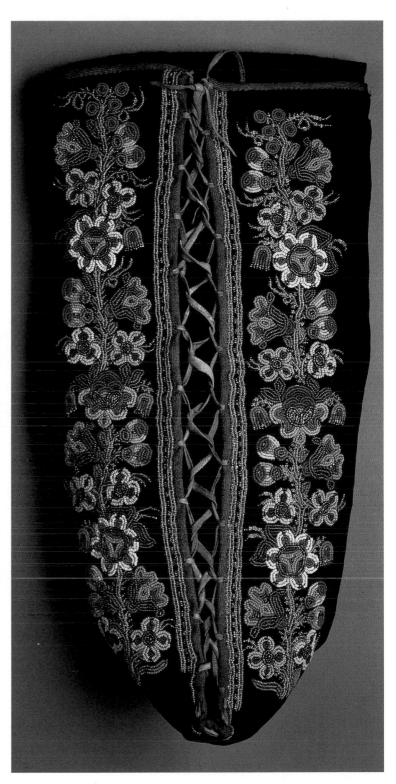

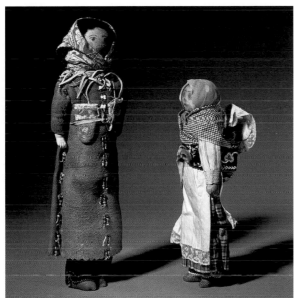

231

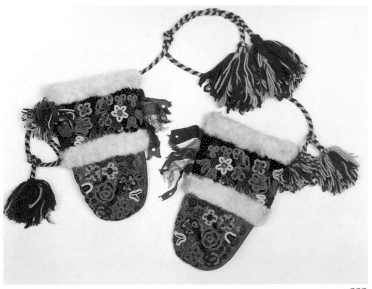

232

233 *Dene babies were diapered with spagnum moss layered in hide and then snugly laced into moss-stuffed carrying bags. Highly absorbent, the moss was obtained by digging under the sphagnum clump's surface to reach the inner, dry moss. Late nineteenth century. Velvet, beads. Length, approximately 22" (55.9 cm). British Museum*

THE MERGING OF INDIGENOUS AND
EUROPEAN-INFLUENCED FLORAL MOTIFS

Beginning in the seventeenth century, when Ursuline nuns in northeastern Quebec introduced silk embroidery and beadwork floral motifs to young Huron and Iroquois girls, European needlework and indigenous curvilinear Native forms gradually converged into designs that the Huron and Iroquois in turn transmitted to their western neighbors, the Ojibwa and Cree. As the floral style traveled westward with the fur trade, Euro-American settlers, and mission-school education, it was adapted by an increasing number of tribes, frequently replacing earlier geometric traditions. Indigenous and European styles merged with the passing of time, and the symbolic power of traditional forms was obscured or lost. Even so, nineteenth- and twentieth-century Native American women would exploit the artistic potential of these new floral designs in distinctive ways.

Prior to the introduction of European motifs, Native floral forms were bilaterally symmetrical, nonrealistic, and flat. Overall compositions were typically symmetrical on one axis. Flowers and leaves were often abstracted curvilinear forms. The main organizing device was the indigenous double-curve motif (236). The European floral style was asymmetrical and realistic and used shading for three-dimensional effects (242, 243). At first, artisans tended to work within one specific style; nonetheless, numerous surviving designs reflect both Native and European influences (241, 244–45).

In the Northeast, the Native floral style was maintained by the Montagnais, Naskapi, Micmac, and Iroquois (240.17) until, in the second half of the nineteenth century, stylized, linear, white-beaded motifs (240.16) were replaced by polychrome floral forms (240.15). Iroquois beadwork of this period reflects Victorian influences (240.18). To the south, Delaware and southeastern floral beadwork remained abstract, within asymmetrical compositions (240.22). Artisans in the Great Lakes region (excluding Potawatomi), made a similar progression from earliest white beaded stylized imagery to more colorful, naturalistic floral forms. Beginning in the early nineteenth century, Ojibwa and Menomini beadwork combined European flower parts and colors with Native bilateral compositions (240.26). By the late nineteenth century, realistic compositions predominated (240.23). Only the Potawatomi continued to work with abstract floral forms (240.27), and their designs influenced the Sauk, Mesquakie, and Omaha (240.28, 240.35). Upon their removal to Oklahoma, both Delaware and Potawatomi examples influenced the work of the southern Plains Kiowa (240.31).

Cree and Cree-Métis designs traveled both east and west from the Lake Winnipeg and James Bay Cree area. While Cree floral beadwork dates to the early 1800s, and western Athapaskan pieces to the 1850s, most central and western Subarctic floral work was produced at the turn of the century. Regional floral styles were shared by groups connected through trading posts. The five northern Athapaskan stylistic regions were Great Slave Lake–Mackenzie River (240.10), the Liard-Fraser (240.11), the Yukon Tanana (240.13), the Tahltan, and the Interior Coastal. Though much work combined indigenous bilateral symmetry with European realistic floral elements (240.7, 240.9), designs from the Cree and Great Slave Lake–Mackenzie River were frequently asymmetrical, with complex floral images (240.6, 240.8). West of this region, floral designs were usually symmetrical, less elaborated, and more stylized (240.13). Far western Subarctic work displays no Russian folk-art or floral influence.

After 1850, the northern Plains Blackfeet developed patterns based on the double-curve motif and abstracted flowers with semirealistic colors (240.33, 240.34). The eastern Santee Sioux's delicate and colorful beadwork was influenced by the Métis (240.29), while the Lakota modified the lazy stitch to depict fewer florals. The Crow merged their own geometry with introduced floral designs. Bilateral compositions were integrated with flower motifs internally "nested" and divided into isosceles triangles (240.36).

Bold floral designs using bilateral organization, double-curve motifs, and stylized forms appeared on the Plateau during the mid-1800s. Stylistic influences filtered in from the central Subarctic and Great Lakes (240.39, 240.41, 240.45). By the 1890s, beaded compositions were moving toward asymmetry and realism (240.40). The use of beaded floral images eventually spread into the northern Basin, where the Shoshone, Bannock, and Northern Ute became famous for their roses. Motifs and stylistic organization essentially followed Plateau trends (240.38).

The distinctive Northwest Coast floral style developed by the interior Tlingit and Tsimshian groups was probably influenced by Athapaskan work. Although these Northwest forms are abstract, symmetry and asymmetry occur in equal measure and frequently together (240.47).

234 Worn by a shaman to lure caribou, this remarkable Naskapi ceremonial robe's painted designs and their organization reflect sacred and ancient Naskapi cosmology, including indigenous plant motifs (see 5). Organically curved lines spiraling around the central sun image connect plant and animal growth with the sun's power. The sun's projecting inner rays suggest transformed flower petals. c. 1740. Tanned caribou skin, porcupine quills, paint, fish glue, brass, hair quillwork. Length, 46⅜" (118.0 cm). Canadian Museum of Civilization

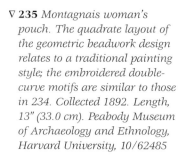

▽ **235** Montagnais woman's pouch. The quadrate layout of the geometric beadwork design relates to a traditional painting style; the embroidered double-curve motifs are similar to those in 234. Collected 1892. Length, 13" (33.0 cm). Peabody Museum of Archaeology and Ethnology, Harvard University, 10/62485

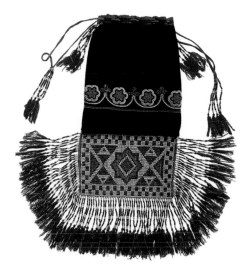

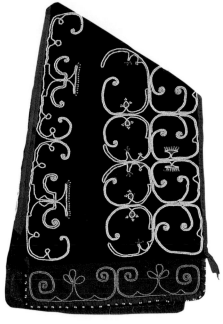

236 Micmac hat displaying an embroidered beadwork elaboration of the double-curve motif. Collected at Pictou Landing, Nova Scotia, c. 1825–60. Length, 13½" (34.3 cm). National Museum of the American Indian, HF, 3/2050

237 Naskapi pouch, made before 1780, displays a double curve and a cardinal-directions motif, possibly intended to appease the spirits of the seasons. Tanned caribou skin, fish glue, sinew. Canadian Museum of Civilization

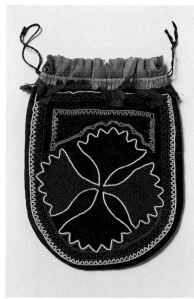

238 The four cardinal-direction forms on this beaded pouch literally break out of their boundaries to transform into floral or organic motifs. The central motifs, contour beading, and colors of this woman's pouch are Lenape (Delaware), but the lacy border designs relate to late nineteenth-century Iroquois work. Its reverse side is seen in the floral chart, 240.19. Collected in Pennsylvania in 1832. Wool cloth, cotton calico, silk ribbons, glass beads. Length, 9" (22.9 cm). National Museum of the American Indian, HF, 24/4153

239 Bead-embroidered gauntlets from Alberta continue the quadrate and double-curve motifs. Date and group unknown, but probably twentieth century. Length, 16⅜" (41.5 cm). Canadian Department of Indian and Northern Affairs

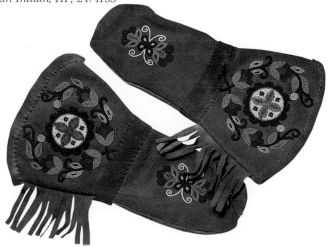

THE SPREAD OF FLORAL BEADWORK THROUGHOUT NATIVE NORTH AMERICA, c. 1880–1900

240 (1–47) *This chart presents a visual overview of floral beadwork throughout Native North America from around 1880 to 1900, an era when flower motifs proliferated. A few examples of earlier beadwork (marked with an asterisk*) important to the foundation of the late nineteenth-century work are included. Arranged as if on an abstracted map, the items have been grouped and numbered by cultural region of origin and to reflect the general movement of floral motifs from east to west, north to south.*

WESTERN SUBARCTIC

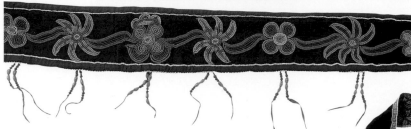

NORTHWEST COAST

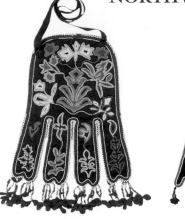

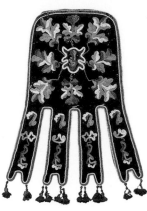

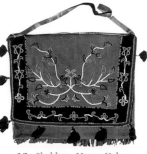

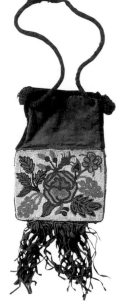

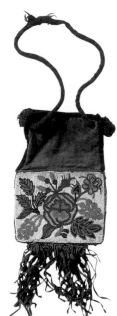

12. *Belt. Glass and metal beads, wool. Loucheux (eastern Gwich'in). Acquired 1902. 50¾" (129.0 cm). American Museum of Natural History, 50-3905*

13. *Sled bag. Upper Yukon Region. Collected 1894–1901. Glass and metal beads, wool, moosehide. Length, 19⅞" (50.5 cm). Lowie Museum of Anthropology, 2-2636*

***47.** Octopus bag. Tsimshian. Acquired 1873. Glass beads, wool. Length, 14¼" (36.2 cm). The University of Pennsylvania Museum, 12889*

46. *Octopus bag. Tlingit. Late 1800s. Glass beads, cloth. Private collection*

PLATEAU

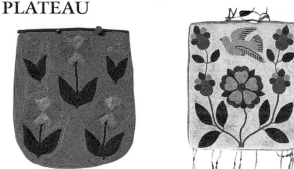

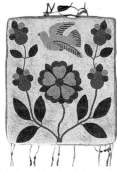

14. *Tobacco pouch. Shuswap. Acquired 1904. Glass beads, hide. Length, 14⅝" (37.0 cm). American Museum of Natural History, 16-9313*

11. *Bag. Kaska. Acquired 1902. Glass beads, wool. Length, 10⅝" (27.0 cm). American Museum of Natural History, 50-3977*

45. *Woman's pouch. Klickitat. c. 1880–90s? Glass and brass beads, wool, cloth. Length, 10⅝" (27.0 cm). American Museum of Natural History, 50/1502*

42. *Bag. The Confederated Tribes of Warm Springs. Late 1800s. Glass beads, hide. Length, 16" (40.6 cm). The Museum at Warm Springs*

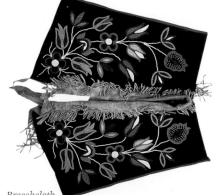

41. *Breechcloth. NLaka'pamux. Mid-late 1800s. Length, 19⅞" (50.5 cm). Peabody Museum of Archaeology and Ethnology, Harvard University, 10/86548*

43. *Cradleboard cover. Flathead. Late 1800s. Glass beads, hide. Length, 18⅛" (46.0 cm). Denver Art Museum, 1945.255*

44. *Pipe bag. Klickitat. c. 1900. Glass beads, silk ribbon, wool. Length, 13⅜" (34.0 cm). American Museum of Natural History, 50/1501*

40. *Baby wrap or bib. Flathead. Late 1800s. Glass beads, cloth. Length, 20¼" (51.5 cm). Denver Art Museum, 1945.255*

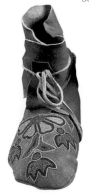

***39.** Moccasins. Nez Percé. c. 1870s. Glass beads, hide. Length, 9⅞" (25.0 cm). Peabody Museum of Archaeology and Ethnology, Harvard University, 10/72409*

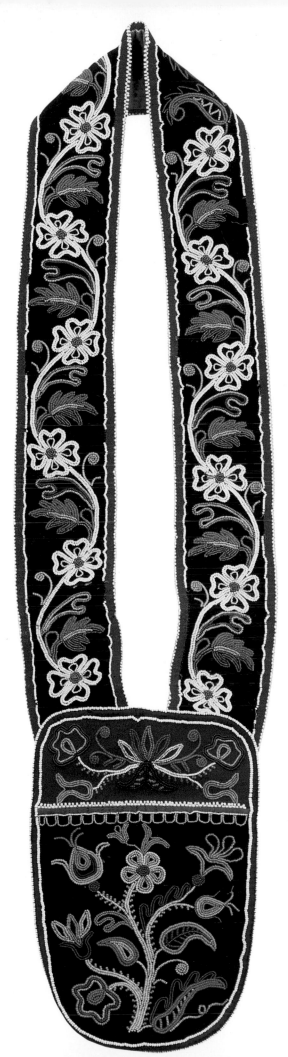

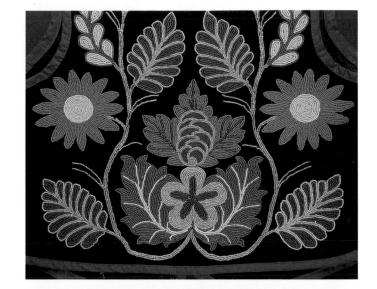

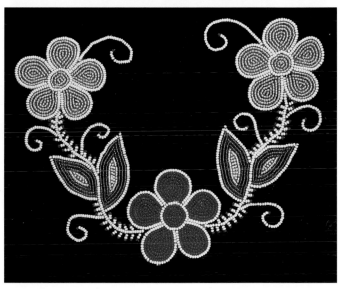

246 *On a Cree bandolier bag, c.1825, the straps exhibit Native symmetrical designs; the middle beadwork maintains the indigenous double-curve motif, whereas the asymmetrical floral assemblage is European-inspired. The use of red and black cloth reflects the traditional importance of these two colors. Wool, cloth, silk, sinew, glass beads. Pouch length, 5⅞" (14.9 cm). McCord Museum, McGill University, M189*

247 *Bilateral symmetry dictates the composition of the beaded detail of an Ojibwa vest from c. 1890. Collection Rene Senogles*

248 *Symmetrical design, the double-curve motif in particular, and traditional red-black color preferences are continued in this detail from a 1980s Ojibwa man's vest. Length of beaded flower strip, 14" (35.6 cm). Collection Tis Mal Crow*

ARCTIC

*8. Panel. Cree-Métis. Before 1874. Glass beads, silk, cloth, antelope skin. Length, 8¹⁄₁₆" (20.5 cm). Royal Ontario Museum, HK548

*7. Panel. Cree-Métis. Before 1874. Glass beads, silk, cloth, antelope skin. Length, 8½" (21.5 cm). Royal Ontario Museum, HK540

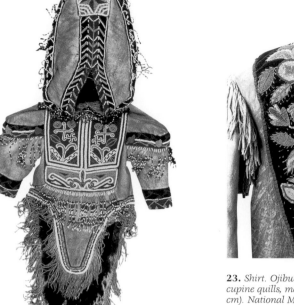

1. Parka. Baffin Island Inuit. c. 1900. Glass beads, hide. Canadian Museum of Civilization

23. Shirt. Ojibwa. 1890. Glass beads, porcupine quills, metal, hide. Length, 32" (81.3 cm). National Museum of the American Indian, 0/8935

*28. Breechcloth. Mesquakie. 1875–1900. Glass beads, cloth. Length, 19" (48.3 cm). National Museum of the American Indian, 2/5457

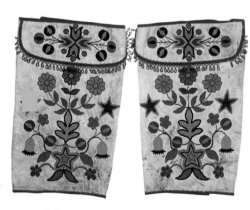

29. Man's leggings. Eastern Sioux (Dakota). c. 1890s. Glass beads, hide. Length, 15¾" (40.0 cm). Indian Museum of North America at Crazy Horse Monument

GREAT LAKES

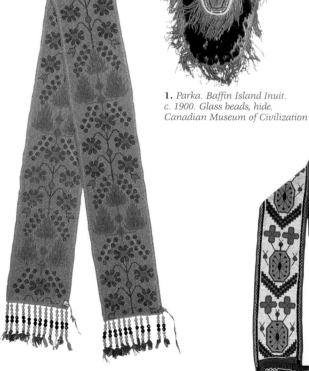

26. Belt. Menomini. Late 1800s. Glass beads. Length, 54" (137.0 cm). Denver Art Museum, Gift of Sarah Coolidge Vance, 1946.102

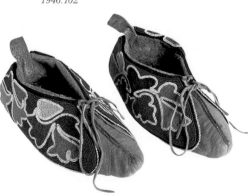

27. Moccasins. Potawatomi. c. 1880. Glass beads, hide. Length, 11" (27.9 cm). National Museum of the American Indian, 2/7614

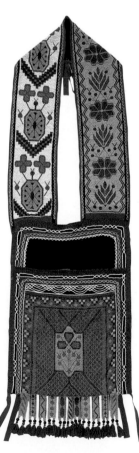

25. Bandolier bag. Ojibwa. c. 1890. Glass beads, cloth, wool. Length, 44" (111.8 cm). Private collection

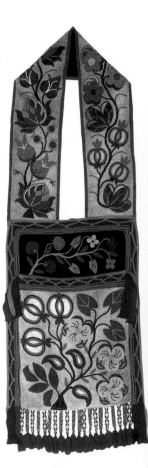

24. Bandolier bag. Ojibwa. c. 1890. Glass beads, cloth. Length without strap, 21½" (54.5 cm). Denver Art Museum, 1956.132

EASTERN SUBARCTIC

3. *Bag. Naskapi. c. 1900s. Glass beads, deerskin. Length, 6½" (16.5 cm). National Museum of the American Indian, 16/2358*

2. *Octopus bag. Montagnais. c. 1890. Glass beads, cloth. Length, 19⅞" (50.5 cm). Peabody Museum of Archaeology and Ethnology, Harvard University, 10/62487*

15. *Collar. Penobscot. Late 1800s. Glass beads, cloth. Width, 22" (55.9 cm). American Museum of Natural History, 50.1/9919*

4. *Hood. Tête de Boule (James Bay Cree style). c. 1890s. Glass beads, cloth. Length, 20⅛" (51 cm). Canadian Museum of Civilization, III-C-512*

NORTHEASTERN WOODLANDS

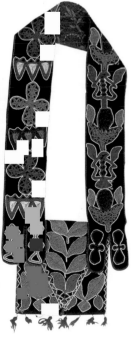

6. *Bag. Eastern Bush Cree. c. 1900. Glass beads, cloth. Length, 31½" (80.0 cm). National Museum of the American Indian, 15/1690*

5. *Pouch. Tête de Boule. c. 1890. Glass beads, hide. Length, 7⅝" (19.4 cm). Denver Art Museum, 1937.97*

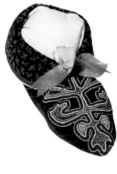

***17.** *Moccasins. Iroquois. 1847. Glass beads, cloth, hide. Length, 9½" (24.1 cm) American Museum of Natural History, 50/859*

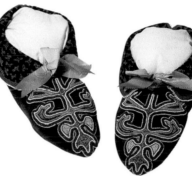

16. *Man's leggings (detail). Mohawk. 1890–1900. Glass beads, cloth. Length, 17½" (44.5 cm) National Museum of the American Indian, 2/9654*

***22.** *Shoulder bag. Cherokee. c. 1838. Glass beads, cloth. Length, 26" (66.0 cm). Peabody Museum of Archaeology and Ethnology, Harvard University, 10/23538*

***21.** *Shoulder bag. Creek. 1810–30. Glass beads, silk ribbon, cotton, wool. Length, 53¼" (135.3 cm). Detroit Institute of Arts, 1988.29*

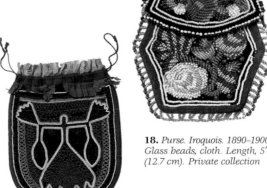

***19.** *Bag (reverse of 238). Iroquois or Lenape (Delaware). Collected 1832. Glass beads, silk, cotton, wool. Length, 9" (22.9 cm). National Museum of the American Indian, 24/4153*

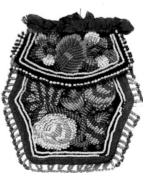

18. *Purse. Iroquois. 1890–1900. Glass beads, cloth. Length, 5" (12.7 cm). Private collection*

***20.** *Shoulder bag. Seminole. c. 1840. Glass beads, cloth. Length, 22" (55.9 cm). Denver Art Museum, 955.142*

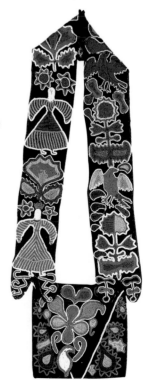

SOUTHEASTERN WOODLANDS

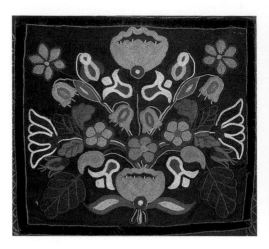

241 *This Eastern Cree beaded panel blends Native and European design traditions: detailed flowers and leaves, some superimposed on others, are reminders of French decorative art while the composition's bilateral symmetry is achieved with the traditional northeastern double-curve. Early 1800s. Military baize, beads. Length, 9¹³⁄₁₆″ (25.0 cm). Denver Art Museum, 1936.24*

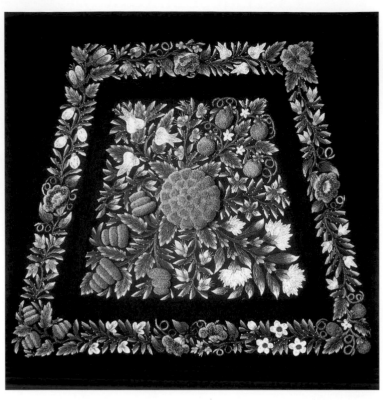

242 *Moosehair embroidery, an ancient Native art form, was expertly worked by the Huron of Quebec into this complex realistic French floral design. The superposition here—buds are partially placed over leaves which traverse stems—is rare in aboriginal Native American art. Other European qualities are the use of color modulation to achieve a three-dimensionality and a tendency toward realism. Made in the mid-nineteenth century for use as a chair panel. Broadcloth base, moosehair. Length, 20¼″ (51.4 cm). Denver Art Museum, 1970.452*

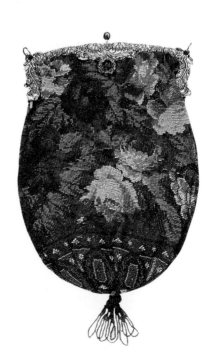

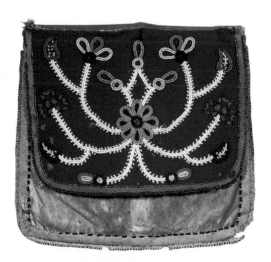

243 *French beaded floral bag, c. 1850s. Length, 11″ (28.0 cm). Private collection*

244 *Prototypically western Subarctic, this Northwest Territories or Upper Yukon pouch dating to the 1870s evenly balances Native concepts with the naturalism of European floral design. Leaves and flowers, depicted in small circles and ovals, are fairly abstract. Color is used imaginatively: white branches sport dark blue leaves. The composition is based on the traditional Native double-curve motif. Leather, trade cloth, beads. Length, 10¹⁄₁₆″ (25.5 cm). Denver Art Museum, 1949.10*

245 *Tête de Boule pouch, c. 1890. Asymmetry occurs within a Subarctic symmetrical composition of white stems and "thorns." Glass beads, hide. Length, 7⅝″ (19.4 cm). Denver Art Museum, 1937.97*

NORTHERN PLAINS

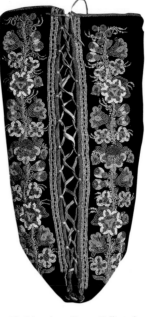

34. *Toilet bag. Piegan Blackfoot. c. 1880s. Chinese melon beads, shell, silver, hide. Length, 7" (17.8 cm). American Museum of Natural History, 50/4482*

33. *Moccasins. Sarsi. Collected 1903. Glass beads, hide. Length, 9" (22.9 cm) American Museum of Natural History, 50/4401*

32. *Knife-sheath panel. Sarsi. Late 1880s? Glass beads, hide. Length, 11½" (29.2 cm). American Museum of Natural History, 50/5975*

10. *Moss bag. Dene. Collected 1881–96. Glass beads, velvet. Length, 19½" (49.5 cm). British Museum*

***9.** *Octopus bag. Cree Red River Métis. c. 1850s–60s. Glass beads, silk floss, caribou skin. Length, 21¼" (54.0 cm). Royal Scottish Museum, L304.128*

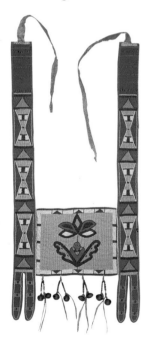

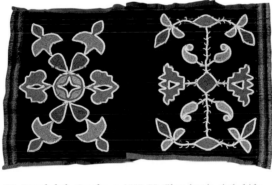

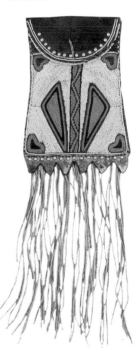

35. *Breechcloth. Omaha. c. 1880–90. Glass beads, cloth, hide. Length, 51½" (103.8 cm) American Museum of Natural History, 50.2/3099*

31. *Bag. Kiowa. 1890. Glass beads, hide. Length, 22½" (57.2 cm). Denver Art Museum, 1952.226*

36. *Martingale. Crow. 1905. Glass beads, hawkbells, canvas, wool. Length, 32⅝" (82.9 cm). Buffalo Bill Historical Center, Gift of Mrs. Henry H. R. Coe, N.A. 403.86*

GREAT BASIN

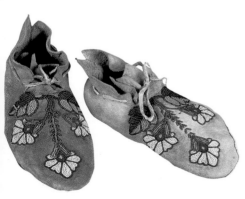

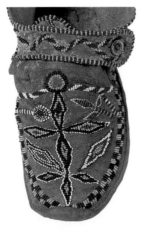

38. *Moccasins. Ute. 1890–1915. Glass beads, hide. Length, 9⅛"(23.2 cm). Colorado Historical Society, E1894.99*

37. *Moccasin. Southwestern Plains. c. late 1800s? Glass beads, hide. Length, 9" (22.9 cm) Courtesy Long Ago and Far Away Gallery, Manchester, Vt.*

30. *Bag. Oto. 1880. Glass beads, hide. Length, 11" (27.9 cm). Denver Art Museum, 1970.423*

SOUTHERN PLAINS

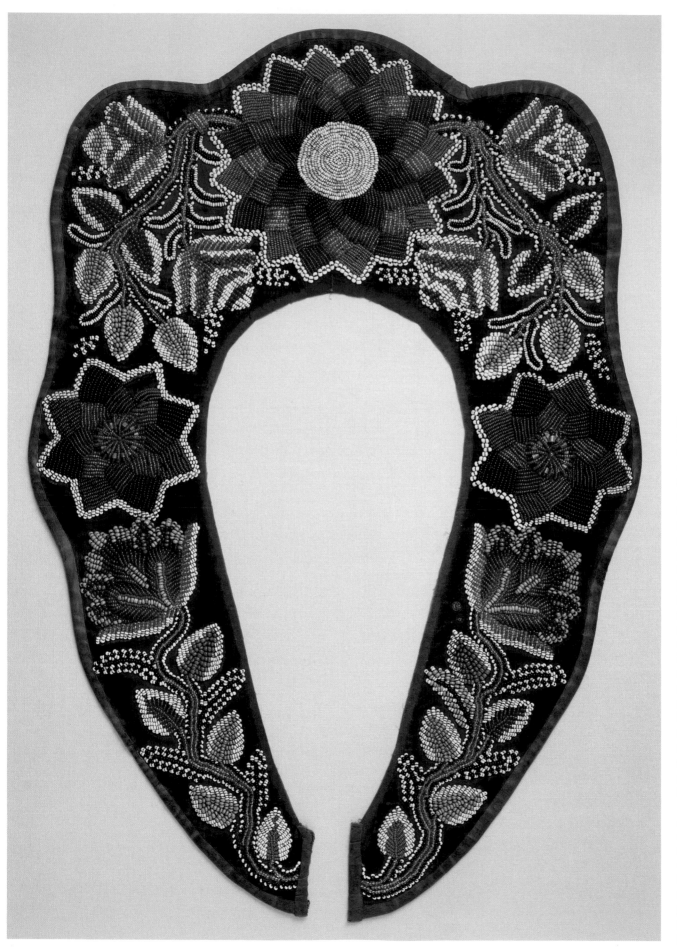

249 *Originally attached to a man's fur jacket, this beaded collar contains a marvelous amalgamation of curvilinear and geometric motifs. The overall form, curvilinear shapes of the twining stems, distribution of elements, and white outlining suggest northeast or Subarctic Woodland influences. The "embossed" (bas-relief effect) beading with its shading, wide color range, herringbone alignment of beading within the leaves, and use of different sizes of beads reflect mid-nineteenth-century Iroquois work. At the same time, geometric checkered patterning within three large stylized floral figures recalls Sekani work from western Canada. The connecting "semihairy" stems are an unusual variation of the thorny-stem motif.*

Iroquois and Great Lakes Indians came west as employees of the fur trading companies. Perhaps a Cree, Ojibwa, or Athapaskan woman married to an Iroquois crewman created this collar for him. Probably late nineteenth century. Length, 25" (63.5 cm). Private collection

Athapaskans had long employed quantities of shell beads as status symbols to ornament their clothing. Thus, beads as indicators of wealth fitted easily into the northern Athapaskans' scale of values. Among the Gwich'in, strings of beads were equated to the Hudson's Bay Company standard of exchange known as Made Beaver (a finished beaver pelt). No Indian was regarded as a leader until he had accumulated two hundred skins' worth of beads. Once beads became generally available, those who continued to work with porcupine quills were regarded as poor.[52] Colorful glass beads became a suitable match for traditional geometric designs, eventually augmenting indigenous shells and quillwork or replacing them altogether (207, 210). By the mid-nineteenth century, medium-sized beads had been followed with tiny seed beads, and beaded floral motifs became increasingly popular.[53]

It was long believed that all Native American floral imagery was European in origin and lacked spiritual significance. Support for this position was based in part on the limitations of technology prior to European contact. Imported steel needles, silk embroidery thread, and tiny glass beads allowed for curvilinear patterns difficult to achieve with porcupine quillwork, the prevalent indigenous northern decorative technique. Further, after contact, Native women learned embroidery from non-Native instructors familiar with the representational botanicals of European textiles. Early observers often interpreted the increasing use of flower motifs as opposed to traditional geometric patterns as symptomatic of the cultural trauma experienced by Subarctic and other Indian groups.[54] Traditional form was thought to mirror intact spiritual values, while the adoption of European-influenced forms reflected increasing impoverishment.

Contemporary scholars, Native Americans among them, have challenged these notions. In earliest times, both plant and animal forms were frequently abstracted as geometric motifs. Floral imagery appeared on Southwestern pottery dating back to A.D. 500 and, by the fifteenth century, was prominent in regional Uto-Aztecan and Pueblo ritual regalia and painted kiva murals. These typically female flower symbols were associated with spirituality and male power.[55] In the northern Woodlands, rare surviving examples indicate that plantlike patterns had embellished perishable hide and bark objects.[56]

Among Southeastern Woodland groups, such as the Creek, early contact beadwork soon became "a visual language that kept beliefs alive." An early James Bay Cree beaded hood (240.4) divides into three vertical design areas that may represent Sky World, Under World, and This World, respectively. Undulating flower stems framing This World replicate the zigzag power lines of Thunderbird and Underwater Panther, which are often united (424). The hood gave spiritual protection; with European-influenced floral patterns, it codified sacred beliefs that were being "forced to go underground."[57]

Flower images may have derived from numerous sources, including direct observation of the environment and a traditional belief in the inherent spirituality of all things in nature. Native artisans drew on a long tradition of transferring this spiritual power to clothing and ornament.[58] The Naskapi painted skin robe (234), for example, articulates sophisticated cosmological beliefs tying the sun's power to plant and animal growth. And thorny stems (244–45), a characteristic Subarctic beaded floral motif, may have originated with the Iroquois as a symbol for leaves or the sun's rays.[59]

Flowers could well have been dream images. Among small Subarctic migratory bands, ceremony was limited; enlightenment came not in elaborate group rituals but in personal visions. Dreams, "the clearest path to the spirit world," were authenticated and their power was secured by being recorded in the adornment of clothing and body.[60]

The far northern environment was undoubtedly a source for floral design. "I got my decoration from the bush, just by looking at all the wild flowers, on my walks in the summer, just going berry picking," remarked Rose Tsetso, a Slavey woman from Fort Simpson,

in 1991. "If one really looks, there are a lot of pretty flowers."[61] The abundant bloom of jewellike, fragrant flowers after the long and dark winter make it unlikely that Subarctic people would have disregarded this profound and joyful aspect of nature, which surrounded them so completely. Flowers did not have the subsistence importance of animals, on whom survival depended; rather, they nurtured the soul and eyes. Perhaps floral beadwork is an intensified dream of summer's abundance transformed into visual prayer.

CONTEMPORARY EXPRESSIONS

Modern seamstresses, particularly among the Cree, Ojibwa, and Dene, maintain roles similar to those of their traditional counterparts. Native clothing conveys pride in Native ancestry to outsiders, and sewing continues to be a highly regarded activity, extremely important to the group's social and economic life. Garments are produced for daily and special occasions as well as for sale to non-Natives. Much contemporary work successfully assimilates aspects of the white culture, reflecting artisans' ability to adapt while retaining cultural traditions and values.[62]

The ideal of the Dene wife as a skilled artisan continues to hold true today as in the past. Tim Trindel, a Métis elder, recalls that "a good sewer" was what men looked for in a wife. "If you're out in the bush and you rip your moccasins, well you can imagine what it's like—your feet full of snow and freezing."[63]

The creative process culminates today, as in the past, with gift-giving. Specially made clothing signifies bonds of kinship and friendship and marks important social and spiritual events. In late fall, seamstresses work diligently to create beautifully decorated slippers, mittens, jackets, and parkas for Christmas (230). Friends often exchange handmade gifts that are rarely worn but put away and cherished.[64]

While smoked moose and caribou hide remain an indispensible feature of many garments, few women have the training or desire to tan hides. Woven quillwork, however, has been revived in recent years. Today, in the Northwest Territories, fine quill and moosehair work is done by a few women in the Fort Providence–Jean Marie River area, generally for sale to outsiders.[65]

The most popular item for decorating contemporary Subarctic clothing is glass beads using the couched (embroidered) beadwork technique (248). Slavey women are widely recognized for their skillful beadwork; finely beaded baby bonnets are still produced at Old Crow and Fort McPherson. Gwich'in women, perhaps the most prolific contemporary Athapaskan beadworkers, continue to make their traditional baby "belts," broad ornamented carrying straps.[66]

Young boys sometimes learn the art while helping their mothers bead. A few men bead, a practice women acknowledge with quiet admiration. As in past generations, beaders are familiar with each other's work and acknowledge those who achieve the highest standard. Local residents, apparently far more than outsiders, appreciate the value of fine beadwork and invest appropriately. When clothing is outgrown or heavily worn, decorative work is carefully removed and packed away. Eventually it will add beauty to another garment.[67]

Subarctic quill- and beadwork artisans are continuing traditions that reached glorious heights in the nineteenth century. Within a swiftly changing world, their clothing and adornment maintain important links to the past while extending cultural values into the future.

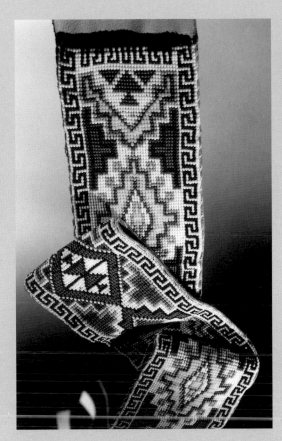

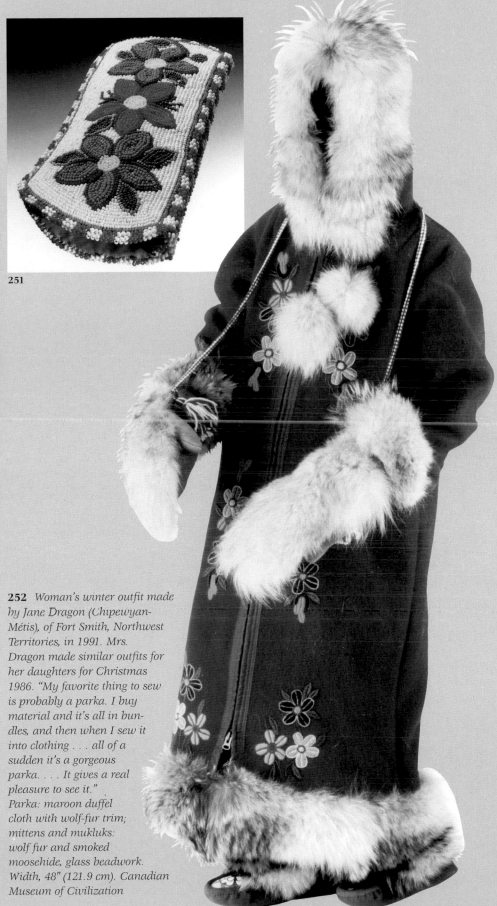

250 *Woven beaded belt by Debbie McDonald (Cree-Métis), a self-taught beadworker. Ms. McDonald's patterns are inspired by antique pieces, brickwork on buildings, and designs seen in magazines. "I look at books from all religions. . . . I research what the pattern is and where it's from, and maybe it will take me in another direction that I am looking for." 1995. Length, 48" (121.9 cm); width, 3¼" (8.3 cm). Collection of the artist*

251 *Embroidered beaded glasses case made by Josephine Beaucage (Ojibwa-Algonquian). Convent-school educated, Mrs. Beaucage decided to learn beading after raising five children. At ninety years old, she continues to bead. A highly regarded teacher, she credits her success to "patience" and believes "inspiration can come from anywhere. We make images the way they look, but always try to use different colors, taking care that they don't contradict one another. They must relate and have harmony." Mrs. Beaucage beaded a similar case as a gift for her friend the actor Chief Dan George. Length, 6⅜" (16.8 cm). Collection Josephine Beaucage*

252 *Woman's winter outfit made by Jane Dragon (Chipewyan-Métis), of Fort Smith, Northwest Territories, in 1991. Mrs. Dragon made similar outfits for her daughters for Christmas 1986. "My favorite thing to sew is probably a parka. I buy material and it's all in bundles, and then when I sew it into clothing . . . all of a sudden it's a gorgeous parka. . . . It gives a real pleasure to see it." Parka: maroon duffel cloth with wolf-fur trim; mittens and mukluks: wolf fur and smoked moosehide, glass beadwork. Width, 48" (121.9 cm). Canadian Museum of Civilization*

253 *Sacred Algonquian art forms were frequently expressed in rock art. Pictograph (painted) and petroglyph (carved) images on rock surfaces made visible the great* manitou *spirits, "seen" only by shamans. Boats symbolized the vehicles by which shamans and spirits journeyed to Sky World. Annie Island, Whitefish Bay, Ontario*

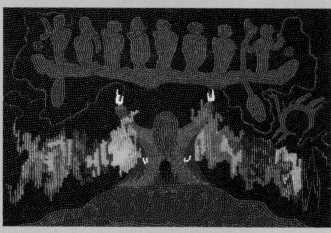

"Artists," **Patrick LaValley** notes, "are storytellers whose stories are portrayed nowadays in loomwork, pottery, quilting, quillwork, and birchbark biting. A pattern on a canvas isn't enough anymore. When I began doing beadwork, I didn't realize there was so much to it. Like everything, you see what's on the surface. But as I looked further and further, I realized that the development of the pattern was a journey in itself. In this picture I wanted to pay tribute to storytellers, to show my respect for keeping the stories alive.

"This picture (254) is a compilation of three different drawings. The northern lights in the background was one original picture; the petroglyph painting was another. The storyteller—the figure in opaque beads—is a character who goes into all of my pictures. I like to show his spiritual side and build up the images and the respect and dignity that the position deserves.

254 *The Storyteller, by Patrick LaValley (Ojibwa). 1994. Beadwork on canvas. 8¼ × 12½" (31.8 × 21.0 cm). Private collection*

"In this picture, the story is bigger than the storyteller; the person is just a piece of the puzzle. His presence means the story continues; it goes through him and then out again. He's a part of the process. The deep red is a rock painting, the color of ocher. This is what the storyteller stands on, and what he is trying to portray. What he is talking about flows through his hands. The image on top is like a television or movie screen image.

"We believe that smoke brings our prayers up; the energy lines are sometimes used in Woodland paintings: from moons, suns, and stars, and from people's voices. In this picture, they are shaped in the form of a face, and they connect to the Northern Lights which for me was once a natural television in the winter and in the autumn.

"The spiritual extension of the storyteller is done with shiny, iridescent beads. When something is rooted in the ground, I use opaque beads. Here the hair and earth have the same gunmetal color because there is a certain amount of quality and importance people give to their hair and to the earth. The sky extension is an oily purple, a color that says that we don't really know when the story is over."

Of Ojibwa, French, and Scottish heritage, LaValley says of his place in Native America's artistic tradition: "I'm a part of the process. I've taken to collecting and redesigning my own tools. I've built my own loom, designed and taken ideas for tools from other skills. I use needles from different types of work, stitches from needlework and embroidery and everything that I can to bring life back to beadwork."

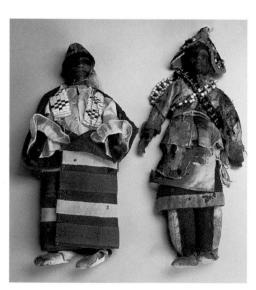

258 *Late eighteenth-century River Desert Algonquian male and female dolls. Replicating the era's actual mode of dressing, most clothing is of trade materials—stroud, cotton, silk ribbon, glass beads, while the moccasins are of smoked hide. The female (right) wears a peaked hood, and her upper body is crossed by beaded "wampum" chains strung in white, blue, and black glass beads. The male (left) wears a* blanket, *an armband of metal, and, around his shoulders, a broad band of woven white and black glass wampum. The use of wampum belts, though originally Iroquoian, spread into the Subarctic. Cloth bodies, molded beeswax head and arms, human hair. Height male doll, 9⁷⁄₁₆" (24.0 cm), height female doll, 11" (28.0 cm). Canadian Museum of Civilization*

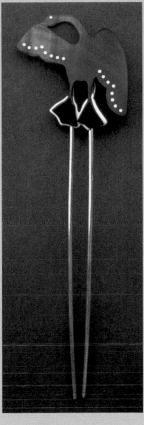

257 *Salmon buckle. Glen Simpson (Tahltan-Kaska). 1996. Sterling, 14-karat gold. Length, 2⅜" (5.5 cm). Private collection*

Glen Simpson, a metalsmith of Native and Canadian heritage, was born in Atlin, British Columbia. "My technical background and formal schooling are in silversmithing and jewelry. Because of my personal interests and family history, the expressive content of my work is usually drawn from northern Native sources. . . . True cultural continuity is more an expression of a worldview than the duplication of historic objects. For example, old Athapaskan beliefs are animistic: everything in the natural world, whether animate or inanimate, has some degree of spiritual power. Within this belief system, the careful use of ivory, bone, and antler is part of a broader pattern of respect for their animal origins. My goal is to produce metalwork that is both contemporary and culturally relevant to the far north."

255 *Yawning Goose hairpiece. Glen Simpson (Tahltan-Kaska). 1983. Moose hoof, sterling silver. Length, 6" (15.2 cm). Collection of the artist*

256 *In recent years, Simpson has increasingly reinterpreted traditional Native Alaskan imagery with nontraditional, often unexpected materials. "My work represents more the spirit of the old ways than exact replicas." Spruce grouse rattle. 1995. Spruce, naval bronze, brass 12-gauge shotgun shells, .22 cartridges, trade beads, grouse gizzard, rocks. Length, 8½" (21.6 cm). Collection of the artist*

260 *In an 1825 lithograph, Nicholas Vincent Tsawanhonei, chief of the Huron, wears trade silver brooches and armbands and holds a wampum belt commemorating the Treaty of Montreal. The agreement reached between French and Huron allies and the English was recorded in wampum in 1701. Wampum belts were important to diplomacy in Woodland Indian culture. Messages were woven into white and purple shell-bead panels, which were formally presented to mark an occasion. 18⅛ × 12¹³⁄₁₆" (45.8 × 33.1 cm). National Archives of Canada*

259 *The wampum belt depicted in 260 commemorates the Treaty of Montreal. Length, 35⅜" (89.9 cm). McCord Museum of Canadian History, Montreal*

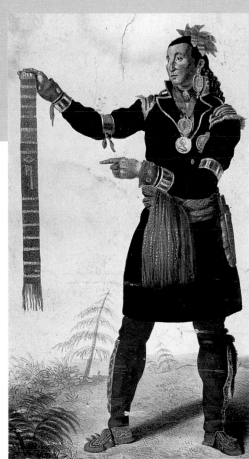

261 *During the eighteenth- and early nineteenth-century fur trade, shining silver brooches were made by European silversmiths in Montreal, Boston, and Philadelphia as gifts for Woodland Indian leaders. Fashionable shapes included round, heart, council square, Masonic, and star. The pierced circular brooches relate to historically distant aboriginal shell gorgets and sun imagery (262). Diameter of center brooch, 3⁷⁄₁₆" (8.8 cm). National Museum of the American Indian, 1/2134, 20/1236, 3/2401, 1/1603, 2/9711*

GIFTS OF SHELL AND SILVER
THE WOODLANDS

"Indians admired people not for accumulating goods but for giving them away.
Cooperation and sharing were necessary for survival; people who hoarded
endangered others. Goods were exchanged for need and honor, not for profit."

—**Carolyn Gilman, 1982**[1]

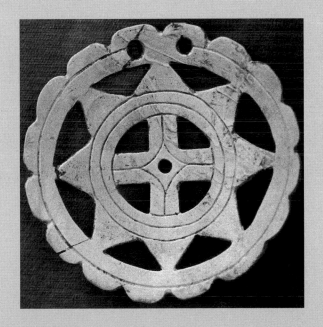

262 *This Mississippian shell gorget
displays sun and cardinal-direction
motifs. Worn centered on the individ-
ual's chest, the spiritual white-shell
disk, with sacred iconography, signified
cosmic-human connections. Gorgets
may have been emblems of authority,
status, or religion. Recovered in Florida.
1200–1400. Diameter, 5⅛" (13.0 cm).
National Museum of the American
Indian, 17/1164*

263 *The importance of wampum
indicates Indians' continuing belief in
the sacredness of shell. This Kanesatake
(Lake of Two Mountains) Mohawk
wampum belt commemorates the com-
munity's founding. 1788. Length, 60½"
(153.7 cm). McCord Museum of
Canadian History, Montreal*

Reciprocity, the guiding principle of traditional Indian conduct, was a concept inseparable from honor. Consequently, gifting and exchange have long been integral to Indian lifeways. Birth, marriage, and death were occasions for generous gift-giving. Leaders distributed gifts to their followers, strengthening bonds of loyalty. Animals gifted humans with their skins; artisans reciprocated by beautifying the dressed hides.

Giving to acquire goodwill and protection also governed behavior toward an omnipresent spirit, called *manitou* by the Algonquian and *orenda* by the Iroquois. So awesome were spirit powers that the Ojibwa cut holes into the soles of an infant's moccasins, believing "that if tempted by the spirits to return to their land, he could inform them that his moccasins were in no condition for the journey."[2] Eastern Woodlanders offered song and tobacco to the rocks and waters, which supplied treasures of crystal, copper, and shell.

The Great Spirit's most valued gift was the sun, acknowledged by the tribes through ritual, sacred sun imagery, and shining artifacts that captured and reflected the sun's own luminosity. White shell's ancient connection with spirituality had bearing on the later use of wampum and its historic complement, silver. Introduced trade goods—glass, brass, silver, and silk ribbon—so closely approximated the physical qualities of desirable indigenous materials that they too were considered gifts of the spirits. Thus, Native inhabitants may have at first perceived their European visitors as *manitous* bearing sacred gifts.[3] The Mesquakie of Iowa favored amuletic silver ornaments, especially bracelets, which they called "sacred or holy bands."[4] Intertribal trading was never solely economic in purpose; it also permitted coveted goods to be converted into status through gift-giving: the more one gave, the more prestige one obtained. Since the Mississippian era (A.D. 1000–1700), Woodlands adornment has contained a potent visual language, with references to gifting, prestige, and cosmology that continue today in tribal regalia.

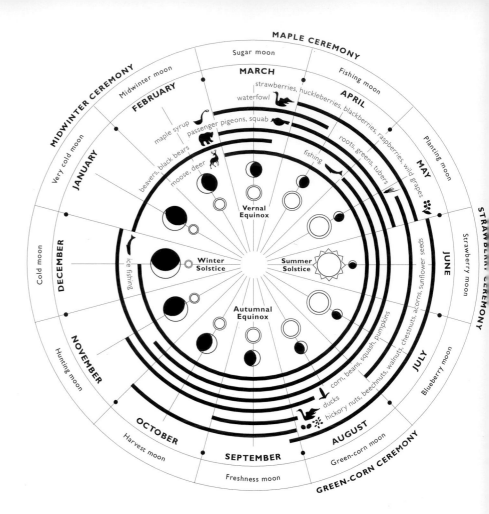

Seasonal Round of the Mohawk (Iroquois)

ANCIENT WOODLAND CULTURES: AN ARCHAEOLOGICAL HISTORY

For early Native Americans, the eastern Woodlands was defined by its sweeping primeval forest mantle, extending from the Atlantic coastline to the western prairie and from Lake Superior's northern rim to the bayous and beaches of the southern United States. But the hallmark of the region's individual ecologies is climatic moderation rather than extremes. And four defined seasons—particularly in the Northeast—produce a diverse palette of plant life that is not seen in the rest of the continent. Eastern North America was inhabited as early as 8500 B.C. by a few Paleo-Indian bands whose ancestors had hunted their way into the region. The generous forest environments gave protection and sustenance, supplying food, animal cover, and most raw material, shelter, transport (dugout and birchbark canoes), clothing, and artifacts, including adornment. Plants and animals were equally valued by people who hunted smaller game, fished, collected mollusks, and gathered wild plants.

The absence of extreme natural boundaries in the Woodlands permitted far-ranging

264 *Slate gorgets, Adena culture (500–100 B.C.), Michigan. Length of top gorget, 6½" (16.5 cm). National Museum of the American Indian, 22/94, 0/6942*

movement and exchange of goods and ideas for thousands of years. Arrowhead flints from North Dakota, Ohio, and Illinois were transported hundreds of miles, perhaps as gifts, among eastern Paleo-Indian bands. Between 5000 B.C. and 4000 B.C., Atlantic and Gulf Coast marine shells, Great Lakes copper, and fine-grained slate and jasper—used for tools, beads, and pendants—were traded into the middle south.[5] As a result of this long-distance exchange, social ranking emerged in Late Archaic societies (3000–1000 B.C.). Adornment played a major role in the display of exotic grave goods and increasingly elaborate burial rituals.

Beginning about 2000 B.C., with the domestication of native seed plants, foraging was augmented by farming. Maize, introduced from Mesoamerica, became a major crop in the period from A.D. 800 to 1100.[6] Subsistence activities varied regionally: hunting and gathering in the extreme north, agriculture supplemented by hunting and gathering farther south. A more plentiful food supply resulted in larger, concentrated populations where ritual adornment flourished.

In the case of the Woodland peoples, surviving archaeological evidence—offering clues about ancient agricultural practices, burial ceremonies, and adornment—is remarkably rich. North America's earliest known pottery, from c. 2500 B.C., comes from coastal and riverine Georgia.[7] Scholars have thus been able to develop a historical record based on these cultural artifacts, many of whose themes and forms were carried forward through the centuries. The first European visitors, in the late sixteenth century, encountered the descendants of these archaic cultural groups, which encompassed tribes speaking dialects of Algonquian, Iroquoian, Siouan, and Muskogean.

Archaic Clothing and Adornment

Early and Middle Archaic Woodland peoples (8000–3000 B.C.) wore beads and pendants crafted from by-products of hunting-gathering activities and skin clothing sewn with bone needles. Artifacts recovered from the Indian Knoll site in Kentucky (c. 3000 B.C.) include thousands of river pearls, tortoise-shell rattles, and bone pins for adorning the hair or closing skin garments. Prestigious shell beads found in children's graves imply kinship with prominent adults and may reveal the beginnings of a hierarchic system.[8] By the Late Archaic (c. 2500 B.C.), Great Lakes artisans—the earliest American metalworkers—cold-hammered copper nuggets into thin, flat sheets, which were rolled into tubular and barrel-shaped beads or cut and shaped into pendants, bracelets, and headdresses.[9] Important to evolving mortuary rituals, copper artifacts were traded throughout the Northeastern Woodlands.[10]

Adornment recovered from the Lake Lamoka site in west-central New York, dating from c. 2700 to 1200 B.C., included antler pendants with engraved geometric designs or painted red stripes, shell-bead and animal-canine-teeth necklaces, and polished bone or turtle-shell pendants.[11] Among the most exquisite beads and pendants were those of imported stone carved by artisans from the southeastern Poverty Point culture of around 1500 to 700 B.C. (265).

Adena and Hopewell (Middle Woodland) Adornment

As Late Archaic evolved into Early Woodland societies (c. 1500 B.C.), burials and grave goods assumed increased importance. Between 500 B.C. and A.D. 500, the Mississippi, Ohio, and Illinois River valleys were sites of separate but related cultural centers, characterized by large populations, burial rituals, elaborate earthworks including burial mounds, wide-ranging trade in exotic raw materials, and the indicating of status through artistic adornment. Special individuals were honored at death with impressive ornamentation.

THE WOODLANDS

1. THE HOPEWELL EXCHANGE SYSTEM, c. 200 B.C.–A.D. 500

Far-ranging ancient trade networks brought a variety of exotic adornment materials into the Woodlands' Hopewell culture centers.

2. NORTHEASTERN INTERTRIBAL TRADE NETWORK, PRE-1650

The Huron, Nipissing, and Ottawa were middlemen in a trade network that exchanged agricultural products from the southern farmers, fishing and hunting products from the northern hunters, and wampum beads, bison robes, and catlinite from coastal and Plains groups. The Hurons were particularly successful after contact with the French and their lucrative fur trade (c. 1600–1650).

3. CULTURE AREA

The approximate territories of: Northeastern and Great Lakes groups in the seventeenth century, Southeastern groups in Florida and along the Atlantic coast at about 1600, and the rest of the region at about 1700. See also the map of contemporary Native lands, page 551.

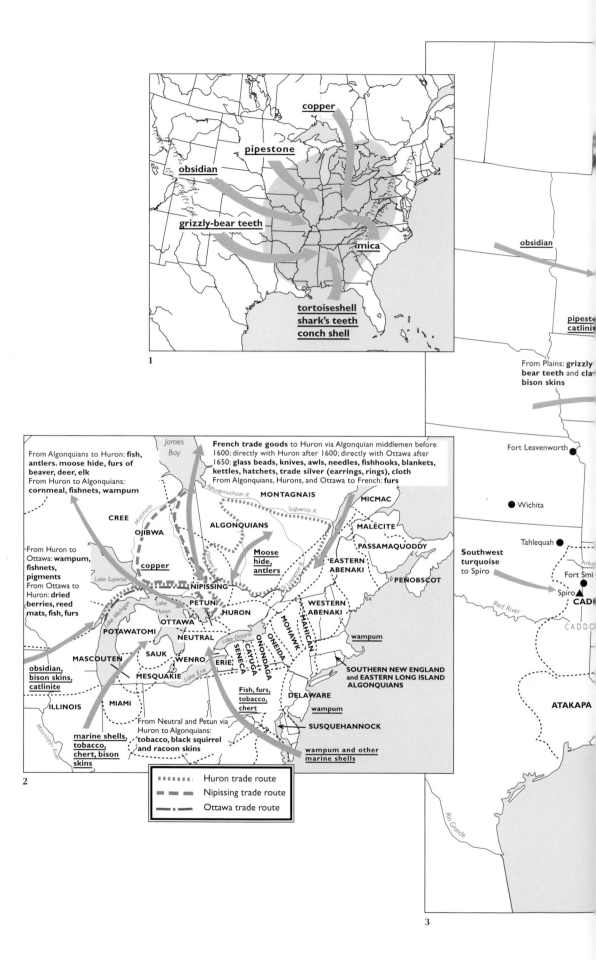

1

From Plains: **grizzly bear teeth** and **cla[...] bison skins**

2

3

154

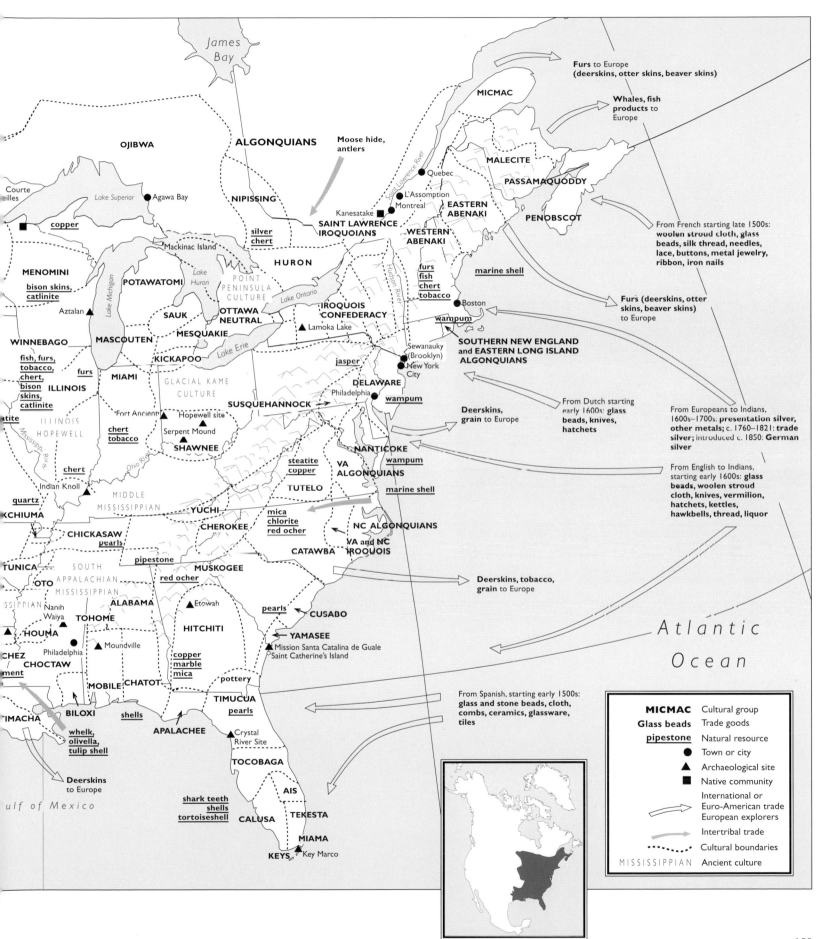

James Bay

OJIBWA

ALGONQUIANS

Moose hide, antlers

MICMAC

Furs to Europe
(deerskins, otter skins, beaver skins)

Whales, fish products to Europe

Courte
eilles

Lake Superior ● Agawa Bay

■ copper

NIPISSING

silver
chert

MALECITE

PASSAMAQUODDY

Quebec

L'Assomption

Montreal

Kanesatake ■

SAINT LAWRENCE
IROQUOIANS

EASTERN
ABENAKI

WESTERN
ABENAKI

PENOBSCOT

From French starting late 1500s:
woolen stroud cloth, glass
beads, silk thread, needles,
lace, buttons, metal jewelry,
ribbon, iron nails

Mackinac Island

MENOMINI

bison skins,
catlinite

Lake Michigan

POTAWATOMI

Lake Huron

POINT
PENINSULA
CULTURE

HURON

Lake Ontario

furs
fish
chert
tobacco

marine shell

Boston

Aztalan ▲

SAUK

OTTAWA
NEUTRAL

wampum

WINNEBAGO

MASCOUTEN

MESQUAKIE

Lake Erie

IROQUOIS
CONFEDERACY

▲ Lamoka Lake

SOUTHERN NEW ENGLAND
and EASTERN LONG ISLAND
ALGONQUIANS

fish, furs,
tobacco,
chert,
bison
skins,
catlinite

furs

KICKAPOO

MIAMI

GLACIAL KAME
CULTURE

jasper

Sewanauky
(Brooklyn)
New York
City

From Dutch starting
early 1600s: glass
beads, knives,
hatchets

atite

Mississippi River

ILLINOIS

ILLINOIS
HOPEWELL

Fort Ancient ▲

chert
tobacco

▲ Hopewell site

Serpent Mound ▲

SHAWNEE

Ohio River

DELAWARE

Philadelphia ●

wampum

Deerskins,
grain to Europe

From Europeans to Indians,
1600s–1700s: presentation silver,
other metals; c. 1760–1821: trade
silver; introduced c. 1850: German
silver

chert

Indian Knoll ▲

MIDDLE
MISSISSIPPIAN

SUSQUEHANNOCK

steatite
copper

NANTICOKE

VA
ALGONQUIANS

wampum

From English to Indians,
starting early 1600s: glass
beads, woolen stroud
cloth, knives, vermilion,
hatchets, kettles,
hawkbells, thread, liquor

quartz

KCHIUMA

TUTELO

marine shell

YUCHI

CHEROKEE

mica
chlorite
red ocher

NC ALGONQUIANS

VA and NC
IROQUOIS

CHICKASAW

pearls

CATAWBA

TUNICA

SOUTH
APPALACHIAN
MISSISSIPPIAN

pipestone

MUSKOGEE

red ocher

OTO

SSIPPIAN

ALABAMA

Nanih
Waiya

▲ Etowah

pearls

CUSABO

Deerskins, tobacco,
grain to Europe

▲

HOUMA

TOHOME

HITCHITI

YAMASEE

Mission Santa Catalina de Guale ▲
Saint Catherine's Island

CHEZ

Philadelphia ●

▲ Moundville

copper
marble
mica

ment

CHOCTAW

MOBILE

CHATOT

pottery

From Spanish, starting early 1500s:
glass and stone beads, cloth,
combs, ceramics, glassware,
tiles

IMACHA

BILOXI

shells

TIMUCUA

pearls

*Atlantic
Ocean*

whelk,
olivella,
tulip shell

APALACHEE

Crystal
River Site

Deerskins
to Europe

ulf of Mexico

TOCOBAGA

shark teeth
shells
tortoiseshell

AIS

CALUSA

TEKESTA

MIAMA

KEYS ● Key Marco

MICMAC Cultural group
Glass beads Trade goods
pipestone Natural resource
● Town or city
▲ Archaeological site
■ Native community
International or
Euro-American trade
European explorers
Intertribal trade
Cultural boundaries
MISSISSIPPIAN Ancient culture

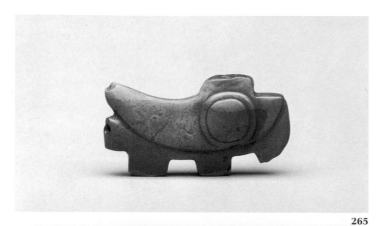

265

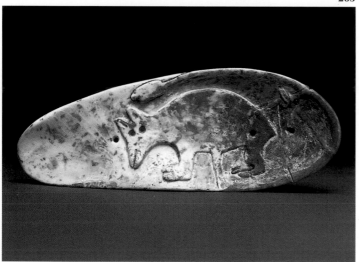

266

267 *Copper beads characteristic of the Glacial Kame phase in Southern Ontario. c. 300 B.C. Length of top bead, ½" (1.27 cm). Rochester Museum and Science Center, New York*

265 *Locust-shaped red jasper bead. Poverty Point–culture carvers used sophisticated techniques to produce tiny stone effigy pendants and beads. Lafayette County, Arkansas. c. 1500–700 B.C. Length, 2¼" (5.7 cm). From the Collection of Gilcrease Museum, Tulsa, 6123.2964*

266 *Marine-shell gorget with an engraved bear or opossum encircled by an elongated umbilical cord. Shamans and animal spirits are still depicted emitting "power lines" from the head, mouth, or navel. Made c. 1000 B.C., by artisans of the Glacial Kame culture, a Great Lakes group who buried their dead in kames—gravel mounds left behind by melting glaciers. Hardin County, Ohio. Length, 7⅝" (19.4 cm). Ohio Historical Society, 5-4 194*

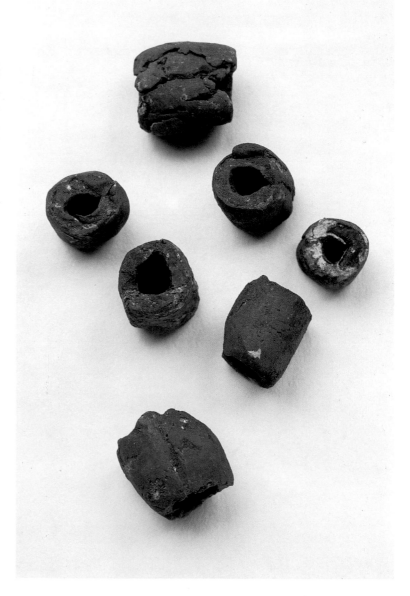

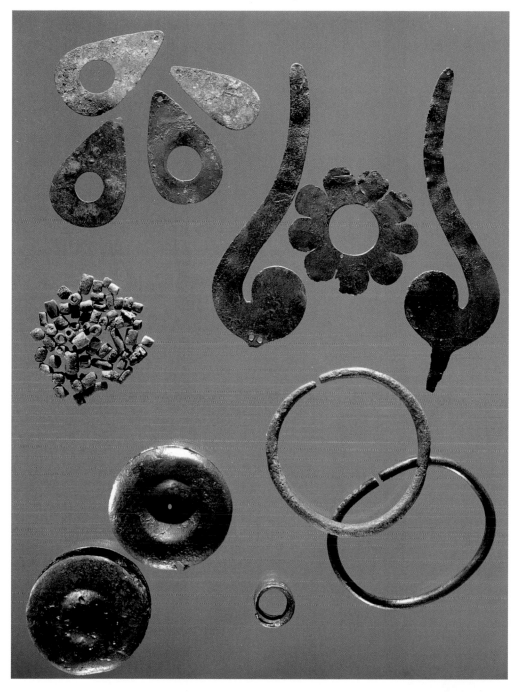

268 *Copper adornment accompanied burials of the Adena (500 B.C.–100 B.C.) and Hopewell (200 B.C.–A.D. 500) cultures. This grouping includes gorgets, earspools, bracelets, pendants, beads, and hairpieces. Recovered near Columbus, Ohio. Peabody Museum of Archaeology and Ethnology, Harvard University, 1580, 39308*

269 *Carved stone pendants and/or plummets from the southeastern reaches of the Hopewell culture, A.D. 1–400, when dual bird motifs—a raptor with curving beak and a broad-billed duck—occur as carvings or adorn pottery. Complementary opposites (the former was associated with the sky; the latter, with the watery underworld), these images never occur on the same artifact, yet together they represent belief in a cohesive universe.* LEFT TO RIGHT: *Shaw's Point, Florida. Amethyst quartz, Crystal River, Florida. Steatite owl, Macon County, North Carolina. Duck beak and birds' heads, Florida. Height of owl, 1⅞" (4.8 cm). National Museum of the American Indian, 23/7994, 7/1093, 5/5481, 24/3652, 4/7338, 4/7339*

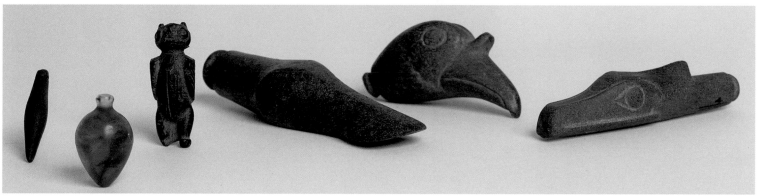

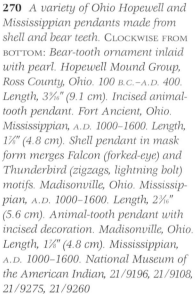

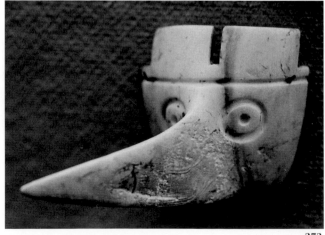

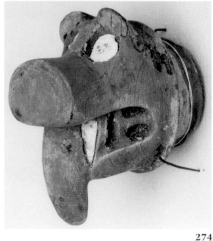

270 *A variety of Ohio Hopewell and Mississippian pendants made from shell and bear teeth.* CLOCKWISE FROM BOTTOM: *Bear-tooth ornament inlaid with pearl. Hopewell Mound Group, Ross County, Ohio. 100 B.C.–A.D. 400. Length, 3⁹⁄₁₆″ (9.1 cm). Incised animal-tooth pendant. Fort Ancient, Ohio. Mississippian, A.D. 1000–1600. Length, 1⅞″ (4.8 cm). Shell pendant in mask form merges Falcon (forked-eye) and Thunderbird (zigzags, lightning bolt) motifs. Madisonville, Ohio. Mississippian, A.D. 1000–1600. Length, 2³⁄₁₆″ (5.6 cm). Animal-tooth pendant with incised decoration. Madisonville, Ohio. Length, 1⅞″ (4.8 cm). Mississippian, A.D. 1000–1600. National Museum of the American Indian, 21/9196, 21/9108, 21/9275, 21/9260*

271 *Shark-tooth beads (left) and shell artifacts (right). Hopewell culture, Lee County, Florida. Average length, ¾″ (2.0 cm). National Museum of the American Indian, 17/1145*

◁**272** *Copper ear ornament recovered in Citrus County, Florida. Copper nuggets from the Upper Great Lakes were traded south where they were hammered into paper-thin sheets, then cut and incised with stone tools. Middle Woodland, Hopewell culture, A.D. 1–400. Diameter, 3½″ (8.9 cm). National Museum of the American Indian, 17/61*

273 *Long-Nose God maskette of marine shell worn as an earring. Similar ornaments (widely distributed c. A.D. 1000–1300) have been excavated from the Mississippian Azatlan site in Wisconsin—contact-period Winnebago territory. Red Horn, the Winnebago mythic hero, was called He Who Wears Human Head Earrings. Collected near Rockport, Illinois. Mississippian. Length, 2″ (5.1 cm). National Museum of the American Indian, 24/3506*

274 *Ear ornament representing a bear's head. Wood with shell inlays and traces of copper. Spiro Mound, Oklahoma. A.D. 1100–1300. Height, 2″ (5.1 cm). National Museum of the American Indian, 21/3861*

273

274

Middle Woodland is that period (200 B.C.–A.D. 500) when Hopewell culture extended throughout eastern North America, uniting peoples with related beliefs and symbols.[12] Hopewell artisans carved stone, wood, shell, and bone and worked with copper and, occasionally, silver and gold.[13] Plain shell gorgets appeared around 1000 B.C.; engraved gorgets were in evidence by the late Hopewell.[14]

Broad trade networks were conduits for both an extraordinary array of exotic materials and cultural exchange. Centers for Hopewell-style finished goods—the Mississippi and Illinois River valleys in Illinois, and the Scioto and Miami valleys in southern Ohio—were supplemented by clusters of activity in Alabama and Florida (see the maps on pages 154–55). Increasingly elaborate ornamentation was interred with the elite (272). A couple, buried together in Hopewell's main mound, wore copper earspools, copper breastplates, necklaces of grizzly-bear teeth, copper-covered wooden and stone buttons, and thousands of freshwater-pearl beads.[15]

Mississippian Regalia

The Mississippian tradition, based on maize horticulture, emerged in the central Mississippi and adjacent valleys shortly before A.D. 1000. Larger settlements may have had held more than ten thousand inhabitants. In Mississippian chiefly societies, ceremonialism was centralized with the building of large flat-topped mounds. Rulers appropriated a disproportionate share of wealth; their power was articulated through the rich materials and symbolism of personal adornment displayed both in life and in death.[16]

Between about 1000 B.C. to A.D. 100, a distinctive Southeastern symbolic system included bird and snake imagery, the forked (falcon) eye, the cross and sun circle, the hand and eye (275, 276). By Mississippian times, duality was pervasive. Mississippian motifs incorporating both sky and underwater creatures were associated with agricultural fertility, warrior societies, and chiefly ancestors (277–81). Sky World's spiritual importance predominated because it housed the sun, of prime importance in Mississippian beliefs.[17]

The Southeastern Ceremonial Complex, a Mississippian iconographic network of shared themes, motifs, and materials, covered most of the East from about A.D. 1150 to 1350. Moundville (Alabama), Etowah (Georgia), and Spiro (Oklahoma) were principal centers. Spiro, located where the forest thins into grasslands, controlled exchange networks from the Plains through the southeast.[18]

Engravings on Mississippian shell gorgets, drinking cups, and copper plates accurately depict the jewelry and regalia of the elite. Beads were numerous and conspicuous in warriors' outfits[19] (see 278). The deceased were adorned with beaded bands at wrists, elbows, knees, and ankles, with gorgets and pendants at the neck and copper plumes behind skulls.[20] The positioning of ornaments at prominent, vulnerable body points indicates their duality as status items and protective amulets. Adornment worn exactly in death as in life remained a constant during the underworld transformation journey.[21]

The decline of the Mississippian cultures, though well under way before the arrival of Europeans in the sixteenth century, was accelerated by European diseases. Mississippian descendants include the Caddo and Wichita, who probably evolved from the Spiro culture.[22] Etowah materials link Mississippian, Natchez, and Creek ceremonial paraphernalia. The central Algonquian tribes—Potawatomi, Sauk, Fox, Kickapoo, Mascouten, Shawnee, Miami, and Illinois—may have archaeological roots in the local cultures of the upper Mississippi Valley. Mississippian influences appear to have survived in Winnebago cosmology.[23] "The mysterious Moundbuilders never really disappeared," writes archaeologist David Hurst Thomas. "They simply became today's Native North Americans."[24]

SACRED VISUAL METAPHORS AND ADORNMENT

The foundation of Woodland artistic traditions derived from ancient concepts of a multilayered universe, belief in the Great Spirit (*manitou/orenda*) and the constant apprehension of duality. As did other Native peoples, Woodland groups incorporated all parts of an animal in hunters' clothing and adornment as invocations to the animal's spirit for strength and protection. Plant life was similarly respected: "the three sisters"—corn, beans, and squash—were both subsistence and spiritual sustainers of life.[25] According to the Mesquakie: "Corn (*tamina*) is a *manitou*, and every little grain is a mortal. . . . All these grains of corn have feelings like you and me, and when they are taken from the cob and wasted they feel sad and begin to weep. When Wisaka created *tamina*, he made it a food for the people. When they eat *tamina*, the *manitou* goes into every part of the body, and that makes the people strong."[26]

At the earliest periods of Euro-American contact, Woodland regions were conjoined by a similar cosmology: the universe divided into the interrelated Sky World, Under (water) World, and This (Earth) World. Sky World harbored the Great Spirit, represented by the sun, beneath which were Thunderbirds (whose flashing eyes caused lightning and flapping wings created thunder, some tribes believed) and raptors, birds of warlike character. In Under World dwelled Horned Panthers (*Misshipeshu*) and Horned Serpents, servants to panthers and themselves potent *manitous.* Thunderbirds and Horned Panthers fought constantly, their antagonism a cosmic competition for human loyalty. Maintaining the balance and restoring harmony was humankind's overriding responsibility[27] (see pages 220–21).

While primarily a warrior symbol, Thunderbird was also revered as a protector, the maker of rain—essential to survival in an agricultural society. Among the Passamaquoddy of northern Maine and the Sauk, Thunderbird was anthropomorphic, dressed in a man's elegant fringed leather leggings.[28]

The sun controlled the seasonal cycles of hunting and farming and was believed to influence warriors' power.[29] Light signified wisdom. The Mesquakie word *Wa Wa Se So Ki* translates as "to shine out" and connotes "the splendid appearance of a person beautifully adorned in ceremonial dress and . . . inner radiance associated with spiritual knowledge and power." Thus, beautifully made bright objects were "visual metaphors for recognized spirituality."[30] Life-energy centers in the sun were symbolized by a circle or series of concentric circles with projecting rays. From ancient times, the distinguishing ornament of a prestigious male was the shell gorget, a large gleaming circular disk analogous to the sun. Shell and early-contact silver gorgets frequently displayed sun imagery (261, 262).

Great Lakes and Iroquois tribes construed This World—home to human beings, most animal, and all plant life—as an island carried on the back of a huge turtle (345). A central vertical axis—the great World Tree—united upper and lower realms, its branches extending through Sky World and its roots anchored in Under World. Called Ever-growing Tree, it symbolized the Iroquois Confederacy, which consisted of the Cayuga, Mohawk, Oneida, Onondaga, Seneca, and, later, Tuscarora tribes (344). Southeastern groups believed the earth-island was suspended from Sky World by four cords attached to the four cardinal points.[31] Sacred cardinal-direction imagery illustrated these universal concepts for all groups (262).

The layered universe was filled with paired opposites signifying cosmological unity. This concept was reflected in village layouts, tribal moieties, iconography, and adornment. Physical attributes of dissimilar creatures combined in Horned Serpent and falcon-man (278). Woodland artisans' tendency toward bilateral asymmetry signified an attempt to create balance by uniting opposing realms[32] (424).

Accordingly we set out and took possession of the land assigned to us, and as was the custom of our Forefathers we immediately set about making a Belt [263]. . . by which our Children would see that the land was to be theirs forever, and as was customary with our ancestors, we placed the figure of a dog at each end of the Belt to guard our property and to give notice when an enemy approached.

—Agneetha, Mohawk speaker at Kanesatake, addressing Sir John Johnson, Superintendent General of Indian Affairs, February 8, 1788

275 *Copper serpent-head effigy ornament symbolizing inhabitants of Under World. Many contact-period Indians believed the dead traveled through the Under World, where they had to avoid or vanquish monsters. Hopewell, Ohio. 200 B.C.–A.D. 400. Length, 20" (50.8 cm). The Field Museum, 56165*

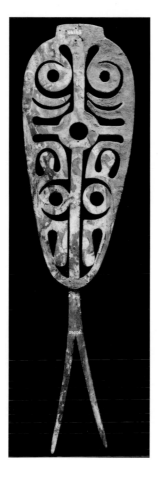

276 *A prestigious Hopewell man's adornment: ear ornaments, pendants, freshwater-pearl necklace, and a copper antler headdress. Antlers and horns frequently represented Horned Serpents rather than mammals in historic Native ceremonies. Hopewell, Ohio. c. 100 B.C.–A.D. 400. The Field Museum*

277 *Marine-shell earplugs and an engraved coiled rattlesnake gorget. The huge eye (concentric circles with a dot) peers at a mouth opened to reveal two rows of teeth. Plumes or antlers extend from the head. Crosshatching and concentric circles shape the coiled body; chevrons denote rattles. By this period (late Mississippian, A.D. 1450–1700), these gorgets were worn by the young and denoted age rather than status (see 372). Gorget width, 6⅜" (16.2 cm). Denver Art Museum, 1987.112, 1957.194AB*

276

277

278 A conch-shell drinking cup displays falcon-man imagery, indicative of military prowess. The speedy and combative peregrine falcon was a predominant Mississippian adornment motif. Falcon-men (or falcon-spirits) were probably guardians of prominent Mississippian warriors. The stepped platform motif above the head is associated with the elite and Sky World. Serpent symbolism (barred ovals and hatch marks) on the wings relates to Under World. Excavated costume details, and the prolific use of shell-bead jewelry, confirm that Mississippian regalia mirrored falcon-man etchings. Spiro engraved shell cups were recycled as gorgets and beads. Spiro Mound, Oklahoma. A.D. 1200–1600. Length, 13" (33.0 cm). National Museum of the American Indian, 18/9121

279 A Mississippian red-slate pendant is engraved with hand-and-eye and cross-within-a-circle, typical sun motifs. The pendant's form and hand-eye theme symbolized the burial ritual of dividing the body into differently treated parts. Oblong gorgets (usually a scalloped circle with tear-shaped protuberance) suggest a round frame to which a scalp with flowing hair is attached. Moundville, Alabama. A.D. 1200–1500. Length, 3⅞" (9.8 cm). Alabama Museum of Natural History, SWM-78

280 This elegant mica pendant, representing the preserved hand of a revered ancestor, accompanied a Hopewell burial. For the Hopewell, translucent mica was spiritually potent, while ancestral relics were sacred (279). Combining the two concepts in one object underscores the power of the individual who took it into the afterlife. Length, 11½" (29.2 cm). Ohio Historical Society, Columbus

278

◁**281** Engraved marine-shell pendant depicting hands joined by a beaded bracelet. Each palm reveals the cross-within-a-circle motif, traditionally associated with the cardinal directions and the rising and setting sun at summer and winter solstice. Spiro, Oklahoma. A.D. 1200–1350. Height, 3⁵⁄₁₆" (8.4 cm). From the Collection of Gilcrease Museum, Tulsa, 9025.451

Rituals, Ceremony, and Regalia

All Woodland groups maintained calendars of elaborate nature-based thanksgiving ceremonies. Richly detailed interpretations of the universe (many with ancient origins) were expressed in the regalia of complex communal rituals. The Narragansett hosted an elaborate ritual akin to the Northwest Coast potlatch; the larger the person's contribution, the greater the admiration he or she enjoyed.[33]

Celestial birds and underwater monsters were representations of ultimate powers, those at the greatest distance from human experience. However, other spirit helpers appeared in individual dreams or vision quests. Numerous ordinary animals adorned Woodland garments, indicating a more personalized spirituality than the cosmological imagery reserved for the elite (354). Protective guardian-spirit images, incorporated onto clothing and ornament, validated dreams and preserved their power.[34]

Female seclusion rites of the eastern Woodlands did not incorporate the elaborate finery of the western Subarctic (206). However, in accord with hidden vision concepts, face-concealing headdresses were worn by newly marriageable Delaware girls for two months following seclusion.[35]

Mortuary ritual was important from ancient times through European contact, when people were still interred in fine clothing and ornaments—trade silver, glass beads, and wampum—objects whose "souls" accompanied the human soul in its difficult journey to the afterworld.[36] Reversing Western tradition, the dying did not bequeath property to the living; the living bestowed material property on the dead.[37] At the northern Great Lakes Algonquian Feast of the Dead (a reburial ceremony following temporary interment), both guests and deceased were gifted. Hosts might devote an entire year to amassing grave goods.

Sacred Materials and Colors

Crystal, mica, shell, and copper had sacred meaning in ancient Woodland cultures. Mississippian copper and marine-shell objects containing elaborate religious iconography also signaled status. These materials, particularly desirable far from their source, were traded throughout the Woodlands late into the sixteenth century until the varied times of Euro-American contact, and in the case of shell wampum, throughout the nineteenth century.[38]

Most tribes identified each quadrant of This World by color. For the Cherokee, east (the direction of the sun) was red, which, as the color of sacred fire and blood, signaled life. The west (the moon segment) provided no warmth: its color was black. North was the direction of cold: its color, blue, signified trouble and defeat. South connoted warmth: its white hue meant peace and happiness.[39]

Red and black were important colors in southeastern mortuary rituals. Archaic graves and Mississippian shell artifacts were frequently marked with red ocher.[40] For his death ceremonial in 1725, the face of the Natchez's great war chief Tattooed Serpent was painted red. The master of ceremony's torso was also red; he carried a red baton with black feathers and wore a red-feather head ornament and skirt of red and black feathers.[41] Eighteenth-century Creek hunters outlined their eyes with red ocher, drawing forked-eye designs evoking falcons to enhance their hunting prowess.[42] Red and black were the Iroquois' predominant mask and body-painting colors.

Shamanic Regalia and Masking

An important motif on Woodland shamanic artifacts was the balanced composition of upper and lower worlds (422). This imagery suggested the shaman's supernatural ability to navigate both worlds and identified him with the spiritual powers for preserving

cosmic harmony.[43] Midewiwin shaman/priests wore particularly beautiful regalia.

A wolf palate from a Late Adena burial (c. 100 B.C.), trimmed to fit inside a man's mouth, may have been a shaman's mask.[44] During the Mississippian era, large numbers of "weeping eye" whelk-shell masks were recovered. Wooden deer masks were found at the Mississippian ceremonial centers of Key Marco, in Florida, and Spiro in Oklahoma.[45] Today, tribes with important masking traditions are the Delaware, Shawnee, Cherokee, Catawba, and particularly the Iroquois, where masks remain central to the False Face Society, a sacred society concerned with the preservation of health. Members of the False Face Society, wearing carved wooden masks depicting beings seen in the forests and in dreams, perform private curing rituals and are believed to have special healing powers.

Body Decoration

Tattooing and body paint were ubiquitous throughout the Woodlands, where the body was substantially exposed during much of the year. Native peoples considered a person adorned with body paint, tattooing, and hair adornment to be richly dressed. Moreover, these physical "transformations" had supernatural implications, since body decoration not only stated identity but also pleased human and spirit communities. Hair, dressed in varied styles, was enhanced with down, feathers, ocher, shell, silver, and beaded streamers to emphasize the head's importance (416, 447). Down symbolized upperworld protection; a warrior's crown feathers signified that Thunderbird had favored him with aggressive powers.[46] Both sexes rubbed their hair with animal grease and red pigment to make it shiny and stiff.

Warrior headdresses, believed to contain spirit guardians, served as powerful amulets. An age-old style called the roach, constructed of red-dyed deer hair, hair from the tail of a porcupine, and black turkey beard, was most common. Warriors plucked, singed, or (later) shaved the head except for a long scalp lock at the crown. When attached to the braided scalp lock at the center of the head, the roach resembled the imposing crest of a large, enraged woodpecker, a traditional warrior symbol. These dramatic headdresses, altered in form and material, are still worn for powwows and other ceremonial purposes.[47] (See also page 560.)

ACCULTURATION AND ADORNMENT

Some Native Americans welcomed trade goods as "magical substances" and made choices in keeping with indigenous aesthetic traditions. Glass and silver extended beliefs in crystal and shell. Cloth in the familiar vegetable-dyed colors—blue, black, and red—as well as the dark shades produced by smoking and dyeing hides were preferred (246). Artisans adeptly transferred skills in painting and moose-hair and quillwork to beadwork (313). Furthermore, they found ornamental uses for European utilitarian objects, turning mirrors and brass kettles into adornment (51).

From the late eighteenth through the early nineteenth century, removals, exposure to non-Natives, and fusions with other groups created diverse communities with blended artistic traditions. By the mid-nineteeenth century, ceremonial regalia was an elaborate assemblage of body decoration, adornment, and clothing. Due perhaps to the bountiful surroundings, "more is better" was axiomatic to this predominant form of artistry. Additive concepts were achieved by varying technique and layering materials and patterns. Incorporating spiritually significant materials such as shell, copper, silver, and glass enhanced the splendor.[48] The predominance of floral and plant motifs in Woodland art attests to the bountifulness of the region's vegetation. Men hunted

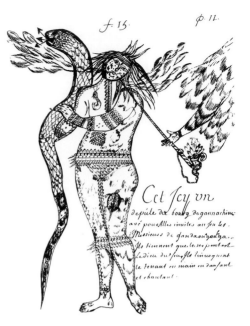

282 *A drawing of an Iroquois man (c. 1680) portrays typical Woodland body adornment. Geometrics, double curves, clan crests, and personal spirit helpers such as a turtle and snake were painted or tattooed. From the* Codex Canadensis *by Louis Nicolas. Collection Thomas Fisher Rare Book Library, University of Toronto*

283 *Iroquois necklace of acorns strung on leather. Seeds and berries were Native America's original beads. n.d. Length, 33" (83.8 cm). American Museum of Natural History, 50.1/1675*

while women gathered, sowed, weeded, harvested, and processed foodstuffs. Since women were the traditional beadworkers, their emphasis on floral and plant imagery is not surprising. In addition, Midewiwin dress reflected the priests' reliance on plant life in the healing process. Their powers reflected "knowledge of plant and self, but also the capacity to conjoin and make one the curative elements of both plant being and human being."[49]

This process of acculturation can be illustrated through the evolution of carrying pouches. Pouches, used for tobacco, personal medicine, and containers, were depicted on Mississippian engraved gorgets (360). The earliest, constructed of whole animal skins, were folded over belts or suspended from the neck on netted vegetable thongs. With exposure to European bags and trade cloth, the style lost favor. However, the "octopus" bag has tabs—vestiges of an animal's legs—while the opening represents the mouth[50] (36, 321). The use of whole animal skins survives among the Midewiwin, who still carry beaded pouches of otter pelts (437).

Shoulder bags, modeled on European military bandolier bags, appeared in the Northeast and Southeast during the eighteenth century and in the Great Lakes region by the second quarter of the nineteenth century. Although the bags' forms were new to Native peoples, their decorative designs continued long-established iconographic traditions. Dream imagery was woven, quilled, or beaded onto pouches, with Thunderbird, Underwater Panther, and Horned Serpent the most frequently depicted spirit guardians (see pages 220–23).

Ancient Southeastern petroglyphs and pottery motifs were transferred into beadwork. In the Northeast and Great Lakes, a similar repertoire of designs appears in pouch ornamentation and tattooing. Both were portable art, carried on the body during travel and hunting.[51] Whereas early bags were practical containers, later, colorfully beaded bags were gifts or prestige items in dress clothing.

REGIONAL DIVERSITY IN WOODLAND ORNAMENT

Northeastern Woodlands

The early-contact northeastern tribes—Micmac, Abenaki, Penobscot, Wampanoag, Mohegan, Delaware (Lenni-Lenape), Powhatan, Shawnee, and Iroquois—were especially noted for their elaborate face painting and tattooing (282). Clothing and accessories were embellished with a variety of beads and ornaments of bone, teeth, claws, seeds, shells, stone, and copper (303). Leather and furs were painted with mineral pigments. Tannic acid, used to stain Iroquois and Huron clothing skins black or dark brown, preserved the leather and created a backdrop for vegetable-dyed porcupine-quill and moose-hair embroidery (311, 312). Men and women wore skin leggings, moccasins, and robes; women also wore wrapped skirts and dresses of leather. Children's clothing mirrored that of adults; babies were encircled in the softest furs or birdskins.[52] Iroquois and Delaware walked in twined cornhusk slippers during summer.[53]

Delaware clothing and ornamentation is representative of many northeastern groups. Untailored deerskins were draped around the shoulders. In cold weather, bear-, raccoon-, and beaver-skin garments were worn fur side in (fur side out in warmer weather). Turkey-feather cloaks were tied into a hemp backing. Copper ornaments and long tassels of red-dyed hair hung from the neck, as did pouches of whole animal skins. Porcupine quills might pierce the nose. Men wore headbands of snakeskin, feathers or feather crowns (large feathers erect in a circle), and roaches of dyed deer hair (1172). Warriors wore a long scalp lock at the crown; otherwise, the hair hung loose, was braided, or tied with wampum.

COMBS

Native Americans believe hair possesses supernatural power. Combs for grooming animal skins have been recovered from archaeological sites. Combs for human hair are an ancient Northeastern Woodlands art form, dating to c. 2000 B.C. Iroquois comb imagery expressed spiritual, totemic, and historic themes: indeed, hair combing, a universal symbol for "ordering and tidying the mind," has mythic significance for the founding of the Iroquois confederacy. "Tadodaho, the leader of the Onondaga Iroquois, was a great sorcerer who is depicted with snakes of discord, instead of hair, on his head. He refused to join in the League of the Iroquois until the culture heroes, Deganawida and Hiawatha, combed the snakes from his hair, symbolically taming him and winning his support."

Carved with flint in Archaic times, combs became greatly elaborated after the arrival of European metal tools (289). The finest were made by the Seneca. On typical Iroquois combs, bilaterally symmetrical pairs of animals, birds, or humans articulate ideals of balance and reciprocity that were fundamental to Woodland cosmology. Animal figures may have also signified clan. The comb's cultural significance gradually diminished. By 1770, the Seneca carried European-made pocket combs of cow horn.

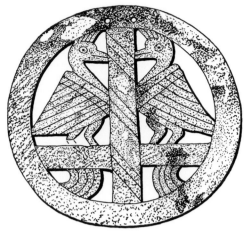

284 *A shell gorget from Etowah, a Mississippian site, with two facing woodpeckers representing messengers from the spirit world. The birds sit on the cosmic tree branch, simultaneously depicting the four sacred directions. Wavy lines at the bottom suggest water. Paired bird motifs on Mississippian artifacts are only found east of the Mississippi River. Etowah, Georgia. 1500. Diameter, 3½" (8.9 cm). Robert S. Peabody Museum of Archaeology*

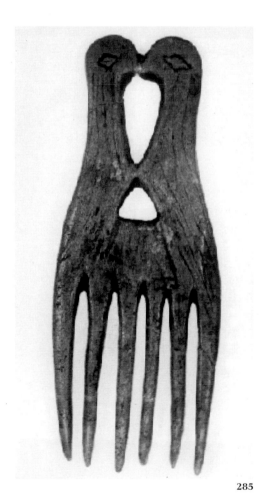

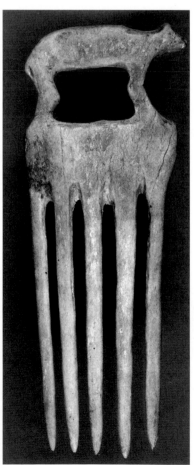

285

286

285 *Archaic bird-effigy antler comb. Facing animals, an ancient motif, continued into contact. Five or six teeth typify the earliest combs. c. 1900 B.C. Length, 3½" (8.9 cm). Rochester Museum and Science Center, New York*

286 *Bear-effigy antler comb. Many Iroquois combs portray the bear, a clan animal and powerful ceremonial figure. Seneca. c. 1570–85. Length, 5⅞" (14.9 cm). Rochester Museum and Science Center, New York*

288

289

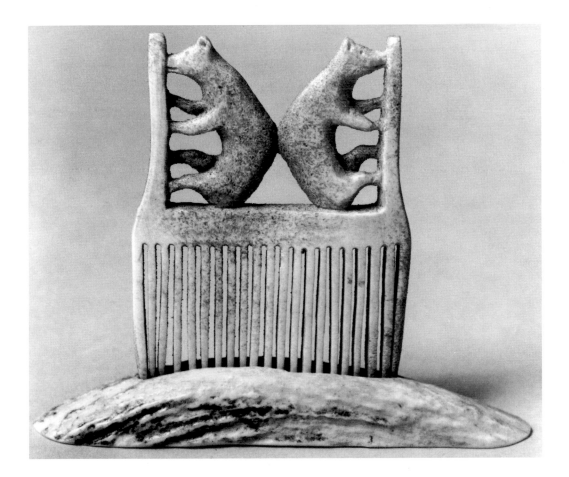

287 *Heron-effigy antler comb. Seneca. c. 1640–60. Length, 4¼" (10.3 cm). Rochester Museum and Science Center, New York*

288 *Antler comb with Sojiosko, the Seneca Iroquois trickster, grasping two geese. Sojiosko promised a flock of geese he would teach them to sing like birds in order to lure them into becoming his dinner. Seneca. 1670–87. Length, 4¹⁵⁄₁₆" (12.5 cm). Rochester Museum and Science Center, New York*

289 *A Seneca wolf-effigy antler comb. By this time, combs had become quite detailed and contained up to thirty-five teeth. 1670–87. Length 4½" (11.4 cm). Rochester Museum and Science Center, New York*

290 *Bear comb of moose antler by Mohawk carver Stanley Hill. Hill made his living constructing buildings and bridges until age fifty-five, when he began a second career as a carver. Inspired by Iroquoian tradition, Hill's innovative work is a direct link to his ancestral past. 1983. Height, 3⅛" (7.9 cm). Natural History Museum of Los Angeles County*

IROQUOIS MASKETTES

askettes, miniature human-face effigies, have been carved by the Iroquois for more than a thousand years. Perforations suggest they were worn as protective amulets. These maskettes are Seneca in origin, with the majority made in the seventeenth and eighteenth centuries. Numerous maskettes are catlinite, a red stone from the upper Great Lakes region. The catlinite maskette (bottom row, left) may depict a cloth head wrap. The earliest (top row, left) dates from c. A.D. 700. Its

features closely mirror those of the Iroquois False Face masks, which had their own protective guardians—maskettes attached at the forehead or chin.

Maskettes played a role in the interpretation of dreams. Extremely important to the Iroquois, dreams revealed desires that, if unfulfilled, caused psychological and physical illness. The person who divined the message would then carve a maskette—a medicine charm to relieve the dreamer from further troubled slumber.

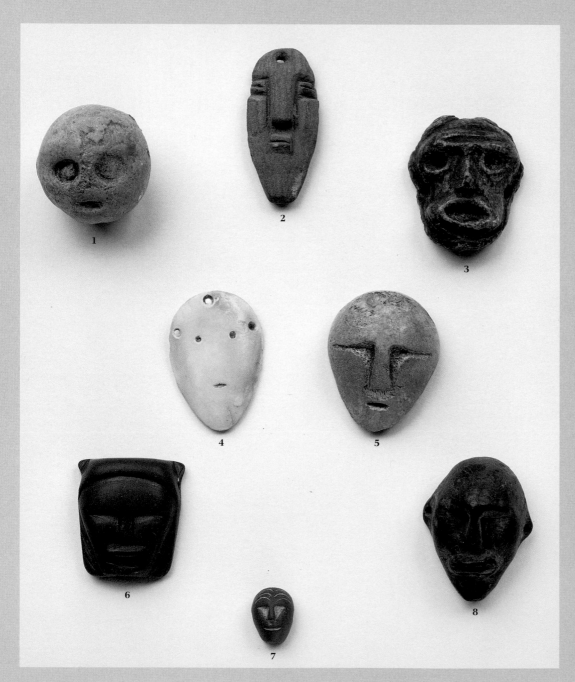

291 *A collection of maskettes, all Seneca (Iroquois), except as noted: 1. Point Peninsula tradition. c. A.D. 700. Stone. 2. Precontact Iroquois. c. 1400. Stone. 3. c. 1580–95. Bone. 4. c. 1625–45. Shell. 5. c. 1625–45. Bone. 6. c. 1688–1710. Catlinite. 7. c. 1775–1820. Catlinite. 8. c. 1745–79. Wood. Length of 2, 1⁹⁄₁₆" (4.0 cm). Rochester Museum and Science Center, New York*

292 *Seneca whelk-shell adornment artifacts.* COUNTERCLOCKWISE FROM TOP: *Earspool. c.1640–60. Bird pendant. c. 1688–1710. Birdman pendant. c. 1670–87. Turtle pendant. c. 1670–1710. Runtees. 1655–75. Width of bird pendant, 5⅛" (13.0 cm). Rochester Museum and Science Center, New York*

293 *Early examples of Seneca wampum.* LEFT: *Protowampum and glass beads. 1560–75. Typical bead: ⅕" (0.5 cm).* MIDDLE: *Quahog shell was used for purple beads, whelk shell for white beads. The scarcer purple wampum was considered twice as valuable. Both, c. 1655–75.* RIGHT: *Council wampum. 1800s. Purple and white shell and glass beads. Length, 9½" (24.1 cm). Rochester Museum and Science Center, New York*

Women braided their hair or tied it into a knot, which they covered with a square, wampum-decorated pouch. After contact, untailored deerskin upper garments were exchanged for duffel blankets. The Delaware's pivotal role in early wampum manufacture was apparent in skin clothing ornamented with wampum beads, tassels, and fringes. Wampum was worked into necklaces, bracelets, patterned headbands, waistbands, and crossbelts.[54]

Among the first to encounter the fur trade, the northeastern tribes were also among the earliest to confront its decline and the resulting loss of their subsistence base. By the mid-1800s, the fur trade had depleted animal populations, reducing traditional sources of food and clothing. By the late eighteenth century, the Huron of Lorette, Quebec, unable to survive on hunting or farming, began to craft items for sale. With great resourcefulness, they embroidered exquisite moose-hair florals onto moccasins (311), sashes, caps, mittens, and bags, which they successfully sold and bartered for European goods.[55] Other groups produced porcupine quillwork and glass beadwork. Nineteenth-century international exhibitions featured Indian work, and dealers sold pieces on consignment in both Europe and non-Native North America.[56] Abenaki and Iroquois moccasins, bags, and caps, ornamented with embossed multicolored floral beadwork (240.18), found buyers at Niagara Falls, an important retail outlet.

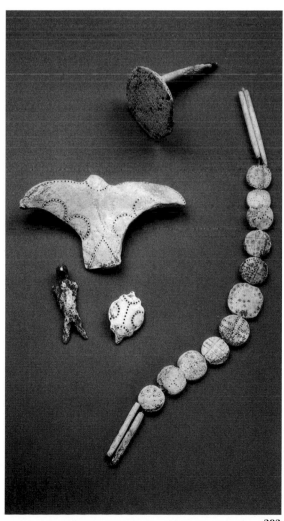

292

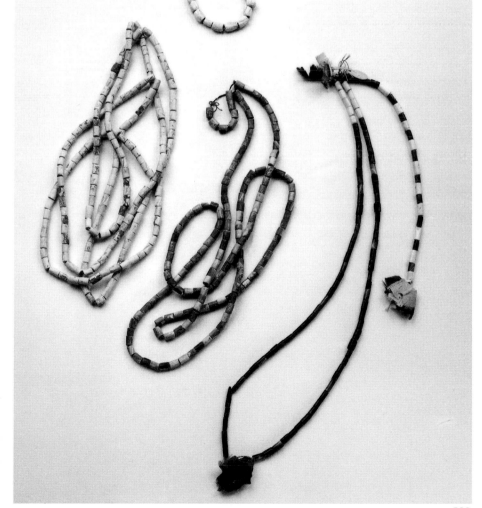

293

WAMPUM

Among the most important items of North American Indian lifeways was wampum—small, cylindrical, centrally drilled purple and white shell beads. Considered a sacred material in precontact Native life, the beads' continuing value was undoubtedly connected to belief in the sacredness of shell.

Size, species, and shape define true wampum. Averaging a quarter of an inch in length and an eighth of an inch in diameter, the white beads were made from the inner whorl (columella) of the whelk, *Busycon canaliculatum* and *B. carica*, while the purple (also called black) beads came from the dark spot or "eye" on the Atlantic Ocean clam shell, the quahog, *Mercenaria mercenaria*. True wampum is tubular in shape.

Shell beads excavated from western New York archaeological sites indicate that the first small tubular white beads meeting the criteria for wampum date prior to A.D. 1510. There is also support for precontact existence of a northeastern inland-coastal marine-shell exchange network. Oral tradition relates that the establishment of peace among the Iroquois League's original five tribes—the Seneca, Onondaga, Mohawk, Cayuga, Oneida—and, later, the Tuscarora—was marked by the exchange of wampum.

In the sixteenth century, wampum was woven into small bracelet-sized strips and, by the early seventeenth century, into larger widths or small belts. A wampum-for-furs exchange system linked Native America to the world economy as traders realized how precious it was to indigenous peoples. Dutch, English, and French middlemen were well aware of the Indians' practice of bartering profitable raw materials and resources for what the Europeans regarded as cheap shell beads.

Wampum was most meaningful to Native Americans in the form of commemoration belts. Because North American Indians recorded information in pictorial rather than written languages, woven wampum became a device for documenting important events regarding peace, war, or other intentions between tribes or between tribes and colonists. Belts were manufactured with background beads of one color and symbolic motifs in a second contrasting color. Patterns were a constant

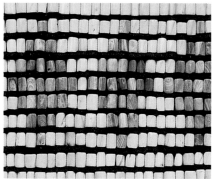
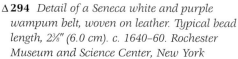
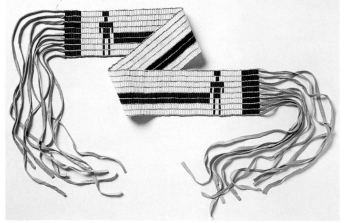
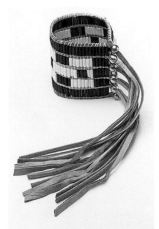

△ **294** *Detail of a Seneca white and purple wampum belt, woven on leather. Typical bead length, 2⅜" (6.0 cm). c. 1640–60. Rochester Museum and Science Center, New York*

295 *A contemporary glass bead and leather belt inspired by historic wampum examples. The colors represent lightning patterns. Artists Linda and Roger Sheehan (Blackfoot-Métis) are committed to researching authentic techniques and traditional patterns. 1993. Width, 3" (7.6 cm). Private collection*

296 *This bracelet of glass wampum-type beads is strung on leather and finished with brass beads. Judy Chrisjohn (Oneida). 1995. Width, 2¼" (5.7 cm). Private collection*

295

296

reminder of the message. White typically represented peace, promise, and good intent, whereas purple (also called black) conveyed hostility, sadness, and death and was especially coveted for political purposes. Although no Indian culture developed universally recognized hieroglyphics, a few images "spoke" across and beyond regions: the hatchet design signified war; figures of people holding hands meant peace, friendship, or alliance. The width and length of the work corresponded to an event's significance.

Millions of wampum beads flowed into the northeastern interior by the mid-seventeenth century. Shell was gathered, processed, and carefully finished primarily by Algonquian bead makers along the coast of southern New England and New York. The Iroquois eventually dominated wampum trade among Native groups.

Wampum was used as currency throughout the thirteen colonies, reaching Wisconson territory by 1715 and the mouth of the Mississippi by 1762. Lewis and Clark gave it to the Sioux and Arikara on the Missouri River. Colonists employed it in transactions with the Indians and among themselves, becoming involved in production when the demand for the bead exceeded the East Coast Indians' capacity to provide it. The Dutch set up wampum workshops; in 1648 the rate of exchange was twenty-four inches of white or twelve inches of purple beads for one beaver pelt. The Algonquian called the

region (modern-day Brooklyn, New York) Sewanauky, "the place of wampum." Dutch colonists established the first Euro-American school in Sewanauky, where Schoolmaster Debevoise earned ten dollars a year, paid in wampum. A wampum factory established in the mid-eighteenth century by John Campbell of Passaic, New Jersey, was operated by his descendants into the 1900s. Euro-American-produced wampun was apparently considered true wampum by the Native peoples.

Following her puberty seclusion, a Delaware girl indicated her marriageability by decking herself out with wampum. A suitor approached the girl or her parents with a gift of wampum after the marriage had been arranged. Algonquians placed wampum along with food and utensils in graves. The Iroquois still use wampum strings and belts in traditional longhouse ceremonies.

Wampum belts were sometimes acquired by museums and collectors under questionable circumstances. In acknowledgment of their great spiritual importance, they are now being reclaimed by the Iroquois. A poignant transaction occurred in 1988, when trustees of the National Museum of the American Indian returned eleven belts to Iroquois chiefs at the Onondaga Longhouse, Six Nations Reserve, in New York State. The sacred belts, dating to the late eighteenth century, had been separated from Six Nations for almost one hundred years.

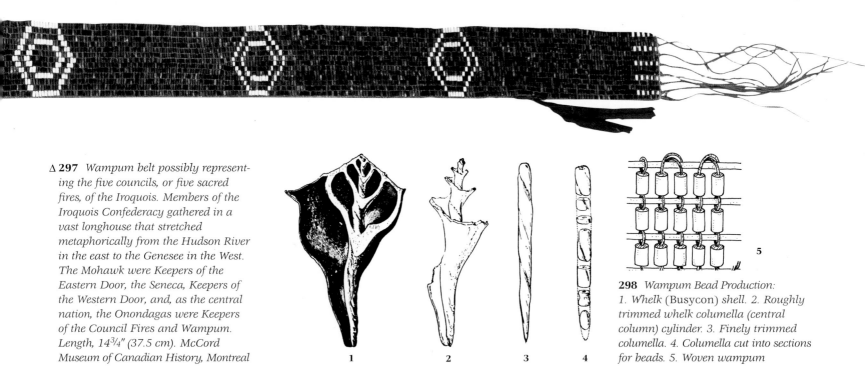

△ **297** *Wampum belt possibly representing the five councils, or five sacred fires, of the Iroquois. Members of the Iroquois Confederacy gathered in a vast longhouse that stretched metaphorically from the Hudson River in the east to the Genesee in the West. The Mohawk were Keepers of the Eastern Door, the Seneca, Keepers of the Western Door, and, as the central nation, the Onondagas were Keepers of the Council Fires and Wampum. Length, 14³/4" (37.5 cm). McCord Museum of Canadian History, Montreal*

1 **2** **3** **4**

5

298 *Wampum Bead Production: 1. Whelk (Busycon) shell. 2. Roughly trimmed whelk columella (central column) cylinder. 3. Finely trimmed columella. 4. Columella cut into sections for beads. 5. Woven wampum*

EASTERN NATIVE AMERICAN TRADE BEADS

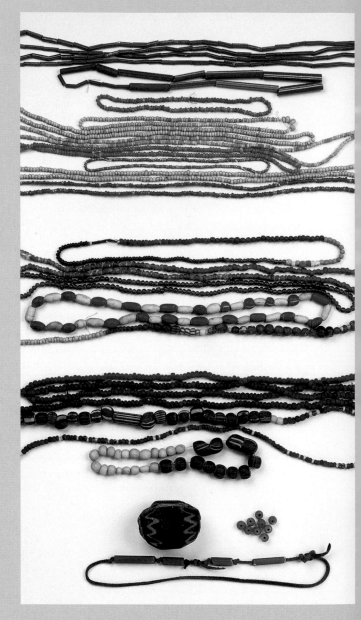

Among the many European products exchanged for goods or given as gifts to Native North Americans were glass beads. An exotic, foreign material, glass—like crystal, shell, and even berries and seeds—was perceived by Woodland groups as a supernatural substance, and they readily incorporated the new material with their existing bead materials. The early names given by Woodland Indians to some glass beads, such as seed and gooseberry beads, may reflect these sacred associations.

Initially, beads were offered mainly as presents and, to a lesser extent, used in religious conversions. As elsewhere in the world, once a market was established, traders found that Native Americans would not accept just any beads offered but had preferences as to color, shape, and material—with ideals of beauty or usefulness varying from place to place.

The first explorers, eager to trade for gold and other precious materials, often arrived with the finest beads they could acquire. This included amber, crystal, jet, coral, and intricate glass beads, as witnessed by beads and rosaries recovered from early-contact sites. The most sophisticated products of the Venetian glass industry—faceted chevron beads, Nueva Cádiz straight or twisted cane beads, and even the occasional millefiori bead, were found. Other, more obscure decorated beads made their appearance but experienced a short-lived popularity before disappearing into the historic record. When merchants realized that Native peoples did not immediately distinguish between glass and stone, the stone or lapidary-worked materials became secondary to glass and, in many instances, were superseded by it.

Native bead-making methods were extremely labor intensive. Obtaining material and shaping, polishing, and drilling each bead by hand made bead manufacture difficult and time consuming. The availability of large quantities of colorful, uniform glass beads eliminated these arduous tasks. Since indigenous beads were produced one at a time and were, therefore, rare and valuable, it is easy to appreciate how Native Americans might initially overvalue whole strands of ready-made, uniform, jewellike glass beads.

Indians liked small glass beads because they were able to assimilate them into their existing artistic traditions, which frequently emphasized decorating surfaces with porcupine quillwork and shell beads. Thus it is not surprising that beads recovered from the early contact period in North America are predominantly small and of uniform size, shape, and color, and might easily have been used in beadwork. Smaller quantities of "fancy" and necklace beads may be due to their relative cost as well as personal taste and intended function.

Although trade or exchange of glass beads between Europeans and Native Americans began with Columbus in Hispaniola in 1492, it was many years before beads were imported in large quantities. Eventually, glass beads arrived in great numbers in the Southeast, where trade was controlled by Spain, and around the Great Lakes, a territory dominated by French, English, and Dutch explorers and merchants. Early bead assemblages from both regions indicate similar sources, probably Venice and Holland, and occasionally other European industries.

299 *1580–1660*

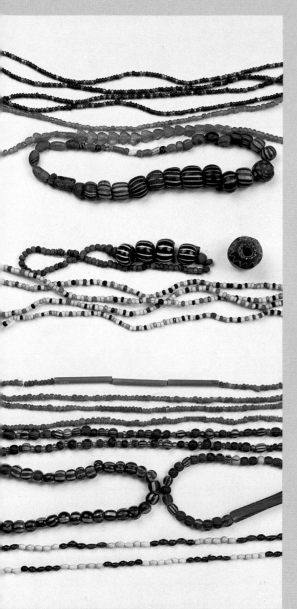

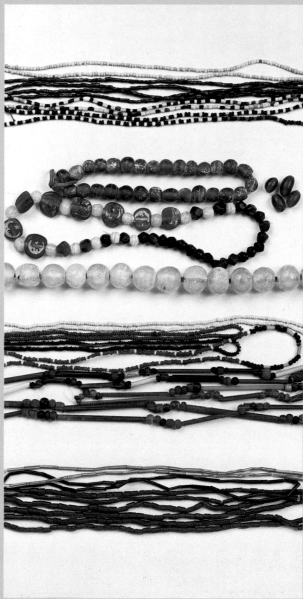

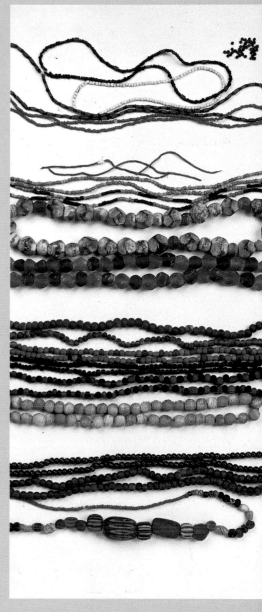

300 *1605–60*

301 *1655–1779*

302 *1655–1820*

SENECA (IROQUOIS) GLASS TRADE BEADS

The Rochester Museum and Science Center, New York, is a repository for trade beads collected at Iroquoian sites around Lake Seneca, dating from 1580 to 1820. Beads from the museum's collection are representative of the majority of trade beads found in the New World during these periods. Recovered beads clearly demonstrate that a wide variety were available to Native consumers—from tiny, plain seed beads to impressively large and colorful chevron beads. A reasonably broad color palate was also accessible, although blue and red beads seem to have been the most desired.

The majority of glass beads from the early-contact period (c. 1500–1700) are primarily of drawn manufacture —a process typical of Venice and other European glass industries of the time. From around 1700 and later, beads of mandrel-wound construction appeared along with drawn beads. The beads shown on these two pages are from the museum's collection. The earliest dated beads are shown at the bottom of each photograph; the latest are at the top. For a fuller explanation of dating and manufacturing techniques, please refer to the notes at the back of the book.

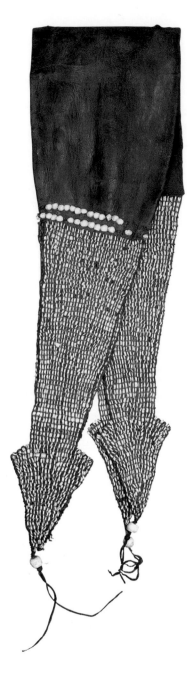

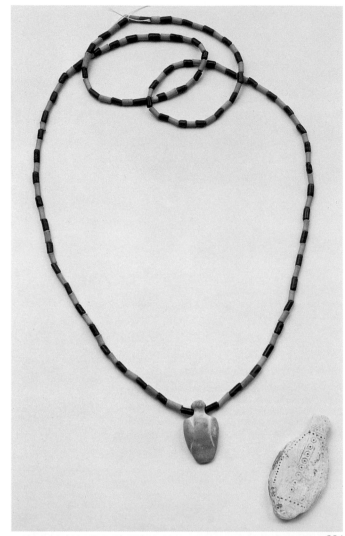

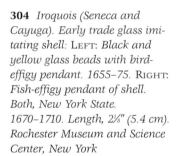

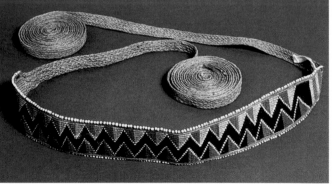

◁**303** *Tanned buckskin purse embroidered with* Marginella nivosa *shells. The Native tendency to adorn surfaces with a repetitive unit such as shells was a precedent for embroidered glass beadwork. Roanoke, Virginia. Powatan. c. 1656. Length, 30⅓" (77.0 cm). Ashmolean Museum, Oxford, 1685 B370*

304 *Iroquois (Seneca and Cayuga). Early trade glass imitating shell:* LEFT: *Black and yellow glass beads with bird-effigy pendant. 1655–75.* RIGHT: *Fish-effigy pendant of shell. Both, New York State. 1670–1710. Length, 2⅛" (5.4 cm). Rochester Museum and Science Center, New York*

305 *Iroquois burden (carrying) strap, a historic representation of an ancient tradition. Before 1775. Hemp, moose hair, and white glass beads. Length, 16' 3" (5.0 m). Width, 2" (5.1 cm). Canadian Museum of Civilization*

306 *Garter of simulated wampum glass beads, wool yarn, quill-wrapped ties. Possibly Iroquoian. Pre-1771. Length, 12¼" (31.1 cm). British Museum*

304

305

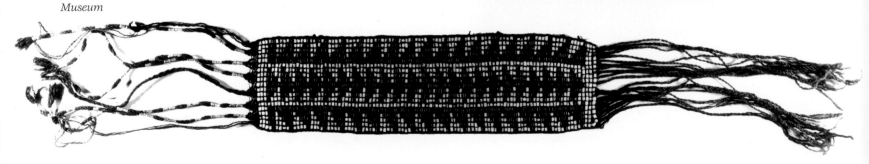

307 *Wool (stroud) sash, embroidered with white glass beads, that belonged to Metacom—called King Philip by the English—sachem of the southeastern Massachusetts Wampanoag. Metacom's father was Massasoit, who, in 1621, signed a treaty of peace with the pilgrims. Throughout the century, however, land disputes and numerous affronts drove the New England Indians to rebellion, culminating in "King Philip's War," from 1675 to 1676. Although the uprising was unsuccessful, it conveyed a crucial message: Indians would fight to their death to defend ancestral homes. White glass beads acknowledge precontact reverence for shell. c. 1674. Length, 51¾" (131.5 cm). Peabody Museum of Archaeology and Ethnology, Harvard University, 10/49333*

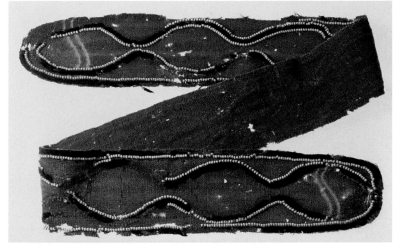

307

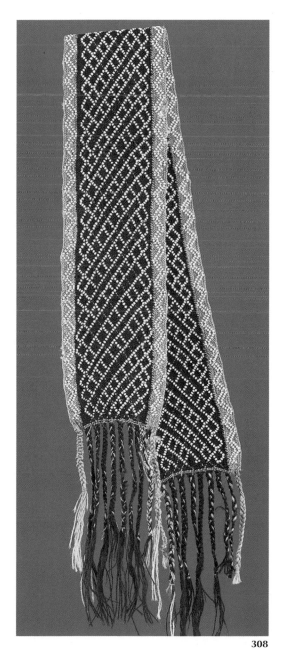

308

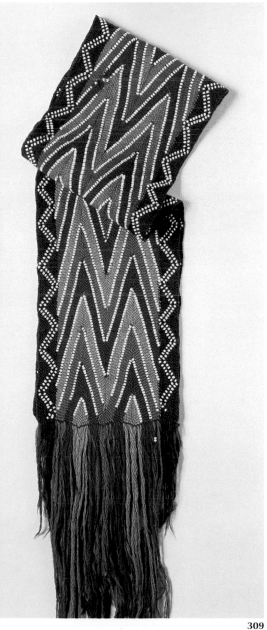

309

308 *Early nineteenth-century Iroquois finger-woven sash of European yarn and beads. The aboriginal prototype was of indigenous animal or vegetable fibers and shell beads. Finger-weaving, created by a multiple-strand braiding technique, is believed to have originated among precontact Great Lakes Indians and was adopted by French Canadians in the mid-eighteenth century. Braided woolen sashes made at L'Assomption, Quebec, were worn by Métis and others during the Great Lakes fur trade. Length including fringe, 44½" (113.0 cm). Denver Art Museum, 1952.476*

309 *An Iroquois finger-braided wool sash with beads. Since braiding is a diagonal process, the diamond motif results from the technique. The beads are either strung on the foundation yarn or carried on a separate thread. Late nineteenth century. Length including fringe, 39⅜" (100.0 cm). Width, 5⅞" (15.0 cm). The University of Pennsylvania Museum, 45-15-286*

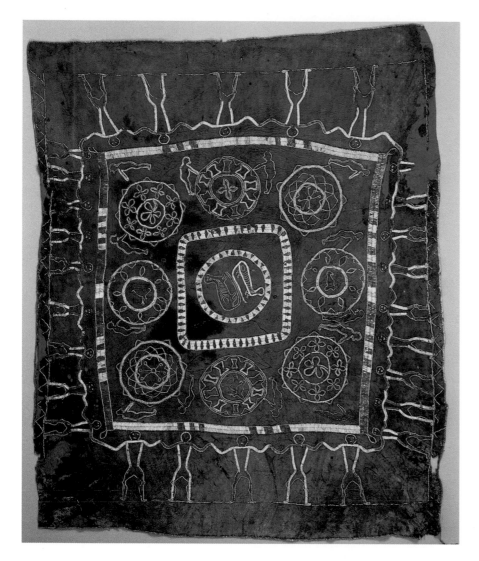

312 *An Iroquois deerskin bag ornamented with porcupine-quill embroidery. The smoked deerskin bag and the robe in 310 exhibit the fine, single-line porcupine-quill embroidery typical of early eastern Woodland Indian work. The original red, blue, and white colors have faded with time. Metal tinklers with blue- and red-dyed moose hair form the fringe. Collected in Quebec in the early 1800s. Length, 9¼" (23.5 cm). Peabody Museum of Archaeology and Ethnology, Harvard University, 10/49318*

313 *Embroidered Micmac purse. Fine open-line bead embroidery and curvilinear motifs derived from Native quillwork designs (312) or the "lacelike" patterns painted on seventeenth-century Micmac leatherwork. The expanded range of bead color shows a growing European influence. Nova Scotia, 1850–60. Width 8" (20.3 cm). Denver Art Museum, 1942.65*

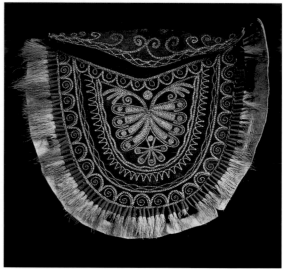

312

310 *This remarkable quilled buckskin robe, made from the skin of a single deer and dating to the eighteenth century, was presented by the Seneca in 1788 to Dr. Samuel L. Mitchell in appreciation for his legislative efforts on behalf of the tribe. The central Underwater Panther motifs suggest a Great Lakes origin. The robe possibly came to the Iroquois in trade. New York. Length, 41" (104.1 cm) National Museum of the American Indian, 14/3269*

311 *Northeastern Woodland peoples decorated bark and leather clothing (dyed dark brown) with moose-hair embroidery. These Huron moccasins, made for sale to non-Natives, replicate the aesthetic technique of work created in traditional contexts. Mid- to late 1800s. Length, 9⅝" (24.5 cm). Peabody Museum of Archaeology and Ethnology, Harvard University, 10/85445*

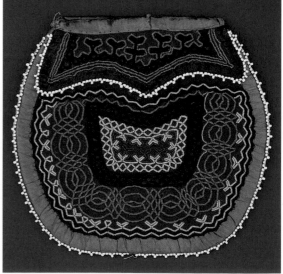

313

MICMAC BEADWORK AND DOUBLE-CURVE MOTIFS

lothing of the Micmac, hunting people of northeastern Canada and Maine, was richly ornamented. Traditional Micmac fur and leather garments were painted with mineral pigments and embroidered with porcupine quills and moosehair. Technology and materials changed with contact—for example, ribbon appliqué replaced the painted parallel lines on leather borders—but belief in the protective power of traditional motifs was not easily dismissed. Painted and quilled lacelike patterns continue today in the familiar beaded double-curve motif.

Among the most beautiful early nineteenth-century examples of Northeastern beadwork were Micmac women's peaked hats; the shape may have originated with French hooded capes. Popular with neighboring tribes (the Maliseet, Penobscot, and Passamaquoddy), these hats exemplify diversity within tradition. Initially, the motif was worked simply with white beads. During the nineteenth century, ornamentation increased, eventually filling the entire design space. By the late 1800s, the patterns were quite elaborate.

314 Three Micmac hats—made of beads, cloth, and silk ribbon—with double-curve motifs. Tiny glass beads strung on horse hair or moose hair were then couched. LEFT: The motif's simplicity suggests an eighteenth-century date. 14¾" (37.5 cm). McCord Museum of Canadian History, Montreal. MIDDLE: A later hat has more complex motifs. RIGHT: Highly elaborated motifs. Both collected in Nova Scotia, c. 1825–60. National Museum of American Indian, 17/6423, 17/6423

315 INSET: A beautifully crafted commercial Micmac "penny-wooden" doll accurately depicts Micmac nineteenth-century style, including the ribbon-appliquéd skirt and peaked cap. Collected 1872–77. Wood, wool, cotton, ribbon, leather, moose hair, glass beads, and a metal button. Courtesy of the Glenbow Museum, Calgary, Alberta

316 Micmac craftswoman Christianne Morris (seated) was known for her exquisite bead- and quillwork. Nova Scotia, c. 1865. Nova Scotia Public Archives

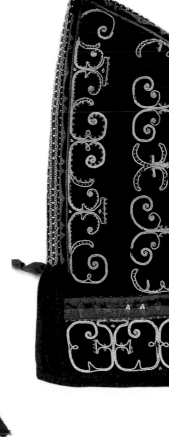

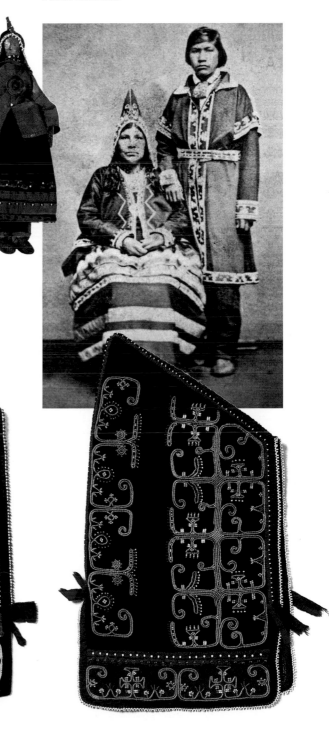

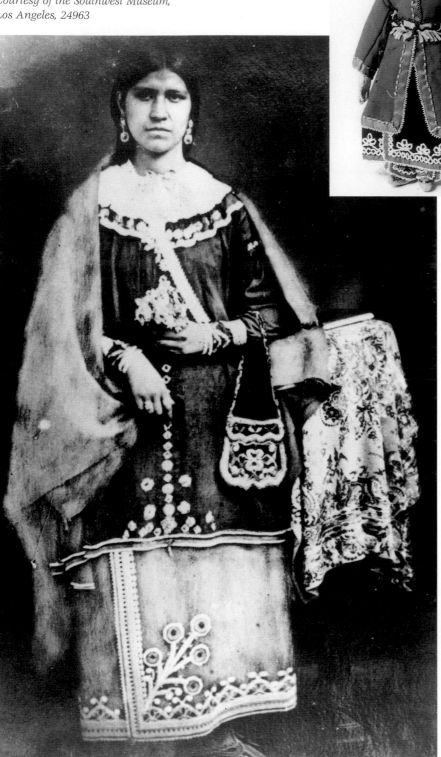

317 *Caroline Parker (Seneca) wearing a traditional Seneca outfit. c. 1850. Courtesy of the Southwest Museum, Los Angeles, 24963*

319

318 *This Iroquois cornhusk doll wears a red stroud dress with white floral beading at the hem—a typical mid-nineteenth-century ceremonial outfit. Corn has been the heart of the Iroquois experience, and these revered dolls are integral to the culture. Authentic dolls, braided from corn-husks initially soaked in water, have featureless faces. Perhaps it was believed that giving a doll eyes, nose, and mouth was analogous to giving it a soul, which would cause it distress were it mishandled, lost, or thrown away. It is also possible that plain faces were intended to give children the freedom to construe features they felt were appropriate. Height, 11½" (29.2 cm). American Museum of Natural History, 50.2/4747*

319 *Silver cornhusk-doll pendant by Arthur Powless (Iroquois), Ohsweken, Ontario. 1970s. Height, 2³⁄₁₆" (5.5 cm). Canadian Museum of Civilization*

At one time cornhusk people had very beautiful faces. The Creator placed them on earth to be companions to children. Their task was to play with and entertain little children. Pretty soon though, the cornhusk people became obsessed with their own beauty. They soon forgot their appointed task and spent most of their time staring at their reflections in calm pools of water. The children began to complain that the cornhusk people would not play with them. The Creator, disturbed at this, took away the faces of cornhusk people and made them into dolls.

—Donna Cole (Mohawk), 1990

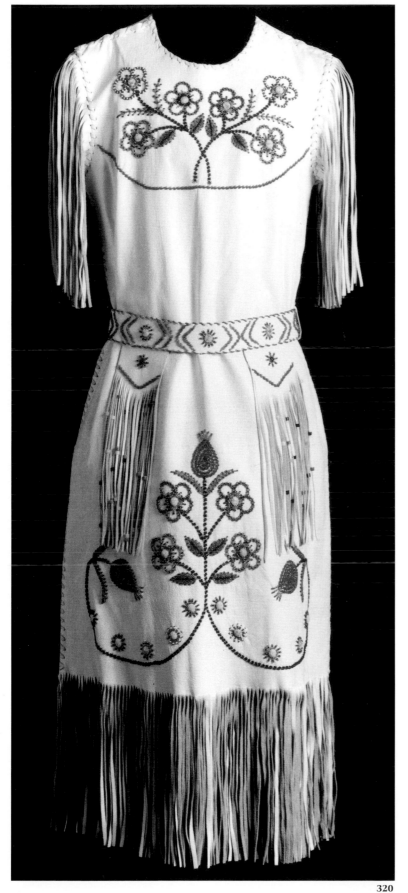

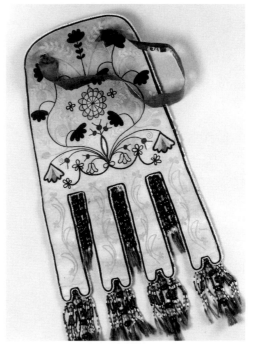

320 *This Huron dress shares iconographic relationships with the floral patterning in 321, created a century earlier. Jean Picard (Huron). 1985. Hide, beads, and moosehair tufting. Length, 46⅜" (118.0 cm). Canadian Department of Indian and Northern Affairs*

321 *A Red River Métis/Cree "octopus" firebag, named for the two sets of four tentaclelike pendants that hang from the bottom. Hide bags with pointed tentacles date to the mid-1600s; fabric versions date to the mid-1700s in the upper Great Lakes. Octopus bags—and woven beaded panel bags—traveled west with the fur trade to the Plains, Plateau, and Northwest Coast. Manitoba. c. 1850s–60s. Smoked caribou skin, silk floss, and glass beads. Length, 21¼" (54.0 cm). Royal Scottish Museum, L304.128*

322 *Contemporary hair ornaments of dyed porcupine quills on birchbark bound with sinew. Rita K. DeRaps (Micmac), Maine. 1994. Length of left ornament, 3¼" (8.3 cm). Collection Vivian Slee*

320

CLAY

Clay, earth's gift, connects traditional and contemporary work. Linda Hogan (Chicasaw) states, "Clay has been important throughout Indian New England for several thousand years. As they shaped clay into cooking and storage pots, bowls, pendants, pipes, and beads, our ancestors remembered they were using the body of the earth. Clan emblems and other symbols were painted on clothing, faces, and bodies with pigments made from powdered clay and minerals. . . . The enduring use of clay expresses the continuation of living traditions."

325 *Seneca clay pot. Livingstone County, New York. c.1585. Height, 6⅞" (17.5 cm). Rochester Museum and Science Center, New York*

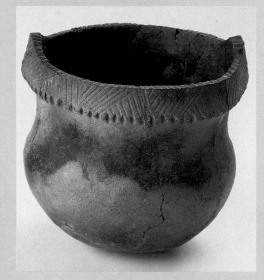

323 *A grouping of three Mother Earth dolls with sculpted clay heads, hands, and feet and soft cloth bodies. The dolls and all of their traditional Iroquois clothing are made by Tammy Tarbell-Boehning (Mohawk). "With clay, beadwork, and dollmaking, I express my feelings about being a Native woman in today's world," says the artist. "The Iroquois imagery and figures are used to uplift the spirit!" All 1995. Doll heights range from right, 27" (68.6 cm), to middle, 36" (91.4 cm). Private collection*

324 *Baby wrap, of pottery, leather, and glass beads by Tammy Tarbell-Boehning (Mohawk). 1995. Length from top of doll to bottom of fringe, 13½" (34.3 cm). Private collection*

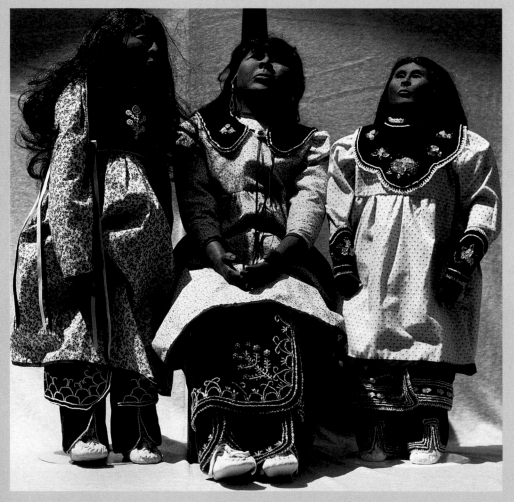

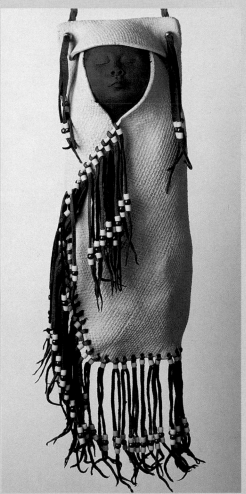

324

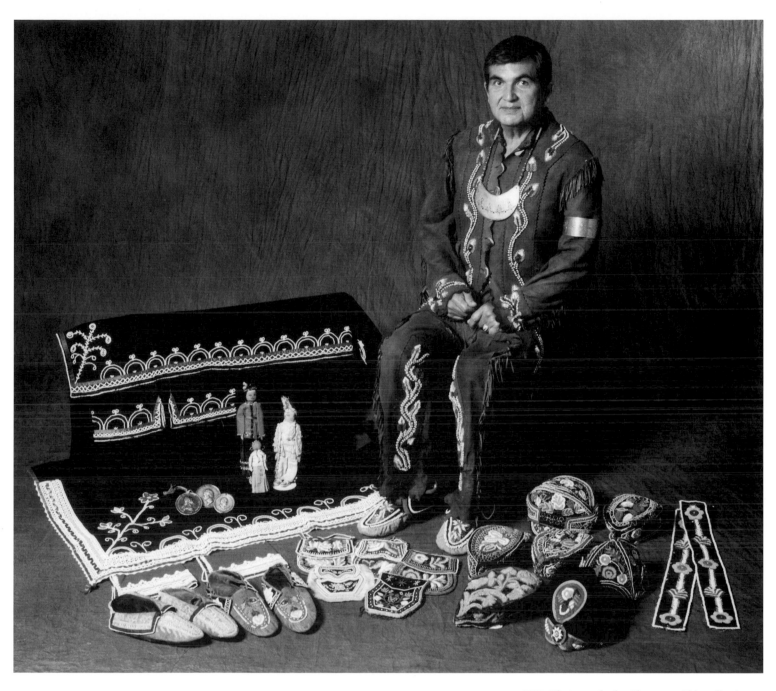

Bob Smith (Oneida) is a teacher, beadworker, and collector of tribal artifacts. Although educated as an electronics engineer, Smith served as director of the Oneida Museum. He cites wide reading about Indian cultures as the catalyst for his own collecting, which "isn't an accumulation of material objects; it is something that is a part of me, an aspect of our heritage for my children." Versed in traditional iconography, he attributes the use of pinks and purples in early Iroquois designs to the influence of Iroquois legend: When the Great Peace Maker called the chiefs together to organize the confederacy, he spread the soft down of thistles underneath the tree for them to sit upon. "Examine the thistle's color combinations; you can observe a cycle of growth: the pink bud, the purple flower; finally the mature thistle goes white into the air."

While studying and teaching, Smith began to design garments for his daughters, Cheryl and Sheila, and to instill in them a regard for their artistic heritage. Cheryl, a silversmith and potter, and Sheila, an accomplished beader who apprenticed with her grandmother, master artist Leona Smith, have joined the creative continuum.

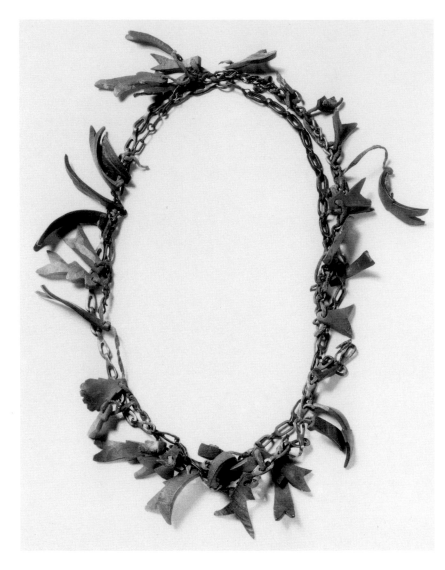

328 *The oldest form of trade silver was the cross; its acceptance was aided by Native America's familiarity with similar dragonfly and cardinal-direction motifs. Initially gifts to Native converts from French missionaries, crosses became popular trade items with little or no religious significance. Silver cross made by Montreal silversmith Robert Cruickshank, collected in Oklahoma among the Shawnee. 1775–1809. Height, 13¾" (35.0 cm). National Museum of the American Indian, 10/2786*

329 *Three silver crosses traded to the Seneca in the late 1700s or early 1800s. Missionaries presented crosses of copper or brass, but rarely silver, to Indian converts. Quickly achieving secular popularity, they were manufactured in large quantities for the fur trade. The most common styles were the single-barred Latin cross and the double-barred Lorraine cross. LEFT: Lorraine cross. Charles Arnoldi (1779–1817). CENTER: Latin cross, Robert Cruickshank (1767–1809). RIGHT: Lorraine cross. Maker unknown. Height, 3¾" (9.5 cm). National Museum of the American Indian, 4/425, 2/8038, 2/9710*

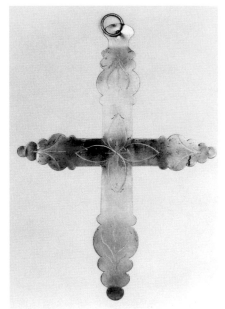

328

327 *A nineteenth-century Iroquois shaman's necklace of chain, carved deer hoof, and dewclaws. The shamanic use of chains has an ancient history in the Arctic (111, 112). Collected at Winnebago Falls, Nebraska. Length, 11" (27.9 cm). American Museum of Natural History, 50/7916*

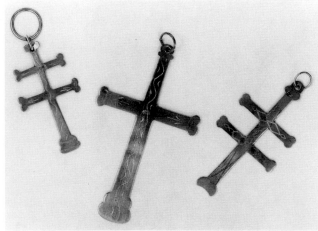

329

TRADE SILVER

The high level of artistry attained by Hopewell and Mississippian metalworkers did not continue into historic times. Metallurgy was reintroduced to Native North America through Europeans. Commencing in the mid-1600s, imported presentation medals of silver, brass, copper, and pewter were used to reward cooperative chiefs and enhance relations with tribes. Some of this silver jewelry reflects clear aboriginal precedents in the shell and copper gorgets worn by high-ranking ancient Woodland Indians (262). By the eighteenth century, Native leaders were receiving crescent-shaped gorgets, decorative vestiges of body armor worn by French and British officers (333). Woodland Indians coveted these gifts, which displayed monarchical insignias and were accompanied by armbands, as symbols of rank and prestige. To seal alliances with tribes, European governments also distributed quantities of smaller silver items, including brooches, crosses, finger rings, and circular gorgets.

Silver adornment became important to the fur trade during the eighteenth and nineteenth centuries. Eventually, the increasing demand for trade silver fostered North American production to supplement European supplies. Ornaments were crafted in Montreal, Philadelphia, and Boston workshops by European-trained smiths. Between 1750 and 1830, Montreal and Quebec silversmiths made tens of thousands of items. At Quebec and Philadelphia, Spanish silver *piastres* coins ("pieces of eight") were hammered into small thin disks as the main resource. The coin size determined the size of most brooches. As the supply of piastres dwindled, "German silver," an alloy of copper, zinc, and nickel (containing no real silver), became an alternative to importing expensive pure silver for jewelry. Although presentation silver was integral to Indian-white relations for several centuries, active trade in silver was limited to the years between 1760 and 1821, primarily in the Great Lakes, East Coast, and upper Mississippi regions. Plains groups, less intensively involved with the fur trade, received less silver. Subarctic Indians do not seem to have been attracted to silver ornaments.

As gifts of silver ceased with the dwindling fur trade, Indian silversmiths began crafting ornaments for their own people. By the early nineteenth century, they were acquiring sheets of the newly developed, less expensive German silver. While never accepted by eastern Indians, German-silver jewelry was quite popular with Great Lakes tribes and developed into a vital art form in the Plains, particularly among Oklahoma's Southern Plains metalsmiths (page 284). Southeastern smiths, however, worked with sterling silver.

Woodlands silverwork has always been a specialized skill, limited to very few artisans at any given time. In Iroquois villages, silversmithing continued through the last half of the nineteenth century, disappearing after 1900. It was revived in New York State in the 1930s and on the Six Nations Reserve in southern Ontario in the 1970s. Modern Iroquois silversmiths, using electric drills rather than traditional punching techniques, create designs based upon trade silver patterns. By the early nineteenth century, Great Lakes silversmiths, working almost exclusively in German silver, eschewed Christian symbols to create non-European stamped and engraved brooch designs. Today, Delaware artist Don Secondine works brilliantly in German silver, using traditional punching and etching techniques (349).

330

331

332

330 *Silver earrings and brooch, collected among the Oklahoma Shawnee before 1909. Diameter of brooch, 4" (10.2 cm). National Museum of the American Indian, 2/4773, 2/570*

331 *A silver gorget belonging to Chief Pandikaikawa (Ojibwa), the son of Chief Panamas, who surrendered Mackinac Island to Britain in the War of 1812. Touchmark: Silversmith John Kinzie (Chicago, 1780–1812). Diameter, 6⅝" (16.8 cm). National Museum of the American Indian, 1/2139*

332 *Choctaw sterling-silver earring by Jim Baptiste (Bayou Lacombe Choctaw), Louisiana. c. 1880s. Length, 2½" (6.4 cm). Denver Art Museum, 1941.71*

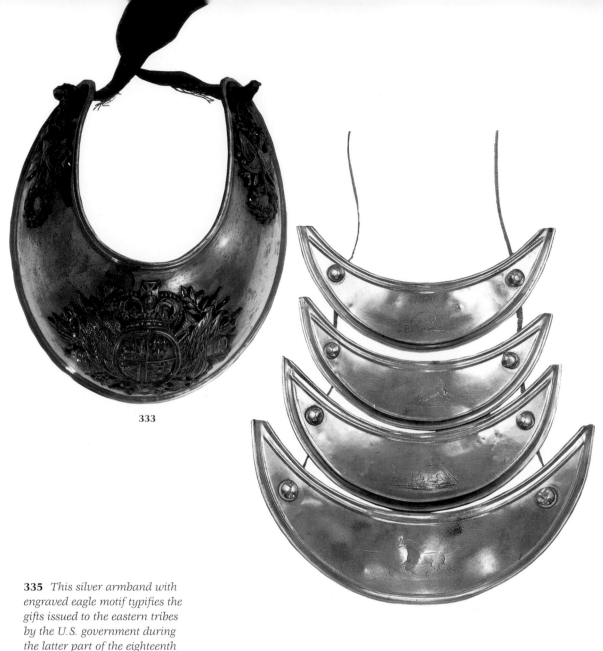

333

333 *This British-made silver and brass gorget with a European coat of arms was given to Mohawk leader Joseph Brant, Dartmouth College graduate, classical scholar, and British ally during the American Revolution. Brant eventually settled his band at the Grand River in southern Ontario. He traveled twice to England, was received by George III, and conferred with George Washington. c.1780–1810. Length, 4½" (11.4 cm). Rochester Museum and Science Center, New York, 70.89.1*

◁**334** *Four silver-crescent gorgets resembling eighteenth-century British and French officers' gorgets. The engraved animals may be decorative or may represent spirit helpers. Collected in Alibamu, Texas. Largest length, 6⁵⁄₁₆" (16.0 cm). National Museum of the American Indian, 2/6725*

335 *This silver armband with engraved eagle motif typifies the gifts issued to the eastern tribes by the U.S. government during the latter part of the eighteenth century. Width, 3" (7.6 cm). National Museum of the American Indian, 15/1752*

336 *Engraved tin bracelets. The depletion of fur-bearing animals meant an end to European gifts of silver; however, Native smiths continued to work with less expensive materials, such as tin. Ojibwa, Ontario. Height, 2½" (6.4 cm). American Museum of Natural History, 50/7890*

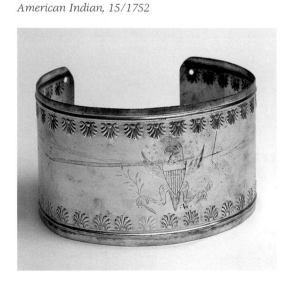

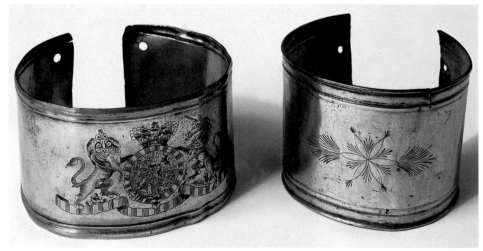

337 *Great Lakes Native-made German-silver brooches and earrings were constructed using punching techniques. 1. Mesquakie brooch, made in 1949 by Peter Morgan, the last Mesquakie silversmith, at Tama, Iowa. 2., 3. Kickapoo brooches, made by Maukaseah. 4. Menomini brooch. 1930s. 5. Potawatomi earrings. Diameter: 2¾" (7.0 cm). Denver Art Museum, 1949.143, 1949.115, 1951.205, 1943.13, 1951.204*

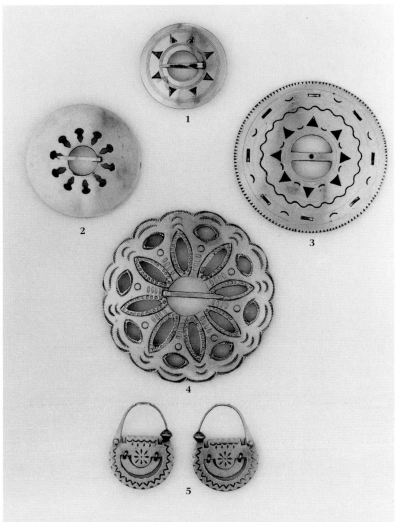

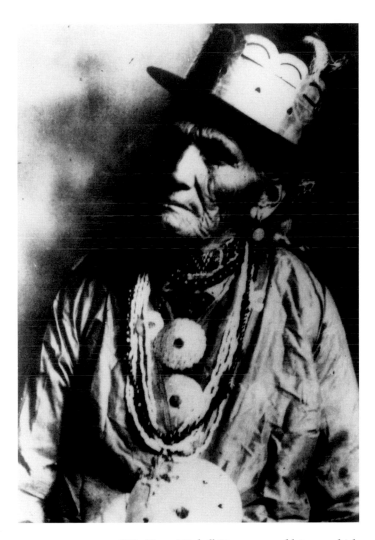

338 *Mary Mitchell (Passamaquoddy) wears high fashion of the late nineteenth century: a man's tall silk beaver hat with a broad band of pierced silver and an array of silver brooches and wampum necklaces. Smithsonian Institution*

339 *Kickapoo woman's German-silver comb, common among Mississippi Valley Algonquian tribes, was worn at the back of the head as a complement to ceremonial dress. By Maukaseah. 1938. Width, 2¼" (5.7 cm). Denver Art Museum, 1953.254*

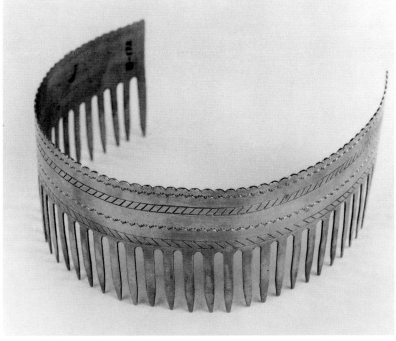

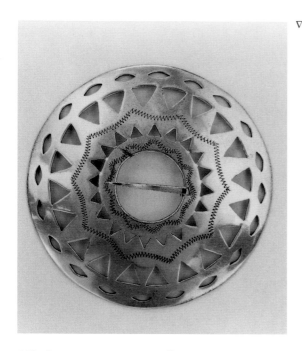

340 *A contemporary cutout silver brooch with engraved rocker design. Elwood Greene (Mohawk).1970. National Museum of the American Indian, 24/7853*

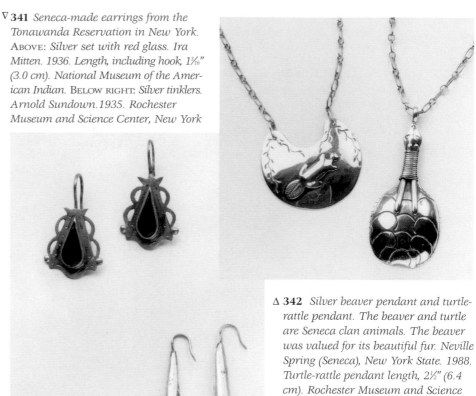

▽ **341** *Seneca-made earrings from the Tonawanda Reservation in New York. ABOVE: Silver set with red glass. Ira Mitten. 1936. Length, including hook, 1³⁄₁₆″ (3.0 cm). National Museum of the American Indian. BELOW RIGHT: Silver tinklers. Arnold Sundown.1935. Rochester Museum and Science Center, New York*

△ **342** *Silver beaver pendant and turtle-rattle pendant. The beaver and turtle are Seneca clan animals. The beaver was valued for its beautiful fur. Neville Spring (Seneca), New York State. 1988. Turtle-rattle pendant length, 2½″ (6.4 cm). Rochester Museum and Science Center, New York*

343 *This collection of jewelry—gorget, armbands, and brooches—and the earrings in 341 were made on the Tonawanda Reservation in New York State under the auspices of the Rochester Museum. The mandate of Rochester's Indian Arts Project was to reestablish traditional Iroquois arts and encourage fine craft work as a source of income. Between 1935 and 1941, twenty-four Seneca participated in the program, working in an abandoned schoolhouse, where they created many thousands of items. Their work inspired several generations of Iroquois artisans. 1. Gorget and chain. Ira Mitten. 1938. Width, 4¹⁵⁄₁₆″ (12.5 cm). 2. Armbands. Ira Mitten. 1939. 3. Heart and crown brooch. Wyman Jemison. 1935. 4. Sunburst brooch. Uriah Printup. 1935. Diameter, 2¾″ (7.0 cm). 5. Council square brooch. Arnold Sundown. 1935. 6. Masonic-style brooch. Arnold Sundown. 1937. 7. Round brooch. Uriah Printup. 1935. Rochester Museum and Science Center, New York*

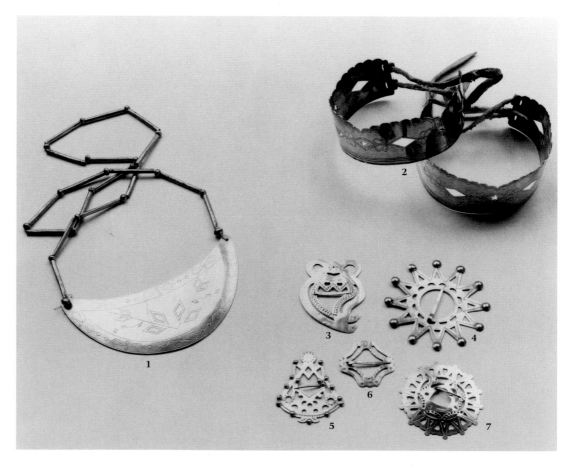

344 *Julius Cook (Mohawk), has adapted ironworking skills he used on high-risk construction sites, including Manhattan's World Trade Center, to crafting jewelry. His turtle-rattle necklace honors the animal that in Iroquois creation "brought up the mud with which the earth was formed as an island floating in the primordial sea." In deference to the turtle, the turtle rattle is the only rhythm instrument used in the most sacred of Iroquois dances, the great Feather Dance. The back of the rattle pendant (inset) depicts the Great Tree of Peace, under which the Iroquois Confederacy was formed. The necklace portrays the nine clans of the Seneca people: Bear, Wolf, Turtle, Snipe, Deer, Hawk, Eel, Beaver, and Heron. Sterling silver, mahogany, leather lacing, turquoise, mother-of-pearl, turtle claws, and sacred tobacco. Julius Cook (Mohawk), Akwesane, New York. 1985. Pendant length, 3" (7.6 cm). Collection of the artist*

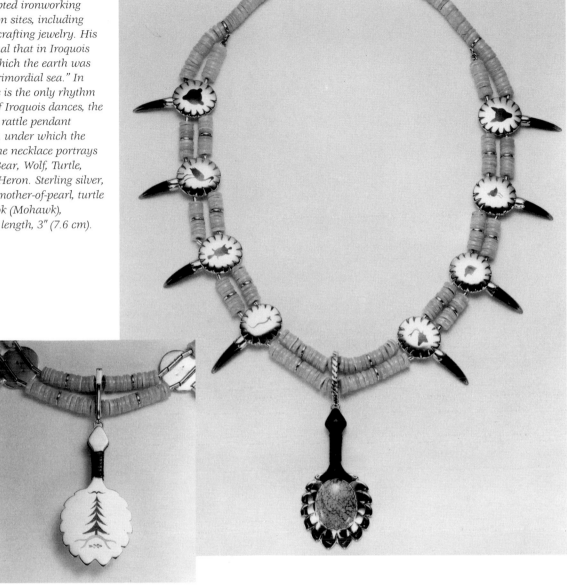

345 *Julius Cook's Creation pendant, shaped as a turtle island, reminds us that all peoples originally had a beginning. Some see the shape of North America as resembling that of a turtle. This pendant, with the Three Sisters symbols—corn, beans, and squash—honors the spirit of the three sustainers of life. It is also a reminder of the many agricultural as well as nonagricultural gifts of the North and South American Indians to civilization. 1985. Turquoise, mother-of-pearl, mother-of-pearl beads, and sterling silver. Pendant length, 4¼" (10.3 cm). Collection of the artist*

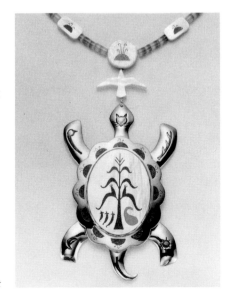

Of primary importance are rhythm-producing, one-tone instruments which accent the melodies of the dance rituals and "prop up the songs." . . . A communion of spirit underlies the use of turtle shell, hickory splints, animal-sinew threads, animal-skin wrappings and kernels of corn, combined in the making of a large snapping turtle rattle and blended into the purpose of the man who uses such a combination of spirit forces as a rhythm marker to accompany his voice.

—Frank Speck

THE DELAWARE (LENAPE)

Among the first Indian groups to encounter the Dutch in the 1600s, the Algonquian-speaking Delaware, who call themselves Lenape, "the People," lived along the middle Atlantic Coast between today's western Connecticut and northern Delaware. A democratic people who valued individual rights, the Delaware nation was a loose federation of family lineages rather than one large tribe. The Delaware participated in the earliest wampum manufacture. Well-regarded as peacemakers, they were also consulted in treaty making. In their initial land transactions, the Pennsylvania Delaware were fortunate to negotiate with William Penn, who honored agreements and treated them fairly. Beginning in the late 1700s, however, European disease would take its toll. Eventually, defrauded of their lands, most were compelled to move westward.

The Delaware aesthetic extended into many parts of North America. In their original East Coast homeland, the tribe was geographically centered between the Iroquois, the northern and southern Algonquian including the Powhatan, and the Southeastern tribes. As wampum manufacturers and distributors, they had contact with Europeans and other Native groups.

Delaware influences upon early nineteenth-century Southeastern beadwork iconography may not have been sufficiently acknowledged. Delaware women made

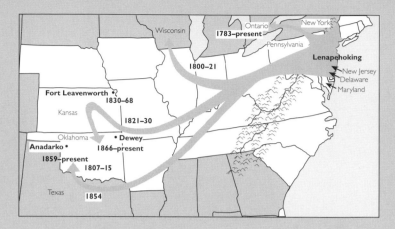

346 *From the 1780s to the late 1800s, the Lenape were forced from their homeland, Lenapehoking. Their westward migration is charted above.*

quilled bags, originally as presentation pieces to Southeastern tribes, and possibly lived among the Seminoles in the 1700s.

The Indian Removal Act of 1830 forced eastern Woodlands people to resettle west of the Mississippi on reservations in Iowa, Nebraska, Kansas, and Oklahoma—the geographical region known as the Prairie.

The interaction of Prairie peoples—the Oto, Osage, Omaha, Iowa, Ponca, and Pawnee—with the relocated Southeast, Northeast, and Great Lakes Woodland and the southern Plains groups led to significant interchange, resulting in numerous design motifs and technical innovations. Prairie-style beadwork, for example, derives primarily from ancient Algonquian double-curve motifs and beaded designs originated by the Delaware, Shawnee, and Southeastern Woodland tribes during the first half of the nineteenth century. (See 240.27, 240.28, 240.30, 240.35, and 441.)

Contemporary Delaware and Munsee Indians, although separated by great distances and the Canadian–United States border, acknowledge a common identity and history. Their continuum of fine artistry is testimony to the strength of their traditions.

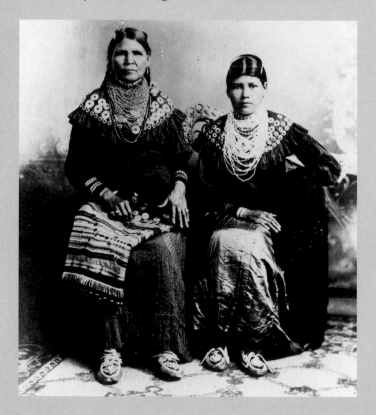

347 *Jennie Bobb and her daughter Nellie Longhat, Western Delaware, wear traditional clothing and adornment, including numerous silver brooches. Collected in Oklahoma, 1910–15. Smithsonian Institution*

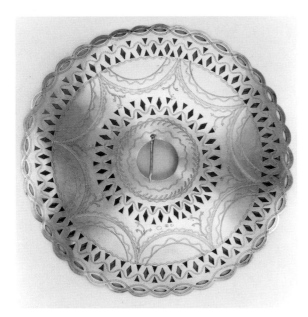

348 *Silver brooch. Maker unknown. Diameter, 6¹¹/₁₆" (17.0 cm). National Museum of the American Indian, 1/2133*

349 *Delaware silversmith Donald Secondine's original interest in trade silver was inspired by turn of the century photographs of Delaware women wearing "great silver brooches, five and six inches in diameter." This brooch, inspired by 348, was made by Secondine with traditional punching and etching techniques. 1994. Diameter, 5¹⁵/₁₆" (15.1 cm). Private collection*

350 *Delaware beadworker Gerry Krausse wears dance regalia with silver brooches crafted by Donald Secondine in 1992. Secondine remarks, "The ladies are starting to look more and more like the old photographs. You see these girls parading, with the ribbons fluttering and their silver shining in the sun, and when they're dancing, it is something spiritual; it puts your heart in your throat." Photographed at Wichita, Kansas, 1995*

THE DELAWARE POUCH: A STORY OF MIGRATION, TRANSFORMATION, AND SURVIVAL

As the Lenape were forced westward from their Atlantic coast home-land, change permeated the tribal culture. Though frequently impoverished and dispossessed, they continued their ceremonies and the wearing of regalia. Delaware artisans not only maintained artistic links but were also leaders in creating nineteenth-century Prairie-style beadwork. The story is poignantly expressed through the following sequence of men's beaded bags.

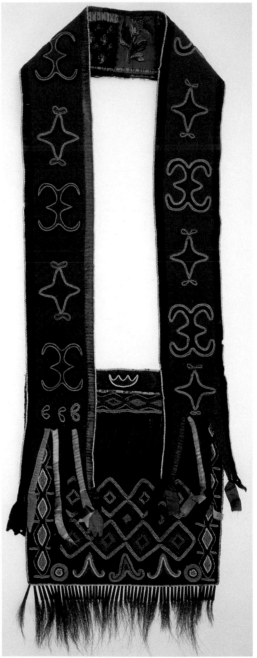

351 *A Mohegan bag made from buckskin, red cloth, and beads. The Mohegan, Algonquian neighbors of the Delaware, had cultural affinities, including the use of red, dark yellow, blue, and black, with both the northern Algonquian—the Naskapi—and the Iroquois. 1830–50. The bag's original owner was Mrs. Marsh (1800–1890), a Mohegan from Norwichtown, Connecticut. Pouch length, 9½" (24.1 cm). National Museum of the American Indian, 10/9723101*

352 *Echoing the pattern and color of 351, this Delaware bag's elegance may indicate a time of some stability and prosperity before the tribe was again forced to relocate. It incorporates southern and northern design influences, reflecting the Delaware's central and changing geographic positions. The pouch, a typical northern square, has wide southern-style shoulder straps and spot-stitch beadwork techniques. It, with leggings and moccasins, was made by a Delaware woman for her husband. Collected in 1838 at Fort Leavenworth, Kansas. Buckskin, cloth, quill, beads. Overall length, 28¾" (73.0 cm). Peabody Museum of Archaeology and Ethnology, Harvard University, 10/23541*

353 In 1859, members of the Texas Delaware presented this bag to Indian Agent Robert S. Neighbors. To prevent the massacre of reservation Indians (including Delaware) by hostile settlers, Neighbors assisted the Delaware in crossing the Red River to Indian Territory in Oklahoma. Returning to Texas, he was killed by a Fort Belknap settler. The Delaware pay homage to Neighbors annually at his Texas gravesite. The bag, made during an extremely stressful time, has minimal detail, yet its Delaware essence remains. Cloth, beads. Length, 23½" (59.0 cm). Texas Memorial Museum

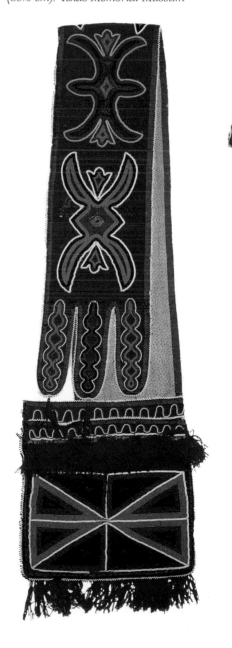

354 Vivid pink and blue beads typify Delaware work during the late nineteenth century, when backgrounds were solidly beaded intentionally to create negative space. While design elements were no longer liberally distributed against a wool background, the old Northeastern double-curve motif continued. By 1792, the Delaware had moved into Canada; the horse motif may reflect interaction with Plains tribes. Ontario, Canada. Accessioned 1910. Silk and cotton pompoms, hide, cloth, glass and metal beads. Length, 23½" (59.0 cm). American Museum of Natural History, 50.1/1408

355 Contemporary Delaware bag. The appliquéd design, an old-style bilateral floral motif, took Joe Baker a year to complete. Baker comments on the effects of his traditional upbringing on his work: "My interest in Delaware culture began in childhood. I grew up in a family that told many stories of the way life was for the early Delaware. My grandmother left the Delaware Reservation in Kansas for Indian Territory in 1897. My ninety-six-year-old aunt is the last living Delaware to have danced in the woman's ceremonial, the Doll Dance, in 1924. . . . I began dancing at an early age; mother made my dance clothes. Beading was a part of this early experience of participating in the culture of my people. Today I am a Southern Straight dancer and beadworker."

The bag was initially "danced" at the 38th Annual Delaware Powwow, Copan, Oklahoma, in 1995. Cloth, beads, length, 32" (81.3 cm). Collection of the artist

Southeastern Woodlands

Mississippian culture was in decline when European explorers entered the Mississippi Valley, yet ancient belief systems would continue to influence the region's lifeways and regalia. Each part of the Indian universe sheltered its own creatures. The glorious, frightful Cherokee monster *Uktena* crossed borders. A large winged serpent with crystal scales and colored rings or spots along its entire body, *Uktena* had deer horns and, on its forehead, a brilliant diamond-shaped crystal crest. *Uktena* presented a seemingly unresolvable contradiction. Viewing him brought destruction, yet his crystal scales and crest—sources of great power—compelled attention and desire.[57] Mica, thin quartz-crystal layers, was part of the ceremonial complex in Adena times. Sewn to clothing, it evoked *Uktena's* crystal scales.[58]

Bird imagery predominated throughout the Southeast. Red jasper beads at Louisiana's Poverty Point site (1800–500 B.C.) were carved in bird forms. The forked-eye design, prevalent in the Mississippian Ceremonial Complex (270), represented the eye markings of Falcon, whose keen eye would alight on unsuspecting prey. A Creek hunter carried a sacred crystal and red-ocher pigment. He exposed the crystal to the sun and then, using the red ocher, drew the forked-eye design around his own eye, symbolically sharpening his own vision. Even today, preeminent men dance wearing or carrying valued bald eagle tail feathers. Rattlesnake, Chief of Snakes, inspired awe and dread. Men decorated their bodies with serpent motifs to obtain power and create anxiety in their enemies.[59]

The predominant game animal in the southeastern fur trade was the white-tailed deer. Early reports numbered herds at two hundred each.[60] Late eighteenth-century traders made the hide of a large white-tailed deer the standard unit of value. Called "the buck," it was equated to an American silver dollar and could be exchanged for metal tools, guns, trade cloth, and glass beads.[61] Bead colors had intertribal significance: red, black, or blue heralded danger, death, or war; white signified peace.[62]

Throughout the Southeast, Natives covered their bodies with bear grease, acorn and walnut oil, and mineral or vegetable paints. On important occasions, men painted their bodies with red, black, and yellow pigments in elaborate designs. Tattooing was practiced by both sexes in some tribes.[63] Shell, agatized coral, bone, copper, and, eventually, glass beads were worn as necklaces, bracelets, and ear ornamentation.[64]

Southeastern men wore breechcloths. Deerskin moccasins and leggings fastened to a belt were used in winter. Upper garments of deerskin were fringed, painted, or adorned with shell. The Virginia Powhatan wore turkey-feather cloaks knotted into a net. In historic drawings, men appear more elaborately adorned than women. Headdresses and hair ornaments—colored deer-hair roaches, single feathers or feather caps, copper ornaments, woven bands of shell beads, and antler—often denoted rank and class. Tocobaga men of Tampa Bay displayed in their ears inflated fish bladders dyed red, while fingernails and toenails were kept long and sharp for use as weapons in battle. Tocobaga women wore short skirts of palmetto fronds and woven moss.[65]

European trade cloth gradually replaced skin garments. Outfits were adorned with shell as well as glass beads, lace, fringe, and embroidery. Brass and copper wire, silver gorgets, and arm plates served as accents, but indigenous material, particularly dewclaws (vestigial digits on mammals), retained importance for rituals. Tribes adopted some European styles. When Scotsmen arrived in Georgia wearing tartans, Indians admired the plaids, headdresses, and lack of trousers, all of which influenced nineteenth-century Native dress.[66]

In the early nineteenth century, women who had occasionally decorated objects with native freshwater pearls exploited new design possibilities with glass seed beads.[67] Vibrant patterns that also retained ancient motifs were created by Creek and Cherokee women (361). Bags of wool or velvet, with calico lining, oversized triangular flaps and

extra-wide shoulder straps, were embroidered with colorful abstract, curvilinear patterns in typical Woodlands asymmetrical compositions. Distinctive finger-woven yarn pouches with a triangular flap were made early in the nineteenth century[68] (362).

Choctaw men wore scroll-patterned, white-beaded sashes both as belts and over the shoulder (394), which contrasted sharply with the early nineteenth-century shoulder bags (361, 363, 364). The disparity suggests that the sash, a sacred item, contained inviolable designs and colors, whereas the shoulder bag, probably modeled on European ammunition pouches, allowed the artisan greater opportunity for innovation.[69]

Early Europeans referred to the Cherokee, Choctaw, Chickasaw, Creek, and Seminole as "the five civilized tribes" out of regard for their agricultural base and assimilation of Euro-American culture. Yet in 1830, responding to President Andrew Jackson's request, Congress passed the Removal Bill, granting presidential powers to exchange lands west of the Mississippi River for Southeastern tribal territory. This policy marks one of the darkest episodes in American history. Between 1831 and 1837, the five tribes—tens of thousands of settled Indians—were forcibly removed to present-day Oklahoma. Despite having fought with General Andrew Jackson against the British at the Battle of New Orleans in 1814, the Choctaw were the first to be relocated. The Cherokee appealed to the Supreme Court, winning a decision to remain on ancestral lands. Ignoring the ruling, President Jackson ordered their deportation by federal troops. During this brutal westward trek of 1838–39, called the Trail of Tears, at least a quarter of the eighteen thousand Cherokee removed died of disease and starvation. Several hundred took refuge in the North Carolina mountains, where their descendants, the Eastern Cherokee, live today. The Seminoles fought for their peninsula. Many were sent west, but some fled into the swamps, and their Florida descendants eventually made peace with the United States government in the late twentieth century.

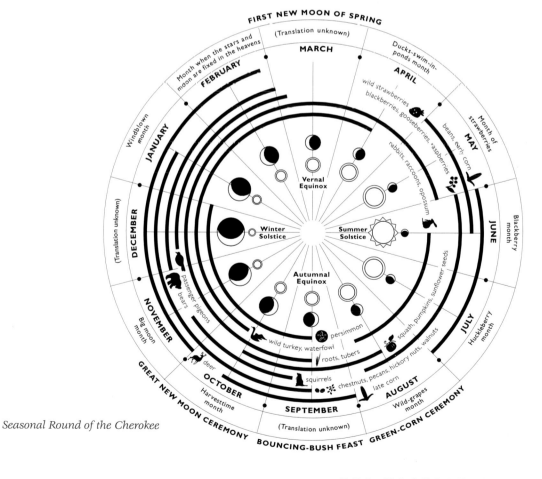

Seasonal Round of the Cherokee

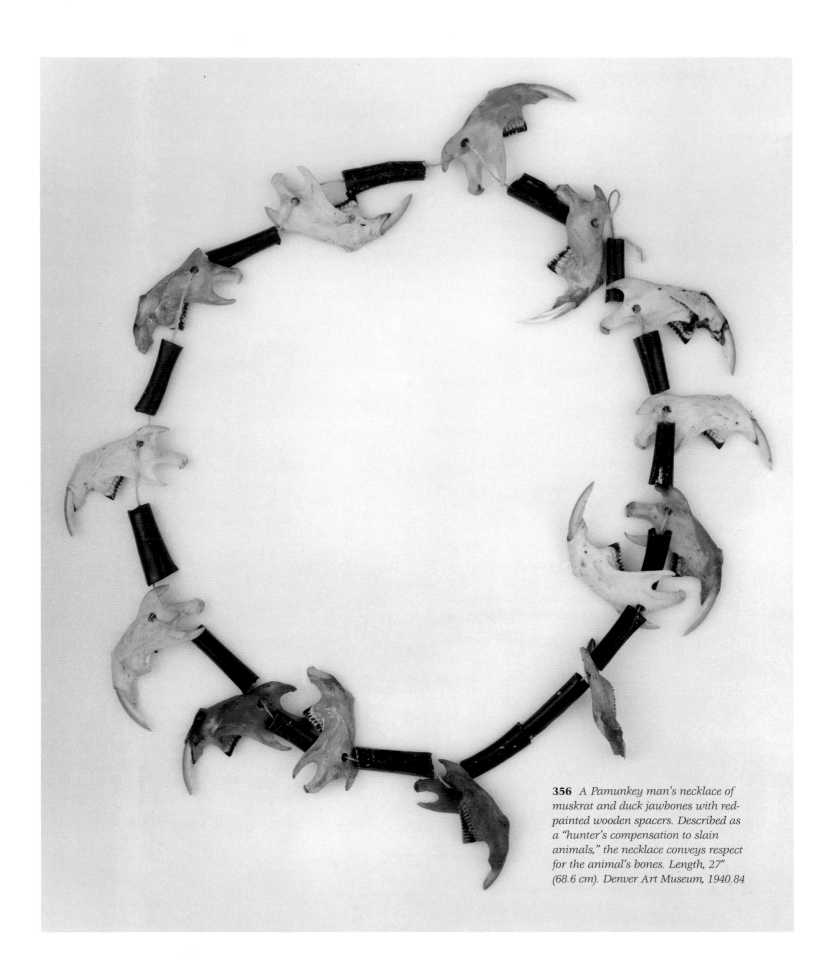

356 *A Pamunkey man's necklace of muskrat and duck jawbones with red-painted wooden spacers. Described as a "hunter's compensation to slain animals," the necklace conveys respect for the animal's bones. Length, 27"* *(68.6 cm). Denver Art Museum, 1940.84*

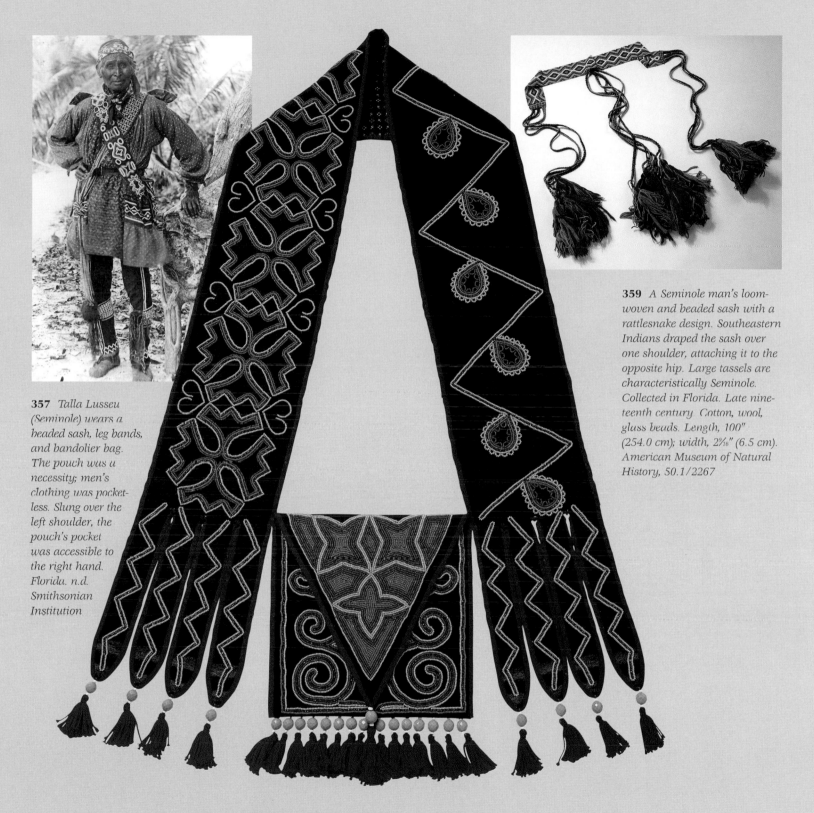

357 *Talla Lusseu (Seminole) wears a beaded sash, leg bands, and bandolier bag. The pouch was a necessity; men's clothing was pocketless. Slung over the left shoulder, the pouch's pocket was accessible to the right hand. Florida. n.d. Smithsonian Institution*

359 *A Seminole man's loom-woven and beaded sash with a rattlesnake design. Southeastern Indians draped the sash over one shoulder, attaching it to the opposite hip. Large tassels are characteristically Seminole. Collected in Florida. Late nineteenth century. Cotton, wool, glass beads. Length, 100" (254.0 cm); width, 2⁹⁄₁₆" (6.5 cm). American Museum of Natural History, 50.1/2267*

358 *This contemporary interpretation of a traditional Southeastern bandolier bag was made by Jay McGirt (Creek-Seminole), beadworker and teacher. McGirt's family was relocated from Georgia and Alabama to Oklahoma during the Trail of Tears. 1994. Length, 32" (81.3 cm). Collection of the artist*

SOUTHEASTERN FLORAL BEADWORK

An elder of the Eastern Band of the Cherokee relates that after contact, beadwork enabled cultural survival: "It was a visual language that kept beliefs alive." Attempting to suppress Native culture, colonists destroyed the Cherokee's wampum belts—the repositories of their sacred and historical knowledge. Cherokee teachings continued, however, though presented in acceptable Western forms. "When we worked with flowers, we made the missionaries happy. But hidden in the flowers, as well as other images, the beliefs were kept alive. In the flowers were messages and telegrams. . . . One bead color touching another meant something. . . . The spiritual teachings still circulated."

360 *The flying shaman etched on this Mississippian gorget wears a pouch similar to 362. Precontact bags held sacred medicine. Castalian Springs, Tennessee. 1200–1400. Length, 3⅞" (9.8 cm). National Museum of the American Indian, 15/853*

361 *British soldiers' ammunition pouches were possibly the prototype for this Creek and other Southeastern men's shoulder bags. The beaded circle and cross motif enclosed within a sun (on the bag's flap) has precontact antecedents. Georgia or Alabama. 1810–30. Wool and cotton fabric, silk ribbon, glass beads. Length, 53¼" (135.3 cm). The Detroit Institute of the Arts, Founders Society. Purchased with funds from the Flint Ink Corporation, 1988.29*

362 *A traditional Creek twined-wool bag with white embroidered beadwork and a finger-woven strap. Collected 1856. Length, 16⅞" (43.0 cm). American Museum of Natural History, 50/885*

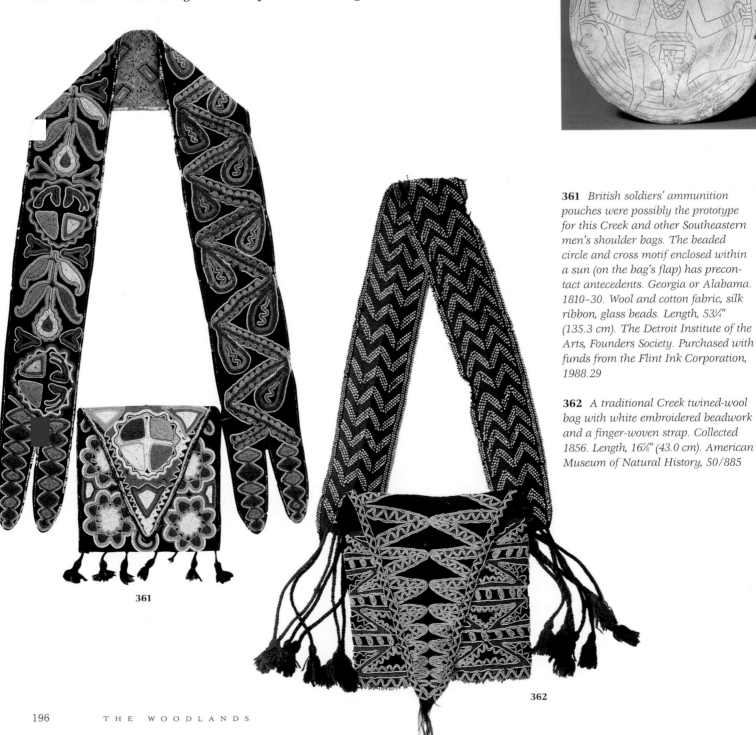

361

362

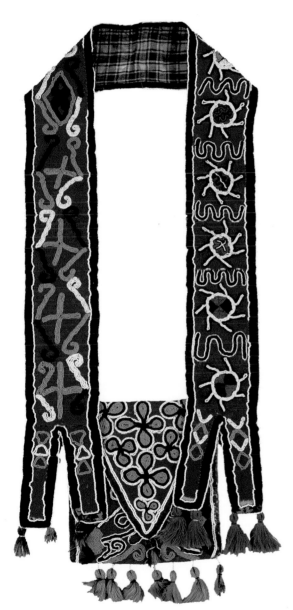

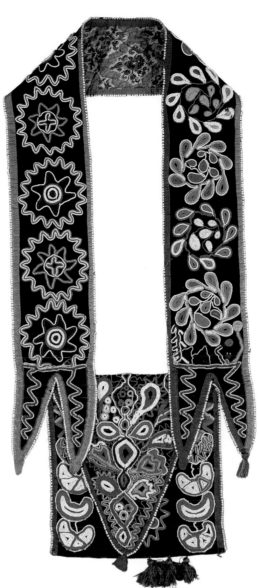

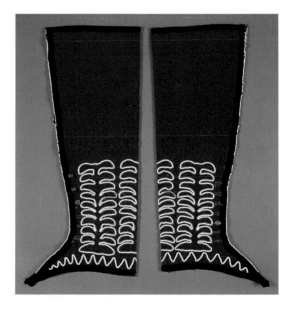

365 *A beaded Creek panel belt of this length indicates a wealthy owner. The cotton lining matches that of 364. c. 1800. Wool and cotton cloth, silk ribbon, glass and metallic gold beads. Length, 104" (264.2 cm). Montclair Art Museum, 00.214*

366 *The design on these Creek men's leggings is probably a cornstalk. c. 1800. Wool cloth, silk ribbon, glass beads, brass buttons. Length, 26" (66.0 cm). Montclair Art Museum, 00.215AB*

364 *Creek bandolier bag with an enormous variety of intertwined single-row beaded designs. c. 1800. Wool and cotton cloth, silk ribbon, glass and metallic gold beads. Length, 26" (66.0 cm). Montclair Art Museum, 00.217*

363 *The sun motifs on the right strap of this Creek bandolier bag may be African influenced. c. 1800. Wool and cotton cloth, silk ribbon, glass beads. Length, 28" (71.1 cm). Montclair Art Museum, 00.218*

367 *Traditional Creek bandolier bag. Collected c. 1820. Hide, cotton, glass beads, and wool tassels. Length, 33" (83.8 cm). American Museum of Natural History, 50.1/1612*

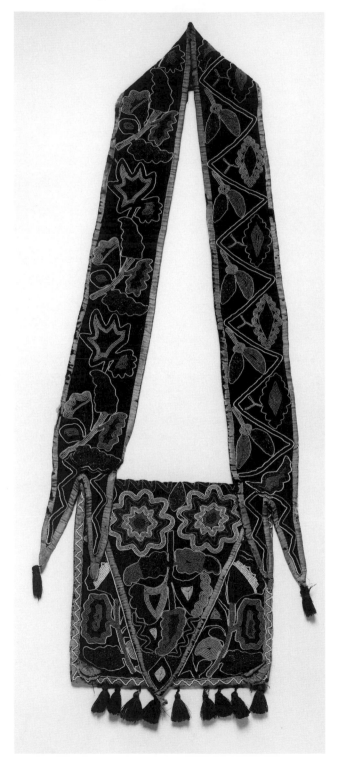

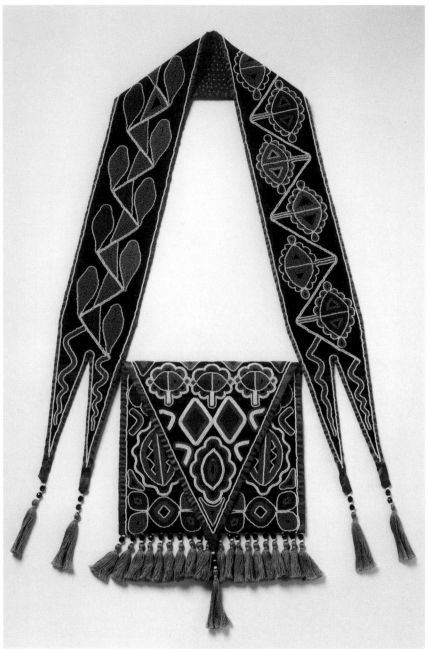

368 *Creek beader Ralph Stegner's bandolier bag is an interpretation of a work that belonged to the influential Creek chief Paddy Carr. Designs on the front, back, and strap include a rarely depicted abstracted female figure and complex florals. The artist has worn this bag, his first, in the ceremonial Green Corn Dance. Stegner explains, "Dancers wear their bags on the left because they move counterclockwise; thus, the beads catch the sparkle of the firelight." The bag is promised to his teenaged son. "The first year he takes medicine as a man, that night at Buffalo Dance, this bag will be his." 1994. Wool, ribbon, calico, glass beads. Length, 33" (83.8 cm). Collection Ralph Stegner*

BEADED MAPS

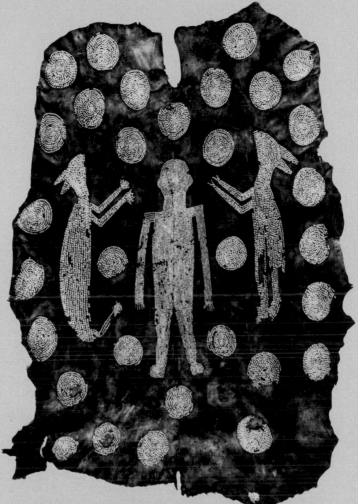

369 The Indians' proficiency as cartographers was known to Christopher Columbus. Indians painted accurate geographical and topographical information on deerskin, much of which was incorporated into very early European maps of the Americas. An intriguing feature of Southeastern Indian maps was their symbolic representation of social groups. An early example is the deerskin robe attributed to Powhatan, c. 1608, the fabled wealthy chief of the Virginia Algonquians. A diagrammatic drawing of the robe (370) shows its relationship to the map (371).

370 Powhatan's robe is made from the tanned hides of four white-tailed deer. Thirty-four solidly beaded circles signify the chiefdoms nominally under Powhatan's control. The circles, which indicate social groups ranging from villages to entire tribes, are arranged in a concentric pattern around three figures. The central figure is presumably the great chief. Marginella-shell beadwork covering the surface clearly indicates a foundation for glass beadwork as a Native American art form. The work's original use is unknown. Speculation includes a garment or a temple hanging. In 1608, Powhatan's mantle was presented to Virginian colonists and subsequently taken to England by Captain John Smith. It is the earliest documented example of postcontact Native American art. Recorded, 1638. 92 × 59" (233.7 × 149.9 cm). Ashmolean Museum, Oxford

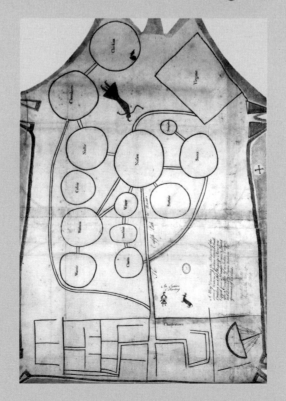

371 English copy of a Catawba-made deerskin map, c. 1721. The rectangular design at bottom right represents Charleston with a ship in the harbor. Squares represented foreigners (in this example, the English). Trade routes from South Carolina and Virginia linked the Catawbas to other tribes. The circles represent communities. British Public Record Office

MISSION SANTA CATALINA DE GUALE, ST. CATHERINE'S ISLAND, GEORGIA

The first indigenous peoples to encounter Spanish explorers north of Mexico were the Guale, a coastal people living about fifty miles south of present-day Savannah. By the 1560s, the Franciscans had built Mission Santa Catalina de Guale. Abandoned in the 1680s and eventually "lost," the mission site, which included a convent, church (Georgia's first), and cemetery, was rediscovered by archaeologists in 1981.

Located under the church's nave and sanctuary, the cemetery, containing graves of Christianized Indians, yielded tin-glaze majolica vessels, a Mississippian shell gorget with an engraved coiled-rattlesnake motif, crosses of metal and wood, small glass and gold-leaf cruciform ornaments, bronze religious medals, a gold and silver medallion, finger rings, and tens of thousands of glass trade beads. The enameled and gold medal was from the monk's cloister.

Gifting the dead by placing valued objects in their graves violated church practice. Thus, the shell gorget, symbolizing both sacred and secular aboriginal values, reveals the Franciscans' willingness to compromise church teachings. According to anthropologist David Hurst Thomas, allowing the Guale to place grave goods into Christian burials suggests that the monks had "baptized" this "pagan" behavior, thus permitting the Indians to enjoy "salvation through conversion while simultaneously retaining selected traditional customs."

△ **373** TOP: *A collection of copper crosses and a medal.* LEFT: *A silver "sacred heart" ring.* BOTTOM: *An enameled and gold medallion with sacred images. American Museum of Natural History, St. Catherine's Island Foundation, 28.0/6500, 28.1/1556*

372 *Guale Indians were buried with an array of treasured items, including (from top) a late Mississippian rattlesnake shell gorget, found around the neck of an adolescent; a ceramic gorget from a potsherd, and a majolica pendant. 1566–1680. American Museum of Natural History, St. Catherine's Island Foundation, 28.0/8069, 28.1/3544, 28.0/8069*

374 *The high quality of these beads indicates the importance placed upon Guale conversion by the Franciscans.* TOP: *Typical blue glass beads and gold leaf over clear glass beads, shown in the original stringing pattern.* MIDDLE LEFT: *Glass cross pendants.* MIDDLE RIGHT: *Blown glass beads with raised dots (dark blue with green dots).* BOTTOM: *Clear glass beads with black (jet) center dot and gold-leaf and raised white dots. 1566–1680. American Museum of Natural History, St. Catherine's Island Foundation, 28.0/6507, 28.1/5753, 28.1/4071, 28.1/1123, 28.1/5158, 28.1/1121*

THE SEMINOLE

The Seminole split off from the Creeks of Georgia and Alabama in the eighteenth century, blending with the remnants of Florida's original Indians. Resisting deportation to Indian Territory (Oklahoma), the Seminole moved deep into the Everglades and Big Cypress Swamp. From 1835 to 1842, they waged guerrilla warfare against U.S. troops intent on relocating them to territories in the West. While most of the population was subdued and expelled from their homelands, some managed to elude capture. Eventually, the government withdrew its troops, leaving the survivors at peace. Today, several thousand live in Florida's Everglades reservations. Having developed distinct lifeways, including their colorful cotton clothing, Seminole people continue to value the unique identity they fought so hard to retain.

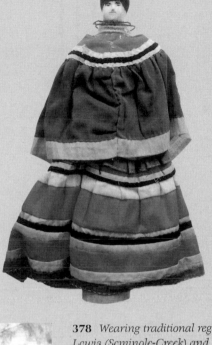

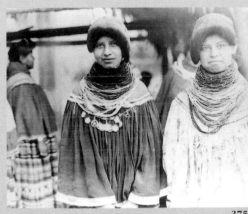

375

376

375 *Brooches and masses of beads were typically worn around the neck by Seminole women during the late nineteenth and early twentieth centuries. The brooches are probably tin, since silver would have been prohibitively expensive for the tribe at this time. Florida Everglades. 1936. Peabody Museum of Archaeology and Ethnology, Harvard University*

376 *Tin brooches attached to the yoke of a cape were worn by twentieth-century Seminole women. Diameter, approximately 1⁹⁄₁₆" (4.0 cm). Peabody Museum of Archaeology and Ethnology, Harvard University, 10/6127*

377 *An early twentieth-century Seminole ▷ cloth doll wears beads and clothing similar to those seen in 375: traditional Seminole patchwork and rickrack solid-color cotton dress with a black bonnet. After the 1930s, doll bodies were made with brown fibers from the base of palmetto fronds. Height, 11⅜" (29.5 cm). Peabody Museum of Archaeology and Ethnology, Harvard University. 10/K208*

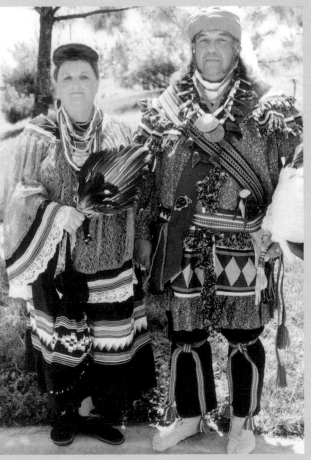

378 *Wearing traditional regalia, Lewis (Seminole-Creek) and Marlena Baugues (Cherokee) express pride in their Southeastern heritage. Great care has been invested in assembling these outfits, reminiscent of nineteenth-century composites of Native and European elements. Lewis wears a long coat, leggings, buckskin moccasins, silver armband, and necklaces of scallop shell, white bone, sea-urchin spines, glass beads, dewclaws, and a peacemedal replica. His wood-stork feather fan was a gift from a Cree friend. The Seminole used numbers of scarves as pocketbooks for change, trade beads, and other items. Bandolier bags held sacred medicine such as herbs and grasses. Marlena wears beads, a medicine pouch, and peacock feathers. The cape and skirt, both Seminole-made, display rickrack, "fire-pattern" patchwork, and traditional red and yellow Seminole colors. Her traditional hairstyle creates a "sun shade." Photographed at Red Earth Festival, Oklahoma City, 1994*

REENTERING THE CIRCLE

Today there is a florescence of Native art in southeastern Oklahoma, where artisans interact regularly, sharing discoveries and nurturing each other's talents. A pivotal figure was Leon Gilmore, an elder of the Cherokee Nation and tribal historian, who, until his death in 1996, directed the Cherokee Studies Institute, a silversmithing and lapidary school in Tahlequah, Oklahoma. A descendant of Cherokee chiefs and of Sequoia, who formulated the Cherokee alphabet, Gilmore, proficient in eleven languages, served as a "code talker" in World War II, speaking Cherokee to foil enemy attempts to monitor Allied radio transmissions.

The Institute's thirty-one-thousand-volume library attracted artists like Knokovtee Scott, who consulted Gilmore on traditional mussel shellwork. Scott, of Creek-Cherokee (Wolf Clan) ancestry, creates luminous purple mussel-shell jewelry that is delicate in form yet has a precisely carved, rich narrative content (387). Scott studied commercial and fine art and found neither particularly relevant to the Native Southeastern aesthetic that had gripped his imagination in childhood. Eager to broaden his background in ancient regional art forms, he consulted medicine men and elders, including Gilmore. "Leon explained where the design was coming from and helped me to understand the symbolism. He owned an ancient shell that was passed down through generations and had never been in the ground. I looked at it; I dreamed about it and started incorporating ideas, not wanting to copy directly but retaining the theme and varying each design, just as the artists of the past had. My ideal was to continue the shell-carving tradition, using a natural material, such as the purple mussel, local to the Cherokee Nation now here in Northeastern Oklahoma."

Cherokee potter Anna Belle Mitchell (390) grew up in a traditional Indian community in Delaware County, Oklahoma, and attended Indian boarding school. "I was

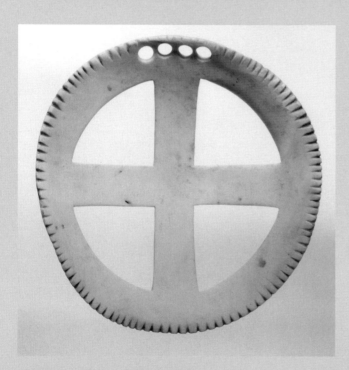

379 *A Calusa shell gorget, 1000–1400, with the Mississippian sun circle and the cardinal-directions motif. The Calusa, at the southern edge of the Florida peninsula, shared some spiritual traditions with Mississippian people. Once economically and politically dominant in southern Florida, they succumbed by 1770 to European diseases and conflicts. Key Marco, Florida. Diameter, 4½" (11.29 cm). The University of Pennsylvania Museum, 40891*

380 *Purple mussel-shell earrings with the ancient whirling sun or whirlwind motif. Artist Knokovtee Scott (Creek-Cherokee) relates: "Phillip Deer, a medicine man, taught me the Strength of Life design, the whirlwind image that represents the movement of our people around our ceremonial fires. I work with the symbols used on the shells thousands of years ago: four logs, the sun, the sides of the whirlwind, the weeping eye." 1995. Length, 1⁷⁄₁₆" (3.7 cm). Private collection*

in the first grade, just learning to read, and I was fascinated by stories with beautiful colored pictures of Indians making pottery. Of course, I wondered where these Indians were." She explains, "After the Trail of Tears, the Cherokee had to build new lives, new homes, start all over again. The tradition wasn't lost, but it wasn't practiced."

The artist's first attempt at potting in 1967 was a clay pipe for her husband, Bob, who is descended from Scottish missionaries and also has Cherokee lineage to Sequoia. "The pipe was like his ancestor Sequoia's. . . . I made a bunch of crude pipes, laid them in the sun, and they were all cracked the next day. I knew I had to discover how the ancients did it." She researched the archives at the Universities of New Mexico and Arizona and the Gilcrease Museum in Tulsa for the subtle colors and spare, forceful Southeastern designs that she would interpret in striking pottery and jewelry.

Knokovtee Scott recalls first seeing Anna Belle Mitchell working: "In traditional hand-built pottery, she was already doing designs I was just attempting. I felt a connection between two Cherokee artists pursuing designs that represented our people and techniques for using them in our work." Mitchell remarks, "I was drawn to Knokovtee because we were doing something similar. I had yearned to pass on what I knew to all of the Cherokees but felt no interest or enthusiasm [in response]. Now artists like Sonya Ayres say I have influenced their work. She's a painter who went and dug her own clay and now she's producing fine clay jewelry and pottery."

Ayres, who is part Cherokee but "raised outside of the tradition," says: "Trying to catch up and living close to Spiro mounds . . . I do research." Regarding her beautifully etched gorgets (388), she notes, "In my claywork, I use a sewing needle to get a fine line." Ayres has consulted Mitchell about firing techniques, noting: "I really enjoy doing the mound people's work, making their art come back to life. . . . According to Indian legend, potters regard their vessels as living, breathing beings. They believe the clay remembers the hands that made it, and sounds from the firing pit may be the cries of the vessel's

spirit. Therefore, at burial ceremonies, we leave a lifeline or spirit path by breaking a hole in the vessel." Anna Belle Mitchell has a similar response to the natural material. "There is a sense of aliveness in clay; I feel that when I'm working on a piece, it is breathing; I think it's the cold clay against your warm hand." Their colleague, Cherokee potter Bill Glass, uses native clay from Georgia for pots that display Mississippian shell and copper jewelry (391).

Ralph Stegner interprets traditional designs in beadwork. Stegner, an architect of Creek heritage, grew up outside of the Native community. In 1986 he moved to a Creek tribal town near Holdenville, Oklahoma. "I immediately felt an affinity and a desire to learn; I began reading, researched museums, and photographed designs. Then I bought beads and materials, sat down . . . cut out a bandoleer bag and made it. Of course, there is a difference in how bags are made today and how they were made when needles were not sophisticated enough to go through the beads. We can be much more precise." Displaying his work at Indian ceremonies and festivals, he says, "I wear it to show it off. There has been so little Southeastern work on view; we've been trying to bring it back."

Stegner has collaborated with Jay McGirt (Creek-Seminole). "We did a lot of research together, but our techniques are different. I stick to the old colors, while Jay likes these new iridescent cut beads to add sparkle. With his tremendous sense of color, he puts together unexpected combinations using both old and new iridescent beads." McGirt has taught Jane Bardis, a non-Native beadworker who has moved with her family to Tulsa for the purpose of recreating Southeastern expressions (1209). Louisa Soap (Cherokee) learned her heritage from her beadworker mother and is now teaching it to others (411).

This constellation of contemporary artists is united by the traditional commitment to excellence. Knokovtee Scott states, "All natural material has its own spirit and we have to find that middle ground between its spirit and our spirit to arrive at the finished product."

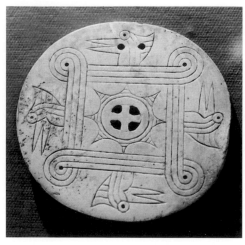

381 *Shell gorget with spider and sun imagery. According to legend, fire came to earth when a lightning bolt ignited a tree on a remote island. After several animals failed, the water spider retrieved fire by swimming to the mainland, carrying hot coals on its back. The water spider with a circle and cross depicts the carrier of sacred fire and is considered a sun symbol. Missouri. Mississippian period, 1200–1400*

382 *Shell gorget with chiefly litter, cross-in-circle, and woodpecker motifs. By symbolically joining the litter (a means of transport exclusive to Southeastern chiefs and priests), cross-in-circle (sacred sun), and woodpecker (representing warriors) designs, the gorget was a potent statement of the the wearer's combined sacred and military power. Tennessee. Mississippian period. Diameter, 3½" (9.0 cm). National Museum of the American Indian, 15/855*

384 *Contemporary Mississippian-style shell gorget inspired by 382. At contact, the Creeks admired the woodpecker's ability to extract insects from tree trunks: priests used woodpecker beaks to "extract" objects from their patients' bodies. The Cherokee believed that a type of woodpecker, the dalala, struck terror in an enemy. Woodpecker gorgets were worn by both Mississippian priests and warriors. Dan Townsend (Eastern Creek–Cherokee). 1989. Diameter, 3" (7.6 cm). Collection Ralph Stegner*

383 *Conch-shell gorget with a Mississippian-style incised spider motif by Dan Townsend (Eastern Creek–Cherokee). This self-taught artist was introduced to Southeastern prehistoric shell engravings by a Creek tribal medicine maker. Researching the tradition, he discovered that ancient images corresponded with the legends and traditional practices of contemporary Choctaw, Cherokee, and Creek.*

Townsend cuts the gorget from the walls of the shell, grinds the edges to a polish, and then engraves the motif using dental tools. Images are highlighted with raw umber paint. His colors have symbolic meaning: white for sky and raw umber (brown) for earth. The artist, determined to work in this almost vanished medium, believes that significant extant themes such as the spider motif will prove "very strong medicine, a powerful education tool for future generations." Florida. 1988. Diameter, 2½" (6.4 cm). Collection Ralph Stegner

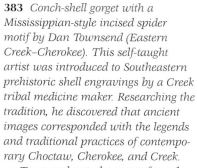

383

384

385 *Carved-stone earspools display important Southeastern Mississippian-era motifs, including: 1. whirling sun/priestly or chiefly litter; 2. cross and circles; 3. chain design (this spool was overlaid with copper); 4. whirling sun or whirlwind; and 5. forked eyes. Diameter of earspool 5, 3¼" (8.3 cm). National Museum of the American Indian, 20/682, not avail., 20/680, 18/6521, 20/684*

386 *Familiar snake and feathered serpent images in Maya temple reliefs at Chichén Itzá and Uxmal encouraged artist Knokovtee Scott's reexamination of Southeastern Spiro motifs and inspired this purple mussel-shell gorget. 1981. Collection Lillian Williams (Pawnee)*

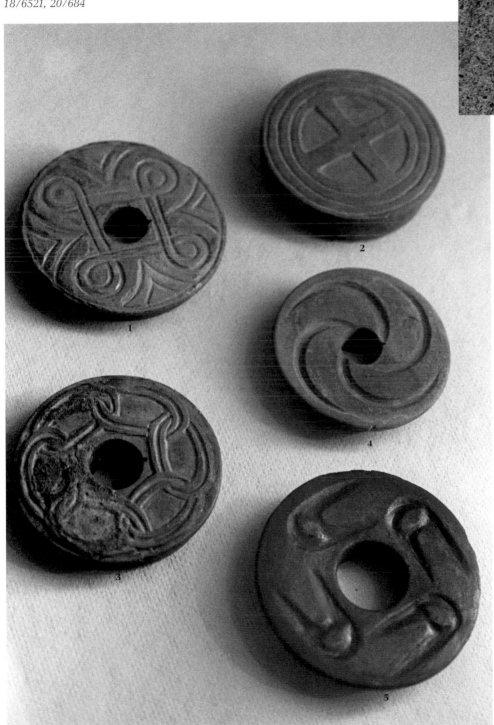

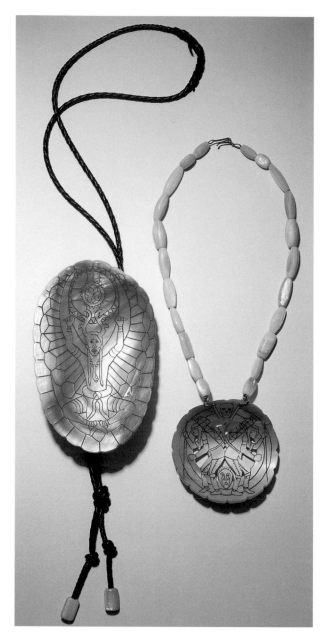

387 Left: The Cherokee Messenger: *Artist Knokovtee Scott describes the figure on this seventy-five-year-old mussel shell as "a temple mound birdman with antlers, wearing a traditional necklace of whelk shell. He holds feathers. The scalloped edge suggests the clouds, sky, and sun. The sun symbol in the background represents the seven Cherokee clans, the four directions, the four seasons, and the four phases of life, making this a cosmic symbol." 1985. Length, approximately 6½" (16.5 cm). Collection Bill Rabbit.* Right: Trail of Burdens *portrays the Southeastern Indians' forced relocation by the U.S. government. Two people struggle under the burden of their few possessions, all they can carry on their bowed backs along the infamous Trail of Tears. "Over the figures is a death's head; beneath them, a weeping-eye mask (warrior society motif) symbolizes the culture they are departing as well as the territories they are entering." Date c. 1986. Collection Traci Rabbit*

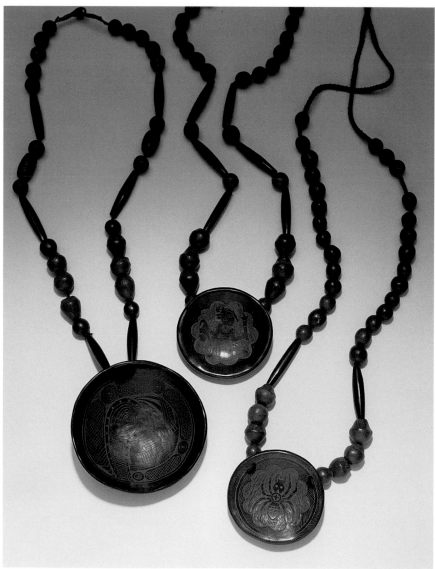

388 *Gorgets of pit-fired Native clay. Left to right: Tennessee Snake. Ceremonial Gorget. Alabama Spider. Sonya K. Ayres (Cherokee). 1994. Largest diameter, 2½" (6.4 cm). Private collections*

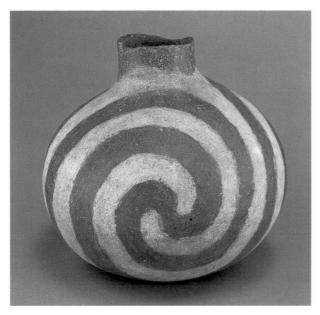

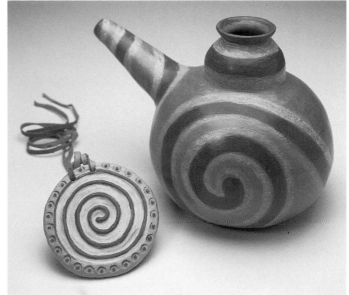

390

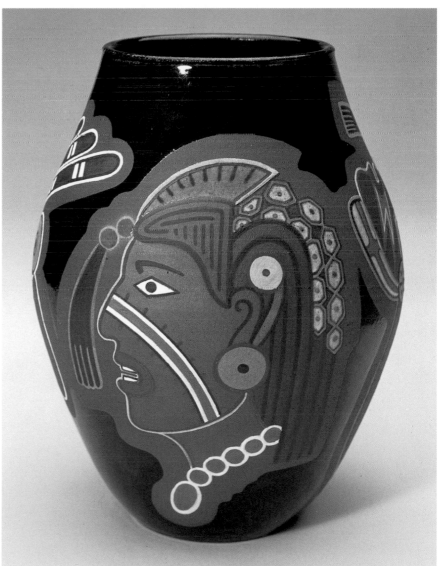

389 *A late fourteenth-century Mississippian painted jar displays a Southeastern white scroll motif on a red background. Cross County, Arkansas. Clay, ground shell, paint. Height, 8¼" (21.0 cm). Denver Art Museum, 1942.220*

390 *In the scroll motif of this contemporary clay pot and medallion, Anna Belle Mitchell (Cherokee) pays homage to her ancient Southeastern heritage. 1994. Pot height, 6¾" (17.2 cm); medallion diameter, 3⁹⁄₁₆" (9.1 cm). Private collections*

391 *A glazed, contemporary clay pot displays Mississippian figures wearing earspools, necklaces, plumes, and hair beads. Bill Glass (Western Cherokee, Blue Clan). 1994. Height, 8¼" (21.0 cm). Private collection*

THE MISSISSIPPI BAND OF CHOCTAW INDIANS

As a result of strong financial initiatives and educational programs carefully implemented under tribal direction, the arts are flourishing on the Mississippi Band of the Choctaw's 22,000-acre reservation. "We want our young people to be educated, productive members of society," says Chief Phillip Martin, "and to be proud Choctaws, too." Tribal identity is the keystone of modern Choctaw life. The ancestors of today's Choctaw were the mound-building Mississippians. The depth of feeling for their east-central Mississippi homeland is symbolized by *Nanih Waiya,* Great Mother, a large earthen, flat-topped mound in Winston County that is connected through oral tradition to the tribe's emergence and migration.

In 1519, Spaniards first encountered the Choctaw, a democratic people with a productive agriculture and strong business acumen. By 1830, foreign powers had fragmented the tribe and destroyed its economy. Agreements culminating in the Treaty of Dancing Rabbit Creek coerced the surrender of Choctaw homelands to the United States. While most Choctaw were forcibly removed to Indian Territory, some remained in Mississippi, becoming tenant farmers on land that was once theirs.

Spiritual beliefs and lifeways were grounded in the Choctaw relationship with nature. Once Europeans introduced the fur trade and a market economy, the subsistence system altered greatly. Overhunting deer for pelts resulted in the extinction of large game by the close of the eighteenth century, and traditional gender roles such as hunting, which was central to male identity, had ceased by the 1880s. At the same time, ritual death rites were abandoned, indicating the end of religion based on a concept of the spirit world as a hunting ground. Furthermore, men became totally enmeshed in the sharecropper labor system and could no longer devote time to pottery and metalwork.

While the role of the Choctaw male was altered by European contact, that of the Choctaw woman was less affected. She continued to work the cotton fields, farm, sew, and supplement income with handiwork, as important to the economy then as now. (In the past, from November through February, when there were no crops to till, plow, plant, or gather, women had made basketry and beadwork for trade.) Nonetheless, despite the obstacles, numerous Choctaw traditions—language, dance, stickball, food, and craftwork—particularly the making of clothing—persisted. Kirby Willis remembers that at home, his mother "would wear anything to work in, but she always wore Choctaw dress when she went out. I think that was because those were her best dresses." Thallis Lewis recalls that her parents wore only Choctaw clothing: "If they went out fishing, they wore their Choctaw dress. That was part of them."

Although the Choctaw government was officially reborn with a constitution in 1945, the development of today's remarkable reservation economy did not begin until 1979. Current members are descendants of those nineteenth-century individuals who withstood removal to Oklahoma while maintaining Choctaw traditions. Most speak Choctaw as their first language. Traditional dance and clothing has changed only minimally in the past hundred years. With the establishment of the Choctaw Arts and Crafts Council and the emphasis on arts in the school curriculum, beautiful work is being created by young artists.

Bob Ferguson, the non-Native Director of the Choctaw Museum of the Southern Indian, describes the museum's remarkably sensitive policies toward young Choctaw artisans. "When our museum opened in 1981, beginning craftspeople came to us because they found an outlet for their work. We bought starter baskets from youngsters, telling them, 'Make a better one and we'll pay more.' One understands this is beginner's work; someday it may be a great craftsperson's first piece. So we've found a meeting ground. It is possible to have museum and collector's quality and at the same time to open doors to improve a young person's self-esteem."

At the same time, Ferguson's Choctaw wife, Martha Ferguson, encourages the finest tribal talent and craftsmanship. "With the goal of a new Choctaw Museum,

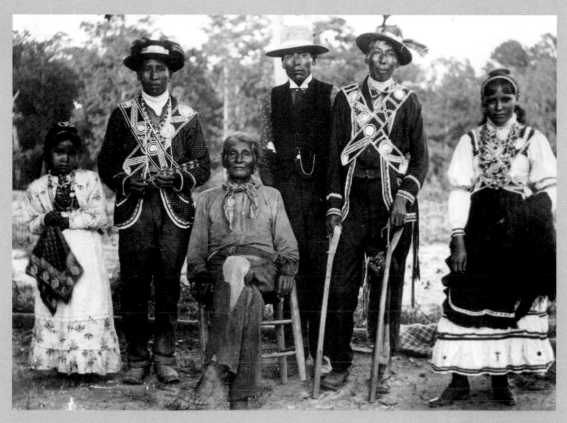

393 *Mississippi Choctaws, c.1908, when tuberculosis and other diseases had reduced the tribe to barely a thousand individuals. Note, however, the dignity and care in their dress, which includes finely beaded shoulder sashes, similar to 394. National Museum of the American Indian*

▽ **394** *Detail of a Choctaw man's beaded sash with scroll designs similar to those on ancient Southeastern pottery is worn around the waist or over the shoulder. Made of European glass beads and trade cloth, it retains aboriginal iconography. Neshoba County, Mississippi. c. 1907. Length, 43¾" (111.0 cm). National Museum of the American Indian, 1.8864*

392 *A beaded sash commissioned for a Choctaw school's cultural-history display. Incorporating venerable Southeastern scroll motifs that may represent ancient water, serpent, and bird duality concepts or fertility cults (25), artist Mary Ferguson Lewis of Philadelphia, Mississippi, asserts that her work "in the Choctaw tradition, has strong meaning and isn't merely a nice pattern." 1996. Length, 36½" (92.7 cm)*

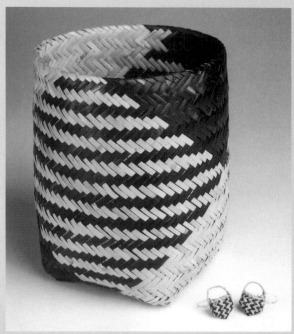

395

395 *A double-weave basket and single-weave miniature basket earrings are made from locally available swamp cane. Double-weave baskets, a complicated plaited basketry technique, requires masterful weaving of one basket inside another using a continuous weave. Basket, Esbie Gibson; earrings, Eleanor Ferris. 1994. Basket height, 6¾"; earrings height, 1" (2.5 cm). Private collection*

396 *Mississippi Band of Choctaw Indians Chief Phillip Martin frequently wears his historic-style scroll-design belt. "It is important," he remarks, "to carry on what the Choctaws did in the past." Philadelphia, Mississippi, 1997*

I want to have things in the shop that sell. I tell the artists that once a piece is sold, it becomes a turnaround investment because I can take more of their work. That incentive maintains quality. The best work is now coming into the shop instead of staying in the family."

Mary Ferguson Lewis (392, 410), Martha and Bob Ferguson's daughter, studied beadworking with Basil Willis (409) at ten years of age. Mary remembers that "the more I learned how to make beadwork, the more I got interested in our culture. Now there's a serious effort to continue the culture through artwork. Children and parents work on a piece and the grandmothers too, teaching the little ones. Mom is right. She says, 'Use the best quality fabric and do it well, and you will have it for years and pass it on to more generations.'"

Lorria Frazier (page 214), from a family of beadworkers, has been beading since she was eight years old. "Mom said, 'If you want to learn, you have to do it on your own.' And that's the way I learned, by watching what she did. I spilled a lot of beads, but she never got mad. She passed on about seven or eight years ago. They still say she did good beadwork and tell me that they're glad I'm continuing the way my mom used to do it." Beadworker and quilter Ersteline Tubby relates that "today, most of the traditional teachings are done in the schools, not the family. Because of the tribe, the schools are bringing back the past. Our young people are holding on to the culture, so we won't ever become the lost tribe."

STICKBALL

Stickball is an ancient Choctaw game similar to lacrosse. Dangerous and fast, it has been played with teams varying in size from ten to more than a hundred men. While the Choctaw frequently settled disagreements on the playing field, major games were occasions for revelry. Days ahead of the event, spectators arrived at the ball field loaded with possessions—furs, skins, beadwork—to gamble. Pregame ceremonies reached a climax the night before a contest, when players painted their bodies, drank sacred medicine, sang, and danced. Martha Ferguson (Choctaw) relates, "Very fine beadwork was wagered for a horse. Some people lost heavily in stickball gambling, but much art was saved because of these traditions."

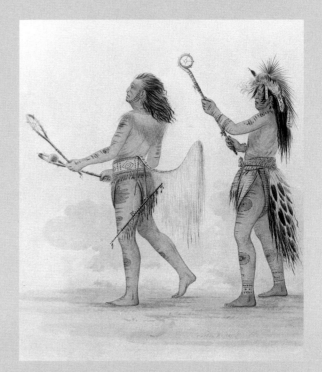

397 *Stickball earrings of hickory and thread are held by the artisan Richard Wilson (Mississippi Band of Choctaw), stickball player and grandson of Will Wilson, a noted stick and drum maker. Self-taught, Wilson's miniature sticks and balls in community team colors are popular with both Choctaw and non-Natives. 1994. Length, 2⅛" (5.4 cm). Private collection*

399 *Portrait of Tullock-chish-ko (He Who Drinks the Juice of the Stone), a distinguished Choctaw ballplayer, in his game outfit, holding ballsticks. George Catlin, who painted the portrait in Oklahoma in 1836, wrote: "It is a rule of play that no man shall wear moccasins . . . or any other dress than his breech-cloth around his waist, with a beautiful bead belt, and a 'tail' made of white horsehair or quills, and a 'mane' on the neck of horsehair dyed of various colours." (403) The horse's tail and mane denote a fast runner.*

398 *Choctaw stickball as played near Philadelphia, Mississippi, in 1925. Smithsonian Institution*

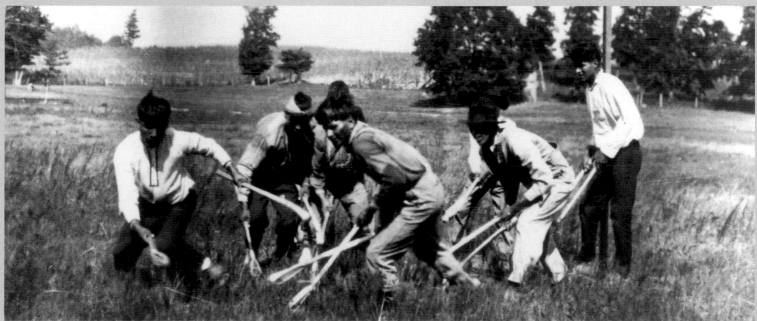

CHOCTAW DANCE AND REGALIA

Choctaw regalia mirrors nineteenth-century southern white styles and is similar to traditional peasant dress of Brittany in France; however, some elements are distinctly Choctaw, including the man's low-crowned black felt hat decorated with bands of ribbons, ribbon- and cloth-appliquéd shirts, and belts and shoulder straps beaded with traditional motifs. The belts, once worn by most Southeasterners, are today exclusively Choctaw. Ribbons fastened to the belt may be a vestige of the ends of the finger-braided yarn sash formerly worn by Choctaw men. Ersteline Tubby, maker of ribbon shirts, explains their significance. "The white people put their ribbons [flags] out in the yard for their soldiers' return. We wear these ribbon shirts to honor our dead—The Trail of Tears, and the men who went to war and died."

Choctaw female outfits include a bead necklace in net or openwork technique formed like a small bib; a traditional long-skirted dress with ruffles and full sleeves, fitted top and appliqué work. A long white apron covers the dress; long ribbons cascade from neck to hem. A traditional Choctaw dress carefully hand-sewn by a mother or loving relative is a special gift for a girl's coming of age. Younger girls sometimes wear Pan-Indian style beaded headbands and "powwow princess" coronets.

Communal occasions, ranging from the annual Green Corn Dance at Nanih Waiya to ribbon-cutting ceremonies for factory openings, incorporate traditional clothing as well as music and dance that have continued with little modification since precontact times. Some dancing techniques disappeared in the twentieth century, but the

401

Choctaw Indian Fair and the schools have rekindled interest. Bob Ferguson cites the role of the annual Choctaw Fair, today a major Mississipppi event, in the resurgence of the tribe's quality craftwork: "The first fair was held in 1949. Initially people brought their produce and played a demonstration game of stickball. Handicrafts were on the wane: there were just a few artisans. Later, special shows from Nashville brought in outsiders, stimulating interest in the Choctaw's area and culture. Eventually younger people were drawn to the elders' traditional dress and regalia." Martha Ferguson recalls her grandmother remarking, "Even when dancing was forbidden, the people believed the dances, passed down from generation to generation, must continue. Saying they were going to church, they actually had dances."

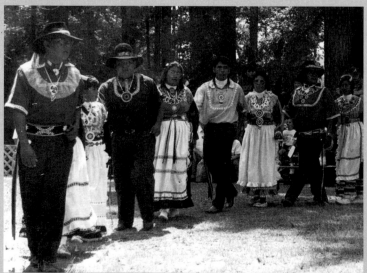

400

400, 401 *Choctaws dancing at the Choctaw Fair in traditional clothing. Shown above is the Stealing the Partner Dance. Both photographs, 1970s. Courtesy of the Mississippi Band of Choctaw*

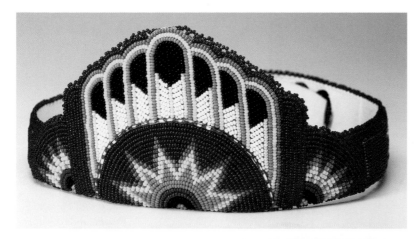

402 *A beaded Princess Pageant crown by Ann Lynn Tubby: "I've made several crowns and I purposely hold back on delivering the crown until the last moment because so many people want to try it on. I feel it should be only for the young lady who is going to be crowned." The Princess Pageant, a contemporary Pan-Indian custom, is held annually to select an outstanding young woman who has the appropriate qualities to represent the tribe.*

Tubby, a talented beadworker since she was a youngster, relates: "A lot of my feelings come in dreams. The eagle feather that I include in my work is strong. My grandfather, a medicine man, had an eagle for guidance; therefore, eagles are part of my lineage. Of course, all the animals are part of us, and we call them our relatives. We respect them, and our life surrounds theirs. Here in Choctaw country, our county Neshoba is named for the gray wolf." 1984. Height, 3¼" (8.3 cm). Collection Choctaw Museum of the Southern Indian

403 *A dyed horsehair collar worn for playing stickball. Predating 1828, it may be the only surviving example of this Southeastern adornment. Length, 17¼" (44.0 cm). Peabody Museum of Archaeology and Ethnology, Harvard University, 99-12-10/53026*

404 *Collar necklaces demonstrating ▷ the Choctaw's old-style "netted" beadwork technique. Using needle and thread, the artist strings three beads at a time. The bottom necklace "burns" in colors reminiscent of the horsehair collar (403). TOP: Sherlyn Farve. 1994. Length, 23" (58.4 cm). UNDERNEATH: Shirley Davis. 1994. Length, 27" (68.6 cm). Courtesy Gift Shop, Choctaw Museum of the Southern Indian*

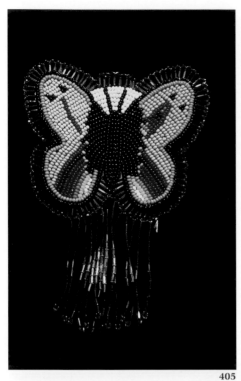

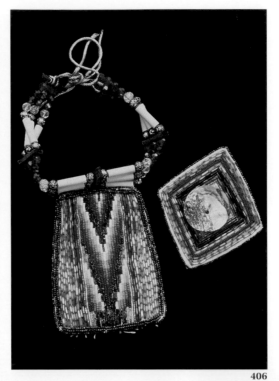

405 *The first in a series of butterfly barrettes made by Choctaw artist Lorria Frazier (see also 410), who relates: "In 1987, when I was still dancing at a powwow in Oklahoma City, I found a dead butterfly. The ends were blue; the rest, multicolor. In the sun, it was like lightning. Afterward, I made this one. Since then, I've made other butterflies, but they've changed a lot. Through the years they've gotten bigger and seemed more alive." From top to bottom of fringe, 6" (15.2 cm). Collection of the artist*

406 *Of the colors in this choker and barrette, Lorria Frazier says: "In the late afternoon as the sun sets, you see the changing colors before the dark. The colors are the sunburst in the sky." 1990. Cow bone, abalone shell, silver, plastic with leather spacers. Choker length, 4½" (11.4 cm) Collection of the artist*

405 406

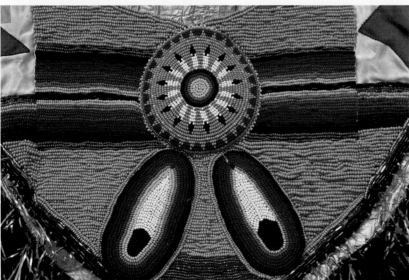

407

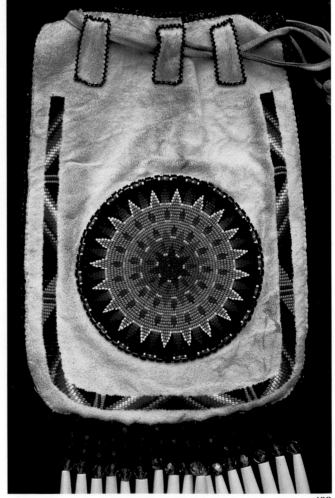

407 *With its Plains-style beaded sunburst and feathers and Great Lakes–derived ribbonwork, this cape (detail) is a Pan-Indian, powwow-inspired creation. The colored Mylar fringe, a daring addition given the high quality of the beadwork, is intended to glow in the light during night dancing. When asked, "What defines this cape as Choctaw?" artist Lorria Frazier responded, "It was my idea to do it!" 1986. From top to bottom of beaded area, 10" (25.4 cm). Collection of the artist*

408 *Beaded bag. Lorria Frazier. 1989. Length, 16" (40.6 cm). Collection of the artist*

408

409 *Earrings by Basil Willis. 1994. Beadwork and leather. Length, 4" (10.2 cm) Private collection*

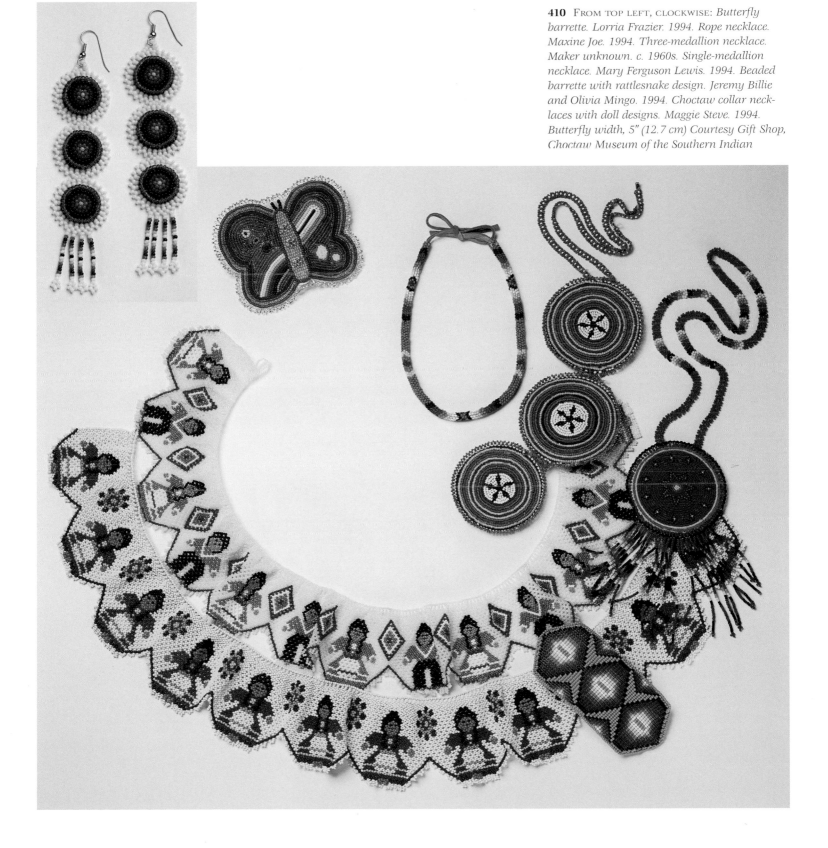

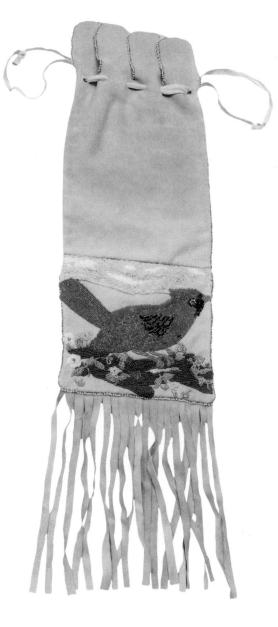

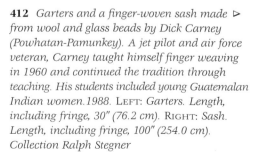

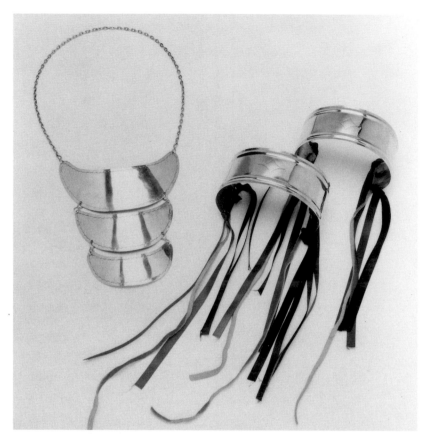

413 *A triple gorget and armbands of sterling silver and ribbons. The gorget is by Woodrow Haney (Creek); the armbands by Coogie Supernaw (Osage-Quapaw). Gorget, 1990; armbands, 1992. Width of gorget top, 5½" (14.0 cm). Collection Ralph Stegner*

411 *A pipe bag with a beaded red cardinal. Artist Louisa Soap (Cherokee) relates: "The medicine man used cardinals as spies to deliver messages." A beadworker for forty years, her first models were ancient shell jewelry. 1994. Hide, beads. Length, 24" (61.0 cm). Private collection*

412 *Garters and a finger-woven sash made* ▷ *from wool and glass beads by Dick Carney (Powhatan-Pamunkey). A jet pilot and air force veteran, Carney taught himself finger weaving in 1960 and continued the tradition through teaching. His students included young Guatemalan Indian women.1988.* LEFT: *Garters. Length, including fringe, 30" (76.2 cm).* RIGHT: *Sash. Length, including fringe, 100" (254.0 cm). Collection Ralph Stegner*

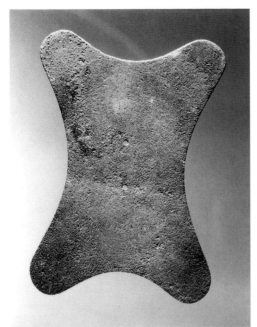

414

415

414 *Adena-culture copper gorget. Montgomery County, Kentucky. c. 500–100 B.C. Length, 6½" (16.5 cm). Peabody Museum of Archaeology and Ethnology, Harvard University, 1580*

415 *Delaware dancer Gerry Krausse's dance regalia includes a traditionally styled hairbow and trailer made by Dana Shannon (Cherokee). Wichita, Kansas, 1995*

416 *Caddo hair ornament, late 1800s. Precontact Southeastern women wore hourglass-shaped hair ornaments of polished stone or leather-covered wood at the nape of the neck. The custom survived into the historic period among this southern Plains tribe. Contemporary examples are decorated with German-silver disks sewn to dark cloth and long ribbon streamers. Length, 57⅞" (147.0 cm). Denver Art Museum, 1942.118*

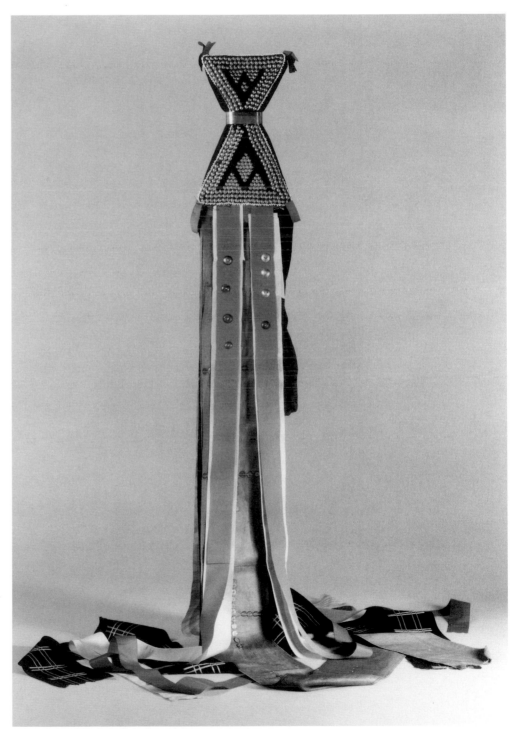

The Great Lakes

Great Lakes adornment reflects a coalescence of traditions: Iroquoian, Mississippian, eastern Plains, and central Subarctic. Motifs and compositions illustrate fundamental beliefs surrounding the cosmos. The frequent use of balanced, asymmetrical design with contrasting patterns and colors reflects a characteristic visual expression of complementary dualities.[70]

The principal *manitous*—Thunderbird and Underwater Panther—were predominant images on Great Lakes artifacts. They were generally rendered in highly stylized forms on woven, beaded, and quilled objects. Underwater Panther, closely related to Horned Serpent, appeared as a horned feline with a long tail—its distinctive feature—curving beneath or encircling its body (424).

Great Lakes artisans, intent upon recording significant experiences while obscuring their private meanings, tended toward stylization and abstraction to create a sense of ambiguity. *Manitous* were believed capable of assuming multiple shapes. A viewer's difficulty in determining whether a spirit image represented Sky World or Under World attested to the artist's skill in depicting a *manitou's* capacity for simultaneity.[71] As elsewhere, in the Great Lakes lavish dress marked success. When a young man demonstrated hunting prowess, he was rewarded with objects of silver, ornaments, or wampum. Bright ornaments, dense patterns, and spirit-power motifs such as Thunderbird and Underwater Panther associated the wearer with the supernatural. Moreover, a rich display was itself a gift to the spirits.[72]

Adornment marked life stages; body decoration began at a child's naming ceremony when the nose septum and/or ears were pierced. In the central Great Lakes, this act was performed by a shaman as a spirit offering, and wearing shell, stone, or metal ear and nose ornaments may have been associated with invoking protection from *manitous.*[73] Although women did not undertake formal vision quests, they observed seclusion at the beginning of puberty. It is possible that some Great Lakes textile designs are women's dream experiences.[74]

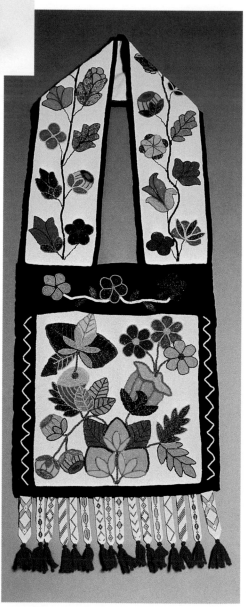

417 *Ojibwa wooden cradle. The carved board, bent with steam, protected the infant's head. Very fine Ojibwa beading is found on baby wrappers. Garden River Reserve, Ontario. 1916. Length, 29¾" (75.6 cm). Denver Art Museum, 1940.184*

418 *This bandolier bag made between 1980 and 1982 resembles Ojibwa bags of the 1890s but contains original and distinctive flower designs. "No two floral elements are treated in exactly the same way, making the color a variegated tour de force," observed Ralph Coe. The strap and panel are spot stitched; the bottom tabs are loomed. Made by Maude Kegg (Ojibwa), Mille Lacs Indian Reservation, Minnesota. Cotton velveteen, linen, beads. Length, 42½" (108.0 cm). Lost and Found Traditions Collection, Natural History Museum, Los Angeles County*

There is a special type of vision at work in Woodland art, and the poetic associations of the designs are wide. Multipointed designs suggest endless snowflakes or stars, a few wild flowers connotes a thicket. Woodland clothing is empathic to nature, and all the clothing has about it an ethereal quality, so that moccasins become soft sculptures made for padding along leafy trails which, when embroidered, transform into the flowers they occasionally crush.

—Ralph Coe, 1975

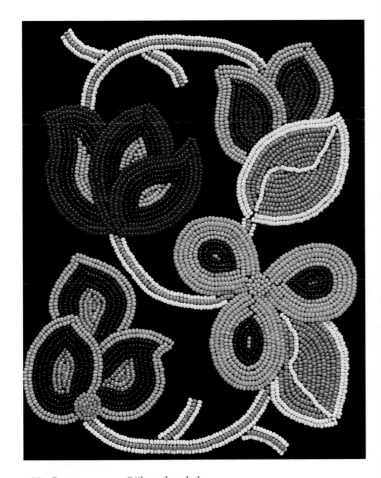

419 *Contemporary Ojibwa beaded flower motif made by Rene Senongles (Ojibwa), Red Lake. Traditional Ojibwa work, such as that shown in 420, has inspired her forms. 1994. 3¼ × 4¼" (8.3 × 10.3 cm). Collection of the artist*

420 *Beadwork detail from an* ▷ *Ojibwa vest. 1890s. Collection Rene Senongles*

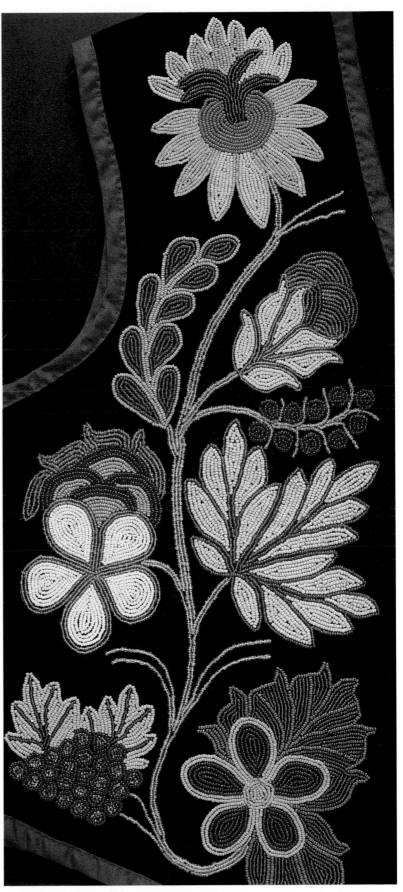

THE COSMOS AND THE POUCH

A combined Thunderbird and Underwater Panther motif creates a far more potent symbol than each does singly. The zones of the universe are replicated on the bag; on opposite sides, Thunderbird and Underwater Panther represent opposing cosmological powers and regions, Sky World and Under World, respectively. As a container for This World medicines—roots, herbs, and leaves—the bag is itself a metaphor, a "cosmic diagram" of the multilayered universe. The association of the two motifs appeared in ancient Mississippian iconography.

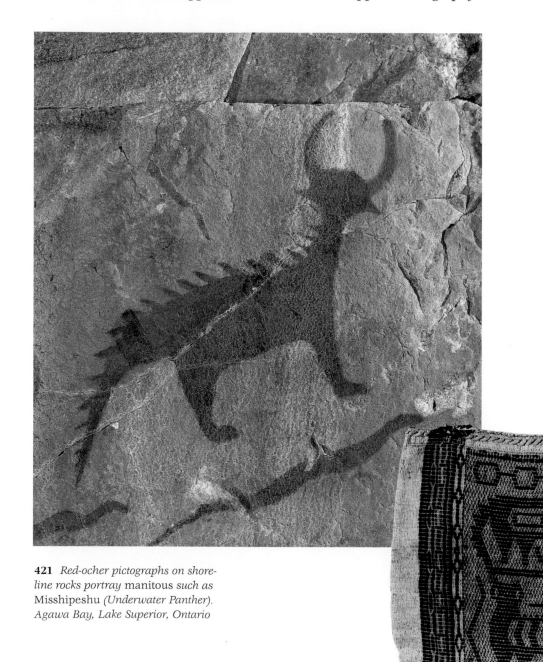

421 *Red-ocher pictographs on shoreline rocks portray* manitous *such as* Misshipeshu *(Underwater Panther). Agawa Bay, Lake Superior, Ontario*

422 *Twined-fiber panel bag with Underwater Panther imagery. The powerful feline was capable of causing storms with its huge (possibly copper) tail. Amphibious, it traveled on land and was familiar with medicinal plants that prolonged life. The creature's "bones" and "scales" were believed to have curative powers. Zigzag or serrated lines represent the levels of the cosmos: the wavy line above the head of the bottom feline may be the surface of the panther's watery home. The rib-cage pattern and lozenge shapes with interior spots represent birch-bark dishes holding sacrificial offerings to pacify Underwater Panther. Potawatomi. 1840–80. Cotton twine, wool yarn. Width, 25½" (64.8 cm). The Detroit Institute of the Arts, Founders Society Purchase, 81.372*

423 An Underwater Panther surrounded by concentric motifs suggests the manitou *descending into the Under World. Horns on the feline image denote supernatural power. The current owner carries this replica of an eighteenth-century bag for both hunting and historical reenactment. "While I am trying to work with authenticity," notes the artist, James Taylor (Eastern Cherokee), "the original piece was worn for sacred ceremonies. Therefore, I feel it is important not to copy it exactly." Quilled bag by James Taylor. Strap by C. J. Wilde. 1990. Smoked buckskin, porcupine quills, dyed horsehair, glass beads, metal cones, wool. Length of bag, top of strap to bottom of fringe, 28" (71.1 cm). Collection Dex Fairbanks*

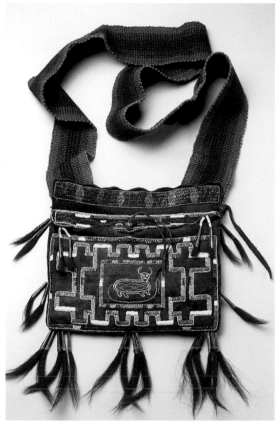

424 Mesquakie beaded and twined bag (front and back) carried by a young man. The rich iconography on the bag and strap includes fragments of abstract or obscured images. On the front, Underwater Panther is surrounded by horizontal zigzags representing water, and elongated hexagon ("otter-tail") shapes further symbolizing Underwater Panther. The back of the bag (near right) features a highly abstracted Thunderbird or, possibly, a Thunderbird colony. Designs joining the two opposing images appear on side bands. Incorporating glass beads into Great Lakes aboriginal fiber bags was common between 1870 and 1880. Collected in Iowa in 1903. Glass beads, cotton wefts, wool warps. Pouch width, 3 1/16" (8.0 cm). American Museum of Natural History, 50/4888.

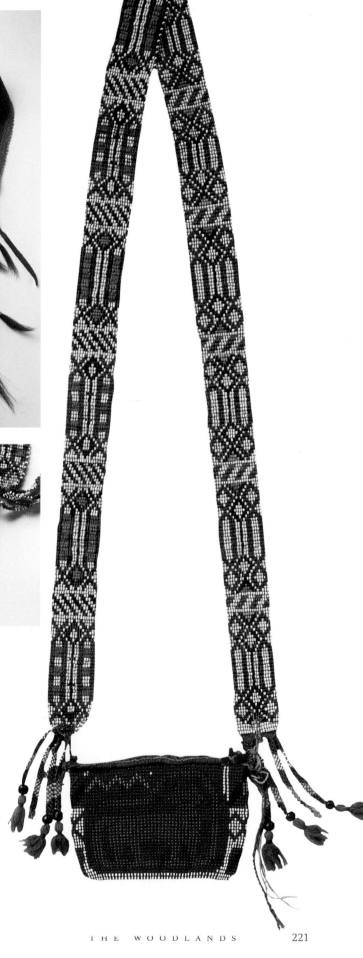

THUNDERBIRD AND HOURGLASS MOTIFS

Stylization within Great Lakes art tended toward abstraction and symbolic images. *Manitous* might be representational, minimalist reductions, or pure geometric forms. Between the eighteenth and nineteenth centuries, easily apprehended Thunderbird bodies developed into hourglass forms and, eventually, elongated Xs, recognizable shorthand to people within the culture. Iconographic similarities between historic and ancient Adena and Hopewell peoples remain unexplained.

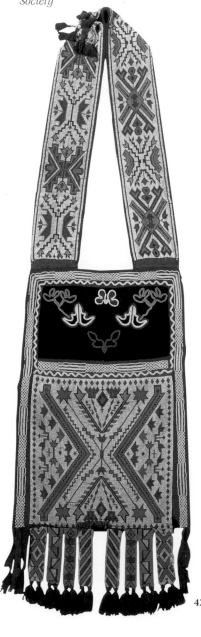

425 *Copper reel-shaped gorget. Adena culture, Ohio. 1000 B.C.– A.D. 200. Ohio Historical Society*

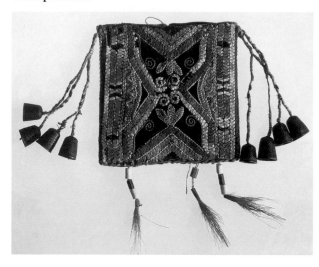

426 *Ojibwa or Cree porcupine-quill pouch with thimbles and shell wampum beads. As Thunderbird evolved into abstracted X imagery, botanicals were located at important junctures in the torso. The thimbles clink like bells. Probably mid-nineteenth century; collected 1890. Width, 5⅛" (13.0 cm). Peabody Museum of Archaeology and Ethnology, Harvard University, 10/49322*

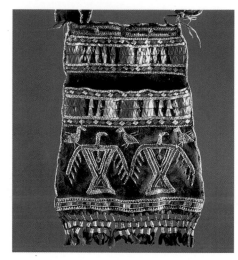

427 *Porcupine-quill embroidery adorns this early nineteenth-century Southeastern Ojibwa black-hide pouch with realistic Thunderbird imagery. An Ojibwa heart-line indicated supernatural power as well as hunting magic. The blue color is indigo; the orange, bloodroot. Collected by Lewis and Clark, 1804–6, for Thomas Jefferson. Width, 6⁵⁄₁₆" (16.0 cm). Peabody Museum of Archaeology and Ethnology, Harvard University, 10/53071*

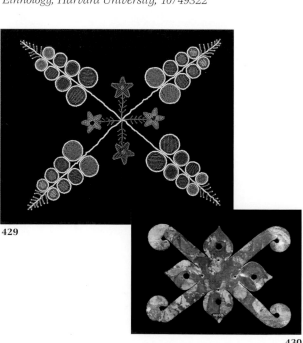

429

428 *Ojibwa bag with abstracted geometric and floral imagery. Woven beadwork panels on cloth base. Collected at Fort Dodge, Iowa, before 1875. Width, 13" (33.0 cm). The University of Pennsylvania Museum, 51-20-2*

429 *Detail of Potawatomi man's breechcloth. Collected in Kansas, 1900–1910. Width, 15" (38.1 cm). National Museum of the American Indian, 24/1996*

430 *Cutout copper ornament, probably sewn onto clothing. The symbolic meaning is unknown. Hopewell, Ohio. 100 B.C.–A.D. 200. Length, 6" (15.2 cm). The Field Museum*

428

430

431 The rare and complex ancient twining technique of making fiber bags (422) produces a surface of small bifurcated diamond or X shapes. The principal geometric and stylized design motifs emerge in the resulting triangles and zigzags. Images worked on panels are often powerful spirit beings. While the X motifs seen on these varied panels could be a vestige of the original manufacturing technique, they are more likely a conscious blending of cosmology and function.

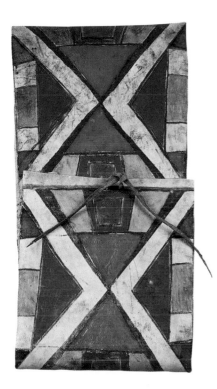

432 Crow parfleche bag with what may be a Thunderbird symbol. 1907. Length, 27" (68.7 cm). American Museum of Natural History, 50/6833

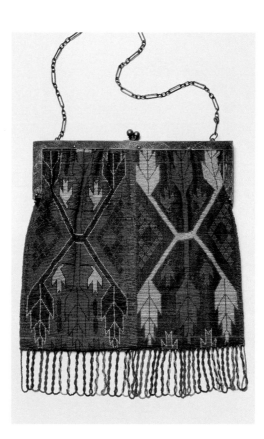

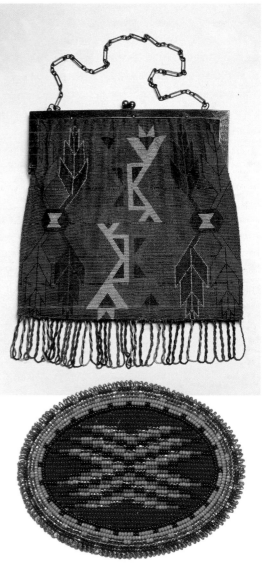

433 Great Lakes beaded bag (front and back) attached to a Victorian silver frame. The merging of geometric, Thunderbird, and floral/botanical imagery continues. Eastern Plains influences appear on the opposite side. This eclectic work embodies several nineteenth-century traditions yet maintains high quality and displays great artistry. Probably Potawatomi. Length, top of frame to bottom of fringe, 13" (33.0 cm). Private collection

434 Beaded belt buckle with the ubiquitous X motif. Warm Springs, Oregon. 1994. Length, 3⅞" (9.8 cm). Private collection

THE MIDEWIWIN

The Midewiwin (Grand Medicine Society), an association of shaman/healers, appears to have become a formal entity in the central Great Lakes region by the late seventeenth century. Pledging their dedication to healing, members of the Midewiwin were in return promised safe passage to the Under World. The Midewiwin Lodge symbolized the cosmos: central posts capped with birds represented the cosmic tree. Beautifully embellished objects were used in ritual performances and ceremonies. The elaborate formal regalia of Midewiwin priests included woven beadwork sashes and beaded shoulder bags.

Shell, which has held spiritual significance in the Woodlands since ancient times, was important to the Midewiwin Medicine Dance. Rooted in the region's earliest religious and ethical beliefs, this dramatic ceremony was the culmination of initiation into the Midewiwin. The following account was recorded at Lac Court Oreilles Reservation in the 1940s: "If someone was sick or dreamed he should go through the Midewiwin, he sought advice from the Mide priest." At initiation, "the candidate received a cowrie shell on a thong, to wear at all times, was sent a small amount of tobacco, and [was] taught songs, meanings, and secrets. The central and dramatic feature of the initiation was the magical 'shooting' of the [sacred cowrie] shell into the candidate's body; actually, the shell was dropped in front of him. This drove out the sickness and renewed life." Midewiwin rituals sustained the high quality of formal regalia, elaborated clothing, and adornment into contemporary times. The society has remained influential among the Ojibwa, Potawatomi, Menomini, Winnebago, Sauk, Mesquakie, and Eastern Sioux.

435 *Midewiwin wooden song "reminder" panel. Ceremonies were lengthy; memory aids helped members recall the sequence of song and prayer. Their graphic style has ancient roots in rock art pictographs and petroglyphs.*

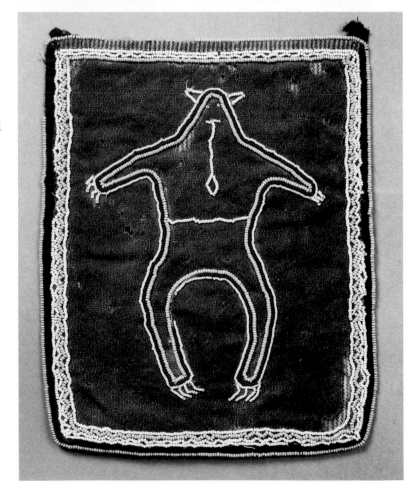

436 *This beaded cloth panel was worn as a health charm by members of the Midewiwin. Small shells are sewn on the back in pockets behind the hands, feet, and heads. Ojibwa, height, 9¼" (23.5 cm). Denver Art Museum, BOj-24*

438 *This necklace of beads and a large cowrie shell was worn by a Menomini woman as a badge of membership in the Midewiwin. Length, 11" (27.9 cm). American Museum of Natural History, 50/9727*

439 *A doll's clothing, adornment, and ceremonial regalia mirror those of a Potawatomi woman, probably a Midewiwin priestess. Her jewelry, miniature replicas of German-silver ornaments and necklaces with jet beads, indicates wealth. Her priestly identity is apparent in the "bear-claw" pendant, and the prescription stick (in her belt), probably marked with formulas for restorative herbs. She carries a beaded charm bag, which held sacred medicine for dosing her patients and a leather paint bag, which contained the curative pigment vermilion. Collected in Kansas, late nineteenth to early twentieth century. Hide, horsehair, cloth, silk ribbon, yarn, beads, animal claws, German silver, wood, vermilion. Length, 9¾" (24.8 cm). National Museum of the American Indian, 24/1799*

437 *A contemporary Midewiwin bag of otterskin embellished with beadwork. The use of otterskin bags relates to a legend that tells of four spirit-beings, each carrying a live otter, who suddenly appeared among the tribe and returned to life a youth who had been dead for eight days. Otter bags were given to Midewiwin initiates for carrying materials and objects used in healing and initiation rites. Judy Coser (Kickapoo/Sauk-Fox). 1994*

438

439

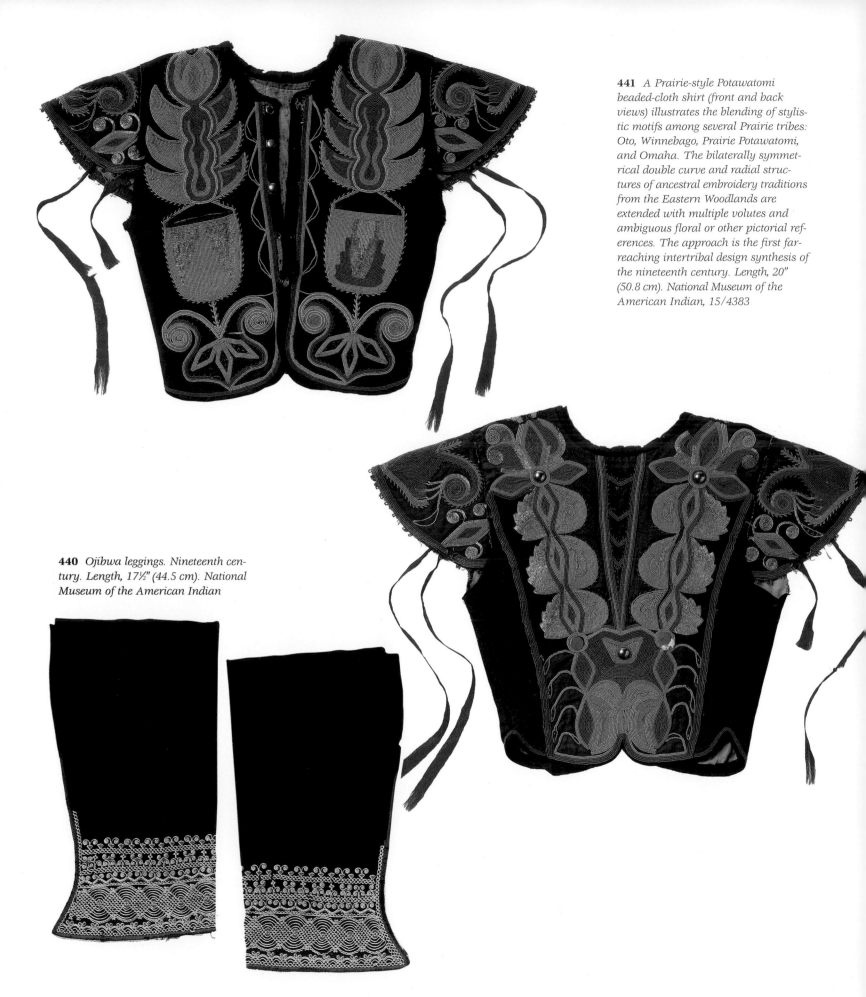

441 *A Prairie-style Potawatomi beaded-cloth shirt (front and back views) illustrates the blending of stylistic motifs among several Prairie tribes: Oto, Winnebago, Prairie Potawatomi, and Omaha. The bilaterally symmetrical double curve and radial structures of ancestral embroidery traditions from the Eastern Woodlands are extended with multiple volutes and ambiguous floral or other pictorial references. The approach is the first far-reaching intertribal design synthesis of the nineteenth century. Length, 20" (50.8 cm). National Museum of the American Indian, 15/4383*

440 *Ojibwa leggings. Nineteenth century. Length, 17½" (44.5 cm). National Museum of the American Indian*

GREAT LAKES RIBBON WORK

Shiny trade-silk ribbon had the luminous surface that precontact Woodlands peoples admired in aboriginal shell and copper. The Micmac were working with ribbon appliqué as early as 1611. When the French revolutionary regime of 1789 legislated simplicity in dress, an abundance of silk ribbon, no longer fashionable in France, entered North America through the fur trade, enabling Native artisans to create elaborate designs.

Silk-ribbon appliqué and glass beadwork grew larger and more exaggerated on dress clothing in the nineteenth century. Enhancement of formal dress became an important means of maintaining presence and pride. By wearing superbly crafted and designed ceremonial regalia, the Indian people responded on their own terms to the Euro-American pressure to adopt white dress.

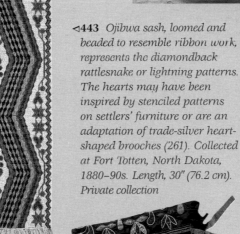

444 *An Osage girl wears a robe decorated with ribbon appliqué, hand motifs, and silver brooches. The robe, though made of trade materials, became a "traditional" style associated with the Osage. Smithsonian Institution*

442 *A Winnebago shoulder bag made with wool fabric and yarn, cotton fabric and thread. The glass beadwork repeats a relatively basic geometric pattern ("otter tail") in alternating colors derived from ribbon work. Collected in Wisconsin, c. 1890. Length, 35¼" (89.5 cm). The Detroit Institute of Arts, Founders Society Purchase, 81.429*

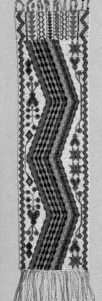

◁**443** *Ojibwa sash, loomed and beaded to resemble ribbon work, represents the diamondback rattlesnake or lightning patterns. The hearts may have been inspired by stenciled patterns on settlers' furniture or are an adaptation of trade-silver heart-shaped brooches (261). Collected at Fort Totten, North Dakota, 1880–90s. Length, 30" (76.2 cm). Private collection*

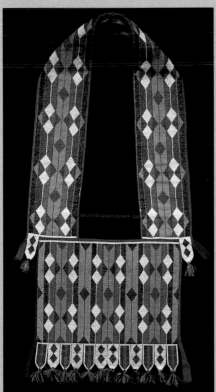

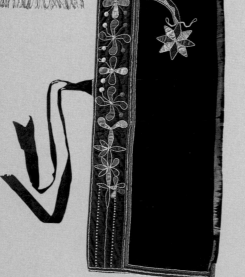

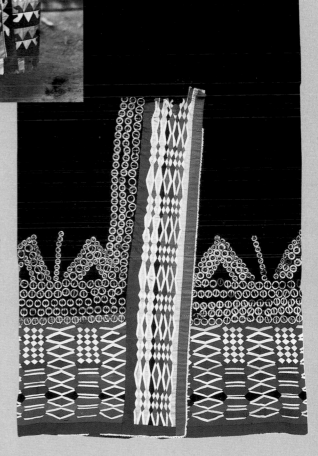

△ **445** *Miami skirt made with wool fabric, silver brooches, silk ribbon. Collected in Indiana, 1820–40. Length, 55½" (141.0 cm). The Detroit Institute of Arts, Courtesy Cranbrook Institute of Science, CI 52221*

◁**446** *Ojibwa hood. Cloth, silk, beads. Length, 26½" (67.3 cm). National Museum of the American Indian, 13/5899*

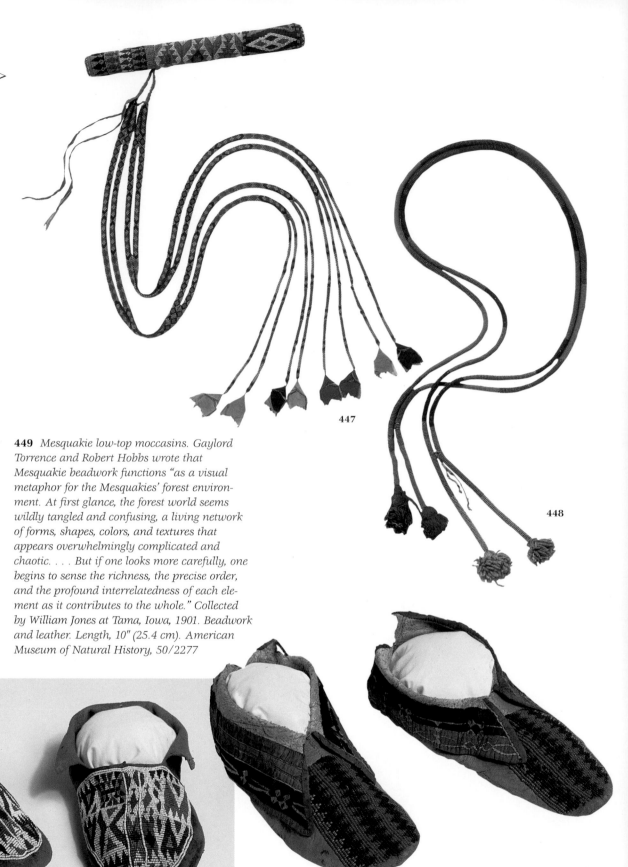

447 *Mesquakie (Fox) woman's hair* ▷ *wrapping. A Mesquakie woman wore ribbons in her long hair, which she parted in the center and bound at the back with an elaborately beaded wool-cloth hair binder. She wound the binder around her hair and secured it with a short band of woven beadwork. Two long beaded pendants hung from the band to within a foot of the ground. The pendants' designs became increasingly complex as the bands divided and subdivided. Both pendants and binder were of great spiritual significance for the woman, particularly the pendants, which were believed to be imbued with her soul and, therefore, equal in spirituality to all of the sacred objects she might own. The act of creating these adornments was celebrated in ritual prayers for health and longevity. Collected by William Jones (Mesquakie) in Iowa, 1902. Wool, cotton, glass beads, silk ribbon. Length of roll, 11¹³⁄₁₆" (30.0 cm). Length of ties, 42⅛" (107.0 cm). American Museum of Natural History, 50/3545*

448 *Menomini necklace made from beads wrapped with cloth and wool tassels. Museum field notes recorded: "Insignia of a sundreamer—they represent the rays of the sun." Collected in Wisconsin, 1911. Length, 35" (88.9 cm). American Museum of Natural History, 50.1/5868*

449 *Mesquakie low-top moccasins. Gaylord Torrence and Robert Hobbs wrote that Mesquakie beadwork functions "as a visual metaphor for the Mesquakies' forest environment. At first glance, the forest world seems wildly tangled and confusing, a living network of forms, shapes, colors, and textures that appears overwhelmingly complicated and chaotic. . . . But if one looks more carefully, one begins to sense the richness, the precise order, and the profound interrelatedness of each element as it contributes to the whole." Collected by William Jones at Tama, Iowa, 1901. Beadwork and leather. Length, 10" (25.4 cm). American Museum of Natural History, 50/2277*

450 *Kickapoo moccasins made from hide, material, and beads. Collected in Oklahoma, 1914. Length, 10" (25.4 cm). American Museum of Natural History, 50.1/8063*

451 *This pair of moccasins with extraordinarily rich iconography was collected by anthropologist William Jones (Mesquakie, 1871–1909) in 1903 among the Turtle Mountain Ojibwa of Minnesota. Jones, born on the Sauk and Fox Reservation in Oklahoma to an English mother and Mesquakie (Fox) father, attended school in the East and became a protégé of the anthropologist Franz Boas. Jones carried out ethnographic work among the Ojibwa, the Sauk, and the Mesquakie in Tama, Iowa.*

Writing to Boas from Thief River Falls, Minnesota, on August 23, 1903, Jones provided a marvelously rare and detailed explanation of the iconography on moccasins worn by a Turtle Mountain Ojibwa for Sundance and Midewiwin ceremonies:

"The designs are seen against a background of white beads with a red border. The white beads stand for sunshine and the light of day; the red border is for the horizon and the limits of the world. . . . There are four diagrams [motifs]. One [the stepped checkerboard motif on the moccasin's front] looks like a manitou dwelling on high which the woman often calls Jesus. [Jones later adds that crosses seen on the moccasin's side are also manitous.*] The blue [pyramid] is for the sky and the world above, the above of the manitou. . . . The green [pyramid] stands for plant life here on earth. . . . At the front of the moccasins, the red beads denote rainfall . . . green beads is for plant life watered by the rain. . . . The red stem and top overhead [blue beadwork] means the ceasing of rain, ceasing with a benign result. All the figures are to be rendered as a whole and not in detail. As near as I could make out, the decoration is a graphic form of prayer. The woman's idea grew vague at this point, and I had to stop pumping."*

Jones further noted: "The woman's religious ideas were pretty well saturated with Christian influence. As a matter of fact, Catholic, Presbyterian, Church of England, and other people have spent time, energy and money to Christianize the little band but without any success whatsoever. It is only natural that in the process, some foreign ideas should fall into the woman's mind and take hold of her in a peculiar way. What interests me most . . . is the graphic form of the woman's ideas. Each element in the decoration is symbolic of something, yet at the same time dependent on others to form one central idea, namely an invocation to the manitou."

Moccasin length, 9⅜" (24.5 cm). American Museum of Natural History, 50/4643

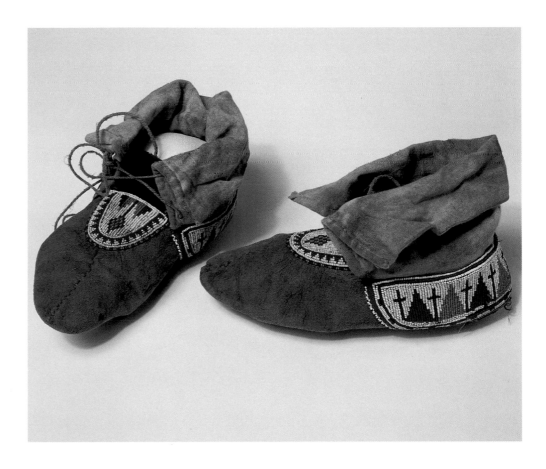

452 *Two Potawatomi men, Jack Davis and Rising Smoke. The leggings worn by Rising Smoke display high-quality Potawatomi ribbon appliqué. Smithsonian Institution*

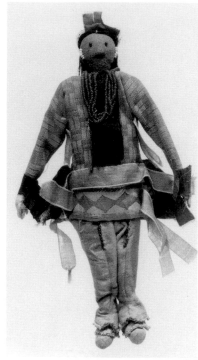

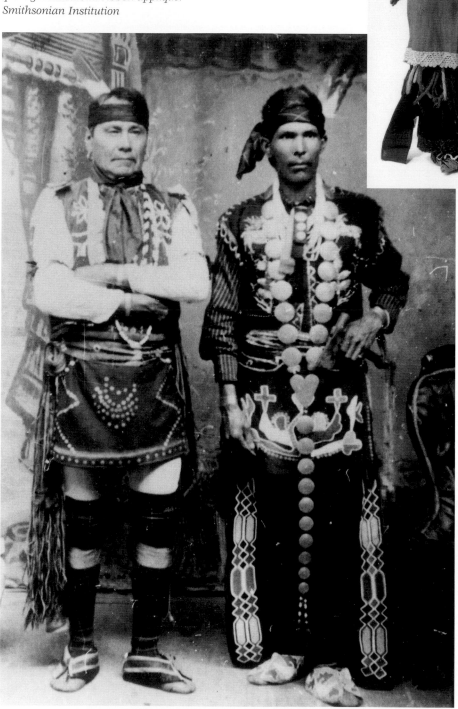

453

454

453 *This Winnebago doll was collected at River Falls, Wisconsin, 1909. Height, 9½" (24.1 cm). American Museum of Natural History, 50/7579*

454 *A Winnebago doll made by a Mrs. Baird, of Winnebago and French heritage, exemplifies Winnebago style, including ribbon appliqué. Green Bay, Wisconsin. 1882. Height, 8¼" (21.0 cm). Peabody Museum of Archaeology and Ethnology, Harvard University, 10/27540*

455 *As a teenager, bead-worker Elaine Buchanan Bear (Winnebago) worked from traditional examples, taking pieces apart "to understand how they were constructed." Like the earliest Winnebago beadwork, Buchanan Bear's floral embroidered skirt is outlined in white. 1995. Glass seed beads, black velveteen, German-silver brooches. Length, 34" (86.4 cm). Collection Buchanan Bear*

456 *Winnebago beaded dress with traditional brooches and modern bead-work colors on velveteen. Elaine Buchanan Bear. 1995. Length, 48" (121.9 cm). Collection Buchanan Bear*

455

457 The Indomitable Navajo. *"My pride and joy," says Winnebago artist Adam Funmaker of Fort Smith, Arkansas, who made the carving at age seventy-three, using a scrimshaw technique. 1995. Montana agate stippled with gold. Length, 2" (5.1 cm). Collection of the artist*

456

◁458 *Leonard McKinney (Potawatomi) wearing regalia that reflects his participation in World War II, the Wichita Warrior Society, and Native American Church: blanket, bandolier sash, and dance fan (459). The outfit's bicultural elements include the eagle—both a national symbol and a sacred aboriginal image—a red, white, and blue blanket adorned with McKinney's Second Infantry Division shoulder patches, emblems of the Warrior Society, and the Native medicine wheel. The U.S. Second Infantry badge displays the image of a Native American. 1980s. Mayetta, Kansas, 1994*

▽459 *Dance fan of macaw feathers for gourd dancing. Leonard McKinney. 1985–86. Describing his inspiration, he states, "In our religious ceremonies, we use everything that God created. This was so even a thousand years before Columbus came. In choosing materials, we don't go to the store to buy things; we don't throw anything away; we take what the creator made for us and use it in spiritual ways."*

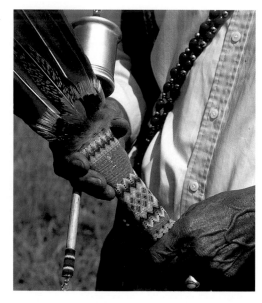

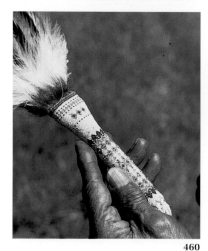

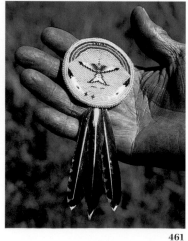

460 *Leonard McKinney combines beadwork and different kinds of feathers for a remarkably refined and elegant effect. This eagle-feather fan with peyote-stitch beadwork is used in healing and spiritual ceremonies. Because military veterans are warriors, they may wear eagle feathers. 1993. Collection of the artist*

461 *Beaded medallion worn to Native American Church ceremonies. The motifs include a rainbow, feathers, and the Waterbird, who carries prayers up to the Creator. The medallion, made by McKinney when he was in his late sixties, contains tiny #18 beads. c. 1986. Dyed woodpecker feathers, beads, leather. Diameter, 2⅜" (6.0 cm). Collection of the artist*

460 **461**

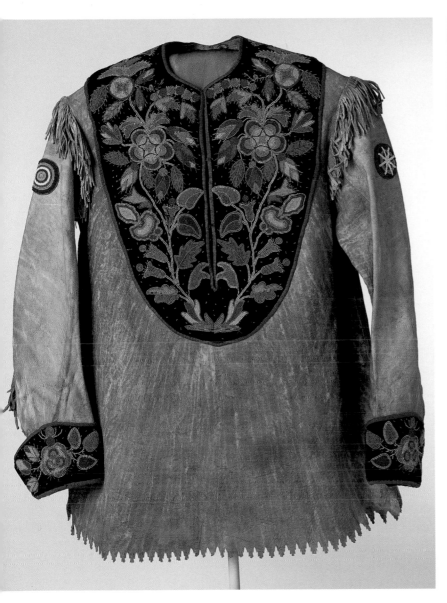
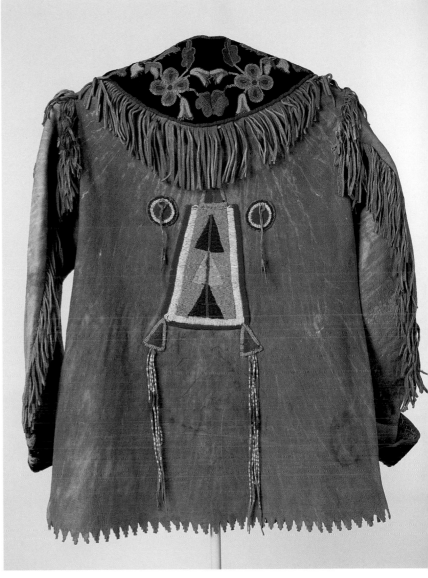

462 *An Ojibwa shirt (front and back) made from hide and adorned with metal danglers and floral beadwork. The Crow tomahawk cover sewn to the back may have been a gift to the shirt's owner. Attending each other's ceremonial activities, Plains and Woodland Indians took pleasure in exchanging gifts of clothing and adornment. Probably late nineteenth century. Length, 32" (81.3 cm). National Museum of the American Indian, 0/8935*

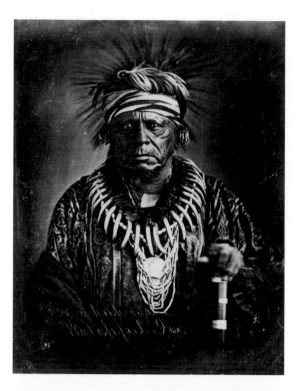

463 *Chief Keokuk, a highly regarded Sauk leader, wearing a bear-claw and otterskin necklace. Iowa. c. 1847. Smithsonian Institution*

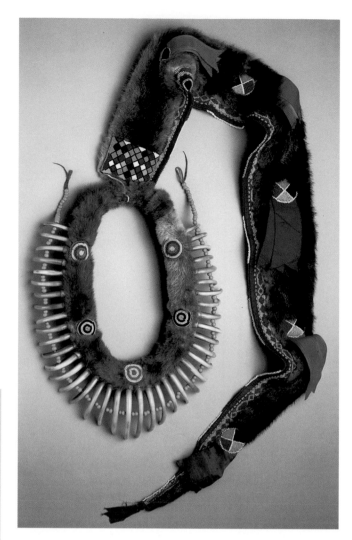

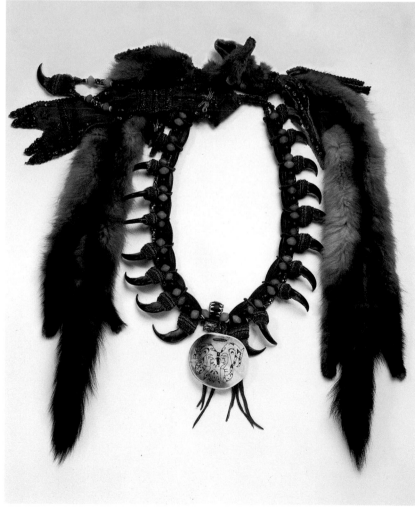

△ **464** *For Plains and Great Lakes warriors, matched bear-claw necklaces were badges of courage. Obtaining the claws from a dangerous animal was considered an act of great bravery. The necklaces of the Mesquakie, who lived where the Plains and Great Lakes merge, were among the finest. This example, elaborately ornamented with bead spacers, beadwork, and silk ribbons, incorporates claws of the now-extinct Great Plains grizzly bear. A long otter-fur trailer with beaded rosettes hangs in the back. Traditional Mesquakie regard this adornment as sacred and honor it annually. Attributed to John Young Bear (1883–1960). Iowa. c. 1920. Necklace diameter, 16" (40.6 cm), trailer length, 60" (152.4 cm). Buffalo Bill Historical Center, Gift of Larry Sheerin, NA 203.213*

465 *A contemporary bear-claw necklace with an etched-shell gorget and a dragonfly motif on the counterpoise. The artist, Tis Mal Crow of Southeastern Hitchiti and Lumbee heritage, grew up in Michigan and Minnesota. The combination of bear-claw necklace and shell gorget with ancient Mississippian cultural motifs acknowledges Tis Mal's dual Woodlands (Great Lakes and Southeast) heritage. Each of the twenty-one bear claws is sheathed in leather and beaded in lazy stitch—the artist's innovation. 1991. Bear claws, mink pelts, assorted antique Venetian glass beads. Gorget diameter, 3⁹⁄₁₆" (9.1 cm). Collection Magaly D. Rodriguez*

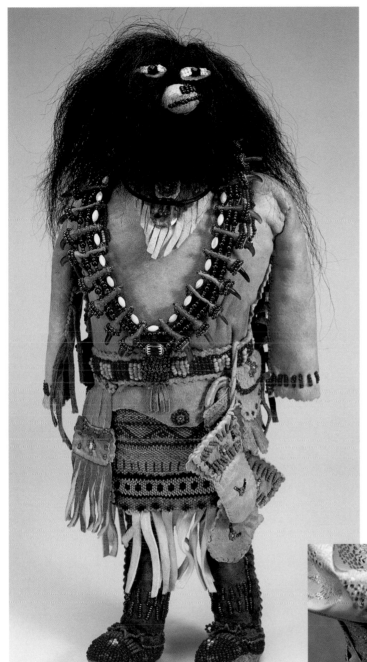

466 *A female bear transformation doll illustrates artisan Tis Mal Crow's belief in the interdependence of human beings and animals. Though clothed in a bear's skin and form, the doll appears human. Her hair is buffalo skin. Tiny, meticulously beaded leather mittens hang from her belt. Also beaded are her eyes and nose, dress yolk, shoes, and belt. The necklace is a miniature bear-claw necklace, perfectly scaled to size. The accessories (necklaces, bag, moccasins) are detachable—a feature of the finest quality dolls.*

Tis Mal's incorporation of animal skins and parts is based on his deeply held belief that an animal's death is a gift to human beings. He thanks the Great Spirit and says a prayer of gratitude to the animal. The bear claws come from controlled Canadian hunts. Parts not used are burned to return to the cycle of life. Extremely sensitive to every aspect of his work, Tis Mal Crow's gift is to transform ancient concepts and forms into his own vision.1994. Height, 16" (40.6 cm). Collection Ellie Sturgis

467, 468 *Johnny Hughes (Kansa), a traditional powwow dancer, wears a silver bracelet and a silver and brass pendant with bear-claw motifs. Both were crafted by his grandfather in the 1930s. His beaded outfit was made by his wife. Photographed at Red Earth Festival, Oklahoma City, 1994*

467

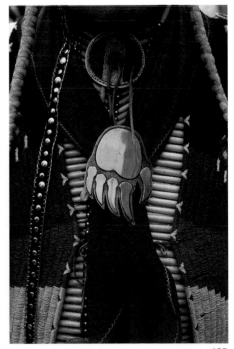

468

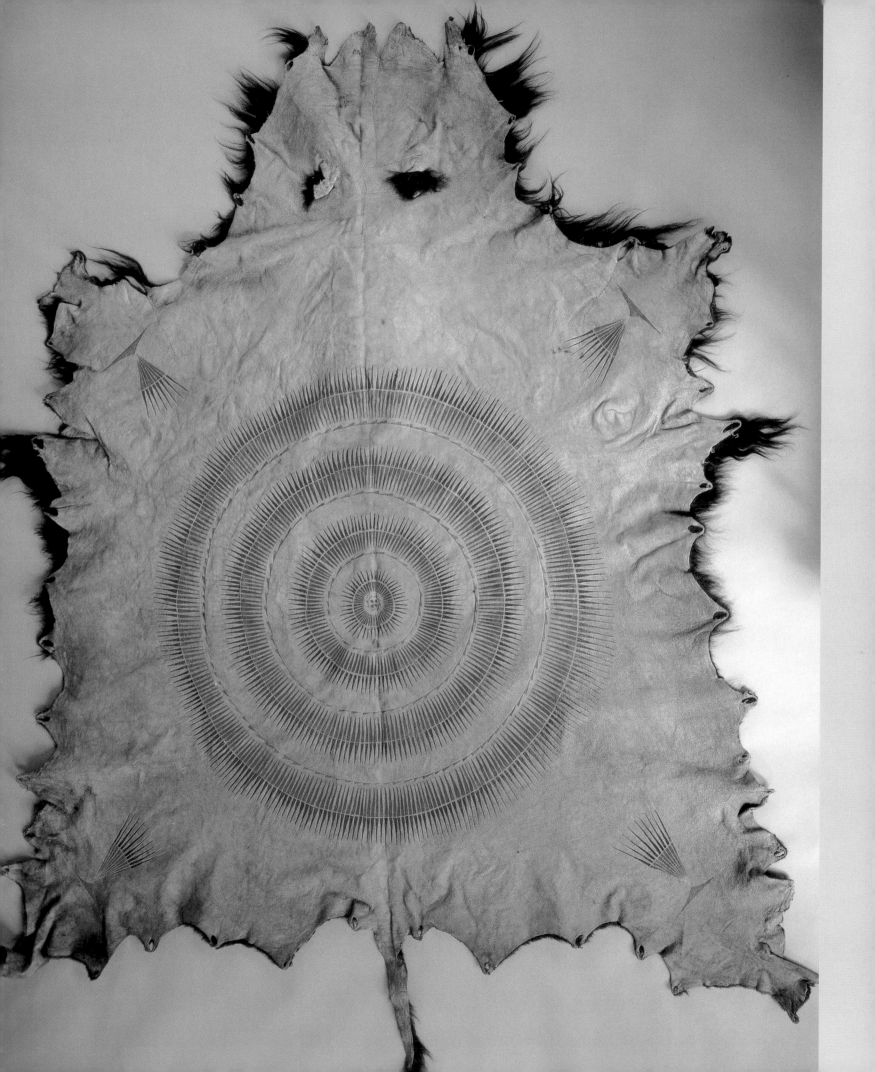

VISION QUESTS AND STRONG MEDICINE
THE PLAINS

"Indeed, when choosing objects for the grave, the ancient peoples chose the most beautiful, and when pecking or scratching images into rock, they rendered their dreams and visions, and to adorn their bodies, they reached up and grabbed the stars."

—**Max G. Pavesic, 1993**[1]

◁**469** *The "feathered-sun" symbol, represented by radiating lines and concentric circles, makes a visual connection between a fully opened eagle-feather warbonnet (65) and the sun. Both were associated with a successful Plains warrior. Wrapped in this majestic buffalo-hide robe, a warrior was allied with central radiating power. Lakota. c. 1870. Length, 10' (3.05 m). The University of Pennsylvania Museum, NA 3985*

470 *Contemporary beaded powwow regalia displays family-clan motifs reminiscent of ancient Plains rock art. Worn by Consuelo Lopez (Northern Arapaho) of the Wind River Reservation, the bear track honors Lone Bear, Lopez's paternal great-grandfather; the sun represents Runs Bear, her maternal great-grandfather. Photographed 1993*

470

471

472

471 *Incised sun petroglyph. Little Popo Agie, Wyoming c. A.D. 1300–75*

472 *Bear-track petroglyph. The powerful bear was an important source of protective medicine. South Pass, Wyoming. c. 500 B.C.–A.D. 100*

Continual movement defined the surroundings of the Indians of the Great Plains. Undulating grass stirred by incessant wind was mirrored by waves of migrating buffalo. Tribes following the great herds through seasonal cycles were themselves migrants in the boundless Plains universe. Lakota philosophy was stated by Iron Shell: "Such things as cherries and even buffalo don't stay long and the people must get them when they can."[2] The arrival of the horse empowered the people to "fly" across the plains and to travel great distances with greater ease than before. Horses and riders moving across the landscape not only participated in an "environment of motion" but also celebrated it by wearing gear and clothing with fringes, feathers, and kinetic colors.[3] Success in life was determined by guidance from spirit helpers. Plains people developed a special category of regalia made according to directions received from these supernatural beings during vision quests. Because of their magical origin, such objects—medicine necklaces, painted-hide robes and shields—held intrinsic protective power. Medicine artifacts were the most sacred thing a Plains individual or community possessed. Some were buried with the owners upon their demise. Others were protected for succeeding generations by specified "keepers."[4]

EARLY LIFE ON THE PLAINS

The Great Plains—stretching from the Mississippi and Missouri Rivers to the Rocky Mountain foothills and from central Alberta to southern Texas—possess a distinctive beauty comprised of expansive horizons and sky, constant wind, and immense grasslands. Although the Plains contain great environmental variation with rapidly changing temperature extremes, they have remained a grass biome for more than ten thousand years. In the eastern prairie, bluestem grows more than six feet high, while farther west, where there is less rainfall, short grasses such as blue grama and buffalo grass predominate. To the south, grasses compete with semidesert plants; along northern boundaries, tall grass merges into aspen groves.

Vast buffalo herds grazed on the nutrient-rich western range. Nathaniel Langford, the first superintendent of Yellowstone National Park, wrote in 1862: "The sky was perfectly clear, when we heard a distant rumbling sound, which we thought was thunder. . . . Soon we saw a cloud of dust rising in the east, and the rumbling grew louder and I think it was about half an hour when the front of the herd came fairly into view. . . . From an observation with our field glasses, we judged the herd to be 5 or 6 (some said 8 or 10) miles wide, and the herd was more than an hour passing us at a keen gallop. There seemed to be no space, unoccupied by buffaloes. . . . As far as we could see was a seemingly solid mass of buffaloes."[5]

Two relationships, practical and sacred, existed between the Plains Indian and the buffalo. The buffalo provided a source of food, clothing, even shelter in the form of buffalo-hide tipis. Their broad usefulness made the buffalo a central aspect of Plains life and an important symbol of the Native universe. Tragically, these animals—estimated at 60 million in the 1850s—were

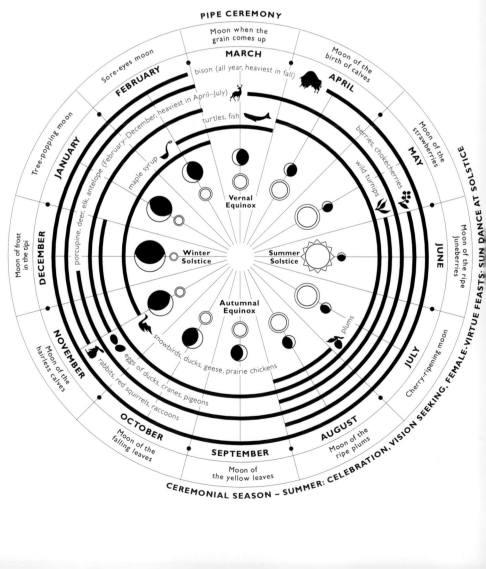

Seasonal Round of the Lakota

nearly extinct by 1890, the result of systematic government attempts to force the Plains tribes onto reservations through eliminating their main source of sustenance.

The ability to adapt and change has been pivotal in Plains human history. Within the region—occupied for at least eleven thousand years by hunting and gathering peoples—cultural adaptations were varied and changing: there was never any "typical" Plains Indian. The most distinctive differences were between tall-grass Prairie farming societies and short-grass Plains nomads, who nevertheless were linked by an exchange of food, hides, and adornment materials.

Among the earliest recorded ornaments in North America were those worn by Paleo-Indian bison hunters. A bone bead, a circular lignite bead engraved with lines radiating from a center hole, and a perforated hematite ornament—were unearthed at the Lindenmeier site in northeastern Colorado; all date back to c. 8800 B.C. The Lime Creek sites in Nebraska yielded traces of yellow and red ocher pigment dating from 6900 B.C. to 6200 B.C. A north-central Kansas site, dating to 3200 B.C., contained a fired-clay tube possibly intended for personal adornment. Paleo-Indians exchanged fine-grained stones—agates, obsidian, flint, and quartzite—for tools, although no adornment made from these stones is recorded. Since A.D. 100, Gulf and Pacific Coast shells were traded onto the Plains. Mound sites at the junction of the Missouri and Kansas Rivers revealed shell beads of marginella and olivella. Dentalium ornaments from Vancouver Island had reached the northwestern Plains by the first millennium.[6]

By A.D. 900, Missouri River villagers were growing maize. Because of their location and stability, the riverine agricultural settlements of the Mandan, Hidatsa, Arikara, Pawnee, and Wichita—(the "Old Settlers")—became natural trade and cultural hubs for Woodlands and Mississippian societies to the east and Plains groups farther west.[7]

The reintroduction of the horse to North America by Spanish explorers during the seventeenth and eighteenth centuries (horses had originally lived on the American continent but disappeared during the Pleistocene) fostered dramatic changes in Plains lifeways. With the greater availability of horses, rifles, and bison, hunter-gatherers already residing on the Plains—the Blackfeet, Crow, Comanche, and Kiowa—as well as Great Lakes agriculturists who moved onto the Plains—the Cheyenne, Dakota, Lakota, Arapaho, and Gros Ventre—swiftly transformed into nomadic equestrian hunters.

Life on the move prohibited heavy possessions. In early semisedentary Prairie and Woodland cultures, goods had been stored in bulky and fragile clay pots, grass baskets, and birch-bark containers. On the Plains, these were replaced by lightweight, water-proof, and durable skin containers available from the multitude of animals hunted for food. Hides were decorated by incising, scraping, painting, quilling, and, eventually, beading. Vibrant, embellished containers used for transporting food, medicine, clothing, weapons, and household goods became, like clothing, an important means of aesthetic expression, meant to be viewed in motion and from afar. For many non-Natives, these horse-mounted, buffalo-hunting Plains people in spectacular regalia—altogether more than twenty tribes—came to symbolize the American Indian.

In the Plains cultures, men were hunters, warriors, and ritual leaders; women raised children, produced food, and were active intertribal traders. Traditional values upheld the importance of women's craftwork: quilling, beading, and tanning hides. In all tribes, women gained status for the excellence of their work, often specializing in a particular craft. Women obtained visions (though they were rarely sought), and some became shamans with curing powers, especially after menopause. To bring her husband good luck (and undoubtedly ensure her faithfulness) during a war party, a Wichita wife would exchange her fine clothes for old or ragged ones and remove herself from society until her husband's return.[8]

474 *Shamanic figure with horns, a petroglyph carved as part of a vision or religious ritual. Whiskey Basin, Wyoming, c. 500 B.C.–A.D. 100*

475 *Bird-man petroglyph, similar to Mississippian bird-man imagery (278). Wyoming*

473

474

473 *An etched dot-and-line tally, probably a form of mnemonic recording. Wyoming*

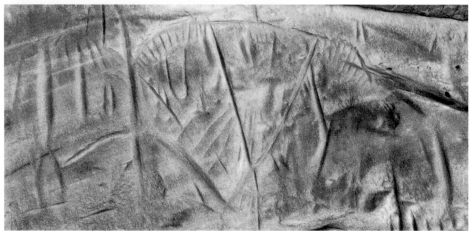

475

478 *Tipi petroglyph exemplifying the increased realism in Native pictorial imagery following contact. Wyoming, c. A.D. 1750–1900*

476

476 *Turtle petroglyph. The turtle is important in many Plains origin stories. Red Canyon Site, Wyoming*

477 *A hunter in pursuit of an elk, an early example of Plains narrative imagery. Wyoming, c. 3000 B.C.–A.D. 500*

477

478

At early contact, Plains fashion consisted of hide clothing decorated with paint, porcupine quills, bird feathers, and shells. Adornment was applied in symbolic designs and colors. Men's outfits included shirts, leggings, and moccasins; women wore dresses, short leggings, and moccasins. Robes were used by all. Children's clothing was a miniature version of adult dress. The cut and decorative elements varied from tribe to tribe. In the north, quillwork was traditional while to the south, outside the porcupine's range, painted attire was common.

Hairdressing and face and body paint were important for self-presentation. Hair ornaments included feathers, beads, "hairpipes" (tubular ornaments of shell), braid wraps, and trailers. Necklaces, chokers, and breastplates of porcupine quills, shells, beads, and bone were popular. Both sexes wore earrings, head- and armbands, bracelets, rings, and decorated belts to which nineteenth-century women often added a trailer with her tools—a knife sheath, awl case, and "strike-a-light" (flint) pouch (593). Mussel-shell gorgets, dentalia, and abalone-shell ornaments were coveted. By the late eighteenth century, cylindrical-shell wampum appeared on the eastern Plains on clothing and war clubs and as jewelry.[9] The Kiowa attached turtle bones, sometimes painted red or black, to dresses and necklaces.

After contact, European trade goods created a new economy and broader aesthetic interchange. The upper Missouri villages, until decimated by European diseases, continued as lively centers of intertribal trade and cultural exchange. The Crow, who coveted Teton-Sioux painted robes, traded their own decorated clothing to the Hidatsa and Mandan. Mandan-Hidatsa quillwork was prized by the Cree and Assiniboine, and Assiniboine beaded moccasins were avidly sought by Blackfoot women. Elaborately decorated clothing was made by the Red River Métis for trade to all of the northern and central Plains groups.[10]

During the nineteenth century, Plains lifeways were drastically altered. From 1825 to 1875, the Prairie groups were decimated by white settlers, tribal warfare, and disease; between 1850 to 1890, the people of the high Plains were subdued by conquest and extermination of the buffalo. Some tribes became extinct; others formed new alliances. All were restricted to reservations. The resilient Plains people, including artisans, reacted to this profound upheaval with remarkable creativity, often by reinforcing or reviving traditional practices and forms. While imported goods considered status items—blue and red cloth, colored glass beads, and metal bells—were associated with sacred regalia during the first half of the nineteenth century, by the century's latter half, European trade goods were used less frequently with sacred articles. Some tribes emphasized using indigenous materials in religious ritual. Glass beads were, after all, unknown to the Sioux when the White Buffalo Calf Woman brought the holy pipe to the people from *Wakan Tanka*, the Great Spirit.[11]

479 *A rock-art panel associated with hunting magic combines a shield-bearing warrior, hunters, a killed buffalo with a "spirit line," and Morning Star—elements from both earthly and sacred worlds. It reflects traditional Plains warrior lifeways in which secular activities were integrated with spiritual beliefs and ceremonial rituals. Little Popo Agie, Wyoming,* A.D. *1300–1775*

THE PLAINS

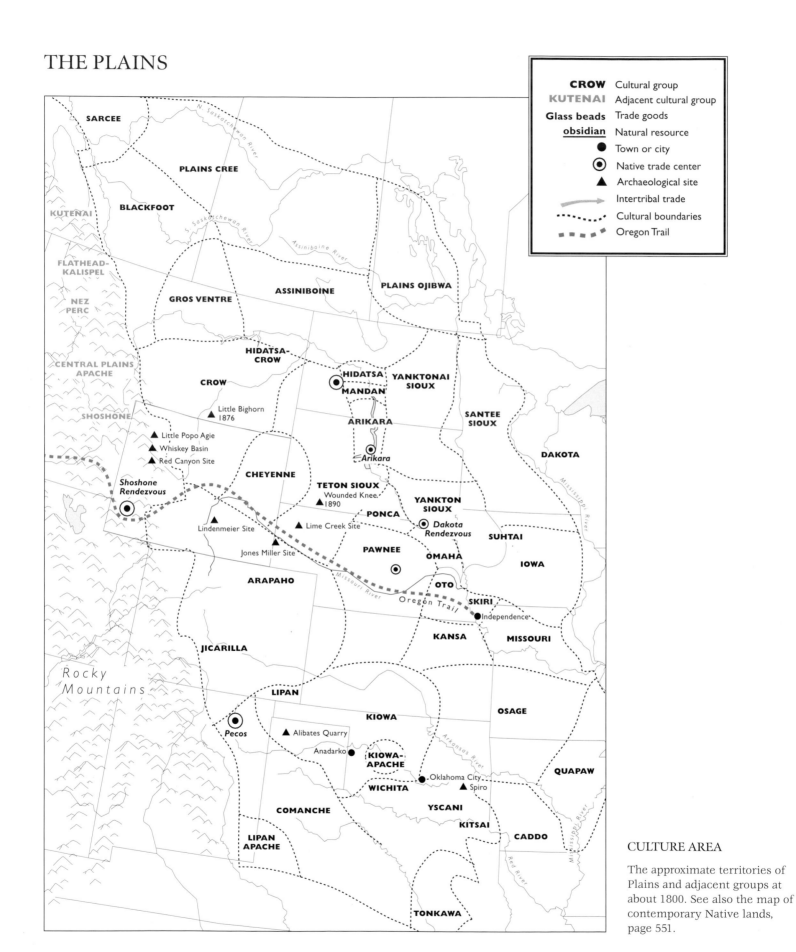

Legend:
- **CROW** — Cultural group
- **KUTENAI** — Adjacent cultural group
- **Glass beads** — Trade goods
- **obsidian** — Natural resource
- ● Town or city
- ◉ Native trade center
- ▲ Archaeological site
- → Intertribal trade
- ···· Cultural boundaries
- - - - Oregon Trail

SARCEE

PLAINS CREE

KUTENAI

BLACKFOOT

FLATHEAD-KALISPEL

NEZ PERC

CENTRAL PLAINS APACHE

GROS VENTRE

ASSINIBOINE

PLAINS OJIBWA

SHOSHONE

HIDATSA-CROW

CROW

HIDATSA

MANDAN

YANKTONAI SIOUX

ARIKARA

SANTEE SIOUX

▲ Little Bighorn 1876

▲ Little Popo Agie
▲ Whiskey Basin
▲ Red Canyon Site

Arikara

DAKOTA

CHEYENNE

TETON SIOUX

Wounded Knee ▲ 1890

YANKTON SIOUX

Shoshone Rendezvous ◉

▲ Lindenmeier Site

▲ Lime Creek Site

PONCA

Dakota Rendezvous ◉

SUHTAI

▲ Jones Miller Site

PAWNEE ◉

OMAHA

IOWA

ARAPAHO

OTO

SKIRI

N. Saskatchewan River
S. Saskatchewan River
Assiniboine River
Missouri River
Mississippi River

Oregon Trail

● Independence

JICARILLA

KANSA

MISSOURI

Rocky Mountains

LIPAN

KIOWA

OSAGE

Pecos ◉

▲ Alibates Quarry

Anadarko ●

KIOWA-APACHE

Arkansas River

QUAPAW

● Oklahoma City
▲ Spiro

WICHITA

COMANCHE

YSCANI

KITSAI

CADDO

LIPAN APACHE

Red River

Mississippi River

TONKAWA

CULTURE AREA

The approximate territories of Plains and adjacent groups at about 1800. See also the map of contemporary Native lands, page 551.

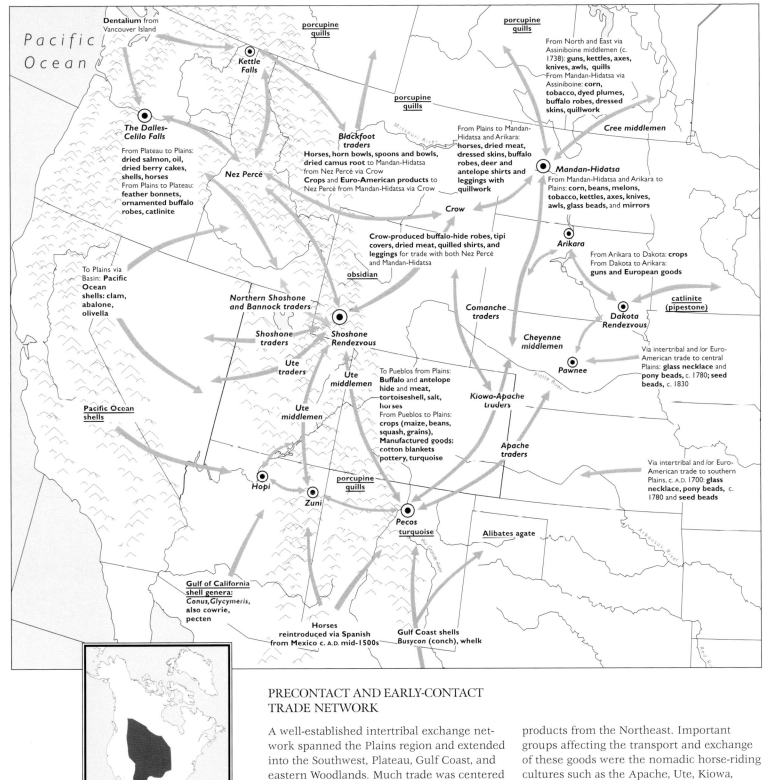

Dentalium from Vancouver Island

Pacific Ocean

porcupine quills

porcupine quills

porcupine quills

From North and East via Assiniboine middlemen (c. 1738): **guns, kettles, axes, knives, awls, quills**
From Mandan-Hidatsa via Assiniboine: **corn, tobacco, dyed plumes, buffalo robes, dressed skins, quillwork**

Kettle Falls

Missouri River

Cree middlemen

The Dalles-Celilo Falls

From Plateau to Plains: **dried salmon, oil, dried berry cakes, shells, horses**
From Plains to Plateau: **feather bonnets, ornamented buffalo robes, catlinite**

Nez Percé

Blackfoot traders

Horses, horn bowls, spoons and bowls, dried camus root to Mandan-Hidatsa from Nez Percé via Crow
Crops and **Euro-American products** to Nez Percé from Mandan-Hidatsa via Crow

From Plains to Mandan-Hidatsa and Arikara: **horses, dried meat, dressed skins, buffalo robes, deer and antelope shirts and leggings with quillwork**

Mandan-Hidatsa
From Mandan-Hidatsa and Arikara to Plains: **corn, beans, melons, tobacco, kettles, axes, knives, awls, glass beads, and mirrors**

Crow

Arikara

From Arikara to Dakota: **crops**
From Dakota to Arikara: **guns and European goods**

Crow-produced **buffalo-hide robes, tipi covers, dried meat, quilled shirts,** and **leggings** for trade with both Nez Percé and Mandan-Hidatsa

obsidian

To Plains via Basin: **Pacific Ocean shells: clam, abalone, olivella**

Northern Shoshone and Bannock traders

catlinite (pipestone)

Dakota Rendezvous

Comanche traders

Cheyenne middlemen

Shoshone traders

Shoshone Rendezvous

Via intertribal and/or Euro-American trade to central Plains: **glass necklace and pony beads,** c. 1780; **seed beads,** c. 1830

Ute traders

Pawnee

Ute middlemen

To Pueblos from Plains: **Buffalo** and **antelope hide and meat, tortoiseshell, salt, horses**
From Pueblos to Plains: **crops** (maize, beans, squash, grains), **Manufactured goods; cotton blankets pottery, turquoise**

Kiowa-Apache traders

Pacific Ocean shells

Ute middlemen

Platte River

Apache traders

Via intertribal and/or Euro-American trade to southern Plains, c. A.D. 1700: **glass necklace, pony beads,** c. 1780 and **seed beads**

Hopi

porcupine quills

Zuni

Pecos
turquoise

Alibates agate

Arkansas River

Gulf of California shell genera: *Conus, Glycymeris,* also cowrie, pecten

Rio Grande River

Horses reintroduced via Spanish from Mexico c. A.D. mid-1500s

Gulf Coast shells *Busycon* (conch), whelk

Red R.

PRECONTACT AND EARLY-CONTACT TRADE NETWORK

A well-established intertribal exchange network spanned the Plains region and extended into the Southwest, Plateau, Gulf Coast, and eastern Woodlands. Much trade was centered on the Mandan-Hidatsa and Arikara villages located along the upper Missouri River, where surplus agricultural products were exchanged for those of the hunt. Tribal groups in the northern Plains were situated between two major primary sources of trade goods: horses from the Southwest and European products from the Northeast. Important groups affecting the transport and exchange of these goods were the nomadic horse-riding cultures such as the Apache, Ute, Kiowa, Comanche, and Cheyenne, some of whom traveled long distances to the upper Missouri mercantile centers, bringing their items and taking away others. These goods were then exchanged within the interior Plains. The Crow became intermediaries between the Mandan-Hidatsa and the Nez Percé to the west.

VISIONARY SYMBOLISM

Plains imagery incorporates both visionary (sacred and ceremonial) and narrative (secular) motifs. Visionary symbols, documenting deeply held beliefs, have remained remarkably consistent for thousands of years.

Although shamans were acknowledged to have special abilities for communicating with the sacred world, each person in the highly individualistic Plains societies desired to receive empowerment through private vision experiences. "This was [and remains] the gift from our creator,"[12] remarks Crow tribal elder George Reed.

Leading the dangerous life of warriors and hunters, Plains men sought visions. To obtain medicine (spiritual aid), they fasted and prayed in secluded places where the supernatural was thought to reside. If the seeker was successful, spirits revealed themselves in the form of birds, animals, or celestial or mythical beings. Each served as a protector by endowing its special potency to the warrior: the coyote its cunning, the bear its strength, the eagle its connection to Sky World. Spirits also provided rituals, songs, and dances to be used during times of need: i.e., hunting, warfare, love, and healing. Those unable to achieve visions could seek the assistance of a medicine man.

Visions were recounted in detail to tribal elders, who interpreted the meaning and confirmed its authenticity. To commemorate the experience and ensure that the power remained, recipients carved a petroglyph, painted a hide shield, and always wore or carried some material form representing the animal or object from which the power was received (489). These paintings and necklaces were more than records: the process of creating them helped transmit supernatural power from the object to the maker.[13]

Ancient Mississippian beliefs reached into the Plains. Woodlands and Plains groups recognized a universe of three parallel worlds—Sky World, This World, and Under(water) World—each with its own pantheon of spirit powers. In both regions, the most powerful Sky World spirit was Thunderbird, whose flashing eyes and flapping wings produced lightning and thunder.

Complex ideas concerning colors, the numbers 4 and 7, stars, and wind power are found throughout Plains cosmology.[14] Peyote-induced hallucinations associated with Native American Church rituals also assist humans in contacting spirit helpers.

Sky-Related Traditions

Plains people, living under a brilliant, looming sky, were close observers of celestial events. The Lakota and Pawnee had particularly sophisticated star knowledge. A fundamental concept in Lakota cosmology is mirroring, or acknowledging the existence of "significant relationships" between the stars and certain land forms. "They are the same," says Stanley Looking Horse, "because what is on earth is in the stars, and what is in the stars is on the earth." The circle of stars correlated to the Black Hills closely resembles the red clay valley encircling the Black Hills. The Lakota Spring journey was tied to "following the sun" through a specific set of constellations that had earthly counterparts in the landscape. The Lakota image of a star is not a two-dimensional triangle but a cone or vortex of light slanted down. The Lakota viewed the true inner shape of the stars and sun as an inverted tipi—V—which embodies a mirror image of the sacred above and below: X. Reflections of each other, together they form a unity.[15] Adds George Reed, "If you observe the two shapes, you notice that one is always upright and the other is upside down. Whatever direction you might go, you will always upend your enemy. You find these shapes on a lot of regalia and pipebags."

The Pawnee, of southern Caddoan heritage, lived in the Kansas and Nebraska prairie. The Skidi band of the Pawnee were especially obsessed with the night sky: the

Milky Way was their Spirit Path. Mapping stars on hide, they followed the tracks of the sun, moon, and planets. Skidi villages were laid out astronomically, and sky symbols decorated the people's belongings (557). Shell symbolized the moon; a constellation found in the Milky Way and known as Bird's Foot was painted with red pigment on a warrior's forehead. A celestial object, probably Orion Nebula, was called *u:pirikiskuhka,* Star-with-the-Downy-Feather-Headdress. A mythical woman is identified as a comet in a Pawnee origin story: "About her throat she wore some glittering object which looked like a star. Her head was in darkness, but down feathers stood up straight from it, signifying that she was in reality a comet."[16]

Standing on the open plains, one sees in every direction a continuous, level horizon encompassed within the dome of the sky. "All points appear equally distant, and there is an impression of living inside a circular field of vision," observed Richard Conn.[17] The sun (the Great Spirit) and the wind, originating from the Great Spirit's breath, were integral with the cardinal directions in that they caused the changing of the seasons. It is not surprising, therefore, that the four cardinal directions comprise the essential Plains motif. Regional variations include a square cross and a concave-sided square or rectangle—generally with a line or feather motif extending from each corner (585).[18]

Large porcupine-quill disks simultaneously represented the sun and cardinal directions; quills symbolized the sun's rays. Distinctive to the northern Plains, these quilled disks adorned men's clothing (558) as well as tipis.[19]

Because of their ability to fly, birds were messengers from sky powers to earth-bound humans. Eagle, chief of all birds and associated with Thunderbird, was a representative of the sun and subsequently the most potent sky creature. A powerful sun symbol is the Plains warrior's eagle-feather warbonnet—"a feathered sun" composed of concentric circles of eagle feathers (65). These radiating lines of feathers represented both the sun's rays and the spiritual power of the bird messenger. Wearing the eagle-feathered bonnet, the warrior actually became the eagle and identified himself with the Great Spirit.[20]

Linked Associations

Within the Plains, a "linked chain of associations" joins seemingly dissimilar companions such as the spider and bull elk. "Their unifying connection is the invisible power of the wind. . . . The spider had access . . . because his ensnaring net stretches out to the four directions, which are conceived as the home of the four winds. The elk's utilization of this wind-power was witnessed in his ability to 'whistle' in such a manner that cows were attracted to him."[21] Both the bull elk and spider were associated with power over women—the bull elk through sexual prowess, the spider through cunning—explaining the appearance of spiderwebs on the back of the Elk Dreamer's vest (540).

Color

Color had meaning for all Plains people, though interpretations differed among tribes. For example, at the foundation of Lakota belief and ritual was the Sacred Pipe story, in which, after bringing the Sacred Pipe to the Lakota, White Buffalo Calf Woman—the Great Spirit's "two-legged" messenger to earth—explained the importance of red: "With this pipe you will be bound to all your relatives. . . . This round rock which is made of the same red stone as the bowl of the pipe . . . is the Earth, your grandmother and Mother, and it is where you will live and increase. This Earth which He has given to you is red; and the two leggeds who live upon the Earth are red; and the Great Spirit has also given to you a red clay, and a red road."[22]

A Lakota warrior's red paint, produced by burning a local yellow clay until it turned red, was manufactured with ceremony in the Black Hills. The paint was given protective power through the songs and prayers performed as the paint was heated, formed into a disk, and perforated.[23]

Blue also held a sacred place in Lakota symbolism. Black Elk described why rites performed after a young girl's first menstrual period included the use of blue paint: "Blue is the color of the heavens, and by placing the blue upon the tobacco which represents the earth, we have united heaven and earth, and all has been made one."[24] A traditional source of the color was blue clay, found in southern Minnesota, the original Lakota homeland. After the arrival of glass beads, the Lakota tended toward sky-blue beaded backgrounds, which may represent sky or water. A blue beaded yoke on a deerskin dress was called "blue breast beading."[25]

The ancient custom of "overpainting" is recorded among the Blackfeet, Sarcee, and Gros Ventre. A Blackfoot hide shirt, for instance, would be stained with red ocher. On the garment's upper portion, the red would be overpainted with another pigment, producing—when viewed at a certain angle—a dark blue to purple shining hue whose symbolism has been interpreted as "hidden sun power."[26]

SYMBOLIC SYSTEMS AND CLOTHING

Sacred imagery was integrated into Plains clothing. Early-contact animal-skin dresses or shirts retained much of the animal's form: almost none of the hide was cut (see 561, 568). In the same way that Arctic Natives identified themselves with the caribou, whose skins they wore (159), Plains people believed that qualities or powers of the buffalo were imparted through clothing made from their hides. Neck flaps on Sioux, Blackfoot, and Cree men's shirts, through both their structure and embellishments, were symbolic statements. Heavily embellished triangular neck elements have also been described as "shields," the designs providing the shielding protection[27] (560). Men's bison bull-hide robes displayed sacred eagle-feather warbonnet symbols; women's bison cowhide robes were decorated with abstract female reproduction motifs.[28] Some designs used to decorate women's clothing were thought to have been received in dreams. Such designs "belonged" to certain families and were handed down from mother to daughter. The individual colors and symbols of parfleche painting may also have influenced beadwork artists, who also expressed family colors and symbols in beadwork.[29]

Fringes were important Plains elements, extending "the individual in a symbolic way beyond the suit of clothing," relates anthropologist Leslie H. Tepper. "Even when fringes are minimal or absent, the ends of a garment hem or sleeves are usually mediated by a pinking cut, dangling tassels or some other form of undulating extension into the surrounding space. . . . The use of extra materials to cut for fringing was also a form of conspicuous consumption among wealthy families."[30]

Crow women's beaded wedding robes are eloquent examples of symbolic imagery in Plains clothing. Crafted for the bride by women of the groom's family, the robe is a "wedding contract" denoting individual, familial, and tribal bonds. The robes are of elk hide, an important product and symbol of the Crow's natural world. Blue and yellow, the colors most frequently used in the robe's beadwork, evoke the bountiful Crow summer landscape. Circles and the number 4, a conceptually significant relationship within Crow beliefs, are also given expression: "The bead, a circular form, is applied through the movement of needle and thread to the surface of the four cornered animal hide," writes Ann S. Merritt.[31]

MEDICINE NECKLACES

Spiritually and visually powerful adornment, medicine necklaces were created following a successful vision quest to commemorate contact with the supernatural and preserve private messages known only to the owner. Their power was weakened if the secrets were revealed. Spirits encountered in visions directed the seeker's choice and assemblage of the highly symbolic objects. Medicine necklaces were often stored as individual or miniaturized medicine bundles within cloth wrappings.

481

480

480 *Cree medicine necklace of buck-skin-covered rolls with painted dots and lines, red-stained animal teeth, and tin cones. Collected near Red River, Manitoba, c. 1936. Length, 37⅜" (94.8 cm). The University of Pennsylvania Museum, L-84-1962*

481 *Sarsi war-charm necklace, worn to keep bullets from penetrating the body during battle. Constructed from fur, feathers, silver, stroud, glass beads, and goldenrod seed pods. A small bag contains the seeds of the plant from which the pods were taken. An owl skin is tied to the necklace's base. Made by Prairie Hen. Collected 1905. Length, 30" (76.2 cm). American Museum of Natural History, 50/5891*

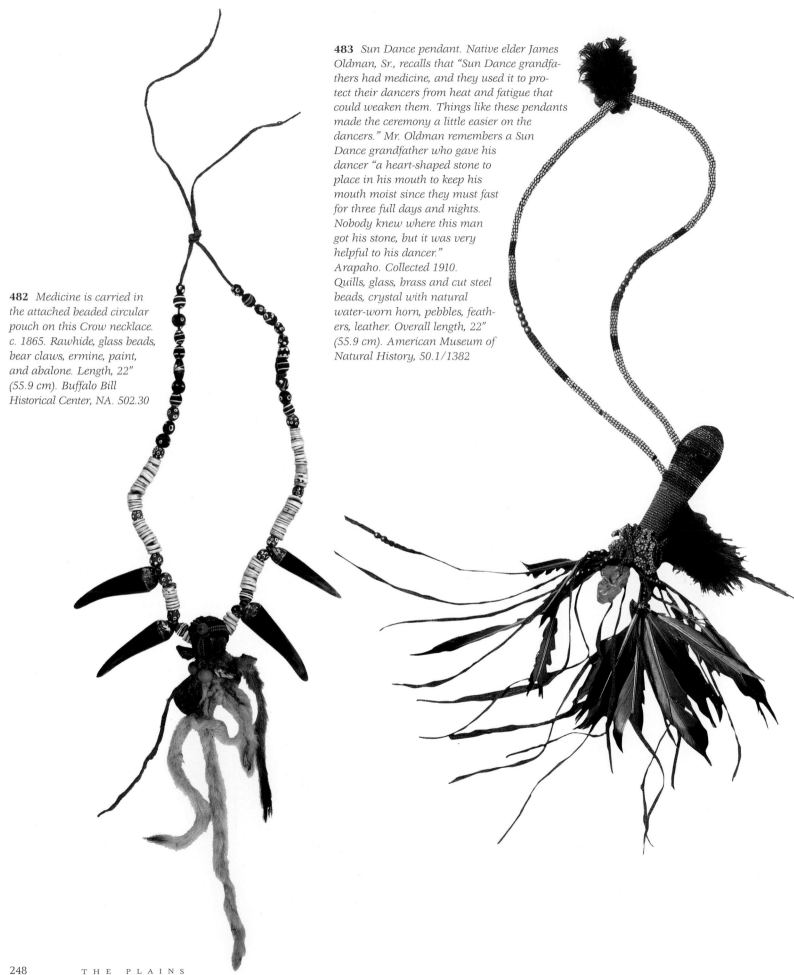

482 *Medicine is carried in the attached beaded circular pouch on this Crow necklace. c. 1865. Rawhide, glass beads, bear claws, ermine, paint, and abalone. Length, 22" (55.9 cm). Buffalo Bill Historical Center, NA. 502.30*

483 *Sun Dance pendant. Native elder James Oldman, Sr., recalls that "Sun Dance grandfathers had medicine, and they used it to protect their dancers from heat and fatigue that could weaken them. Things like these pendants made the ceremony a little easier on the dancers." Mr. Oldman remembers a Sun Dance grandfather who gave his dancer "a heart-shaped stone to place in his mouth to keep his mouth moist since they must fast for three full days and nights. Nobody knew where this man got his stone, but it was very helpful to his dancer." Arapaho. Collected 1910. Quills, glass, brass and cut steel beads, crystal with natural water-worn horn, pebbles, feathers, leather. Overall length, 22" (55.9 cm). American Museum of Natural History, 50.1/1382*

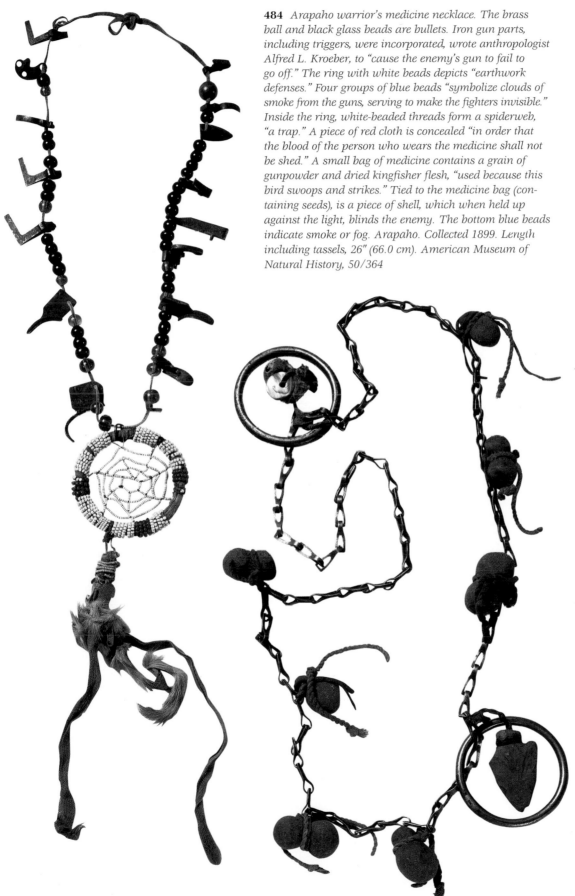

484 *Arapaho warrior's medicine necklace. The brass ball and black glass beads are bullets. Iron gun parts, including triggers, were incorporated, wrote anthropologist Alfred L. Kroeber, to "cause the enemy's gun to fail to go off." The ring with white beads depicts "earthwork defenses." Four groups of blue beads "symbolize clouds of smoke from the guns, serving to make the fighters invisible." Inside the ring, white-beaded threads form a spiderweb, "a trap." A piece of red cloth is concealed "in order that the blood of the person who wears the medicine shall not be shed." A small bag of medicine contains a grain of gunpowder and dried kingfisher flesh, "used because this bird swoops and strikes." Tied to the medicine bag (containing seeds), is a piece of shell, which when held up against the light, blinds the enemy. The bottom blue beads indicate smoke or fog. Arapaho. Collected 1899. Length including tassels, 26" (66.0 cm). American Museum of Natural History, 50/364*

△ **485** *Ghost Dance hair ornament. A blue beaded-bird-feather hair ornament attached to the back of the head has a crescent of red, yellow, and green beads and two black feathers with red-dyed plumes. James Oldman, Sr., notes that "the bird itself represents the Ghost Dance. Beaded bird feathers were worn by the dancers for protection as well as decoration." Northern Arapaho. Collected 1899. Length, 7" (17.8 cm). American Museum of Natural History, 50/66A*

486 *A Southern Arapaho necklace consists of an iron chain to which are attached several red pear-shaped, natural stone formations, two iron rings, and an arrowhead. Kroeber describes the components: "The stones, being shaped like small medicine-bags, are used as medicine. They are rubbed over the body, or in the case of intoxication, held in the mouth. The iron rings, being hard and indestructible, preserve the wearer in sound health. The arrow-head symbolizes old life." "Whoever had this went out and fasted for it," observed James Oldman, Sr. Collected 1899. Length, 24" (61.0 cm). American Museum of Natural History, 50/711*

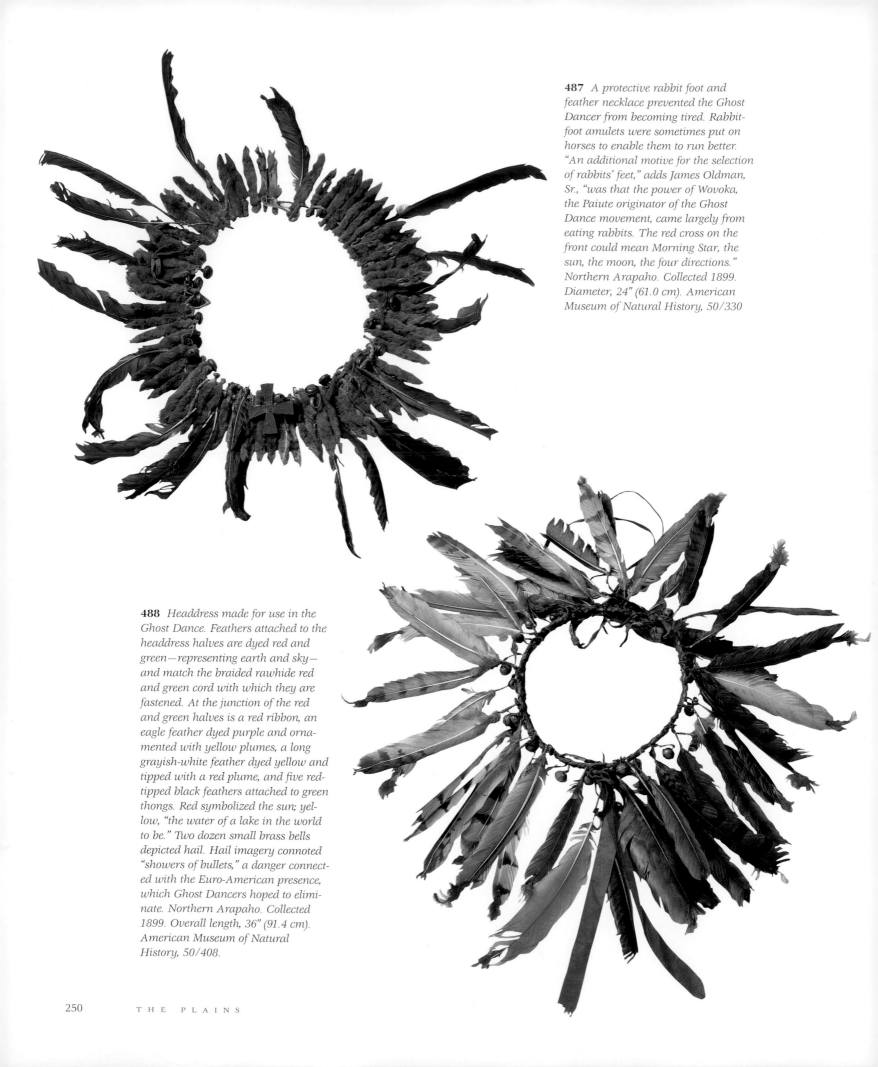

487 *A protective rabbit foot and feather necklace prevented the Ghost Dancer from becoming tired. Rabbit-foot amulets were sometimes put on horses to enable them to run better. "An additional motive for the selection of rabbits' feet," adds James Oldman, Sr., "was that the power of Wovoka, the Paiute originator of the Ghost Dance movement, came largely from eating rabbits. The red cross on the front could mean Morning Star, the sun, the moon, the four directions." Northern Arapaho. Collected 1899. Diameter, 24" (61.0 cm). American Museum of Natural History, 50/330*

488 *Headdress made for use in the Ghost Dance. Feathers attached to the headdress halves are dyed red and green—representing earth and sky—and match the braided rawhide red and green cord with which they are fastened. At the junction of the red and green halves is a red ribbon, an eagle feather dyed purple and ornamented with yellow plumes, a long grayish-white feather dyed yellow and tipped with a red plume, and five red-tipped black feathers attached to green thongs. Red symbolized the sun; yellow, "the water of a lake in the world to be." Two dozen small brass bells depicted hail. Hail imagery connoted "showers of bullets," a danger connected with the Euro-American presence, which Ghost Dancers hoped to eliminate. Northern Arapaho. Collected 1899. Overall length, 36" (91.4 cm). American Museum of Natural History, 50/408.*

RECEIVING A VISION

After failing to receive visions during Ghost Dance ceremonies, Black Man, a Southern Arapaho, retreated to Coyote Hills, where he vowed to fast for seven days. During the last three days, supernatural images appeared and a spirit communicated to Black Man that if he was "generous and uncritical of others," guardian birds and animals would give protection. With each new moon, a "dream would show him the future," while a "star exactly overhead" and Morning Star would provide security as he slept. When the "dawn of the new world" (regeneration) came, the following colors would be visible at sunrise: black, green, red, yellow, and white. Although the sun supplied strength to complete his seven days of fasting, clouds would go with him afterward, threatening rain. Finally, the spirit told him to run home after ending the fast, but to stop if he met anyone.

Upon completing the fast, he ran, and, although it seemed as if his feet were not touching the ground, he saw his feet upon the earth. Soon he came to a round hill on which stood a man with a dark blue blanket. Thinking of the spirit's instructions, he stopped. The man said, "I am the turtle and own the rain. When you want rain, pray to me, for I am the fog. I know about your fasting, that you have a strong heart, and I will help you if you want rain. You have done well to fast for seven days, for Above-Nih'a'ca' thinks well of that number. When you are at a feast, let the people take a little food and give it to me. Let them do this whenever they can, and I will remember them and protect them. You have done right to obey the spirit and stop here. Do not speak evil of people. You will have no difficulties hereafter. Everything will be pleasant." When the turtle spoke, it was as a man, but, after finishing, he was again a turtle.

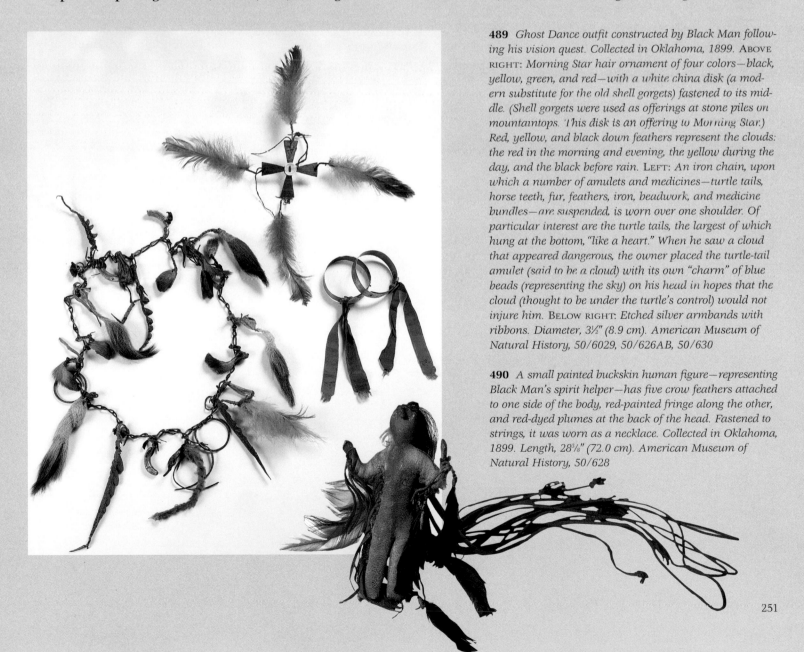

489 *Ghost Dance outfit constructed by Black Man following his vision quest. Collected in Oklahoma, 1899.* ABOVE RIGHT: *Morning Star hair ornament of four colors—black, yellow, green, and red—with a white china disk (a modern substitute for the old shell gorgets) fastened to its middle. (Shell gorgets were used as offerings at stone piles on mountaintops. This disk is an offering to Morning Star.) Red, yellow, and black down feathers represent the clouds: the red in the morning and evening, the yellow during the day, and the black before rain.* LEFT: *An iron chain, upon which a number of amulets and medicines—turtle tails, horse teeth, fur, feathers, iron, beadwork, and medicine bundles—are suspended, is worn over one shoulder. Of particular interest are the turtle tails, the largest of which hung at the bottom, "like a heart." When he saw a cloud that appeared dangerous, the owner placed the turtle-tail amulet (said to be a cloud) with its own "charm" of blue beads (representing the sky) on his head in hopes that the cloud (thought to be under the turtle's control) would not injure him.* BELOW RIGHT: *Etched silver armbands with ribbons. Diameter, 3½" (8.9 cm). American Museum of Natural History, 50/6029, 50/626AB, 50/630*

490 *A small painted buckskin human figure—representing Black Man's spirit helper—has five crow feathers attached to one side of the body, red-painted fringe along the other, and red-dyed plumes at the back of the head. Fastened to strings, it was worn as a necklace. Collected in Oklahoma, 1899. Length, 28⅜" (72.0 cm). American Museum of Natural History, 50/628*

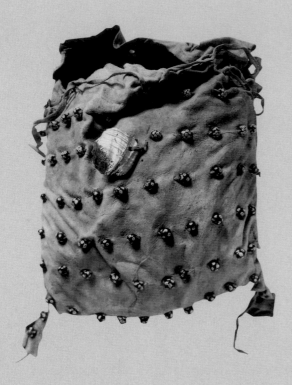

491 *Crow tobacco bag or pouch. Tobacco, the most distinctive Crow medicine, is not the common smoking tobacco but a sacred species identified with the stars. Tobacco bags hold the seeds as well as other elements beneficial to the plant's growth. Bags decorated with stripes, circles, and dot designs are said to represent seeds or planted crops. The use of beads with dots reinforces the seed association. Ancient tobacco planting and harvesting ceremonies are still held annually. Collected c. 1910. Hide, glass beads. Length, 9" (62.9 cm). American Museum of Natural History, 50.1/3905*

492 *A Piegan (Blackfoot) medicine necklace. The brass button represents Morning Star; the carved crosspiece is the Sun Woman. Along the latter's edge are twelve brass nails, symbolizing stars. The small bell grouping stands for star clusters. Pendant plumes and a bit of weasel fur were common on objects related to Morning Star and the sun. Collected in Montana, 1903. Length, 7" (17.8 cm). American Museum of Natural History, 50/4434*

493 LEFT: *Piegan warrior's medicine necklace, which, according to anthropologist Clark Wissler, was given to "its last owner together with a particular song: the whole formula is supposed to keep off bullets and blows." A string of black glass beads represents the night sky; seven small buckskin bundles (each containing plant leaves and edged in blue beads) are the seven stars, or Great Dipper. A compound brass disk, the sun, contains a strip of weasel fur. A cluster of four small black buttons suggests bells. Fifteen long pendants with a red bead and brass button symbolize stars in general. RIGHT: A Piegan hair ornament, worn to bring prosperity, was bestowed on its owner in a dream. The disk signified the sun; the horse hair was a talisman to protect the owner's horse. Collected 1903. Length of hair ornament, 22" (55.9 cm). American Museum of Natural History, 50/4539, 50/4540*

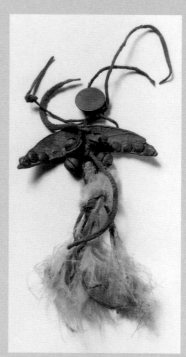

492

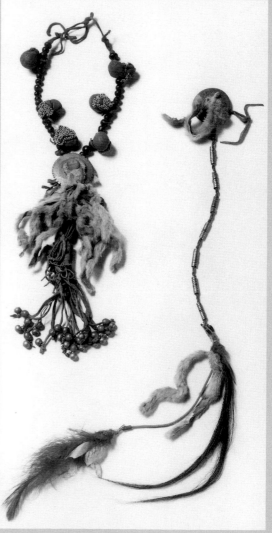

493

494 *Eagles work and fly together and mate for life. Sky symbols—Morning Star and Half Moon—represent the eagles' environment. This matching pair of bracelets, with facing male and female eagles and heart-shaped pipestones, was made by Mitchell Zephier as a twenty-fifth-anniversary gift for the owners. 1993. German silver and jeweler's gold. Length, 2⅞" (7.3 cm). Collection Cheryl and Paul Jones*

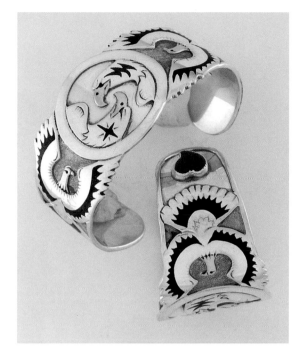

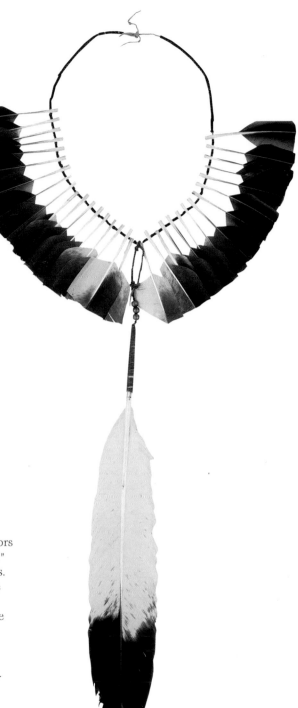

For **Mitchell Zephier** (Lower Brulé Lakota), called Pretty Voice Hawk in the Lakota language, artistry, teaching, and social activism are complementary and exemplify tribal values acquired as a child from his grandparents. Zephier regards his work as purposeful: "I wanted to create a style recognizable as Lakota. I consider my jewelry a new tradition. Our tradition included quilling, featherwork, and pipe carving, but jewelry was virtually unknown. Today, our jewelry carries Native America into everyday life." Moreover, "art has great healing power: the human spirit is nourished by things of beauty and creativity."

To ensure that all can afford his work, Zephier produces both museum-quality pieces and Lakota Jewelry Visions, a light-manufacture line. He notes: "I used to go with my grandmother and pick wild turnips. She would put the soil back the way it was, explaining that if you take medicine or healing plants from the earth, there's going to be a cavity, and you should place tobacco there. Lakota Jewelry Visions is my way of returning something back to the people."

Zephier favors working with "gifts of the South Dakotan land: petrified wood, jade, agates, rose quartz, red or black pipestone,

garnets, and bone. . . . With the inlay technique, I'm trying to duplicate the earth colors of hide painting. The colors are significant." Zephier has trained many aspiring jewelers. As a teacher, he believes he can ensure the continuation of Plains silverwork and an awareness of the history that is its narrative base. But Zephier's teaching effects even greater change in his apprentices' lives. "They find a center within themselves, a source of creativity. I've seen a transformation in people that have worked with me. When they realize they have the power in their hands to fashion metal into beautiful things, it can bring about self-esteem. It's wonderful that Indian people can make a living through their art. It validates and recognizes the artists and craftsmen; for too many years, fine pieces like beaded war shirts were sold for groceries and gas money.

"Contemporary Native art has as much value as what was done in the past. To me that is exciting because, until recently, anything done after the late 1800s was diminished. It says a lot for the strength of our culture that the artists want to express themselves and keep it going. Our culture is a gift that we have to hang on to."

495 *While the Lakota people rarely altered feathers for adornment, they occasionally trimmed feathers to symbolize war honors and then wore them on the head or incorporated them into necklaces. Dr. J. Walker, a government physician in Sioux country during the 1880s and 1890s, recorded that this necklace came from the Little Big Horn battlefield in 1876. Featherwork, hide, glass beads. Total length, 27⅜" (69.5 cm). Denver Art Museum, 1947.180*

496 *Plains shield belt. Artist Mitchell Zephier describes his work: "I wanted to depict the shield's beauty, not only as a weapon of war, but as sacred art [left to right]: 1. Shield of Chief Hump, an uncle and mentor of Crazy Horse, also recognized as a leader and a warrior. The shield shows the Lakota and Crow in battle. 2. Shield of Two Lands, a Lakota warrior-artist. The Thunderbird has power lines radiating from its wings. The shields, adorned here with trade cloth and feathers, were multimedia art employing many different materials. 3. Cheyenne shield with a bull cow, crescent moon, and feathers. 4. Lakota shield with a singing bull elk. The radiating lines symbolize the elk's bugling sound. Inlaid yellow sandstone and black pipe-stone capture the colors of the original painted rawhide. 5. The Circle of Feathers shield, a unique Plains Indian symbol. The copper sheet simulates red trade cloth. 6. A Crow shield with a bear charging into a hail of bullets, tracks simulating a running bear, and trade-cloth edging. Tied to the shield's front is medicine in the form of a small rock and a rawhide pouch with varied beads and feathers. The bottom bars had personal meaning only for the shield's owner. 7. Known as Turtle Spirit, this Mandan shield evokes the quality of the turtle's protective shell. It is bordered by four dragonflies and adorned with eagle feathers. 8. An old Lakota shield design [top] depicting the Thunder Horse with a rainbow, four Morning Stars, and golden eagle feathers. The Thunder Horse's body is covered by hailstones, and on his forehead is a Morning Star."*

Each spacer shows "a type of weapon or dance instrument such as a horse dance stick. Warriors would ride into battle carrying lances or dance sticks . . . things that were not really weapons since in Plains Indian warfare it was considered more honorable to strike an enemy and count coup than kill." 1990. Sterling silver, jeweler's gold, ground minerals. Typical concha diameter, 3" (7.6 cm). Collection Ann Simmons Alspaugh

One of the shield's primary purposes was for defense in battle, but they also had a spiritual aspect. Received in visions, the shield designs were really supernatural power or protection given to that individual.

—Mitchell Zephier (Lower Brulé Lakota)

497 *Shield-bearing warrior petroglyph, probably of Shoshonean origin. Wind River Reservation area, Wyoming, c. A.D. 1300–1700*

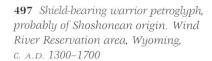

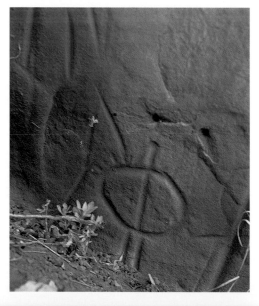

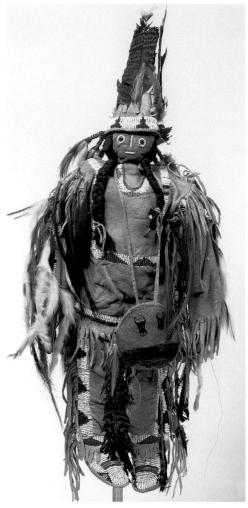

△ **498** *Blackfoot doll dressed in traditional garments, including a painted-hide dream-vision shield and upright Plains eagle-feather bonnet. James Oldham, Sr., recounts: "People used to make dolls like this one for power or protection." Late 1800s. Hide, glass beads. Height, 17½" (44.3 cm). The University of Pennsylvania Museum, NA 3558*

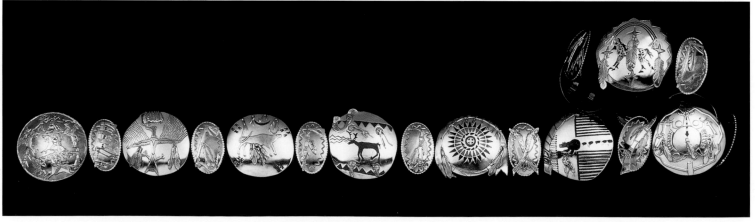

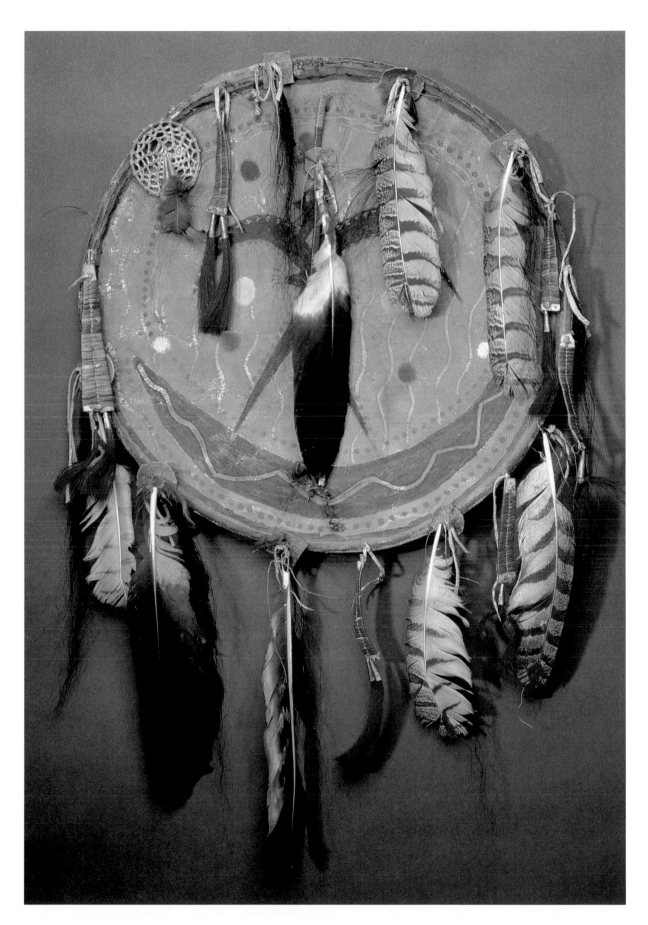

499 *Sioux dance shield. c. 1890. Hide, wood, feather, horsehair, and quill. Diameter, 17½" (44.5 cm). Courtesy of the Glenbow, Alberta*

In prereservation times, men wore robes with quilled parallel stripes. After 1890, women in beaded robes honored their men by continuing earlier quillwork patterns (63). The lines encircle the wearer; the rhythm of the stripes evoke movement. "Thus," continues Merritt, "the lines portray for the Crow people a sense of life on the Plains, where movement is a central environmental and cultural motif. . . . Through their use of materials, colors, patterns and design, the robes reflected the Crow's physical and sacred landscape. In this way they endow the wearer as well as the viewer with a sense of place and tradition."[32]

Adds George Reed: "The robe has always been the wrap of the Plains Indian and has significance. A robe means comfort, contentment, and peace. A person under panic situations may be out and about without various attire that he may normally use. A person with a problem is not his normal self: he is said to be like someone without a blanket. So in presenting gifts you always see Pendleton blanket robes and quilts. The robe is comfort by day and the quilt comfort by night. The thought of peace, tranquillity, and well-being is behind the gesture."

RITUAL AND CEREMONIAL REGALIA

Warrior Regalia

Outstanding warriors were accorded high status. Successful horse raids and battle scenes painted on rock surfaces, tipis, hide shirts, and robes communicated a warrior's achievements to the entire community. At the foundation of the warrior's honor system was "the coup"—the act of touching but not killing an enemy. "There was only one coup per skirmish. The first one to touch a live enemy, either with the hand or a coup stick, counted first coup," explains Crow artisan and horseman Kennard Real Bird. Among the Lakota, the first man to touch an enemy was awarded the right to wear an eagle feather horizontally. "Keeling [marking with red ocher] an adversary in hand-to-hand battle permitted the victor to paint a red hand on his clothing or upon his horse. . . . Saving a man in battle entitled the painting of a cross upon his clothing . . . painted red stripes indicated that the wearer had been wounded. Coup feathers dyed red also signified wounds. Horse hoofs painted upon leggings or on a man's horse, indicated the number taken."[33]

Some warriors dressed for battle clothed only in breechcloths and moccasins; most wore their finest regalia, believing it was the only way to die. Each man painted himself and his horse according to sacred formulas. Otter skins and feather trailers were placed on lances, feathers in horse's manes and tails.[34] Those who owned eagle-feather bonnets (65) put them on. Eagle-feather bonnets signaled exceptional warriors. To wear one, a warrior must have accomplished four honors during battle: leading a war party, counting coup, horse raiding, and removing a gun from another warrior.[35] It appears that the deeds required to attain chieftainship are much the same throughout the Plains.

The use of shields and lances is ancient: most warriors carried them even before horses were available. Vision-inspired images were painted on circular shields made from the heavy heat-tempered rawhide of the bison bull's hump. The protective designs gave the shields power to deflect arrows and bullets. In a practice resembling Naskapi caribou-robe rituals (5), a tribesman hung his shield outside the tipi before sunrise, so that the first rays of the sun would fall upon it. Throughout the day the shield was rotated, always facing the sun, and returned to the tipi after sunset, having completed a sun circuit. Early shields had sun designs, suggesting that initially the entire shield was considered a sun symbol.[36] Among the Crow, a man's shield, which was more or less the marriage license, was carried by his wife in processions and caravans.

A man's standing within his tribe was identified with his success as a warrior, which was displayed in turn through his horse's artistic presentation. Owning many horses brought prestige and provided important opportunities for giving. "The horse embodies the Lakota concept of generosity. It is considered a gift from *Wakan Tanka, the Great Spirit*."[37] A horse might be given to a young man for killing his first buffalo, or to a widow in memory of her fallen husband. The importance of the horse was reflected in elaborately beaded gear—saddles, bridles, cruppers, and martingales. The horse trappings of Crow women have special meanings. For example, a cushion made from the fur of a mountain lion signaled that the men of that family were hunters.[38] Although horse gear was patterned after early Spanish prototypes, the Indians soon altered it into something uniquely their own. Horse imagery appears in Plains' artwork, clothing, and jewelry. Chief Luther Standing Bear, a Lakota Sioux born in the 1860s, recounted the story of "The Faithful Horse,"[39] which he had heard in his youth:

The Sioux had returned victorious from a war excursion, and the village was preparing a feast and victory dance for them. Everyone was happy and excited. There was no enemy within many miles, and the territory of the Sioux was free from any who might steal their horses or chase away their buffalo.

The women were busy cooking for the feast and the men were putting on their beautiful feather headdresses. Those who had received wounds in battle painted themselves red to mark the place of injury. There was much display of painted quivers, lances decorated with strips of otter-skin, fans and banners. Everywhere feathers fluttered in the air. Even the horses which had returned with the men from war were being combed and sweetgrass wreaths placed about their necks. Their tails were braided and decorated with weaving fluffs of eagle feathers. They also were painted red if they had been wounded in battle. Every man was proud and fond of the horse that had been with him through battle, and it seemed as if the horses were aware of the unusual attention that was being given them, for they danced and pranced to the sound of the tom-tom and the songs of the warriors.

Regalia was integral with personal vision quests and communal rites, such as smoking the pipe, the Ghost Dance, and the Sun Dance. The continuing observance of these rituals and ceremonies has enabled the survival of numerous traditional forms of ornament.

The most direct method to gain spiritual power is by demonstrating will and strength at the Sun Dance, a sacred Plains rite performed annually (see page 264). Although the Sun Dance was outlawed in the mid-eighteenth century and suppressed by the government in the late nineteenth century (its piercing rituals were considered brutal), it was nonetheless continued by several tribes and has been revived by others. Sun Dance is traditionally still held in mid-summer, the season of plenty and of large tribal gatherings, when "buffalo are fat, chokecherries are ripe, and a full moon rises as the sun sets."[40]

A ceremony of great beauty and dignity, the Sun Dance takes place within a circular lodge understood as the universe. The central element of the rite is a tree—ritually chosen, felled, and re-erected—representing the cosmic axis that joins earth to Sky World and allows contact with the power of the sun. For three or four days, in sweltering heat, the participants drink no water and fast. Dancing almost continuously to the rhythm of large drums and powerful songs, they move toward the central tree, each blowing an eagle-bone whistle and shaking eagle-feathered rawhide rattles. After reaching the pole, the dancers move backward to their places at the periphery—while always facing the center—to start the cycle over again.[41]

THE HORSE AND RELATED REGALIA

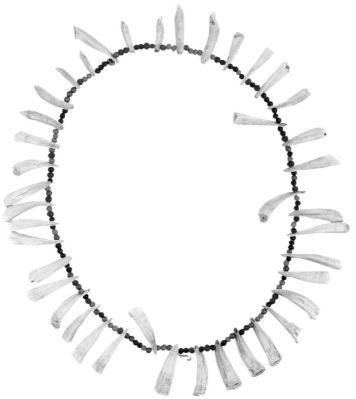

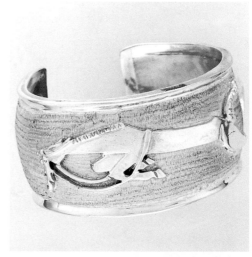

◁ **501** *Horse-tooth and bead necklace. Rosalie Little Thunder believes "the necklace could have been made from an old friend who is now gone. It would have great sentimental value to this person." Adds James Oldman, Sr.: "Horse teeth were used for medicine—to control the horse and its health. Horse-tooth necklaces were worn to protect the horse from becoming lame. The horse was very important to our Arapaho people. Protection for the horse is like insurance on a car." The necklace belonged to Circling Hawk (Sioux, Standing Rock Reservation). Glass and brass beads. c. 1895. Length, 40" (101.6 cm). South Dakota State Historical Society, Pierre, 1974.002.100*

502 *Sioux horse-effigy stick bracelet. Mitchell Zephier (Lower Brulé Lakota). 1992. Height, 2¼" (5.7 cm). Collection Cheryl and Paul Jones*

▽ **500** *A Sioux horse effigy, incorporating the horse's own hair and pieces of its bridle, was probably carved to "honor a fallen friend killed in battle," remarks Rosalie Little Thunder. The horse was revered for its role in warfare. Military society members carried horse-effigy sticks as personal medicine and for dancing. c. 1875. Length, 38.5" (97.8 cm). South Dakota State Historical Society, Pierre, 1974.002.122*

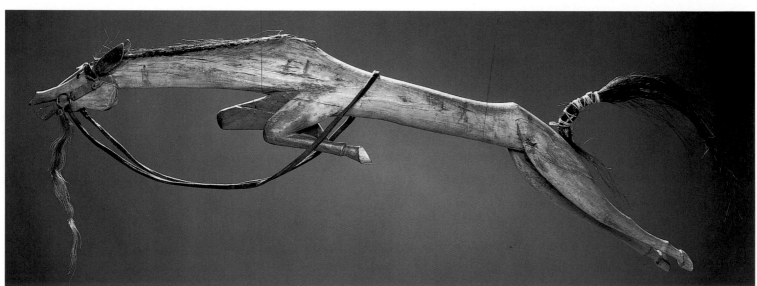

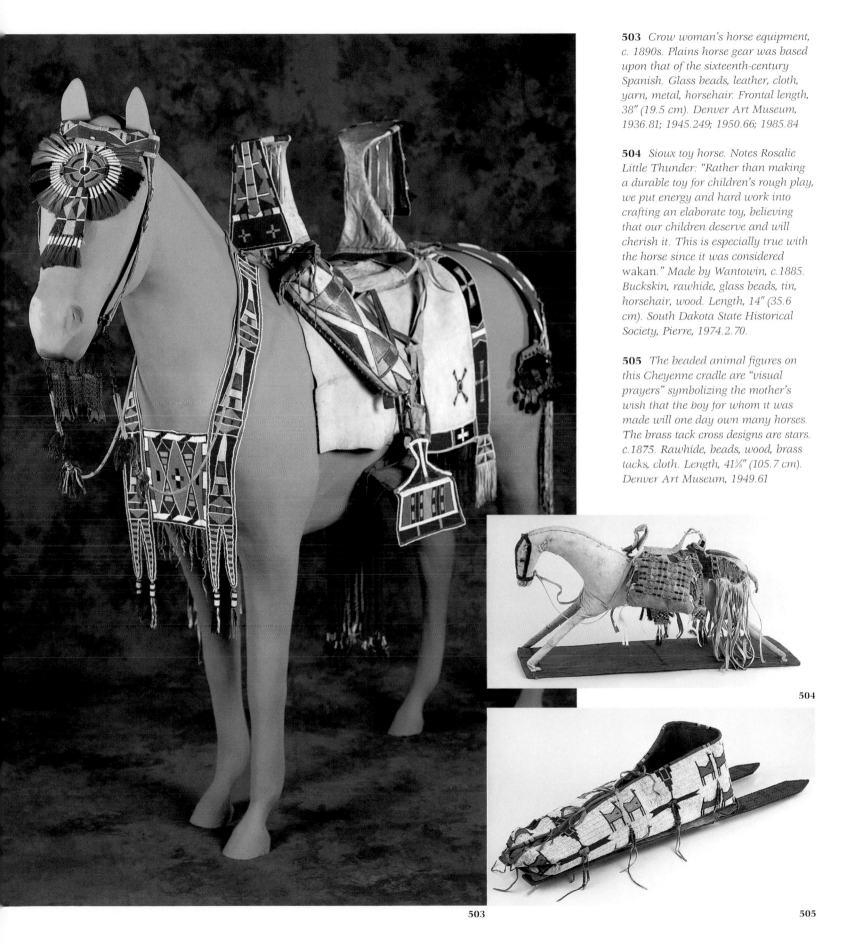

503 *Crow woman's horse equipment, c. 1890s. Plains horse gear was based upon that of the sixteenth-century Spanish. Glass beads, leather, cloth, yarn, metal, horsehair. Frontal length, 38" (19.5 cm). Denver Art Museum, 1936.81; 1945.249; 1950.66; 1985.84*

504 *Sioux toy horse. Notes Rosalie Little Thunder: "Rather than making a durable toy for children's rough play, we put energy and hard work into crafting an elaborate toy, believing that our children deserve and will cherish it. This is especially true with the horse since it was considered wakan." Made by Wantowin, c.1885. Buckskin, rawhide, glass beads, tin, horsehair, wood. Length, 14" (35.6 cm). South Dakota State Historical Society, Pierre, 1974.2.70.*

505 *The beaded animal figures on this Cheyenne cradle are "visual prayers" symbolizing the mother's wish that the boy for whom it was made will one day own many horses. The brass tack cross designs are stars. c.1875. Rawhide, beads, wood, brass tacks, cloth. Length, 41⅜" (105.7 cm). Denver Art Museum, 1949.61*

503

504

505

506 *Paintings on Reservation-era Sioux tipis record the past exploits of warriors. c. 1890s. Courtesy Azusa Publishing*

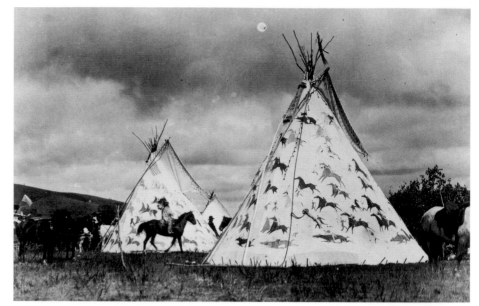

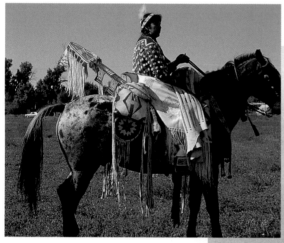

△ **507** *In a scene nearly identical to that of the century-old photograph (508), Kristi Jefferson (Crow) and her horse display the family's beaded regalia at the 1993 Crow Fair in Hardin, Montana. Included is a symbolic beaded lance case, traditionally slanted to the right. Essential to both hunting and warfare, lances remain important elements of Plains ceremony and ritual. Magnificent clothing, adornment, and horse trappings have been proudly exhibited at Crow equestrian parades for more than a hundred years.*

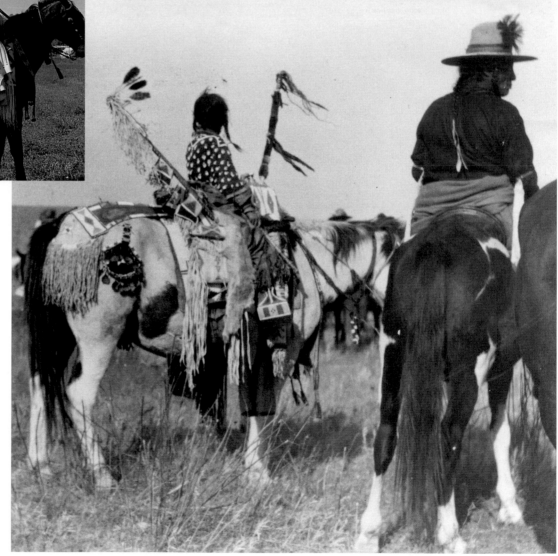

508 *A Crow girl and horse in full regalia. c. 1890. Denver Art Museum, 2139*

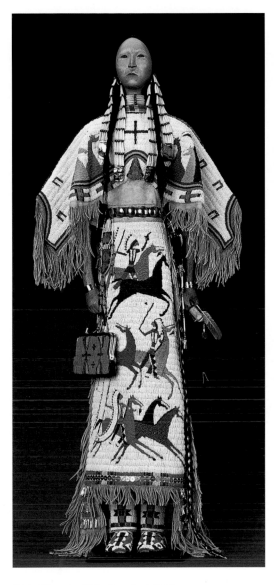
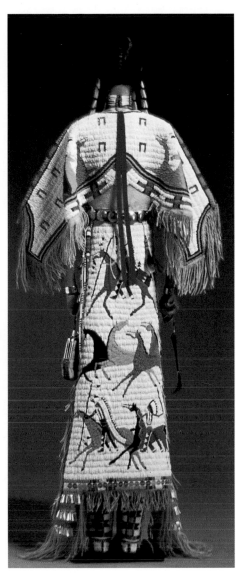

Rhonda Holy Bear (Lakota), a self-taught artist born on the Cheyenne River Reservation, mastered traditional techniques to create cloth dolls in outfits that replicate the dress of several Plains tribes. Stylized and symbolically bedecked, they suggest memories of past lives. "I am so moved by old beadwork. The women wove a prayer into each one. That is what goes out from the pieces. Creating dolls has really helped me to reconnect with my people and the past," says Holy Bear.

The dolls are carved of basswood; facial features "are discovered" in the wood grain. Great attention is given to miniature adornment: tiny porcupine quills, fringe, ribbons, feathers, and antique beads. "While some artists are inspired by silver and jewels, I'm just having a love affair with beads. I personally love the color. You have to become very free . . . like a child with a coloring book and colors. You just color and color until you get it."

509 *Rhonda Holy Bear's doll (three views) wears a beaded dress honoring the last Lakota horse raid in the 1880s. The tiny moccasins have fully beaded soles. 1991. Glass micro beads, wood, cloth. Doll height, 30" (76.2 cm). Collection Bruce and Joyce Chelberg*

THE PARFLECHE

arfleche designs reflect a collective tradition. Distinguished by their geometric motifs and bold colors outlined in black, these folding bags were highly visible from great distances, and best appreciated when seen on the side of a fast-moving horse. When tribes set up camp, parfleches were hung inside tipis as decorative elements.

The evolution of the Plains buffalo-hide parfleche was closely tied to the acquisition of horses, the ability to travel greater distances, and the subsequent need for lightweight containers to transport food and family goods. Buffalo hides were available and plentiful, although it has been suggested that the parfleche form originated with eastern Woodlands and Northwest Coast bark containers. Even the basic parfleche motifs—elongated triangles, rectangles, and circles—can be found on early-contact Great Lakes robe and tattoo designs. Crow tribal elder George Reed believes that the parfleche emerged at the same time as pants for Native men and became larger with the reintroduction of the horse to the Plains. Before the horse, the dog had been the beast of burden, so the early parfleches were designed to fit a dog.

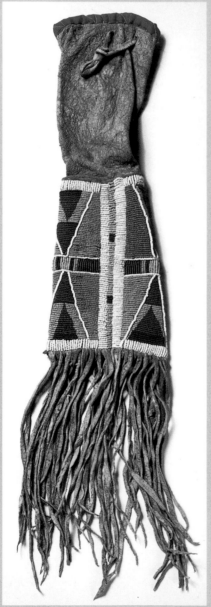

510

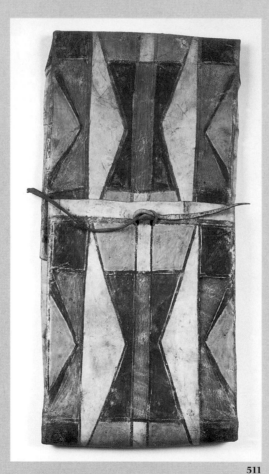

511

510 Pipe bag with designs relating to parfleches. Crow. Late nineteenth century. Length including fringe, 24" (61.0 cm). American Museum of Natural History, 50.1/696

511 Painted parfleche bag. Crow. Among the Crow, parfleche painting was done by women who had the right to paint with certain colors. Before 1910. Length, 25½" (64.7 cm). American Museum of Natural History, 50.1/3858a

▽ 512 Concha belt with parfleche designs. c. 1994. Tchin (Blackfoot-Narraganset). Typical concha height, 2¾" (7.0 cm). Collection of the artist

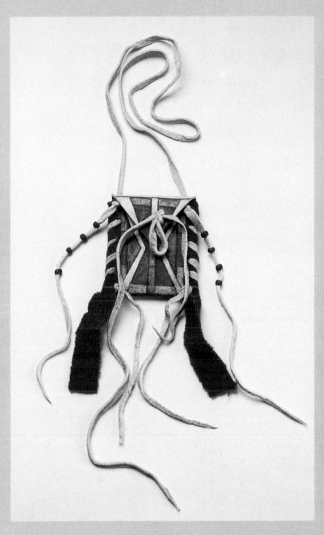

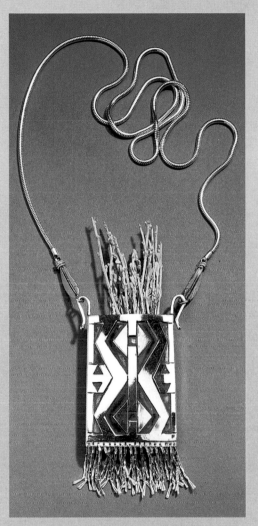

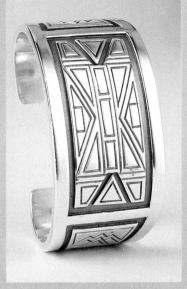

515 *A silver bracelet based upon a parfleche design. Kennard Real Bird (Crow). 1993. Height, 2½" (6.4 cm). Private collection*

513 *Miniature parfleche-envelope necklace. Crow (Montana). 1994. Buffalo rawhide, trimmed in old-style wool trade cloth. Pouch length, 3" (7.6 cm). Private collection*

514 *A sage sprig is carried in a sterling-silver parfleche neck pendant. Tchin (Blackfoot-Narraganset). 1994. Length from top of pouch to bottom of fringe, 3½" (8.9 cm). Private collection*

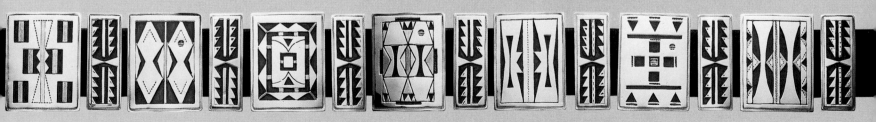

516

517

For the Sun Dance, the dancers paint their bodies with images of sun, moon, and stars, and anthropomorphic figures, wear only breechcloths and prescribed adornment. Sunflowers are frequently painted on their breasts since, like the flowers, the dancers always turn toward the sun.[42] An Oglala tribal elder's instructions to the dancers for constructing some of their adornment was recounted by Black Elk.[43]

You should prepare a necklace of otter skin, and from it there should hang a circle with a cross in the center. At the four places where the cross meets the circle there should hang eagle feathers which represent the four Powers of the universe and the four ages. At the center of the circle you should tie a plume taken from the breast of the eagle, for this is the place which is nearest to the heart and center of the sacred bird. This plume will be for Wakan Tanka, *who dwells at the depths of the heavens, and who is the center of all things.*

A hanhepi wi [night sun or moon] should be cut from rawhide in the shape of a crescent, for the moon represents a persona and, also, all things, for everything created waxes and wanes, lives and dies. You should also understand that the night represents ignorance, but it is the moon and the stars which bring the Light of Wakan Tanka *into this darkness. As you know the moon comes and goes, but* anpetu wi, *the sun, lives on forever; it is the source of light, and because of this it is like* Wakan Tanka.

A round rawhide circle should be made to represent the sun, and this should be painted red. . . . When you wear this sacred sign in the dance, you should remember that you are bringing Light into the universe, and if you concentrate on these meanings you will gain great benefit.

Sacred materials for the dancers' ritual regalia include tobacco, red willow bark, sweet grass, tanned buffalo-calf hide, eagle plumes, red ocher and blue paint, a buffalo skull, eagle tail feathers, and eagle wing bones.[44] Lakota men used to place rabbit skins on their arms and legs, "for the rabbit represents humility, because he is quiet and soft and not self-asserting—a quality which we must all possess when we go to the center of the world."[45]

516 *Sage headrings, "worn like a crown during Sun Dance," are "a sign that our minds and hearts are close to* Wakan Tanka *[Great Spirit] and His Powers," relates Madonna Thunder Hawk. Sage is used today as in the past: for ceremonies, medicine, and cleansing. "We smudge and purify ourselves as well as our surroundings. We brush sage smoke onto things which we think need purifying for protection." c. 1935. Width, 13" (33.0 cm). Duhamel Collection*

517 *Eagle-bone whistle on a strand of red mescal (peyote) beans and glass beads. Flutes were considered especially* wakan (sacred) *and full of power. Suspended from the neck and often decorated with eagle down and quills, eagle-bone whistles were used during Sun Dance "to call the spirits in to hear their prayers," says Rosalie Little Thunder (Lakota). The peyote-bean beads have no meaning to the Sioux, however. Made in 1962 by Frank Fools Crow (1890–1989), a medicine man and Sun Dance leader at Pine Ridge Reservation. Length, 8" (20.3 cm). U.S. Department of the Interior, Indian Arts and Crafts Board, Sioux Indian Museum, 64.40.39*

Pipes have always been held sacred by the Indians: smoking was not recreation but a ritual associated with ceremonies and solemn occasions. As smoke was said to make one think clearly, the pipe was passed around to everyone before signing agreements or treaties. Pipes continue their use on the Plains as "the essential ceremonial tool of human prayer, the vehicle by which breath ascends to the heavens, and . . . therefore a direct spiritual conduit between man and the spiritual beings."[46] All contributed to its manufacture: men carved the wooden stem and bowl; women decorated the stem with quill- or beadwork (532).

In response to the devastation of former lifeways, a Native revitalization movement—called the Ghost Dance—spread throughout the Plains during the late 1800s. Enacting the Ghost Dance promised the disappearance of white people and the return of buffalo and the past good life. Bringing back the old ways, which required discarding non-Native dress, stimulated an abundance of vision-inspired clothing art. Traditionally cut muslin and buckskin garments were painted and beaded with bird and celestial forms reminiscent of ancient Plains religious symbols. Many feather objects, especially headdresses, were worn. Although most Ghost Dance imagery signaled protection, the clothing was used for dancing, not combat. The southern tribes believed that during the actual regeneration, "a new section of the earth would slide over the old." In the process, Indians would be "lifted up" (aided by the feathers in their hair) and "the white men would be crushed by a landscape of sod and timber."[47]

PLAINS ARTISTRY: ROCK ART TO BEADWORK

From about 2500 B.C. through the nineteenth century, images painted and carved into rock surfaces (pictographs and petroglyphs) and painted on animal skins recorded Plains spiritual beliefs and warrior narratives. This symbolic visual language—paralleling Native oral tradition—conveyed religious, social, and historical information. During the nineteenth century, Plains iconography extended into ledger-book drawings, glass beadwork, and metal jewelry.

By the reservation era, beadwork was the Plains people's major form of artistic expression. While sacred motifs continued, narrative imagery, reflecting social and historical change, was greatly altered. Domestic scenes of reservation life were common; warrior exploits were recorded as memories rather than active lifeways. The change in subject matter was accompanied by further shifts resulting from access to new materials and realistic European painting styles. Paintbrushes replaced willow sticks or buffalo bones; glass seed beads and needles allowed for curvilinear images, which were nearly impossible with quillwork and weaving. The economic situation also necessitated new sources of income. In prereservation Plains art, realistic forms had been painted by men and abstract or geometric images by women. By the late nineteenth century, women who had previously decorated buffalo hides for intertribal trade now beaded pictorials, frequently for sale to non-Natives.

Quillwork

The ancient woman's art of quill embroidery achieved wide popularity in the northern and central Plains. A few specimens of Plains quillwork and quillworking tools dating to the sixth century have been discovered in Alberta, Canada.[48] Oral traditions explain quillwork beginnings. Buffalo Wife brought quillwork to the Cheyenne. The Sioux describe "an old woman who is eternally quillworking while her dog lies beside her. When the woman sleeps, the dog tears apart her work, and she begins again. They believed that if she ever completed her quilling, it would signal the end of the world."[49]

CHILDREN, BABIES, AND DOLL CARRIERS

Native Americans have deeply respectful relationships with children. Girls assist in the care of younger siblings and relatives. Dolls in miniature baby carriers were treasured by Plains youngsters. Most groups carried babies on cradleboards. These "vertical cradles" allowed children to view the world from the same perspective as their parents.

518 *Contemporary beaded cradle-board by Janice Little Light (Crow). 1997. Hide, beads. Length excluding fringe, 37" (94.0 cm). Courtesy Custer Battlefield Trading Post*

◁ **519** *Baby carrier–motherhood pin. Says artist Mitchell Zephier: "The cradleboard is an extension of the mother's womb. In another sense, it is an extension of the extended family. The cradleboard was made by the aunts of the child: a family way of welcoming and nurturing the newborn child. It's so logical: before you are born, you are in the mother's womb. Afterwards, all the clan participates." 1992. German silver, brass. Length, 1⅞" (4.8 cm). Courtesy Sioux Trading Post*

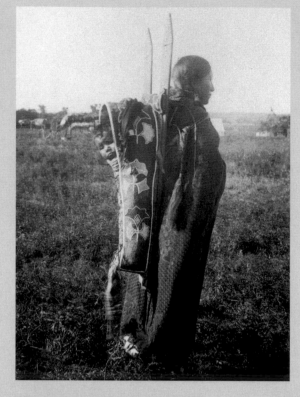

520 *Kiowa mother with baby carrier, c. 1890. Denver Art Museum*

◁ **521** *The young Kiowa girl's cloth dress is decorated with treasured elk teeth. Her doll's cradleboard may replicate the one she was carried in as a baby. Oklahoma Territory. 1890s. Smithsonian Institution*

▽ **522** *Kiowa baby carrier. Mid-to late nineteenth century. Smithsonian Institution*

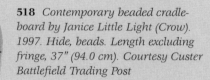

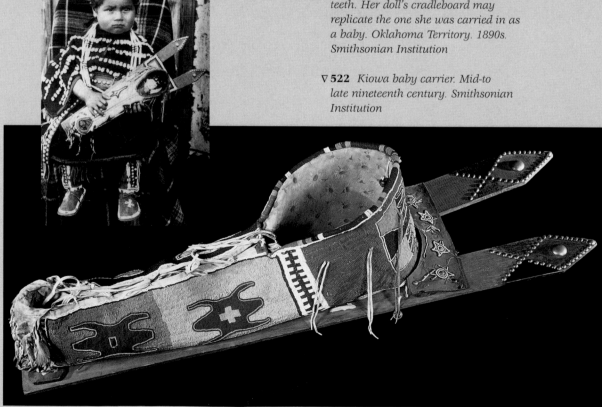

518

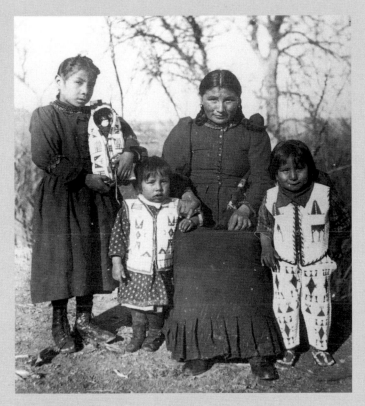

523 *Sioux mother with her three children, c. 1890. Although the late nineteenth century was a traumatic period, Plains beadwork—particularly on children's outfits and toys—became more complex. The young boy wears a fully beaded vest and trousers similar to the outfit in 524; his sister carries a fine doll cradleboard. It has been suggested that the elaborate reservation-era work reflected women's increased available time. Another explanation is that by demonstrating extra effort, the women hoped for greater spiritual assistance during a time of great stress. South Dakota Historical Society, Pierre*

524 *Sioux boy's knee-length trousers and matching vest, completely embroidered on cowhide with sinew-sewn glass seed beads in lazy stitch. Buttons inside the waist secured suspenders. Fancy trousers were worn for special occasions such as powwows and rodeos. Similar cloth outfits were sold through the 1897 Sears, Roebuck and Co. catalogue. c. 1900–1909. Length of vest, 13" (33.0 cm). South Dakota State Historical Society, Pierre*

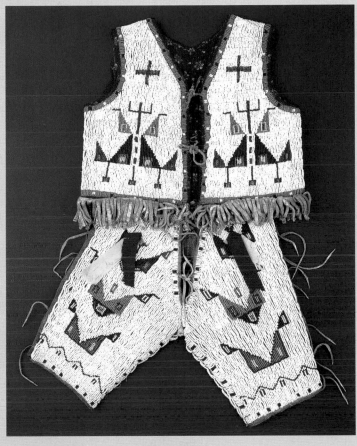

UMBILICAL AMULETS

Sacred medicines took many forms. Umbilical-cord container amulets resembled lizards, turtles, even snakes—animals hard to catch or kill. The amulet held the dried umbilical cord, which protected the child during its formative years. Hung from the cradleboard, an amulet could also serve as a playful distraction for the baby.

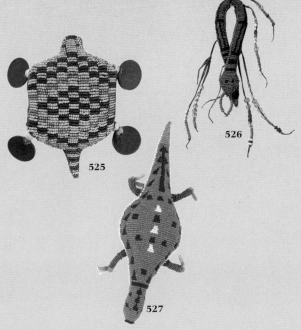

525

526

527

525 *Turtle-shaped umbilical amulet. According to Rosalie Little Thunder, "Turtles have hard shells that are tough, like the Lakota people!" Lakota. c. 1890s. Length, 3½" (8.9 cm). Private collection*

526 *Twined-serpent umbilical amulet of quills and beads. Piegan. Collected 1903. Length, 8" (20.3 cm). American Museum of Natural History, 50/4586*

527 *Lizard-shaped umbilical amulet. Lizards hold male umbilical cords and turtles hold female umbilical cords. Lakota. c. 1883–85. Length, 7" (17.8 cm). Atka Lakota Museum, 91 PA 11 74*

A CONTINUUM OF SACRED IMAGERY: FROM ROCK ART TO HIDE PAINTINGS AND BEADWORK

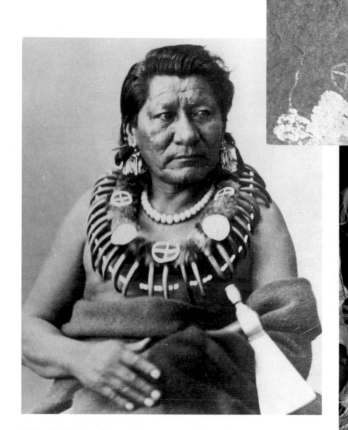

530 INSET: *A sacred cardinal-direction petroglyph. Whiskey Basin, Wyoming; c. 500 B.C.–A.D. 100*

531 *Traditional dancer Brooks Good Iron (Nakota Sioux) wears contemporary beaded regalia incorporating eagle and cardinal-direction motifs. Black Hills Powwow, 1992*

528 *Medicine Horse (Oto) wears a bear-claw necklace with cardinal-direction pendants. Late 1800s. South Dakota State Historical Society, Pierre*

529 *Fully beaded Blackfoot hide moccasins with cardinal-direction and Thunderbird imagery. Late 1800s. Length, 9½" (24.1 cm). American Museum of Natural History, 50.1/1057*

▽**532** *A contemporary beaded belt buckle celebrates sacred Plains symbols and materials: a quilled four-directional motif, a pipe with wooden stem and catlinite bowl, and an eagle talon. Rick Quinn (Lakota). 1993. Length, 4½" (11.4 cm). Private collection*

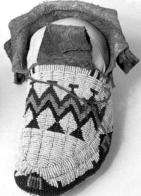

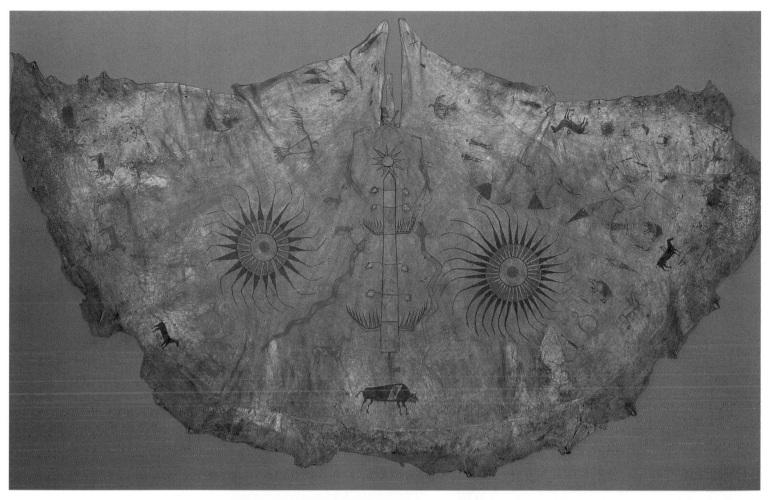

533 *A buffalo-hide cover with painted spiritual motifs—a sacred pipe, eagle-feather warbonnet, Morning Star, Buffalo, Thunderbird, Turtle—adorned a sacred tipi lodge. Probably Dakota Sioux, c. 1820–30. Width, 97" (246.4 cm). Staatliche Museum zu Berlin, IV B 196*

534 *Contemporary version of the eagle-feather-warbonnet motif: detail from the shield belt seen in 496. Mitchell Zephier (Lower Brulé Lakota). 1990. Silver, jeweler's gold, ground minerals. Diameter, 3" (7.6 cm). Collection Ann Simmons Alspaugh*

535 *Beaded buckskin bag illustrating a buffalo-hide robe with an eagle-feather warbonnet. The design, derived from multiples of four, unites four holy images: sun, eagle-feather warbonnet, buffalo, and cardinal directions. Lakota. Collected c. 1890. Length, 12" (30.5 cm). U.S. Department of the Interior, Indian Arts and Crafts Board, Sioux Indian Museum*

534

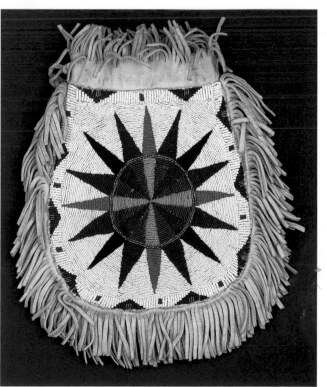

535

537

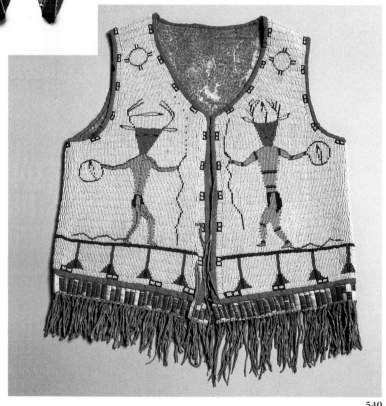

536 *The curved horns and large round eyes of this half-human/half-animal creature imply a supernatural being. Petroglyph. Wyoming. c. A.D. 1000–1775*

537 *Plains Cree necklace. Worn at Rain Dance, the human form with horns is the half-buffalo child. Collected in Saskatchewan c. 1870. Glass beads, fur. Overall length, 30⅝" (78.0 cm). Courtesy of the Glenbow, Alberta, AP-389*

538 *A Red Earth Festival dancer's shield displays a horned figure. Oklahoma City, 1994*

◁**539** *Contemporary horned anthropomorphic earrings. Little Elk (Lakota). 1994. Silver, carnelian, jet. Length, 2½" (6.4 cm). Private collection*

540 *The society to which one belonged was determined by the animals that appeared during a dream or vision. Those who saw elks joined the Elk Dreamers, where they created "medicine for attracting women" and "tested their powers" through singing and dancing. Depicted on this beaded Lakota vest are two ceremonially dressed Elk Dreamer dancers. They wear rawhide masks with branches representing antlers and an attached eagle feather enabling the wearer "to run as fast as the eagle flies." Hoops with central "spiderwebs" were carried and mirrors were flashed to "catch the eye of a girl and bring back her heart." Zigzag lines suggest transferred power between items and wearers. c. 1875. Buffalo hide, sinew, glass beads, porcupine quills (fringe). Length, 20" (50.8 cm). Denver Museum of Natural History, 4011*

540

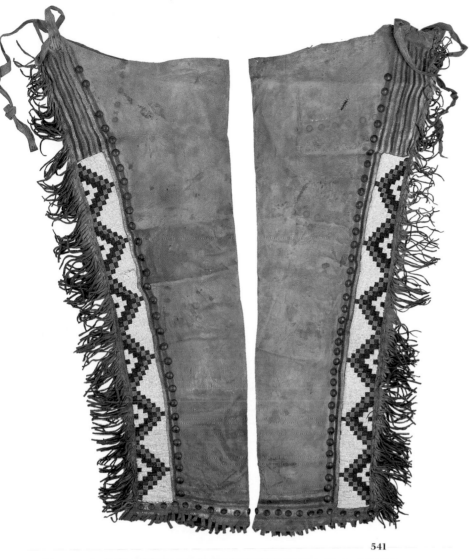

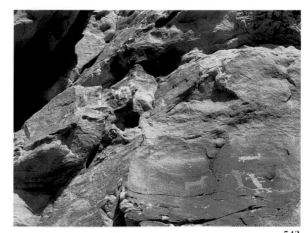

542

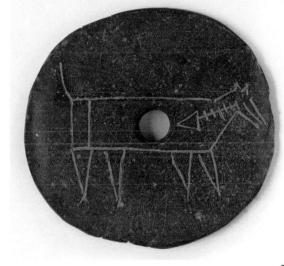

543

541

541 *These fringed buckskin leggings are a composite of several tribes, time periods, and biographical and sacred imagery. The leggings and painted images, dating from 1860 to 1870, were made by a Mandan or Arikara. The canid (see detail at left) represents the identity of the wearer or the vision spirit helper. Painted vertical stripes indicate coups; red signifies that the wearer had been wounded. The brass tacks and loomed beadwork with tipi or mountain designs were added later by a Sioux. Collected c. 1906–15. Overall length, 30¾" (78.0 cm). Canid length, 5¾" (14.6 cm). South Dakota State Historical Society, Pierre, 989.15.03*

542 *Pictograph of a canid, either coyote, wolf, or dog. Wyoming, c. A.D. 1000–1700*

543 *A precontact catlinite disk with an incised canid and spirit line. Rosalie Little Thunder (Lakota) relates: "The spirit line represents breath and was the essence of life to our people. The coyote is believed to have a similar social structure to the Lakota. Elders told me the coyote was respected." Jones County, Iowa. Diameter, 2⅜" (6.0 cm). National Museum of the American Indian, 4/3763.*

All tribes associated porcupines, who climb high into trees, with the sun and porcupine quills with the sun's rays. (George Reed tells a Crow story about a young maiden who ascended a tree into the sky, trying to catch a porcupine. Each time she neared the porcupine, it would climb a little higher, until finally the maiden came onto a land in the sky, where she encountered the sun, who married her.) Quillwork was thus accorded religious significance, and the first item a Blackfoot woman quilled was offered to the sun.[50]

Quillwork guilds existed among the Blackfeet, Cheyenne, Sioux, and Arapaho. Membership was tightly regulated, indicating high status and achievement. The ability to produce traditional porcupine quillwork was considered as important for women as was bravery and success among men. While men recorded their war exploits, women kept tallies of the robes they made.[51] An analogous situation exists today among Kiowa beadworkers, who recall the number and histories of buckskin dresses they have crafted.

The earliest quillwork coloration was somewhat muted due to the use of organic dyes obtained from berries, wood ash, mosses, twigs, barks, water, and urine. However, after the introduction in early contact times of aniline (commercial) dyes, the bright colors typically associated with beadwork were also quite common in Plains quillwork. Beadwork began to replace quillwork after the less labor-intensive glass beads became widely available. Further, as clothing shifted from hide to cloth, fabric was too loose to hold quill ornamentation properly. Among some groups, such as the Lakota, quilling,

544 *Blackfoot man's necklace from the Canadian Plains. Rawhide, glass, and brass beads. Length, 25" (63.5 cm). McCord Museum of Canadian History, Montreal, 13/23*

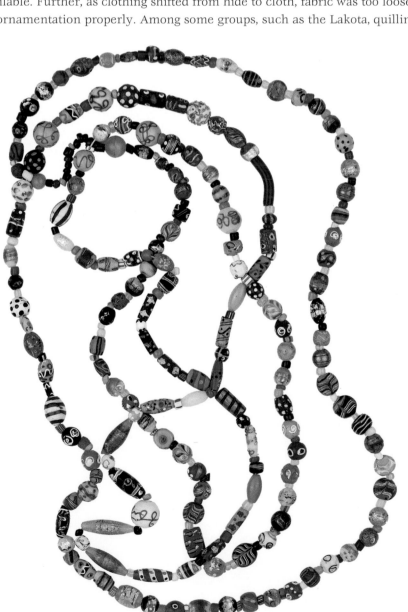

545 *A string of three hundred and twenty "fancy" glass beads, predominantly Venetian-made. Collected among the Sioux, c. 1890. Longest bead, 1½" (3.8 cm). U.S. Department of the Interior, Indian Arts and Crafts Board, Sioux Indian Museum*

which never completely died out, has experienced a resurgence. Contemporary quillworkers are usually from families where women have continued the tradition for several generations. Though neither the guilds nor rituals associated with quilling still exist, the sacred significance of quillwork may have contributed to its endurance.[52]

Glass Beadwork

Glass beads may have been introduced to the southern Plains as early as 1700, though their initial purpose is unclear.[53] European fur traders brought large opaque necklace and pony beads to the central Plains about 1780. By 1830 seed beads were available. Between 1830 and 1870, with the availability of pony and seed beads in quantity, women began to decorate their clothing and accessories with solidly beaded narrow bands in a generalized geometric style. After 1870, beadwork became more intricate and varied with recognizable regional, tribal, and reservation styles. Plains beaded designs typically evolved from simple to complex. The bold, simple blocks and lines of color beaded in 1850 were vastly different from the intricate, intensely colored designs covering large areas seen in pieces from 1890.[54]

Early Plains beadwork designs reflect geometric patterns in tattooing, quillwork, and painted rawhide parfleches.[55] Great Lakes fiber-woven bags have geometric and animal motifs closely related to those found in Plains beadwork.[56] Beadwork techniques such as lazy stitch may have been influenced by quilling techniques that created straight rows. With plentiful sources of native geometric motifs, speculation that Plains geometric beadwork was influenced by tribal rug designs from Central Asia's Caucasus Mountain region brought west by settlers appears doubtful. Among many tribes, geometric designs continued and were elaborated, even after floral patterns became popular.

Floral beadwork appeared on the northern Plains during the second half of the nineteenth century. Usually attributed to the Santee Dakota, this early floral beading has several styles, although all of it features delicate forms, a predominance of small cut and metallic beads, and a lack of background beading.[57] A large number of Red River Métis joined the Santee Dakota about 1860. Many of these Métis women were of Cree and Ojibwa heritage and known for their skills in creating delicate yet elaborate silk and beaded floral embroidery. They undoubtedly influenced and helped disseminate floral styles attributed to the Santee. The Kiowa derived their abstract floral designs from contact with Southeastern and Prairie groups as well as the Northeastern Delaware. (See also page 188.)

Early necklace and pony beads were typically white, blue, and black; seed beads came in a great variety of colors. Both availability and personal choice dictated the beadworker's color palette. Santee Dakota, Kiowa, and Cheyenne beadworkers incorporated tiny faceted seed beads to sparkle in the sunlight. The Blackfeet and Crow favored floral-patterned polychrome necklace beads. *Cornaline d'Aleppo* beads were popular throughout the Plains, possibly because of their resemblance to indigenous beads of catlinite and magnesite.

REGIONAL VARIATIONS IN PLAINS BEADWORK STYLES

Plains beadwork can be divided into four major categories: northern, central, and southern Plains, and Transmontane (formerly referred to as Crow). These stylistic categories were highly variable, due to nomadic lifeways, forced migrations, and complex trade patterns. There were divisions at some borders; merging at others.[58]

Leading northern Plains beadworkers were the Blackfeet and Cree. Those identified with the central Plains style include the Sioux, Cheyenne, and Arapaho. Friends and political allies, they produced similar artifacts with reciprocal artistic influences.

546 *Three-string bracelet from the Upper Missouri Valley. The white wound-glass beads are typical of the large, coarse beads carried by early Plains traders. c. 1850s. Length, 10" (25.4 cm). Smithsonian Institution*

The Southwest's Mescalero Apache, Utes, and Jicarilla Apache participated in the central Plains style, as did Prairie groups on the Plain's eastern edge—the Pawnee, Omaha, Oto, Iowa, and Ponca. The Gros Ventre and Assiniboine, located between the northern and central Plains areas, blended both styles. Plateau and Basin peoples influenced—and were influenced by—northern, central, and Transmontane styles.[59]

Transmontane beadwork became a major and distinctive northern Plains style with closer artistic relationships to Plateau groups than any surrounding tribes. As the Crow were enemies with neighboring Blackfeet, Sioux, Cheyenne, Assiniboine, and Cree, there was little artistic influence from any of these tribes. Furthermore, Crow horse gear is Plateau in character. Since the Nez Percé were the main source of Crow horses, their gear and some beadwork designs were undoubtedly also exchanged.[60]

Among southern Plains tribes—the Kiowa, Comanche, southern Cheyenne, southern Arapaho, Pawnee, and Kiowa Apache—the earliest decorative emphasis was not on beadwork but on painted hides, fringes, and attached metal cones, possibly because these tribes lived outside the porcupine's habitat and had no quill embroidery tradition upon which to base their beadwork. A later beadwork style was influenced by the Woodland and eastern and central Plains tribes who moved into Oklahoma's Indian Territory during the last half of the nineteenth century.

CONTEMPORARY EXPRESSIONS

Elaborately beaded skin garments remain fundamental in ceremonial regalia. Visual images continue to affirm ancient values. Painted designs applied to the face and body stem from sacred objects and spiritual powers. These ways of painting are handed down through the generations and continue to be taught to young tribal members. The buffalo, having returned from near extinction, represents cultural as well as physical survival and has been revived as an important symbolic image in contemporary Plains art.[61] One aesthetic value still prevailing is originality of design. Plains artisans take pride in being able to "dream" new designs and continually search for new ideas.[62]

Metal and beaded belt buckles—a prolific Plains jewelry form—are miniature canvases that provide numerous surface design possibilities. Other popular items include hatbands, pendants, tie slides, bracelets, earrings, rings, pins, chokers, necklaces, and concha belts. The principal Plains artistic expression remains beadwork, though "it's difficult to make a living as a beadworker," according to anthropologist (as well as painter, weaver, quiltmaker, and beader) JoAllyn Archambault (Lakota-Creek). "So most of the wonderful clothing seen at powwows is made by relatives or commissioned when there aren't beadworkers in the family. Few non-Indians will pay fair value for a man's beaded shirt. And many artists will not bargain. The established market is for small, inexpensive items such as beaded belt buckles."[63]

The Plains area continues as a vital region of Indian identity and creativity. Most participate in some traditional activities, including bead and quillwork, hide tanning, and ceremonials. Plains people still believe that decorated apparel given to relatives or friends will bring health and prosperity. Self-confidence and prestige obviously "come to anyone looking fine, whether this is intended to please spirits or other people."[64] Urban-based tribal members make frequent trips to the reservation and consider it home. Movement is still a central principle of Plains lives. Although the car has replaced the horse, people think nothing of traveling hundreds of miles on a weekend to visit family or attend a powwow. Despite growing pan-Indianism, there is a strong commitment among Plains peoples toward maintaining tribal identity. Above all, there remains a continuum of ancient spiritual and cultural values expressed in the tradition of adornment.

547 *Sioux woman's leggings. Though made early in the reservation period, the green star figures of these leggings exemplify the simple geometric style of prereservation times. Other prereservation elements are the blue-painted legging top and the vertical "backbone" figure at the center back. Late 1880s. Leather, beads, paint, tin cones. Length, 18" (45.7 cm). South Dakota State Historical Society, Pierre*

548 *Sioux woman's leggings, fully beaded in geometric designs on buckskin with cloth upper portion rubbed in green pigment. Although leggings were traditionally made from tanned hides, these incorporated cloth, a common practice during times of hardship or when game was less abundant. The high quality of the craftsmanship, however, is equal to the all-hide leggings seen in 547. c. 1890. Length, 17" (43.2 cm). South Dakota State Historical Society, Pierre*

549 *Moccasins with beaded soles were made from the early 1880s until about 1910. Worn as status items and in burials, they also represent the Native tendency toward incorporating self-directed, hidden designs. The split tabs imitate the cloven hoofs of buffalo or deer. Lakota. Late nineteenth century. Length, 11" (27.9 cm). Collection Robert Preszler*

550 *An abstracted bird motif is set* ▷ *off by a subtle background of crystal beads that blends with the buckskin. On viewing this piece, Lakota beadworker Rosalie Little Thunder commented: "Before the reservation period, beadwork was pure and simple and had meaning. Now the beadwork has become complicated, and really exquisite with hardly any meaning except to be fancy and nice to own." Sioux. c. 1890. Deerskin, cloth lining. glass seed and cut beads, metal cones, feathers. Length including fringe, 12" (30.5 cm). U.S. Department of the Interior, Indian Arts and Crafts Board, Sioux Indian Museum*

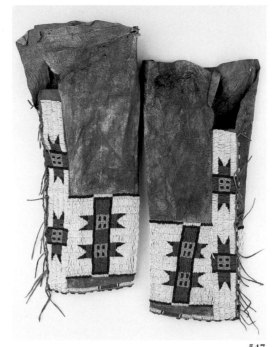

547

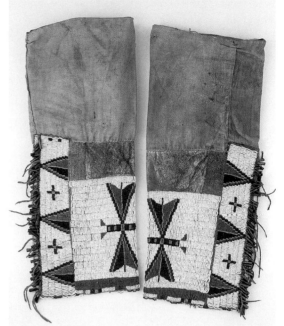

548

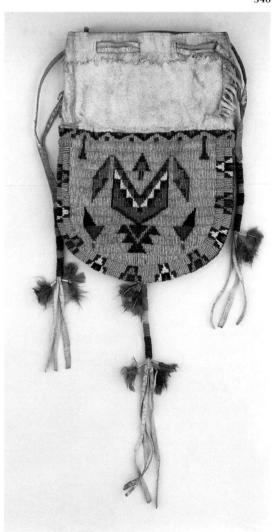

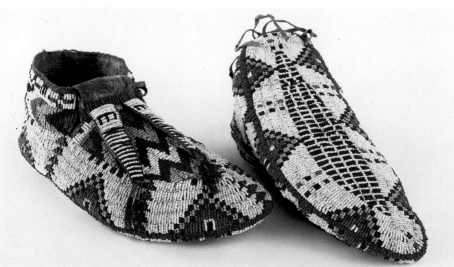

PICTORIAL BEADWORK

Rock art, painted-hide, and ledger-book imagery was extended into glass beadwork. Ceremonial (sacred) images derived from dreams, visions, and rituals were expressed in motifs of Sky World (sun, moon, and stars); natural forces (wind, lightning, and thunder); special creatures (dragonfly, eagle, buffalo) and spirit beings. Narrative (secular) art primarily documented important events in the life of a warrior, particularly battles and horse raids (551, 552).

Many spiritual images have been maintained until today. Narrative art, however, shifted during the nineteenth century from warrior scenes to reminders of old lifeways (553) and social activities such as courting (554).

551

551 *A painted buffalo hide depicting autobiographical exploits of the Cheyenne-Sioux leader Kills Eagle. c. 1870–80. Length, 87" (221.0 cm). The Philbrook Museum of Art, Tulsa*

552 *Pawnee warrior's pipe bag. The hoof prints designate how many horses were caught in raids. Four pipes means that the warrior led four raiding expeditions. Both horses and pipes were spiritually empowered. c. 1870. Hide, beads. Length, 35⅝" (90.5 cm). The Southwest Museum, Los Angeles, 1423G*

553 *A reservation-era pipe bag with horses and riders. Oglala Sioux, c. 1880s. Hide, beads, quill. Length, 38⅞" (99.0 cm). Denver Art Museum*

554 *Reservation-era beaded bag depicting a courting scene with identifiable items of clothing and jewelry. The young woman displays dentalium-shell earrings (572). The man in the center wears a striped blanket and vertical silver hair plates and carries an eagle feather fan. The suitor (right) has face paint, a red blanket, and a coup feather in his hair. Minneconjou Sioux, Cheyenne River Reservation. c. 1885–90. Hide, beads. Length including fringe, 26" (68.0 cm). The Southwest Museum, Los Angeles, 1409 6140*

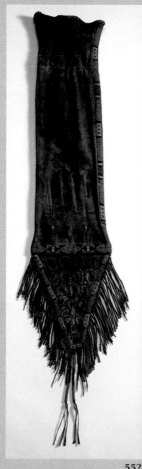

552

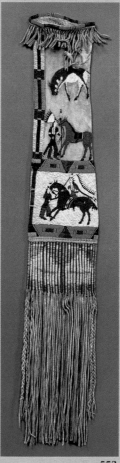

553

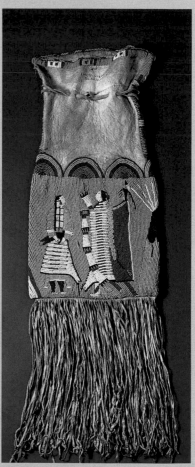

554

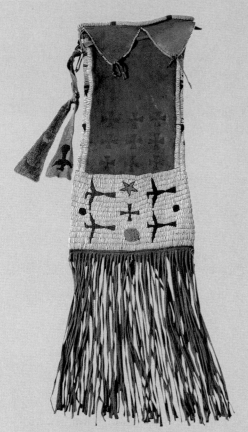

555 *Ghost Dance motifs included ancient and sacred celestial imagery: the bird, cross, star, and sun. Cheyenne. c. 1880s. Glass beads, hide. Length, 30¼" (77.0 cm). The Southwest Museum, Los Angeles, 1253 G2*

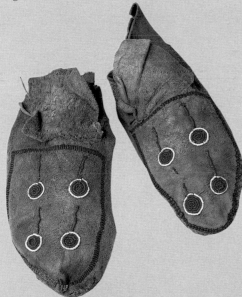

556 *Tobacco Dance moccasins. The close relationship between the circle and the number four are beautifully expressed in Crow spiritual beliefs and iconography. The circle may symbolize the tobacco seed with its sprout rising toward the sun. Collected at Crow Reservation, 1910. Length, 10" (25.4 cm). American Museum of Natural History, 50.1/3996 a,b*

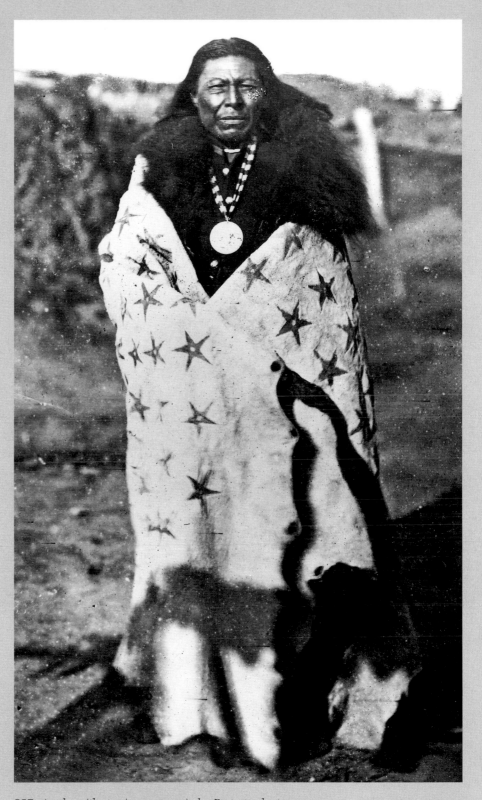

557 *A robe with star imagery encircles Ra-tu-tsa-ku-te-saru (Raruhcakure:sa:ru), His Chiefly Sun (Pawnee). The Pawnee, descendants of Mississippian peoples, had a sophisticated knowledge of astronomy. Incorporating cosmic symbols upon the robe reminded Ra-tu-tsa-ku-te-saru of his relationship to the universe. Late nineteenth century. Smithsonian Institution*

558 *Blackfoot man's shirt. Circular designs, painted upon men's shirts in the Northeastern forests, became quilled rosettes with stylized Thunderbird imagery on the northern and central Plains. Parallel lines are an old Plains design motif, which, when painted on men's skin clothing, may be a tally of the battles, coups, or wartrails tracked by the wearer. Such shirts were part of a warrior's regalia and designated as Saam— holy objects imbued with protective and helping powers. c. 1840. Deer and antelope hides, ermine skins, stroud, quillwork, glass beads, paint, horsehair, sinew. Length, 35" (89.0 cm). Canadian Museum of Civilization*

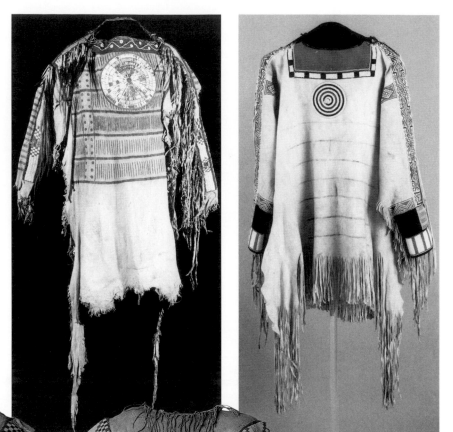

559 *Salteaux (Plains Ojibwa) decorated deerskin coat presented to Lieutenant Governor E. Morris by Yellow Quill, Chief of the Salteaux, during the Treaty of Canada negotiations at Round Plain on the Assiniboine, June 20, 1876. This coat illustrates a transitional type of garment combining both Native (Great Lakes and Plains) and European influences: Eastern Ojibwa loom-woven beaded panels are cut and placed in the Plains style. While blue-painted horizontal lines signaled war coup to the Ojibwa, the target design, wide decoration on the sleeves, and horizontal bands typify northern Plains clothing. The fitted sleeves with cuffs resemble nineteenth-century French and English military uniforms. Deer hide, ermine fur, stroud, glass beads, paint. Length including fringe, 45⅞" (116.0 cm). Royal Ontario Museum, 913.14.388*

560 *Piegan buckskin war shirt (front and back). Central medallions or disks represent the sun. Ermine (weasel) skins line the shirt's sides and encircle the front medallion. (The ermine was acknowledged as a fierce fighter and source of good war medicine.) Broad bands on the sleeves and shoulders and medallions on the chest and back are characteristic of nineteenth-century northern Plains shirt styles. The medallions, as well as the triangular neckpieces (562), were also called "shields." It was believed that they served as protective devices, similar to the designs upon shields in earlier times. Collected 1910. Front medallion diameter, 7" (17.8 cm). Rear medallion length, 11" (27.9 cm). American Museum of Natural History, 50.1/1216*

561 *The earliest Plains men's skin shirts retained the shape of the hides from which they were made. Two skins of deer, elk, antelope, bighorn sheep, or small buffalo— matched for size and shape—were sewn in a poncho style. Cut just below the forelegs (left), the skins were joined at the shoulder, with a slit for the neck. After cutting each skin's upper part along the spine for sleeves, the long forelegs became decorative dangles (right). The hind legs, retaining the fur and dewclaws, usually fell below the hemline. The skin that had covered the animal's head became a rectangular or triangular neck flap, ultimately replicated in cloth and adorned with quills and beadwork.*

562 *Council or war shirt worn by the great warrior Chief Red Cloud, a member of the Oglala band of the Teton Dakota and its Shirt Wearer Society. Shirt Wearers were community leaders as well as warriors. Even after Plains warfare ceased, embellished shirts were often worn at tribal social and political events. They signified that the wearer was a man of importance among his people. In addition to maintaining the triangular neckpiece (possibly symbolizing the head of the animal that had once decorated this area on most buckskin war shirts), Dakota artisans painted the shirt's upper half blue, for the sky, and the lower yellow, for the earth. Hair fringes on such shirts were incorrectly associated with scalp locks taken in warfare. More often, the hair belonged to people, such as family, in the wearer's charge. c. 1870. Length, 42½" (108.0 cm). Buffalo Bill Historical Center*

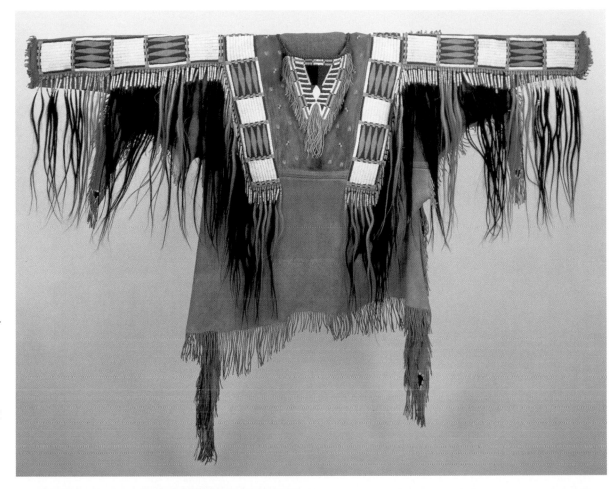

563 *Ceremonial shirt made by Joyce Growing Thunder Fogarty (Assiniboine-Sioux). Believing in traditional ways, Fogarty has crafted old-style moccasins, eagle-feather bonnets, leggings, and war shirts. Nationally recognized as a master bead-worker, she wishes that "my old grandmothers could have received some sort of recognition; they were great artists and lived in poverty." Responding to a question about the source of inspiration for this shirt, she replied, "Just tried to do an old-style shirt from what I know or have seen during my life." Fort Peck Indian Reservation. 1982–83. Cloth, hide, old glass beads, thread, weasel strips, otter fur, brass beads. Length, 32" (81.3 cm). Natural History Museum, Los Angeles County*

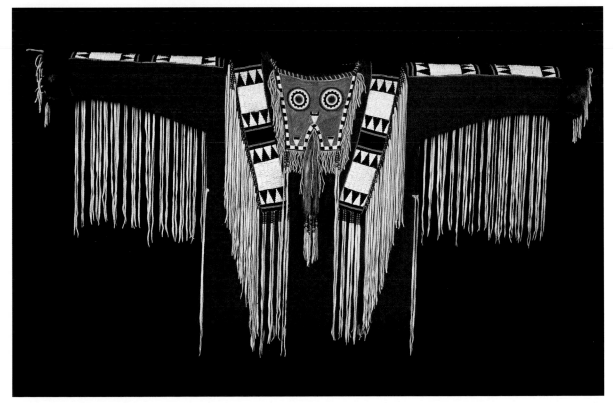

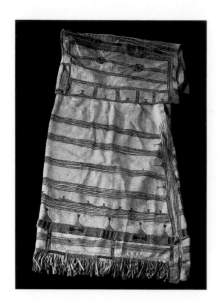

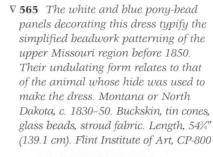

564 A moosehide painted and beaded side-fold dress, a rare and important style of Plains Cree women's clothing. Side-folded dresses are made from a skin large enough to wrap around the body so that there is a seam only on one side. The top is folded down to produce a top edge and flap that usually hangs to the waist. The linear patterns (created by using a multipronged bone tool) resemble painted designs on Montagnais and Naskapi caribou-hide garments (213). Collected in Saskatchewan by Lewis and Clark during their 1804–6 expedition, the dress was originally owned and displayed by Thomas Jefferson. Length, 46⅜" (118.0 cm). Peabody Museum of Archaeology and Ethnology, Harvard University, 99-12-10/53046

▽ **565** The white and blue pony-bead panels decorating this dress typify the simplified beadwork patterning of the upper Missouri region before 1850. Their undulating form relates to that of the animal whose hide was used to make the dress. Montana or North Dakota, c. 1830–50. Buckskin, tin cones, glass beads, stroud fabric. Length, 54¾" (139.1 cm). Flint Institute of Art, CP-800

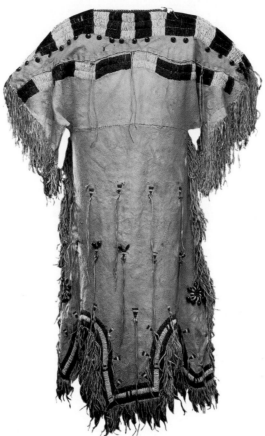

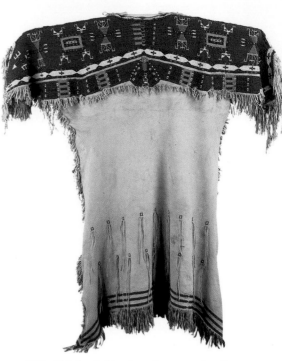

566 This buckskin dress incorporates Sioux, Hidatsa, and individual design elements embroidered with sinew using seed beads of two time periods—greasy yellow and white hearts from the 1890s and brightly colored cut-glass and metallic beads from the 1920s. It was made between 1920 and 1929 by Martina Claymore Sherwood (Minneconjou Sioux) of Standing Rock Reservation. Her son, Robert Sherwood, remembers the dress as "the first thing packed and unpacked," the object with which the family took the most care. Mrs. Sherwood (1882–1980) was born while her parents, Jenny La Framboise Claymore and Antoine Claymore (both children of French trappers and Sioux women), were returning from the Sioux's last buffalo hunt. Length, 49" (124.5 cm). South Dakota State Historical Society, Pierre

◁**567** Sioux-style child's beaded hide dress. The U-shaped design at the yoke's center represents the original elk or deer tail. Its symbolic interpretation, however, was a turtle, considered beneficial for women's fertility and a source of protection during childbirth and infancy. The dress style evolved from the two-skin dress (568). The sleeves are cut to accentuate the deerleg shape, but the corners are squared and natural irregularities are trimmed to form a standardized shape as a base for the geometric beadwork designs. Collected at Pine Ridge, South Dakota, 1897–99. Length, 21½" (54.5 cm), Peabody Museum of Archaeology and Ethnology, Harvard University, 10/87003

568 Plains woman's two-skin dress, constructed of two full untrimmed deer or elk hides sewn together. The neckline (left), is formed from the folded-down skin of the tail portion of the hide. The hind legs became the shoulders (right). Ornamentation followed the lines of the original skins.

569 *Cheyenne River Sioux dentalium cape. The shells have been carefully graded according to size and color: there is much pink in this selection. "If a family had shells like these, they were very prosperous," asserts Madonna Thunder Hawk. Dentalium shells were highly prized on the Plains because of the relationship of shells to money. c. 1900. Dentalia, brass beads, ribbons, aluminum trade tokens labeled* ELLEN THUNDER HORSE. *It is believed she was Yankton Sioux. Height, 19" (48.3 cm). South Dakota State Historical Society, Pierre*

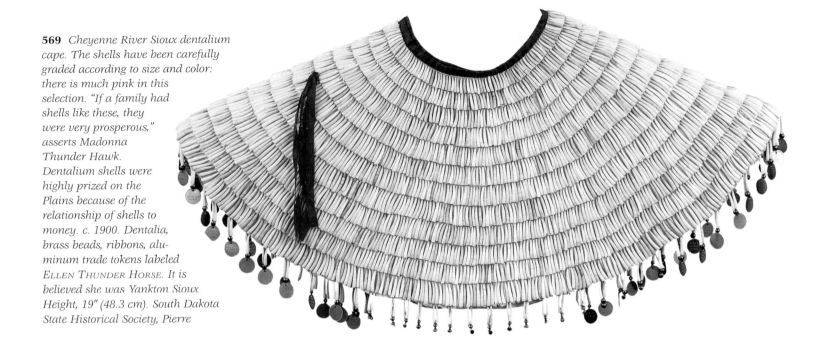

570 *Crow hair bows of dentalia, glass beads, stained rawhide, and brass. n.d. Length, 6" (15.2 cm). Buffalo Bill Historical Center, NA. 203.861*

571 *An Oglala Sioux doll wears a blue trade-wool dress with a dentalium yoke. Cecilia Fire Thunder. c. 1980–89. Length, 15¼" (38.7 cm). South Dakota State Historical Society, Pierre*

572 *Nineteenth-century Plains earrings of dentalium shell and rawhide. McCord Museum of Canadian History, Montreal*

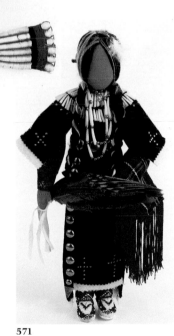

571

572

573 *Edith Otterman (Dakota), dressed in the height of late nineteenth-century fashion, wears dentalium-shell and silver adornment and a trade-cloth blanket. c. 1895–99. Smithsonian Institution*

THE ELK-TOOTH DRESS

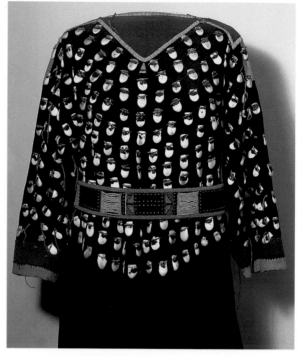

Plains women wore the elk-tooth dress, a signal of wealth and prestige, for special occasions. As an elk has only two upper ivory teeth (the others, like human teeth, eventually disintegrate), owning such a dress implied that the owner had a father or husband who was a good hunter or had enough wealth in horses or other belongings to trade for teeth. In 1852, it was noted that a Crow elk-tooth dress with a hundred teeth cost as much as a good horse. Using elk teeth as overall rather than isolated decoration continued a long-standing embroidery tradition.

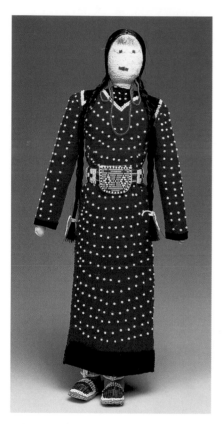

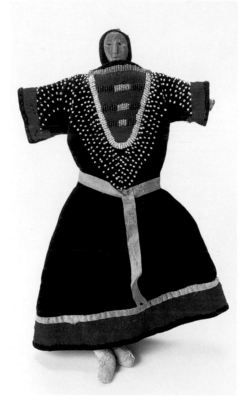

576 *A Crow dress embellished with both natural and imitation elk teeth. The latter are carved from elk antler or bone and disguised with brown pigment to simulate tartar. c. 1880s. Length, 44" (111.8 cm). The Southwest Museum, Los Angeles 11.0.14*

574 *A contemporary Crow doll in her elk-tooth dress. Jane Holde (Crow). 1996. Cloth, beads, hide, paint, hair. Height, 16" (40.6 cm). Private collection*

575 *A Blackfoot doll wears a trade-cloth dress with tiny white-glass seed beads representing elk's teeth. Montana, c. 1850. Wood, trade cloth, ribbons, beads. Height, 14¼" (36.2 cm). National Museum of the American Indian*

577 *Elk-tooth dress earthenware* ▷ *sculpture. In her symbolic clay forms, Anita Fields (Osage-Creek) uses tribal clothing to honor the courage and spiritual strength of Native American women. 1995. Slab and core built earthenware colored with sawdust smoke, red iron oxide and gold glaze. Height, 21½" (54.6 cm). Private collection*

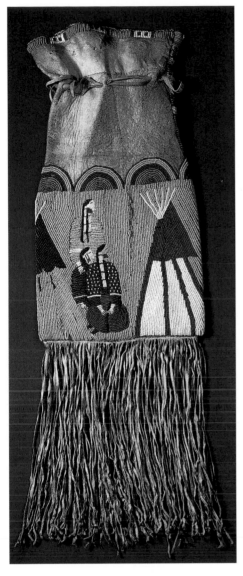

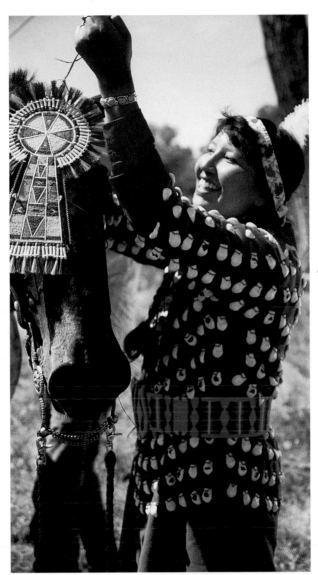

△579 *Kristi Jefferson (Crow) in her elk-tooth dress at Crow Fair, 1993, Hardin, Montana. As in the past, a majority of today's toothlike shapes are carved from elk ribs to imitate real teeth. Crow people call them bone dresses rather than elk-tooth dresses.*

580 *Jessica and Jaime Siemion (Crow), at Crow Fair, 1993. "In observing the carcass of an elk it is found that two teeth remain after everything else has crumbled to dust," explained Shooter, a Teton Sioux, in the early 1900s. "These teeth will last longer than the life of man, and for that reason the elk tooth has become the emblem of long life. . . . We desire long life for it, and for this reason an elk tooth is given to a child if its parents can't afford the gift."*

578 *As noted in this beaded courting scene, young women wishing to present a fine appearance to prospective mates wore their elk-tooth dresses and dentalium-shell earrings (572). Minneconjou Lakota. c. 1880s. Length, 26" (68.0 cm). The Southwest Museum, Los Angeles 1409 6140*

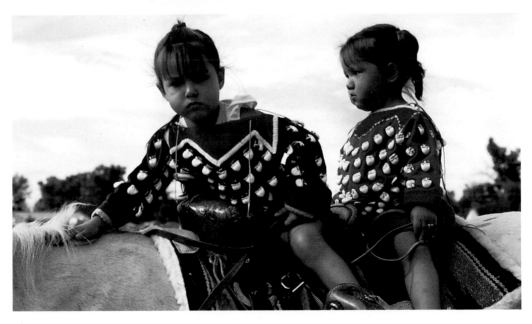

PLAINS METALWORK

A variety of influences provided inspiration for Plains Indian metalwork: trade pieces manufactured in the East for the Indian trade, Spanish ornaments produced by Mexican metalsmiths, and design styles brought into the region by the Woodlands tribes. By the 1820s, southern Plains metalworkers, who probably learned their craft from Mexican blacksmiths, had mastered the basic processes of cutting, stamping, and cold hammering.

Most work was produced in German silver, an alloy of copper, zinc, and nickel. At the same time, various Southwestern designs introduced an array of shapes, including *najas* (583), several types of crosses (599, 604), and punched-pattern designs (586). Many of these patterned designs are taken from previous forms of clothing and adornment, such as quillwork and parfleches (see 511 and 515).

581 *Good Buffalo Bull (Oglala Sioux) of the northern Plains wears a pectoral with crescent pendants. It is unclear if this pectoral style was made by eastern Euro-American silversmiths or Native Plains smiths. c. 1872. Smithsonian Institution*

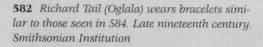

582 *Richard Tail (Oglala) wears bracelets similar to those seen in 584. Late nineteenth century. Smithsonian Institution*

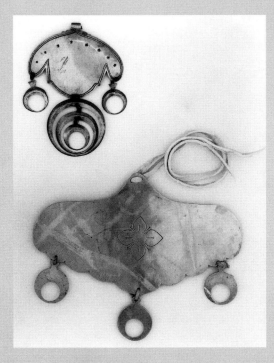

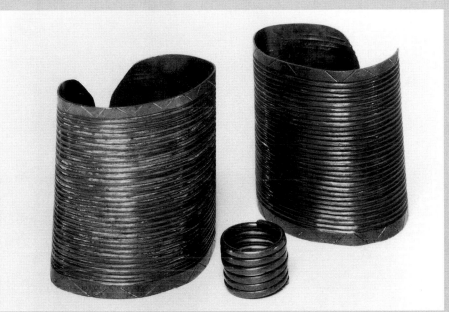

584

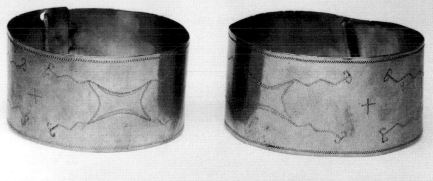

585

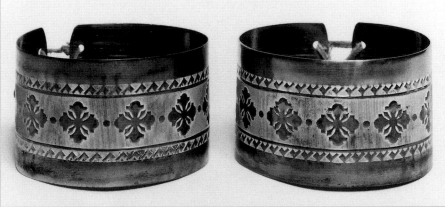

586

△583 Top: *A rare sterling-silver pectoral in the southern Plains style. c. 1848–55. Height, 7" (17.8 cm), Denver Art Museum, 1969.429.*
Above: *This Shoshone pectoral's prototype (as well as that seen in 581) was the bridle face plate—borrowed by the Spanish from the Moors—implements thought to protect warriors' horses from injury. The Navajo also adapted crescent forms for najas on squash-blossom necklaces (see 1046). The pectoral, of German silver with an engraved quatrefoil, was worn as a neckerchief slide or attached to a bone-tube breastplate. 1880. Height, 4½" (11.4 cm). Denver Art Museum, 1956.154*

584 *Shoshone brass bracelets and Piegan Blackfoot spiral-curled finger ring. Collected 1900 at the Wind River Reservation, Wyoming. Left bracelet height, 6¹¹⁄₁₆" (17.0 cm). The University of Pennsylvania Museum, 36776, 45-15-656*

585 *Lakota armbands worn around the man's upper bicep muscle. The association of trape-zoidal-shaped spider webs, cross-shaped dragon-flies, and thunder's zigzag lines (at the web's corners) implies protection. The web stretches out toward the cardinal directions, home of the four winds and thunder power. Collected before 1893. German silver, rocker engraving. Height, 1⅝" (4.2 cm). The University of Pennsylvania Museum, 10996*

586 *Lakota armbands stamped with floral designs. German silver and buckskin ties. Height, 2" (5.1 cm). The University of Pennsylvania Museum, 45-15-682*

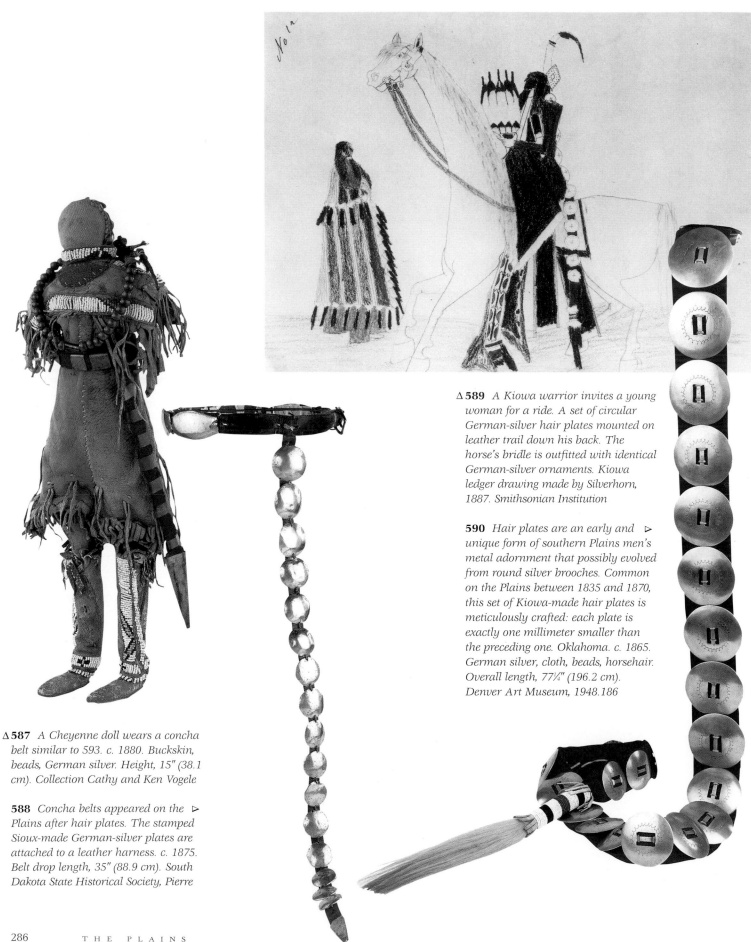

△ 589 *A Kiowa warrior invites a young woman for a ride. A set of circular German-silver hair plates mounted on leather trail down his back. The horse's bridle is outfitted with identical German-silver ornaments. Kiowa ledger drawing made by Silverhorn, 1887. Smithsonian Institution*

590 *Hair plates are an early and* ▷ *unique form of southern Plains men's metal adornment that possibly evolved from round silver brooches. Common on the Plains between 1835 and 1870, this set of Kiowa-made hair plates is meticulously crafted: each plate is exactly one millimeter smaller than the preceding one. Oklahoma. c. 1865. German silver, cloth, beads, horsehair. Overall length, 77¼" (196.2 cm). Denver Art Museum, 1948.186*

△ 587 *A Cheyenne doll wears a concha belt similar to 593. c. 1880. Buckskin, beads, German silver. Height, 15" (38.1 cm). Collection Cathy and Ken Vogele*

588 *Concha belts appeared on the* ▷ *Plains after hair plates. The stamped Sioux-made German-silver plates are attached to a leather harness. c. 1875. Belt drop length, 35" (88.9 cm). South Dakota State Historical Society, Pierre*

591 *German-silver Kiowa earrings in the form of a crawdad (crayfish) continue a traditional nineteenth-century motif. c. 1900. Length, 2½" (6.4 cm). Denver Art Museum, 1949.124a, b*

592 *Pawnee-made German-silver earrings. Their length—5¹¹⁄₁₆" (14.5 cm)—recalls long dentalium earrings (572). Manuel Knife, Anadarko, Oklahoma. 1954. Denver Art Museum, 1954.233a, b*

∇ **593** *A Kiowa woman's belt set. The cases held a sewing awl, whetstone, and flint and steel for making fire. Hide, beads, German silver. 1920. Typical concha diameter, 3" (7.6 cm). Denver Art Museum, 1937.42*

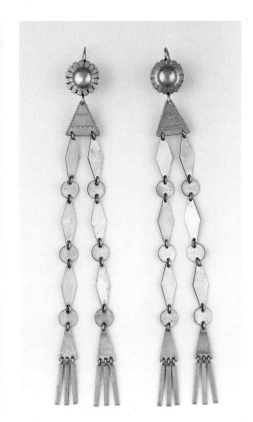

591

592

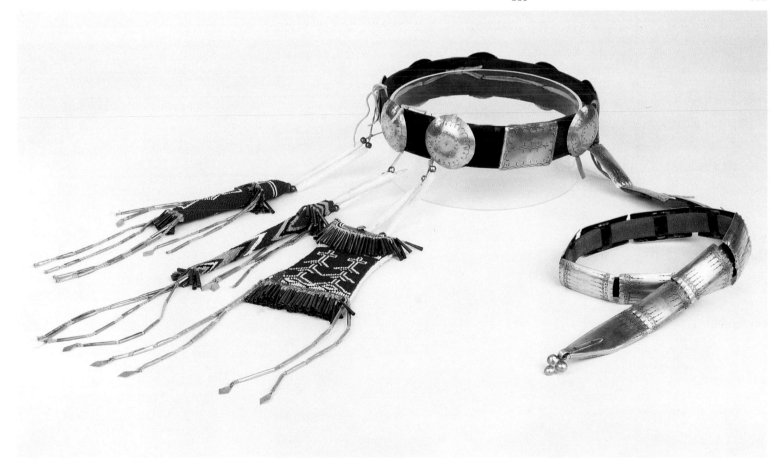

THE CHURCH AND NATIVE ADAPTATION

594 *Photograph of Chief Gall, or Pizi, war chief of the Hunkpapa Sioux and principal warrior at the Battle of Little Big Horn, 1876. His dragonfly design earrings, signaling kinship with thunder, were worn for protection. Smithsonian Institution*

595 *A silver trade cross distributed by the Hudson's Bay Company is strung on a buckskin thong with a bear tooth and red-yarn tassel. Collected among the Sioux, c. 1845. Overall length, 16" (40.6 cm). South Dakota State Historical Society, Pierre*

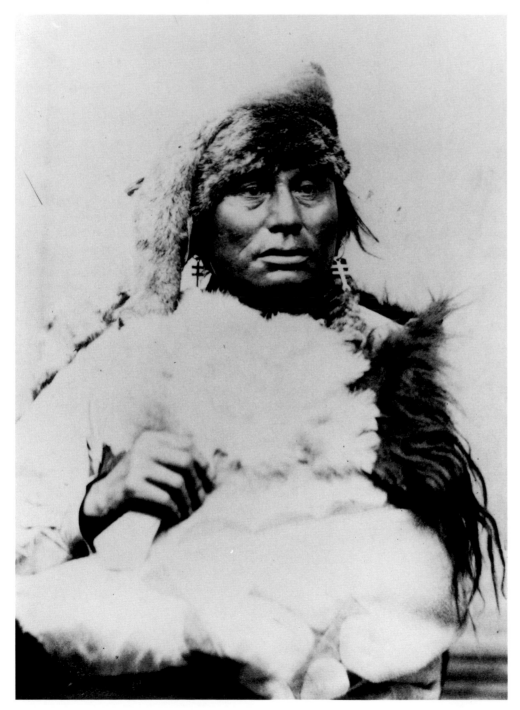

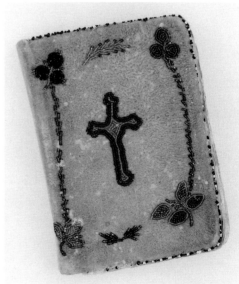

596 *Lakota buckskin Bible cover displays a beaded Episcopalian cross, following a long-standing Native American tradition of embellishing ritual objects. c. 1871. Length, 8" (20.3 cm). U.S. Department of the Interior, Indian Arts and Crafts Board, Sioux Indian Museum*

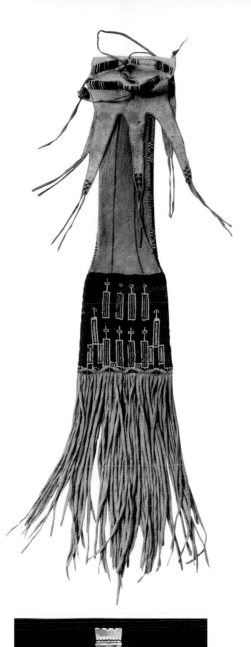

597 *A beaded Kiowa pipe bag unites Euro-American church imagery and indigenous religious practice. The pipe has been the Plains Indians' "principal instrument of prayer" for centuries. c. 1890. Hide, paint, beads. Length, 24" (61.0 cm). The Heard Museum, Phoenix*

598 *Southern Cheyenne chief Little Robe wears a trade-cross necklace with crescent-shaped pendants. c. 1870. Displaying the cross did not always indicate Christianity—Morning Star and the dragonfly had long been represented by cross-shaped motifs. At the same time, the borrowing of Christian symbols such as the cross more frequently signaled another sort of protection by incorporating Euro-American power imagery. National Museum of the American Indian*

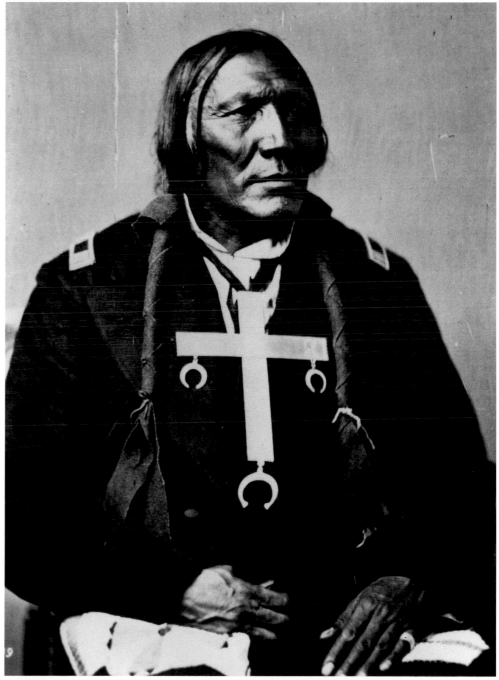

599 *Cross with crescent pendants. George Silverhorn (Kiowa). 1967. German silver. Length, 12½" (31.8 cm). U.S. Department of the Interior, Indian Arts and Crafts Board, Southern Plains Indian Museum, 67.57.2*

THE PEYOTE CULT AND NATIVE AMERICAN CHURCH JEWELRY

The Peyote Cult, of precontact origins among northern Mexican tribes, centers around the eating of peyote (*Lophophora williamsii*), a vision-inducing cactus. During the 1870s, peyotism—blended with Christian morality—was embraced by several southern Plains tribes. Swiftly spreading throughout the West, by 1918 it was formally chartered as the Native American Church. The most important pan-Indian religion today, the majority of its members are Plains Indians.

Jewelry associated with the Native American Church relates in either form or applied imagery to the Church's ritual equipment and concepts. Foremost in church symbolism is the aquatic spirit bird, represented by the scissortail *(Muscivora forficata)*, who carries worshipers' blessings upward to the Great Spirit. Typifying "ascend-

ing prayer," they are usually depicted with neck and wings outstretched as if in flight. Other iconographic motifs include the tipi, drum, fan, and rattle.

Native American Church jewelry originally served as a communication symbol. Although now legally incorporated, the Church initially functioned underground since it used peyote. Wearing stickpins or earrings of waterbirds was one way Church members identified each other. The Native American Church, and its adornment, continues to be important in many Indian people's lives. Simultaneously, the jewelry's lyrical form has wide appeal and is frequently worn for other than religious purposes, particularly by non-Natives. As in the past, few Plains metal artisans specialize; most create both ritual and secular adornment.

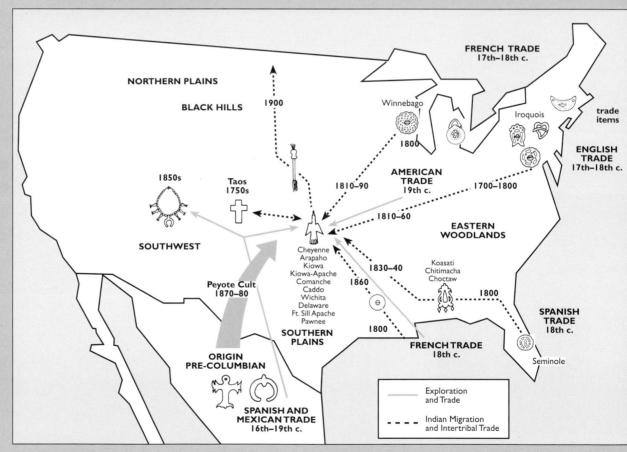

This map illustrates the important routes of trade and intertribal stylistic influences that have been significant to the development of contemporary German-silver and Native American Church metalwork by Southern Plains craftsmen during the past several centuries.

600 *By the late nineteenth century, peyotists began wearing neckties as alternatives to neckerchiefs, and tie pins replaced slides. 1. Sun-form tie pin. Kiowa. Early 20th century. 2. Tie slide, connected with the Peyote Cult. Osage. c. 1880. 3. Tie slide representing two peyote buttons and an outspread eagle tail, a bird-prayer reference. Twentieth century. Kiowa. 1951. All, German silver. Above diameter, 2¾" (7.0 cm). Denver Art Museum, 1951.198, 1952.331, 1951.192*

601 *1. Earrings. Moses Boitone (Kiowa). 1942. 2. Earrings representing peyote buttons. George Silverhorn (Kiowa). Late 1940s. 3. Waterbird pin. The movable tail feathers dangle like a fringe, a common component in Plains clothing and adornment. Joe Ziwack (Potawatomi). 1934. All, German silver. Above length, 1⅝" (4.0 cm). Denver Art Museum, peyote: 951.186*

602 *Belt buckle. Jhon-Goes-In-Center (Oglala Lakota). c. 1992. Rocker-engraved silver. Horizontal length, 4⅛" (10.5 cm). Sioux Trading Post*

602

603 *Native American Church breastplate pectoral. Mitchell Zephier (Lower Brulé Lakota). 1993. Silver. Horizontal width, 6¼" (15.9 cm). Sioux Trading Post*

604 *Sioux warrior's cross for Native American Church ceremonies. Mitchell Zephier. 1992. Length, 9" (22.9 cm). Sioux Trading Post*

603

604

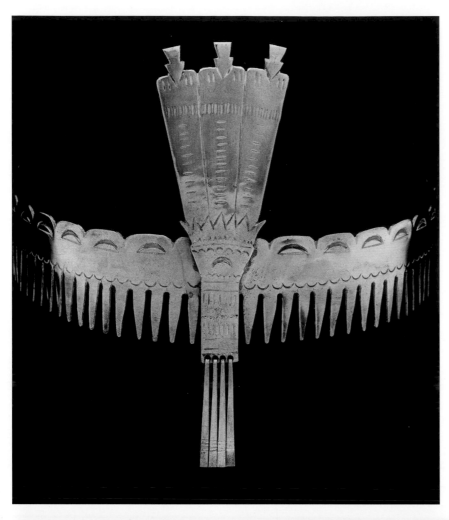

605 *Southern Plains woman's headcombs reflect metalwork styles carried into the region by the Caddo, originally from the southeastern Woodlands. George Silverhorn (Kiowa). 1966. German silver. Diameter, 6" (15.2 cm). U.S. Department of the Interior, Indian Arts and Crafts Board, Southern Plains Indian Museum, A-66.5.1*

606 *Earrings with symbolic designs or images identified with the Native American Church include a tipi, spirit bird, gourd rattle, and crescent moon.* LEFT TO RIGHT: *Murray Tonepahote (Kiowa). 1976. Homer Lumpmouth (Arapaho). 1971. Julius Caesar (Pawnee). 1972. Edward Parker (Comanche). 1974. All, German silver. Longest length, 3" (7.6 cm). U.S. Department of the Interior, Indian Arts and Crafts Board, Southern Plains Indian Museum, AD-67.57.13, AD-71.5.6, AD-74.8.32, AD-74.8.23*

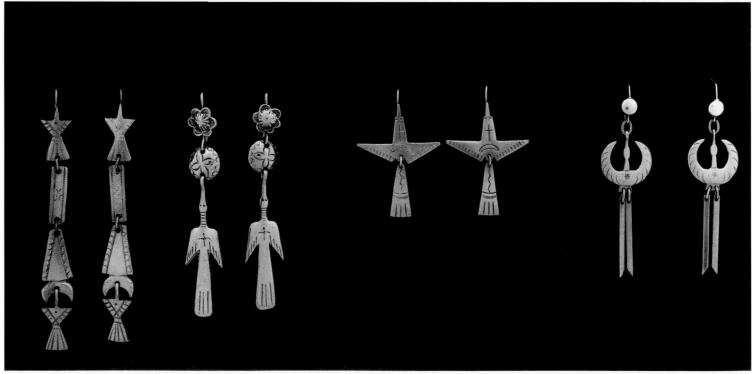

Marlene Manteah (Pawnee), finger weaver, beader, potter, and painter, has been a German silversmith for twenty years. "German silver [is] really hard on your hands. You do everything by hand: make your own cutout, file it, shape it, stamp it. Unlike sterling, nothing is bought to be soldered on; it's all done from scratch." The artist's husband, Clayton, completes each piece. "He takes a buffer and buffs the rough edges off as he polishes. Actually, he does the hard work."

Most of Manteah's traditional work is made for the Indian community and peyote ritual. "I take a lot of time with the details. If it's not good, I won't put it out." Defining her inspiration, she says, "Indians express their feelings through their art. It's something in you that has to come out. It isn't work, it's creating."

607 *Stickpin with a sun symbol. Dennis Tule (Kiowa-Apache/Comanche). 1995. German silver, garnet. Height, 3¼" (8.3 cm). Private collection*

608 *Stickpin with a sun symbol. Thomas Tointigh (Kiowa). German silver, 1974. Length, 3" (7.6 cm). U.S. Department of the Interior, Indian Arts and Crafts Board, Southern Plains Indian Museum, AD-74.8.18*

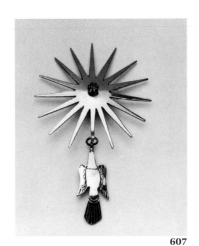

607

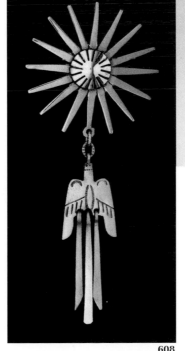

608

609 *Marlene Manteah gives contemporary expression to traditional motifs such as in these earrings and bolo tie. 1995. German silver and brass. Earring length, 7½" (19.1 cm). Private collection*

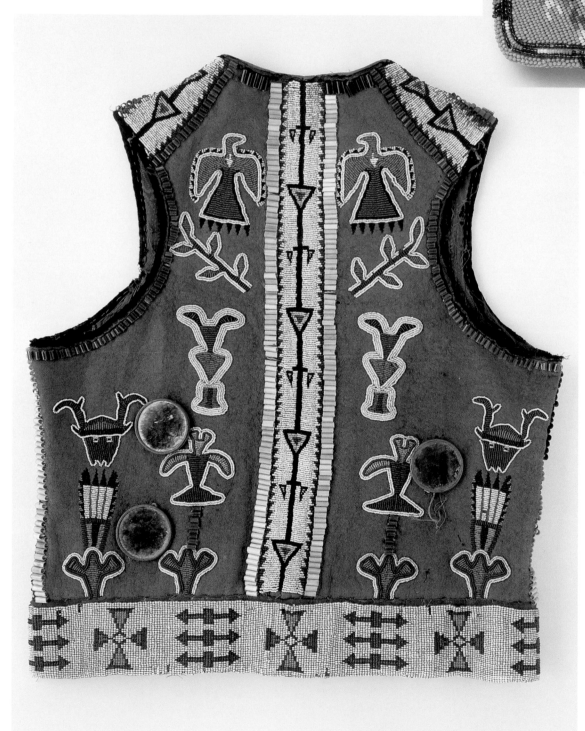

△ **610** *Native American Church beaded belt buckle. Navajo. 1980s–90s. Private collection*

611 This buckskin vest, containing both decorative and spiritual Native American motifs, was most likely worn for a late nineteenth-century religious revitalization ceremony. Horned anthropomorphic figures emerge from Native American Church eagle-feather fans; geometric shapes alternate with plant forms and thunderbirds, showing influences of the Prairie or Missouri River beadwork style. The beaded panels may have been added later. Vests were among the more common European garments adapted by Plains artisans. While cloth vests were available to Indians as annuity goods, they inevitably preferred those fully beaded on hide. Possibly Oto-Missouri, Osage, or Kiowa. Collected in Oklahoma, late nineteenth century. Cotton, silk, glass beads, mirrors, metal. Length, 21¼" (54.0 cm). The Gilcrease Museum, Tulsa

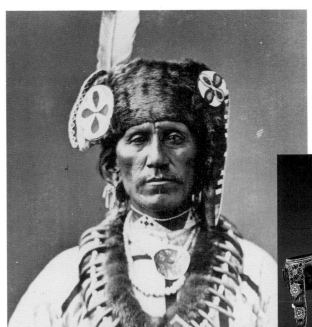

614 *Decorated gourds accompany the singing during peyote ceremonies. "Inside the gourd they place a pheasant's gullet, prairie chicken, or stones from an ant pile." relates James Oldham, Sr. (Arapaho). Late 1800s. Length, 22" (55.9 cm). Denver Art Museum, 1949.3637*

615 *A beaded peyote fan by Chad Nielsen, 1990. Private collection*

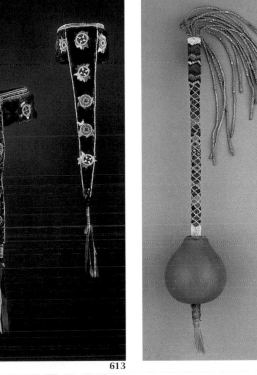

613

614

615

612 *Haregare (Oto) wears an otter fur turban, similar to those shown in 613. Probably c. 1870s South Dakota Historical Society*

613 *Osage turbans, formerly worn by men participating in Native American Church activities, were modeled after fur turbans originally used on the eastern Plains and Midwest regions by the Mesquakie and Iowa, who were forced to relocate to Oklahoma in the late nineteenth century. The style was adopted by southern Plains people, who, finding otter and other furs scarce, simplified the turban's form and added distinctive decorations, such as the beaded disks and the bands of netted beading on the pendants. Early 1900s. Otter fur, beads, ribbon, metal. Length, 36⅛" (92.0 cm). Denver Art Museum, 1950.104*

616 LEFT TO RIGHT: *Cross by Robyn ▷ Ariquoe (Kiowa-Creek). Buckle by Darrell Underwood (Kiowa). Kiowa buckle, maker unknown. Buckles, 1960s–80s; cross, 1993. Cross length, 3" (7.6 cm). Private collection*

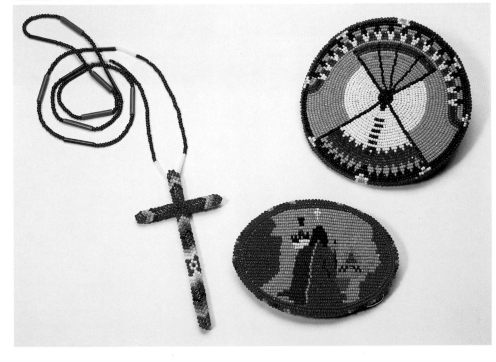

Preeminent among southern Plains craftsmen is **Julius Caesar** (Pawnee), born in Oklahoma in 1910. He first apprenticed to Pawnee smith Hiram Jake, a creator of jewelry related to the Peyote Cult of the Native American Church. Moving to Iowa's Sauk and Mesquakie settlement after marrying, Caesar learned Woodlands-style metalwork while studying with renowned smith Bill Leaf, who bequeathed his tools to his student. A half-century later, Caesar's son, silversmith **Bruce Caesar** (Sauk-Mesquakie/Pawnee), would recall the fascination he and his younger brother, Harry, had with their father's tools: "When he was gone, we'd use his tools. Even the forming blocks and pegs were works of art. And we loved to see how he produced them. He eventually taught us everything."

For over a decade and into the 1960s, Julius Caesar traveled extensively through Indian territory, systematically recording tribal variations in motifs and symbols. His sketches, amplified by extensive museum research in Pre-Columbian and historic Native metalwork, provided a foundation for unique interpretations of original tribal styles. Caesar's special technique was to refine and embellish a basic design, such as the aquatic bird, into a contemporary statement in German silver, often enhanced with polished stones and shell. The sketchbooks of original works became important references for his artisan sons.

Bruce Caesar recalls that he and Harry began working in silver at seven and nine years old, respectively. Their commitment grew steadily, the result he believes of love and esteem for their father. "We loved his work: it was beautiful. In the early stage, we'd literally look over his shoulders as he sat at his workbench. He'd tell jokes; he'd tell us coyote stories. He was very Indian, very Pawnee. We had to understand what his images meant.

"We had our own regimen: first to build rings and, only eventually, bracelets and earrings. They were simple rings with a little image stamped on the surface. Our father made his own stamps with symbols. He explained to us how he used these symbols to develop sentences or a thought. In the process we learned a lot of the symbolism. I'm sure this was his purpose.

"Our apprenticeship lasted many years. We weren't really allowed to produce anything aesthetically of our own artistic heart. Eventually though, if we wanted to make something better, if we had a way to prove something, then it was, 'Go ahead, we'll see what it looks like.' I worked for my father for many years and I stayed with him until the end of his life. When I left the business to go on my own, I was already getting recognition. It was a professional decision.

"Some things made by my father were given to me after his death [in 1982] by both Indians and non-Indians. But as much as he felt about the work, he always said to sell it. 'You made one; you can make another. If it's something you can't part with, you'll sit around with a warehouse full of them.'

"I work in silver and gold and like my father, I'm known for southern Plains jewelry. So is my son, Adam. A lot of the work itself is functional, directly connected to the culture in the sense that it is used for a specific purpose. It wasn't just a commercial thing. Funeral jewelry, for example, had certain elements made for people who were on their way. It wasn't worn haphazardly or frivolously. Many things are used specifically by the Indians themselves such as the dancer's armbands. Another is the roach spreader (617). It used to be worn by a warrior; today it is only seen on dancers (1173).

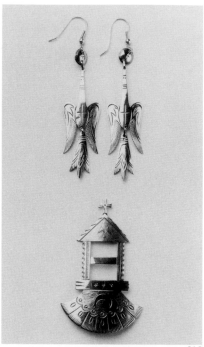

618

617 *An innovative roach spreader by southern Plains artisan Bruce Caesar. Roach spreaders—originally carved of elk antler—held and spread open the distinctive porcupine hair headpiece called a* roach. *Although the form and materials of roaches have changed (see 39), they remain the favored headdress for powwow dancers. 1973. Etched and cut German silver, feathers. Length, 6½" (16.5 cm). U.S. Department of the Interior, Indian Arts and Crafts Board, Southern Plains Indian Museum, AD-73.19.2*

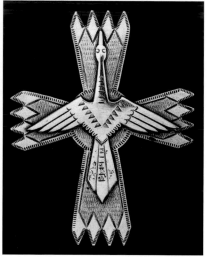

619

618 *Waterbird earrings and a tie slide with a tipi and peyote-fan motifs. Bruce Caesar. 1994. German silver. Earrings length, 2⅞" (7.3 cm). Private collection*

619 *A ritual medal combines the Native American Church waterbird with the Christian cross. Layering the aquatic spirit bird upon the cross represents a conscious synthesis of Native and Catholic forms. Julius Caesar (Pawnee). 1969. German silver. Length, 3¼" (8.3 cm). U.S. Department of the Interior, Indian Arts and Crafts Board, Southern Plains Indian Museum, AD 69.7.13*

MAINTAINING ANCIENT TRADITIONS

Silversmith Kennard Real Bird (Crow) considers the circumstances of his birth to be most fortunate for his life and art: "I was born into a traditional family that valued the old way and to a degree resisted assimilation. We're about as Indian as Indian can be. My mom, Lucy Real Bird, is still dressed the old way, from the 1800s. And we take a lot of pride in that, because that means that my mom has self-esteem, self-confidence in herself. Her mother's name was Otter Stays in Water. Her great-grandfather, Plays With His Face, was chief in 1840, and the most fearless warrior in Crow history. They talk about Plays With His Face as if he were still here, about his courage and his exploits on the battlefield.

"On my dad's side, Medicine Crow—also a distinguished warrior and founder of Crow Fair—was my great-great-grandfather. The mother of grandfather Mark Real Bird was Annie Medicine Crow. Without being conscious of my mom ever telling us, I knew that I had to be the best that I could be."

Ken Real Bird draws an interesting analogy between riding broncos and creating jewelry. "I was a professional bronco rider. There's intricacy and delicacy there. I wasn't the best, but I rode the best bucking horses in the stiffest competitions. For me giving my best shot was the greatest feeling in the world. Making jewelry is like riding a bronco in the rain with nobody watching. I remember one time, there were cloudbursts coming on, the wind was blowing, the rain was coming down. Riding felt good. I didn't need ten thousand people cheering, I didn't need women watching. When you're an artist, it's the same thing. You sit in the studio, and nobody is watching you; nobody cares. As you design and start fabricating and applying the techniques, personal satisfaction lets you like yourself well enough so that you don't have to do anything that is contrary to the process.

"Looking for inspiration, I found things that would identify me as a Crow man, a Crow Indian. That was what I could present. I examined the traditional Crow parfleche and beadwork designs and beautiful colors; they were natural artists. I looked at my mom's beadwork: She would do it just perfectly. Using motifs like these isosceles triangles, I began dissecting them: taking the design apart and putting it together in different combinations of images and symbols. I take most pride in the lines (515). Nothing is ever perfect because in a piece that is one of a kind, so many welds need to be done, and there's always a chance for error."

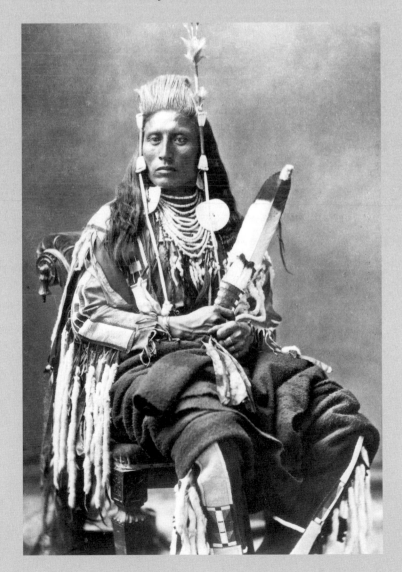

620 *Medicine Crow (Crow), great-great-grandfather of Kennard Real Bird. His shirt displays his prowess as a warrior. 1880. Courtesy Azusa Publishing*

THE OKLAHOMA ARTS AND CRAFTS COOPERATIVE

Several generations of superb southern Plains artisans come together in the Oklahoma Indian Arts and Crafts Cooperative. Chartered under state law in 1955, this organization fosters the careers of contemporary Indian artists and provides them a retail outlet in the Southern Plains Indian Museum at Anadarko, Oklahoma. An earlier crafts guild funded by the Department of the Interior was unsuccessful. "That's when our women thought about an economic venture," recalls LaVerna Capes, current manager and daughter of one of the founders, Nettie Standing (624, 1191), a legendary Kiowa beadworker and matriarch of an extended family of accomplished beaders. "They had nowhere to sell; there was only one pawnshop downtown where they got whatever they could. After talking all year, eleven people (ten women and one man) formed the co-op. They were Wichita, Comanche, Kiowa, and Cheyenne. We're kind of a neutral ground for all the tribes. That's how we meet a lot of craftspeople—the Shoshone-Bannock, Navajos, and others."

To supply the co-op, Capes describes a collaborative mode of working among families. "We'd make big harness and fancy dancer sets for the men. I would start the belt, and after getting the design on, I strung the looms for the two oldest girls so they could do the harness sets. Then my husband would take over on the belt. Our youngest boy was an expert with gourd stitching; the other two girls beaded the belt drops. Then I worked on the medallions and cut-bead items. When we finished, we had a fifteen-piece set.

"When working on a ceremonial dress," she continues, "you start it and somebody else will help—usually a friend. I begin the basic design, then ask another lady to do the skirt. After I see her design on the skirt, I finish the dress top. Because we have such close ideas, we understand what each one is doing. So it makes a difference, and it's interesting. We all work on the dress. It's never said, 'I make everything.'"

At the same time, "people have always brought new ideas into the co-op. For example, Mary Inkanish (Cheyenne) made wonderful suede bags. One is still called the 'Inkanish Special.' Angeline Stevens, a Delaware lady, cut the bags, and many of the patterns were hers. I was very fortunate to know these women."

621 *Beaded leaves by LaVerna Capes (Kiowa). "They say, for a real Kiowa design, put a leaf on it." Capes uses an actual leaf as a model. 1994. Length, 3" (7.6 cm). Collection LaVerna Capes*

Anadarko is a popular tourist spot, though 85 percent of the co-op's patrons are Native American. "We're very fortunate to have an Indian population that appreciates good beadwork," states Capes. "A lot of times, when the girl is maybe thirteen, she'll start with a pouch set. Soon we're building up to purses, a dress. . . . For her whole life, the girl keeps these items. They're put away, given to her daughter, or maybe a cousin will wear them, but they'll always come back to her. So there may be three generations of things made here. And it's usually the grandmother who buys the item to start the granddaughter off."

In their memories of co-op founder Nettie Standing, who died in 1987, all family members—her husband,

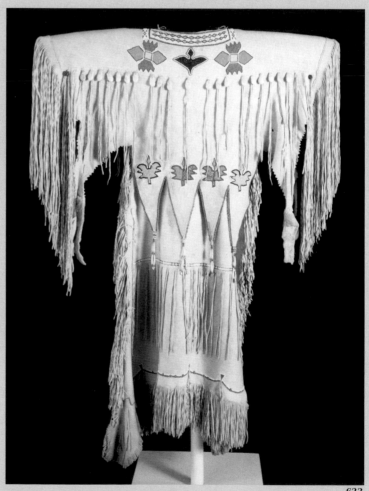

622

seven children, their various spouses and children—emerge in a colorful and captivating tableau. "You wouldn't believe how she worked," recalls daughter Josephine. "You never saw my mother without her beadwork. Her hands were constantly busy." Adds another daughter, Donna Steinberg: "One time while mom was carrying some beads, she got dizzy and fell off the top of her porch. . . . She broke her shoulder, but didn't drop a bead. She held them way up as she fell!"

Although a seamstress for years, Nettie Standing didn't start beadwork until she was in her forties. Similarly, her eldest son, McKinley Standing, didn't begin beading until after retiring from the Navy in 1972. "He was excellent, and of course he taught his kids, including Jackie Priore. Jackie's [is] the most wonderful of any of the work now" (633). The young artist, who joined the co-op at the age of thirteen, attributes her color and design sense to her father, who died in 1990.

Jackie Priore remembers a family of working artists. "We sat at that big long table, my mom at one end, my dad at the other. He had the most extraordinary talent to be working on one design while instructing me across the table how to do something completely different. I used to think we were like a little factory, we were all beading. For us kids it meant spending money, Disneyland money." Priore has also inherited her insistence on quality from her grandmother. "You'd bring work to show her and if it was not done right, she gave it back to you, telling you to take it apart and do it right. I'd say, 'Nobody will see that mistake, Grandma,' and she'd say, 'I see it.'"

The women believe Nettie Standing's spirit lives on in their own creativity. Relates LaVerna Capes: "When my mom used to bead at home, she'd sit near a certain lamp. I took that lamp after she passed away. But it won't come on for just anybody. It's very delicate. . . . You have to really sit and hold it to make it work. Sometimes we'll be sitting there and the light will come on, and my husband will say, 'I think your mom wants you to do beadwork.' But I won't throw away that lamp for anything, because of who owned it before."

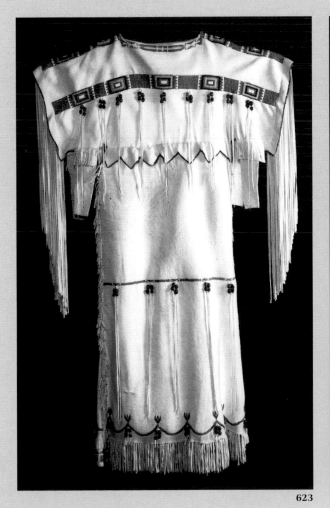

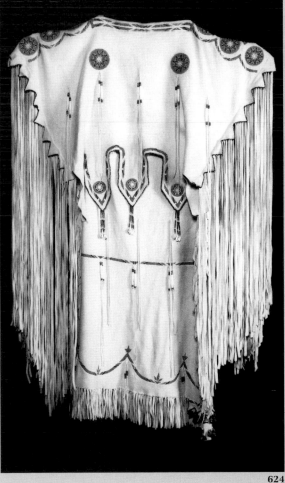

622 *Kiowa-style embroidered woman's dress of hide and beads. c. 1920. Buffalo Bill Historical Center, NA 202.442*

623 *Cheyenne-style buckskin dress embellished with cut-glass beads, fringe, and mescal beans. Melvin Blackman (Cheyenne-Arapaho). 1966. Collection Melvin Blackman*

624 *Kiowa-style buckskin dress worn in 1981 by Miss Indian Oklahoma, Nancy Gail Tsoodle. It is ornamented with dewclaws and cut-glass and bone beads. Nettie Standing (Kiowa). 1976. Collection Nancy Gail Tsoodle*

623

624

Silversmith **Tim Whirlwind Soldier** (Lakota Sioux), from Rosebud Reservation, traces his ancestry to Wanagi Pa. Introduced to silversmithing in 1980, Whirlwind Soldier works primarily with familiar images from nineteenth-century quilts and beadwork, which he interprets in metal inlaid with ground minerals. He describes a recently completed bracelet: "On the bracelet's interior is a message that only the wearer knows, a hidden beauty that can surprise. Some people who have my jewelry show the world the outside, but the inside is their own little secret." He believes that the most highly skilled and demanding element of silversmithing is the soldering, "using the flame. . . . You can be the best designer, can cut well and do the stonework, but if you put the materials together crudely or haphazardly, go find another trade."

▽ **625** *Buckle. Tim Whirlwind Soldier (Lakota). 1991. Silver, jeweler's gold, inlay of crushed turquoise, shell, pipestone, and lapis lazuli. Length, 3½" (8.9 cm). Private collection*

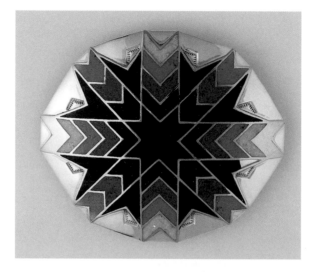

626 Wolf Memories. *Conchas for a belt. The scenes, from left to right, row by row, depict: 1. Creator's hands giving wolf to the world—birth of the wolf. 2. Young Wolf looking out over the land—the searching of youth. 3. Wolf traveling toward the mountain and plains—travel begins growth. 4. Wolf on cliff overlooking man's way of life—man at peace, in the beginning. 5. Wolf passes through mountains to new wilderness—creation of new land, new way of life. 6. Wolf watches on cliff over adobes (wolves were hunted to near extinction in the late 1800s– 1900s)—watching the change in man's life. 7. Wolf in night scene, on cliff with moon—end of innocence; wolf now travels by night to survive. 8. Wolf in forest finds mate and mates for life—completion of life. 9. Wolf returns to his creator—born in light; death is in darkness. 10. Wolf in his self-image—memories. Edna Varela (Caddo-Pawnee). 1994. German silver. Typical concha length, 2" (5.1 cm). Private collection*

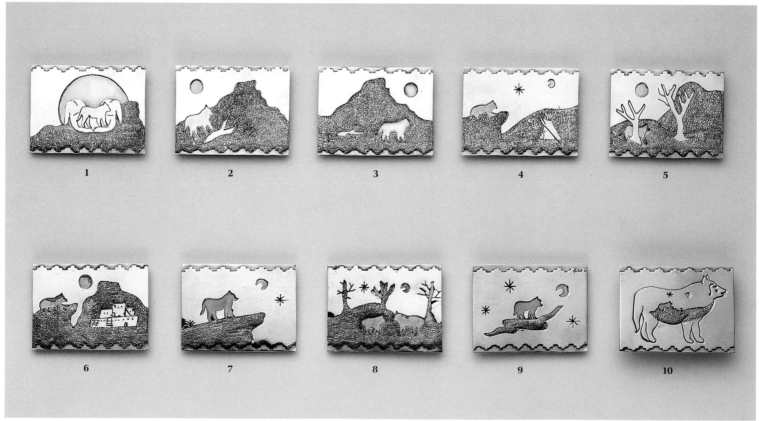

1 2 3 4 5

6 7 8 9 10

626

Nelda Schrupp (Nakota Sioux), born on White-bear Indian Reservation in Saskatchewan, says, "A great deal of my work revolves around the rattle, a sacred object in many spiritual ceremonies. Medicine men use the rattle during prayer, believing that the sound helps carry their prayers to the Great Spirit. I call my art pieces amuletic forms with audio aesthetics, referring to the sacredness of the rattle and the sound (voice) that emanates from the pieces.

"I enjoy the geometric shapes of Piet Mondrian and analytic cubism of Georges Braque and Pablo Picasso. Constantin Brancusi's *Bird in Space* and Alexander Calder's mobiles and monoliths influence my creative process. . . . The visual thread of continuity present in all my work is the use of organic and geometric design elements: hard-edged geometric shapes mixed with soft, pillowlike hollow forms. . . . The circle represents the Circle of Life; squares, rectangles, and triangles represent how Native people were boxed in on reservations where their freedom was taken away. Free-flowing shapes represent how the spirit of Native people could not be harnessed or tied down. Deer antler and horsehair are used to honor the animals for their special role in helping Native people persevere and survive."

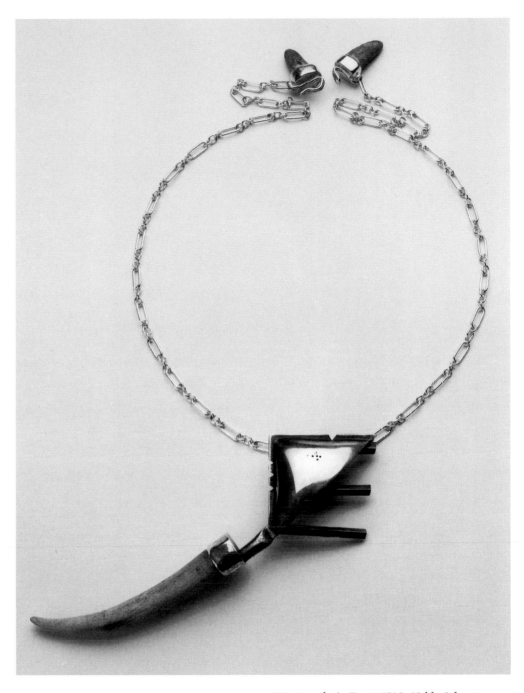

627 Amuletic Form #319. *Nelda Schrupp explains the title of her work: "This amulet is a combination of my Christian and Native spirituality, illustrated by my using a numerical system hidden in different forms: notches, dots, semiprecious stones, and precious metals. Three prongs represent the Holy Trinity of Father, Son, and Holy Ghost, four notches on the rim represent the four directions, and the fifth hole represents Mother Earth. Metal suggests how hard life can be but life, like metal, can be made into anything you want it to be. Deer antler represents the beauty of life." 1994. Length, 6" (15.2 cm). Private collection*

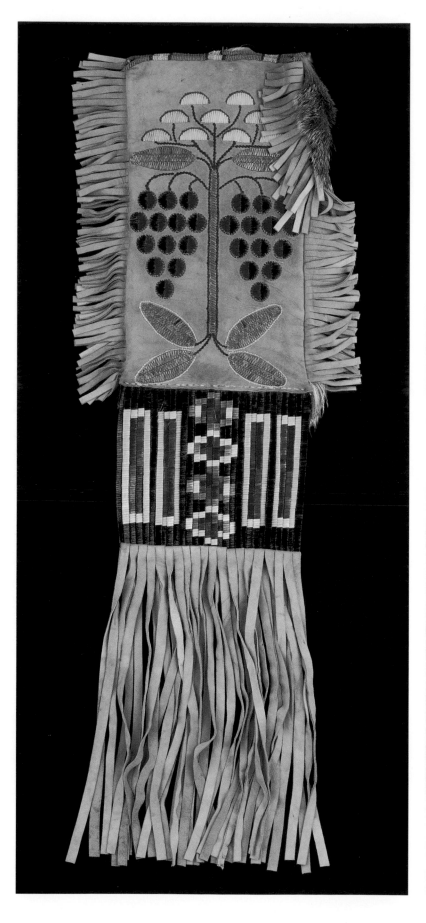

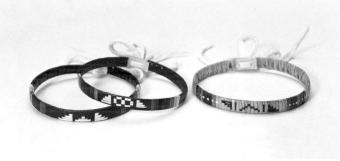

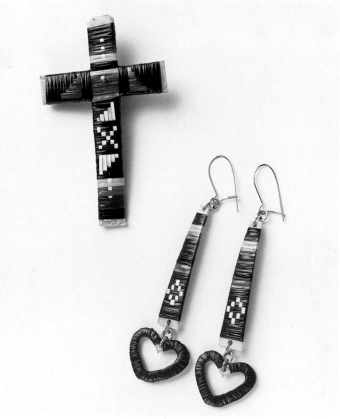

◁ **628** *A contemporary quilled pipe bag with designs and colors signifying plant medicine. Four leaves stand for the cardinal directions. Red choke cherries represent life. Ted Wolf (Lakota). 1986. Quill, glass beads, hide. Length including fringe, 32" (81.3 cm). Private collection*

629 *Quilled bracelets, pin, and earrings, by Christine and Bernard Red Cloud (Oglala Sioux). The artists cherish the old ways and have passed this on to their daughter, Geri Red Cloud, her granddaughter, Anita Big Crow, and numerous other family members. Today, more than thirty relatives craft quilled jewelry at the Red Clouds' studio on the Pine Ridge Reservation. 1992. Dyed and plaited quillwork woven on rawhide. Height of cross, 2¹⁄₁₆" (5.2 cm). Height of yellow bracelet, ¼" (0.7 cm). Private collection*

The work of **Rosalie Little Thunder** (Lakota Sioux) is rooted in tradition. The bold geometric designs in Rosalie's and daughter Amy Little Thunder's beadwork are inspired by patterns that predate reservation art. "The old patterns are peaceful and natural to me—so peaceful and powerful that when I start doing them, it's almost as though I can recover that peace; I can achieve a kind of meditation. I can relate today and tomorrow with yesterday.

"The beadwork is the material part of it. Consciousness of the environment, self-discipline, and being focused are the other part," behaviors that Rosalie acquired in early childhood. "I grew up with my grandfather and his generation in a community of elders who refused to be relocated in town by the BIA. Growing up, everything made sense. Your behavior had a lot of relevance to survival. Discipline wasn't imposed. They let you learn from making mistakes, and if you made a mistake, there was no anger."

Her grandfather was and remains a moral center for Rosalie: "I learned from him the work ethic and if you're going to do anything, do a good job. He was very self-sufficient, had large gardens and never wasted time. He never gave direct orders. Responsibility wasn't imposed. He would say, 'It's a good day to mend the fence,' so I knew to get started."

Rosalie attributes her keen awareness and respect for the environment to her grandfather. "If I needed medicine from a plant he would say to it: 'My daughter has an injury so I need this plant. Thank you for giving it to us.' He taught me that before an animal is killed, you apologize for having to do it, but also be thankful it is there. Grandfather's attitude was that we coexist with the animals: we're not here to dominate."

After a period in a reservation boarding school, Rosalie married and returned to traditional life but "experienced a terrible sense of confusion. I see it connected to my loss of identity at boarding school, but I also see it in the designs of the reservation period. The work is so busy, it assaults your eyes. When I tried to do those designs, I felt their chaos so demanding of conscious attention. You almost have to do it on graph paper and count the beads this way and that. It's frustrating. Those patterns reflect people's frustration in the early reservation years. Being enclosed on reservations, their whole lifestyle was disrupted."

Today Rosalie primarily beads Sioux patterns but also turns to the Arapaho and Cheyenne for ideas. "I really like Cheyenne design because it stayed simpler and bolder for a longer period of time." She describes her time-consuming commitment to excellence: "My work requires careful preparation: the correct material, not just what's at hand. I research photographs, talk to people, find and prepare the materials, do the tanning, prepare the sinew. The hide is brain-tanned. The brain has a lot of lanolin and conditions the hide. They say you should always use the brain of the same animal that the skin comes from. I've been asking butchers to save deer brain, the backstrap sinew, the dewclaws, and the antlers. The butcher told me he felt guilty because they are usually so wasteful. I said that I could use any part of the animal. I know someone who makes deer-antler earrings, and I could pass it on to them.

"I'm working on an Arapaho bag with my daughter. She tends to watch what I do. All of my children are curious; they have a lot of exposure. I furnish them with material, books, photographs. They even have my antique beads. I leave them out in the basket; the hide is there in the hide basket. They start rummaging. I like to watch. I see it evolving through them. I used to instruct them a bit: 'Look at this design; see the color combination.' I'm taking them back to that earlier prereservation period. The more I do this work, the more I see its relevance to my role from my grandfather's generation to my children's."

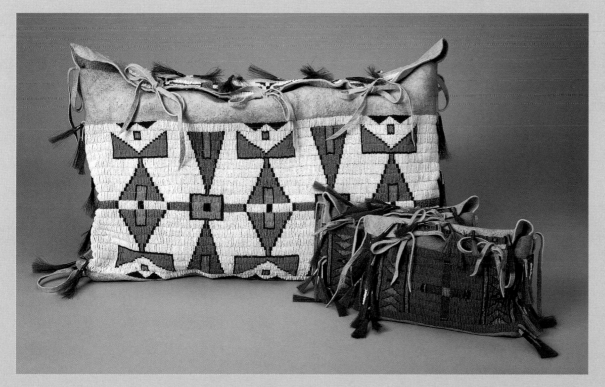

630 *Prereservation style Lakota-patterned tipi bag and saddlebags by Rosalie and Amy Little Thunder. Both, 1992. Rosalie's bag (left): Hide, beads, silver cones with dyed horse-hair. Length, 22" (55.9 cm). Amy's miniature saddlebags: Hide, beads. Length, 8¼" (21.0 cm). Courtesy Buffalo Gallery, Alexandria, Virginia*

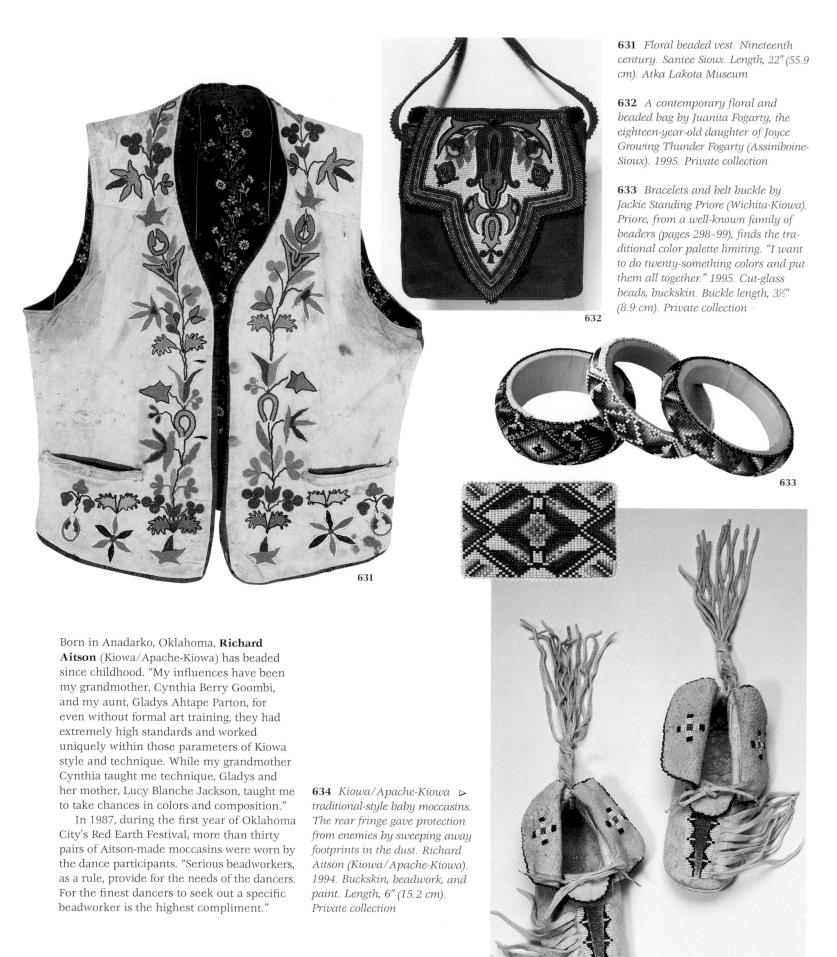

631 Floral beaded vest. Nineteenth century. Santee Sioux. Length, 22" (55.9 cm). Atka Lakota Museum

632 A contemporary floral and beaded bag by Juanita Fogarty, the eighteen-year-old daughter of Joyce Growing Thunder Fogarty (Assiniboine-Sioux). 1995. Private collection

633 Bracelets and belt buckle by Jackie Standing Priore (Wichita-Kiowa). Priore, from a well-known family of beaders (pages 298–99), finds the traditional color palette limiting. "I want to do twenty-something colors and put them all together." 1995. Cut-glass beads, buckskin. Buckle length, 3½" (8.9 cm). Private collection

Born in Anadarko, Oklahoma, **Richard Aitson** (Kiowa/Apache-Kiowa) has beaded since childhood. "My influences have been my grandmother, Cynthia Berry Goombi, and my aunt, Gladys Ahtape Parton, for even without formal art training, they had extremely high standards and worked uniquely within those parameters of Kiowa style and technique. While my grandmother Cynthia taught me technique, Gladys and her mother, Lucy Blanche Jackson, taught me to take chances in colors and composition."

In 1987, during the first year of Oklahoma City's Red Earth Festival, more than thirty pairs of Aitson-made moccasins were worn by the dance participants. "Serious beadworkers, as a rule, provide for the needs of the dancers. For the finest dancers to seek out a specific beadworker is the highest compliment."

634 Kiowa/Apache-Kiowa ▷ traditional-style baby moccasins. The rear fringe gave protection from enemies by sweeping away footprints in the dust. Richard Aitson (Kiowa/Apache-Kiowa). 1994. Buckskin, beadwork, and paint. Length, 6" (15.2 cm). Private collection

EdNah New Rider Weber (Pawnee) is a storyteller and highly original beadworker. She once created work for sale but now beads mostly pipe bags for her medicine people or just for herself. EdNah carefully chooses her hides. "I look for the hide; it's my canvas. Perfection is not important. People look for what's perfect but I like imperfection. The flaws—the cut and the knife marks, even the bullet holes—are beautiful too. I use things like that to select the hides."

635 *Flute bag. EdNah New Rider Weber. Mid-* ▷ *1980s. Smoked deerhide, beads. Length including fringe, 24" (61.0 cm). Collection of the artist*

636 *Wolf Dance bag. EdNah New Rider Weber said of this bag, "Amid the showers and butter-flies, I rejoice." Her work, she believes, means that "when my time comes to travel on, there'll be a bit left of me—for healing and dancing." 1985. Doeskin, beads. Length including fringe, 19" (48.3 cm). Collection of the artist*

637 *Poor Baby. In 1995, EdNah New Rider Weber began to make dolls. The name* Poor Baby *came from her husband. It was originally made of just scraps—the doll had a ragged little dress and no elaborate beadwork on her yoke. EdNah's husband loved her as she was—but EdNah "felt sorry for her and gave her this beautiful robe so she'd be more presentable." The baby is sewn into the bag; when the string is drawn, the bag closes. EdNah continues: "This is based on a traditional Plains idea. Plains people were always on the move. As we all know, it's hard for kids to keep track of things even when they are in one constant place. Little girls were given dolls, and the dolls were secured in the bag so they wouldn't be lost. The bags were tied around the waist on a belt, or around the shoulder." 1995. Unsmoked deerhide, rabbit fur, beads. Length including fringe, 21" (53.3 cm). Collection of the artist*

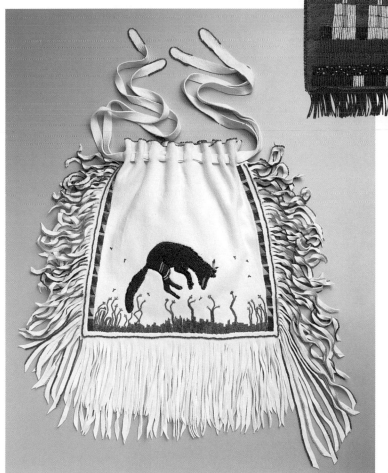

Clarence Rockboy, Dakota Sioux beadworker and spiritual leader, was born in Dickson, South Dakota. "I grew up through the boarding-school system, which was very hard. We were sent to our rooms or hit on the back of the head with rulers for speaking our language. So when I speak of those times, I get angry and ask why they were trying to assimilate us into their society so much. Now it's not a matter of being angry; we have to learn to get along with each other."

In 1952 Rockboy would turn to beadwork. "My father said, 'Why don't you learn how to do beadwork? This will teach you patience.' And I was fortunate to have not only my father, but my cousin who was a bead artist. But I was more or less self-taught because I'd just take a piece of work apart and study it. I specifically chose to work on sacred ceremonial objects." Rockboy further adds that he worked with sacred objects because "women weren't allowed to handle the material. If the woman is on her moon, her power is too strong. The medicine man spirits don't want to come near. Of course, Sioux people have a lot of respect for women. We come from mother earth, and we go back to mother earth. . . . Our colors are from the fire. Just about everything an Indian does uses fire: I go to sweat lodges and Sun Dances; you ought to see the fires." He describes his preferred brick stitch: "The reason why they call it brick stitch is the beads sit diagonal, they stack. That's part of a staff."

"My influences other than Plains are the Shoshone-Bannock. I like their appliqué work. The Winnebago have good designs and colors. We share the Thunderbird, waterbird, and numbers. Seven plays an important role in our society. Look up north at night: you'll see a constellation with seven stars called the Big Dipper. And in your head there are seven openings. On this planet there are seven major continents, seven major seas or bodies of water. And Judeo-Christianity tells us that this planet was made in six days and on the seventh day the Great Spirit rested. And we keep that seventh day holy, the sabbath. So everything is seven. Now most of our major tribes have seven clans. Our tribe didn't have clans; we had councils of fire. In the state of South Dakota there's seven tribes of the real Sioux nation."

The artist believes art is integral to the future of Native America. "I've always known the extraordinary depth of greatness that existed here. And in such a short period of time, thousands of years was just wiped out. Now Native American culture is getting

stronger. Everyone is trying to mend the hoop that has been broken. We just had a summit on our reservation, the Seven Generation Summit. So we're thinking about the future generations . . . by teaching each other and our children how to do beadwork, crewel work, and above all our language." Rockboy's creative legacy continues with, among others, his adopted nephew, Chad Nielsen (page 576).

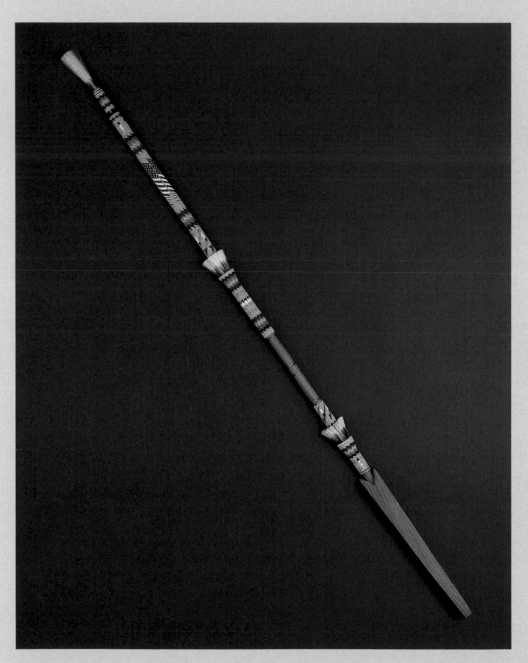

638 *A beaded Native American Church ceremonial staff, made by Clarence Rockboy in 1978, was displayed at the state capitol building during 1990, South Dakota's year of Reconciliation—the centennial anniversary of Wounded Knee. Length, 40¾" (103.5 cm). South Dakota State Historical Society, Pierre*

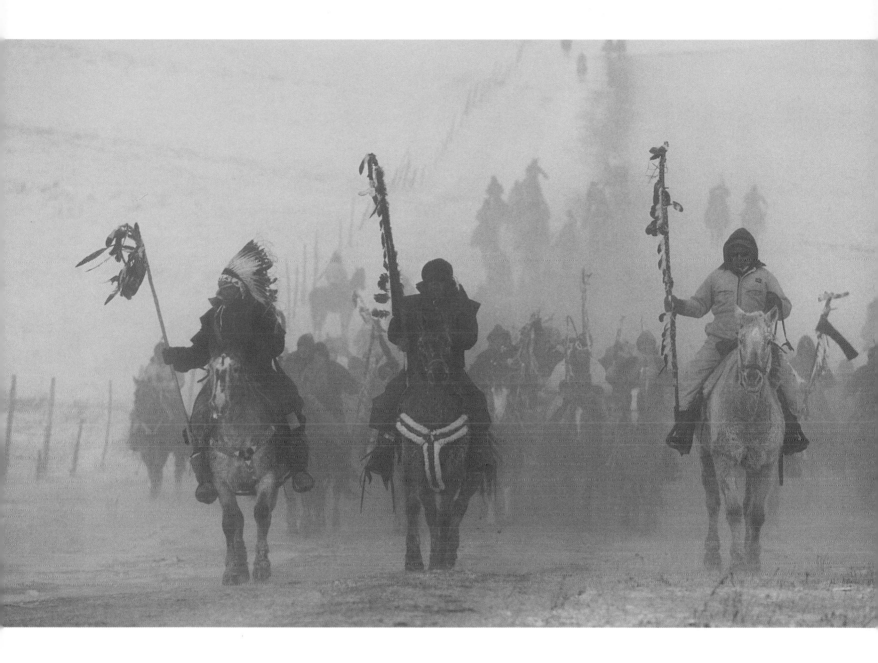

639 *To commemorate the centennial of the 1890 Wounded Knee massacre at the Pine Ridge Reservation in South Dakota, a memorial ride was held. Photographer James Cook recalls: "On December 29, 1990, nearly 350 mounted Lakota riders, led by Arvol Looking Horse, Birgil Kills Straight, and Dan Afraid of Hawk, approached Wounded Knee to mark the end of seven generations of mourning. Throughout seven days of blowing snow and wind-chill temperatures averaging 50 degrees below zero, the riders had retraced the path of Chief Big Foot and his people. As they came over the last few hills, the frozen horses and riders took on a timeless and ghostly appearance, almost as if they were riding in from the past. The suffering we all experienced from the cold that day seemed that much more appropriate as we remembered the results of one culture's failure to understand and tolerate another."*

It is said that where the four powers cross, it is sacred. The great power of the North with its cleansing cold and wind once again wiped away what is bad and gave us new understanding of the sacred. As we return to the center, let us not forget all that we learned and experienced in this journey back from the past. Let us rebuild our nations and mend the sacred hoop.

—Birgil Kills Straight (Lakota), 1990

640 (1–8) *A concha belt depicts the Lakota Nation's past buffalo culture. Entitled* Blessed Are the Buffalo for They Will Return Again, *its imagery illustrates the importance of the buffalo to Lakota traditional beliefs. Notes artist Mitchell Zephier: "Although they were on the verge of extinction, buffalo—like Sun Dances—are having a resurgence. And there appears to be a parallel. My grandfather told me: 'The Indian and the buffalo, they're one and the same; there's a reason why they put the Indian and the buffalo on that coin.' The tribes are now looking at buffalo herds as economic foundations." Made by Mitchell Zephier and Webster Two Hawk, Jr. (Lakota). Design concept, Robert Stroup. 1994. Sterling silver, brass, jeweler's gold (brass and copper), German silver, copper, inlaid with black buffalo and white buffalo bone, mother of pearl, malachite, red and black pipestone. Typical concha length, 4" (10.2 cm). Prairie Edge Collection*

2. *Elder praying for a good buffalo hunt. Wrapped in a buffalo hide, the elder raises his pipe in supplication to the Great Spirit. A buffalo-skull altar and crossed-willow pipe rest complete the ritual. Four stylized buffalo emanate from the pipe, symbolizing the elder's prayer to the cardinal directions. A yellow mother-of-pearl setting depicts the sun and daylight while the half moon and stars on the right depict the receding light.*

1. *Buffalo skull with gold horn caps and stamped buffalo tracks. The Lakotas believe the buffalo's spiritual essence was contained within the buffalo caps or horns. The buffalo skull was used as an altar during ceremonies. Also depicted is a buffalo pipe with a medicine wheel and buffalo hunters pursuing buffalo across a hand-engraved buffalo hide stretched on gold willow hoops.*

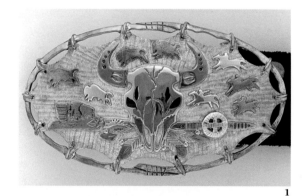

1

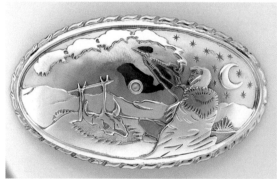

2

3. *Buffalo hunter on his buffalo horse. Buffalo horses were trained specifically for hunting buffalo in contrast to those trained for battle. An essential part of the hunt, they were fed special herbs for endurance. In the background stands a painted buffalo-hide tipi with empty meat-drying racks. The young buffalo hunter carries with him the hopes and prayers of his people that he may return safely.*

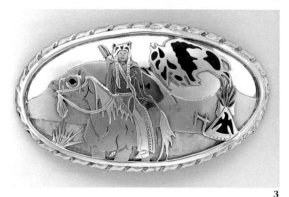

3

4

4. *"Only the Strong Survive and May All the Hungry Be Fed Tonight," a prayer said by a hunter as he rode into the hunt. Buffalo hunting was a dangerous pursuit. Buffalo are agile and quick to attack hunters when wounded. Some hunters distinguished themselves by having killed a buffalo with a single arrow. The braided buffalo-hide lariat trailing behind the rider served as a means to hang on to or recapture his horse if he was dislodged during the hunt.*

5. *Butchering of buffalo after the hunt. A Lakota woman butchers her husband's kill. In the background is the woman's son chewing on a piece of meat. A small offering of meat was first offered to the Great Mystery and spirit of the buffalo. A select piece of meat was then given to any children present. It was believed children should always be fed first as they were sacred and represented the future.*

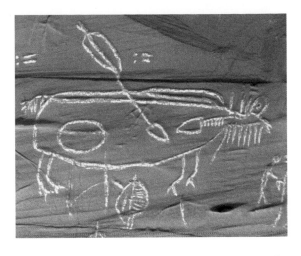

641 *Petroglyph of a killed buffalo with a "spirit line." Little Popo Agie, Wyoming. 1300–1775.*

5

7

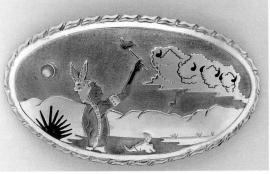

8

6. *"Everything Given Must Be Used." No part of the buffalo was wasted as this would offend the spirit of the buffalo. A woman drops red-hot stones into a buffalo paunch. She uses elk antlers to carry the stones—an old method of cooking buffalo soup. The second woman kneels on a staked-down buffalo hide and begins the tanning process with an elk-horn scraper. In the background the drying racks are loaded with choice pieces of meat.*

8. *Thanksgiving to the Spirit of the Buffalo. An elder of the tribe holds aloft a piece of buffalo meat on a willow wand as a thanksgiving offering to the buffalo spirit. Four "cloud buffalo" form in answer to the people's prayer that the buffalo would always be with the Lakota people.*

7. *Buffalo Dance. After a successful buffalo hunt, an honoring dance was held in the village. The dancers carried sprigs of sage and buffalo-horse dance wands and emulated the actions of the buffalo—grunting, snorting, and pawing the earth. The dancers would stomp and try to "shake the earth" until the buffalo returned again.*

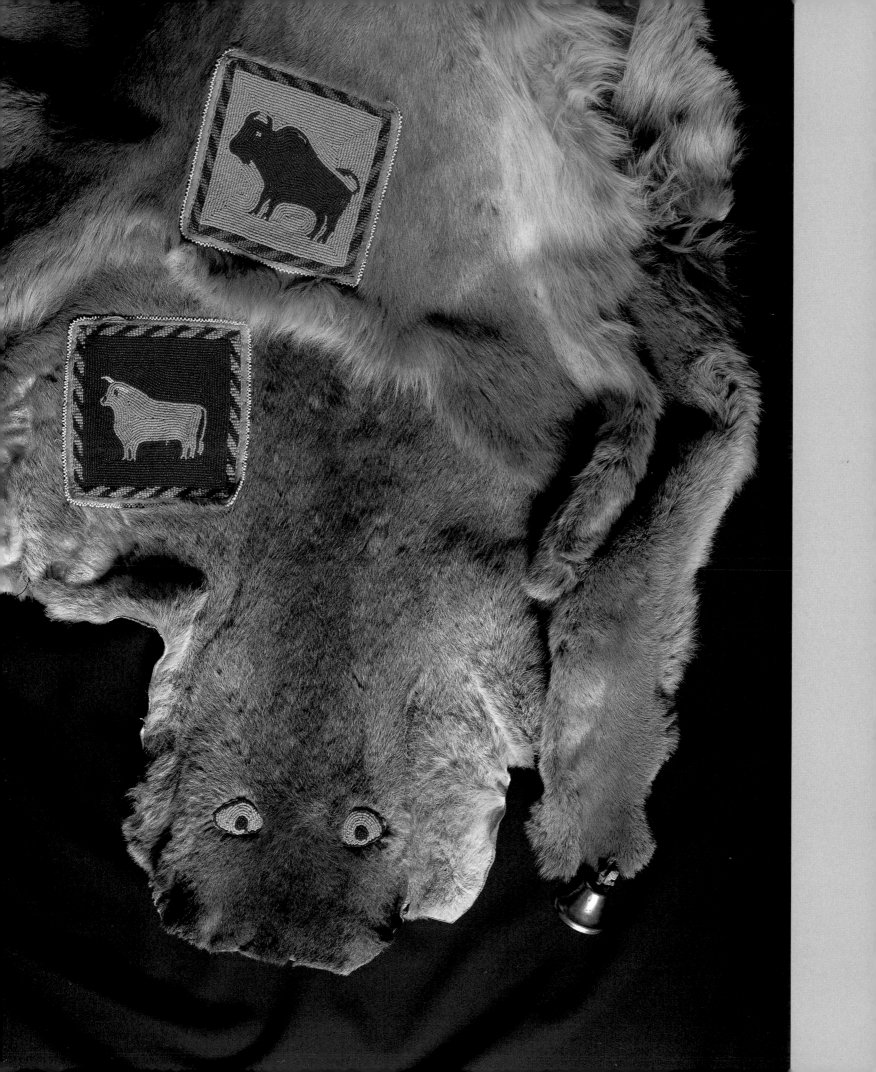

CONVERGING TRADITIONS
THE GREAT BASIN

"In our family we do beadwork to pay tribute to relatives that have passed on. Often I feel their presence when I sit down to bead. I can sense my mother, and sometimes I can hear her voice. She would hum or sing to give herself inspiration and go back into time; my grandmother was the very same way. So when I sit down for beadwork, I do the same. I can hear them, and that gives me inspiration to do what I have to do."

—**Drusilla Gould (Shoshone-Bannock), 1994**[1]

642 *This powerful robe of mountain-lion skin has beaded eyes and two panels that illustrate a buffalo and steer. Worn at public events, the robe possibly served as a metaphor for the profound and unsettling changes to which the Shoshone were forced to adjust. By the 1860s, their traditional way of life had ended: the buffalo—an important resource after the arrival of the horse—were decimated, and encroaching settlers and cattle ranchers pressured the Shoshone onto reservations. Made c. 1900 by Julia Baker Ballard (Shoshone), wife of John Ballard, the last traditional Shoshone chief. Fort Hall, Idaho. Beaded patches, 6 × 6" (15.2 × 15.2 cm). Collection Ballard Family*

643 *This belt buckle's highly original beadwork literally breaks traditional design boundaries in that the buffalo's hump and leg interrupt the outside border. Realistic details, such as the fluffy and shaggy hair, reflect the artist's close observation of his tribe's large buffalo herd. Glass microbeads (bead sizes 16s to 18s; see the bead chart in the glossary at the back of the book) on canvas attached to metal. Buffalo in Sage. Edgar Jackson (Shoshone-Bannock). 1993. Length, 4¼" (10.3 cm). Private collection*

The Great Basin is a geographic crossroads, adjacent on all sides to widely differing environments and cultures. Placed between the Sierra Nevada and Rocky Mountain ranges, it spans present-day Nevada and Utah, most of Colorado, and portions of Wyoming, Idaho, and Oregon, eastern California, northern Arizona, and New Mexico. As Ice Age glaciers retreated and lakes evaporated, the region's bedrock remained as a succession of mountains and valleys. The term Great Basin refers to the large geological basin created from the interior drainage of rivers and streams into residual Pleistocene lakes. Climate in the lower valleys was extremely arid, yielding little more than shrub and cacti. To the north, fertile plains developed between tributaries formed by runoff from the mountains. Nonetheless, jagged landscapes and unpredictable rain patterns made permanent settlement difficult. Thus, Basin communities typically consisted of egalitarian nomadic bands of four to ten families.

The Basin's range in topography and semiarid climate produces a diversity of plants, animals, fish, and waterfowl, although overall supplies are generally sparse and widely distributed. Sagebrush and piñon-juniper woodland is the most typical vegetation. While immense buffalo and elk herds seasonally migrated into the Basin's eastern regions, more typical game included antelope, moose, mountain sheep, sage hen, wood rat, and, particularly, the jackrabbit.[2]

Ecologies varied from desert to mountain, with most fiber plants and other vegetation existing between the two areas. Although some Basin bands settled at the highest and lowest altitudes, the majority maneuvered within the extremes, moving up the mountains in summer and down to the valleys in winter. Borders were fluid since seasonal migration rounds, encompassing mountain perimeters, reached into the Great Plains and California desert. Band size varied according to region and resources. The horse-mounted Fort Hall Shoshone and Bannock formed a large composite group each fall to hunt buffalo, but split into smaller units for spring salmon fishing and summer camas root digging.[3] The Western Shoshone and Southern Paiute, who neither owned horses nor participated in the buffalo hunt, lived in smaller scattered groups with localized rabbit drives. With no fixed territorial affiliations and with transitory bonds to a larger populace, family groups depended upon each other for identity, belonging, and survival.

Because of the various ecological shifts, Basin people never relied on a single food source. This concept of multiple sources extended into their adornment. Although Basin artisans were quite adept in utilizing locally available resources, their adornment and clothing benefited from contact with adjoining Plateau, Southwest, California, and Plains groups. Numerous materials and artistic influences entered the region: shells from the Pacific Coast, clothing and motifs from the Plains and Plateau. As there were no set physical borders, neither were there aesthetic boundaries. New forms and colors could be explored without the restraints of more formalized traditions common to

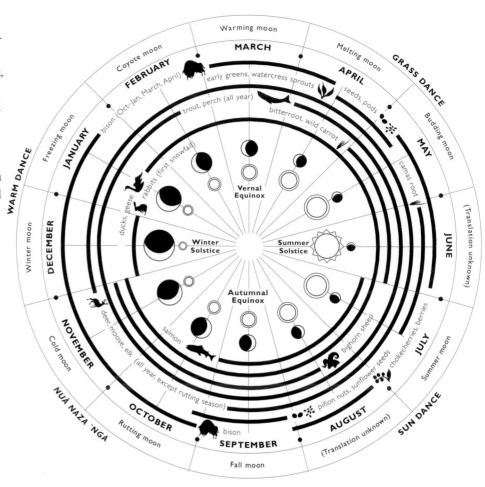

Seasonal Round of the Northern Shoshone-Bannock

644 *Ancient ornaments excavated at Hidden Cave, Nevada. From around 1800 B.C. to A.D. 500, small bands used Hidden Cave during seasonal rounds to cache tools, food, and ornaments; storage lessened the load. Even precious adornment such as a rare abalone pendant traded in from the Pacific Coast was safely hidden until retrieved on the return trip.* TOP: *A Bighorn sheep pendant manufactured by cutting sections of sheep horn to the desired shape, drilling the perforations, and then polishing both faces and the margins with a series of finely graduated polishing tools. It was probably finished with an exceptionally soft material such as hide.* MIDDLE ROW: *Abalone-shell pendant, 1350–1300 B.C., incised-bone artifact, antler-tine pendant, highly polished and burnished.* BOTTOM: *Juniper-berry beads (Juniperus osteosperma), a rare item in Great Basin archaeological contexts, were recovered in bulk from Hidden Cave. Their nearest source is the Stillwater Mountains, 9.3 miles from the cave. Abalone pendant length, 2¼" (5.7 cm). American Museum of Natural History, 20.4/1229, 20.4/931, 20.4/453, 20.4/359, E456*

neighboring areas. Even as Western ways intruded into Native lives, Basin artisans remained remarkably flexible, exploiting the design possibilities of glass seed beads, for example, while maintaining strong links to their unique heritage. Beadworkers' primary responsibility continued to be to family traditions.

When Great Basin reservations were formed, many groups were split apart, forcing people from different backgrounds to live together. As cultures converged, and intertribal marriage escalated, it became increasingly important for families to reinforce their identities and supplement oral tradition. Colorful glass beadwork provided the means for individual as well as tribal expression. From the Southern Utes of Colorado to the Shoshone-Bannock of Idaho, colors, symbols, and even stitch types delineated family and tribal histories and conveyed respect for those who had come before. Beadwork also minimized cultural separation and competition: a skilled artisan might place different tribes' motifs next to one another, thus signifying coexistence and cooperation.

EARLY HISTORY

The Basin region became increasingly arid following the Pleistocene epoch. By 8,000 B.C., the people called the Desert culture arose as gatherers of plant life; hunting was of secondary importance. With few variations, these basic subsistence patterns continued until European contact. The Fremont culture (c. A.D. 400–1300), sedentary agriculturists who flourished briefly in present-day Utah on the northern edge of the Southwest's pre Puebloan cultures (645, 646), left no identifiable historic heirs.

The region's major groups at eighteenth-century contact—Paiute, Shoshone, Ute—all spoke Numic, a northern branch of the Uto-Aztecan languages, and are considered by many to have been descendants of later nomadic tribes who entered the region about A.D. 1000. Yet others believe that these Numic speakers had connections with the inhabitants of ten thousand years ago. Whatever the case, Basin people's traditional ability to adapt and integrate outside influences is strongly expressed in adornment.

This ability to integrate many influences ties in with the Basin region's long history of trade, dating back to the Early Archaic period (c. 5000 B.C.), when obsidian and Pacific Coast shells entered western Nevada and northwestern Utah and were incorporated into adornment. Square-shaped beads of haliotis (abalone) possibly extend back to 4000 B.C., olivella shells to 2500 B.C.[4] Fremont culture clay figurines wear necklaces, possibly representing obsidian, shell, or Southwestern turquoise (645). Because Basin people often lived on the fringes of their region, and settlement fluctuated according to season and availability of food, the first trade may have occurred through random contact or collecting.

By the early Middle Archaic period (2000–200 B.C.), however, organized trade routes led to the dissemination of beads and ornaments. Obsidian, shell, lignite, and catlinite were important trade elements for Basin adornment. Frog-shaped shell pendants came from the Southwest, pine-nut (piñon) beads from northern California, haliotis and clamshell beads from central California. Middle Archaic dentalia was from Vancouver Island on the Northwest Coast.[5] During the Late Archaic (A.D. 700–1500), resources moved easily within the region, and trade expanded throughout North America. When the first Spanish explorers entered the Great Basin in early 1776, Native peoples were already aware of European goods via the Plains, California, and Southwestern tribes. Silvestre Vélez de Escalante noted in his journal that the Southern Paiute wished to trade "only for red clothes."[6]

THE GREAT BASIN

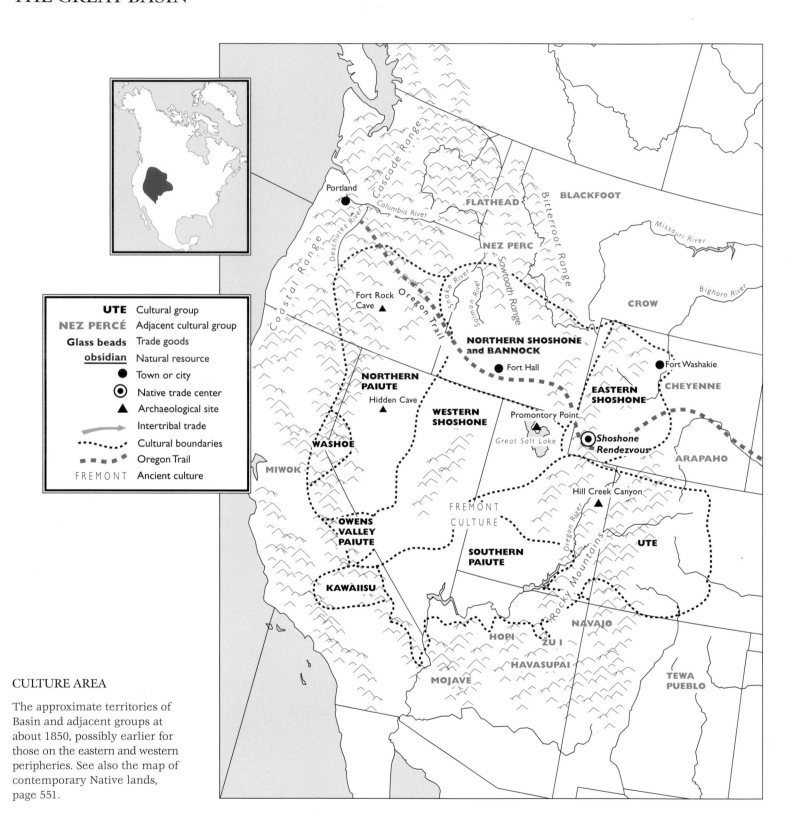

LEGEND

UTE Cultural group
NEZ PERCÉ Adjacent cultural group
Glass beads Trade goods
obsidian Natural resource
● Town or city
◉ Native trade center
▲ Archaeological site
➤ Intertribal trade
⋯ Cultural boundaries
▬ Oregon Trail
FREMONT Ancient culture

CULTURE AREA

The approximate territories of Basin and adjacent groups at about 1850, possibly earlier for those on the eastern and western peripheries. See also the map of contemporary Native lands, page 551.

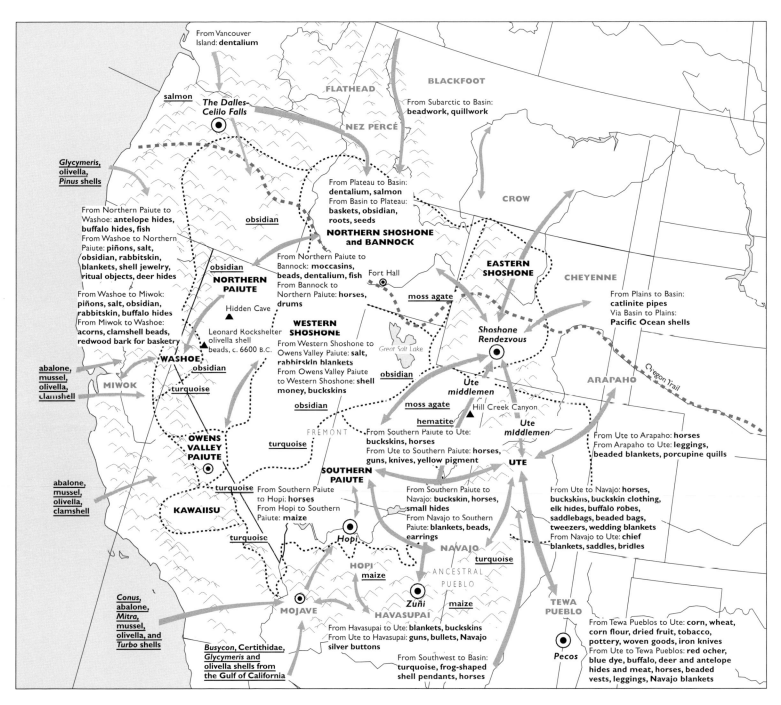

From Vancouver Island: **dentalium**

salmon

The Dalles-Celilo Falls ⊙

FLATHEAD

BLACKFOOT

NEZ PERCÉ

From Subarctic to Basin: **beadwork, quillwork**

Glycymeris, olivella, Pinus shells

obsidian

From Plateau to Basin: **dentalium, salmon**
From Basin to Plateau: **baskets, obsidian, roots, seeds**

CROW

From Northern Paiute to Washoe: **antelope hides, buffalo hides, fish**
From Washoe to Northern Paiute: **piñons, salt, obsidian, rabbitskin, blankets, shell jewelry, ritual objects, deer hides**

obsidian

NORTHERN SHOSHONE and BANNOCK

From Northern Paiute to Bannock: **moccasins, beads, dentalium, fish**
From Bannock to Northern Paiute: **horses, drums**

Fort Hall ⊙

EASTERN SHOSHONE

CHEYENNE

From Washoe to Miwok: **piñons, salt, obsidian, rabbitskin, buffalo hides**
From Miwok to Washoe: **acorns, clamshell beads, redwood bark for basketry**

NORTHERN PAIUTE

▲ Hidden Cave

moss agate

From Plains to Basin: **catlinite pipes**
Via Basin to Plains: **Pacific Ocean shells**

abalone, mussel, olivella, clamshell

WASHOE

obsidian

turquoise

WESTERN SHOSHONE

▲ Leonard Rockshelter olivella shell beads, c. 6600 B.C.

From Western Shoshone to Owens Valley Paiute: **salt, rabbitskin blankets**
From Owens Valley Paiute to Western Shoshone: **shell money, buckskins**

Great Salt Lake

obsidian

Shoshone Rendezvous ⊙

ARAPAHO

Oregon Trail

MIWOK

obsidian

Ute middlemen

moss agate

hematite

Ute middlemen

From Ute to Arapaho: **horses**
From Arapaho to Ute: **leggings, beaded blankets, porcupine quills**

OWENS VALLEY PAIUTE ⊙

turquoise

FREMONT

From Southern Paiute to Ute: **buckskins, horses**
From Ute to Southern Paiute: **horses, guns, knives, yellow pigment**

▲ Hill Creek Canyon

UTE

abalone, mussel, olivella, clamshell

turquoise

SOUTHERN PAIUTE

From Southern Paiute to Hopi: **horses**
From Hopi to Southern Paiute: **maize**

From Southern Paiute to Navajo: **buckskin, horses, small hides**
From Navajo to Southern Paiute: **blankets, beads, earrings**

From Ute to Navajo: **horses, buckskins, buckskin clothing, elk hides, buffalo robes, saddlebags, beaded bags, tweezers, wedding blankets**
From Navajo to Ute: **chief blankets, saddles, bridles**

KAWAIISU

turquoise

Hopi ⊙

HOPI

maize

NAVAJO

turquoise

ANCESTRAL PUEBLO

Conus, abalone, Mitra, mussel, olivella, and Turbo shells

⊙ Mojave

MOJAVE

Zuñi ⊙

maize

HAVASUPAI

TEWA PUEBLO

From Havasupai to Ute: **blankets, buckskins**
From Ute to Havasupai: **guns, bullets, Navajo silver buttons**

From Tewa Pueblos to Ute: **corn, wheat, corn flour, dried fruit, tobacco, pottery, woven goods, iron knives**
From Ute to Tewa Pueblos: **red ocher, blue dye, buffalo, deer and antelope hides and meat, horses, beaded vests, leggings, Navajo blankets**

Busycon, Certithidae, Glycymeris and olivella shells from the Gulf of California

From Southwest to Basin: **turquoise, frog-shaped shell pendants, horses**

Pecos ⊙

PRECONTACT AND EARLY-CONTACT TRADE NETWORK

Intertribal trade networks revolved around trade centers or communities of various sizes and degrees of permanence. These ranged from large, permanent villages, such as those of the Mandan-Hidatsa, to small, minor hubs at shifting locations, to important trade fairs such as the Shoshone Rendezvous in Wyoming.

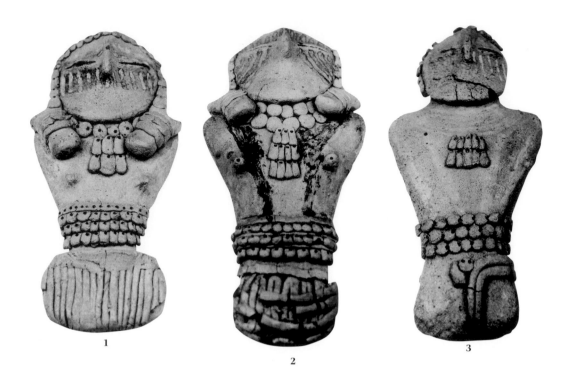

645 *Fremont culture clay figurines. Dating A.D. 1100–1200, the figures are in male and female pairs: females have breasts and aprons (1, 2); males wear breechcloths (3). Both sexes wore beaded necklaces, waistbands, and body paint. Women's hair, bound with cords, hangs down over the shoulders. The carefully observed distinctions between genders and male-female pairing point to ritualistic use, and they were probably used in fertility rites. Fremont groups reflect indigenous Basin traditions. After ritual use, the figurines may have been passed on to children for play. Found near the Green River, Utah. Height of (1), 6³⁄₁₆″ (15.7 cm). College of Eastern Utah, Prehistoric Museum, A-141*

1 2 3

646 *Life-sized effigy petroglyphs from Dry Fork Canyon, Utah. Fremont culture, c. A.D. 950. Laboratory of Anthropology/Museum of Indian Arts and Culture, Santa Fe, New Mexico, 70.1/365*

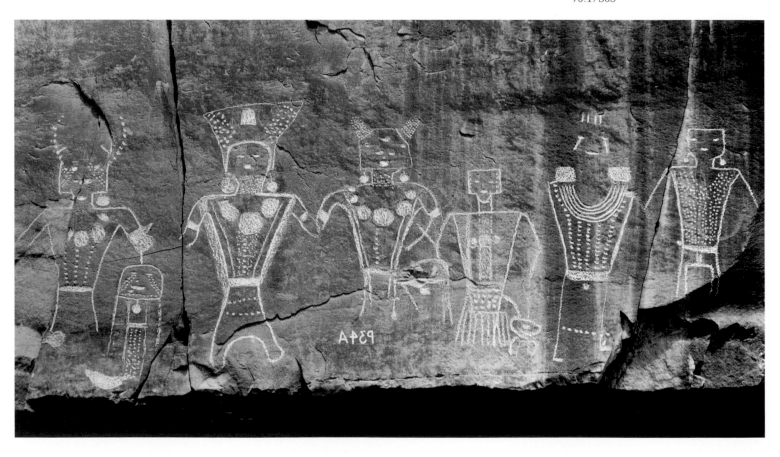

CLOTHING AND ADORNMENT: A MERGING OF MATERIALS AND TECHNIQUES

Clothing mirrored the region's resources and history. Those in areas with good supplies of game wore garments of buckskin, antelope, or bighorn sheep. Dresses and shirts were made of two skins sewn together with sleeves and fringes added if sufficient material was available. Bone and shell beads and porcupine-quilled strips sometimes decorated the fringe.[7] For many Basin peoples, however, jackrabbit pelts were the primary source of fur. Cut into continuous spiral strips and twisted into ropes, the skins were then woven together on a willow-stick loom to produce a cloaklike blanket for winter wear. A man's robe required one hundred skins; a child's, forty. For greater density and warmth, each strip was wrapped around a core of yucca, nettle, or cedar fiber.[8]

When skin clothing was scarce, dresses, shirts, aprons, and winter leggings of twined sagebrush and cedar bark were used by many groups. Those living near marshes and lakes wore aprons made of rushes and duckskins. Northern Paiute babies were wrapped in rabbitskin with softened sagebrush bark or cattail fluff used as diapers.[9] Coyote fur, though available, was taboo to some because of its mystical significance.[10] Moccasins were made from animal skins or coarsely woven tree bark, but, except for winter or hunting trips in the brush, Basin people frequently went barefoot. Nineteenth-century Ute wore sandals of yucca fiber or sagebrush bark, or muskrat hide lined with soft sagebrush bark.[11] Most women wore basket caps, which not only protected the head from the sun and tumpline, but also kept pitch out of the hair when pine nuts were harvested and served as a standard unit of measure for seeds and other foods. Men's skin or fur caps with a tuft of quail feathers on the crown denoted chiefs and good hunters.[12]

Jewelry—necklaces, earrings, pendants, and bracelets—took the form of decorated beaver claws or objects manufactured from teeth, bone, or shell. The Kawaiisu and Southern Paiute associated ear piercing with longevity and apparently followed Coyote's dictates that pierced ears were necessary for crossing "the chasm to the other world" after death. Among the Southern Paiute, ritual nose pins of stick or bone or a pendant of abalone shell or turquoise were worn by men.[13] The mythic Coyote, when preparing for a great event, would stick "an ornament through the septum of his nose." and "put something inside his mouth so as to look pretty with a gaping mouth."[14]

Necklaces, made of locally available animal claws and teeth, bone beads, fish vertebrae, stones, and juniper seeds (647–49), were regarded as tributes to the animals and plants that the Indians depended on for survival. No animal parts were wasted; no piece of clothing was insignificant. Even straps and belts were painted, braided, and decorated with eagle feathers plucked from the tail and wings. (The birds were then set free.) Materials for body painting were easily accessible to all groups. Various colors, combinations of minerals mixed with marrow fat, enhanced the body in ceremonies and also provided protection from the elements. Tattooing was common: a pigment of black ash and grease was applied with cactus thorns.

The arrival of the horse—in the mid-1600s among the Southern Ute and late 1600s for the Northern and Eastern Shoshone—fostered stronger connections among eastern Basin groups, the Great Plains, and the buffalo. The introduction of glass beads lessened the demand for shell. New materials, including trade cloth, furs, and ribbon, found their way into the region with settlers crossing the Oregon Trail. And from the Southwest came horse bridles, Navajo silver shoe buttons, and brass bracelets.[15]

By the nineteenth century, most Basin clothing reflected some degree of Plains influence. Among the mounted people, both sexes wore buffalo robes (obtained via hunting or trade) in winter and dressed in elk skins (with hair removed) in summer.

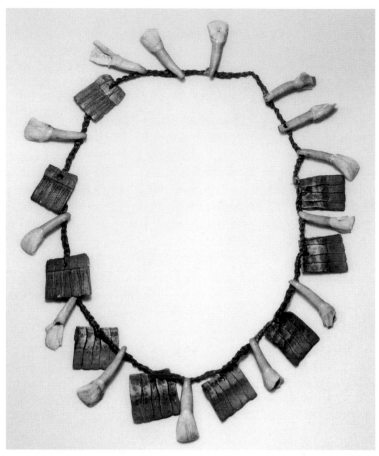

649 *This Shoshone medicine necklace of rattlesnake and bird claws or cat claws probably belonged to someone with rattlesnake medicine. Shoshone tribal elder Eva McAdams of Fort Washakie, Wyoming, remembers: "A lot of people had various animals which they thought gave them power and protection. My husband's great-uncle, Adrian Narland, was a very powerful person, and his medicine was that of the rattlesnake. This man would ride out into the hills on horseback to see his protector, a huge black rattlesnake. He was a strange person and people tended to keep their distance, but he was a very strong medicine man." Collected in Wyoming, 1901. Length, 28" (71.1 cm). American Museum of Natural History, 50/2316*

647 *Ute necklace of armadillo plates and bovine teeth alternating on plaited hemp. Nineteenth century. Length, 25½" (65.0 cm). Haffenreffer Museum of Anthropology, Brown University*

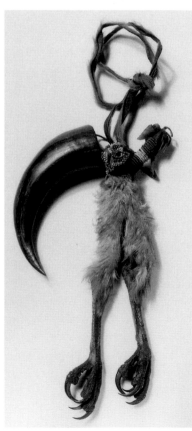

648 *Shoshone amulet for protection and medicine made with buffalo horn and animal claws and legs, beadwork, and an arrowhead. Collected at Fort Washakie, Wyoming, 1915. Length, 15" (38.1 cm). American Museum of Natural History, 50/2434*

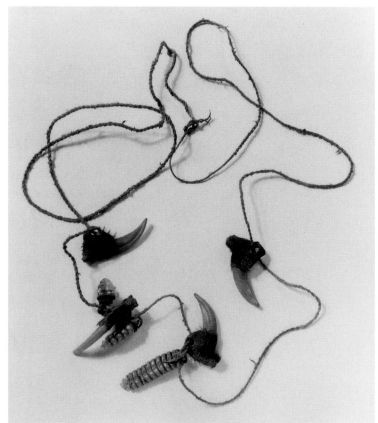

Trade, well developed among neighboring Indian groups, usually occurred in the summer months at trade fairs (later called *rendezvous*) when resources were more plentiful. Although the Shoshone were important middlemen in the introduction of the horse from the Plains to the Plateau, they were not as involved in the fur trade as were the Algonquians and Athapaskans of Canada.[16] By 1840, the fur trade had generally collapsed; that decade also marked the beginning of Euro-American emigration to California and Oregon. Those factors, and the disappearance of buffalo herds, contributed to the end of Shoshone and Bannock autonomy in the 1860s, and that of other groups in the following decades.

FROM BASKETRY TO BEADWORK: TRANSFORMATION OF AN ANCIENT TRADITION

Due to its arid climate and an extensive network of dry caves, the Basin region contains some of the oldest examples of weaving in North America, including finely twined baskets, moccasins, and textiles at least nine thousand years old. Mats, loom-woven from marsh plants (*tule*) with a diamond-plaiting technique, indicate a heritage of textile production as sophisticated as any similar technique known anywhere in the world.[17] A few feathered baskets, resembling examples from California (see 896), may date to 1500 B.C.[18]

The basic design feature of ancient Basin weaving was the division of the object into a series of horizontal zones or bands of various sizes.[19] Weavers produced striking internal geometric patterns (654). Overlapping junctures of perpendicular lines created points of intersection that were carried over into beadwork designs (655). While geometric designs were influenced by angular weaving techniques, beaded pictorials— flowers, animals, and landscapes—developed with the availability of small, flexible glass seed beads.

Other patterns came from Plateau quillwork, which in turn drew upon patterns of the northern Plains and the western Great Lakes regions (722). Quillwork was never prevalent in Basin cultures, where porcupine quill was scarce and time-consuming labor impractical. (Ironically, one of the earliest known examples of quillwork was found in a cave at Promontory Point, Utah. Dating to the thirteenth century, it may have been Athapaskan in origin.[20]) Once beadwork was introduced, however, quillwork patterns were easily incorporated into Basin iconography.

Basin Lifeways, Spirituality, and Symbolism
Because migratory lifeways limited the size of settlements, chiefly power was non-hereditary, decision making was shared with councils, and Basin people formed their strongest bonds with immediate and extended families. Marriages were important for connecting families and solidifying ties to other communities. Families would exchange gifts following the marriage. While mostly symbolic, these gifts assured formal relationships with members outside the immediate group that sometimes developed into limited trade relations.

The size of most Basin groups precluded elaborate religious organization. Annual subsistence rites, such as the first fishing, first pine-nut picking, or prayers offered to a medicine plant before it was gathered, were informal.[21] Spirituality was an individual experience in the Basin region. Thus, even when shamanism was practiced in larger communities, spirit helpers were obtained through one's own ingenuity.

Among many groups, gifts of beads were integral with ritual. Immediately after a Northern Paiute baby's birth, the father bathed and left his old clothing by a stream

with an offering of bone or shell beads. During female puberty ceremonies, Washoe girls joined in the Round Dance while holding out small gifts of shell, beads, or coins to the circle of dancers. At burial ceremonies, the Northern Paiute sprinkled seeds and beads on graves.[22]

In traditional Basin belief, sickness was considered an unnatural body state, indicating that the body was "possessed" by demonic spirits. Thinking positive thoughts and looking to the future were encouraged as ways to preserve or restore spiritual well-being. These values continue to inform aspects of everyday life, including craftwork. After making a mistake in beading, one neither dwells upon nor undoes it, because it is impossible to go back in time. "Rather," says Drusilla Gould, "one looks forward to the next piece of work to correct past imperfections."[23]

Dualities abound within the region. They are embodied in the principal figures of Shoshone mythology, Wolf and Coyote. Wolf, believed to have created people and the solar system, is regarded as serious and benevolent. Coyote is a trickster who obstructs Wolf's efforts, fermenting chaos. Out of their struggle, the world as human beings know it has taken shape. Coyote-Wolf stories occur mainly in the Great Basin and California.[24]

Traditional Basin ceremony reflected this duality of beliefs. The Bear Dance, among the oldest Ute ceremonies, illuminates connections between human and animal life and between legend and religion. Depicted in ancient petroglyphs of the Uinta Mountains of Utah, and in Fremont art, Bear Dance was and remains a social occasion of tremendous importance. A time of renewal, remembrance, and giving thanks to the Creator, it was celebrated in spring with three days of dancing in imitation of the bear, an animal the Utes recognized as brother and protector.[25] Bear claws worn in jewelry transmitted power for a successful hunt (713).

Symbols common in much Shoshonean art—triangle, rectangle, jagged line, arc, and circle—all occurred in early rock art, as did spirals, representing whirlwind, and swastikas, indicating the four directions.[26] Rock art also gave expression to mythological themes. Gifted storytellers recounted to generations the exploits and wisdom of a pantheon of legendary beings. "In all probability," wrote anthropologist Max G. Pavesic, "these characters . . . guided the mind through the living labyrinth and haunted to some degree the dreams and visions of rock artists, sculptors, weavers, beaders and so on."[27]

Color was integral with lifeways and aesthetics throughout the region. Dorothy Naranjo (Southern Ute) relates: "Each color had meaning and was used to represent an individual, a family, and a tribe in the Southern Ute culture. [The] four main colors represented the cycle of life. First you had yellow, which was seen as birth, when the sun rises in the east and sheds light, energy, and warmth across the land, giving direction to life. Red is the color you get in your youth, when you become frustrated or angry, trying to decide what you want to do and where you want to go. Red is also the color of fire, as in the hot summer heat. Blue is soothing, when one comes to an understanding in life, like in the fall. And white is wisdom, like the winter, when everything becomes clear and one can understand what life is. Purple is the culmination of all the colors [mixed] together, representing the full life cycle.

"In beading, colors represent different meanings. Green refers to plants; blue, to sky and water; and purple, the mountains. These colors, along with stitchwork and symbols, identify an individual, a family, and tribal background. Individuals must find a favorite color and use it in all their work, but also maintain a connection to where they came from so that people will identify the maker and where he came from."[28]

650 *Although these beaded bands are recorded as Shoshone infant necklaces, James Oldman, Sr., of the Wind River Reservation believes they are bracelets. "Friendship bracelets were passed between friends on the reservation and also between friends from other tribes." Collected at Wind River Reservation, Wyoming, before 1900. Hide and glass beads. Top length, 12¼" (31.1 cm). The University of Pennsylvania Museum, 36784, 36785*

◁ **651** *An ancient stone arrowhead, laced and set with silver, continues the Native practice of reusing ancient heirlooms. Tchin (Blackfoot-Narraganset), Brooklyn, New York. 1994. Length, 2½" (6.4 cm). Private collection*

650

652 *Shoshone-Bannock necklace made with Chinese wound-glass and Native-made wampumlike shell beads. Collected in Idaho, 1901. Typical shell bead length, ¾" (1.7 cm). The University of Pennsylvania Museum, 38083*

653 *Ute amulet. The beadwork above ▷ the ancient obsidian arrowhead is itself "wearing" a smaller red obsidian point, more highly valued than the black variety because it was scarcer and stronger. Made into triangular shapes, arrowheads were beautiful, useful, and economical. Collected in 1912. Length, 3¼" (8.3 cm). Peabody Museum of Archaeology and Ethnology, Harvard University, 10/84385*

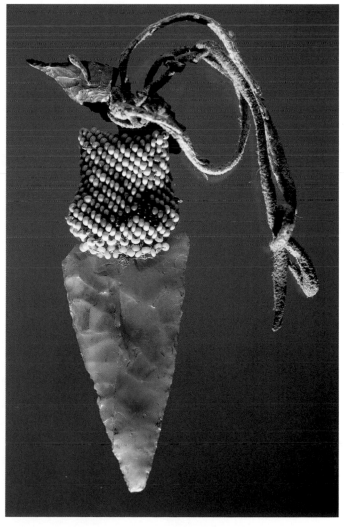

Burial Ritual

Distinctive artifacts found in western-Idaho Archaic-period graves indicate ritual treatment of the dead. A woman's burial site near Buhl, Idaho, dated about 8600 B.C., contained a black obsidian point, a bone needle, and a badger baculum (penis bone). It was common practice to place in graves large-scale, artistically rich, unused exotic stone items—quartz crystal, agate, jasper, obsidian, or chalcedony—covered with red ocher, a ritual suggesting the aesthetic and symbolic rather than the pragmatic and utilitarian. Burials four to six thousand years old contain olivella-shell beads and stone gorgets, which were possibly protective amulets. About A.D. 1000, dentalium shells began to replace olivella.[29]

Ancient Basin burial objects were gifts to the dead, signifying status, wealth, and affection. By late precontact times, however, the personal belongings of the Shoshone deceased were buried or burned to render them powerless against the living. It was believed that because a person's essence imbued the objects he made or cherished, they had to be removed with his body. These objects—particularly dream-inspired medicine—could work wonderful magic for the rightful owner, but in the hands of the wrong person could cause great harm, as related in the tale of Coyote:

Coyote is chased by a rock which he is barely able to outrun. At wit's and breath's end, Coyote happens upon a man's camp. "Brother," he cried, "the rock is killing me." As the rock approached, the man pushed out his elbow and hit it, shattering the boulder into small pieces. The man had large beads on his elbow, which formed his medicine, and it was this charm that killed the rock.

Coyote killed the man and stole the beads. Approaching a rock, he struck it with the beads and it split apart. Feeling confident, he then attempted to destroy yet a bigger rock tumbling toward him. The rock came, but before Coyote had time to stretch out his elbow, it crushed and killed him. Only his tail stuck out beneath.[30]

Consequently, many arrows, stones, baskets, clothing, and pieces of jewelry were lost or destroyed. This practice kept the culture materially sparse yet "rich in dreams and dream logic."[31] Shoshonean burial practices may have been rooted in the concept of *puha* (spirit force) analogous to the Inuit's *inua* and Algonquian *manitou*. *Puha*, the ability to cure illness or craft something beautiful, was thought to originate in nature: animals, rocks, or a rock-art site. It was revealed in dreams, visions, or trances, or by intuition.

Death was an occasion for the production of beautiful beadwork. Women made special burial dresses (often their own) with great attention to detail since the garment's beauty accompanied the deceased to the next world. When Eva Broncho of Fort Hall showed the author her beadwork, however, she stated: "I told my daughter that when I die, I want these things to be with the family, not buried with me. Just put me in a nightgown!"[32]

THE RESERVATION ERA: ADAPTATION AND SURVIVAL

Whereas traditional Plains religions disappeared underground, Great Basin Indians accommodated both Christianity and their own sacred ceremonies with little sense of conflict. They believed that the more paths one followed toward the sacred, the better one's chances of achieving spirituality. The Native American Church, founded on a synthesis of Native and Christian beliefs, remains popular in this region. It, too, reflects the ancient Indian value of achieving balance within discord. In their adornment, also, Basin peoples took what suited them and made it their own. The Ghost Dance, a cere-

mony incorporating song, dance, and beautifully painted clothing, developed by two Great Basin Paiute prophets—begun by Wodziwob in 1870 and revived by Wovoka in 1890—was originally conceived to reconcile Indian and Christian beliefs and promote peaceful coexistence.[33] Unfortunately, these peaceful expressions of defiance were perceived as threatening by Euro-Americans.

The Sun Dance, a sacred Plains ceremony, has become a significant Basin event among the Southern Utes, the Fort Hall Shoshone-Bannock, and especially their eastern counterparts, the Shoshone-Arapaho at the Wind River Reservation in Wyoming. Serving to reify Native American heritage, the Sun Dance has also become a place for displaying special regalia (701–3).

CONTEMPORARY EXPRESSIONS

Shoshone-Bannock beadwork is acknowledged by other Indians as among the best contemporary work in the country. At the region's center along the Oregon Trail is Fort Hall, where tribes from all parts of North America gather at a summer festival and display spectacular regalia.

The strength of Basin work is its inherent ability to maintain a balance, adapting outside influences while connecting to family continuums through color and motifs. Therefore, beadwork design is evolving without losing its grounding in history. The belt buckle (643) and beaded bag (706) are contemporary Basin pieces that use Plains-influenced motifs in a painterly style. Other works, such as 678, blend disparate elements; still others juxtapose modern and traditional motifs so that symbols from the past are celebrated in the present.

Perhaps the fundamental Basin philosophy of adaptation is responsible for the beauty and excellent craftsmanship of its contemporary beadwork. These enduring people refuse to dwell on the difficult past, an attitude reflected in work that is experimental, rather than a conservative repetition of design. Adaptability may also explain why men have recently entered this traditionally female field of beadwork and are today some of the region's outstanding beaders.

The Southern Ute, unlike their northern counterparts, had difficulty sustaining artistic continuity through the reservation period. During the latter half of the nineteenth century, finely crafted clothing and beadwork helped maintain tribal dignity; following the deaths of leaders such as Ignacio and Ouray, however, traditional adornment ceased. The recently established Southern Ute Golden Sinew Arts Guild seeks to recover this community's aesthetic heritage.

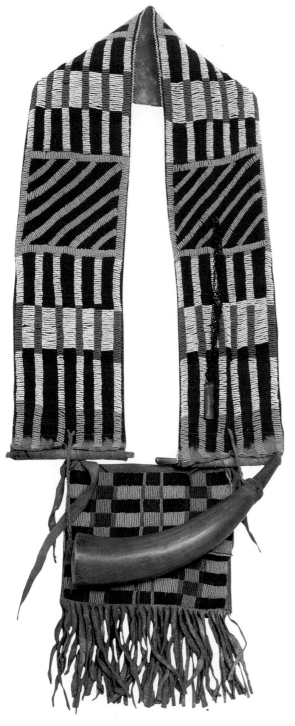

654 *The possible influence of twined textile and basketry traditions on Great Basin beadwork patterns is illustrated by these ancient Fort Rock–type sandals of twisted sagebrush bark. Dating about 8200 B.C., the front and back views of the two different sandals display a twining technique of slanting the pitch of the weft stitch down to the right. Horizontal, vertical, slanted, and sectional divisions of the rows are reinterpreted in beaded geometric motifs seen in 655. Length of back, 9⁷⁄₁₆"* (24.0 cm). University of Oregon Museum of Natural History, 1-31699, 1-33612*

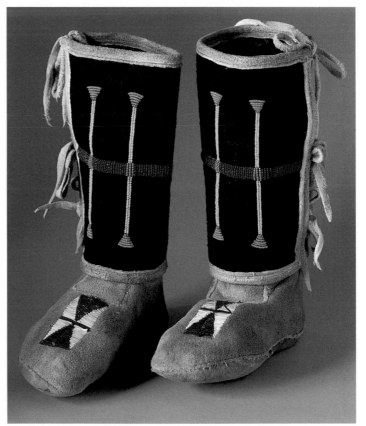

655 *A Bannock beaded hunting bag contains a buckskin shot pouch, arrowpoint medicine pendant, and a shoulder sash with an attached powder horn. The beadwork patterns were influenced by indigenous basket weaving. Acquired 1919. Overall length, 34½" (87.6 cm). National Museum of the American Indian, 9/6570*

656 *Moccasins by Eva Broncho (Shoshone-Bannock) for granddaughter Kylie display some geometric iconography similar to the Bannock hunting bag (655) and John Ballard's legging panel (670). Fort Hall, Idaho. 1993. Cloth, tanned buckskin, glass beads, quills. Height, 9" (22.9 cm). Collection Kylie Broncho*

GREAT BASIN BEADWORK

The mixture of elements in Great Basin beadwork reveals considerable interaction among Plains, Plateau, and Subarctic Indians. The horse's arrival from the Southwest in the early 1600s permitted long-distance trade and travel. Subsequently, Great Basin groups incorporated the work of other tribes. A predominance of light blue and pink beads was frequently evidence of Crow influence; floral motifs at the northern edges of the region came through the Plateau groups, Canadian Athapaskans, and Cree. Southern Ute semifloral motifs were derived from the Kiowa. By the late nineteenth century, Great Basin women, reflecting these influences and their own love of fine craftsmanship and design, had developed distinctive, lively beadwork styles.

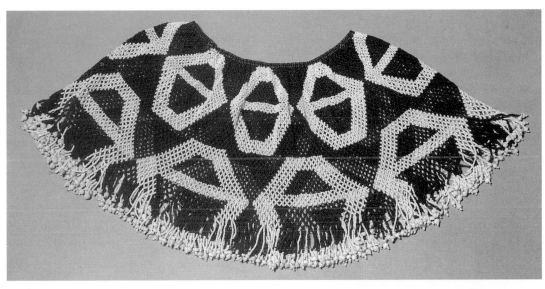

657 *Mohave woman's beaded collar. Using a netting technique, the Mojave, Apache, Paiute, and others made glass beaded collars, probably based on earlier Native prototypes. The Mojave preferred dark blue and white beads. California or Arizona, late nineteenth century. Overall length, 22" (56.0 cm). Denver Art Museum, 1948.1127*

658 *Although this collar is from an unidentified tribe, the red, black, white, yellow, and blue glass bead colors suggest Southern Paiute, who used identical pigments to paint their faces and bodies for festivals. Collected 1930s. "Netted" beads. Height from neck to fringe, 7¾" (19.7 cm). Denver Art Museum, 1965.21*

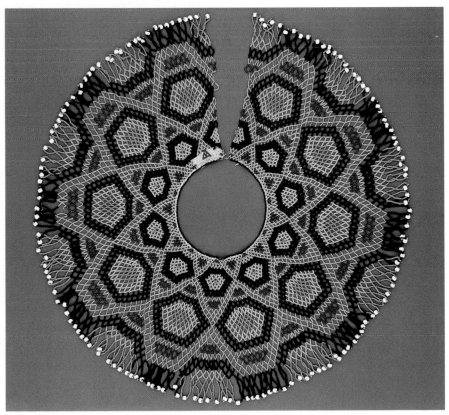

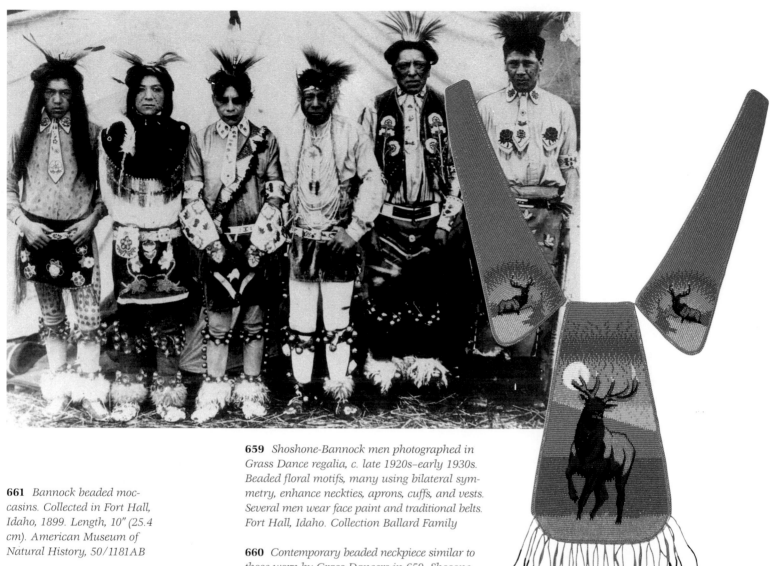

659 *Shoshone-Bannock men photographed in Grass Dance regalia, c. late 1920s–early 1930s. Beaded floral motifs, many using bilateral symmetry, enhance neckties, aprons, cuffs, and vests. Several men wear face paint and traditional belts. Fort Hall, Idaho. Collection Ballard Family*

661 *Bannock beaded moccasins. Collected in Fort Hall, Idaho, 1899. Length, 10″ (25.4 cm). American Museum of Natural History, 50/1181AB*

662 *Cheyenne beaded buckskin moccasins made before 1911. Length, 10½″ (26.7 cm). San Diego Museum of Man*

660 *Contemporary beaded neckpiece similar to those worn by Grass Dancers in 659. Shosone-Bannock, Fort Hall, Idaho. 1996. Length, 21″ (53.4 cm). Private collection*

660

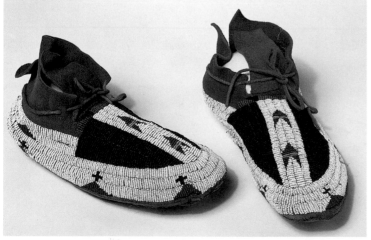

661

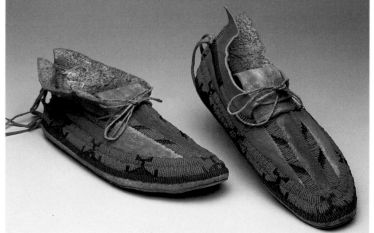

662

663 *This Southern Ute beaded pipe pouch uses a crystal-color beaded background to blend subtly with the hide. Although the Ute borrowed neighboring Cheyenne and Arapaho geometric motifs, they rearranged proportions and colors. There is less contrast between the design motifs and background in this bag than in 664. Accessioned 1910. Beads, hide, red horsehair, tin cones. Length with tassels, 28" (71.1 cm). American Museum of Natural History, 50.1/437*

664 *A Cheyenne pipe bag's geometric patterning displays some relationship with the Ute bag (663). Beaded motifs around the bag's opening are peyote birds. Leather, glass beads, raffia binding, tassels of antelope nails and animal hair dyed yellow and red. Collected in Oklahoma. n.d. Length, including fringe, 38⅝" (99.0 cm). The Heard Museum, Phoenix, Arizona*

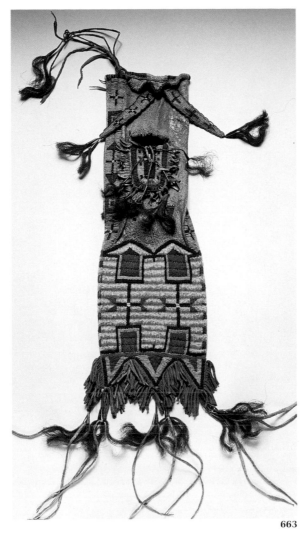

663

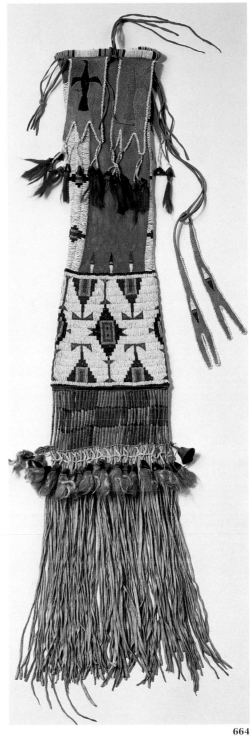

664

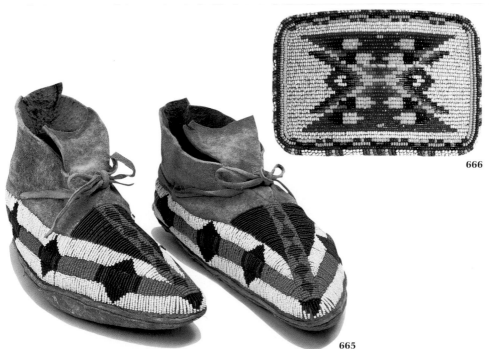

666

665

665 *Ute moccasins made with deer hide, seed beads, raw hide, and pigment. Collected c. 1885. Length, 11" (27.9 cm). Buffalo Bill Historical Center*

666 *Belt buckle with a Ute design made by Charlotte Tendoy (Shoshone-Bannock). The Ute, Shoshone, and Bannock speak dialects of the Shoshonean language. Fort Hall, Idaho. 1970s. Length, 4⅜" (11.1 cm). Collection Clinton Houtz*

667 *Effie Diggie Houtz (Shoshone) photographed with her dolls at Sun Valley, Idaho, c. 1940*

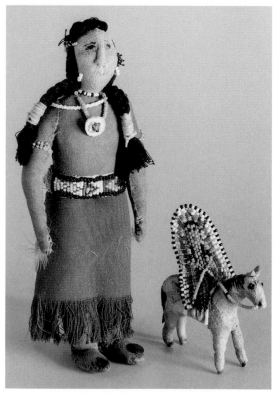

668 *Two souvenir dolls by Effie Diggie Houtz. Born in 1900 at Fort Hall, Mrs. Houtz attended boarding school in Carlisle, Pennsylvania, and then returned to Fort Hall. After her husband passed away in 1934, she began making curios to support the family—small baby carriers and dolls dressed in Sun Dance outfits, "anything that people would buy," says her son Rusty Houtz, himself a cowboy, sculptor, and curator at the Shoshone-Bannock Tribal Museum at Fort Hall. Several years later, Mrs. Houtz and Emma Cutch opened Fort Hall's first arts and crafts shop. Today, Effie Houtz's dolls are collector's items. Mid-1930s. Height of standing doll, 7½" (19.1 cm). Collection Rusty Houtz*

669 *Vidal Ballard (Shoshone), son of Julia and John Ballard, and father of Joyce Ballard, was a community leader. "Although the title of chief was not handed down, or else my dad would have taken on that responsibility," related Joyce Ballard in 1994, "a lot of people nonetheless went to him for advice, information, and support. He was additionally a professional boxer in the 1940s—the middleweight champion of the Northwest."*

670 *Julia Ballard (Shoshone) in an elk-tooth dress, with her husband, Shoshone Chief John Ballard. Early 1900s. Photograph Collection Ballard Family*

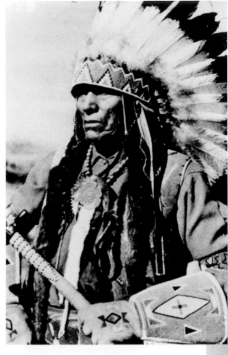

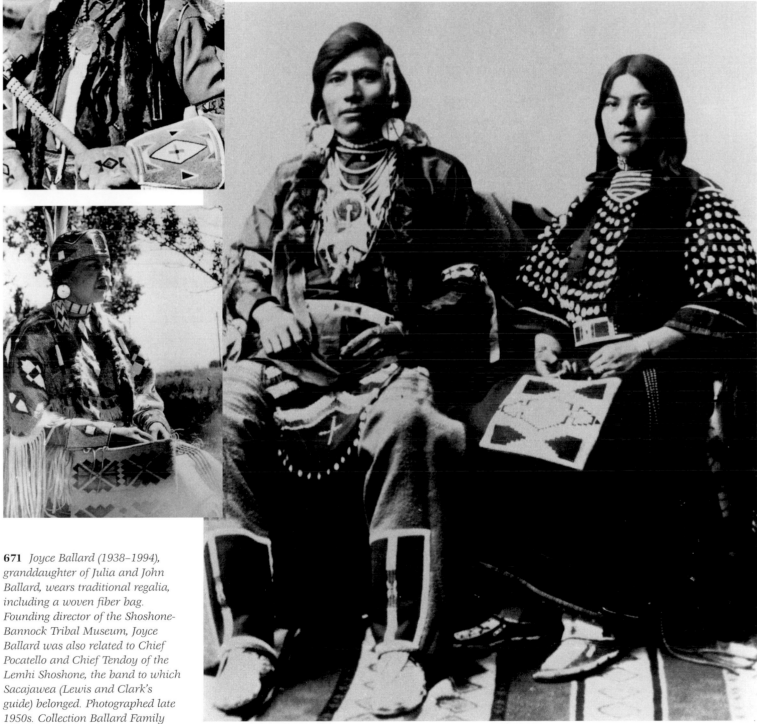

671 *Joyce Ballard (1938–1994), granddaughter of Julia and John Ballard, wears traditional regalia, including a woven fiber bag. Founding director of the Shoshone-Bannock Tribal Museum, Joyce Ballard was also related to Chief Pocatello and Chief Tendoy of the Lemhi Shoshone, the band to which Sacajawea (Lewis and Clark's guide) belonged. Photographed late 1950s. Collection Ballard Family*

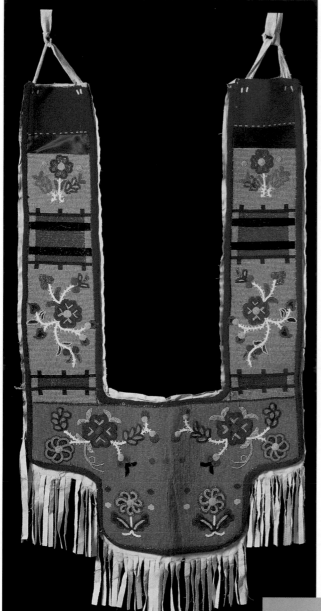

673 *A vest made at Fort Hall, with ancient double curves and bilaterally symmetrical design. Irene Ponzo Edmo (Shoshone-Bannock), paternal grandmother of Drusilla Gould. c. 1920s–30s. Length, 20" (50.8 cm). Collection Drusilla Gould*

675 *High-top moccasins by Phoebe Burton Martin (Shoshone-Bannock), Fort Hall, Idaho. c. 1930s. Height, 13" (33.0 cm). Collection Drusilla Gould*

672 *Shoshone-Bannock horse collar, worn in numerous parades throughout Idaho, combines Shoshone-Bannock geometric and Canadian Athapaskan floral motifs. Julia Ballard (Shoshone), Fort Hall, Idaho. c. 1920s. Length, 35" (88.9 cm). Collection Ballard Family*

674 *Shoshone-Bannock high-top beaded buck-skin moccasins with Cree-influenced design. Made in the 1920s by Lucille Pocatello (Shoshone), Chief Pocatello's granddaughter, the moccasins were handed down to the artist's granddaughter, Joyce Ballard, and are now with her great-granddaughter, Valerie Hernandez. Fort Hall, Idaho. Height, 11" (27.9 cm). Collection Valerie Hernandez*

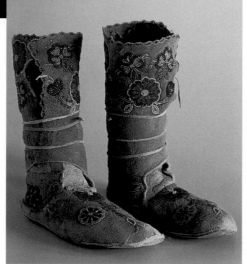

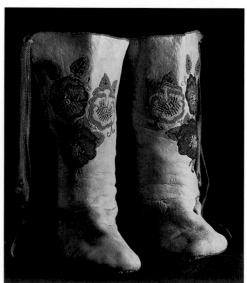

674

675

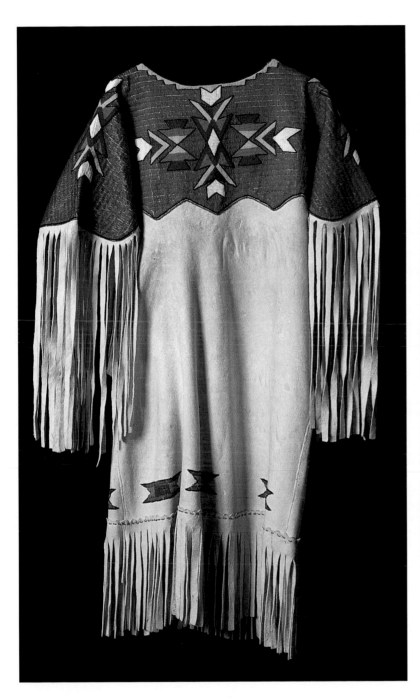

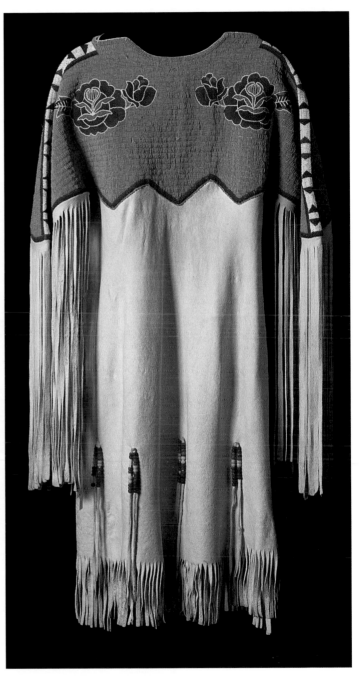

676 *A beaded star design adorns this buckskin dress made by Truma Davis (Shoshone-Bannock) for daughter Andrea in 1969. Fort Hall, Idaho. Length, 46" (116.8 cm). Collection Truma Davis*

677 *This buckskin dress with rose motifs was made by Truma Davis for her daughter Pam in the early 1970s. Mrs. Davis, who learned beadwork from her aunt, beaded coin purses for sale to air force personnel stationed at Pocatello during World War II. Fort Hall, Idaho. Length, 46" (116.8 cm). Collection Truma Davis*

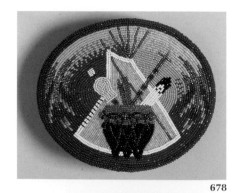

678

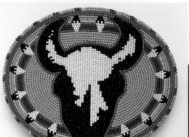

679

678 *Belt buckle used for Native American Church rituals includes images of a tipi (the church), day sky with sunrise, rattle gourd, drum, sage, staff, eagle fan, and night sky with sunset. Length, 5¾" (14.6 cm). Clinton Houtz (Shoshone-Bannock), Fort Hall, Idaho. 1980s. Collection Clinton Houtz*

679 *Contemporary beaded buffalo-head belt buckle. Fort Hall, Idaho. 1990s. Length, 5" (12.7 cm). Private collection*

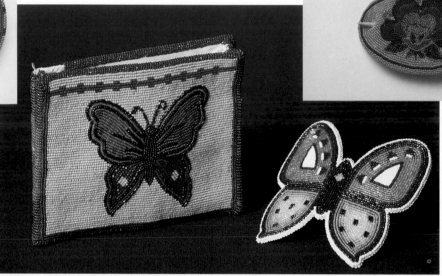

680

680 *Two beaded belt buckles and a hairpiece by Millie Guina (Eastern Shoshone) illustrate local flora, including the prairie rose. Born in 1915, the artist was raised and still lives on the Wind River Reservation. She beads on buckskin she has brain-tanned herself. 1994. Right belt buckle length, 4⅜" (11.1 cm). Private collection*

681

681 *Butterfly motifs span sixty years.* LEFT: *Beaded purse. Effie Ballard (Shoshone-Bannock). c. 1930s.* RIGHT: *Beaded barrette. Audrey Gould Bearing (Shoshone-Bannock). 1994. Purse width, 6¼" (15.9 cm). Collections Ballard and Bearing Families, respectively*

682 *Moccasins and leggings by Eva Broncho (Shoshone-Bannock) and her son, Weldon Broncho, for Weldon's daughter Kylie. (The left legging is unfinished.) The combining of floral and geometric motifs continues. Fort Hall, Idaho. 1994. Leggings height, 8½" (21.6 cm). Collection Kylie Broncho*

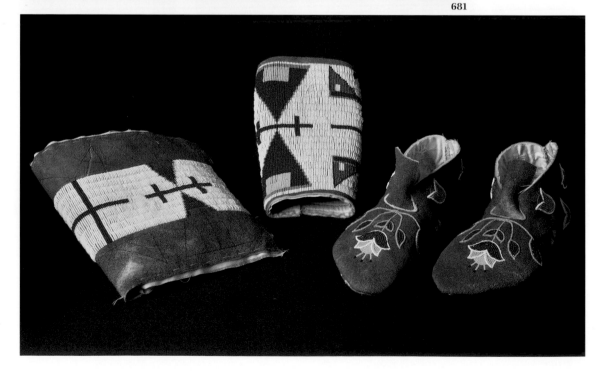

683 *Peyote fan of imported macaw and local bird feathers and beadwork and a rattle gourd of horsehair and beadwork. Both, of Shoshone-Bannock manufacture, were used in Native American Church ceremonies. Fort Hall, Idaho. n.d. Fan length including fringe, 21" (53.3 cm). Shoshone-Bannock Tribal Museum*

684 *Dance fan with buckskin, beads, bald- ▷ eagle tail feathers, made by Eva Broncho. Superb artistry and tight, clean, and flat stitchwork characterize "Sho-Ban" beadwork. Fort Hall, Idaho. 1970s. Length, 33" (83.8 cm). Collection Eva Broncho*

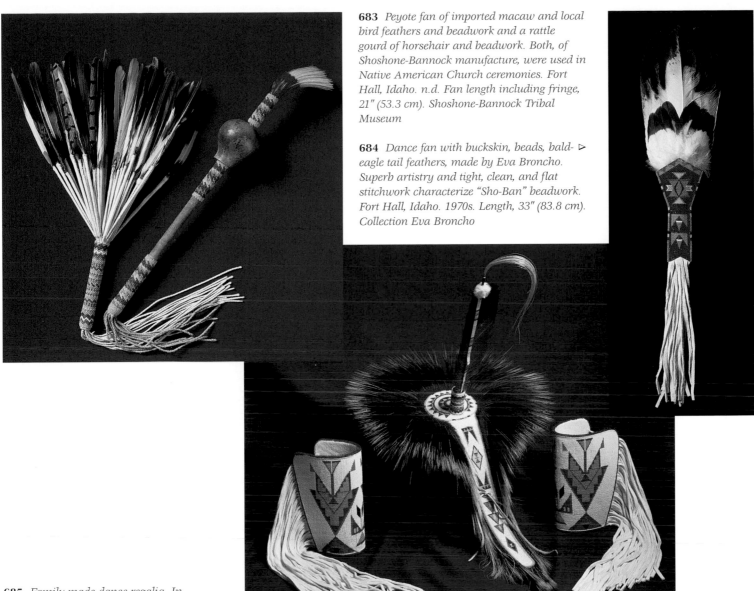

685 *Family-made dance regalia. In 1980, after the dance cuffs' designs were outlined by Murphy Broncho, his mother, Eva Broncho, completed the beading. The porcupine roach, made in 1981 by brother Weldon Broncho (who spent years collecting the porcupine quills), was beaded by Murphy. Construction took three months. Fort Hall, Idaho. 1981. Length of beadwork on roach, 27" (68.6 cm). Collection Weldon Broncho*

685

686 *Belt, moccasins, purse, and a purple quilled horse by Eva and Weldon Broncho, Fort Hall, Idaho. Mrs. Broncho scrapes and brain-tans her own hides and Weldon dyes his own quills. 1990. Belt embroidery height, 4⅛" (10.5 cm). Collection Eva Broncho*

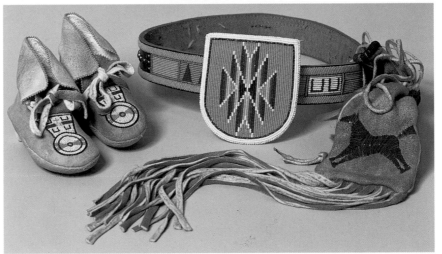

686

THE GOULDS: CONTINUING A FAMILY BEADWORK TRADITION

"Beadwork is not anything to be taught, it's something you learn by hands-on experience, watching," says Drusilla Gould (Shoshone-Bannock). "One of the ways you know if beadwork is good is by running your hand over it: if you don't feel any bumps, you know it's excellent work. This method was passed down to my mother from her great-great-grandmother, Dinguizi, who was blind. All she knew was sight by hand. If there was a mistake, she'd never let anyone take it apart because, just as in life, you couldn't go back and change the wrongs you've done. So you put it away and start a new one. You go from today forward. This is an important lesson to take into consideration, especially when doing certain kinds of beadwork. For instance, if you are beading for a dancer, you tack down every two beads, instead of the regular three beads, and you don't do too much lazy stitch because, if a thread breaks, you lose only a smaller group of beads at a time.

"It is also important to work on several things at once, rather than completing one whole thing. When a car organization asked my grandmother to make twenty-five belt buckles for each of their members, she worked on all of them at the same time, like an assembly line. She started with the wheels first, then the tires, and finally the frames. She said that it gave her more time to get an entire picture of what she wanted them to be like.

"Our elders believed in looking into the future, and preparing for those times. When our maternal grandmother, Phoebe Burton Martin—who was from the Lemhi band of Shoshone—talked about passing on to the next world, she told us of how her elders prepared for their passing by making their own burial clothing. As she talked, she worked on her own burial dress. Some family members did not accept this; they thought it would shorten her life. Grandmother asked those who were confused to come see her, so she might explain her reasons for preparing the dress. She told them that she knew her future: the dress would not be completed by her own hands and only finished when she is near to making her journey. Grandmother said, 'I know how long I have to live, I know when I'm ready to go, and that's when this dress will be finished.'

"Burial can sometimes be a problem because of the lack of knowledge of traditions by some of our people. When grandmother passed on, some relatives wanted to bury her in a regular dress. But she eventually wore the burial dress." Family members who helped to finish the dress were Phoebe Burton Martin, Agnes Martin Gould (Phoebe's daughter), Drusilla Gould, Audrey Gould Bearing and Delphina Gould (Phoebe's granddaughters), and Vidella Gould (Phoebe's great-granddaughter).

"My mother did fantastic work. Before she passed on, she made about thirty-six fully beaded buckskin dresses and outfits. We each have one that she made for us. In Indian fashion, she would give many of her works as gifts to friends and relatives. Sometimes she would trade her beadwork for a hide (or two), beads, or just ask for a prayer from the individual.

"Our family colors are an important part of everything that we do. Each color represents an individual or symbolizes an important event. Our maternal grandmother's color is green, our mother's color is blue, our father's were the flame colors. Whenever we do beadwork, we almost always place the strong colors as borders or to cover large areas (backgrounds). The lesser colors make up the design, usually a combination of family colors. The strong colors represent the elders, the lesser ones represent new life. All this combined represents the elders protecting the youth within a circle, which is the cycle of life, with no beginning and no end."

▽ **687** *Parfleche bag made and painted by Drusilla Gould's blind great-great-great-grandmother in the mid-1800s. It was used by her great-grandmother, her grandmother, Phoebe Burton Martin, and mother, Agnes Martin Gould, for carrying beadwork. Length, 26" (66.6 cm). Collection Gould Family*

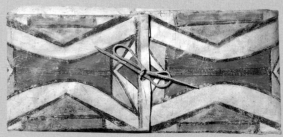

688 *A small beaded buckskin pouch by Drusilla Gould. Although inspired by the heirloom parfleche bag (687), the artist changed colors. 1994. Length, 9" (22.9 cm). Private collection*

689 Agnes Martin Gould's unfinished roses. Inherited by Drusilla Gould from her mother, they will be incorporated into her own work. "Out of respect for Mother I will continue to use turquoise [Mother's color] as the background color." Fort Hall, Idaho. Glass beads, canvas. Length, 7¾" (19.7 cm). Collection Gould Family

690 Unfinished roses made by Phoebe Burton Martin; hair ties with roses by Agnes Martin Gould. The Shoshone were famous for their roses. Drusilla explains: "They loved to make roses because no rose is exactly alike. It's easier to do roses because if you make a mistake, go on. Flowers are never perfect, there's always a flaw." Fort Hall, Idaho. Glass beads, hide. Hair tie length, 7" (17.8 cm). Collection Gould Family

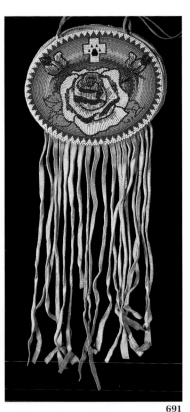

691

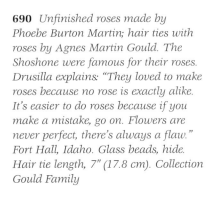

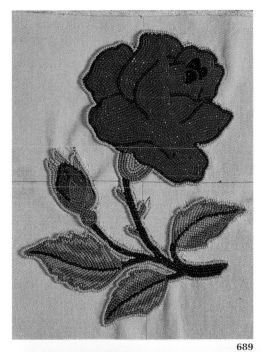

689

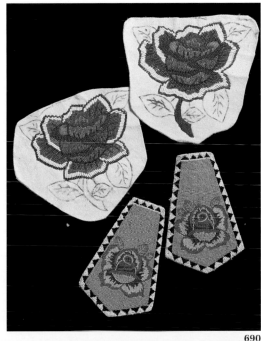

690

691 The bicultural motifs on this bag include a paw print and Native American Church cross. Beaded by Audrey Gould, her work always incorporates a paw print, representing the Osborne side of her family, whose beadwork used animal tracks or mountain lion prints. Fort Hall, Idaho. 1990. Length, including fringe, 16" (40.6 cm). Collection Gould Family

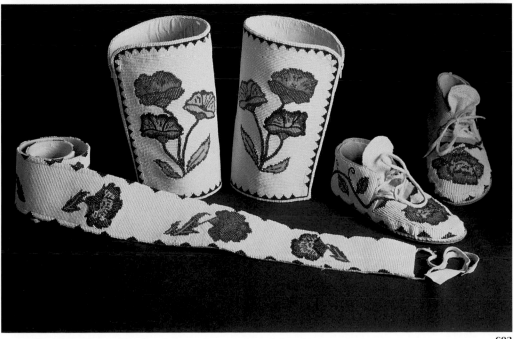

692

692 Belt and leggings by Drusilla Gould, to be shared with daughter Vidella. The original unfinished belt had three flowers beaded by Drusilla Gould's grandmother, Phoebe Burton Martin. The artist completed the belt in 1994 using beads that Mrs. Martin had left her in a little pouch. "We continue where Grandma or Mother left off." The leggings reproduce her grandmother's design. The moccasins, made for Vidella, incorporate her paternal great-grandmother's vines, maternal great-grandmother's flowers, and her mother's design and technique, which tie it all together. "When Vidella wears them," says Drusilla Gould, "I think she'll have the spirit." Fort Hall, Idaho. Belt width, 3¼" (8.3 cm). Collection Drusilla Gould

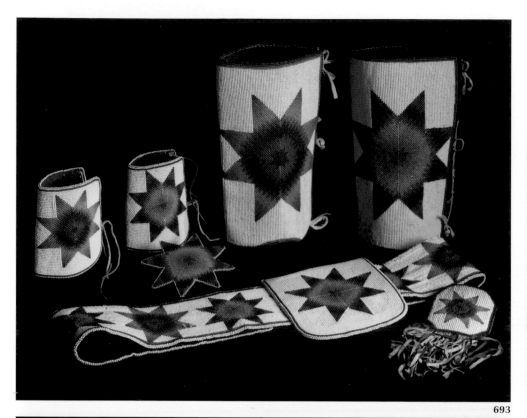

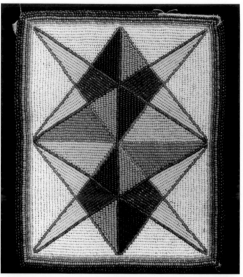

693 *A beaded dance outfit with star motifs using family colors. The juxtaposition of colors signifies important family relationships. Delphina Gould. Fort Hall, Idaho. 1982. Leggings height, 11" (27.9 cm). Collection Gould Family*

694 *Drusilla Gould's first beaded bag, made at eight years of age. Fort Hall, Idaho. Length, 9¼" (23.5 cm). Collection Gould Family*

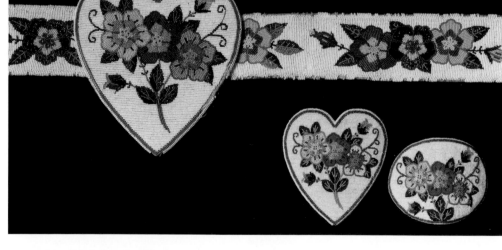

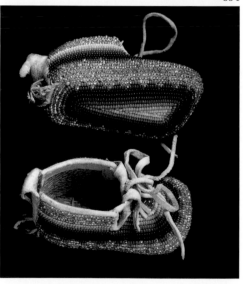

695 *Belt and belt drop by Phoebe Burton Martin, c. 1930s. Matching barrettes and belt drop by granddaughter Audrey Gould, 1989. Fort Hall, Idaho. Large belt drop, 9" (22.9 cm). Collection Gould Family*

696 *Baby Zara's moccasins have beaded soles, "since Zara couldn't walk yet anyway." Delphina Gould. Fort Hall, Idaho. 1985. Length, 4" (10.2 cm). Collection Gould Family*

697 *Dondi Gould wears the cuffs and crown in 699. Fort Hall, Idaho. 1994*

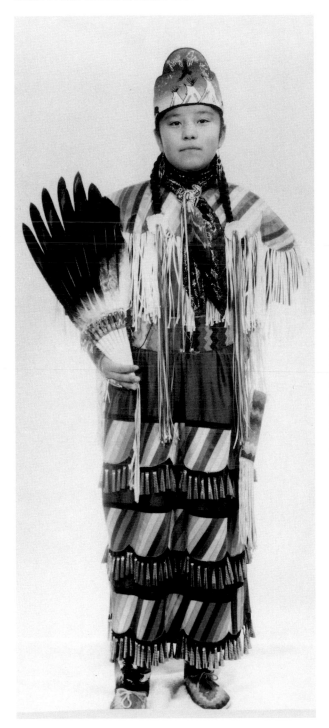

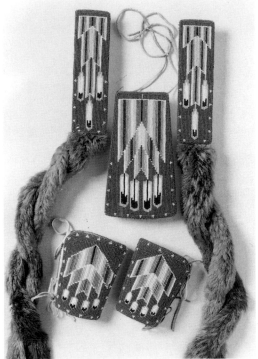

698 *Necklace, cuffs, and hair ties made by Drusilla Gould's daughter, Vidella, at age fourteen. Fort Hall, Idaho. Height of cuff, 10" (25.4 cm). Collection Gould Family*

699 *Dance cuffs and crown made by Delphina Gould for her daughter, Dondi, for the Junior Princess pageant at the Shoshone-Bannock Festival. Fort Hall, Idaho. 1994. Height of crown, 6½" (16.5 cm). Collection Gould Family*

698

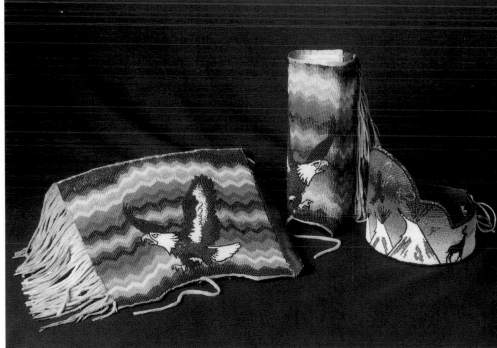

699

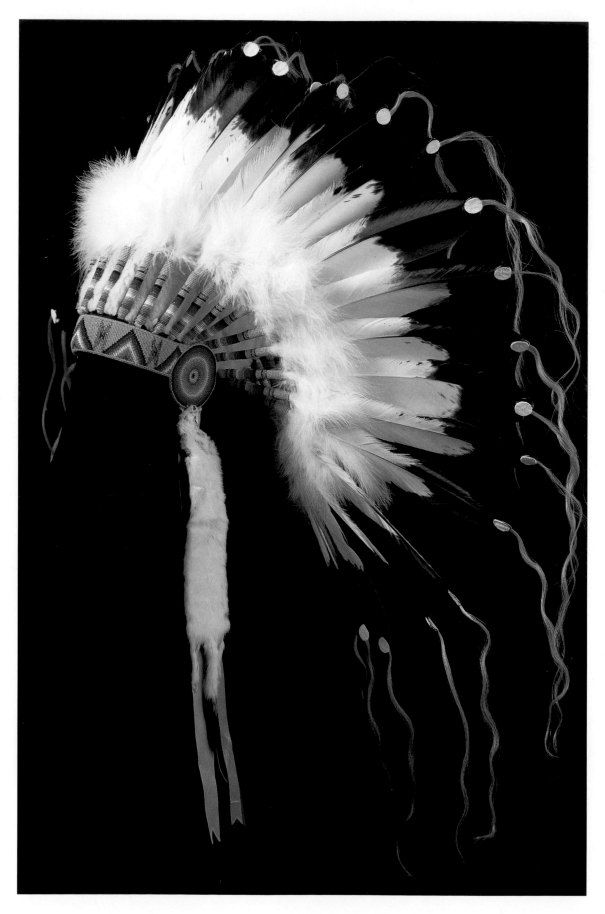

700 *Austin Gould's bonnet of bald-eagle feathers was created for the Warbonnet Dance revived by his wife, Agnes Martin Gould, in the early 1970s. Mr. Gould was highly respected within the community. The bonnet indicates that his authority and wisdom had earned these feathers. Tipi-shaped forms (representing the family home) hold the family colors. The bull's-eye circles symbolize life—no beginning, no end—with the strongest family colors on the inside. The ermine represents winter. Beadwork by Agnes Martin Gould; bonnet by Austin Gould. Fort Hall, Idaho. Dyed cowtail. Length, 42" (106.7 cm). Collection Gould Family*

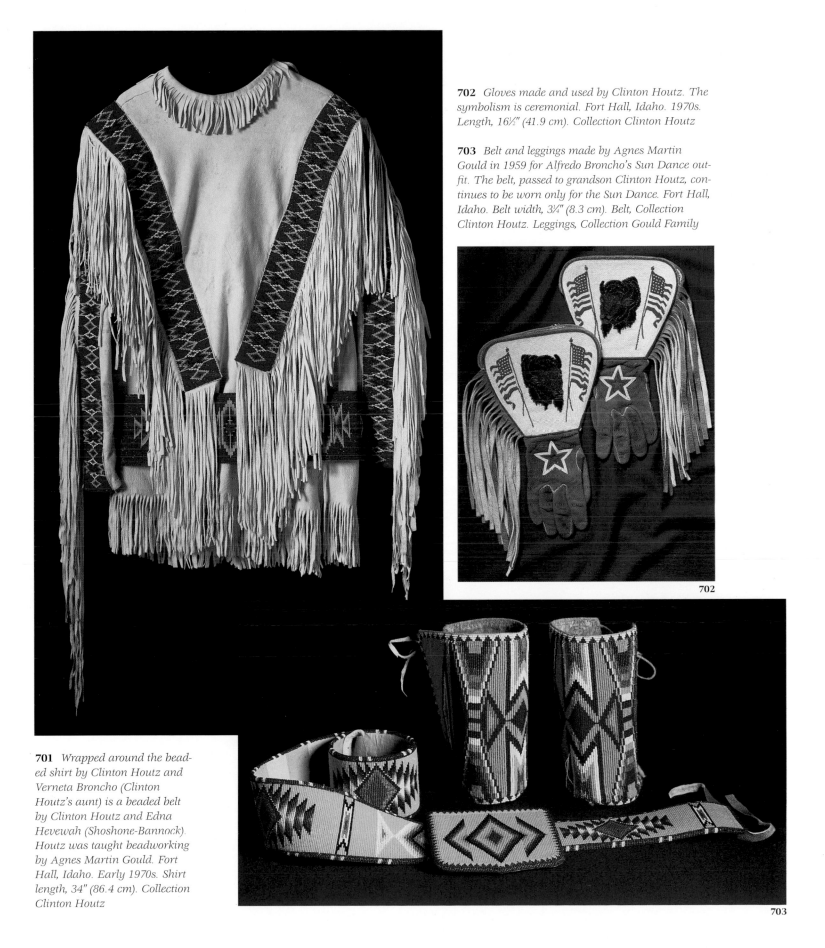

702 *Gloves made and used by Clinton Houtz. The symbolism is ceremonial. Fort Hall, Idaho. 1970s. Length, 16½" (41.9 cm). Collection Clinton Houtz*

703 *Belt and leggings made by Agnes Martin Gould in 1959 for Alfredo Broncho's Sun Dance outfit. The belt, passed to grandson Clinton Houtz, continues to be worn only for the Sun Dance. Fort Hall, Idaho. Belt width, 3¼" (8.3 cm). Belt, Collection Clinton Houtz. Leggings, Collection Gould Family*

701 *Wrapped around the beaded shirt by Clinton Houtz and Verneta Broncho (Clinton Houtz's aunt) is a beaded belt by Clinton Houtz and Edna Hevewah (Shoshone-Bannock). Houtz was taught beadworking by Agnes Martin Gould. Fort Hall, Idaho. Early 1970s. Shirt length, 34" (86.4 cm). Collection Clinton Houtz*

702

703

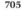705

704 *A partially beaded canvas on a loom illustrates Edgar Jackson's technique. It will eventually be mounted on a metal buckle and backed with hide. 1994. Height, 3¾" (9.5 cm).*

705 Custer's Last Stand, *a beaded bag based on the Charles Russell painting, by Edgar Jackson (Shoshone-Bannock). After an aunt left him her beads, Jackson tried beading out of curiosity and immediately liked it. He sketched well, an ability that gave his beadwork a unique painterly quality. Jackson's imagery is particularly influenced by the Western-style paintings of Charles Russell (1864–1926). "I just try to portray how things are," says Jackson. In the belt buckle [643], for instance, the buffalo's rear shows his dung. "I put it all in because that's life. I don't try to protect people. That's the way the animals are naturally." 1981. Diameter, 7" (17.8 cm). Collection The Clothes Horse, Fort Hall*

706 *In this beaded bag, Edgar Jackson used size-16 seed beads in the nondirectional "brickwork" pattern he created in 1980 to set off the pictorial images. Jackson worked originally with larger beads, sizes 12 and 13. Within a few years, he had shifted to 16 and 18 because smaller beads permitted a wider range of color (see 643) and made the very intricate painterly effect possible. The artist prefers his pieces to be useful and flexible, not heavy or stiff.* Buffalo Hunter. *1980s. Diameter, 7⅛" (18.1 cm). Collection JoAllyn Archambault*

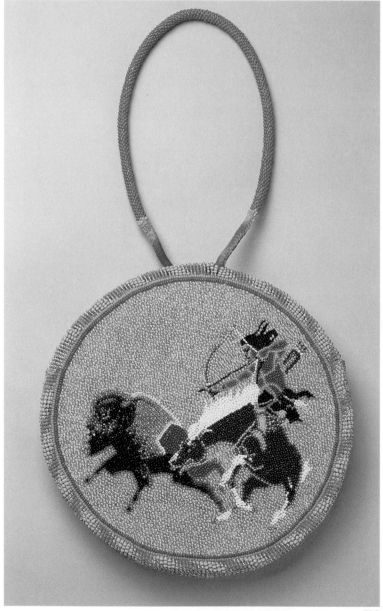

706

707 *Paul Manning LaRose in beaded dance regalia, 1995. His Native name, Bald-Headed Eagle, was given to him by his grandfather, Moon, an Eastern Shoshone from Fort Washakie, Wyoming. All the animal designs, helpers in everyday life, came through dreams. Powwow dancing has become an extension of LaRose's beadwork, giving him the opportunity to travel throughout the country, reaching people directly and giving them the strength to carry on, "to bring them into the circle."*

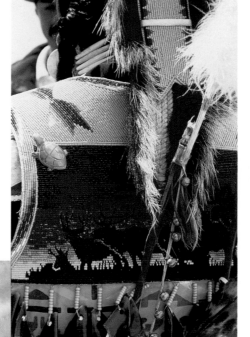

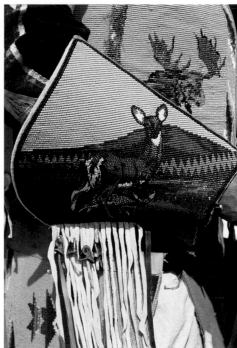

708

709

708 *The beadwork tells a story; each animal has meaning. The buffalo with the sunset on the back of the vest signifies the unity of Native nations. Every tribe comes from a different animal clan, and all the animals will come together as one. Paul LaRose's Northern Ute and Shoshone background calls for combining art traditions from different tribal groups. "We do the lazy stitch like the Sioux, which looks similar to the older quillwork and beaded floral patterns, which were passed on to the Woodlands by the French. We adapted the styles and mastered them into our own."*

709 *Paul LaRose's work reflects the values of the Shoshone-Bannock beading traditions and the influence of his combined families of teachers. LaRose uses some family designs but always his own colors. He defends "new" colors. "We are living in modern times, and you've got to move on. If the old people had had access to today's colors, they would have used them." The geometric designs come from the Gould family of Fort Hall, where he learned beading from his adopted sister, Delphina Gould. The outfit, displaying Northern Ute and Shoshone influences, has, says LaRose, "something of theirs and something of mine."*

SOUTHERN UTE BEADWORK AND ADORNMENT

Southern Utes, through trade and war booty, shared many bead patterns with the Kiowa, Apache, Arapaho, and Southern Cheyenne. At the same time, they developed their own designs and color combinations. During the difficult years of the nineteenth century, Ute leaders—Ignacio, Ouray, and Sapiah (Buckskin Charlie)—stressed the importance of wearing traditional clothing for maintaining tribal identity.

710 *Ute peyote-pouch necklace. Around 1890, the Southern Utes adopted both the Sun Dance and peyotism, two ceremonies that helped unite Utes trying to maintain their traditions and Indian identity. Glass beads, hide. Length, 42" (106.7 cm). Colorado Historical Society, E1894.50*

711 *Ute beaded fob. Undated. Length, 4" (10.2 cm). Colorado Historical Society, E1894.56*

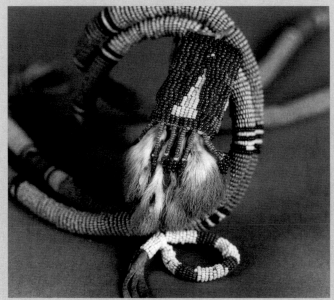

710

711

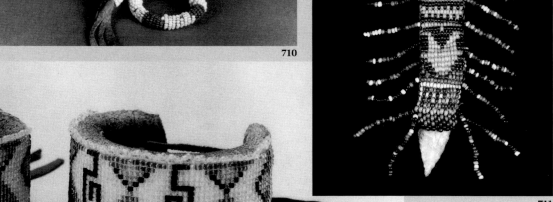

712 *Beaded dance cuffs on smoked elk hide. Tom Weaver (Southern Ute). 1995. Height, 1¾" (4.5 cm). Private collection*

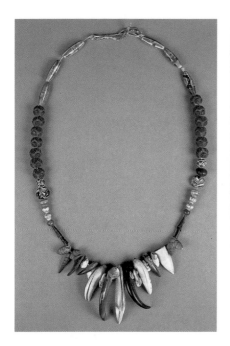

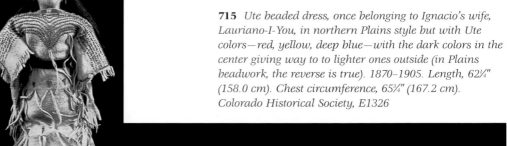

715 *Ute beaded dress, once belonging to Ignacio's wife, Lauriano-I-You, in northern Plains style but with Ute colors—red, yellow, deep blue—with the dark colors in the center giving way to to lighter ones outside (in Plains beadwork, the reverse is true). 1870–1905. Length, 62¼" (158.0 cm). Chest circumference, 65¾" (167.2 cm). Colorado Historical Society, E1326*

713 *Ute bead and claw necklace that belonged to Ignacio (1828–1913), leader of the Weeminuche band. Chief Ignacio guided his people through perhaps the most difficult period of Ute history. He refused to accept the individual allotments of land that the government offered to his people, fearing that the communal aspects of their life would be lost forever. In 1895, he persuaded the government to set aside for the Weeminuche a separate tract of land in the extreme western sector of the Southern Ute Reservation. Ignacio died, leaving his people, now called the Mountain Ute, thoroughly convinced of the value of maintaining traditional Ute lifeways. Before 1913. Carved wood, Chinese and Venetian glass beads, elk teeth, mountain lion teeth, shells, claws. Length, 27" (68.6 cm). Colorado Historical Society, E456*

714 *Ute doll. Collected before 1905. Hide, glass beads. Height, 18⅛" (46.0 cm). Peabody Museum of Archaeology and Ethnology, Harvard University, 05-53-10/65715*

714

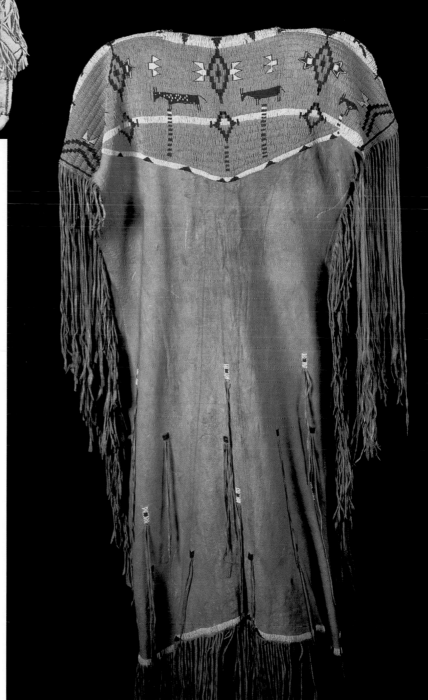

CHIEF OURAY AND CHIPETA OURAY

mong the many outstanding Ute negotiators and leaders during the nineteenth century, none had the renown of Ouray and his wife, Chipeta. Ouray's intelligence, fair-mindedness, ability to speak several languages, and awareness of the United States' power made him the government's choice to represent all Utes. Under Ouray's guidance, the Utes signed the 1868 Kit Carson Treaty, which provided a single 1.5 million-acre reservation encompassing almost the entire western slope of Colorado for all Southern Ute bands. Unfortu-nately, this was an area rich in minerals and agricultural lands coveted by settlers and miners, and future treaties would take most

of this land from the Utes. Ouray, who died in August 1880, was saved the sorrow of seeing his people herded into Utah to live on reservations.

As Ouray's wife, Chipeta lived in both Native and non-Native worlds. With her people, she maintained Tabeguache Ute ways, but, in accompanying her husband to the capital, she became a Washington belle. Outliving her husband by forty-five years, Chipeta remained with her tribe after his death. When the Utes were expelled from Colorado in late 1880, Chipeta saw the last of the land her husband had struggled to save.

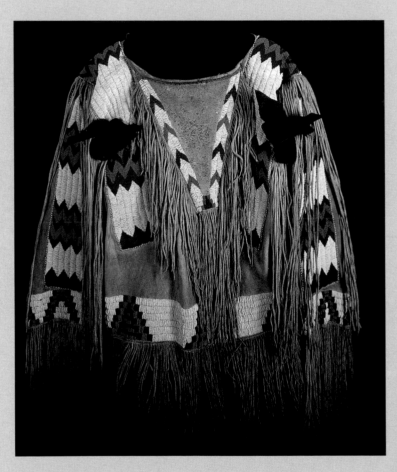

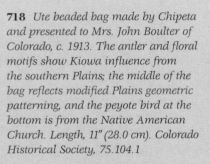

718 *Ute beaded bag made by Chipeta and presented to Mrs. John Boulter of Colorado, c. 1913. The antler and floral motifs show Kiowa influence from the southern Plains; the middle of the bag reflects modified Plains geometric patterning, and the peyote bird at the bottom is from the Native American Church. Length, 11" (28.0 cm). Colorado Historical Society, 75.104.1*

718

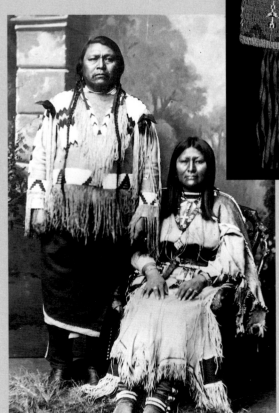

717

716 *Ute beaded shirt, made for Ouray by Chipeta and worn on his trip to Washington in 1880. "Ouray shunned the business suits provided for Washington visitors. He preferred to wear and be photographed in his native attire." Height, 14" (35.5 cm). Colorado Historical Society, E1930*

717 *Chief Ouray and his wife, Chipeta, pose for their last formal photograph together in Washington, D.C., in January 1880. He wears the shirt seen in 716. By August, Ouray had died. Smithsonian Institution*

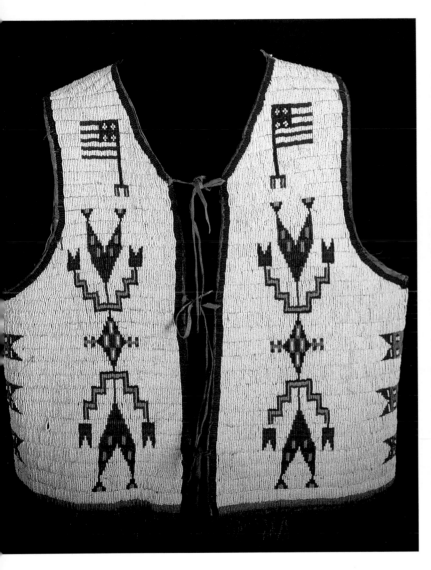
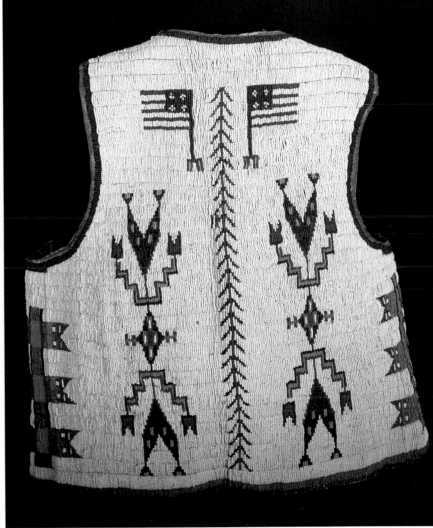

719 *Ute beaded vest, front and back views, worn by Sapiah (1840–1936), also called Buckskin Charlie. Chosen by Chief Ouray as his successor, Sapiah also worked for peace between Indian and white. Half Ute and half Apache, the chief grew up among the Southern Utes at a time when his culture was in the midst of tremendous flux. Much of his time was spent in Washington, D.C., in negotiations with government officials. (On one trip, he marched in Theodore Roosevelt's inaugural parade.) Realizing that the white rule was inevitable, he counseled his tribes to accept the land allotments offered by the United States. At the same time, he encouraged retaining the traditional ways of life. Especially proud of the beadwork and leather tanning for which the Utes were well known, he usually appeared publicly in Native clothing. The last traditional chief of the Capote band of Utes, he died in 1936 at the age of ninety-six. His son, Antonio Buck, was elected the first tribal chairman. 1890–1910. Length, 11" (28.0 cm). Colorado Historical Society, 75.104.1*

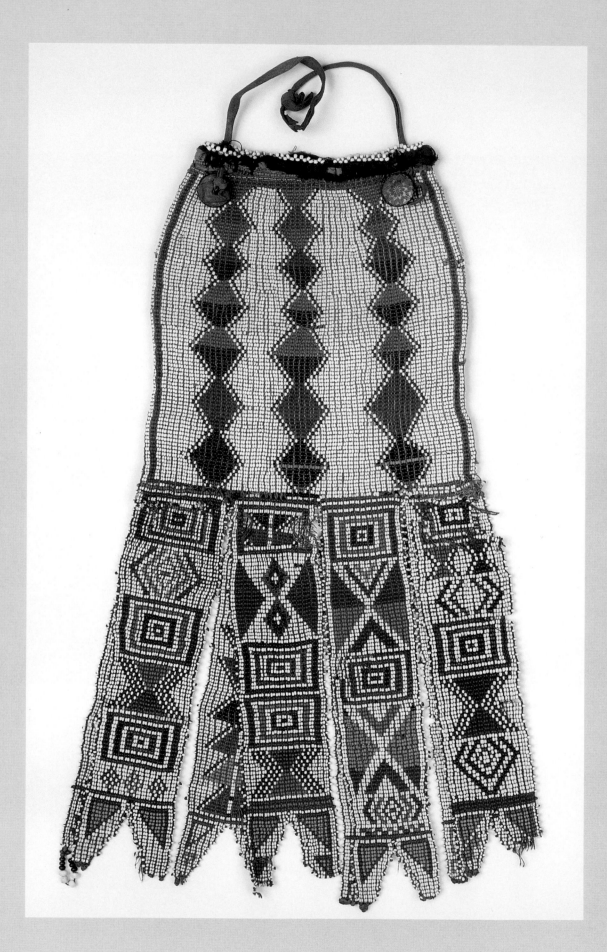

720 *The woven beadwork style of this "octopus" bag's pouch adapts the Plateau's indigenous basketry motifs and techniques. Related geometric patterns are found on Wasco-Wishram baskets (721). Bead weaving and the octopus-bag form were brought to the area by Great Lakes fur traders in the early 1800s. Wasco-Wishram style, but collected among the Paiute in White Pine, Nevada, 1870. Length, 15" (38.1 cm). National Museum of the American Indian, 10/85*

BASKETRY AND BEADWORK
THE PLATEAU

"Cedar Tree said to the young woman, 'Take the first perfect basket with the beautiful designs behind the bushes and sacrifice it as an offering. This will teach you to be thankful. Then make five small baskets and give them away to the oldest women members in the village.' (This is still practiced by the Klickitat people.) The young woman was reluctant to do this. She selfishly wanted to keep all the baskets. Cedar Tree patiently told her if she didn't give away the baskets she would never be an accomplished basket weaver."

—Recorded by Virginia Beavert (Yakama), 1974[1]

721 *A Wasco-Wishram root-gathering basket twined from hemp* (Apocynum cannabinum). *Within the overall diamond-grid pattern are animals (dogs, wolves, or coyotes) and human faces, perhaps of* Tsagagla'lal, *She-Who-Watches—motifs found in Columbia Basin rock art. Collected by the Lewis and Clark Expedition along the Columbia River near The Dalles, 1805–6. Height, 11¹³⁄₁₆" (30.0 cm). Peabody Museum of Archaeology and Ethnology, Harvard University, 53160*

722 *This porcupine-quill pouch (front and back views) has intriguing but unexplained design and color relationships with the beadwork in 720. A note in the bag reads, "Potawatomee tribe . . . Michigan America. 1833." Quillwork on bark, fastened to a cloth bag by tape. Height, 6¼" (15.9 cm). Idaho Museum of Natural History, 4718*

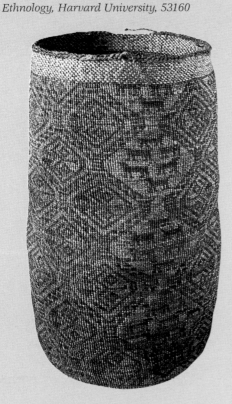

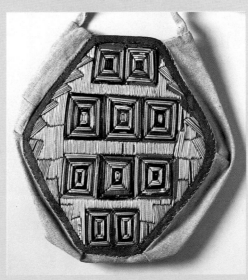

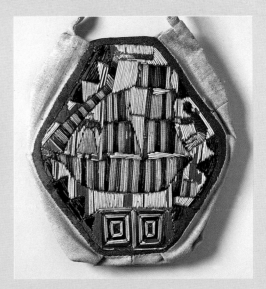

From baskets to garments, weaving has played an important role in Plateau people's daily and ceremonial life. Nets were assembled to catch salmon swimming upstream; baskets and bags were carefully twined or coiled to collect roots and berries and transport water. Woven bark clothing was worn as a cool summer fabric or when animal skins were scarce, and for rituals. The making of these items was an expression of gratitude to spirits responsible for nature's generosity. This philosophy later transferred into Plateau beadwork, where a bold and vibrant beading style depicted the plants, flowers, and animals that sustained human life.

Plateau peoples—inhabitants of Earth World (elsewhere called This World, the middle ground)—were conscious of their mediating role between Upper (Sky World, sun and stars) and Lower Worlds (Under World, salmon and roots) and their responsibility for maintaining a balance. Simultaneity abounds: leaves and bark require upper-world sun to grow from lower-world roots. Baskets, bags, and caps created of bark-fiber hemp (*Apocynum cannabinum*) were an essential and interdependent component of Plateau life. Basket caps were worn with round bags during rituals associated with the gathering of the first roots. Dried roots collected in round bags were then stored in flat bags; flat bags are still carried during festivals when the caps are worn.[2]

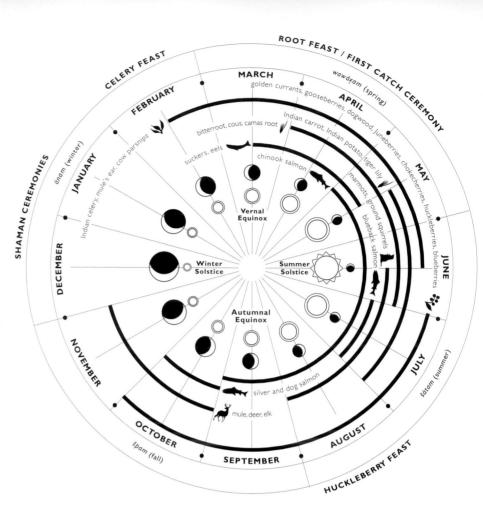

Seasonal Round of the Yakama

The Plateau adjoins regions with varying adornment. Northwest Coast tribal regalia denoting wealth and status differed greatly from the egalitarian work of the Subarctic and Basin. The Californians' restrained use of organic materials contrasted with the exuberant, colorful clothing of late-nineteenth-century Great Plains horse people. However, while Basin groups frequently blended surrounding influences, Plateau peoples more typically retained them as clearly definable additions. The result is a unique aesthetic, receptive to new forms yet rarely abandoning old ones. The incorporation of new elements that supplemented rather than replaced previous items was noted by ethnologist James Teit in his description of nineteenth-century NLaka'pamux (Thompson) adornment: "Both men and women wore ear-ornaments, which consisted of strings of bark or skin passed through holes in the ear, from which hung dentalium shells. Later on, colored beads, and brass, copper, and silver buttons, were used with the shells."[3] NLaka'pamux additive concepts were also exemplified technically in their woven cedar and willow capes (see 770, 771). Above all, many Plateau artisans followed two separate but complementary paths with the continuation of ancient basketry techniques while enthusiastically embracing and creating glass beadwork.

LIFEWAYS OF THE PLATEAU PEOPLES

The Plateau, located between the Rocky and Cascade Mountains, extends south into central Oregon and southern Idaho, where it merges into dry volcanic basin. The region, whose name derives from a sequence of high-altitude plateaus included within the watershed of the Fraser, Thompson, and Columbia Rivers and their major tributaries (excluding the Upper Snake River in southern Oregon), is marked by fir- and

pine-forested mountains and rushing streams, all of which drain into the Pacific. The central and southern Plateau is classified as high desert filled with sage and juniper. The generally mild, dry climate is marked by hot summers and cold winters, when temperatures can range from extremes of −30 to 115 degrees Fahrenheit.

Lush river valleys enabled the Plateau's population to settle in fertile areas close to water in summer and at the base of sheltering mountains in winter. Subsistence was dependent equally on fishing, fowling, hunting, and the gathering of plants. The area's rich bounty provided all necessities, including shelter, tools, food, clothing, and most ornamentation. Large and stable settlements flourished.

Parts of the Plateau area have been occupied by hunters, fishermen, and gatherers for at least twelve thousand years. Between 6000 B.C. and 1500 B.C., severe climatic changes were accompanied by an influx of other Native groups who mixed with local populations and introduced new languages and tools. By 1500 B.C., semipermanent Plateau communities existed along river ravines, which supplied seasonal roots, fish, and game. The people carved wooden canoes and participated in long-distance trade.

Flexibility and Multiple Alliances

At the time of European arrival in the early nineteenth century, dozens of separate groups inhabited the Plateau. Around the Columbia River and its tributaries were Chinookian and Sahaptian speakers; those living in the Fraser River basin spoke Salishan. While sharing subsistence, communal life, and spiritual beliefs, each group developed as a unique entity. Strong bonds existed among those with similar cultures and a common language. At the same time, Plateau people retained cultural and linguistic ties to the tribes in surrounding lands.

Within the larger Plateau region, lifeways varied according to location. In the arid south, bands adopted a seminomadic lifestyle similar to that of the Basin people. To the east, groups on the edge of the Plains participated in limited buffalo hunting. In the north and northwest, dependable supplies of salmon, which could be dried and stored through winter, and camas roots supported more sedentary societies.

Plateau women paralleled the men as providers of food. To ensure that the roots would return, it was the women who harvested them, always making certain that the earth was replaced. Whereas other regions honored young men after their first hunt, young Plateau women were honored after their first root digging.[4] Deep respect was accorded women elders, who wove the baskets used for collecting the roots and berries.

Political structures were egalitarian, organized into bands or small villages and based upon leadership acquired through personal achievement. Systems of status existed among some groups who lived nearer the Northwest Coast. An intertribal network wove groups together in a strong but pliant political and economic fabric. As families shifted their residences seasonally, they developed extended relationships with numerous other tribes and bands. This complex pattern of multiple alliances fostered individual and tribal flexibility and peaceful coexistence. Marriage and shared gathering and fishing territories further generated strong bonds of loyalty.[5] Although retaliatory measures were occasionally taken against hostile outsiders and horse raiders, Plateau societies were generally quite peaceful and were preoccupied with trade more than war. Consequently, they never acquired the formalized honor systems, military societies, and regalia that developed on the Plains.[6]

Spirituality

Plateau people were and remain deeply spiritual, with women equal to men in all leadership roles, including those related to shamanism and the Indian Shaker and Christian churches.[7] Beliefs centered around vision quests, spirit helpers, and "first food" rituals.

THE PLATEAU

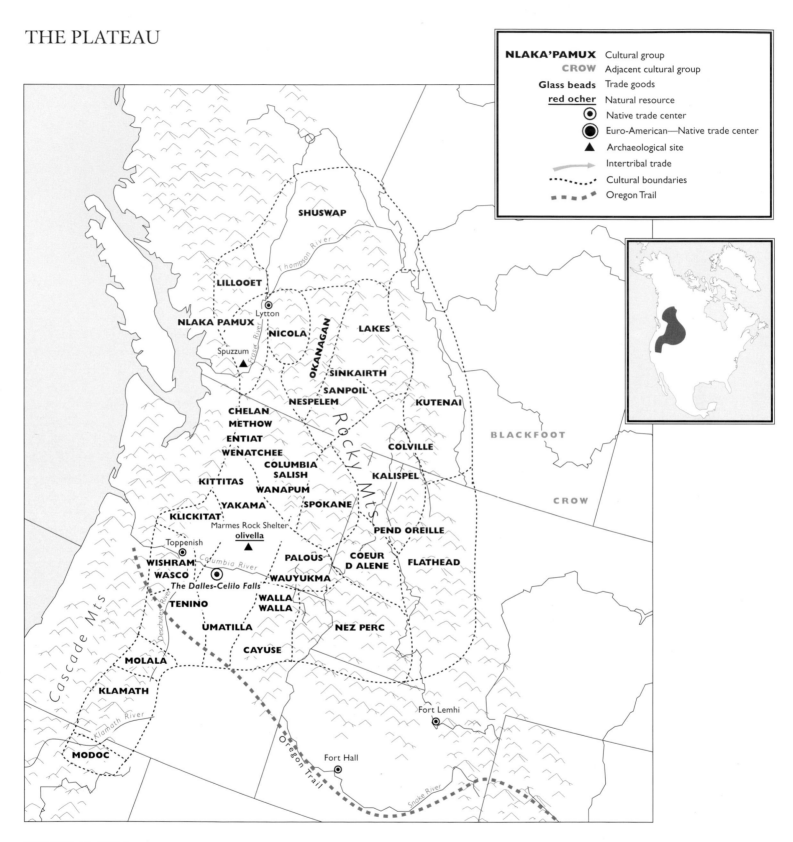

NLAKA'PAMUX Cultural group
CROW Adjacent cultural group
Glass beads Trade goods
red ocher Natural resource
⊙ Native trade center
◉ Euro-American—Native trade center
▲ Archaeological site
→ Intertribal trade
⋯⋯ Cultural boundaries
▬ ▬ ▬ Oregon Trail

SHUSWAP

LILLOOET

NLAKA PAMUX

Lytton

NICOLA

OKANAGAN

LAKES

Spuzzum ▲

SINKAIRTH

SANPOIL

NESPELEM

KUTENAI

CHELAN

METHOW

ENTIAT

WENATCHEE

COLVILLE

COLUMBIA
SALISH

KITTITAS

WANAPUM

KALISPEL

YAKAMA

SPOKANE

KLICKITAT

Marmes Rock Shelter
olivella ▲

PEND OREILLE

Toppenish

WISHRAM

WASCO

PALOUS

COEUR
D ALENE

FLATHEAD

The Dalles-Celilo Falls

WAUYUKMA

TENINO

WALLA
WALLA

UMATILLA

NEZ PERC

MOLALA

CAYUSE

KLAMATH

Fort Lemhi

Oregon Trail

MODOC

Fort Hall

Snake River

Columbia River

Fraser River

Thompson River

Deschutes River

Klamath River

Rocky Mts

Cascade Mts

BLACKFOOT

CROW

CULTURAL AREA

The approximate territories of Plateau and
adjacent groups at about 1850. See also the
map of contemporary Native lands, page 551.

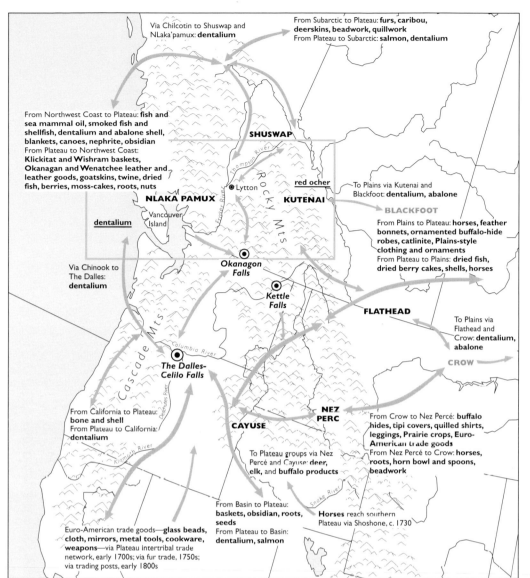

PRECONTACT AND EARLY-CONTACT TRADE NETWORK

The Dalles-Celilo Falls, situated along waterfalls along the Columbia River and itself an important subsistence site for salmon fishing, was one of the major trade centers in all of North America. From there, an extraordinary array of goods was exchanged among Plateau, Basin, Plains, California, and Subarctic groups.

Via Chilcotin to Shuswap and NLaka'pamux: **dentalium**

From Subarctic to Plateau: **furs, caribou, deerskins, beadwork, quillwork**
From Plateau to Subarctic: **salmon, dentalium**

From Northwest Coast to Plateau: **fish and sea mammal oil, smoked fish and shellfish, dentalium and abalone shell, blankets, canoes, nephrite, obsidian**
From Plateau to Northwest Coast: **Klickitat and Wishram baskets, Okanagan and Wenatchee leather and leather goods, goatskins, twine, dried fish, berries, moss-cakes, roots, nuts**

SHUSWAP

red ocher

To Plains via Kutenai and Blackfoot: **dentalium, abalone**

Lytton

NLAKA'PAMUX

KUTENAI

BLACKFOOT

dentalium

Vancouver Island

From Plains to Plateau: **horses, feather bonnets, ornamented buffalo-hide robes, catlinite, Plains-style clothing and ornaments**
From Plateau to Plains: **dried fish, dried berry cakes, shells, horses**

Via Chinook to The Dalles: **dentalium**

Okanagon Falls

Kettle Falls

FLATHEAD

To Plains via Flathead and Crow: **dentalium, abalone**

Columbia River

CROW

The Dalles-Celilo Falls

From California to Plateau: **bone and shell**
From Plateau to California: **dentalium**

NEZ PERC

CAYUSE

From Crow to Nez Percé: **buffalo hides, tipi covers, quilled shirts, leggings, Prairie crops, Euro-American trade goods**
From Nez Percé to Crow: **horses, roots, horn bowl and spoons, beadwork**

To Plateau groups via Nez Percé and Cayuse: **deer, elk, and buffalo products**

From Basin to Plateau: **baskets, obsidian, roots, seeds**
From Plateau to Basin: **dentalium, salmon**

Horses reach southern Plateau via Shoshone, c. 1730

Euro-American trade goods—**glass beads, cloth, mirrors, metal tools, cookware, weapons**—via Plateau intertribal trade network, early 1700s; via fur trade, 1750s; via trading posts, early 1800s

TRADE NETWORK AMONG THE NLAKA'PAMUX AND NEIGHBORING GROUPS, PRECONTACT–LATE 1800S

This detail of the map above gives a microview of the remarkably lively local exchange of goods among the various bands of one Native group—the NLaka'pamux —and their neighbors within the northern Plateau.

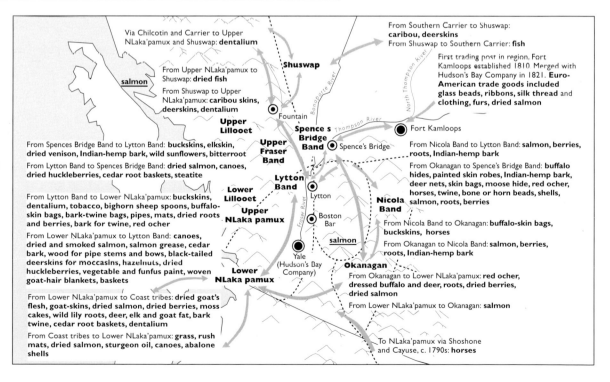

Via Chilcotin and Carrier to Upper NLaka'pamux and Shuswap: **dentalium**

From Southern Carrier to Shuswap: **caribou, deerskins**
From Shuswap to Southern Carrier: **fish**

salmon

From Upper NLaka'pamux to Shuswap: **dried fish**
From Shuswap to Upper NLaka'pamux: **caribou skins, deerskins, dentalium**

Shuswap

First trading post in region, Fort Kamloops established 1810 Merged with Hudson's Bay Company in 1821. **Euro-American trade goods included glass beads, ribbons, silk thread and clothing, furs, dried salmon**

Fountain

Fort Kamloops

Upper Lillooet

Spence s Bridge Band

Spence's Bridge

From Spences Bridge Band to Lytton Band: **buckskins, elkskin, dried venison, Indian-hemp bark, wild sunflowers, bitterroot**
From Lytton Band to Spences Bridge Band: **dried salmon, canoes, dried huckleberries, cedar root baskets, steatite**

Upper Fraser Band

From Nicola Band to Lytton Band: **salmon, berries, roots, Indian-hemp bark**

From Okanagan to Spence's Bridge Band: **buffalo hides, painted skin robes, Indian-hemp bark, deer nets, skin bags, moose hide, red ocher, horses, twine, bone or horn beads, shells, salmon, roots, berries**

Lytton Band

Lytton

Lower Lillooet

Nicola Band

From Lytton Band to Lower NLaka'pamux: **buckskins, dentalium, tobacco, bighorn sheep spoons, buffalo-skin bags, bark-twine bags, pipes, mats, dried roots and berries, bark for twine, red ocher**

Upper NLaka pamux

Boston Bar

From Nicola Band to Okanagan: **buffalo-skin bags, buckskins, horses**
From Okanagan to Nicola Band: **salmon, berries, roots, Indian-hemp bark**

From Lower NLaka'pamux to Lytton Band: **canoes, dried and smoked salmon, salmon grease, cedar bark, wood for pipe stems and bows, black-tailed deerskins for moccasins, dried huckleberries, vegetable and funfus paint, woven goat-hair blankets, baskets**

salmon

Yale (Hudson's Bay Company)

Okanagan

From Okanagan to Lower NLaka'pamux: **red ocher, dressed buffalo and deer, roots, dried berries, dried salmon**
From Lower NLaka'pamux to Okanagan: **salmon**

Lower NLaka pamux

From Lower NLaka'pamux to Coast tribes: **dried goat's flesh, goat-skins, dried salmon, dried berries, moss cakes, wild lily roots, deer, elk and goat fat, bark twine, cedar root baskets, dentalium**
From Coast tribes to Lower NLaka'pamux: **grass, rush mats, dried salmon, sturgeon oil, canoes, abalone shells**

To NLaka'pamux via Shoshone and Cayuse, c. 1790s: **horses**

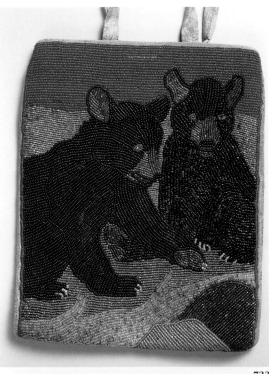

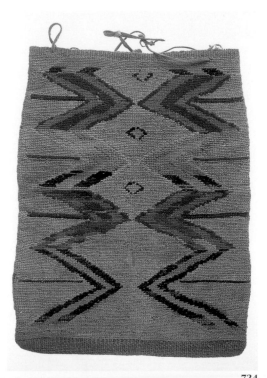

723 *The bear was revered by Plateau Indians. They appear on this beaded bag as playful cubs rather than shamanic spirit helpers. c. 1900. Length, 10½" (26.7 cm). Collection Charlotte Pitt. The Museum at Warm Springs, 79.4.2*

724 *Cornhusk bag used to store dried roots. Geometric designs, integrated with the weaving process, are twined in spun hemp and accented with yarn. Collected among the NLaka'pamux but probably Nez Percé. Late nineteenth century. Length, 13⅝" (34.6 cm). Peabody Museum of Archaeology and Ethnology, Harvard University, 10/86279*

725 *Beaded yoke with fringes for a buckskin dress. The beadwork patterns and colors are grounded in earlier woven fabrics (see 724). Nez Percé. Collected 1890s. Width, 14⅞" (38.0 cm). Peabody Museum of Archaeology and Ethnology, Harvard University, 10/44064*

723

724

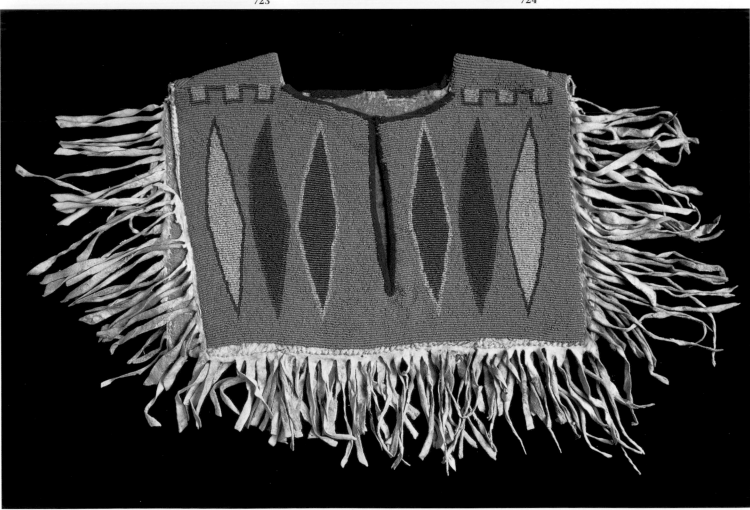

725

Traditionally, girls and boys undertook vision quests before puberty. Guardian spirits who appeared during the quests frequently awarded gender-specific powers. Girls, for example, would be gifted with powers to find roots easily, while boys would be awarded powers for fishing salmon or hunting. A girl's first menses required a time of isolation; some of the most elaborate rituals, clothing, and adornment relating to this occurred among the NLaka'pamux.

Public rites thanking the Creator and marking the return of fresh foods still occur during seasonal ceremonies marking the gathering of that year's First Salmon, First Roots, and First Fruits. The Warm Springs people say, "The Great Spirit gave the food for us to live on. We didn't have to plant it, cultivate it, or water it. That is why we thank him with our prayers."[8]

Coyote—who provides instructions and ethics mixed with wisdom and humor—remains at the heart of Plateau stories. To explain the origin of weaving materials, the NLaka'pamux describe hemp- or bark-fiber, the principal thread spun by their women, as having been created from Coyote's pubic hair.[9]

INDIGENOUS MATERIALS AND TECHNIQUES

The earliest Plateau dwellers wore clothing of sewn skin and vegetable fibers and adornment made from the region's animal and plant resources. Bone and antler needles, beads, awls, and fleshing tools date from c. 8500 B.C. to 6000 B.C. Two basketry-weaving techniques—twining and coiling—were developed in ancient times: twined-fiber fragments dating to around 7000 B.C. have been excavated near The Dalles, an important Columbia River trade center and burial complex active from about 4000 B.C. to A.D. 1850.[10] Between 1500 B.C. and 1000 B.C., increasingly closer relationships with Northwest Coast people strengthened Plateau wood and stone carving.

In time, art styles and adornment became more elaborate. Artifacts recovered at The Dalles include beads, gorgets, pendants, and hairpins; some are carved with human and animal motifs.[11] Nineteenth-century Euro-American explorers and traders in the region recorded the abundant use of indigenous adornment by the Nez Percé, Yakama, Tenino, Umatilla, and NLaka'pamux. Mentioned were horn and bone beads, elk teeth, horsehair, porcupine quillwork, feathers, breastplates with horizontal rows of polished bison bone, necklaces of native copper and bear claws, and pendants, bracelets, and "sea beads" of shell.[12] A few groups pierced holes in the nasal septum and inserted tubular ornaments of dentalium and other shells, quill, and bone (735). Face painting and tattooing were sometimes practiced by both sexes.

Although oral tradition records that the region's early inhabitants wore sagebrush-bark clothing, at contact only a small community of northern Plains artisans produced fiber garments. Capes, skirts, and hats were woven from cedar and spruce root or goat hair by northwestern tribes; to the south and east, fiber clothing was made by the Coeur d'Alene. Woven-fiber fabric made strong, flexible garments that kept the individual warm and dry in winter and was cooler than buckskin during summer months. In a region where people depended equally upon plant and animal life for sustenance, cedar and willow headbands, sashes, and capes were worn at religious dances, for ceremonial occasions, and to mark life changes. Among the finest fiber weavers were the NLaka'pamux.[13]

Skin clothing of the Plateau groups was similar to that of the Plains tribes. Uncut, whole skins were used as outer wraps while the more fitted men's shirts and women's dresses retained the shapes of the hides from which they were constructed (see 561, 568). Men wore shirts, breechcloths, and long leggings; women were typically attired in long dresses and short leggings. Robes and caps were added during the winter.

NLAKA'PAMUX CLOTHING TRADITIONS

Archaeology and oral tradition suggest that, until influenced by European styles in the 1860s, traditional NLaka'pamux fiber and decorated buckskin attire had a two-thousand-year continuity. Extraordinary artistry and craftsmanship were achieved using minimal materials and tools. The construction of their twined-fiber garments was ingenious: fabrics were shaped into form-fitted clothing without any cutting or sewing (see 771). NLaka'pamux weavers' remarkable ability to maintain a consistent spacing and tension in the warp and weft resulted in the highest quality hand-woven materials.

The main areas of decoration on NLaka'pamux deerskin clothing were bibs and fringes. The bib, centered on the breast, was semicircular or triangular in shape and resembled necklaces, capes, or small ponchos. Similar in design concept to that of southern Plateau and Plains dress yokes, the bib symbolized a deer tail. Plateau bibs differed, however, by hanging outside rather than inside the garment. Detailed pictures were beaded and painted in this "encircled space." Like that of their Subarctic neighbors, most NLaka'pamux attire displays fringe, which was frequently painted and beaded.

Colors used on the face, body, and clothing were links to spiritual beliefs. Red and brown signified life, existence, blood, heat, fire, light, day, and earth. Black probably represented Lower World: death, cold, darkness, and night. Yellow and green stood for earth, grass, trees, vegetation, stones, and water. Blue was used for Upper World; white for the spirit world, skeletons, and bones. All paints and dyes came from clay, berries, and other plants of the surrounding environment. The addition of crushed mica gave face and body paint a shiny, shimmering appearance.

Color was woven into NLaka'pamux legends. Rainbow, for example, was once a man who often painted his face with bright colors. When collecting food, women picking berries or digging for roots on certain mountains always painted their faces red. After hunters killed a bear, they painted their faces in alternate stripes of red and black and sang the bear song. The shaman visited patients with his face painted red and,

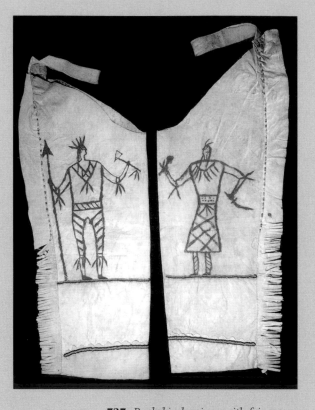

727 *Buckskin leggings with fringes, beadwork, and painted ocher designs of two warriors. The warrior on the left holds a spear to hunt beaver and a tomahawk with its own feather pendant. He has long hair with attached eagle tail feathers and down and wears a necklace, armlets with pendants, belt, close-fitting breechcloth, close-fitting stripped leggings, and garters with pendants. The warrior on the right has two braids and two head feathers, carries a knife and war claw, and wears a necklace, armlets with pendants, belt, and war shirt. The vertically beaded lines at the seams replace those of traditional ocher; of the two horizontally beaded lines, one is possibly an earth line; the other may represent the earth and trees. NLaka'pamux. Received 1915. Length, 36¾" (93.5 cm). Peabody Museum of Archaeology and Ethnology, Harvard University, 10/86539*

726 *Hidden imagery: Fringes inserted down the side seam of a pair of leggings are decorated with a pattern of alternating white and blue beads. This decoration, which Boas called "a rhythmic arrangement of beaded strings," is not particularly apparent when the leggings are worn and the fringes hang down. Yet, for unknown reasons, artisans took great care to follow a set pattern of five elements: two strings of one blue glass bead and two bone beads in alternating order; one undecorated string; one of alternating glass and bone beads; one undecorated string.*

Rattlesnake motifs were popular in NLaka'pamux decoration, evidenced by these examples from the late 1800s:

728 *Choker-style necklace made from a rattlesnake skin sewn to a rounded stuffed buckskin core. Canadian Museum of Civilization*

729 TOP: *Shoulder sash of buckskin with fringes and beaded "snake-tracks" design. Sash width, 8⅞" (22.5 cm).* BOTTOM: *Buckskin dance or puberty rites rattling anklet with deer hoofs, and ocher grizzly-bear and rattle-snake figures, probably painted as spirit helpers in connection with the owner's dreams. Peabody Museum of Archaeology and Ethnology, Harvard University, 10/86549, 10/86450*

728

729

directed by his dreams or the guardian spirit, painted designs on the patients' bodies. During raids, warriors wore red and black face and body paint but little clothing, so as to have the greatest freedom of movement. Red lines, painted on clothing edges and openings and in hair parts, were used for both protection and as decoration to hide the seams.

Simple geometric forms—straight lines, circles, squares, and triangles—were the main design units. The circle was used as half-circle, arc, or a U shape. A square became a diamond; half a diamond, a triangle. Each form represented many different objects. A single dot or circle was a star, moon, cloud, or raindrop. A cross represented simultaneously a star, crossed trails, fallen timber, a log over a stream, or the four points of a compass.

Circles were essential to all aspects of NLaka'pamux culture. Ethnologist Leslie Tepper has pointed out that in both architecture and clothing (capes, cloaks, and blankets) "people wrapped themselves in circular structures. . . . Painted motifs at the hem, waist, or collar and on belts and headbands are described as earth lines. . . . Often decorated with designs of trees or mountains, they encircle the individual in a symbolic representation of the NLaka'pamux landscape."

Early contact clothing was decorated with horn, bone, dentalium or other shell beads, elk teeth, feathers, tassels, and quills. Seeds and, eventually, glass beads were sewn along the seams and inserts of buckskin to emphasize separate elements of the garment. Hair was washed and greased daily and adorned with feathers. Bracelets and anklets of native copper and horn were eventually replaced by copper and brass wire. Necklaces of grizzly-bear claws were worn only by hunters who killed bear or shamans who had grizzly-bear guardian spirits.

After 1858, NLaka'pamux artisans replaced beadwork with silk and thread embroidery. By 1860, indigenous buckskin and plant-fiber clothing was mixed with European styles. This mixture continued until 1900, when the missionaries discouraged the use of language and traditional clothing. As James Teit noted: "Young people were afraid to wear anything pertaining to the old style of dress such as feathers, skin caps, etc. They say that a strange shaman, seeing them wearing any of these items, might test their powers and as a consequence they might be bewitched or killed, because none had proper puberty rites and most had no guardian spirits."

James Teit was a Scotsman who, after immigrating from the Shetland Islands to southern British Columbia in 1883, married a NLaka'pamux woman and became deeply committed to recording traditional NLaka'pamux lifeways. His photographs and writings—the foundation of this section—contain a wealth of reliable information about the tribe's clothing and adornment. Although the photographs 730, 732, and 770 were posed specifically for Teit's 1913–14 sessions, the outfits seen in them illustrate traditional styles. By the early twentieth century, the NLaka'pamux wore Euro-American rather than traditional clothing. Nonetheless, the use of skin clothing never entirely disappeared from their culture. Buckskin moccasins and gloves, jackets, and dance outfits continue to be crafted, and traditional skills of fiber weaving and hide preparation are increasingly practiced by community members.

730 *Although NLaka'pamux painted-hide clothing was sometimes biographical, most often the imagery, obtained during vision quests, was abstract and carried private meanings. Paint, fringes, beads, grasses, feathers, and fur are combined on this remarkable shirt. At the lower right are designs identified as Morning Star; to the left is Evening Star. Across the chest are the Earth and other planets. A triangular mountain, further divided into three areas of white, red, and black, sits beneath a circular sun. Designs on the back include stars and clouds. This assemblage includes a floral-beaded breechcloth (240.41). Canadian Museum of Civilization, 23575*

731 *Kali'tāa (NLaka'pamux) wears a painted hide cape and a headdress made from the entire skin of a loon, probably a bird spirit helper. Photographed 1913. Canadian Museum of Civilization*

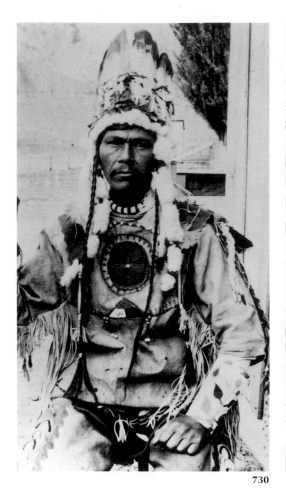

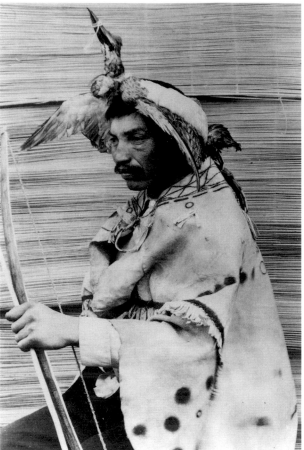

730

731

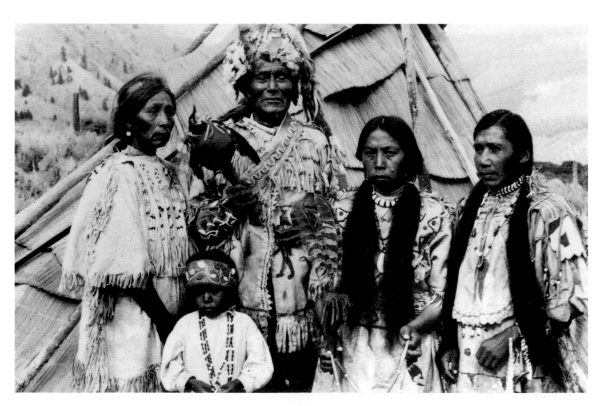

732 *Sinsimtko Roi.pellst Kwolalp, John Roi.pellst, Amy Roi.pellst, and XaxalExkEn stand in front of a mat tipi. All wear a mixture of Plains-influenced and traditional Plateau clothing, including the sash seen in plate 729 and skin garments adorned with paintings, beadwork, and dentalium shell. Photographed 1914. Canadian Museum of Civilization*

All wore deerskin moccasins, including "high-tops"—which included a strip of hide at the top of the moccasins as protection for the lower legs (674). The NLaka'pamux also made fish-skin slippers by layering salmon skin and pitch.[14] Plateau craftspeople were justifiably proud of their high-quality tanned deer and elk-hide clothing decorated with shells, feathers, quillwork, and, following contact, elaborate glass beadwork.[15] By the mid-nineteenth century, as traditional sources of hides became rarer, Plateau clothing material often transformed from buckskin to fabrics and blankets.

LIFE STAGES AND ADORNMENT

Among all Plateau groups, the wearing and exchange of clothing and ornaments defined significant life stages—birth, puberty, marriage, death. The birth of twins (representing the Duality of Life) was regarded as special. The NLaka'pamux required that the father of newborn twins wear a willow headband with eagle feathers, paint his face red, walk around the house in a circle and strike the ground with a fir bough while singing the grizzly-bear song (the grizzly would become the twins' protector) to deflect the twins' powers.[16]

Pubescent NLaka'pamux were clothed in special garments reflecting their sur-roundings. Secluded in a separate hut, a girl was given a conical hat and tunic of woven or tied-fir branches to wear and wrapped in a skin or blanket. She made sun-flower leaf and grass moccasins and "prayed that her real moccasins, even when thin and frail like these, might not wear out or burst when traveling." After eating, she wiped her mouth with cedar or sagebrush bark, which, like her comb, scratcher, and drinking tube, hung from a string around her neck. Each day, she painted her face red and placed strings of rattling dewclaws around her ankles, knees, and waistband. Using red pigment, she recorded her ritual experiences on boulders and small stones.[17]

Ceremonial rites were observed by a NLaka'pamux boy until he received animal or bird guardian spirits. He painted his face with dream imagery daily but allowed no one to see the designs until he had obtained his spirit helper. He also wore animal skins, dewclaw ornaments on his ankles and knees, and used a drinking tube and bone scratcher. After obtaining the guardian spirit, he painted his face and clothing with symbolic designs and wore or carried part of its skin or feathers.[18]

Ritualistic ear piercing was performed by a tribal elder on young Wishram chil-dren. A large elk skin, upon which the ritual was conducted, was divided and distrib-uted to all participants at the ceremony's completion. Dancing, singing, and the giving of dentalium shell and bead pendants were part of the rites.[19]

Ritualized gift-giving remains a particularly important part of consummating Plateau marriage negotiations and joining families. Although most tribes exchanged gifts after the wedding, Wasco and Warm Springs people observed "wedding trades"— premarital gifting ceremonies in which both treasured heirlooms and beautiful items made especially for the event were given away. The materials gifted were typically gender-related, representing the skills that each partner brought to the marriage. Pendleton blankets, horses with complete trappings, and rawhide parfleches with roots and salmon came from the man's relatives. The woman's family distributed cornhusk bags and finely beaded bags filled with roots and berries. On top of their own garments, women wore articles of clothing that they removed and presented as gifts. Shell beads were a traditional present from one family to another. Following the cere-mony, a meal was shared by both families.[20]

Gift-giving ceremonies helped preserve family ties and strengthen mutual bonds. "If both sides respected their wedding," notes Delores George (Yakama), "they traded all the time. This was one way we have of taking care of each other."[21] If there were

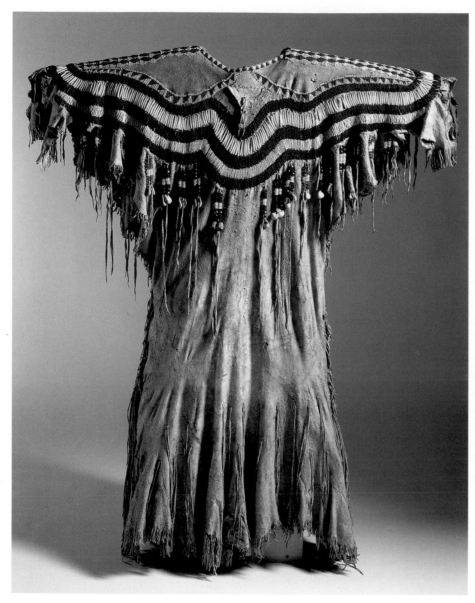

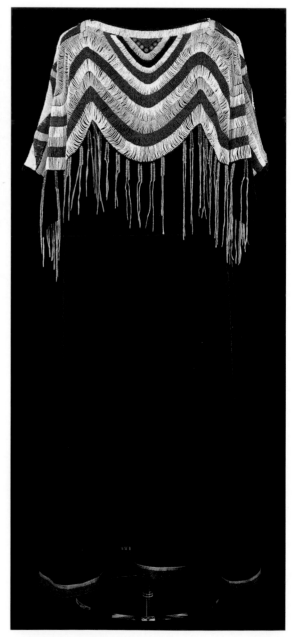

734 *This Nez Percé trade-cloth dress has patterns and glass beadwork designs derived from earlier hide and shell-embroidered dresses. Similar clothing is worn by the woman depicted on the beaded bag in 744. 1910. Length, 52½" (132.4 cm). Denver Art Museum, 1940.2*

733 *Although similar to Plains hide dresses, this early traditional Plateau deer-tail dress is differentiated by its wide contoured bands of dentalium shell and larger "pony" beads (3 to 4 mm) lazy-stitched to the front and back yoke. The symbolic deer tail remains enclosed by one undulating band on top, the remaining below. Constructed of two full deerskins and decorated with a rich array of Native and Euro-American trade goods— dentalium shells, elk teeth, glass beads, brass thimbles, and fringes wrapped with porcupine quill—this is one of the earliest documented Plateau dresses. Nez Percé. Early nineteenth century. Length, 54¼" (138.0 cm). Nez Percé National Historical Park*

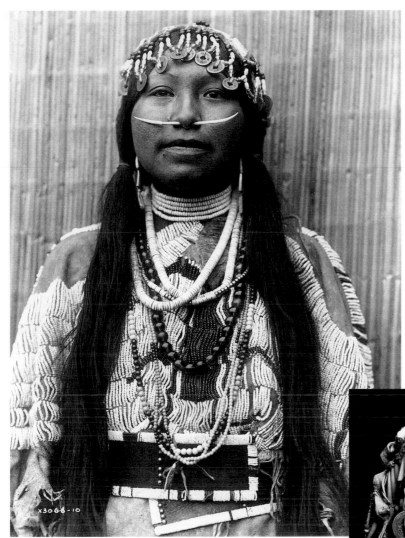

735 Headdresses of shells, glass beads, and Chinese brass coins were worn by some Columbia River people for special occasions. The coins entered the Plateau via Chinese immigrants in the mid-nineteenth century. This Wishram woman's pierced nose and dentalium-shell ornament denotes her elite status. 1910. Library of Congress, USZ62-64853

▽ **736** Yakama bridal headdress, similar to the one worn in 735, of shells, glass beads, and coins. The bride's wealth is reflected in the highly valued dentalium shells. Both the Chinese coins and imported blue glass beads were dispersed as part of the trans-Pacific fur trade during the mid-nineteenth century. Length, 12 9/16" (32.0 cm). Denver Art Museum, 13/8

Ant was a very clever young man who wished to marry the daughter of a great chief. The latter told Ant that he could not marry his daughter until he performed a difficult task. At that time, beads were scattered all over the earth, and the chief asked Ant to gather them all up, heaping each color in a pile by itself. This seemed impossible to Ant, and he went to his grandmother, Short-tailed Mouse, for advice. She told him how to do it: so he accomplished his task and won the girl. He heaped the beads in seven piles—red ones in the first, then blue, white, black, yellow, green, and bone beads in the seventh. After this, his father-in-law used beads on his clothes, and other people began to do the same. Since that time the ant has always been noted for gathering things together in heaps; for instance, sand, sticks, and its eggs.

—Recorded by James Teit, 1912

objections to the marriage, a family—displaying tongue-in-cheek Indian humor—gave presents of wormy roots or blankets with holes. The marriage, however, still occurred.[22]

The food-filled bags distributed at wedding giveaways also represented the broad emphasis on generosity and coexistence among Plateau groups. The bags were later refilled and given to others, who, in a continuous cycle of giving and receiving, might yet pass them on to another.[23]

Burial Ritual

Since it was believed that the owner's spirit permeated personal objects, many Plateau groups either burned or buried the deceased with their most prized tools and adornment, an ancient practice that continues today at several reservations. In the early twentieth century, ethnologists Leslie Spier and Edward Sapir observed that the Wishram typically adorn the deceased's body with beads of marine fish bone, shell, glass, and strings of Chinese coins, before carrying it to the burial grounds. Anthropologist Herbert Spinden was informed that the ghost of a deceased Nez Percé wore ornaments that had been interred with the body.[24] An ancient burial accidentally uncovered by the NLaka'pamux inhabitants of Spuzzum, British Columbia, contained a group of twenty people sitting in a circle and wrapped in birch bark. Many had grave offerings of dentalia and grizzly-bear claws.[25] Among the NLaka'pamux, wooden figures, carved to resemble the deceased and dressed in clothes indicating the family's social position, were placed near grave sites.[26] At contemporary Sahaptian-speaker funerals, the body is dressed in its finest buckskin clothing and jewelry, with eagle feathers attached to the right arm. All personal effects are given away, writes Eugene Hunn, "both to break the power of the person's shades or ghosts" and to "ensure that a person's death enriches those who knew him, just as in his life he generously shared whatever he had with others."[27]

Adornment was also related to mourning ritual. Four days after a NLaka'pamux person's death, the surviving spouse's hair was shorn. He or she tied buckskin thongs around the right ankle, knee, wrist, and neck and wore them for a year or until they fell away. Remarriage was not permitted until the thongs were removed.[28] Throughout the region, valued goods such as baskets, beadwork, and shells continue to be dispensed at memorial services, usually held a year following the death. In this way, surviving family members could publicly thank those who had been especially helpful. Mary Schlick recounts that in 1985, a "widow who had been brought up in the old ways along the mid-Columbia presented a beaded bag, an embroidered shawl, and a shell dress, all in a large coiled basket, to a niece who had helped her." As Schlick observed, "Again the valuable basket served as a container for valuable contents, each enhancing the other."[29]

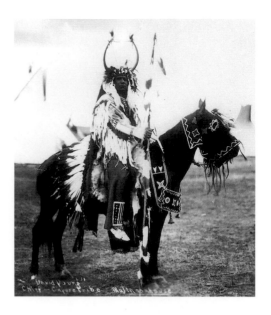

737 *Cayuse Chief David Young, c. 1900. Chief Young wears a spectacular horned headdress and ermine-fringed shirt. His lavish horse regalia—typical of the Plateau region—includes a mask and matching martingale. Smithsonian Institution*

TRADE AND ADAPTATION

Trade was pivotal to the Plateau economy, serving both to distribute food during seasonal scarcity and to receive items not locally available. Gifting traditions also encouraged a continual exchange of adornment goods. Two major river systems—the Columbia River in the south and the Fraser River in the north—and several overland mountain passes were ancient routes of trade and travel that linked people on both sides of the Cascade Mountains. Long-distance trade probably began about 4500 B.C. on the Columbia River. For centuries, Plateau traders served as middlemen in the passage of dentalium shell from the Pacific Coast to the Plains and prairies.[30]

Marine shell, greatly coveted for adornment, was first imported into the south-central Plateau nine to ten thousand years ago. The earliest shells, dating from 8000 B.C. to

738 *A Flathead mother and daughter. The horse carries a cradle (with the beaded floral bib seen in 741) attached to the saddle. Both floral and geometric motifs were used by Plateau people at this time, c. 1900. Smithsonian Institution*

▽ **739** *Traditional-style martingale (horse collar) made in the 1990s by Maynard White Owl-Lavadour (Cayuse–Nez Percé). The distinctive elongated red triangular motifs on the strap represent the flesh marks made by a grizzly bear's clawing and evoke similar nineteenth-century Nez Percé designs. The yellow, green, and blue triangles below are bear paw prints. The center panel motif signifies male twins. White Owl-Lavadour's work, while inspired by the Plateau heritage, is ultimately synthesized into his own imagery. Cloth, glass beads. Length, 48" (121.9 cm). Collection Tamastslikt Cultural Institute, Umatilla Indian Reservation, Pendleton*

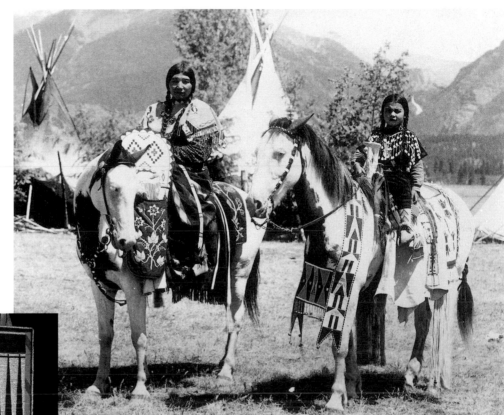

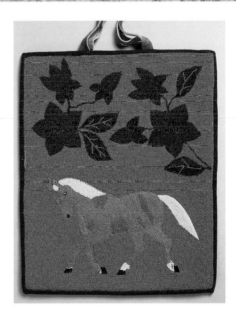

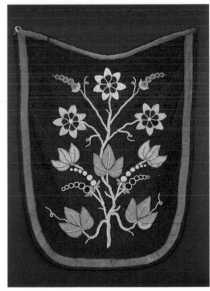

740 *A pony under a blossom arbor was a favorite design for early twentieth-century Plateau beadworkers. Although cars arrived at the Warm Springs Reservation during the 1920s, horses and wagons were the major form of transportation until the 1950s. Warm Springs. c. 1920s. Cloth, wool, canvas, beads. Length, 17¼" (43.8 cm). The Museum at Warm Springs, 92.36*

741 *This beaded floral baby's bib, attached to a horse's bridle in the photograph above, shows early signs of the asymmetry that would prevail in Plateau floral design. Flathead, Montana. Late nineteenth century. Commercial cloth, beads. Length, 20¼" (51.5 cm). Denver Art Museum, 1945.255*

7000 B.C. and recovered at the Marmes Rock Shelter site, were *Olivella biplicata;* a single fragment of the genus *Haliotis,* has been dated from 5000 B.C. to 4000 B.C. Between 1000 and 1 B.C., *Dentalium pretiosum* from Vancouver Island entered the Canadian Plateau, and, during the first century A.D., became a common Plateau trade item. Dentalium ornaments with incised geometric designs forming patterns of zigzags, chevrons, and crosshatches appeared about A.D. 1000. Between 1350 and 1750, the importation of marine shells expanded to include the genera *Glycymeris, Pecten,* and *Haliotis.* As new shell species were introduced, each supplemented rather than replaced those already in use.[31]

Sometime after 1700, European trade goods appeared in the Plateau through inter-tribal trading networks. When horses spread to the southern Plateau about 1730, Plains culture became the largest influence on the area's clothing and beadwork. Groups on the Plateau's eastern periphery quickly took to bison hunting and the equestrian lifestyle and regalia of the northwestern Plains. Elsewhere in the region, those living in close proximity to large river basins had less desire to change a satisfactory way of life. However, they too eventually took on some Plains traits, including the wearing of cut, sewn, and fringed skin clothing, parfleches, and feathered headdresses.[32] (See 730.)

Most Plateau trading centers, including Kettle Falls in northeast Washington and Okanagan Falls in British Columbia, were located along riverbanks at major waterfalls with important fisheries. The Dalles-Celio Falls, situated where the Columbia River cuts through the Cascade Mountains, was one of the largest and best-known trading centers in North America. People came to The Dalles from the Plateau, Basin, and Northwest Coast, as well as from northern California and the upper Missouri River. Plateau baskets, leather and leather goods, twine, dried fish, and pressed berry cakes were exchanged for obsidian, nephrite, and dentalium and other shells from the Pacific Coast, and for buffalo hides and horses from the Plains. Glass beads, cloth, mirrors, and metal tools were eventually added to the trade network.

Trading, never strictly business to Native Americans, produced a "festive atmos-phere," with opportunities to exchange ideas as well as see family and friends and meet new people from other regions. The acquisition of the horse allowed expansion of overland routes and permitted a larger inventory of trade goods,[33] although Plateau trade continued to be conducted primarily at centers along main waterways.

European explorers, traders, missionaries, and settlers arrived in the Plateau in the early nineteenth century, and the region's first permanent trading post was established in 1810.[34] Yet Euro-American goods had already been present in the area for genera-tions. Passing through the Columbia River Gorge in 1805, the explorers Meriwether Lewis and William Clark recorded: "The articles which they appear to trade mostly i.e. Pounded fish, Beargrass, and roots; cannot be an object of commerce with furin merchants. However they git in return for those articles Blue and white beeds, copper Kettles, brass arm bands, some scarlet and blue robes and a fiew articles of old clothes,—they prefer beeds to any thing, and will part with the last mouthfull or arti-cles of clothing they ave for a fiew of those beeds,—those beads they trafick with Indians still higher up this river for roabs, Skins, cha-pel-el (biscuitroot) bread, bear grass, &c. who in their turn trafick with those under the rockey mountains for Beargrass, quarmash roots & robes &c."[35]

Plateau artisans were influenced during the nineteenth century by Woodlands bead-work. When the Hudson's Bay Company merged with the Northwest Company in the 1820s, Woodland Indian guides and middlemen active in the Plateau fur trade arrived wearing floral beaded garments. Many of these Iroquois, Ojibwa, Cree, and Métis men married local women, who created beaded clothing that blended Woodlands and Plateau styles.[36]

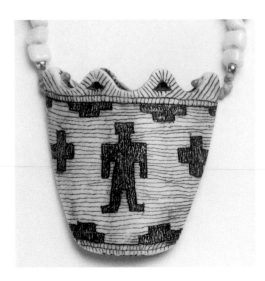

742 *Etched-bone pendant with figural and Morning-Star motifs in the form of a traditional Plateau pail-shaped, coiled, Klickitat-style basket, associated with autumn and the collecting of huckleberries. The loops at the top were used to lace thongs over a layer of leaves, which helped to contain the berries. Chico Matta (Yakama). 1994. Length, 1½" (3.8 cm). Private collection*

Fiber Art

Highly skilled weavers employed fibers from the inner bark of willow, cedar, and sagebrush for constructing baskets, bags, and garments. Decoration was applied with imbrication, a "false embroidery" technique where strips of bear grass, horsetail root, cornhusks, and eventually wool yarn were placed over and under the split bark of the basket's surface as it was woven. Imbricated designs, which resemble "raised tiles" or beadwork, are unique to Pacific Northwest basketry.[37]

Designs and colors, although not sketched out, were visualized and developed as the artisan worked on the object.[38] "There was a time when women and families owned their designs," says Lena Smartlowit (Cayuse-Umatilla). "A woman was very careful about her basketry skills. Her designs and tricks are what made her work special. They increased the value of her work."[39] Minnie Marie Slockish (Klickitat-Yakama) related in 1942: "The most common designs that we used were salmon gill, trail of the eel, geese in flight, a mountain butte, and sturgeon. . . . A design was an inspiration, from spiritual feelings the basket maker had about a basket. Often the designs were the maker's own individual expression of what she had seen, such as a sturgeon, or mountain, or other things of nature. Designs could also be made specifically for the person who would receive the basket: flowers for women, deer for men, or what that person was recognized as doing well, such as fishing or hunting."[40]

Five major types of baskets were made in the Plateau: soft twined baskets called "sally bags" (the origin of the name is uncertain but may have evolved from their use in travel, i.e., to sally forth),[41] used for carrying roots or storing personal items (721); flat twined bags (cornhusk bags), used for storing dried roots and other valuables and later carried as handbags (724); twined basket-shaped hats (743); coiled cedar-root baskets for berry picking; and folded cedar baskets for other foods. Twined basketry was most prevalent in the central and southern Plateau; coiled baskets predominated in the north. As newcomers entered their country, Plateau weavers experimented with newly introduced materials: cornhusks, wool yarn, cotton string, raffia, and commercial dyes. Even so, the distinction between the two basic styles of weaving has remained intact. Flexible twined baskets or bags continue to hold and store roots; rigid, coiled baskets are still used to gather and store soft huckleberries, which require a protective container.[42]

Tribal elder Adeline Miller of Warm Springs—referring to cornhusk bags as baskets—describes traditional cornhusk bag production: "In the fall, before the snow came, they'd go out and cut the tall cornhusks. Then they'd pack them into bundles and bring them back to the camp. Next they'd dig a trench and put all the hemp in the pit, and cover it up for a few days so that the moisture could get to it. When they dug it up it would be soft and they'd peel the hemp off in long strips, and when that got done, they'd roll it on their knees and make great big balls of it. Twine was never used, and all the dyes were natural, boiled from different types of berries, leaves, bark, and roots. In winter, great cornhusk workers sat around together making the baskets. For some of the elders, it was their livelihood. They'd start from the bottom and work in their color, not knowing what their design was going to look like. They just wrapped it until they came out with a design, and still did it differently on the other side. They'd finish one of these things the whole winter long. In spring, they'd use the basket when they went root digging, and if somebody came to pick up roots, they'd give him a full basket and trade him for his empty one. Nobody cared about which basket was better or how long it took them to make. Once the basket was finished it became part of a larger cycle, until the next fall when they would have to start all over again."[43]

TWINED BASKET HATS

Twined, fez-shaped basketry hats were the usual headgear for mid-Columbia region women when Lewis and Clark first explored the area. The hats were worn during ritual ceremonies, especially in winter when basket making was at its peak. Made from a variety of vegetable fibers (hemp, cattail, bear grass, cornhusk), they date to around the eighteenth century. The wrapped and twined basketry technique used for hats is closely related to that of Wasco-Wishram twined cylindrical baskets (721). However, the hats must be twined very tightly in order to retain their distinctive truncated cone shape. Colors were initially made from vegetable dyes and selected for contrasts that gave vitality to the preferred zigzag patterns.

Since the mid–nineteenth century, Plateau women have continued wearing and making basket hats to maintain their heritage and as quiet acts of defiance in an increasingly westernized world. Today, the hats, kept safely by families for many generations, are prized heirlooms, proudly displayed at the sacred spring Root Feast as well as at secular powwows. Bernice Tohet Mitchell of Warm Springs Reservation continues to wear a basket hat that had originally belonged to her great-great-grandmother. She calls it "my hat of wisdom."

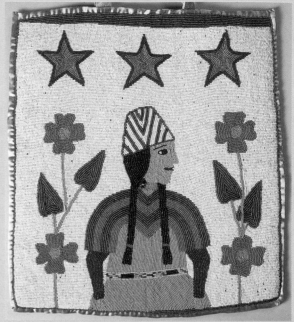

744

743 *Traditional basket hats of the Plateau were worn only by women recognized for exemplary personal qualities. Both, Warm Springs. 1800s.* LEFT: *Beaded hat based on the basket-hat form.* RIGHT: *Woven cornhusk basket hat with an attached eagle plume, which provides spiritual protection to the cap's wearer. Height, 7½". The Museum at Warm Springs, 85.14.1, 88.03.1*

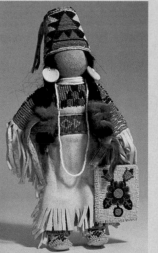

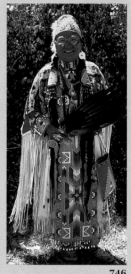

745 746

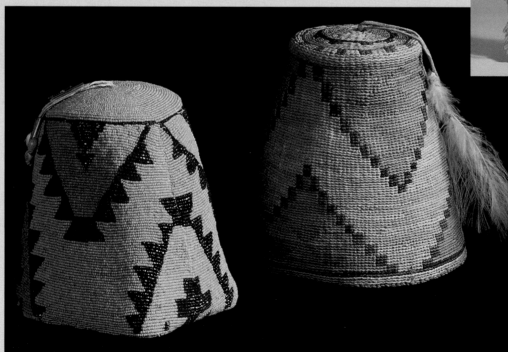

744 *A beaded bag displays a woman with a beaded basket hat. Annie Jim (Yakama). c. early 1900s. Length, 14" (35.6 cm). The Museum at Warm Springs, 83.14.2*

745 *A contemporary Nez Percé doll wears tribal regalia, including a beaded basket hat. Laine Thom (Shoshone/Goshiute-Pauite). 1993. Height, 10¼" (26.0 cm). Collection Tanja Dorsey*

746 *Esther George (Yakama) wears an heirloom twined basket hat and a beaded outfit made by her parents, Delores and Leander George. Photographed August 1994 at the Shoshone-Bannock Festival, Fort Hall, Idaho*

With increased Euro-American settlement, many root-digging grounds were lost and the use of large storage bags declined. Therefore, many women applied their weaving skills to the making of smaller personal items such as woven handbags.[44] The introduction of glass beads and trade cloth provided artisans additional opportunities for artistic expression, yet they never abandoned their weaving heritage.

Beadwork

The distinctiveness of Plateau beadwork may reflect a combination of several factors common to all the region's groups: the importance of plant life, a cultural emphasis on individuality, a prolific use of adornment, and a strong basketry heritage. The process of starting from and weaving around a central reference point was not only necessary in basket making, but it was also consistent with the idea of everything growing out of roots—the food of life. This concept is restated in contour beadwork, where designs and backgrounds radiate from a central, sacred image. Basket hats are frequently ornamented with an eagle feather that protects the wearer and is attached to a thong that forms the starting point of the weaving.[45]

Creating a basket was a way of paying tribute to the root that grew the plant that supplied the bark; the contour beadwork surrounding a bag's design paid tribute to the depicted object—often a plant. John M. Gogol, a scholar of Plateau basketry and beadwork, amplifies: "The roots of flowering plants were one of the mainstays of life on the Plateau. . . . Sacred foods to which songs were sung before gathering and preparation, and the flowering manifestations of the blue camas and pink bitterroot, were a magical guide to the world beneath the ground that produced food that was both staple and sacrament. Thus it is not surprising that the contour bag—initially a foreign art form, derived from the floral patterns of eastern Indian beadwork—flourished, transformed into a dynamic and colorful celebration of the spiritual life of native plants."[46]

Early Plateau glass beadwork—dating to about the 1830s—was embroidered with predominantly black and white "pony" beads, 3 to 4 millimeters in diameter, sewn onto a hide backing. Designs were simple, and bold geometric patterns initially reproduced motifs created within the horizontal/vertical structure of basket-weaving techniques. However, as Plateau women turned from basketry to beading, they found other ways to channel their weaving tradition into beadwork.

A small but significant genre of loom-woven Plateau beadwork was made by the Wasco-Wishram women. It is found on octopus bags (720), panel bags, and small pouches beginning in the 1840s—a decade that coincides with the initial period when Plateau people began creating floral designs.[47] At the same time, a new and unique embroidery technique involved stitching around central motifs, rather than back and forth in straight lines, producing an organic, contoured background. This "contour beading" had the effect of highlighting a central, frequently sacred image. The sun, the flower (which announces the life-giving root), and the hand are all central figures from which energy was thought to radiate outward (747, 748, 751). Additionally, the earliest Plateau floral beadwork, dating from the 1850s to the 1870s, was frequently composed of symmetrical designs based on the double-curve motif. The overall layouts typically feature a three-part division, both horizontally and vertically, of the floral design element. Three leaves or flowers are combined with a floral motif at the top or as a central element.[48] (See 240.39 and 240.43.) Floral patterns—as well as complex landscape pictorials—became more naturalistic and asymmetrical toward the late 1800s. It is understandable that, as the Plateau people were moved onto reservations and their sacred imagery and traditions came under European influences, spiritual symmetries and contour beading were discontinued.[49]

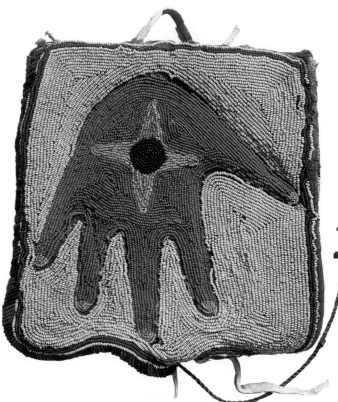

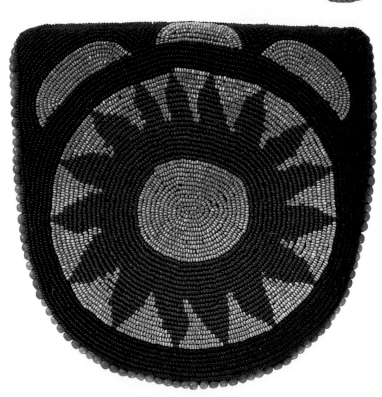

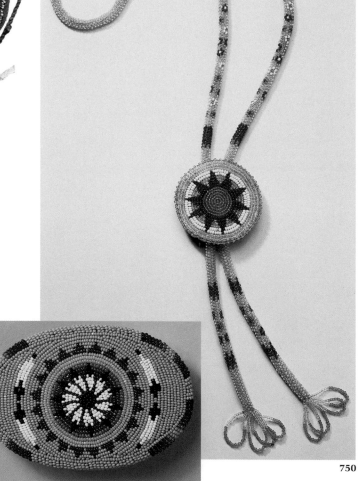

◁ 747 *An important person, perhaps a medicine man or chief, owned this beaded bag. The spiritual symbolism of the hand and Morning Star are emphasized by the radiating and contour beadwork. Dating to the 1850s, the bag is attributed to Allicot, the family name of Nez Percé Chief Joseph's brother, also a leader. It was given to Ellen Squiemphen by Ta-mana-shut's wife. Ta-mana-shut (Dan Howard) was the door bellman of the Simnasho district's longhouse in the 1920s and 1930s. Deerskin, beads, sinew. Length, 7½" (19.1 cm). The Museum at Warm Springs, 88.5.1*

750

748 *A beaded pouch with a sun motif spiraling out from the center visually evokes basketry construction, which is woven from the bottom upward. Sun motifs, common in the region's rock art, symbolized vision quests. Many of the earliest Plateau beaded bags are rounded at the bottom. Nez Percé. Probably mid-nineteenth century. Length, 6½" (16.5 cm). American Museum of Natural History, 50/3742*

749 *Beaded belt buckle with a "feathered-sun" motif (see page 245). Maxine Switzler (Warm Springs), 1993. Length, 4" (10.2 cm). Collection Rebecca Hendrickson*

750 *A contemporary beaded medallion echoes the sun motif of 748. Caroline Tohet (Warm Springs). 1993. Diameter, 2⅛" (5.4 cm). Private collection*

Characteristic Plateau floral beadwork features parallel rows of beads that outlined floral elements and filled the inner spaces in contoured rows. Originally, only the design element was beaded on a background of red or blue trade cloth. Beaded backgrounds eventually transformed from contoured to horizontal rows (754).

By the end of the nineteenth century, a more elaborate Plateau beadwork style—called Transmontane, because since it was produced by women on both sides of the Rocky Mountains (notably the Crow and Nez Percé)—was characterized by asymmetry, a combination of animal and floral images, and atypical color combinations. As historian Kate Duncan has noted, Plateau beaders were quite aware of the "visual impact of color" and worked with a "subtle, ambiguous interplay between the background and foreground, using colors of predominantly the same value," including pink with orange, or aqua with green.[50] (See 747, 752.) However, Charlotte Shike (Warm Springs) relates that while Plateau women "had their own colors they created themselves, our area was usually the last stop on the traders' route, and the people had to work with whatever items were available."[51] This undoubtedly accounts for some of the unusual color combinations in the region's beadwork.

The Plateau beader's tendency to create individual designs corresponds to basket-making traditions. Armenia Miles (Cayuse-Palous) who learned beadworking from her great-grandmother (who stressed individuality), told Kate Duncan in 1991 that people were not encouraged to copy old designs because "it's a meaning for them, the person who made it."[52]

The large quantity of Plateau beaded bags emphasizes their importance as "personal, family and prestige items." By the 1880s—the reservation period—they were used in the same manner as cornhusk bags: for gifts, in trade, and to be carried on special occasions rather than as items made for sale to non-Natives.[53] The cornhusk bag's transition from large utilitarian object to smaller, more decorated handbag was also a locus through time and space. Large-scale beaded bags—with differing designs on the front and back sides—mirror the size of earlier cornhusk bags. Today, both are considered prestige items.

Painted rawhide parfleche bags were decorated with geometric images similar to those of twined bags and beadwork designs. It is not known whether the painting style developed before, after, or with the twined and beaded designs, or whether it began with the Plateau or Plains people. There was much borrowing and exchange between the Nez Percé and Crow, Flathead, and Blackfeet. In particular, the close friendship of the Nez Percé and Crow allowed them to influence each other. "Sharing was the natural thing to do," relates historian Barbara Loeb. It is also possible that, in the 1850s, Plateau women began exploring floral designs before their Plains neighbors did.[54] (See 751.) The background on a Blackfoot bag (240.34) dated about 1880 may have been influenced by Plateau contour-beading concepts.

CONTEMPORARY EXPRESSIONS

Many elements of the Plateau people's cultural heritage have been retained, despite hardships. By the late 1800s, all Plateau tribes had been removed to reservations. From the 1880s through the 1920s, the young people were sent to boarding schools where traditional languages, hairstyles, and clothing were forbidden. Nonetheless, the women continued to produce beautiful basketry, beadwork, and clothing, conserving significant elements of their culture.[55]

Despite the government's suppression of shamanism and other Native religions, ceremonies such as the Prophet Dance (characterized by a prophet or dreamer who received sacred knowledge during a temporary death or vision experience) instructed

the people to live righteously and to follow the spiritual teachings and traditions of their people. Traditional religions are still actively practiced throughout the region, stimulating the production of ritual regalia.[56]

On the Plateau today, extended family relations continue to give the children varied role models and sources of support. Elders share traditional skills. "The traditional art of hide tanning is very labor intensive," says Ann McCormack (Nez Percé). "It allows time to realign your rhythmic patterns with Mother Earth and Father Sky, working with what nature gives you, as you reflect on your ancestors and wonder how they achieved balance in their lives. . . . Especially today, it is considered a great compliment within the Native community to be considered a master artist of a traditional art form."[57] Joanne Bigcrane (Pend Oreille) a quill- and beadwork artist, told Ann McCormack in 1992: "Following traditional aesthetics means you have to strive not for perfection, but you have to strive for quality. You have to strive in a sense not for personal worthiness, but for an honoring statement to the Creator for what He has given you—to give respect to everything he has provided."[58]

Fiber weaving and beadwork in tandem remain important creative activities: Maynard White Owl-Lavadour, a Cayuse–Nez Percé bead artisan, also weaves caps, bags, and baskets. As in the past, a family in its finest attire displays beautifully crafted beadwork incorporating geometric, floral, and pictorial motifs. Dress clothing, moccasins, bags, and particularly basket hats and beaded caps are important for dress occasions. White buckskin dresses are decorated by the NLaka'pamux with beadwork, silk embroidery, and quillwork. All are worn at powwows and ceremonials. Little of the spectacular Plateau beadwork is made for sale. Most of these costly, prized possessions are crafted for personal use or as gifts for close relatives.

Efficient tribal management of reservation lands has begun to provide a solid economic base for several Plateau groups. Consequently, the arts have gained financial support. The Museum at Warm Springs, opened in 1993 on the Warm Springs Reservation in central Oregon, is among the finest tribal museums in North America. The museum is chartered to "preserve and perpetuate the heritage and culture of the Confederated Tribes and the Tribes—the Wasco, Paiute, and Warm Springs—that comprise it." Prior to the museum's opening, an accession committee, consisting of enrolled members of the Confederated Tribes, searched throughout the region and purchased numerous heirlooms that were rapidly disappearing. These now form the "heart and soul" of the permanent collection. Each carries life-history documentation. Many of these works, now on public view for the first time, were protected for generations by their tribal families.[59]

It has not been easy for families to part with their treasures. Charlotte Shike relates: "Some pieces were from my husband's grandmother dating to the 1880s or 1870s. My mother-in-law also used to do beadwork. She told us about some stuff she made, and gave us the background for a lot of them. I always admired their style of beadwork. . . . We felt the museum would be a safer place than our home for keepsakes. It makes me sad when I see our beaded bag—and a dress that was given to me by my mother-in-law—in a showcase. We would have liked to keep them, but they're protected here and everyone can enjoy them."[60]

Michael Hammond, executive director of the museum, says: "The spirit of The Museum at Warm Springs comes from the founding belief in the oneness of everything. We have no dates on our labels in our permanent exhibit. There is no difference in the minds of tribal members between artifacts that were made one hundred years ago versus those that were made yesterday. Life and peoples' material culture are timeless. It is this timelessness that we try to convey to the visitors. We want them to understand that traditions are not a concept of the past but are alive and well today—a continuum."[61]

751 *Flowers growing from the center of this beaded bag possibly combine sun and root symbolism. Projecting rays of the sun end in flowers, leaves, and berries organized in multiples of four. The radiating background pattern may be a genesis for contour-style beading. The beadwork is on flour-sack material. Made 1850s–70s by Mumahtsut (Warm Springs), great-grandmother of the last owner, Phyllis Miller. Buffalo hide backing. Length, 13" (33.0 cm). The Museum at Warm Springs, 6.18.82*

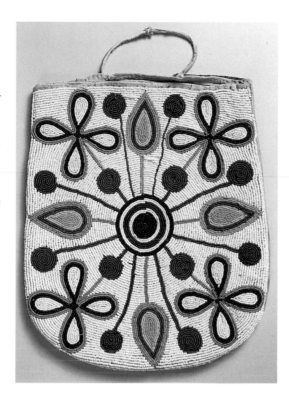

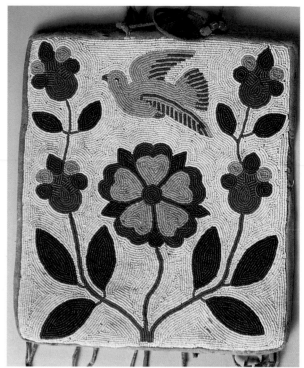

752 *Depicting flowers and a bird, this bag with contour-beaded background perhaps pays tribute to the spirits above and below. Contemporary Yakama beadworker Jeanette Smartlowit gives another reason for incorporating flowers, birds, and other "living things" on her bags. "They talk to me when I sew." Warm Springs. Late 1800s. Length, including fringe, 16" (40.6 cm). The Museum at Warm Springs, 74.34.2*

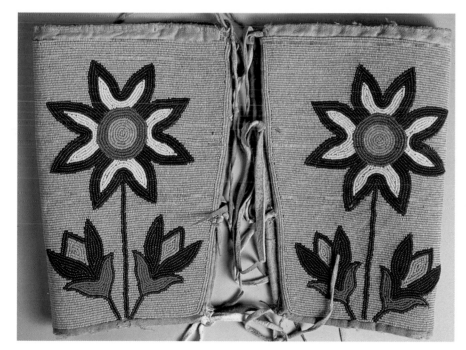

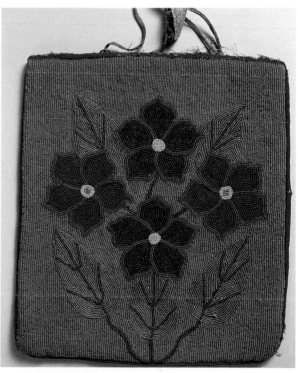

753 *Each beaded flower within these leggings displays a sunlike center and two buds. The Museum at Warm Springs*

754 *Beaded bag with four flowers, five green leaves. c. 1930s. Length, 14½" (36.8 cm). The Museum at Warm Springs, 79.4.6*

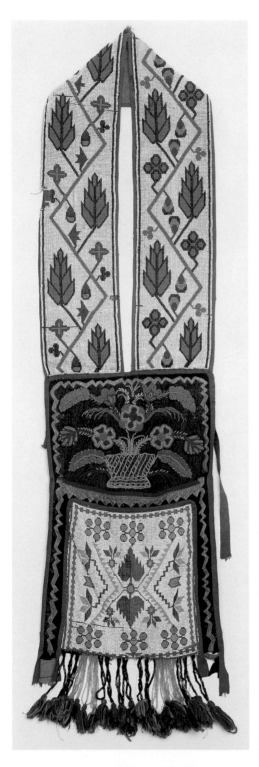

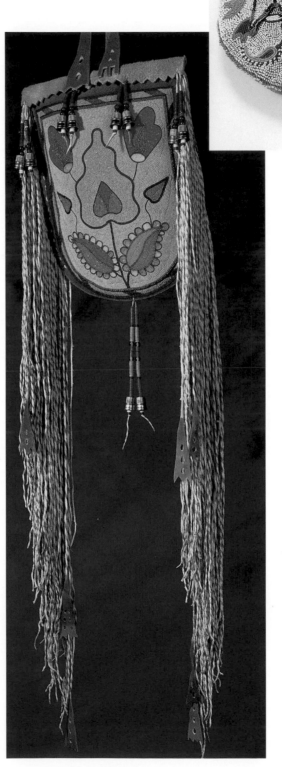

755 *A beaded Winnebago pouch given to Chief Joseph, the Nez Percé leader, in 1900 by a Winnebago friend at a "giveaway." Exchanging or giving personal garments symbolized close friendship between individuals or, in a formal situation such as the meeting of different group leaders, peaceful intent. It was also a means by which designs traveled intertribally. National Museum of the American Indian, 0/8922*

757 *White glass beads, sewn individually onto deer-hide moccasins, create a nondirectional, weavelike textured background on Nez Percé moccasins. In general, earlier beaded flowers are more symmetrical and abstract than later ones. Nineteenth century. Length, 9¾" (24.8 cm). National Museum of the American Indian, 21/944*

756 *Traditional-style beaded bag made by Maynard White Owl-Lavadour (Cayuse–Nez Percé). Born and raised on the Umatilla reservation, Lavadour was trained in traditional Plateau arts by his grandmother, Eva Lavadour, and great-grandmother, Susie Williams. Both stressed craftsmanship as much as aesthetics. Raised hearing tribal stories and understanding tribal symbols and colors, he incorporates them into his work. 1995. Moose hide, glass beads. Length, 14" (35.6 cm). Collection Tamastslikt Cultural Institute, Umatilla Indian Reservation, Pendleton*

Leander George (Yakama, 1938–1995) found images in nature, in history, and, at times, in prayer. His customized bead and quillwork displays his personal style of innovative stitchery. Beading in the George family was a reason for intergenerational pride. Mr. George explained: "I learned from my wife, and she learned from her mother. Now our older daughter is making jingle dresses. And she did a full beaded outfit for her son. I made the feather bustles for him. He's a good dancer, and in the powwow, he's outstanding. My younger daughter [see 746] is completing a full beaded dress. She's done the outline. Her work is nice and smooth and even. It's beautiful."

The quality of evenness that beadworkers prize isn't easily accomplished. "We've learned that the beads aren't uniform, some are larger or wider. . . . So I put eight beads per row here when I started the design, but I used only seven to complete that longest line. You really have to count in order to compensate."

The Georges purchased the Wapinish Trading Post in 1988. "It was our dream to be involved in a craft supply store, to buy, sell, and to create our own Indian art." At the trading post, there is an exchange in beading techniques as well as in beaded objects. "People come in and ask, 'How do you do this?' Then they turn around and say, 'This is how I do it.' You may incorporate their ideas into your work, and the thing about making things is production becomes faster with different techniques. For example, I've incorporated into the basic lazy stitch the Cheyenne lazy stitch, where you sew one end down, and the other end you pick up. You're putting two lines on, stitching twice rather than four times."

758 *This beaded vest (above), created for actor Steven Seagal, incorporates motifs envisioned in a Medicine Ceremony conducted by Mr. George's mother-in-law. "Seagal is a veteran, so she saw him as a warrior on a palomino horse. I added a coup stick with seven feathers. I'm not saying he earned them in his lifetime. My application of the seven feathers—for the days of the week—was because of cultural tradition. We look at the past—at our history, our ancestry—and try to bring it back into our work. The rest was from the vision: the colors, the horse, the rider. Mr. Seagal also requested a grizzly bear. On the back is the head of an eagle with the feathers fluffed out." The inside lining (below) is printed cotton. Mr. George collaborated on the work with his wife, Delores, who provided background and borders for his pictorials. Completed in 1994, the vest was Mr. George's last major work. Bear height, 8" (20.3 cm). Collection Steven Seagal*

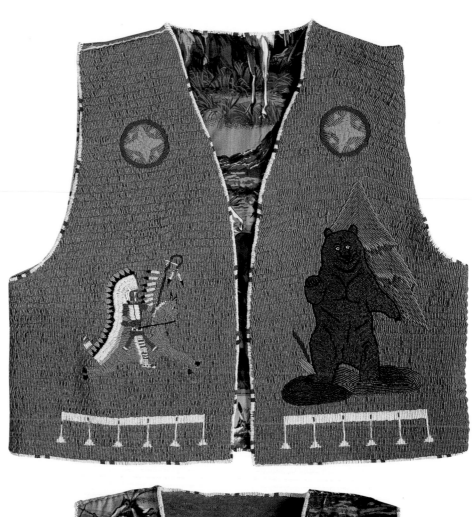

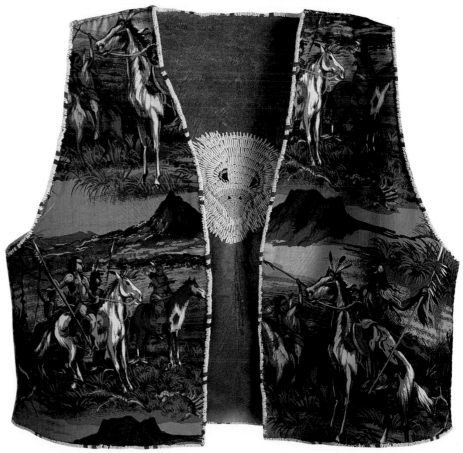

WARM SPRINGS: A LIVING TRADITION OF BEADWORK

Emily Waheneka is deeply respected within her own community. Known for outstanding artistry and craftsmanship, she received the state's Women's Caucus for Art award in 1993 for "excelling in . . . personal, original beadwork designs that embody your Warm Springs people's legacy."

Mrs. Waheneka is the daughter of Annie Anderson Tewee, an expert beader. "I learned from my mother when I was about six years old, though I've not done beadwork every day of my lifetime. I quit doing it for ten or twelve years. Then when I had nothing to do, I picked it up again." Wishing to keep beadwork as her area of personal freedom, Mrs. Waheneka does "whatever comes to my mind. If I want to do beadwork with animal designs, I do that. If I have too many people come and ask me to do things like that, it just takes all the ambition out of it. It's like an artist that's painting: I'm my own boss."

Beaded faces are Emily Waheneka's speciality. "She is," says close friend and fellow beadworker Maxine Switzler, "nationally known for her faces." Called "the Michelangelo of Warm Springs" by another beader, Mrs. Waheneka works meticulously by centering the design and drawing a line through the eyes. "Then, I use my judgment on the nose, lips, and chin. I study faces and features, whether I look in the magazines or I look at a person." In painterly fashion, she shades her faces and contours the hair with beads. All her beaded medallions wear their own "jewelry of shell, bone, feathers, and beads. And I fill in every little space, I don't leave a gap in any of them. To make the work flat and even, we wind our thread on our little finger, and our little finger is trained to release that tension on the thread. My beadwork is done on the highest quality canvas and backed with buckskin."

In 1994, at seventy-five years of age, Mrs. Waheneka was still working with size 16 and 18 glass seed beads and would have used 20s and 22s but couldn't find any needles. From the Walla Walla band, she has family "every which way," including Umatilla, Kutenai, Palous, and Wanapam.

Maxine Switzler learned beading during the 1930s at the age of four or five. "My mother got tired of me asking if I could bead, so she threw me some odds and ends, and cut out a little bag four by four, and drew simple flowers on it, and told me to fix that bag and quit bothering her. She beaded not only for herself, but for other people to make a living for us. When I finished the bag, my aunt wanted it. So she brought me a little bit bigger bag and traded me for it. . . . Then I didn't do anything until I was about

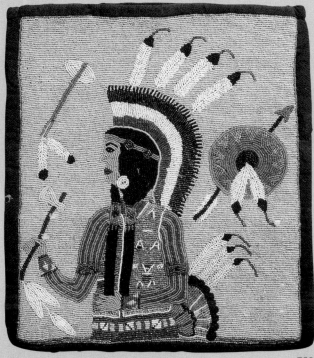

759

eleven, when my mother taught me how to loom. After high school, we had a Hiawatha Pageant, and I needed horse trappings. Mother gave me the material to work with and showed me how to do it, but I never finished. Then I continued to go to school and did more tailoring with the sewing machine. Somebody came and asked if I could make them an outfit. So for maybe six or seven years, I made horse trappings and dance regalia. I like to work with fashion; I try to use whatever color comes into fashion, so that people can wear our work comfortably. My designs have always been . . . more modern than traditional."

Mrs. Switzler was honored by the tribes in 1990 for sharing her Native American culture with the staff and students of Timber Lake Job Corps. Her main goal, however, is to help create a financial base with tribal artisans, particularly the disabled.

And, she adds, "Before I get too old, I want to make dance outfits for all my grandchildren."

Maxine Switzler discusses her emphasis on quality: "It's like wearing a gold medal. You can look across the room and recognize your work, and you're proud that lady wore it to that particular banquet. Or that man wore your bolo to Washington, D.C. It's pride. You're proud that somebody else will display your work for you."

759 *A beaded bag illustrating a dancer wearing beaded regalia: vest, cuffs, belt, hair ties, headband, earrings, and a roach. He carries a tomahawk with feather amulets. A stone club and warrior's shield with eagle feathers and an arrow appear in the background, evoking the past. In early Plateau pictographs, weapons are shown floating above warriors' heads, signaling their importance. Yakama or Warm Springs. 1915. Length, 14" (35.6 cm). The Museum at Warm Springs, 82.49.1*

760 *This fully beaded dance cape was made for Miss Warm Springs 1990, Trude Clemins. Emily Waheneka beaded the eagle; Ms. Clemins's mother and sisters completed the background. Width, 16" (40.6 cm). Private collection*

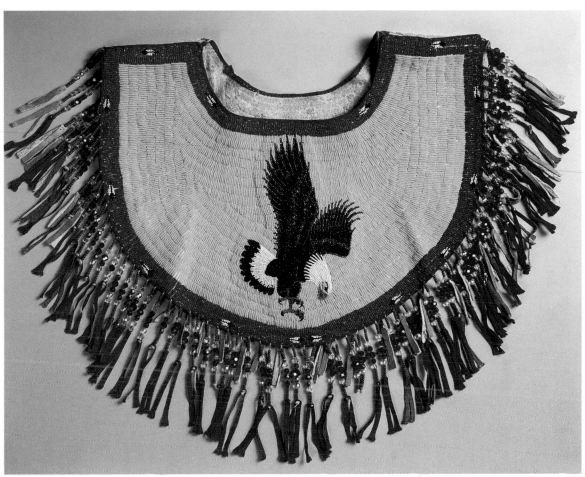

760

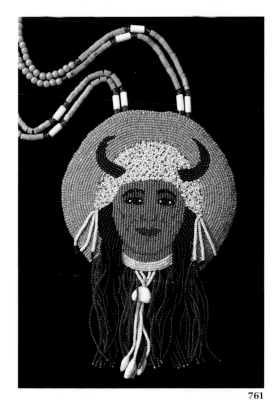

761

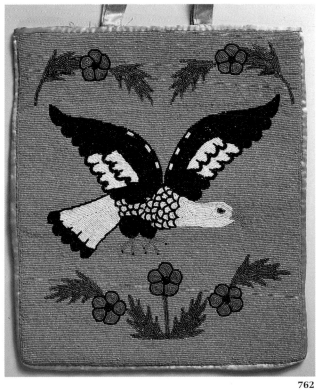

762

761 *Beaded medallion featuring a medicine man with a white buffalo cap, ermine earrings, and a shell necklace. Emily Waheneka. Late 1970s. Diameter, 4¼" (10.8 cm). Collection Grant Waheneka*

762 *A beaded bag by Annie Anderson Tewee, mother of Emily Waheneka. c. 1915. Length, 12¼" (31.1 cm). The Museum at Warm Springs, 87.9.1*

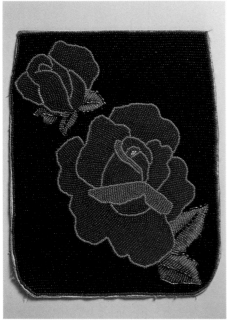

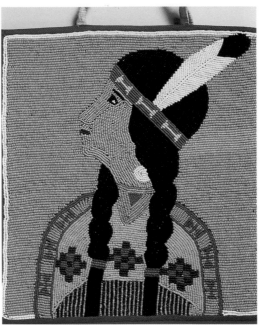

763

764

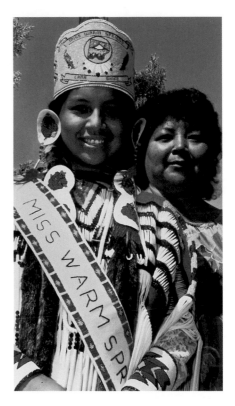

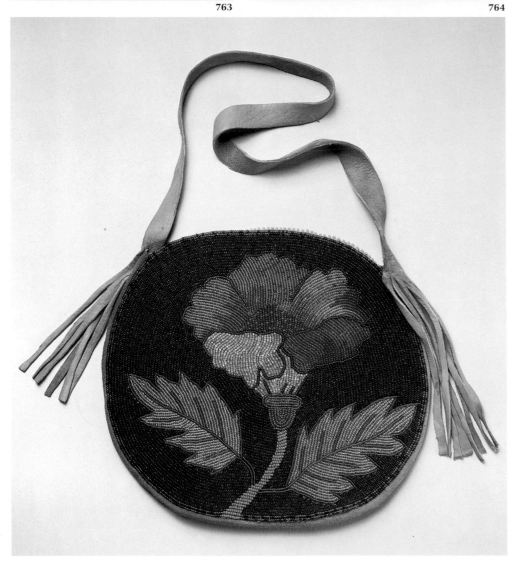

763 *Beaded bag made by Maxine Switzler for her son when he was six years old. Length, 9¼" (23.5 cm). Switzler Collection*

764 *Beaded bag showing a maiden with a single feather (indicating she is unmarried) in her headband. Warm Springs. c. 1930. Length, 12½" (31.8 cm). The Museum at Warm Springs, 94.12*

765 *Miss Warm Springs 1986, Lana Shike Leonard, shown with her mother, Charlotte Shike. Lana wears her great-great-grandmother's bead and dentalium-shell dress. Mrs. Shike meticulously maintains the dress, tacking down every dentalium shell. The crown is by Rosie Tom. The cuffs are by Edna Winishut, the mother of Maxine Switzler.*

◁ **766** *A beaded poppy on a hide bag made in the 1970s by Mrs. Aleck (Yakama) of Colville Reservation. Diameter, 10" (25.4 cm). Private collection*

767 *Four generations of a Warm Springs* ▷ *family's beadwork: dress (rear) by Sally Paul Suppah (great-grandmother); beaded child's dress by Myrtle Yahpin Frank (grandmother); beaded bag by Margaret Frank Suppah (mother); beaded cuffs and belt by Wanda Suppah Van Pelt (daughter). Late 1880s–1991. Family collection*

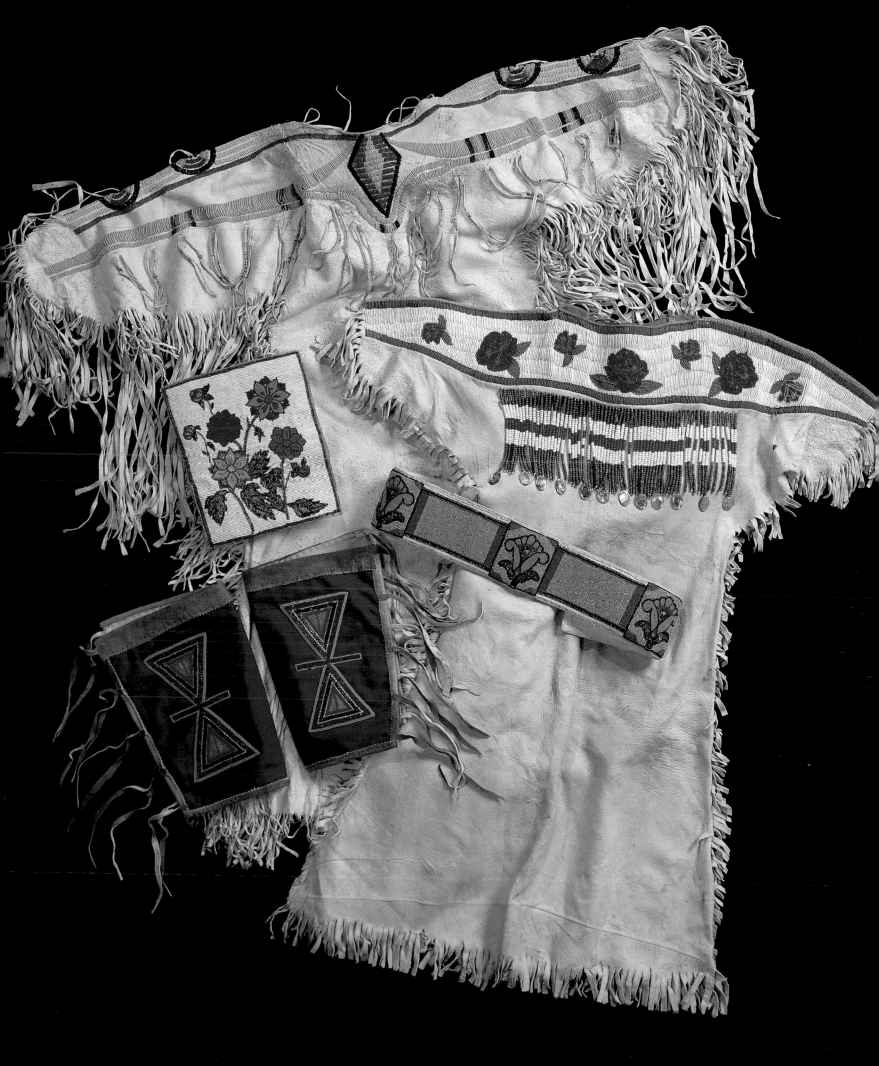

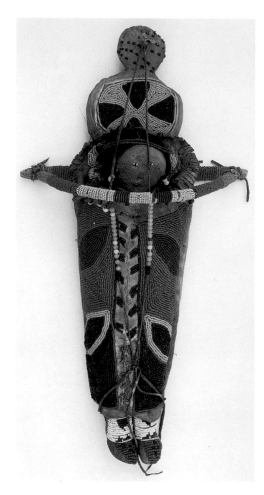

768 *Toy cradle and doll. c. 1890. Leather, beads, horsehair, cotton, thread, and canvas. Length, 16½" (41.9 cm). Buffalo Bill Historical Center, NA 507.83*

769 *Traditional-style baby carrier made by Maynard White Owl-Lavadour (Cayuse–Nez Percé). Cradleboards are still used by Plateau groups. The infant is securely laced into the pouch, and the hood offers protection from the sun and rain. This cradleboard has floral beaded motifs (as do most Nez Percé cradles), but the two-toned geometric border pattern is a holdover from the earlier geometric style. 1994. Tanned deerskin, moosehide, wood, elk teeth, wool, glass beads. Length, 40" (101.6 cm). Collection Tamastslikt Cultural Institute, Umatilla Indian Reservation, Pendleton*

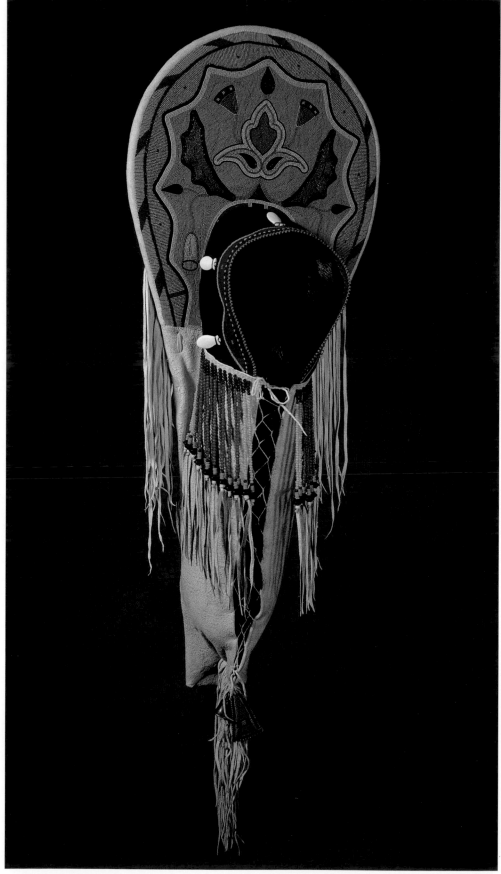

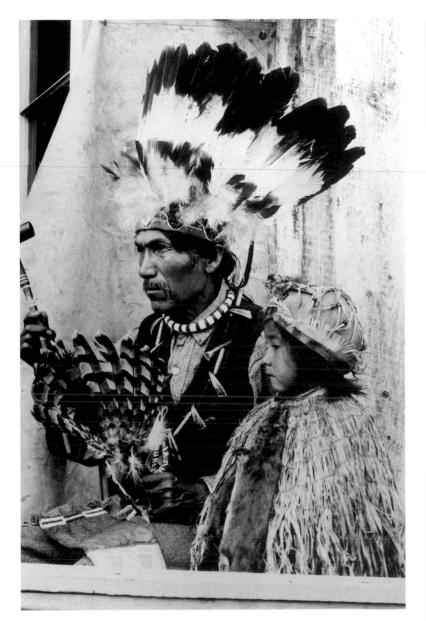

771 *Techniques for expanding twined-weave fabric, such as the cedar cape seen in 770, with the addition of warp threads (after Dorothy K. Burnham): 1. Twined weave. 2. Twined weave with one added warp. 3. Twined weave with two added warps*

770 *John XwistEmnitsa displays a chief's beaded eagle bonnet, a choker-length glass-bead necklace, and a longer necklace wrapped with bark, horsehair, horses' teeth, and weasel-skin pendants encircled with beads. He holds a fan of hawk-tail and magpie feathers. LexomtinEk, the young NLaka'pamux girl, wears a decorated buckskin cap and woven willow or cedar bark cape. Photographed 1913. Canadian Museum of Civilization*

772 *NLaka'pamux elder Nathan Spinks, left,* ▷ *conducts a cedar bark workshop organized by Wally Henry, right. Although woven-bark clothing is no longer worn, traditional fiber weaving and its technology continues to be taught by tribal elders. Lytton, British Columbia. 1993*

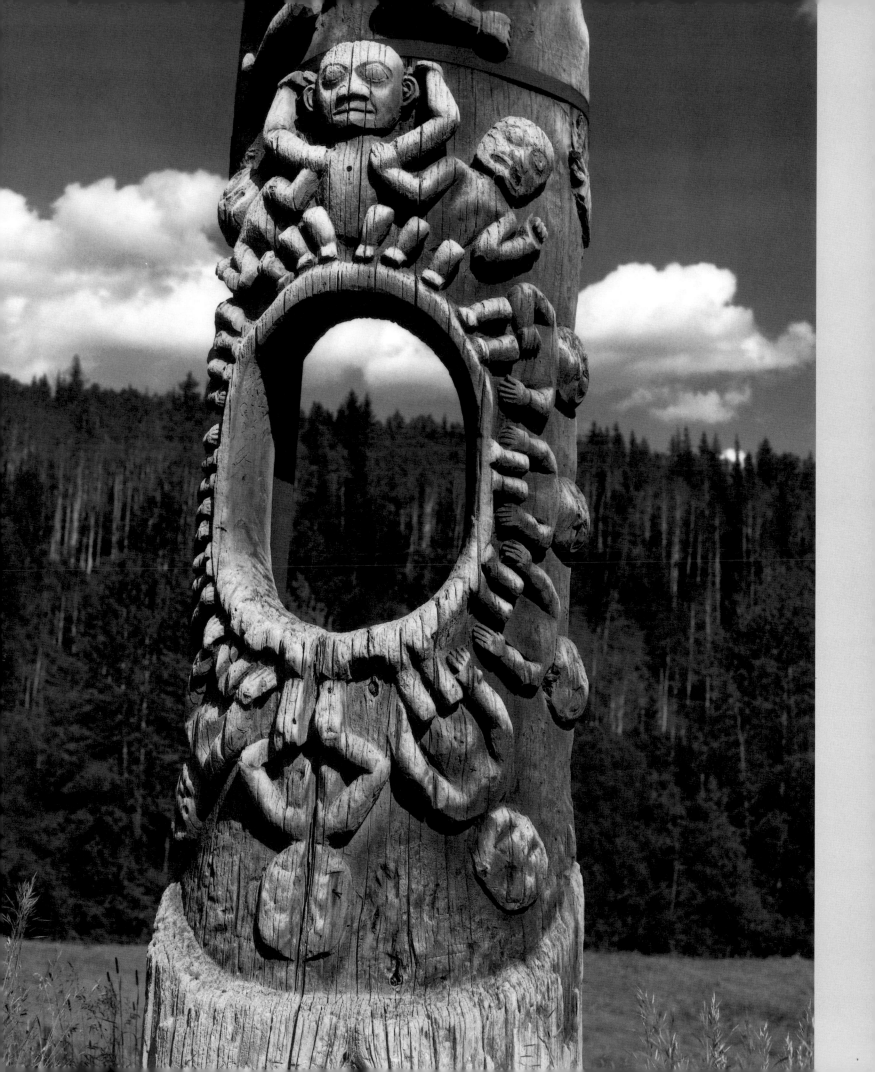

CARVERS AND JEWELERS
THE NORTHWEST COAST

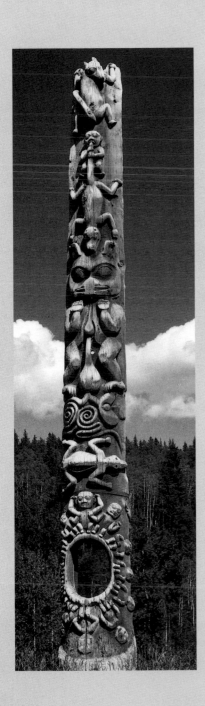

"For me, a Northwest Coast artist is someone who has mastered the two-dimensional and three-dimensional design field in any size and any medium. The only difference I notice in going from one material to another is the compression of time."

—Don Yeomans (Haida–Cree-Métis), 1994[1]

773 *Cut-through-to-the-Sky (Wil'naq'oq Laxa) crest pole, at Kitwancool, a Gitksan settlement in British Columbia. Raised more than a century ago by Haydzemaxs, this curved-cedar crest, or totem pole, was a visual record of the owner's heritage. Placed in front of the house and covered with interlocking images of supernatural clan ancestors (wolf and bear), it proclaimed the antiquity of the family's lineage.*

Crest poles sometimes contained a hole (see detail, opposite) that served as a ceremonial passageway to and from the house. This opening replicated the cosmic hole through which the ancestors came into This World or the ancestral shaman traveled to Sky World to obtain knowledge. The twelve figures surrounding the hole may be guardian spirits.

As part of an ancient North Pacific tradition honoring the deceased, totem poles were originally simple, unadorned wooden structures symbolizing a cosmic axis or cosmic tree, thus also associated with shamanism. By the time of European contact, the elaborately carved poles represented social status and had already lost most of their spiritual meaning. Only in its symbolic form did the pole continue to mirror the sacred.

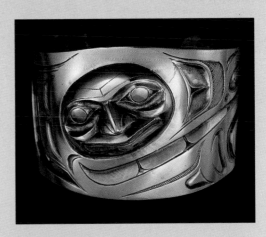

774 Raven Transforming. *"I find that working on a totem pole sometimes gives me insight for laying out a face on a bracelet," says carver Don Yeomans (Haida–Cree-Métis). "A lot of knowledge is transferred." Silver bracelet. 1992. Height, 1⅟₁₆" (4.2 cm). Collection Trace Yeomans*

Transformation is a pervasive theme in every aspect of Northwest Coast life and art. Shamans move between the secular and supernatural realms; a mask opens during a ceremony to reveal a face within. Upon a totem pole, one carved figure emerges from the mouth of another. Individuals transform to a new state and then return to their original form—"everything was possible, when whale was now himself, now beaver, now canoe, now whale once more, when human beings and their animal counterparts easily assumed each other's form simply by taking off or putting on each other's skin."[2] Northwest Coast art, design, and adornment acknowledge that all is connected and life is a process or cycle—the ultimate expression being life, death, and rebirth itself.

A shaman amulet depicts two beings occupying a single space simultaneously, sharing various parts and transforming into each other (789). In other examples, a single figure such as a bear or beaver is shown with its body split, the parts laid out flat against the surface of a hat or box. Frontal and back views, both sides, and the inside are seen at once.

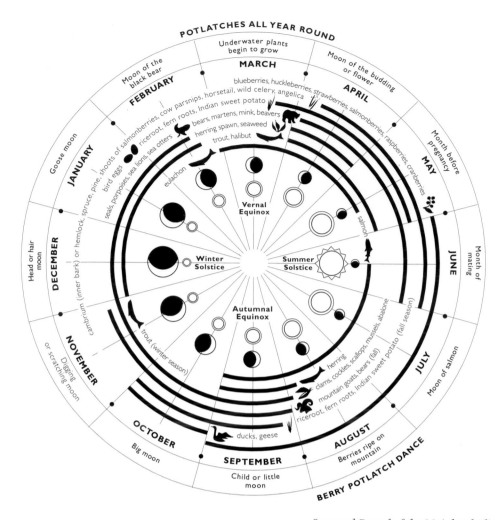

Seasonal Round of the Mainland Tlingit

Mirroring the shaman's ability to straddle both the supernatural and natural worlds, Northwest Coast carvers shift between two- and three-dimensional work, often combining both. A pair of Haida dance leggings of skin displays a painted whale design in which the whale's tail forms a flap over the dancer's foot and has an attached wooden dorsal fin.[3] Carvers are adept at straddling a range of mediums: from the immensity of the totem pole to the intensity of a bracelet. Since everything was part of an intricate web, the power of an image had nothing to do with size. It was as cosmically potent on the face of a ring as it was on the base of a totem. "This is what makes Northwest Coast art," wrote Haida artist Bill Reid, "this tremendous compressed power, tension, monumentality in all the good pieces, no matter what the scale."[4]

EARLY ART FORMS AND TRADITIONS

Twelve thousand years ago, retreating glaciers opened various paths of immigration to the coast. Maritime peoples and those who traveled along interior river routes settled the Northwest Coast region from approximately 10,000 B.C. to 8000 B.C.[5] Stone tools such as microblades and "choppers" (large pebbles flaked at the bottom), dating from 8000 B.C. to 3000 B.C., are relics of the first inhabitants, small family bands that moved seasonally with the salmon. As larger groups developed, techniques for preserving salmon expedited the growth of the region's social complexity. Shell middens that remain today reveal layers of history, suggesting villages with a row of communal dwellings facing the beach as early as 3,000 B.C.[6]

A Northwest Coast artistic tradition extends back at least fifty-five hundred years, with the earliest objects appearing from the southern coast. A small antler sculpture of a human with a beard and elaborate topknot hairdo—found at the Glenrose site on the Fraser River—may have served as the handle of a beaver-tooth carving tool.[7] By 1000 B.C., earspools, labrets, and bone pendants, as well as small stone carvings of abstracted animal forms that foreshadowed future developments in art, appear at the Locarno Beach site. Earspool fashion would eventually fade out, but labrets remained a mark of high distinction on the northern coast.

The Northwest Coast's most distinctive artifacts surfaced about 1500 B.C. Ancient bone and ivory combs have design elements seen in contact-era items. These relatively sophisticated objects of personal adornment were probably the product of an emerging elite stratum of society. An antler carving of a man wearing a conical hat, dated to about 1500 B.C., recalls nineteenth-century high-status basketry hats. Three-thousand-year-old basketry provides evidence that the Locarno people were superb weavers.[8]

Southern coastal caches containing thousands of stone and clamshell beads and a variety of stone and bone pendants dating from 500 B.C. to A.D. 500 imply the early existence of wealth-conscious societies, with full-time artisans supported by an upper echelon.[9] Dentalium shells, gathered from the west coast of Vancouver Island, were worn and eventually traded over a large part of western North America (page 423). Graves of northern coastal warrior-chiefs contained copper bracelets and amber beads.[10]

The animal motifs and "restrained ferocious power" of Northwest Coast art are particularly reminiscent of certain Asian styles. An animal split in half can also be seen as two animals facing each other (19). Sisiutl—the double-headed serpent that embodies much of Kwakwaka'wakw (Kwakiutl) style and thought—recalls ancient Chinese sculpture (790).[11] Coppers (shield-shaped items of prestige) have not only visual but also conceptual parallels to Chinese axes: both are emblems of authority and power (806). Ancient Arctic cultures also shared certain iconographic concepts with the Northwest Coast (15, 846).

When Russian and European explorers and traders entered the Northwest Coast area in the 1700s, vast cedar, fir, hemlock, and spruce forests stretched along the coastline from southern Alaska to northern California. Steeply sloped mountains edged the Pacific Coast, where a mosaic of islands shaped waterways (avenues of trade and travel) and offered protection from the open ocean. Traditional villages along the rugged coast occupied slivers of beach beyond the immense trees that led right down to the sea. Inland settlements were clustered along bays and salmon-stocked rivers such as the Fraser, Columbia, and Yukon. The Japanese current, flowing south, brought mild, wet temperatures, cooling the summers and warming the land in winter.

Surrounded by a generous world of water and wood, Northwest Coast peoples were able to remain in villages without relying on agriculture. The sea provided a bounty of saltwater fish, otter, fur seal, and whale; rivers were full of salmon, halibut, trout, cod, and herring. One small fish, the eulachon, was especially dense with oil. Shellfish were harvested from the teeming intertidal zone. As villages faced the sea, the people's mentality was directed more toward the water than the dark woods, though land resources, including berries and starchy roots as well as deer, elk, mountain goat, wolf, bear, and beaver, supplemented their diets.

Salmon fishing was vital to subsistence and a major influence on Northwest Coast lifestyle. Salmon runs provided a supply of food that was easily preserved. Salmon were thought to dwell as Salmon People in their own longhouses under the sea, where they removed their scaly robes and carried on an existence remarkably similar to that of humans. All groups observed some form of the First Salmon rite. As Alan McMillan

THE NORTHWEST COAST

CULTURE AREA

The approximate territories of Northwest Coast and adjacent groups in the early nineteenth century. See also the map of contemporary Native lands, page 551.

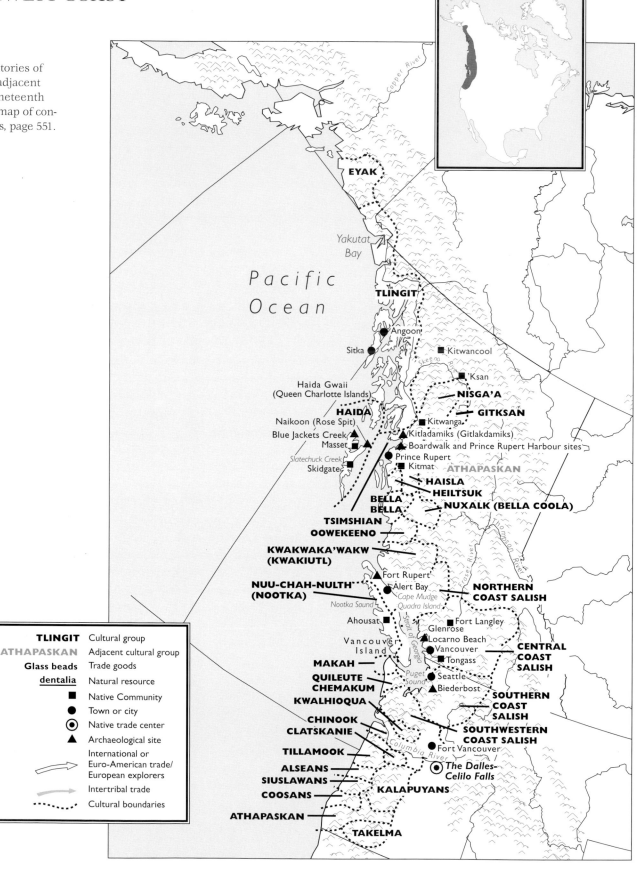

Pacific Ocean

Copper River

EYAK

Yakutat Bay

TLINGIT

Angoon

Sitka

Kitwancool

Haida Gwaii (Queen Charlotte Islands)

Skeena River

'Ksan

NISGA'A

GITKSAN

HAIDA

Naikoon (Rose Spit)
Blue Jackets Creek
Masset

Kitwanga

Kitladamiks (Gitlakdamiks)
Boardwalk and Prince Rupert Harbour sites

Slatechuck Creek
Skidgate

Prince Rupert
Kitmat

ATHAPASKAN

HAISLA

HEILTSUK

NUXALK (BELLA COOLA)

BELLA BELLA

TSIMSHIAN

OOWEKEENO

Thompson River

KWAKWAKA'WAKW (KWAKIUTL)

NUU-CHAH-NULTH (NOOTKA)

Fort Rupert
Alert Bay
Cape Mudge
Quadra Island

Nootka Sound

Fraser River

NORTHERN COAST SALISH

Ahousat

Vancouver Island

Fort Langley
Glenrose
Locarno Beach
Vancouver
Tongass

Strait of Georgia

CENTRAL COAST SALISH

MAKAH

QUILEUTE
CHEMAKUM

Puget Sound

Seattle
Biederbost

SOUTHERN COAST SALISH

KWALHIOQUA

CHINOOK
CLATSKANIE

SOUTHWESTERN COAST SALISH

TILLAMOOK

Columbia River

Fort Vancouver

ALSEANS

SIUSLAWANS

The Dalles-Celilo Falls

COOSANS

KALAPUYANS

ATHAPASKAN

TAKELMA

Legend

TLINGIT	Cultural group
ATHAPASKAN	Adjacent cultural group
Glass beads	Trade goods
<u>dentalia</u>	Natural resource
■	Native Community
●	Town or city
◉	Native trade center
▲	Archaeological site
⇨	International or Euro-American trade/ European explorers
→	Intertribal trade
·····	Cultural boundaries

PRECONTACT AND EARLY-CONTACT TRADE NETWORK

For millennia, an active seafaring trade network extended along the Pacific Coast into California and via the rivers (the "grease trails") to the interior Athapaskan peoples. During the era of the Russian and Euro-American fur trade, certain Northwest Coast groups became important and wealthy middlemen, brokering Euro-American goods within the region as well as inland to the Athapaskans. Dentalium shells, found on the western coast of Vancouver Island, reached the Plains and Prairies via intertribal trade.

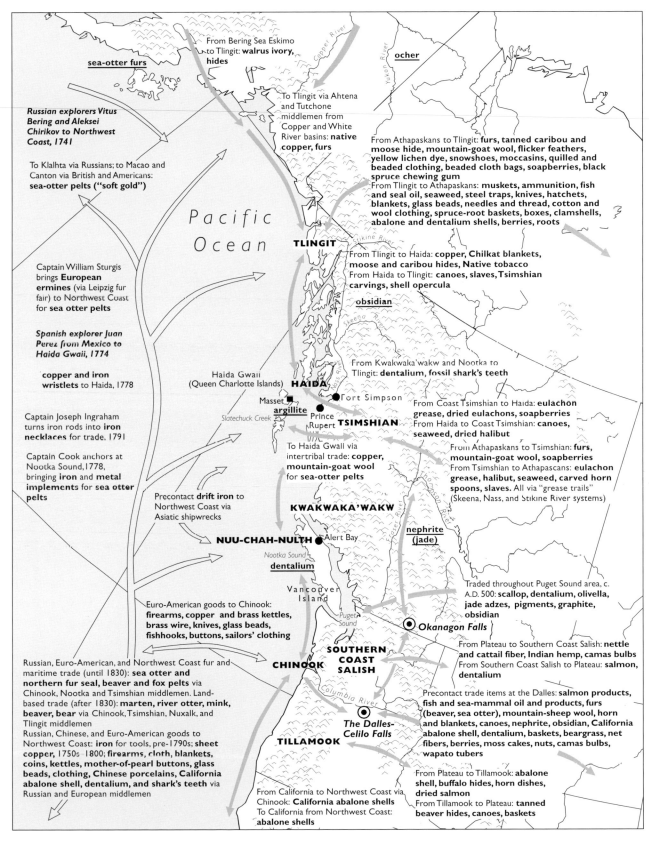

Pacific Ocean

sea-otter furs

From Bering Sea Eskimo to Tlingit: walrus ivory, hides

ocher

To Tlingit via Ahtena and Tutchone middlemen from Copper and White River basins: native copper, furs

Russian explorers Vitus Bering and Aleksei Chirikov to Northwest Coast, 1741

To Klahlta via Russians; to Macao and Canton via British and Americans: **sea-otter pelts ("soft gold")**

Captain William Sturgis brings **European ermines** (via Leipzig fur fair) to Northwest Coast for **sea otter pelts**

Spanish explorer Juan Perez from Mexico to Haida Gwaii, 1774

copper and iron wristlets to Haida, 1778

Captain Joseph Ingraham turns iron rods into **iron necklaces** for trade, 1791

Captain Cook anchors at Nootka Sound, 1778, bringing **iron** and **metal implements for sea otter pelts**

Precontact **drift iron** to Northwest Coast via Asiatic shipwrecks

Euro-American goods to Chinook: **firearms, copper and brass kettles, brass wire, knives, glass beads, fishhooks, buttons, sailors' clothing**

Russian, Euro-American, and Northwest Coast fur and maritime trade (until 1830): **sea otter and northern fur seal, beaver and fox pelts** via Chinook, Nootka and Tsimshian middlemen. Land-based trade (after 1830): **marten, river otter, mink, beaver, bear** via Chinook, Tsimshian, Nuxalk, and Tlingit middlemen
Russian, Chinese, and Euro-American goods to Northwest Coast: **iron** for tools, pre-1790s; **sheet copper, 1750s-1800; firearms, cloth, blankets, coins, kettles, mother-of-pearl buttons, glass beads, clothing, Chinese porcelains, California abalone shell, dentalium, and shark's teeth** via Russian and European middlemen

From California to Northwest Coast via Chinook: **California abalone shells**
To California from Northwest Coast: **abalone shells**

From Athapaskans to Tlingit: furs, tanned caribou and moose hide, mountain-goat wool, flicker feathers, yellow lichen dye, snowshoes, moccasins, quilled and beaded clothing, beaded cloth bags, soapberries, black spruce chewing gum
From Tlingit to Athapaskans: muskets, ammunition, fish and seal oil, seaweed, steel traps, knives, hatchets, blankets, glass beads, needles and thread, cotton and wool clothing, spruce-root baskets, boxes, clamshells, abalone and dentalium shells, berries, roots

From Tlingit to Haida: copper, Chilkat blankets, moose and caribou hides, Native tobacco
From Haida to Tlingit: canoes, slaves, Tsimshian carvings, shell opercula

obsidian

From Kwakwaka'wakw and Nootka to Tlingit: dentalium, fossil shark's teeth

From Coast Tsimshian to Haida: eulachon grease, dried eulachons, soapberries
From Haida to Coast Tsimshian: canoes, seaweed, dried halibut

From Athapaskans to Tsimshian: furs, mountain-goat wool, soapberries
From Tsimshian to Athapascans: eulachon grease, halibut, seaweed, carved horn spoons, slaves. All via "grease trails" (Skeena, Nass, and Stikine River systems)

nephrite (jade)

Traded throughout Puget Sound area, c. A.D. 500: **scallop, dentalium, olivella, jade adzes, pigments, graphite, obsidian**

From Plateau to Southern Coast Salish: nettle and cattail fiber, Indian hemp, camas bulbs
From Southern Coast Salish to Plateau: salmon, dentalium

Precontact trade items at the Dalles: **salmon products, fish and sea-mammal oil and products, furs (beaver, sea otter), mountain-sheep wool, horn and blankets, canoes, nephrite, obsidian, California abalone shell, dentalium, baskets, beargrass, net fibers, berries, moss cakes, nuts, camas bulbs, wapato tubers**

From Plateau to Tillamook: abalone shell, buffalo hides, horn dishes, dried salmon
From Tillamook to Plateau: tanned beaver hides, canoes, baskets

To Haida Gwaii via intertribal trade: **copper, mountain-goat wool for sea-otter pelts**

TLINGIT
HAIDA
Haida Gwaii (Queen Charlotte Islands)
Masset
argillite
Slatechuck Creek
Fort Simpson
Prince Rupert
TSIMSHIAN
KWAKWAKA'WAKW
NUU-CHAH-NULTH ● Alert Bay
Nootka Sound
dentalium
Vancouver Island
Puget Sound
● Okanagon Falls
SOUTHERN COAST SALISH
CHINOOK
Columbia River
● The Dalles-Celilo Falls
TILLAMOOK

Copper River
Yukon River
Stikine River
Nass River
Skeena River
Thompson River

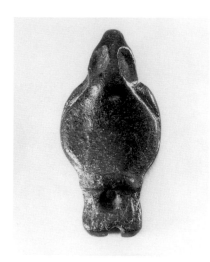

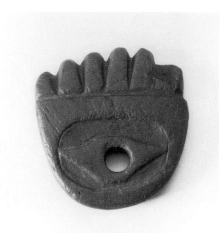

776

△ **775** *One of the earliest known raven images is this carved stone amulet. Perforated through the tail for suspension, the hollowed eye sockets may once have held abalone-shell inlays. Excavated at the Boardwalk site in British Columbia, possibly a winter village of coastal Tsimshian or Tlingit ancestors. c. 1000 B.C. Length, 2" (5.0 cm). Canadian Museum of Civilization*

776 *Stone amulet with an ovoid eye form. Kitladamiks, British Columbia. Nisga'a cultural area. n.d. Height, 1⁹⁄₁₆" (4.0 cm). Canadian Museum of Civilization*

777 *Segmented stone carving of a highly abstracted fish or animal form showing only the ribs and vertebrae. c. 500 B.C. Length, 3³⁄₁₆" (8.0 cm). Canadian Museum of Civilization*

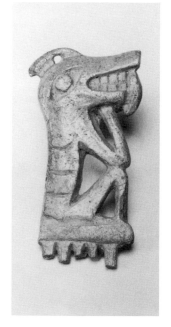

778 *Early evidence for Northwest Coast formline designs (see page 398) are seen in bone and antler combs that appeared at Prince Rupert Harbour between A.D. 500 and 1000. FAR LEFT: A comb incorporating eyes, Us, and split-U forms. LEFT: A wolf's exaggerated eye form, extended tongue, and skeletal ribs foreshadow classic Northwest Coast art. Length, 2³⁄₁₆" (5.5 cm). Canadian Museum of Civilization*

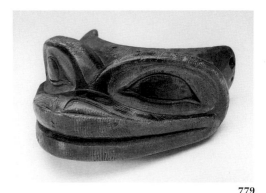

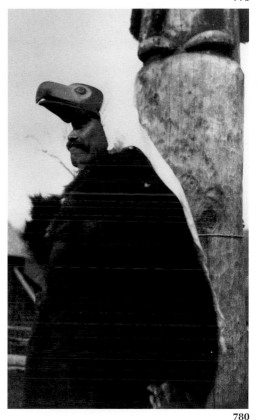

779 *Haida wooden visor with a frog motif, a prominent crest figure. Nineteenth century. Length, 9" (22.9 cm). Private collection*

780 *Laxskik (Gitksan) of Kitwanga seen with the eagle-feather headdress of Tewalasu. 1924. Canadian Museum of Civilization*

recounts: "The earliest fish of the season were ceremonially welcomed, being placed on new mats in the chief's house and sprinkled with white eagle down." After the flesh was eaten, the bones were returned to the water, the head pointing downstream. Many fishermen believed that, by allowing fish bones to float back to the sea, the fish would be reborn from their skeletal parts and the salmon would come back the next year.[12] Blessing the salmon's transformation—life, death, and rebirth—assured the people good fortune.

Amulets from 500 B.C. showing ribs and vertebrae (777) may have been highly abstracted fish forms used in First Salmon ceremonies, which remain part of the Northwest Coast culture. In 1989, Haida artist Robert Davidson hosted a First Salmon celebration in the village of Old Masset. A new mask, song, and dance created for the occasion have since traveled through many communities.

The cedar tree, as essential to life as the salmon, was the material most relied upon in the region. With a supernatural spirit referred to as Long Life Maker, cedar provided life's necessities—clothing, dwellings, seafaring canoes, and majestic totem poles. Trees, like animals, possessed souls and were living beings. Woodworking tools that cut planks from cedar without "killing" (felling) the trees were frequently ornamented with imagery to please the trees' spirits. When its cloak of bark was stripped for weaving clothes, the cedar tree was thanked in prayer.[13]

NORTHWEST COAST SOCIETY: CLANS AND CRESTS

A strict hierarchy made up the Northwest Coast social structure. While differences existed between northern and southern groups, all shared similar concepts of wealth and rank. Society was divided among three classes: nobility (chiefs), commoners, and slaves. Nobles were privileged with inherited titles, territory, and wealth. Commoners provided labor for the chief's accumulation of wealth, which was then offered as gifts in ceremony—a means of keeping status intact. Slaves lived similarly to commoners, although with fewer rights in the group; in extreme cases they were sold, traded, or even killed as expressions of power. This social system included a specialized class of artists whose principle responsibility was to create art commissioned by the nobility. Generally, women were weavers while men were carvers and painters.

The role of the shaman in Northwest Coast society reflected that of the carver, creating a balance between the sacred and secular worlds. Even the process of carving a spiritual mask was like that of a secular totem pole: the carver worked with the same half-carved, frontal form. A gifted carver was thought to have been supernaturally inspired and was honored accordingly. In the same way that shamans were chosen and initiated because they possessed the appropriate abilities, boys with artistic promise were encouraged to become carvers. They were trained in magical practices and placed under the strict observation of an expert craftsman. An advanced apprentice of carving, known as an *other-side man,* would copy on one side of a totem pole what the master carver did on the other.[14]

A tribal structure was superimposed upon the social structure. Clans were made up of lineages, and each lineage was composed of large communal households. Clan members believed themselves descended from a common legendary ancestor. Crests distinguished each clan. Clan privileges were validated by a potlatch, a feast accompanied by the giving away of presents during which claims to heraldic crests were publicly asserted. Two or more clans might claim a further relationship between each other and form a tribal division.[15]

The elaborate societies encountered by eighteenth-century explorers were made

CEDAR

I always tell the tree I'll be back for some more.
—Maggie Jack, Penelakut Reservation

⊓orthwest Coast children grew up to respect the shaggy giant cedar tree above all others, believing in its power and sacredness. Cedar provided the raw material for most physical and spiritual needs. From the wood of its massive straight trunk, men built and carved monumental houses and totem poles, seafaring canoes and paddles, fishing implements, masks, and bentwood boxes for storing substances and treasures. Women used the fibers of shredded cedar bark to weave clothing, baskets, mats, fishing nets, and adornment. Branches and bark supplied the ingredients for healing. While the tasks of daily life may have been divided according to specific roles, all skills were unified for the preparation of regalia.

783 *Tlingit neck ring of twisted red-cedar bark and eagle down. Collected in Southeast Alaska, 1926. Length, 56¼" (142.9 cm). The University of Pennsylvania Museum, NA 11753*

781 *Laxskik (Gitksan) of Kitwanga wears a cedar ring with eagle down and a garment of bear fur. 1924. Canadian Museum of Civilization*

782 *Haida neck ring made with twisted copper, an adaptation of twisted cedar bark. Diameter, 11" (28.0 cm). The University of Pennsylvania Museum, 37813*

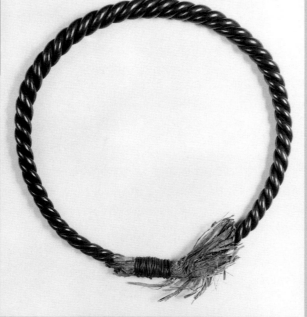

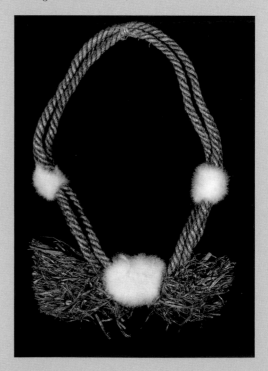

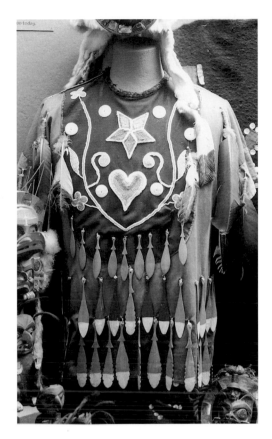

784 *Dance shirt, traditionally worn by the Salishan people during the Winter Ceremonial. The embroidered beadwork patterns may reflect the dancer's guardian spirits. Cedar amulets—which fringe the shirt and clatter during dancing—resemble canoe paddles but, suggests Bill Holm, are more likely "miniatures of ancient war clubs." Vancouver Island. Nineteenth century. Cloth, glass beads, wood, feathers, snail shells. Length, 28" (71.2 cm). National Museum of the American Indian, 15/4606*

up of seven major language families speaking at least twenty-eight separate languages. The main linguistic families and their subgroups are, from north to south: Nadene, within which are included Eyak and Tlingit speakers; Xhaaydan, including Haida; Smalgyaxian, including Tsimshian and Nishga (the language of the Nisga'a and Gitksan peoples); Wakashan, which encompasses Haisla, Heiltsuk, Xaixais, Oowekeeno, Kwakwala (the language of the Kwakwaka'wakw (formerly Kwakiutl), Nootka (the language of the Nuu-chah-nulth), Nitinaht, and Makah; Salishan, including Nuxalk (Bella Coola); Chemakuan; and Chinookan.[16]

Yet, fluid communication and exchange between villages, permitted by a continuous network of coastal and riverine waterways, led to a shared coastal culture with subtle diversities. Along the slender land edge defining the Northwest Coast region, groups depended upon marine resources, traveled by canoe, and lived in permanent winter villages featuring cedar-plank architecture. Houses, canoes, and (in the north) crest, or totem, poles were the principal measure of a family's material wealth.

CLOTHING AND REGALIA AS SYMBOLS OF STATUS

Strips of cedar bark, pounded soft, were loom woven to make water-repellent capes. Bark was more sensible against the constant drizzle than the hide worn inland; both were accompanied by plain woolen blankets and buckskin pants and shirts. In summer, men wore breechcloths or went naked; women wove plant fiber into skirts. During cooler weather, bearskin robes and sea-otter pelts added warmth. Waterproof rain hats often included designs to indicate the wearer's status. For coastal people constantly in and out of canoes, shoes were a burden and only those who lived upriver found the need for hide moccasins.[17]

Southern tribes like the Nuu-chah-nulth might paint their skin with red clay, adding mica for a glitter effect. Bird down was sprinkled on hair during festivals; dentalium shells were strung as necklaces.[18] Piercing the ears and nose was a mark of prestige; earrings made of shark teeth (825) were especially popular among the Tlingit.[19] Farther north, high-status women used labrets, although in earlier times, they were apparently the adornment of both sexes. Men and women wore rings of iron in their nose, and men might also sport bone or metal pins. Men commonly had facial hair, rare among other Native North Americans. Both sexes were tattooed.[20] Skull deformation, a sign of status, was practiced on the central and southern but not the northern coast. It was commonly done on the central coast by wrapping the head with kelp to elongate the skull. Flattening with a cradleboard was the tradition of the Salishan peoples of the Puget Sound and Georgia Strait and of the Chinook around the mouth of the Columbia.[21] Haida warriors wore wooden-slat armor (a custom possibly traced back to China), large wooden helmets, and carved wooden visors to protect their faces.

Northwest Coast apparel articulated social position. Regalia also confirmed feelings from within the wearer, reinforcing self-perception and translating dreams into reality. It served as a link between the supernatural and human worlds, giving the spiritual a concrete form.[22] To this day, ceremonial regalia remains a visual confirmation of the wearer's identity. Wrapped in blankets of glittering buttons depicting clan crests with feathers radiating outward, a Kwakwaka'wakw dancer appears larger than life (812).

Northwest Coast ornamentation is imbued with animal legends. "All the arts are driven by the story, and by all the creatures who inhabit them," said poet Robert Bringhurst. "There are tales of Haida princes arriving at feasts wearing necklaces of

live frogs, and their wives with live rufous hummingbirds tied to their hair."[23] Oral narratives, filled with creatures of supernatural power, inspired the predominant imagery in Northwest Coast art, regalia, and jewelry.

Apparel and adornment set the Northwest Coast shaman apart from the community, indicating the awe he inspired by his otherworldliness. The shaman's hair was long and gnarled. During performances, his apron was embellished with claws, hooves, and puffin beaks to add sound and movement. Amulet necklaces, head or neck rings of hemlock or cedar bark, crowns, and rattles were important paraphernalia. Though much shamanic clothing was undecorated, Tlingit and Haida shamans' regalia displayed painted spirit helpers or guardian figures. Others wore robes of lynx, bear, and mountain goat to absorb the animals' powerful qualities.[24]

The natural materials used to create works of art possessed spiritual qualities that would emanate from the final piece, whether a wooden canoe, woolen blanket, or bone amulet. Other important symbolic associations dictated the use of red cedar bark, copper, or mountain-goat wool.[25]

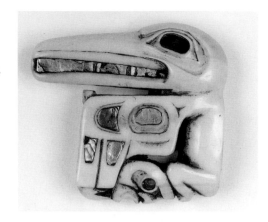

785 *Nisga'a shaman's amulet incorporating a raven. Ivory inlaid with abalone shell. Collected at Nass River, British Columbia. Length, 2¼" (5.7 cm). National Museum of the American Indian, 9/7947*

COSMOLOGY

As elsewhere, the Northwest Coast cosmos was divided into layered zones: Sky World, This World, and Under World.[26] Since most coastal villages were sited on a thin strip of land located between dangerous ocean currents and dense forest, "their world," writes George F. MacDonald, referring specifically to the Haida of the Queen Charlotte Islands [Haida Gwaii], "was like the edge of a knife cutting between the depths of the sea, which to them symbolized the underworld, and the forested mountains which marked the transition to the upper world. Perhaps because of their precarious position, they embellished the narrow human world of their villages with a profusion of boldly carved monuments and brightly painted emblems signifying their identity."[27] Representations of Sky and Under World creatures (birds and animals for the former, killer whales and fishes for the latter) populated the "human zones," possibly as reminders of the forces of the universe. Amphibians such as frogs, beavers, and otters were symbolic of the transition between the Sky and Under World realms. Composite beings, including Sea Grizzly (837) and Sea Wolf, represented the joining of cosmic zones. Thunderbird, who dwelled on mountaintops, stood for power and prestige, primarily among tribes of the central southern coast. Although visually similar to Eagle, Thunderbird has two curved appendages on his head sometimes referred to as "horns."[28] One spirit common to all Northwestern Coast people was Raven, trickster, transformer, and creator of the world.

Northwest Coast shamans relied on personal experience, guided by the power of spirit helpers, to create the remarkable artwork that came to represent their spiritual world.[29] In the shamans' mostly small-scale regalia, characteristic Northwest Coast monumentality resides not in the size but in an item's potency.

Animals, believed to inhabit the earth before humans, owned a unique knowledge. During performances, the shaman would become possessed by an animal that represented his spirit helper and guided him through the three world levels. Shamanic spirit helpers usually lived at environmental borders—the water's surface, a shoreline, or treetops.[30] Spirits summoned during performances entered the shaman's body and spoke through his mouth.[31] Animals with strange combinations of attributes, or that combined parts of different creatures, were common. Waterbirds served as messengers between the different levels of the universe, guiding the shaman to the "watery underworld" in search of stray or abducted human souls, or to seek knowledge of the dead.[32]

HAIDA ORIGIN STORY: THE RAVEN AND FIRST HUMANS

The great flood that had covered the earth for so long receded, leaving abundance in its wake. The Raven, who had flown to the area now named Rose Spit, was not hungry for food, but his lust and curiosity, and his desire to interfere and play tricks, remained unsatisfied. He had stolen the light and scattered it throughout the sky; now he was bored. He called to the empty sky and was startled when far below his great height came a muffled, meek response. At his feet he found a clamshell full of creatures cowering in terror. A diversion! With the smooth trickster's tongue that had got him in and out of so many misadventures during his troubled and troublesome existence, he coerced them out. Hesitantly, but curiously, they all emerged eventually. Two-legged, like Raven, but without feathers, beaks, or wings, they had pale skin and thick stick-like appendages that waved and fluttered constantly. These were the original Haidas, the first humans.

Raven watched them explore and squabble as their world expanded. Suddenly noticing they were all males, he picked them up and flew them on his back to a rock, exposed by a low tide and covered with red chitons. Leaving the men on the sand, he pried the chitons from the rock and, with unerring aim, flung a chiton at each man. One by one, the chitons attached in the delicate groin area of the shell-born creatures.

The men were confused by the rush of new physical and emotional sensations. Agitated, they threw themselves on the beach and, suddenly, a great storm seemed to break over them, followed just as suddenly by an intense calm. Then, as each chiton dropped off, the men dispersed and disappeared down the beach. The Raven laughed and laughed.

Meanwhile, the chitons had reattached themselves to the rock. They too were changed. Through tides and seasons they grew until they far exceeded their usual size and their shells seemed ready to burst open. One day, a wave tore them from their holds and carried them to the beach. The water receded, the warm sun dried the sand, the chitons stirred. From each emerged a brown-skinned, black-haired human. Some were male, others female—and the

Raven began his greatest game, one that still goes on.

The shell dwellers became the children of the wild coast. Their descendants built grand longhouses on beaches between the sea and land and embellished them with carvings that illustrated the legendary beginnings of the great families, all the heroes and heroines and the gallant creatures that had shaped their universe. For generations thereafter, the Haida flourished and lived according to the changing seasons and the unchanging ritual of their rich and complex lives.

786 *Bill Reid (Haida) holds his jewellike boxwood carving,* The Raven Discovering Mankind in a Clamshell. *Illustrating the Haida origin story (Reid's version of the story is the basis for the one told here), the tiny carving (2¾" high) was the forerunner of the larger sculpture seen in 787. 1970*

▽ **787** *Sculptor Bill Reid with his work* The Raven and the First Men. *"Although a world view might hold that man migrated over a Bering land bridge," says Reid, "the Haida know that the Raven coaxed the first men from a clamshell on the beach at Naikoon." The sculpture's theme—humankind's origin—has archetypal significance throughout the Northwest Coast. 1983. Carved from a laminated cube made of yellow cedar sections. Height, 82⅜" (210.0 cm). University of British Columbia Museum of Anthropology, Vancouver*

786

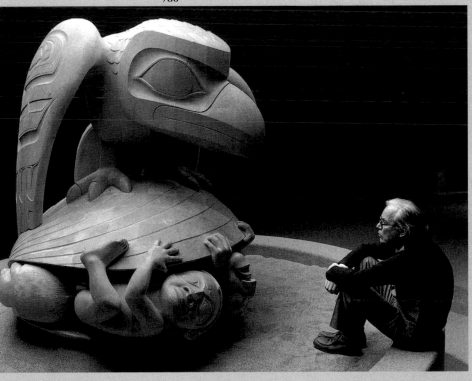

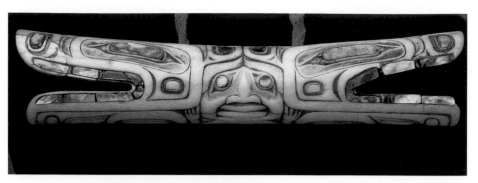

788 Tsimshian soul catcher portraying a human between two wolflike animal heads. Double-headed creatures were important Northwest Coast beings that could change shape and navigate through air, land, and water. The motif may connect a mythological otter canoe—depicted as "having a mouth at each end"—with soul catchers. Such canoes were used by shamans as they traveled in search of lost souls. c. 1840–60. Bone, abalone, rawhide. Length, 7⅝" (19.4 cm). Seattle Art Museum, Gift of John Hauberg, 91.1.83

789 Nisga'a amulet in the form of a sculpin or diving whale. The tail (above the whale face) is also a human's face and hands. It belonged to a chief shaman. Carved whale tooth inlaid with abalone shell. c. 1820–50. Width, 3¹⁵⁄₁₆" (10.0 cm). National Museum of the American Indian, 9/7942

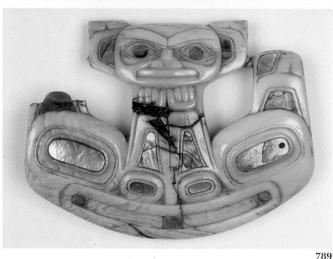

789

▽**790** Sisiutl, the double-headed serpent, was one of the Kwakwaka'wakw's most frequently depicted supernatural characters. Central to themes of warrior power and strength, Sisiutl served as the warrior's assistant. Its body can act as a self-propelled canoe; its glare can cause a man to die; its joints can turn backward. Its flesh was impervious to any spear. The blood of Sisiutl, rubbed on the body of a warrior, makes him invulnerable. Warriors used the figure of the Sisiutl on dancer headdresses, ceremonial belts, and cloaks or aprons. Nineteenth century. Painted wood and cord. Length, 50" (127.0 cm). University of British Columbia, Museum of Anthropology, Vancouver, A3791

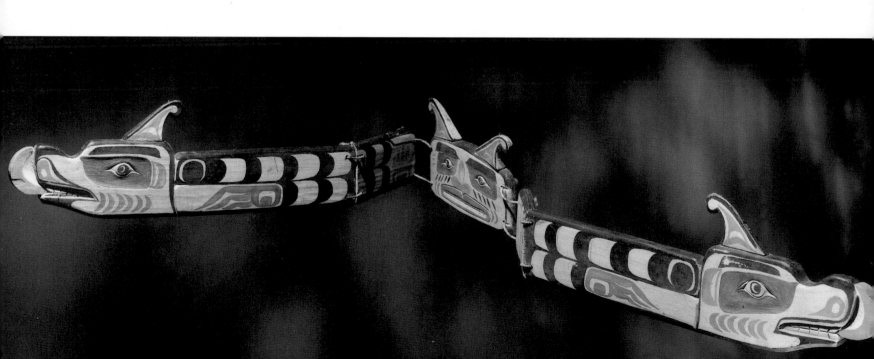

FRONTLETS

One of the most magnificent pieces of Northwest Coast ceremonial regalia is the dance headdress with a frontlet. The frontlet, depicting a major crest figure, is carved and inlaid in the form of a panel and worn above the forehead. Surmounting the panel is a circle of sea-lion whiskers, which holds eagle down. Frontlets were both status symbols and transformed forehead masks that embodied the animal as guardian spirit. Their tradi-

tion initially derived from the custom of wearing animal headdresses with skins attached and falling down the back. However, when displayed with a Chilkat blanket, rattle, and dance apron, this visually impressive assemblage announced a chief's dual social and supernatural power. Worn by women and men, frontlets continue to be made for ceremonials.

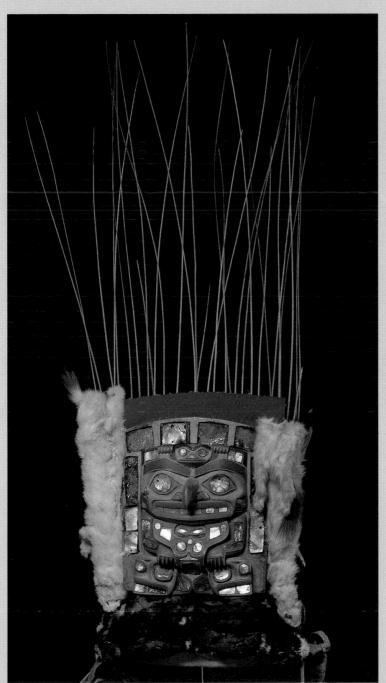

791

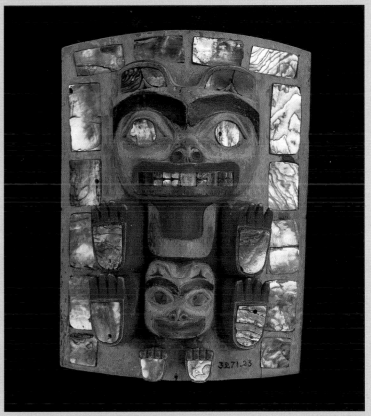

792

791 *Tlingit frontlet headdress worn by women and children while performing a dance to imitate the flopping of a halibut. At some point during the dance, the performers would drop to their knees and fall rapidly backward and forward. This action shook out the eagle down, which floated out over the assembled guests, coating their clothing and hair. Down from the last performance in which this headdress was used still clings to the headdress. Collected in 1922. Flicker feathers, sea-lion whiskers, ermine skins, abalone, wood, cloth. Length, 11⁷⁄₁₆" (29.1 cm). The University of Pennsylvania Museum, NA 9472*

792 *A Tlingit frontlet representing a mother bear and cub. 1830–50. Carved wood inset with abalone shell and painted with vermilion imported from China and a copper-based blue-green pigment. Height, 6⅞" (17.5 cm). Private collection*

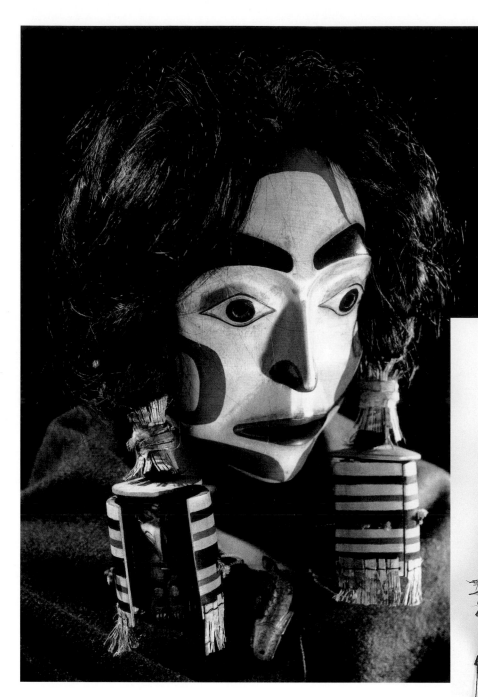

794 Atlakim *dance mask. Another important winter ceremonial society is the Atlakim. Scores of masked dancers perform a story of tribal history and spirit-world wisdom. Their masks comprise "treasures of the forest": cedar wood, spruce and hemlock twigs, bird feathers, tree moss, and ferns. They were traditionally made to be worn only for the four-day event and burned at the end of the seasonal dance cycle. New masks were created for next year's performances. Beau Dick (Kwakwaka'wakw). Late 1970s. Painted cedar mask with red cedar "hair" and spruce-tree and feather decoration. Height, 12" (30.5 cm). Collection Dorsey*

793 *A carved and painted wooden mask represents the legend of Eagle Woman, a woman who married an eagle. After bearing him two children, she became dissatisfied and fled, carrying her children. Upon reaching a river, she attached the children to her braids and safely swam across. The mask's human-hair braids conceal hidden strings that enable the dancer to reveal, during the performance, eagle children with movable wings. Made by Walter Harris (Tsimshian), this mask was inspired by an older version in the Portland Art Museum. Early 1970s. Painted birch. Mask height, 9" (22.9 cm). Collection British Columbia Provincial Museum*

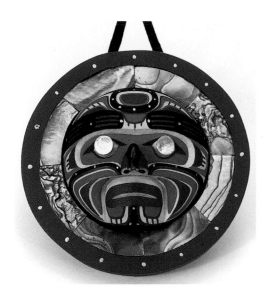

795 *Kwakwaka'wakw carver Kevin Cranmer's moon-mask pendant is a smaller version of his ceremonial moon masks. Cranmer is a member of the renowned Hunt family and has been initiated into the Hamatsa society. His deep knowledge of tradition is reflected in his work, while his greatest satisfaction as an artist is creating regalia for family festivals. The Cranmer family has a rich history of potlatching. 1996. Yellow cedar, abalone, paint. Diameter, 2¾" (7.0 cm). Private collection*

Eagles, bears, wolves, ravens, and salmon represented the known world, where the shaman returned after a supernatural journey.[33]

Carvings on shamanic paraphernalia, such as headdresses, masks, rattles, and drums, brought the associated spirit to life; as did amulets of ivory, antler, and bone.[34] Bone, considered the part of the body that regenerates after the body has been killed, was symbolic of the source of life and image of the soul. Shamans touched a patient's body with an animal-tongue charm for health. The tongue, particularly of a frog, was thought to be the main organ for transferring life force; it also symbolized the shaman's ability to communicate with animals.[35]

Rattles and drums—essential shaman tools—were often adorned with supernatural images (801). Amulet necklaces were meant to clack as the shaman danced. His or her paraphernalia held great power and was only exposed in controlled situations. Objects buried with a shaman might include spruce-twig bracelets with ermine skins attached; a devil's-club-root neck ring; and a medicine bundle composed of an animal tongue, spruce twigs, devil's-club roots, and the jaw of a brown bear.[36]

Masks

Elaborate and complex masks were a major expression in Northwest Coast ceremony, and they embodied many concepts of Native life. In origin stories, masks were pulled from the water like fish. Full of anguish, fright, and power, masks were vehicles of transformation in dramas that reenacted heroic deeds and shaman vision quests. Worn to celebrate the seasons, they merged ancient and present time. Masks were the supernatural treasures of noble families.[37]

Masks not only transformed the wearer, but also were often themselves embodiments of transformation. The nose of a mask figure, at second glance, becomes the head of a bird; the figure's nostrils are the bird's eyes. As with shamans' amulets, multiple beings could simultaneously occupy the same space in masks. Some masks were rigged with hidden strings, which were pulled to reveal inner beings (6, 793).

Masks came alive during dramatic Northwest Coast performances. The array and intensity of creatures—animal, human, and supernatural—in the surrounding landscape and stories were caught in the masks and evoked through dance drama. Mica or copper set in the mask's eyes reflected the firelight; eagle down floated from the headdresses of blanket-clad dancers.[38] In some performances, bloody killing and various fearful acts were simulated; in others, the "shaman evoked his spirit familiars, running around the fire with the rattle and clash of his bone necklace until he [fell] exhausted in a trance."[39]

CONNECTIONS

The layering of cosmic zones with associated animals—not unlike the layers of Northwest Coast society with its crests—provided a grand ordering, an organizational structure that acted as a template for all aspects of life and art. The principles of the universe were condensed within the structure of a house, a canoe, a blanket, or a bracelet, so that each part of daily life had a similar composition, forming a cohesive, interrelated whole. Each component—whether a plank house or a silver bracelet—was again divided into parts or zones. Houses were separated into social realms that regulated the different echelons of society. Totem poles, originally symbolic links that connected the layers of the universe, were divided horizontally to provide a sense of order among the flowing carved creatures. Animals such as the eagle and beaver—independent yet coexistent in the Haida social order—wrap around a bracelet (844).

796 *Shaman's doll of carved wood and a painted skin robe used in healing ceremonies. Its significance is unclear. It may have been used to teach boys about shaman activities, or as an amulet left for the patient. Collected 1867. Height 10" (25.4 cm). Peabody Museum of Archaeology and Ethnology, Harvard University, 10/1681*

797 *Kwakwaka'wakw shaman's amulet. Grateful recipients of shaman aid gave the shamans gifts of amulets or rattles. Nineteenth century. Ivory, human hair. Height, 3¾" (9.5 cm). Private collection*

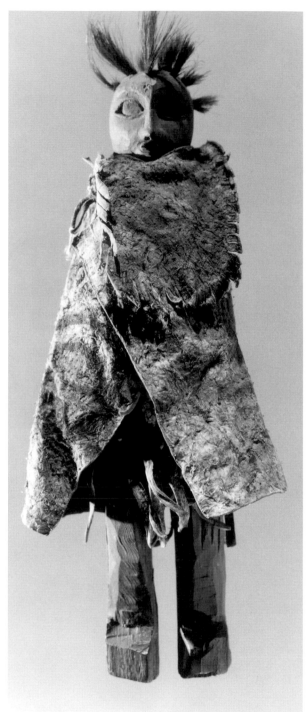

796

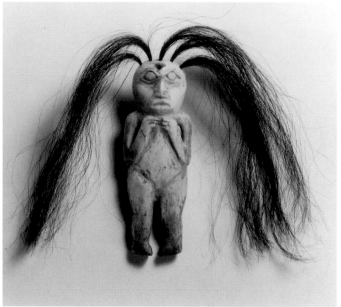

797

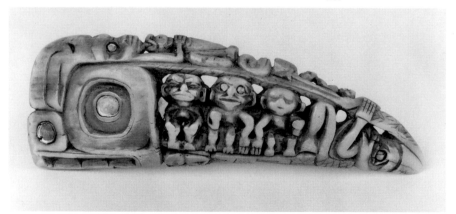

798 *Described as a shaman's dream, this amulet is symbolic of a Tsimshian shaman's alliance with his spirit helpers and represents a sea monster containing three seated spirits. On the bottom is a bear spirit; on the right, a kneeling shaman holds a spirit canoe with two dead men stretched across the top. On the reverse side, a shaman's spirit holds a spirit canoe with a land otter. The canoe was both a container and a means of transportation between worlds. Whale tooth inlaid with abalone shell. Nisga'a. Skeena River, 1820–40. Length, 5¾" (14.3 cm). National Museum of the American Indian, 9/7952*

SHAMAN AMULETS

Ivory and bone amulets, containing the spirit power of zoomorphic spiritual assistants, were worn by every shaman, either grouped on aprons and necklaces or worn singly as pendants. Multiple amulets added a rhythmic sound to the shaman's dance performances. Inspired by dreams and visions, the shaman used amulets to cure illness, control weather, expose and punish witches, and guarantee success in battle.

Amulets are tokens of the shaman's flight between the secular and supernatural worlds and convey transformation in various ways: a human figure between an animal's tail and legs suggests giving birth; a figure under a belly may have recently left the womb. A face in a mouth replicates the life and death continuum, for in death the soul leaves the body through the mouth. Skeletal imagery suggests the animal's close affiliation with man. Exposed bones are a reminder of the bone's

powerful life force. The inner and outer parts of a body are visible, representing a "magic anatomy" that the shaman can see in his trance.

Soul catchers—an important amulet type—were probably made only by the Tsimshian, though they were exchanged with Tlingit, Haida, and Bella Bella (a Wakashan group) shamans. Hollow-bone cylinders, thought to be carved from a bear's femur, usually represent an open-mouthed animal—wolf, whale, or bear—at each end and a human figure in the center. Suspended from the shaman's neck, they were used to capture the soul that had left a patient's body and was causing illness. With chanting and singing, shamans located the wayward soul, had it enter the container, held it there by inserting cedar bark stoppers, and returned it to the patient to restore his or her health.

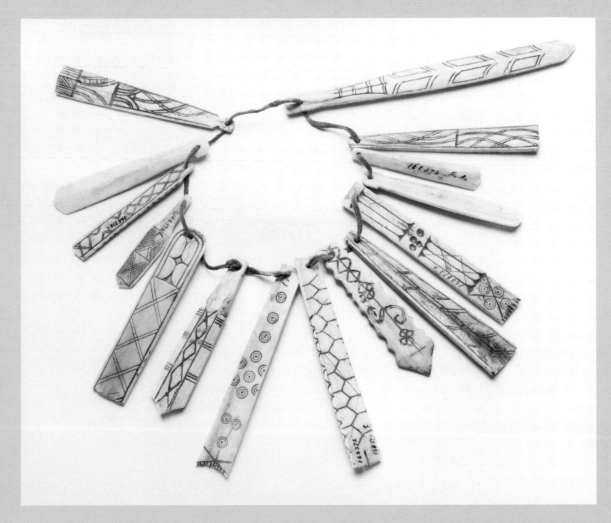

799 *This Tlingit necklace, with its engraved designs of possible Athapaskan origin, may well have belonged to a shaman. Acquired in Gonaho, Alaska, 1894. Bone, ivory, hide, pigment. Length, 16⅞" (43.0 cm). National Museum of Natural History, 168372*

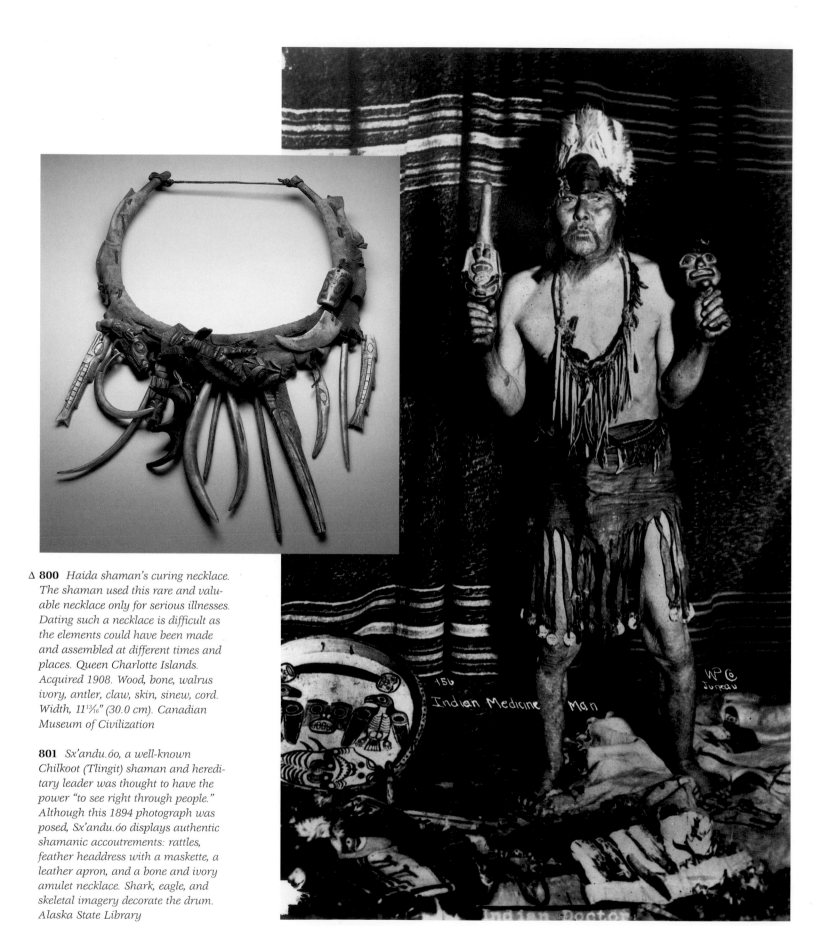

△ **800** Haida shaman's curing necklace. The shaman used this rare and valuable necklace only for serious illnesses. Dating such a necklace is difficult as the elements could have been made and assembled at different times and places. Queen Charlotte Islands. Acquired 1908. Wood, bone, walrus ivory, antler, claw, skin, sinew, cord. Width, 11¹³⁄₁₆" (30.0 cm). Canadian Museum of Civilization

801 Sx'andu.óo, a well-known Chilkoot (Tlingit) shaman and hereditary leader was thought to have the power "to see right through people." Although this 1894 photograph was posed, Sx'andu.óo displays authentic shamanic accoutrements: rattles, feather headdress with a maskette, a leather apron, and a bone and ivory amulet necklace. Shark, eagle, and skeletal imagery decorate the drum. Alaska State Library

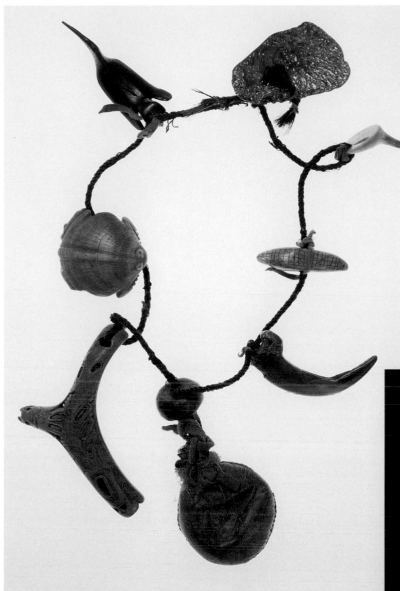

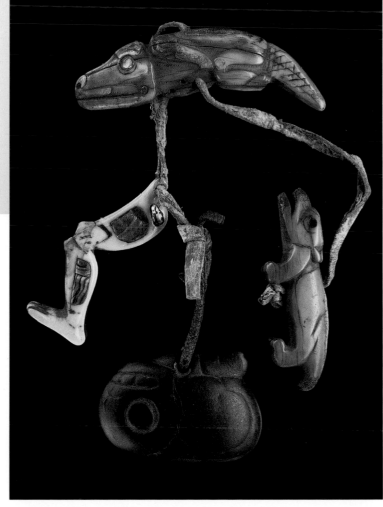

803 *A set of carved shaman's amulets show traces of ocher and are strung on a strip of tanned skin. Included are (clockwise from top) a stone killer whale with folded dorsal fin, a wolf, a large-headed mythical beast, each with shell eyes, and an ivory human leg inlaid with shell. Tsimshian. Collected in British Columbia, 1879. Length, 11¹³⁄₁₆″ (30.0 cm). Canadian Museum of Civilization*

802 *Tlingit shaman's necklace strung with ivory, shell, and antler. Both the ivory bird and incised ivory piece are probably of Eskimo origin. The metal bird may have come from Siberia, and the carved shell representing a frog from the southwestern United States. Such exotic objects added to the necklace's power. 1820–80. Overall length, 23⅝″ (60.0 cm). Carved antler length, 4⅝″ (11.8 cm). The University of Pennsylvania Museum, NA 3226*

THE NORTHWEST COAST 397

Often, the components of Northwest Coast life and art expressed qualities of containment or enclosure. Containers were the vehicles of transformation that moved between zones.[40] The universe contained all of life, as a house does its inhabitants, a canoe its passengers, a box its sacred regalia, a bracelet its wearer's wrist. Carvings were wrapped around a memorial pole, containing the core of a tree. Similarly, cherished Chilkat blankets (made from the wool of mountain goats by the Tlingit, Tsimshian, and Haida women for high-ranking people) "enclosed" or "contained" the wearer "like a different skin," relates art historian Doris Shadbolt, "just as in the myths the salmon can don his human skin when he leaves his water domain."[41] Animal motifs on a cloak design were split down the center, opened, and each half spread out on either side. In this way, the creature "wrapped around" the wearer, enclosing and empowering the body.[42]

House designs were microcosms of the universe. Among the Haida, each house had four corner posts, representing the four corners of the world and acting as symbolic supports between earth and sky. A smoke hole above the large central hearth was the cosmic passage between this world and the celestial realm; smoke rising from the fire carried messages to the spirits above.[43] In addition to providing shelter, the house was also the site of sacred events, including winter rituals that validated the lineage's origins. As Peter and Jill Furst observed, houses were as "sentient as any human being or animal. Each bore as its own distinguished name the hereditary name of its owner (e.g., Killer Whale House, Grizzly Bear House)."[44] They were adorned accordingly with carved screens, paintings, and totem poles.

The comparative standing of each house in the community was reflected by its crest, or totem pole, the erection of which was a symbolic reenactment of the world's creation. Representing a Tree of Life, it connected the three layers of the cosmos.[45] During potlatches, some wore tall, carved wooden hats with a column of rings and animal crests to evoke the pole (814). "Humans with their spinal vertebrae that extend symbolically upward via the rings on their hats became totem poles, living representations of the lines that connect the middle world to the upper world and underworld."[46]

Connecting lines were part of the Northwest Coast's ancient aesthetic language, expressed in ovoid, U-form, and S-form design elements called *formlines*. The formline, described by Bill Reid as one of the most "refined and powerful" systems of aesthetic expression in the world, is a continuous network of curvilinear, swelling, and tapering lines that delineate the major features of an image and relate disparate images to one another (858). Thus, formlines encapsulate the fragmented parts of an animal motif and create a series of frames that "contain" the different parts of the overall composition within a harmonic whole.

Another characteristic of Northwest Coast design is its apparent bilateral symmetry, whose source is frequently the split image. Dividing a composition into "answering halves" around a central axis is another way to contain a design, using an internal structure, the axis, rather than the enclosing frame as a device.[47] While appearing symmetrical in shape, however, an item's detailed decoration will often differ on its two sides. Since "art forms reflect the social order," writes Martine Reid, "such designs occur within a ranked society when persons belong simultaneously to several ranked descent groups. . . . The greater the number of cross-affiliations in which social stratification becomes blurred, the more likely symmetry and asymmetry will be found simultaneously in art."[48]

In contrast to the northern preoccupation with formline design and crest figures, southern coastal art often reflects a narrative intent, as demonstrated in contact-era *story poles* and contemporary Haisla artist Lyle Wilson's story bracelets (854, 855).[49]

THE CEREMONIAL COPPER

Shield-shaped ceremonial coppers were emblems of prestige and wealth among Northwest Coast societies. Important in the potlatch economy of the Haida, Tsimshian, Tlingit, and Kwakwaka'wakw, coppers were broken, burned, or distributed in pieces as expressions of wealth, or distributed whole to high-status individuals as gifts. Destroying a copper to accompany a deceased chief's spirit implied reincarnation. Coppers were named, which permitted tracking during the course of their "lives."

Coppers were made of rolled sheet copper, a material received shortly after Euro-American contact at the end of the eighteenth century. Although the original coppers may have been constructed from naturally occurring copper nuggets (traded in from the Coppermine River area), none are known to survive. Usually ornamented with motifs of animals or humanlike figures, coppers ranged in size from over two feet to fifteen feet high. Most had a raised, horizontal bar across the midsection and a vertical bar from midsection to the bottom. The form has been described as a human metaphor, with the two bars representing the human skeletal structure.

Copper's properties inspired associations of lineage, chiefly wealth, and supernatural power. Copper was pure and enduring and thus linked to the spirits of everlasting life; its reddish color and malleability linked it to various living material, namely blood, salmon, and the sun's reflective rays, all of which have sustaining and regenerative qualities. The image of salmon magically transforming into copper appears in Northwest Coast oral poetry. A Tlingit man with reddish hair was predestined to the profession of shamanism. Supernatural qualities were in turn attributed to the colors similar to copper.

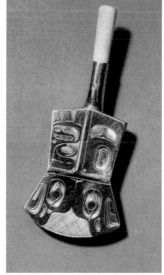

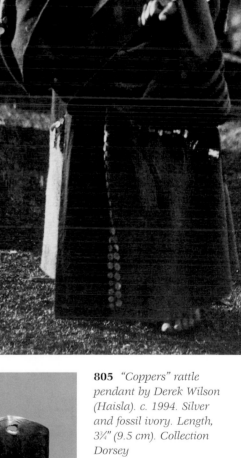

805

806

804 *Small ornamental coppers, two to three inches long, were worn as personal adornment on clothing or as earrings by the wealthy. Although not part of the potlatch exchange, their significance was greater than mere adornment. Important ceremonies were conducted for the ear piercing of children of high-ranking individuals, who were privileged to wear such earrings. The Kwakwaka'wakw wore up to four on each ear.* LEFT: *Silver earrings shaped like coppers. Probably Tlingit. Collected 1906.* RIGHT: *Copper ornaments attached to a child's dance apron symbolized large coppers. Nimpkish (Kwakwaka'wakw), Alert Bay, British Columbia. Received 1876. Peabody Museum of Archaeology and Ethnology, Harvard University, 66386, 50471*

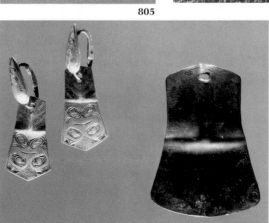

804

805 *"Coppers" rattle pendant by Derek Wilson (Haisla). c. 1994. Silver and fossil ivory. Length, 3¾" (9.5 cm). Collection Dorsey*

806 *Chief holding a copper. Fort Rupert. 1894. American Museum of Natural History*

THE WINTER CEREMONIAL: *TS'EQUA* (CEDAR BARK DANCE)

Among the most spectacular ceremonies in North America were winter dances held by the Kwakwaka'wakw's *Hamatsa* (cannibal) society. They were a vehicle for a privileged family to initiate a son into society, whereby the boy reenacted the "conquest and taming of a man-eating spirit." The boy traditionally went into the woods for four months, where he was trained under *hamatsa* seniors. Upon completion of the training, Kwakwaka'wakw groups from surrounding villages were invited to witness his ceremonial reentry into the world as a man.

Powerful regalia helps intensify performances. The supernatural ability of humans and animals to transform into one another is dramatically portrayed by the masked dancers. Monumental masks of supernatural birds have clacking beaks measuring two to ten feet in length. Skilled dancers carry the masks' weight and snap the beaks with the aid of body harnesses and rigging, all concealed under cedar bark fringes. The *hamatsa* initiate wears a different set of head and neck rings at each stage of the ritual. Hemlock indicates his long sojourn in the forest; red cedar bark announces his safe return from the dangerous spirits. Skull-like rattles are shaken by attendants to calm the *hamatsa*. Light and shadow add to the drama; abalone shell glistens in the firelight. During his final, "tamed" state, the *hamatsa* may wear a Chilkat blanket.

Illustrations 808–9 and 811–12 are a reenactment of the dance performed by the Hunt family, in the winter of 1972, under the guidance of Henry Hunt. The setting for the dance was the house of the late Mungo Martin, a great Kwakwaka'wakw carver, song maker, painter, storyteller, and mentor to Henry Hunt, his son-in-law. All dance regalia used in the event is from the collection of the British Columbia Provincial Museum.

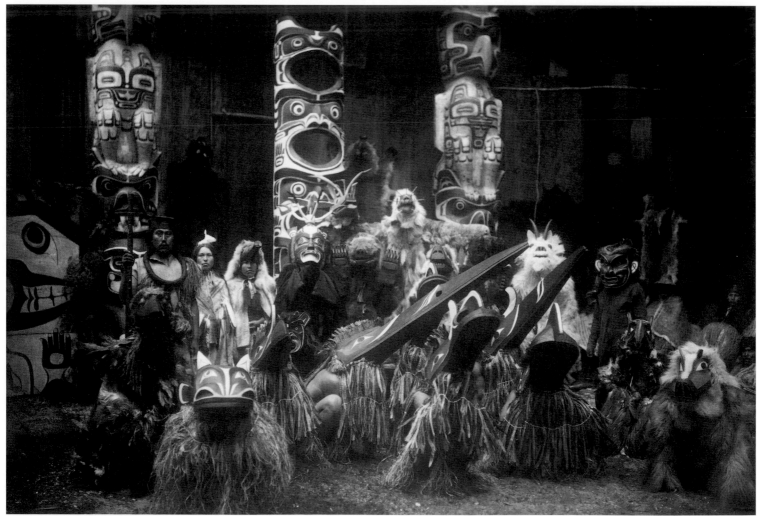

807

807 *Kwakwaka'wakw dancers assembled in the house of Yaklus for the Humsumala,* the *sacred winter dance ceremonial. Their masks and regalia portray the totemic animal ancestors of clans and families. Raven, sea eagle, mountain goat, grizzly bear, wasp, and orca the killer whale are seen in this 1914 photograph. Courtesy of the Library of Congress*

808 *A dancer wears a cannibal bird attendant mask representing Raven. The masks are placed on the back of the head so that the beak projects diagonally upward in front of the dancer. Red cedar bark covers the dancer's body. Although the masks are splendid as sculptural carvings, they are best comprehended when danced around the firelight during an actual Humsumala ceremony.*

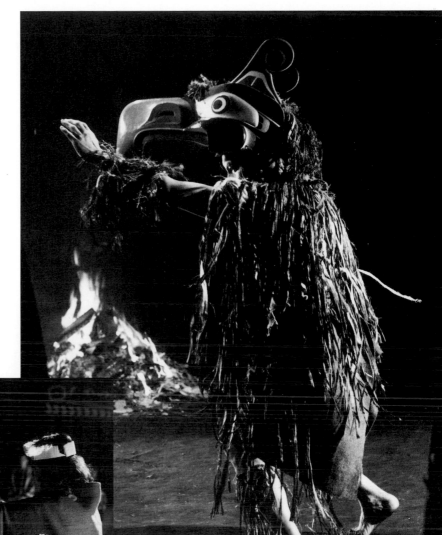

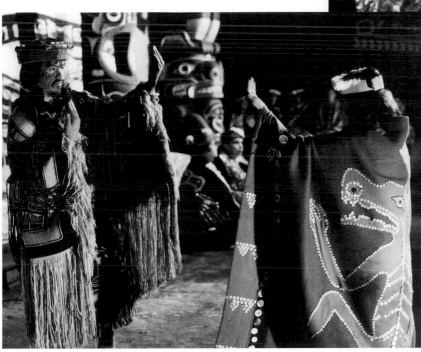

808

809 *The fully tamed initiate (portrayed by Tony Hunt), wearing his cedar bark headring and neck ring and a button blanket, dances proudly as a full-fledged* hamatsa. *A close female relative (right), who has helped to placate his frenzy, faces him with her arms extended. Tony Hunt, an accomplished artisan and current chief of the southern Kwakwaka'wakw, received instruction in dancing and carving from his grandfather Mungo Martin and carved totems with his father Henry Hunt.*

810 *These fossil-ivory earrings of a hand inlaid with an abalone pupil (hand gestures are used frequently throughout the winter ceremonial) were made by Patty Fawn and her daughter Nwesee, members of a Cherokee artist family, who were adopted into the Kwakwaka'wakw tribe. 1995. Hand length, 1½" (3.8 cm). Private collection*

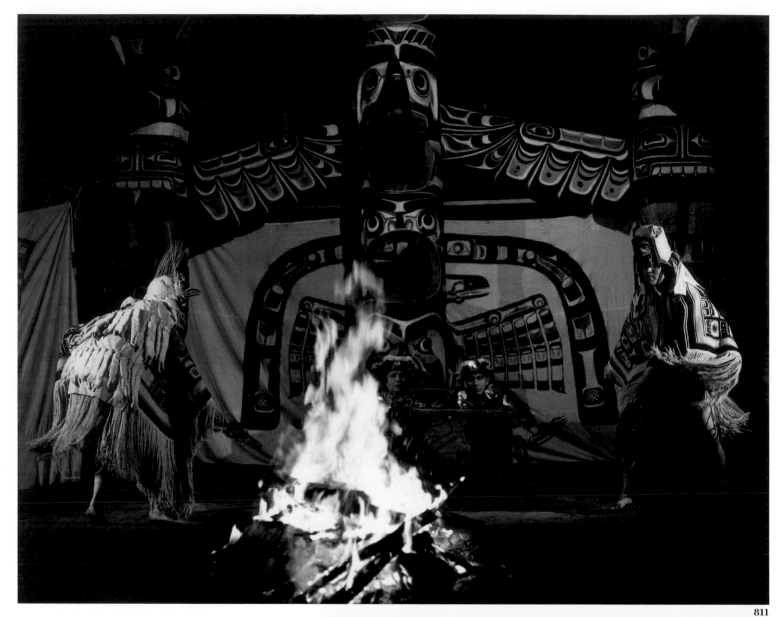

811 *Dancers performing the* Tlasila *(Peace Dance) display frontlet headdresses, Chilkat blankets, and decorated aprons.*

812 Iakim *dance.* Iakim, *a monster, lives at the bottom of the sea, where, as the creator of riptides and sudden storms, he is greatly feared by seafarers. Circling the floor, the dancers' undulating movements suggest* Iakim *diving under a kelp bed and emerging on the other side. Long trails of kelp may fall from behind his shoulder. A wool blanket with a crest figure outlined in mother-of-pearl buttons drapes around the dancers' bodies. Copper eyebrows, eyes, and teeth on the masks signal* Iakim's *great wealth.*

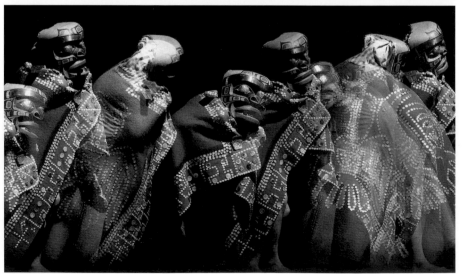

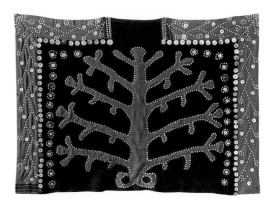

813 *Tree of Life design appliquéd on red flannel with white mother-of-pearl buttons on a blue wool cloak or blanket. Button blankets remain important ceremonial garments. Village Island. 1890–1925. Width, 74" (188.0 cm). University of British Columbia Museum of Anthropology, Vancouver, A4251*

Wilson approaches the design of a bracelet as he would that of a totem pole. "I like texture. When you carve, it's easier to see the glitter of the material, whether it's silver, gold, or platinum. Whereas when I engrave, I try to put in as much texture as I can. This is the closest I can come to sculpture in this medium."[50] Northwest Coast artists are all ultimately sculptors, no matter what material they are working with.

CEREMONIALS

Summer was a time to focus on gathering and storing food. In the winter, however, spirits drew near the village, and dancing and feasting were almost continual. Power and privilege were attained through encounters with spirit beings and the accumulation of wealth. Ceremonies were occasions for the legitimate display of both. They explored spiritual realms and, at the same time, affirmed social status.[51] Much of Northwest Coast art had a ceremonial function, drawing inspiration and themes from supernatural experiences. More theater than dance, masked performances enlivened potlatches.

Potlatches began with the obligation to share surplus food and evolved into competitions for social position through wealth. The term *potlatch* comes from the Nuu-chah-nulth word *pa-chitle*, meaning "to give."[52] The ultimate expression of wealth was not simply in its accumulation and display, but also the ability and power to part with great quantities of it—whether by giving it away or destroying it publicly. Potlatches were ceremonies for this purpose. They also marked births, marriages, and deaths, the construction of a dance house, and the raising of a totem pole. As the pole was raised, "artist and apprentices watched, their necks and wrists encircled with twisted cedar bark rings to which their carving tools had been attached."[53] Guests were recorded witnesses of the events. Large gifts went to high-ranking guests, validating the status not only of the one who gave, but also of those who received.

Chiefs spent years accumulating enough wealth to host a potlatch. Elaborate regalia worn by the chiefs at these gatherings included Chilkat blankets and carved frontlet headdresses. Cedar boxes, masks, jewelry, and blankets were among the items ceremonially given away. The presents a chief dispersed during a potlatch were in part considered investments because gifts of equal value would be owed to him in subsequent gatherings. In a spirit of rivalry, each potlatch was given to outdo the last, perpetuating a round of accumulation and distribution of wealth.

TRADE AND ACCULTURATION

The mountains and dense forest that separated coastal villages from the interior did not hinder trade; waterways compensated for any potential isolation. The ocean provided a transportation corridor, and northwesterners traveled in remarkably carved and painted cedar canoes. The Tlingit were renowned traders, exchanging copper and wool blankets for slaves and shell ornaments. Highly skilled navigators, they thought nothing of canoeing for days in any direction. Farther south, overland trade routes leading to the interior were jealously guarded, especially the Russian sea-otter fur trade started in the 1700s.

European and Asian trade profoundly influenced Northwest Coast lifeways and aesthetics. Early Russian traders in Tlingit territory brought Chinese goods, including glass beads and metal coins, prior to the entry of Europeans. Northwest Coast Indian traders returned to their villages with iron tools, paint, varnish, sheet copper, and trade cloth.[54]

The arrival of the English captain James Cook in 1778 was a turning point in Northwest Coast history. Nootka Sound, on the west coast of Vancouver Island, quickly

became an international trading center. The Northwest and Hudson's Bay Companies established a series of trading posts between 1800 and 1850. The Hudson's Bay Company built its first post, Fort Langley, on the Fraser River, in 1827.[55] Trading between Europeans and Native peoples was done with mutual respect; chiefs drove hard bargains. Southern tribes, such as the Chinook, became important middlemen in an extensive commercial network that encompassed coastal tribes as well as those of the Subarctic, California, and interior Plateau.[56]

Early explorers of the Northwest Coast encountered resplendent, complex cultures whose ceremonial systems ensured the equal distribution of goods throughout the hierarchical social structures. Although crests and clan hierarchy were established within the culture before European arrival, the fur trade stimulated material wealth and spurred the competition associated with status.[57]

Chiefs invested new wealth in traditional ways, throwing impressive ceremonies, generously distributing goods at potlatches, and commissioning art on a huge scale. With metal tools to expedite carving and an economy bolstered by trade, the arts prospered. Increasingly elaborate crest poles were one result. During the nineteenth century, Northwest Coast carving reached a high level of monumentality and beauty.

Early Native artisans hammered copper nuggets into bracelets, anklets, earrings, nose ornaments, and beads. After contact, artists continued crafting the same pieces with commercial copper wire. When gold and silver coins became available, artists applied engraving techniques that had been refined over many centuries to the new materials, creating splendid jewelry, including much-admired bracelets (see foldout, pages 411–13). With the influx of European traders, a new style of ceremonial blanket known as the *button blanket* (813) came into use, made from introduced trade goods: mother-of-pearl buttons and melton cloth sewn onto Hudson's Bay blankets. The blankets were derived from older concepts of crest images outlined in shell on robe (47); buttons were carefully chosen according to size, color, and shape.[58]

814 *Tlingit Chief Yeilgooxo and members of the Gaanaxteidl clan outside the ceremonial Whale House in traditional dancing aprons and leggings, spruce-root hats, wooden masks, and painted and beaded clothing. The men also wear Western-style vests, watch chains, neckties, and trousers, attesting to the acculturation process. c. 1895. Courtesy of the Library of Congress*

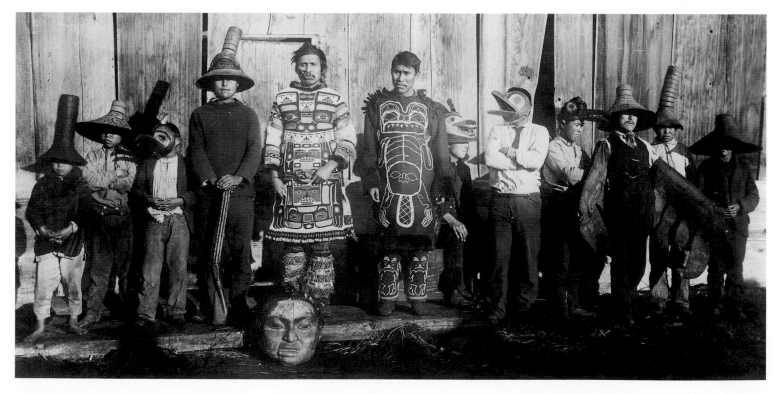

HATS

Northwest Coast hats were passed from generation to generation and worn on important occasions. Among the Tlingit, a conical basketry hat, woven from spruce root and usually painted with a design depicting a clan's crest animal, was topped with series of cedar-bark rings (see 814). Often called potlatch rings, they reputedly varied in number according to the rank of the wearer (established by the number of potlatches given by him) and by the number of times the hat had been displayed and revalidated as a crest object. The tall hat with cedar-bark rings is—like the crest pole—a metaphor for wealth and the cosmic tree (page 398). "I'm sure the people who wore those hats had some concept of how they looked in them—they're so deliberately designed," says Lloyd Kiva New, a Cherokee and arts educator. "In terms of shape, form, design, and decoration, they transcend time. . . . I'd like to live in a village designed to look exactly like this group of hats. . . . They have a sense of beauty, shape, color, design—all the aesthetic requirements are there."

817 Haida spruce-root earrings made by Ginny Hunter (Haida), daughter of Florence Davidson. 1995. Width, 1½" (3.8 cm). Collection Dorsey

818 Pendant depicting a Tlingit man wearing traditional dress, including a spruce-root hat and woven blanket. The pendant, which opens to show an interior view, embodies Northwest Coast concepts of containment, adorned adornment, hidden imagery, and transformation (similar to 96). Detail of the Crossroads of Continents belt (page 106). Denise Wallace (Chugach Eskimo–Aleut) and Sam Wallace. 1988. Sterling, 14-karat gold, fossilized ivory. Height, 3¾" (9.5 cm).

815 Hand-woven cedar-bark hat by Florence Davidson (Haida), daughter of Charles Edenshaw. The painted eagle design is by Florence's grandson, Reg Davidson. c. 1988. Width, 16½" (41.9 cm). Collection Dorsey

816 Whaling chief's hat, similar to those recorded by Captain James Cook in 1778. The hat is constructed of a wrapped, twined weave in cedar bark and natural and aniline-dyed grasses. Jesse Webster (West Coast Ahousaht), Vancouver Island, British Columbia. 1980. Height, 10½" (26.7 cm). Collection Dorsey

816

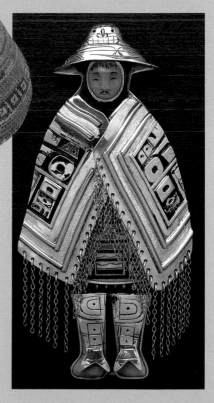

815

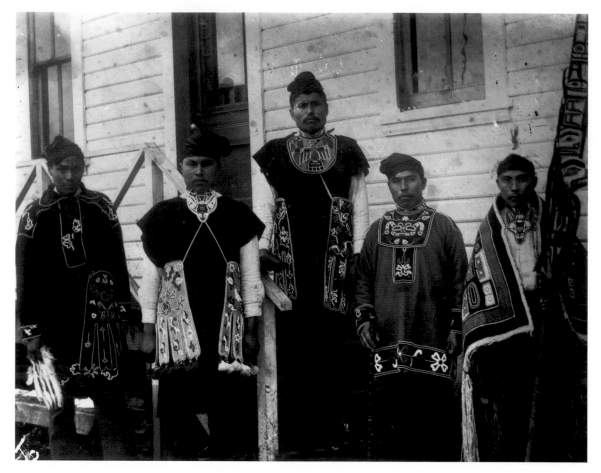

820 *Tlingit dance collar. Two-dimensional painted designs were transferred into glass beadwork on cloth. Southeast Alaska. 1925. Length, 8¹⁵⁄₁₆″ (22.8 cm). The University of Pennsylvania Museum, NA 10515*

821 *Northwest Coast animal motifs and eastern Woodlands florals merge within a Tlingit octopus bag—named for its tentacles (two sets of four) extending below the pouch. One can follow the white-bead patterning to see the approximate anatomical positioning of a beastly creature's facial parts: eyes, ears, teeth, mouth, nasal cavity, and jowls (see 19). The lower central circle outlined with white recalls the blowing mouth on many ceremonial masks. The double-curved lines at the bottom close the "face." Hide, beads. Length, 15⅜″ (39.6 cm). The University of Pennsylvania Museum, NA 8380a*

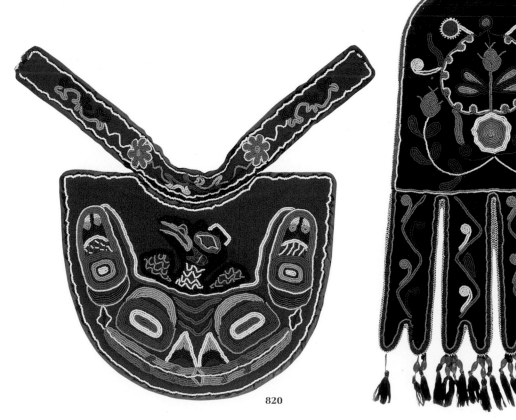

820

821

822 *Tlingit rubbing stone or charm. In their status-conscious society, where an offhand remark could be interpreted as a grave insult, the Tlingit were taught from a young age to choose their words carefully. To achieve such control, an individual frequently rubbed his lips with a stone. The stone weighted a person's tongue, thus preventing hasty speech. When incised with special markings and worn around the neck, the stone also protected the wearer from witchcraft. Length, 2⁹⁄₁₆" (6.5 cm). The University of Pennsylvania Museum, NA 5334*

823 *Small stones carved by the Haida for sale to tourists since 1820. The stone at top right is ophiolite (verde antique marble); at bottom left is a jadeite stone, possibly traded in from the upper Fraser and Thompson River valleys. All others are of argillite, found in surface quarries at Slatechuck Creek on Haida Gwaii. During the nineteenth century, the Haida people were the only ones to exploit it for foreign trade, which generally remains true today. The carvings depict creatures from the Haida cosmos, coveted by non-Native buyers. Collected by Edward Fast, 1867–68. Diameter, top left, 2⅜" (5.7 cm). Peabody Museum of Archaeology and Ethnology, Harvard University, 10/1810, 1838, 1831, 1799, 1821, 1658, 1836*

824 *Abalone, as well as iron and shark's teeth, all traded widely, were highly valued as materials for making body ornaments.* ABOVE: *Abalone earrings. Haida, 1880s. Width, 5¹⁵⁄₁₆" (15.0 cm).* BELOW: *Tsimshian iron and abalone hair ornament formed into a bifurcated scroll. Accessioned 1871. Length, 6¹¹⁄₁₆" (17.0 cm). National Museum of Natural History, 88900, 10313*

825 *Tlingit earrings of shark's teeth. Shark's teeth were crests of the Tlingit's wolf clans. During potlatches, the host paid a member of his moiety to pierce the rims of children's ears. At additional potlatches, other holes were added. The resulting series of holes marked an individual as a member of the nobility. Early twentieth century. Length, 1⁵⁄₁₆" (3.3 cm). The University of Pennsylvania Museum, 8482*

826 *Silver ear pendants resembling shark's teeth. Length, 2" (5.1 cm). Peabody Museum of Archaeology and Ethnology, Harvard University, 87526*

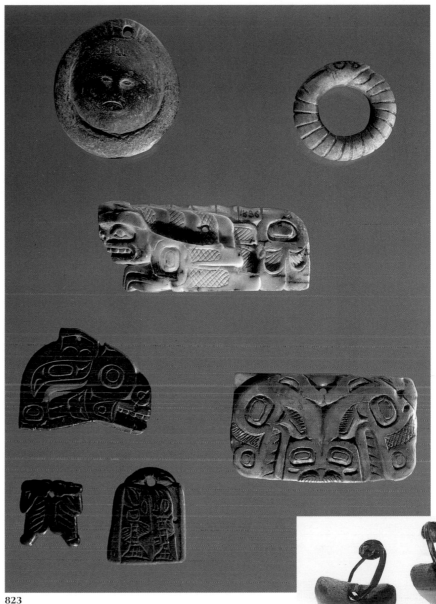

823

824

825

826

828 *Mabel Stanley's ceremonial headring of cedar bark, with crest of abalone and eagle skin and down. The headring was made by Bob Harris (Kwakwaka'wakw), Mabel Stanley's stepfather, after the birth of her first child. Width, 7⅞" (20.0 cm). Collection Stanley Family*

827 *Mabel Stanley in her assemblage, including a chief's headdress with carved frontlet of wolf, eagle, and bear figures, sea-lion whiskers holding eagle down, abalone shells, and ermine trailers. She also wears a beaded button cloak, dance apron, and silver bracelet and holds a rattle. c. 1960*

Mabel Stanley (Kwakwaka'wakw) was born in 1901 at the village of Cape Mudge on Quadra Island. She spent her early childhood in the large community house belonging to her father, Chief Joseph Johnson, and his family. As a chief's daughter, she was expected to learn the teachings and traditions of her family and one day follow in his footsteps, assuming his responsibilities. In 1910, however, Chief Johnson died and Mabel was sent to Coqualeetza residential school in Sardis, British Columbia, where she graduated with honors in 1919.

Following her marriage to non-Native William Arthur Stanley, she lost her Native status (under Canada's Indian Act, which continued until 1985). By the 1950s, however, her children grown, Mrs. Stanley was actively representing Native people and other ethnic groups she felt were in need of support. From the 1950s to the 1980s, she campaigned for aboriginal rights across Canada. A fluent Kwakwala speaker, she also worked with linguists Neville Lincoln and John Rath to write a Native language book.

Mrs. Stanley often spoke at public gatherings wearing her ceremonial regalia, most of which had been inherited from her mother, Lucie Harris. Donning her robe at public functions, this clothing signaled her Kwakwaka'wakw culture and status. In 1979, the Stanley family requested that the University of British Columbia Museum of Anthropology preserve the family's ceremonial attire. In 1992, at the family's request, the pieces went on public display.

"We had to be creative in making our own toys—boats, bows, and arrows," says Haida carver and jeweler **Robert Davidson**. Born in Masset in the Queen Charlotte Islands (Haida Gwaii) in 1946, Davidson is the great-grandson of Charles Edenshaw. At the age of thirteen, Davidson's father, Claude Davidson, started him carving on a totem pole. "I didn't think of it as anything serious. . . . It was one step beyond making toys. . . . He carved one side and my job was to match up what he carved on the other side," the artist recalls. The carving repertoire was limited; nothing remained in Masset of the monumental classical Haida work. Young Davidson's carvings, therefore, were the third generation of works based on published photographs. At the same time, Davidson's deep artistic heritage derives from the community and his family. He speaks with particular respect for the artistic achievements of his grandfather, Robert Davidson, Sr., who in his early days worked with Edenshaw. It wasn't until Robert, Jr., traveled to Vancouver, where he apprenticed to Bill Reid and was mentored by Doug Cranmer, that he saw and understood the depth of his ancestor's artistry. He considers the Northwest Coast formline alphabet "magical. . . . When a person gains knowledge in that formula, you can create absolutely anything in any given shape or space."

In 1969, Davidson returned to Masset to carve a forty-foot-high totem pole, the first raised since the 1880s. Davidson describes the ritual presentation of the pole to the village as "the reawakening of our souls, of our spirits. It was the reconnection of some of the values that still existed. Its presence appears to have released people's collective memories of dance, songs, and stories of the past." Davidson is said to have "potlatched the Haida tradition" by awakening it, both in Masset and in himself. Seeing the dances inspired Davidson to start carving masks. "Once I achieved a very comfortable confidence with the art form, then it automatically led into ceremony, the very secret part of being Haida, or of being human. Learning the song actually gave life to the art form. . . . When I saw the very first carved object that I did being worn by a chief, I was really moved by it. I felt, that's where art comes from and that's where it belongs. It gave the art a whole new meaning for me."

Davidson's primary artistic task is to give objective form to the spirit world; and his works seem to have a life apart from the creator. He carved an eagle spirit mask exuding such power that he hid it away for a year. He finally took it out during the potlatch he hosted in 1981. The eagle mask "was given birth that evening. The meaning behind it is, we are gaining strength as a people. We are gaining love for ourselves, we are gaining the strength we need to reclaim our position in the world." Later, the eagle spirit mask became the first mask to be used to bring back the spirits of departed souls.

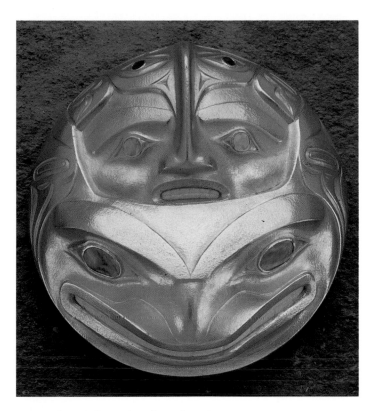

829 *Killer-whale pendant/brooch. Robert Davidson. 1987. 22-karat gold, abalone, mastodon ivory. Diameter, 2" (5.1 cm). Gallery of Tribal Arts, Vancouver*

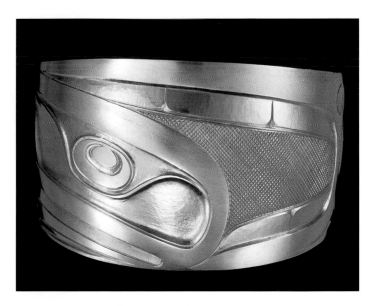

830 Cormorant and Kagann jaad (Mouse woman) *bracelet. The interplay of positive and negative is important to Davidson. He may treat the same part of a symmetrical design differently on opposite sides, carving it on one side and crosshatching it on the other. The bracelet remains a major Northwest Coast jewelry form to many of the region's artists. Robert Davidson. 1994. Silver. Height, 1⁹⁄₁₆" (4.0 cm). University of British Columbia Museum of Anthropology, Vancouver, Nb1.727*

NORTHWEST COAST BRACELETS

No item of jewelry was as important for historic Northwest Coast people as the bracelet. Viewed as a sign of rank for both men and women, wealthy people wore as many as five or more on each arm. Hammered from gold and silver coins and medals brought in after contact, the bracelet became favored adornment. It may have been intended to replace tattooing, an important Northwest form of body art discouraged by the missionaries. Other than the Haida, who applied tattoos to the breast, arms, hands, and legs, most tribes confined tattooing to the backs of the hands and women's forearms. As the application of tattoos was often connected to a feast—young girls were typically tattooed during an important potlatch, when property was distributed and slaves were freed—the distribution of bracelets was also tied to gift-giving rituals.

Bracelets became a favored, visible means of continuing indigenous customs, such as clan designations. They allowed the artist to record in smaller scale totemic aspects of clan design. Bracelets extended tattooing as portable art; however, whereas the tattoo was permanent, the bracelet was temporal. Bracelets would also appear to reinforce joint-marking concepts (see page 43) while emphasizing the importance of the hand in oration, dance, and as a tool of creation and center of power (see page 401).

An artistic link between the past and the present, bracelets continue as a major Northwest Coast jewelry form. The following pages present a visual history of Northwest Coast bracelet design.

831 *Tattooing seen on the hand and arm of a very old Tlingit woman at Angoon, 1889. The sketch was made by ethnologist G. T. Emmons. The double line symbolizes a bracelet at the juncture of the hand and arm.* American Museum of Natural History

832 *Haida men often had their upper bodies tattooed with crest figures as expressions of beauty, protection against misfortune, and identification of status. On his chest is* xuuts, *a grizzly or brown bear; on each forearm,* ghuut, *an eagle*

833 *Bracelets stacked on poles await distribution at a late nineteenth-century Alert Bay potlatch. A special contemporary potlatch may still include bracelets.* Royal British Columbia Museum

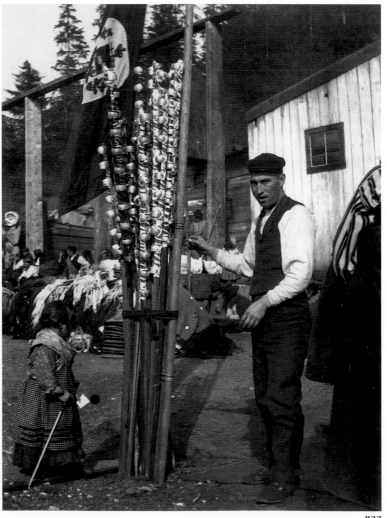

833

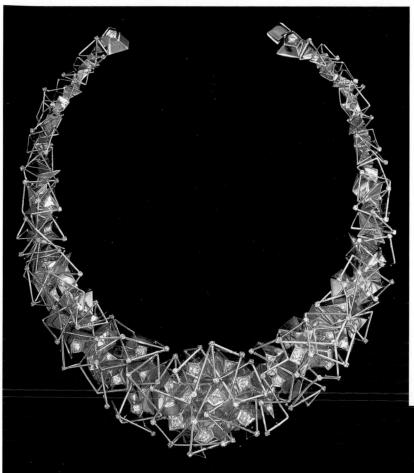

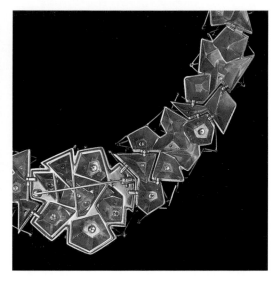

Reverse of 859

△ **859** *Gold and diamond necklace with a central detachable section that is also a separate brooch. "Beneath the western format," writes anthropologist Martine Reid (Bill Reid's widow), "a Northwest Coast principle is still at work. Two distinct forms, the necklace's gold ground and its jewelled web seem to occupy the same space at the same time." Bill Reid. 1969. Diameter, 6⅝" (16.8 cm). Collection Martine Reid*

860 *Necklace. Bill Reid. 1972. Sterling silver and white gold. Diameter, 7¹⁄₁₆" (18.0 cm). Collection Martine Reid*

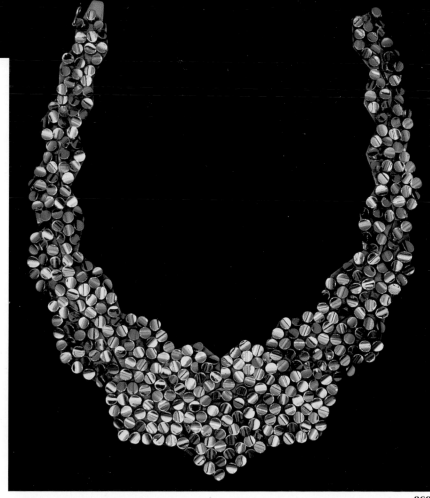

860

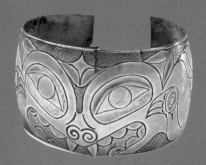 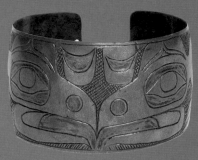 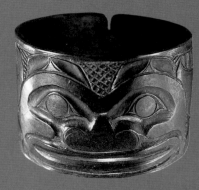

837 *Sea Grizzly (Tsaaghan xuuwaji) bracelet. Ginaskilas of Ttanuu (Haida). Accessioned 1876. Silver. Diameter, 2¾" (7.0 cm). National Museum of Natural History, Smithsonian Institution, 202516*

838 *Two eagle-head or Thunderbird profiles. Tlingit. Collected in the 1880s. Silver. Diameter, 2⁵⁄₁₆" (5.8 cm). The University of Pennsylvania Museum, 31.6.1*

839 *Tlingit. No date. Copper. Peabody Museum of Archaeology and Ethnology, Harvard University, 04-10-10/64666*

840 *Haida. Designs inspired by those on silver dollars. c. 1875. Coin silver. Height, 1⅝" (4.1 cm). University of British Columbia Museum of Anthropology, Vancouver, A7036*

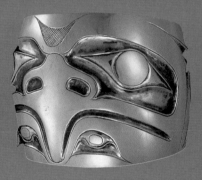 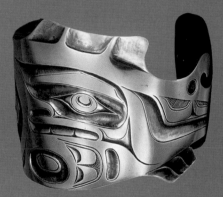 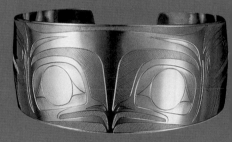

846 *Eagle. Reg Davidson (Haida). 1988. Height, 2" (5.1 cm). Courtesy Leona Lattimer Gallery*

847 *Salmon. Don Yeomans (Haida–Cree-Métis). Silver. Height, 2³⁄₁₆" (5.5 cm). Collection Trace Yeomans*

848 *Owl. Francis Williams (Haida). Silver. Height, 1¼" (3.2 cm). University of British Columbia Museum of Anthropology, Vancouver Nb1.729*

854 Gl'Wa Mountain ▷
(Eulachon Fishing),
three views. Lyle Wilson
(Haisla). 1993. *Engraved
silver. Height, 1" (2.54
cm). Collection Anne-
Marie Fenger*

 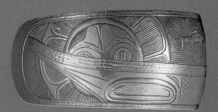 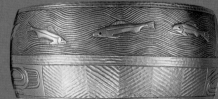 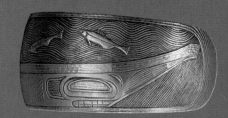

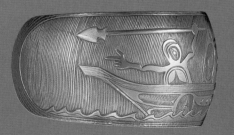 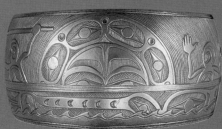 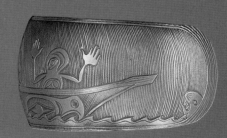

◁ **855** Nanakwa (Dawn
on the Coast), *three
views.* Lyle Wilson
(Haisla). 1993. *Engraved
silver. Height, 1³⁄₁₆" (3.0
cm). Collection Anne-
Marie Fenger*

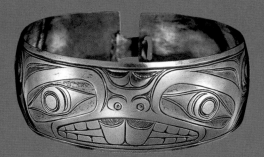

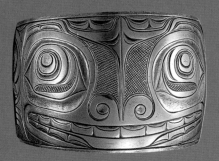

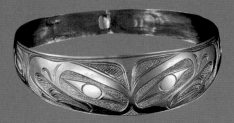

841 *Beaver design. Charles Edenshaw (Haida). c. 1900. Height, ⅞" (2.2 cm). University of British Columbia Museum of Anthropology, Vancouver, Nb1.722*

842 *Tsaamuus/Snag design. Charles Edenshaw (Haida). c. 1900. Collected at Queen Charlotte Islands, British Columbia. Silver. Height, 1¾" (4.5 cm). University of British Columbia Museum of Anthropology, Vancouver, A8094*

843 *Double eagle. Charles Edenshaw (Haida). c. 1900. Gold. Height, ⅔" (1.7 cm). University of British Columbia Museum of Anthropology, Vancouver, NB1.725*

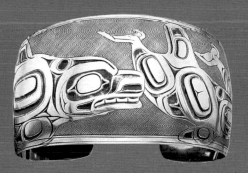

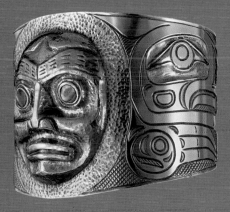

849 *Killer-Whale Family. Richard Adkins (Haida). Sterling silver. 1994. Width, 1½" (3.8 cm). Gallery of Tribal Arts, Vancouver*

850 *Human and eagle. Russell Smith (Kwakwaka'wakw). 1981. Silver with abalone eyes. Height, 1" (2.54 cm). University of British Columbia Museum of Anthropology, Vancouver, NB3 1459*

856 *Weget (raven) bracelet. Philip Janze (Gitksan). 1990. Silver and gold. Height of top bracelet, 1¹⁵⁄₁₆" (5.0 cm). Leona Lattimer Gallery*

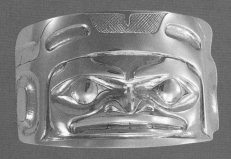

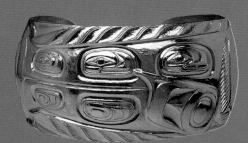

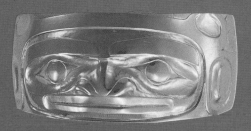

857 *Gold bracelet. Jim Hart (Haida). 1996. Private collection*

Bill Reid (1920–1998), born to a Haida mother and American-German-Scots father, was raised outside the Native culture. It was not until he was in his early twenties that he journeyed to Haida Gwaii (the Queen Charlotte Islands) to visit his maternal grandfather, argillite carver Charles Gladstone, who had lived with Charles Edenshaw as a youth. Through his grandfather, Reid met Haida elders who retained both memories of the old traditions and pride in their ancestry and themselves. Drawing strength from the island's people and landscape, Reid thereafter returned as frequently as possible.

An early broadcasting career preceded any thoughts of art. In 1948, however, Reid began to study and master the techniques of European jewelry and was drawn to Scandinavian industrial design. At the same time, he carefully analyzed old Haida collections stored in museums up and down the coast and in Toronto and New York. With a growing understanding of Haida traditions, Reid explored his own style. He started working on a larger scale in the late 1950s, when he briefly helped Mungo Martin, a Kwakwaka'wakw carver, re-create a totem pole. Reid appreciated equally Martin's abilities as a teacher of the old ways and as a story-teller who sometimes sang when he worked. Shortly thereafter, Reid assisted in the rescue of Haida poles from abandoned villages in Haida Gwaii and worked with others to build a permanent home for the rescued poles, which resulted in the Museum of Anthropology at the University of British Columbia. Together with Bill Holm and Wilson Duff, Reid also decoded the ancient Northwest Coast vocabulary of formlines, helping transform classical Haida forms and their essence into new mediums: boxwood, silkscreen prints, cast gold, and bronze.

Reid's artistic career originated with jewelry. "His monumental sculptures," wrote Robert Bringhurst, have "grown out of objects that you could hold in the palm of your hand" (786, 787). Although Reid's jewelry was initially influenced by nineteenth-century Haida metalwork—particularly that of Charles Edenshaw—his introduction of overlay, repoussé, and casting resulted in the creation of wearable sculpture rather than simply two-dimensional etched designs. While pivotal in rekindling the rich Haida artistic traditions, Reid had an intensely individual vision. As a master of both European techniques and Native art traditions, he was a "mediator not only between two art traditions but also between two worlds." Reid delighted "in making connections" and wanted the Haida to apprehend that "only three generations ago, they lived richer, fuller, more satisfying lives" and "came from *marvelous* men." Above all, Bill Reid was a committed maker of things with quality, in love with and sensitive to materials with which he has a special affinity, be it cedar, argillite, bronze, or gold. "The well-made object was a moral imperative that guided his life," said Doris Shadbolt.

Reid drew upon the richness of Haida oral literature where physical and aesthetic sustenance came primarily from animal sources. Innovations in Reid's work included freeing his animals from the restrictions of the crest and totem poles, allowing them to be seen on their own as three-dimensional sculptures and carved bracelets. Although diagnosed in 1973 with Parkinson's disease, he continued to conceive and create art of monumental power, such as the inspired *Spirit of Haida Gwaii,* a twenty-foot-long bronze canoe sculpture steered by Raven and brimming with potent Haida mythical beings.

"I consider myself one of the most fortunate of men, to have lived at a time when some of the old Haidas and their peers among the Northwest Coast peoples were still alive, and to have had the privilege of knowing them," Reid stated in the introduction to *The Raven Steals The Light,* the book of Haida tales he illustrated and wrote in 1984 with poet Robert Bringhurst. During a profoundly moving, seven-hour memorial service held for Reid on March 24, 1998, at the University of British Columbia Museum of Anthropology, more than sixty speakers, dancers, and singers, including First Nation elders and youth, returned the tribute. Seated among the totems he had rescued from Haida Gwaii in the museum building that houses them today, one was clearly reminded—through a myriad of Native and non-Native perspectives—of Reid's seminal role as a thinker and doer, storyteller and shaman, spokesperson and artist.

"We are indebted to Bill Reid, that incomparable artist," wrote Claude Levi-Strauss, "for having tended and revived a flame that was so close to dying. That is not all; for Bill Reid by his own example and by his teachings has given rise to a prodigious flowering, the results of which the Indian designers, sculptors and goldsmiths of British Columbia offer today to our wondering eyes."

858 *Monumentality and function are beautifully integrated in this hinged gold bracelet with fossil ivory inlay and a representation of* Tsaamuus *or Snag (frequently portrayed as the fearsome Sea Bear). This is the first of Bill Reid's sculptural, three-dimensional bracelets. The owner had requested that Reid make her a "totem pole to wear." 1964. Height, 2⅛" (5.3 cm). Collection Jean MacKay-Fahrni*

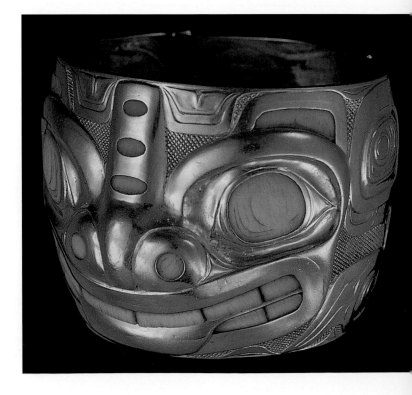

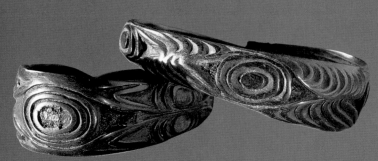

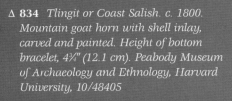

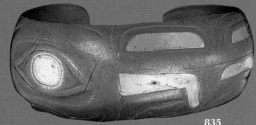

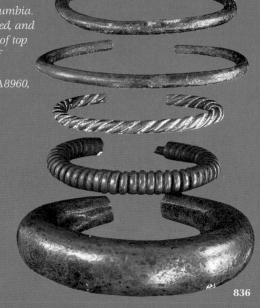

836 *Kwakwaka'wakw. British Columbia. Nineteenth century. Rolled, hammered, and twisted copper bracelets. Diameter of top bracelet, 2¾" (7.0 cm). University of British Columbia Museum of Anthropology, Vancouver, A3827, A8960, A8962, A8961, A87173*

Δ **834** *Tlingit or Coast Salish. c. 1800. Mountain goat horn with shell inlay, carved and painted. Height of bottom bracelet, 4¾" (12.1 cm). Peabody Museum of Archaeology and Ethnology, Harvard University, 10/48405*

835 *Tlingit. c. 1850. Copper with gold inlay. Height, 1³⁄₁₆" (3.0 cm). University of British Columbia Museum of Anthropology, Vancouver, Nb22.97*

835

836

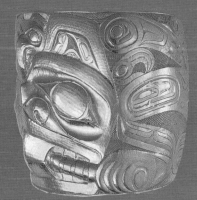

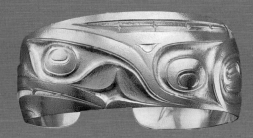

844 *Gold bracelet with beaver and eagle motifs. Bill Reid (Haida). 1970. Height, 2⅜" (6.3 cm). Collection Mrs. V. M. Kovach*

845 Big Thunder, Little Thunder. Robert Davidson (Haida). 1991. 22-karat gold. Height, 1" (2.54 cm). Gallery of Tribal Arts, Vancouver

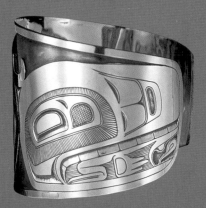

851 *Wolf design. Earl Muldon (Gitksan). 1992. Sterling silver. Height, 2" (5.1 cm). Leona Lattimer Gallery*

852 *Thunderbirds and Tsonokwa. Lloyd Wadhams (Kwakwaka'wakw). c. 1965. Engraved silver. Height, 2" (5.1 cm). University of British Columbia Museum of Anthropology, Vancouver, NB3 1461*

853 *Killer whale. Norman Tait (Nisga'a). 1977. Silver. Height, 2⅛" (5.3 cm). University of British Columbia Museum of Anthropology, Vancouver, NB7.339*

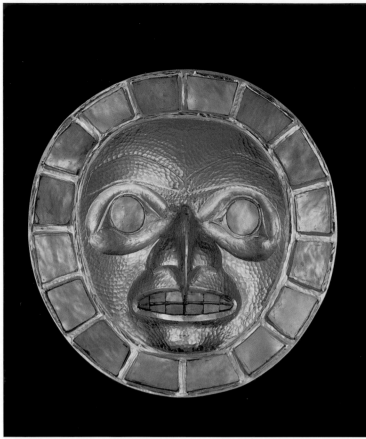

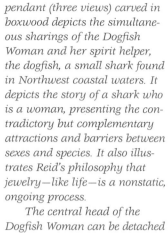

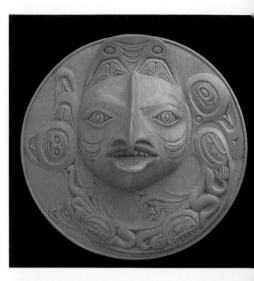

864 *Bill Reid's transformation pendant (three views) carved in boxwood depicts the simultaneous sharings of the Dogfish Woman and her spirit helper, the dogfish, a small shark found in Northwest coastal waters. It depicts the story of a shark who is a woman, presenting the contradictory but complementary attractions and barriers between sexes and species. It also illustrates Reid's philosophy that jewelry—like life—is a nonstatic, ongoing process.*

The central head of the Dogfish Woman can be detached and worn separately while simultaneously revealing her hidden alter ego. She has a high forehead with deep wrinkles, gill slits on her cheeks, sharp triangular teeth, and eyes with elliptical pupils. In addition, her nose has become a beak that curves into her mouth, and her lower lip carries the labret worn by aristocratic Haida women. The hooked beak is a traditional Haida symbol of metamorphosis, probably originating with the hooked nose of spawning salmon. Reid loved boxwood for its fine grain and density, which can take the most detailed and intricate carving. 1982. Diameter, 3 1/16" (8.0 cm); length of mask head, 2 3/16" (5.5 cm). Collection Martine Reid

861

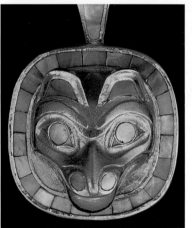

862

863

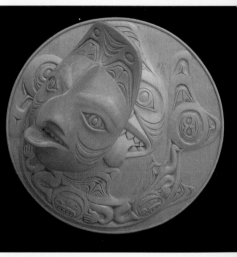

861 *Hawk brooch of gold and abalone shell. The stippled gold surface evokes adzed wood. Bill Reid. 1971. Height, 2 5/16" (5.8 cm). Private collection*

862 *Pendant with wolf design. Bill Reid. 1982. Gold inlaid with California abalone. Height, 4/5" (2.0 cm). Private collection*

863 *Pendant with wolf design. Bill Reid. 1977. Yew wood, painted and inlaid with copper and abalone shell. Length, 3 1/4" (8.3 cm). Collection Martine Reid*

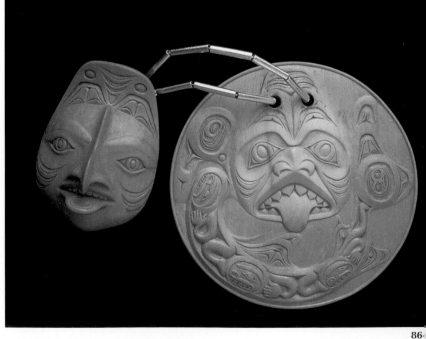

86

Throughout these transitional times, intertribal influences continued to harmonize the coast's culture. A Tongass Tlingit woman, Mrs. Mary Hunt, married into the Kwakwaka'wakw and took her textiles with her. She followed the traditional Chilkat design, abandoning Tlingit "coloration of cream yellow, pale blue, natural, and black in favor of the bright green, yellow, and reds of the highly expressionistic Kwakwaka'wakw mask paints."[59] Such blending of styles was not uncommon.

In the early nineteenth century, the Haida started carving in argillite (a slatelike soft stone), making objects for sale specifically to non-Natives. This new medium departed from classical Northwest Coast styles. Commercially driven argillite objects and design forms ignored traditional compositions of symmetry, containment, and frontality. This shift reverberated through the culture, eventually having an affect on other art forms.[60] At the same time, argillite art objects, carved with woodworking tools, reflected the continuing importance of high quality among the Native craftspeople.[61]

At the end of the nineteenth century, however, Northwest Coast art was at a low point. Both deliberately and unknowingly, traditional life had been displaced. Several major epidemics, including the 1862 smallpox epidemic, had a net effect of decreasing the population by 90 percent. During the late nineteenth century, the government banned potlatches, imprisoning chiefs who disobeyed. But a few resolute tribes carried on their traditions in secret. When the ban was lifted in the 1950s, it took twenty to thirty years—almost a generation—for ceremonial life to rebound.

CONTEMPORARY EXPRESSIONS

The tenacity of the Northwest Coast people in retaining and reviving their culture during two centuries of change and frequent hardship has been impressive. Some traditions were maintained; others wavered but were never entirely lost. Oral history and museum collections have had important roles in harboring and preserving the region's heritage. Several exceptionally gifted Native artists laid the groundwork for today's wealth of talent.

From the 1880s through the first decades of the twentieth century, jewelry techniques and forms were carried forward by Charles Edenshaw (Daxhiigang), a Haida chief and highly original artist working on Haida Gwaii. A fine carver, painter, and jeweler, Edenshaw was born at Skidegate about 1839. His fame comes mainly from his work in nontraditional materials—silver, gold, and argillite—produced for sale to non-Natives, but Native people also coveted his bold, flowing, and detailed engraved bracelet designs, exchanging them along the coast from Alaska to Vancouver Island.[62]

Tlingit adherence to social and clan structure was unbending through the group's history; hence many clan emblems and chiefly items remained intact. The Northwest Coast ceremonial continuum, however, was strongest among the southern Kwakwaka'wakw, where the production of ritual carving and painting never stopped. Artisans Willie Seaweed (1873–1967) and Mungo Martin (1881–1962), both skilled mask carvers and high-ranking chiefs, were fully committed to the potlatch. As orators, singers, composers, actors, and "keepers of knowledge," they preserved the tradition into the 1950s, when the bans were finally repealed. Today, the children and grandchildren of Seaweed and Martin, including Tony Hunt, Richard Hunt, and Kevin Cranmer (795, 809), sustain Northwest Coast ceremonials and the accompanying regalia.[63]

In the 1960s and 1970s, a number of talented young people began to recover their heritage, further awakening and enriching the realm of Northwest Coast art. The work and talents of Bill Reid, in particular, elevated public awareness of Haida art (pages 414–16). While raised in the non-Native world, Reid found among past Haida artists, especially Charles Edenshaw, a source of inspirational artistic depth. Cognizant of his

Don Yeomans (Haida–Cree-Métis) grew up in Prince Rupert and started carving under his Aunt Frieda Diesing. "This is all I ever wanted to do. I never considered that there would be a time when I wouldn't be able to," remarks Yeomans. "I worked in wood for the first ten years; then I branched into design and graphics. Jewelry was for me—and I believe it should be—the last frontier. One lays the foundation for the other."

Yeomans worked with Robert Davidson in the carving of four Haida house posts, and with Bill Reid on *The Spirit of Haida Gwaii*. "Earlier, in 1978 when I wanted to learn about jewelry making, I looked around the community and found Phil Janze and Jerry Marks and began working with them. I made a deal with Phil that I would teach him to carve wood and he would teach me jewelry."

As wood carving has helped his jewelry, he also "learned a lot from the texturing process that comes from the hammering of metal. I transfer that directly into my panel work and door carving to add a different way of catching light, so everything shifts back and forth." Yeomans perceives deep carving in metal as a means of achieving "color" from black to white. Flat metal reflects white; the straight etched line is the lightest tone of gray; the crosshatched area is medium gray; the beveled edge is dark gray; the deepest recesses are black.

Don describes how the artists assist one another. "Generous sharing is a characteristic of the best. If Robert Davidson buys a new tool and it cuts one hour off production and makes a line sharper, he phones me. Bill Reid has been my mentor in another area. He taught me that dealing with people, expressing one's ideas articulately and directly to the people responsible for recording it, makes your vision that much clearer to the general public. I think what makes us all compatible, so open to each other, is an innate sense that what we are doing and what we want to do will be good for the art."

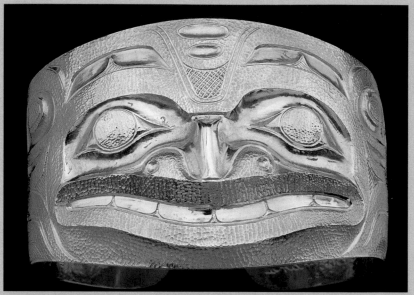

865

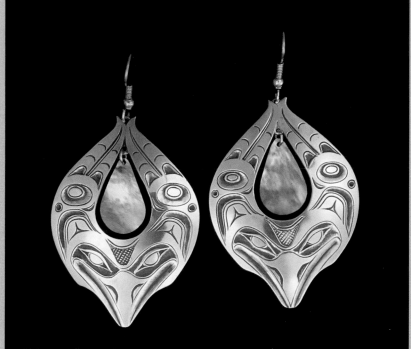

866

865 *Bear bracelet. Don Yeomans. Sterling silver. Height, 2" (5.1 cm). 1994. Gallery of Tribal Arts, Vancouver*

866 Raven Creating Water *(earrings). Don Yeomans. 1994. Silver and abalone. Height, 1¹⁵⁄₁₆" (5.0 cm). Collection Trace Yeomans*

responsibility to pass on the great traditions, Reid was mentor to several apprentices, including Robert Davidson, Jim Hart, and Don Yeomans, all of whom have gained recognition as outstanding carvers and artists.

Although museums initially separated the Northwest Coast people from their art, they have also preserved it. Northwest Coast artists have acknowledged the role of museum collections in their creative and personal development. Robert Davidson, great-grandson of Charles Edenshaw, has said: "I feel the art form would have died completely if nothing had been collected and saved. . . . Artists must have a certain knowledge of how things worked in the past. Museum collections that chart progression can offer knowledge and insights into innovation to the Haida artist of today."[64] For his 1992 Vancouver exhibition, *A Voice from the Inside*, Davidson wrote, "Since the almost complete destruction of our spirit, the disconnection of our values and beliefs, it has been the art that brought us back to our roots."

Appreciative of their heritage and its gifts, coastal artists continue to reaffirm the symbols of Native life. In the late 1960s and early 1970s, Robert Davidson and Bill Reid each carved a pole for their Native villages of Masset and Skidegate, respectively. These were the first poles raised at Haida Gwaii for more than one hundred years. In writing about the experience, Davidson reflects, "People were very cooperative and also very critical because I am an Eagle and carving this totem pole I should also put an Eagle on top of the pole. But I said, 'No, I want this pole to be for everybody; it belongs to the village.' The totem pole became a focal point, a school, a vehicle for knowledge."[65]

Today's potlatches serve a similar role. Although commercially manufactured blankets, towels, socks, napkins, and laundry hampers are typically distributed in lieu of the handmade items of the past, the essence of gift-giving has not been lost.[66] In 1981, to celebrate a Nuu-chah-nulth artist's adoption into the Haida Eagle Society, Robert Davidson hosted a two-day potlatch for more than four hundred people. It required an

Though trained as a printmaker, **Lyle Wilson** (Haisla) now focuses on large sculptural works. "Like sculptures masquerading as masks, I want to do totem poles as sculptures, using mask wood to every possible advantage. In a more traditional totem pole, that may not happen. It's a frontal design, whereas with sculpture you can go 360 degrees around it." Wilson thinks of his bracelets as printing plates transformed into jewelry. He has actually run some through a press.

Wilson continues to draw inspiration from the rugged beauty and experiences of his childhood home in Kitimat, British Columbia. "I used to go out with one of my uncles who was a fisherman, and shortly afterward I decided to put all of this together in a few bracelets. One bracelet [854] is called *Gl'Wa Mountain (Eulachon Fishing)*; it's across from Kitimat village, where the shape of the mountain resembles the dip in a canoe. When the sun sets behind the mountain in a certain place, the people know it's time for the eulachon fish to come. So I put the eulachon in the dip of the mountain as well as the sun. The wavy representation of water— there's not actually water there, you would never see this in Kitimat—nonetheless represents when the sun hits the mountain.

"Anybody who has hunted seal knows what *Nanakwa (Dawn on the Coast)* [855] is all about. Growing up in Kitimat, we used to see a lot of wildlife. One of the most common sights on the water was seals. Here, I've transported the incident back in time to when they had canoes and spears. You have one guy who drives the boat, and one who is the hunter. You come up to the seals, they disappear and then pop up on the other side of the canoe. But they are very curious animals; they never really go that far. So this is the two hunters: one is pointing to where he saw the seal."

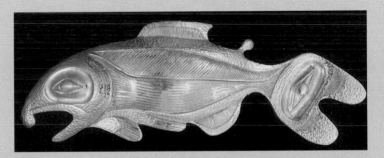

867 *This pin, though quite sculptural, has connections with the artist's printmaking training and was conceived as a balance of the two disciplines. "The back is a fish. The wavy pattern represents water. I fished quite a few years in my life. When I was getting into repoussé, I wanted something simple, strong, and basic. The salmon was it. I did it as a sculptural piece, but I left most of the details missing, so that when I cast it, I could engrave and rework it. Each one of the limited edition of fifteen would be different." Lyle Wilson. 1993. 18-karat gold repoussé, cast and engraved. Length, 2¾" (7.0 cm). University of British Columbia Museum of Anthropology, Vancouver, Nb3.1471*

immense effort, more than a year of organization and work. Along with the exchange of stories, songs, and dances, those involved created and distributed woven spruce-root hats, hand-painted drums, button blankets, and carved silver and gold bracelets. The elders reached into their memories to rekindle the name-giving tradition. "I gave names to all my children and grandchildren," Grace Wilson Dewitt explained. "This is the first time I announced them in public. It just came naturally to do it, just like my weaving when I first started it."[67]

But the artists' most valuable contribution to society is the passing on of knowledge. Whether they instruct future artisans or contribute art imbued with meaning, Northwest Coast artists have taken the lead in revitalizing many of the cultural traditions of their people.

Northwest Coast art—totem poles, blankets, bracelets—is a visual language and, like a spoken one, must be mastered in order to shape narratives. Also representing a *process* of communication, coastal creativity, with its often monumental scale and use of huge trees as material, required cooperative teamwork. An entire community must join forces to raise a pole, build a longhouse, or carve a canoe. Many of the region's artists seem to draw upon an innate articulateness when speaking about their art to those outside the culture, an essential asset for increasing understanding.

The resurgence of the Northwest Coast culture, although rooted in Native efforts, could not have happened without non-Native participation. Scholar Bill Holm's book *Northwest Coast Indian Art: An Analysis of Form* has remained a prime resource for the region's artists in understanding their ancestors' art. Indians and non-Indians worked together to establish 'Ksan, a historic and ceremonial center located at the site of an old Gitksan village. It has since become an important education center, with the initial purpose to teach Native art traditions. Many of today's finest Northwest Coast artists received some training at 'Ksan, and respected gallery owners, such as Leona Lattimer, have for years encouraged high-quality contemporary Northwest Coast Indian art. "I never felt I should buy anything old," she says, "because it wasn't mine—it was theirs."[68]

Perhaps nothing has better kept Northwest Coast artistry alive than the artists' adherence to the term *deeply carved*. In the Haida language, to say something is "deeply carved" is to say it is well made. It is this dedication to quality that has, in large part, maintained the intensity of Northwest Coast art. Literally, cutting deeply into low-relief material intensifies the sculptural depth, "creating . . . tension in addition to that of surface design." On another level, the carved design must "carry the charge" through it. It is the carving that gives life to form, and therefore gives meaning, "empowering [art objects], in short, to be deeply carved into our consciousness." When Bill Reid returned to Skidegate for his grandfather's funeral, he saw two "deeply carved" bracelets by Charles Edenshaw. Their power startled him. "After that," he said, "the world was not really the same."[69]

Doing things well is a central morality for most Northwest Coast artists, and it lies at the heart of their aesthetic beliefs. "One basic quality unites all the works of mankind that speak to us in human, recognizable voices across the barriers of time, culture, and space: the simple quality of being well made," says Bill Reid. "I try to make a well-made object; that is all anyone can do."[70]

While Northwest Coast artists acknowledge and honor the region's complex history, the finest among them believe that art and culture should not dwell in the past but should expand and transform traditional boundaries.[71] The challenge is to find a balance between the classical canons and one's individual voice. Robert Davidson struggles with this issue. "I want to go beyond the constraints imposed on my creativity . . . to go beyond an anthropological understanding of my culture." The artist, like the shaman, must transcend traditional boundaries to offer universal insights. "What I try to do," says Davidson, "is connect people to the world—through art."[72]

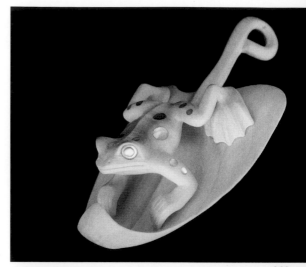

868

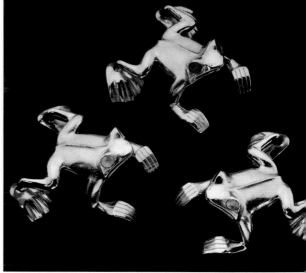

869

868 *Frog on lily-pad pendant. With the ability to live both on land and water, the frog embodies the concept of transformation and is highly revered on the Northwest Coast. Fred Davis (Haida). 1994. Boxwood, abalone. Length, 3¼" (8.3 cm). Gallery of Tribal Arts*

869 *Tree-frog pendants. Fred Davis. 1994. 18-karat gold and sterling silver with abalone inlay. Length, 1½" (3.8 cm). Gallery of Tribal Arts*

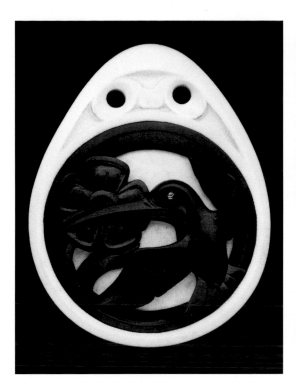

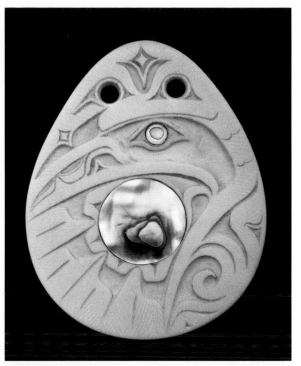

∧ **870** *Hummingbird/Raven pendant, front and reverse views. Fred Davis (Haida). 1994. Argillite, mastodon ivory, abalone. Length, 2½" (6.4 cm). Gallery of Tribal Arts*

871 *Volcano Woman pendant. Fred* ▷ *Davis. 1994. Arbutus wood, turquoise, catlinite, argillite, and black bear fur. Length, 3" (7.6 cm). Gallery of Tribal Arts*

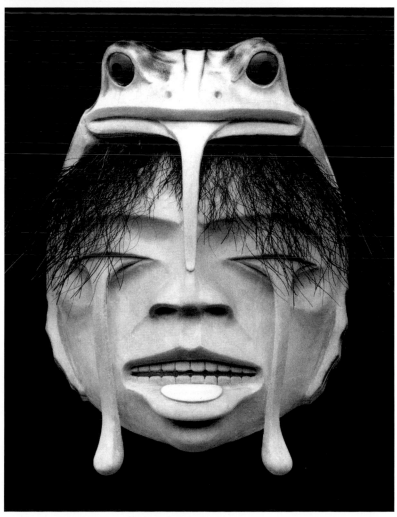

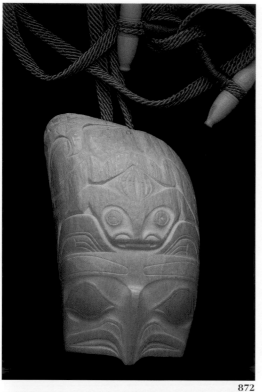

872

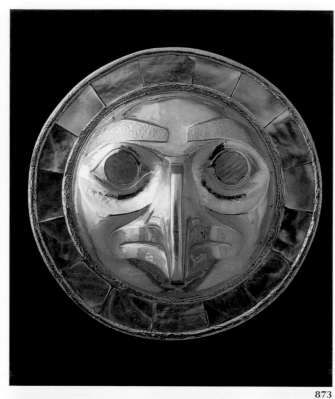

873

872 *Carved ivory pendant of eagle, frog, and raven. Earl Jones (Haida). 1987. Center height, 3⁷⁄₁₆″ (8.7 cm). Collection Yvonne Symons*

873 *A gold repoussé and abalone representation of a Gitksan chief's eagle frontlet, signifying that the wearer is one who "has the ability to see beyond." It can be worn as a brooch or pendant. "This piece is important to me as it was a personal challenge to my technical abilities," states the artist, Philip Janze (Gitksan). 1989. Diameter, 2⅛″ (5.4 cm). Gallery of Tribal Art*

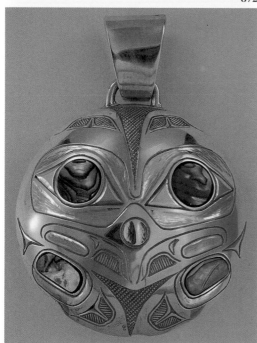

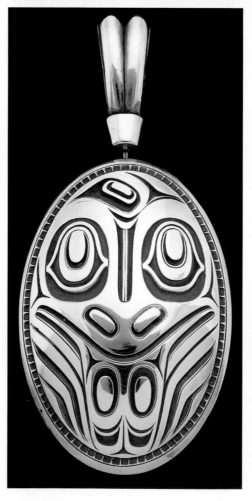

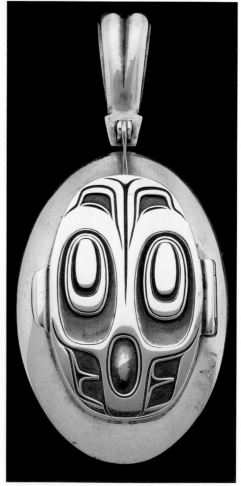

874 *Eagle pendant. Barry Wilson (Haisla). 1994. Silver with abalone shell. Diameter, 2⅜″ (6.0 cm). Leona Lattimer Gallery*

875 *Frog/Mouse–Woman locket, front ▷ and reverse views. Richard Adkins (Haida). 1994. Sterling silver. Length, 2½″ (6.4 cm). Gallery of Tribal Arts*

NORTHWEST COAST DENTALIUM SHELL

Dentalium shells were gathered by the Nuu-chah-nulth in deep coastal waters off the west coast of Vancouver Island. Although dentalia were used in some Northwest Coast ornaments, they were especially valued as trade items throughout the western regions of Native America.

876 *A young Northwest Coast girl wears a dentalium and glass-bead necklace and head-band. Among the Nuu-chah-nulth, this type of adornment was worn by high-status pubescent girls. Ownership, however, was restricted to the families of certain chiefs; permission to wear it required payment by gifts. Its removal was celebrated by a feast and potlatch, after which the girl was considered marriageable. Courtesy of the Library of Congress*

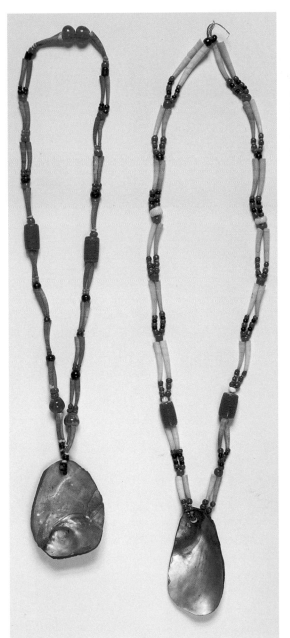

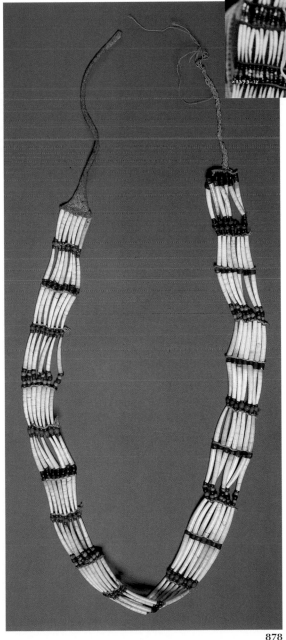

877 *Both of these necklaces were made with dentalium shells strung between groups of red, black, and blue or large carnelian-colored cylindrical glass beads, and abalone-shell pendants.* LEFT: *Lakota, South Dakota.* RIGHT: *Tlingit, Alaska. Late nineteenth–early twentieth century. Longest length, 26⅝" (67.6 cm). The University of Pennsylvania Museum, NA10765, L-84-1464*

878 *Athapaskan dentalium and glass-bead necklace. Dentalia and iron, like trade beads, were prestige items; the more a man owned, the richer and more socially prominent he was. The expensive cornaline d'Aleppo glass trade beads incorporated into this dentalium band also reflected the owner's wealth and social status. The owner of this strand was a wealthy man, indeed, for the band includes more than 140 dentalium and 420 glass trade beads. Collected in Southeast Alaska, 1917. Length, 46" (117.0 cm). The University of Pennsylvania Museum, NA 5774*

877

878

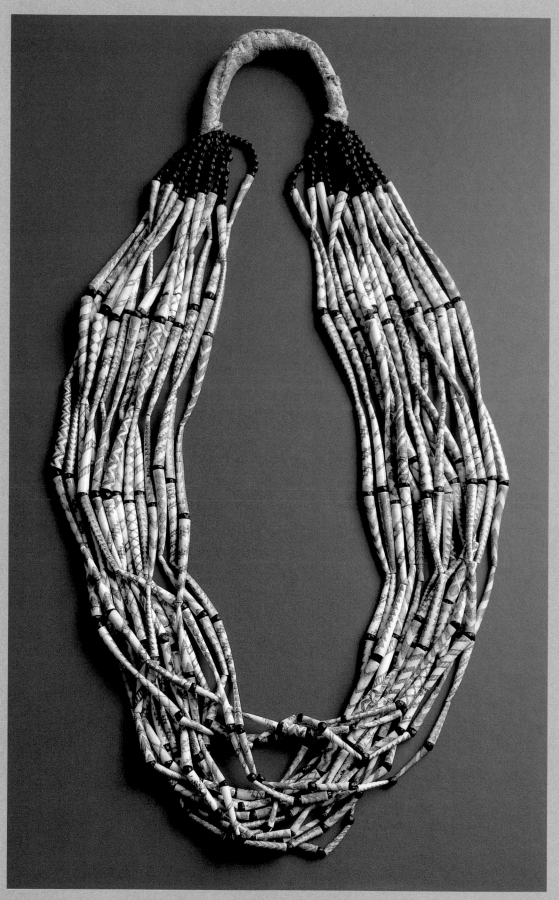

879 A contemporary dentalium-shell and juniper-berry necklace worn for northwestern California ceremonies. Richard McClellan (Hupa-Karuk), spiritual Indian doctor, Jump Dance Medicine Man, and the necklace's creator, explains: "These necklaces—the knowledge and the messages within the shell's carvings—are worn around the heart. And spirituality rests upon your heart. But more important, it's worn around the self, it's worn around who you really are." Crafted over a nineteen-year period, the more than two hundred etched patterns are old Hupa, Karuk, and Yurok designs similar to those on baskets. Patterns are Double Snake, Spider, Flint, Strength, Fire, Snake Nose Piled Up, Crab, Quail, Family, Rattlesnake, and Flying Butterfly. The dentalia were traded into northern California from Vancouver Island. Typical shell length, 2" (5.1 cm). Collection Richard McClellan

REGALIA FROM SKY, LAND, AND SEA
CALIFORNIA

"Sacred ceremonial regalia is the thread that keeps the ancient religious practices alive and serves as a constant reminder that these ceremonies have been given to the Indian people by the Creator. Legend teaches the People that when the Creator formed the world and placed all life forms on earth, he put live Spirits on the earth to help establish an orderly system of natural existence. Before the Spirits were called back to the heavens, they set up the religious ceremonies that would be beneficial in worshipping the Creator and 'keeping the world in balance.' The regalia was carefully selected by the 'immortals' and instructions were given to the People for its use. Thus, the regalia became a tool and a reminder for worship and prayer to the Creator."

—**Wilford Colegrove (Hupa)**, **1997**[1]

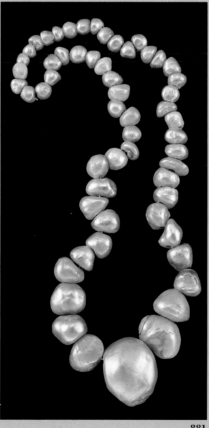

880 *Two strings of incised dentalium-shell money. One is adorned with tiny tufts of red pileated woodpecker feathers; both are wrapped or wound with the skin of a small black and white snake. Such embellishment did not enhance the shell's monetary value but reflected the high regard in which the shells were held. The association of woodpecker, snake, and dentalium may relate to ancient three-layered-world beliefs. Klamath River. Collected 1910. Typical shell length, 2" (5.1 cm). American Museum of Natural History, 50.1/1002, 50.1/2038438*

881 *A precontact Gabrielino pearl necklace collected at San Nicholas Island. Largest pearl diameter, ⅞" (2.2 cm). Natural History Museum of Los Angeles County*

880

881

425

To achieve a life in harmony with their surroundings, the California tribes melded a high regard for the natural world with spiritual and creative experience. The northern wind inspired song; southern rituals celebrated the sun. The ceremonial regalia with which all groups adorned themselves represented the sacred union between humans and nature. "You can't pretend to understand any kind of spirituality without understanding the family members of creation," says Richard McClellan, Hupa-Karuk and Jump Dance Medicine Man. "Each one is just as equal as I am within the spiritual. His life, his radiance, will be the same as mine. We'll dance shoulder to shoulder."[2]

Redheaded woodpecker feathers and dentalium-shell beads were cherished by northern groups; large obsidian blades were proudly displayed at dances. Abalone pendants, olivella shells, and piñon and juniper-berry beads ornamented ceremonial aprons throughout the region; medicine men and women wore feather headdresses and collars. Deer hides gave meaning and drama to ritual. The bounty of sky, earth, and sea was transformed into the adornment of a culture.

For centuries, limited tribal conflict resulted in only subtle changes in daily life and ceremonies. Indians maintained a balance between their needs and respect for their surroundings until the arrival of the Spanish and missionaries in the south in the eighteenth century and the gold miners in the north during the mid-nineteenth century. After a period of decline, the twentieth century has witnessed a resurgence in the song, dance, and regalia of California's first people.

ORIGINS: EARLY NATIVE CULTURES

Approximately eight hundred miles long and two hundred miles wide, the California region is a land of sharp contrasts: the extreme northwest receives more than seventy inches of rainfall annually; the southern desert, fewer than seven. The Klamath and Trinity river systems flow down from Oregon, emptying into the Pacific. Mountain ranges surround the Great Central Valley, separating the valley and Mojave Desert from the coast. The result is a patchwork of distinctive microenvironments. By the time of the arrival of Spanish explorers in the sixteenth century, more than fifty tribes resided in California, with most inhabiting a territory that encompassed several ecologies. California thus provided its early inhabitants with an abundance of resources. No single element held the key to survival, no particularly harsh season threatened subsistence.

California groups chronicle their histories within their current homelands, although archaeologists and linguists suggest a series of initial migrations. Represented altogether in California have been perhaps eighty distinctive languages grouped within six linguistic families, including Algonquian, Nadene (Athapaskan), Penutian, Hokan, Uto-Aztecan, and Yukian. The Hokan-speaking Chumash have lived within the Santa Barbara Channel area for at least seven thousand years. To the northwest, the ancestors of the Karuk (also Hokan speakers) may have been the earliest of the present-day peoples to settle the area. The Wiyots (Algonquian speakers) brought to the Klamath River region an elaborate technology based on fishing, wood carving, and ceremonial regalia. Related Yurok bands, also from the north, perhaps arrived about A.D. 1100, with the Hupa and other Athapaskan groups following about A.D. 1300.[3]

Food was plentiful for California's early hunters and gatherers. Salmon was a staple in the riverine north; marine life—sea mammals and shellfish—was important along the southern coast. Deer roamed freely. Roots and seeds supplemented the diet and were reliable should any stress hinder primary food sources. The richness of natural resources made an agricultural subsistence base unnecessary. California clothing and adornment—whether of abalone, juniper-berry beads, or the cherished

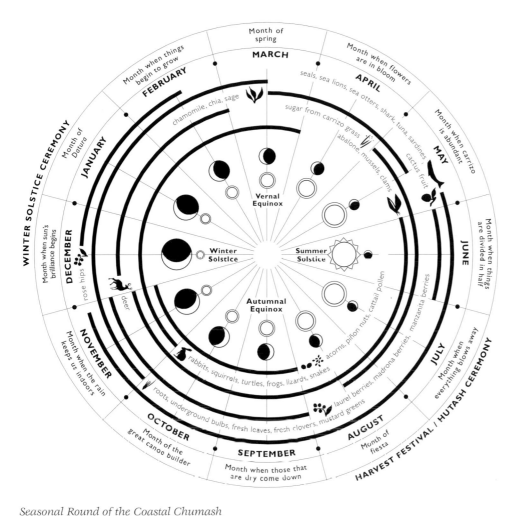

Seasonal Round of the Coastal Chumash

white deerskin—reflected this abundance.

Acorn, the seed of the oak tree (*Quercus*), was revered here as corn was in other areas. It was ground, leached, and cooked into mush. Che-Na-Wah Weitch-Ah-Wah (Lucy Johnson), a Yurok woman, tells a story that suggests the acorn's significance as a source of life: "There was a young Indian girl out with her basket picking acorns. . . . As she was going along, she happened to open one where the kernel was in four parts, which at once became very amusing to her. So she set her basket down, . . . took the outer hull off and made a neat little cradle out of it; then she took the inner skin part and made a nice set of baby clothes. After she did this she took the whole of the kernel and covered it with the clothes and placed it in the cradle that she had made of the hull. After all was finished she looked at it and then put it in the hollow of an oak tree and went on picking her acorns. . . . When it came time for them all to return to their homes, she had forgotten what she had done. One day while she was preparing some acorn flour she heard a noise behind her, someone saying, 'Mother, mother,' and on looking behind her she beheld a little boy, and as soon as she saw him she knew that he was formed from the acorn that she had fixed and left in the hollow oak tree."[4]

Groups within neighboring ecologies shared cultural traits. Northwestern California tribes reflected some of the values of coastal Washington, British Columbia, and Plateau peoples; northeastern societies related to Basin and Plains tribes. From the Colorado River to the southern coast, the Southwest and Basin exerted an influence.[5] Nonetheless, the intimacy each individual had within a specific environment defined the region's identity. It was not unusual to reside within a ten- or fifteen-mile radius from a village and interact with fewer than a hundred people in one's lifetime.[6] This localized vision of the world deepened familiarity with the animals, trees, rivers, hills, and rocks that accompanied one through life.

EARLY LIFEWAYS AND ADORNMENT

Surviving artifacts from inland California Paleo-Indian settlements dating to as early as 9000 B.C. (earlier coastal sites may have been obliterated by rising sea levels) indicate that big-game hunters slowly gave way to seed collectors.[7] Sites in the Santa Barbara and San Francisco Bay–Sacramento–San Joaquin Delta regions provide evidence of extensive exploitation of acorn and marine resources, sophisticated artistry and technology, and an elaborate social structure.

Between 6000 B.C. and 3000 B.C., many of the deceased were buried in red-ocher-sprinkled graves with shell beads and milling stones. On Santa Cruz Island, dwelling

CALIFORNIA

1. CULTURE AREA

The approximate territories of California groups as of about 1800. See also the map of contemporary Native lands, page 551.

2. PRECONTACT AND EARLY-CONTACT TRADE NETWORK

An extensive intertribal exchange system crisscrossed California (see key below). Pacific Coast shells were coveted by many groups in the Basin, Plateau, Southwest, and Plains. In exchange, the Californians received Pueblo pottery, Plains hides, Great Basin obsidian, and Northwest Coast dentalium.

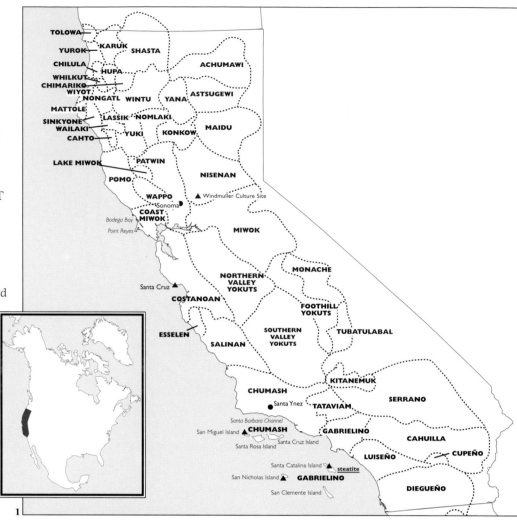

1. Karuk to Shasta: (via Klamath River) dentalium, salt, seaweed, baskets, acorns, canoes, pepperwood gourds
 Shasta to Karuk: obsidian, white deerskins, pine nuts, wolfskins, woodpecker scalps
 Shasta to Karuk, Hupa, Yurok: pine nuts, obsidian blades, juniper beads, Wintu beads
 Karuk, Hupa, Yurok to Shasta: acorns, baskets, dentalium, abalone and other shells
2. Yurok to Hupa and Karuk: redwood canoes
 Hupa to Yurok: acorns, inland foods, skins
 Yurok to Hupa: dried seaweed, salt, surf fish, mussels, dentalium
3. Wintu to Shasta: acorns
 Shasta to Wintu: obsidian, deerskins, pine nuts, dentalium
4. Achumawi middlemen between Wintu, Modoc, and Paiute: shell beads up Pit River; furs down Pit River
5. Wintu to Achumawi: clamshell disks, seeds, acorns, salmon flour
 Achumawi to Wintu: salt
 Southwest Pomo to Miwok: magnesite cylinders
6. Chumash to Miwok via Yokuts: clamshell beads
7. Wintu to Chimariko: red and black obsidian, dentalium
8. Shasta to Achumawi: buckskin, obsidian, dentalium
 Achumawi to Shasta: obsidian
 Shasta to Wintu: buckskin, obsidian, dentalium
 Wintu to Shasta: piñon-nut necklaces, acorns
9. Cahto to Lassik: clamshell disk beads
 Cahto to Coast Yuki: hazelwood bows
 Cahto to Wailaki: baskets, arrows, clothing
 Coast Yuki to Cahto: salt, mussels, seaweed, abalone, surf fish, clamshells, dry kelp
 Wailaki to Cahto: baskets
 Northern Wintu to Cahto: salt
10. Yuki to Pomo and Cahto: mussels, fish, ocean products
 Pomo and Cahto to Yuki: clamshell disks and beads, magne-

site, dentalium, acorns, wild grasses, seeds, salt
Interior tribes to Yuki: flint, obsidian, tobacco
11. North Pomo to Wappo: bows and yellowhammer headbands, magnesite cylinders
 Pomo to Wappo: clamshell disk beads, baskets
12. Pomo trade cycle: between Northern, Central, Southeastern and Coastal Pomo: fish, salt cakes, basketry materials, bows and arrows, arrowheads, obsidian blades, shells, clamshell disk beads, magnesite cylinders, snares, belts, robes, feathers, skins
13. Nomlaki trade cycle: River Nomlaki to Hill Nomlaki: fish
 Hill Nomlaki to River Nomlaki: seeds, animals
 Yuki to Nomlaki: salt
14. Nomlaki middlemen: shells from Bay region for skins, obsidian, yew wood for bows from north
15. Patwin to Nomlaki: salmon, river otter pelts, game animals
 Nomlaki to Patwin: shell beads, bows
16. Pomo to Patwin: salt, manganese beads, shells
17. Yana to Atsugewi: buckeye firedrills, deer hides, dentalium, salt, buckskin
 Atsugewi to Yana: arrows, buckskin, wildcat quivers, woodpecker scalps
18. Yana to Wintu: salt
 Wintu and Maidu to Yana: clamshell disk beads, magnesite cylinders, dentalium shells from Wintu
19. Yana to Nomlaki: baskets
20. Achumawi and Shasta to Yana: obsidian
21. Konkow to Maidu and Wintu: arrows, bows, deerhides, food
 Neighboring groups to Konkow: shell beads, pine nuts, salmon
 Wintu to Konkow: abalone shell, dentalium
 Maidu to Achumawi: bows, deerskins
 Achumawi to Maidu: shell beads, obsidian, green pigment
22. Nisenan trade cycle: Hill Nisenan to valley Nisenan: black oak acorns, pine nuts, manzanita berries, skins, bows, bow wood

Valley Nisenan to hill Nisenan: fish, roots, grasses, shells, beads, salt, feathers
23. To Nisenan from west: shell, magnesite, steatite, obsidian
 To Nisenan from east: obsidian
 To Nisenan from Patwin and Maidu: bead necklaces of steatite and clamshell, whole olivella shells, abalone-shell pendants
24. Costanoan to Eastern Miwok: salt, abalone shells, baskets
 Costanoan to Sierra Miwok: olivella shells
25. Costanoan to Yokuts: mussels, abalone shells, salt, dried abalone
26. Coast Miwok to Pomo: clamshell.
 Pomo to Coast Miwok: magnesite cylinders
27. Tubatulabal to coast: piñon nuts, tobacco
 Coast to Tubatulabal: clamshell disks
28. Yokuts trade cycle: fish for acorns from tribes to east; coiled baskets from Plains Yokuts; marine shells, especially olivella and abalone, for necklaces from coastal peoples; obsidian
29. Northern Yokuts to Miwok: dog pups
 Miwok to Northern Yokuts: baskets, bows, arrows
30. Costanoans to Northern Yokuts: mussel and abalone shells
 Yokuts to Costanoans: piñon nuts
31. Monache to Foothill Yokuts: rabbitskin blankets
32. Yokuts to Salinans: fish, saltgrass salt, obsidian, seeds, lake fish, tanned antelope and deerskins
 Salinans to Yokuts: shell beads, unworked shell
33. Chumash to Salinans: univalve columella ornaments, wooden dishes, steatite vessels
 Salinans to Chumash: deerskins, acorns, grasshoppers
34. Eastern Coastal Chumash to Yokuts: white pigment, shell beads, Pismo clam, abalone, olivella, limpet, periwinkle, and cowrie shells, dried sea urchins, starfish
 Yokuts to Eastern Coastal Chumash: black pigment, antelope and elk skins, obsidian, salt, steatite beads, seeds, herbs, pottery

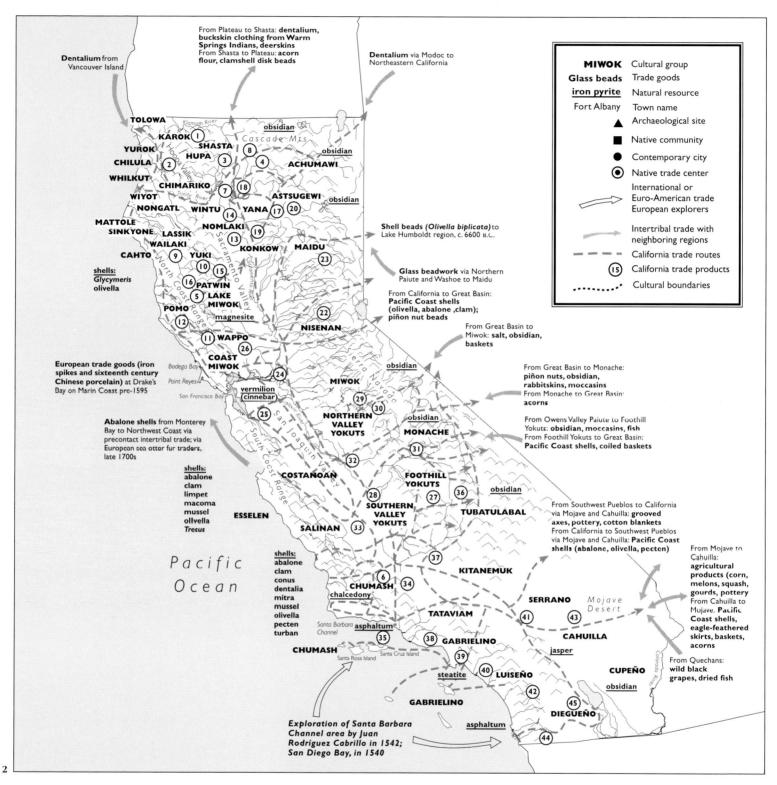

From Plateau to Shasta: **dentalium,
buckskin clothing from Warm
Springs Indians, deerskins**
From Shasta to Plateau: **acorn
flour, clamshell disk beads**

Dentalium via Modoc to
Northeastern California

Dentalium from
Vancouver Island

TOLOWA
KAROK ①
YUROK
SHASTA
CHILULA
HUPA ③
WHILKUT
CHIMARIKO ⑦ ⑱
WIYOT
NONGATL
WINTU ⑭ YANA ⑰ ⑳
MATTOLE
SINKYONE
NOMLAKI ⑲
LASSIK
WAILAKI ⑬ KONKOW
CAHTO
⑨ YUKI
⑩ ⑮
⑯ PATWIN
⑤ LAKE
MIWOK
POMO
⑫
⑪ WAPPO
⑳ COAST
MIWOK

Klamath River
Cascade Mts.
obsidian
obsidian
ACHUMAWI ④
⑧
obsidian
ASTSUGEWI
obsidian
MAIDU ㉓
NISENAN ㉒
magnesite

Shell beads (*Olivella biplicata*) to
Lake Humboldt region, c. 6600 B.C.

Glass beadwork via Northern
Paiute and Washoe to Maidu

From California to Great Basin:
**Pacific Coast shells
(olivella, abalone ,clam);
piñon nut beads**

From Great Basin to
Miwok: **salt, obsidian,
baskets**

From Great Basin to Monache:
**piñon nuts, obsidian,
rabbitskins, moccasins**
From Monache to Great Basin:
acorns

From Owens Valley Paiute to Foothill
Yokuts: **obsidian, moccasins, fish**
From Foothill Yokuts to Great Basin:
Pacific Coast shells, coiled baskets

shells:
Glycymeris
olivella

European trade goods (iron
spikes and sixteenth century
Chinese porcelain) at Drake's
Bay on Marin Coast pre-1595

Bodega Bay
Point Reyes
San Francisco Bay
vermilion
(cinnebar)

Abalone shells from Monterey
Bay to Northwest Coast via
precontact intertribal trade; via
European sea otter fur traders,
late 1700s

shells:
abalone
clam
limpet
macoma
mussel
olivella
Tresus

ESSELEN

shells:
abalone
clam
conus
dentalia
mitra
mussel
olivella
pecten
turban

⑳
MIWOK
㉙
㉚ obsidian
NORTHERN
VALLEY
YOKUTS
MONACHE
㉛
㉝
COSTANOAN
FOOTHILL
YOKUTS
㉘
SOUTHERN
VALLEY
YOKUTS ㉗ ㊱
SALINAN
㉝ TUBATULABAL
obsidian
㊲

Pacific
Ocean

⑥
CHUMASH
chalcedony
㉞
KITANEMUK

Santa Barbara
Channel
asphaltum
㉟
TATAVIAM
㊳ GABRIELINO

CHUMASH
Santa Rosa Island
Santa Cruz Island
㊴
steatite
㊵ LUISEÑO
㊷

GABRIELINO

From Southwest Pueblos to California
via Mojave and Cahuilla: **grooved
axes, pottery, cotton blankets**
From California to Southwest Pueblos
via Mojave and Cahuilla: **Pacific Coast
shells (abalone, olivella, pecten)**

SERRANO
Mojave
Desert
㊶ ㊸
CAHUILLA
jasper
CUPEÑO
obsidian
㊺
DIEGUEÑO
㊹
㊷

From Mojave to
Cahuilla:
**agricultural
products (corn,
melons, squash,
gourds, pottery**
From Cahuilla to
Mojave. Pacific
Coast shells,
eagle-feathered
skirts, baskets,
acorns**

From Quechans:
**wild black
grapes, dried fish**

Colorado River

asphaltum

Exploration of Santa Barbara
Channel area by Juan
Rodríguez Cabrillo in 1542;
San Diego Bay, in 1540

MIWOK Cultural group
Glass beads Trade goods
iron pyrite Natural resource
Fort Albany Town name
▲ Archaeological site
■ Native community
● Contemporary city
◉ Native trade center

 International or
Euro-American trade
European explorers

Intertribal trade with
neighboring regions

California trade routes

⑮ California trade products

Cultural boundaries

2

35. Eastern Coastal Chumash to Island Chumash: seeds,
acorns, bows and arrows
Island Chumash to Eastern Coastal Chumash: chipped
implements, fish-bone beads, baskets, basaltic rock
36. Eastern Coastal Chumash to Tubatulabal: asphaltum, shell
ornaments, steatite, fish
Tubatulabal to Eastern Coastal Chumash: piñon nuts
37. Eastern Coastal Chumash to Kitanemuk: wooden and shell
inlaid vessels
38. To Chumash from Santa Catalina Island via Gabrielino:
steatite, steatite pots, beads and ornaments

39. Inland Serranos to coastal Gabrielinos: acorns, seeds,
obsidian, deerskins
Coastal Gabrielinos to inland Serranos: shell beads, dried
fish, sea otter pelts, salt, steatite
40. Steatite from Santa Catalina Island to Chumash, Yokuts,
Ipai-Tipais, Luiseño, Serrano and via Chumash to Tubatulabal
41. Cahuilla from Gabrielino: steatite, asphaltum, shell beads
Gabrielino from Cahuilla: food products, furs, hides, obsidian,
salt
Exchange of rituals and songs
42. Cahuilla from Luiseño: tourmaline

43. Cahuilla from Serranos: Joshua tree blossoms
44. Coastal Tipais to Ipais: salt, dried seafood, dried greens,
abalone shells
Ipais to coastal Tipais: inland acorns, agave, mesquite beans,
gourds
45. Tipais trade loop: garden produce, fresh fish, granite,
steatite, red and black minerals, yucca fiber, agave fiber, jun-
cus rushes, clamshells, abalone, eagle feathers, carrying nets,
basketry caps, winnowing trays, seed flour, acorn flour,
processed agave

sites dating from 5500 B.C. to 4800 B.C. contained bone pendants, olivella beads, abalone ornaments, and wicker baskets. In the Sacramento River valley, the Windmiller culture's grave goods (c. 2200–2000 B.C.) included shell necklaces, pendants, bone whistles, and quartz crystals. Both Sacramento Valley and San Francisco Bay groups left olivella and abalone shells that had been pierced for beads and ground into similar rectangular-shaped pendants.[8]

From 2000 B.C. to A.D. 500, southern coastal economies were increasingly based on shellfish; the presence of basket mortars (grinding tools) suggests the use of acorns for food. Long bone tubes with finely incised decorations, from c. A.D. 300, are believed to be drinking tubes used by some groups in connection with women's puberty rites. From A.D. 500 to 1500, southern ceremonial life intensified, objects of shell were abundant, and, late in the sequence, limited amounts of pottery appeared. Similarly, as the populations of central California's coastal and valley region grew, so did the range of crafted objects, including coiled basketry, bone awls, and a great variety of beautifully made abalone beads and ornaments.[9]

California's generally mild climate required minimal daily clothing under most circumstances. In warmer seasons, men wrapped folded deerskin around their hips or went without garments. Chumash men frequently wore nothing except a netted belt or fiber string from which they could suspend tools and food. Women wore short aprons of twine or buckskin slit into fringes and often adorned with berries or shells. A second, broader fringed skirt was tied from behind. In winter, men put on buckskin leggings, while both sexes added capes of grass fiber, rabbit skin, bear, deerskin, or, if wealthy, sea-otter fur. Unique materials were used for some clothing. A San Nicholas Island Chumash woman sewed cormorant bird skins together to form a full-length sleeveless gown. Seagull-skin capes were fastened with abalone, whale, and bird-bone and wooden toggles. Chumash commoners wore tule or sea-grass skirts with small globular pieces of asphaltum placed onto the bottom end of the tule to weigh it down and keep the skirt hanging correctly in the wind.[10]

Moccasins were worn by northerners for hunting or travel; southern travelers put on sandals. Otherwise, the fashion was to go barefoot. Finely woven basketry caps—created within a well-developed basketry tradition—were far more common among northern than southern women, and not worn by central Pomo or most Maidu groups.[11] Basket caps protected the head from the sun and cushioned it under heavy burdens when used with a carrying strap or tumpline.

Everyday adornment was spare, although some people embellished their garments and themselves. Wealthy Yurok women sewed abalone and clamshells onto their skirts; most Yurok women tattooed their chins to avoid looking like men when they grew old.[12] Pomo women wore etched bird bones with feathers as ear ornaments. Southern women decorated skin skirts with a variety of shells and often wore necklaces of abalone, olivella, and clamshell. Elaborate clothing, displayed at ceremonies, included a great variety of headdresses, cloaks, capes, and dance skirts. Many adorned their bodies with paint and beautifully crafted ornaments of various materials.[13]

An extensive trade network existed throughout precontact California. As early as 2500 B.C., Sacramento delta groups were acquiring olivella and abalone shells and ornaments from the Pacific, as well as obsidian from coastal-range sources and the eastern Sierras. Dentalium was passed southward from Vancouver Island. The Chumash, especially, traded widely, venturing far into the Southwest.[14]

By A.D. 1100, the Chumash had developed a monetary system based on the use of olivella or clamshell disks as currency, an uncommon practice in most Indian societies. The standard unit of value in the Chumash nation was a string of small white

882 *Precontact male and female pottery effigy figures wearing a rabbit-skin fur blanket (right) and grass skirt and necklace (left). Similar clothing was worn in the region through the early twentieth century (see 908, 1101). Collected at Shasta County, California, n.d. Length of left figure, 2½" (6.3 cm). American Museum of Natural History, DM 858, 859*

shell beads that could be wrapped once around the hand. These "money beads" were bartered for food and other commodities in southern and central regions. The Pomo used as currency small dentalia as well as clamshells from Bodega Bay. Farther north, people relied less on shell money, reserving dentalium-shell beads for people of special status or inherited rank.[15]

Yoimut, a Yokuts woman born in 1855, described long-established trade rituals between the inland Yokuts and the coastal Chumash or Salinan at Poso Chana, located somewhere in present-day southern San Luis Obispo County:

The bead and seashell traders from the coast met the Tachi traders at Poso Chana. . . . The people who wanted to trade carried their things in baskets on their backs. They had to have their Teah (chief) with them. When they came up to trade they marched up in a straight line from each side. The Teah was in front. When the two parties got close to each other they all took hold of the basket straps at the sides of their heads and swung from side to side, singing: Ho-hoo-hoo Yoo-nah (sung five times). . . . When the song was done each took his basket down and spread his things on the ground in front of him. . . . Then the trade started. . . . It was all done by rules. Kahnte told me that his people used to trade off fish, kots (obsidian), salt grass, salt and some seeds. Sometimes they traded kuts (soapstone) beads. They brought back shell beads and seashells.[16]

Glass beads, brought in by the Europeans, supplemented some previous beads of organic materials but did not significantly alter aesthetics. Although their use never took hold in the north, trade beads were more quickly incorporated into Chumash ornaments in the south.[17] The majority of California's trade beads are faceted clear and translucent beads of crystal, amber, blue and green glass, and *cornaline d'Aleppo* with both yellow and green interiors. The beads were both used for necklaces and attached to clothing or garment fringes.[18]

During the early sixteenth century, a few Spanish explorers entered California from Mexico. Extended contact, however, did not begin until the Mission of San Diego was built in 1769 to convert the Indians to Christianity and protect Spain's political interests. Eventually, twenty other coastal missions, from San Diego to Sonoma, were constructed, disrupting ancient ways of life. With the Spanish-Mexican colonists weakened after the Mexican revolution of 1832, their devastating impact on the coastal and several central tribes had affected a relatively contained area: most of California's northeastern Indian groups were still intact. By 1848, gold was discovered in the north, and California's peaceful times ceased. Miners stormed the territory, intruding on regions that had had little, if any, previous contact with outsiders. Within a short period, 1845 to 1865, many California tribes were decimated. The Indian population in California was reduced from an estimated 310,000 before Spanish contact to about 20,000 by 1900.[19]

Yet, numerous indigenous rituals and art forms survived the traumas of the colonial period, the gold rush, and its catastrophic aftermath. In northwestern California, where the use of glass and other trade items were limited, basket, feather, and shell regalia has changed only gradually over the past two and a half centuries.

RELIGION AND RITUALS

California tribes shared a basic cosmology with other Native Americans, including belief in a universal spiritual power, dream helpers, shamanism, and the perception of multiple worlds. The major religious systems of native California—the Kuksu and Toloache cults, and the World Renewal ritual—had strong roots in shamanism.

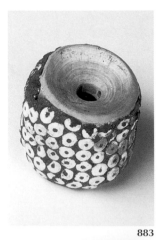

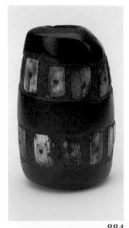

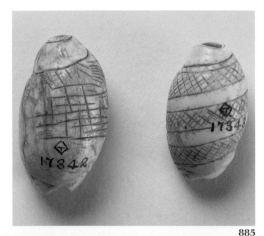

883

884

885

883 *A Chumash bead made from two fish vertebrae joined by asphaltum and decorated with tiny shell beads. Asphaltum was indispensable to the Chumash. Found in natural seeps along the Santa Barbara channel, it was used for caulking canoes, inlaying shell, and lining tightly woven water-carrying baskets. Collected before 1879. Point Magic, California. Diameter, 1½" (3.8 cm). American Museum of Natural History, T12724*

884 *Black stone bead with shell inlays held in place by asphaltum. Chumash. Length, 1½" (3.8 cm). Private collection*

885 *Precontact olivella-shell beads with asphaltum emphasizing etched cross-line patterns. Gabrielino. Collected on San Nicholas Island, 1883.* RIGHT: *Length, 1³⁄₁₆" (3.0 cm). American Museum of Natural History, T17343, T17342*

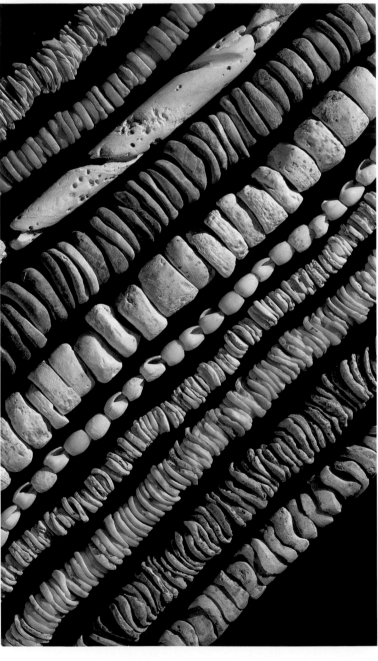

886 *Clamshell beads with incised and asphaltum-filled patterns. Probably precontact mainland Chumash. Typical bead width, ¼" (0.6 cm). Natural History Museum of Los Angeles County, A5600/135*

887 *Shell beads were worn as both money and adornment by the Chumash and Gabrielino. San Nicholas and San Clemente Island. Precontact era.* FROM TOP: *Abalone with red ocher; red abalone; columella; mussel; clam. The last five strands are olivella. The perforations on the long columella beads were drilled into the center from each side using sea-lion or seal whiskers and sand. Columella, largest bead length, 2⁷⁄₁₆" (6.2 cm). National History Museum of Los Angeles County, (from top) A1664/113, 4616/38, A5600/130, A5600/144, A1664/105, A1664/109, A5600/71, unnumbered, A5600/73, A5600/65*

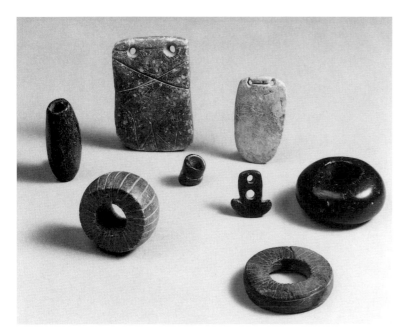

888 *Large, beautifully polished stone beads and pendants were cherished by the early southern California tribes. Height of top pendant, 3¼" (8.3 cm). The Southwest Museum, Los Angeles County, 615-G-9482, 186.229:733-G-21*

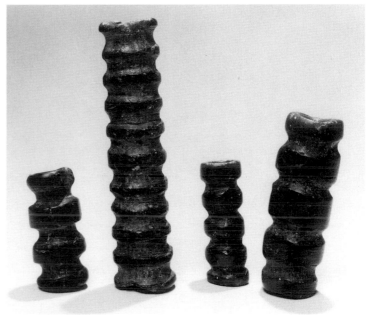

889 *Precontact grooved steatite beads, biconically drilled and worked with long, needlelike chalcedony drills. Chumash. Collected at San Miguel Island. Tallest, 2⅛" (5.3 cm). Natural History Museum of Los Angeles County*

890 *These fish vertebrae (possibly shark) may be Gabrielino game pieces rather than beads. Collected at San Nicholas Island. Diameters, ¾" to 1⅜" (2.0 to 3.5 cm). Natural History Museum of Los Angeles County, A5600*

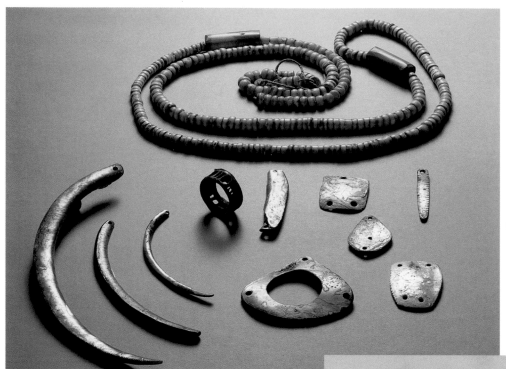

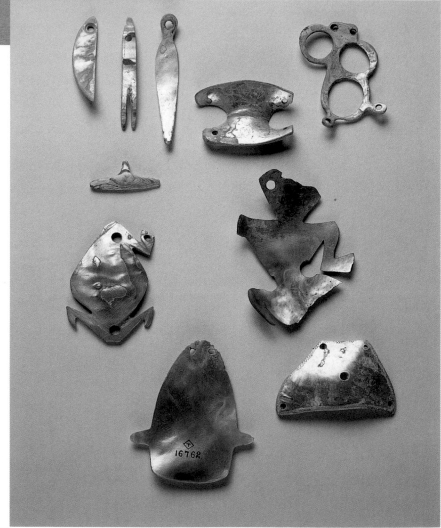

△ **891** *Clamshell beads (top), a fish-vertebra ring (middle row, left), abalone pendants (middle right), and abalone head scratchers (left). The value of clamshell beads varied regionally, depending on the site of the raw material, the artisan who worked it, and the route of transport. The clamshell necklace, made by the Pomo of northern coastal California, is adorned with one tubular-shaped magnesite stone bead, referred to as "gold" in comparison to the plentiful clamshells. Too valuable to be sold by the string, magnesite beads were inserted like jewels on shell-bead necklaces.*

Abalone, scarce on the mainland, was coveted as finished ornament. On the southern islands, however, where abalone was the chief food, its shell was put to more practical use. Long curved pieces made from the edge of the shell were young girls' head scratchers in puberty ceremonies; Santa Rosa Islanders wore sharpened abalone around the neck for use as sweat scrapers. Length of far-left object, 5¹³⁄₁₆" (14.8 cm). The Southwest Museum, Los Angeles

∇ **892** *This collection of precontact Chumash abalone pendants in luminous blues and greens—some shaped as whales and small fish—embodies the sea's bounty. The items were probably personal talismans. All collected in Santa Barbara County, 1880. Length of bottom whale, 2¹³⁄₁₆" (5.5 cm). American Museum of Natural History*

434 C A L I F O R N I A

The Ghost Dance, Dreamer or Bole-Maru religion, and the Shaker Church developed after contact, essentially in response to changing socioeconomic conditions and frequently under the guidance of Native shamans or spiritual leaders.[20]

California's World Renewal ritual has unique variations but is clearly part of a larger belief system extending into Alaska.[21] In a ceremony somewhat similar to the Northwest Coast potlatch, California tribes acquired and exchanged resources in ritual feasts in order to renew the established world and another round of seasons. A good life was balanced between the spiritual and the earthly; renewal rites made this possible. The main annual ceremony, the White Deerskin Dance, involved kinetic singing, dancing, and elaborate displays of sacred regalia.

Although a secret male society, the Kuksu cult stressed curing rituals or rites of well-being for the entire group.[22] Thus, World Renewal rites also played a part in Kuksu ritual. In central California, Kuksu World Renewal ceremonies were shared by the Pomo, Maidu, and Wintu.

Toloache, based upon ingesting jimsonweed (*Datura stramonium*), a hallucinogen that produces visions enhanced by fasting, was practiced in south-central and southern California. The correspondence of the Toloache religion with southern California's elaborated polychrome rock implies a possible connection. The usual dance outfit worn during their individualistic spiritual dream ceremonies was a net skirt with eagle feathers. Its simplicity, compared to the group-oriented northwestern regalia, may be because the dancers were focused inward on their personal visions.[23]

Annual mourning ceremonies were held throughout California. In the south, this most sacred religious rite drew together many families. Its dual purpose was to end the grieving period and ensure that the deceased would not return to inflict illness or harm on the living. The dead, whose spirits hovered nearby, were important to the living, whom they advised from the underworld. Many believed that their messages came in dreams carried by rattlesnakes, which they considered underground beings. Objects with rattlesnake designs (frequently symbolic of dream prophecy) were usually burned at the departed relative's honoring feast.[24]

Among the northern Maidu, the mourning ceremony was held on or near a cemetery (burning ground). Mourners applied to overseers for a string of beads. Wearing the strings as necklaces permitted them to grieve. The rite, performed around a central fire, included burning extensive property and food and wailing and singing to honor the dead. Games, gambling, and feasting followed. Those with bead strings were entitled to mourn ("cry") for a period of five years, after which the string was burned.[25]

CALIFORNIA'S REGIONAL REGALIA

Regalia's place at the core of tribal identity is evident in origin stories. The Yurok say: "The first living thing placed upon the earth was the white deer. . . . This is why [it] is so sacred to their hearts and they use the skin as an emblem of purity in one of their greatest festivals . . . the White Deerskin Dance which reenacts the creation of the world."[26] In the Hupa's White Deerskin Dance, blades carved of obsidian (volcanic rock associated with water) are carried by performers called *rock packers* before a line of dancers. Admiring a blade, one says, "It shines just like water." According to Julian Lang (Karuk), "To own and to dance a matched pair of blades means one is a *Yaas'ara*, a rich person. The name is the same word used when referring to the first Human Beings."[27]

The ancient spiritual traditions of Native Americans do not always translate easily into non-Native words, and misconceptions can occur. This is particularly true for the word *wealth*. "When discussing our creation and religious practices, the subject touches

the core of our being and touches our soul," explains Wilford Colegrove, a Hupa spiritual leader and dance maker. "Connotations that [northern California Native] people strive for accumulation thus indicating a competitive society was not the case."[28]

"Regalia means wealth, but not the Wall Street wealth of today," writes Julian Lang (Karuk). "Instead we mean a wealth that is of the 'other world,' the spirit world. Regalia is not to be traded or sold like stocks and bonds, and shouldn't be regarded as just a valuable collectible. . . . The wealth system of northwestern California brings together the earth, nature and spiritual enlightenment. . . . Among Klamath River people, each element [of regalia] has its associated creation story and gender affinity. . . . It is through the stories that we learn whether certain wealth is of the air, the water, the earth or fire."[29] Karuk beginnings are recounted in the legend of Pithváva, Big Dentalium, related by Lang:

Pithváva was born alone in a lake. When he grew up, he contemplated the future of the First People to come. "What will they have as money?". . . He then created the whole range of "Indian treasure" [smaller dentalia] to be used by the future First People. He created the way dentalia-money would look, how it would be stored, and what it would mean to the First People. He went on to create other forms of wealth, and then, from his hair he created the First People as well!

Lang continues: "Pithváva's story reveals the basis of the affinity between northwestern California Indian people and the objects of wealth: the fúrax [the woodpecker's scarlet crests], obsidian, white deerskins and dentalia. They are us."[30]

Northwest

Three northwestern tribes—the Yurok, Karuk, and Hupa—benefited from generous Pacific coastal and river environments. The Yurok lived in villages on the coast and the Klamath River; the Karuk resided along the middle course of the Klamath River and tributary streams. The Hupa inhabited the six-mile Hoopa Valley, along the lower course of the Trinity River. Language expressed the centrality of rivers in northern tribal life. The Yurok perceived direction in terms of the flow of water: east was designated as "upstream," from the speaker's standpoint. The name Yurok means "downstream" in the Karuk's language—the Yurok live down the Klamath River from the Karuk.[31]

Despite linguistic differences—the Hupa are Athapaskan speakers, the Yurok language is Algonquian, and the Karuk speak Hokan—the three tribes had comparable customs and values. Their trading area—mainly the river routes—provided early interaction. They joined each other's ceremonies, shared shamanistic or medicine practices, traded goods, and had similar priorities regarding abundance and gifting. As the southernmost extension of the status-conscious cultures of British Columbia and Alaska, their societies were distinguished by rank and inherited privilege. As on the Northwest Coast, much of the Californians' subsistence was derived from fishing, and artistic skills were highly developed.[32] Women created intricate basketry; men carved wood and horn. The medicine woman, or "doctress," held power through the control of "pains." Adorned in special feathered regalia (910), she often smoked a pipe and dislodged a pain by sucking it out. Afterward, payment was expected, to appease both the spirits and the medicine woman.

Dentalium, an important part of northern California's regalia, was also the most revered item of exchange. Prosperous Yurok men paid large sums for brides, which enhanced personal standing and eventually that of their children.[33] Gambling for dentalia and other treasures was the favorite pastime of many Karuk men. Hupa regalia

DENTALIUM SHELL

For the northern tribes, all other shells were insignificant compared to dentalium, which conveyed status and prestige. Among the Karuk, dentalium shell was regarded as a deity, an "almost-creator." A Yurok's mind was always on the shell, envisioning it while staring at a river or collecting wood for the sweat house. Some mothers hung dentalia from a baby's basket to ensure abundance in the child's life. Collected by the Indians of Vancouver Island, dentalium was passed down the coasts of Washington and Oregon and then traveled inland along the Klamath River. Anthropologist Alfred L. Kroeber related in the early 1900s: "Since the direction of these sources is 'downstream' to them, they speak in their traditions of the shells living at the downstream and upstream ends of the world, where strange but enviable peoples live who suck the flesh of the univalves."

Value is determined by a shell's length and quality. A fine-grade dentalium shell was typically 2¼" inches (5.7 cm), with twelve to a string. Similar sizes were kept on strings about 27½" inches long (69.9 cm), which, of course, frequently varied. A redwood dugout canoe cost one string of dentalia; a fishing place, five to ten strings. Size was often measured against marks tattooed on the inside of a man's forearm. Tattooed men became known as "Indian bankers."

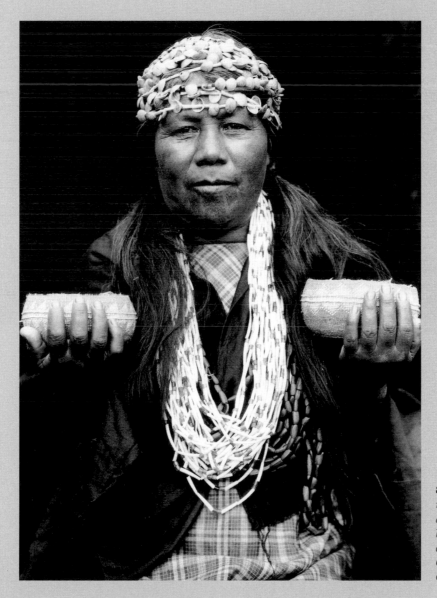

893 *A Hupa female shaman wears shell headbands and dentalium-shell necklaces and holds two baskets. Photographed c. 1923 by Edward S. Curtis. Courtesy of the Library of Congress*

was inherited—owned and cared for by community dance makers. It changed hands only as a bride price, a payment to a shaman, or an indemnity for an insult or killing.[34]

The amount of work involved in constructing the regalia was staggering: feathers were collected, shells and seeds gathered, bear grass harvested. Then all materials were treated and prepared. There was a continual cycle of trading, accumulating, tanning, sewing, weaving, and braiding. All was accomplished with great care and quality.[35] "It takes about five years to build a dress, and about five or six years to gather the material for it," mentions Loren Bommelyn, dressmaker for the Tolowa dances.[36] Woodpecker scalp feathers were worked into headdresses and used as regalia trimming. The birds were sometimes raised in an old tree trunk in the house, their feathers plucked periodically, and then the birds were released as adults.

There were no chiefs; men became leaders as a result of heritage, tradition, and the prestige of their regalia. Those who acquired abundance in the form of soft, scarlet woodpecker feathers, large black or red obsidian blades, albino deerskins, dentalia, and other regalia held a place of leadership in the dance ceremony. A leader was perceived as the keeper—not the owner—of regalia; the concept holds true today, relates Wilford Colegrove.[37] He has obligations to his community: to put on annual dances, to display the treasures, and most important, to allow the regalia to dance and come alive.

Northwestern California Carving

The men of the Klamath River region were splendid woodworkers who perfected their skills constructing large plank houses. Carved objects of wood, elk, antler, and stone played important roles in these cultures. To protect organic materials such as skins and feathers from insect damage, and fragile dentalia and obsidian from breakage, storage containers were crucial. The Yoruk kept large items of regalia—hide, featherwork, large obsidian blades—in carved redwood chests. Dentalium shell was placed in smaller elk-antler purses (923). The Karuk stored woodpecker rolls, dentalium strings, and other small treasures in tightly woven baskets. These chests, purses, and baskets and the riches they contained were held in the "great houses," the homes of Klamath River aristocrats. Today, those holding regalia often use store-bought suitcases.[38]

Most carved items—canoes, bows, antler spoons, and purses—as well as fur and feather regalia, were made and used by men. The most talented Klamath River carvers were hired and paid by the elite to produce prestige items. The making of elk-antler purses and spoons, which died out in the 1950s, commenced again in the 1960s with gifted artisan George Blake (Hupa-Yurok).[39] (See pages 452–55.) Yurok basketry is a continuing tradition.

Yurok craftsmen Homer Cooper (c. 1880–1975), Dewey George (1899–1975), and Haynes Moore (1900–early 1970s) made canoes and taught canoe making and other traditional work into the late twentieth century (920). After retiring from ranching in the Eureka area, Homer Cooper returned to old-style crafts: tanning, making women's dresses, and creating sinew-backed bows. George Blake recalls that Cooper was in his sixties when he began to make all the objects he remembered, and what he didn't remember he made in other ways. The current Klamath River cultural revival sprang in great part from the legacy left by these men.[40]

North Central

The Pomo, representative of this region's tribes, occupied an area north of present-day San Francisco. Shamanism existed, but the Kuksu cult was dominant. Kuksu ceremonies were extremely complex. Dancers' identities were concealed by regalia, which

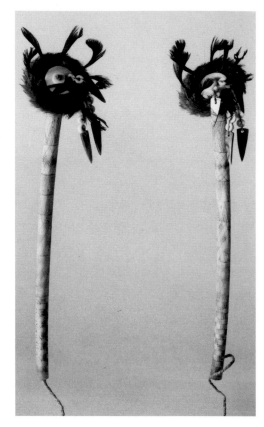

894 *Pomo men traditionally wore ear tubes of long, incised bird bones or wooden rods tipped with small, brilliant feathers, an art form continued by Pomo artisans into the early 1900s. William Benson (Pomo). Early 1900s. Length, 7⅞" (20.0 cm). The Southwest Museum, Los Angeles, 648.G.237,238*

895 *California basketry techniques: 1. Simple twining. 2. Interlocked coiling stitch. 3. Woven beadwork: square weave with beads*

differed among groups. In the most sacred Kuksu events—the Coyote, Condor, and Hawk dances—society members impersonated spirits wearing a "crown of eagle or buzzard feathers, and sometimes a basket headdress of radiating feathered sticks."[41] Capes of condor feathers have been worn by the Pomo since ancient times, as have feathered belts. Six- to seven-foot-long belts crafted from milkweed fiber, woodpecker and mallard feathers, and clamshell disk beads in a checkered pattern were specialized items affordable only by the elite. The flicker—a type of woodpecker valued as a food source for most native Californians—was the source of the salmon-pink quills bordered by black feather tufts that were sewn into long headbands. Indispensable for Kuksu regalia and the best-known piece of central California dance regalia, flicker-quill headbands were originally worn throughout California.[42]

A bird-messenger concept existed among the Pomo. Their sun priest–shaman and his messenger wore feather regalia in order to fly through the sky to contact the sun's messengers and thereby acquire powers to shape the contents of people's dreams.[43] Pomo shamans also dressed in elaborate bearskin outfits: "First, the bear shaman wrapped strands of shells or beads around his stomach, chest, arms, and legs, and then covered these with a layer of woodpecker skins . . . over which he pulled a bearskin, sewing it together so it would fit tightly over his body. The bear's head was sewn over an openwork basket of white oak, with openings for eyes, nose and mouth."[44] Rituals included piercing the ears so that ornaments could be hung from them. Although ear ornaments were popular throughout California, the Pomo and Maidu developed a particularly elaborate style of long, polished wooden sticks or bones that were inserted through an opening in the earlobe and embellished with feathers, deer sinew, shell beads, abalone pendants, and feathered basketry disks (894). Pomo women were masters of the art of basketry. Combining techniques from both the north and south, they wove baskets by twining and coiling (896, 897).

Central Interior

The Yokuts and Miwok occupied all of central California's San Joaquin Valley. The shift from northern group-oriented ceremonies to individualistic, dream-inspired rituals of the south begins with the Yokuts. A boy's initiation centered around the hallucinogenic effects of jimsonweed. For these ceremonies, elaborate feathered dress was displayed: yellow-hammer forehead bands, skirts of eagle-down strings, and headdresses of magpie-tail plumes encircled at the base by crow feathers.[45] Men and women wore feathered topknots. Feathered capes made on a net foundation and of a variety of feathers, including condor, had an ancient heritage. The Chico Maidu, out of respect for the live bird, arranged feathers on capes similar to the actual pattern. Turn-of-the-century cloaks were of red-tailed hawk, eagle, or turkey-vulture feathers.[46]

The Yokuts shaman owned a disembodied spirit, an animal that turned into a man. The shaman would keep the spirit in his body by swallowing a special fetish or amulet representing the animal.[47] This spirit aided and consulted with the medicine man in visions or dreams.

Southern Coast

Since the advent of the Spanish missions resulted in the loss of much of the region's early-contact culture, most knowledge of southern California's indigenous people stems from archaeology, rock paintings, oral tradition, and Spanish journals. Because they resided in richly endowed coastal areas, two of the most powerful tribes in aboriginal southern California were the Gabrielino and their northern neighbors, the Chumash, both of whom created marvelous adornment.

CALIFORNIA BASKETS

Susan Billy, a contemporary Pomo basket weaver, continues a tradition that may be five thousand years old. "When I look at the Pomo baskets and hold them, I feel a real connection to the past, to all grandmothers who have gone before me." Basketry, the most highly developed textile art throughout indigenous California, served both utilitarian and artistic purposes. Although there existed a great diversity of techniques, forms, designs, and functional uses from north to south, some similarities also existed as a result of nearly identical procedures in the processing of acorns. The gathering, storing, milling, and cooking of acorns were performed approximately the same way in all areas. Another characteristic of California basketry is that each group used only a small portion of available material for warp and wefts.

Incorporating twining techniques in the north, coiling in the south, and a balanced combination of the two in the central regions, baskets were and remain in use as baby cradles and clothing accessories and in religious rituals. Chumash baskets were ceremonially employed to collect offerings and hold sacred herbal water—"tears of the sun." Pomo baskets were given as gifts and were displayed suspended to twist and turn in the sunlight (896). Mable McKay, one of the last of the Pomo healers and dreamers, was also a renowned basket maker. Mrs. McKay told George Blake that she "dreamt every basket before making it." During the Jump Dance, the basket is raised to the heavens to acknowledge the spirit world and heal the ills of this one. Basket hats represent a culmination of the California basket weaver's skill. Finely twined rounded hats are worn in northern regions (900). The coiled, conical-shaped hats of the southern Chumash resemble those of the Plateau.

The baskets' balance, symmetry, and decoration are an extension of their makers and culture. Only a focused, centered woman could create smooth, composed basketry out of the seeming randomness of the grasses, feathers, and beads with which she works. Making a basket is like fixing the world: smoothing it out, finding patterns in the design, and creating overall balance. A basket weaver re-creates the world by making it whole and contained. Designs are named after animals, animal tracks, weather, and the environment. Dat-So-La-Lee, a Washo basket maker, beautifully describes a basket's pattern as "rainy weather in month succeeded by clear sky after the storm." A Maidu pattern is called simply Geese Flying.

Traditionally, girls began weaving at six years of age, although today, some begin later. Susan Billy relates: "I sat at [my great-aunt Elsie Allen's] feet for five years and studied with her every day. And as I began to learn about the basket weaving I realized that I couldn't separate it from learning the traditions and the customs, the religion, all their way of living, their whole lifestyle. To me the traditional techniques have a power of their own, something that I can't understand, and it gives me a link to my ancestors."

Frank Tuttle (Yuki-Wailaki-Maidu) is a painter and basket maker: "You say prayers when you start a basket and you let it know that it is going to be started, to be created, and when you are finished you end with prayers to let it know that its birth is complete. . . . A basket whirl will talk to you. Songs will come, designs will come. We are always told that when you make baskets you never, never think of it as a chore or you'll become hunched over. And that's true. Resentments do that to your back, twist it and bend it. I'd rather go to the flip side of that and take the pleasure in the basket making itself. That makes the baskets live."

Hunting and gathering and praying and fasting is a good thing. When you're sitting there making your baskets and saying your prayers and you're alone, that's a good thing.

—Jeanette Cramplet (Karuk)

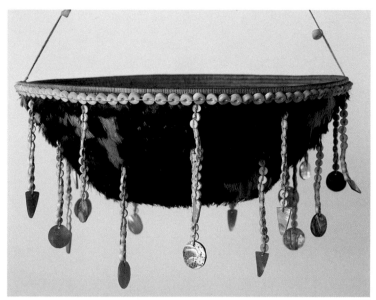

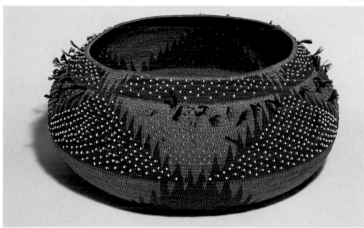

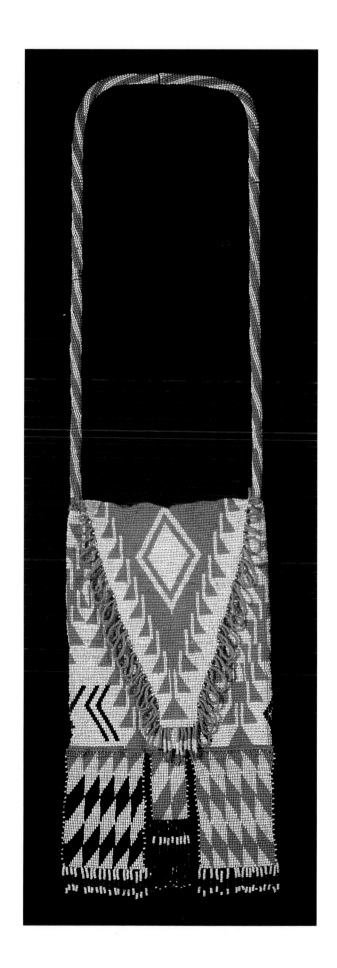

896 *"To weave a basket is to reenact the process of creation, and the finished basket is the image of the universe," writes Peter Matthiessen. This Pomo gift basket, presented to women during rite-of-passage ceremonies (birth, puberty, marriage) wears its own feathers, abalone pendants, and clamshell beads. Abalone disks signify the sun and moon; arrow shapes represent stars. Encircling the basket, they indicate the stars' respective day and evening positions. The red feathers are associated with bravery and pride, white with riches. Generosity is represented by the clamshell. Nineteenth century. Diameter, 9" (22.9 cm). American Museum of Natural History, 50/2590*

△ **897** *Pomo basket with white seed beads, sedge root, redbud, or bullrush over coiled willow and feathers. While thirty stitches per inch is the norm in California baskets, the Pomo wove as many as sixty stitches or more per inch. Late 1800s. Diameter, 12" (30.5 cm). Texas Memorial Museum, 1074-82*

898 *Beadwork from the Plains* ▷ *may have influenced this northwestern Achumawi bag, although the designs, colors, and weaving technique clearly reflect northern California basketry. Collected in California, early 1900s. Bag width, 6⁹⁄₁₆" (16.7 cm). Denver Art Museum, 1948.135*

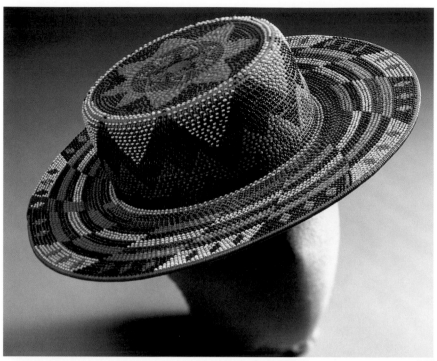

899 *A unique, early-twentieth-century Pomo beaded hat strays from the traditional basket hat. Width including brim, 13¾" (35.0 cm). The Southwest Museum, Los Angeles, 811-G-2365*

900 *Geometric designs on silver bracelets echo traditional basket-hat designs based upon nature, such as Frog Foot (far right). The third bracelet from the right is a variation of the quail-feather pattern common on northern California and Columbia Plateau basketry. All the bracelets are by George Blake (Hupa-Yurok), who views the use of basket designs as a means of preserving his cultural heritage. 1993–94. Height of far-left bracelet, 1¼" (3.2 cm). The basket hat was made in the 1970s by Lena McCovey (Yurok), one of the last hat masters and great-aunt of George Blake's wife, Annabelle (Yurok-Narraganset). Private collections*

899

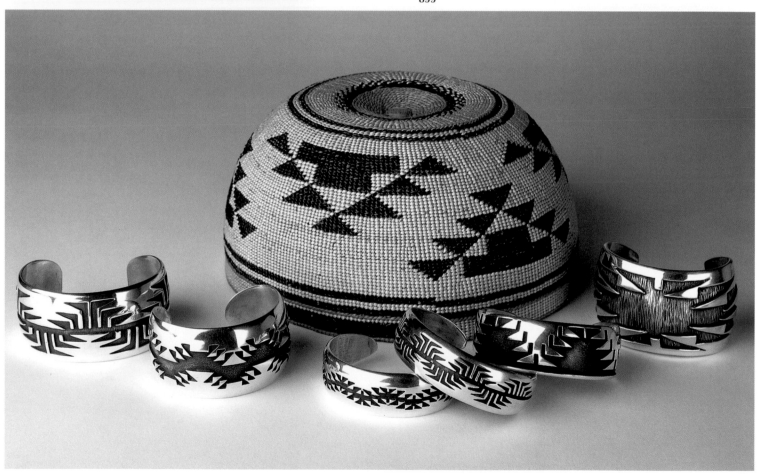

900

901

902

901 *Sand-dollar ornament. In Chumash legends, the sun, as it crosses the heavens daily, rests momentarily in the hole of the sand dollar while leaving its rays outside. Gabrielino. Collected at San Nicholas Island, 1880. Diameter, 3¼" (8.3 cm). American Museum of Natural History, T14412*

902 *This shell disk quartered by three rows of dots is possibly a cardinal directional representation. Chumash. Collected on San Miguel Island, 1883. Diameter, 2⅛" (5.3 cm). American Museum of Natural History, T17124*

The Chumash, a semisedentary, highly stratified maritime culture, occupied an area centered around the Santa Barbara channel and off-shore islands. From abundant natural resources, they produced a wide range of artifacts, including large plank canoes decorated with shells. Many items were carved from steatite and embellished with incised or painted designs and shell inlay. Since they furnished much of southern California's supply of clamshell money, the Chumash were among the wealthiest of California Indians. The name Chumash derives from *michumash*, a word of multiple meanings, including "those who make shell bead money."[48] The shell most useful to the Chumash for adornment was abalone, which was abundant along the channel.

The Chumash employed color lavishly in both daily and ceremonial life. Everything was painted: faces, bodies, clothing, canoes, and rock caves. Body paint was both decorative and functional. The chief's messenger painted his face with white and black patterning in imitation of mud-hen markings. Red, a favorite color, was obtained from hematite (red ocher) or yellow ocher burned to red. Women covered their bodies with red ocher to prevent sunburn and create a glossy look. Face painting, in stripes, checks, and zigzags, was common during ceremonies. Tattooing was done with cactus spines and burned piñon-nut pigment.[49]

Chumash Ceremonies and Regalia

Southern California tribes honored the sun with the same reverence northerners expressed for water. A sun festival was held during the winter solstice, when the sun rises at its southernmost point on the eastern horizon. Festival regalia included erecting an eighteen-inch-high sun staff with a perforated stone on top painted green or blue to resemble a sand dollar.[50] The Hutash Ceremony, following the late-summer acorn harvest, honored the Earth Goddess, offering her food and shell beads. Dances, songs, and regalia evolved around special plants and animals, such as seaweed, swordfish, and bear. The Swordfish Dance (swordfish were revered, as it was believed they drove whale ashore) has a known two-thousand-year history.[51] A dancer wore a swordfish beak attached to a "scaly" headdress composed of overlapping triangular ornaments of abalone shell. The bear dancer donned an elaborate feather headdress and carried bundles of feathers; two bear paws hung from around his neck.[52]

Feathers were used ceremonially in many forms. Feathered ornaments were held in the hands, while headgear—headbands made from hundreds of bright orange, vertically arranged quills of the red-shafted flickers—were worn in rainmaking rituals.[53] Chumash shamans' outfits included feather headdresses, shell beads, and skirts of milkweed fiber with eagle down and feathers attached to the lower ends.[54]

Connections were made between the eagle and the sun. Shamans took jimsonweed in an attempt to transform themselves into birds—eagles or condors—and make magical flights into other worlds. The Chumash venerated the condor, believing that it supported the Sky World and caused solar and lunar eclipses. Rare, highly prized Chumash dancing capes and skirts were made from condor feathers.[55]

The Chumash had a sophisticated knowledge of astronomy and held complex beliefs regarding the cosmos. Shamans were also astrologer-priests who functioned as intermediaries with Sky World, keeping all forces in balance. Chumash associations of white with stars and some planets may have extended into personal adornment. White dots on the seaweed dancer's cheek possibly symbolized the Pleiades. White down from an eagle's breast perhaps was connected with magical flight and represented stars.[56] Celestial beings resided in crystal houses. Crystals enabled shamans "to capture light from celestial objects and magically transform it into the colors of the sacred rainbow."[57] Quartz crystals were highly prized and frequently incorporated into talisman necklaces.[58]

903

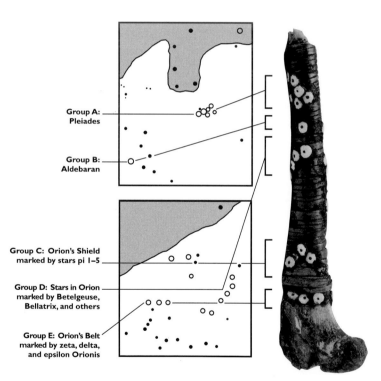

903 *Precontact rock-art painting, perhaps of a condor. Cueva Pintada, Baja California*

904 *Life-size rock-art paintings (pictographs) of human figures—probably shamans—are bisected by color (half-red, half-black). Prayer plumes, similar to those still worn in northern California rituals, are attached to the top of the head. A migrant hunting people, attracted to this Baja California canyon by abundant water and game, may have created these paintings within the past five hundred years.*

Group A:
Pleiades

Group B:
Aldebaran

Group C: Orion's Shield
marked by stars pi 1–5

Group D: Stars in Orion
marked by Betelgeuse,
Bellatrix, and others

Group E: Orion's Belt
marked by zeta, delta,
and epsilon Orionis

905 *A Chumash ceremonial deer-tibia whistle with inlaid-shell star and constellation depictions, possibly a "star map" used to determine the earth's seasons. Complex beliefs in astronomy were uniquely expressed in Chumash rock art and small, portable artifacts. Precontact to Mission period (mid–late 1700s). Length, 7½" (19.1 cm). Ventura County Museum of History and Art (Chart after Travis Hudson)*

904

One can see a visual correlation between some Chumash rock-art motifs and designs placed on small, portable objects. Many of these objects, including decorated beads and pendants, feature white-shell inlay and may well have transmitted cosmological concepts (901–2, 905). Frank La Pena (Wintu) discusses the importance of early rock art for contemporary Native Americans:

As I relate to the meaning of these symbols, I am reminded of their grandeur by the concepts they represent, not by their size. Many of the rock art paintings and petroglyphs are not large, yet they carry the function, meaning, and concretization of a vision and the relationship and connection of that vision through the use of specific symbols. . . . We are concerned with the larger sense of meaning inherent in those places used by the people who have gone before us. . . . We know the elements of weather and time take their toll . . . [and] that this art, exposed as it is to nature, will eventually be lost through weathering. . . . This seemingly fatalistic attitude is an acceptance of time and change. This attitude of acceptance also allows an artist to use concepts found on rock art for contemporary art work. It is important to remember that the . . . realities and . . . visions depicted in rock art are still being used in the ceremonies and dances of the Native Americans.[59]

Through most of the twentieth century, the Chumash have maintained aspects of their traditional culture. Today, on their reservation near Santa Ynez, they host dances and festivals based upon ancient traditions. Ritual clothing, including that of a swordfish dancer, has been re-created.[60] Artisans are active in basket weaving, bone carving, beadwork, and canoe building.

The Mojave

The Mojave lived in a desert valley along the Colorado River, part of today's California, Nevada, and Arizona. They planted corn, wheat, and beans in the damp springtime soil left by the retreating Colorado River. California's only agriculturalists, they formed a bridge to southwestern farmers and gardeners. The Mojave put great faith in dreams. Knowledge was acquired only according to one's dreams; luck was referred to as "good dreaming." So deep were their convictions that the Mojave blurred distinctions between knowledge and dreams.[61] They excelled at pottery (1100) and sand paintings. In collar necklaces, they reworked traditional designs using trade glass beads.

LINKING PAST TO PRESENT: NORTHWESTERN CALIFORNIA CEREMONIAL DANCES

Tradition remains vital in northwestern California, where ceremonial dance continues to renew the world for another year. In 1993, Jimmy Jackson, then an eighty-three-year-old member of the Hoopa Valley Indian Reservation, attested: "We still perform the old dances: the White Deerskin Dance, the Jump Dance, all of them. We keep them going to keep everything right—the fishing, hunting, everything. Using the medicine. You've got to keep it right, you see. Keep the balance."[62] Among the Klamath River groups, "the Hupa were the stewards of the dance because we kept the dances going," states George Blake. "We didn't have the dance just for ourselves. Everyone participated. Except for a short period during World War II, the Hupa dances have never stopped."[63] "The dance and regalia give stability," says Wilford Colegrove, whose Hupa family has been a dance leader and keeper of the regalia for generations.[64] The Yurok revived their World Renewal ceremonies in the 1950s.

Renewal rites such as the White Deerskin Dance are necessary to achieve balance. The Jump Dance, according to one Yurok elder, is performed because "when man and

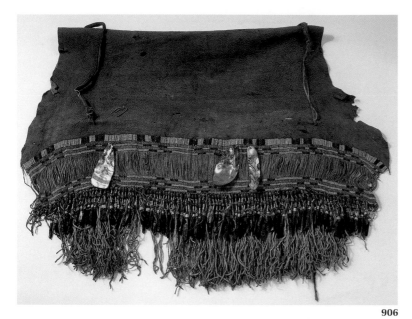

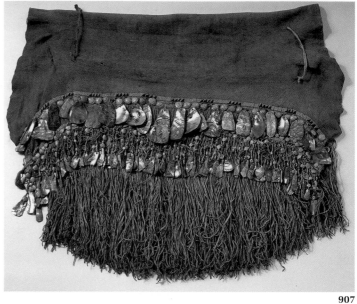

906

907

906 *Yurok dance apron of plant fiber, hide, Chinese glass beads, and abalone shell and obsidian pendants. Such pieces became heirlooms. Collected 1902. Length, 49" (124.5 cm). American Museum of Natural History, 50/3451*

907 *Yurok dance apron made with abalone and other shells, plant fiber, fur, and hide. All the organic materials are traditional, but one tiny, European blue-glass seed bead is attached to the bottom layer of the fringe. Collected 1902. Length, 57" (144.8 cm). American Museum of Natural History, 50/3452*

908 *Tolowa skirt made of pine nuts, dewclaws, juniper berries, bear grass, and cloth. As preparers of food and producers of daughters who would attract a bride price, women were an important part of the Tolowa's "wealth-quest." A skirt's beauty and the wealth it represented could increase a bride's value. Juniper berries were placed near anthills. Ants devoured the centers and the berries became stringable beads. Length, 18¼" (46.5 cm). Peabody Museum of Archaeology and Ethnology, Harvard University, 10/87399*

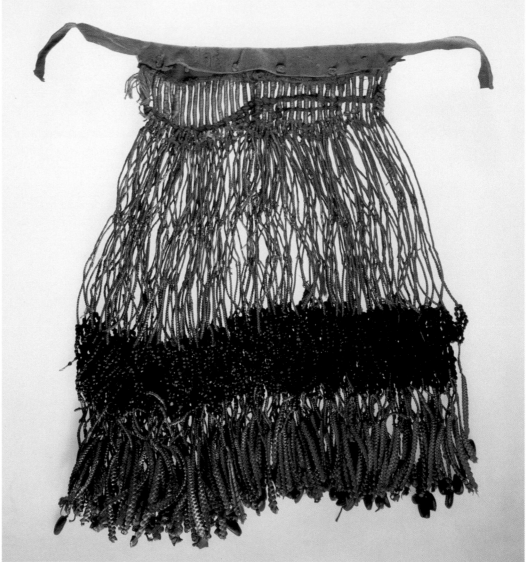

908

909 *Hupa hair ornaments for women's braids are made with abalone and glass beads, strung on buckskin and wrapped in grass. A ten-day ceremony celebrating adolescence culminated when the girl "threw off her blanket, went outside, and looked into two haliotis [abalone] shells held to the south and north of her, seeing therein the two celestial worlds." Abalone adornment may be a reminder of this powerful feeling. The combined use of shell and grass relates these hair ornaments to California basketry. Purchased 1914. Length, 11" (28.0 cm). The University of Pennsylvania Museum, NA 2381*

909

910 *Shasta ear ornaments worn by a "doctress" during healing rites. The assemblage includes orange flicker and black crow feathers, deer dewclaws, bear grass dyed with wolf moss, and limpet shells. Becoming a doctress required accumulating such ritualistic paraphernalia, acquired during dreams. As she danced for the community, the doctress's spirits reappeared to inspect her paraphernalia. Collected 1911. Length of right ornament, 23⅝" (60.0 cm). Peabody Museum of Archaeology and Ethnology, Harvard University, 10/84012*

911 TOP: *Shasta neck band of flicker feathers and rattlesnake rattles. A doctress with a rattlesnake spirit cured snakebites. After sucking out the venom and dancing, she described the spirit and the gifts he desired for himself and the doctress.* BOTTOM: *Achumawi neck ornament of deerskin trimmed with weasel skins, orange flicker feathers, abalone-shell pendants, and large Chinese glass beads. Both collected in California, c. 1890–1910. Length of Achumawi ornament, 13⅞" (35.0 cm). Peabody Museum of Archaeology and Ethnology, Harvard University, 84010*

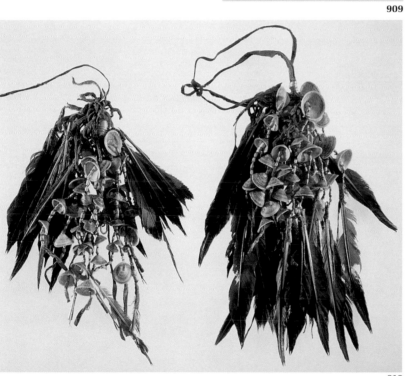

910

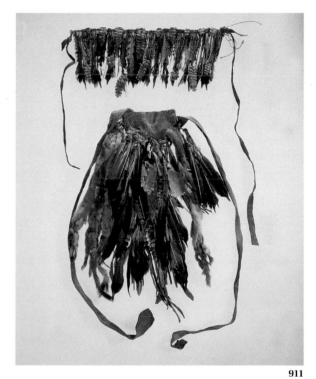

911

912 *A unique Shasta dance sash of braided human hair, glass beads, abalone, hide with pigment, and elk(?) teeth. The northern Shasta danced to acknowledge female adolescence, to acquire shamanistic power, to cure, or to prepare for war. Collected 1902. Length, 30" (76.2 cm). American Museum of Natural History, 50/3180*

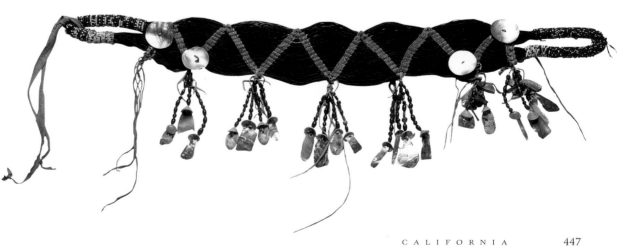

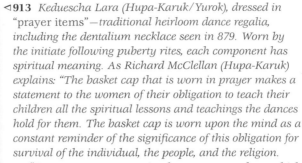

◁913 *Keduescha Lara (Hupa-Karuk/Yurok), dressed in "prayer items"—traditional heirloom dance regalia, including the dentalium necklace seen in 879. Worn by the initiate following puberty rites, each component has spiritual meaning. As Richard McClellan (Hupa-Karuk) explains: "The basket cap that is worn in prayer makes a statement to the women of their obligation to teach their children all the spiritual lessons and teachings the dances hold for them. The basket cap is worn upon the mind as a constant reminder of the significance of this obligation for survival of the individual, the people, and the religion.*

"Our young women purity dancers wear a dress which contains many prayers and which includes other family members of creation, such as abalone, pine nuts, juniper, deer, bear grass, etc. Knowing the meanings and teachings that these items have to offer us, one can understand the prayer and teachings of each dress. The fringe represents the participation of deer, and the movement of the fringe in prayer, the swaying, provides for the cleansing and healing of the injury and harm that have been done to the People. The dancer adjusts her walk to the movement of the dress, which allows the dress to speak its prayer. Within the religion no one can see or hear the dress's movements and sounds being lifted in prayer without remembering it and the lessons that it gives." Photographed 1993

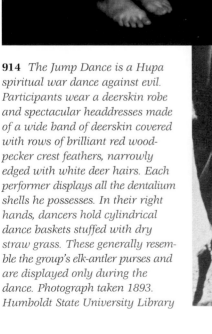

914 *The Jump Dance is a Hupa spiritual war dance against evil. Participants wear a deerskin robe and spectacular headdresses made of a wide band of deerskin covered with rows of brilliant red woodpecker crest feathers, narrowly edged with white deer hairs. Each performer displays all the dentalium shells he possesses. In their right hands, dancers hold cylindrical dance baskets stuffed with dry straw grass. These generally resemble the group's elk-antler purses and are displayed only during the dance. Photograph taken 1893. Humboldt State University Library*

the world become unbalanced, then we must dance the great dances."[65] Male dancers rhythmically stamp the earth in a steady cadence to drive out illness and evil and bring the world back into harmony. With each stomp, the dancer lifts a small cylindrical basket toward the sky. When the basket comes back, it brings with it the spirit world's acknowledgment and luck. Accompanied by songs that were originally inspired by the wind, the dance soon brings collective illumination. Adds Julian Lang, the dancers spread their prayers "all around this world and the sky world. . . . They fix the world for us all."[66]

Jump Dance Medicine Man Richard McClellan (Hupa-Karuk) describes the Jump Dance movements of the Center Man: "The flow of water demonstrates and teaches the flow of time within physical existence. The Center Man raises the basket upstream first, and sways in prayer, asking for the Creator and Mrs. Creator and all of our people and all of the peoples of the other family members of creation to come join with us in prayer. Center Man then moves downstream in reference to the future of our people in time, again asking Creator and Mrs. Creator and all our yet unborn children and generations to join us in prayer. Center Man then moves the prayer basket straight ahead to the flow of time before us in joining the prayers and people of this dance and the people of today. These movements combine peoples and prayers of the past, present, and future—joining all time together. When we pray within high dance, we pray with all of our people and all of time together. We dance and pray with, and in the presence of, our ancestors."[67]

Considered a living entity, dance regalia is not to be flaunted or displayed casually. Loren Bommelyn (Tolowa) recalled how Tolowa elder Irene Natt used to ask him to come and sing to her regalia when it wasn't being used, "just to keep it happy."[68] Keeping the regalia happy, healthy, displayed, and danced is part of the people's obligation. Fine regalia is also brought in for ceremonies from neighboring tribes. Dance leaders and their helpers are responsible for the goods, and they spend hours carefully unpacking and, later, rewrapping the objects whose owners they are expected to know. Older spectators sometimes weep when viewing regalia that had once belonged to departed relatives.[69]

Falene Blake, a fourteen-year-old junior high school student and daughter of Annabelle and George Blake, writes: "I went with my father to Takimidin and watched the Jump Dances. As we pulled up, I looked around the flat dusty grounds and felt right at home. The elders, the children, leaders, and dancers; they all had familiar faces. These were my people. . . . Every dance time I get this same feeling of belonging, but this was the first time I realized how much it meant to those around me. . . . I finally became aware of how important the Jump Dances are to the Hupa people's religion."[70] Richard McClellan further explains:

The red woodpecker scalp upon a cap that has dentalium has meaning in the dances. The color red represents continuance of the individual, the religion, and the people. It represents the knowledge that the religion provides in making everyday life decisions. We never know it all, nobody ever knows it all. We just keep moving.

So you have all these meanings. Where the woodpecker feathers are placed on a cap, there's a message. You can read the Deerskin Dance and Jump Dance like a white man reads a book. There's no movement, sound, color, individual prayer item, or positioning of the dance that doesn't have meaning. That's why they try so hard to keep [the dance] the same. Each regalia item is a paragraph within that reading of the dance. You change something in the dance, you'll be removing knowledge. The expectation and the obligation for us to learn what these dances mean . . . dictate how we live.[71]

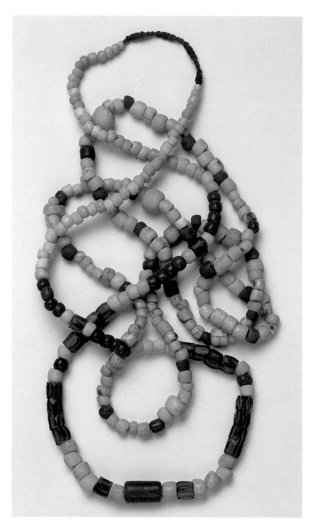

915 *This representative group of glass trade beads recovered in California includes faceted clear and translucent beads in crystal, amber, blue and green glass, and* cornaline d'Aleppo. *Collection Jamey D. Allen*

916 *Karuk necklace made with dentalium shell, glass beads, and fur. Late nineteenth century. Length, 19⅝″ (50.0 cm). The Southwest Museum, Los Angeles, 511-P-1*

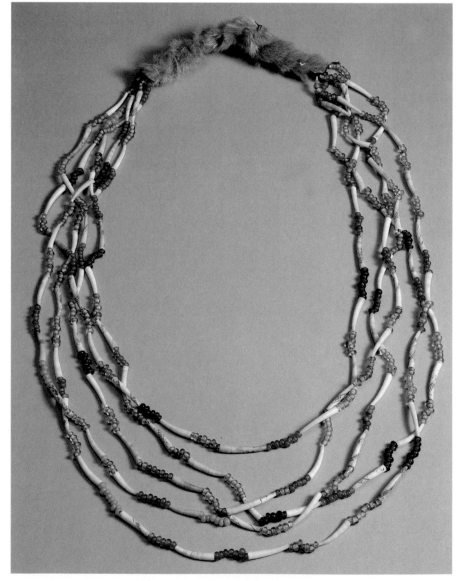

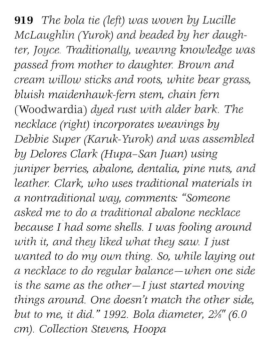

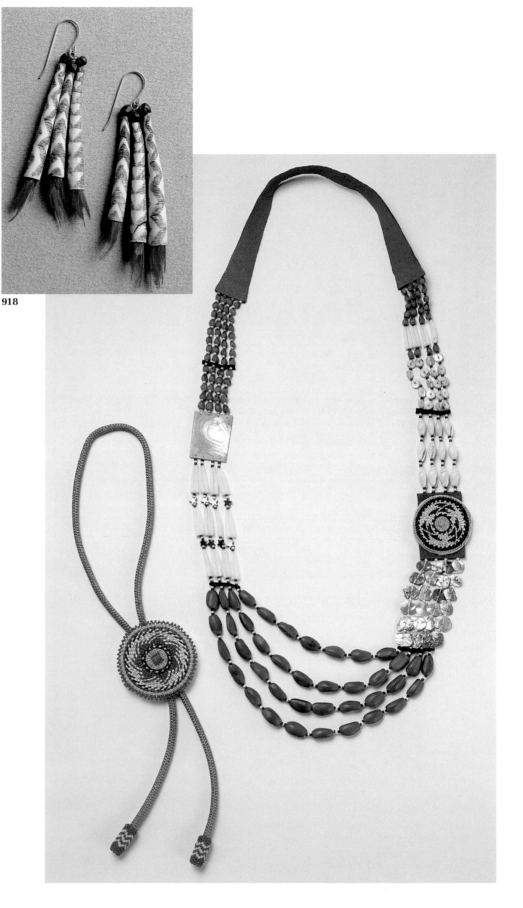

917 *Earrings of bone and woodpecker feather tied with sinew. Charlie Randall (Hupa). 1980s. Length approximately 1" (2.54 cm). Private collection*

918 *Earrings of dentalia and woodpecker feathers fastened with sturgeon glue. The incised patterns represent the repetition in nature. Richard McClellan (Hupa-Karuk). 1992. Collection Norton*

919 *The bola tie (left) was woven by Lucille McLaughlin (Yurok) and beaded by her daughter, Joyce. Traditionally, weaving knowledge was passed from mother to daughter. Brown and cream willow sticks and roots, white bear grass, bluish maidenhawk-fern stem, chain fern (Woodwardia) dyed rust with alder bark. The necklace (right) incorporates weavings by Debbie Super (Karuk-Yurok) and was assembled by Delores Clark (Hupa–San Juan) using juniper berries, abalone, dentalia, pine nuts, and leather. Clark, who uses traditional materials in a nontraditional way, comments: "Someone asked me to do a traditional abalone necklace because I had some shells. I was fooling around with it, and they liked what they saw. I just wanted to do my own thing. So, while laying out a necklace to do regular balance—when one side is the same as the other—I just started moving things around. One doesn't match the other side, but to me, it did." 1992. Bola diameter, 2⅜" (6.0 cm). Collection Stevens, Hoopa*

Like his versatile forebears, Klamath River artisans who worked equally in wood, antler, and stone, **George Blake** (Hupa-Yurok) is an expert maker of traditional dugout canoes, sinew-backed bows, elk-horn purses and spoons, obsidian blades, etched dentalia, and featherwork regalia. He is also an innovative jeweler, potter, dollmaker, sculptor, and painter. Born in 1944 at Hoopa Valley Indian Reservation, Blake was brought up in the Colegrove family of traditional dance makers and leaders (see page 436). Blake began to carve seriously in the 1960s while still in high school and living with his aunt Lila Colegrove. "When she started making baskets, and they needed acorn spoons, I said, 'I've got to be able to make a spoon on a band saw.'" Blake crafted a set of wooden spoons for the feast, "and I've made acorn spoons ever since."

Upset that a Hupa bow maker had died without passing on his carving knowledge, Blake sought out Yurok elder Homer Cooper. "My first attempt to meet him, I was on my way down river, and I was bringing an old lady down there. . . . I knocked on the door and let her go in first. She spoke to him in Indian, and he turned and shook my hand, and it was almost like we were relatives. Whatever she said, I don't know, but it was something that just melted everything away that would be preventing a lasting friendship. . . . He was my mentor. He had a funny way of teaching. He'd tell me to go out and get a piece of yew wood and I'd bring it back and show him, and he laughed and said, 'What are you going to hunt, an elephant?'

"I started twisting sinew, and I couldn't make a string. I was totally frustrated. . . . I went to him and I watched him—he was maybe eighty-five years old—and I told him how frustrated I was, and he said, 'It's easy.' He reached over and grabbed some sinew that was already shredded. He laid it in his palm, and knotted one end, and made two bunches, and he just spun the two pieces forward until they tightened. Then he pulled them together and pulled them backward. And it was so unbelievably simple, even with his knobby hands—and he was fairly slender, and bony, and it didn't look like he had any dexterity. And it was so simple, and here I was fighting it. That's where just a little bit of knowledge goes a long way, and it was so beautiful to connect with him.

"To me, within the dances, tradition is a remnant. Whatever is left to us we should keep. I went back and researched the bowl, the purse, the dugout canoe, and thought it was necessary to make them. And to make them so that they looked like those that were made before, but with their own personality. You have a chance to design them, to make them, but still have them reflecting that same cultural tradition."

Although he has a degree from the University of California at Davis, Blake is largely self-taught. In addition to observing elders, he has also learned arrow making and more about sinew from a non-Indian in Oregon who restored bows for museums throughout the world. Breaking boundaries while extending tradition, he carves traditional materials and shapes such as elk antler and acorn spoons into jewelry; basketry transforms into silver bracelets or gold earrings; clay pots are imprinted with basket designs and shaped like northwestern California tobacco pouches. In 1991, Blake, whose work is represented in numerous museums, received the National Endowment for the Arts Heritage Award.

Although he lives and works in Hoopa, Blake's vision encompasses both Native and non-Native worlds. He describes the inspiration behind *Mandela Rock*, created in 1990: "A week before my show opened at Point Reyes Station, Nelson Mandela walked out of the penitentiary. He was almost seventy, yet he walked with such an erect, stately manner, like a man with a purpose. A strong emotion emanated from him, and I watched him, completely awestruck. The twenty years he was incarcerated flashed through my mind. You'd think this kind of punishment would diminish his resolve to see his people free, but it seemed like his cause only magnified within him. It showed in how he walked. There was an indescribable glow about him. I selected a special place to find a rock to represent my feelings about him. It was across the river from the Deer Dance and Jump Dance grounds, and up the river from the site of the Boat Dance. I knew the rock had to be heavy, and able to stand up on its own. It had to command you to walk around it."

920 *Yurok-made redwood dugout canoes. As the Native peoples of northwestern California lived along rivers and ocean, canoes were the principal form of transportation. Canoes were considered living beings. Even in canoes made today, various interior projections are anthropomorphized as body parts. A carved ornament (the headdress) is often on the prow. Projecting into the canoe from the prow (the ears) is a hook or handle (the nose). Passing through two holes (the eyes) at the sides of the prow is a loop of grapevine or hazel (the necklace) used to secure a towing rope. A pair of incised lines leads from the nose toward the stern (the lungs or lifeline). In the bottom center of the canoe (the belly) is a rounded knob (the heart). Finally, the paddles were called the boat's legs. The first two canoes (left foreground) were carved by Dewey George and Haynes Moore, the remaining five by George Blake between 1975 and 1991.*

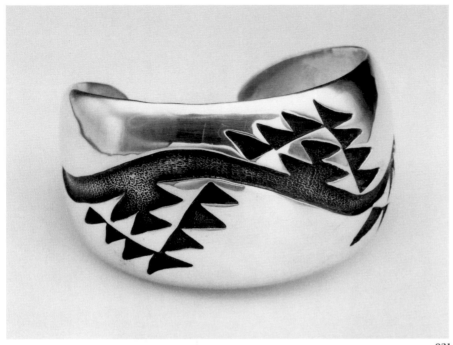

921 *In this bracelet, a flowing line reminiscent of northwestern California rivers is integrated with basket designs. George Blake. 1996. Silver. Height, 1⁷⁄₁₆" (3.7 cm). Private collection*

▽**922** *An otter quiver with sinew-backed, flat yew-wood bow and arrows with obsidian points. George Blake. 1992. Bow length, 42" (106.7 cm). Collection Chuck Williams, Jr.*

921

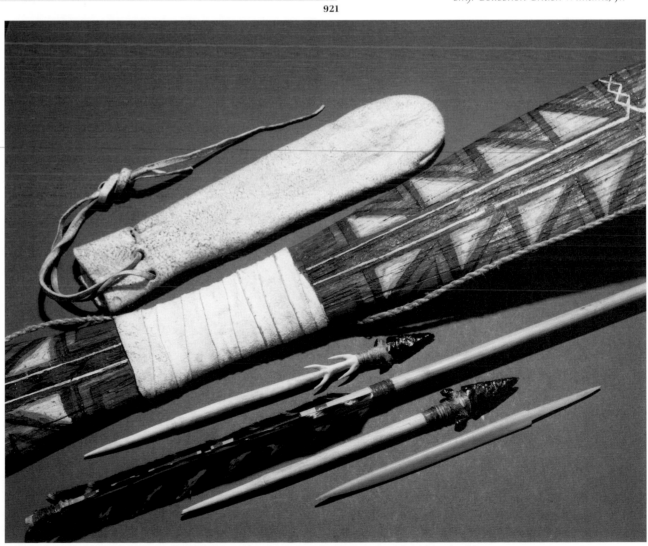

923 *These purses, made from hollowed-out and lined elk antler, hold dentalium-shell wealth and are secured by a wrapped hide thong. George Blake recalls, "The finest elk-antler purse I've ever seen was supposed to be alive. There was spirit in that thing. The people that it was given to had to feed it a bowl of fur every so often. . . . This is what they were told to do." George Blake. 1993. Length of top purse, 8½" (21.6 cm). Private collection*

924 *A contemporary tobacco pouch. "The traditional ones were small and would fit in your hand," says its creator, George Blake. 1992. Pottery and leather. Height, 13" (33.0 cm). Collection George Blake*

925 *George Blake's modern version of traditional upright-style purses in the Phoebe Hearst Museum. George Blake. 1991. Elk antler, black pigment, hide. Height, 5" (12.7 cm). Collection George Blake*

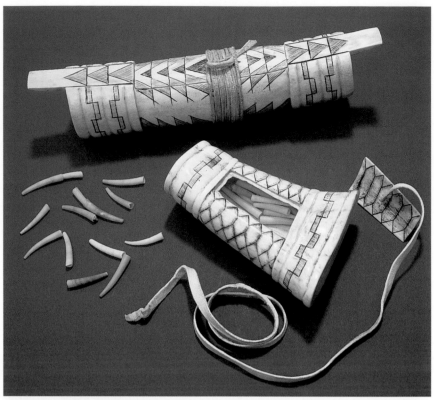

923

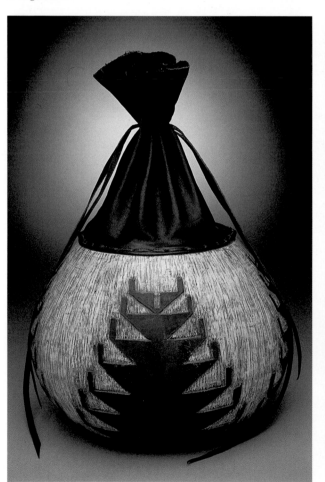

924

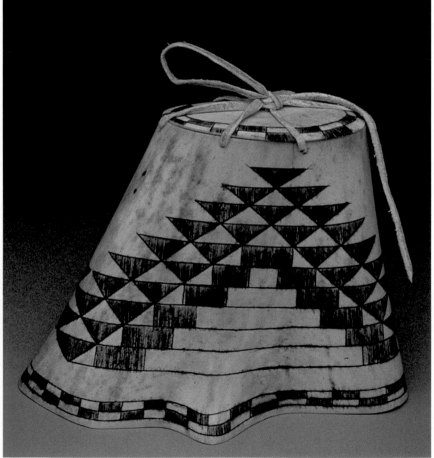

925

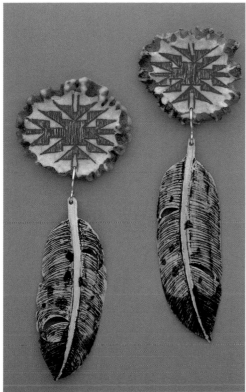

◁ **928** *Elk-antler spoon earrings, a miniaturized version of the spoons used by Klamath River men for eating acorn mush. Elk-antler spoons, carved in a wide variety of designs, were displayed at feasts. George Blake. 1997. Length, 2″ (5.1 cm). Private collection*

▽ **929** *George Blake explains his Coyote Moon pendant: "Coyote traveled between heaven and earth. The piece has double movement to travel back and forth: moves on the chain, and it moves within itself." Blake gives the diamonds, mined from the earth and set in this pendant, the same respect he accords traditional woodpecker scalps, feathers, and shells. 1994. 14-karat gold, ¹/₄-carat diamond. Diameter, 1″ (2.54 cm). Collection Annabelle Blake*

926

927

926 *Eagle-feather earrings carved from elk bone. George Blake says of his work: "The idea for these earrings was not to make just a feather—a feather doesn't necessarily have to mean Indian. But a round rosette assembled with the feather hanging off does spell Indian, in a different way." 1994. Length, 4″ (10.2 cm). Private collection*

927 *George Blake's bird earrings of elk antler fly as a flock. The swallow design was inspired by the swallow-tail basket design. Blake comments, "I just added these wings and head, they went back into a bird from its tail." Although bone takes a higher shine, antler is stronger and can be cut thinner. 1994. Left length, 2³/₈″ (6.0 cm). Private collection*

930

931

930 *Jewelry is Larry Golsh's (Pala Mission–Cherokee) way of returning to his Native origins. The geometric forms, adapted from southern California basketry and rock art, recall his Mission background. He notes, "I always consider jewelry as miniature sculptures." 1993. 18-karat gold, diamond, sugilite. Necklace diameter, 7" (17.8 cm). Courtesy Lovena Ohl Gallery*

931 *Larry Golsh's bracelet brings together California rock-art iconography and Southwest sand-casting techniques. Concentric circles are possibly solstice markers; the zigzag line is a water motif. Trained as an architect, Golsh was influenced by Hopi artist Charles Loloma to become a jeweler. 1992. Silver, gold. Height, 1 1/16" (2.7 cm). Private collection*

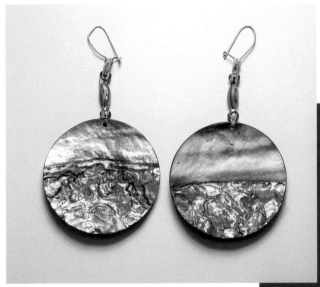

932 *Abalone, valued for centuries, continues as beautiful adornment. Earrings. Vivian Hailstone (Karuk). 1987. Diameter, 1½" (3.8 cm). Collection Margaret Hardin*

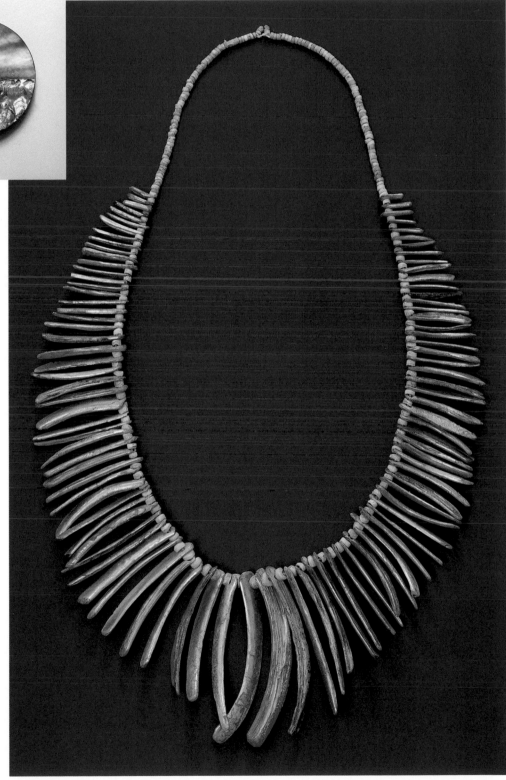

933 *A precontact Chumash abalone-shell necklace retains its iridescent luster. San Miguel Island. Longest pendant, 3¾" (9.5 cm). Natural History Museum of Los Angeles County, A5600-133*

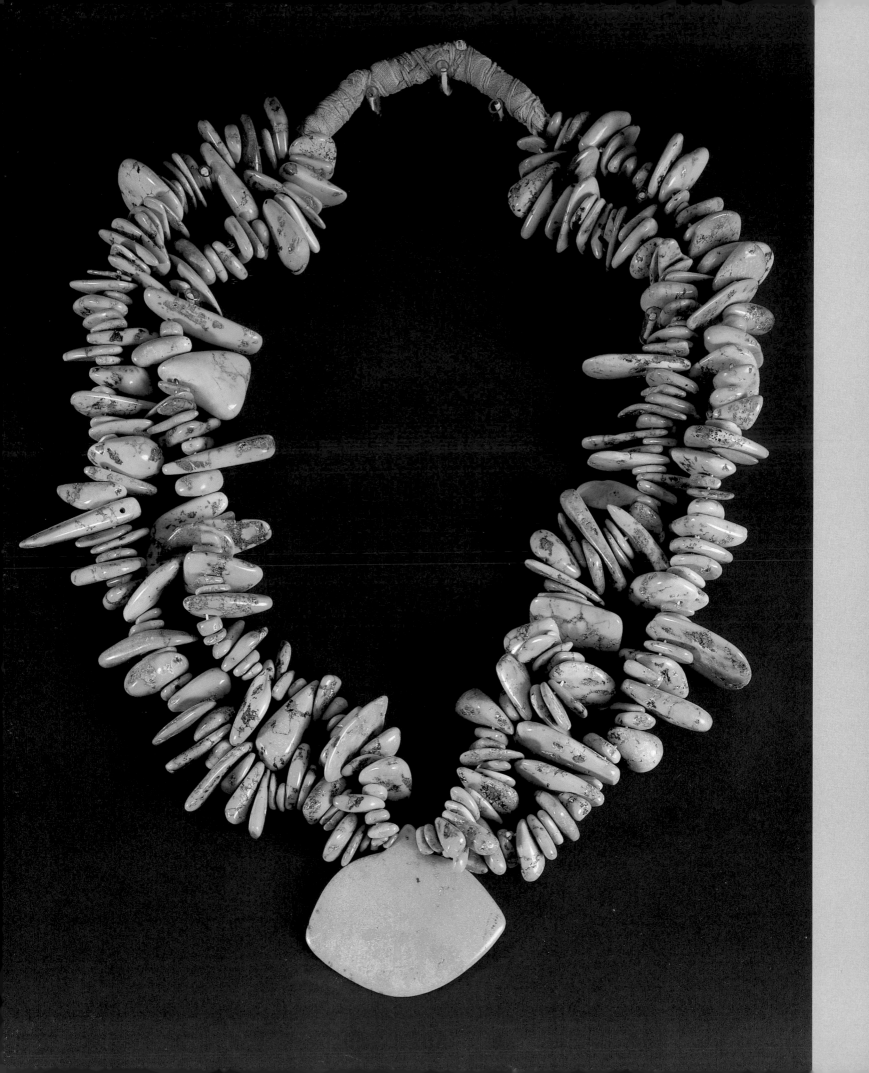

VEINS OF TURQUOISE
THE SOUTHWEST

"At Taos Pueblo in New Mexico, Indians may still be seen taking shoes off horses and walking around in soft-soled shoes themselves in the spring, for at that time of year, they believe, the earth is pregnant and they must not harm her body."

— **Alvin M. Josephy, Jr., 1968**[1]

◁ **934** *A spectacular double strand of large gem-quality, sky-blue Cerrillos turquoise nuggets. The necklace, weighing nearly three pounds, was made by Leekya Deyuse (Zuñi), who "carved each stone to mother nature's dictate." c. 1935. Length, 30" (76.2 cm). Millicent Rogers Museum of Northern New Mexico, 1958-6*

936 *Stone figurine wearing turquoise. Ancestral Pueblo. Pueblo Bonito, Chaco Canyon. A.D. 1040–1120. Length, 3⁷⁄₁₆"* (8.7 cm). American Museum of Natural History, H/10418*

935 *Abalone-shell and turquoise pendants, strung on the original yucca-fiber cord, were worn by ancestral Puebloans. Both materials were imported: abalone from coastal California; turquoise possibly from only a few miles away. Southwestern adornment such as these tabular turquoise pendants exhibit striking connections between past and present. Apache County, Arizona. c. A.D. 450–750. Length, 15¾" (40.0 cm). Arizona State Museum, The University of Arizona*

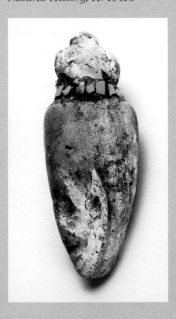

From the piñon-juniper forests and sage plains of the Colorado Plateau to the mesquite and cactus Mojave and Sonoran Deserts, the bluffs and canyons of the Southwest form a landscape of "colored rock and blue sky unsoftened by the pale of moisture."[2] One is riveted to the sky, where fast-moving storms end suddenly in sun, a rainbow, and an endless sweep of blue.

The region's generally arid to semiarid climate has dictated human lifeways for at least eleven thousand years. The land, bountiful only with specialized knowledge, once sustained the ancient Puebloan, Hohokam, and Mogollon cultures and remains the source of Pueblo, Navajo, Apache, O'odham, and Yuma life. In return, Southwestern people have ensouled Mother Earth into their daily prayers, seasonal ceremonies, and adornment.

Every aspect of life—daily pursuits as well as grand ceremonials—is guided by convictions that one can coexist harmoniously with the supernatural if things are done in the proper way. "In this dry country," wrote anthropologist Alfonso Ortiz of San Juan Pueblo, "even after a mild rainfall, such fragrances emanate from the land that the earth itself seems to smell grateful for the moisture."[3] Beadworkers Terry and Joe B. Reano of Santo Domingo Pueblo say that, "as you cut and wet down natural turquoise, it smells like rain." Shell and turquoise are important and widely used materials. Coming from water, shell is a symbol of life. Perceived as a piece of the sky, reverence for turquoise began with the ancient cultures and remains an integral part of Pueblo and Navajo adornment.

Southwestern cosmologies relate sacred geographies (mountains and lakes), food (maize), and jewels (shell, turquoise, jet) to the origins of the First People. The cosmos is understood to be a complex pattern of contrasting but complementary pairs embodied in the familiar metaphor of Mother Earth and Father Sky. Water—fertilizing rain—links earth and sky; the womb of earth is the point of emergence of all life forms. Emphasis is placed upon maintaining balance while recognizing the male and female sides of life and the universe as a whole. Integrating matter and spirit and achieving a state within that is identical to the greater state of being in the cosmos at large is known by the Navajo as *hózhó*, or "harmony."[4]

Water has influenced Southwestern ritual and craft for centuries. Rituals maintain and restore individual and communal harmony. Complex ceremonies—mosaics of dance, song, prayer, and regalia—pay respect to those who control the environment. In the delicate balance of Southwestern life, Pueblo peoples, reliant on precious rain for maize, honor the *katsinas*—spirit beings who bring blessings—during celebrations. In return, rain sanctifies the people and land. Frogs and lizards, creatures emblematic of

Seasonal Round of the Hopi

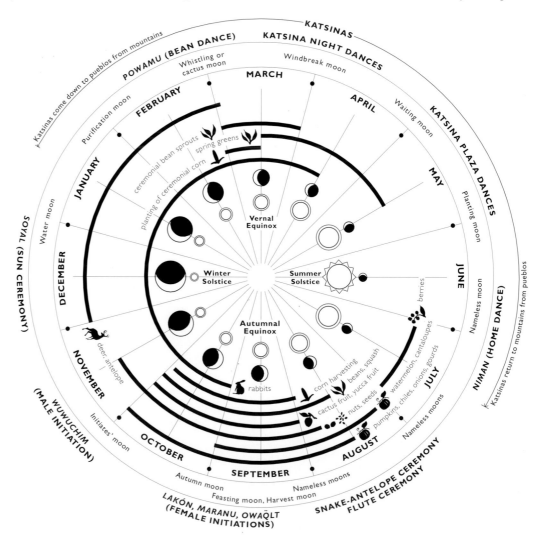

desert survival, recur in motifs and jewelry. Animals, plants, feathers, pollen, and stones from the local terrain are transformed into objects that attract the supernatural and remove the dangerous.

Like the ephemeral Navajo sandpaintings, the Southwest is a place of transient boundaries and frequent movement. Throughout their long history, the Southwestern people have, as necessary, adapted to environmental and social stresses. Tribes have traded, come together, and drifted apart. Even so, the region is defined by a cohesive mentality. In every respect, Southwestern Indians see themselves as "crystallizations of the substance and energy of their places on earth,"[5] and their views of reality and most material and spiritual work reflect this connection.

ORIGINS

All groups regard wind as the matrix of life. They clothe and adorn the first beings in nature's abundance and describe a series of previous existences layered one atop the other out of which the ancient ones emerged.

"In the beginning," say the Zuñi, "*A'wonawil'ona* with the Sun Father and Moon Mother existed above. . . . All was *shi'pololo* [fog] rising like a steam. With the breath from his heart *A'wonawil'ona* created clouds and the great waters of the world. He-She is the blue vault of the firmament. The breath clouds of the gods are tinted with the yellow of the north, the blue-green of the west, the red of the south, and the silver of the east of *A'wonawil'ona*. The smoke clouds of white and black become a part of *A'wonawil'ona*; they are himself, as he is the air itself; and when the air takes on the form of a bird it is a part of himself—is himself. Through the light, clouds, and air he becomes the essence and creator of vegetation."[6] Among some Hopi Indians, the world is believed to have been formed by *Huruing Wuhti* (Hard Beings Woman), who was closely associated with the creation of turquoise and fire. One of the Hopi first beings was *Masau'u*, a consort of *Huruing Wuhti* in the Under World, who wore "four strands of turquoise around his neck and very large turquoise ear pendants. In his face he had two black lines running from the upper part of his nose to his cheeks and made with specular iron."[7] Another origin story, of the Acoma Pueblo people, tells of *Miochin*, the spirit of summer, wearing a shirt made of woven cornsilk, a belt of green corn leaves, a hat of corn leaves with corn tassels, leggings of moss, and moccasins embroidered with butterflies.[8]

The *Diné* (Navajo) migrated upward to This World through four underworlds supported by pillars of precious materials: white shell, turquoise, abalone, and red stone. Navajo ancestors arrived at the confluence of four sacred mountains—Blanca Peak, Mount Taylor, San Francisco Peak, and Hesperus Peak—each representing a cardinal direction. Light, which "misted up" from the four mountains, is said to have been the mountains' breath. Four winds join the phenomena of light and color associated with the cardinal directions. White Wind, Blue Wind, Yellow Wind, and Dark Wind are reflected in the white of dawn, the blue of sky, the yellow of twilight, and the dark of night, respectively.[9]

Colored mists gave Earth People life, including Changing Woman (also called White Bead or White Shell Woman), who, assisted by Sun, created the Navajo from her own skin. "She made our toes and fingernails of abalone shell, our bone of white shell, our flesh of red-white stone, our hair of darkness, our skull of dawn, our brains of white shell . . . our tears of collected waters, our pupils of shaken-off stone mica and rock crystal, our ears of red-white stones. . . . A straight lightning furnished our tongues, a rainbow our arms, plants of all kinds furnished our pubic hair and skin pores."[10]

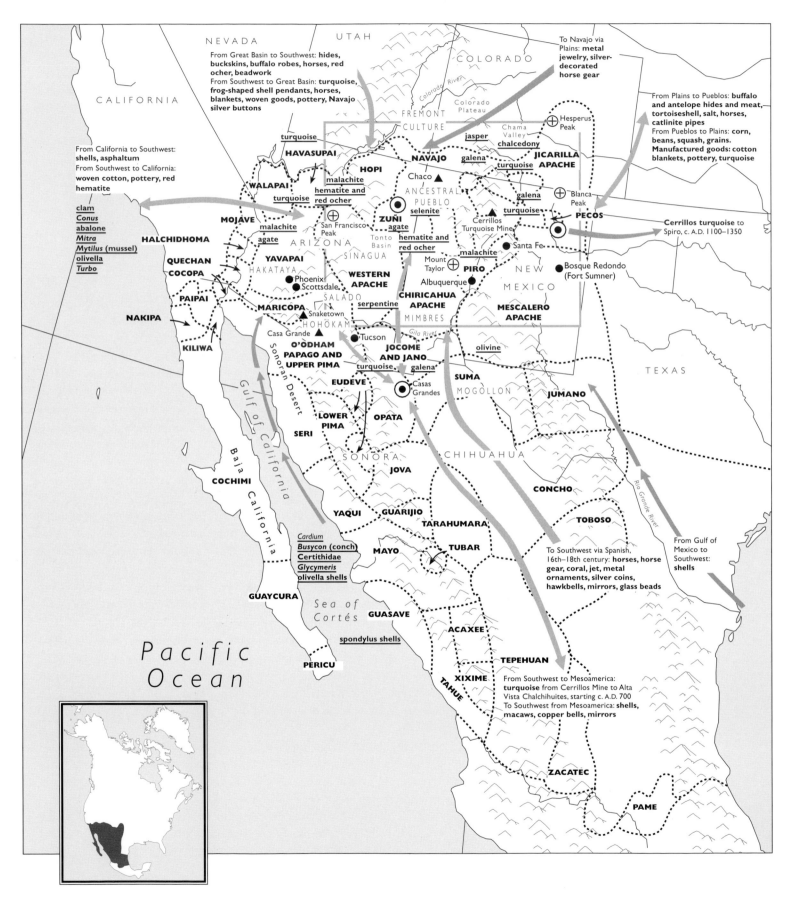

NEVADA

UTAH

COLORADO

CALIFORNIA

From Great Basin to Southwest: **hides, buckskins, buffalo robes, horses, red ocher, beadwork**
From Southwest to Great Basin: **turquoise, frog-shaped shell pendants, horses, blankets, woven goods, pottery, Navajo silver buttons**

Colorado River

Colorado Plateau

FREMONT CULTURE

Chama Valley

To Navajo via Plains: **metal jewelry, silver-decorated horse gear**

turquoise

HAVASUPAI

HOPI

jasper
chalcedony

NAVAJO

galena

turquoise

JICARILLA APACHE

Hesperus Peak

From Plains to Pueblos: **buffalo and antelope hides and meat, tortoiseshell, salt, horses, catlinite pipes**
From Pueblos to Plains: **corn, beans, squash, grains.**
Manufactured goods: **cotton blankets, pottery, turquoise**

From California to Southwest: **shells, asphaltum**
From Southwest to California: **woven cotton, pottery, red hematite**

WALAPAI

malachite

turquoise

malachite
hematite and red ocher

Chaco ▲

ANCESTRAL PUEBLO

selenite

ZUÑI

galena

turquoise

Cerrillos Turquoise Mine

Blanca Peak

PECOS

clam
Conus
abalone
Mitra
Mytilus (mussel)
olivella
Turbo

MOJAVE

malachite
agate

San Francisco Peak

ARIZONA

SINAGUA

Tonto Basin

hematite and red ocher

malachite

Santa Fe

Cerrillos turquoise to Spiro, c. A.D. 1100–1350

HALCHIDHOMA

QUECHAN
COCOPA

YAVAPAI

HAKATAYA

Mount Taylor

PIRO

Albuquerque

NEW MEXICO

Bosque Redondo (Fort Sumner)

PAIPAI

WESTERN APACHE

NAKIPA

SALADO

MARICOPA

Phoenix
Scottsdale

serpentine

CHIRICAHUA APACHE

MIMBRES

MESCALERO APACHE

KILIWA

Snaketown

HOHOKAM

Casa Grande ▲

Tucson

JOCOME AND JANO

turquoise

olivine

Gila River

TEXAS

O'ODHAM PAPAGO AND UPPER PIMA

galena

SUMA

JUMANO

Sonoran Desert

Gulf of California

EUDEVE

LOWER PIMA

OPATA

Casas Grandes

MOGOLLON

SERI

JOVA

SONORA

CHIHUAHUA

CONCHO

Bala California

COCHIMI

YAQUI

GUARIJIO

TARAHUMARA

TOBOSO

Rio Grande River

From Gulf of Mexico to Southwest: **shells**

Cardium
Busycon (conch)
Certithidae
Glycymeris
olivella shells

MAYO

TUBAR

To Southwest via Spanish, 16th–18th century: **horses, horse gear, coral, jet, metal ornaments, silver coins, hawkbells, mirrors, glass beads**

GUAYCURA

Sea of Cortés

GUASAVE

spondylus shells

ACAXEE

Pacific Ocean

PERICU

TEPEHUAN

XIXIME

TAHUE

From Southwest to Mesoamerica: **turquoise** from Cerrillos Mine to Alta Vista Chalchihuites, starting c. A.D. 700
To Southwest from Mesoamerica: **shells, macaws, copper bells, mirrors**

ZACATEC

PAME

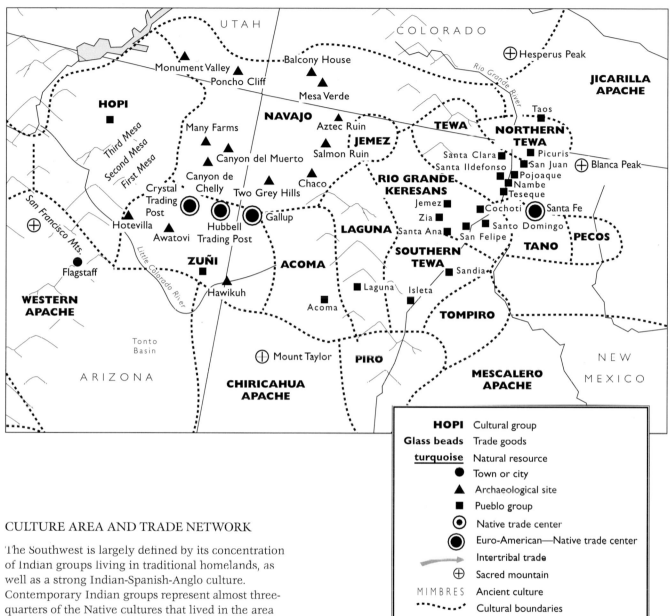

UTAH COLORADO

▲ Monument Valley ● Balcony House ⊕ Hesperus Peak

Poncho Cliff

JICARILLA APACHE

▲ ▲ Mesa Verde

Rio Grande River

HOPI
■

NAVAJO

▲ Many Farms ▲ Aztec Ruin

Taos

Third Mesa
Second Mesa
First Mesa

JEMEZ
▲ Salmon Ruin

TEWA

NORTHERN TEWA

▲ Canyon del Muerto

Santa Clara ● Picuris
Santa Ildefonso ● San Juan ⊕ Blanca Peak
■ Pojoaque
Nambe
Teseque

Canyon de Chelly ▲ Chaco

RIO GRANDE KERESANS

Crystal Trading Post

▲ Two Grey Hills

Jemez ■
Zia ■
Santa Ana ■

Cochoti ■
● Santa Fe
Santo Domingo

PECOS

San Francisco Mts.

▲ Hotevilla

◉ ◉ ◉ Gallup
Hubbell Trading Post

Awatovi ▲

LAGUNA

San Felipe

Santa Ana

TANO

⊕

Little Colorado River

ZUÑI
■

ACOMA

SOUTHERN TEWA

● Flagstaff

▲ Hawikuh

Sandia ■

■ Laguna
Isleta

WESTERN APACHE

Acoma ▲

TOMPIRO

Tonto Basin

⊕ Mount Taylor **PIRO**

MESCALERO APACHE

NEW

ARIZONA

CHIRICAHUA APACHE

MEXICO

HOPI	Cultural group
Glass beads	Trade goods
turquoise	Natural resource
●	Town or city
▲	Archaeological site
■	Pueblo group
◉	Native trade center
◉	Euro-American—Native trade center
→	Intertribal trade
⊕	Sacred mountain
MIMBRES	Ancient culture
·····•	Cultural boundaries

CULTURE AREA AND TRADE NETWORK

The Southwest is largely defined by its concentration of Indian groups living in traditional homelands, as well as a strong Indian-Spanish-Anglo culture. Contemporary Indian groups represent almost three-quarters of the Native cultures that lived in the area during the original Spanish explorations. Extensive ancient exchange networks linked the Southwest with the Pacific and Gulf Coasts, Mesoamerica, and the Plains.

The map at left shows approximate territories of the Pueblo groups during the sixteenth century; the southwestern part of the region during the seventeenth century; and the Apache, Navajo, and northwestern groups during the eighteenth century. The detail above highlights the Pueblo groups and their neighbors. See also the map of contemporary Native lands, page 551.

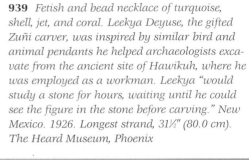

939 *Fetish and bead necklace of turquoise, shell, jet, and coral. Leekya Deyuse, the gifted Zuñi carver, was inspired by similar bird and animal pendants he helped archaeologists excavate from the ancient site of Hawikuh, where he was employed as a workman. Leekya "would study a stone for hours, waiting until he could see the figure in the stone before carving." New Mexico. 1926. Longest strand, 31½" (80.0 cm). The Heard Museum, Phoenix*

937 *Ancestral Pueblo fertility figurine. Canyon de Chelly, Navajo Cave.* A.D. *650–850. Clay, plant fiber, cordage. Length, 3³⁄₁₆" (8.1 cm). American Museum of Natural History, 29.1/4539*

938 Inset: *Contemporary Hopi maiden pendant recalls the ancient Pueblo figurine. Charles Supplee (Hopi-French). 1980s. Sugilite, coral, shell heishi, Lone Mountain turquoise, 18-karat gold. Length, 3½" (8.9 cm). Private collection*

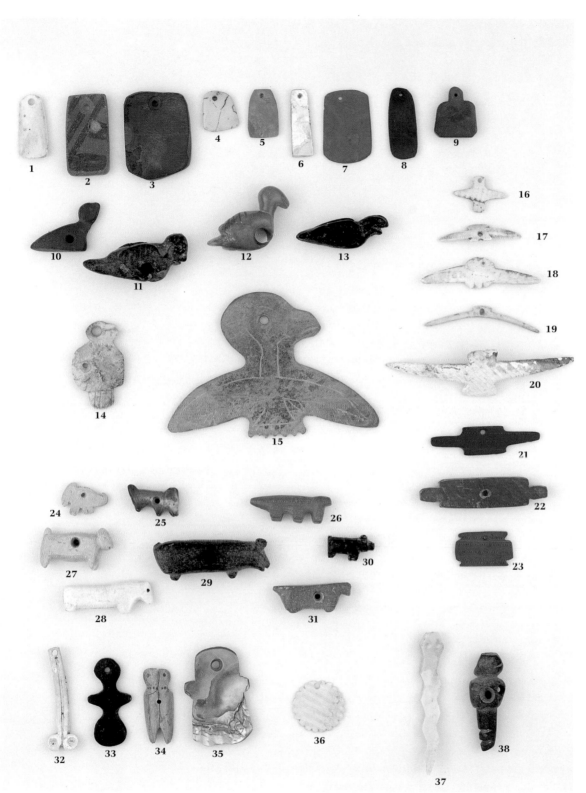

940 *Representative collection of pendants worn by ancient Southwestern peoples. (Pendants are listed by materials; groups and/or dates are given where known.)*

Top row: *Tabular pendants:* 1. Shell. Ancestral Pueblo. 2. Potsherd. Ancestral Pueblo. A.D. 800–1000. 3. Argillite. Ancestral Pueblo. A.D. 750–1300. 4. Turquoise. Salado culture. A.D. 1250–1400. 5. Turquoise. Patayan. A.D. 1050–1200. 6. Abalone shell. Mogollon. A.D. 1150–1265. 7. Argillite. Ancestral Pueblo. A.D. 1100–1300. 8. Argillite. 9. Argillite. Second row: *Side-view bird pendants.* 10. Argillite. Sinagua culture. A.D. 1100–1300. 11. Steatite. Mogollon. A.D. 1250–1400. 12. Greenstone serpentine. Snaketown. 13. Steatite. Middle: 14. Shell. 15. Phyllite. Hohokam Snaketown. A.D. 850–1000 Right column: *Birds in flight, naturalistic to abstract:* 16. Shell. Hohokam. 17. Shell. 18. Shell. Salado culture. 19. Shell. 20. Shell. Sinagua culture. 21. Argillite. 22. Potsherd. 23. Argillite. Second row from bottom: 24. Turquoise. 25. Spiny oyster shell. 26. Stone. 27. Shell. 28. Shell with eye. 29. Stone bear. 30. Steatite wolf or dog. 31. Green serpentine. Bottom Row: *Abstract figures:* 32–38. Shell, stone, bone. Sinagua culture. A.D. 700–1250. Width of 15, 3¾″ (9.6 cm). Arizona State Museum, The University of Arizona

Within this context, surrounded by earth's riches, Southwestern peoples have transformed adornment to its highest attainment. As George Blueeyes, Navajo, writes:

Blanca Peak is adorned with white shell
Mount Taylor is adorned with turquoise.
San Francisco Peaks are adorned with abalone.
Hesperus Peak is adorned with jet.

This is how they sit for us.
We adorn ourselves just as they do,
With bracelets of turquoise,
And precious jewels about our necks.
From them and because of them,
We prosper.[11]

Physical evidence of the region's ancient inhabitants can be found in surviving petroglyphs, potsherds, and stone and adobe architecture. Beads and pendants were worn as early as 8800 B.C. by buffalo-hunting Paleo-Indians living on the southwestern Plains. Small Archaic Desert culture bands, migrating with seasonal food sources, collected animal teeth and bear claws for ornaments and made stone disk and pendant necklaces. Bird and small mammal bones were used as beads and strung with olivella shells from the California coast. Necklaces, worn by both sexes, were strung in contrasting colors with repetitive patterns. Bone, shell, and stone rattled as people walked or danced. With the emergence of the Southwestern cultures, a wide variety of materials was crafted into adornment—including wood, bone, slate, travertine, mica, jet, and argillite—but most important were turquoise and white shell. Turquoise was mined from local sources; shell came from distant oceans.

By the second millennium B.C., Mesoamerican agricultural methods began to reach the Southwest. As the early Archaic tribes adopted agriculture and settled into small villages, they developed distinctive architecture and pottery. From their remains, archaeologists have defined three major cultures—the Hohokam, Mogollon, and ancestral Pueblo (formerly called Anasazi). The earliest ancestral Puebloan sites are those designated as Basketmaker II (300 B.C.–A.D. 450), the name given by the archaeologists when the sites were first discovered. (Since they made exceptional basketry but had not yet developed pottery, it was believed they were a different people.) Regional groups—the Sinagua and Hakayata—blended traits from all their neighbors. In east-central Utah, Fremont culture people were a mixture of ancestral Pueblo, Great Basin, or Plains groups.

The ancient people created a farm-based culture that made maximum use of the scarce water supply. The ancestral Puebloans practiced rainfall farming in the Colorado Plateau while the Hohokam engineered elaborate canal irrigation systems in the Sonoran Desert. Populations gathered near fields of maize, squash, and beans, though all practiced some hunting and gathering. People congregated into villages and towns. Productive trade and efficient economies supported local artisans; traders and travelers passed through, opening avenues of thought and creativity. Pottery, weaving, and adornment expanded, leading to the development of aesthetic traditions that have endured.

Hohokam origins are traced to either an indigenous hunter-gatherer group or to an immigrant group from Mexico. Since typical elements of Hohokam culture—worked shell, stone, and maize agriculture—were present during the earlier Archaic period, most archaeologists now believe that Hohokam lifeways essentially developed out of those of the Archaic group.[12] The Hohokam introduced to the region certain pottery

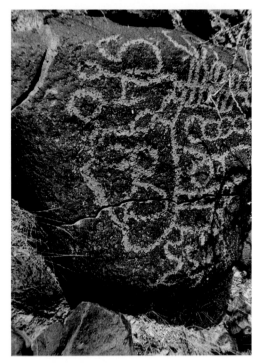

941 *In this petroglyph—possibly marking the Southwest to California route—a shell trader carries a bag of shell goods on his back. Long-distance traders were an essential part of the Southwest's cultural development. These rock-art images guided the traders on their routes. Many of these ancient trails became the routes followed by early explorers and settlers and are today's highways. Arizona State Museum, The University of Arizona*

techniques and turquoise mosaics. The Mogollon, from the forests and upland meadows of the Arizona–New Mexico border, brought a regionally diverse and eclectic style—a commingling of ancestral Puebloan and Hohokam traits. Their stone and shell jewelry resembles that of both cultures, although some stylized bird pendants are distinctly Mogollon. The ancestral Pueblo, surrounded by the high mesas and canyons of the Colorado Plateau, brought a geometric order to everything, from their multiroomed terraced buildings (pueblos) to their jewelry. A formal beauty characterizes ancient Puebloan artifacts. Strings of olivella, long enough to wrap around the neck several times, disk-bead necklaces with turquoise and shell pendants, and mosaics of turquoise, shell, and jet suggest the extent of Puebloan craftsmanship.

Baskets, clothing, and adornment frequently were buried with the ancestral Puebloan deceased. Bags, sandals, bands, and small aprons were finger-woven of fibers, particularly yucca. Coiled and twined baskets with carrying straps had red-and-black-dyed designs. A few bags featured exterior painted patterns mirrored on the interior. Blankets were prepared from strips of rabbit fur, deerskin, and woven, split feather-wrapped hide strings. Skin bags of prairie-dog hide possibly had ritual significance.[13] From A.D. 500 to 1500, adornment was clearly part of ceremonial regalia, used as offerings at shrines and sacred places and as dedicatory deposits during construction events. Jewelry was also an object of trade, helping to bind the greater ancient Southwest into an elaborate web of social and trade alliances.

A far-ranging network of trails linked the Plains, Great Basin, Sonoran Desert, California, and Mesoamerica with all areas of the Southwest. Obsidian from west of the Rio Grande was identified in Paleo-Indian sites; trade for marine shells from the Gulf of California and Pacific Coast began in Archaic times. Pottery was exchanged throughout the Southwest; by A.D. 1000, turquoise, copper, and macaw feathers were bartered along with stone, marine shell, and pots.[14]

Between A.D. 900 and 1100, an elaborate shell-trade network developed among the Hohokam of southern Arizona and the Mimbres of southern New Mexico. More than twenty genera of shell, including *Haliotis* (abalone), *Glycymeris, Olivella,* and *Conus* were made into jewelry in ways that took advantage of their natural shapes. Finished beads and bracelets were then traded north.

Hohokam middlemen, whose communities were strategically located along the long-distance trade routes, bartered Gulf of California salt and Pacific Coast shells—two pivotal products in Southwestern life—as well as Great Plains buffalo hides, deerskins, turquoise, obsidian, rare minerals, pigments, finished textiles, pottery, and Mexican copper bells and exotic feathers. They also traded with Puebloan and Mogollon contemporaries.[15] Snaketown, adjacent to the Gila River in Arizona, was from A.D. 950 to 1150 an impressive Hohokam center of trade. The infusion of ideas and materials into the Hohokam inspired lively adornment. *Glycymeris* shells were made into pendants by placing a hole in the thickened umbo joint, or fashioned into bracelets by cutting out the interior and grinding down the edges. Hohokam artists arranged hundreds of pieces of turquoise, mosaics in the shapes of birds, turtles, frogs, and lizards. Copper bells from Mexico were probably strung as necklaces.[16] "In a number of ways," writes anthropologist Wesley Jernigan, "the vitality and creative energy of this fascinating people set the pattern in the development of jewelry in the whole Southwest."[17]

To the north, where access to marine shell was more difficult, the Chacoans (of Chaco Canyon in northeastern New Mexico) considered turquoise as their principal valuable. The brilliant coalescence of aesthetics, politics, and economics at Chaco paralleled a time, between A.D. 1000 and 1200, when the Chacoans traded as well as processed vast quantities of turquoise into jewelry and ritual artifacts.

RECIPROCAL INFLUENCES

Southwestern cultures often elaborated upon each other's ideas. Inlay mosaic work appears to have spread from the Mesoamericans to the Hohokam to the ancestral Puebloans. Bilobed spiny-oyster-shell beads reached across Pueblo, Hohokam, and Mogollon cultures. Cleverly carved, the bilobed strands resembled a double-strand necklace.

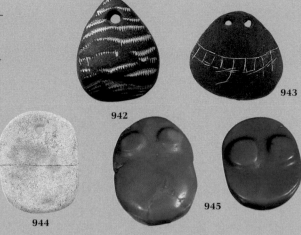

943

942

946

947

945

944

948

942 *Shale pendant. Ancestral Pueblo. Aztec Ruin.* A.D. *1110–21. Length, ¹⁵⁄₁₆" (2.3 cm). American Museum of Natural History, 20.0/8774*

944 *Mimbres-culture calcite pendant painted with traces of malachite pigment to simulate valued turquoise. New Mexico.* A.D. *1000–1500. Length, 1⅛" (2.8 cm). Laboratory of Anthropology/ Museum of Indian Arts and Culture, Santa Fe, New Mexico, 51466/66*

943 *Etched-clay pendant. Ancestral Pueblo. Chama Valley, New Mexico.* A.D. *1100. Length, ¾" (1.9 cm). Laboratory of Anthropology/ Museum of Indian Arts and Culture, Santa Fe, New Mexico, 512/11*

945 *Two turquoise frog beads. Frogs, a symbol of water and fertility, were revered in the arid desert. Ancestral Pueblo. Salmon Ruin, New Mexico.* A.D. *1000. Length of frog at right, ⅜" (0.9 cm). San Juan Archaeological Research Center and Library, Bloomfield, New Mexico*

946 *Hohokam bilobed shell beads. Snaketown.* A.D. *950–1150. Average bead length, ⅜" (0.9 cm). Arizona State Museum, The University of Arizona*

947 *Ancestral Puebloan bilobed shell beads. Arizona.* A.D. *450–1300. Typical bead length, ¼" (0.7 cm). Arizona State Museum, The University of Arizona*

948 *Mogollon bilobed shell and stone beads, typical of the Mimbres culture.* A.D. *1000–1200. Bead lengths, ¼₁₆–⅞" (0.6–2.2 cm), Laboratory of Anthropology/ Museum of Indian Arts and Culture, Santa Fe, New Mexico, 37413/11*

949 *Ancestral Puebloan turquoise, spiny-oyster shell, and jet (lignite) beads and pendants recovered from Pueblo Bonito, Chaco Canyon. The shell and jet necklace contains more than five thousand beads, with sizes ranging from 1 to 2 mm.* A.D. *1000–1200. Frog length, 3³⁄₁₆" (8.0 cm). American Museum of Natural History, H/10426, H/3764, H/3871, H/9233, H/5149, H/5138, H5133*

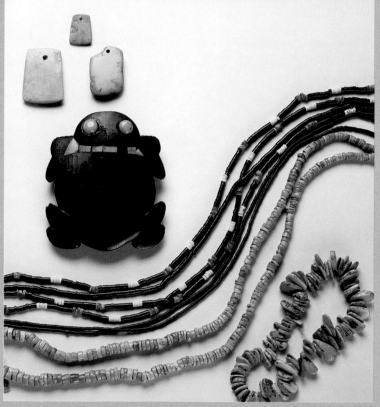

949

950 *Circular disk pendants with notches. Two Navajo workmen discovered these ancestral Pueblo disks in a corrugated pot near a spring at the Balcony House site in Mesa Verde National Park. They kept the stash hidden in its original crevice, protecting their secret for seventeen years before relaying the information to archaeologists in 1991. The disks of burned shale (found tied with the original cotton yarn) are inlaid with imported materials—turquoise, shell, and specular hematite, the nearest source being from southwestern Utah. c. A.D. 1100–1300. Diameter, 1⁷⁄₁₆" (3.7 cm). Collection Mesa Verde National Park Museum*

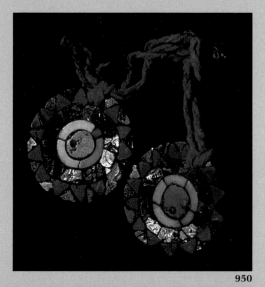

950

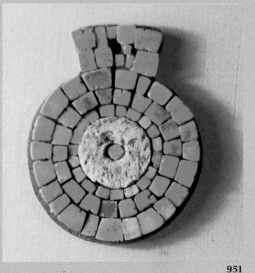

951

951 *Earring of turquoise and shell. Hohokam. Casa Buena, Arizona. A.D. 1100–1450. Pueblo Grande Museum and Cultural Park, 90.1.458*

952 *Turquoise and spiny-oyster-shell earrings with a flower or sunburst motif. Salado culture. c. A.D. 1150–1400. Tonto Basin, Arizona. Private collection*

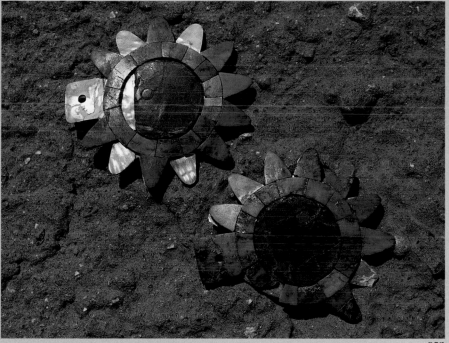

952

953 *Sinagua shell and turquoise carved quadruped pendant. The Sinagua culture arose when the Mogollon came into close contact with the ancestral Pueblo and Hohokam. c. A.D. 1200. Diameter, ⅞" (2.2 cm). Museum of Northern Arizona, NA3673.T.25*

954 *Hohokam shell pendant with carved bird motif. A.D. 1200–1400. Arizona State Museum, The University of Arizona*

953

954

955 *Argillite lizard pendant. Snaketown. Length, 2%6" (6.5 cm). Arizona State Museum, The University of Arizona*

956 *Lizard pendants. The ability of snakes and lizards to exist with scarce water must have impressed the Hohokam desert dweller; such life forms were not just acknowledged but revered. Increased stylization and "horizontal compression" marked the development of shell and stone lizard pendants over time—legs become small tabs; drill bits on the back suggest scales. These shell pendants (the second from right is of phyllite) range in date from A.D. 700 to 1500. Length of far-right pendant, 4%6" (11.6 cm). Arizona State Museum, The University of Arizona*

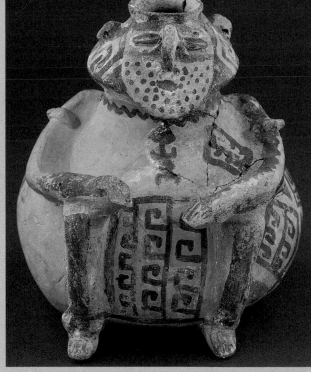

957 *Terra-cotta male effigy jar adorned with a lizard pendant similar to 955. Snaketown. Tenth century. Length, 6⅜" (16.2 cm). Arizona State Museum, The University of Arizona*

THE SNAKETOWN SITE: SOUTHWESTERN-MEXICAN CONNECTIONS

The Hohokam and the northern Mexicans interacted for millennia. Excavations at the Hohokams' Snaketown site (A.D. 300–1350) in Arizona suggest a rich cultural exchange in adornment materials. Turquoise from New Mexico's Cerrillos mine traveled south, while Mesoamerican artifacts recovered include mirrors, copper bells, shell jewelry, and macaw feathers, all of which were probably valued ritual goods. Aztec motifs—an eagle with a snake in its mouth (see 963) and *Cipactli*—a mythical monster with no tail—appear on shell jewelry.

958 **959** **960**

958 *Glycymeris-shell ring. Snaketown.* A.D. *950–1150. Diameter, ¾″ (2.0 cm). Arizona State Museum, The University of Arizona*

959 *Steatite earspool. Snaketown.* A.D. *950–1150. Diameter, 1⁷⁄₁₆″ (3.65 cm). Arizona State Museum, The University of Arizona*

960 *Funerary stone and ceramic nose plug. Argillite and turquoise half-beads with lac. Sinagua culture.* C. A.D. *1200. Diameter, ½″ (1.3 cm). Museum of Northern Arizona, 1785.1316.115*

▽ **961** *The Hohokam appear to have cherished frogs, which are represented in numerous Glycymeris-shell pendants and bracelets. Anthropologist Wesley Jernigan writes: "Given the natural rounded swelling shape of the shell, it takes surprisingly few, but judicious, cuts with a stone file to produce a frog that fairly croaks. I, having witnessed the sudden and elf-like emergence of desert frogs after a summer thunderstorm, have no doubt that these frog pendants had a strong magical connection with water."* LEFT TO RIGHT: *Frog pendants,* A.D. *1200–1500. Length of middle pendant, 1¹⁵⁄₁₆″ (4.9 cm). Olivella-bead necklace with Glycymeris-shell bracelet, inlaid with turquoise and argillite tesserae.* A.D. *1100–1400. Glycymeris-shell bracelet with the thickened umbo carved to represent a frog. Diameter, 2⅛″–2¼″ (5.4–5.7 cm). Arizona State Museum, The University of Arizona*

962 *The Hohokam painted many* ▷ *objects, including shells. A design scratched through a layer of pitch or wax was then daubed with fermented cactus juice. Design elements on this piece were highlighted with the addition of turquoise and red pigment.* A.D. *1050–1200. Length, 4⅝″ (11.8 cm). Arizona State Museum, The University of Arizona*

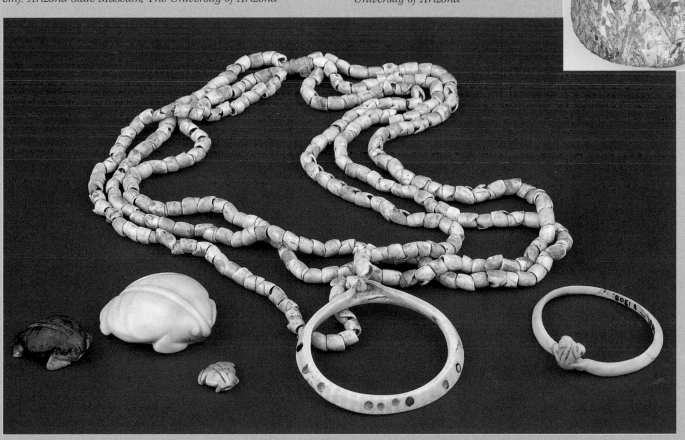

963 *1. Glycymeris-shell* ▷
bracelet fragment showing a
bird and snake motif on umbo.
The eagle-with-a-snake-in-its-
mouth motif became icono-
graphically important among
the Aztecs after the founding of
the Aztec capital, Tenochtitlán,
in 1325. The motif appears on
today's Mexican flag. Hohokam.
A.D. *1000. Length, 1¾" (4.5 cm).*
2. Glycymeris-shell bracelet with
bird and snake motif. Hohokam.
Umbo height, ⅗" (1.8 cm). A.D.
700–1000. 3. Hohokam depiction
of an Aztec Cipactli figure.
Snaketown. Abalone shell. A.D.
850–1150. Length, 1¼" (3.2 cm).
4. Mesoamerican copper bells
were combined with disk beads,
probably as necklaces. A.D. *1300–*
1400. Length, 1⅛" (2.9 cm). 5–8.
Pendants possibly replicating
copper bells. 5. Argillite. Length,
⁷⁄₁₆" (1.1 cm). 6. Spiny oyster.
7. Steatite. Salado culture. A.D.
1250–1400. 8. Chrysoprase. A.D.
900–1400. Arizona State Museum,
The University of Arizona

964 *Aztec double-headed-*
serpent mosaic pectoral encrusted
with turquoise tesserae and
shell over wood. Worn by Aztec
royalty, turquoise exported to
Mesoamerica from New Mexico's
Cerrillos mine attests to exten-
sive trade and cultural exchange
between the precontact
Mesoamericans and Puebloans.
c. 1375–1550. Length, 17⅛"
(43.5 cm). British Museum

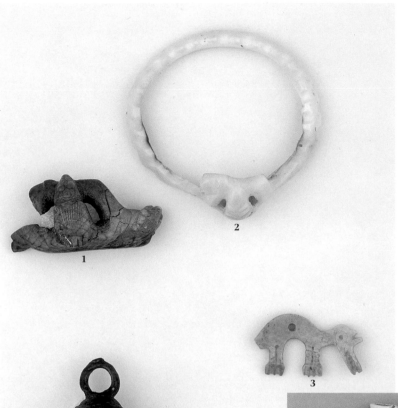

965 LEFT: *Conus-shell tinklers.*
RIGHT: *Irregularly shaped*
spiny-oyster shell. Casas Grandes,
Chihuahua, Mexico. Both, A.D.
1150–1400. Arizona State
Museum, The University of
Arizona

966 *Bighorn-sheep pendant of*
ricolite, a banded serpentine
stone found only in Arizona.
Casas Grandes, Chihuahua,
Mexico. A.D. *1150–1450. Length,*
2³⁄₁₆" (5.6 cm). Arizona State
Museum, The University of
Arizona

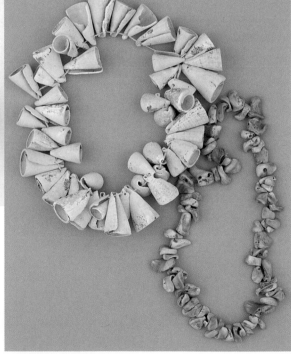

965

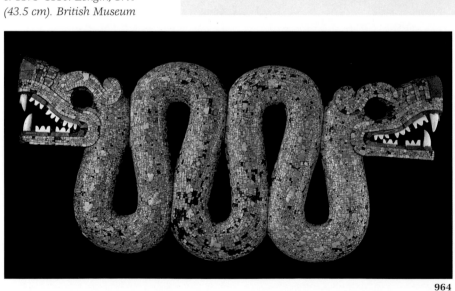

964

966

TURQUOISE

Turquoise has both sacred and economic value in Southwestern culture. In the Hopi creation story, a handsome young man adorned with turquoise necklaces and earrings was among the original people who came to This World from Under World. The Spanish explorer Coronado, seeking the fabled Seven Cities of Cibola, arrived at Zuñi Pueblo in 1540. Although he found no gold, he encountered people adorned with "turquoise earrings, combs and tablets set with turquoises," who gave turquoise offerings to sources of water. Turquoise is the central ingredient in Navajo prayer offerings for rain. A Navajo hunter provides turquoise to the deer as a sign of respect so that the deer may allow its life to be taken. Similarly, the Navajo give turquoise to each other as expressions of friendship and kinship. Among the Pueblo Indians, turquoise operated as a medium of exchange, its value calculated on the basis of the stone's quality and upon the amount of time necessary to produce an artifact from it. A necklace of turquoise disk beads, measured from shoulder to shoulder, was estimated by a San Ildefonso Indian to be worth one Navajo horse. Turquoise's sacredness to the Puebloans is nonetheless evidenced through the archaeological record. From Chaco kivas at Pueblo Bonito, Pueblo del Arroyo, and Chetro Ketl, turquoise offerings made during construction were recovered under pilasters and support posts, and from sealed wall crypts and niches.

Turquoise is a mineral (cuprous aluminum phosphate); the blue and green colors are determined by its copper content. All turquoise mines produce a wide variety of turquoise. As many of the stones are soft, porous, and pale, they are often injected with plastic resins and dyes to produce intensely colored, "stabilized" turquoise. Beads and jewelry crafted from stabilized stones have little worth. The small percentage of natural turquoise of good color and hardness sufficient to cut and polish to a shiny luster is highly valued. It is this stone that is used in fine-quality Indian jewelry.

Ancient turquoise trade, which extended from the West Indies and the Yucatán Peninsula to Ontario, Canada, and from California to Mississippi and Arkansas, provides some of the most concrete evidence for systematic contact between Mesoamerica and the Southwest. The earliest known use of turquoise in the Southwest dates to about A.D. 300 and is found in Snaketown. By A.D. 700, inhabitants of Alta Vista, a major northwestern Mexican ceremonial center, began importing large quantities of raw turquoise from New Mexico's Cerrillos mine, famous as the New World's "mother lode" of turquoise. The Indians of the Rio Grande Pueblos, in particular the Keresan speakers of Santo Domingo and Cochiti, are thought to have controlled the Cerrillos mines and traded turquoise to the Mayan region in southern Mexico.

Between A.D. 975 and 1180, Chaco Canyon workshops converted enormous quantities of turquoise into beads, pendants, and small flat pieces (tesserae) for mosaic work. Most was shipped down to Mesoamerica. Initially, the Chacoans simply distributed the raw material. Afterward, upon mastering the Mexicans' standardization of tesserae and beveling technology to produce a smooth, finished appearance in mosaic work, they began to finish the turquoise themselves.

Chaco Canyon seems to have lost its monopoly on turquoise sometime during the twelfth century, and Aztec Ruin, north of Chaco on the Animas River, came to dominate the region. As Mesoamerican turquoise consumption increased during the thirteenth century, so too did its use within the Southwest. Formerly the exclusive possession of the elite, turquoise began to adorn those of all social rank. To meet the growing need for supplies, additional mines were opened, challenging the Cerrillos mine's centuries-old monopoly. Turquoise recovered at Casas Grandes in Mexico came from these new sources, which included sites in the Mojave Desert and Nevada. Strangely, turquoise seems never to have been used by the West Coast or California groups who supplied marine shells to the Southwest.

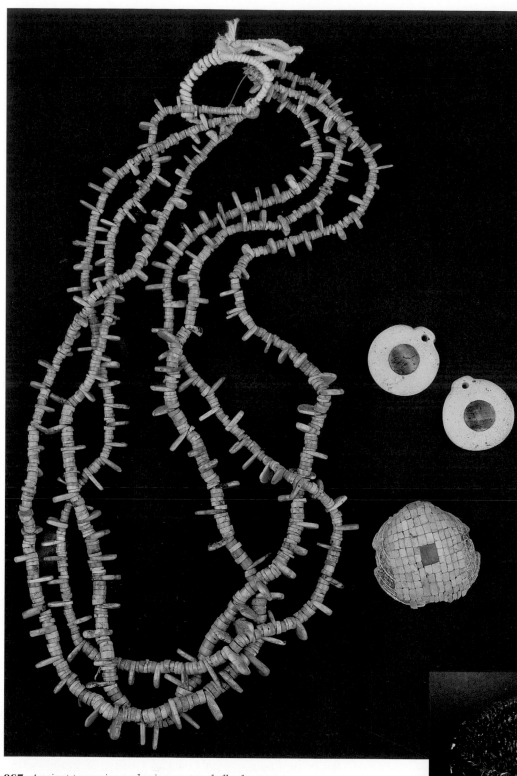

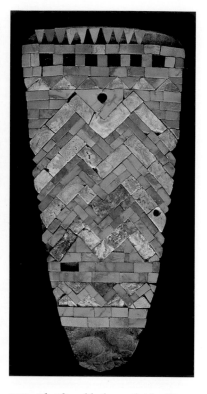

968 *Obsidian blade overlaid with turquoise, shell, and jet mosaic that may have been worn as a gorget. Found in a seed jar at Poncho Cliff, southeastern Utah. Ancestral Pueblo. A.D. 1000–1200. Length, 4⁹⁄₁₆" (11.5 cm). Peabody Museum of Archaeology and Ethnology, Harvard University, 10/A5633*

969 *Ancient basketry bracelet encrusted with turquoise plaques and pine-pitch adhesive. Found at Ceremonial Cave, Texas, the date of this bracelet is uncertain, but most likely is A.D. 800 or later. Height, 1¹⁵⁄₁₆" (5.0 cm). Texas Archaeological Research Laboratory, Austin*

967 *Ancient turquoise and spiny-oyster-shell adornment included Hohokam beads, a mosaic frog, and ancestral Pueblo earrings from a Sinagua-culture site. Sinaguan sites (near the current city of Flagstaff, Arizona) yielded much overlaid jewelry because turquoise was moderately abundant in the area. Beads: A.D. 1050–1200. Length, 9½" (49.5 cm); frog, A.D. 1325–1400; earrings, A.D. 1100–1300. Arizona State Museum, The University of Arizona*

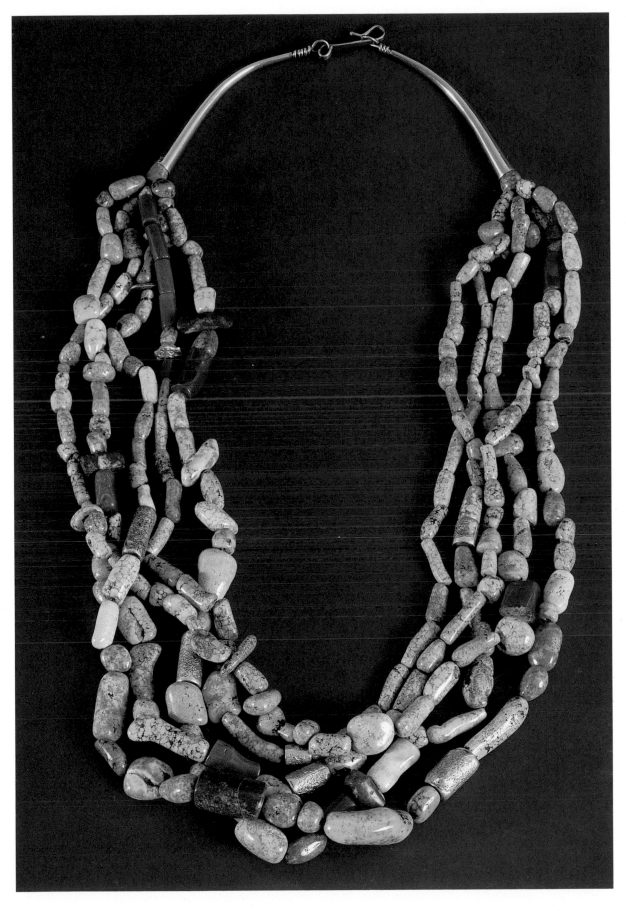

979 *Pieces of gold, which appear to have been placed at random, balance perfectly with the coveted fossilized Spider Web Mountain turquoise beads in this necklace, made by contemporary Hopi jeweler Charles Loloma. "The people who own this mine wanted Charles to work with their stones," notes niece Verma Nequatewa. "They knew Charles was always looking for something unusual, something that most people don't get hold of." 1983. Turquoise, lapis lazuli, gold, coral. Length, 14½" (37.0 cm). Millicent Rogers Museum of Northern New Mexico, 1983-52*

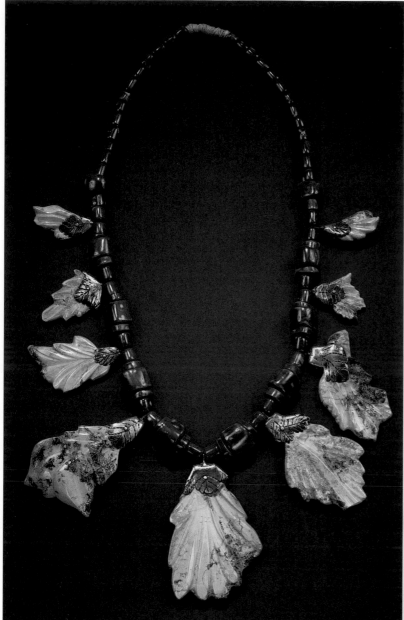

973

973 *Massive carved leaves of Blue Gem turquoise are joined by silver mounts to a coral-bead necklace. Leekya Deyuse (Zuñi). c. 1936. Bottom leaf length, 3½" (8.9 cm). The Heard Museum, Phoenix, Arizona*

974 *Squash-blossom necklace with crescent (naja) pendant, by Della Casa Appa, the first Zuñi woman silversmith. She learned the craft by assisting her husband and was encouraged by C. G. Wallace in 1927 to produce nugget-style silverwork for sale. Apparently, she visited the post at night, "hiding her jewelry in an apron because she perceived the others disapproved of her activities." Late 1920s. Arizona turquoise. Naja diameter, 3⅞" (9.8 cm). Collection Tanner*

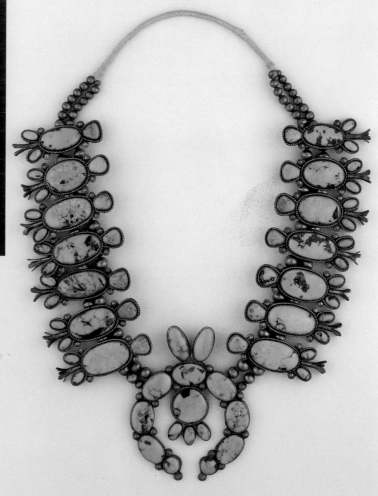

974

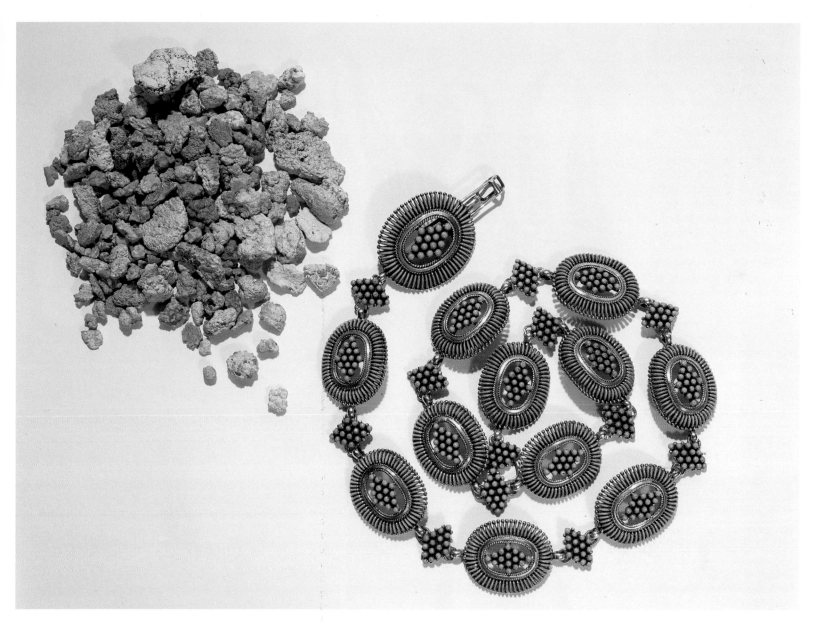

975 *Navajo Yei dancers holding feathers. Silver and Lone Mountain turquoise belt buckle. Phil Long (Navajo). c. 1988. Length, 5¼" (13.3 cm). Private collection*

976 *Turquoise and silver linked concha belt. The fine turquoise stones set in needlepoint technique—a Zuñi specialty—are worked from raw Lone Mountain turquoise nuggets (left). Artist Edith Tsabetsaye of Zuñi Pueblo, who does all her own silversmithing and stonework, says: "I take extra time; it needs lots of patience. The turquoise comes in rough. I have to match the stones so I grind over one thousand stones for each necklace to get what I need. I have no assistants, and nobody taught me." Because "I want to do it well," she uses a template and measures her work for accuracy. Each of Mrs. Tsabetsaye's stones is a domed, perfectly symmetrical cabochon, which requires a different process than the normal, flat-cut of needlepoint. Joe Tanner explains, "To do this work, each stone has to be perfect, gem quality, the very best. She'll take two hundred pounds of turquoise to end up with three or four pounds in the piece."*

"It comes from my dreams," she explains. "My head, my mind. I don't sketch. I just sit down and work with my hands." Belt, 1970s. Length, 32" (81.3 cm). Collection Tanner

977 *Turquoise mines each yield turquoise of unique character, reflected in the nuances of color and texture: 1. Turquoise beads from Lone Mountain Nevada, terminating in silver tabs with cabochon stones. Cheryl Yestewa (Hopi-Navajo). 1970s. 2., 3. High-grade nuggets from the Morenci mine with* heishi, *cut and arranged by Mary Marie Lincoln (Navajo). 1970s. 4. Bracelet of Lone Mountain turquoise nugget and silver. Wilson Tsosie (Navajo). 1970s. 5. Blue Gem turquoise jaclas. 1930s. 6. Old Arizona turquoise with two sets of jaclas, stamped ingots, and hammered silver eagles, crosses, and animals. 1900–30s. Overall length, 22" (55.9 cm). Restrung by Mary Marie Lincoln (Navajo). 1980s. 7. Nugget from the Montezuma mine, Nevada. 1960s. 8. Montezuma choker with gold chisel beads. Made by Lee Yazzie (Navajo), arranged by Mary Marie Lincoln (Navajo). 1970s. Length, 10½" (26.7 cm). 9. Persian turquoise and 14-karat gold choker. Cheryl Yestewa (Hopi-Navajo). 1970s. Length, 7" (17.8 cm). 10. High-grade Morenci turquoise, 14-karat gold. Mary Marie Lincoln (Navajo). 11. Fossilized Lone Mountain turquoise and 14-karat gold chokers. Lee Yazzie (Navajo). 1970s. All, Collection Tanner*

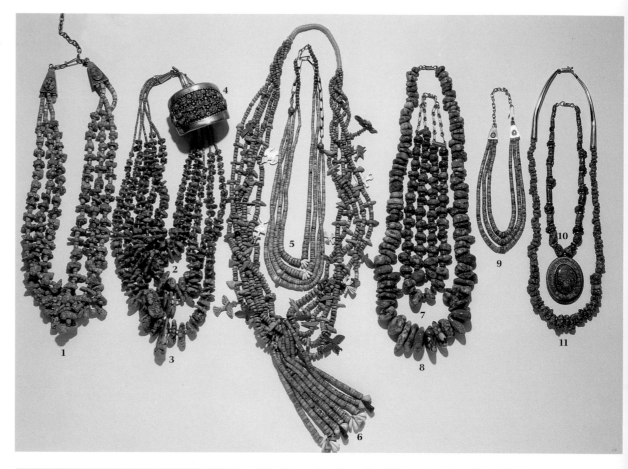

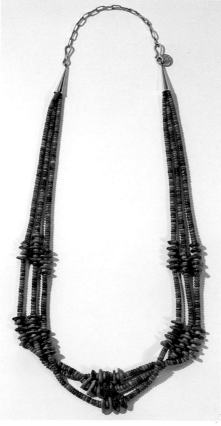

978 *Turquoise (from the Bisbee mine) "corn" and disk-shaped bead necklace by the preeminent turquoise bead-workers Joe B. and Terry Reano of Santo Domingo Pueblo. Asked what she was thinking of to come up with this pattern, Terry Reano answered, "Just beauty!" Both Reanos grew up in families "where lapidary art was a way of life" and have passed on a jewelry heritage to their own children and grandchildren, who start by stringing Cheerios, then glass beads, and, finally, turquoise. Using traditional methods, all stones are hand cut, shaped, drilled with a pump drill, hand rolled, and polished. A strand of beads may take three months to finish. One turquoise nugget may take three hours just to perforate. The Reanos work only with unstabilized turquoise. "It's so much more relaxing to work with natural stones, and you do better work when you aren't so tense," says Terry. "The most important thing is concentration. If I don't feel good, I'll just lay off until I feel better. Because you put your feelings into things that you make." She adds, "When you start wearing good turquoise, it sort of grows with you—the chemicals, minerals, and you. It doesn't change overnight, maybe two, three years, but it gets better with wear."*

The Reanos build up the quantities of beads needed for their necklaces over long periods of time. When an eighty-year-old woman ordered a necklace, relates Joe, "We told her it will take seven or eight years to get all the turquoise and she still wants it!" 1980. Length, 15" (38.1 cm). Collection Tanner

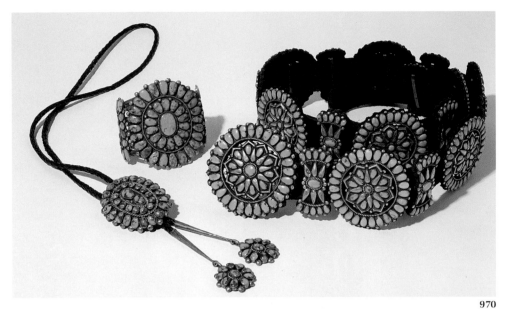

970

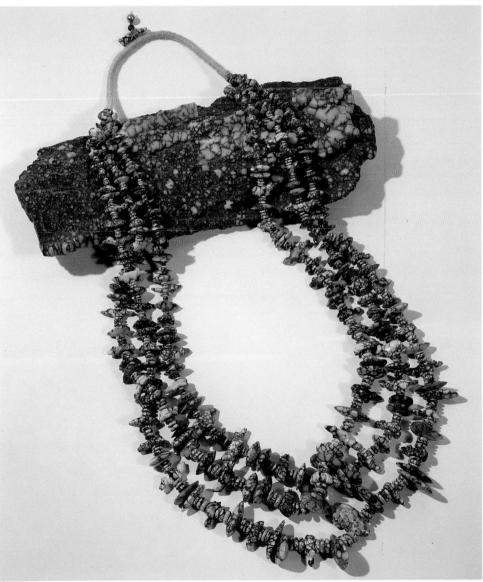

971

970 *Classic examples of Zuñi cluster work coveted by the Navajo. Whereas the Navajo emphasize the silver, Zuñi silversmiths prefer multiple turquoise settings secondary to the silverwork. The bola tie (left), of Bisbee turquoise, is by Mary and Lee Weebothee (Zuñi), c. 1960s. Mary is the lapidary; Lee does the silversmithing. The concha belt, of Lone Mountain turquoise, and bracelet of Villa Grove turquoise are by Raymond Gasper (Zuñi). c. 1940s–60s. Bola tie length, 22" (55.9 cm). Collection Tanner*

971 *Royal Web turquoise fetish necklace, draped across a slab of the raw material. Mined at Crescent Valley, Nevada, Royal Web is a rare and recently discovered variety of turquoise with a strong navy-blue quartz matrix. (When the matrix is green it is varasite; when white, cream, or palamino, it is chalcosiderite; when light blue or navy, it is turquoise.) The fetishes were made by Pete and Dinah Gaspar (Zuñi); Mary Marie Lincoln (Navajo) cut the beads and arranged the necklace. c. 1980s. Length, 18½" (47.0 cm). Collection Tanner*

972 *Appaloosa horses run free in the Nevada territory where the Royal Web turquoise is mined. Joining imagery and materials, collaborating Navajo artisans Roland Long (lapidary) and Chester Kahn (silversmith) inlaid Royal Web turquoise, shell, and coral onto a silver belt buckle. 1993. Length, 3⅜" (8.6 cm). Collection Tanner*

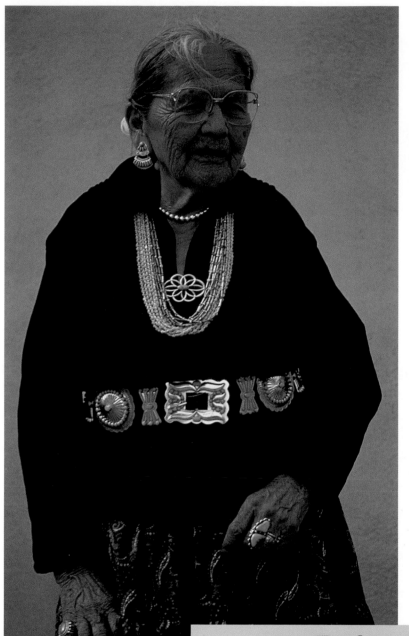

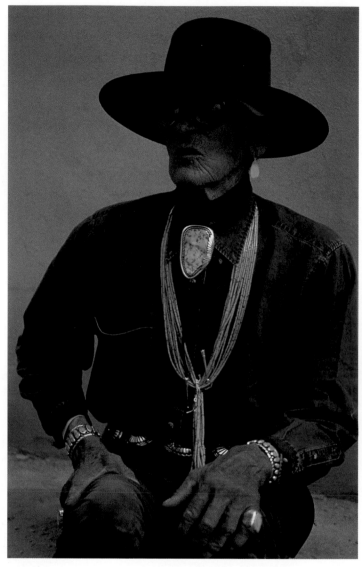

982 *A horse's profile is represented in this turquoise mosaic inlay. Leonard Martza (Zuñi). c. 1940. Width, 2½″ (6.4 cm). Collection Carol Krena*

983 *Navajo-made cluster pin set with high-grade turquoise. c. 1940. Diameter, 3″ (7.6 cm). Collection Lea Simonds*

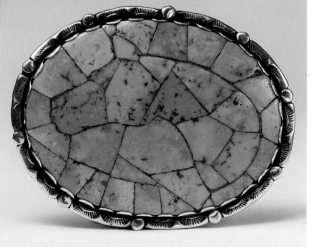

982

983

MOVEMENT, COALESCENCE, AND CONTINUITY

After 1300, the Hohokam and Mimbres trade networks were, for unknown reasons, replaced by the great trading center at Casas Grandes in northern Chihuahua, Mexico. Retreating from the Colorado Plateau during the twelfth and thirteenth centuries, the ancestral Puebloans had by 1450 regrouped farther south into three regions—the Hopi mesas, Zuñi territory, and the Upper Rio Grande. These were the Pueblo people—the Uto-Aztecan-speaking Hopi, the Zuñi with their own unique language, and the Rio Grande villagers speaking either Keresan or Tanoan (the latter including the Tiwa, Tewa, and Towa subgroups)—encountered by the Spanish during the sixteenth century. They continue to dwell there today. Many of their lifeways, especially those involved with spirituality, ceremony, and regalia, endure as significant components of contemporary Pueblo life. The Rio Grande area remains a center for stone and shell beads and the ancient mosaic-on-shell technique.

Although the Hohokam culture had vanished by the fifteenth century, the O'odham (Pima and Papago), who succeeded the Hohokam on their land, are believed to be their direct descendants. (Hohokam is a Pima word meaning "those who have gone.") Other Southwestern tribes include the Yuman speakers—the Yuma and Cocopa, Mojave, Havasupai, Yavapai, and Maricopa, all of whom live throughout Arizona.

Reasons for the early thirteenth century mass migration from the northern portions of the Colorado Plateau are debated. Unpredictable weather patterns coupled with the "pull" of a new religion (possibly the Pueblo Katsina cult) may have been the cause (1078).

There is a growing belief that most ancestral Puebloans chose to migrate to the Rio Grande area.[18] "Our ancestors," says anthropologist Edmund Ladd, of Zuñi heritage, "weren't traveling because there were droughts or there was pestilence. They were traveling because they were looking, searching, for the center place. . . . Of course we know where we come from . . . why we call ourselves A:shiwi. . . . We don't really need to go searching the archaeological records. . . . From our point of view . . . when they found the center place, that's where they settled. That's where Zuñi is today. That's where Hopi is. That's where Acoma is. That's where San Ildefonso is. That's where Santo Domingo is. . . . They moved from the San Juan River basin areas and settled into modern-day pueblos."[19]

Similar ideas are discussed with regard to the emergence in the Southwest of the Navajo or Diné (the People), and the Apache, whose Athapaskan ancestors are thought to have migrated from the north in the fourteenth and fifteenth centuries. (In chants recounting their origins, the Mescalero Apache sing of a great lake in the far north, either Lake Athabasca or Great Slave Lake in Canada.)[20] As anthropologist Peter Gold put it: "Why did Navajos finally make this place their home?. . . Because they were places of deep inspiration and insight, in addition to being places of pure water, readily available food, and abundant materials for shelter. . . . In this place, one vividly perceives a balanced partnership of the four primal essences: the elements of earth, water, (sun's) fire, and air. Centuries ago, the Navajos discovered a landscape that was conducive to developing a state of being that they called Beauty."[21]

The Navajo swiftly adopted existing Southwest ritual, elaborating and refining elements to conform to their own cultural style. They learned agricultural techniques from the Pueblos but, following sixteenth-century Spanish contact, took more naturally and passionately to the culture of horses (derived from the Spanish) and, subsequently, the caballeros' personal adornment. By the 1700s, they were the region's shepherds and raiders, and Navajo life became centered on the horse.

As Spanish power in the New World abated and that of Anglo-Americans increased,

the Navajo and Apache were pursued to exhaustion. Between 1863 and 1868, the Navajo were interned at Bosque Redondo, where some learned metallurgy. Relocated to the reservation, the Navajo craftspeople became world-renowned silversmiths. What Navajo artisans absorbed from the Pueblos, and later the Spaniards and Americans, has been blended with their lifeways to form a unique and vital synthesis. Southwestern history reverberates through Navajo silverwork.

CORRESPONDENCES: SOUTHWEST CULTURE AND ADORNMENT

Stories, ritual, songs, prayers, masks, concepts of space, time, color, and number—all are joined in Southwestern belief systems. Together they form the basis of an elaborate system of correspondences that gives order to much of what is significant in the Pueblo, Navajo, Apache, and O'odham worlds. All share numerous oral traditions and ceremonial elements. The Navajo's Changing or White Shell Woman, for example, is associated with the Hopi's Hard Substance Woman, who lives where the Colorado River flows into the ocean and controls the precious shell, turquoise, and coral offering stones.[22] A sharing of ritual paraphernalia among tribes was also pervasive. The Tewa used Ute red ocher, Comanche and Taos buffalo hides, and feathers and shells from the Keresans; the Cochiti wore Comanche buffalo-chin beards, while Navajo ceremonial objects came from the Southern Ute, Hopi, and Zuñi.[23]

Beauty and prayer are intertwined with every aspect of Navajo reality. Navajo culture is embodied in the word *hózhó.* Loosely translated as "beauty, balance, or harmony," the creation, maintenance. and restoration of *hózhó* is the goal of every Navajo. Peterson Zah, former Navajo tribal chairman, explains: "*Hózhó* . . . goes beyond the physical aspect of beauty. Beauty means the earth, the universe. So when you finish your prayer, your chants, in the Navajo language, you close with that. It's very powerful and it means everything to a Navajo person."[24] Adds Navajo artist Conrad House, "What you strive for in this world is *hózhó.* How you live, how you treat one another, the way you cook, how you arrange your home, how you live in your surroundings in the Diné way, this would be art and religion."[25]

Above all, Southwestern groups define and represent everything by reference to a center; the instinct to center remains important as the basis of prayer, ceremony, and design. The dominant spatial orientation of Pueblo people is centripetal (moving inward),[26] contrasting with the Navajo, who emphasize a centrifugal (moving outward) orientation. Thus a Zuñi lapidary will carefully set out the boundaries and then work inward toward the center, while Jesse Lee Monongye, who "thinks like a Navajo," forms his bezel and lays stone from the inside out.

985

984 *Earrings representing a cloud, lightning, and a drop of rainwater. Gail Bird (Santo Domingo–Laguna) and Yazzie Johnson (Navajo). 1980s. Freshwater pearl, sapphire, 14-karat gold. Length, 1⅞" (4.8 cm). Collection Bernice and Herbert Beenhouwer*

985 *Rainbow earrings with lightning-shaped loops. Phil Navayasa (Hopi). 1990. Turquoise, opal, coral, lapis, sugilite, gold. Length, 3⅛" (7.9 cm). Collection Bernice and Herbert Beenhouwer*

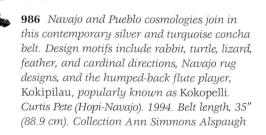

986 *Navajo and Pueblo cosmologies join in this contemporary silver and turquoise concha belt. Design motifs include rabbit, turtle, lizard, feather, and cardinal directions, Navajo rug designs, and the humped-back flute player, Kokipilau, popularly known as* Kokopelli. *Curtis Pete (Hopi-Navajo). 1994. Belt length, 35" (88.9 cm). Collection Ann Simmons Alspaugh*

SOUTHWESTERN SILVERWORK

Silver arrived in the Southwest via several means. One was in horse gear from Mexico and Spain, derived in turn from Renaissance and medieval times. "The Spaniards handed on their skill to the Mexicans, and the Mexicans have taught the Navajos to work silver, but it all came from the Moors," wrote Willa Cather. Plains Indians—often the victims of Navajo horse raids—also had an important influence on Navajo metallurgy. Wire bracelets of copper, brass, or iron were among the earliest metal ornaments worn by the Southwestern Indians. Many of them reached the region in the 1700s through trade with Plains Indians, who had acquired them from French fur traders. And some jewelry types clearly resemble forms earlier used by Plains groups such as Comanche, Kiowa, and Ute. However, the Spanish and Mexican traditions of ironworking, silverworking, and leather tooling took strongest hold over the Navajo. The advent of silver in the Southwest also coincided with a crucial period of cultural change. Although not an indigenous art form, silver was soon an important part of Navajo life.

Atsidi Sani (the Old Smith), the first Navajo credited with silversmithing, learned the craft from a Mexican smith as early as 1853. Soon, the Navajo sought not only the caballero's bridles and iron bits, but also Spanish rosaries, necklaces, crosses, metals, beads, and bells, changing the styles into their own. Under Atsidi Sani's guidance, the Navajo began to experiment with silver. Life on the reservation meant that prestige and wealth could no longer come from raiding. A new lifestyle evolved: warrior men became herders and, in their free time, silversmiths. Around 1870, Navajo smiths began making beads from U.S. and Mexican coins. The first pieces were hammered out of silver dollars, then stamped and engraved with design (989). Buttons quickly became popular (994). Concha belts and bracelets, bridle decoration, and naja necklaces of silver all became fashionable during the 1870s. The so-called Classic Period of Navajo silversmithing (1880–1900) was a prosperous time. The art mastered, silversmiths created pieces for their own joy. This changed in the early 1900s, when the Santa Fe railroad brought tourists and demand for light-weight silver jewelry. Regardless of the continuing tourist phenomenon, silver, for the Navajo, remains a symbol of wealth and prestige.

In 1872, Lanyade, a Zuñi, learned silver working from a Navajo smith named Atsidi Chon, and soon the Zuñi were taking the craft in their own direction. By 1890, Zuñi silver work consisted primarily of settings for turquoise.

In 1898, Lanyade passed knowledge of the craft on to Sikyatata, a Hopi. Early Hopi silverwork resembled that of the Navajo. However, by 1938, when Dr. Harold S. Colton and his wife, Mary Russell Colton—founders of the Museum of Northern Arizona—encouraged Hopi silversmiths to apply their famous pottery, basket, katsina, and mask designs to silverwork, the Hopi developed a distinct style called overlay(1025). They still specialize in the technique, where one silver sheet, cut with an openwork design, is soldered on top of another. The blackened, cutout portion emphasizes the design. In 1947, the Hopi Silvercraft Cooperative Guild grew out of silversmith classes that had been arranged for Hopi World War II veterans, including Fred Kabotie and Paul Saufkie.

987 *Silver bridle attributed to Atsidi Chon. Early Navajo silverwork tends toward simplicity, with little turquoise and limited stamping and engraving. 1870s. Length, 14¾" (37.5 cm). Laboratory of Anthropology/Museum of Indian Arts and Culture, Santa Fe, New Mexico, 10330/12*

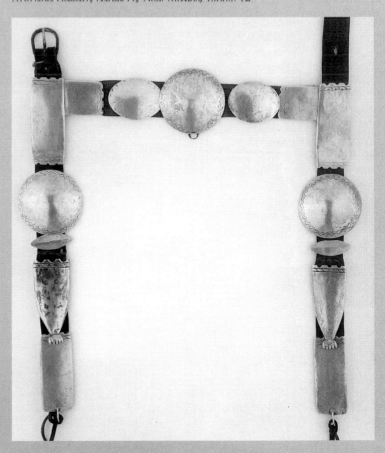

988

989

988 *Stamping tools made from railroad spikes, local volcanic rock, and tufa stone. Chester Kahn, a contemporary Navajo jeweler, acknowledges the early silversmith process: "Traditionally, going back to my grandfather's and uncles' era, they produced most of their own tools and stamps and then had to make the jewelry." The earliest stamping was done with a cold chisel; by 1885 other stamps were used. Train rails served as anvils, as did wagon wheels, kingpins, stones, or tree stumps. Stylized bird design (middle). Approximately 5″ square (12.7 cm square). Stamps probably used for making butterflies (left) and conchas (right). The Heard Museum, Phoenix, Arizona*

989 LEFT: *Navajo silver beads of coin silver from the 1870s. Two half beads were pounded from a peso and soldered together with a mixture of borax, saliva, and silver.* RIGHT: *Navajo hand-stamped sheet-silver beads, 1970s. Typical bead width, $\frac{13}{16}$″ (2.0 cm). The Heard Museum, Phoenix, Arizona*

990 *Stamped-silver bead necklaces made from coins. The Navajo created these necklaces for the marketplace rather than for themselves.* INNER: *c.1910–20.* OUTER: *Minnie Porter. 1930s–40s. Length, 9½″ (24.1 cm). Collection Tanner*

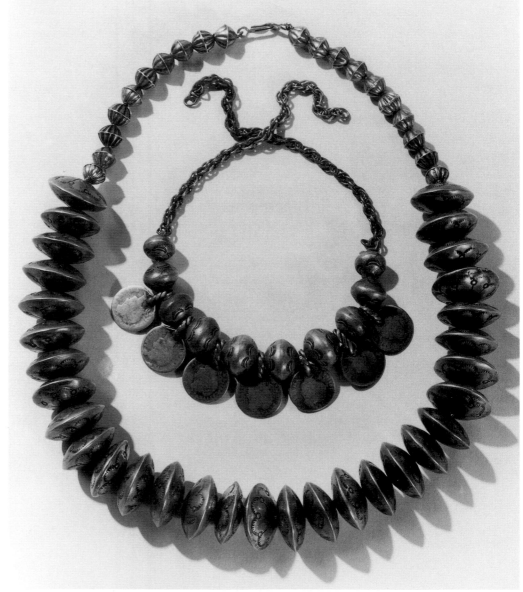

990

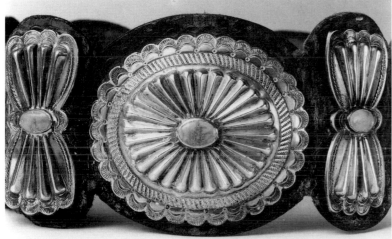

991 *Navajo silver bridle concha decorated with a traditional silver button. Arizona. c. 1885. Diameter, 2¹⁵⁄₁₆″ (7.5 cm). Laboratory of Anthropology/ Museum of Indian Arts and Culture, Santa Fe, New Mexico, 10326/12*

992 *Detail of a 1930s Navajo concha belt, probably by Horton Goodluck, with turquoise settings and tooled leather patterns. Leather stamped with the same designs and tools used in silverwork was a technique derived from Mexico. Concha length, 3¾″ (9.5 cm). Collection Pat and Richard Panicco*

991

992

▽ **994** *Buttons, one of the first Navajo silver items, lost their fastening function and became applied ornament. Hammered out of silver and used by men and women to decorate their clothing or equipment, buttons were accepted by traders in place of money. Indian agent Bowman observed in 1886: "When they wish to buy anything and have no wool to exchange, they simply cut off the needed number of buttons. These vary in value from 2½ cents to $1—and are never refused as legal tender anywhere in this vicinity." The variety of button patterns is remarkable; rarely are any duplicated. c. 1940s. Millicent Rogers Museum of Northern New Mexico*

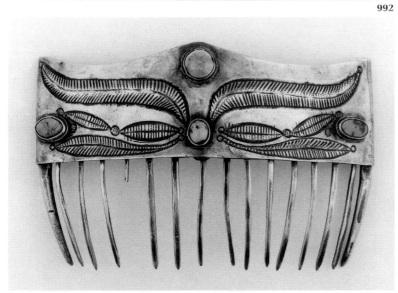

993

993 *Navajo silver comb with repoussé work and turquoise stones, adapted from Spanish mantilla-comb designs. 1910–20. Length, 5½″ (14.0 cm). Laboratory of Anthropology/ Museum of Indian Arts and Culture, Santa Fe, New Mexico, 10483/12*

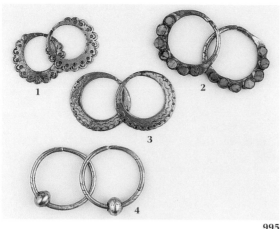

995 996

997

998

999 *Bracelet of soldered leaf patterns. Dan Simplicio (Zuñi) or Joe Yazzie (Navajo). 1930s–40s. Diameter, 2⅓" (5.8 cm). Private collection*

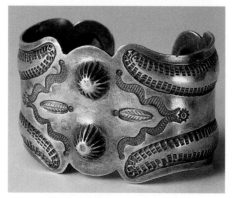

1000 *Navajo bracelet made from silver ingots with stamped and punched designs. 1890–1910. Diameter, 2½" (6.4 cm). Courtesy Four Winds Gallery*

995 *Typically Southwestern Indian-made silver and turquoise earrings. 1880s–90s. 1. Pincer type, scalloped and stamped. 2. Turquoise set in bezels. Diameter, 1¾" (4.5 cm). 3. Flat scalloped earrings, simply stamped and punched, were worn by both the Navajo and Zuñis. c. 1890. 4. Silver ball on a silver hoop, an earring style worn by both Navajo and Pueblo Indians. In the 1920s, men abandoned the flat silver hoops and started wearing turquoise loops in their ears, which later became the jaclas on necklaces (997). Laboratory of Anthropology/Museum of Indian Arts and Culture, Santa Fe, New Mexico, 40354/12ab, 40357/12ab, 40303/12ab, 40351/12ab*

996 *This silver hoop earring is the earliest known silver artifact found in the Southwest. Possibly made by a Spaniard or Mexican, it may have been worn by a Navajo. Arizona. c. 1800. Width, ⅜" (1.15 cm). Museum of Northern Arizona, NA11375.1*

997 *Early Navajo silver bracelets. 1870s–80s. LEFT TO RIGHT: Round cross section with file cuts. Diameter, 2 9⁄16" (6.5 cm). Flat rectangular cross section with serpent head at both ends. Cast silver, with heavy rectangular main band. Laboratory of Anthropology/Museum of Indian Arts and Culture, Santa Fe, New Mexico, 10102/12; 10103/12b, 10719/12*

998 *Though construction techniques and materials differ, a contemporary Navajo silver bracelet by Michael Begay (right) bears a striking resemblance to an early Navajo copper bracelet from the 1870s (left). Silver did not become plentiful until the 1890s. Before then, the Navajo would cut copper from kettles, pans, scrap sheets, and wire. RIGHT: 1973. Width, 1 1⁄16" (2.75 cm). Collection Zinzi. LEFT: The Heard Museum, Phoenix, Arizona*

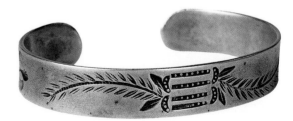

1001 *This Southwestern-made silver bracelet's thin shape is characteristic of the Plains, although Plains smiths worked with German silver. The design was created by a punch, used by the Spanish on leather goods (see 992); its simplicity indicates a pre-1900 manufacture date. Diameter, 2⅜" (6.0 cm). Courtesy Four Winds Gallery*

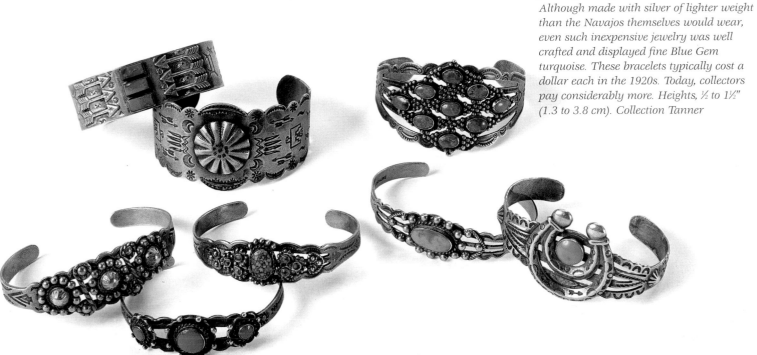

1002 *These silver and turquoise tourist bracelets sold by the Fred Harvey Company in the 1920s are typical of "Indian" jewelry produced by the Navajo for the growing Southwestern tourist trade. Although made with silver of lighter weight than the Navajos themselves would wear, even such inexpensive jewelry was well crafted and displayed fine Blue Gem turquoise. These bracelets typically cost a dollar each in the 1920s. Today, collectors pay considerably more. Heights, ½ to 1½" (1.3 to 3.8 cm). Collection Tanner*

1003 *Navajo and Zuñi (top row, third and fourth from left) heavy-gauge silver and high-quality gemstone-turquoise bracelets produced for their own use. 1900–1960s. Center, middle row, height, 5⁹⁄₁₆" (14.2 cm). The Heard Museum, Phoenix, Arizona*

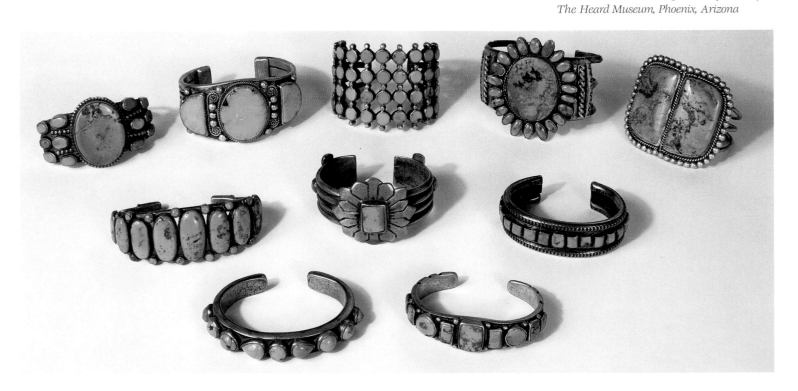

THE BOW GUARD

The bow guard—called *ketoh* by the Navajo—is worn around the wrist while shooting with a bow and arrow to protect from the stinging snap of a released bowstring. This initially functional object eventually became adornment of striking design and beauty. Early bow guards were pieces of leather. The Navajo were the first to use silver bands, scratched or stamped with designs and fastened to leather, in the late 1870s.

The bow guard features a center motif (sometimes with a central ornament) and four "curvilinear" shapes that radiate toward the corners. Often, bars bridge the center to the sides. The inside (hidden) part of the leather strap is frequently covered with designs. Their conceptual resemblance to the four sacred directions and originary center have earned bow guards a place in some rituals, such as the Hopi and Zuñi summer rain dances. Most dancing katsinas have, on the left wrist, a silver bow guard, and on the right a strand of yarn and a bracelet. Ceremonial dancers still wear Archaic-style bow guards covered with olivella shells.

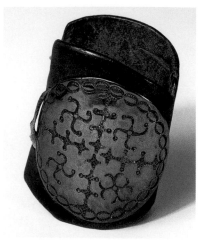

1004 *Navajo* ketoh. *Wrought silver with stamped design and leather band. Late 1800s. Band length, 5⅛" (13.0 cm). The Heard Museum, Phoenix, Arizona*

1005 *Bow guards in varying techniques and materials representative of their respective Southwestern cultures.* LEFT TO RIGHT: *Navajo. Early 1900s. Stamped silver with butterfly motifs. Victor Coochwytewa (Hopi). 1969. Silver overlay with butterfly motif and turquoise. Height, 3" (7.6 cm). Zuñi. 1900–1930. Inlaid frog and tadpole motifs of spiny-oyster shell, mother-of-pearl, turquoise, jet. The Heard Museum, Phoenix, Arizona*

1006 *Sandcast silver and turquoise Navajo* ketohs. *Four-directional, centered motif (left) with (right) the incorporation of steer and possibly equinox markers. Possibly 1906. Length of right, 3⁵⁄₁₆" (8.4 cm). The Heard Museum, Phoenix, Arizona*

1007 *Navajo-made* ketohs *of wrought silver (except second row, middle, which is cast) with repoussé and stamped designs mounted on leather bands. All maintain a quadrate, centered design. Late 1800s to early 1900s. Silver, turquoise. Length of bottom right ketoh, 3½" (8.3 cm). The Heard Museum, Phoenix, Arizona*

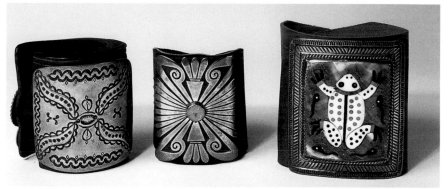

1005

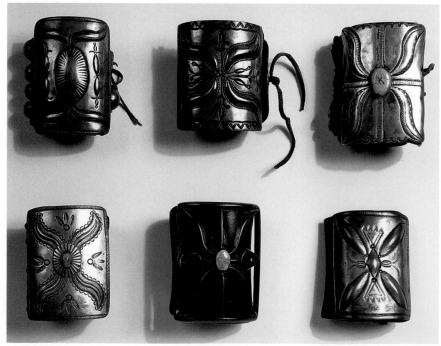

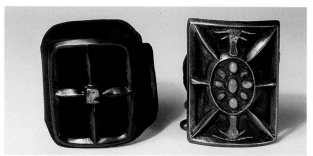

1006

1007

THE CONCHA BELT

The Navajo concha belt exemplifies a mingling of Plains Indian and Spanish ideas to produce a strictly Navajo art form. It is believed that the Navajo derived the concha concept from the Plains Indians. The Ute, Comanche, and Kiowa wore a series of round and oval plaques of German silver as hair ornaments or attached to leather belts. The art of making conchas originally diffused to the Plains tribes from the Delaware and Shawnee, two eastern tribes skilled in silverwork who moved from the east to the southern Plains. Navajo concha design elements, however, appear to be of Spanish origin as they resemble designs in Spanish colonial ironwork.

Often hammered out of single Mexican or American silver dollars, the concha had a decorated outside edge and, through the 1880s, a slotted center for threading onto a leather belt. When silversmiths started soldering, to conserve silver the leather was threaded through copper loops soldered to the back of the concha. In the 1890s, the open center, no longer functional, remained as an oval or diamond-shaped stamped design element. Belt buckles, copied from harness buckles, were plain and small until the turn of the century, when they became an integral part of the design. Between 1900 and 1920, turquoise stones and butterfly-shaped spacers appeared along with repoussé work. The Zuñi often inlaid their conchas with shell. Linked belts of small conchas began to be produced during the 1920s. By the 1940s, a lighter weight of silver was common.

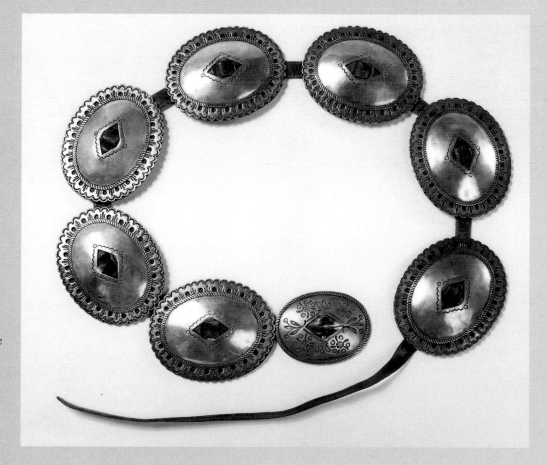

1008 *Navajo wrought-silver concha belt with a stamped and filed design. The leather strap is laced through the opening in the center of each concha, a Classic Period detail. 1870–80. Length, 50" (127.0 cm); conchas, 3½" × 4⁵⁄₁₆" (9.0 × 11.0 cm). The Heard Museum, Phoenix, Arizona*

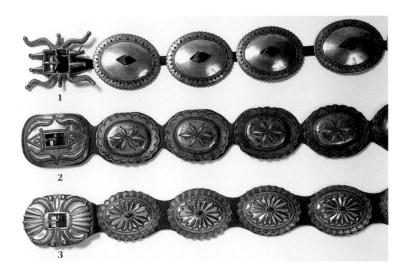

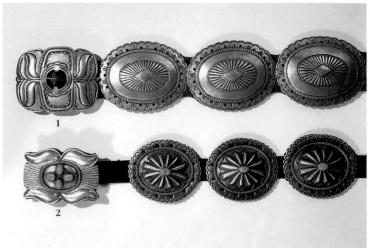

1009 From top: *1. Classic Period (first phase) belt of oval-shaped, stamped, and cutout conchas. Sandcast buckle. c. 1870–1900. 2. Stamped and repoussé conchas. Hosteen Goodluck. 1923. Typical concha, 4 × 3¼" (10.2 × 8.3 cm). 3. Repoussé conchas and belt buckle. This belt's use of turquoise portends the turquoise setting as a general technique among the Navajo smiths. c. 1900. The Heard Museum, Phoenix, Arizona*

1010 *1. Repoussé silver. c. 1910. Typical concha, 4½" × 3½" (11.4 × 8.9 cm). 2. Repoussé and stamped silver and Morenci turquoise. Joe Quintana (Cochiti Pueblo). Second phase style, 1950s or earlier. Concha, 3½" × 3" (8.9 × 7.6 cm). Collection Tanner*

△ **1011** *Contemporary stamped silver belt. Perry Shorty (Navajo) makes most of his own stamps, often decorating his pieces with twisted-wire and delicate scroll designs. 1993. Typical concha length, 2⅛" (5.4 cm). Courtesy Four Winds Gallery*

◁ **1012** *Silver belt by Roger Skeet (Navajo), set with turquoise bears carved by Leekya Deyuse (Zuñi). 1943. Concha length, 4¼" (10.3 cm). The Heard Museum, Phoenix, Arizona*

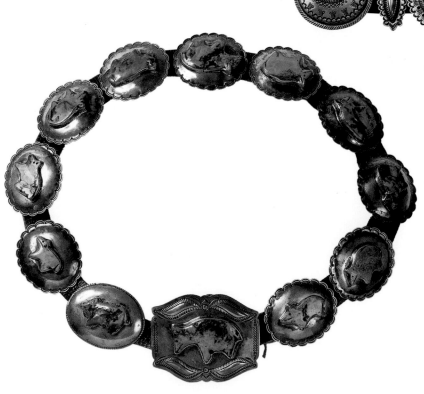

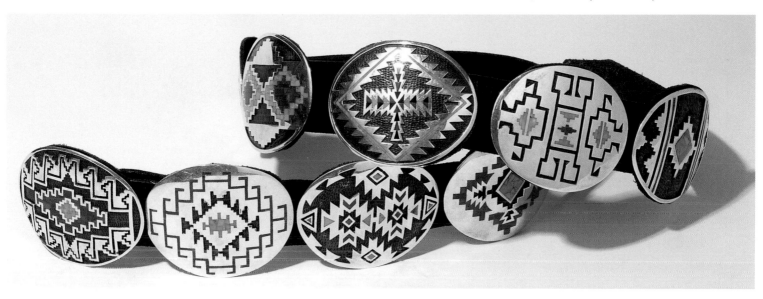

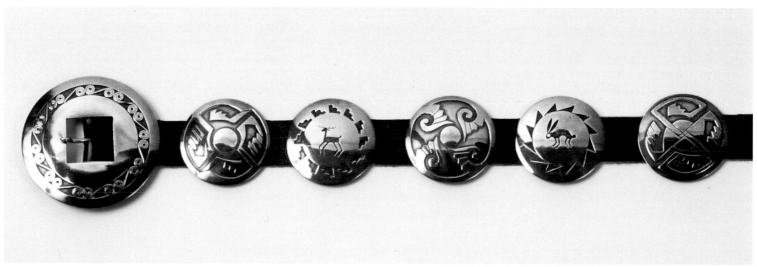

The Kiva and the Hogan

All Southwestern peoples try to align their "definitions of group space with their cosmologies," but the Pueblos are "unusually precise about it," relates Alfonso Ortiz. "This precision has many, almost inexhaustible, implications because the Pueblos in particular attempt to reproduce this mode of classifying space on a progressively smaller scale. Since all space is sacred and sacred space is inexhaustible, these models of the cosmos can be reproduced endlessly around them."[27] The influence of the Pueblo kiva and Navajo hogan on tribal jewelers beautifully illustrates this point.

The Hopi kiva is a communal ceremonial structure, cylindrical or rectangular, "sunk deep like a womb into the body of mother earth."[28] A pit in the center of the floor, called the *sipapu,* represents the "earth navel," or emergence of This World from Under World; an opening in the roof leads to Sky World. During ceremonies, spirit beings called katsinas enter the plaza from the kiva. There is a striking similarity between the kiva layout, representing the larger Hopi spiritual focus, and Hopi mosaic design (1036–37). Such adornment may have been intended as a map of the Hopi's spiritual environment, which is itself a layout of the larger worldview.

Anthropologist Cosmos Mindeleff recorded the Navajo's description of the "First Hoghan" in 1896: "It was covered with gorgeous rainbows and bright sunbeams instead of bark and earth. At that time, the firmament had not been made, but these first beings possessed the elements for its production. Rainbows and sunbeams consisted of layers or films of materials, textiles, or at least materials pliable in nature, and these materials were laid across the hut alternately, first the rainbows from north to south, then the sunbeams from east to west."[29]

The hogan, a family-oriented dwelling that is "circular like the horizon,"[30] is a dome constructed of logs and wood, the embodiment of Navajo spirituality. Its architecture mirrors the vast architecture of the universe. The door always faces east (sunrise). Four upright wooden pillars support the roof, each oriented toward the points of the equinoxes and solstices—northeast, northwest, southeast, and southwest—and therefore toward the four sacred mountains and the entire Navajo homeland. The central fireplace is a cosmic center, from which incense smoke rises to the Sky People. Hogans are not just places to eat and sleep; they also occupy a central place in the sacred world, where, in the Navajo creation myth, First Man and First Woman fashioned life. Standing at the emergence place, the hogan came to symbolize the universe. A Navajo is hence always related to the cosmic order.[31]

Lee Yazzie, a contemporary Navajo jeweler, explains, "I was raised in a hogan. And that's an influence in itself. You lay at night, you dream, and you see all those logs, the patterns they make, their order. Somebody put that together. In your mind this is all registered, so when it comes time to create something, you have a base to work off of. My ability to create jewelry relies on structural strength rather than thickness of metal to give strength."

Hidden Vision

Every phenomenon in the Southwestern world is characterized by both visible outer forms and hidden, or inner, qualities.[32] Inner, invisible essence is what gives life to all things.

"The tendency toward 'hiddenness' in the material world of the Pueblo Indians is there now and may have been from time immemorial," observed writer Ian Thompson. "I have encountered numerous instances in the archaeological record where something I thought was created for the public was, in fact, hidden from view from the moment the act of creation was completed. It may be connected to 'understated sacredness' in the Puebloan cosmos."[33]

1015 *A buckle showing a Navajo man holding a prayer stick. Richard Tsosie (Navajo, b. 1953). Influenced by his brother Boyd, who had taken classes with Kenneth Begay, and Navajo jeweler Lee Yazzie, Tsosie's designs and reticulated background textures are inspired by his Navajo heritage and the natural world. Early 1990s. Tufa-cast silver, ironwood, turquoise, coral, fossil, ivory. Width, 2¼" (5.7 cm). Private collection*

An ancient example of hidden quality removed from the public eye can be seen in a pair of Basketmaker sandals (1126). The inside of the elaborately woven sandals were covered by the wearer's foot, while the densely patterned soles faced the ground. Possibly inspired by the exquisitely constructed masonry walls at Pueblo Bonito, which were covered under plaster, contemporary Hopi artist Charles Loloma created a tufa-cast gold bracelet with an intricate turquoise and coral mosaic interior visible only to the wearer (1129). Lee Yazzie adds a Navajo perspective with his corn bracelet (1119), in which an elaborate gold bridgework—itself a fine work of art—was concealed in order to feature the corn kernels and make the cob appear more natural.

CEREMONIES AND REGALIA

Southwestern rituals range from the medicine man's chants for a single individual's healing to grand communal ceremonies with sacred music and dances to ask for rain. The agricultural cycle, particularly that related to maize, is the central focus of most Pueblo ritual activity. Taken in its totality, the ritual and its dance are an intense prayer, either for something to come or in thanksgiving for something that has already arrived. To achieve results, the individual pueblos are divided into moieties and ceremonial associations. In Pueblo and Navajo belief, water, moisture, and clouds are essences of supernatural beings called katsinas by the Puebloans and *Yei* by the Navajo. During ceremonies, both are represented by masked dancers.

Present-day Pueblo dance ceremonies preserve traditional patterns in dances, paraphernalia, and songs. Dominant elements are expressed in multiplicity and repetition. Rituals incorporate recurring objects, sounds, colors, and movement; each gesture is dense with meaning.

Among Pueblo people, turquoise, shell, and other jewels perform an important ritual role. "In ceremonial dances," relates anthropologist Ruth Bunzel, "the decorating of the body with these and other natural substances is essential. Paints were prepared from sacred minerals and plants—the preparation itself was an elaborate ceremony—and then applied to the face and body in patterns having cosmic correspondences. A man whose body and face was thus painted was transformed into a sacred being with a specific ritual role to play: For the Zuñi, 'Next to the mask, the face and body paint [are] the most sacred part of a dancer's regalia. No one must touch a man while he has on his body paint.'"[34] In addition to masks and paint, the dancers often wear necklaces of shell and turquoise (1073–74).

There is a strong esoteric relationship between Pueblo dancers' villages and surrounding landscape and their regalia. Observing Pueblo ceremonials, it is difficult to visualize them occurring anywhere else. At a Zuñi summer rain dance, writes Erna Fergusson, "the dancers are painted with a yellow mud from the Sacred Lake, even those who appear as women. No women take part in this dance, but eight men wear the squaw dress and white mantle, with their long hair done in elaborate swirls which are the Hopi squash blossoms, emblems of fertility. They wear anklets of spruce, which typifies life, and carry cattails as symbols of moisture. The men, long-haired too, wear topknots of macaw feathers and three fluffy eagle-plumes on rattles, a string down the back. Their bodies are saffron yellow. . . . Spruce is tied to their bare ankles, and they carry live tortoises, as many as may be. Those who do not have tortoises carry gourds."[35]

"In taking the branches from the sacred Douglas fir tree," Joe Sando (Jemez) reminds us, "the Pueblo men will inform the Creator that the intent is not to mutilate the tree, but to decorate the human being in the performance of a sacred ritual or dance in His honor."[36]

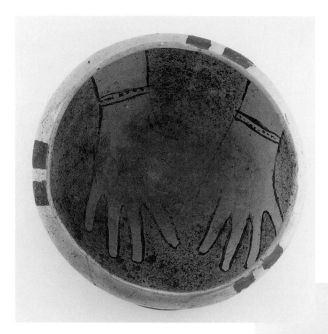

1016 *Two human hands wearing bracelets decorate the interior of an ancestral Pueblo pottery bowl. Arizona. A.D. 1200–1450. Diameter, 9¼". Laboratory of Anthropology/Museum of Indian Arts and Culture, Santa Fe, New Mexico*

1017 *The design of this silver-overlay belt buckle was inspired by a Hopi kiva mural from the precontact village of Awatovi. Michael Kabotie (Hopi). 1981. Length, 3" (7.6 cm). Millicent Rogers Museum of Northern New Mexico*

1018 *Ancient Puebloan half-terraced geometric forms reappear in a twentieth-century Hopi silver-overlay bracelet. By the late 1930s, Hopi silversmiths were incorporating traditional basketry and pottery designs within their silverwork. Pottery bowl. Ancestral Pueblo. New Mexico. Diameter, 8⁷⁄₁₆" (21.4 cm). Silver bracelet. Arthur Yowytewa (Hopi). Late 1940s. Museum of Northern Arizona, 8152, E2957*

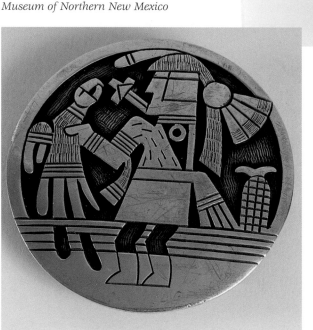

Many traditional Puebloan motifs remain central to existing beliefs and ceremonies. "Rain-magic symbolism" on pottery and clothing are valued as "constant prayers" and "fetishes to insure crops," wrote Oliver LaFarge. The Hopi Corn Maiden "wears terraced clouds on the top and each side of her head, an ear of corn across the forehead and a rainbow over her mouth. Her dress has cloud and rain symbols." There is "appeal by pictures for the magical help of frogs or tadpoles and dragonflies, since they are always found near water. Then comes the powerful plumed serpent believed to dwell in storm clouds; his body is marked with clouds and rainstreaks and his tongue is barbed lightning. Finally there are the 'Cloud People,' gods of rain, who live in cloud mansions where they drum out thunder and hurl lightning at other times in lakes; and who walk to Indian dances on mist streaks and rainbow bridges. They are imitated in very sacred dances by masked dancers in spectacular regalia. The details of headdresses and mantles worn by these impersonators of the gods again deal with symbols of rain and freshly awakened flowers."[37]

At Zuñi Pueblo's Our Lady of Guadalupe Church, murals of more than two dozen life-sized katsinas wearing traditional dance regalia line the north and side walls, while above the altar, Jesus, dressed in Zuñi blankets and turquoise jewelry, hovers on a stylized rain cloud above the church. All were conceived and painted by Alex Seowtowa (a Roman Catholic Zuñi Indian) and his sons. Christian and Pueblo cultural icons easily coexist, says Seowtowa, "as a form of prayer."[38]

Southwestern peoples incorporate bird and feather images into every aspect of daily and sacred life. Appearing as early as 1000 B.C., bird depictions occur in rock art, on pottery, and as jewelry and fetishes. Birds are messengers between the earth-bound and sacred sky beings. Resting on mountaintops, they are in the sky, yet accessible to those on earth. A prayer feather (or "feathered prayer") represents the messenger bird with its petition to the Sky Father.

A horned-and-feathered serpent motif is generally associated with the powerful life force hidden in the earth and its emergence to the surface. According to Joseph Campbell, the celebrated scholar of mythology, "The serpent was thought of as a very important power. . . . At Hopi Pueblo, they take the snakes in their mouths and make friends with them and then send them back to the hills. The snakes are sent back to carry human messages to the hills, just as they have brought the message of the hills to the humans. The interplay of man and nature is illustrated in this relationship with the serpent. A serpent flows like water and so is watery, but its tongue continually flashes fire. So you have this pair of opposites together in the serpent."[39] (see 1043)

1019 *This turquoise and silver bracelet's craftsmanship and style suggest the work of Dan Simplicio (Zuñi). The snake may have been overlaid on the turquoise to cover a crack. 1940. Height, 3¼" (8.3 cm). Courtesy Four Winds Gallery*

1020 *The dragonfly, associated with the sprouting of corn in early times, represents fertility and power to the Zuñi. Chiefs pray to dragonflies; no one touches or harms them. When a chief dies, he is thought to become a dragonfly. Dragonfly pin. Leo Poblano (Zuñi). c. 1940. Turquoise, silver. Height, 3¾" (9.5 cm). Collection Carol Krena*

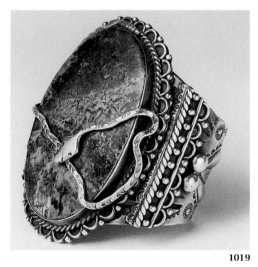

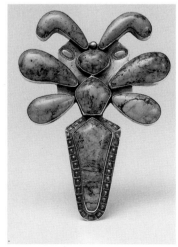

1019

1020

1021 Silver earrings with a spiral motif derived from ancient Southwestern petroglyphs. The artist uses only hand tools to create her jewelry. Jan Loco (Warm Springs Apache). 1994. Length, 1½" (3.8 cm). Collection Jeanne Fischer

1022 Top: Although the Hopi never hunted buffalo, they relate to the buffalo's group behavior and collective migrations. Silver bracelet with Bisbee turquoise and coral. Bottom: Flute-playing Kokopellis, borrowed from ancient petroglyphs, encircle this silver belt buckle set with a Royal Web turquoise stone. Manuel Hoyungowa (Hopi). Late 1970s. Belt height, 3" (7.6 cm). Collection Tanner

1023 Navajo turquoise and silverwork with a Hopi wind pattern. c. 1960s. Height, 1½" (3.8 cm). Collection Rosa Content

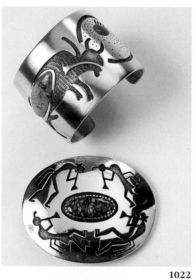

1022

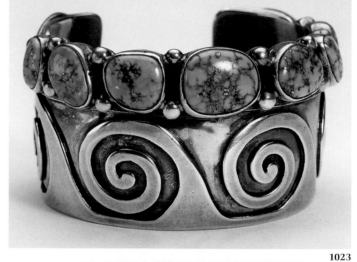

1023

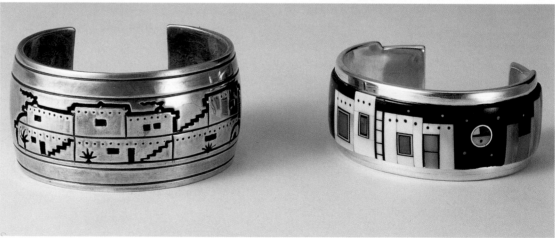

1024 Two bracelets with a pueblo motif. Left: Sequeoptewa (Hopi). 1940s. Overlay silver. Height, 1¼" (3.2 cm). Right: Irving Tsosie (Navajo) interprets Cindy and Joe Tanner's home. 1992. Silver inlaid with turquoise, mammoth ivory, jet, yellowlip oyster, coral. Collection Tanner

1025 Bracelet in silver-overlay technique by
Victor Coochwytewa (Hopi), one of the earliest
artisans to practice overlay. A student of Paul
Saufkie and Fred Kabotie's jewelry-making
classes (see page 483), Coochwytewa textured
the backgrounds of his designs to emphasize the
cut silverwork details. He was also among the
first Hopi overlay artists to use gold and, eventu-
ally, diamonds. Coochwytewa's life is divided
between farming and jewelry: both his corn and
metalwork win top awards. 1976. Height, 2" (5.1
cm). The Heard Museum, Phoenix, Arizona

1026 The Shalako, portrayed on this silver
bracelet, is a Hopi katsina, an impressive, ten-
foot-tall, birdlike creature who celebrates the
annual arrival of the winter solstice. Shalakos
arrive in a procession and take turns dancing
after midnight. Manuel Hoyungowa (Hopi). Late
1970s. Height, 2¼" (5.7 cm). Collection Tanner

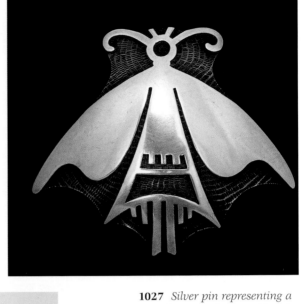

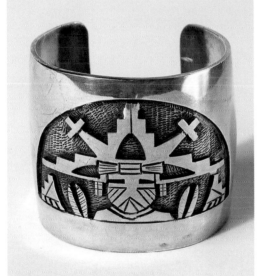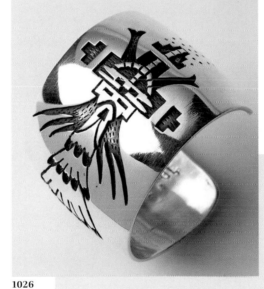

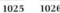

1025 1026

1027 Silver pin representing a
Hopi butterfly dancer with rain
designs. 1960s. Private collection

1028 A celebration of the corn harvest is seen
on the bracelet (top), while a prayer for the har-
vest is illustrated on the belt buckle (bottom).
The mask of the sun katsina, Tawa, is bordered
with plaited cornhusk in which radiating eagle
feathers are inserted. In his left hand, Tawa car-
ries the flute, associated with certain Hopi solar
myths. Chalmers Da (Hopi). 1994. Silver over-
lay. Buckle length, 3½" (8.9 cm). Collection
Tanner

1029 The Keepers of the Beautiful Mother Earth. *Concha belt by Karen Hoyungowa (Hopi). Depicted are (from top): Spider, guardian of the earth. Thunderbird, who brings rain. Bee, who gives honey for healing. Waterbird, who gives rain for better crops. Rabbit, food for the people. Quail, the keeper of life. Roadrunner, a Hopi clan bird. Turtle, whose shell is used at ceremonials to make thunder sounds. Turkey feathers, used in ceremonials, symbolizing clouds. Lizard, who protects the hot sand. Hummingbird, representing the beauty of the rainbow. Scorpion, the guardian of the desert. Hummingbird. Thunderbird. Quail. Eagle, whose feathers are used for prayer sticks for a happy everlasting life.*

The single concha (above left) by Troy Hoyungowa displays Kokopelli the flute player, who gives blessings for the whole universe. The bracelet shapes by Todd Hoyungowa (right) are called "lightning." They are adorned with bear paws for good health and corn and rain clouds to bring good crops. All 1994. Typical concha length, 2" (5.1 cm). Private collection

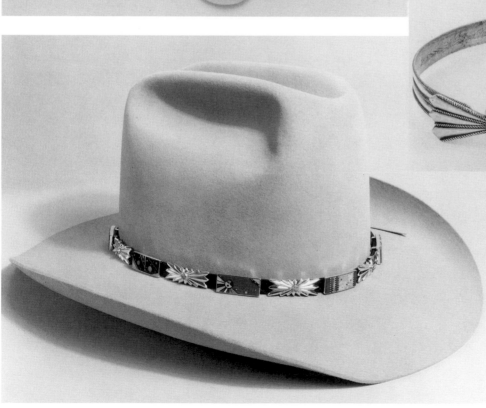

△ **1030** *Navajo silver and turquoise hatband, possibly of heritage silver from crowns (see 1193). Late 1920s. Diameter, 7¼" (18.4 cm). Laboratory of Anthropology/Museum of Indian Arts and Culture, Santa Fe, New Mexico*

◁ **1031** *Contemporary hatband replicating a concha belt. Day- and night-sky imagery is joined by silver butterfly conchas. Jesse Lee Monongye (Hopi-Navajo). 1990. Coral, lapis, sugilite, turquoise, gold, silver, shell, jet, opal (inlay). The concha units were made from father Preston Monongye's internal castings. Typical unit length, 1⁵⁄₁₆" (3.3 cm). Collection Pat and Bert Corcoran*

1032 *Shell pendants with mosaic inlay continue as significant Pueblo adornment. A spiny-oyster-shell pendant inlaid with Blue Gem turquoise is suspended on strands of Blue Gem beads with gold clasp. Inside is a choker of Indian Mountain Nevada turquoise and coral beads with silver clasp. Cheryl Yestewa (Hopi), an associate of Charles Loloma. 1970s. Length, 17½" (44.5 cm). Collection Tanner*

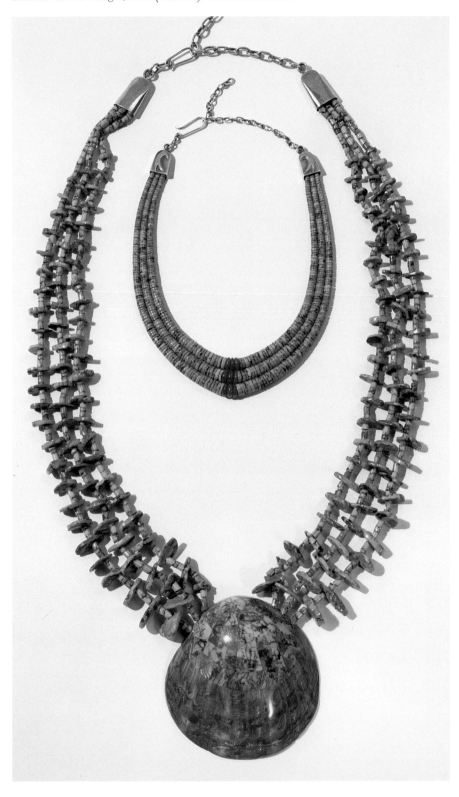

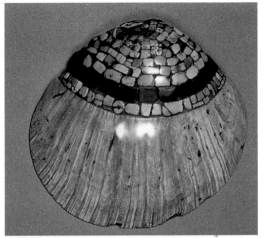

1033

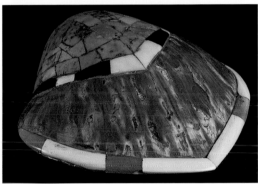

1034

1033 *Spiny-oyster-shell pendant inlaid with a turquoise and jet mosaic. Mosaic work was an efficient means of using fragments. Pueblo Bonito, Chaco Canyon, New Mexico, A.D. 1000–1200. Length, 3" (7.6 cm). National Museum of the American Indian, 7/1615*

1034 *Spiny-oyster-shell pendant with jet, turquoise, and shell-mosaic inlay. Santo Domingo. Early twentieth century. Width, 4½" (11.4 cm). Millicent Rogers Museum of Northern New Mexico*

1035 Ancestral Pueblo turquoise-mosaic pendants. Canyon de Chelly, c. A.D. 1100–1200. Left diameter, 3¹⁄₁₆" (7.8 cm). American Museum of Natural History, 29.1/879, 29.1/880

1036 Hopi turquoise and abalone-shell earrings. The mosaic includes turquoise beads found at ancient ruins. 1870–1900. Inlay on wood. Length, 4½" (11.4 cm). The Southwest Museum, Los Angeles

1037 Earrings of turquoise and abalone shell set into ironwood. The style of Southwestern mosaic-inlay work—from the ancient pre-Puebloans to contemporary artisans—remains constant. Charles Loloma (Hopi). 1978. Length, 1½" (3.8 cm). The Heard Museum, Phoenix, Arizona

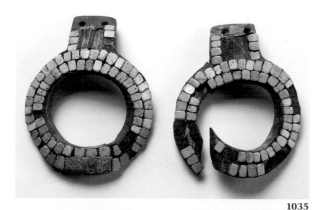

1035

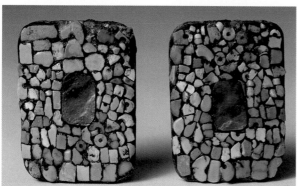

1036

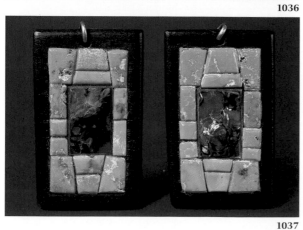

1037

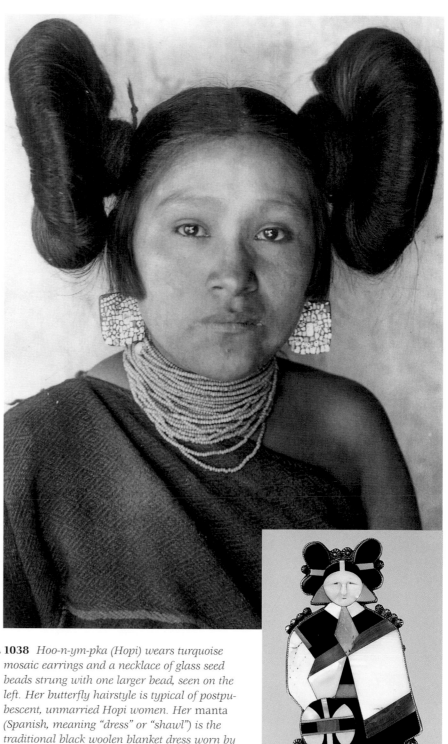

△ **1038** Hoo-n-ym-pka (Hopi) wears turquoise mosaic earrings and a necklace of glass seed beads strung with one larger bead, seen on the left. Her butterfly hairstyle is typical of postpubescent, unmarried Hopi women. Her manta (Spanish, meaning "dress" or "shawl") is the traditional black woolen blanket dress worn by Pueblo women. Mishongnovi. 1901. The Southwest Museum, Los Angeles

1039 Pin depicting a Hopi maiden wearing turquoise and a butterfly hairstyle. Leo Poblano (Zuñi). c. 1940. Jet, turquoise, mother-of-pearl, spiny-oyster shell, melon shell. Height, 5⁵⁄₁₆" (14.1 cm). Collection Carol Krena

1039

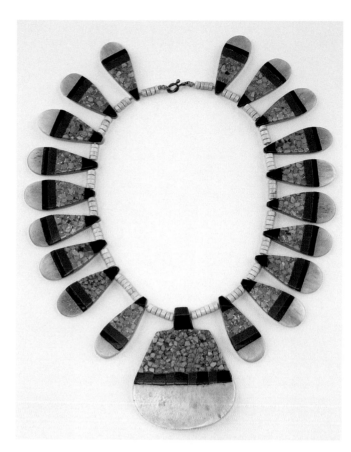

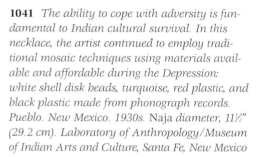

1040 *Shell pendants overlaid with a mosaic of turquoise, jet, and red plastic. Zuñi. Early 1900s. Length, 2⅝" (6.7 cm). Collection Conrad and Elaine Angone*

1041 *The ability to cope with adversity is fundamental to Indian cultural survival. In this necklace, the artist continued to employ traditional mosaic techniques using materials available and affordable during the Depression: white shell disk beads, turquoise, red plastic, and black plastic made from phonograph records. Pueblo. New Mexico. 1930s. Naja diameter, 11½" (29.2 cm). Laboratory of Anthropology/Museum of Indian Arts and Culture, Santa Fe, New Mexico*

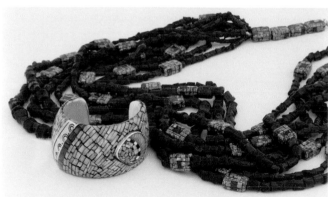

1042 *Timeless mosaic-inlay designs incorporated into contemporary beads and a bracelet by Angie Reano Owens (b. 1945), the daughter of Santo Domingo Pueblo* heishi *and beadworkers Clara and Joe I. Reano. Their close-knit family has heavily influenced Owens's artistic development. Among Owens's earliest work were earrings with mosaic work on cottonwood backings, similar to that of her ancestors. In the early 1970s, she began researching ancient Hohokam and ancestral Pueblo mosaic techniques—using* Glycymeris *and other shells—in museums and private collections. Subsequently, she has developed her distinctive style, blending ancient and contemporary aesthetics. Like her ancestors, Owens has traveled to California to buy the shells needed for her work. 1980s. Turquoise, coral, spiny-oyster shell, jet, silver. Bracelet width, 2¾" (7.0 cm). Collection Bernice and Herbert Beenhouwer*

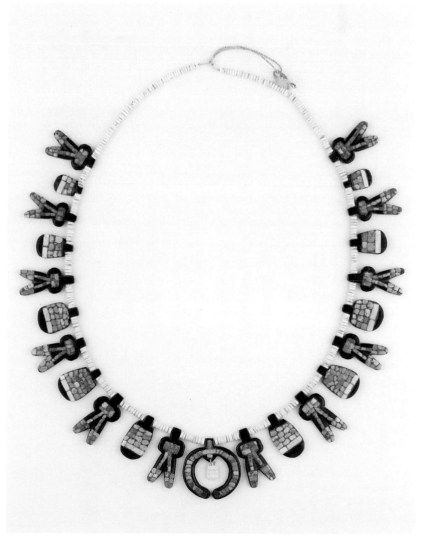

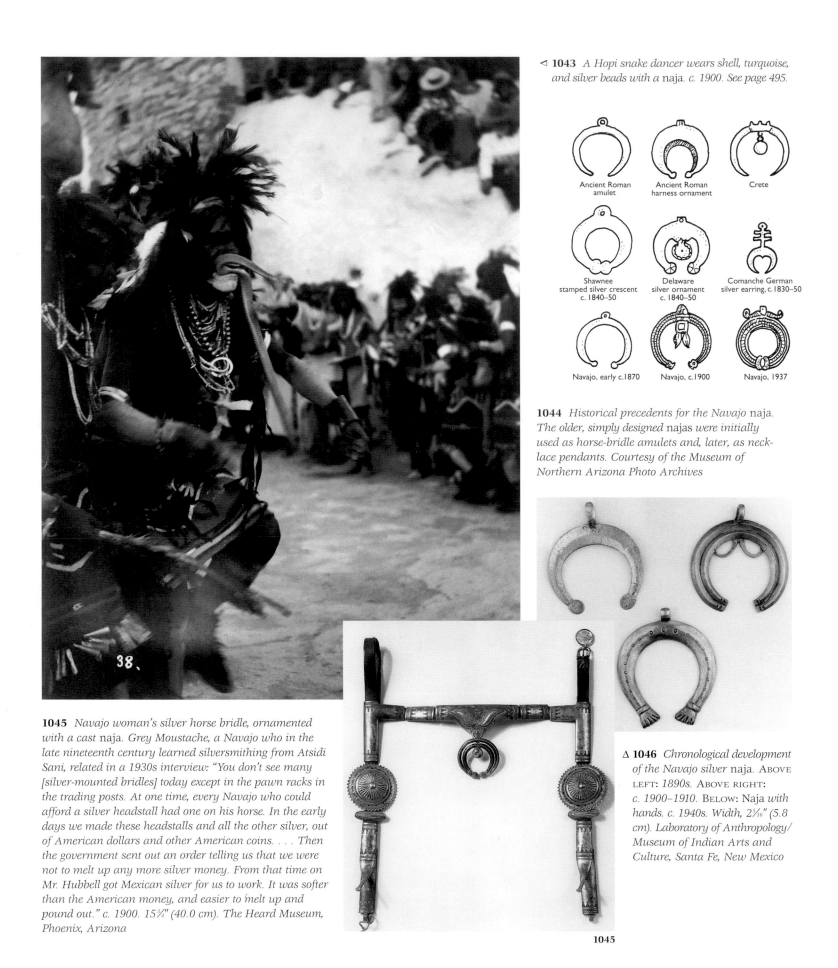

◁ **1043** A Hopi snake dancer wears shell, turquoise, and silver beads with a naja. c. 1900. See page 495.

Ancient Roman amulet

Ancient Roman harness ornament

Crete

Shawnee stamped silver crescent c. 1840–50

Delaware silver ornament c. 1840–50

Comanche German silver earring, c. 1830–50

Navajo, early c.1870

Navajo, c.1900

Navajo, 1937

1044 Historical precedents for the Navajo naja. The older, simply designed najas were initially used as horse-bridle amulets and, later, as necklace pendants. Courtesy of the Museum of Northern Arizona Photo Archives

1045 Navajo woman's silver horse bridle, ornamented with a cast naja. Grey Moustache, a Navajo who in the late nineteenth century learned silversmithing from Atsidi Sani, related in a 1930s interview: "You don't see many [silver-mounted bridles] today except in the pawn racks in the trading posts. At one time, every Navajo who could afford a silver headstall had one on his horse. In the early days we made these headstalls and all the other silver, out of American dollars and other American coins. . . . Then the government sent out an order telling us that we were not to melt up any more silver money. From that time on Mr. Hubbell got Mexican silver for us to work. It was softer than the American money, and easier to melt up and pound out." c. 1900. 15¾" (40.0 cm). The Heard Museum, Phoenix, Arizona

Δ **1046** Chronological development of the Navajo silver naja. ABOVE LEFT: 1890s. ABOVE RIGHT: c. 1900–1910. BELOW: Naja with hands. c. 1940s. Width, 2⁵⁄₁₆" (5.8 cm). Laboratory of Anthropology/ Museum of Indian Arts and Culture, Santa Fe, New Mexico

1045

THE *NAJA*

With probable Paleolithic origins, the inverted crescent form (called *naja* by the Navajo) has represented the Phoenician goddess of fertility, Astarte, and is mentioned in the Book of Judges among the "ornaments on camels' necks." The Moors—who dominated Spain for eight centuries—adopted the crescent as a horse's bridle ornament, to protect the horse and rider from "the evil eye." The Spanish brought the idea to the Americas. The Navajo, whether directly from the Spanish, or indirectly through the Plains Indians, adopted the crescent form as a horse headstall (front center band of the bridle), and later as the crowning achievement of their squash-blossom necklaces. Although the Navajo claim that the *naja* has no precise symbolic or spiritual significance, it is ubiquitous in their culture and held in high esteem.

1047 *Introduced to the Navajo at the turn of the century, the flowerlike pendant form known as a squash blossom is actually a symbolic representation of the Spanish-Mexican pomegranate. Spanish colonial gentlemen wore silver versions of pomegranates (a motif of Granada, Spain) on their shirts, capes, and trousers. It was probably seen and copied by the Navajo. The top necklace dates from the 1880s to the 1890s. Made from hand-hammered, Mexican coin silver, it has ties to the Moorish bridle. The bottom necklace, dating to the 1920s, features silver squash-blossom pendants and incorporates fine Persian turquoise in the corn-blossom drops. Length of each, including naja, 15" (38.1 cm). Collection Tanner*

1048 *Squash-blossom pendants vary in shape and design. Navajo. 1930s. Silver and Blue Gem turquoise. Length, 37" (94.0 cm). Collection Margaret Kilgore*

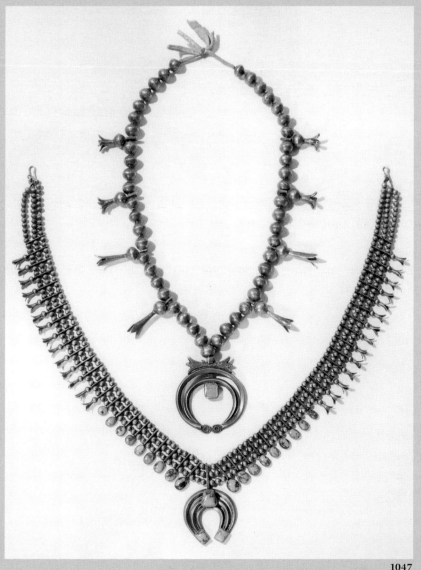

1047

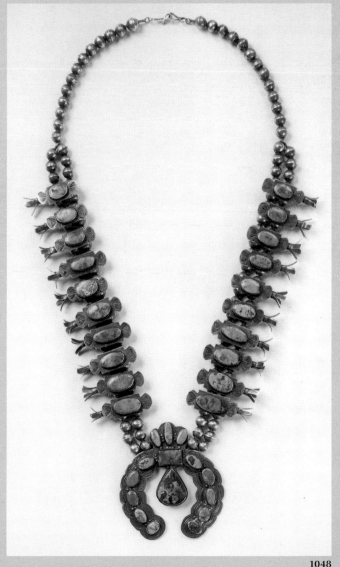

1048

SACRED CROSS SYMBOLISM

Debate continues over the Native origins of sacred-cross iconography. The double-barred cross, with or without an Immaculate Heart at the base, was introduced by Franciscan priests from the area of Caravaca in Spain. It was often equated with the important Pueblo dragonfly symbol or lizard effigies (1049). It also resembles the Spanish Catholic rosary, a basic necessity for every Catholic, whether Hispanic or Indian.

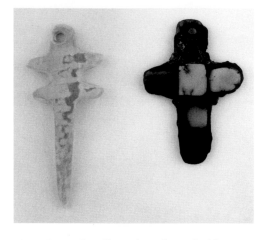

1050 *Pueblo necklace with single-barred cross pendant. Late nineteenth to early twentieth century. Coral and silver beads with silver crosses. The smaller crosses are based on the Mexican crucifix design. Pendants became more elaborate as smiths improved their casting skills. Collected at Acoma Pueblo. Pendant length, 3⁵⁄₁₆" (8.4 cm). Collection Robert and Cindy Gallegos. Courtesy Four Winds Gallery*

1051 *A silver necklace composed of beads, single-barred crosses, and a double-barred cross pendant clearly representing a dragonfly. Isleta Pueblo. c. 1920. Length, 15½" (39.4 cm). Collection Robert Gallegos. Courtesy Four Winds Gallery*

1049 Left: *Cruciform-shaped wood with turquoise-mosaic pendant. Salado culture. Tonto National Monument, Arizona.* A.D. *1250–1400. Length, 1¼" (3.2 cm).* Right: *Lizard-effigy shell pendant. Hohokam. Santa Cruz Flats, Arizona.* A.D. *1200–1500. Length, 1⅝" (4.1 cm). Arizona State Museum, The University of Arizona*

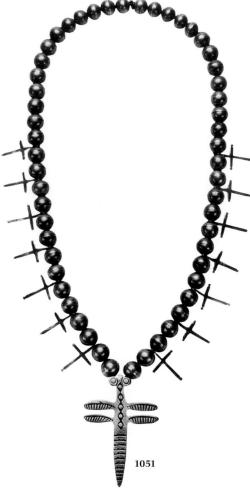

1051

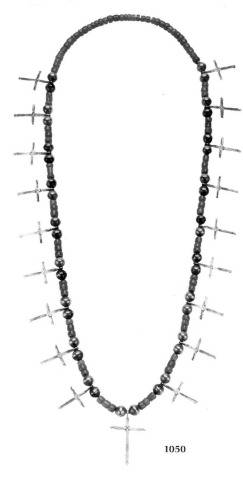

1050

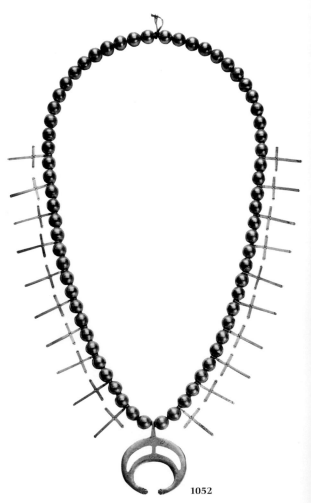

1052

1052 *Silver necklace with handmade beads, crosses, and a* naja *made by Mike Bird-Romero (San Juan), an accomplished metalsmith who wears this necklace for his own ceremonial dancing. Self-taught, Bird-Romero's work has been greatly influenced by his research of historic Navajo and Pueblo jewelry. Beginning in 1990, Bird-Romero and his wife, Allison, conducted extensive studies of turn-of-the-century Southwestern cross necklaces. Inspired by the diversity of forms, Bird-Romero created more than 140 cross pendant designs. 1991. Necklace length, including* naja, *16" (40.6 cm). Collection of the artist*

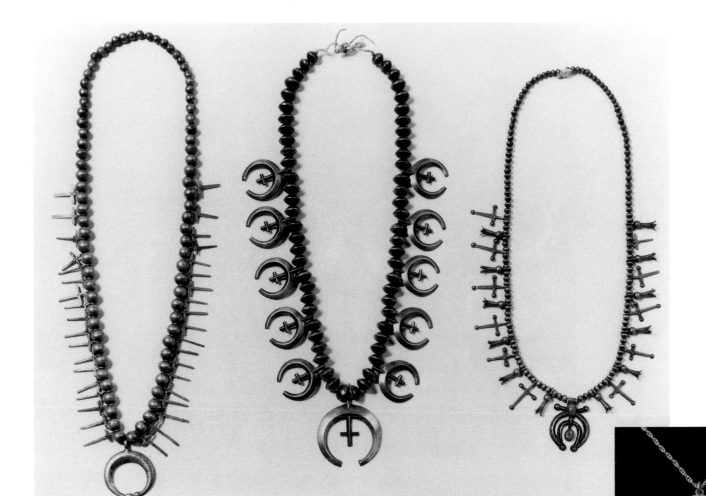

1053 *Although these handwrought, soldered silver necklaces are distinctly Southwestern, the components' origins are varied and span history.* LEFT: *Single barred crosses terminate with a naja. Navajo. Late 1800s.* MIDDLE: *The* najas, *of ancient origin, embrace crosses, introduced by Spanish missionaries. Rio Grande Pueblo. Early 1900s. Length, 28¾" (73.0 cm).* RIGHT: *Squash-blossom designs, influenced by Spanish pomegranate motifs, are interspersed with crosses and a* naja. *Juan Di Deos (Zuñi). 1930. The Heard Museum, Phoenix, Arizona*

1054 *A silver necklace of Mexican or Guatemalan* ▷ *origin displaying a cross and silver* milagros, *small body-part amulets that serve as votive offerings for cures. Glass beads simulate turquoise and coral. Among Hispanic cultures, wearing coral was considered protection against the evil eye. Early twentieth century. Length, 18½" (47.0 cm). Millicent Rogers Museum of Northern New Mexico, RM 1982-6-3*

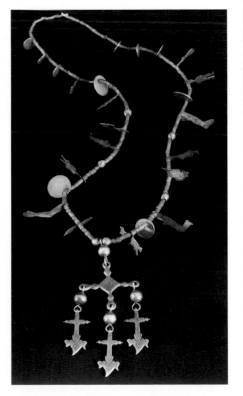

1055 *Hispanic crucifix necklace resembling crucifixes found in Mexican churches, a religious icon that Southwestern Indians borrowed from their southern neighbors. Latino art is a uniquely American aesthetic form resulting from the cultural collision of Spanish, Indian, and Anglo cultures. Larry Martinez, New Mexico. Gold, sapphire, and coral. 1992. Cross length, 4" (10.2 cm). Millicent Rogers Museum of Northern New Mexico, RM 1992-34*

1056 *Rainbow god pin by Teddy Weahkee, the first contemporary Zuñi to make inlay jewelry. 1929. Channel work of turquoise, coral, white shell, and jet form. Height, 5¼" (13.3 cm). The Heard Museum, Phoenix, Arizona*

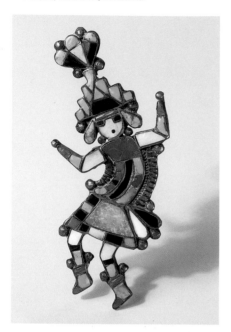

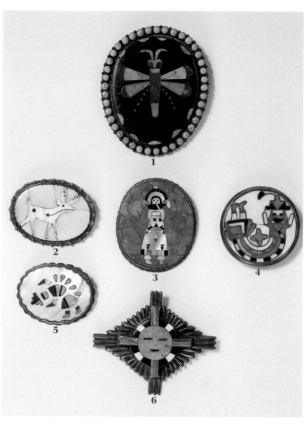

1057 *Collection of Zuñi-made channel-work pins. 1. Dragonfly pin. John Gordon. 1940s. Coral, turquoise, spiny-oyster shell, jet. Length, 3¹¹⁄₁₆" (9.4 cm). 2. Deer with heart-line pin. The heart-line image may have been introduced to the Southwest by the Navajo and Apache, Athapaskan-speaking peoples from the western Subarctic. Lambert Homer. 1938. Shell, mother-of-pearl, jet, coral. Length, 2⁹⁄₁₆" (6.75 cm). 3. Pin representing Shalako, a courier for the priests of Katsina Village. Walter Nahktewa. 1947. Turquoise, jet, shell, mother-of-pearl. Height, 2¾" (7.0 cm). 4. Rainbow god pin. Frank Vacit. 1946. Turquoise, jet, shell. Diameter, 2¼" (5.7 cm). 5. Rainbow god pin. Teddy Weahkee. 1925. Turquoise, jet, coral, mother-of-pearl. Length, 2¼" (5.7 cm). 6. Sun-god pin. Dan Simplicio. 1939. Turquoise, jet, coral, shell. Width, 3½" (8.9 cm). The Heard Museum, Phoenix, Arizona*

▽ **1058** *Members of the Paquin family plant crops in their "waffle" garden at Zuñi, 1910–12. The rectangular compartments, enclosed by clay ridges, retain water in the arid western New Mexico area. Conceptually recalling channel-work jewelry, these gardens exemplify the Zuñi propensity toward "everything clearly in its place," remarked anthropologist Margaret Hardin. Laboratory of Anthropology/Museum of Indian Arts and Culture, Santa Fe, New Mexico*

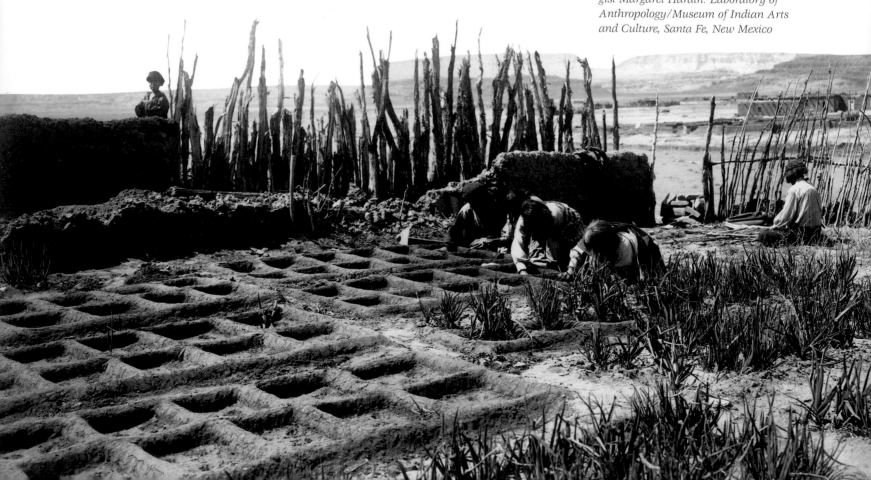

1059 *Pueblo design elements (after Armand Labbé). 1. Terraced element: rectangles or hemispheres representing clouds. 2. Stepped element: cloud. 3. Simple triangle: cloud. 4. Zigzag line: lightning. 5. Crooks (quasi-scrolls): wind, migration (Hopi). 6. Dot: the point of emergence, a kernel or seed, and thus potential for new life. 7. Parallel, repeating chevron: a water symbol for Pueblo (Hopi) people. 8. Square or circle (enclosure): kiva and kernel of corn; both are places of emergence. 9. Cross: an association of eagle feathers and sun; the use of feathers in depicting the sun symbol emphasizes the eagle's close relationship with the sun.*

1060 *Kokopelli. Water and lightning are intimately associated in the Hopi mind. Both emerge from clouds and are perceived as agents of fertility. This association is graphically portrayed in the common Southwestern rock-art figure Kokopelli (Kokipilau), the Hump-Backed Flute Player. As Armand Labbé describes him: "The head is formed by the symbol for* kiva, *the sacred ceremonial enclosure. The dot represents the* sipapu *or point of emergence. The head is the sacred enclosure of the human being. It encloses the brain which is the matrix for thought, in which case the dot (in the head of Kokipilau) represents the point of emergence for thought. Thought emerging from the brain is transformed and emanates from the mouth as sound. As the sound travels through the* boga, *or circuit, of the reed flute, it is transformed into fertilizing music.*

"The combination of circle, dot and reed flute, however, also has phallic significance; in which case, the dot represents the seminal seed, the circle of enclosure of the testicles and the reed, the phallus of transmission and final emergence. . . .

"The hump, which forms the body of the figure, is the curvilinear form of the triangular cloud symbol. The cloud is the storehouse of water and lightning. The parallel chevrons forming the arms of the Kokipilau figure are in fact a clever placement of the water symbol. The imagery is that water not only emerges from the storehouse-womb, which is the cloud, but it also supports (represented by the arms of the figure) the fertility of the semen-seed, that is to be transmitted through the phallic-reed. . . . The zig-zag legs of the figure represent lightning, which also emerges from the cloud and links the cloud (sky) with the ground (earth). The lightning symbolizes the emerging male principle, as the fiery life-force. . . . Kokipilau (from koko—wood—and pilau—hump) *is said to carry seeds of plants and flowers in his hump; while the music of his flute creates warmth."*

THE BUTTERFLY

First of all, I would feed cornmeal of all colors to the butterflies,
because they know how to make themselves beautiful.

—Rina Swentzell (Santa Clara)

Butterflies—embodying important Southwestern concepts of centering and balance—are the focus of Pueblo song, prayer, and adornment. The first butterflies signal the arrival of spring and acknowledge that the people have survived another difficult winter season. Among the Zuñi, the butterfly represents the beneficence of summer, when the country abounds in flowers and plants. A Papago story tells of the butterfly's origin, when the Creator gathered "a spot of sunlight, a handful of blue from the sky, the whiteness of cornmeal, the shadow of playing children, the blackness of a beautiful girl's hair, the yellow of the falling leaves, the green of the pine needles, the red, purple, and orange of the flowers around him. All these he put into his bag. . . . At once hundreds and hundreds of colored butterflies flew out, dancing around the children's heads, settling on their hair, fluttering up again to sip from this or that flower. And the children, enchanted, said they had never seen anything so beautiful." The butterfly appeared as a Zuñi jewelry motif in the 1920s and remains popular today.

1061 *Butterfly pin. c. 1930. Jet, coral, turquoise, shell, silver. Width, 2¼" (5.7 cm). Formerly Collection Shirley R. Sherr*

1062 *Butterfly pin. 1928. Pink shell with inlay of jet and turquoise. Width, 2⅛" (5.4 cm). The Heard Museum, Phoenix, Arizona*

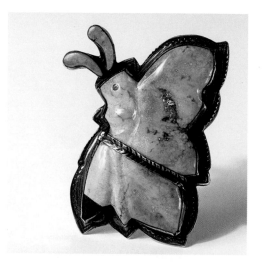

1063 *A turquoise butterfly in profile. Leekya Deyuse (Zuñi). 1928. Length, 3¼" (8.3 cm). The Heard Museum, Phoenix, Arizona*

KNIFE WING GOD

The Zuñi Knife Wing god (*A-tchi-a la-to-pa*), a sky being, has a combined human-bird form. Though an animistic spirit, he holds no religious significance when rendered in silver but is merely decorative.

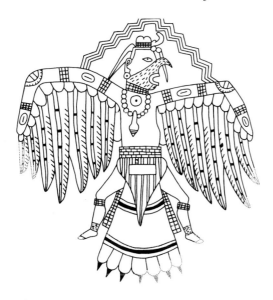

△ **1064** *Remarkable parallels exist between the falcon-man warrior of the ancient Southeastern Mississippian culture and the Zuñi's Knife Wing god. This sketch of falcon-man is from an engraved shell cup found at Spiro and dating to c. A.D. 1200.*

1065 *Shield of the Priesthood of the Bow. The composite of bird, snake, and man on this Zuñi shield embodies imagery from all three worlds. Drawing by Frank Hamilton Cushing, c. 1880*

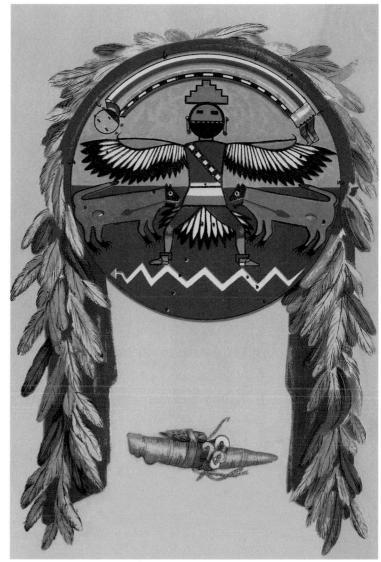

1065

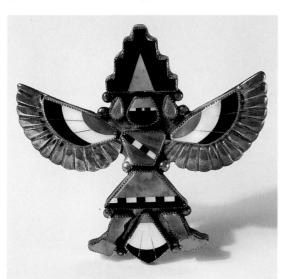

1066

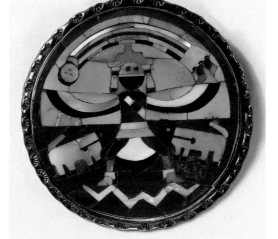

1067

1066 *Knife Wing god mosaic-inlay pin. Teddy Weahkee (Zuñi), c. 1942. Turquoise, shell, coral, jet, silver. Length, 3" (7.6 cm). The Heard Museum, Phoenix, Arizona*

1067 *Knife Wing god mosaic-inlay pin based upon the shield imagery in 1065. Although appearing in human form, the Knife Wing god is dressed in a terraced cap (representing his dwelling place among the clouds) and has "feathered pinions and tail." He is guarded by mountain lions. His weapons include the Bow of the Skies (rainbow) and the Arrow of Lightning. Frank Vacit (Zuñi). 1940. Turquoise, coral, white shell, jet, colored shell; stamped silver border. Diameter, 2½" (6.4 cm). The Heard Museum, Phoenix, Arizona*

ZUÑI FETISHES

Powerful Southwestern spirits dwell in rocks that naturally resemble an animal or human and are believed to be petrifications of these forms, with the soul or breath of the spirit inside. Made into fetishes, they act as mediators between people and supernatural beings, and they empower the owner with the strength of the animal represented. The Zuñi people are said to have traded fetishes and amulets to the Navajo and other Pueblo people for generations.

"Carver David Tsikewa was probably the best Zuñi friend I ever had," relates Joe Tanner. "I'd spend hours with him. He is the one that helped me understand the fetish so well. And the way he explained the fetish to me was that these fetishes were alive at one juncture of time.

And for some reason the gods turned them to stone. And the way the Zuñi people use them now is, the fetish is a bear or a fox. As the owner, you inherit all of that power. If you want the fishing ability of a bear, the hunting savvy of a coyote, you get that when you own the fetish, feed it and treat it properly. I've hunted with David and other Zuñis and I have never hunted with a Zuñi hunter that found a fresh track, gave the scent to himself and his fetish, that didn't get the deer. They just know when it's time to go after that particular animal, and it might take them five minutes or three days from when that happens, but they'll stay with it. The Zuñi and their fetishes are inseparable. They build their whole understanding around the fetish."

1068 *Joe Tanner's collection of Zuñi fetish necklaces from the 1960s.* LEFT: *"This necklace has the free spirit form of the fetishes," notes Tanner. "The fetish is in stone, or the stone is in fetish. The carver will bring out enough form so that the rest of us can identify the piece." Edna Leekya (Zuñi). Bisbee turquoise, shell heishi.* MIDDLE: *Tanner continues, "David Tsikewa made the stone into what he saw in his mind's eye. He would utilize the stone to the best possible fetish, but he had to make them perfect. He had to make them so you knew it was a bird or a parrot. And he did it better than anyone. That was his hallmark." Coral fetish by David Tsikewa (Zuñi); inlaid figures, Phil Loretto (Jemez-Cochiti). Length, 17½" (44.5 cm).* RIGHT: *Five strands of multianimal fetish and coral beads. Katsina inlay by Veronica Poblano (Zuñi); assembled by Mary Marie Lincoln (Navajo). Serpentine, mother-of-pearl, Bisbee turquoise, Zuñi-made pipestone beads*

1070 *Among Southwest Indians, esteem for coral is second only to that for turquoise. In this eighteen-strand necklace, Victor Beck (Navajo) combined coral beads with inlaid gold and turquoise beads, a 14-karat gold ring bead, as well as turquoise, gold, agate, and onyx beads. 1993. Length, 18" (45.7 cm) (36" overall [91.4 cm]). Courtesy Four Winds Gallery*

1069 *A turquoise, shell, jet, and coral bead necklace strung with two turquoise-colored glass beads, possibly predecessors of "Hubbell" beads (the name derives from the Hubbell Trading Post at Ganado, Arizona) that were manufactured in Czechoslovakia to imitate turquoise. This style of Navajo necklace has its origins in ancient Puebloan jewelry. c. 1880. Length, 13¾" (34.9 cm). The Heard Museum, Phoenix, Arizona*

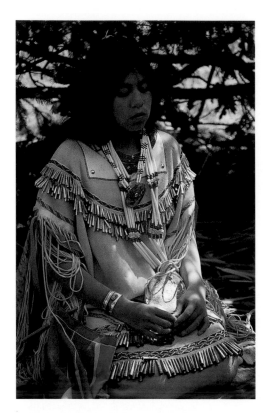

1071 *Fourteen-year-old Connie Rae Rice (Chiricahua Apache) at her traditional puberty ceremony, New Mexico, 1991. In an elaborate twelve-day rite of passage, the young girl will become the embodiment of White Painted Woman, Apache symbol of fertility and longevity. She will perform a series of rituals symbolizing her new life. During the event she is also showered with gifts and song and given instruction on the duties and privileges of a woman. In a ritual similar to Subarctic Athapaskan puberty ceremonies, some southern Athapaskan Apache girls wear a necklace with a scratching stick and drinking tube (198). The ceremony has passed unchanged for centuries. Geronimo, a Chiricahua Apache medicine man, assisted in this custom, observed even in time of war and captivity. The celebrant is dressed in beaded buckskin with tin tinklers, and corn pollen is rubbed on her face. The buckskin dress—painted yellow to resemble maize pollen, with its fringes representing sunbeams—and white abalone shell signify long life and protection for the girl and her community. The gaan, mountain-spirit dancers (9), come to dance with the girl at night.*

1072 *Apache cloth doll dressed in a typical deerskin outfit. Four sacred directions and color symbolism—important Apache concepts—are expressed in the glass-bead design. Blue, black, yellow, and white are colors associated with each direction. Apache dolls are typically dressed in clothing and jewelry styles of the time they were made. c. 1855–60. Height, 11¾" (29.9 cm). Peabody Museum of Archaeology and Ethnology, Harvard University, 10/59182*

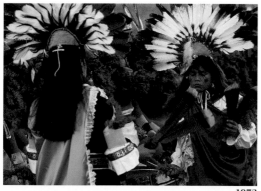

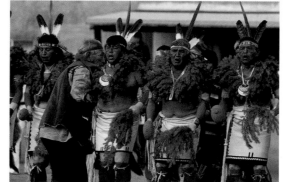

1073

1074

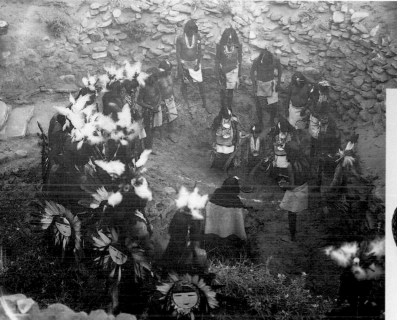

1075

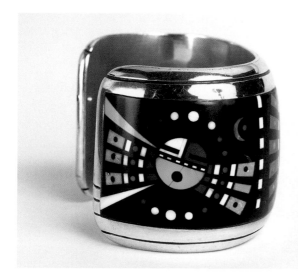

1076

1077

1073, 1074 *Contemporary Pueblo people ask for rain as their ancestors did thousands of year ago. The Santa Clara Cloud Dance is a fertility ceremony related to the agricultural cycle. In addition to the traditional kilt, male dancers wear a thick collar of spruce and two upright golden eagle-tail feathers at the back of the head. If the dancer's hair has been cut short, the feathers are held in place by a headband. Relates Thomas E. Mails, "The dance dramatizes the contest between the seasons, with the clouds of summer contesting with the clouds of winter for the supremacy that marks the rising of one season and the decline of the preceding one."*

Every part of a Rio Grande dancer's outfit has meaning, although interpretations may vary among differing Pueblo people. Eagle feathers symbolize clouds; sprigs of evergreen represent everlasting life. **1073:** *Dancers.* **1074:** *Singers. New Mexico, 1991*

1075 *Tawa, Father Sun, is the Hopi Giver of Life. The Hopi often offer a morning prayer and corn meal to the sun; war and fertility powers are sought from it in ceremony. The Flute Ceremony, held on alternate years with the Snake Dance, was meant to ensure the corn crop. This photograph, according to archivist Joanna Scherer, is probably "a preliminary ritual to the Flute Ceremony held at a spring to bless the source of water. The priests represent the sun by wearing sun emblems." Late 1800s. Smithsonian Institution*

1076 *Detail of Hopi sun face inlaid on a bracelet. Image length, 1½" (3.8 cm). Jesse Lee Monongye (Hopi-Navajo), 1979. Private collection*

1077 *Sun-face bola tie with squash-blossom dangles. Preston Monongye (Hopi-Mission) selected the colors and fabricated the silverwork to make sure "it was done in the Hopi way." The stonework is by Morris and Sadie Lahati, a Zuñi couple famous for their sun-face inlays. 1972. Morenci turquoise, jet, shell, coral, mother-of-pearl. Diameter, 3¼" (8.3 cm). Collection Tanner*

KATSINAS

Katsinas are supernatural forces, messengers between the people and their gods, who personify the spiritual essence of everything—ancestors, natural forces, plants, and animals. Appearing as clouds or masked dancers, katsinas are best understood as part of a rich ceremonial complex found among all the Pueblo people, especially among the Zuñi and the Hopi. Hopi katsinas live on the San Francisco Peaks; Zuñi katsinas live in the Zuñi Mountains; Rio Grande katsinas come from *Wenimats*, which are the Zuñi Mountains. (*Wenimats* is a Keresan word, and the katsina cult probably spread from the Rio Grande to Hopi territory.) Katsinas come down from their mountain homes during the winter solstice in mid-December and remain through July, participating in numerous dances and ceremonies. Erna Fergusson's description of a Hopi katsina dancer, although written in the 1920s, remains essentially unchanged three-quarters of a century later:

"Against the dun-colored rocks was a brilliant figure of turquoise-blue and dull green. As he came closer, uttering his queer hoots, we picked out the detail of his costume: a turquoise-blue mask with snakes painted under the eyes, feathers sticking out of the ears, feathers on top, a collar of spruce. His body was painted green and yellow, and his moccasins were brilliant blue. . . . He had brought dolls and gay-colored rattles for the girls, bows and arrows for the boys, and for both the long, pale-green sprouts of the beans which had been forced out in the over-heated kivas. All the time the dancer kept his feet moving in short jerky steps, a little as though to fight the cold; but we knew that this constant motion and the high falsetto hoots were to create the illusion of a being of another world."

The katsina ancestral spirit is manifested in *Navala*, the clouds and rains that sustain life. Katsina dancers and clowns embody the spirits in ceremonies that revolve around the need and deep respect for water, the Southwest's most precious element. Water ensures corn's growth, which is the essence of life. A dancer becomes a spirit by putting on the mask and adorning his body with paint, feathers, and rattles, after which the ceremonies commence. Taking place mostly outdoors, dances coincide with preparations for the planting season, bringing clouds and rain, promoting harmony in the universe, and ensuring long life and happiness for the people.

Timothy Mowa (Hopi) of Second Mesa explains, "What our katsinas do is for water and for rain. We act through our songs. It's not just for us, if you own animals, it's for them too. It's not just for the crops, it's for all living things, and that's what we really try to go for. But we all have to be as one, we can't have bad hearts in order to make the rains come. We all have to be as one, to get the clouds together to make the rain come."

Masks are the revered central elements of katsina regalia with their own sacred power. Periodically fed with cornmeal and other sacred matter, they are respectfully groomed and repaired.

During the time they remain in the villages, katsinas initiate young boys into the katsina societies and reinforce good behavior and the social values of cooperation and hard work, important aspects of Pueblo life. At the end of the ceremony to initiate the growing season, the katsina dancers present dolls as gifts to all the little girls (only the men and boys can be in the katsina societies), with a prayer-wish that they may grow up healthy and strong and be blessed with many children. Dolls stand in for the katsina dancers.

Ancient petroglyphs, as well as scenes depicted in wall murals excavated from a kiva at the great Hopi ruin of Awatovi, dating about A.D. 1500, may indicate the presence of katsinas at a very early date. The strong similarities of these ancient figures to contemporary katsinas highlight the strength and persistence of the katsina cult.

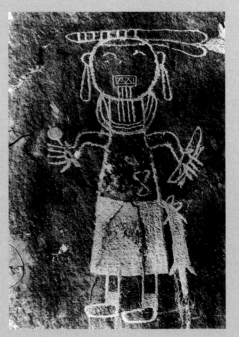

1078 *Pictograph of an adorned and masked* Teakwaina *katsina. Located at Second Mesa, Hopi, the pictograph dates to sometime after* A.D. *1300—an archaeological period named Pueblo IV—that time in Pueblo history following the abandonment of the Colorado Plateau and before the Spanish cultural impact. Peabody Museum of Archaeology and Ethnology, Harvard University*

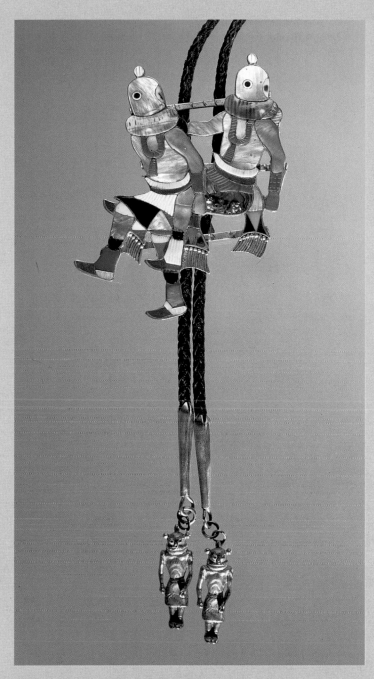

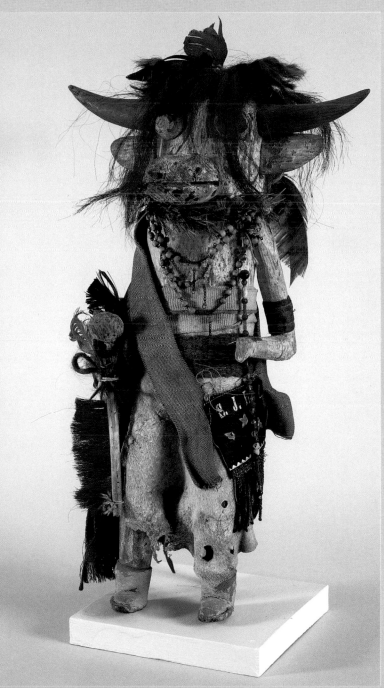

1080 *A cow katsina displays turquoise jewelry, a medicine bag, and a woven sash, all items worn by katsina dancers. Zuñi. c. 1880. Painted wood. Height, 16⅞" (43.0 cm). Millicent Rogers Museum of Northern New Mexico*

1079 *Bola tie adorned with inlaid stone katsinas, themselves adorned with turquoise necklaces. Edward Beyuka (Zuñi) Possibly 1950s. Shell, jet, turquoise, silver. Height of left dancer 4" (10.2 cm). Peabody Museum of Archaeology and Ethnology, Harvard University*

THE ZUÑI FIRE GOD KATSINA

A naked boy, covered with round dots painted in different colors, personifies the Zuñi fire god (also called *Shulawitsi*). Black paint, rubbed on the body in lieu of clothes, comes from the dried smut of corn. The god carries a burning cedar-bark torch with which he sets fire to dry grass, whose smoke clouds are believed to bring on rain.

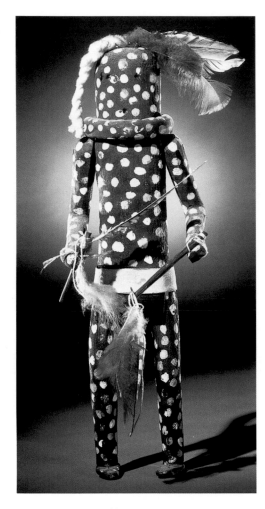

1081 *Zuñi fire-god katsina wears body paint instead of a costume. New Mexico. 1903. Wood, feathers, wool, cotton, hide, and silk. Height, 17¾" (45.1 cm). Brooklyn Museum, 03.325.4651*

1082 *Zuñi fire-god katsina interpretations in mosaic and channel work.* LEFT: *Pin by Teddy Weahkee (Zuñi). 1951. Weahkee worked as a laborer at Hawikuh, an ancestral Pueblo site near Zuñi, and is credited with the revival of this style of mosaic-inlay technique in which tesserae of shell or stone are placed directly together with no intervening silver. Although the ancient mosaics were overlaid on shell or wood, Weahkee adapted the technique to silver. Turquoise, coral, shell, jet, mother-of-pearl, silver.* MIDDLE: *Bracelet by Red Leakala (Zuñi). 1950s. Turquoise, jet, mother-of-pearl, coral, yellow stone. Width, 2¼" (5.7 cm).* RIGHT: *Tie slide by Walter Nahktewa (Zuñi). 1959. Jet, mother-of-pearl, coral, turquoise, shell. All, The Heard Museum, Phoenix, Arizona*

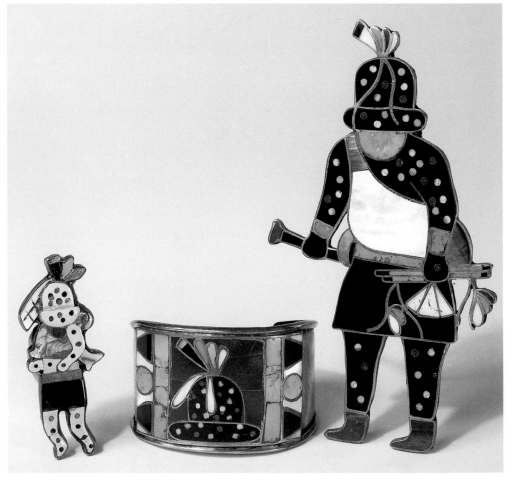

THE MARKETPLACE

The Southwest, in addition to being "one of North America's great cultural meeting grounds,"[40] is also a vital marketplace. These dual aspects of the region are, in fact, remarkably interrelated. "Cultural stimulation through trade has deep and profound roots in the Southwest," wrote Florence and Robert Lister, "beginning with the . . . fundamental idea of agriculture and its plants—corn, squash, and beans from Mesoamerica about 500 B.C."[41] Exchange networks linking Southwestern Native groups with the Euro-American world were established in the late nineteenth century by the reservation traders and their associated mercantile companies. Trading posts appeared in the Southwest on or near the Navajo Reservation after 1868, when the Navajo returned from confinement at Bosque Redondo.

It had all begun with the marketing of the region itself—with its magnificent scenery, ancient ruins, and strong spiritual traditions—as an exotic alternative to Europe. Both Native and non-Native groups were mutually affected by the relationship: the best traders understood that to deal successfully, they had to adopt the Indian ethos of fairness, quality, and generosity. The Indians, in turn, found markets that helped sustain them.

One example was the pawn system. Valuable silver jewelry was held by a trading post in guarantee of a debt, a system unique to the Southwest that grew out of Navajo skill in working silver and turquoise, combined with a shortage of money. In times of need, the Navajos pawned their concha belts, bridles, and bracelets. In the spring and fall, after shearing their sheep, the Indians brought the wool to the trading post and redeemed their pawned property. Objects taken in pawn were tagged with the owner's name, the date, and the amount of money lent for it. Many Indians would pawn their best jewelry for only a fraction of its price so they would be sure they could redeem it. While pawn legally had to be kept only six months before it could be sold, some traders allowed the Indians more time. It was not uncommon for an Indian to borrow his pawn for a special occasion and return it to the trader when the ceremony was over.[42] Old, unclaimed pawn was frequently bought by Anglos.

The Traders

Since the late nineteenth century, the Southwest has generated a remarkable group of traders and businesspeople, many of them Euro-Americans. "They were the 'uplifters,' the people who found the best artists, were honest with them, and encouraged their best work," says John Bonnell, owner of the White Hogan in Scottsdale. "The traders' influence is part of the reason for the quality of things today," remarks Joe Tanner, a fourth-generation merchant-trader from Gallup, New Mexico. "They played a vital role in seeing that quality materials were in talented hands." They also helped develop jewelry styles, encouraged fine craftsmanship, and educated the taste of the non-Native world that was paying for these artifacts, while never forgetting that some ancient and sacred traditions were inviolable. Anglo traders worked with Southwestern tribes to develop markets and marketing skills essential to the survival and florescence of Southwestern jewelry—and in many ways Southwestern culture. For the Navajo in particular, art has been central in their efforts to build successful relations with the Anglos as well as other Southwestern Indians.[43] To cite just a few, J. L. Hubbell recognized the broad sales potential for Navajo jewelry. In 1884, Hubbell, himself half-Mexican, employed two Mexican silversmiths at his trading post at Ganado to teach more Navajo artisans how to work with silver.[44] J. B. Moore's Crystal Trading Post, at Cottonwood Pass on the Reservation, published the first mail-order rug catalogue, followed by one

in 1906 offering silver flatware (tableware) and jewelry made of coin silver. While the tableware was obviously geared to the non-Native market, Moore noted that "his most valued customers for jewelry were the Navajo themselves."[45] From 1913 to 1921, C. N. Cotton hired Indian silversmiths to make concha belts for Indians living on the reservation.[46]

The completion of the Santa Fe Railroad at the turn of the century increased the number of travelers to the Southwest. Fred Harvey, a British immigrant with great business acumen, established restaurants, hotels, and dining cars along the railroad's western route. As tourists discovered the Southwest, the market for Indian jewelry grew. By 1899, Herman Schweizer, Indian art buyer for the Fred Harvey Company's gift shops, began suggesting ways of modifying the Navajo's massive jewelry to make it more salable to Anglos. Smaller and lighter, it was a commercial success, and others adopted Schweizer's ideas.[47] (See 1002.) The Harvey Company also built a museum collection of fine Indian art that served "both as a standard by which the quality of purchased pieces could be judged and as a resource by which Navajo artisans could refresh their own sense of tradition."[48]

C. G. Wallace exerted a pivotal influence on silver and stone jewelry produced at Zuñi Pueblo after 1920. Born in 1898 in North Carolina, Wallace came to Zuñi in 1919 as a company clerk and by 1927 had purchased his own trading post. By making tools, equipment, and materials available, Wallace directly affected the manufacture of silver and lapidary work by Zuñi and Navajo smiths who resided at Zuñi. When he arrived at Zuñi, he found only eight active silversmiths; by 1938, the Pueblo had ninety.[49] Wallace encouraged the use of indigenous archaeological and ethnographic imagery—rainbirds and rainbow gods, *Shalakos* (couriers for the priests of Katsina Village) and Knife Wing God or Bird—and techniques such as mosaic inlay. He also encouraged innovations, including channel work, leaf designs, and the use of imported coral. He facilitated collaboration by bringing the best of both Zuñi and Navajo talents together in pieces that joined Zuñi mosaic or channel work with Navajo silverwork. While all worked for or sold to Wallace, the trader retained a special relationship with stone carver Leekya Deyuse (1889–1966), one of the most famous Indian jewelers of his time.[50] (See 934, 939, 973.)

During the 1930s depression, Wallace created an economic base for numerous artisans. Simultaneously, he fostered quality work and advocated handcrafted Zuñi art on a regional and national scale. His legacy undoubtedly contributes to the contemporary Zuñi having more than one thousand jewelers, fetish carvers, potters, and weavers among their fewer than nine thousand residents. Today, approximately half of Zuñi Pueblo family income derives from art, primarily jewelry.[51]

The Tanner family of Gallup, New Mexico, has been influential in the Indian mercantile business since Joe Tanner's English great-great-grandfather, Josh, settled in the west during the time of Brigham Young. Josh's son Seth (Joe's great-grandfather) was one of Brigham Young's scouts. Both his great-grandfather and grandfather Joe (after whom Joe is named) mined turquoise and worked with the Indians to keep their arts alive. Joe relates: "My family has been very Indianized. My great-grandfather had an Indian wife and a Mormon wife. My grandfather lived with the Indians, learned Indian ways, and spoke their languages. I believe, though I can't yet prove it, that Chee Dodge, the last Indian chief and first tribal chairman and organizer of the Navajo government as we know it today, was my grandfather's half brother.

"Granddad grubstaked mines—sometimes personally mining the turquoise—and would bring it to the Navajo, Zuñi, Hopi, and Santo Domingo beadmakers. He would show up with ten pounds of turquoise for each beadmaker, including old man Leekya

Lee Yazzie (Navajo) is "the Indian jeweler's jeweler," remarks trader Joe Tanner. A designer, metalsmith, and lapidary, Yazzie trained under Preston Monongye at Tanner's workshop in Gallup.

"It bothers me when I have to sacrifice a stone—to take that beautiful stone to the grinder and destroy something that you will never see again. So that's why the stone is what I always try to teach. When you have a beautiful stone, you have to study the structure of the rough stone to find which way to cut it, the best surface. It took nature a long time to create that piece of rock. You don't want to come up with something that's not as beautiful as what [was] there.

"Simple things are important, like the appreciation and love of corn—it's the staple of life, it nourishes our body. I always enjoy the different colors of Indian corn. The white is when something is right and pure—purity. It gets us to combine colors. We need a source to learn how to combine color, like looking at the sunset.

"The sun radiates on all of us. All mankind, all plants, cannot live without the sun. So we have to recognize it. In history, everyone always worshiped the sun in various ways. My way is not to worship the sun—but it's recognizing something in the universe that we rely on. We look at turquoise as a sacred stone. Each individual is a sacred being. We radiate a lot of energy. To recognize this, hopefully, all of this will be positive.

"Everything has a center: the earth, the sun. I like doing pieces that are centered, because everything has an origin, a place where the sun originates. I like something that can draw your attention to a point, because your eye has to come to a point in the surrounding area. So in my designs, I always have something that draws your attention, even if it's off-center."

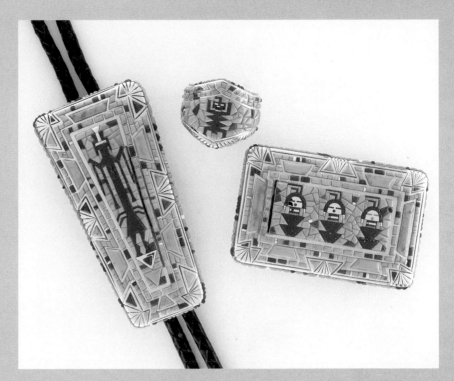

1083 *"This is my rendition of a Hopi katsina," says artist Lee Yazzie (Navajo). "I appreciate things of other tribes, especially the Hopi. I always admired their katsinas and color combinations. It's almost like trying to capture something that's in motion, in action. They are spiritual beings. You have to believe in them, and you have to be a part of it and feel it in order to do it justice, to capture the spirit."*

Constructed over a three-year period, this remarkable bracelet, representing a corn-dancer-katsina, resulted from an intense, creative relationship between collectors Don and the late Kay Mundy, gallery owner Joe Tanner, and artist Lee Yazzie. The complexity of the bracelet's construction—three-dimensional mosaic inlay on an unusually wide curved surface—required Yazzie to make several trips from Gallup, New Mexico, to the Mundy's East Coast home. He wanted to ensure that the gold cuff fit Don's arm comfortably before inlaying, since any stressful bending or moving could cause cracks. In retrospect, the Mundys found the process of making to be as important as the finished masterpiece. Bracelet. 1980–83. Bisbee turquoise, jade, coral, mammoth ivory, jet, ironwood, serpentine, 14-karat gold. Height, 3⅛" (7.92 cm). Collection Mundy and Tanner

Δ **1084** *Gifts of Gods: The Navajo* Yei— the bringer of blessings—is illustrated on the bola tie. The rain is the healer and thus the answer to the prayer. Cloud people with gold faces grace the belt buckle. The lapidary work is by Raymond Yazzie (Navajo), who was inspired to cut stone through watching his brother, Lee Yazzie. Stones are cut in a variety of shapes and put together at many different angles. Each three-dimensional stone is sized, polished, and finessed to fit into the whole. The smaller ones are the Cloud People, the larger figure is a Yei.

Raymond was raised with quality jewelers and materials, so it was bred in him. He wasn't afraid because he felt he was on an even keel with the rest of the group. "When you learn all the qualities that you can do yourself, you manage to carry it on, because you learned from the best." The silverwork is by Manuel Hall. The design came from the concept of a painting by Ted Klauss. The set took one year to complete. 1979–80. Blue Gem, Bisbee, Morenci, Lone Mountain, and Persian turquoise, lapis lazuli, coral, 14-karat gold. Buckle length, 3⅝" (9.2 cm). Collection R.C. Cannady*

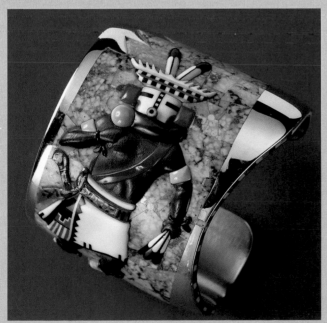

1083

at Zuñi, and old man Leekya would make the ten pounds into beads. After a given time, granddad would come back and pick one until the pile was gone. That's the way they divided it.

"Then he would take the finished beads and jewelry and trade it with everybody in the Four Corners area. When they saw old Joe Tanner coming down the lane, they knew there was something in those bags for everyone that was exciting to trade for."

Tanner is noted for his ability to identify top-grade materials (he is a world-class turquoise expert) as well as talent and then place them together. He recalls, "An old German artist said to me, 'Joe, no one loves turquoise more than you do. When you die, we're just going to fill your coffin with gem-quality turquoise. You take it with you, because there's a great responsibility with it! When Mother Earth delivers you a precious beauty, it's your responsibility to bring it to its finest fulfillment.' And I take that literally, in that I think each time something special comes to me, it needs to go to a talented hand who will show it off."

Tanner's extraordinary Indian jewelry collection is an important part of his life, and it has influenced his approach to business. "The years I worked with Joe were the most creative years of my life," says Navajo jeweler Raymond Yazzie. "He gives you time, but at the same time he's a creative person. When you work with Joe, you can show him how far you've gone, where you're stuck, and he can come along and say, 'You know, why don't we do it this way?' I think it's just a creative imagination that he has, seeing an unfinished piece being done in a certain way. Joe is more a collector. . . . He's not the type to say, 'I'm going to buy this because I can make more money off of it.' He would rather enjoy the piece, until finding it a good home with somebody that's going to really appreciate it." Joe adds, "I've been so excited to fulfill my career by helping a few people that I've met to become who they are through their art."

Kenneth Begay, a leader in major stylistic changes in Navajo silver, worked with John and Virginia Bonnell at the White Hogan gallery from 1946 until 1964. Both Bonnells were born in Pennsylvania. Son Jon Bonnell, who today runs the gallery, relates: "My dad figured he could starve just as easily out west as he could back east and it was warmer here, so he came out and established the White Hogan in the 1940s."

The Bonnells took an unusually broad-based approach to working with their artists. "Soon after opening the White Hogan, Dad showed Kenneth books on early English and American silverware, and how things other than jewelry could be made from silver. Kenneth's reputation is really for his hollowware and flatware. The other thing that helped was being encouraged . . . not to worry if a mistake is made, we'll start over. And after a while, the artist develops such a level of confidence—not ego, confidence—that he can do anything he wants. It was also important to give the artist time to daydream, take him to a show, just open up horizons, because there weren't very many horizons for Native Americans or their art in 1946. Let them meet people and see how those people were wearing their jewelry, so they could construct it properly. I think my dad, like [early trader M. L.] Woodard and Wallace, did an outstanding job helping the craftsmen develop applications for their work, and from a commercial standpoint, making a living, because if they don't understand how people are going to wear and use it, they are not going to make a living." In order to relieve financial stress and allow for even greater creativity, Begay was included in the Bonnell company's profit sharing, as well as being salaried, a rare business arrangement for its time.

"Lovena Ohl is, to put it plainly, one of the principal figures in the whole world of American Indian art, and especially the Indian art of the American Southwest," remarked N. Scott Momaday, Kiowa artist and Pulitzer Prize–winning writer, at the

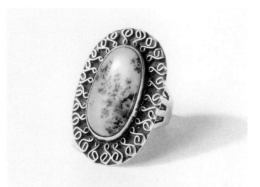

1085

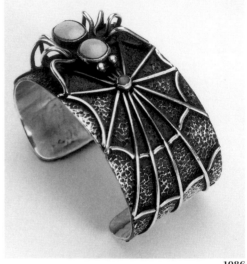

1086

1085 *Silver ring with a turquoise cabochon stone set within a framework of silver filigree by Fred Peshlakai (Navajo), one of the first silversmiths to stamp his work with a hallmark. Peshlakai was the nephew of Atsidi Sani's brother (Slender-Maker-of-Silver; d. 1916), a fine Navajo silversmith of the 1880s and 1890s who taught Peshlakai silversmithing, and had himself learned the craft from Atsidi Chon. At Fort Wingate Boarding School in the 1930s, Peshlakai instructed Kenneth Begay, the father of contemporary Navajo silversmithing. 1935–36. Height, 1¼" (3.2 cm). Collection Mrs. Joseph Harlan*

1086 *The spider emerges here in a contemporary guise. Navajo bracelet. 1975. Silver, turquoise, coral. Height, 2⁹⁄₁₆" (6.5 cm). Collection Tis Mal Crow*

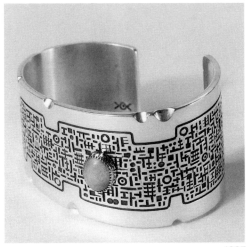

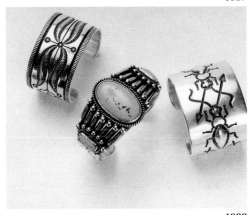

1087 *Silver and opal bracelet. Navajo Norbert Peshlakai, a fourth-generation silversmith, created the patterns on this bracelet with his own tiny stamps and dies, customized from concrete masonry nails. 1992. 1¾" × 2⅜" (4.5 × 6.7 cm). Collection Mrs. Joseph Harlan*

1088 *Three bracelets illustrate the range of Navajo silversmith McKee Platero's abilities. Technically proficient and highly imaginative, Platero casts all his own silver from ingots, blending tradition with whimsy and occasional social commentary.* LEFT: *Classic Navajo design and form.* RIGHT: *Crafting in a traditional way, Platero used handmade stamps to create an innovative and contemporary bracelet. Height, 1⅝" (4.1 cm). Collection Carol Krena.* MIDDLE: *A combination of traditional and contemporary designs and techniques. Courtesy Four Winds Gallery*

tenth-anniversary party of the Lovena Ohl Gallery in Scottsdale, Arizona. As manager of the Heard Museum shop in the 1960s, Ohl not only discovered talented artists, but also campaigned to educate the public about Indian art, then a vaguely understood art form. At the Heard, continues Momaday, "she came to be known as an authority on American Indian arts, someone to seek out, to ask for sound advice, to trust. It seems she was always there—for artists and craftsmen, for collectors and tradesmen, and perhaps most especially for young and struggling artists, who were not yet secure in their talent, who needed encouragement. Lovena encouraged them and helped them to understand the reality of their potential." Her own gallery, opened in 1977, was a "brilliant success, to no one's surprise."[52]

Lovena's advice to Hopi artist Charles Loloma, a longtime close friend whom she represented for years, was: "Learn to do everything; to work with all stones and gold, not only silver. I don't want to take you away from your culture, but I want you to learn, because this is a big world and you have to work with many terms. But keep it within your culture." One artist commented, "Dealing with Lovena is less a representation than a collaboration, a creative partnership between artist and gallery."[53]

In Lovena's honor, the Heard Museum established the Lovena Ohl Studio and Exhibition Gallery. In March 1994, Ohl received the Arizona Governor's Art Award for her contributions to the "development and achievements of American Indian artists." The award also paid tribute to the Lovena Ohl Foundation, a fund established from gallery profits augmented by public contributions. Yearly cash awards are granted to Indian artists to further education, travel, or any option that will develop artistic abilities. Lovena passed away in September 1994 at age eighty-six. At her memorial service in Phoenix, Reverend William Dowling, Pastor of Grace Lutheran Church, said, "Lovena was a loving, talking, walking value system. I can recall no other person in my life—man or woman—whose business so consistently reflected her belief system. There was no such thing as a customer, everyone was a friend."[54]

MUSEUMS AND EDUCATION

Lovena Ohl's work continued the tradition of Southwestern museums and organizations that have encouraged Indian art and adornment, including, since 1922, the Inter-Tribal Indian Ceremonial in Gallup and Indian Market in Santa Fe. By the 1950s, however, concern mounted over the future of Indian art. It was not being taught or emphasized, although, remembers Navajo silversmith Chester Kahn, a "few families kept it going for economic reasons." A 1959 conference changed the direction of Southwestern arts and adornment. Indian artisans, traders, educators, and administrators assembled to discuss what could be done to reawaken the depth of available talent and enable the artists to earn a living. The outgrowth of this conference was the Southwest Indian Art Project, sponsored by the Rockefeller Foundation and held during the summers of 1960, 1961, and 1962 at the University of Arizona in Tucson. Among the student artists who took part in the project was Chester Kahn (972), taught by teacher-artists Charles Loloma and Lloyd Kiva New, a Cherokee and arts educator, who had been Loloma's high school art teacher. Chester Kahn describes the importance of the project: "We were introduced to modern techniques and modern concepts, exposed to avenues of contemporary ideas and concepts. And from then on we started to grow." The same year the project ended, 1962, the Bureau of Indian Affairs established the Institute of American Indian Arts in Santa Fe under the directorship of Lloyd Kiva New. Many of today's finest Native artists have attended the Institute.

SOUTHWESTERN GLASS BEADWORK

Glass beads are thought to have been introduced to the Pueblos by the Coronado Expedition in 1540. Among the few glass beads excavated at Hawikuh (the ancient site of Zuñi Pueblo) were two chevron (star) beads. By 1825, glass beads were exchanged between Southwestern Native groups and Euro-American fur traders. After the establishment of trading posts on the Navajo Reservation in 1868, glass beads became readily available. Those in coral and turquoise-blue colors—in obvious imitation of the beloved stones—were favored in particular by the Navajo. Two of the more well-known examples are the wound-glass beads of Chinese manufacture known as padre beads (a similar bead is seen in 139) and mold-formed Czechoslovakian beads, which were traded by Don Lorenzo Hubbell at his trading post in Arizona (1069).

By the third quarter of the nineteenth century, Apache women wore multiple-strand glass-bead neck-laces, while the men wore multiple strands of glass beads on their wrists and around their neck with tweezer pen-

dants. By 1900, they made a variety of woven necklaces from glass seed beads, including shawl collars and T-necklaces (1092, 1094). The Yuma tribes, most notably the Mojave, created glass seed-bead netted collars (1091), which were borrowed by the Western Apache for their own work.

Glass beadwork, while not common among Southwestern Indians, nonetheless became an art form among both the Eastern and Western Apache. Combining painting and beadwork on clothing, Apache beaders originally attached beads to buckskin using the lazy stitch. One can see similarities between Jicarilla Apache and Ute beaded clothing, with initial influences having come through trading partners north and east in the Plains— most notably the Cheyenne and Crow. The Apache and Yuma people continue to bead, especially the Mojave and Walapai. The Navajo, who have produced a small but interesting body of beading since the late nineteenth century, are currently creating significant work (1097).

1089 *O'odham (Pima) basketry patterns transformed into glass-bead belts (left) and a baby carrier strap (right). Late 1800s. National Museum of the American Indian*

1090 *Yuma girl in a beaded collar. In Yuma creation stories, Kwikumat arose from the waters, created dry land, and, from mud, fashioned Yuma people, who lived upon the West Bank of the Colorado River. With the luxury of time, the Yuma embarked on trading trips, created magnificent beadwork, and practiced ritualized warfare with their Maricopa enemies. Colorado Historical Society*

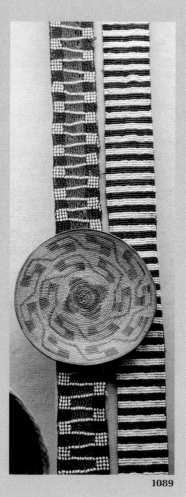

1089

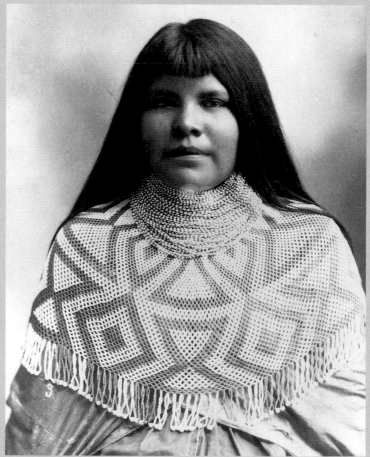

1090

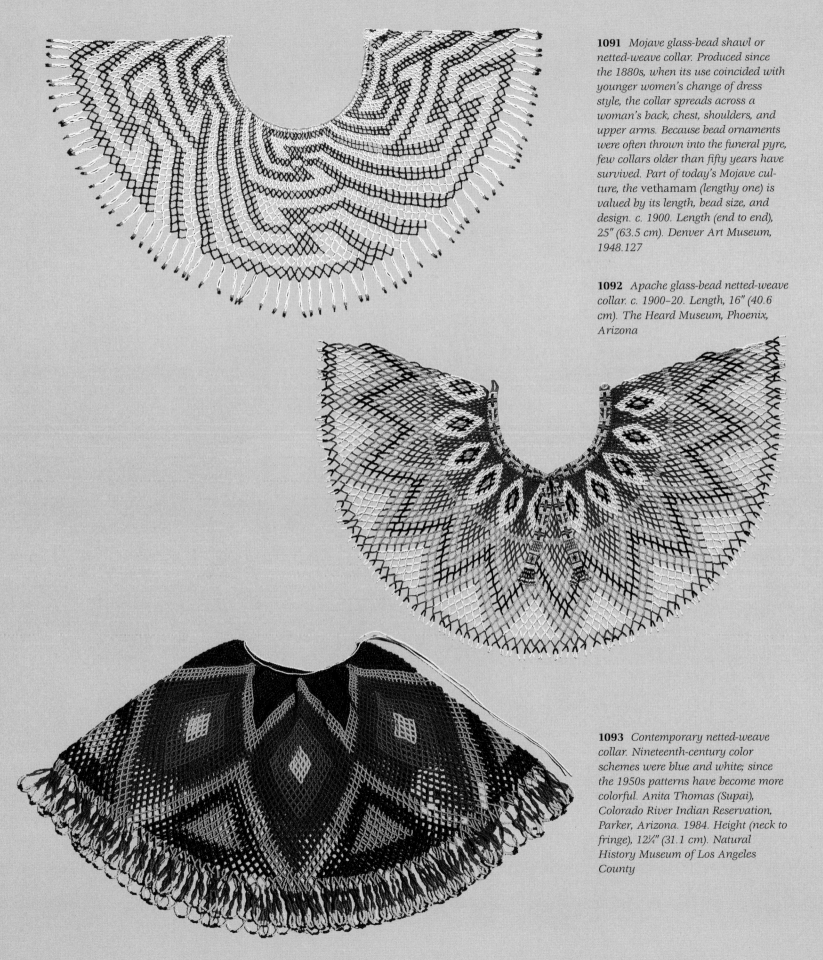

1091 Mojave glass-bead shawl or netted-weave collar. Produced since the 1880s, when its use coincided with younger women's change of dress style, the collar spreads across a woman's back, chest, shoulders, and upper arms. Because bead ornaments were often thrown into the funeral pyre, few collars older than fifty years have survived. Part of today's Mojave culture, the vethamam (lengthy one) is valued by its length, bead size, and design. c. 1900. Length (end to end), 25" (63.5 cm). Denver Art Museum, 1948.127

1092 Apache glass-bead netted-weave collar. c. 1900–20. Length, 16" (40.6 cm). The Heard Museum, Phoenix, Arizona

1093 Contemporary netted-weave collar. Nineteenth-century color schemes were blue and white; since the 1950s patterns have become more colorful. Anita Thomas (Supai), Colorado River Indian Reservation, Parker, Arizona. 1984. Height (neck to fringe), 12¼" (31.1 cm). Natural History Museum of Los Angeles County

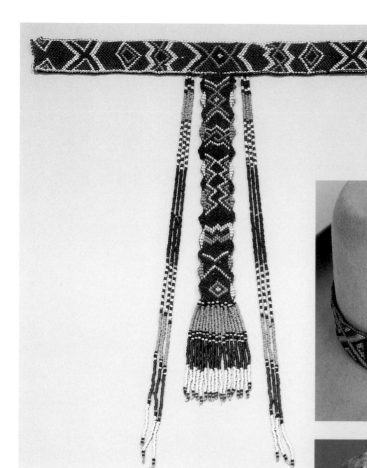

1094 *Western Apache glass-bead T-necklace. Although now a standard part of the pubescent girl's attire, T-necklaces seem to have been in existence only since the turn of the century. c. 1900–1920. Length, 10½" (26.7 cm). The Heard Museum, Phoenix, Arizona*

1095 *Beaded hatband, transformed from a belt. Navajo. 1992. Width, 1¼" (3.2 cm). Collection Don Owens*

1096 *Chiricahua Apache high-topped moccasins worn for the Mountain Spirits ceremony. Edgar Perry (White Mountain Apache) tells us: "Moccasins were very important. Some moccasins have uppers made from deerhide, with the soles from cowhide. Before the use of cowhide they used hide from the neck of a deer, which was thick and good for the sole. The distinctive, round toe of the moccasins protected the toes from sharp cactus, rocks, sticks, snakes, and other dangers.*

"Our people are very religious and some of our moccasins have crosses on them. When we're walking on the holy ground, in God's country, we dance with the moccasins on. . . . The people know they've got to get ready for certain special times. In the old days the people would get everything they needed together and make preparations. . . . When a girl becomes a woman, for example, we make moccasins for her. Moccasins have a vital role. The first thing you do when you get up is put on your moccasins, so you're ready to go. If your enemies are nearby, you're prepared to jump and go. And when you put on the moccasins you put on the right foot first and then the left in a clockwise fashion that shows respect for Mother Nature— that's Apache tradition." Collected 1888–1916. Height, 12 3/16" (31.0 cm). Peabody Museum of Archaeology and Ethnology, Harvard University, 38-44-10/12859

1097 *The loomed beadwork of this Navajo belt buckle relates conceptually to rug weaving. The patterns and colors appear as rainbows or sunsets among the mesas. Although a relatively recent Navajo art form, glass beadwork "expresses spirituality based on fundamental beliefs and motifs rooted in Navajo life," writes Ellen Moore, "especially those related to nature and patterns of light and color. . . . Navajo beadworkers not only observe light in detail, but also map the dimensionality that light and color create in their beadwork." 1994. Length, 4 1/8" (10.5 cm). Private collection*

1098

1099

1098, 1099 *Approximately one hundred years separate these two finely crafted Mojave effigy water jugs. The painted designs are reminiscent of Mojave facial tattoos.* **1098**: *Painted pottery jug with glass-bead adornment made for non-Native trade. Arizona, c.1890. Height, 9½" (24.1 cm). Laboratory of Anthropology/Museum of Indian Arts and Culture, Santa Fe, New Mexico 18938/12.* **1099**: *Contemporary water jug crafted for the marketplace in 1972 by the late Elmer Gates, the last of the Mojave potters. Height, 9½" (24.1 cm). Collection Mrs. Joseph Harlan*

1100 *Mojave pottery dolls provided information about the adornment, clothing, and facial tattooes of vanished ways of life. Conceived around the time of European contact and sold to travelers, such dolls were possibly inspired by prehistoric Hohokam pottery figures. Late 1800s. Pottery, glass beads, paint, cloth. Height, 7½" (19.1 cm). American Museum of Natural History, 1/4681 & 1/4682*

1101 *Mojave potter wearing a rabbit-skin robe (see 882) works on a jar similar to 1098. c. 1907. Courtesy of the Library of Congress*

CONTEMPORARY EXPRESSIONS

Southwestern jewelry innovations of the past five decades began with Kenneth Begay (Navajo, 1913–1977), Charles Loloma (Hopi, 1921–1991), and Preston Monongye (Mission-Hopi, 1927–1987). The technical and artistic abilities of these three deeply creative men have influenced generations of jewelers who followed them. Lee Yazzie comments, "We borrow from our older silversmiths; what we do is an extension of what they introduced." Technical training from non-Native goldsmiths such as Frank Patania of Italy and Pierre Touraine of France helped Indian artists refine gemstone setting and other techniques. During the 1950s, goldsmith Patania offered custom-made Indian jewelry at his Santa Fe and Tucson galleries. Patania and his Indian workers, including Julian Lovato (Santo Domingo) and Louis Lamay, a Hopi who trained with Navajo silversmith Ambrose Roanhorse at the Santa Fe Indian School, taught each other techniques and concepts.[55] Touraine introduced Begay to diamonds. Ted Charveze (Isleta) noted, "Pierre was a very important person in my life. He gave me the courage I needed to step out beyond the traditional aspect, to break away from the conformity."[56] Charles Loloma and Larry Golsh also studied under Touraine.

Unfortunately, due to the success of Southwestern jewelry, foreign and United States factories have copied Navajo and Pueblo artists' designs, making inexpensive, mass-produced items. Zuñi fetishes, gold-leaf designs by Navajo smiths Ramon and Lucille Platero, and fine-gauge "liquid silver" tubular beads invented by Ray and Mary Rosetta of Santo Domingo have all been appropriated.[57] To control the situation, the state of New Mexico legislated requirements for authenticity, such as hallmark stamping. The controls have been only partially successful, however. "The safest way to purchase authentic Indian jewelry is either directly from a long-established dealer or directly from the artist," says Marquetta Kilgore Monongye, herself from a gallery-owner family.

Southwestern Native peoples excel in maintaining what is most essential in spite of long and vigorous pressure from the non-Native world and the enormous number of acculturative changes over the decades. At the same time, a synthesis of outstanding design and technique forms the basis of Southwestern jewelry as fine art. Superior craftsmanship "breathes out the design quality, makes the design real, gives the design its essence," wrote Clara Lee Tanner.[58] "It was instilled in me by my grandfather to be perfect," remarks Jesse Lee Monongye. "Why do something wrong and do it over again? Everything that I do, I make sure of all the possible ways of not making a mistake, that it's durable and strong." Verma Nequatewa adds, "Our grandfather, and of course, Charles [Loloma] always said, 'If you're going to make a piece of art, to put your hands to work, do a good job. If there's something not quite right with the piece, fix it. Don't leave it like that, because you know it's there.'"

"My great-grandmother was a weaver," says Chester Kahn. "It was probably in her generation or maybe back where they learned to weave, when the Spanish brought wool and the sheep, that it was developed. My grandmother was on [an even] higher level of weaving the various styles. . . . And then it went on to my aunt, [who took the work to] another level. They always try to improve it. And in my own life that's what I'm trying to do in every piece that I make—whether it's a ring or a bracelet—to try to make something that is higher quality. It's hard, it's a difficult challenge. You can always get there, but slowly."

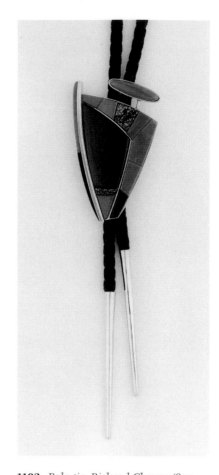

1102 *Bola tie. Richard Chavez (San Felipe, b.1949). Though initially taught the* heishi *technique by his grandfather while in college, Chavez's main design influences and inspiration derive from his architectural studies, the paintings of Joan Miró and Josef Albers, and from Scandinavian jewelry. Chavez is a sophisticated and restrained designer who stays "away from combining religion with my work. It is too personal. Instead I design with color." The subtle "Indianness" that nonetheless emerges in his work reflects his having had a traditional Pueblo upbringing. 1990. Coral, jet, turquoise, 14-karat gold. Bola length, 2¼" (5.7 cm). Collection Bernice and Herbert Beenhouwer*

Kee Joe Bennally (Navajo) started making jewelry for financial reasons when he was ten years old. "I started looking for the trading posts, looking for a job. I didn't know anything about anything but I knew a little bit of stonecutting. I was talking to this old man at the trading post, he said he wanted me to cut some stone for him. Then I started that grinding, winding by hand. That's when I started, a long time ago. That's how I became a silversmith. . . . I started the hard way," he explains. "That time we didn't have any tools like they have nowadays. We worked in dark quarters, it was very bad for the eyes.

"Nobody taught me, but myself. I just try, try, try, every day and night. I did something every day, keep going, keep going, and keep working on it. Year after year. Silver, stonecutting, buffing, all the way out to the complete finish. I like to work with silver and I like to work with it all the time. And after twenty-five years, it's coming out okay."

1103 *"Every time when I make something, I never did plan what I'm going to make, and I never think about what it's going to be," says Kee Joe Bennally. "I was looking at a Navajo basket that they use in their ceremonial. That's what it is, coming out to my mind. That's how I made [the belt, displayed in a Navajo basket]." The open form of the Navajo ritual ("wedding") basket signifies the earth, and, when turned over, it becomes the sky dome. The triangular designs are mountains and thunderclouds. The east—place of power and beginning—is signified by a break in the design, purposely created to allow the power of the east to pass within. Belt by Kee Joe Bennally. 1990. Belt length, 28" (71.1 cm). Collection Tanner*

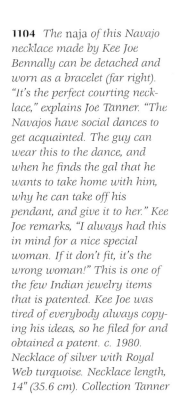

1104 *The naja of this Navajo necklace made by Kee Joe Bennally can be detached and worn as a bracelet (far right). "It's the perfect courting necklace," explains Joe Tanner. "The Navajos have social dances to get acquainted. The guy can wear this to the dance, and when he finds the gal that he wants to take home with him, why he can take off his pendant, and give it to her." Kee Joe remarks, "I always had this in mind for a nice special woman. If it don't fit, it's the wrong woman!" This is one of the few Indian jewelry items that is patented. Kee Joe was tired of everybody always copying his ideas, so he filed for and obtained a patent. c. 1980. Necklace of silver with Royal Web turquoise. Necklace length, 14" (35.6 cm). Collection Tanner*

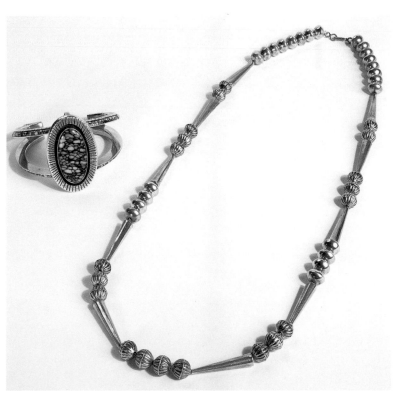

HEISHI

Heishi (from the Santo Domingo word meaning "shell") traditionally referred to necklace shell beads. Today, however, it describes tiny, handmade beads of any material. The Santo Domingo Pueblo carvers are the most proficient *heishi* producers. To make the minuscule beads, the material (shell, stone, or coral) is sliced into strips, then cut into small squares, after which holes are drilled through the center. Strung together, the rough squares are shaped and smoothed by holding the string against a turning stone wheel. In the process, 60 to 70 percent of the original material is lost.

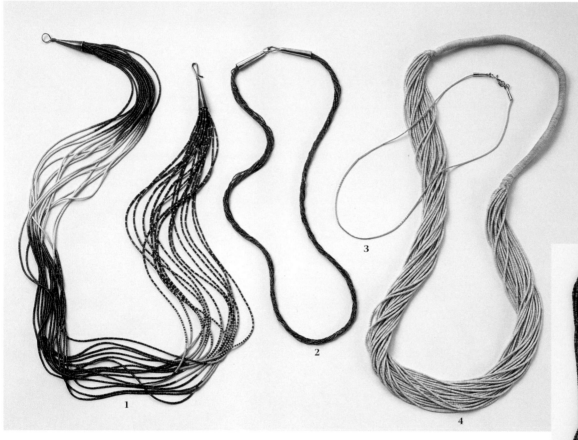

1105 Heishi *necklaces so fine that they look like hair and feel like silk. All were made at Santo Domingo Pueblo. 1. Rosetta family. 1988. Shell and turquoise. 2. 1970s. Shell, aguilarite, strung 32 beads per inch. Length, 12½" (31.8 cm). 3. Turquoise and gold. 4. Melon shell. 1, 4, Private Collection. 2, Collection Tanner. 3, Collection Lynn Sherr*

1106 *Ancient Puebloan necklace made with around fifteen thousand tiny (1 mm) steatite, argillite, and turquoise disk beads—the ancestors of contemporary* heishi. *Holes were drilled individually with a cactus needle and sand. The beads were shaped by stringing the rough blanks tightly together and then rolling the string across a sandstone slab. Polishing was accomplished using increasingly finer grits and buckskin.* A.D. *1225–1300. Total length, 27½" (70.0 cm). Arizona State Museum, The University of Arizona*

Although **Johnny Rosetta** of Santo Domingo Pueblo has lost the use of his left arm, he continues to create fine silver *heishi*. "I put my hand in the sling and do the cutting and soldering. I have learned to improvise. I couldn't polish, so I made some wooden handles and now I can polish." His children shape the cones, he solders them, and they reshape them—a true family collaboration. His parents, Mary and Ray Rosetta, originated "liquid silver" (necklaces of silver tubes so tiny they look like shimmering water) in 1955. Their grandson, Dillon Moses Rosetta, Johnny and Marlene Rosetta's son, continues the tradition.

Marlene Rosetta, who works with Johnny, explains, "Everything is handmade, even the hook and eyes. We don't buy readymade cones, we make them. Truly handmade." There are great differences between mass-produced liquid silver and the Rosettas' own: "The mass-produced is very thin silver: 32 gauge, bezel wire. Ours is 28 gauge, hand drawn and hand cut. When it's cut, the edges are really rough. We put them on a wire and sand them down to remove all the rough edges." Johnny believes that "making it by hand is very important in order for it to be true, Native American jewelry."

1107 *Santo Domingo artisans are the masters of* heishi. *1. Shell graded dark brown to white. Length, 12" (30.5 cm). 2. Shell, lapis lazuli, turquoise, coral, 14-karat gold. 3. Olivella and melon shell* heishi *by Charles Lovato. 1970s. Charles Lovato is credited with the concept of finely shaded* heishi, *accidentally originated by Clara in 1968 while stringing. 1, 3, Collection Tanner. 2, Collection Lynn Sherr*

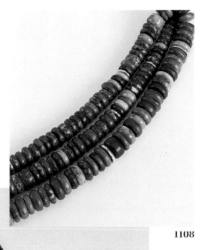

1108

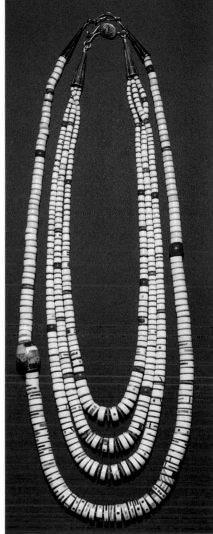

1109

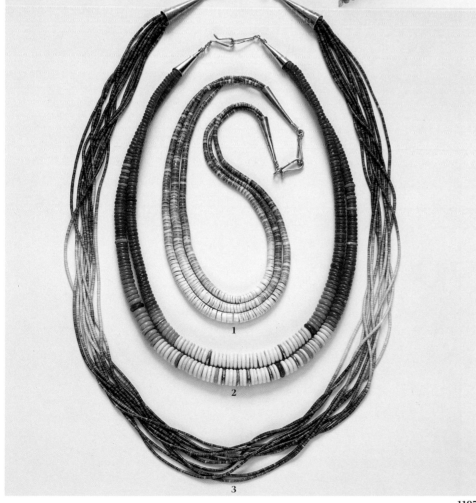

1

2

3

1107

1108 *Charles Lovato, one of the finest Santo Domingo* heishi *artists, made this necklace with his wife Clara during the last years of his life. Nearly blind and ill with cancer, he was unable to work with tiny* heishi. *These beads, however, "a fiesta of color," in Joe Tanner's words, still maintain the marvelous energy of his earlier pieces. 1986. Turquoise, lapis lazuli, 14-karat gold, pipestone, obsidian, sugilite, and coral. Largest bead diameter, ½" (1.27 cm). Private collection*

1109 *Ivory beads inlaid with coral, turquoise, lapis lazuli, and shell. Johnny Rosetta (Santo Domingo). 1970. Outside length, 17" (43.2 cm). Collection Tanner*

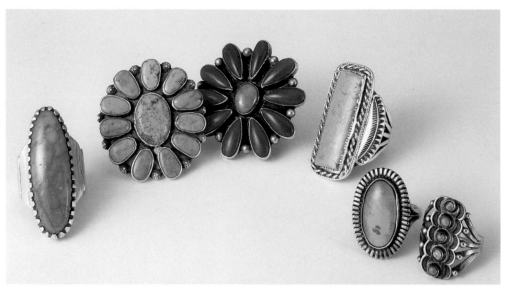

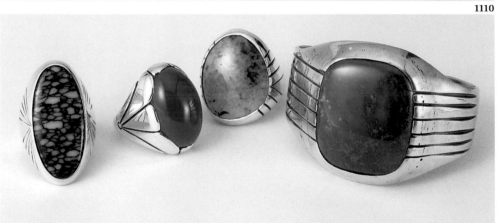

1110 *Turquoise mined from the earth, and coral collected from the sea, create startling beauty when brought together. Navajo and Zuñi rings. Twentieth century. Turquoise blossom diameter, 1½" (3.8 cm). Private collection*

1111 *Following Joe Tanner's suggestion to "design to the spirit of the stone," Sam Begay, who dominated Navajo silversmithing competitions in men's rings from 1940 to the early 1980s, created these graceful objects of turquoise, coral, and silver. The ring at far left is of Royal Web turquoise. Height, 1⅜" (3.5 cm). In the middle are a coral ring and one of turquoise. At far right is a bracelet of Blue Gem turquoise. Height of bracelet, 2⅜" (6.0 cm). All, 1970s to 1980s. Collection Tanner*

1110

1111

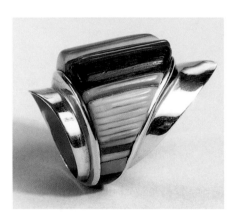

1112 *Ring made of ironwood, coral, lapis lazuli, turquoise, and mastodon ivory. Charles Loloma (Hopi). Late 1950s, early 1960s. Length, 1⁹⁄₁₆" (4.0 cm). Collection Margaret Kilgore*

1113 *Contemporary Navajo silver and turquoise ring, birdlike in shape and fitting over the knuckle, has the spirit of ancient anthropomorphic pendants. James Little (Navajo). Length, 1¹¹⁄₁₆" (4.2 cm). Collection William Faust II*

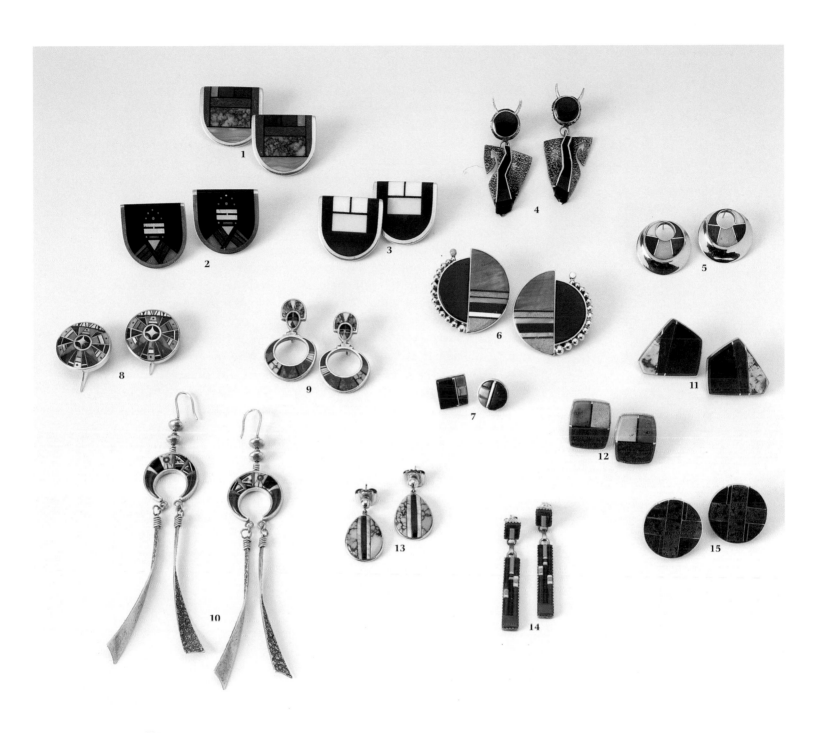

1114 *Earrings with stone inlay. 1980s–early 1990s.
Turquoise, sugilite, coral, jet, spiny oyster, serpentine, lapis
lazuli, shell, mammoth ivory, silver, gold. Longest length,
4½" (11.4 cm). Collections Tanner, Lynn Sherr.
Artists, from top, left to right: 1–3. Jimmy Harrison (Navajo).
4. Little Elk (Lakota living at Window Rock). 5. Frank
Cerillos (Laguna). 6–7. Jesse Lee Monongye (Hopi-Navajo).
8–10. Phil Loretto (Jemez-Cochiti). 11–12. Duane Maktima.
13. Ben Nighthorse Campbell (Cheyenne).14. Carolyn
Bobelu (Zuñi). 15. Ray Tracy (Navajo).*

*The earrings created by Phil Loretto on the anniversary
of Wounded Knee (10) were made "as homage to those who
put their life on the line."*

CORN

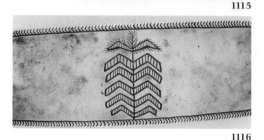

First domesticated five thousand years ago in Mesoamerica, maize, the staff of life, has been the foundation of Southwestern subsistence and ritual life for thousands of years. In a land of arid environments, each stalk of corn is respected. Popavi Da (San Ildefonso) relates: "Our Pueblo people eat gently, recognizing with inner feelings that the corn or squash were at one time growing, cared for, each plant alive, now prepared to become part of us, of our bodies and our minds, quite sacred. We reflect on the plant." Prior to attending the "stately" Tablita or Corn Dance at Cochiti Pueblo in July 1995, anthropologist Charles Lange informed the author and her group that "the *Koshare* [Delight Makers] feed cornmeal to the drums to feed the voices."

The Hopi associate each of the six directions (the cardinal directions plus the zenith [above] and nadir [below] with an appropriately colored ear of corn. Hopi corn varieties are yellow, blue, red, white, black, and sweet (called "katsina corn"). *Mi'li* is the Zuñi name for corn and for the spirit of *A'wonawil'ona* (He-She-Who-Created-Everything), represented as the ear of corn clothed in beautiful plumage. Macaws or parrots, like Indian corn, are multihued. Since macaws are birds from the distant south (having been brought north in Hohokam times), they are fellow travelers with the sun, the sun being the main force that governs the corn cycle. Hence, it is not surprising that macaw or parrot feathers crown the Corn Mother fetishes.

During the Navajo's Blessingway rites, pollen is eaten during prayer, and many Southwestern Indians make offerings to the spirit world by casting ground cornmeal to each direction. When pieces of shell and coral and turquoise (earth) as well as corn pollen are added to the ground grain, writes Hamilton A. Tyler, "all the essentials of life are brought together."

1115 *Corn petroglyph panel at Todie Canyon, Grand Gulch, Utah. Basketmaker culture*

1116 *Corn motif on the headstall of an early Navajo silver horse bridle. The Navajo shared the Pueblo people's deep respect for corn. c.1885. Length, 5⅟₁₆" (13.2 cm). Laboratory of Anthropology/ Museum of Indian Arts and Culture, Santa Fe, New Mexico, 10326/12*

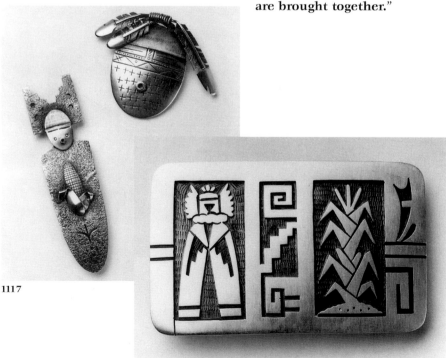

1117

1118

1117 *Corn maiden (left) and a katsina mask with water symbols. In 1993, Myron Panteah, a prizewinning stone inlay jeweler, sliced his hand so badly on a saw that he no longer had the ability to do delicate inlay work. He subsequently developed an alternative style, exemplified by these pendants. Myron Panteah (Zuñi). 1995. Sterling silver corn on cast-iron corn maiden, cast-iron mask. Corn maiden length, 3¼" (8.3 cm). Private collection*

1118 *Silver belt buckle by Timothy Mowa (Hopi) of Second Mesa. Mowa, a deeply traditional man who follows the Hopi ways of life, explains the symbolism on the buckle. To the left, "is an eagle dancer. Next is the kiva symbol, important because of the dances we perform in there. The place is sacred: everything is done in the kiva, praying for all this. There are clouds and water, all forming from the ground. The corn represents the land everywhere; it never ends. And on the right, the sun rays, for warmth. Below is the migration." c. 1994. Length, 3" (7.6 cm). Private collection*

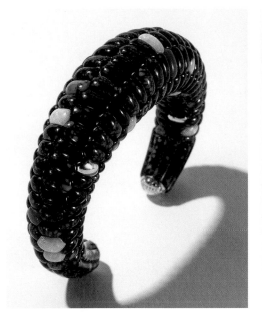

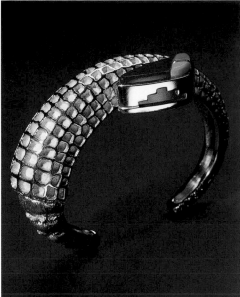

1120 *Corn bracelet. "The brown is the earth, the turquoise is sky, and the green is corn—the growth or joint between the two. It grows up happy," said artist James Little (Navajo) of his bracelet. 1992. 18-karat gold, lapis lazuli, turquoise, chrysoprase, coral. Diameter, 2¹⁵⁄₁₆" (7.5 cm). Private collection*

1121 *Corn bracelet. Charles Supplee (Hopi-French). 1985. Coral, lapis lazuli, turquoise, gold. Length, 3". Collection Bernice and Herbert Beenhouwer*

1122 *Filled with marvelous detail, the design of this corn maiden was inspired by ancestral Puebloan petroglyphs and the sky. Artist Phil Loretto (Jemez-Cochiti) explains: "I'm very interested in celestial events. Living out here [Jemez Pueblo], you get to see and record them. It's so dark here—it's pitch black—you really get to observe the sky." Although Phil has a degree in architecture, he is a self-taught jeweler who has made about one hundred twenty-five small tools. To ensure that his stone inlay has tight joins, "I put the stones against the sun so that no light comes in." 1981. 14-karat gold with inlay of ivory, shell, turquoise, and coral. Length, 4" (10.2 cm). Collection Tanner*

1120

1121

1119 *Upon completing this tour-de-force bracelet, Lee Yazzie (Navajo) commented to Joe Tanner: "I suppose I don't have to be ashamed for spending seven months of my life creating one piece of jewelry. I was thinking to myself, it takes Mother Nature three months to grow one ear of corn. So I guess that makes me half as good as Mother Nature!" Remarkably engineered, a solidly braced bridgework that is hidden accommodates the stones. Although Yazzie originally thought to expose the complex metal structure, he changed his mind: "When you look at the corn you see [only] the kernels. So I decided to set the stones that way."*

Lee describes how the bracelet's concept evolved. "In August, I went to help my brother harvest his corn. I always like to see the colors of the corn. That's where we get a lot of ideas for the color combinations—from Mother Nature. So one time after we got the corn from the field and shucked it, I saw all those colors. After observing them, I picked one up and looked at it and said, 'Wouldn't it be nice if I could take this ear of corn, spin it around my wrist, and wear it.' A short while afterwards, Joe Tanner distributed Royal Web turquoise to several of the major artists to see what we could do with the material. I had my pick of a good selection of the stone. Suddenly I knew this is what I was looking for. This is what I could do with that material. The color is close to blue corn. So this is how it came about." Blue-corn bracelet. 1984. Lapis lazuli, coral, Bisbee turquoise, Royal Web turquoise, opal. Length, 3¼" (8.3 cm). Collection Tanner

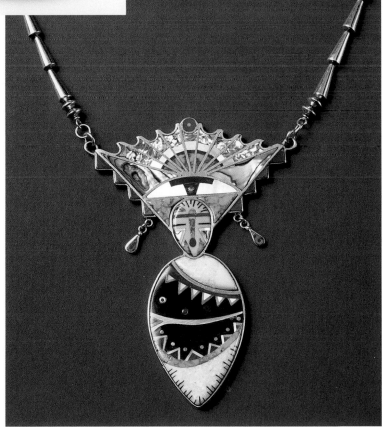

1122

THE JEWELRY OF CHARLES LOLOMA AND FAMILY

harles Loloma's jewelry transformed Southwestern Indian art. Combining a deep respect for his heritage with the ability to change preconceived notions and stereotypes of Indian art and artists, Loloma inspired a generation of innovative artists.

Born in 1921, Loloma (Hopi for "Many Beautiful Colors") grew up with traditional Hopi parents, participating in ceremonies and continuing Hopi oral tradition. Originally trained in painting and ceramics, he turned to silverwork in the mid-1950s, combining elements of his Hopi background with a less tangible, contemporary sense of aesthetics.

As a boy, he watched his grandfather pour molten silver into sandstone molds to create buckles, conchas, and bracelets. Charles saw beauty in the textures of sandstone and cast silver and later incorporated these textures into his designs by casting pieces from molds carved in tufa stone, without buffing and filing to produce a smooth surface. His trademark, however, was his ability to turn casting imperfections into attributes: allowing an unintentional hole to become the focal point of a piece (1129), encouraging the rough quality of the cast metal into his design.

The effect of Loloma upon his community was beautifully expressed by Kiowa writer N. Scott Momaday, who delivered the eulogy at Loloma's 1992 memorial service: "Charles Loloma was a Hopi man. . . . He was the definition of the word Native. And yet, as much as any man of his time, he was a citizen of the world. In his art he achieved universal expression. . . . Beyond other men, Charles Loloma perceived beauty in the earth, in the water, and in the sky. And with great precision and boundless imagination he reflected it truly in the nearly perfect things that came from his hands."

Though trained by her uncle Charles Loloma, Verma Nequatewa is an original and talented designer. "Charles was an excellent teacher. . . . We really listened to him and looked up to him and what he was doing. The people who deal in turquoise and valuable stones saved the best for Charles and they save it for me. They say, 'We want you to have it.'"

A fine stone inlay jeweler, Verma lives and works at the Hopi village of Hotevilla atop Third Mesa. Verma frequently chooses a stone and lets the stone dictate what will happen when it is cut and finds its form. "When you find a big chunk of coral or lapis lazuli, you start from there and design around it. I hate cutting it into small pieces." She does all of her own cutting, grinding, polishing, and metalwork. Her designs are sold under the name Sonwai, the Hopi word for the feminine form of beautiful.

Verma and her family are members of the Badger Clan; she wears a cast silver badger-paw pendant, one of Charles Loloma's earliest pieces, which he wore as a ring. The family continues to live by the Hopi calendar.

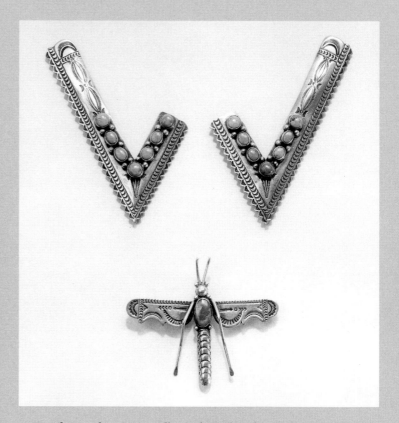

1123 *Silver and turquoise collar tucks and cricket pin by Hopi artist Morris Robinson (d. 1987), uncle of Charles Loloma. "Morris was underrated; he was a transition: he could do flatware, hollowware, jewelry," says Jon Bonnell of the White Hogan. "He was the premier silversmith of the generation prior to Kenneth Begay and Charles Loloma." Robinson was also possibly the Southwest's first goldsmith: he fabricated a gold bracelet in 1929 that is worn every day by its present owner. In the early 1960s, after working as a smith in Phoenix for many years, Robinson returned home to the village of Bacobi on the Hopi Reservation to become a sheepherder. 1940s–50s. Cricket pin. 3" × 2½" (7.6 × 6.4 cm). Collection Mrs. Joseph Harlan*

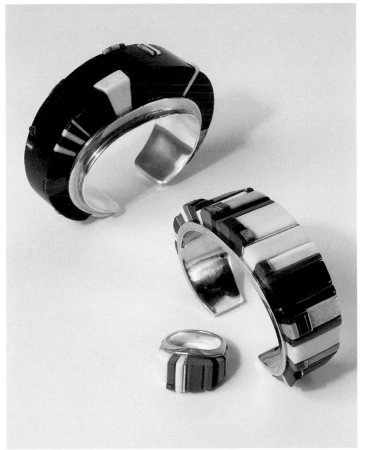

1125

1124 *Echoing local rock formations and mesas (top), Charles Loloma used vertical slabs of turquoise, coral, shell, and multicolored stones to construct the bracelet above. c. 1970. Circumference, 7" (17.8 cm). Millicent Rogers Museum of Northern New Mexico, 1992-16*

1125 *Loloma's "height" bracelets and ring illustrate his remarkable ability to blend traditional and contemporary aesthetics. The patterns recall ancient Pueblo settings. On the bracelet at right, perhaps, is a tiny plaza; adjacent is a rooftop from which the katsinas would chant; the small abalone slab alongside would incarnate the glint of sun on a window. Yet Loloma was also extremely conscious that jewelry was meant to be worn and that, to be successful, it must work with the body. An important aspect of the height bracelets is the careful way in which they are balanced. The asymmetry found in many of these bracelets results from making their center balance over the index finger.* TOP: *Ironwood mosaic bracelet. Mid- to late 1970s. Height, 2⅝" (6.7 cm). Private collection.* MIDDLE: *Bracelet. Early 1980s. Collection Mrs. Joseph Harlan.* BOTTOM: *Fossil-ivory ring. 1950s. Collection Lovena Ohl*

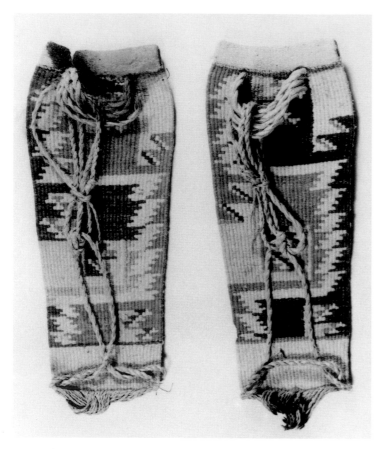

1126 *Basketmaker III sandals ornamented on the upper surface with colored figures and on the sole with an elaborate system of knots and overlaid strands to form neat patterns. Superb examples of skilled finger weaving and hidden imagery, the sandals were found by the hundreds in cave rubbish, worn through and discarded. The time and care put into making them, however, strongly indicates the Basketmaker artisans' pride in fine craftsmanship. Recovered from a cave at Canyon del Muerto, Arizona.* A.D. *500–750.*

1127 *An exquisitely constructed masonry wall at Pueblo Bonito, Chaco Canyon, that was then covered with plaster.* A.D. *1011–1130.*

1128 *Bola tie of turquoise, malachite, lapis lazuli, coral, and ironwood. Charles Loloma. Mid-1970s. Length of male figure, 3¹³⁄₁₆" (9.7 cm). Collection William Faust II*

1130 *This pendant (front and reverse) was inspired by Charles Loloma's secret "window" design concept. Verma Nequatewa (Hopi). 1994. Gold, coral, turquoise, jade, sugilite, fossil ivory. Height, 2⅞" (7.3 cm). Private collection*

1131 *Snake pin commissioned from Charles Loloma by a teenage Bill Faust II as a gift for his beloved great-aunt, gallery owner Lovena Ohl. (Bill made many monthly payments.) The combination of colors—coral, lapis lazuli, turquoise, and gold—was popular with the ancient Egyptians, a culture deeply admired by Loloma. 1982. Length, 3½" (9.0 cm). Collection William Faust II*

1129 *"Charles used to talk about the inside inlay of a bracelet or the inlay on the back side of a pendant as 'inner gems.' He used to say that what is inside a person is often different than what shows on the outside. The inner gems of the jewelry play to the inner gems of the person. We don't always have to show everyone all of what we are. We can share those elements with those we wish. But even if we never show the inside, we know beauty is there and it makes us better," wrote Robert Rhodes, an educator and husband of Verma Nequatewa. Creating a secret inner design, known only to the wearer, is an important Loloma concept. Though not visible when worn, the craftsmanship of the interior mosaic is just as meticulous as that of the exterior. In the catalogue accompanying Loloma's 1978 retrospective at the Heard Museum, Erin Younger explained: "As he developed his concept of interaction, he expanded his exploration of flaws in casting. Where he once left chance holes alone, or accented them with surrounding inlays, he now inlaid the back of the piece, using the holes as windows to give a glimpse of what lies beyond sight. To Loloma, these pieces are symbolic of the inner beauty people possess, the inner strength they keep hidden beneath the surface." Verma Nequatewa did the interior inlay work for this and many of Loloma's other pieces. Early 1970s. Turquoise, coral, lapis lazuli, silver. Height, 1⅞" (4.8 cm). Collection Bernice and Herbert Beenhouwer*

1132 *Bracelet and ring. Verma Nequatewa.* ▷ *1994. Lapis lazuli, turquoise, coral, 14-karat gold, ironwood, opal. Bracelet diameter, 3⅟₁₆" (7.7 cm). Courtesy Lovena Ohl Gallery*

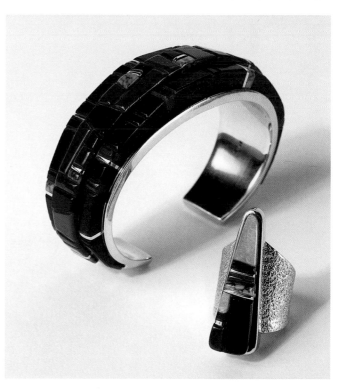

THE MONONGYES: FATHER AND SON

Preston Monongye (1927–1987), of Mission Indian and Mexican heritage, was brought to the Hopi Reservation as a young boy. Adopted into the Monongye family, he lived the Hopi way and participated in traditional Hopi ceremonies, frequently mirrored in his art. Involved in the Katsina Society, he incorporated much katsina imagery in his work. Described by Joe Tanner as a "great warehouse of ideas," Preston Monongye was a sculptor, painter, potter, and jeweler. "Our art, as in non-Indian art, takes form from what we see today," said Monongye. "We may use old techniques, along with old designs taken from potsherds or pictographs, but then we re-design them or add innovations of our own and we have 'the new Indian art.'"

Apprenticing with his uncle, Hopi silversmith Gene Pooyouma, at the age of nine, Monongye helped melt down the silver Mexican pesos and American coins then used in Southwestern silverwork. When he began making jewelry after World War II, it was Indian trader Roman Hubbell who encouraged him. Artistically and technically innovative, Monongye was best known for his tufa-cast silver jewelry combining a variety of finishes in bold designs and colors. Although capable of fine stone inlay, Preston preferred to concentrate on metalwork, and have the stones set by others. Some of his finest collaborative efforts were achieved with Lee Yazzie for Joe Tanner in Gallup, New Mexico, and with Navajo artist Roland Long after Preston died. Monongye's son, Jesse Lee, also assisted his father with stone inlay. Their jewelry won many awards.

Abandoned as an infant, Jesse Lee Monongye (Hopi-Navajo) did not know his father until he was twenty-one. Shortly thereafter, Jesse began working with Preston to learn jewelry making and discovered he had innate abilities. One year later, following a dream in which he was encouraged by his mother (whom he has never found) to focus these talents, Jesse became a full-time jeweler. Today he is acclaimed for his incandescent, richly detailed jewelry.

Raised on the Navajo reservation by distant relatives, whom he calls Grandmother and Grandfather, Jesse was profoundly influenced by the old Navajo lifeways of discipline and beauty and by the teachings of his grandparents, respected tribal elders. At an early age, he was aware of the perfection and balance sought by the neighboring Two Grey Hills rug weavers in their work, and "the beautiful songs the women would sing as they wove."

Jesse speaks of a Navajo initiation ceremony called the Opening of the Mind, in which he participated at the age of thirteen. "It gave you a vision of what you can become. The Navajo prepare you in life with different types of experiences: how to survive alone with the sheep, how to survive alone with the horses, how to survive migrating to the mountains and back to the flats. Those things are very important for a young man. They prepare you for a long-lasting life: to survive with what you have and know."

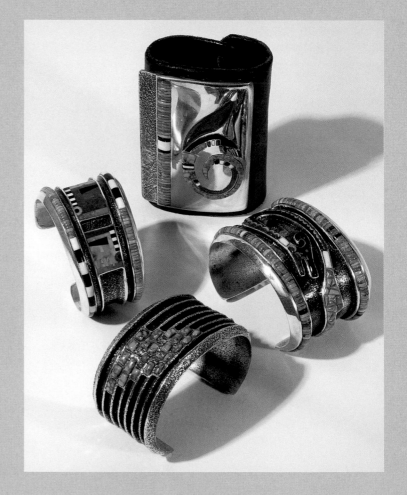

1133 *Objects made by Preston Monongye and inlaid by Lee Yazzie. 1970s.* TOP: Ketoh *(bow guard) denoting a bow and arrow; the arrow is also a parrot, a symbol for sureness of flight. Height, 4" (10.2 cm).* MIDDLE LEFT: *Bracelet of Blue Gem turquoise, coral, jet, ivory, serpentine.* MIDDLE RIGHT: *Bracelet depicting the Great Serpent Protector, who brought rain. Blue Gem turquoise, coral, ivory, jet, silver.* BOTTOM: *Bracelet of tufa-cast silver channels inlaid with Lone Mountain turquoise. All Collection Tanner*

"The ceremony begins about nine o'clock at night. They bring in some food—raisin, corn, shredded beef—and let you eat. The way you handle the corn, just the way you talk about the beef; all these things were meaningful. Then they bring some herbs and you continue to talk. About midnight, the medicine man will put together different types of herbs and grind a peyote button until it's nice and powdered, and they put corn and stuff in there and they roll it up into a little ball and they pray for you, that you will have a long-lasting life and you will become a great leader, a great example.

"They have this charcoal that's red-hot, and they open it up down into the center and it's the earth. As they are talking to you and praying with you, they tell you to look down into this opening of the charcoal which is just red-hot or fire . . . and then they said, 'Whatever you see down in there is what you'll become.'

"When I looked down into this red-hot charcoal, flames all around it, there was this little Indian fancy dancer wearing a beautiful warbonnet. Every time he

moved, he would have different color feathers coming off of him, yellow turning into green and orange, and purple into turquoise and fading out. Just beautiful colors coming off of him. I watched him dance. As he turned, his face became turquoise [with] red and yellow stripes down the middle, and black and white underneath his neck. It was just beautiful.

"He was dancing on the side of the hill and every time he moved around, the formation of the rock would shift. There was a layer of turquoise underneath him. He would dance around and bow his head. This beautiful color danced right down the center of his head—turquoise and flashes of orange and really beautiful rich rainbow colors. There were layers of color just underneath the ground. All the feathers in the back of him were so beautifully a balance of colors. And it all happened against a slab of turquoise! Afterward, the ceremony leader said, 'You look up and don't tell nobody about this thing you saw down in there, whatever it was, you keep it to yourself and you make that as your goal to reach as you travel.' I looked up and sat back down and they all were praying that this was what I would become."

The correlation between Jesse's nearly thirty-year-old vision and his glorious jeweled imagery is startling. "Its influence," he believes, "has really helped me to create better and better every day." Furthermore, "I picked up so much information from my father; he was a very versatile artist and knew a little bit about everything: casting, fabricating, the color of stones, when to buy stone rough. The most amazing thing is in all that I do today, I've never done some of them before, but I know how it's going to look. . . . It's just instilled in me. I guess you might say that the fish migrates to the ocean and then comes back to spawn and die; that it makes a complete cycle."

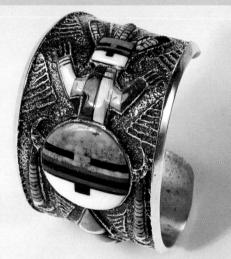

1134

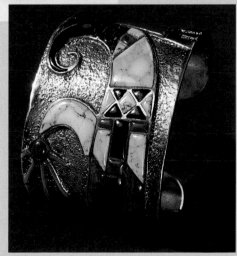

1134 A tufa-cast silver bracelet portraying a katsina with a Hopi sun face and wearing earrings and a necklace of turquoise and coral. Additional materials include shell and jet. Preston Monongye. 1970s. Width, 1¾" (4.5 cm). Collection Jenny and John Foulke

1135 This bracelet, made by Preston Monongye and set by Lee Yazzie, contains an unusual type of Bisbee turquoise with a green matrix in it. "Preston wanted this to be part of the parrot," remembers Joe Tanner. "A lot of Lee Yazzie is in this too, to get that flow away and create the dimension." 1970s. Width, 2¼" (5.7 cm). Collection Tanner

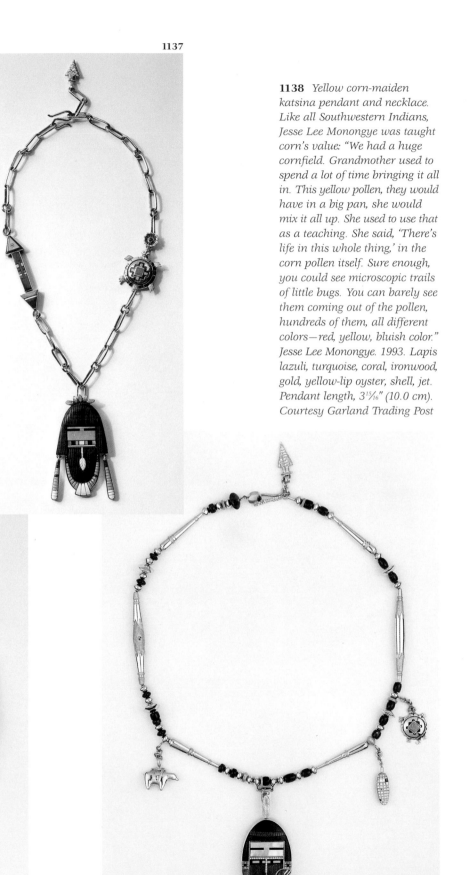

1137

1136 *Long-haired Hopi katsina necklace, itself wearing a turquoise and shell necklace, made by Preston Monongye and Lee Yazzie. Early 1980s. Silver inlaid with turquoise, coral, shell, ironwood, bone or ivory, yellow-lip mother-of-pearl in head feathers. Jacla of turquoise, clamshell, and coral. Pendant length, 2¹⁵⁄₁₆" (7.5 cm). Collection Jenny and John Foulke*

1137 *Long-haired katsina created by Jesse Lee Monongye after seeing the same concept created by his father, Preston (1136). 1994. Opal, ironwood, turquoise, tanzanite, coral, white dolomite stone, 14-karat gold. Length, 2¾" (7.0 cm). Collection Bill Garland*

1138 *Yellow corn-maiden katsina pendant and necklace. Like all Southwestern Indians, Jesse Lee Monongye was taught corn's value: "We had a huge cornfield. Grandmother used to spend a lot of time bringing it all in. This yellow pollen, they would have in a big pan, she would mix it all up. She used to use that as a teaching. She said, 'There's life in this whole thing,' in the corn pollen itself. Sure enough, you could see microscopic trails of little bugs. You can barely see them coming out of the pollen, hundreds of them, all different colors—red, yellow, bluish color." Jesse Lee Monongye. 1993. Lapis lazuli, turquoise, coral, ironwood, gold, yellow-lip oyster, shell, jet. Pendant length, 3¹⁵⁄₁₆" (10.0 cm). Courtesy Garland Trading Post*

1136

1138

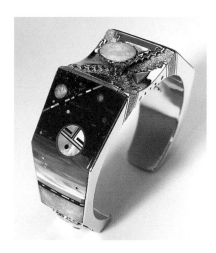

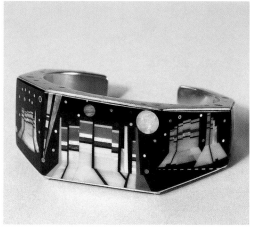

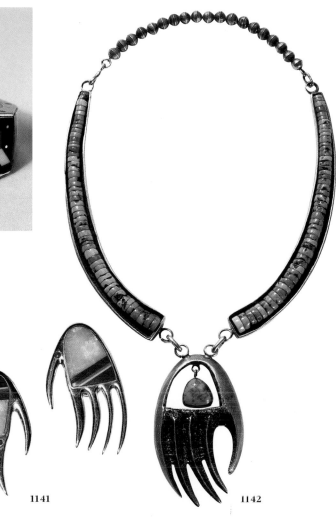

1139 *Jesse Lee Monongye considers this bracelet to be one of his finest pieces. "In a way, it has images of most of the important things in my life": cardinal directions on top (coral, turquoise, shell, and gold); Hopi rain clouds and Monument Valley with the "highway" (life-line) running through; Bear Clan, bear paw; night sky with full moon (opal); Hopi sun face. Inside is a gold "Jesse" bear with a red heart line for his daughter, Sophie. 1994. Height, 2½" (6.4 cm). Private collection*

1140 *Monument Valley bracelet. "Sometimes you have to search for the stone. You can't just find them, you have to actually know what you're looking for, what kind of vision that you had at this one time to achieve that color. It's the balancing of your colors, without overdominating." Jesse Lee Monongye. 1991. Coral, turquoise, jet, gold, mother-of-pearl. Height, 2¾" (7.0 cm). Collection Dan Garland*

1141

1142

1141 *Bear-paw earrings by Jesse Lee Monongye, who received his bear spirit in a dream. 1995. Opal, tanzanite, gold. Length, 1⁹⁄₁₆" (4.0 cm). Private collection*

1142 *The Hopi bear paw is a symbol of strength. Preston Monongye considered himself a bear, according to Tanner. Jacla, 1920s. Metal link, 1960s. Length, 10½" (26.7 cm). Collection Tanner*

1143 *Halley's Comet belt. Jesse Lee Monongye. 1993. Turquoise, sugilite, lapis lazuli, coral, opal, shell, gold, silver. Typical concha length, 2¼". (5.7 cm). Private collection*

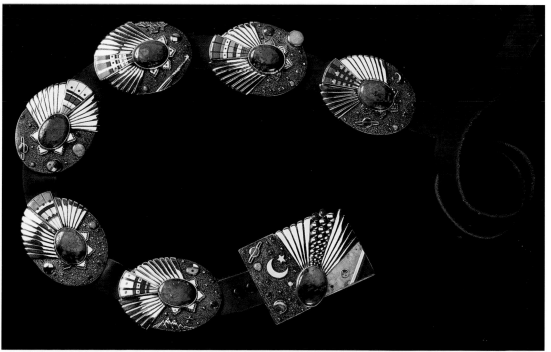

1143

KENNETH BEGAY'S LEGACY

Kenneth Begay (Navajo), a traditionally trained silversmith, created innovative jewelry designs as well as hollowware and flatware. Working with the Bonnells at the White Hogan for eighteen years, Begay not only diverged from traditional designs, but he also used new materials. As early as 1951, he had incorporated ironwood into jewelry, and he began winning numerous awards for his totally original concepts.

Jon Bonnell recalls: "Kenneth was considered one of the masters because he could manipulate the metal. He was trained as a blacksmith, and though he never practiced, he had a real feeling for metal; he had a fullness."

Kenneth Begay influenced contemporary jewelers both by teaching and by example. From 1968 to 1973, he taught silversmithing at Navajo Community College in Many Farms, Arizona. His students included James Little and Boyd Tsosie. In addition to the "technical excellence of his work," writes curator Diana Pardue, Kenneth Begay was known for his extraordinary ability to combine new ideas while still maintaining "the old Navajo design style."

Harvey Begay (Navajo) blends traditional styles with contemporary materials and techniques to create work that is simultaneously vigorous and refined. Begay elegantly combines turquoise and coral with silver, gold, and diamonds. His designs are inspired by a myriad of sources: Navajo basketry, ancient Southwestern pottery, mother Eleanor Begay's textiles.

While a student at Arizona State University, Harvey Begay worked with his father at the White Hogan in Scottsdale. Although he graduated with a degree in aeronautics, served as a fighter pilot in Vietnam, and tested F4 Phantom jets, Harvey Begay eventually returned to jewelry making. In Phoenix, he refined his techniques under Pierre Touraine and continued to develop his unique style of jewelry. Internationally recognized, he has won many awards. Today, he runs his own gallery in Steamboat Springs, Colorado. Returning to Phoenix, Harvey refined his techniques under Pierre Touraine and continued to develop his unique style in jewelry. Internationally recognized, he has won many awards.

1144 *Kenneth Begay at his workbench, Window Rock, Arizona, 1976*

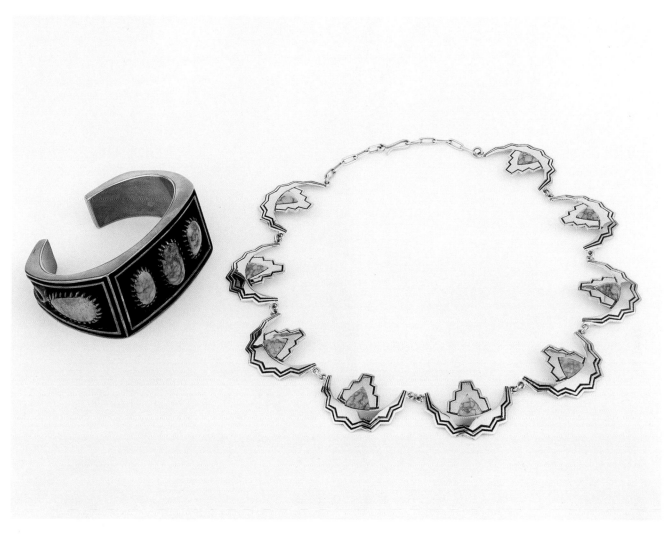

△ **1145** *Bracelet. Kenneth Begay. Late 1960s–early 1970s. Silver and Lone Mountain turquoise. Top surface, 2¾" × 2¼" (7.0 × 5.7 cm). Necklace. Harvey Begay. 1992. 14-karat gold, Lone Mountain turquoise. Necklace length, 6" (15.2 cm); diameter of bracelet, 1¼" (3.2 cm). Courtesy Lovena Ohl Gallery*

1146 *Kenneth Begay. Three bracelets, worn as a set. Early 1950s. Sterling silver overlay. Width, 2½" (6.4 cm). Collection White Hogan*

James Little's elegant gold jewelry reflects elements of both the natural world and his Navajo heritage. Because of childhood deafness, he never went to school, but stayed on the reservation until the age of twenty, herding sheep. As a young boy, he watched his mother as she created beadwork, weavings, and featherwork. His father, Mark Littleman, was the founder of the Native American Church on the Navajo reservation as well as a medicine man. The spiritual values of Little's father influenced his early work, which was used for the medicine man's ceremonies—"prayers with God"—that people still have and for which they thank him.

In 1968, encouraged by his brother Woody, James took silversmithing and leathercraft classes, eventually studying with Kenneth Begay. Self-taught in tufa and lost-wax casting, Little was by 1979 one of the first Native jewelers to work in gold. That same year, he won first place at both the Heard Museum and Museum of Northern Arizona Indian art shows. He also became an artist with the newly established Lovena Ohl Gallery.

Ohl's influence had a profound effect on Little's life and work. In 1980, the Lovena Ohl Foundation financed Little's schooling, therapy, and medical operations that enabled partial hearing. "Because I couldn't hear," says James, "I was shy and very lonely. When I got the hearing aid I started learning."

James Little is highly respected by his peers, including Lee Yazzie and Jesse Lee Monongye. Of his work, James says, "'I made it,' is my favorite theme. Some of my very special pieces are from my inside life: what I'm feeling and thinking. Earth, the air, the colors. Quietly, by myself, I work life into the pieces. I want to create life."

◁ **1147** *Mastodon-ivory eagle-feather bola tie. When detached from the bola cords, the feather can be worn separately. James Little. 1993. Mastodon ivory, malachite, leather, gold. Feather length, 5 5⁄16" (13.5 cm). Private collection*

1148 *Turquoise and silver bracelet, an early work by James Little (Navajo). 1970s. Height, approximately 4" (10.2 cm). Private collection*

1149 *An ancestral Pueblo pot motif borders this bracelet. The stones are an anthropomorphic design: the sugilite is the face; the diamond, the neck; the body is the coral. "I saw an ancient broken pot in the desert; then I looked at it more and thought, Maybe I'm going to make a bracelet. So I guess I saw it in the pot." James Little. 1993. 18-karat gold, coral, sugilite, diamond. Height, 2 3⁄4" (7.0 cm). Lovena Ohl Gallery*

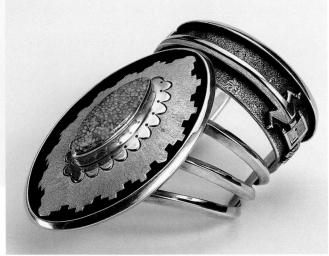

1148

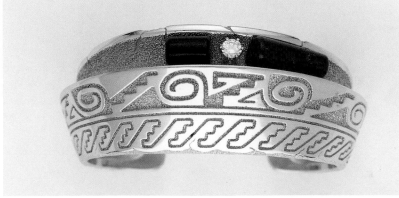

1149

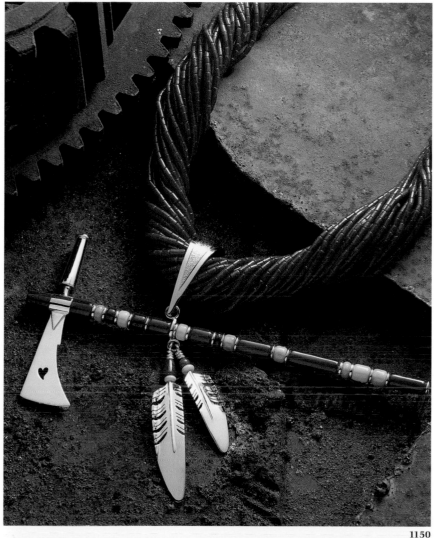

1150 *Tomahawk and peace-pipe necklace, a design combining opposing symbols of war and peace. Artist Ray Tracey (Navajo) explains, "I'm not a symmetrical person, and being asymmetrical means you're full of surprises!" The necklace includes thirty strands of handmade red coral beads. The eagle feather is considered the ultimate protection symbol in many Indian cultures. "The eagle was thought of as the messenger for the Great Spirit. Indians believed the eagle could fly so high he could touch the face of God and carry his power back to earth," says Tracey. Like many Native American artists, Ray draws inspiration from tribes other than his own. "For too long, Indian has been fighting Indian. Making tribal art brings Indians together." 1994. 14-karat gold, sugilite, turquoise, red and pink coral. Necklace length, 24" (61.0 cm); Tomahawk length, 5¾" (14.6 cm). Courtesy Southwest Studio Connection, N.Y.*

1151 *Each concha on this belt commissioned by Bernice and Herbert Beenhouwer incorporates motifs adapted from their extensive collection of Southwestern pots, weavings, baskets, katsinas, and jewelry. Gail Bird (Santo Domingo–Laguna) and Yazzie Johnson (Navajo). Late 1980s. 14-karat gold, coral, turquoise, picture agate, jasper. Concha length, 2¾" (7.0 cm). Collection Bernice and Herbert Beenhouwer*

1150

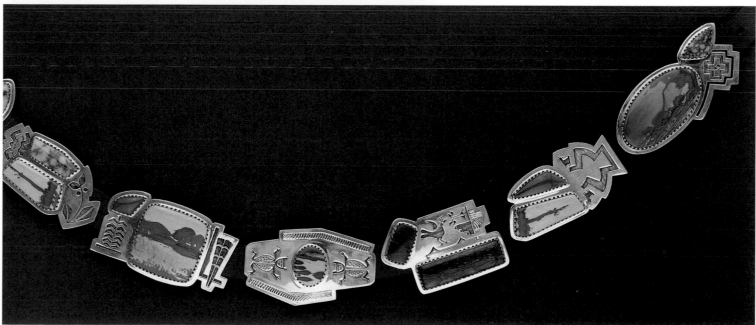

1151

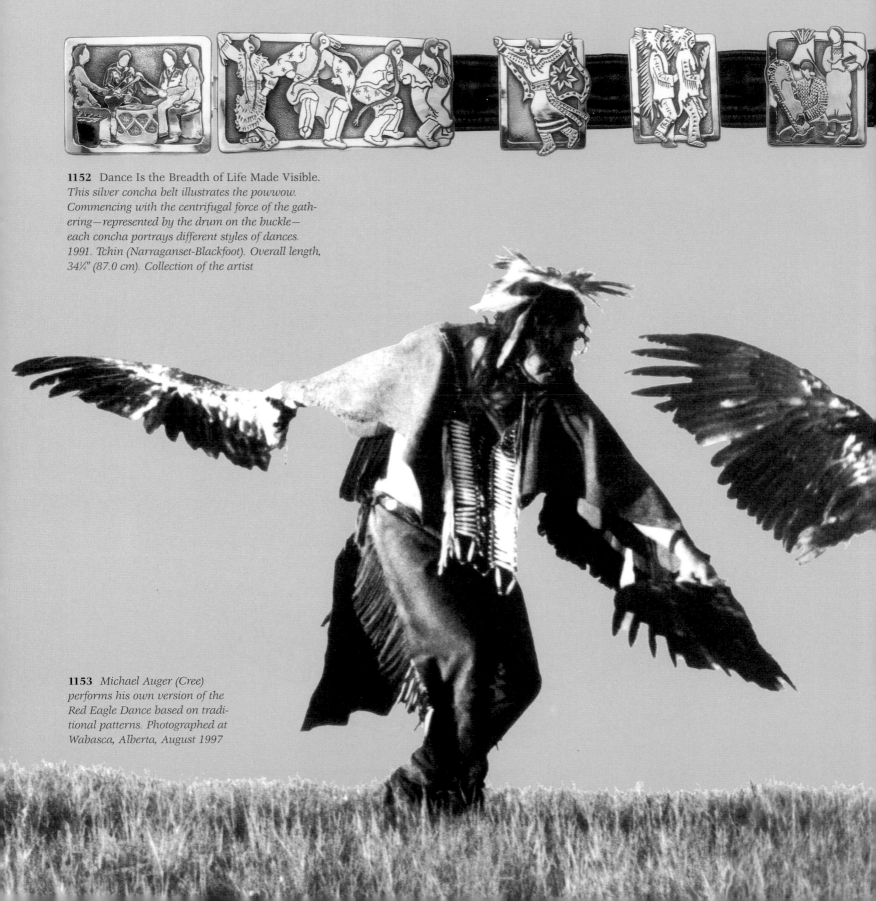

1152 Dance Is the Breadth of Life Made Visible.
*This silver concha belt illustrates the powwow.
Commencing with the centrifugal force of the gathering—represented by the drum on the buckle—
each concha portrays different styles of dances.
1991. Tchin (Narraganset-Blackfoot). Overall length,
34¼" (87.0 cm). Collection of the artist*

1153 *Michael Auger (Cree)
performs his own version of the
Red Eagle Dance based on traditional patterns. Photographed at
Wabasca, Alberta, August 1997*

WITHIN THE CIRCLE

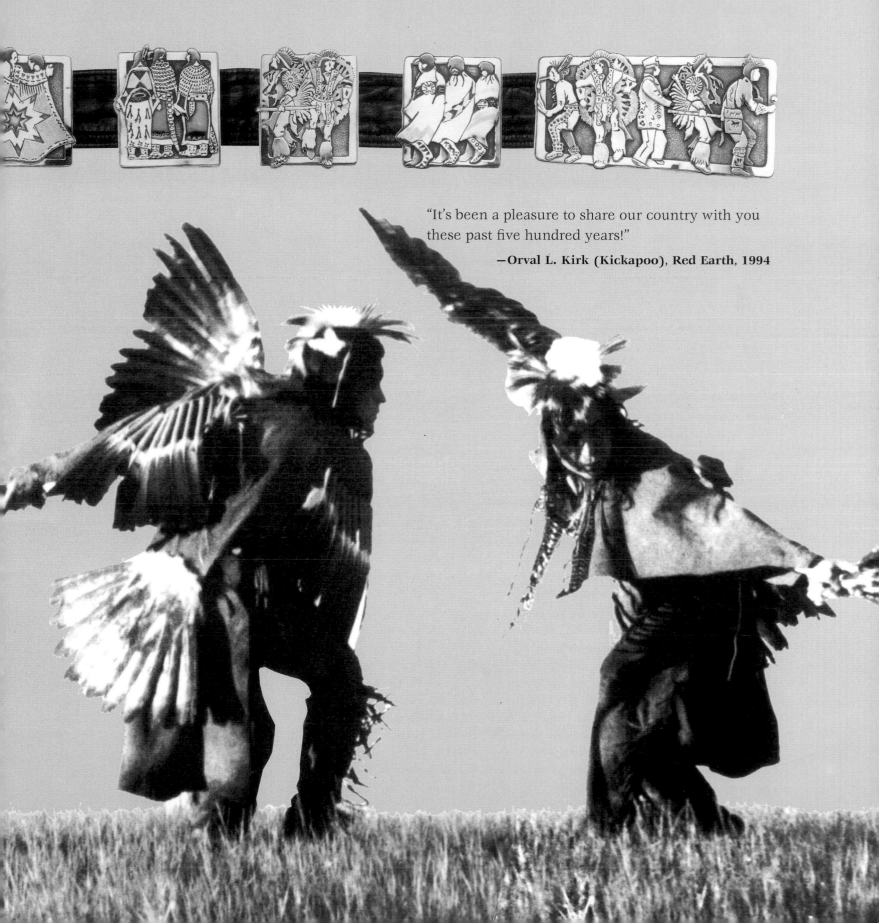

"It's been a pleasure to share our country with you these past five hundred years!"

—**Orval L. Kirk (Kickapoo), Red Earth, 1994**

With the words quoted on the previous page, Orval L. Kirk, master of ceremonies at Oklahoma City's Red Earth Native American Cultural Festival, greeted the many non-Native and Native visitors at the start of the festival's final day. Red Earth is a gathering to which Native peoples from all over North America come together in dance and art to celebrate their undeniable survival as indigenous peoples. Although neither a ceremonial nor technically a powwow, Red Earth, with its spectacular color and kinetic energy, is a marvelous way to experience contemporary Indian dance and regalia.

Born a little over one hundred years ago among northern Plains tribes, powwows and festivals provide the Indian peoples with a means of reinforcing identity and sharing common cultural threads. With the passing of time, tribes had dispersed, tribal boundaries had been crossed, and a need for intertribal ceremony had become important. The powwow combined sacred celebration, socializing, and the rekindling of tribal ties during the summer. Today, the modern powwow has also become a time and place where Native and non-Native peoples can interact, bridging the gap between the cultures. Indians from various nations—by joining in song, dance, and dress—can extend to all their impressive heritage. As Mike Hotaine, Dakota announcer at the 1992 Black Hills Powwow stated: "We gather together and it's a beautiful thing."[1]

THE POWWOW TODAY: A VISITOR'S PERSPECTIVE

The following narrative by Terry Guzman, a student of Native American Studies and an avid powwow goer, relates her perceptions and experiences while attending powwows:

Arriving a little early, I find the vendors still setting up their booths and a familiar aroma calming the air. It's coming from the corner, where a vendor is burning white mountain sage. He says it "cleanses, rids all of impurity." The dreamy smoke takes me back to the sage-filled roadsides on the way to Window Rock, Arizona, in Navajo country. I had just come from the Gallup Inter-Tribal Indian Ceremonial in New Mexico. It was difficult not to remember the sound of the drumbeats bouncing off of the red rocks or the Gourd Dancers, who wore beautiful hand-crafted ceremonial sashes. They danced for hours before the powwow began at sunset. On the East Coast, it's a little different. There is no Gourd Dancing before Grand Entry, and powwows usually start early in the afternoon.

Powwows are conducted differently in each region, with varying protocol, dance categories, and ground-blessing ceremonies. But all dancers respect each other's distinctiveness. Darrell Wildcat (Pawnee) explains: "My son has really caught on to the northern style of dancing; the Grass Dance is very foreign to me and my wife, who is Comanche. But that's what he wants to do. . . . So we went to every effort to learn about the Grass Dance because it isn't a dance that's native to Pawnees or Comanches."

Powwow dances recall those medicine, victory, and sacred dances that permeated past Indian lifeways. When Cherokee, Winnebago, Comanche, and Navajo dance side by side, the circle comes alive with more than Indian ancestry and a people celebrating their Indianness. It builds upon commonalities that reach across all nations to strengthen the continuity of the circle.

Friends suggested that I bring a blanket to claim a spot in the bleachers. As I try to figure out where the dancers are going to enter the circle, a young Traditional dancer comes bounding toward me. Jingling the bells on his knees and ankles, he shyly lets me know, "We always enter from the east." Now oriented, I place my blanket across the fifth row, just about twenty feet from the entryway. It's important that I don't miss a thing. I want to see the dancers' eyes and expressions, feel their movement, and hear their song because the powwow is more than just an entertaining event. It's a living and dynamic paradigm.

The soft flute music coming through the loudspeakers is interrupted for announcements

of dancer and drum registration. I walk through the powwow grounds, smelling, listening, and seeing; my senses lead me from one vendor to the next. The distinctive handcrafted goods reveal the continuing quality of Indian lifeways. The work makes one realize that the Indian peoples, long believed to be disappearing, are still very much alive. Powwows and Native cultural festivals help to showcase the talents of Native artisans. Much of the finest work offered for sale at powwows sells out quickly to other Native people.

I'm inspecting a beautiful Navajo bracelet when I hear the emcee call out to all the dancers and drums: "Grand Entry will be in just five minutes. That's twelve o'clock sharp!" Instantly, the sounds of deer toes clacking, bells jingling, and drum warm-ups fill the air. I return the wonderful bracelet to the vendor, hoping that no one else will take to it as I have, and depart to find my spot in the bleachers.

The dancers are lining up and anxiously moving around. They adjust and readjust their regalia and help to make sure that their friends and family look as good as they do. Hair is being braided and songs are being sung in low voices as the emcee calls out to the host drummers, asking if they are ready. They bang their drums in positive reply. "Okay, dancers, let's go! Line up and make sure your numbers are showing. You must be accounted for during Grand Entry or you will lose points in competition. All right then, let's do it, folks. And let's do it the Indian way. Hoka hey!" It is time for all, that means Natives and non-Natives alike, to share in the celebration of Indian culture, family, friends, dance, song, and life.

The first thing I see is the Eagle Staff [1160]. Pointing straight up to the sky, it stretches about seven feet in height and represents all Indian peoples. Seeing that staff reaching for the sky reminds me of the description of Grand Entry by Lynn Burnette, Sr., Lakota artist and founder of the National Native American War Memorial: "At the turn of the century Wild West rodeos brought Indians into their shows to attract bigger audiences. During the rodeo's grand entry Indians danced-in wearing their colorful traditional garb and through the years it was a way—a good way—that Indians could honor their warriors. They brought in what you might say is our symbol more so than our flag. [It is] a symbol of our spirituality and our unity—the Eagle Staff. That's the thing we believe in more than anything."

This particular Eagle Staff is hook-shaped at the top. It is partly wrapped in fur, accented with red wool strips, and adorned with eagle feathers. The feathers tell of warriors' triumphs of long ago, when the scalps of enemies were conquered in battle. Just as the cavalry posted their flag, Indians symbolically placed their staffs either at the center of their village or in front of their tipis.

The bearer of the Eagle Staff is always a veteran such as Patrick Spotted Wolf [1162], a Cheyenne and Arapaho Vietnam veteran from Bessie, Oklahoma, who participates in many powwows. Patrick, memorable in his star-spangled, red, white, and blue beaded regalia, is accompanied on each side by two other veterans bearing United States and tribal flags. Following these flag bearers are usually the young girls known as Indian Princesses.

All the royalty are young and dance with a proud grace. Leading in the rest of the dancers are the head man and lady dancers. They are followed by the Men's Traditional dancers, who represent the providers, protectors, and preservers of traditional ways and who are honored by leading in the Women's Traditional, the Men's Fancy and Grass, and the Women's Fancy Shawl and Jingle Dress. Immediately afterward are the Teen Boys' and Teen Girls' categories, the Boys' and Girls' categories, and finally the Tiny Tots.

Watching and listening to the emcee talk about each of the different dance categories brings to mind what I have seen and read about Indian cultures over the last couple of years. It is coming to life now: the way in which traditional Indian dances inspired seasonal and agricultural events, honored deities, and paid tribute to their mighty warriors and hunters; events where feasts were shared and stories told of a time when the ancestors danced "according to ancient calendars and belief systems," as Charlotte Heth (Cherokee) wrote.[2]

1. THE STATE OF OKLAHOMA (INDIAN TERRITORY) AND EARLIER LOCATIONS OF ITS INDIAN PEOPLES

Oklahoma is the home of at least sixty different tribal groups, the result of government policies in the 1800s that forced the resettlement of Indians from a wide range of geographic areas, including California, Pennsylvania, Wisconsin, and Florida. Today, with the largest Native American population of any state in the nation (252,420, according to the 1990 census), Oklahoma maintains a remarkably dynamic Indian culture.

2. NORTH AMERICAN INDIAN AND INUIT/ ESKIMO LANDS AND COMMUNITIES TODAY

This map gives a general overview of Indian lands, called reservations in the United States and reserves in Canada. Indian reservations are those land areas reserved for Indian use that are both tribally and individually owned and held in trust by the federal government. The areas range in size from the Navajo Nation's more than 17 million acres to some California rancherias of less than one acre. Indian communities without reservations are shown as dots.

Today, many more contemporary North American Indian people live in cities than on reservations, but most urban Indians frequently return to the "res" to visit family and retain connections to their Native communities. The list below, whose numbers are keyed to the map opposite, represents the major contemporary North American Indian, Inuit, or Eskimo communities mentioned in the text.

1. Saint Lawrence Island, Bering Sea
2. Spence Bay, Northwest Territories
3. Baker Lake, Northwest Territories
4. Rankin Inlet, Northwest Territories
5. Cape Dorset, Northwest Territories
6. Povungnituk, Quebec
7. Old Crow, Yukon
8. Fort McPherson, Northwest Territories
9. Fort Simpson, Northwest Territories
10. Fort Providence, Northwest Territories
11. Kahnawake, Quebec
12. Akwesasne, Quebec
13. Tonowanda Reservation, New York
14. Kanesatake, Quebec
15. Mashantucket Pequot Indian Reservation, Connecticut
16. Oneida Reservation, Wisconsin
17. Garden River Reserve, Ontario
18. Red Lake Band of Chippewa Indians Reservation, Minnesota
19. Mille Lacs Indian Reservation, Minnesota
20. Lac Courte Oreilles Indian Reservation, Wisconsin
21. Mesquakie Indian Settlement, Tama, Iowa
22. Prairie Band, Potawatomi Indian Reservation, Mayetta, Kansas
23. Mississippi Band of Choctaw Reservation, Mississippi
24. Whitebear Indian Reservation, Saskatchewan
25. Devil's Lake Reservation, North Dakota
26. Fort Peck Indian Reservation, Montana
27. Standing Rock Reservation, South Dakota, North Dakota
28. Cheyenne River Reservation, South Dakota
29. Lower Brulé Reservation, South Dakota
30. Pine Ridge Reservation, South Dakota
31. Rosebud Reservation, South Dakota
32. Yankton Reservation, South Dakota
33. Crow Reservation, Montana
34. Wind River Reservation, Wyoming
35. Tahlequah, Oklahoma
36. Anadarko, Oklahoma
37. Fort Hall, Idaho
38. Southern Ute Reservation, Colorado
39. Lytton, British Columbia
40. Colville Reservation, Washington
41. Yakama Reservation, Washington
42. Warm Springs Reservation, Oregon
43. Umatilla Indian Reservation, Oregon
44. Masset, British Columbia
45. Skidegate, British Columbia
46. Kitimat, British Columbia
47. Hoopa Valley Indian Reservation, California
48. Navajo Reservation, Arizona, New Mexico, Utah
49. Hopi, Arizona
50. Pueblos, New Mexico
51. Colorado River Indian Reservation, Arizona, California

REPRESENTATIVE NORTH AMERICAN INDIAN POWWOWS AND CULTURAL ART FESTIVALS

Seminole Tribal Fair and Rodeo, Hollywood, Florida (February)

Denver Powwow, Denver, Colorado (March)

Gathering of Nations Powwow, Indian Market and Miss Indian World Contest, Albuquerque, New Mexico (April)

MODOC • ARAPAHO • KIOWA • CHEYENNE • OTTAWA • WYANDOT • COMANCHE • PONCA • PAWNEE • FOX • SAC • SENECA-CAYUGA • DELAWARE • IOWA • OTO • MISSOURI • POTAWATOMI • KICKAPOO • KANSA • KASKASIA • MIAMI • PEORIA • PIANKASHAW • SHAWNEE • WICHITA • QUAPAW • OSAGE • CHICKASAW • CHEROKEE • APACHE • WACO • TAWAKONI • CADDO • CHOCTAW • CREEK • TONKAWA • KITSAI • LIPAN • KICKAPOO • SEMINOLE

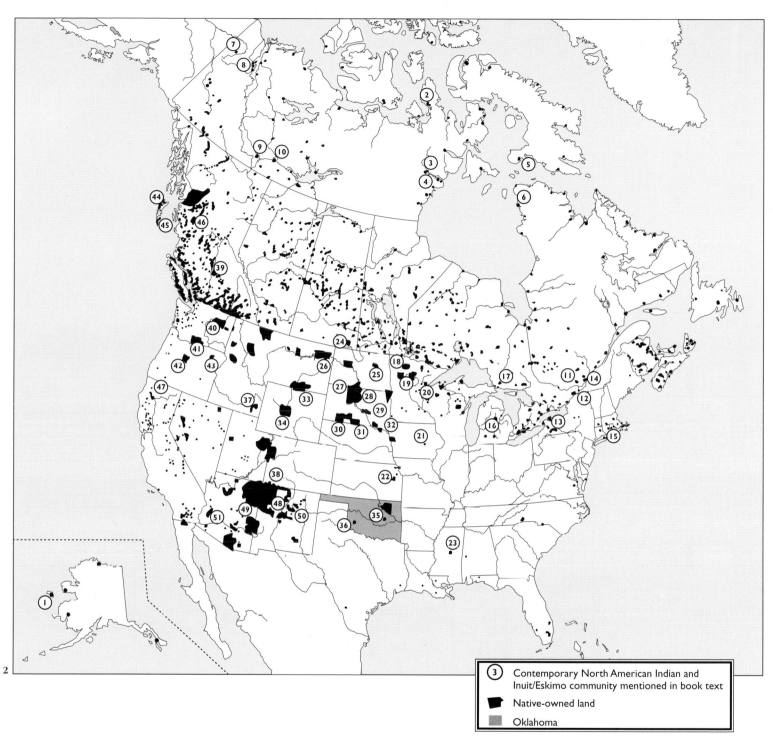

2

3	Contemporary North American Indian and Inuit/Eskimo community mentioned in book text
	Native-owned land
	Oklahoma

Red Earth Native American Cultural Festival, Oklahoma City, Oklahoma (June)

Black Hills and Northern Plains Indian Exposition, Rapid City, South Dakota (July)

Choctaw Indian Fair, Philadelphia, Mississippi (July)

Grand Casino, Minneapolis, Minnesota (July)

Grand River Champions or Champions Powwow, Ontario, Canada (July)

San Buenaventura Feast Day, Cochiti Pueblo, Cochiti, New Mexico (July)

Oglala Sioux Nation Fair and Powwow, Pine Ridge, South Dakota (July/August)

American Indian Exposition, Anadarko, Oklahoma (August)

Crow Fair, Crow Agency, Montana (August)

Gallup Intertribal Ceremonial, Red Rock State Park, Gallup, New Mexico (August)

Santa Fe Indian Market, Santa Fe, New Mexico (August)

Shoshone-Bannock Festival and Rodeo, Fort Hall, Idaho (August)

White Mountain Apache Tribal Fair and Rodeo, Whiteriver, Arizona (August/September)

Northern Plains Tribal Arts Show, Sioux Falls, South Dakota (September)

Schemitzun, Mashantucket, Connecticut (September)

1154 *One of the many jackets worn by Buffalo Bill to reflect his image as a rugged frontiersman. These coats were produced by both Métis and Sioux women for sale to non-Natives. c. 1891. Buckskin, beadwork, brass buttons. Length, 30" (76.2 cm). Buffalo Bill Historical Center, 1.69.776*

1155 *William "Buffalo Bill" Cody in his beaded hide jacket, standing in front of his tent, c. 1891. Buffalo Bill Historical Center*

1156 *Lakota leaders form a circle around Chief Kicking Bear, an evangelist within the Ghost Dance Movement. Pine Ridge Agency, South Dakota, January 1891*

1154

1155

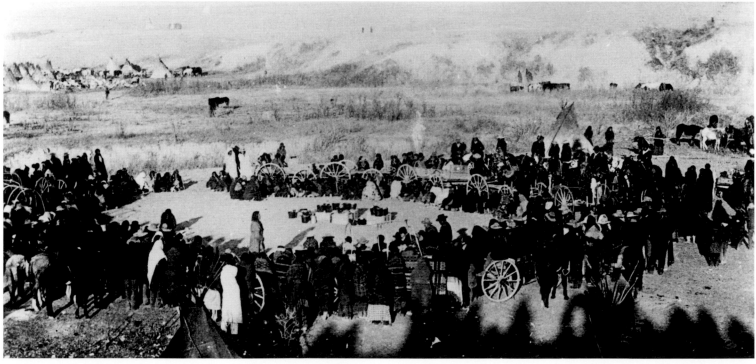

1157 *Mixing traditional and contemporary imagery, beadworker Marcus Amerman, of Choctaw and Czechoslovakian descent, also blends Native and non-Native design. Amerman states, "I am from both cultures. I use it as a power." Front (top) and back views of this beaded buckskin shirt illustrate sacred animals, modern icons, and men who were important in Plains Indian history. Believing that "art is war," Amerman juxtaposes that which has endured with that of today. To achieve unity, Amerman says he does not balance opposites but combines them into something new. The beaded likeness of Michelangelo's famous Head of God (front center) is 6 inches (15.2 cm) square. An accomplished painter and fashion designer, Marcus is also active in mixed media and performance art. 1994. Collection of the artist*

1158 *Black Lodge Drum, representing the Cheyenne, surrounded by fans recording their songs at the Red Earth Native American Cultural Festival, Oklahoma City, 1995.*

1159 *Dancers join the honor guard during Grand Entry. Red Earth, 1995*

1160 *Veteran honor guard bringing in the Eagle Staff during Grand Entry. Red Earth, 1994*

1158

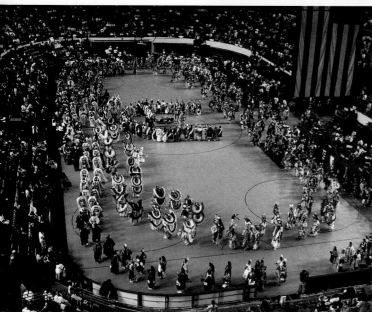

1159

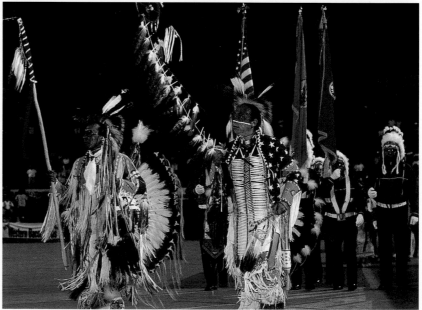

1160

Patrick Spotted Wolf, a Vietnam veteran from Bessie, Oklahoma, is of Cheyenne and Arapaho heritage. Powwow dancing, participating in the Sun Dance, learning and following traditional Indian ways, and being a warrior are very important aspects of Patrick's life. He explains: "Veterans were number one in everything. Nowadays it's so hard for the younger generation to get into the service. You see . . . among our tribe sacrifice of the body is among the highest things you can attain. One way to reach this is through fasting and the sweat lodge. We have these younger people that want to do these things that will carry them through. That's what I do; it's not what you might call a rich life, I mean material wise, but it's through spiritual feelings. It means a lot. It's just praying, smoking the pipe, and taking care of the little ones. That's about what it amounts to."

Following in the footsteps of his forefathers, who were important spiritual leaders, arrow keepers, and peace-treaty makers, Patrick considers himself an Indian doctor. "On my Cheyenne side, my grandfather was one of the arrow keepers for the southern Cheyenne. He was a Sun Dance leader, ceremonial person, and a medicine man. When I was a little boy, back in the 1950s, I used to ride with him on a wagon; we traveled from Clinton, Oklahoma, all the way to Selin, Oklahoma, to carry the sacred arrows. He used to talk to me about things that he wanted me to remember. I lost him when I was in the service. Then my other grandfather passed on in 1967. So I was grown into an adult and I didn't have them to talk to. The things that they told me I had more or less kind of lost. But through ceremonies that I now attend, such as the Arapaho Sun Dance, I have tried to [re]learn what my grandfathers used to try to teach me.

"I am considered one of the Rabbit Men. There is a large theater called the Rabbit Lodge, and it only contains men that have put up the Arapaho Sun Dance. I am one of those. There are about thirty or forty of us left, and each year another one comes up. You might say it's our religion. We still have our sacred pipe through which we ask for help in healing. It takes care of us."

For Patrick, powwow events connect to all the aspects of what his father and grandfathers tried to share with him. "It's all a part of your life." Again, following in his father's footsteps, Patrick spends his summers on the powwow circuit with his family. "It means a lot to get together and dance. It's been in my family. When I first started walking, I was taken into the circle and I fancy-danced until I was oh, I'd say, forty-five years old. Then I changed over to traditional style. My grandmother, on my Cheyenne side, used to bead for both me and my father. Today I do my own beadwork."

The powwow, a time for sharing and feeling good, evokes beauty and passion. "When we dance," says Patrick, "some kind of song will be very touching and it almost brings tears to one's eyes. In the back of your mind you pray and you dance. This has meaning for us. It's just all part of our way of life and we try to carry it on. Some of the younger generations don't understand. But I guess they will over time. I know some of the younger ones who have been dancing for a long time do feel it and understand what I am talking about. It's a beat and the way a song sounds. Some songs are beautiful and you'd like them to go on and on. That's why sometimes you'll hear an eagle whistle blown. It means that someone wants to hear the song go on, they want to show it honor."

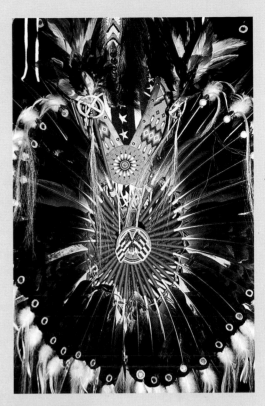

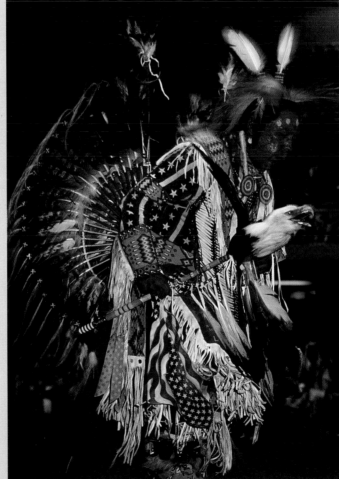

△ **1161** *Detail of Patrick Spotted Wolf's bustle with beaded American flag motifs*

◁ **1162** *Patrick Spotted Wolf (Cheyenne-Arapaho) dancing the Men's Traditional at the Black Hills Powwow, 1993*

I am brought back to the present by a male dancer's war cry, which resounds through the air. The Grand Entry is in full swing now, and the dance circle teems with dancers in dazzling outfits and adornment and carrying brilliantly beaded dance sticks and fans. The circle is now filled with life. Mother Earth's heartbeat resounds from the drum as dancers move in harmony with its beat. After Grand Entry comes a Flag Song and an invocation. Subsequently, the Eagle Staff (always positioned above the American flag) is posted. Now the honoring of all veterans, Native and non-Native, takes place, and the veterans and their families dance to show respect and pay tribute to those who have fought and died in battle. Once the Veterans' Dance is over, it is time to powwow.

The emcee requests a couple of intertribals to warm up the contest dancers: "Let's get these people warmed up and ready to show their stuff! Rocky Park, give us the first intertribal. Mystic River, the second, Whitefish Bay, Jr., the third, and Eastern Eagle, the fourth. All right . . . let's get ready to rumble!"

Intertribals are a chance for visitors, including non-Natives, to dance, even in street clothes, and participate in the celebration. Many of the dancers take this opportunity, with smiles and joyful emotion, to acquaint or reacquaint themselves with friends and distant family members. As they dance and move 'sunwise' (clockwise) or counterclockwise (according to tribal worldviews) about the circle, they talk about their homes, work, and families and loved ones. It's a time for socializing, feeling good, and making others feel good as well.

Once the intertribals have ended, everyone settles down and makes sure their feathers, bustles, and anything that should be straight are just that. Contesting is now ready to start. The emcee announces the first dance category and, while the dancers ready themselves, he recalls how powwows started. "Everyone has their own rendition of how the powwow came about. I was told by Jacquetta Swift (Comanche) that powwows, which were originally referred to as celebrations *or* doings, *were held during spring. They celebrated the renewal of life and were a time for naming ceremonies, prayers to the Great Spirit, and demonstrations of reciprocity. Today, giveaways (ceremonial gifting presentations), storytelling, honoring, and acts of selflessness illustrate Indian values. Teresa Provost, a Métis artisan selling a friend's work and not her own during a powwow held at the Mohawk's Kahnawake Reservation, believes, 'If you don't hold each other's hand, the circle won't be complete.'*[3]

"Peoples gathered to share in feasting, friendship, dancing, singing, and tradition. The term powwow *has its own history. One story says the term is an Anglicization of the Algonquian phrase* pau au, *meaning 'any gathering of people.' Another is that Europeans present at a Narraganset curing ceremony heard* pau wau *being repeated over and over. Not understanding that the people were calling the medicine man who was to perform a ceremony, the Europeans interpreted it as referring to the gathering itself. Thereafter,* powwow *was used to refer to all such meetings."*

We are now going into the young boys' categories and the emcee continues to talk about the history of the powwow: "It was during the 1920s that contest dancing became popular and ever since has played an important role in providing these beautiful dancers and their families with a way of subsidizing their financial stability. Our contests are judged according to dance style and age group. Judging is executed by the dancers' peers and elders and is based on dancing ability and how one presents or carries oneself in dance regalia. If you lose any part of your outfit, miss an honor beat, or overstep that final beat of the drum, it can eliminate you from competition or have a negative outcome on your score at the end of competition." Dropping a sacred eagle feather signifies a fallen warrior. Believed to possess powerful medicine, the feather must be retrieved in a sacred manner. After a ceremonial dance and prayer is performed, the feather is lifted from the ground.

THE INDIAN AND THE AMERICAN FLAG

There are two main reasons why the American flag and its design are prevalent in Indian artwork and carried alongside the Eagle Staff and tribal flags, says Lynn Burnette, Sr., member of the Lakota tribe and founder of the National Native American War Memorial. The first "is because we have fought for and died for it. Carrying the flag also shows honor and respect for those men and women who have died for it." Second, continues Burnette, "The American flag's red, white, and blue colors have always been interesting, good colors to Native Americans. The blue to us was where the forces we pray to are. The spirit world, Upper World. Red is power. White represents purity. The colors worked in very neatly. The story further goes that when the Indians were attacked by the United States, they recognized that every place the cavalry went they carried this red, white, and blue flag. When they fought and when they went into their forts, they flew this flag. So, thought the Sioux, if they carried it with them everywhere they went, that this must be part of their power. When they defeated some of the cavalry, [the Sioux] took the flags and wrapped themselves in the colors. What they were trying to do was take the power of the United States, put it on themselves, and then use the power against [their enemies], which worked many times. This was a big reason why the flag and its colors were used."

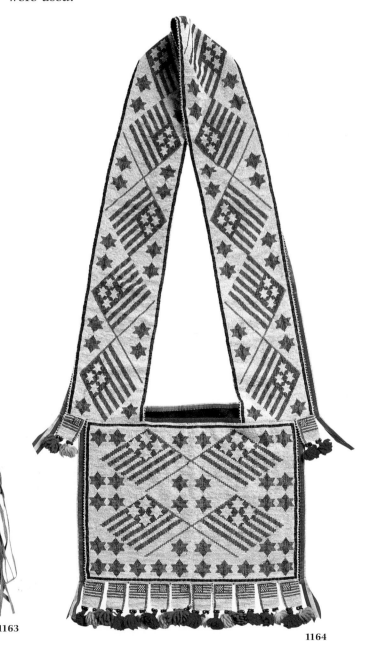

1163 *Beaded pipe bag with upside-down American flag atop a school-house. Originally the upside-down flag was used by soldiers in the forts as a signal of distress. It is not clear why the Lakota artist beaded the flag this way, but it may suggest the Lakota's perspective of the Bureau of Indian Affairs school programs, which the children were forced to attend. c. 1890–99. Length including fringe, 34½" (87.6 cm). South Dakota Historical Society, Pierre*

1164 *Ojibwa beaded bag with red, white, and blue ribbon and multicol-ored wool tassels. Great Lakes. c. 1890–1900. Length, 35" (88.9 cm). National Museum of the American Indian, 19/3217*

1163

1164

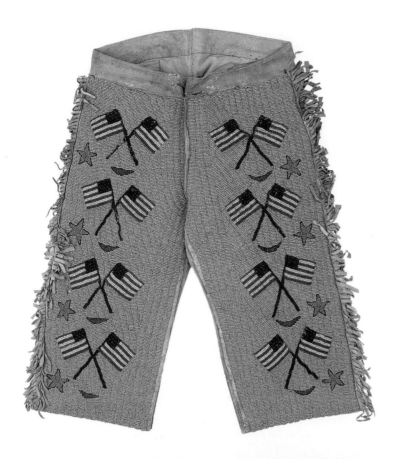

1165 *Young boy's beaded chaps bearing motifs of the American flag, crescent moon, and stars. Early twentieth century. Collection David and Karen Gerdes, Fort Pierre, South Dakota. The following description from a letter describing the provenance of the chaps tells a poignant story:* "Dave Sheppard was a black cowboy who came north with the D-Z Cattle Company from New Mexico at the time the D-Z Cattle Company leased thousands of acres of Indian land in the vicinity of LaPlant, South Dakota. Dave married an Indian woman and they lived in LaPlant and had one son and several daughters. Dave's mother-in-law, who of course was a Sioux Indian, made the chaps for the little son. The little boy was injured badly while riding horse-back and was never able to ride after that. Dave fell upon hard times and gave the chaps to my father, William C. Boyle, for the loan of $25, with the understanding that he could have the chaps back when he repaid the $25 which he was never able to do."

1166 *Members of the Buddy Bond chapter of the Oklahoma Intertribal Veterans' Association Color Guard carry in the American flag in recognition of those who suffered and died as a result of the tragic Oklahoma bombing incident. Red Earth, 1995*

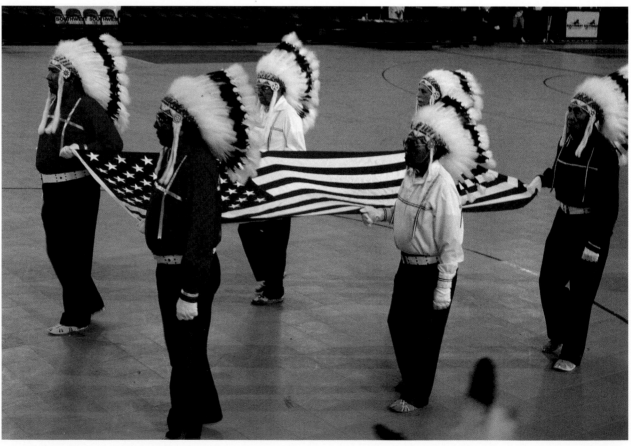

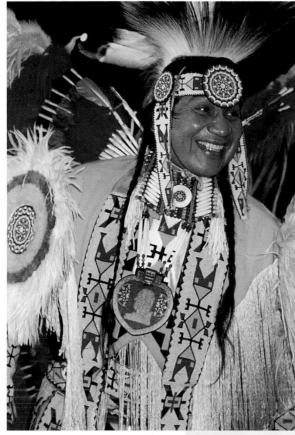

1167 *Vietnam veteran Boye Ladd, Winnebago Fancy dancer, showing off his beaded Purple Heart, beautiful smile, and fancy footwork at the Black Hills Powwow, Rapid City, South Dakota, 1993*

1168 *Beaded belt buckle with an eagle motif, made for United States army veteran Willard Ballard of Fort Hall by his wife, Vida Mae Ballard (Shoshone-Bannock). Length, 4½" (11.4 cm). Collection Willard Ballard*

1168

1169 *Purple Heart medal placed into a stamped silver bracelet and set with turquoise stones. It was acquired prior to 1969 at a trading post in Tusuque, New Mexico. The Purple Heart medal, originated by George Washington in 1792, has borne his likeness since 1932. Navajo. Width, 2¾" (7.0 cm). The Heard Museum, Phoenix, Arizona*

1169

1170 *Color guard dancing-in the flags during the Grand Entry. Shoshone-Bannock Festival, Fort Hall, Idaho, 1994*

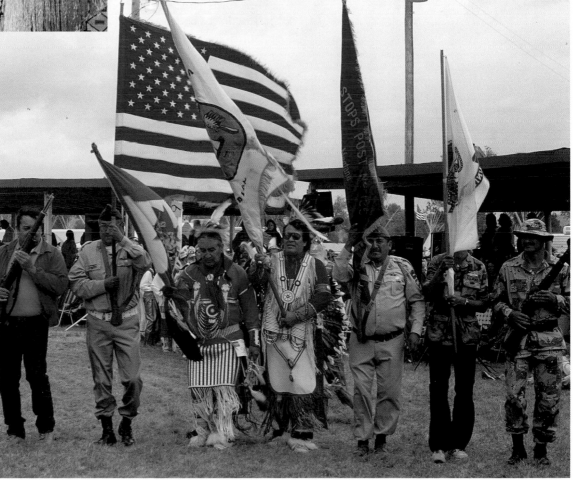

TIMELESS REGALIA: THE ROACH

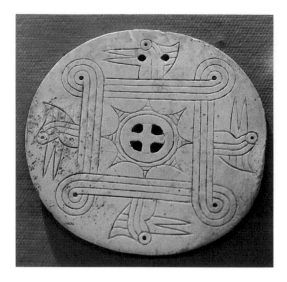

1171 *Mississippian-era (c. A.D. 1100–1300) engraved shell gorget showing woodpecker crests, the probable origins of the warrior's roach concept. National Museum of the American Indian*

1172 *Arapaho-made dyed deer-hair roach and bone roach spreader. Late nineteenth century. Roach length, 13" (33.0 cm). American Museum of Natural History, 50/6029*

1173 *Silver roach spreader worn by Johnny Hughes (Kansa), Mens Southern Straight Dancer. Red Earth, 1994*

Traditionally constructed of red-dyed deer hair and black turkey beard, the roach, a powerful amulet, has an ancient history. It was customary for men to shave their heads, except for a narrow strip down the center with one piece—the scalp lock—that was allowed to grow long and be braided. The roach headdress extended into an imposing crest intended to represent that of large woodpeckers—noted for their tenacity when going after prey—and associated with war and warriors in the Woodland region since precontact times. Although the form and materials of animal-hair roaches have changed over time, they remain the traditional headdress of groups such as the Mesquakie and are today worn on ceremonial occasions and for powwow dancing.

It is also believed that the roach originated out of a Native Woodland hunting ceremony. Knowing that deer were sensitive to their surroundings and quickly dispersed when faced with the unfamiliar, hunters would place deer tails on their heads. Thus possessing the deer's powers and scent, a hunter could get close enough to make his kill. Wearing the deer tail served both a practical and spiritual function. Following a successful kill, the hunter offered thanks to the deer for giving itself up to fulfill the needs of the people with whom it shared the land. Later the roach evolved into a longer, more elaborate headdress worn as part of Plains Indians' dance outfits. In that context, it appears to represent the rolled-back mane of horses. Watching the Men's Traditional Dance, one notices that many of the dancers' steps and head movements reflect a horse shying or stepping to the side, causing the roaches to sway back in accompaniment.

1172

1173

The Men's Fancy competition is just about to come to an end and it's time for my favorite dance category, the Men's Traditional. As the dancers are masking their faces with paint, the emcee informs the crowd, "What you see here today came out of dances originally held by members of southern Plains warrior societies. These dances, known by many as Grass or Omaha Dances, were held to benefit tribal members." The dances were used to recount a warrior's battle and celebrate his victory. Boye Ladd, Winnebago Fancy dancer [1167], related: "A great-great-great-grandfather said that powwow dancing originated from our Omaha brothers who were warriors. They had returned from an expedition and performed a war dance in celebration of their success. This was way before the coming of the White man. They were not necessarily celebrating the taking of a life but pride in their good medicine. The dance they performed was a celebration of their good fortune as members of a family, a society, a clan and a tribe. It was a dance based on pride."[4]

The first round of contesting is over and most of the dancers who participated earlier have already been dismissed. The emcee calls for a dinner break, telling the dancers where they can get their meals and addressing the crowd, "It's not over, folks, we've only just begun. So please visit with our wonderful arts and food vendors. We have people here from all over the country selling their fine work and Native foods. So please, take some time to stretch your legs, visit our vendors and satisfy your hunger with some good cooking. See you in a couple of hours."

I dash off to find the bracelet I had seen earlier. I ask to see it again, and the vendor gladly takes it out of the glass case. It's exquisite. The vendor, smiling, tells me I have good taste. Talking at length with the Navajo vendor, I learn where he and his family are from and how his grandfather and grandmother taught him his craft. He said it was important to respect the gift he had. "We must always remember that this is a gift given by the creator. [We are] always creating out of who and where we come from." I have to buy the silver, turquoise, and coral bracelet, not only because of its aesthetics but also because of what it holds: a piece of Father Sky and Mother Earth.

Continuing on to the other vendors, I encounter a woman beading. The floral pattern shades a turtle. It is almost completed and it's glorious. I think of how lucky the young woman is who will be wearing it upon her shoulders. I have seen all the vendors and can't go home without having some Indian food. There's quite a bit to choose from: Indian tacos, buffalo burgers, wild rice, corn soup, and venison stew. After making a decision and settling down to eat, I hear a woman telling a story over the loudspeaker. She's well known for her storytelling and is quite dramatic in her tone. The kids and adults alike seem to be enjoying her tale about the trickster Raven.

As I finish up my meal, I look forward to the rest of the evening's events. There will be a few more intertribals, a switch dance (male dancers dance in women's regalia and vice versa), which is always fun. There's even going to be a two-step contest. That's always wonderful to watch because it's one of the few times male and female dancers dance holding one another. There's the emcee; he's calling everyone back to the circle.

On my way back to the bleachers, I run into some of the dancers I met throughout the day and wish them luck because I won't be around when the winners are announced the following day. They all look rested now and seem ready to enjoy the rest of the evening. There will be no more serious contesting tonight, only friendly dancing and later a '49 (Indian social gathering).

Driving away from the fairgrounds, I reflect on the day's events and am deeply moved by the proud demonstration of Indianness I have witnessed. For hundreds of years Native peoples resiliently faced cultural assimilation and persisted in perpetuating "who they are" in the realm of Western civilization. It is inspiring and wondrous to see their perseverance reflected in adornment, the arts, and ceremonialism. The circle continues.

CROW FAIR

One of the largest and most well known Native events in North America, Crow Fair is held annually at Crow Agency, Montana. It began in 1904 as a country fair. The residing BIA agent, S. C. Reynolds, believed that such an event would encourage the Crow to change into "self-supporting farmers" and abandon their nomadic lifestyle. To promote participation, Reynolds worked with a committee of chiefs and elders to schedule events that would appeal to the Crow people. The committee arranged for parades, horse racing, and dancing—activities in conflict with the Federal government's strict policies forbidding traditional Native American celebrations. Reynolds overlooked the legalities, and the fair was a great success. In time, reenactments, storytelling, victory dances, and giveaways were combined with exhibitions of livestock, produce, traditional Native foods, clothing, and handicrafts.

Pius Real Bird, uncle of Kennard Real Bird (515) and grandson of Chief Medicine Tail—one of those involved in the founding of Crow Fair—directed the fair for many years. Pius recalls that, as rodeo manager in 1962, he decided to hold an all-Indian rather than a mixed Indian/non-Indian rodeo. "At first we feared there might not be enough contestants. But when the rodeo started, four hundred cowboys and cowgirls from all over Indian country came here. When they got to know each other, a lot married into each other's tribes."

Today, more than one hundred tribes participate in the festivities that attract visitors from around the world. A highlight is the mile-long parade held Sunday morning (the final day), when hundreds of Crow riders on horseback and others in flatbed trucks display heirloom Crow regalia, Pendleton blankets, elk-tooth dresses, cradleboards, and headdresses. Adds Pius Real Bird, "Four generations are often represented in the parade."

1174 At the largest encampment in North America, more than fifteen hundred tents are set up in assigned sites for the six-day Crow Fair. Some camping areas have been occupied for years by generations of the same families. 1997

1175

1176

1175 A Crow woman wears a traditional beaded dress during Crow Fair's Sunday parade. 1993

1176 A family's beaded finery is displayed on a truck—the contemporary "horse"—during the parade. 1993

DANCERS AND THEIR REGALIA

1179 *The Men's Fancy Dance is ▷ exactly what its name implies. Quick on their feet, the dancers are creating new and varied moves as they keep to the beat of the drum. The dance is believed to have originated in Oklahoma during the early 1900s. Wearing two colorful bustles, the men do more than dance; they also perform brilliant acrobatic feats.*

1177 *The Men's Southern Straight was originally a ceremonial dance in which only men who had distinguished themselves, either in military action or tribal affairs, were allowed to participate. Like Men's Northern Traditional, this dance details heroic acts committed by warriors and successful kills accomplished by hunters. When it is danced, as an exhibition or in a contest, at contemporary powwows, all present are asked to stand in honor of its history. The regalia worn for this dance shares many of the articles used by Northern Traditional dancers but is distinctive in that no bustle is worn. Instead, the dancer wears an otter-skin trailer hanging down the back, frequently decorated with beadwork, ribbon work, or mirrors.*

1178 *The Men's Northern Traditional Dance comes out of dances practiced by the Heluska Society of Omaha. It tells of the bravery of scouts before battles and victories by warriors in defending their peoples. The single bustle worn on the lower back denotes the battlefield. It derived from the so-called "Crow" bustle— originally of crow and hawk feathers, today of eagle and hawk feathers. Along with the bustle, traditional dancers carry dance staffs and eagle-wing fans and wear porcupine roaches.*

1180 *Women's Traditional Buckskin and Cloth Dances feature distinctive regional variations. Northern dance steps are characterized by a graceful bouncing in place, whereas southern dancers deliberately step and sway. Both groups of dancers must keep to the drumbeat. Upon hearing an honor beat, all the women raise their fans, "calling out the spirit of the drum." The buckskin dresses, sometimes heirlooms, are fashioned with fine beadwork and long fringe flowing like water from the dancers' arms and backs. Like Men's Traditional dancers, the women adorn themselves with bone hairpipe breastplates and chokers. One eagle feather usually is set straight up on their heads.*

Cloth Dances reflect the same distinguishing regional styles as seen in the Women's Traditional Buckskin. This separate category is marked by dress style. Cloth dresses are finished with ribbon work, beadwork, and finger weaving.

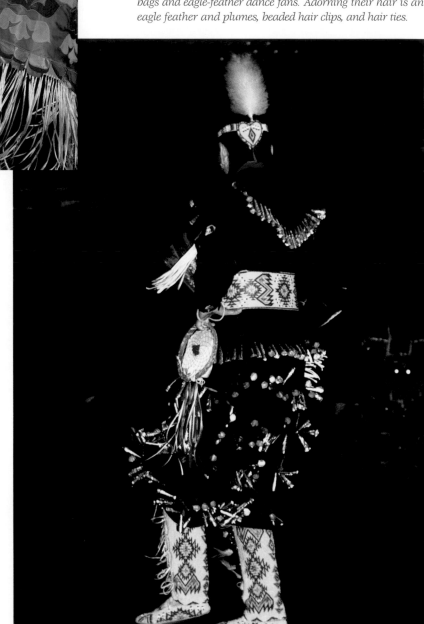

1183 *The Women's Jingle Dress and Dance has recently experienced a resurgence after dying out in the 1950s. In 1919, an Ojibwa medicine man of Mille Lacs, Minnesota, received a vision in which four women appeared wearing jingle dresses. These women taught him how to build these dresses, what special songs were to accompany the dance, and how the dance was to be effected in order to heal the body and spirit. The dance spread from Mille Lacs to other Ojibwa and on to the peoples of the Dakotas. Today it is danced by many tribes.*

In movement, the cloth dress, covered with hundreds of tin cones shaped from tobacco-can lids, creates the soft jingle sounds particular to this dance style. Along with the cones, the dress is accessorized with concha belts, neck scarves, moccasins, and leggings. The women carry beaded bags and eagle-feather dance fans. Adorning their hair is an eagle feather and plumes, beaded hair clips, and hair ties.

△ **1181** *The Men's Grass Dance came out of the northern tribes. Some say that men would go out to grassy areas that needed clearing and dance there until the grass was flattened. Today the dance, with its fancy ribbon, fringe, and soft-shoed movements, evokes the swaying of grass.*

1182 *The Women's Fancy Shawl Dance is fairly new to dance competition. Like the Men's Fancy, the dance is based on elaborate footwork and a great deal of movement and spinning. The spinning allows the dancer to spread her shawl like the wings of a butterfly, revealing its beautiful colors and patterns. Along with her fanciful shawl, fringed with flowing hues, the dancer's cloth or taffeta dress is complemented by matching leggings and beaded moccasins. Her hair is adorned with hair ties, beaded clips, an eagle feather, and plumes.*

The dance possibly originated during the 1930s and 1940s, when it was common for women to show off their impressive handcrafted shawls at socials by twirling gracefully in dance. As tradition has it: "A newly widowed woman was given a beautiful shawl to bring her comfort during her time of mourning. She wrapped it about herself like a cocoon and passed through a long winter. In the springtime she entered the dance circle, dancing like a butterfly."

1182

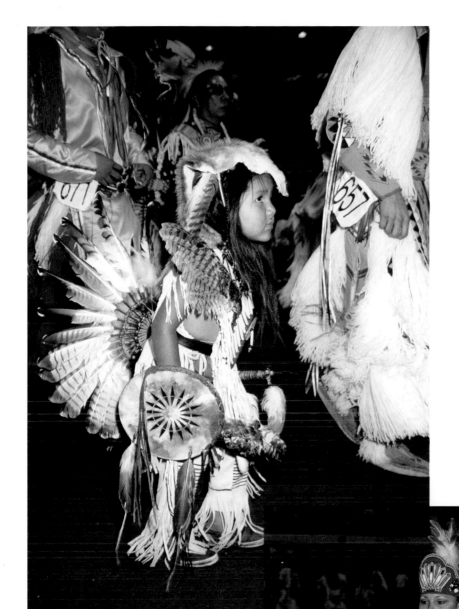

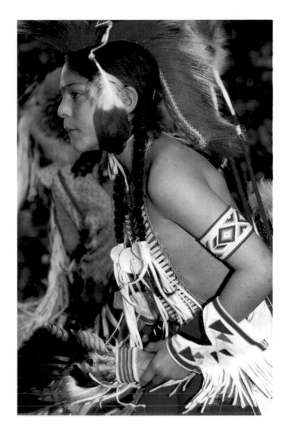

1187 *Young dancer at Red Earth, 1995*

1184 *A tiny tot proudly dances the Young Men's Traditional at Black Hills Powwow, 1993. The little ones (ages one to five) are usually in an outfit and in the dance arena as soon as they can walk. Starting at a young age is important as it teaches values and respect for their culture.*

1185 *A tiny tot in full regalia participates in the Women's Southern Traditional at Red Earth, 1995.*

1186 *A youngster in beads and buckskin regalia participates in an intertribal dance at Black Hills Powwow, 1993.*

1185

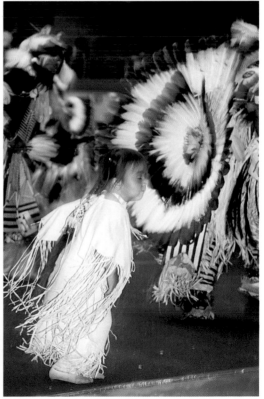

1186

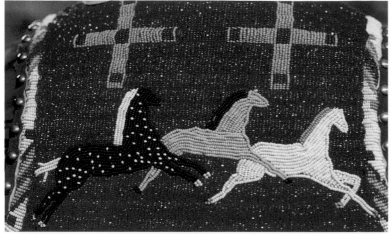

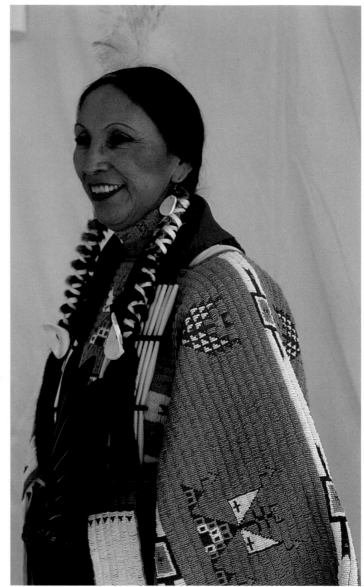

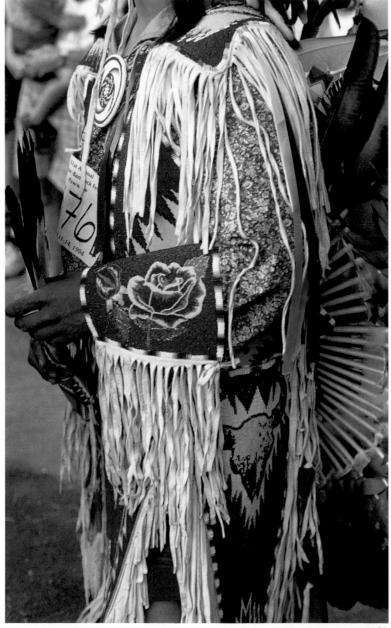

1188 *Detail of a beaded vest. Made and worn by Charles Dru (Arikara). 1995*

1189 *Detail of a dancer's beaded regalia*

1190 *Beaded buckskin dress made by Charles Dru (Arikara) and worn by his mother, Laverne Dru, in 1995 at Schemitzun, the Mashantucket Pequot's annual powwow. (Schemitzun is a Pequot word meaning the "Feast of Green Corn and Dance.")*

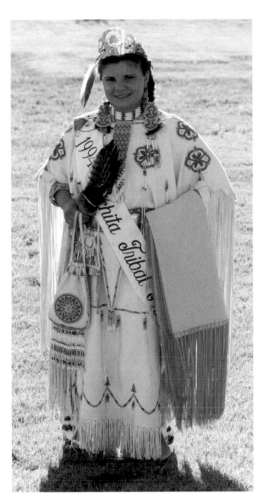

1191 *Jennifer Standing, Miss Wichita 1994, wears grandmother Nettie Standing's coveted buckskin dress (pages 298–99) and a crown commissioned from Bruce Caesar (page 296).*

1192 *A Mohawk beader at the ▷ Kahnawake powwow, Quebec, 1995*

Powwow season, following tradition, begins early in spring and continues until late September. Today, because many of the celebrations are held indoors, you can attend powwows into the winter months. Dancers and their families travel long and far to dance and sing in the powwow circle. Some "go on circuit" for the entire season.[5]

At the powwow itself, the dancers are physically in the center of the circle, with the audience forming a larger circle around them (1159). Black Elk, an Oglala Sioux medicine man, once said that the "circle is holy, it is being endless, and thus all power shall be one power in the people without end."[6] Reinforcing this belief, the powwow serves as a centripetal force that brings the "circle of people closer together—closer to their family, friends and their Indian culture."[7] It empowers and teaches the young and allows the peoples to keep some of the old ways while growing into the new.

My initial exposure to "powwow magic" was at the Black Hills Powwow in the heart of Lakota country in the northern Plains. Seeing people dance while wearing their art considerably changed this book's direction and immeasurably enriched my life. By following the powwow trail for several years, I have acquired a chain of friendships, gained new insights, and met superb artists—particularly beadworkers.

Mary Ferguson Lewis, of the Mississippi Band of Choctaw Indians (page 210), told the author that much of her interest in beadwork came from taking part in the Princess Pageant segment of the powwow. "You had to get the best beadwork, the best dress," related Mary. "You made every effort to look good in front of everybody. So you would look for the best quality makers since you were putting yourself on the line. Not that you're judged on the quality of what you're wearing, but having a completed set of beadwork made you feel good. Becoming a Tribal Princess is not the same as winning a beauty contest. You are distinguished as a tribal representative. You are questioned on the tribal past, present-day occurrences, your beadwork, and all your cultural arts. It is important that you are knowledgeable about the tribe. You have to be a good student and have good morals. Becoming a princess is a source of pride in the family and everybody gets into good spirits."

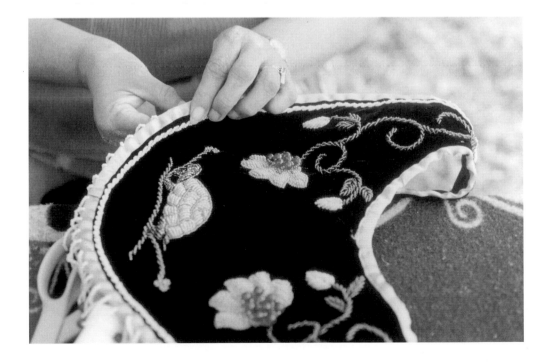

The respect accorded fine dance regalia is illustrated by Kiowa artisan Nettie Standing's beaded buckskin dress, worn by her granddaughter, Jennifer Standing, at Red Earth in 1994 (1191). Nettie's daughter, LaVerna Capes, in a discussion held at Anadarko a few days prior to Red Earth, explained: "It's a magical dress, it fits everybody. I've worn it, my daughter has worn it. Jennifer is the Wichita Princess and she'll be wearing it. Jennifer is a wonderful jingle dress dancer, but dancing with the buckskin dress is entirely different because you don't have to move, but you do have to pop those fringes. You don't move your arms; it's your legs that make that fringe snap." The dress was originally made for Loribeth Parker, Nettie's granddaughter, the 1985 Wichita Princess. "After she outgrew it, mom gave it to the family, so that whoever wanted to wear it could. The buckskin—the color, the texture—is very special, the finest quality imaginable. When people put that buckskin dress on, they should be very graceful, very dignified in dancing. When you put that buckskin dress on, people are looking at you, and you have to treat it with the respect that it deserves."

While modern powwows are not sacred ceremonials, neither can they be labeled totally secular. In that uniquely Indian way, splendid regalia, dazzling footwork, prize money, courtship, and humor coexist with the spiritual. Powwows begin and end with prayer, and dancing is frequently interrupted with additional prayers or honorings. Drums are named and blessed. Dancers wear sacred eagle feathers, ancient cosmic designs of sun circles and crosses, and red paint on their hair and faces.[8] Phillip Paul, a Flathead Traditional dancer, observed: "The best outfits come from dreams and visions. We are told in this way how to put them together."[9] Dance forms and spaces continue as circles. And there is the essential connection between motion, breath, and wind.

"The powwow drum is thunder, the singers are the wind, the dancers the life force of the people, and the eagle feather is the channel to the Great Spirit," a Cree grandmother told her granddaughter.[10] In an article referring to Navajo dance, but appropriate for other Indian groups, David McAllester wrote: "Motion is a key to sacred power. . . . Wind is the basic metaphor of the power of motion. Speech, song, and prayer are wind in motion shaped by the added power of human articulation. It follows that all song and all movement partake of this power. . . . People moving together in constructive ways. . . . The element of repetition has the connotation of focused energy accumulating with each recurrence."[11]

Powwows tap into an innate Indian egalitarianism, unrelated to income, schooling, or religion. "While a payout may attract some dancers," said Lynn Burnette, Jr. (Lakota), himself a fine Grass dancer, "money is not the main reason people dance. They dance for the fun, for pride in their hearts received from the drum, and to enjoy life and celebrate through dance."

I am profoundly affected by Native peoples' core values and creative continuum. "Many still believe that the natural world is an analogue to the spiritual one," wrote Ralph Coe in 1986, "and inasmuch as they can, still abide by that concept."[12] Indian aesthetics, derived from the heart and soul, remain spiritually connected through the concept that everything is related. The dances continue to pass on important information from one generation to the next. Even the dancer's shifting from everyday (practical) to ceremonial (special) life echoes the shaman's ability to traverse multiple worlds. Most remarkable is the unceasing commitment of time that is needed to maintain ceremonials and create fine adornment and regalia.

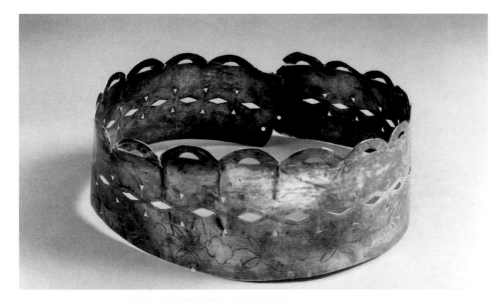

1193 *Silver head ornament, worn by the northeastern Passamaquoddy of Maine, made from thin sheet silver with cutout and stamped designs. c. 1875. Height, 2⁹⁄₁₆" (6.5 cm). Peabody Museum of Archaeology and Ethnology, Harvard University, 10/60273*

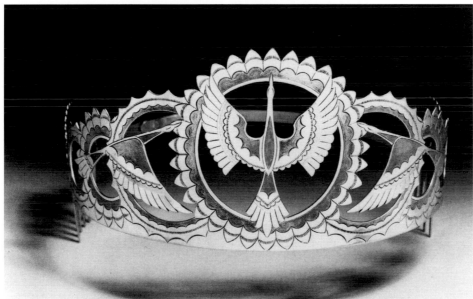

1194 *Tiara-style crown worn by a Southern Plains Indian princess. This particularly elegant example features a cutout and engraved German silver peyote bird depicted in a feather circle. Bruce Caesar (Pawnee-Sauk/Fox). 1975. Center height, 3¼" (8.3 cm). Lost and Found Traditions Collection, Natural History Museum, Los Angeles County*

▽ **1195** *Beaded velvet dancing crown with hair clip beaded on hide. The beadwork is the traditional raised embossed technique. Dolores Montour (Mohawk). 1995. Crown height at center, 5" (12.7 cm). Collection Dorsey*

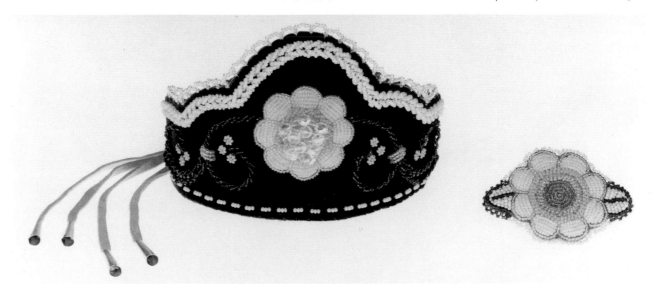

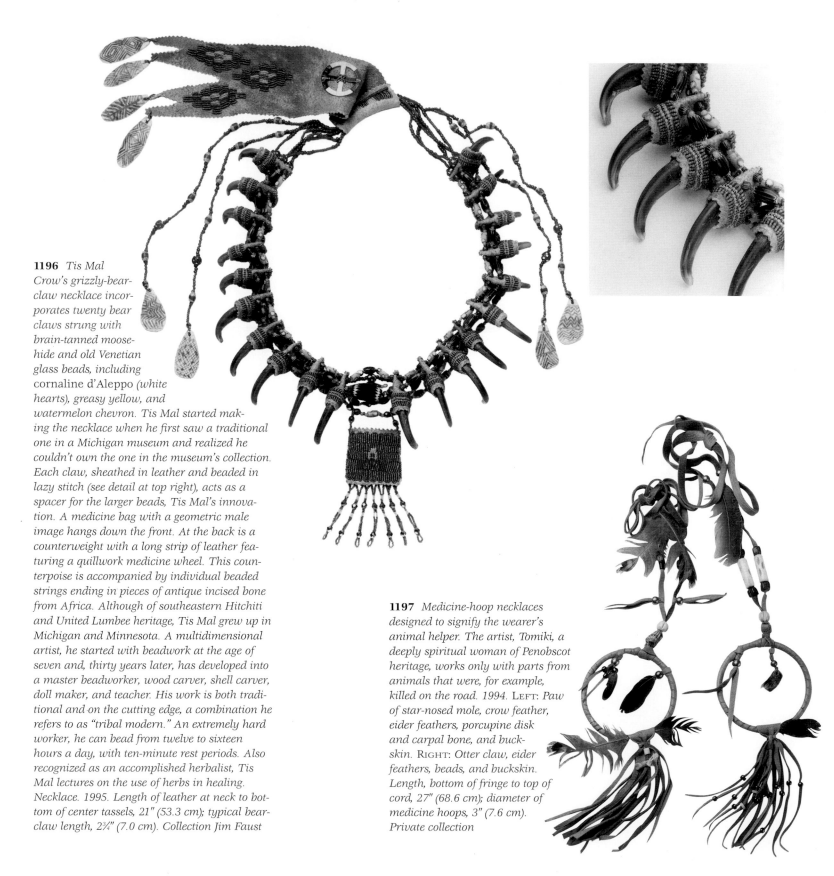

1196 *Tis Mal Crow's grizzly-bear-claw necklace incorporates twenty bear claws strung with brain-tanned moose-hide and old Venetian glass beads, including* cornaline d'Aleppo *(white hearts), greasy yellow, and* watermelon chevron. *Tis Mal started making the necklace when he first saw a traditional one in a Michigan museum and realized he couldn't own the one in the museum's collection. Each claw, sheathed in leather and beaded in lazy stitch (see detail at top right), acts as a spacer for the larger beads, Tis Mal's innovation. A medicine bag with a geometric male image hangs down the front. At the back is a counterweight with a long strip of leather featuring a quillwork medicine wheel. This counterpoise is accompanied by individual beaded strings ending in pieces of antique incised bone from Africa. Although of southeastern Hitchiti and United Lumbee heritage, Tis Mal grew up in Michigan and Minnesota. A multidimensional artist, he started with beadwork at the age of seven and, thirty years later, has developed into a master beadworker, wood carver, shell carver, doll maker, and teacher. His work is both traditional and on the cutting edge, a combination he refers to as "tribal modern." An extremely hard worker, he can bead from twelve to sixteen hours a day, with ten-minute rest periods. Also recognized as an accomplished herbalist, Tis Mal lectures on the use of herbs in healing. Necklace. 1995. Length of leather at neck to bottom of center tassels, 21" (53.3 cm); typical bear-claw length, 2¾" (7.0 cm). Collection Jim Faust*

1197 *Medicine-hoop necklaces designed to signify the wearer's animal helper. The artist, Tomiki, a deeply spiritual woman of Penobscot heritage, works only with parts from animals that were, for example, killed on the road. 1994.* LEFT: *Paw of star-nosed mole, crow feather, eider feathers, porcupine disk and carpal bone, and buckskin.* RIGHT: *Otter claw, eider feathers, beads, and buckskin. Length, bottom of fringe to top of cord, 27" (68.6 cm); diameter of medicine hoops, 3" (7.6 cm). Private collection*

1198 *Sterling silver suite—bracelet, earrings, ring, and parfleche neck piece—designed by Tchin (Narraganset-Blackfoot). Using overlay and hand-made stamped and cut-out designs, the artist depicts in petroglyph style a family of animals, ranging from the youngest to the oldest members. Faceted stones placed on the bodies represent the animals' inner organs, or "life lines." Stamped on the back of the bracelet and parfleche (far right) are hoof prints indicating animal tracks. In addition to feathers and petroglyphs, the parfleche holds the protective and healing medicine of sweet grass. 1995. Length of pouch with fringe. 4¾" (12.1 cm). Collection of the artist*

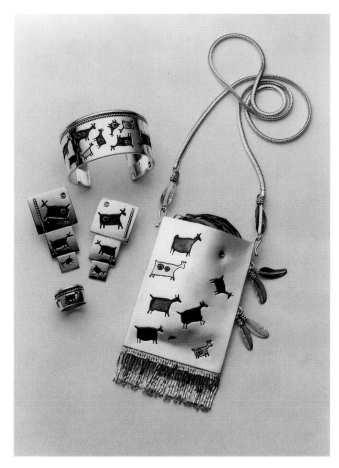

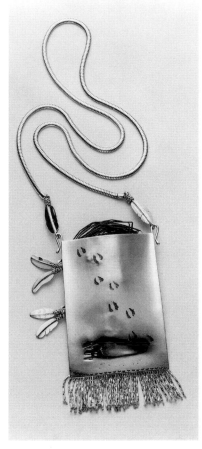

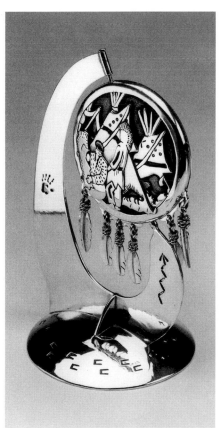

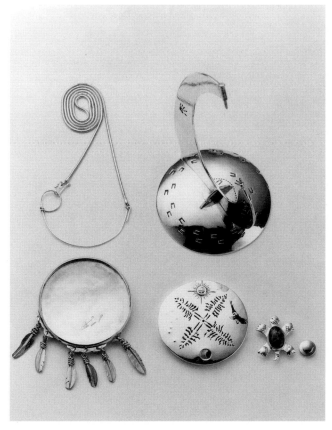

1199 *Tchin's ingenious Jewelry on a Stand includes a turtle pin, pendant, and necklace. When not being worn, the separate pieces are displayed as a medicine wheel (far left) stamped with figures detailing Northeastern cosmology and traditional beliefs. Tchin—jeweler, flutist, and fashion designer—made the pieces to honor the powerful and spiritual aspects of his Native American heritage. He represents the growing number of contemporary Native American artisans who have attended institutions such as the Institute of American Indian Arts in Santa Fe, New Mexico, where modern skills are used to revitalize traditional culture in creating contemporary work. 1994. Sterling silver. Collection of the artist*

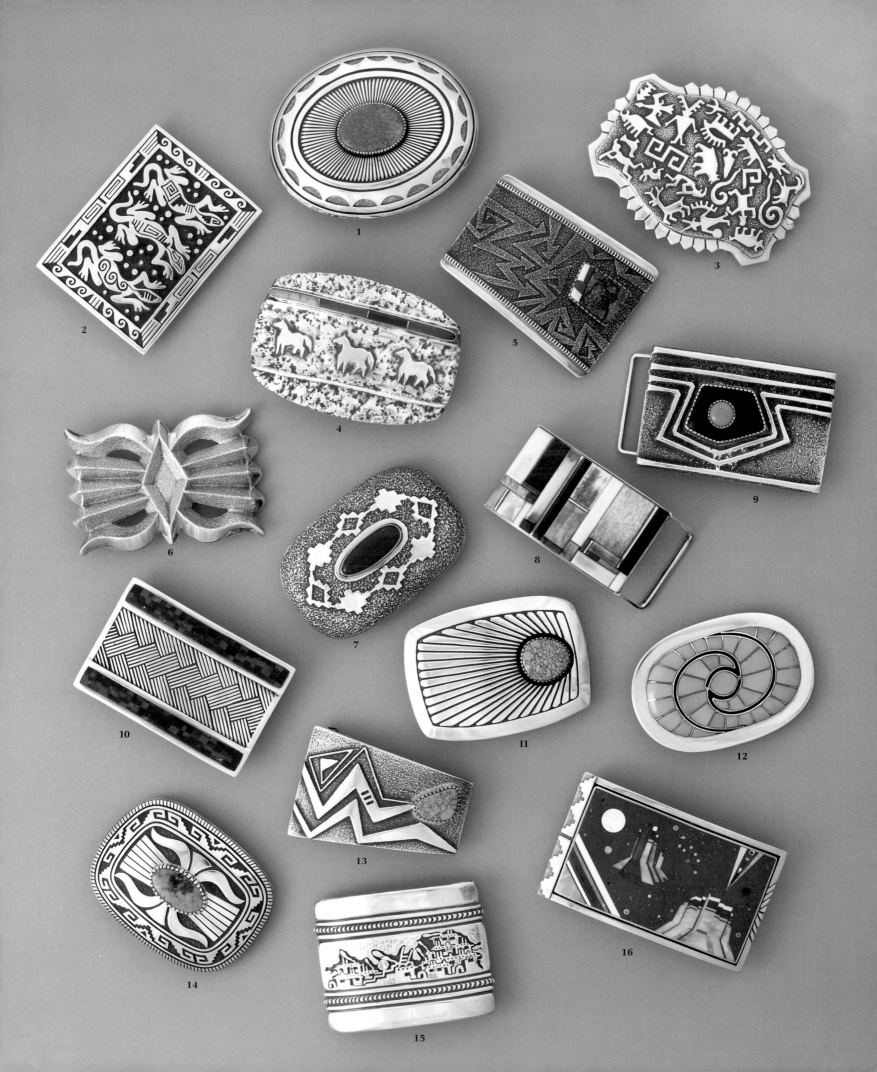

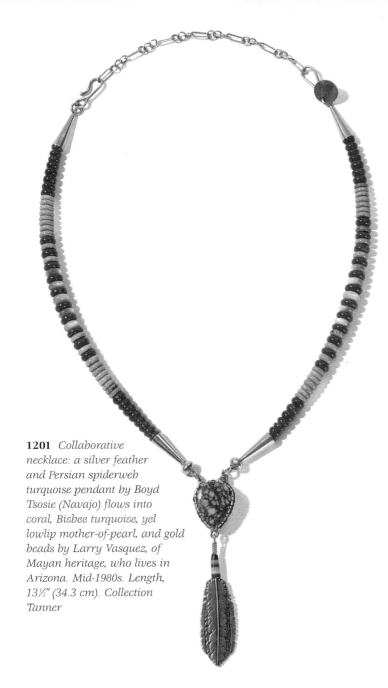

1201 *Collaborative necklace: a silver feather and Persian spiderweb turquoise pendant by Boyd Tsosie (Navajo) flows into coral, Bisbee turquoise, yellowlip mother-of-pearl, and gold beads by Larry Vasquez, of Mayan heritage, who lives in Arizona. Mid-1980s. Length, 13½" (34.3 cm). Collection Tanner*

◁ **1200** *The Anglo (non-Native) owner of these contemporary Southwestern belt buckles collected examples of every major style group—representing Hopi overlay, Zuñi needlepoint, and Navajo use of stones. He has also managed to assemble work by many of the region's outstanding artists, buying "what bites me on the ankle." 1978–96. Gold, silver, turquoise, coral, mastodon ivory, lapis lazuli, sugilite, rosewood. Length of 3., 3½" (8.9 cm). Private collection*
1. Gibson Nez (Navajo). 2. Salamanders. *Richard Taylor (Navajo). 3.* Petroglyphs. *Ben Nighthorse Campbell (Cheyenne). 4.* Horses. *Ben Nighthorse Campbell (Cheyenne). 5. Richard Tsosie (Navajo). 6. Al Nez (Navajo). 7. Lee Yazzie (Navajo). 8. Charles Loloma (Hopi). 9. Al Nez (Navajo). 10. Alan Wallace (Maidu-Washoe). 11. Joseph Lovato (Santo Domingo). 12. Quandelacy (Zuñi). 13. Larry Golsh (Mission). 14. Lee Yazzie (Navajo). 15. Vidal Aragon (Santo Domingo). 16.* Navajo Night Sky. *Jesse Lee Monongye (Hopi-Navajo).*

1202 *Ancient Pueblo potsherd necklace of 22-karat and granulated gold. Born and raised in Casablanca, Morocco, the artist, Luna Felix, currently lives in Santa Fe. Drawing inspiration from the landscape, natural resources, and Native cultures of North America, she creates with no boundaries. 1987. Length, 16" (40.6 cm). Private collection*

1203 *"Petroglyph" necklace recalls rock art of the ancient Southwestern peoples. 22- and 18-karat gold with granulation. Luna Felix. 1988. Center pendant width, 2" (5.1 cm). Private collection*

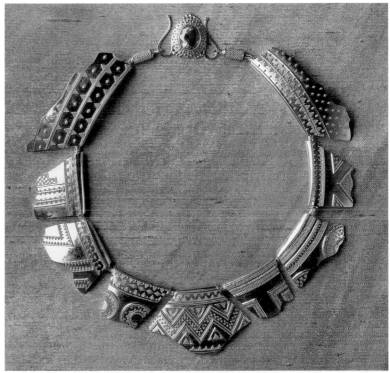

1202

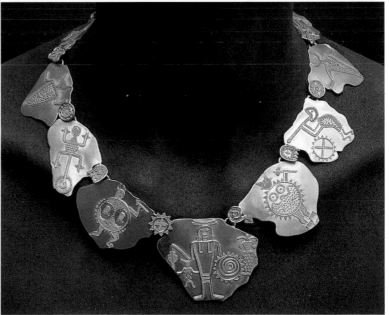

1203

Eveli (Evelyn Sabatie), born in Algeria to French parents, grew up among the mosaics and inlaid facades of Morocco. After obtaining a Ph.D. and teaching languages for several years, she traveled to the United States, eventually finding her way in 1968 to the Hopi Reservation in northern Arizona. After a chance meeting with Charles Loloma, and upon his urging, Eveli (her Hopi-given name) spent four years at Hotevilla studying and working with the famed jeweler. Eveli recalls, "Our encounter was like an explosion. All the diverse influences of our different backgrounds came together." Whereas Loloma had just discovered inlaid Egyptian jewelry, Eveli was overwhelmed by Navajo silver. "I couldn't believe it. These were the same designs I had seen in North Africa. The squash blossom and so forth—they are transformed here, but are exactly the same Moorish designs I had seen all my life. When I looked back in history I saw the connection. . . . Suddenly everything in my own history made sense. I felt that I had come home." When she left the reservation in 1972, her style was distinctly her own. "Although influenced by Loloma, I carried within myself my own ideas and heritage." A resourceful and profound designer, Eveli aptly describes her work: "Day and night the sky is filled with jewels, and the jewelry I try to create is a reflection of this: it comes from the sky like rain, sunlight, thunderbolts, meteorite, and wearing it places one within the drama of the universe."

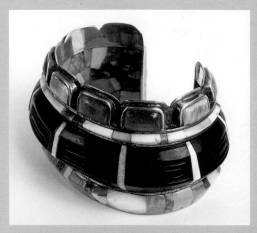

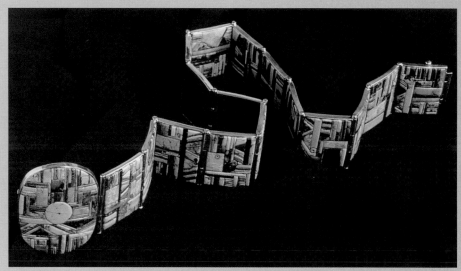

1204 This cuff's interior features hidden mosaic imagery. Eveli. 1976. Silver inlaid with ebony, ivory, turquoise, shell, and coral. Height, 2¼" (5.7 cm). Collection Ann Simmons Alspaugh

1205 Sacred Wall. Eveli. 1976. Silver belt inlaid with turquoise, coral, and ivory. Length, 39" (99.1 cm). Centerpiece width, 4" (10.2 cm). Private collection

1206 Coral, turquoise, and silver necklace by Frank Patania, an Italian-born and -trained goldsmith who moved to the Southwest in 1924 and lived and worked there for many years. Reciprocally teaching and learning from Native artisans, Patania had a special regard for silver and turquoise. The silver clasp "spray" designs were a Patania signature. Undated. Clasp length, 3" (7.6 cm). Collection Sandra Kerno

1207 In making this silver and black water-buffalo-horn bead necklace, artists Doug and Mary Hancock were inspired by an Indian choker of dentalia at the Denver Art Museum. The necklace includes a replicated sixteenth-century Spanish coin centerpiece, a large silver turkey feather, a smaller silver owl feather, Ethiopian white brass beads, and silver Navajo buttons. 1992. Top of coin to bottom of feather, 8" (20.3 cm). Collection Dolores Schapiro

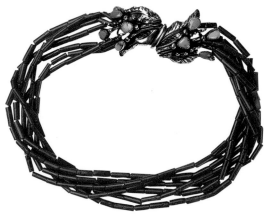

1206

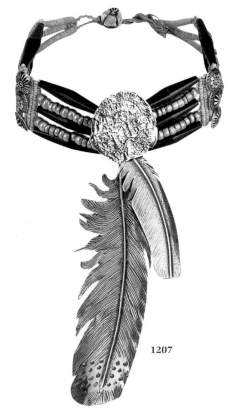

1207

1208 *A muslin dress beaded with "Indian" motifs by the author's mother, Shirley Rosenfeld Sherr, worn when she was a teenage Camp Fire girl in Connellsville, Pennsylvania, c. 1915. While turn-of-the-century government policies sought to eliminate "Indianness" and assimilate Native peoples into mainstream American culture, youth and scouting movements encouraged adaptation of numerous Native ways. The name Koalan, embroidered on the right sleeve, supposedly meant "Evening Star," although in what language remains a family mystery. Length including fringe, 46" (116.6 cm). Collection Lois Sherr Dubin and Lynn Sherr*

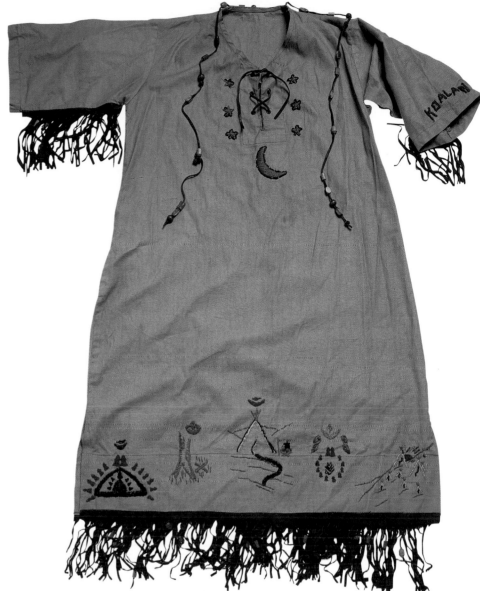

1209 *Beaded cloth panel belt by non-Native Jane Bardis, who studied Southeastern beadworking under Creek beadworker Jay McGirt of Oklahoma. 1994. Overall length including fringes, 15' 4⅛" (468.6 cm). Width, 5½" (14.0 cm). Collection Jane Bardis*

Chad Nielsen creates fine beadwork in the Dakota (Sioux) style; Nielsen, however, is not a Native American. His is a unique story of cultural conversion. While an adolescent, he was "claimed" by Joseph Rockboy, spiritual leader of the Dakota people. As a young boy, he explains, "I had strong dreams, and my dreams ran me. I would see pictures, and in memories I'd hear this language. When I told my grandpa, he'd smile and say, 'Well, that was a Sun Dance.' When my grandpa picked me up for the first time from my mom . . . his cousin was a medicine man . . . they took me into a sweat lodge. I started talking that language. And then I felt home. I'm really uncomfortable in a non-Indian world."

Nielsen's artistic education began almost immediately with his adoption. "You know how you are when you're thirteen. My [Dakota] grandpa told me, 'You really need to slow down, so why don't you ask your uncle to teach you how to do beadwork?' Uncle Clarence [Rockboy] was a really hard taskmaster. He said, 'How I learned was somebody took a little piece [of cloth] with this stitch and with a knife cut the bottom and peeled it back a little bit and put it in front of me and said, 'Now learn . . . and don't get up from the table until you do.' So he did that to me, and he was pretty rough. I did a twelve-year apprenticeship with him." (See 638.)

Nielsen's early style was greatly influenced by his mentor. "When my grandfather died, I didn't do beadwork because I was in mourning for four years. However, a few years later, I started to work again and needed my own style. After a vision quest, I got seven designs. . . . I closed my eyes and, like on the theater marquee, those designs were going around . . . the buffalo's one of them. People see my work; they know it's mine." Nielsen also attributes his artistic divergence from Clarence Rockboy to their religious affiliations. Rather than follow his uncle into the Native American Church, he remains connected to the orthodox teachings of Joseph Rockboy, noting, "Differences in Native American Church and our more traditional ways extend to jewelry and regalia. . . . Native American Church [artists] might use macaw feathers, where we use eagle feathers, hawk feathers, or even a prairie chicken or woodpecker."

Similarly, Nielsen defines his style as traditionalist: "People classify me as a contemporary beader but I really resist that very, very strongly. I think that [those people] conceive of traditional beadwork as boring, something you see in a history book. I say we're alive, we're living. And traditional is what our experience is now in the context of our culture. I don't do things out of context." Nielsen insists that in individual pieces he can be innovative while still observing Native conventions. "My friend had a dream, and in his dream he saw himself wearing a necklace that I had made; he saw it a certain way, so he drew it and he asked if I could make it. And I said, sure. So I helped his dream come true."

Offering interesting remarks on traditional designs and contemporary innovations, Nielsen says, "The whirling sun is a design that I used a lot for anything I would make for my grandfather because he specifically requested it. He told me that it was one of the very first designs of the ancient Sioux. Among the United Dakota, Nakota, and Lakota, *Joaquii*, the Thunderbird, is one of the sixteen original creators. And each creator has a design and a personality. The medicine wheel, for example, is a constellation. And our constellations take a whole year to unfold. They have to be observed from the center as well. You see, before there were only six directions: the earth, sky, and the cardinal points. But with our generation, when the hoop was broken, there [came] the realization of a seventh generation and a seventh direction, which translates from Indian as universe. I represent it as spirit at the center. You're at the center of the universe. So that's why I use the heart design to signify the seventh direction.

"Among the Dakota people, if you're going to do something, you think seven generations ahead. You're not even going to be alive; so if you're thinking that far ahead, you know you're not thinking for yourself. You put everything into a different perspective. And right now we're just in a tough place. But we all know that a new age is coming."

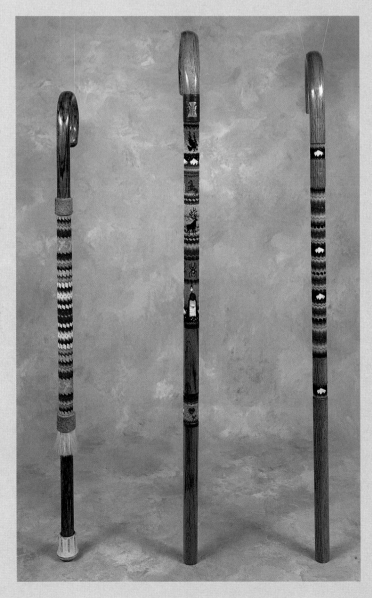

1210 *Beaded canes by Chad Nielsen. Early 1990s. Collection of the artist*

1211 INSET: *A pin in the form of an oak leaf is inlaid with glass seed beads set into black mastic within a silver frame. Though unintentionally achieved, the pin's internal contour patterning and outlining is reminiscent of nineteenth-century Great Lakes tribal beadwork, a style much admired by non-Native Mary Kanda. 1995. Length, 3⅞" (9.8 cm). Private collection*

1212 *Working in a traditional style, Rene Senogles (Ojibwa) of Minnesota beads a leaf style design on a dancer's outfit (detail). 1994*

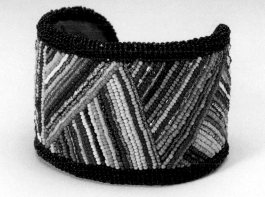

1213 *Contemporary beaded bracelet. Marcus Amerman. 1995. Height, 2" (5.1 cm). Private collection*

1214 *Crow-inspired bag of buckskin, ▷ glass seed beads, and ermine tails. The artist, non-Native Michael Lekberg, grew up in the Black Hills, where there was a strong Native tradition of beadworking. Lekberg himself has beaded for thirty-five years. 1992. Length including tails, 29" (73.7 cm). Collection of the artist*

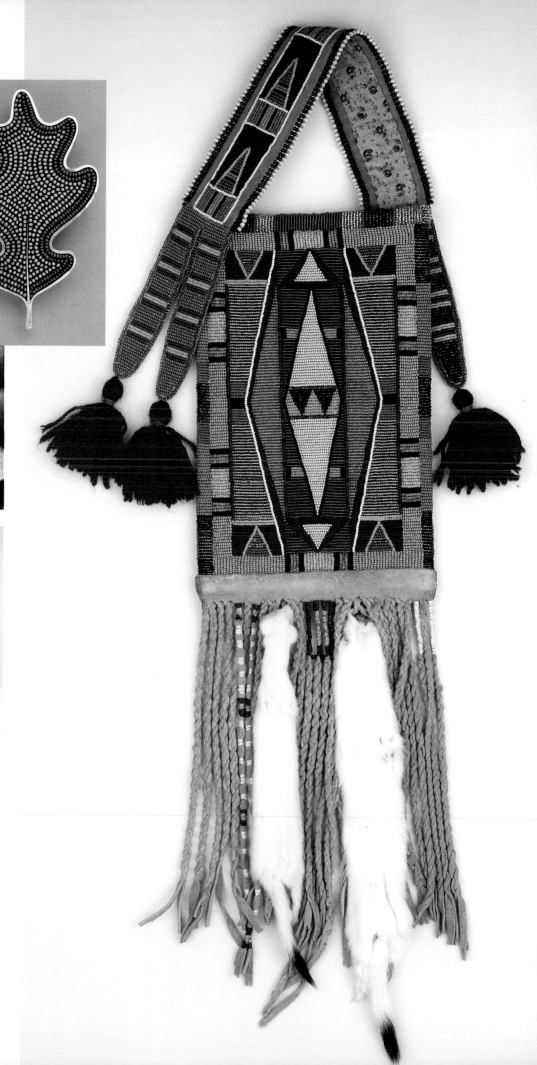

THE ROACH FAMILY

Ramona and Norman Roach take pride in being Indian and share their talent and creativity with their daughter, Shannon, who has been dancing since the day she could walk. Dancing is high on the Roaches' list of priorities. It binds them to each other, to friends, to extended family, and to their culture. For five years, the family danced and toured through Europe and the United States with the Native American Dance Theater.

As a young girl, Ramona, of Navajo heritage, attended powwows with her sisters, and felt drawn to the Fancy Dance style. When they returned home, the girls would re-create the dance, using towels for shawls. Later, Ramona and Norman, a Lakota, met at a powwow in Albuquerque, New Mexico, while both were attending college. Also a fancy dancer, he presented her with her first full dance outfit.

Ramona feels strongly about teaching Shannon to be the best person she can. "She should be aware of herself as a Native American woman and that she has somewhat of an advantage because she has a very powerful mind." Ramona hopes that, by encouraging her in this way, Shannon "will teach her child in the same manner." Also a state-ranked runner, Shannon was recently honored by the family at a powwow for all of her accomplishments. Reaching out to other children, Norman and Ramona also spend hours training a group of eight- and nine-year-olds—many from single-parent families—to excel in athletics and dancing.

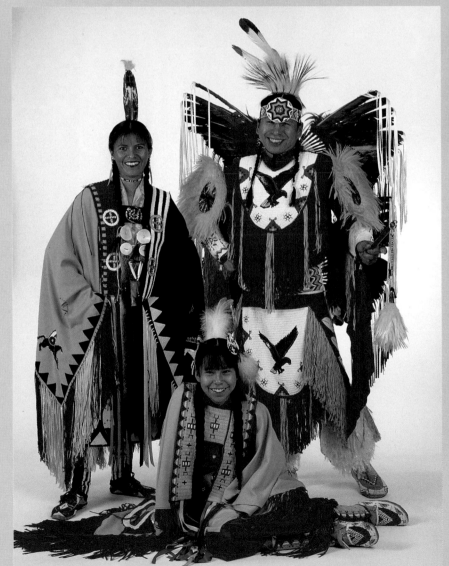

1215

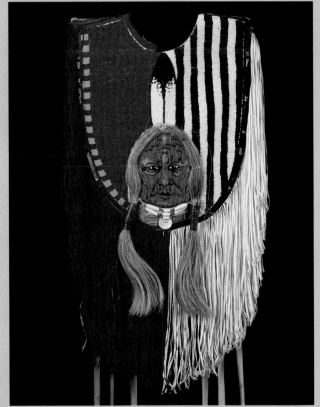

1216

1215 *Ramona, Norman, and Shannon Roach in Fancy Dance beaded regalia. Rapid City, South Dakota, 1995*

1216 *Beadwork on a fancy shawl by Norman and Ramona Roach. The intricately beaded face with horsehair is that of Sitting Bull, which came from a dream by Norman Roach. 1993. Collection of the artist*

Winnebago beadworker **Elaine Buchanan Bear**, born in Wisconsin, lives today in Oklahoma. She describes her mother, Wolf Not Woman, as "strong, a woman before her time, a leader." Her parents divorced when she was six, and she was raised on the Navajo Reservation by her father, a schoolteacher employed by the Bureau of Indian Affairs. Buchanan Bear began beading at age thirteen. "I loved to dance as a teenager, but I didn't have an outfit. My aunts gave me my first one, and then I decided to make my own. I would look at pieces and take them apart to understand how they were constructed." Since childhood, she has sought instruction from elders of different tribes. "My dad would take me to the old woman who was the best basket maker; and then to another to learn the diagonal weave that was almost extinct. Still another taught me tanning." The artist studied at the Institute of American Indian Arts in Santa Fe, New Mexico, where her mentor in beadworking was Josephine Webb.

Today Buchanan Bear creates customized outfits (455, 456) and credits much of her success to the support of her Creek husband, Philip. "If it weren't for him, there's no way that I could do this. Beadwork is in my heart. . . . I'm eager to carry on by teaching the tradition." The artist's daughter, Rain Buchanan Bear, also dances and beads, and has been ceremonially "feathered."

1217 *Elaine Buchanan Bear's handmade double-knit Indian doll wears traditional dance regalia, including a beaded buckskin dress, porcupine-quill breastplate, and medicine-wheel hair ties, and holds a dance fan. 1995. Height, 11½" (29.2 cm). Private collection*

1218 *Elaine Buchanan Bear in her traditional beaded regalia, 1996. The eagle was beaded by her friend Paul LaRose (Northern Ute/Shoshone-Bannock, see page 341).*

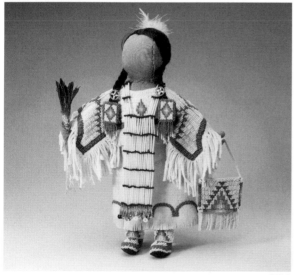

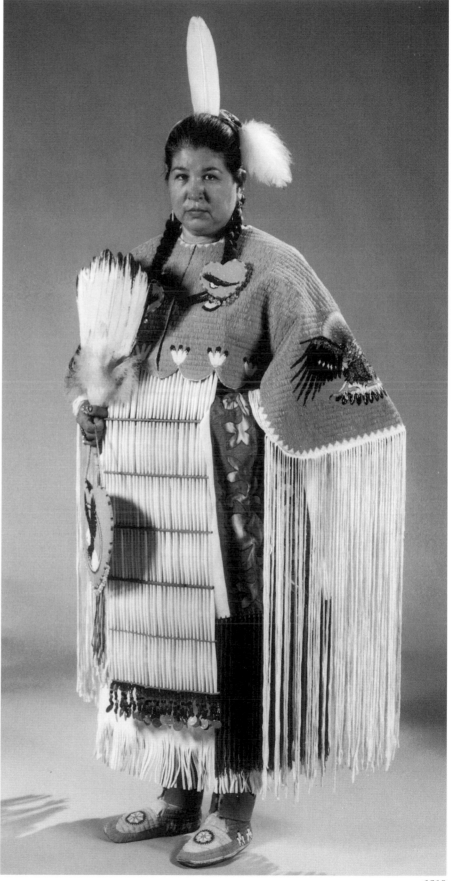

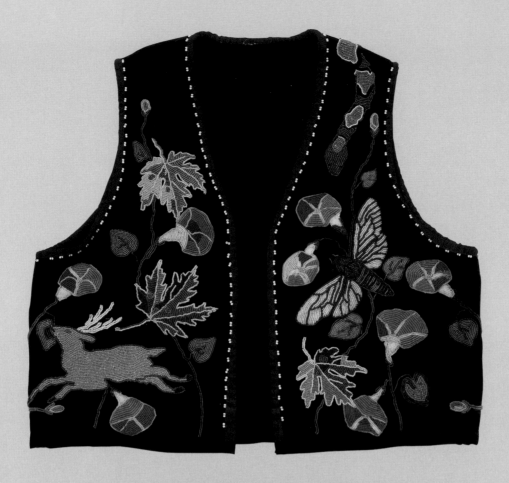

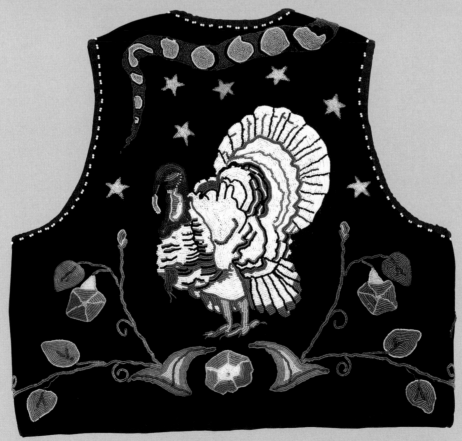

1219 *Beaded biographical vest by Delaware beader and artist Joe Baker (a member of the White Turkey Clan). 1996. Length, 22"* *(55.9 cm). Collection of the artist*

The following letter from Delaware beadworker and painter Joe Baker (see opposite and 355), eloquently expresses what *North American Indian Jewelry and Adornment* has tried to convey:

July 11, 1996

Dear Lois:

I have a bit of a lull before I head for San Antonio and the Fall Semester. I am excited to share with you that I have begun another bag. And of course, as it unfolds, I find it beautiful. Lots of blue happening. . . . I'm sending along some thoughts I have had regarding beading.

Creation requires sacrifice. As I start this bag I am aware of the fact that obligations and to some extent responsibilities will be set aside for approximately one year. I will need to go inward and be open to the possibilities of that space. As I sit and pull the loaded needle through trade cloth, I am almost always home. Home in the sense that this quiet time allows me to think of family, friends, the Old Ones. Childhood memories, red cedar groves, and the taste of corn soup. Memories containing all the sweetness and bitterness of experience, held in place by an invisible thread. Like a string of beads connected by a single thread.

Mother made all my dance clothes. The items seemed always in process . . . feathers being tied and re-configured, new colors added, re-directions and last minute repairs. The treadle sewing machine hummed forward into early morning in advance of a powwow. The ironing board seemed never to be put away, it stood in constant readiness. This making was a part of daily life, it happened while fried potatoes sizzled in iron skillets in the kitchen and Saturday night pitch games formed around the dining room table. Art making was a tangible force, one that could be tasted, understood. A force that lived, as we lived in our way, season to season. These early experiences shaped my understanding of Art.

I marvel at the spirit of beadwork. People touch the cool tactile surface and smile. Seldom do they speak. I feel there is great beauty in this fact. Sometimes a bag will be passed from one to another being cradled in two hands, much like you would pass a cherished child to another to hold. Smiles wash over faces and for that moment there is a direct link to that which is sacred.

My thoughts as I move along this day. Hope all is well for you and your good efforts regarding your book. We will stay in touch.

Best regards,
Joe

NOTES

PRINCIPAL MAP SOURCES

General: Tribal territories, archaeological sites, material sources, and trade routes from *Handbook of North American Indians* series, Taylor and Sturtevant 1992; Ball 1941, plate 4; Hughes and Bennyhoff 1986, 238; Swagerty 1988, 352; Thomas 1994; Walman 1985.

Cultural Areas, c. 1580–1815: Buffalo Bill Historical Center exhibition information; Dickason 1992, 64–65; Fagan 1987; Fagan 1995; Josephy 1991, 56.

Arctic: Fitzhugh and Crowell 1988; Snow 1980.

Subarctic: Bebbington 1982, fig. 1; Dickason 1992, 77.

Woodlands: Brose, Brown, and Penney 1985; Fagan 1995; Hudson 1976; Swanton 1946; map 13; Thomas, Miller, White, Nabakov, and Deloria 1993, 83; Tooker 1978, 419. Woodlands map 2, page 154: Drawn after the Northeast Trade Network map in *The Native Americans*, by Thomas, Miller, White, Nabakov, Deloria 1993, 158. Delaware migrations map, page 188: Drawn after Herbert C. Kraft, *The Lenape or Delaware Indians.* South Orange: Seton Hall University Museum, 1991.

Plains: Thomas, Miller, White, Nabakov, and Deloria 1993, 198, 314; Wood and Liberty, fig.1, map 14.5.

Great Basin, Plateau: Adovasio 1986, 194; Erickson 1990, 113; Thomas, Miller, White, Nabakov, and Deloria 1993, 314.

Northwest Coast: Emmons 1991; Fitzhugh and Crowell 1988; Hawthorn 1988; Holm 1989; Jonaitis 1989; Jonaitis 1991; MacDonald 1994; Vaughn and Holm 1990.

California: Fagan 1995, 254–55; Grant 1965, 73; Swagerty 1988, 352; Williams 1988, 112.

Southwest: Fagan 1995, 286; Harbottle and Weigand 1992, 84.

Indian Lands Today, Oklahoma: American Indian Digest 1995, 35, 36; Josephy 1991, 344; National Atlas of Canada, Indian and Inuit Population Distribution, 1976, map 15.2; Waldman 1985, 183, 196, 200.

PRINCIPAL SEASONAL-ROUND SOURCES

Bering Strait Eskimo: Fitzhugh and Kaplan 1982, 47–51.

Teetl'it Gwich'in: Betty Vittrekwa, coordinator, Gwich'in Language Center, Fort McPherson, Northwest Territories.

Mohawk: Brasser 1976; Fenton 1978, 296–302.

Cherokee: Hudson 1980.

Lakota: Hassrick 1989.

Northern Shoshone-Bannock: Drusilla Gould; Shimkin 1986, 310.

Yakama: Buan and Lewis 1991, 8; Kay French; Hunn 1995.

Mainland Tlingit: Brown 1977, 235–36; Emmons, 1991.

Coastal Chumash: Grant 1978; Miller 1988; Santa Barbara Museum of Natural History, 1991.

Hopi: Kennard 1979, 554–67; Ortiz 1969, 98, 104, 116.

ENTERING THE CIRCLE

Text References
1. Woodard 1989, 48.
2. By 1821 Cherokee scholar and silversmith Sequoyah had invented a system of writing based on the Cherokee alphabet.
3. Institute of American Indian Arts Museum 1995, 9.
4. Conversation with author, 1995.
5. The writings of, and a conversation with, Dr. K. C. Chang at Harvard University in 1993 were of immense importance. I have incorporated Dr. Chang's notions regarding shamanism into the first chapter, "Forming the Circle: The First Americans." Chang has formulated a composite model of shamanism based on the ancient Chinese, some of the Tungusic and Paleo-Siberian groups, and a few of the ancient New World civilizations. In Chang 1993.
6. It has been suggested by anthropologists and prehistorians that there was widespread cultural diffusion from mainland Asia throughout the Pacific Rim. Similarities between the areas' cosmologies are too persuasive to conclude that iconography and belief systems emerged simultaneously. See in particular Chang 1986, 414–22. Also, conversations with Dr. Richard Pegg, 1993–94.
7. Conversation with author, March 1994.
8. Hudson and Underhay 1978, 132–33.
9. Lee 1983, 32.
10. Pasztory 1982, 11, 28.
11. Swinton 1993, 46.
12. The motifs, however, have also been used in nonshamanistic contexts. See plate 8.30.
13. Furst and Furst 1982, 15.
14. While simultaneity is sometimes called transformation, the terms differ. Simultaneity indicates concurrent images, one of which is visible; transformation implies a change from one state to another.
15. Furst and Furst 1982, 144.
16. Webber 1983, 64.
17. Phillips 1988, 68.
18. Whitehead 1988, 25.
19. Coe, 1976, 12.
20. Maurer in Wade 1986, 144.

Caption References
1 Vastokas 1974, 130, 137. **5** Brasser 1976, 23–24, 90; Phillips 1988, 58; Webber 1983, 64–69.

THE FIRST AMERICANS

Text References
1. Woodard 1989, 20–21.
2. Fagan 1987, 71–72.
3. Turner 1988, 114–15.
4. Dental morphology is particularly important. Crown and root traits, including the scooped-out shape on the inside of the front incisor teeth of American Indians, are highly characteristic Asian traits and are similar to those of Northern Asians. See Turner 1988, 114.
5. For Ipiutah artifacts, see Larsen and Rainey, 1948.
6. Letter to author, March 25, 1997.
7. Lee 1983, 32.
8. Thomas 1994, 24. For Paleo-Indian woven fabrics in Basin region, see Goldberg 1996.
9. Thomas 1994, 22.
10. Dickason 1992, 78.
11. Thomas 1994, 188.
12. Brasser 1976, 38.
13. Penney 1992, 36.
14. Lanford 1990, 73.
15. Brasser 1976; Alden Hayes, letter to author, October 1997.
16. Wade 1986, 33.
17. White 1995, 96.
18. Calloway 1990; Leacock and Lurie 1988; Maxine Switzler, conversation with author, January 1994; Warner 1986, 177.
19. Phillips 1990, 29, 30; Warner 1986, 177.
20. Penney 1992, 34.
21. Ibid., 34.
22. Hail 1987, 12.
23. Phillips 1990, 31–32.
24. Penney 1992, 49–50; Leacock and Lurie 1988, 435.
25. Coe 1986, 17.
26. Fagan 1995, 93–94.
27. Leacock and Lurie 1988, 448.
28. Coe 1986, 42.
29. Armand Labbé, letter to author, October 1997.
30. MacDonald 1993, 42.
31. Conversation with author, March 23, 1993.

Sidebar References
Native North American–Asian Connections: Maurer 1992, 36. *Skeletal Rib-Cage Imagery:* Pericot-Garcia, Galloway, and Lommel 1967, 316; Schuster 1951; National Museum of Man 1977, 216; Wade 1986, 243; Brown 1992, 103; Taylor and Swinton 1967, 41; Jonaitis 1986, 130–31; Ewers 1957. *Feathers:* Brown 1989, 58; *Dream Catchers:* Condit 1989, 4; Heard Museum exhibition information; Hunt 1991, 216. *Bear:* Thomas 1994, 61; Larsen 1969–70, 27–42; Ritzenthaler 1978, 756; Rockwell 1991.

Specific Caption References
8 Phillips 1984, 27; Phillips 1988, 58; Brasser 1976. **9** Hadingham 1984, 14–15; Hirschfelder 1992, 187; Alden Hayes. **10** Solstice concept: Armand Labbé. **30** Maurer 1992, 270. Another opinion of this cap was offered by Madonna Thunder Hawk: "The continual pattern shows this design to be decorative. During the reservation period, many people fell in love with Indian beadwork, mainly non-Indians, so a lot of different items were beaded that normally would not be" (3/14/94 interview). **35** Brasser 1976, 130. **39** Conn 1982. **41** Rodee and Ostler 1990, 21. **45** Carpenter 1973, 120. **65** Schuon 1990, 72. **70** University Museum Bulletin 1938, 25; Brown 1992, 48; Crazy Horse Museum exhibition information. **75** Kirk 1943–44, 118. **78** Carpenter 1973, 98–99. Xs (cross marks) are not as common in Bering Sea Eskimo art as in Dorset art. The meaning of the motif is unknown.

Sometimes crosses or circles appear to coincide with major body joints. Fitzhugh and Kaplan 1982, 250. **81** N. Scott Momaday quote, in Woodard 1991, xi.

THE ARCTIC

Text References
1. Jenness 1922, 229
2. Carpenter 1973, 20.
3. Kaplan 1983, 11.
4. Chaussonnet 1988.
5. Fienup-Riordan 1994, 51.
6. Kaplan 1983, 26; Lantis 1984, 170.
7. Carpenter 1973, 58.
8. Fitzhugh and Crowell 1988.
9. McGhee 1987, 13.
10. Burch 1993, 328.
11. Fitzhugh and Crowell 1988, 294–312.
12. Black 1991; Fitzhugh and Kaplan 1982, 244; Fitzhugh and Crowell 1988.
13. Fitzhugh and Crowell, 1988, 130.
14. Willey 1966, 422; Fitzhugh and Crowell 1988, 134–35.
15. Burch 1993, 328.
16. McMillan 1988, 250.
17. Snow 1980, 231-32.
18. Etchings made with iron-tipped tools are known from Ipiutak (c. A.D. 600) and Punuk artifacts (c. A.D. 900).
19. Fitzhugh and Crowell 1988, 300.
20. Ibid., 19.
21. Black 1991, 42–43.
22. Varied Sedna stories—primarily that of Franz Boas—have been paraphrased and combined for this version.
23. Chaussonnet 1988.
24. McGhee 1988, 11.
25. Kaplan 1983, 11; Carpenter 1973.
26. Lommel 1970, 218.
27. Fitzhugh and Crowell 1988, 129.
28. Victor-Howe 1994, 179.
29. Ibid.
30. Ibid.
31. Chaussonnet 1998, 223.
32. Driscoll 1984.
33. Fienup-Riordan 1988, 265
34. Fienup-Riordan 1994, 193, 298.
35. Ibid., 309.
36. Lowenstein 1993, 59.
37. Nelson 1899, 436, in Fitzhugh and Crowell 1988, 261.
38. Fitzhugh and Crowell 1988, 261; Schuster 1951, 17–18; Smith 1984, 352–53.
39. Black 1991, 42–44; Fitzhugh and Crowell 1988, 24.
40. Collins, de Laguna, Carpenter, and Stone 1977, 12.
41. Ibid., 12.
42. Larsen 1957, 16, in Soby 1969–70, 63.
43. Jenness 1922, 181.
44. Lowenstein 1993; Spencer 1984, 334.
45. Rainey 1947, 259.
46. Lowenstein 1993, 103; Murdoch 1892, 434–37.
47. Murdoch 1892, 437.
48. Egede 1925, 354, in Soby 1969–70, 50.
49. Victor 1992, 72.
50. Spencer 1984, 333–34.
51. Victor 1992, 74–75.
52. Driscoll 1988, 190–91.
53. Lowenstein 1993.
54. Jordan and Kaplan 1980, 42.
55. Fitzhugh and Crowell 1988, 235–38.
56. Stricker and Alookee 1988, 36.
57. Fitzhugh and Crowell 1988, 301.
58. Francis 1988, 341.
59. Brower 1942, 32–33.
60. Ray 1981, 72; 1977, 56–58; 1961, 109.
61. Mitchell 1993, 343–45.
62. Eber 1993, 426; Routledge and Hessel 1993, 474.
63. Ray 1961, 27.
64. Eber 1993, 432.
65. Goetz 1993, 378–79.

Sidebar References
Walrus-Man and Labrets: Fitzhugh and Kaplan 1982, 144–46, 186; Fitzhugh and Crowell 1988, 120, 135; Murdoch 1892, 143–47; Nelson 1899, 45. *Hunting Hats:* Black 1991. *Arctic Shamans:* Fitzhugh and Crowell 1988, 128. *Shaman Helpers:* Rasmussen 1921–24, 59. *The Parka:* Driscoll 1988. *Tattooing, Glass Beadwork, and the Parka:* Driscoll 1984, 44–45, 47. *The Ulu:* Snow 1980, 222; Murdoch 1892, 161–62. *Ookpik Pitsiulak:* Leroux, Jackson, and Freeman 1994, 189–95. *Thomassie Kudluk:* Craig 1981, 324. *Dolls:* Fitzhugh and Kaplan 1982, 153; Strickler and Alookee 1988; Jones 1982.

Caption References
The major source of caption information is from the following: Damas 1984; Driscoll 1988; Fienup-Riordan 1988, 1994; Fitzhugh 1988; Fitzhugh and Crowell 1988; Fitzhugh and Kaplan 1982; Hall, Oakes, and Webster 1994; Jordan and Kaplan 1992; Kaplan 1983; Karklins 1992; Nelson 1899; Peabody Museum Harvard University exhibition information; Jack Bryan, personal conversations.

Specific Caption References
92 Black 1991. **106** Fitzhugh and Crowell 1988, 99, 244. **108** Kaplan 1983, 14. **113** Driscoll 1988, 192–93. **126** A letter from Dr. Frederick J. Dockstader to Jack Bryan dated March 9, 1995, identified the mask's Third Reich provenance. **178, 179, 180, 181** Leroux, Jackson, and Freeman 1994, 118 20. **182** D'Anglure 1984, 495–96. **186** Fitzhugh and Crowell 1988, 249.

THE SUBARCTIC

Text References
1. Rutherford 1939, 23.
2. Fagan 1995, 190.
3. Thompson 1994, 17–18.
4. Fagan 1995, 189–90; McMillan 1988, 33–35.
5. McMillan 1988, 35–36.
6. Brasser 1976, introduction.
7. Brasser 1976, 17.
8. Whitehead 1988, 27–28.
9. Turner 1955, 71. Much earlier is the find from Lovelock Cave, Nevada, in which porcupine quillwork was used as a bonding element in a wrapped-twine process. The radiocarbon date of material at the level of discovery is 531 B.C.
10. Osgood 1932, 65; Brasser 1976, 18a.
11. Thompson 1994, 5.
12. Tepper 1994, 62.
13. Thompson 1988, 155.
14. Ibid., 147.
15. Phillips 1988, 78, 79, 83; Osgood 1976, 53, 95.
16. Taylor and Sturtevant 1992, 193.
17. Phillips 1988, 85–86.
18. Osgood 1976, 175.
19. Emmons 1911, 113.
20. Whitehead 1988, 23.
21. Brasser 1976, 24; Burnham 1992; Phillips 1988, 27, 79.
22. Honigmann 1981, 222; Osgood 1976, 175; Thompson 1994, 35–36.
23. Thompson 1994, 34–35.
24. Light 1972, 3, 6, 7.
25. Thompson 1988, 146.
26. Teit 1956, 100.
27. Fitzhugh and Kaplan 1982, 68.
28. Duncan and Carney 1988, 39; Slobodin 1981, 517.
29. Phillips 1988, 77–78.
30. Krech III 1981, 47.
31. Phillips 1988, 79.
32. Chaussonnet 1995, 19.
33. Ray 1974, 65.
34. Krech III 1984, 112; McMillan 1988, 106, 288.
35. Cruikshank 1992, 271.
36. Ibid., 271–72.
37. Harrison 1986, 55. The Canadian Constitution of 1982 gave the Métis aboriginal status.
38. Hail and Duncan 1989, 21; McMillan 1988, 107.
39. Thompson 1994, 54; Townsend 1981, 627.
40. McMillan 1988, 107.
41. Helm, Rogers, and Smith 1981, 148.
42. Thompson 1994, 71.
43. Turner 1955, 53.
44. Brasser 1976, 38; Phillips 1988, 76–77.
45. Thompson 1994, 47, 64.
46. Brasser 1976, 40.
47. Thompson 1994, 55–56.
48. Ibid., 52, 58–59.
49. Duncan 1989; Thompson 1994.
50. Phillips 1988, 77.
51. Michael 1967, 246.
52. Krech III 1976; VanStone 1981, 28.
53. Duncan 1989; VanStone 1981, 27–28.
54. Brasser 1976, 42.
55. Hays-Gilpin and Hill 1996.
56. Speck 1927.
57. Oberholtzer 1991, 24–25.
58. Phillips 1988, 61.
59. Lyford 1982, 76.
60. Whitehead 1988, 23.
61. Thompson 1994, 108.
62. Ibid., xiv, 1313.
63. Ibid., 97.
64. Ibid., 98, 118–19.
65. Ibid., 106–7; 117.
66. Duncan and Carney 1988, 15.
67. Ibid., 42, 75; Thompson 1994, 108.

Sidebar References
Puberty Ceremonial Adornment: Duncan 1989, 72. *Spiritual Symbolism:* Thompson 1988, 142–43; Fitzhugh 1985, 103–5. *The Merging of Indigenous and European-Influenced Floral Motifs:* Richard Conn and Kate Duncan have written extensively on Native American floral styles and their diffusion. Most of the information presented in this section references to their work. See Conn 1979a, 1979b; Brasser 1976; Duncan 1989, 1991; Feest 1992; Gogol 1990; Hail and Duncan 1989. *The Métis:* Conn 1979b, 164. *Glen Simpson:* Artist's Statement, 1996.

Caption References
The major source of caption information is from the following: Brasser 1976; Coe 1986; Conn 1979b; Duncan 1989; Hail and Duncan 1989; Phillips 1988; Thompson 1988, 1994; VanStone 1988.

Specific Caption References
193 Phillips 1988, 92. **212** Burnham 1992, 11. **213**
Brasser 1976, 19. **217** Kaplan and Barsness 1986,
186; Emmons 1991, 220–21. **218** Duncan 1989,
164. **223** Duncan and Carney 1988, 64–65. **227**
Thompson 1994, 72; Duncan and Carney 1988, 69.
242 Conn 1979b, 79. **244** Conn 1979b, plate 76.
250 Author interview, Toronto, 2/17/96. **251**
Author interview, Toronto, 2/17/96. **253** Vastokas
1974, 138, 139. **254** Author interview, Toronto,
2/17/96.

THE WOODLANDS

Text References
1. Gilman 1982, 5.
2. Skinner 1911, 121; in Ritzenthaler 1978, 750.
3. Hamell 1983, in White 1995, 99–100.
4. Torrence and Hobbs 1989, 19.
5. Fagan 1995, 112, 391–92.
6. Thomas, Miller, White, Nabakov, and Deloria
 1993, 79.
7. Ibid., 80.
8. Fagan 1995, 389.
9. Penney 1985, 148.
10. Fagan 1995, 383–84.
11. Ibid., 386.
12. Hopewell is named for the Ohio farm site of
 early discoveries. Thomas 1994, 134.
13. Thomas, Miller, White, Nabakov, and Deloria
 1993, 83.
14. Wilson 1985, 48.
15. Fagan 1995, 415, 420.
16. Webb 1989, 292; Trigger 1978, 801.
17. Brown 1985, 129; Muller 1989, 13; Penney
 1985, 185.
18. Thomas 1994, 166.
19. Brown 1989, 185.
20. Fundaburke and Foreman 1957, 43.
21. Larson 1989, 139–40.
22. Thomas 1994, 170.
23. Trigger 1978, 802.
24. Thomas 1994, 134.
25. Brasser 1976, 21.
26. Jones 1939, 17.
27. Brasser 1976, 25; Penney 1985, 180; Phillips
 1988, 61.
28. Wilson 1982, 435.
29. Phillips 1988, 59, 89.
30. Torrence and Hobbs 1989, 6.
31. Maxwell 1978, 83.
32. Phillips 1988, 90.
33. Simmons 1986, 46.
34. Penney 1985, 195; Phillips 1988, 61.
35. Goddard 1978, 231.
36. Phillips 1988, 59.
37. White 1995, 102–3.
38. Penney 1985, 149.
39. Maxwell 1978, 83.
40. Fagan 1995, 388.
41. Taylor 1992, 17, 20.
42. Hudson 1976, 129.
43. Phillips 1988, 64.
44. Western Indians are similarly masked in a
 nineteenth-century Catlin painting. Fagan
 1995, 406–7.
45. Hudson 1980, 382.
46. Phillips 1988, 78–83.
47. Torrence and Hobbs 1989, 20.
48. Phillips 1988, 57, 88.
49. Johnston 1990, 80, 82.
50. Octopus bags are more recent interpretations

of ancient Great Lakes pouches. Rectangular
skin bags with tabs or fringes were made by
1720, though the first octopus bags were
acquired in southern Manitoba in the 1840s.
Wooley 1990, 35–39.
51. Phillips 1984, 26.
52. Whitehead 1992, 71.
53. Fenton 1978, 303; Goddard 1978, 218.
54. Goddard 1978, 218.
55. Morissonneau 1978, 390.
56. Whitehead 1988, 41, 45.
57. Emerson 1989, 59; Maxwell 1978, 88.
58. Emerson 1989, 81.
59. Hudson 1980, 127, 129, 164.
60. Ibid., 274–75.
61. White 1995, 484.
62. Braund 1993, 123–24.
63. Hudson 1980, 380.
64. Feest 1978, 260.
65. Mulder 1991, 7.
66. Braund 1993, 124–25.
67. Conn 1979b, 41.
68. Penney 1992, 97.
69. Conn 1979b, 42.
70. Phillips 1984, 29.
71. Phillips 1984, 26; 1988, 61.
72. Brasser 1982, in Phillips 1984, 29.
73. Phillips 1988, 80.
74. Carter 1933, in Phillips 1984, 29.

Saying and Sidebar References
Kanesatake wampum belt (p. 160): in Williams
1990, 31. *Tree story* (p. 165): in Jones 1939, 20–21.
Combs: Furst 1982, 223; Rose 1983, 20; Wray 1973;
Rochester Museum and Science Center exhibition
and 1988 brochure information. *Iroquois Maskettes:*
Furst 1982, 205; Rose 1983, 6, 7. *Wampum:* Ceci
1989, 63–76; Brasser 1982; Francis 1986, 25;
Goddard 1978, 219–20; Museum of the American
Indian, Heye Foundation exhibition information
1991; Orchard 1975; Snow 1994, 217–19. *Eastern
Native American Trade Beads:* This essay was pri-
marily researched and written by Jamey D. Allen
with some additions by Lois S. Dubin. Allen
1983–84; Fairbanks 1967, 3–21; Hamell 1983;
Harris 1982; Hayes 1983; Karklins and Sprague
1987; Ritchie 1954; Smith and Good 1982; Wray
1953, 53–63. *Micmac Beadwork and Double-Curve
Motifs:* Whitehead 1980, 42. *Cornhusk-doll story*
(p. 178): in Cole 1990, 64. *Clay:* from the American
Indian Archeological Institute's exhibition. See
Northeast Indian Quarterly (winter 1990). *Trade
Silver:* Fredrickson 1980; *One-Tone Instruments*
(p. xx): Speck 1982, 77. *The Delaware:* Grumet
1989, 26–27; Penney 1992, 114; Salomon 1982, 52;
Torrence and Hobbs 1989, 16. *Mission Santa
Catalina de Guale:* Thomas 1988. *The Mississippi
Band of Choctaw Indians:* Bordewich 1996; Ferrera
1996; Howard and Levine 1990; Mississippi Band
of Choctaws 1981; Peterson 1987; Weills 1987;
Wolfe 1987; Woods 1993. *The Cosmos and the Pouch:*
Penney 1992, 84. *Thunderbird and Hourglass
Motifs:* Phillips 1984, 27. *The Midewiwin:* Penney
1992, 49; Ritzenthaler 1978, 754. *Woodlands bead-
work quote* (p. 219): Coe 1976, 75. *Great Lakes Ribbon
Work:* Penney 1992; Phillips 1988; Whitehead 1980.

Specific Caption and Figure References
266, 269, 275 Penney 1985, 185, 194. **276** Penney
1985, 188. **278** Brown 1989, 185; Larson 1989,
139–40; Penney 1985, 188; Strong 1989, 220. **279**
Hudson 1980, 251. **280** Penney 1996, 18. **281**
Kopper 1986, 157. **284** Strong 1989, 215.

299–302, Seneca Glass Trade Beads:

299 *A–C: A.D. 1580 to 1610:* A. Four small tubular
Nueva Cadiz beads. B. Large seven-layer faceted
chevron bead. C. Nine specimens of heat-rounded
blue beads. *D–G: c. A.D. 1605 to 1625:* D. Heat-
rounded white beads, with eight heat-rounded
five-layer star beads, and two double-beads of
brick red with blue and white stripes. E. Blue seed
beads with various heat-rounded striped beads.
F. Blue seed beads. G. White, blue, and brick-red
seed beads, with ten rare "flush eye" decorated
beads, of blue glass covering a white core. *H–K:
c. A.D. 1625 to 1645:* H. Alternating blue and white
ellipsoidal-to-spheroidal beads. I. Violet seed
beads. J. Greenish blue seed beads. K. Blue, dark
blue, brick-red and yellow, and white seed beads.
L–U: c. A.D. 1640 to 1660: L. Blue and bluish seed
beads. M. White seed beads. N. Bluish seed beads.
O. Greenish blue seed beads. P. Yellow seed beads.
Q. Light blue seed beads. R. Bluish and white
seed beads. S. Yellowish, or decayed white, seed
beads. T. Tubular brick-red beads with stripes;
blue bugle beads. U. Brick-red bugle beads with
white stripes.

300 *A–E: c. A.D. 1605 to 1610:* A. (Wound?) alter-
nating dark blue and opaque white ellipsoidal
beads. B. Head-rounded beads of dark blue with
white stripes. C. Heat-rounded beads of dark blue
with white stripes, small rosetta beads, and a single
slightly twisted Nueva Cadiz bead. D. Heat-rounded
beads of dark blue with white stripes. E. Blue beads
with three tubular "straw" beads. *F–H: c. A.D. 1625
to 1645:* F. White, blue, and dark blue seed beads.
G. Black seed beads with four large three-layer
blue beads with white stripes (called Dutch cane
beads, though not necessarily made in Holland).
H. Faceted seven-layer chevron bead. *I–K: c. A.D.
1640 to 1660:* I. Predominantly striped blue, white,
or red beads. J. Translucent yellow seed beads,
with twenty specimens of wound beads imitating
corn kernels. K. Dark blue seed beads.

301 *A–C: c. A.D. 1655 to 1675:* A. Tubular brick-
red beads. A1. Similar to A, except slightly small-
er. B. Yellow tubular bugle beads with blue
stripes. C. Blue tubular bugle beads. *D–H: c. A.D.
1670 to 1687:* D. Brick-red and black heat-rounded,
and tubular brick-red beads. E. Opaque medium-
blue seed beads with a few white seed beads. F.
Black seed beads. G. Brick-red seed beads. H.
Yellow seed beads. *I–L: c. A.D. 1710 to 1745:* I.
Spheroidal wound beads of slightly opalized
translucent glass. J. Faceted black and/or blue,
with wound white beads; eight specimens of
"man-in-the-moon" beads of wound and pressed
construction. K. Spheroidal translucent brownish
yellow wound beads. L. Four ellipsoidal translu-
cent blue beads. *M–O: c. A.D. 1745 to 1779:* M.
Dark blue and white seed beads. N. Tubular dark
blue short bugle beads. N1. Tubular dark blue
short bugle beads. O. White seed beads.

302 *A–C: c. A.D. 1655 to 1675:* A. Monochrome
and polychrome beads, including large seven-
layer chevron bead and several other rosetta
beads. B. Opaque brick-red heat-rounded beads.
C. Opaque black heat-rounded beads. *D–H: c. A.D.
1670 to 1687:* D. Opaque white spheroid wound
necklace beads. E. Opaque brick-red and black
heat-rounded beads. F. Dark blue heat-rounded
beads. G. Opaque green and brick-red heat-rounded

beads. H. Opaque brick-red heat-rounded beads. *I–L: c. A.D. 1710 to 1779:* I. Alternating translucent blue and yellow wound, faceted necklace beads. J. Translucent brownish faceted "pentagon" necklace beads. K. Seed beads, predominantly opaque yellow and dark blue. L. Remarkably tiny opaque blue seed beads. *M–Q: c. A.D. 1775 to 1820:* M. Green seed beads. N. Dark blue seed beads alternating with blue bugle beads. O. Opaque white seed beads. P. Dark blue seed beads. Q. Dark blue seed beads.

307 Peabody Museum exhibition information. **308** Conn 1979b, 56. **313** Conn 1979b, 66; Whitehead 1980, 1992, 73. **318** Mogelon 1994, 43. **321** Duncan 1991, 195; Wright 1991, 72. **326** Bruchac and Landau 1993, 100. **344** Furst 1982, 206. **356** Archival notes at the Denver Art Museum. **367** Listed at the museum as Delaware, but according to Ralph Stegner, probably Creek. **369** Waselkov 1989. **371** Waselkov 1989. **381** Penney 1985, 189. **383** Agard-Smith 1993. **384** Hudson 1980, 386. **399** Catlin 1973, vol. 2. **418** Coe 1986. **422** Flint Museum catalogue, xxxvii; Wilson 1982, 433. **423** Phillips 1984, 49. **424** Lurie 1989, 71; Lurie 1989, 71. **427** Wilson 1982, 431. **431** A technique known as "spaced alternative-pair weft twining" creates a warp-faced design by alternating nettle fiber and buffalo wool warps from interior to exterior. Twined bags made by Indians of the Great Lakes represent a weaving tradition that flourished perhaps as early as 5000 B.C., spread over most of North America, and is now practically extinct. Twined weaving is known from Danger Cave, Utah, dating from 5000 to 3000 B.C. At Salts Cave, Kentucky, c. 1200 to 250 B.C., inhabitants used Indian hemp, cattail and rush fibers, and the inner bark of basswood trees to fabricate bags, loincloths, belts, shoes or slippers, and possibly blankets. Moundville and Etowah provide many evidences of cloth fabricated by open-spaced alternate-pair weft twining (twill twining). Penney 1992, 84; Whiteford 1977, 61. **436** Feder 1965. **437** Penney 1992, 69. **439** Lenz 1986. **441** Penney 1992, 114. **447** Torrence and Hobbs 1989, 15. **449** Torrence and Hobbs 1989, 15. **451** American Museum of Natural History archival records. **464** Maxwell 1978, 148; Torrence and Hobbs 1989, 19. **470** Waselkov 1989.

THE PLAINS

Text References
1. Pavesic and Studebaker 1993.
2. Hassrick 1964, 174.
3. Merritt 1988, 46.
4. Brown 1992, 59; Conn 1986, 18–19.
5. McHugh 1972, 15.
6. Wedel 1986, 75; Wilmsen and Roberts 1978; Wood and Liberty 1980, 29–30, 40, 107.
7. Wood and Liberty 1980; Maurer 1992.
8. Wood and Liberty 1980, 259–60, 262.
9. Buffalo Bill Historical Center exhibition information; Karklins 1992, 228–29; Hassrick 1964, 228.
10. In Bebbington 1982, 18.
11. Densmore 1918, in Galante 1980, 69.
12. All George Reed comments are in a letter to the author dated 11/2/97.
13. Brown 1989, 45; Keyser 1992, 33–34.
14. Goodman 1990; Taylor 1994; Von del Chamberlain 1982.
15. Goodman 1990, pages I–III, 15, 19.
16. Von del Chamberlain 1982, 11–12, 95, 114, 142, 247.
17. Conn 1982, 8.
18. Lanford 1990, 76.
19. Schuon 1990, 71, 73; Taylor 1994, 41.
20. Brown 1989, 6; Schuon 1990; Taylor 1994, 57.
21. Brown 1992, 113.
22. "The 'red road' is that which runs north and south and is the good or straight way, for to the Sioux, the north is purity and the south is the source of life. This red road is thus similar to the Christian 'straight and narrow way.' It is the vertical of the cross" (Brown 1989, 7).
23. Wissler 1907, 42–43.
24. Brown 1989, 123.
25. Lyford 1982, 85.
26. Taylor 1994, 37.
27. Ibid., 37; Wissler 1912, 41.
28. Brown 1992, 103.
29. George Reed, letter to author, 11/2/97.
30. Tepper 1994, 62.
31. Merritt 1988, 43–44.
32. Ibid., 42–43.
33. Hassrick 1964, 96–97.
34. Ibid., 86.
35. Kennard Real Bird, conversation with author, 4/13/94.
36. Taylor 1994, 15; Wissler 1907, 30–31.
37. Mullaney 1991, 31.
38. George Reed, letter to author, 11/2/97.
39. Standing Bear 1988, 61–62.
40. Ute Museum exhibition information.
41. Brown 1992, 106; Maurer 1992, 16–19; Schuon 1990, 94–98.
42. Schuon 1990, 122.
43. Brown 1989, 68.
44. Ibid., 68.
45. Brown 1989, 85.
46. Maurer 1992, 36.
47. Erickson 1976, 20–21; Wissler 1907, 38.
48. Bebbington 1982, 6.
49. Ibid., 16.
50. Ibid., 16.
51. Wood and Liberty 1980, 205.
52. Bebbington 1982, 7, 10.
53. Wood and Liberty 1980, 204.
54. Brasser 1972, 58; Lanford 1990, 79.
55. Ewers 1945, 36; Lanford 1990, 74. Upper Missouri men had tattooed arms and chests showing strips with geometric patterns extending from the base of the arm to the sternum. Diamond, triangle, and hourglass designs on painted parfleche bags are identical to geometric motifs seen in later Plains beadwork.
56. Lanford 1990, 76.
57. Hail 1988, 63–64. "One style incorporates mixed floral and geometrics in many colors (especially pink, yellow, light blue, and mauve) and is outlined in white. The beading is executed in contoured rows of overlaid stitches. Long stems connecting floral elements are often two rows wide, with one row white and one black. Another style is characterized by linear beading: straight rows of lazy stitch in semifloral patterns, not outlined; often there are narrow pointed leaves. Both of these styles are dated 1860s from the Upper Missouri area. Also common are many beaded lozenge shapes, rosettes, and double curves."
58. Lessard 1990. This beadwork division is based upon Lessard's concept regarding Plains art areas. It is most helpful from about 1860 to 1910, the period of prolific artistic production and readily identifiable tribal characteristics.
59. Lessard 1990, 38–40.
60. Lessard 1980, 57.
61. Maurer 1992, 35.
62. Wood and Liberty 1980, 207. Even in past situations where a design could be copied, such as for ritual regalia, the times it was repeated was limited to a specific number, often four.
63. Conversation with author, March 1993.
64. Ewing 1982, 18.

Saying and Sidebar References
Medicine Necklaces: Taylor 1994, 15; Wissler 1912, 91–92. *Sage quote* (p. 265): Written by Sidney Keith specifically for this book, September 1993. *The Parfleche:* Torrence 1994. *Maintaining Ancient Traditions:* Author interview, August 1993. *Children, Babies, and Doll Carriers:* Hill and Hill 1994, 23. *Umbilical Amulets:* Maurer 1992, Rosalie Little Thunder. *The Elk-Tooth Dress:* Hail 1988, 90, 94. *Plains Metalwork:* Ellison 1976. *The Peyote Cult and the Native American Church:* Ellison 1976, Laverna Capes interview. *Julius and Bruce Caesar* (page 296): Author interview with Bruce Caesar, June 1994. *Oklahoma Arts and Crafts Cooperative:* Author interviews, June 1994.

Caption and Figure References
The major source of caption information is: Brasser 1976, 1982; Brown 1989; Conn 1972, 1979b, 1982, 1986; Ellison 1976, 1978; Feder 1984; Hail 1988; Maurer 1992; Lynn Burnette Jr. (Lakota) interviews: Rosalie Little Thunder, March 1994; James Oldman, Sr., February 2, 1994; Madonna Thunder Hawk, March 1994. Author interviews: Rosalie Little Thunder, July 1993; Clarence Rockboy, July 1992; Nelda Schrupp, June 1995; Tim Whirlwind Soldier, July 1992; Mitchell Zephier, July 1993.

Specific Caption and Figure References
481 Wissler 1912. **484** Kroeber 1983, 440. **486** Kroeber 1983, 440. **488** Kroeber 1983; Maurer 1993, 174. James Oldman, Sr. believes the bells were probably placed for their sound, not hail. **489** Kroeber 1983, 428–33. **490** Kroeber 1983, 428–33. **491** Lowie 1983, 274, 286. **492** Wissler 1912. **493** Wissler 1912. **496** Mitchell Zephier to author, January 1993. **504** Madonna Thunder Hawk believes it was not a toy but "decorative— the platform gives it away." **505** Information from Mary Inkanish, Cheyenne elder. Conn 1979b, 139. **516** Brown 1989, 92. **517** Hassrick 1989, 162. **527** Rosalie Little Thunder. **540** Brown 1992, 68; Maurer 1992, 132, 133; Taylor 1994, 41; Wissler 1907, 46–47. **541, 542** Madonna Thunder Hawk (Lakota) believes the hide was used for something else and then turned into leggings. "The drawings are from an individual's vision quest. Anything received from a vision is considered very powerful and treated with more respect. Long ago, the people would not wear their fringe straight. It wasn't our way to be wasteful and cut excess fringe off to make it look good. Our fringe was made for a reason—water shed, not looks. The cuts would follow the contour of the hide." Madonna Thunder Hawk to Lynn Burnette, Jr., March 1994. **558** Hail 1988, 43; Taylor 1994, 48–61. **559** Hail 1988, 44, 71; Wissler 1907, 38. **560** Hail 1988, 44, 71; Wissler 1907, 38. **561, 568** Hail 1988, 68. **562** Hail 1988, 68; Hassrick 1989, 26; Porsche 1987, 89. **563** Coe 1986, 142. **564** Feder 1984. **580** Densmore

1992, 176. **585** Brown 1992, 49; Hassrick 1989, 227. Rosalie Little Thunder: "The old people used to tell me that the dragonfly represented swiftness and agility. The web most likely represents Iktomi, the Lakota trickster." **597** Maurer 1993, 61. **611** Porsche 1987, 55. **630** Author interview, July 1993. **634** Southern Plains Indian Museum 1992.

THE GREAT BASIN

Text References
1. Drusilla Gould, author interview, May 4, 1984.
2. Shimkin 1986, 317.
3. Murphy and Murphy 1986, 284.
4. Hughes and Bennyhoff 1986.
5. Ibid., 1986, 240.
6. Malouf and Findlay 1986, 501.
7. Fowler and Liljeblad 1986, 444.
8. Maxwell 1978, 252.
9. Fowler and Liljeblad 1986, 449.
10. Maxwell 1978, 255.
11. Maxwell 1978, 255; Pettit 1990, 47; Tepper 1994, 44.
12. Fowler and Dawson 1986, 705; Fowler and Liljeblad 1986, 445; Kelly and Fowler 1986, 373.
13. Kelly and Fowler 1986, 375.
14. Pavesic and Studebaker 1993, 56.
15. Hughes and Bennyhoff 1986, 240.
16. Tepper 1994, 14.
17. DNA technology has confirmed this early date at Nevada State Museum. Goldberg 1996.
18. Adovasio 1986, 199.
19. Ibid., 196.
20. Flint 1973, xxxi.
21. Liljeblad 1986, 643.
22. D'Azevedo 1986, 486; Fowler and Liljeblad 1986, 449–50.
23. Author interview, August 1994.
24. Murphy and Murphy 1986, 296.
25. Ute Museum exhibition information; Pettit 1990, 93.
26. Pavesic and Studebaker 1993, 53.
27. Ibid., 55.
28. Author interview, January 27, 1996.
29. Pavesic and Studebaker 1993, 5–8, 28–29, 42–45.
30. Ibid., 45, 56–57.
31. Ibid., 57–58.
32. Author interview, March 1994.
33. Conn 1986, 24.

Sidebar and Saying References
Fremont bracelet (p. 317): Williams 1994, 142. *The Goulds:* Drusilla Gould, May and August 1994. *Chief Ouray and Chipeta Ouray:* Ute Museum exhibition information; Pettit 1990, 116, 126.

Caption References
The major source of caption information is author interviews at Fort Hall, Idaho, during May and August 1994 with Joyce Ballard, Eva Broncho, Weldon Broncho, Drusilla Gould, Delphina Gould, Rusty Houtz, Clinton Houtz, Edgar Jackson, and Truma Davis; author interview with Paul Manning La Rose, September 1995; Lynn Burnette, Jr. interviews with Eva McAdams and James Oldman Sr., February 1994.

Specific Caption References
644 Thomas 1994, 51–57; Thomas 1985, 232. **645** Mehringer 1986, 31; Tuohy 1986, 234. **653** Hausman 1992, 1–2. **657** Conn 1979b, 234. **658** Kelly and Fowler 1986, 375.

THE PLATEAU

Text References
1. Ackerman 1996, 38.
2. Schlick 1994, 8.
3. Teit 1900, 222. Anthropologist Kevin Erickson points out that Teit explicitly says "with" rather than "instead of." Erickson 1990, 98.
4. Schlick 1994, 34.
5. Haines 1991, 155.
6. Conn 1972, 24.
7. Ackerman 1996, 14.
8. Schlick 1994, 53.
9. Tepper 1994, 3.
10. Schlick and Duncan 1991, 37.
11. Keyser 1992, 28.
12. Erickson 1990.
13. Tepper 1994, 44–45.
14. Conn 1996, 73; McMillan 1988, 159; Tepper 1994, 48–49.
15. Haines 1991, 159–60.
16. Keyser 1992, 77; Teit 1900, 310–11.
17. Teit 1900, 311–17.
18. Ibid., 317–21.
19. Erickson 1990, 102.
20. Museum at Warm Springs exhibit information, March 1994.
21. Wright 1991, 91.
22. Museum at Warm Springs exhibit information, March 1994.
23. Loeb 1995, 9.
24. Spier and Sapir 1930, 270; Spinden 1908, 252. Both in Erickson 1990, 100, 102.
25. Teit 1900, 336.
26. Ibid., 329.
27. Hunn 1995, 263.
28. Teit 1900, 333–34.
29. Schlick 1994, 90.
30. Erickson 1990.
31. Ibid., 130.
32. Keyser 1992, 28; Tepper 1994, 12.
33. Erickson 1990, 109; Haines 1991, 160; Keyser 1992, 32.
34. Loeb 1995, 10–11.
35. DeVoto 1953, in Gogol 1990, 30.
36. Duncan 1996; Gogol 1990, 30.
37. Ackerman 1996.
38. Schlick 1994.
39. Wright 1991, 89.
40. Ackerman 1996, 57.
41. Wright 1991, 182.
42. Miller 1991, 184.
43. Author interview, 3/4/94.
44. Schlick 1994, 19.
45. Miller 1996, 50.
46. Gogol 1990, 33.
47. Duncan 1991, 195.
48. Gogol 1990, 33.
49. Ibid., 31.
50. Duncan 1991, 189.
51. Author interview with Charlotte Shike, 3/4/94. Michael Hammond added: "It's called 'down the line trade,' meaning that those people who are furthest from the source do not get the prime material and in many cases don't even know what the source is. Group A trades with B, B with C, C with D, but D never trades with A."
52. Duncan 1996, 115.
53. Gogol 1990, 31.
54. Loeb 1991, 201; Duncan 1993, 58, 61, in Loeb 1995, 11.
55. Pankonin 1993, 16.
56. Wright 1991, 39.
57. Ackerman 1996, 86.
58. Ibid., 132.
59. Thomas 1994, 235; Museum at Warm Springs.
60. Author interview, March 1994.
61. Letter from Michael Hammond, 11/13/96.

Sidebar and Saying References
NLaka'pamux Clothing Traditions: Teit 1900; Tepper 1994. *Ant and the beads* (p. 359): Teit 1912, 392. *Twined Basket Hats:* Schlick 1994, 9–10, 32; Wright 1991. *Leander George* (p. 371): Author interview with Delores and Leander George in February 1994, a year prior to Mr. George's death. *Warm Springs:* Author interviews in February and March, 1994.

Caption References
The major source of caption information is author interviews conducted at Warm Springs Reservation in March 1994 with Adelaine Miller, Charlotte Shike, Ilene Spino, Maxine Switzler, and Emily Waheneka.

Specific Caption References
720 Duncan 1991, 35; Schlick and Duncan 1991, 39. **721** Wright 1991, 75. Tsagigla'lal was a death cult guardian spirit used by shamans near The Dalles in their attempts to cure epidemics of smallpox and other diseases that killed much of the resident Indian population between A.D. 1700 and 1840. Keyser 1992, 124. **726** Tepper 1994, 63–65. **730** Teit's notes, no. 320, Peabody Museum of Archaeology and Ethnology; Tepper 1994, 121. **731** Tepper 1987. **732** Tepper 1987. **740** Duncan 1991, 192; Millstein 1991, 117. **743** Miller 1996, 50. **748** Keyser 1992. **752** Schlick 1993, 19. **755** Thompson 1988, 149. **756** United States Department of the Interior and Indian Arts and Crafts Board brochure 1989. Letter to author, 3/6/98. **769** Lessard 1980, 61; Loeb 1991, 201. **770** Tepper 1987. **771** Burnham in Tepper 1994.

THE NORTHWEST COAST

Text References
1. Conversation with author, 3/20/97.
2. Furst and Furst 1982, 104.
3. Holm 1974, 18.
4. Holm and Reid 1975, 35.
5. McMillan 1995, 188; Reid 1988, 204.
6. MacDonald 1994, 4.
7. McMillan 1995, 189.
8. Ibid., 191.
9. Fitzhugh and Crowell 1988, 138; McMillan 1995, 192.
10. Ibid., 192.
11. Coe 1972, 85; Covarrubias 1954.
12. Furst and Furst 1982, 130; McMillan 1995, 199.
13. McMillan 1995, 199; Ruddell 1995, 48; Stewart 1984, 18.
14. Furst and Furst 1982, 100; Hawthorn 1988, 5, 20.
15. Bancroft-Hunt and Forman 1988, 37; Coe 1977, 125; de Laguna 1988a, 61.
16. Robert Bringhurst, letter to author, 4/26/98.
17. Josephy 1991, 78; McMillan 1995, 202.
18. McMillan 1995, 211.
19. Emmons and de Laguna 1991, 173, 243–44, 315.
20. Josephy 1991, 78; Suttles 1990a, 12.
21. Robert Bringhurst, letter to author, 4/26/98.
22. Reid 1988, 235–36.
23. Robert Bringhurst at Bill Reid's memorial service, March 1998; Bringhurst and Steltzer 1992, 16.
24. Wardwell 1996, 283.

25. Reid 1988, 235.
26. Martine Reid (1988, 218) suggests a cosmic realm division of Sky (above), Land (nearby), Ocean (below), and Underworld (underneath).
27. MacDonald 1994, 3.
28. Ibid., 3; Averill and Morris 1995, xxx.
29. Wardwell 1996.
30. Ibid., 17, 40.
31. De Laguna 1988a, 62.
32. Furst and Furst 1982, 103–4.
33. De Laguna 1988a, 62.
34. Holm 1990, 609.
35. Jonaitis 1978, 64, 66.
36. Wardwell 1996, 75.
37. Furst and Furst 1982, 100; Lévi-Strauss 1988.
38. De Laguna 1988b, 275, 277; Furst and Furst 1982, 100; Macnair, Hoover, and Neary 1984, 27.
39. De Laguna 1988b, 277.
40. Reid 1988, 220, 222.
41. Shadbolt 1986, 67.
42. Ibid., 68.
43. Furst and Furst 1982, 98.
44. Ibid., 98.
45. Vastokas 1973.
46. Ruddell 1995, 24.
47. Shadbolt 1986, 69.
48. Reid 1988, 218.
49. For differences in Northern and Southern art, see Averill and Morris 1995, xxxvi; Reid 1988.
50. Author interview, 3/10/94.
51. De Laguna 1988, 271.
52. Stewart 1993, 17.
53. Sheehan 1995, 92.
54. Josephy 1991, 78.
55. Suttles 1990b, 470.
56. Josephy 1991, 79.
57. Vastokas 1974, 147–48.
58. Sheehan 1995, 100.
59. Coe 1972, 89.
60. Shadbolt 1986, 70.
61. Thom 1993, 8.
62. Macnair, Hoover, and Neary 1984, 69.
63. Holm 1990, 630–32; Macnair, Hoover, and Neary 1984, 77.
64. Halpin 1979, 3.
65. Steltzer 1984, 1.
66. Jill Baird, author interview, 3/9/94.
67. Steltzer 1984, 23.
68. Author interview, 3/11/94.
69. Shadbolt 1986, 84, 86.
70. Ibid., 83, 86, 88, 92.
71. Reid 1993, 74–76.
72. Thom 1993, 3, 23.

Sidebar References
Cedar: Steltzer 1994, 112; Stewart 1984, 113. *Haida Origin Story:* Based upon Bill Reid's version of the story in *Museum Notes*, no. 8, University of British Columbia, Museum of Anthropology, 1980. Published with permission from the University of British Columbia, Museum of Anthropology. *Frontlets:* Furst and Furst 1982, 102. *Shaman Amulets:* Bancroft-Hunt and Forman 1988, 81; Jonaitis 1978, 62, 64; Ruddell 1995, 27; Wardwell 1996, 9, 20, 71. *Winter Ceremonials:* Furst and Furst 1982, 101; Hawthorn 1988, 29; Macnair, Hoover, and Neary 1984, 94–103; Sheehan 1995, 98; Bringhurst, letter to author, 4/26/98. *The Ceremonial Copper:* Averill and Morris 1995, xxxiii; De Laguna 1988a, 61, 175; Hawthorn 1988, 35; Jopling 1989, 16, 20, 41, 43. *Hats:* Furst and Furst 1982, 102; Kiva New 1994, 46; Vaughan and Holm 1990, 37. *Mabel Stanley* (p. 408): Alana Stanley and

Deborah Tuyttens. *Robert Davidson:* Thom 1993; quotes from the audiotape accompaniment to the "Eagle of the Dawn" exhibition, Vancouver Art Gallery, 1993. *Bracelets:* De Laguna 1991, 254. *Bill Reid* (pp. 414–16): Bringhurst and Steltzer 1992, 31, 42, 61, 77, 79; Jones 1987, 123; Reid and Bringhurst 1988; Shadbolt 1986, 94; Barbara Shumiatcher, letter to author, 4/14/98; Vancouver Art Gallery 1994. *Don Yeomans:* author interviews, 3/10/94, 3/20/97. *Lyle Wilson:* author interview, 3/19/94.

Caption References
773 Robert Bringhurst, letter to author, 4/26/98; Furst and Furst 1982, 97–98; Vastokas 1974, 147–48. **774** Interview with author, 3/10/94. **787** Jones 1987, 115. **788, 789, 798** Wardwell 1996, 43, 180, 197 **790** Hawthorn 1988, 124. **793** Macnair 1974, 186. **794** Hawthorn 1988, 29; Wyatt 1994, 7. **796** Wardwell 1996, 88. **801** Wardwell 1996, 54. **802** Wardwell 1996, 8. **804** Jopling 1989, 7. **807** Zimmerman 1996, 105. **808** Averill and Morris 1995, xxx. **809, 811, 812** Macnair 1974, 103, 107–8. **822** De Laguna 1972, 666. **824, 825, 826** De Laguna 1972, 464, 636–37. **832** Robert Bringhurst, letter to author, 4/26/98. **859** Reid 1993, 87; Shadbolt 1986, 425. **864** Bringhurst and Steltzer 1992, 55–56; Shadbolt 1986, 51. **873** Garfunkel 1992.

CALIFORNIA

Text References
1. Letter to author, December 1997.
2. Heffner 1996.
3. Shipley 1978, 80–90.
4. Thompson 1991, 280–81.
5. Downs 1988, 292; Heizer and Elsasser 1980, 203.
6. Heizer 1978, 649.
7. Fagan 1995, 222.
8. Wallace 1978, 28, 31–34.
9. Josephy 1991, 140; Snow 1980, 164.
10. Hudson and Blackburn 1985, 38, 46; Miller 1988, 91–92.
11. Elsasser 1978, 638.
12. Kroeber 1976, 76.
13. Hudson and Blackburn 1985, 18; McLendon and Lowy 1978, 310; Miller 1988, 91, 93.
14. Fagan 1995, 248; Santa Barbara Museum of Natural History Docent Project 1991, 31.
15. Gibson 1991, 43–44; Kroeber 1976, 249.
16. Latta 1949, 274–75, in Grant 1965, 73.
17. In 1792 the Spanish naturalist José Longinos Martine wrote of the popularity of glass trade beads in southern California. In Simpson 1961, 55.
18. Greenwood 1978, 521, 523.
19. Cook 1978, 91.
20. Bean and Vane 1978, 662.
21. Ibid., 663; Kroeber 1976, 105.
22. Heizer 1978, 297.
23. Grant 1978, 517; Garbarino 1985, 194.
24. Denver Art Museum exhibition information.
25. Hirschfelder and Molin 1992, 188–89.
26. Thompson 1991, 68.
27. Lang 1994, 7.
28. Letter to author, December 1997.
29. Lang 1994, 5; Margolin 1994, 9.
30. Lang 1994, 7.
31. Kroeber 1976, 15–16.
32. Bell 1991, 83.
33. Kroeber 1976, 29.
34. Bell 1991, 49–51; Wallace 1978, 169.

35. Margolin 1994, 12.
36. Heffner 1996.
37. Author interview with Wilford Colegrove, 2/6/94; letter to author from Wilford Colegrove, December 1997.
38. Jacknis 1995, 19.
39. Ibid., ix, 23.
40. Ibid., 43.
41. Bates 1982, 32–33.
42. Ibid., 37, 40–44.
43. Hudson and Underhay 1978, 89.
44. Cody 1940, 132–36, in Rockwell 1991, 73.
45. Kroeber 1976, 502–3, 508.
46. Bates 1982, 38–40.
47. Kroeber 1976, 513.
48. Miller 1988, 112.
49. Ibid., 97; Hudson and Blackburn 1985, 313–23.
50. Miller 1988, 121–22.
51. Gibson 1991, 85.
52. Santa Barbara Museum of Natural History Docent Project 1991, 35.
53. Miller 1988, 93.
54. Grant 1978, 513–14.
55. Hudson and Underhay 1978, 15, 43, 146, 150.
56. Ibid., 150.
57. Ibid., 146.
58. Hudson and Blackburn 1985, 261.
59. Van Tilburg 1983, 25–27.
60. Gibson 1991, 85.
61. Kroeber 1976, 754.
62. Yeadon 1993, 76.
63. Telephone conversation with author, 12/10/96.
64. Telephone conversation with author, 5/27/98.
65. Bell 1991, 104.
66. Lang 1991, 85.
67. Letter to author, 10/7/97; author interview, 2/7/97.
68. Margolin 1994, 10.
69. Bell 1991, 96.
70. Blake 1992, 22.
71. Author interview, 2/7/94; Letter to author, 10/97.

Sidebar and Saying References
Dentalium Shell: Heizer 1978, 654; Kroeber 1976, 22–23; Lang 1994, 7; Margolin 1994, 9. *California Baskets:* Abbott 1994, 260–61; Bell 1991, 49; Billy 1994, 204; Coe 1986, 48; Elsasser 1978, 626, 634, 638–40; Furst and Furst 1982, 73, 88; Heizer 1978, 634–40; George Blake, conversation with author, 11/30/96; Santa Barbara Museum of Natural History Docent Project 1991, 49; quote (p. 440): Heffner 1996. *George Blake:* Author interview, 2/8/94; Jacknis 1995, 47; Ortiz 1995, 13.

Specific Caption References
879 Author interview with Richard McClellan, 2/7/94. **880** Kroeber 1976, 24. **889** Heizer 1978, 525. **891** Heizer 1978, 526; Kroeber 1976, 249. **896** Furst and Furst 1982, 74, 75; Matthiessen 1981, 10; Downs 1988, 298. **901** Miller 1988, 122. **904** Grant 1965, viii, 119. **908** Gould 1978, 133; Margolin 1994, 11. **909** Kroeber 1976, 136. **910** Kroeber 1976, 302. **912** Kroeber 1976, 304. **913** Letter to author, November 1997. **919** Author interview, 2/6/94. **920** Jacknis 1995, 13, 15. **921–27** Author discussions with George Blake, 1994–98.

THE SOUTHWEST

Note: All quotes are from author interviews and correspondence unless otherwise credited.

Interviews conducted 1991 through 1998 with: Jesse Lee Monongye, Lee Yazzie, Raymond Yazzie, Roland Young, Kee Joe Bennally, Terry and Joe B. Reano, Verma Nequatewa, Timothy Mowa, Chester Kahn, Edith Tsabetsaye, James Little, Clara Lovato, Manuel Hoyungowa, Karen Hoyungowa, Todd Hoyungowa, Troy Hoyungowa, Phil Loretto, Robert Rhodes, Johnny and Marlene Rosetta, Mary and Ray Rosetta, Jon Bonnell, Joe Tanner, Cindy Tanner, Lovena Ohl.

Text References
1. Josephy 1991, 27.
2. Schmidt and Thom 1994, 76.
3. Ortiz 1979, 3.
4. Labbé 1986, 78.
5. Gold 1994, 109.
6. Stevenson, M. C. 1985, 23.
7. Armand Labbé, letter to author, February 1998; Labbé 1986, 37; Voth 1905, 12.
8. Bahti 1988, 26.
9. McNeley 1981, 51; Williams 1994, 30–31.
10. Moon 1970, 180–81.
11. Claudeen, Bingham, and Bingham 1994, 2.
12. Fagan 1995, 332; Gumerman 1991, 8.
13. Alden Hayes, letter to author, 10/28/97; Wormington 1975, 42–45.
14. Ford 1983, 711.
15. Fagan 1995, 334; Thomas 1994, 109, 112.
16. Gumerman and Haury 1979, 80, 86.
17. Jernigan 1978.
18. Thompson 1994, 9–10.
19. Widdison 1991, 34–35.
20. Gold 1994, 300, endnote 24.
21. Ibid., 17–18.
22. Kelley and Francis 1994, 206–7.
23. Ford 1983, 711.
24. Baker 1989, 58–59.
25. House 1994, 101.
26. Ortiz 1972, 142.
27. Ibid., 142.
28. Waters 1963, 126.
29. "Navajo House," Bureau of American Ethnology, no. 18, in Gold 1994, 308, endnote 2.
30. Lamphere 1983, 752.
31. Campbell 1988a, 91; Kelley and Francis 1994, 115; Suzuki and Knudtson 1992, 155.
32. Labbé 1986, 53.
33. Letter to author, 6/12/97.
34. Bunzel 1932, 868.
35. Fergusson 1991, 87.
36. Hirschfelder 1995, 233.
37. La Farge 1979, 81–83.
38. Niebuhr 1995, 14.
39. Campbell 1988a, 47.
40. Jernigan 1981, 9.
41. Lister and Lister 1993, 46.
42. McNitt 1989, 56–57.
43. Brugge 1993; Jernigan 1981.
44. Zachary 1988.
45. Moore 1987, 102.
46. Kirk 1953.
47. Davies 1979, 74; Jernigan 1981, 11.
48. Ibid., 11–12.
49. Bahti 1980, 43.
50. Slaney 1992.
51. Biederman 1992, B10; Rodee and Ostler 1990, 13–14; Slaney 1992.
52. Composed and read by N. Scott Momaday, 1987.
53. Whitehead 1983, 59.
54. Author notes from funeral sermon, September 1994.
55. Baxter 1996, 39.
56. Jacka 1984.
57. Baxter 1996, 38–39.
58. Tanner 1985.

Sidebar References
Turquoise: Ball 1941, 17, 25; Harbottle and Weigland 1992; Heard Museum and Museum of Northern Arizona exhibition information; Pogue 1975, 98; Snow 1973, 46; Joe Tanner, personal conversations. *Southwestern Silverwork:* Adair 1989; Baxter 1996; Bedinger 1973; Cather 1931, 45; Ellinger 1952, 11; Frank 1990; Heard Museum and Museum of Northern Arizona exhibition information; Jacka 1995; Whiteford et al., 1989; Woodward 1975. *The Bow Guard:* Bedinger 1973; Ellsberg 1977; Alden Hayes, personal communication. *The Concha Belt:* Bahti 1980; DiNoto 1992; Heard Museum and Museum of Northern Arizona exhibition information. *The Naja:* Bedinger 1973, 75; Tanner 1982. *The Butterfly:* Erdoes & Ortiz 1984, 408; Swentzell 1989, 24. *Knife Wing God:* Cushing 1974; Millicent Rogers Museum; *Zuñi Fetishes:* Wilson 1982, 441. *Pueblo Dance Saying* (p. 512): Da 1979, xix. *Katsinas:* "'Wenimats' is a Keres word, and the katsina cult probably spread from the Rio Grande to Hopi. Closer to Santa Fe, it was suppressed by the Church and driven underground in the east but flourished in the west, where most of the katsinas were invented since the Reconquest. There were katsina murals in a kiva in Mound 7, Pueblo de las Humanas at Gran Quivira that dated between 1416 and 1467. Paul Martin excavated a katsina carved of a sandstone that dated in the late 1300s" (Alden Hayes, letter to author, 10/28/97). Adams 1991; Bahti 1970, 42; Fergusson 1991, 133; Griffith 1983, 766; Timothy Mowa, author interview, 5/15/94; Peabody Museum, Harvard University, exhibition information; Wade 1986, 245. *Zuñi Fire God Katsina:* Fewkes 1985, 27; Fergusson 1991, 87. *Heishi:* Indian Arts and Crafts brochure. *Corn:* Da 1979, xx–xxi; Heib 1979, 579; Thomas 1994, 92–93; Tyler 1991, 2; Young 1994. *The Jewelry of Charles Loloma and Family:* Cirillo 1988, 46; Jacka 1984; Younger 1978, 13; Verma Nequatewa, 1994. *The Monongyes:* Jesse Lee Monongye, May 1993, August 1995; Monthan 1975, 147, 150. *Kenneth Begay's Legacy:* Cirillo 1992, 168–71; Pardue 1997, 6, 17; Harvey Begay, July 1998.

Specific Caption References
934 Joe Tanner, author interview, March 1993. **939** Slaney 1992, 81. **956** Jernigan 1978. **961** Jernigan 1978, 55. **974** Slaney 1992, 50. **988** Jacka and Jacka 1995, 17. **989** Jacka and Jacka 1995, 21. **993** Frank 1990, 96. **994** McNitt 1989, 85. **1001** Letter from Robert V. Gallego, 3/17/92. **1002** Joe Tanner, author interview, March 1993. **1020** Fane, Jacknis, and Breen 1991, 134. **1025** Pardue 1997, 24. **1026** Lamphere 1983, 757. **1028** Fewkes 1985, 99–101. **1042** Cirillo 1992, 47, 49. **1045** Adair 1989, 8. **1047** Adair 1989, 44; Jacka and Jacka 1995, 21. **1052** Pardue 1997, 20. **1056** Slaney 1992. **1057** Wilson 1982, 441. **1059** Labbé 1986, 54–75. **1060** Labbé 1986, 70–72. **1064** Strong 1989, 221. **1065** Cushing 1974. **1071** Bahti 1970, 47; Lamphere 1983. **1073, 1074** Bahti 1970, 20; Mails 1983, vol. 2, 449. **1075** Bahti 1970, 39; Scherer 1973, 134. **1088** Cirillo 1992, 131. **1096** Perry 1994. **1102** Jacka 1993, 46. **1129** Robert Rhodes, letter to author, 8/1/94; Younger 1978, 40. **1131** Carnelian, however, not coral, was used by the Egyptians. **1150** Ray Tracy brochure.

CROSSROADS WITHIN THE CIRCLE

Text References
All direct quotes are from author interviews unless otherwise credited. Elaine Buchanan Bear, September 1995; Lynn Burnette, Jr., May 1993; Lynn Burnette, Sr., June 1996; Laverna Capes, June 1994; Eveli, July 1992; Mary Ferguson, June 1994; Chad Neilsen, July 1992; Pius Real Bird, August 1993; Norman Roach, September 1995; Ramona Roach, July 1997; Patrick Spotted Wolf, July 1993; Tomiki, August 1995. Terry Guzman's essay was written for this book in 1997.

1. Tobin 1992, 1.
2. Heth 1992, 8.
3. Recorded by Tanja Dorsey at Kahnawake, July 1997.
4. Roberts 1992, 11.
5. Black Hills Powwow Program, 1992.
6. Neihardt 1988, 35.
7. Stephenson 1993, 2.
8. Huenemann 1992, 139.
9. Roberts 1992, 11.
10. Cook 1996.
11. McAllester 1979, 31.
12. Coe 1986, 56.

Sidebar References
The Roach: Lynn Burnette, Sr.; Torrence and Hobbs 1989, 20. *Eveli:* Kingsolver 1986, 25.

Specific Caption References
1157 Saltzstein 1995. **1177–83** Campbell 1991, 6; "Red Earth" exhibition information, 1994.

GLOSSARY

Selected terms, techniques, and tools relating to North American Indian adornment.

Appliqué: Attaching one material to the top of another.

Awl: A pointed tool used for punching holes or engraving surfaces.

Bangle: Early-style Southwestern bracelet. Usually a strip of heavy wire decorated with stamping or file work.

Beadwork: The embroidering (appliquéing) or loom weaving of glass beads. Glass-bead embroidery has two basic stitches—*spot* or *overlay stitch* and *lazy stitch* (couching) or its variant, *Crow stitch*—and is attached to a foundation material such as hide or fabric. Loomed beadwork requires a frame to support the warp and weft threads, and, like a weaving, becomes its own fabric. Until the nineteenth century, glass trade beads were generally too large or too expensive to be used in great quantities. About 1800, 3- to 4-millimeter glass beads, called *pony beads*, were introduced; after about 1840, smaller glass *seed beads* replaced pony beads in the Indian trade and became the standard material in bead appliqué and other beadwork.

Brain tanning: The preparation of hides by soaking, scraping, and then curing or rubbing with animal brains to preserve the skin and give it softness.

Cast: To form or shape metal by melting and pouring it into a mold.

Catlinite: An easy-to-carve stone or slate, mined at Pipestone, Minnesota, named after the painter George Catlin, the first non-Native to discover the material. Also called pipestone.

Channel work: A number of metal compartments arranged side by side as a setting for stones.

Chevron bead: See *rosetta bead*.

Cluster work: A group of stones, each with its own bezel, arranged in a geometric pattern.

Coin silver: Metal used to make jewery, obtained by melting down silver coins.

Compound bead: In drawn and wound beads, *compound* means having two or more distinct layers of glass, one upon the other.

Concha (or concho): Silver plaques, usually round or oval, frequently attached to a leather strap and worn as a group on a belt.

Cornaline d'Aleppo: Compound beads of two layers of glass, usually a reddish exterior over a white, yellow, or pink core. The beads may be either *drawn* or *wound*. It is thought that the form originated to imitate banded carnelian onyx beads and stones.

Crow stitch: A modified lazy stitch in which beads are strung on one thread and secured with an overlaid second thread that runs at right angles to the first. Its name derives from the tribe that frequently used it.

Die: A metal tool bearing a design that is impressed into a piece of metal jewelry by hand hammering.

Drawn-glass beads: In the manufacture of glass beads, drawn canes with a central hole are produced as raw material from which multitudes of nearly identical beads can be created in a short time. In contrast to wound-glass beads, which are individually made and therefore expensive, drawn beads are made in great numbers and are relatively cheap. At the same time, the process allows for a great diversity of pattern, color, and finished shapes. Drawn beads are finished by

Glass-seed (micro) beads graded in size from 10 to 24, shown at approximately actual scale.

Spot-stitch beadwork

Lazy-stitch beadwork

Appliqué quillwork. Quills are folded between two rows of stitches.

reheating (tumbling and constricting) and lapidary (grinding) techniques.

German silver: An alloy of copper, zinc, and nickel used for adornment primarily by the Plains Indians. Sterling silver—an alloy of 925 parts silver to 75 parts copper—is the predominant silver employed by all other groups, as pure silver is too soft to be worked easily.

Hairpipes: Long tubular bones strung into a breastplate by Plains Indians.

Hallmark: A mark stamped on metal to attest to its purity or the identity of the maker of a piece of jewelry or article of precious metal. Hallmarks have been added to American Indian jewelery only since the twentieth century.

Hubbell glass beads: Turquoise-blue glass beads imported from Czechoslovakia around 1900 and sold as substitutes for turquoise at trading posts such as Lorenzo Hubbell's at Ganado, Arizona.

Imbrication: A "false embroidery" technique, used by basket weavers, in which strips of bear grass, horsetail root, cornhusks, and, eventually, wool yarn were placed over and under the split bark of the basket's surface as it was woven.

Inlay: The arrangement of stone, shell, and other materials, each piece enclosed in a bezel, to create a design. See also *mosaic*.

Lazy stitch: An embroidered beadwork technique, used by many Plains groups, in which a thread is pulled through three to five beads before they are stitched down by a second thread. Lines are straight and usually form slightly ridged bands of constant width, which make the technique easily recognizable. Resembling quillwork, lazy-stitch beadwork naturally lends itself to the creation of solid and rectilinear designs. Also called *couching*.

Moosehair tufting: Technique in which three-dimensional flowers and leaves are created by tightly pulling small bunches of moosehair under a loop stitch and fastening it off. The resultant hairs are then fanned out on all sides of the stitch and scissor-trimmed into smooth, rounded tufts.

Mosaic: Stones fitted side by side against one another within one bezel.

Needlepoint stonework: A Zuñi style of jewelry characterized by small, elongated stones (typically turquoise), each set in its own bezel in multiple rows and supported by thin frames of silver. In fine needlepoint stonework, the stones are matched and the settings perfectly aligned.

Nueva Cádiz bead: A long, tube-drawn bead with a square cross section that is closely related to chevron beads in its manufacturing technique. A major difference is that Nueva Cádiz beads were sometimes "twisted" and generally consisted of three layers of glass—chevron beads from the same period have seven layers—and their distribution was limited primarily to the Spanish New World between the late 1400s and 1560. The bead is named for an archaeological site on an island off the coast of Venezuela that was occupied by the Spanish from 1498 to 1545.

Obsidian: Volcanic glass coveted by North American Indians because it could be easily flaked to a sharp point or edge.

Overlay silverwork: Technique in which a design is cut in one flat piece of metal, which is then soldered to a piece of the same size and shape. The recessed areas are darkened to form the design.

Peyote stitch: A beadwork technique in which the beads form a twilled pattern. The name evolved from Native American Church implements (used in sacred ceremonies involving the peyote cactus) that were covered with this style of beadwork.

Polychrome-glass bead: A glass bead having more than one color, decorated by hand through the application of molten glass.

Quillwork: Ancient technique of weaving or sewing dyed and flattened porcupine or bird quills, a craft unique to North American Indian peoples.

Repoussé: A relief design worked on metal by pushing out the metal from behind. The raised design can be further decorated by modeling, chasing, embossing, or texturing the surface.

Ribbon work: Cutout designs or patchwork in silk, applied to garments as decoration. Also referred to as *silk appliqué* or *ribbon appliqué*.

Rocker engraving: An early technique used to decorate metal from about 1868 to 1875. To create applied patterns, a short-bladed chisel was rocked back and forth while simultaneously pushing it forward.

Rosetta bead: Any drawn-glass cane bead with an internal pattern of multiple-layer construction. *Star beads* are rosetta beads with starry patterns. *Chevron beads* are star beads with their ends cut or ground down.

Sand casting: The casting of jewelry by pouring molten metal into a mold of volcanic tufa in which a design has been carved. After cooling, the metal is removed from the mold, filed, sawed, or ground, and then polished to its finished form.

Spot stitch: Beadwork stitch in which one to three beads are sewn or embroidered on a backing. Because curved lines present no problem, outline patterns and solid areas can be beaded this way, and colors can be added or deleted easily, this flexible technique offers a wide range of artistic possibilities.

Stamping: The decoration of metal and/or leather with stamps or punches. A tool with a design on the end is repeatedly struck until the pattern is impressed on the metal or leather.

Stroud: A coarse woolen trade cloth, often red or blue in color.

Tinklers: Metal cones used as fringe ornaments and noisemakers.

Tufa: A rock of compacted volcanic ash used by Southwestern artisans to make molds for casting metal objects.

Warp/weft: *Warp* threads are the vertical threads that are attached lengthwise from the top to the bottom of a loom. *Wefts* are the horizontal threads that carry the beads and are woven over and under the warps.

Wound-glass bead: A bead made when molten glass is wound around a metallic rod or wire similar to the way in which thread is wound onto a spool. The wire leaves a hole when removed from the hardened bead.

SELECTED BIBLIOGRAPHY

Abbott, Lawrence. *I Stand in the Center of Good*.
 Lincoln: University of Nebraska Press, 1994.
Ackerman, Lillian A., ed. *A Song to the Creator*.
 Norman: University of Oklahoma Press, 1996.
Adair, John. *The Navajo and Pueblo Silversmiths*.
 Norman: University of Oklahoma Press, 1989.
Adams, E. Charles. *The Origin and Development of
 the Pueblo Katsina Cult*. Tucson: University of
 Arizona Press, 1991.
Adovasio, J. M. "Prehistoric Basketry." In *Handbook
 of North American Indians*, edited by William C.
 Sturtevant. Vol. 11, *Great Basin*, edited by
 Warren L. D'Azevedo. Washington, D.C.:
 Smithsonian Institution, 1986.
Agard-Smith, Nadema. Bemidji, Minn. *Southeastern
 Native Arts Directory*: American Indian Studies
 Press of Bemidji State University, 1993.
Allen, Jamey D. "Chevron-Star-Rosetta Beads." 4
 pts. *Ornament* 7, nos. 1–4 (1983–84).
American Indian Digest. *Contemporary
 Demographics of the American Indian*. Phoenix:
 Thunderbird Enterprises, 1995.
Averill, Lloyd J., and Daphne K. Morris. *Northwest
 Coast Native and Native-Style Art*. Seattle:
 University of Washington Press, 1995.
Bahti, Mark. *Collecting Southwestern Native American
 Jewelry*. New York: Media Projects, 1980.
—*Pueblo Stories and Storytellers*. Tucson: Treasure
 Chest Publications, 1988.
Bahti, Tom. *Southwestern Indian Ceremonials*. Las
 Vegas, Nev.: KC Publications, 1970.
Baker, Rob. "A Canoe against the Mainstream:
 Preserving the Navajo Way: An Interview with
 Peterson Zah." *Parabola* 14, no. 2 (1989).
Ball, Sidney H. "The Mining of Gems and
 Ornamental Stones by American Indians."
 Anthropological Papers Nos.13–18. Smithsonian
 Institution, Bureau of American Ethnology
 Bulletin 128. Washington, D.C.: U.S.
 Government Printing Office, 1941.
Bancroft-Hunt, Norman, and Werner Forman.
 People of the Totem. Norman: University of
 Oklahoma Press, 1988.
Bates, Craig. "Wealth and Power." In *Pleasing the
 Spirits*, edited by Douglas C. Ewing. New York:
 Ghylen Press, 1982.
Baxter, Paula. "Navajo and Pueblo Jewelry,
 1940–1979." *American Indian Art Magazine*,
 autumn 1996.
Bead Museum. *Beads before Columbus*. Prescott,
 Ariz.: Bead Museum, 1993.
Bebbington, Julia M. *Quillwork of the Plains*. Alberta:
 Glenbow Museum, 1982.
Bedinger, Margery. *Indian Silver: Navajo and Pueblo
 Jewelers*. Albuquerque: University of New
 Mexico Press, 1973.
Bell, Maureen. *Karuk: The Upriver People*. Happy
 Camp, Calif.: Naturegraph Publishers, 1991.
Biederman, Patricia Ward. "Zuni Tribe Exports Art
 to Upscale Areas." *Los Angeles Times*, May 10,
 1992.
Billy, Susan. "So the Spirit Can Move Freely." In *All
 Roads Are Good*. Washington, D.C., and London:
 Smithsonian Institution, 1994.
Black, Lydia T. *Glory Remembered: Wooden Headgear
 of Alaska Sea Hunters*. Alaska State Museums, 1991.

Blake, Falene. "The Blessing of Our People." *New
 from Native California* 6, n. 3 (summer 1992).
Blue, Martha. "A View from the Bullpen: A Navajo
 Ken of Traders and Trading Posts." *Plateau* 57,
 no. 3. Flagstaff: Museum of Northern Arizona,
 1986.
Bordewich, Fergus M. "Mississippi Moguls: The
 New Choctaw Middle Class." *Smithsonian* 26, no.
 12 (March 1996).
Brasser, Ted. J. *"Bo'jou, Neejee!"* Ottawa: National
 Museum of Man, National Museums of Canada,
 1976.
—"Plains Indian Art." In *American Indian Art:
 Form and Tradition*. Minneapolis: Walker Art
 Center; Minneapolis Institute of the Arts, 1972.
—"Pleasing the Spirits: Indian Art around the
 Great Lakes." In *Pleasing the Spirits*, edited by
 Douglas C. Ewing. New York: Ghylen Press,
 1982.
Braund, Kathryn E. Holland. *Deerskins and Duffels:
 Creek Indian Trade with Anglo-America,
 1685–1815*. Lincoln: University of Nebraska
 Press, 1993.
Bringhurst, Robert, and Ulli Steltzer. *The Black
 Canoe: Bill Reid and the Spirit of Haida Gwaii*.
 Seattle: University of Washington Press, 1992.
Brose, David A., James A. Brown, and David
 Penney. *Ancient Art of the American Woodlands*.
 New York: Harry N. Abrams, 1985.
Brower, Charles D. *Fifty Years below Zero*. New York:
 Dodd, Mead, 1942.
Brown, James A. "The Mississippian Period." In
 Ancient Art of the American Woodland Indians.
 New York: Harry N. Abrams, 1985.
—"On Style Divisions of the Southeastern
 Ceremonial Complex: A Revisionist
 Perspective." In *The Southeastern Ceremonial
 Complex: Artifacts and Analysis*, edited by
 Patricia Galloway. Lincoln: University of
 Nebraska Press, 1989.
Brown, Joseph Epes. *Animals of the Soul*. Rockport,
 Mass., and Shaftesbury and Dorset, Vt.:
 Element, 1992.
—*The Sacred Pipe*. Norman and London:
 University of Oklahoma Press, 1989.
Brown, Vinson. *Native Americans of the Pacific
 Coast*. Happy Camp, Calif.: Naturegraph
 Publishers, 1977.
Bruchac, Joseph, and Diana Landau. *Singing of
 Earth*. Berkeley, Calif.: Nature Company, 1993.
Brugge, David M. *Hubbell Trading Post*. Tucson:
 Southwest Parks and Monuments Association,
 1993.
Brundige-Baker, Joan. "Restoration and Preservation
 of Historic Trading Posts." In *Historic Trading
 Posts* (*Plateau* 57, no. 3). Flagstaff: Museum of
 Northern Arizona Press, 1986.
Buan, Carolyn M., and Richard Lewis, eds. *The First
 Oregonians*. Portland: Oregon Council for the
 Humanities, 1991.
Bunzel, Ruth L. "Zuni Kachinas: An Analytical
 Study." In *47th Annual Report of the Bureau of
 American Ethnology*. Washington, D.C.: U.S.
 Government Printing Office, 1932.
Burch, Ernst S., Jr. "Canadian Inuit Culture
 1800–1950." In *In the Shadow of the Sun:

Perspectives on Contemporary Native Art.
 Canadian Ethnology Service, Mercury Series
 Paper No. 124. Ottawa: Canadian Museum of
 Civilization, 1993.
Burnham, Dorothy K. *To Please the Caribou*. Seattle:
 University of Washington Press, 1992.
Calloway, Colin G. *The Western Abenakis of Vermont,
 1600–1800*. Norman: University of Oklahoma
 Press, 1990.
Campbell, Joseph. *The Power of Myth*. New York:
 Doubleday, 1988a.
Campbell, Liz. *Powwow 1992 Calendar*. Tennessee
 Book Publishing, 1991.
Carpenter, Edmund. *Eskimo Realities*. New York:
 Holt, Rinehart and Winston, 1973.
Cather, Willa. *Death Comes to the Archbishop*. New
 York: Alfred A. Knopf, 1931.
Catlin, George. *Letters and Notes on the Manners,
 Customs, and Conditions of North American
 Indians*. Vol. 2. New York: Dover Publications,
 1973.
Ceci, Lynn. "Tracing Wampum's Origin: Shell Bead
 Evidence from Archaeological Sites in Western
 and Coastal New York." In *Proceedings of the
 1986 Shell Bead Conference*. Rochester, N.Y.:
 Rochester Museum and Science Center, 1989.
Chamberlain, Von Del. *When Stars Came Down to
 Earth*. Los Altos, California: Ballena Press.
 Center for Archaeoastronomy Cooperative
 Publication, 1982.
Chang, K. C. *The Archeology of Ancient China*. New
 Haven: Yale University Press, 1986.
—"Shamanism in Human History: A Preliminary
 Definition." In *Bulletin of the Department of
 Archaeology and Anthropology*, no. 49. Taipei:
 National Taiwan University, 1993.
Chaussonnet, Valérie. *Crossroads Alaska: Native
 Cultures of Alaska and Siberia*. Washington, D.C.:
 Arctic Studies Center, National Museum of
 Natural History, Smithsonian Institution, 1995.
—"Needles and Animals: Women's Magic." In
 *Crossroads of Continents: Cultures of
 Siberia and Alaska*, edited by William W.
 Fitzhugh and Aron Crowell. Washington D.C.:
 Smithsonian Institution Press, 1988.
Cirillo, Dexter. "Back to the Past." *American Indian
 Art Magazine* 13, no. 2 (spring 1988).
—*Southwestern Indian Jewelry*. New York:
 Abbeville Press, 1992.
Cody, Bertha Parker. "Pomo Bear Impersonators."
 Masterkey 14, no. 1 (1940).
Coe, Ralph T. "Asiatic Sources of Northwest Coast
 Art." In *American Indian Art: Form and
 Tradition*. Minneapolis: Walker Art Center and
 the Minneapolis Institute of Arts, 1972.
—*Lost and Found Traditions: Native American Art
 1965–1985*. New York: American Federation of
 Arts, 1986.
—*Sacred Circles*. Arts Council of Great Britain,
 1976.
Cole, Donna. "Cornhusk People." *Northeast Indian
 Quarterly* (winter 1990).
Collins, Henry B., Frederica de Laguna, Edmund
 Carpenter, and Peter Stone. *The Far North*.
 Bloomington and London: Indiana University
 Press, 1977.

Condit, Becky. *Keeper of Dreams*. Roseville, Miss.: Dynamic Printing & Typesetting, 1989.

Conn, Richard. *Circles of the World*. Denver: Denver Art Museum, 1982.

——"Floral Design in Native North America." In *Native American Art from Permanent Collections*. Claremont, Calif.: Claremont Colleges, 1979a.

——"Indian Arts of the Intermontane Region." In *American Indian Art*. Minneapolis: Walker Art Center, 1972.

——*Native American Art in the Denver Art Museum*. Seattle and London: University of Washington Press, 1979b.

——*A Persistent Vision: Art of the Reservation Days*. Seattle: University of Washington Press, 1986.

Cook, Kathleen Norris. *Native American Dance 1996 Calendar*. Carson, Calif.: Avalanche Publishing, 1996.

Cook, Sherburne F. "Historical Demography." In *Handbook of North American Indians*, edited by William C. Sturtevant. Vol. 8, *California*, edited by Robert Heizer. Washington, D.C.: Smithsonian Institution, 1978.

Covarrubias, Miguel. *The Eagle, the Jaguar, and the Serpent*. New York: Alfred A. Knopf, 1954.

Craig, Mary M. "The World according to Thomassie Kudluk." *Arts and Culture of the North* 5, no. 2. (1981).

Cruikshank, Julie. *Life Lived Like a Story*. Lincoln: University of Nebraska Press, 1992.

Cushing, Frank Hamilton. *Zuñi Fetishes*. Las Vegas, Nev.: KC Publications, 1974.

Da, Popovi. "Indian Pottery and Indian Values." In *Maria*, edited by Richard L. Spivey. Flagstaff, Ariz.: Northland Press, 1979.

D'Anglure, Saladin. "Inuit of Quebec." In *Handbook of North American Indians*, edited by William C. Sturtevant. Vol. 5, *Arctic*, edited by David Damas. Washington D.C., Smithsonian Institution, 1984.

Damas, David. "Copper Eskimo." In *Handbook of North American Indians*, edited by William C. Sturtevant. Vol. 5, *Arctic*, edited by David Damas. Washington, D.C.: Smithsonian Institution, 1984.

——Introduction to *Handbook of North American Indians*, edited by William C. Sturtevant. Vol. 5, *Arctic*, edited by David Damas. Washington, D.C.: Smithsonian Institution, 1984.

Davies, Cindy. "Fred Harvey Indian Art Collection." *American Indian Art Magazine* 4, no. 2 (spring 1979): 74–75.

de Laguna, Frederica. "Potlatch Ceremonialism on the Northwest Coast." In *Crossroads of Continents: Cultures of Siberia and Alaska*, edited by William W. Fitzhugh and Aron Crowell. Washington, D.C.: Smithsonian Institution Press, 1988b.

——"Tlingit: People of the Wolf and Raven." In *Crossroads of Continents: Cultures of Siberia and Alaska*, edited by William W. Fitzhugh and Aron Crowell. Washington, D.C.: Smithsonian Institution Press, 1988a.

——"Under Mount Saint Elias: The History and Culture of the Yakutat Tlingit." 3 pts. *Smithsonian Contributions to Anthropology* 7. Washington, D.C., 1972.

Densmore, Frances. *Teton Sioux Music and Culture*. Lincoln and London: University of Nebraska Press, 1992.

Dickason, Olive Patricia. *Canada's First Nations*. Norman: University of Oklahoma Press, 1992.

DiNoto, Andrea. "Return of the Native." *Connoisseur*, January 1992.

Downs, James F. "California." In *North American Indians in Historical Perspective*, edited by Eleanor Burke Leacock and Nancy Oestreich Lurie. Prospect Heights, Ill.: Waveland Press, 1988.

Driscoll, Bernadette. "Pretending to be Caribou." In *The Spirit Sings*. Toronto: McClelland and Stewart; Alberta: Glenbow Museum, 1988.

——"Sapangat: Inuit Beadwork in the Canadian Arctic." *Expedition* 26, no. 2. Philadelphia: University Museum, 1984.

Dubin, Lois Sherr. *The History of Beads: 30,000 B.C. to the Present*. New York: Harry N. Abrams, 1987.

Duncan, Kate C. "Beadwork and Cultural Identity on the Plateau." In *A Song to the Creator*, edited by Lillian A. Ackerman. Norman: University of Oklahoma Press, 1996.

——"Beadwork on the Plateau." In *A Time of Gathering*, edited by Robin K. Wright. Seattle: Burke Museum; University of Washington Press, 1991.

——"Images and Objects from Father DeSmet and the Indians of the Rocky Mountain West." *American Indian Art Magazine* 18, no. 3 (summer 1993).

——*Northern Athapaskan Art: A Beadwork Tradition*. Seattle: University of Washington Press, 1989.

Duncan, Kate C., and Eunice Carney. *A Special Gift: The Kutchin Beadwork Tradition*. Seattle and London: University of Washington Press, 1988.

Eber, Dorothy Harley. "Talking with the Artists." In *In the Shadow of the Sun: Perspectives on Contemporary Native Art*. Ottawa: Canadian Museum of Civilization, 1993.

Ellinger, Edgar. "The Zuñis and Their Jewelry." *Arizona Highways* 27, no. 8 (August 1952).

Ellsberg, Helen. "Ketohs." *American Indian Art Magazine* 2, no. 3 (summer 1977).

Elsasser, Albert B. "Basketry." In *Handbook of North American Indians*, edited by William C. Sturtevant. Vol. 8, *California*, edited by Robert Heizer. Washington, D.C.: Smithsonian Institution, 1978.

Emerson, Thomas E. "Water, Serpents, and the Underworld: An Exploration into Cahokian Symbolism." In *The Southeastern Ceremonial Complex: Artifacts and Analysis*, edited by Patricia Galloway. Lincoln: University of Nebraska Press, 1989.

Emmons, George Thornton. *The Tlingit Indians*, edited with additions by Frederica de Laguna. Seattle: University of Washington Press, 1991.

Erdoes, Richard and Alfonso Ortiz. *American Indian Myths and Legends*. New York: Pantheon Books, 1984.

Erickson, Jon T. "I Wear the Morning Star." *American Indian Art Magazine* 1, no. 4 (autumn 1976).

Erickson, Kevin. "Marine Shell Utilization in the Plateau Culture Area." *Northwest Anthropological Research Notes* 24, no. 1. Moscow, Idaho: University of Idaho, 1990.

Ewers, John C. *Blackfeet Crafts*. Haskell Institute, 1945.

Ewing, Douglas C. *Pleasing the Spirits*. New York: Ghylen Press, 1982.

Fagan, Brian M. *Ancient North America: The Archaeology of a Continent*. New York: Thames & Hudson, 1995.

——*The Great Journey*. London: Thames & Hudson, 1987.

Fairbanks, Charles H. "Early Spanish Colonial Beads." *Conference on Historic Site Archaeology Papers* 2, no. 1 (1967).

Fane, Diana, Ira Jacknis, and Lise M. Breen. *Objects of Myth and Memory*. Brooklyn, N.Y.: Brooklyn Museum, 1991.

Feder, Norman. *American Indian Art*. New York: Harry N. Abrams, 1965.

——"The Side Fold Dress." *American Indian Art Magazine* 10, no. 1 (winter 1984).

Feest, Christian F. *Native Arts of North America*. London: Thames & Hudson, 1992.

——"Virginia Algonquians." In *Handbook of North American Indians*, edited by William C. Sturtevant. Vol. 15, *Northeast*, edited by Bruce G. Trigger. Washington, D.C.: Smithsonian Institution, 1978.

Fenton, William N. "Northern Iroquoian Culture Patterns." In *Handbook of North American Indians*, edited by William C. Sturtevant. Vol. 15, *Northeast*, edited by Bruce G. Trigger. Washington, D.C.: Smithsonian Institution, 1978.

Fergusson, Erna. *Dancing Gods: Indian Ceremonials of New Mexico and Arizona*. 1931. Reprint, Albuquerque: University of New Mexico Press, 1991.

Ferrera, Peter J. "Choctaw Uprising." *National Review* 48, no. 4, March 11, 1996.

Fewkes, Jesse Walter. *Hopi Katcinas*. New York: Dover Publications, 1985.

Fienup-Riordan, Ann. *Boundaries and Passages: Rule and Ritual in Yup'ik Oral Tradition*. Norman: University of Oklahoma Press, 1994.

——"Eye of the Dance: Spiritual Life of the Bering Sea Eskimo." In *Crossroads of Continents: Cultures of Siberia and Alaska*, edited by William W. Fitzhugh and Aron Crowell. Washington, D.C.: Smithsonian Institution Press, 1988.

Fitzhugh, William W. "The Nulliak Pendants and Their Relation to Spiritual Traditions in Northeast Prehistory." *Arctic Anthropology* 22, no. 2 (1985).

Fitzhugh, William W., and Aron Crowell, eds. *Crossroads of Continents: Cultures of Siberia and Alaska*. Washington, D.C.: Smithsonian Institution Press, 1988.

Fitzhugh, William W., and Susan A. Kaplan. *Inua: Spirit World of the Bering Sea Eskimo*. Washington, D.C.: Smithsonian Institution Press, 1982.

Flint Institute of Arts. *The Art of the Great Lakes Indians*. Exhibition catalogue. Flint, Mich.: Flint Institute of Arts, 1973.

Ford, Richard I. "Inter-Indian Exchange in the Southwest." In *Handbook of North American Indians*, edited by William C. Sturtevant. Vol. 10, *Southwest*, edited by Alfonso Ortiz. Washington, D.C.: Smithsonian Institution, 1983.

Fowler, Catherine S., and Lawrence E. Dawson. "Ethnographic Basketry." In *Handbook of North American Indians*, edited by William C. Sturtevant. Vol. 11, *Great Basin*, edited by Warren L. D'Azevedo. Washington, D.C.: Smithsonian Institution, 1986.

Fowler, Catherine S. and Sven Liljeblad. "Northern Paiute." In *Handbook of North American Indians*, edited by William C. Sturtevant. Vol. 11, *Great Basin*, edited by Warren L. D'Azevedo. Washington, D.C.: Smithsonian Institution, 1986.

Francis, Peter, Jr. "Beads and Bead Trade in the North Pacific Region." In *Crossroads of Continents: Cultures of Siberia and Alaska*, edited by William W. Fitzhugh and Aron Crowell. Washington, D.C.: Smithsonian Institution Press, 1988.

——"Beads and the Discovery of the New World."

Center for Bead Research Occasional Paper, no. 3. Lake Placid, N.Y.: Bead Press, 1986.

Frank, Larry. *Indian Silver Jewelry of the Southwest: 1868–1930.* Schiffer Publishing, 1990.

Fredrickson, N. Jaye. *The Covenant Chain.* Ottawa: National Museum of Man, National Museums of Canada, 1980.

Fundaburk, Emma Lila, and Mary Douglass Fundaburk Foreman. *Sun Circles and Human Hands.* Alabama: Southern Publications, 1957.

Furst, Peter T., and Jill L. Furst. *North American Indian Art.* New York: Rizzoli, 1982.

Galante, Gary. "Crow Lance Cases or Sword Scabbards." *American Indian Art Magazine* 6, no. 1 (winter 1980).

Garbarino, Merwyn. *Native American Heritage.* Prospect Heights, Ill.: Waveland Press, 1985.

Gibson, Robert O. *The Chumash.* New York: Chelsea House Publishers, 1991.

Gilman, Carolyn. *Where Two Worlds Meet: The Great Lakes Fur Trade.* Minnesota Historical Society, 1982.

Goddard, Ives. "Delaware." In *Handbook of North American Indians,* edited by William C. Sturtevant. Vol. 15, *Northeast,* edited by Bruce G. Trigger. Washington, D.C.: Smithsonian Institution, 1978.

Goetz, Helga. "Inuit Art: A History of Government Involvement." In *In the Shadow of the Sun: Perspectives on Contemporary Native Art.* Ottawa: Canadian Museum of Civilization, 1993.

Gogol, John M. "The Archetypal Columbia River Plateau Contour Beaded Bag." In *Eye of the Angel,* edited by David Wooley. Northampton, Mass: White Star Press, 1990.

Gold, Peter. *Navajo and Tibetan Sacred Wisdom: The Circle of the Spirit.* Rochester, Vt: Inner Traditions, 1994.

Goldberg, Carey. "Oldest Mummy 'Found' on Museum Shelf." *New York Times,* April 27, 1996.

Goodman, Ronald. *Lakota Star Knowledge.* Rosebud, S.D.: Sinte Gleska College, 1990.

Gould, Richard. "Tolowa." In *Handbook of North American Indians,* edited by William C. Sturtevant. Vol. 8, *California,* edited by Robert Heizer. Washington D.C.: Smithsonian Institution, 1978.

Grant, Campbell. "Eastern Coastal Chumash." In *Handbook of North American Indians,* edited by William C. Sturtevant. Vol. 8, *California,* edited by Robert Heizer. Washington, D.C.: Smithsonian Institution, 1978.

——*The Rock Paintings of the Chumash.* Berkeley: University of California Press, 1965.

Griffith, James Seavey. "Kachinas and Masking." In *Handbook of North American Indians,* edited by William C. Sturtevant. Vol. 10, *Southwest,* edited by Alfonso Ortiz. Washington, D.C.: Smithsonian Institution, 1983.

Grumet, Robert S. *The Lenapes.* New York: Chelsea House Publishers, 1989.

Gumerman, George J., ed. *Exploring the Hohhokam.* Dragoon, Ariz: Amerind Foundation; Albuquerque: University of New Mexico Press, 1991.

Gumerman, George J., and Emil W. Haury. "Prehistory: Mogollon." In *Handbook of North American Indians,* edited by William C. Sturtevant. Vol. 9, *Southwest,* edited by Alfonso Ortiz. Washington, D.C.: Smithsonian Institution, 1979.

Hadingham, Evan. *Early Man and the Cosmos.* Norman: University of Oklahoma Press, 1984.

Hail, Barbara A. "Beaded Bibles and Victory Pouches: Twentieth-Century Lakota Honoring Gifts." *American Indian Art Magazine* 13, no. 3 (summer 1988b).

——*Hau, Kóla!* Seattle: University of Washington Press, 1988a.

Hail, Barbara A., and Kate C. Duncan. *Out of the North.* Rhode Island: Haffenreffer Museum of Anthropology, 1989.

Hail, Barbara A., and Gregory C. Schwartz. *Patterns of Life, Patterns of Art.* Hanover, N.H.: University Press of New England, 1987.

Haines, Roberta. "Eastern Washington Native Peoples: A Personal Introduction." In *A Time of Gathering,* edited by Robin K. Wright. Seattle: Burke Museum; University of Washington Press, 1991.

Hall, Judy, Jill Oakes, and Sally Qimmiu'naaq Webster. *Sanatujut Pride in Women's Work: Copper and Caribou Inuit Clothing Traditions.* Quebec: Canadian Museum of Civilization, 1994.

Halpin, Marjorie M. *The Graphic Art of Robert Davidson: Haida.* Vancouver: University of British Columbia Museum of Anthropology, 1979.

Hamell, George R. "Trading in Metaphors." In *Proceedings of the 1982 Glass Trade Bead Conference,* edited by Charles F. Hayes III. Rochester, N.Y.: Rochester Museum and Science Center, 1983.

Harbottle, Dr. Garman, and Phil C. Weigland. "Turquoise in Pre-Columbian America." *Scientific American,* June 1992.

Harris, Elizabeth J. "Nueva Cádiz and Associated Beads: A New Look." *Archaeological Research Booklets,* vol. 17. Lancaster: Fenstermaker Publications, 1982.

Harrison, Julia D. "Metis: A Glenbow Museum Exhibition." *American Indian Art Magazine* 11, no. 2 (spring 1986).

Hassrick, Royal B. *The Sioux.* Norman and London: University of Oklahoma Press, 1989.

Hausman, Gerald. *Turtle Island Alphabet.* New York: St. Martin's Press, 1992.

Hawthorn, Audrey. *Kwakiutl Art.* Seattle: University of Washington Press, 1988.

Hayes, Charles F. III, ed. *Proceedings of the 1982 Glass Trade Bead Conference.* Rochester, N.Y.: Rochester Museum and Science Center, 1983.

——*Proceedings of the 1986 Shell Bead Conference: Selected Papers.* Rochester, N.Y.: Rochester Museum and Science Center, 1989.

Hays-Gilpin, Kelley, and Jane H. Hill. "The Flower World in Prehistoric Southwest Material Culture." Paper presented at the 1996 Southwest Symposium, Tempe, Ariz.

Heib, Louis. "Hopi World View." In *Handbook of North American Indians,* edited by William C. Sturtevant. Vol. 9, *Southwest,* edited by Alfonso Ortiz. Washington, D.C.: Smithsonian Institution,1979.

Heizer, Robert F. "Natural Forces and Native World View." In *Handbook of North American Indians,* edited by William C. Sturtevant. Vol. 8, *California,* edited by Robert Heizer. Washington, D.C.: Smithsonian Institution, 1978.

Heizer, Robert F., and Albert B. Elsasser. *The Natural World of the California Indians.* Berkeley: University of California Press, 1980.

Helm, June, Edward Rogers, and James G. Smith. "Intercultural Relations and Cultural Change in the Shield and Mackenzie Borderlands." In

Handbook of North American Indians, edited by William C. Sturtevant. Vol. 6, *Subarctic,* edited by June Helm. Washington, D.C.: Smithsonian Institution, 1981.

Heth, Charlotte, ed. *Native American Dance: Ceremonies and Social Traditions.* Washington, D.C.: National Museum of the American Indian; Starwood Publishing, 1992.

Hill, Tom, and Richard W. Hill, Sr. *Creation's Journey: Native American Identity and Belief.* Washington, D.C.: Smithsonian Institution Press, 1994.

Hinsley, Curtis M., Jr. *Savages and Scientists: The Smithsonian Institution and the Development of American Anthropology 1846–1910.* Washington, D.C.: Smithsonian Institution Press, 1981.

Hirschfelder, Arlene B. *Native Heritage.* New York: Macmillan, 1995.

Holm, Bill. "Art." In *Handbook of North American Indians,* edited by William C. Sturtevant. Vol. 7, *Northwest Coast,* edited by Wayne Suttles. Washington, D.C.: Smithsonian Institution, 1990.

——*Northwest Coast Indian Art.* Seattle: University of Washington Press, 1974.

——*Spirit and Ancestor.* Seattle: University of Washington Press, 1989.

Holm, Bill, and William Reid. *Form and Freedom: A Dialogue on Northwest Coast Indian Art.* Houston: Institute for the Arts, Rice University, 1975.

Honigmann, John J. "Expressive Aspects of Subarctic Indian Culture." In *Handbook of North American Indians,* edited by William C. Sturtevant. Vol. 6, *Subarctic,* edited by June Helm. Washington, D.C.: Smithsonian Institution, 1981.

House, Conrad. "The Art of Balance." In *All Roads Are Good.* Washington, D.C.: Smithsonian Institution Press in association with the National Museum of the American Indian, Smithsonian Institution, 1994.

Howard, James H., and Victoria Lindsay Levine. *Choctaw Music and Dance.* Norman: University of Oklahoma Press, 1990.

Hudson, Charles. *The Southeastern Indians.* Knoxville: University of Tennessee Press, 1980.

Hudson, Travis, and Thomas C. Blackburn. *The Material Culture of the Chumash Interaction Sphere.* Vol. 3, *Clothing, Ornamentation, and Grooming.* Menlo Park, Calif.: Ballena Press, 1985.

Hudson, Travis, and Ernest Underhay. *Crystals in the Sky: An Intellectual Odyssey Involving Chumash Astronomy, Cosmology, and Rock Art.* Menlo Park, Calif.: Ballena Press, 1978.

Huenemann, Lynn F. "Northern Plains Dance." In *Native American Dance: Ceremonies and Social Traditions,* edited by Charlotte Heth. Washington, D.C.: National Museum of the American Indian; Starwood Publishing, 1992.

Hughes, Richard E., and James A. Bennyhoff. "Early Trade." In *Handbook of North American Indians,* edited by William C. Sturtevant. Vol. 11, *Great Basin,* edited by Warren L. D'Azevedo. Washington, D.C.: Smithsonian Institution, 1986.

Hunn, Eugene S. *Nch'i-Wána "The Big River": Mid-Columbia Indians and Their Land.* Seattle: University of Washington Press, 1995.

Hunt, Norman Bancroft. *Native Americans.* New York: Mallard Press, 1991.

Jacka, Jerry D. "Southwestern Indian Jewelry: Fine Art in the 1980s."*American Indian Arts Magazine* 9, no. 2 (spring 1984).

Jacka, Lois Essary. "Southwest Indian Jewelry." *American Indian Art Magazine* 18, no. 4 (autumn 1993).

Jacka, Lois Essary, and Jerry D. Jacka. *Navajo Jewelry: A Legacy of Silver and Stone.* Flagstaff, Ariz.: Northland Publishing, 1995.

Jacknis, Ira. *Carving Traditions of Northwest California.* Berkeley: Regents of the University of California, 1995.

Jenness, Diamond. *Indians of Canada.* Toronto and Buffalo: University of Toronto Press, 1989.

——*Report of the Canadian Arctic Expedition 1913-1918.* Vol. 12, *The Life of the Copper Eskimos.* Ottawa: F. A. Acland, 1922.

Jernigan, E. Wesley. *Jewelry of the Prehistoric Southwest.* School of American Research Books, edited by Douglas W. Schwartz. Albuquerque: University of New Mexico Press, 1978.

——"White Metal Universe." In *White Metal Universe: Navajo Silver from the Fred Harvey Collection.* Phoenix: Heard Museum, 1981.

Johnston, Basil. *Ojibway Heritage.* Lincoln and London: University of Nebraska Press, 1990.

Jonaitis, Aldona. *Art of the Northern Tlingit.* Seattle: University of Washington Press, 1989.

——*From the Land of the Totem Poles.* New York: American Museum of Natural History; Seattle: University of Washington Press, 1991.

——"Land Otters and Shamans: Some Interpretations of Tlingit Charms." *American Indian Art Magazine* 4, no. 1 (winter 1978): 62–66.

Jones, Dewitt. "Homeland of the Haida." *National Geographic,* July 1987.

Jones, Suzi. *Eskimo Dolls.* Anchorage: Alaska State Council on the Arts, 1982.

Jones, William. "Ethnography of the Fox Indians." Smithsonian Institution, American Bureau of Ethnology Bulletin 125. Washington, D.C.: U.S. Government Printing Office, 1939.

Jopling, Carol F. *The Coppers of the Northwest Coast Indians: Their Origin, Development, and Possible Antecedents.* Transactions of the American Philosophical Society, vol. 79, pt. 1. Philadelphia: American Philosophical Society, 1989.

Jordan, R. H., and S. A. Kaplan. "An Archaeological View of the Inuit/European Contact Period in Central Labrador." *Études/Inuit/Studies* 2, nos. 1–2 (1980).

Josephy, Alvin M., Jr. *The Indian Heritage of America.* Boston: Houghton Mifflin, 1991.

Kaplan, Susan A. *Spirit Keepers of the North: Eskimos of Western Alaska.* Philadelphia: University Museum, 1983.

Kaplan, Susan A., and Kristen J. Barsness. *Raven's Journey: The World of Alaska's Native People.* Philadelphia: University Museum, 1986.

Karklins, Karlis. *Trade Ornament Usage among the Native Peoples of Canada.* Ottawa: Canada Communication Group, 1992.

Karklins, Karlis, and Roderick Sprague. *A Bibliography of Glass Trade Beads in North America.* Promontory Press, 1987.

Kelley, Klara Bonsack, and Harris Francis. *Navajo Sacred Places.* Bloomington: Indiana University Press, 1994.

Kelly, Isabel T., and Catherine S. Fowler. "Southern Paiute." In *Handbook of North American Indians,* edited by William C. Sturtevant. Vol. 11, *Great Basin,* edited by Warren L. D'Azevedo. Washington, D.C.: Smithsonian Institution, 1986.

Kennard, Edward A. "Hopi Economy and Subsistence." In *Handbook of North American Indians,* edited by William C. Sturtevant. Vol. 9, *Southwest,* edited by Alfonso Ortiz. Washington, D.C.: Smithsonian Institution, 1979.

Keyser, James D. *Indian Rock Art of the Columbian Plateau.* Seattle: University of Washington Press, 1992.

Kingsolver, Barbara. "Ancient Symbols." *Southwest Profile,* January/February 1986.

Kirk, Ruth F. "Navaho Silver Work." *Societies around the World.* Vol. 1, 204–43. New York, 1953.

Kiva New, Lloyd. "Translating the Past." In *All Roads Are Good.* Washington, D.C., and London: Smithsonian Institution, 1994.

Kopper, Phillip. *The Smithsonian Book of North American Indians.* Washington, D.C.: Smithsonian Books, 1986.

Kraft, Herbert C. *The Lenape or Delaware Indians.* South Orange, N.J.: Seton Hall University Museum, 1991.

Krech, Shepard, III. "The Eastern Kutchin and the Fur Trade, 1800–1860." *Ethnohistory* 23 no. 3, 1976.

——*Indians, Animals, and the Fur Trade.* Athens: University of Georgia Press, 1981.

——*The Subarctic Fur Trade.* Vancouver: University of British Columbia Press, 1984.

Kroeber, Alfred L. *Handbook of the Indians of California.* New York: Dover Publications, 1976.

——*The Arapaho.* Lincoln and London: University of Nebraska Press, 1983.

Labbé, Armand J. "Art, Myth, and Cognition: An Exploration of the Esoteric Content of Southwest Indian Geometric Art." Unpublished paper, 1986.

LaFarge, Oliver. *Introduction to American Indian Art.* Glorieta, N.M.: Rio Grande Press, 1979.

Lamphere, Louise. "Southwest Ceremonialism." In *Handbook of North American Indians,* edited by William C. Sturtevant. Vol. 10, *Southwest,* edited by Alfonso Ortiz. Washington, D.C.: Smithsonian Institution, 1983.

Lanford, Benson. "Origins of Central Plains Beadwork." *American Indian Art Magazine* 16, no. 1 (winter 1990).

Lang, Julian. "The Basket and World Renewal." *Parabola* 16, no. 3, (fall 1991). New York: Society for Myth and Tradition.

——"The Dances and Regalia." *Indian Regalia of Northwest California.* Berkeley, Calif.: Phoebe Apperson Hearst Museum of Anthropology, 1994.

——"The Embodiment of Wealth." *Indian Regalia of Northwest California.* Berkeley, Calif.: Phoebe Apperson Hearst Museum of Anthropology, 1994.

Lantis, Margaret. "Aleut." In *Handbook of North American Indians,* edited by William C. Sturtevant. Vol. 5, *Arctic,* edited by David Damas. Washington, D.C.: Smithsonian Institution, 1984.

Larsen, Helge. *En alaska-eskimoisk boplads i fortid og nutid* (K. Birket-Smith: Menneskets Mangfoldighed). København, 1957.

——"Some Examples of Bear Cult among the Eskimo and Other Northern Peoples." *Folk* 11–12 (1969–70). Copenhagen.

Larson, Lewis H., Jr. "The Etowah Site." In *The Southeastern Ceremonial Complex: Artifacts and Analysis,* edited by Patricia Galloway. Lincoln: University of Nebraska Press, 1989.

Latta, F. F. *Handbook of the Yokuts Indians.* Oildale: Bear State Books, 1949.

Leacock, Eleanor Burke, and Nancy Oestreich Lurie. *North American Indians in Historical Perspective.* Prospect Heights, Ill.: Waveland Press, 1988.

Lee, Georgia. "The Art of the Chumash." In *Ancient Images on Stone,* edited by Jo Anne van Tilburg. Los Angeles: Regents of the University of California, 1983.

Lenz, Mary Jane. *The Stuff of Dreams: Native American Dolls.* New York: Museum of the American Indian, 1986.

Leroux, Odette, Marion E. Jackson, and Minnie Aodla Freeman. *Inuit Women Artists.* Quebec: Canadian Museum of Civilization, 1994.

Lessard, F. Dennis. "Crow Indian Art: The Nez Perce Connection." *American Indian Art Magazine* 6, no. 1 (winter 1980).

——"Defining the Central Plains Art Area." *American Indian Art Magazine* 16, no. 1 (winter 1990).

Lévi-Strauss, Claude. *The Way of the Masks.* Seattle: University of Washington Press, 1988.

Light, D. W. *Tattooing Practices of the Cree Indians.* Calgary: Glenbow-Alberta Institute, 1972.

Liljeblad, Sven. "Oral Tradition: Content and Style of Verbal Arts." In *Handbook of North American Indians,* edited by William C. Sturtevant. Vol. 11, *Great Basin,* edited by Warren L. D'Azevedo. Washington, D.C.: Smithsonian Institution, 1986.

Lister, Robert H., and Florence C. Lister. *Those Who Came Before.* Tucson: Southwest Parks and Monuments Association, 1993.

Loeb, Barbara. "Dress Me in Color: Transmontane Beading." In *A Time of Gathering,* edited by Robin K. Wright. Seattle: Burke Museum; University of Washington Press, 1991.

——"The Historic and Artistic Background of Beaded Flat Bags." In *Glass Tapestry,* edited by Gloria A. Lomahatfewa. Phoenix: Heard Museum, 1995.

Lommel, Andreas. *Masks.* New York: Excalibur Books, 1970.

Lowenstein, Tom. *Ancient Land, Sacred Whale: The Inuit Hunt and Its Rituals.* New York: Farrar, Straus & Giroux, 1993.

Lowie, Robert H. *The Crow Indians.* Lincoln and London: University of Nebraska Press, 1983.

——"Oral Tradition and History." *American Anthropologist* 17 (1915): 597–99.

——"Oral Tradition and History." *Journal of American Folk-Lore* 30, no. 116 (1917): 161–67.

Lurie, Nancy Oestreich. "Beaded Twined Bags of the Great Lakes Indians." In *Great Lakes Indian Art,* edited by David W. Penney. Detroit: Wayne State University Press, 1989.

Lyford, Carrie A. *Quill and Beadwork of the Western Sioux.* Boulder, Colo.: Johnson Books, 1982.

MacDonald, George F. *Haida Monumental Art: Villages of the Queen Charlotte Islands.* Seattle: University of Washington Press, 1994.

MacDonald, Joanne. "The Whites Are Thick as Flies in Summertime." In *In the Shadow of the Sun: Perspectives on Contemporary Native Art.* Canadian Ethnology Service, Mercury Series Paper no. 124. Ottawa: Canadian Museum of Civilization, 1993.

Macnair, Peter L. "Inheritance and Innovation." *ArtsCanada,* December 1973/January 1974.

Macnair, Peter L., Alan L. Hoover, and Kevin Neary. *The Legacy: Tradition and Innovation in Northwest Coast Indian Art.* Vancouver: Douglas & McIntyre, 1984.

Mails, Thomas E. *The Pueblo Children of the Earth Mother.* Vol. 1–2. Garden City, N.Y.: Doubleday, 1983.

Malouf, Carling I., and John M. Findlay. "Euro-American Impact before 1870." In *Handbook of North American Indians*, edited by William C. Sturtevant. Vol. 11, *Great Basin*, edited by Warren L. D'Azevedo. Washington, D.C.: Smithsonian Institution, 1986.

Margolin, Malcolm. "Wealth and Spirit." *Indian Regalia of Northwest California*. Berkeley, Calif.: Phoebe Apperson Hearst Museum of Anthropology, 1994.

Matthiessen, Peter. "Native Earth." *Parabola* 6, no. 1 (1981). New York: Society for Myth and Tradition.

Maurer, Evan M. *Visions of the People*. Minneapolis: Minneapolis Institute of the Arts, 1992.

——"Visions of the People." *American Indian Art Magazine* 18, no. 2 (spring 1993).

Maxwell, James A., ed. *America's Fascinating Indian Heritage*. Pleasantville, N.Y.: Reader's Digest Association, 1978.

McAllester, David. "A Paradigm of Navajo Dance." *Parabola* 4, no. 2 (May 1979). New York: Society for Myth and Tradition.

McGhee, Robert. "Material as Metaphor in Prehistoric Inuit Art." *Inuit Art Quarterly* 3, no. 3 (summer 1988).

——"Prehistoric Arctic Peoples and Their Art." *American Review of Canadian Studies* 17, no. 1 (1987).

McHugh, Tom. *The Time of the Buffalo*. New York: Alfred A. Knopf, 1972.

McLendon, Sally, and Michael J. Lowy. "Eastern Pomo and Southeastern Pomo." In *Handbook of North American Indians*, edited by William C. Sturtevant. Vol. 8, *California*, edited by Robert Heizer. Washington, D.C.: Smithsonian Institution, 1978.

McMillan, Alan D. *Native Peoples and Cultures of Canada*. Vancouver and Toronto: Douglas & McIntyre, 1988.

McNeley, James Kale. *Holy Wind in Navajo Philosophy*. Tucson: University of Arizona Press, 1981.

McNitt, Frank. *The Indian Traders*. Norman: University of Oklahoma Press, 1989.

Mehringer, Peter J. "Prehistoric Environments." In *Handbook of North American Indians*, edited by William C. Sturtevant. Vol. 11, *Great Basin*, edited by Warren L. D'Azevedo. Washington: Smithsonian Institution, 1986.

Merritt, Ann S. "Women's Beaded Robes: Artistic Reflections of the Crow World." In *To Honor the Crow People*, edited by Father Peter J. Powell. Chicago: Foundation for the Preservation of American Indian Art and Culture, Inc., 1988.

Miller, Bruce W. *Chumash: A Picture of Their World*. Los Osos, CA: Sand River Press, 1988.

Miller, Lynette. "Basketry Styles of the Plateau Region." In *A Time of Gathering*, edited by Robin K. Wright. Seattle: Burke Museum; University of Washington Press, 1991.

——"Basketry Styles of the Plateau Region." In *A Song to the Creator*, edited by Lillian A. Ackerman. Norman: University of Oklahoma Press, 1996.

Millstein, Henry Morrison. "Giving the Past a Voice: The Confederated Tribes of the Warm Springs Reservation." In *The First Oregonians*, edited by Carolyn M. Baun and Richard Lewis. Portland: Oregon Council for the Humanities, 1991.

Mitchell, Marybelle. "Social, Economic, and Political Transformation among Canadian Inuit from 1950 to 1988." In *In the Shadow of the Sun: Perspectives on Contemporary Native Art*. Canadian Ethnology Service, Mercury Series

Paper No. 124. Ottawa: Canadian Museum of Civilization, 1993.

Mogelon, Alex. *The People of Many Faces: Masks, Myths, and Ceremonies of the Iroquois*. Ontario: Waapoone Publishing and Promotion, 1994.

Monthan, Guy, and Doris Monthan. *Art and Indian Individualists*. Flagstaff, Ariz.: Northland Press, 1975.

Moon, Sheila. *A Magic Dwells: A Poetic and Psychological Study of the Navajo Emergence Myth*. Middletown, Conn: Wesleyan University Press, 1970.

Moore, J. B. *Collection of Catalogs Published at Crystal Trading Post 1903 and 1911*. Albuquerque: Avanyu Publishing, 1987.

Morissoneau, Christian. "Huron of Lorette." In *Handbook of North American Indians*, edited by William C. Sturtevant. Vol. 15, *Northeast*, edited by Bruce G. Trigger. Washington, D.C.: Smithsonian Institution, 1978.

Mulder, Kenneth W. *Tampa Bay Days of Long Ago*. 2d ed. Tampa: PM Publishing, 1991.

Muller, Jon. "The Southern Cult." In *The Southeastern Ceremonial Complex: Artifacts and Analysis*, edited by Patricia Galloway. Lincoln: University of Nebraska Press, 1989.

Murdoch, John. "Ethnological Results of the Point Barrow Expedition." *United States Department of Ethnology, Ninth Annual Report*. Washington, D.C.: U.S. Government Printing Office, 1892.

Murphy, Robert F., and Yolanda Murphy. "Northern Shoshone and Bannock." In *Handbook of North American Indians*, edited by William C. Sturtevant. Vol. 11, *Great Basin*, edited by Warren L. D'Azevedo. Washington, D.C.: Smithsonian Institution, 1986.

Neihardt, John G. *Black Elk Speaks*. Lincoln and London: University of Nebraska Press, 1988.

Nelson, Edward W. "The Eskimo about Bering Strait." In *Bureau of American Ethnology Annual Report 18*. Washington D.C.: U.S. Government Printing Office, 1899.

Nin-a Saan: Set Here for You. Produced by Kathy Heffner. USDA Six Rivers/Shenandoah Films, 1996.

Oberholtzer, Cathy. "Embedded Symbolism: The James Bay Beaded Hoods." *Northeast Indian Quarterly*, 3, no. 2 (summer 1991).

Orchard, William C. *Beads and Beadwork of the American Indians*. New York: Museum of the American Indian, Heye Foundation, 1975.

Ortiz, Alfonso. Introduction to *Southwest*, vol. 9 of *Handbook of North American Indians*, edited by William C. Sturtevant. Washington, D.C.: Smithsonian Institution, 1979.

——*New Perspectives on the Pueblos*. Albuquerque: University of New Mexico Press, 1972.

——*The Tewa World: Space, Time, and Becoming in a Pueblo Society*. Chicago: University of Chicago Press, 1969.

Osgood, Cornelius. *The Ethnography of the Tanaina*. Yale University Publications in Anthropology, no. 16. New Haven: Human Relations Area Files Press, 1976.

Pankonin, Lynn. "In the Spirit of Tradition: The Voices within the Collection." In *Glass Tapestry*, edited by Gloria A. Lomahaftewa. Phoenix: Heard Museum, 1993.

Pardue, Diana. *The Cutting Edge: Contemporary Southwestern Jewelry and Metalwork*. Phoenix: Heard Museum, 1997.

Pasztory, Esther. "Shamanism and North American Indian Art." In *Native North American Art History*, edited by Zena Matthews and Aldona

Jonaitis. Palo Alto, Calif.: Peek Publications, 1982.

Pavesic, Max G., and William Studebaker. *Backtracking: Ancient Art of Southern Idaho*. Pocatello: Idaho Museum of Natural History, 1993.

Penney, David W. *Art of the American Indian Frontier*. Seattle and London: University of Washington Press, 1992.

——"Continuities of Imagery and Symbolism in the Art of the Woodlands." In *Ancient Art of the American Woodland Indians*. New York: Harry N. Abrams, Inc., 1985.

——*Native American Art*. Hugh Lauter Levin Associates, 1996.

Pericot-Garcia, L., L. Galloway, and A. Lommel, eds. *Prehistoric and Primitive Art*. 1967.

Peterson, John H. "The Mississippi Choctaws: A Pattern of Persistence." In *Persistence of Pattern*, edited by Patti Carr Black. Mississippi: Mississippi Department of Archives and History, 1987.

Pettit, Jan. *Utes*. Boulder, Colo.: Johnson Books, 1990.

Phillips, Ruth B. "Like a Star, I Shine." In *The Spirit Sings*. Toronto: McClelland and Stewart; Alberta: Glenbow Museum, 1987. 1988 ed.

——"Moccasins into Slippers." *Northeast Indian Quarterly* (winter 1990).

——*Patterns of Power*. Kleinberg, Ont.: McMichael Canadian Collection, 1984.

Pogue, Joseph E. *Turquoise*. Glorieta, N.M.: Rio Grande Press, 1975.

Porsche, Audrey. *Yuto'Keca: Transitions, The Burdick Collection*. State Historical Society of North Dakota, 1987.

Rainey, Froelich G. "The Whale Hunters of Tigara." *Anthropological Papers of the American Museum of Natural History*, vol. 41, no. 22. New York, 1947.

Rasmussen, Knud. "The Netsilik Eskimos: Social Life and Spiritual Culture." *Report of the Fifth Thule Expedition 1921–24*, vol. 8, nos. 1–2. Copenhagen, 1929.

Ray, Arthur J. *Indians in the Fur Trade*. Toronto: University of Toronto Press, 1974.

Ray, Dorothy Jean. *Aleut and Eskimo Art*. Seattle: University of Washington Press, 1981.

——*Artists of the Tundra and the Sea*. Seattle: University of Washington Press, 1961.

——*The Eskimos of Bering Strait, 1650–1898*. Seattle: University of Washington Press, 1992.

Reid, Martine. "In Search of Things Past, Remembered, Retraced, and Reinvented." In *In the Shadow of the Sun: Perspectives on Contemporary Native Art*. Canadian Ethnology Service, Mercury Series Paper no. 124. Ottawa: Canadian Museum of Civilization, 1993.

——"Silent Speakers: Arts of the Northwest Coast." In *The Spirit Sings*. Toronto: McClelland and Stewart; Alberta: Glenbow Museum, 1988.

Ritchie, William A. "Dutch Hollow: An Early Historic Period Seneca Site in Livingston County, New York." Research Records, no. 10. Rochester, N.Y.: Rochester Museum and Science Center, 1954.

Ritzenthaler, Robert. "Southwestern Chippewa." In *Handbook of North American Indians*, edited by William C. Sturtevant. Vol. 15, *Northeast*, edited by Bruce G. Trigger. Washington: Smithsonian Institution, 1978.

Roberts, Chris. "Pow Wow Fever." In *Inter-Tribal America*. Collector's ed. Church Rock: Inter-Tribal Indian Ceremonial Association, 1992.

Rockwell, David. *Giving Voice to Bear*. Niwot, Colo.: Roberts Rhinehart Publishers, 1991.

Rodee, Marian, and James Ostler. *The Fetish Carvers of Zuni.* Albuquerque: Starline Printing, 1990.

Rose, Richard. *Face to Face Encounters with Identity.* Rochester, N.Y.: Rochester Museum and Science Center, 1983.

Routledge, Marie, and Hessel, Ingo. "Contemporary Inuit Sculpture." In *In the Shadow of the Sun: Perspectives on Contemporary Native Art.* Canadian Ethnology Service, Mercury Series Paper No. 124. Hull, Quebec: Canadian Museum of Civilization, 1993.

Ruddell, Nancy. *Raven's Village.* Hull, Quebec: Canadian Museum of Civilization, 1995.

Rutherford, Helen. "An Indian Agent's Wife." *The Beaver* 270, no. 2 (1939).

Salomon, Julian Harris. *Indians of the Lower Hudson Region.* New York: Publishing Center for Cultural Resources, 1982.

Santa Barbara Museum of Natural History Docent Project. *The Chumash People.* San Luis Obispo, Calif.: EZ Nature Books, 1991.

Scherer, Joanna Cohan. *Indians.* New York: Crown Publishers, 1973.

Schlesier, Karl H. *Plains Indians A.D. 500–1500.* Norman: University of Oklahoma Press, 1994.

——*The Wolves of Heaven.* Norman: University of Oklahoma Press, 1985.

Schlick, Mary Dodds. *Columbia River Basketry.* Seattle: University of Washington Press, 1994.

——"Too Precious to Trade: Yakima Beaded Handbags." In *Glass Tapestry.* Phoenix: Heard Museum, 1993.

Schlick, Mary Dodds, and Kate C. Duncan. "Wasco-Style Woven Beadwork: Merging Artistic Traditions." *American Indian Art Magazine* 16, no. 3 (summer 1991).

Schmidt, Jeremy, and Laine Thom. *In the Spirit of Mother Earth.* San Francisco: Chronicle Books, 1994.

Schuon, Frithjof. *The Feathered Sun.* Bloomington, Ind.: World Wisdom Books, 1990.

Schuster, Carl. *Joint Marks: A Possible Index of Cultural Contact between America, Oceania, and the Far East.* Amsterdam: Uitgave Koninklijk Instituut Voor De Tropen, 1951.

Shadbolt, Doris. *Bill Reid.* Seattle: University of Washington Press, 1986.

Sheehan, Carol. "The Northwest Coast." In *Native American Arts and Crafts,* edited by Colin F. Taylor. New York: Salamander Books, 1995.

Shimkin, Demitri B. "Eastern Shoshone." *Handbook of North American Indians,* edited by William C. Sturtevant. Vol. 11, *Great Basin.* Edited by Warren L. D'Azevedo. Washington, D.C.: Smithsonian Institution, 1986.

Shipley, William F. "Native Languages of California." In *Handbook of North American Indians,* edited by William C. Sturtevant. Vol. 8, *California,* edited by Robert Heizer. Washington, D.C.: Smithsonian Institution, 1978.

Simmons, William S. *Spirit of the New England Tribes: Indian History and Folklore, 1620–1984.* Hanover, N.H., and London: University Press of New England, 1986.

Simpson, Lesley, ed. *Journal of José Longinos Marinez.* San Francisco: John Howell Books, 1961.

Slaney, Deborah Christine. "The Role of C. G. Wallace in the Development of Twentieth-Century Zuni Silver and Lapidary Arts." Master's thesis, University of Oklahoma, 1992.

Slobodin, Richard. "Kutchin." In *Handbook of North American Indians,* edited by William C.

Sturtevant. Vol. 6, *Subarctic,* edited by June Helm. Washington, D.C.: Smithsonian Institution, 1981.

——"Subarctic Metis." In *Handbook of North American Indians,* edited by William C. Sturtevant. Vol. 6, *Subarctic,* edited by June Helm. Washington, D.C.: Smithsonian Institution, 1981.

Smith, Derek G. "Mackenzie Delta Eskimo." In *Handbook of American Indians,* edited by William C. Sturtevant. Vol. 5, *Arctic,* edited by David Damas. Washington, D.C.: Smithsonian Institution, 1984.

Smith, Marvin T., and Mary Elizabeth Good. *Early Sixteenth Century Glass Beads in the Spanish Colonial Trade.* Mississippi: Cottonlandia Museum Publications, 1982.

Snow, David H. "Prehistoric Southwestern Turquoise Industry." In *Turquoise,* edited by Stuart A. Northrop, David L. Neumann, and David H. Snow. Reprinted from *El Palacio* 79, no. 1 (1973). Museum of New Mexico.

Snow, Dean R. *The Archaeology of North America.* London: Thames & Hudson, 1980.

Soby, Regitze Margrethe. "The Eskimo Animal Cult." *Folk* 11–12 (1969–70). Copenhagen.

Speck, Frank G. "Symbolism in Penobscot Art." American Museum of Natural History, Anthropological Papers, vol. 29, pt. 2. New York.

Spencer, Robert F. "North Alaska Coast Eskimo." In *Handbook of North American Indians,* edited by William C. Sturtevant. Vol. 5, *Arctic,* edited by David Damas. Washington, D.C.: Smithsonian Institution, 1984.

Spier, Leslie, and Edward Sapir. "Wishram Ethnography." *University of Washington, Publications in Anthropology* 3, no. 3. Seattle, 1930.

Spinden, Herbert Joseph. "The Nez Perce Indians." *American Anthropological Association, Memoir No. 9.* Lancaster, 1908.

Standing Bear, Luther. *Stories of the Sioux.* Lincoln and London: University of Nebraska Press, 1988.

Steltzer, Ulli. *A Haida Potlatch.* Seattle: University of Washington Press, 1984.

——*Indian Artists at Work.* Vancouver: Douglas & McIntyre, 1994.

Stephenson, Lisa. *Powwow: Questions and Answers.* Bismarck, N.D.: United Tribes Technical College, 1993.

Stevenson, Matilda Coxe. *The Zuñi Indians.* Bureau of American Ethnology, Twenty-Third Annual Report, 1901–1902. Glorieta, N.M.: Rio Grande Press, 1985.

Stewart, Hilary. *Cedar: Tree of Life to the Northwest Coast Indians.* Vancouver: Douglas & McIntyre, 1984.

Stewart, Hilary. *Looking at Totem Poles.* Vancouver: Douglas & McIntyre, 1993.

Strickler, Eva, and Anaoyok Alookee. *Inuit Dolls: Reminders of a Heritage.* Toronto: Canadian Stage & Arts Publications, 1988.

Strong, John A. "The Mississippian Bird-Man Theme in Cross-Cultural Perspective." In *The Southeastern Ceremonial Complex: Artifacts and Analysis,* edited by Patricia Galloway. Lincoln: University of Nebraska Press, 1989.

Supplee, Charles, Douglas Anderson, and Barbara Anderson. *Canyon de Chelly: The Story behind the Scenery.* Edited by Gweneth Reed Den Dooven. Las Vegas, Nev.: KC Publications, 1981.

Suttles, Wayne. "Central Coast Salish." In *Handbook of North American Indians,* edited by William C.

Sturtevant. Vol. 7, *Northwest Coast,* edited by Wayne Suttles. Washington, D.C.: Smithsonian Institution, 1990b.

——Introduction to *Northwest Coast,* vol. 7 of *Handbook of North American Indians,* edited by William C. Sturtevant. Washington, D.C.: Smithsonian Institution, 1990a.

Suzuki, David, and Peter Knudtson. *Wisdom of the Elders.* New York, Toronto, London, Sydney, and Auckland: Bantam Books, 1992.

Swagerty, William R. "Indian Trade in the Trans-Mississippi West to 1870." In *Handbook of the North American Indians,* edited by William C. Sturtevant. Vol. 4, *History of Indian-White Relations,* edited by Wilcomb E. Washburn. Washington, D.C.: Smithsonian Institution, 1988.

Swanton, George R. *The Indians of the Southeastern United States.* Smithsonian Institution, Bureau of American Ethnology Bulletin 137. Washington, D.C.: U.S. Government Printing Office, 1946.

Swentzell, Rina. "The Butterfly Effect: A Conversation with Rina Swentzell." *El Palacio* (fall/winter 1989).

Swinton, George. "Multiple Realities: Inuit Images of Shamanic Transformations." *Inuit Art Quarterly* 8, no. 4 (winter 1993). Nepean, Ont.: Inuit Art Foundation.

Taylor, Colin F. *Saam:* Wyk aur Foehr. Germany: Verlag für Amerikanistak, 1994.

Taylor, Colin F., and Sturtevant, William C. *The Native Americans: The Indigenous People of North America.* New York: Smithmark Publishers, 1992.

Taylor, William E., Jr., and George Swinton. "Prehistoric Dorset Art." *The Beaver* 298 (autumn 1967).

Teit, James. "Field Notes on the Tahltan and Kaska Indians: 1912–15." Edited by June Helm MacNeish. *Anthropologica* 3 (1956).

——"Mythology of the Thompson Indians." *Memoirs of the American Museum of Natural History,* no. 12. *Publications of the Jesup North Pacific Expedition,* vol. 8, no. 2. 1912. Reprint, New York: AMS Press, 1975.

——"The Thompson Indians of British Columbia." *Memoirs of the American Museum of Natural History.* Vol. 2, *Anthropology* 1, pt. 4. New York: Knickerbocker Press, 1900.

Tepper, Leslie H. *Earth Line and Morning Star.* Hull, Quebec: Canadian Museum of Civilization, 1994.

Tepper, Leslie H., ed. *The Interior Salish Tribes of British Columbia: A Photographic Collection.* Canadian Ethnology Service, Mercury Series Paper No. 111. Ottawa: National Museums of Canada, 1987.

Thom, Ian M. *Robert Davidson: Eagle of the Dawn.* Seattle: University of Washington Press, 1993.

Thomas, David Hurst. "The Archaeology of Hidden Cave, Nevada." *Anthropological Papers of the American Museum of Natural History,* vol. 61, pt. 1. New York: American Museum of Natural History, 1985.

——*Exploring Ancient Native America.* New York: Macmillan, 1994.

——*St. Catherines: An Island in Time.* Atlanta: Georgia Endowment for the Humanities, 1988.

Thomas, David Hurst, Jay Miller, Richard White, Peter Nabokov, and Philip J. Deloria. *The Native Americans: An Illustrated History.* Atlanta: Turner Publishing, 1993.

Thompson, Ian M. *An Overview of Archaeological Research at the Crow Canyon Archaeological Center for Use by the Native American Advisory*

Committee and Native American Consultants. Cortez: Crow Canyon Archaeological Center, August 1994.

Thompson, Lucy. *To the American Indian: Reminiscences of a Yurok Woman.* Berkeley, Calif.: Heyday Books, 1991.

Tobin, Paulette. "Powwow Announcer Hopes to Instill Pride," *Rapid City (S.Dak.) Journal,* July 11, 1992.

Tooker, Elisabeth. "The League of the Iroquois: Its History, Politics, and Ritual." In *Handbook of North American Indians,* edited by William C. Sturtevant. Vol. 15, *Northeast,* edited by Bruce G. Trigger. Washington, D.C.: Smithsonian Institution, 1978.

Torrence, Gaylord. *The American Indian Parfleche: A Tradition of Abstract Painting.* Seattle: University of Washington Press, 1994.

Torrence, Gaylord, and Robert Hobbs. *Art of the Red Earth People: The Mesquakie of Iowa.* Seattle and London: University of Washington Press, 1989.

Townsend, Joan B. "Tanaina." In *Handbook of North American Indians,* edited by William C. Sturtevant. Vol. 6, *Subarctic,* edited by June Helm. Washington, D.C.: Smithsonian Institution, 1981.

Trigger, Bruce G. "Cultural Unity and Diversity." In *Handbook of North American Indians,* edited by William C. Sturtevant. Vol. 15, *Northeast,* edited by Bruce G. Trigger. Washington, D.C.: Smithsonian Institution, 1978.

Tuohy, Donald R. "Portable Art Objects." In *Handbook of North American Indians,* edited by William C. Sturtevant. Vol. 11, *Great Basin,* edited by Warren L. D'Azevedo. Washington, D.C.: Smithsonian Institution, 1986.

Turner, Christy G., II. "Ancient Peoples of the North Pacific Rim." In *Crossroads of Continents: Cultures of Siberia and Alaska,* edited by William W. Fitzhugh and Aron Crowell. Washington, D.C.: Smithsonian Institution Press, 1988.

Turner, Geoffrey. *Hair Embroidery in Siberia and North America.* Pitt Rivers Museum, University of Oxford. Occasional Paper on Technology, 7. Oxford: Oxford University Press, 1955.

Tyler, Hamilton A. *Pueblo Birds and Myths.* Flagstaff, Ariz.: Northland Publishing, 1991.

VanStone, James W. "Athapaskan Clothing and Related Objects in the Collections of Field Museum of Natural History." Fieldiana Anthropology, n.s. 4. Chicago: Field Museum of Natural History, 1981.

——"Northern Athapaskans: People of the Deer." In *Crossroads of Continents: Cultures of Siberia and Alaska,* edited by William W. Fitzhugh and Aron Crowell. Washington, D.C.: Smithsonian Institution Press, 1988.

Van Tilburg, Jo Anne. *Ancient Images on Stone.* Los Angeles: Regents of the University of California, 1983.

Vastokas, Joan M. "The Shamanic Tree of Life." In *Stones, Bones and Skin.* Toronto: Artscanada, December 1973/January 1974.

Vaughan, Thomas, and Bill Holm. *Soft Gold: The Fur Trade and Cultural Exchange on the Northwest Coast of America.* Portland: Oregon Historical Society Press, 1990.

Victor-Howe, Anne-Marie. "Pathfinders of the Universe: Inupiak and Siberian Yupik Dance." In *Proceedings of International Symposium on the Comparative Studies of the Music, Dance, and Game of Northern Peoples.* Hokkaido, Japan, January 20–25, 1992.

——"Songs and Dances of the St. Lawrence Island Eskimos." *Etude/Inuit /Studies* 18, nos. 1–2. Inuit and Circumpolar Study Group, Quebec, Canada, 1994.

Voth, H. R. *The Traditions of the Hopi.* Field Columbian Museum Publication 96, Anthropological Series, vol. 8. Chicago: Field Columbian Museum, 1905.

Wade, Edwin L. *The Arts of the North American Indian.* New York: Hudson Hills Press, 1986.

Waldman, Carl. *Atlas of the North American Indians.* New York: Facts on File Publications, 1985.

Walker Art Center. *American Indian Art: Form and Tradition.* Minneapolis: Walker Art Center; Minnesota Institute of the Arts, 1972.

Wallace, William J. "Post-Pleistocene Archeology, 9000 to 2000 B.C." In *Handbook of North American Indians,* edited by William C. Sturtevant. Vol. 8, *California,* edited by Robert F. Heizer. Washington, D.C.: Smithsonian Institution, 1978.

Wardwell, Allen. *Tangible Visions: Northwest Coast Indian Shamanism and Its Art.* New York: Monacelli Press; Corvus Press, 1996.

Warner, John Anson. "The Individual in Native American Art: A Sociological View." In *The Arts of the North American Indian,* edited by Edwin L. Wade. New York: Hudson Hills Press, 1986.

Waselkov, Gregory A. "Indian Maps of the Colonial Southeast." In *Powhatan's Mantle,* edited by Peter H. Wood, Gregory A. Waselkov, and M. Thomas Hatley. Lincoln: University of Nebraska Press, 1989.

Waters, Frank. *Book of the Hopi.* New York: Penguin Books, 1963.

Webb, Malcolm C. "Functional and Historical Parallelisms between Mesoamerican and Mississippian Cultures." In *The Southeastern Ceremonial Complex: Artifacts and Analysis,* edited by Patricia Galloway. Lincoln: University of Nebraska Press, 1989.

Webber, Alika Podolinsky. "Ceremonial Robes of the Montagnais-Naskapi." *American Indian Art Magazine* 9 (winter 1983).

Wedel, Waldo R. "An Introduction to Pawnee Archeology." Smithsonian Institution, Bureau of American Ethnology Bulletin 112. Washington, D.C.: U.S. Government Printing Office, 1936.

——*Central Plains Prehistory: Holocene Environments and Culture Change in the Republican River Basin.* Lincoln and London: University of Nebraska Press, 1986.

Weills, Susan. *The Mississippi Choctaw: Their Own Story.* Transcripts from videotaped interviews with members of the Mississippi Band of Choctaw Indians, 1984.

White, Richard. *The Middle Ground: Indians, Empires, and Republics in the Great Lakes Region, 1650–1815.* Cambridge, Eng.: Cambridge University Press, 1995.

Whiteford, Andrew Hunter. "Fiber Bags of the Great Lakes Indians." *American Indian Arts Magazine* 2, no. 3 (1977).

Whiteford, Andrew Hunter, Stewart Peckham, Rick Dillingham, Nancy Fox, and Kate Peck Kent. *I Am Here.* Santa Fe: University of New Mexico Press, 1989.

Whitehead, Ardelle Coleman. "Lovena." *Scottsdale Scene,* November 1983.

Whitehead, Ruth Holmes. *Elitekey.* Halifax: Nova Scotia Museum, 1980.

——"I Have Lived Here Since the World Began." In *The Spirit Sings.* Toronto: McClelland and Stewart; Alberta: Glenbow Museum, 1988.

——*Six Micmac Stories.* Halifax: Nimbus Publishing; Nova Scotia Museum, 1992.

——*Stories from the Six Worlds: Micmac Legends.* Halifax: Nimbus Publishing, 1988.

Widdison, Jerold G. *The Anasazi: Why Did They Leave? Where Did They Go?* New Mexico: Southwest Natural and Cultural Heritage Association, 1991.

Willey, Gordon R. *An Introduction to American Archaeology.* Vol. 1. Englewood Cliffs, N.J.: Prentice-Hall, 1966.

Williams, Paul. "Reading Wampum Belts as Living Symbols." *Northeast Indian Quarterly* (spring 1990).

Williams, Terry Tempest. *Pieces of White Shell.* Albuquerque: University of New Mexico Press, 1994.

Wilmsen, Edwin N., and Frank H. H. Roberts, Jr. "Lindenmeier, 1934–1974: Concluding Report on Investigations." In *Smithsonian Contributions to Anthropology,* no. 24. Washington, D.C.: Smithsonian Institution Press, 1978.

Wilson, Lee Anne. "Bird and Feline Motifs on Great Lakes Pouches." In *Native North American Art History,* edited by Zena Pearlstone Mathews and Aldona Jonaitis, Palo Alto, Calif.: Peek Publications, 1982.

Wissler, Clark. "Blackfoot Bundles." In *Anthropological Papers of the American Museum of Natural History,* vol. 7, 1912.

——"Some Protective Designs of the Dakota." In *Anthropological Papers of the American Museum of Natural History,* vol. 1, 1907.

Wolfe, Cheri L. "Something Tells Me This Feeling about the Land Is the Old Choctaw Religion." In *Persistence of Pattern,* edited by Patti Carr Black. Mississippi Department of Archives and History, 1987.

Wood, W. Raymond, and Margot Liberty, eds. *Anthropology on the Great Plains.* Lincoln and London: University of Nebraska Press, 1980.

Woodard, Charles L. *Ancestral Voice: Conversations with N. Scott Momaday.* Lincoln and London: University of Nebraska Press, 1991.

Woods, Wilton. "American Indians Discover Money Is Power." *Fortune,* April 19, 1993.

Woodward, Arthur. *Navajo Silver.* Flagstaff, Ariz.: Northland Press, 1975.

Wooley, David. *Eye of the Angel.* Northampton, Mass.: White Star Press, 1990.

Wormington, H. M. *Prehistoric Indians of the Southwest.* Denver: Denver Museum of Natural History, 1975.

Wray, Charles F. *Manual for Seneca Iroquois Archeology.* Rochester, N.Y.: Cultures Primitive, 1973.

Wray, Charles F., and Harry L. Schoff. "A Preliminary Report on the Seneca Sequence in Western New York, 1550–1687." *Pennsylvania Archaeologist* 23, no. 2 (1953).

Wright, Robin K. *A Time of Gathering.* Seattle: Burke Museum; University of Washington Press, 1991.

Wyatt, Gary. *Spirit Faces.* Vancouver: Douglas & McIntyre, 1994.

Yeadon, David. "California's North Face." *National Geographic* 184, no.1 (July 1993): 48–79.

Young, David C. *One with the Earth.* Institute of American Indian Arts, 1994.

Younger, Erin. *Loloma: A Retrospective View.* Phoenix: Heard Museum, 1978.

Zachary, Robert. *Introduction to Southwestern Indian Jewelry and Turquoise.* Albuquerque: Indian Arts & Crafts Association, 1988.

Zimmerman, Larry J. *Native North America.* Boston: Little, Brown, 1996.

INDEX

PHOTOGRAPH AND ILLUSTRATION CREDITS

The author and publisher wish to thank the museums, galleries, and private collectors, named in the illustration captions, who supplied photographs for reproductions. Additional photograph credits are listed below. Abbreviated citations are given for those images reprinted from book sources; please see the bibliography for complete reference information. Numbers refer to illustration numbers, unless otherwise indicated.

Anthropological Archives, National Museum of Natural History, Smithsonian Institution, Washington D.C.: 38, 50, 73, 86, 94, 338, 347, 357, 398, 444, 452, 463, 522, 557, 573, 581, 582, 589, 594, 717, 737, 738

The Arctic Studies Center, Smithsonian Institution, Washington D.C.: 19, 21, 81, 89, 91, 92, 97, 103, 109, 110, 111, 122, 202, 203, 210, 837

Richard Baumgardner: 758

George Blake: 920

Tim Boehning: 323

Keith Brantley: 396

J. J. Bratley: 523

Hillel Burger: 52, 59, 76, 134, 154, 156, 191, 193, 196, 235, 240.2, 240.22, 240.39, 240.41, 268, 307, 311, 312, 352, 376, 377, 403, 414, 426, 427, 454, 564, 567, 653, 714, 721, 724, 725, 727, 729, 796, 804, 823, 826, 834, 839, 908, 910, 911, 968, 1072, 1079, 1096, 1193

Eduardo Calderón: 733

Courtesy Canadian Museum of Civilization: 178–82

Fred Chapman: 476

Chromogenics: 879, 917, 918

James Cook: 639

Lawrence Cook: 239, 320

Edward Curtis: 141, 807, 893

Lea Cyr: drawings, page 589. Reprinted from *The History of Beads*, by Lois Sherr Dubin, published by Abrams, 1987.

William B. Dewey: 905

Jay DiLorenzo: 240.38, 710, 711, 713, 715, 716, 718, 719

Tanja Dorsey: 1174, 1192

After Drew 1982, p. 73, reproduced courtesy Hancock House Publishers Ltd.: 832

Lois Dubin: 40, 42, 49, 350, 405, 406, 407, 408, 415, 437, 457, 458, 459, 460, 461, 467, 468, 470, 472, 473, 477, 478, 497, 507, 531, 536, 579, 580, 621, 704, 705, 707, 708, 709, 746, 904, 1124 (top), 1158, 1159, 1161, 1162, 1166, 1167, 1170, 1173, 1175, 1176, 1178, 1179, 1180, 1181, 1182, 1184, 1185, 1187, 1188, 1189, 1190

Tom Fields: 455, 456, 1218

Harry Foster: 178, 179, 180, 181, 182

Brian Fox: 286, 288

Reproduced from Frederickson 1980, plate 199, with permission from the National Museums of Canada: 319

Karen Furth: 74, 218, 232, 240.6, 261, 269, 270, 274, 328, 329, 330, 331, 334, 335, 340, 348, 351, 378, 386, 538, 543, 655, 720, 755, 785, 789, 798, 1160, 1177, 1183, 1191

Lynton Gardiner: 240.46, 662, 1027, 1040

Rip Gerry: 647

Michael Guran: seasonal rounds, pages 63, 112, 152, 193, 238, 312, 348, 380, 427, 460

John Griebsch: 289

Bobby Hansson: 224, 290, 418, 563, 1093, 1193

O. C. Hastings: 806

Karen Hayes: 9, 1071, 1127

Murrae Haynes: 1095

The Heard Museum, The Fred Harvey Fine Arts Collection: 597, 664, 989, 998 (left), 1003 (except top row: 1, 2), 1004, 1005 (left, right), 1006, 1007 (all excluding bottom right), 1008, 1009 (3), 1046, 1053 (1, 2), 1169; C. G. Wallace Collection: 939, 973, 988, 1012, 1053 (right), 1056, 1057, 1062, 1066, 1067, 1082

Bruce Hucko: 1073, 1074, 1115·

After Hudson and Underhay, 1978, figure 18, redrawn with permission of Santa Barbara Museum of Natural History: 905 (star-map drawings)

Jerry Jacka: 952, 969

Paul Jones: 30, 31, 55, 56, 57, 62, 65, 70, 75, 240.5, 240.20, 240.29, 240.30, 240.31, 240.40, 240.43, 245, 277, 313, 332, 337, 339, 356, 417, 494, 495, 501, 502, 503, 504, 505, 516, 517, 519, 524, 527, 535, 541, 545, 547, 548, 549, 550, 566, 569, 571, 583, 587, 588, 590, 591, 592, 593, 595, 596, 600, 601, 602, 603, 604, 614, 625, 628, 631, 638, 640, 658,

734, 741, 930, 935, 938, 940, 943, 944, 946, 947, 948, 953, 954, 955, 956, 957, 958, 959, 960, 961, 962, 963, 965, 966, 967, 972, 974, 984, 985, 987, 991, 993, 995, 996, 997, 1016, 1018, 1030, 1041, 1042, 1046, 1049, 1084, 1091, 1098, 1102, 1106, 1116, 1121, 1128, 1129, 1131, 1132, 1138, 1145, 1146, 1147, 1148, 1149, 1151, 1163, 1165, 1186, 1214, 1215, 1216

Earl Kage: 287

Reproduced from *Kao gu xue bao*, 1988: 14

S. Kuzuharu: 20

Courtesy Armand Labbé: 940, 942

Jean LeGwin: map design and production, pages 30–31, 64–65, 114–15, 154–55, 242–43, 314–15, 350–51, 382–83, 428–29, 462–63, 550–51

Rob Levine: drawings and diagrams, pages 171(5), 188, 199, 233, 280, 377, 438, 444, 507

Bill McLennan: 774, 787, 828, 830, 835, 836, 840, 841, 842, 843, 844, 846, 847, 848, 850, 851, 852, 853, 854, 855, 856, 858, 859, 860, 861, 862, 863, 864, 866, 867, 872, 874

Dick Meier: 881, 886, 887, 889, 890, 993

Trevor Mills: 829, 845, 849, 857, 865, 868, 869, 870, 871, 873, 875

Billy Moore: 32, 353, 897

Bernard Moosbrugger: 17

David Mort: 12

Paul Myers: 950

Courtesy of the National Museum of Natural History, Smithsonian Institution, Washington D.C. From the SITES exhibition, "Crossroads of Continents: Cultures of Siberia and Alaska": 106, 124, 144, 149, 186, 204, 205, 775, 776, 777, 778, 799, 824

Natural History Museum of Los Angeles County. Lost and Found Traditions Collection, a gift of the American Federation of Arts, made possible by the generous support of the American Can Corporation, now Primerica: 224, 290, 418, 563, 1093, 1193

Otto Nelson: 34, 206, 240.24, 240.26, 241, 242, 244, 245, 657

Mark Nohl: 82, 96, 114, 183, 208, 818

Sean O'Neil: 794, 816, 1195

Eberhard Otto: 1, 45, 100, 250, 251, 253, 421, 435, 773, 790, 793, 808, 811, 812, 813

Ann Parker: 980, 981

Reproduced from Philip Phillips and James A. Brown. *Pre-Columbian Shell Engravings from the Craig Mound at Spiro, Oklahoma.* Vol. 2. Cambridge: Peabody Museum Press. Copyright 1975 by the President and Fellows of Harvard College: 1064

George Post: 922, 923, 924, 925, 929

Public Records Office, Image Library CO 700/North America: 371

John Ratzloff: 247, 419, 420, 1212

A. B. Regan Lab Inc.: 646

Lloyd Rule: 22, 58

Claude Sandell, Sandell Commercial Photo: 240.42, 642, 656, 666, 668, 672, 673, 674, 675, 676, 677, 678, 681, 682, 683, 684, 685, 686, 687, 689, 690, 691, 692, 693, 694, 695, 696, 698, 699, 700, 701, 702, 703, 722, 723, 740, 743, 744, 747, 749, 751, 752, 753, 754, 759, 760, 761, 762, 763, 764, 767, 1168

Polly Schaafsma: 903

Schenck and Schenck: 37, 552, 554, 555, 576, 578, 888, 891, 894, 899, 916, 1036

Fred Schoch: page 1; 8, 48, 54, 139, 145, 146, 147, 150, 163, 164, 219, 220, 240.47, 309, 379, 428, 480, 498, 584, 585, 586, 650, 652, 782, 783, 791, 802, 820, 821, 838, 877, 878, 909

Debra Schuler-Murray: 1153

The Silver Image: 739, 756, 769

Reproduced from Smithsonian Institution, Bureau of American Ethnology, Second Annual Report, 1880–81, plate 10: 1065; plate 29: 298 (1–4); plate 61: 381; Ninth Annual Report, 1887–88, figure 97: 90; Eighteenth Annual Report, 1896–97, figure 15: 85; plate 93: 185; Bulletin 137, 1946, plate 80: 399

Richard Spas: 934, 979, 994, 1017, 1034, 1054, 1055, 1080, 1124

Simon Spicer: 615, 1210

Vilhjálmur Stefánsson: 138

Ulli Steltzer: 786

Jim Stewart: 46, 471, 474, 475, 479, 530, 542, 641

George Swinton: 99

V. Tagland: 78

Reproduced from Tepper 1994, plate 27, with permission of the Canadian Museum of Civilization: 772.

Togashi: page 4, endpapers, page 589; 3, 4, 7, 11, 15, 23, 28, 29, 36, 41, 51, 60, 61, 63, 64, 66, 67, 68, 69, 71, 72, 80, 83, 87, 88, 93, 98, 101, 102, 104, 105, 112, 116, 117, 119, 120, 125, 126, 127, 129, 130, 131, 132, 133, 135, 140, 142, 143, 151, 157, 167, 168, 169, 170, 171, 172, 173, 174, 175, 177, 184, 187, 188, 189, 190, 192, 197, 209, 222, 226, 229, 230, 232, 236, 238, 240.3, 240.11, 240.12, 240.14, 240.15, 240.16, 240.17, 240.18, 240.19, 240.23, 240.25, 240.27, 240.28, 240.32, 240.33, 240.34, 240.35, 240.37, 240.44, 240.45, 243, 246, 248, 249, 254, 259, 262, 263, 264, 267, 271, 273, 283, 291, 292, 293, 294, 295, 296, 297, 299, 300, 301, 302, 304, 310, 314, 318, 322, 324, 325, 326, 327, 336, 341 (bottom), 342, 343, 344, 345, 349, 354, 355, 358, 359, 360, 362, 367, 368, 372, 373, 374, 380, 382, 383, 384, 385, 387, 388, 390, 391, 392, 395, 402, 404, 409, 410, 411, 412, 413, 423, 424, 429, 432, 433, 434, 438, 439, 440, 441, 443, 446, 447, 448, 449, 450, 451, 453, 462, 465, 466, 481, 483, 484, 485, 486, 487, 488, 489, 490, 491, 492, 493, 496, 510, 511, 512, 513, 514, 515, 518, 525, 526, 529, 532, 534, 539, 544, 556, 560, 572, 574, 575, 577, 597, 607, 609, 610, 616, 618, 626, 627, 629, 630, 632, 633, 634, 635, 636, 637, 643, 644, 648, 649, 651, 660, 661, 663, 664, 679, 680, 688, 706, 712, 742, 745, 748, 750, 757, 766, 779, 784, 792, 795, 797, 805, 810, 815, 817, 880, 882, 883, 884, 885, 892, 896, 900, 901, 902, 906, 907, 912, 915, 919, 921, 926, 927, 928, 931, 932, 936, 937, 939, 942, 949, 970, 971, 973, 975, 976, 977, 978, 982, 983, 986, 988, 989, 990, 992, 998, 999, 1000, 1001, 1002, 1003, 1004, 1005, 1006, 1007, 1008, 1009, 1010, 1011, 1012, 1013, 1014, 1015, 1019, 1020, 1021, 1022, 1023, 1024, 1025, 1026, 1028, 1029, 1031, 1032, 1035, 1037, 1039, 1045, 1047, 1048, 1050, 1051, 1052, 1053, 1056, 1057, 1061, 1062, 1063, 1066, 1067, 1068, 1069, 1070, 1076, 1077, 1082, 1083, 1085, 1086, 1087, 1088, 1089, 1092, 1094, 1097, 1099, 1100, 1103, 1104, 1105, 1107, 1108, 1109, 1110, 1111, 1112, 1113, 1114, 1117, 1118, 1119, 1120, 1122, 1123, 1125, 1130, 1133, 1134, 1135, 1136, 1137, 1139, 1140, 1141, 1142, 1143, 1152, 1164, 1169, 1171, 1172, 1196, 1197, 1198, 1199, 1201, 1204, 1206, 1207, 1208, 1209, 1211, 1213, 1217, 1219

Tom Travis, Travis Studio: 1200

Courtesy of the United States Department of the Interior, Indian Arts and Crafts Board, Southern Plains Indian Museum: 599, 605, 606, 608, 617, 619, 623, 624; from Ellison 1976, 8–9: map, page 290.

Lucille Waters: 665

Reproduced from Woodward 1971, plate 11: 1044

Photograph Negative Numbers

In cases where negative numbers are unavailable, artifact numbers are given (labeled *art*).

5 (CMC S77-1849); 34 (LCUSZ 62-101161); 35 (CMC *art*.237.111-B-594); 44 (CMC 73-12911); 77 (42403); 78 (CMC S71-3820); 94 (3846); 115 (CMC J5989); 123 (CMC S90-3114); 141 (LC-US262-74130); 152 (CMC 18704); 153 (CMC 42535); 155 (CMC 20282); 158 (CMC S87-121); 159 (CMC 51678); 162 (PA 53606); 165 (CMC S95-24811); 176 (CMC S92-5135); Courtesy Canadian Museum of Civilization 178-182; 194 (CMC 74-8266); 195 (CMC 76-793); 198 (CMC 95-7); 201 (CMC *art*.Ja Vg 2:93-101); 207 (CMC S95-24217); 215 (S8-137221); 227 (CMC S95-24216); 234 (CMC 74-91); 237 (S75-497); 240.4 (CMC *art*.111-C-512); 252 (CMC S95-24002); 258 (CMC 80-6675); 260 (C-038948/C-043504); 275 (A110046); 276 (A110012); 286 (RM 3181); 287 (RM 3125-15); 288 (RM 3183); 289 (RM 2932); 305 (CMC S81-4335); 333 (RM 3180); 338 (74-8344); 347 (56928); 357 (44352); 375 (H5234); 393 (P12149); 398 (57081); 425 (A-364); 430 (A110027); 444 (T-13409); 452 (47747-A); 463 (617); 499 (P-945-3719); 508 (2139); 557 (1285); 558 (CMC *art*.V-B-413); 562 (NA.202.598); 581 (3234A); 582 (57074); 594 (3189-B7); 598 (N34997); 646 (70.1/36); 717 (1553); 728 (CMC *art*.S94-36777); 730 (CMC 23575); 731 (CMC 23205); 732 (CMC 27000); 735 (USZ62-64853); 737 (3073-B-68); 755 (56805); 770 (CMC 23589); 780 (CMC 62607); 781 (CMC 62606); 800 (CMC *art*.VII-B-87); 801 (87-258); 803 (CMC *art*.592-4320); 806 (11577); 814 (USZ 44194); 831 (338691); 833 (A9181); 875 (518496); 893a b (LC USZ62-101261); 1058 (8742); 1075 (T-162); 1155 (P.69.86)

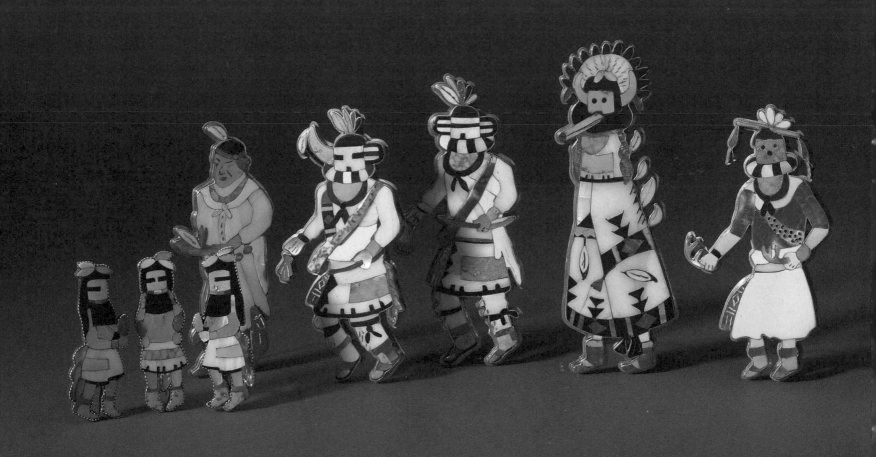